KT-488-930

VISUAL ARTS	PERFORMING ARTS	LITERATURE	MUSIC	DATE AD
Sun Pyramid, Teotihuacan, Mexico	Latin dramas of Seneca recited	Ovid, *Metamorphoses*		1–99
Column of Marcus Aurelius, Rome Amarāvatī stūpa, Madras	Roman theatre built at Verulanium (St. Albans)	Juvenal, Roman poet Apuleius, Roman novelist	early lute in China Chinese octave divided into 60 notes	100–199
Coptic art, Egypt, flourishes	*Nāţyaśastra* Indian treatise on theatre		*Nāţyaśastra* Indian treatise on music	200–299
	burlesque and mime, Rome		hymn-singing evolves	300–399
Basilica, Sta Maria Maggiore, Rome	Kālidāsa's courtly drama, *Śakuntalā*, India	Tao Qian, Chinese poet	drums and wind instruments, Peru	400–499
Church of Hagia Sophia, Constantinople	itinerant dancers in Europe	Imru al-Qays, Arab poet	Gregorian church music gradually appears	500–599
porcelain invented in China building of Mahabalipuram temples, India	recitative and arias developed in Chinese drama	great lyric poetry of Tang dynasty, China Cædmon, *Song of Creation*, England	Celtic plucked instruments develop Indonesian gamelan	600–699
Umayyad palace, Khirbat al-Mafjar	Bhavabuti, Indian dramatist	Chinese lyric poetry *Beowulf* epic, England	Japanese lute wind organs in Europe	700–799
Book of Kells, Ireland The Great Mosque of Córdoba, Spain Mississippi valley culture, North America	choral drama develops in the West	*Hildebrandslied*, Old High German poem first Arabic version of *A Thousand and One Nights*	development of ragas in Indian classical music earliest surviving (neumatic) notation	800–899
Nayin Mosque, Iran Fatimid style in Islamic architecture Gero Crucifix, Cologne Monastery Church, Cluny	Easter play, dialogue of the Three Maries, performed in church liturgical drama flourishes in the West	*The Exeter Book*, English poems Firdausi, Persian poet	court music flourished in Japan beginnings of organum, earliest form of Western polyphony	900–999
Golden Age of Buddhist art, Pagán, Burma St Sophia Cathedral, Novgorod, Russia Santiago de Compostela Cathedral, Spain Palace city of Great Zimbabwe Durham Cathedral begun	*dengaku* dance, Japan tournaments and pageantry develop in Europe *skomorokhi* mummurs and puppeteers, Russia	Hindi verse romances celebrate Rajput chivalry Murasaki, *The Tale of Genji*, Japan Su Dongpo, Chinese poet and painter Ibn Gabirol's poems in Hebrew and Arabic Yehuda Halevi, Hebrew poet in Spain	organ with multiple pipes, Winchester Bardic music in Ireland and Wales sight-reading practised at Pomposa Monastery, Ravenna solmization in music, introduced by d'Arezzo	1000–1099
second era of Maya civilization Yoruba brass and terra-cotta sculpture, Nigeria Angkor Wat, Cambodia Church of St Denis, Paris: beginnings of Gothic style	earliest recorded English miracle plays *Jeu de St Nicholas* play by Jehan Bodel, at Arras, France	*Song of My Cid* in Spain first *renga* poetry in Japan *Le Chanson de Roland*, France Ibn al Farid, Arab poet	troubadour and *trouvère* music, France earliest *Minnelieder*, Germany Ars Antiqua: Notre Dame polyphony	1100–1199
Master of Naumburg sculptures, Germany Palace of the Alhambra, Spain Rheims Cathedral, France Zhao Mengfu, Chinese painter	*jongleurs* in France mystery plays in Europe variety theatre flourishes in China Adam de la Halle, 'Jeu de Robin et Marion'	Eschenbach, *Parzival* *Kokinshu*, anthology of Japanese poetry *Roman de la Rose* celebrates courtly love Icelandic *Prose Edda* Sa'di, Persian poet, 'The Fruit Garden'	'Carmina Burana' Latin monastic songs, Germany beginnings of the motet The Summer Canon ('Sumer is icumen in') earliest multi-part Passion (the *Gros Livre* of the Dominicans)	1200–1299
Ni Zan, Chinese painter Giotto, frescoes, Padua Doge's Palace, Venice Charterhouse, London Golden Pavilion, Kyoto	*The Harrowing of Hell*, English miracle play Gao Ming, *The Story of the Lute*, China No drama, Japan	Dante, *Divine Comedy* Boccaccio, *Decameron* Petrarch, first sonnets Chaucer, *The Canterbury Tales*	beginnings of Ars Nova music Machaut, *Messe de Notre Dame* Keyboard tablature, Europe	1300–1399

THE ARTS

THE ARTS

Volume Editor

John Julius Norwich

OXFORD

OXFORD UNIVERSITY PRESS

NEW YORK MELBOURNE

1990

Oxford University Press, Walton Street, Oxford OX2 6DP
Oxford New York Toronto
Delhi Bombay Calcutta Madras Karachi
Petaling Jaya Singapore Hong Kong Tokyo
Nairobi Dar es Salaam Cape Town
Melbourne Auckland
and associated companies in
Berlin Ibadan

Oxford is a trade mark of Oxford University Press

Published in the United States
by Oxford University Press, New York

© *Oxford University Press 1990*

All rights reserved. No part of this publication may be reproduced,
stored in a retrieval system, or transmitted, in any form or by any means,
electronic, mechanical, photocopying, recording, or otherwise, without
the prior permission of Oxford University Press

British Library Cataloguing in Publication Data
Oxford illustrated encyclopedia.
Vol. 5, The arts.
1. Encyclopedia in English
I. Judge, Harry, 1928- II. Norwich, John Julius, 1929-
032
ISBN 0-19-869137-8

Library of Congress Cataloging in Publication Data
Oxford illustrated encyclopedia of the arts / volume editor, John
Julius Norwich.
1. Arts—Dictionaries. I. Norwich, John Julius, 1929-
II. Title: Illustrated encyclopedia of the arts.
NX70.094 1990 700'.3—dc20 89-71125
ISBN 0-19-869137-8

Text processed by the Oxford Text System
Printed in Hong Kong

Foreword

All life, whatever form it may take and wherever it may be found, is primarily impelled by two fundamental instincts. The first is survival; the second reproduction. Man alone recognizes a third necessity. Its roots lie in remote prehistory when early hunters, in all probability performing a supernatural ritual designed to bring success to the hunt, painted images of animals on the walls of caves. It was only much later that the skilled professional artist emerged. Similarly, music and dance were at first inextricably linked with myth; out of the simple drum beat and reed pipe has developed, over many centuries and in different parts of the world, a whole spectrum of music of profound rhythmic and melodic intricacy. Along with music came religious incantations and the telling of stories and the discovery that, by adopting a heightened rhythmical language, the words became more powerful and easier to remember. With that discovery, drama and poetry were born. And so—slowly, uncertainly, and by fits and starts—early man and woman began to create art. Since then in every one of the cultures that have been established over the centuries and around the world, the aesthetic instinct has extended the boundaries of our perception.

It is the myriad forms of its expression and the principal milestones that have marked its path that form the subject of this volume. Its compilation has presented at once a huge task and a formidable challenge: to describe, and where possible, to illustrate the artistic achievement of all the main civilizations of the world from their first beginnings to the present day, has been no easy task. Much careful planning has gone into the selection of entries to be covered. For example, a decision had to be made whether more space should be allocated to creators than performers, and we chose to include only those performers who have been particularly significant in furthering the development of the art-form, whether music, dance, or drama, with which they are connected. This has allowed a more detailed and global coverage of the art-forms themselves and the inclusion of the art and architecture, theatre, dance, music, literature, and applied arts of other cultures. We were next faced with the contentious issue of the kind of coverage that should be given to each nation. Our policy has been to reach beyond the English-speaking and European cultures towards a global view of the arts. Where we believed the literature of a nation to be unfamiliar but substantial (for instance that of the Chinese), we have included the subject under an introductory entry that leads the reader through cross-references to individual authors and schools. Conversely, modern authors writing in English or French are familiar enough to be found under their own names and thus are not presented in an introductory entry. French titles have been kept in the original; those of other languages have been translated.

From all that has been said above it will already be clear—even to those who have not yet had an opportunity to study the following pages in detail—that this volume, like its fellows in the *Oxford Illustrated Encyclopedia* series, embraces an extraordinarily wide range of knowledge. To cover it satisfactorily, the editors have been obliged to enlist the services of over 120 individual advisers and contributors, all acknowledged experts in their fields. I should like to thank every one of them for the sympathetic understanding and unfailing good humour with which they have accepted all our requests for the last-minute entries, expansion, abridgements, clarifications, alterations, and supplementary references that are inseparable from any editorial work on a project of this scale; and also, on a note more personal but none the less sincere, for the amount that they have taught me over the five years that I have had the privilege of being their collaborator. The work has been an education in itself, and I would not have missed it for the world.

Finally, I must record my gratitude to Bridget Hadaway, Christopher Riches, and all those other members of Oxford University Press, who, more than anyone else, were really responsible for putting this book together. Without their advice and assistance, to say nothing of their enthusiastic co-operation and support, I myself should have foundered long ago. It is thanks above all to their dedication and sheer hard work that we have won through to the end; and it is their names, far more than my own, that should adorn the title-page.

JOHN JULIUS NORWICH

CONTRIBUTORS

Dr Glenda Abramson

Dr Janet Adshead

Dr Yasemin Aysan

Dr Christopher Baldick

Dr A. D. Best

Professor John Blacking

David Blackwell

T. Richard Blurton

Professor Gordon Brotherston

Dr K. Brusack

Ian Chilvers

Peter Colvin

Dr David Culpin

Professor G. Cushing

Dr A. R. Deighton

Dr Michael S. Dillon

J. V. Dugdale

Marian Ellingworth

Professor Simon Evans

Dr David Fallows

Dr P. Fernandez-Armesto

Rosemary M. Flanders

Dr Colin Ford

Professor Anthony Forge

Peter Found

Dr Janet Garton

John Guy

Bridget Hadaway

Patricia Herbert

Dr Dunja Hersak

David R. Howitt

Dr Rosemary Hunt

Michael Hurd

Dr Alan Jones

Dr J. A. Jones

Dr Ahuviah Kahane

Dr Dovid Katz

Michael Kennedy

Karel Kyncl

Dr June Layson

Dr E. A. McCobb

Professor J. J. Macklin

Judith Mackrell

Jeremy Montagu

Peter Morgan

Michael Morrow

Michael A. Morrow

Dr Roger Neich

Professor J. Peterkiewicz

Jane Portal

Dr B. J. Powell

Belinda Quirey

Andrew Read

Felicity Rhodes

Christopher Riches

Dr Christopher Robinson

Nigel Roche

Judith Ryan

Molly Scott

Graham Shaw

Professor G. S. Smith

Andrew Solway

Jennifer Stringer

Dr Donald Tayler

Dr Laurie Thompson

William Toye

David Turner

Abdallah al-Udhri

Dr Maria Unkovskaya

Guido Waldman

Dr Michael Winterbottom

Dr Simon Wright

General Preface

The *Oxford Illustrated Encyclopedia* sets out, in its eight independent but related volumes, to provide a clear and authoritative account of all the major fields of human knowledge and endeavour. Each volume deals with one such major field and is devoted to a series of entries arranged alphabetically and furnished with illustrations. One of the delights of the Encyclopedia is that it serves equally those who wish to dip into a particular topic (or settle a doubt or argument) and those who seek to acquire a rounded understanding of a major field of human knowledge.

The first decision taken about the Encyclopedia was that each volume should be dedicated to a clearly defined theme—whether that be the natural world, or technology, or the arts. This means that each volume can be enjoyed on its own, but that when all the volumes are taken together they will provide a clear map of contemporary knowledge. It is not, of course, easy to say where one theme begins and another ends and so each volume Foreword must attempt to define these boundaries. The work will be completed with a full index to guide the reader to the correct entry in the right volume for the information being sought.

The organization within each volume is kept as clear and simple as possible. The arrangement is alphabetical, and there is no division into separate sections. Such an arrangement rescues the reader from having to hunt through the pages, and makes it unneccessary to provide a separate index for each volume. We wanted, from the beginning, to provide as large a number as possible of clearly written entries, since research has shown that readers welcome immediate access to the information they seek rather than being obliged to search through longer sections. The decision, which has been consistently applied, must obviously determine both the number and nature of the entries, and (in particular) the ways in which certain subjects have been divided for ease of reference. Care has been taken to guide the reader through the entries, by providing cross-references to relevant articles elsewhere in the same volume.

This is an illustrated encyclopedia, and the illustrations have been carefully chosen to expand and supplement the written text. They add to the pleasure of those who will wish to browse through these varied volumes as well as to the profit of those who will need to consult them more systematically.

Volumes 1 and 2 of the series deal respectively with the physical world and the natural world. Volumes 3 and 4 are concerned with the massive subject of the history of the world from the evolution of *Homo sapiens* to the present day. Volume 5 introduces the reader to the visual arts, music, theatre, film, dance, photography, and literature, and Volume 6, on technology, both historical and contemporary, provides a guide to human inventiveness. The last two volumes help to place all that has previously been described and illustrated in wider contexts. Volume 7 offers a comprehensive guide to the various ways in which people live throughout the world and so includes many entries on their social, political, and economic organisation. The series is completed by Volume 8, which places the life of our shared world in the framework of the universe, and includes entries on the origins of the universe as well as our rapidly advancing understanding and exploration of it.

I am grateful alike to the editors, advisers, contributors, and illustrators whose common aim has been to provide such a stimulating summary of our knowledge of the world.

HARRY JUDGE

A User's Guide

This book is designed for easy use, but the following notes may be helpful to the reader.

ALPHABETICAL ARRANGEMENT The entries are arranged in a simple letter-by-letter alphabetical order of their headings (ignoring the spaces between words) up to the first comma (thus **Scott, Sir Walter** comes before **Scottish-Gaelic literature**). When two entry headings are the same up to the first comma, then the entries are placed in alphabetical order according to what follows after the comma (thus **Rosetti, Christina (Georgina)**, comes before **Rosetti, Dante Gabriel**). Names beginning with 'St' are placed as though spelt 'Saint', so **St Denis** follows directly after **Saint-Exupéry**.

ENTRY HEADINGS Entries are usually placed after the key word in the title (the surname, for instance, in a group of names, or the title, for example, **Palestrina, Giovanni Pierluigi da; Absurd, Theatre of the**). The entry heading appears in the singular unless the plural form is the more common usage. When an entry covers a family of several related individuals, important names are highlighted in bold type within an entry.

ALTERNATIVE NAMES Where there are alternative forms of names in common use a cross-reference, indicated by an asterisk (*), directs the reader to the main headword: **Direct Cinema *cinéma vérité**. In the case of pseudonyms, the person appears under the name he or she is commonly identified by (thus **Le Corbusier**, not **Jeanneret, Charles-Edouard**). For Chinese names the pinyin romanization system has been used. Examples of pinyin use that may not be familiar include **Li Bai** (rather than **Li Po**) and **Beijing Opera** (rather than **Peking Opera**).

CROSS-REFERENCES An asterisk (*) in front of a word denotes a cross-reference and indicates the entry heading to which attention is being drawn. Cross-references in the text appear only in places where reference is likely to amplify or increase understanding of the entry being read. They are not given automatically in all cases where a separate entry can be found, so if you come across a name or a term about which you would like to know more, it is worth looking for an entry in its alphabetical place even if no cross-reference is marked. The limited space available has meant that some contributors to the arts have no biographical entry, but they are often covered in entries on the schools, movements, or art-form with which they are principally associated. Thus, for example, Jean-Luc Godard is covered in the entry for **Nouvelle**

Vague. In most cases cross-references are provided to indicate this. Again for reasons of space, many writers or artists could only be included in major entries (such as Alfonso Sastre under **Spanish literature**), so that you must look for them under the entry for their national literature or art.

ILLUSTRATIONS Pictures and diagrams usually occur on the same page as the entries to which they relate or on a facing page. The picture captions supplement the information given in the text and indicate in bold type the title of the relevant entry. Where a picture shows a work of art of which only one original exists (for example, a painting, sculpture, drawing, or manuscript), the caption concludes, wherever possible, by locating the work of art. Where multiple copies of an original exist (for example, printed books, engravings, or woodcuts), no location has been given, except sometimes in the case of rare items. The time-charts to be found on the endpapers provide easy-to-read information on major artistic developments from the earliest times to the present.

WEIGHTS AND MEASURES Both metric measures and their non-metric equivalents are used throughout (thus a measure of distance is given first in kilometres and then in miles). Large measures are generally rounded off, partly for the sake of simplicity and occasionally to reflect differences of opinion as to a precise measurement.

RELATIONSHIP TO OTHER VOLUMES This volume on the Arts is Volume 5 of a series, the *Oxford Illustrated Encyclopedia*, which will consist of eight thematic volumes (and an index). Each book is self-contained and is designed for use on its own. Further information is contained in the Foreword to this volume, which offers a fuller explanation of the book's scope and organization.

The titles in the series are:

Aalto, Alvar (1898–1976), Finnish architect, designer, sculptor, and painter. One of the most illustrious architects of the 20th century, Aalto was also a talented abstract sculptor and painter and an important furniture designer: more than anyone else he is responsible for Finland's high contemporary reputation in architecture and design. In the 1920s and 1930s much of his work was in the sleek vein of the *Modern Movement, but after World War II his style became more personal, original, and expressive. He used free plans and undulating walls, working extensively in wood. Brick was also a favourite material and in the latter part of his career he employed white marble for major cultural buildings, such as the Finlandia Concert Hall in Helsinki (1962–75). As a designer he is renowned as the inventor of bent plywood furniture.

Abbasid art, a term applied to art associated with the dynasty of caliphs that ruled the Muslim empire from 750 to 1258. The capitals of Baghdad (founded 762) and Samarra (founded 836) were centres of Arabic learning and culture, but little Abbasid art survives in good condition. The outstanding work of Abbasid architecture is the Great Mosque at Samarra (begun 848). This was the largest mosque ever built, and although much of it has disappeared, the enormous spiral minaret (a winding ramp leads to the top) still stands. Wall paintings excavated at Samarra, which show Persian hunting and banqueting themes, are the chief remains of pictorial art. Stimulated by Chinese imports, ceramics with lustre and blue-painted decoration were developed in the 8th and 9th centuries. Paper, introduced after c.750, was used for Korans, which after the 10th century often have painted frontispieces. (See also *Islamic art, *Islamic ceramics, and *Islamic decorative arts.)

Abbott, Berenice (1898–), US photographer. A student of Man *Ray in Paris, Abbott took revealing portraits of Ray's fellow artists. After her return to New York, she became an accomplished photographer of the American cityscape.

Aboriginal art and poetry, the visual and literary culture of the Aboriginal people of Australia. Aboriginal art, song, and dance transmit knowledge of the Dreaming—an eternal time when spirit ancestors created all living things, geographical features of the landscape, and the rationale for all life. A large variety of art-forms are, or were, in use by the Aborigines. The most important among these include cave and rock paintings and rock engravings. Today the indigenous art of Australia is limited to a very few areas, but traditionally Aborigines painted on the human body, on rock-surfaces, on the earth, on man-made objects, and on bark. Engraving was done on stone or wood, on shells or artefacts and even, in New South Wales, on trees. More unusual were the large figures which used to be made out of soil and branches on ritual occasions (South Australia), and the use of feathers and human blood as decorative materials. The Aborigines decorated many objects used in everyday life, such as paddles, spear-throwers, boomerangs, baskets, shields, and message-sticks. From 1970 onwards Aboriginal artists have adapted their ancient designs to introduced media of acrylic on canvas, print-making, batik, and pottery. Aboriginal poetry takes the form of song or chant, rather than spoken verse. Myths are told in sacred song-cycles and dramatic epics, dense with esoteric symbolism. Apart from magical and ritual songs, there is a rich tradition of stories transmitted orally.

Aboriginal music, the music of Australia's indigenous people, who migrated there from South-East Asia some 50,000 to 40,000 years ago. The music enshrines the Aborigines' centuries-old beliefs and customs, and is one of the oldest extant musics in the world. Unusually, it has developed in the absence of any scale-producing instrument, and in concept is derived almost entirely from the voice. As a consequence there is much variety of vocal sound, from hissing and wailing, through rhythmic, syllabic chanting, to elaborate melismatic singing (having many notes to a syllable). Melodies typically descend from a loud high pitch to a softer lower one; both microtonal (the division of a semitone into smaller units) and scalic structures are also found. Aboriginal music is primarily *isorhythmic; however, once overlaid with syncopations and other asymmetric *rhythms, the effect is extremely complex. The *didjeridu, an instrument demanding great virtuosity, provides a *drone and elaborate rhythms and timbres below a singer's melody, and also accompanies dances and other ceremonies.

abstract art, a term that can in its broadest sense be applied to any art that does not represent recognizable objects, but which is most commonly applied to those forms of *modern art in which the traditional European

Aboriginal art is predominantly symbolic, linking man with nature. This example is from Arnhem Land, the extreme northern part of Northern Territory in Australia. Painted on hardboard, it features snakes and emus, creatures associated with creation stories, as well as a human figure.

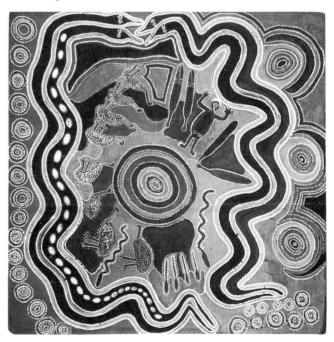

conception of art as the imitation of nature is abandoned. *Kandinsky is usually credited with having made the first entirely non-representational picture in about 1910, and since then modern abstract art has developed into many different movements and 'isms'. Two broad tendencies are, however, recognizable within it: the reduction of natural appearances to radically simplified forms, exemplified in the work of *Brancusi; and the construction of art objects from non-representational (often geometric) forms, as in Ben *Nicholson's reliefs.

Abstract Expressionism, a movement in US painting that developed in New York in the 1940s. The painters whose work is embraced by the term (among them *Pollock, *de Kooning, and *Rothko) varied considerably in style, being linked rather by a similarity of outlook, which called for freedom from traditional aesthetic and social values, and abandoned the naturalism that had dominated 20th-century US painting in favour of spontaneous freedom of expression. Traditional technical procedures were sometimes replaced by those of *action painting. Abstract Expressionism made a strong impact in several European countries in the 1950s and 1960s; it was the first American movement to do so, marking the fact that New York had replaced Paris as the world centre of avant-garde art.

abstract music *programme music.

Absurd, Theatre of the, theatrical movement originating in France in the early 1950s. It is characterized by outlandish characters, behaving without motivation, and preposterous (or non-existent) plots. There is also a pervading sense of futility and the constant deferral of hope. Its exponents include Eugène *Ionesco and Samuel *Beckett, the movement's most notable practitioner, whose *Waiting for Godot* (1953) is an aimless dialogue between two tramps. Outside France, other playwrights who have been classed as 'absurdist' for the illogical or unexpected action of their plays include Harold *Pinter, Edward *Albee, and Tom *Stoppard.

Abū Nuwās, al-Ḥasan ibn Hani' (c.750–c.814), Arab poet. It is not certain when he moved to Baghdad, but he was soon recognized as the leading poet of his time. His particular excellence lay in lyrical compositions: amatory pieces and, above all, wine poems, which he developed into a separate genre. His lyrics had immense influence on later generations, particularly in Muslim Spain.

Académie française, an organization founded by Cardinal Richelieu in 1635, its original purpose being to regulate the French language. To this end it compiled a dictionary (1694) which originally included only words acceptable in polite society. Now in its ninth edition, this continues to be an authoritative work. During the 17th century in particular the Académie also acted as an arbiter of literary norms and on one famous occasion was invited to pass judgement on Corneille's play *Le Cid.* Membership, though not confined to writers, is frequently conferred on eminent literary figures.

Academy of Motion Picture Arts and Sciences (AMPAS), organization formed in the USA in 1927

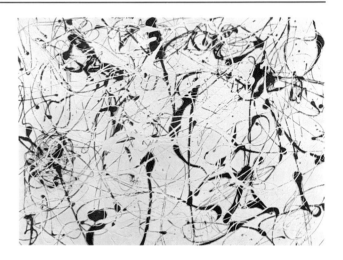

Number 23 (1948) by Jackson Pollock, the most famous exponent of **Abstract Expressionism**, is a fairly early example of the technique with which he is particularly associated: dripping or pouring paint on to the canvas or (as it is here) paper. He began using the technique in 1947, creating an intricate surface pattern through the rhythmical movements of his arm, improvising, but retaining a high degree of control over the picture's appearance. (Tate Gallery, London)

to improve artistic standards in the film industry and encourage co-operation in the technical and cultural fields. The Academy is best known for its annual Academy Awards, known as Oscars, for achievement in various categories, such as best film, best screenplay, and best director.

accordion, a *free-reed musical instrument strapped to the player's body. The right hand plays a short piano keyboard, or on some continental European models several rows of buttons. The left hand, which is responsible for the bellows, also controls rows of buttons which produce bass notes or chords. The more elaborate accordions also have 'register' keys, which can add higher and lower octaves. A simpler version, the melodeon, produces two notes from each key, one on pushing and the other on pulling the bellows, and has fewer bass and chord keys.

Achaemenid art *Persian art.

Achebe, Chinua (1930–), Nigerian novelist. His novels *Things Fall Apart* (1958) and *Arrow of God* (1964) are classic studies of traditional Ibo society undermined by colonialism. In *No Longer at Ease* (1960) and *A Man of the People* (1966) he directs his *satire against the corruption of modern Lagos.

acrostic, a poem in which the initial letters of each line can be read down the page to spell either an alphabet, a name (often that of the author, a patron, or a loved one), or some other concealed message.

acrylic paint (acrylic vinyl polymer emulsion paint), a synthetic paint combining some of the properties of *oil paint and *water-colour. It is soluble in water, quick-drying, and can be applied to virtually any painting base. The surface it produces can be matt or gloss, and in

texture it can range from thin washes to rich *impasto. It was first used by artists in the 1940s and the results it gives appear to be permanent.

acting, the depiction of a character in a dramatic production. Acting has probably existed from the earliest days of man, at first in the form of singing and dancing. The first acting about which much is known was in Ancient Greece, where actors participated in religious ceremonies. *Greek theatre flourished in the 5th and 4th centuries BC, the *chorus originally playing a prominent role. In the Roman theatre of the 3rd century BC onwards, women began to appear on stage; the status of actors declined as the *pantomimus was replaced by the *mime. With the rise of Christianity in Europe acting was forbidden, and had virtually ended by the 6th century. It survived in the Middle Ages through *jongleurs and other itinerants who performed on *booths, and in the *mystery plays. Professional actors emerged with the rise of secular drama in the *Elizabethan theatre, the *commedia dell'arte, and elsewhere. Professional actresses were first seen in Italy and did not appear in London until after the Restoration of 1660: before this time women's roles were taken by *boy actors' companies. It was, however, centuries before acting was considered respectable. Acting styles have varied throughout history, responding to changes in the design of *theatre buildings and to the introduction of *stage machinery, theatrical *costume, *make-up, and stage *lighting. But the biggest changes to the actor's art were produced by the advent of cinema and television, which also created vast new audiences. On the screen, where close-ups capture every nuance, acting is normally more restrained. The influence of the screen—together with modern theatre design (which made declamatory styles unnecessary) and techniques such as method acting (see *Stanislavsky), developed in New York and based on the personal exploration of the character—has encouraged the trend towards greater naturalism on the stage.

action painting, term describing a technique of painting in which the artist applies paint by random actions. The paint is dribbled, splashed, and poured over the canvas, which is often laid on the floor, rather than placed upright. The term was first used in 1952 to describe the approach to art of certain New York painters, notably Jackson *Pollock. Although it is often used as a synonym for *Abstract Expressionism, not all the artists associated with the latter can be considered action painters.

Adam, Robert (1728–92), British architect and designer, the outstanding member of a family of architects. Although he had a deep knowledge of Roman architecture, his work was never chilly or pedantic in the way of many other *Neoclassical architects. Indeed, although grand in effect and erudite in detail, his interiors have something of the gracefulness of *Rococo art. Much of his work consisted of the remodelling of existing houses (as at Syon House, Middlesex, 1762–9, and Kenwood House, London, 1767–9), but he also made some handsome contributions to Edinburgh's townscape (notably Charlotte Square, designed 1791) and he designed a number of romantic pseudo-medieval country houses in his native Scotland, in which the rugged exteriors contrast with the refined interiors; Culzean Castle in Strathclyde (1777–92) is the most famous example.

Adam de la Halle (Le Bossu) (c.1240–c.1288), French poet, musician, and innovator of the earliest French secular theatre. He is chiefly remembered for his dramatic works the *Jeu de la feuillée* (c.1262) and the *Jeu de Robin et Marion* (c.1283). The first of these is a satirical comedy giving a realistic picture of life in medieval Arras, while the second is a pastoral work. The term *jeu* means simply a dramatic work, though it was originally applied to the *mystery and miracle plays on religious themes out of

Masks were an essential part of the stylized type of **acting** practised in the Greek and Roman theatre. They made characters easily recognizable at a distance and enabled actors to change swiftly from one role to another. In this vase-painting, Roman actors are seen holding masks of characters such as Hercules and Dionysus (Museo Archeologica Nazionale, Naples)

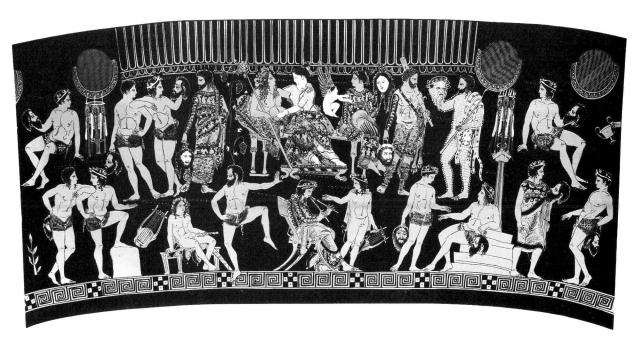

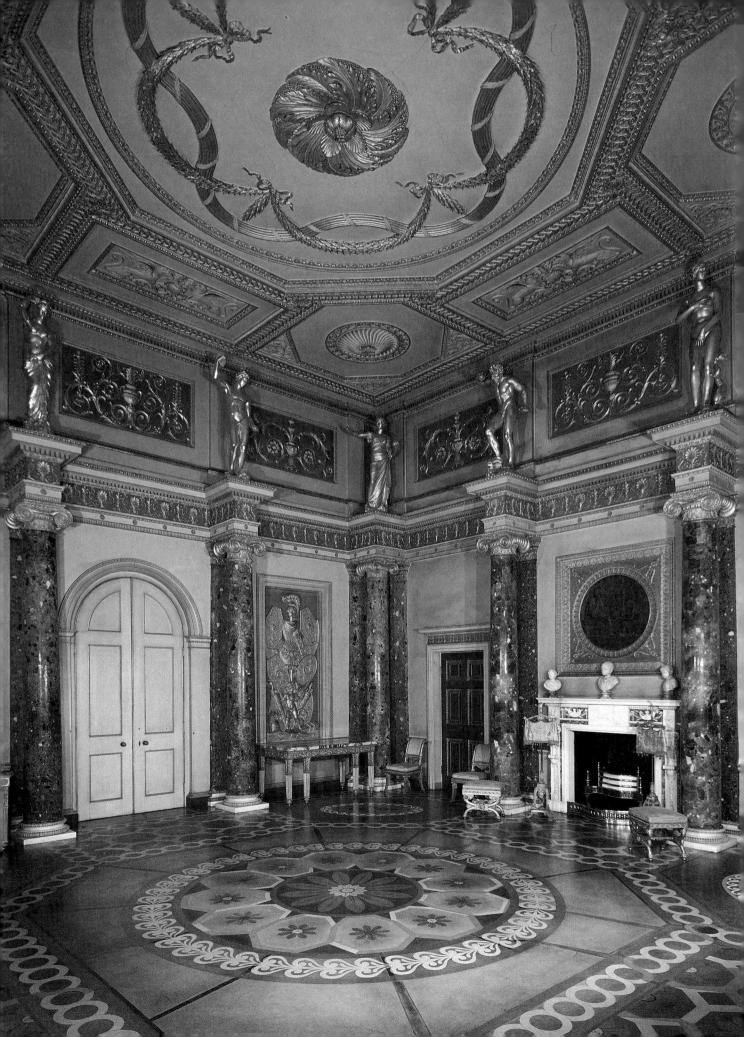

which French theatre developed. As a court musician he became famous for his polyphonic songs as well as for his motets and stage productions on topical themes, considered the predecessors of comic opera.

Adams, Ansel (1902–84), US landscape photographer. Adams is famous for his photographs of the scenery of the Yosemite National Park in California. His 'Zone System' for determining correct exposure, and his mastery of darkroom skills (he considered each negative a musical score and each print a performance), enabled him to make sharply detailed, dramatically large black-and-white prints: they are among the most highly sought after by any modern collector. (See also *Group f. 64.)

Adams, Henry (Brooks) (1838–1918), US historian, essayist, and novelist. After completing two novels, *Democracy* (1880) and *Esther* (1884), he travelled extensively, completed a nine-volume history of the USA under Thomas Jefferson and James Madison (1889–91), and wrote *Mont-Saint-Michel and Chartres* (1904) about medieval France. His autobiography, *The Education of Henry Adams* (1907), describes the failure of his education as preparation for the 20th-century 'multiverse'.

Addison, Joseph (1672–1719), English poet, dramatist, politician, and essayist. Addison's simple, unembellished prose style marked the end of the mannerisms and conventional classical images of the 17th century. He is noted for his contributions to the journal the *Tatler* (1709–11). In 1707 he wrote the libretto to the opera *Rosamond*, later set to music by Thomas Arne. His name is inseparably linked with Sir Richard *Steele as joint founder of the journal the *Spectator* (1711–12). His neoclassical drama *Cato* was produced with great success in 1713.

Ady, Endre (1877–1919), Hungarian poet. He shocked readers with *New Poems*, 1906, a mixture of eroticism, prophecy, Calvinist theology, radical politics, and desperate patriotism that was repeated in subsequent volumes and made him the focus of lasting controversy. He combined symbolic imagery and often brutal language with strict form. A lone figure, he heralded modernity in *Hungarian literature.

Aeneid *Virgil.

aeolian harp, a stringed musical instrument sounded by the wind, invented by Athanasius Kircher in 1650 in Rome, and popular into the 19th century. The commonest form is a long rectangular box, with a number of strings running along it, which is wedged in a partly open window so that the draught, passing across the strings, makes them vibrate and sound. Other versions were designed to hang in trees and other places out of doors. Although the strings are all the same length, they differ in thickness and thus produce different pitches.

The anteroom at Syon House, Middlesex (1762–3), *left*, is one of the richest and most splendid of Robert **Adam**'s interiors. It was commissioned by Sir Hugh Smithson, later the Duke of Northumberland, to replace the 'ruinous and inconvenient' Tudor house built on the site of a former nunnery. The floor is of polished scagliola (plasterwork imitating marble) and the columns are of mottled green marble with gilded capitals.

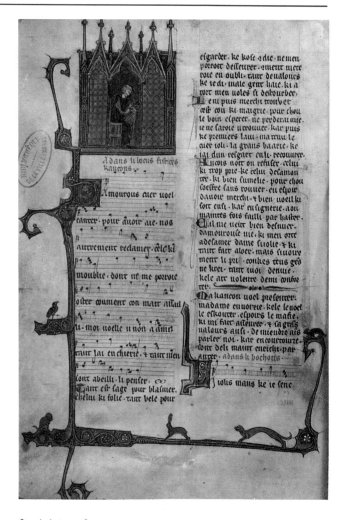

A miniature from a contemporary manuscript shows **Adam de la Halle** seated at a writing-desk, with one of his songs, *'D'amourous cuer'*, *below*. Little is documented of his life, but there are numerous legends about him. His music, which lay unsung in libraries for centuries, is now enjoying a revival. (Bibliothèque Municipale d'Arras)

aerial perspective, a way of producing a sense of depth in a painting by imitating the atmospheric effect that makes objects look paler and bluer the further away they are from the viewer. The term was invented by Leonardo da Vinci, but the effect was exploited by painters much earlier—for example, the mural painters of Roman times. Generally, aerial perspective has been most subtly exploited in northern Europe, most notably by Turner; in some of his late paintings the atmosphere is virtually the subject of the painting. (See also *perspective.)

Aeschylus (525–456 BC), Greek writer of *tragedies. Of his many plays only seven survive complete. In his masterpiece, the *Oresteia* trilogy (*Agamemnon, Choephori, Eumenides*), he portrays the killing of Agamemnon by his wife Clytemnestra and the revenge of their son Orestes. Aeschylus' world is dominated by an omnipotent and rigorous Zeus, the supreme Greek god; wrongdoing and arrogant behaviour bring their own punishment, even after a long delay, and curses are handed down from generation to generation. Aeschylus was parodied in

*Aristophanes' *Frogs* for the portentous silences and high-flown language characteristic of his plays, which are sharply contrasted with the homelier and more argumentative drama of *Euripides.

Aesop (6th century BC), Greek teller of moral animal *fables, reputed to have lived as a slave on the island of Samos. Originally the tales were orally transmitted, but some were put into verse by Babrius (3rd century AD), while others were later translated into Latin. They became known to the West in the Renaissance. Erasmus produced a Latin edition in 1513 which was then widely used in schools.

Aesthetic Movement, an English art movement of the later 19th century, characterized by an exaggerated belief in the doctrine of 'art for art's sake'—the view that art is self-sufficient and need have no ulterior purpose, whether moral, political, or religious. Central figures of the movement included *Whistler, *Wilde, and Beardsley. It was frequently ridiculed for its tendency towards precious affectation, most notably in Gilbert and Sullivan's opera *Patience* (1881). Nevertheless, the movement helped to focus attention on the formal qualities of works of art, and so contributed to the outlook of critics such as Bernard Berenson and Roger Fry.

African architecture. African buildings are made of stone, mud, brick, timber, bamboo, and grass in a wide variety of structural combinations. Dwellings are commonly based either on cylindrical, rectangular, or square plans, and are often single-cell units, built by the inhabitants themselves to serve specific household functions or to accommodate different family members. However, symbolic factors may also be significant, as among the Dogon (Mali), whose buildings and interior spaces are disposed with reference to procreation and cosmology. Most dwellings in a community are single storey and frequently similar in form; larger than usual scale or emphasis on the height of the roof are factors indicative of prestige, political power, or special purpose. Granaries of the Dogon are taller than domestic buldings; meeting houses of the Mangbetu (Zaïre) are enormous, rectangular structures also differentiated in form from the domestic round houses. Decorative treatment of buildings is highly varied (for example, carved, incised, moulded, painted) and indicative not only of status and political and religious power but also of individual aesthetic taste. Chiefs' houses among the Bamileke (Cameroon) have complex figural carvings embellishing veranda posts and door frames. In the former palace of Benin (Nigeria), commemorative bronze plaques, depicting important events and glorifying the institution of kingship, were attached to the pillars. At the domestic level, skill and creativity express personal and community identity. For example, Ndebele women in southern Africa take pride in painting the walls of their houses in an array of geometric patterns, which have become bolder and more vivid due to the use of commercial paint.

African body arts. The term 'body arts' refers to forms of aesthetic modification and adornment of the body shape, skin, teeth, nose, ears, lips, and hair. Hair manipulation is among the most widespread practices in Africa and may include parting, packing, tying, or braiding into complex sculptural configurations, sometimes adorned with beads, buttons, or thread, or held in shape with mud and other pastes. Tonsure, or the shaving of heads in various patterns, is often either a sign of mourning or of adult status after passage through a puberty ritual (East Africa). Skin modification may be temporary or permanent. Temporary treatment includes painting with vegetable pigments or coating with camwood powder, kaolin, or oil. This is done at puberty and during funerals or initiation into specific societies and associations; alternatively, it may simply be a form of premarital aesthetic enhancement. Permanent skin marking includes scarification, made by simple cuts; cicatrization, which produces raised keloids by cutting, pulling, and sometimes inserting substances under the skin: and tattooing, made by pricking the skin and adding colour. Tattooing is less common in Africa than in many areas, perhaps because it does not show up well on dark skin, but scarification and cicatrization are extremely common; they may be done for aesthetic enhancement, erotic stimulation, as a convention of ethnic identity, for medicinal and healing purposes, or as a mark of special status. The patterns—normally scarred on the head and the torso—may have symbolic meaning, as with the Tabwa (Zaïre), whose motifs reflect profound cosmological concepts. Among the Tiv (Nigeria) the changing conventions in patterns marked different generations, all of whom equate the degree of pain experienced during the process with the 'beauty' of the design. Other forms of body modification in Africa include the fattening of women in preparation for marriage, elongation of the skull, filing and removal of teeth, and lip and ear modification and embellishment. Although many of these body arts are slowly being abandoned, they remain documented in much of the figure sculpture.

The mosque at Jenné (or Djenné) in Mali is one of the outstanding examples of Islamic influence in **African architecture**. From the 13th century to the 16th century Jenné was a great trading centre for gold, salt, and slaves, rivalling the more famous Timbuktu in prosperity. The original elaborately pinnacled mosque, built of mud, dated from this period; it was destroyed in about 1830, but has been rebuilt in similar fashion.

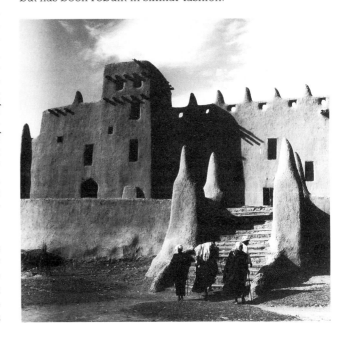

African costume and textiles. Textiles and dress are significant expressions of secular and ritual life in Africa. Of the raw materials used for textiles, cotton is the most widespread, particularly in West Africa, but also East Africa; silk is also important in West Africa, and raffia in West and Central Africa; bast, made from stems of jute and flax, is restricted in use today to pockets of West Africa; all these materials are found in Madagascar. Both men and women weave, although men tend to use the more complex technology of a double-heddle loom and their skill is usually regarded as a specialization, while women use the single-heddle loom within the sphere of domestic activities. Patterns may be created by stripes in warp and weft, by float weaves, and by the alignment and sewing together of separately woven strips. Other methods of creating designs include dyeing with vegetable and mineral products, as with the indigo-dyed *adire* cloth of the Yoruba (Nigeria). Among the Bamana in Mali cloth is dyed with brown patterns following a lengthy application of iron-rich mud. Texture, colour, and design are also enhanced by appliqué, using not only cloth on cloth but also materials such as beads, cowrie shells, mirrors, and animal substances. Embroidery, especially of men's garments, is prevalent in West Africa among peoples influenced by Islam, such as the Mossi and Hausa, while in Central Africa, among the Kuba, raffia cloth, woven by men, is embroidered by women in an array of named and coded geometric patterns. Wraparound styles of dress are worn by both men and women. Often the emphasis is on voluminous cloth display to draw attention to parts of the body, such as the hips of a woman, or to project the imposing image of a leader as in the case of the floor-length, gathered, raffia skirts of Kuba chiefs in Central Africa. Wraparound head-dresses, common among women, are worn by men mainly in areas influenced by Islam. Although styles of dress, textile patterns, and gender distinctions in the production process have been changing through the influence of trade, Westernization, and inter-ethnic contact, in many areas dress is still a major indicator of status and social and ritual roles, and textile production flourishes.

African literature. In its hundreds of languages, Africa has long had an oral tradition of poetry and legend, a small part of which has recently been recorded. This oral literature is often very rich in *proverbs and riddles, while *narrative verse is rare. Its most elaborate poetic forms are usually those connected with ceremonial chant, notably *dirges and *panegyrics. Notable among ancient Egyptian and pre-colonial African literatures are the great Aton Hymn, a prayer preserved in several versions in the tomb of Akhenaten (*fl.* 14th century BC); the epic *Sundiata* about the 13th-century West African monarch Mari Jata; and the 14th-century Ethiopian chronicle *Pillar of Zion*. Other written literature, predominantly religious, survives from the Islamic societies of the North and West. The earliest writings in English by Africans are those of slaves taken to America in the late 18th century, notably the poet Phyllis Wheatley and the autobiographer Olaudah Equiano. From the 1930s several African authors, often educated abroad, published significant works in European languages, led by the French-speaking poets Jean-Joseph Rabearivelo (Madagascar) and the co-founder of the négritude movement *Senghor (Senegal) (see also *Césaire), and later by the novelists Camara Laye (Guinea) and *Ousmane

(Senegal). Protesting against the French policy of assimilation, they asserted the values and dignity of African traditions against the soullessness and materialism of Western culture. In English, novels by the Nigerians Amos Tutuola, Cyprian Ekwensi, and *Achebe in the 1950s began a flourishing of Nigerian literature including the drama and poetry of *Soyinka and J. P. Clark, and the poetry of Christopher Okigbo and Gabriel Okara; the younger writer Buchi Emecheta has been increasingly admired for her novels since the 1970s. West Africa also produced the novelist Ayi Kwei Armah (Ghana) and the poet Lenrie Peters (Gambia), while East African writing has been led by *Ngugi (Kenya) and the Ugandan poet Okot p'Bitek; South African literature includes the novels of *Schreiner and *Gordimer, the plays of *Fugard, and the poetry of Dennis Brutus. Much African writing has been concerned with the social and political problems of colonialism and post-colonial independence, but it also embraces literature on more personal themes.

African masks and masquerades. Masquerades are a form of performance art incorporating masking, dance, music, and drama. Their origins are uncertain, but according to some oral traditions women are said to have devised masking practices, which were then taken over by men who feared their mystical and social powers. Today, except for the Sande society of the Mende (Sierra Leone), masquerades and mask production is almost entirely the prerogative of men, although in the public arena women's audience participation and aesthetic responses are frequently an essential component of performances. Since masking is often used by men's secret societies and cults for such purposes as initiation, investiture, funerals, and entertainment, different levels of secrecy and exposure exist. Moreover, maskers embody different degrees of power; they represent male and female characters and spirit transformations in animal, human, or conglomerate forms. Frequently maskers mediate between the unrestrained powers of the bush and the organized social sphere of the village, so their visual and behavioural characteristics may be extraordinary. They may perform superhuman feats and acrobatic displays, or speak in disguised voices and in esoteric languages. Masking disguises vary from the naturalistic to the highly schematic and are multi-media assemblages. The costume may be made of woven or loose raffia fibres, plant and animal components, or cloth, with suspended items such as bells, mirrors, or beads. Masks may be either facial coverings, helmet masks, or head-dresses worn on top of the head. Wooden facial masks are sometimes also carved with enormous superstructures, as among the Dogon (Mali), or with inventive figurative sculpture, as among the Yoruba (Nigeria).

African music (south of the Sahara). Despite a considerable variety of cultures, music throughout Black Africa shares a number of characteristics, making general discussion possible. Traditional African music is a community affair, and is primarily a group activity, often associated with dance. It accompanies many aspects of life, such as the variety of manual labour, hunting, and warfare, and is also part of important social, political, or religious events. For example, music is used extensively at ceremonies marking the installation of a new chief, and songs relate tribal history in the absence of written texts. Political status among the Venda is determined in

part by the type of music a chief may command, and in West Africa political protests are sung rather than said. As an example of music's importance in religion, each deity in various West African cults is accorded its own distinctive set of *drums and rhythms. Less common is the concept of music as entertainment, performed by itinerant professional musicians. Some trained musicians perform ceremonial or religious duties and are subject to the patronage of kings, and amongst the Hausa of northern Nigeria praise singers laud an individual according to the money offered. The social status of such performers is low, however. A significant aspect of African music is its highly intricate *rhythm, which is achieved through individual lines of much complexity and through their combination in ensembles. Individual lines use syncopation (stress at points other than the main beat), 'silent' beats (sometimes bearing the main stress), additive rhythms (the unequal subdivision of a larger time-span, especially 12 into 2+2+3+2+3), and hemiola (the juxtaposition of 2s and 3s). When combined in ensembles these independent rhythmic patterns produce complex polyrhythms, the whole being co-ordinated by a 'time-line', a repetitive rhythm providing a reference point, and over which the master drum improvises rhythmic patterns. Melodies employ a large variety of *scales, most frequently recognizably diatonic scales, or pentatonic and heptatonic *modes. Vocal melodies reflect closely the rhythm and stress of language. Also, since most sub-Saharan languages are tonal (that is, the pitch of a word affects its meaning), the melodic contour is determined by the words. This feature is also exploited in *talking drums. Choral singing is usually homophonic (see *polyphony), in which thirds predominate, with some fourths and fifths. Vocal forms typically alternate solo and chorus, the latter either repeating the solo line or remaining fixed while the solo improvises different melodies. Instrumental polyphony also employs such antiphonal and responsorial techniques, as well as using rounds and the type of polyphony derived from the concurrent renditions of various independent lines. Heterophony—the simultaneous performance of a single theme by several performers, each introducing slight rhythmic and melodic differences—is also used, for example in the Chopi *xylophone orchestras. Performances generally blur the distinction between creation and improvisation, mixing both: it is unusual for a piece to be performed twice in the same way.

African musical instruments. A wide variety of instruments is found, their distribution determined by local terrain and the life-style of tribes (for example hunting groups, such as Central African pygmies, use only easily portable instruments, such as whistles). Instruments have four important roles in African society: a purely musical one, in the various social, political, and religious contexts described above; as mediator between human and god, a power invested in some instruments such as the *bull-roarer; transmission of verbal messages; and as representatives of power and prestige. Since rhythm is so highly developed in African music this feature is much exploited in instruments, there being many *percussion instruments, such as *rattles (made from gourds or woven baskets with pebbles or seeds inside), wooden and metal bells (often imbued with religious significance), and the many varieties of drums. Drums range from membranes stretched over simple clay pots to large decorated wooden

cases. They are played both with hands and beaten with sticks, and often played in pairs or in ensembles organized by size and pitch, for example the *entenga* drum-chimes of Uganda, which use fifteen tuned drums. Although characteristic of many areas of Africa, drums are largely absent in southern Africa. An instrument unique to African and Afro-American cultures is the lamellaphone, which consists of six to thirty thin metal or bamboo tongues tied to a resonator, which also has metal jingles or shells attached to it, giving a buzzing sound. Lamellaphones and xylophones vary greatly in size, tuning, and construction. The largest log xylophones are played by up to four musicians. Wind instruments are less common, but types of trumpet (made of wood, bone, horn, or ivory) are used for signalling, while *flutes (made from cane, wood, or bamboo, with and without finger-holes) and *shawms are popular in many regions. Stringed instruments are represented by the musical *bow, and more complicated with *harps mostly arched with a curved neck and from five to ten strings; they are used to accompany song. *Zithers are especially important in Central Africa, while *lutes, harp-lutes including the *kora, which is played by professional musicians, and lyres are also found throughout Africa. Among some African peoples, such as the Mandinka, music is a profession followed only by particular castes; among others, such as the pygmies or the Venda, it is a necessary social accomplishment for everyone.

African pottery. Pottery is found in almost all parts of Africa where there is a sufficient supply of clay and of wood to fuel the open fires in which it is hardened. The potter's wheel was unknown before it was introduced by Europeans, and is still unusual, although simpler and much slower turntable devices are used. Women, rather than men, are usually responsible for making pottery, using various techniques of moulding clay or coiling strips of it. Over such a huge area there is naturally great variation in types, but common to most African pottery is the fact that decoration consists mainly of incised patterning rather than painting (although there is sometimes a simple overall wash of colour). Glazing is unknown, but shiny finishes can be obtained by rubbing with various vegetable substances. Typical forms of incised decoration are zigzags, dotted lines, wavy comb-like patterns, and string-like ribbing recalling the textures of basketry. Pottery has been used not only for domestic vessels, but also for various other practical and decorative objects, including drums, lamps, and figure sculpture.

African rock art, the painting and incising of rock surfaces in sub-Saharan Africa. Of the various independent traditions southern African paintings in the Apollo II caves in Namibia seem to be the oldest examples of rock art in the world, dating from about 25,000 BC. These, and the profusion of other southern rock paintings, were done mostly by hunter-gatherers who depicted trance or medicine dance experiences during which shamans cured the sick and controlled rain and game. Among the characteristic motifs are representations of medicine men bending forward with arms extended as if 'flying'. Among the animals represented, the eland predominates because of its supposed magical potency, which medicine men tried to harness.

African sculpture. This encompasses three-dimensional

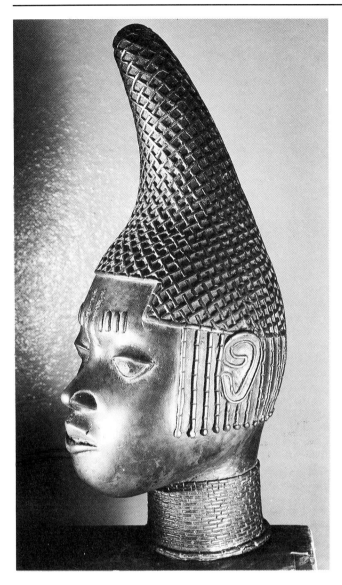

This beautiful, aristocratic bronze head (c.1500) is one of a number from the Nigerian kingdom of Benin that were captured in 1897 by a British military expedition. As products of a sophisticated court, the Benin heads are a superb example of bronze-casting technique, outstanding in **African sculpture**. (British Museum, London)

objects of wood, pottery, metal, stone, ivory, or cement, made for secular and religious purposes. Within this range, there is a preponderance of figure sculpture in wood, human or animal, which may be painted and/or covered with other natural and manufactured items such as skin, fur, cloth, raffia, mirrors, blades, or beads. Figurative forms are also carved on staffs, sceptres, bowls, snuff and tobacco containers, musical instruments, head-rests, stools, combs, and architectural details. Human figures may relate to ancestors or represent deities such as Eshu, the Yoruba trickster god, they may be power objects, which magically engender a spirit reaction, or they may commemorate kings and culture heroes. The concern with continuity and hence procreation and transition through different phases of life and afterlife is apparent in the use of male and female pairs of figures and mother and child imagery. Animal representations are frequently used as metaphors of power (for example,

the leopard in Benin art) or as mediators between the bush and the village. Pottery heads and figures (some of them roughly life-size) are particularly associated with the Nok culture, which flourished in Nigeria from about 500 BC to about AD 200. The bronze heads from Ife (the religious centre of the Yoruba in Nigeria) dating from perhaps as early as the 13th century, are outstanding for their skill in carving and restrained naturalism, and may have influenced the later Benin bronzes.

African traditional dance. In many African societies dance is an integral part of rituals and ceremonies that go back many centuries. Dance has been crucial to the way people communicate with their gods, prepare for war, or celebrate birth, marriage, and death. Ritual dances like these are usually governed by strict rules and are specific to the tribe: among the Bantu a common form of greeting is 'What do you dance?', since what a man dances expresses his social customs, his religion, and his tribal identity. Unlike the straight lines and vertical stance of Western ballet, many African dances are characterized by percussive stamps, bent knees, and rippling movements of the spine. African dance and *African music are inextricably linked, although modern recordings of traditional music have tended to divorce the two components. As traditional societies die out, most of their dances die too, though those that do survive are increasingly being performed by professional companies to audiences around the world; in Britain traditional African dances have been a starting-point from which black dance companies have created their own work.

Afro-American music in South America. Many of the traditions of *African music south of the Sahara were transplanted to South America with the first black slaves in the 16th century. Today the populations of African descent are mostly prevalent in Brazil, the Caribbean, the northern coasts of South America, Panama, and western Colombia. All of these regions have maintained African traditions, though these have been blended to a greater or lesser extent with native Indian and imported European elements (see *Latin American and *Caribbean music). Instrumentally, the influence can be seen in the marimbas (see *xylophone) of south Mexico and Guatemala, and the seed-filled *rattles and other percussion instruments, but most importantly in the continued prevalence of *drums in their many varieties, which use the patterns and ensembles (for example, three drums, bells, and rattles) of West African models. Songs with texts in both African and European languages are sung in the characteristically African call and response fashion (that is, the alternation of soloist and a group of singers). Religious practices retain the style and content of African music, even when blended with Christianity, and the combination of music and dance remains very imporant. Specific African musical characteristics are also identifiable, from the frequent duple and compound duple metres to the use of diatonic and pentatonic *scales. Most characteristic of all, however, is the complex *rhythm, achieved from both the syncopations of individual lines and the combination of rhythmically simpler but disparate lines. (See also *American Indian music.)

Agnon, Shmuel Yosef (Samuel Josef Czaczkes) (1888–1970), Hebrew novelist and short-story writer. His work reflects life in the East European *shtetl* (village), (*A Guest*

for the Night, 1938), the early settlement in Palestine (*Yesterday and the Day Before*, 1945), and life in modern Jerusalem. He also described the sense of loss following the breakdown of Jewish orthodox tradition, and expressed the life of the unconscious in collections of stories such as *The Book of Deeds*. Agnon developed a distinctive linguistic style, a mixture of modern and rabbinic Hebrew. He received the Nobel Prize for Literature (shared with the poet Nelly Sachs) in 1966.

Ailey, Alvin (1931–89), US dancer, choreographer, and director. He trained with Horton and then with *Graham and Holm, going on to form a company in 1958 to perform his own works. He blends primitive, *modern, and *jazz elements of dance with a concern for black rural America, as in his signature work *Revelations* (1960).

air brush, an instrument for spraying paint or varnish in a fine mist by means of compressed air. An air brush looks rather like an outsize fountain pen and is operated in a similar fashion, the pressure of the forefinger on a lever regulating the air supply. It can be controlled so as to give large areas of flat colour, delicate gradations of tone, or a fairly fine line. Although it is particularly associated with commercial art (for example, in retouching photographs), it is also used by painters who require a very smooth surface.

Ajaṇṭā caves, a complex of more than twenty Buddhist caves in the north-western Deccan area of India (Maharashtra state), famed for their architecture, sculpture and, above all, their wall paintings. The caves are hollowed out of granite cliffs in a crescent-shaped ravine, and date from between *c*.200 BC and AD 700. Columned halls with *stupas façades decorated with figure sculpture are among the noteworthy features. The paintings (among the most beautiful and venerable in Indian art) are painted in *fresco and mainly date from the 5th century AD. They depict the Buddha and Buddhist legends with great dignity and vitality.

Akhmatova, Anna (Andreyevna) (b. Gorenko) (1889–1966), Russian poet. She published six books of lyrics (1912–22) inspired mainly by the themes of love and God, and notable for their compactness, clarity, and perfection of form. Her work was condemned by the authorities for its 'eroticism, mysticism, and political indifference', but she continued to write. Her epic *Poem without a Hero* (written 1940–62, published in the Soviet Union 1974) deals with St Petersburg (now Leningrad) on the eve of war and revolution. *Requiem* (1935–40, published abroad 1963, Soviet Union 1987) is an elegy for the prisoners of Stalin, including her son. She was recognized at the time of her death as the greatest woman poet in Russian literature.

Aksyonov, Vasily (Pavlovich) (1932–), Russian novelist. He was the foremost among the 'young prose' writers who revitalized the short story during the Khrushchev thaw (1956–64). Increasingly in conflict with the authorities, especially because his novel *The Burn* (published abroad 1979) was denied publication, he left the Soviet Union in 1981 and became a US citizen.

Akutagawa Ryūnosuke *Japanese literature.

alabaster ornaments, decorative objects made from alabaster, a form of limestone or gypsum. Soft, fine-grained, easy to carve, and taking a good polish, alabaster has been much used for sculpture and the decorative arts, though it is a rather fragile material (readily scratched with the finger-nail) and therefore generally unsuitable for large-scale or exterior work. It is usually white, but sometimes reddish or yellowish, and when cut in thin slabs it is translucent (it has sometimes been used in small windows in place of glass). Alabaster can be carved with a knife or turned on a lathe. It can be made to resemble marble more closely by treating it with heat, and it can also easily be dyed or painted. In the Middle Ages it was popular for small devotional statues, portable altar-pieces, and to a lesser extent for tomb sculpture, but it then went out of favour. Its popularity revived in the late 18th century—in ornaments such as vases, clock-cases, and so on, and commercial figurines. Manufacturing of such objects continues today, especially in Italy, in particular Florence.

Alain-Fournier (Henri-Alban Fournier) (1886–1914), French novelist. His one work, *Le Grand Meaulnes* (1913), a landmark in modern French fiction, evokes with charm and simplicity the adolescence of Augustin Meaulnes. The hero's adventures unfold in an atmosphere of mystical unreality, beyond which, from time to time, the world of adulthood and of the absolute is tantalizingly perceived. The book is partly drawn from his own happy childhood in the small town of Épineuil in central France. Alain-Fournier was killed at the first Battle of the Marne during World War I.

Alas y Ureña, Leopoldo (Clarín) (1852–1901), Spanish critic and novelist, the leading literary critic of his day. His major novel *The Regent's Wife* (1884) gives a *Flaubertian analysis of the life of the Regent's wife in the small cathedral city of Vetusta. Its melodramatic plot is outweighed by the naturalism in its treatment of life in 19th-century provincial Spain.

Albee, Edward (Franklin) (1928–), US dramatist. The leading American representative of the Theatre of the *Absurd, he first came to public attention with the short works *The Zoo Story* (1959), *The Death of Bessie Smith* (1960), and *The American Dream* (1961). His best-known work, *Who's Afraid of Virginia Woolf?* (1962), is a three-act play in which a college professor, his wife, and a second couple eventually achieve catharsis through the verbal torturing of one another. He found success more elusive after the early 1960s, although both *A Delicate Balance* (1966) and *Seascape* (1975) won Pulitzer Prizes.

Albéniz, Isaac (Manuel Francisco) (1860–1909), Spanish composer and pianist. He perfected his piano technique with Liszt, but gave up his concert career in 1890, to concentrate on teaching and composition. Apart from the comic opera *The Magic Opal* (1893), his most important works are for the piano. The mature examples use Spanish folk music as their inspiration; their *Impressionist qualities influenced Debussy and Ravel.

Alberti, Leon Battista (1404–72), Italian architect, sculptor, painter, and writer. Apart from his artistic talents, he was a playwright, musician, mathematician, and athlete, embodying the *Renaissance ideal of the 'universal man'. Little trace survives of his work as a

painter and sculptor, but he was one of the leading architects of his period and the most important art theorist of the Renaissance. His first theoretical book on the arts, *De Pictura* (On Painting, 1436), contains the first description of scientific *perspective. Alberti's other treatises on the arts were *On Sculpture*, probably written in the 1460s, and *Concerning Architecture*, which he worked on until his death and which became the first printed book on architecture when it was posthumously published in 1485. In all his writings he turned away from the medieval notion of art as the expression of religious ideas, seeing it instead entirely in human terms and emphasizing its rational and scientific basis. He showed a deep admiration for classical antiquity, and his architectural treatise was based on that of *Vitruvius. As an architect, too, he stressed the intellectual side of the art, such as theories of *proportion. His two most important buildings are the churches of S. Sebastiano (1460) and S. Andrea, both in Mantua.

Alberti, Rafael (1902–), Spanish poet. His upbringing in an impoverished family and his Jesuit education provided the themes for his major works, and his autobiographical *The Lost Grove* (1959) helps explain many of the allusions in his poems. His early works, *A*

Alberti's church of San Andrea in Mantua was designed in 1470 and completed after his death. His debt to Roman architecture is particularly clear in the majestic barrel vaults over the nave and side chapels. In using such chapels instead of adhering to the traditional scheme of aisles flanking the nave, Alberti created a type of plan that became immensely influential throughout Europe.

Sailor Ashore (1924), *The Lover* (1925), and *The Last Duke of Alba* (1925–6) are inspired by traditional songs and folklore. This soon gives way to a poetry of crisis, first *Tightly Constructed* (1926–7), with its dual influence of *Góngora and the *Generation of '27, and then his major work *Concerning the Angels* (1927–8), in which angels represent different forces in the poet's tortured psyche. On another level, the work is an indictment of modern civilization, expressed in distorted syntax and through private images of loss and alienation. In the 1930s Alberti's espousal of communism led him to write politically partisan works, inferior in quality to his early, subjective poetry.

Albinoni, Tomaso Giovanni (1671–1751), Italian composer. Born into a wealthy family, he was able to compose without reference to the dictates of an official post. His output was enormous, and includes operas, concertos, sonatas (for between one and six instruments), sinfonias, and solo cantatas. Though never an innovator, he was a skilled craftsman and possessed exceptional melodic gifts, which won him considerable popularity. The work for which he is now most admired, the Adagio in G minor, is in fact by the later hand of Remo Giazotto.

Alcott, Louisa May (1832–88), US writer. She wrote novels but is best known for her children's classic, *Little Women* (1868–9), modelled on her own New England childhood. *An Old-Fashioned Girl* (1870), *Little Men* (1871), and *Jo's Boys* (1886) are the best known of her many other works. She remained active throughout her life in such reform movements as temperance and women's suffrage.

aleatory music (indeterminacy), the deliberate inclusion of chance elements as part of a composition or performance of music. Thus the performers may be given several sections of music and told to decide for themselves which order to play them in. They may also be invited to 'interpret' unusual forms of *notation, which may or may not involve actual notes. In such circumstances no two performances will be alike, and indeterminacy can be seen as a reaction against the over-organization of *serialism. Aleatoric experiments began in the 1940s and have involved such composers as *Cage, *Boulez, *Stockhausen, and *Xenakis. Computers are sometimes used to generate 'random music'.

alexandrine, a verse line of twelve syllables adopted by poets since Ronsard as the standard verse-form of French poetry, especially dramatic and narrative. The division of the line into two groups of six syllables in the age of Racine was later challenged by Hugo and other 19th-century poets, who preferred three groups of four. A rare example of the English alexandrine, an *iambic line with six stresses, is found as the final line in the stanza invented by Spenser in *The Faerie Queene* (1590-6).

Alfieri, Vittorio, Count (1749-1803), Italian poet and tragedian. Alfieri travelled widely and found in England the political liberty that was to become his ideal; on his return he settled in Florence. Considered the herald of the Risorgimento (the movement in the mid-19th century to liberate Italy), he wrote nineteen *tragedies (1775-89) expressing his hatred of tyranny. His rugged heroes, reflecting his own blunt, vehement, and uncompromising nature, caught the Italian imagination. Besides his tragedies, he wrote *sonnets, *satires (among them 'The Anti-Gaul' (1793-9), on the excesses of the French revolution), and a notable autobiography.

Pierre Boulez, *right*, shown here working at a computer, is one of the 20th century's most distinguished and imaginative composers. His experiments with **aleatory music** and electronic techniques are part of a constant search for a new kind of composition, and he is also an outstanding interpreter of other composers' music.

Algardi, Alessandro (1598-1654), Italian sculptor. He was trained in the Carracci Academy, and in 1625 settled in Rome. There he became a leading sculptor of the day, second only to *Bernini. His style was more sober and classical than that of Bernini, but his portrait busts—the works for which he is now most admired—have great vivacity as well as great dignity.

allegory, a story or visual image with a second distinct meaning hidden behind its literal or visible meaning. The principal technique of allegory is personification, whereby abstract qualities are given human shape—as in public statues of Liberty or Justice. In literature, allegory involves a continuous correspondence between two levels of meaning in a story, so that all persons and events conform to a system of ideas external to the tale: each character and episode in *Bunyan's *The Pilgrim's Progress* (1678), for example, fits a pre-existing doctrine of salvation. As a method of seeking correspondences between spiritual and physical realms, or between the Old Testament and the New, allegorical thinking permeated the Middle Ages, flourishing in the *morality plays and in the works of Dante and *Langland. Later writers such as Dryden and Orwell used allegory as a method of political *satire.

allemande (almain, alman, almayne), originally a German peasant dance which gained popularity in the mid-16th century. Performed in slow to moderate duple time, it was a stately and solemn dance consisting of steps and a hop in which the free leg was brought up to make a right angle with the knee. It was danced in processional form with couples behind each other in a line or circle formation. The allemande was often followed immediately by quicker, livelier dances such as the *courante. By the mid-17th century the allemande had become unfashionable, although the name was retained and used to describe a figure in a quadrille or square dance or simply any dance with German origins or style.

Allen, Woody (Allen Stewart Konigsberg) (1935-), US film actor, director, and writer. Born in New York City, he is a humorous delineator of the neuroses, sexual hang-ups, and cultural pretensions of New York intellectuals. He made his directorial début with *Take the Money and Run* (1969). Since making *Love and Death* (1975), a comedy set during the Napoleonic wars that was largely filmed in Europe, he has worked only in and around New York. With *Annie Hall* (1977), for which he won three Academy Awards, including best film, and *Manhattan* (1979) he achieved enormous success and his introverted, neurotic but witty persona became well established. He has written, directed, and usually acted in a new film almost annually since 1977, including *Broadway Danny Rose* (1984), in which he played an unsuccessful theatrical agent, and *Hannah and Her Sisters* (1986) (Academy Award for best screenplay). His two serious films, *Interiors* (1978) and *September* (1988), were coolly received.

alliteration, the repetition of the same sounds—usually initial consonants of stressed syllables—in any sequence of neighbouring words: 'Landscape-lover, lord of language' (Tennyson). Obligatory in Old English and Celtic verse, alliteration later became an optional decorative effect in verse or prose. The British poet Hopkins used the technique with great skill, for example in his poem 'The

Windhover': 'I caught this morning morning's minion, king- | dom of daylight's dauphin, dapple-dawn-drawn Falcon'.

Allston, Washington (1779–1843), US landscape painter, one of the outstanding artists of the *Romantic movement in his country. He worked mainly in and around Boston, but he made two visits to Europe (1801–8 and 1811–18). A poet as well as a painter, he was a friend of Samuel Taylor Coleridge. He was the first important US landscape painter and influenced many of his countrymen. His early works concentrate on grandiose and spectacular aspects of nature; later he adopted a more subjective and visionary approach.

Alma-Tadema, Sir Lawrence (1836–1912), Dutch painter who settled in London in 1870. He specialized in *genre scenes set in the ancient world—lush and sensuous works depicting beautiful women wearing exotic costumes in opulent surroundings. One of the most popular Victorian painters, he enjoyed a sumptuous life-style in a house modelled on a Roman villa. His success encouraged imitators, but his work went out of favour after his death, and his reputation has only recently revived.

alphorn, a long trumpet usually made by splitting wood lengthways, hollowing it, and reuniting the halves. Many alphorns are covered with bark or other material to seal them against leaks. They vary from about 1 m. (3 ft.) to 4 m. (12 ft.) long, and allow up to twelve natural harmonics. Alphorns are used in many parts of the world by herdsmen, and sometimes for rituals.

Alston, Richard (1948–), British dancer, choreographer, and director. He trained at the London School of Contemporary Dance and in 1972 formed Strider, one of the first British *postmodern dance companies. After studying with *Cunningham in the USA he returned to choreograph for modern dance and large-scale classical companies, notably the Royal Ballet and Royal Danish Ballet. He joined the Rambert Dance Company in 1981 as resident choreographer, becoming artistic director in 1986. His works include *Windhover* (1972), which uses a collage of bird-like sound, *Soda Lake* (1981), a silent work, and *Pulcinella* (1987), using the Stravinsky score.

Altdorfer, Albrecht (c.1480–1538), German painter and print-maker. Most of his paintings are religious works, but he is remarkable in being one of the first artists to take an interest in landscape as an independent subject. Usually the landscape helps to create the mood of the picture, but two paintings by him in which there are no figures at all are among the earliest pure *landscape paintings in European art. Altdorfer's patrons included the emperor Maximilian, for whom he painted the picture that is generally regarded as his masterpiece, *The Battle of Issus* (1529), now in the Pinakothek, Munich. With its teeming figures and dazzling effects of light and colour it shows to the full the imaginative powers that made Altdorfer one of the most original German artists of his time.

Amarāvatī sculpture, a tradition of sculpture associated with the site of this name in the south-eastern Deccan area of India. Amarāvatī was a major Buddhist centre and, particularly in the 2nd and 3rd centuries AD,

witnessed the development of a magnificent school of sculpture. The site was destroyed in the 19th century, but much of the sculpture survives in museums. The most important monument was a huge and extremely elaborately carved *stupa. Amarāvatī sculpture is notable for grace and suppleness in the portrayal of the human figure and for its vigorous sense of narrative.

amber ornaments, decorative objects made from amber, a translucent, yellowish fossil resin derived from various trees and found in deposits throughout the world, but mainly on the shores of the Baltic Sea. Always an expensive luxury material, amber was particularly prized by the Romans and Etruscans, but the golden age of European amber carving was the 17th century. Its use in Europe is now virtually confined to jewellery, but amber carving is still a living craft in China.

American art, the art and architecture of the North American colonies and the United States from the advent of European settlers in the early 17th century. The first buildings were generally unpretentious versions of types prevailing in the home countries, and painting at the time was almost exclusively confined to modest portraiture. In the 18th century, art and architecture concentrated in cities and became more sophisticated, and at the end of the Colonial period there emerged in John Singleton *Copley a portraitist who could compare with his best European contemporaries. Both Copley and Benjamin *West spent major parts of their careers in Britain and made important innovations in *history painting. In architecture, an elegant classical style was widely adopted,

The *Birth of the Virgin* (c.1521) is set in a Gothic church, demonstrating **Altdorfer**'s interest in architecture and his skill with perspective. There is no reference to the birth of Christ's mother in the Bible, so artists drew on tradition and their own imaginations in representing the subject; the whirling ring of child angels shows Altdorfer's imagination at its richest. (Alte Pinakothek, Munich)

This picture, *The Agnew Clinic* (1889), is the second of two masterpieces in which Thomas Eakins depicted distinguished surgeons at work. Both pictures aroused much adverse comment because of the uncompromising way in which they treated their gory subject-matter, but they are now regarded as being among the most powerful works in the history of **American art**. (Jefferson Medical College, Philadelphia)

temple porticoes appearing on houses as well as churches and public buildings. During the 19th century several US sculptors adopted the *Neoclassical style and enjoyed some success in Europe. Many US painters looked to Europe for inspiration, but there also arose a native school of landscape painting—the *Hudson River School. The best of 19th-century US art, however, is found in the bold and vivid naturalism of Winslow *Homer (famous particularly for his powerful seascapes) and Thomas *Eakins. In architecture the period was characterized (as in Europe) by the revival of historical styles: 'Gothic' was often used for churches and the wealth that patrons now enjoyed led to ostentation and a stylistic free-for-all in private houses or other buildings designed for personal or corporate prestige. Towards the end of the century there was a movement towards functional design. Chicago was the birthplace of the skyscraper and of the steel skeleton construction that made it possible, and the name *'Chicago School' is given to a group of architects, led by Louis *Sullivan, who made the city the centre of progressive developments. The most important landmark in the development of modern art in the USA was the Armory Show, a huge exhibition of 19th-century and contemporary art (European as well as American), which was held in New York, Chicago, and Boston in 1913. It aroused controversy and hostility, but also created a climate more favourable to artistic experimentation. Various US artists worked in abstract styles, but in the period between the two World Wars there was also a movement, called American Scene Painting, towards depicting aspects of US life and landscape in a naturalistic, descriptive style (following on the slightly earlier *Ashcan School, which had favoured urban realist sub-

jects). After World War II, the development of *Abstract Expressionism by artists such as Jackson *Pollock gave US art an international prominence it had never previously enjoyed, and in sculpture David *Smith was a figure of comparable stature and influence. Subsequent movements include *Pop art and *Post-Painterly Abstraction. American architecture in the 20th century has been highlighted by the work of *émigrés* such as *Mies van der Rohe as well as of native-born talents, of whom Frank Lloyd *Wright was the most illustrious. The skyscraper continues to be a dominant form, a notable example being Chicago's sleek Sears Tower (by *Skidmore, Owings, & Merrill, completed 1973), the world's tallest building, but other very different strands of development are represented by Eero *Saarinen's Dulles International Airport, Washington DC (1958–62), with its hanging roof suspended from diagonal supports; Buckminster *Fuller's ingeniously constructed geodesic domes; and Louis *Kahn's bold geometrical forms. (See also *North American Indian art.)

American Ballet Theatre, a ballet company founded in 1939 by ex-members of the New York-based Mordkin Ballet, renowned for its wide-ranging, eclectic programme and as a platform for internationally famous dancers. Originally called simply Ballet Theatre, the company was co-founded by the dancer Lucia Chase and the designer Oliver Smith. Ballet Theatre's early history was chequered, and Chase reputedly saved the company from bankruptcy with money from her private fortune. The company has never had a clear repertory policy, but its programmes have at different times focused around ballets by *Tudor, *Fokine, Agnes *de Mille, the Swedish choreographer Birgit Cullberg (1908–), and, recently, classics such as *Swan Lake* and *Giselle*. Since 1980 *Baryshnikov has been the company's Artistic Director.

American Indian music, music of the indigenous tribes of North, South, and Central America. Their ancestors were Mongoloid peoples who crossed the Bering Strait between 20,000 and 35,000 years ago, and spread through the continents, reaching the foot of South Amer-

ica around 6000 BC. By the 15th century, when Europeans first reached the New World, many different Indian cultures existed, from the simplest hunting tribes like the Inuit (Eskimos) to the complex Pueblo, Aztec, and Inca civilizations. South American Indians have now been absorbed into European culture, hence their music betrays the influence of Iberian art and folk music (see *Latin American music). By contrast, the enforced segregation by whites of Indians in North America from the mid-19th century, has prompted a cultural unity or pan-Indianism that has resisted the influence of Euro-American society. The traditional music of all these peoples is mostly functional, accompanying social and religious gatherings, with songs for hunting, warfare, healing, and the celebration of the year and life cycles. Generally the cultures have no professional musicians, but because music and religion are closely connected, songs are in the charge of priests, medicine men, and shamans: hence music is a predominantly male activity. There is no written tradition, songs being handed down orally. In contrast to some other traditions (such as European folk music) there is little emphasis on individual improvisation and embellishment of the repertoire, and the accurate reproduction of material is considered very important: indeed, Aztec musicians who made mistakes during the performance of some religious ceremonies were traditionally withdrawn for execution. Music is judged by how effectively it fulfils its function, for example providing food and shelter or healing people, and it is closely associated with myth. Several distinct musical areas have been identified for the Indian tribes of North America, though a number of characteristics are shared. Generally the music comprises a single sung melody accompanied by percussion instruments such as *drums and *rattles, though eastern tribes like the Cherokee and Chippewa employ responsorial singing. Melodic shapes vary from the 'descent in steps' patterns of tribes of the Plains region

Quechua Indian band playing side-blown flutes in the Andean regions of Peru. Flutes are the main melody instrument in **American Indian music**. In addition to the side-blown flutes shown here are the panpipes and *quena-quenas*, or vertical flutes. Archaeological remains indicate that flutes have been played since as early as 100 BC in this area.

(for example, Blackfoot, Flathead, and Sioux), to the undulating structures of eastern tribes, or the repeated sectional nature of melodies of Californian tribes like the Yuma, one section being repeated at a higher pitch, the 'rise'. *Scales are loosely diatonic or pentatonic, though tribes of the Pacific north-west coast use microtones (intervals smaller than a semitone). Vocal style is generally tense and hard, the more relaxed timbre employed by tribes of the Great Basin (the Paiute and Ute) being untypical.

American Indian musical instruments. The greatest number of instruments is found in Central and South America, especially in the Andean region of Bolivia and Peru. Simple instruments like *slit-drums and *conch shells (both used for signalling), rattles, *bull-roarers, and *stamping tubes are common, but there are also more sophisticated instruments like the wide variety of flutes, made from cane, wood, or bone, some capable of playing three- or four-note chords, and various types of trumpets, constructed from clay, bamboo, or bark, some of them sung through. *Panpipes of one or two rows, some playing a complete scale, are common in the Andean region, and are organized into bands in northern Argentina. Many Latin American instruments are believed to have magical or religious significance. Being mostly nomadic, tribes of North America have no large or complex instruments, using instead easily portable ones like flutes as the main melody instrument, and simple percussion instruments. The Apache violin is a curious hybrid, mixing the musical *bow and European violin, and consisting of a wooden tube with a single horsehair string stretched over a bridge and played with a bow.

Amis, Kingsley (1922–), British poet and novelist. He came to fame with his first novel, *Lucky Jim* (1954), whose hero, a lower-middle-class history lecturer at odds with conservative social attitudes, was hailed as an *Angry Young Man; its provincial university setting was indicative of a new realism in fiction which Amis further developed in *That Uncertain Feeling* (1955) and *Take a Girl Like You* (1960). He is best known for his satiric comedies, including *One Fat Englishman* (1963), *Ending Up* (1974), *Jake's Thing* (1978), and *The Old Devils* (1986: Booker Prize). His *Collected Poems 1944–1979* appeared in 1979.

amphitheatre, a circular or oval unroofed building with tiers of seats rising outwards from a central open space or arena, used by the Romans for gladiatorial combats and similar spectacles. The earliest known amphitheatres date from the 1st century BC, and they later became common throughout the Roman empire. The largest and most famous example is the Colosseum in Rome, begun in about AD 75. It held about 50,000 spectators and, as well as being an architectural masterpiece, exemplifies the Roman genius for organization, for it has a vast network of passages, staircases, and chambers to facilitate the circulation of the audience, the handling of wild animals, and so on.

amulet, an object, usually worn around the neck, believed to be endowed with special powers for warding off evil, thus protecting and bringing good fortune to the owner. Amulets may be natural or man-made, and can be made of materials that are extremely valuable (for example, gemstones) or intrinsically worthless; often they

bear inscriptions. They are particularly associated with the ancient Egyptians, but they have been used in most parts of the world. The Christian Church condemned the wearing of them in AD 726. Pendants derive from the practice of wearing amulets, so they often have religious or superstitious associations.

anamorphosis, a picture (or a part of one) executed in such a way that it gives a distorted image of the object represented until it is seen from a particular angle or by means of a special lens or mirror, when it appears in lifelike aspect. Anamorphosis is first mentioned in the notes of Leonardo da Vinci, and probably the most famous example of its use is in Holbein's *The Ambassadors* (1533, National Gallery, London), which features a distorted skull, probably a symbol of the brevity of life. Generally, however, the purpose of anamorphosis was to mystify or amuse.

Anand, Mulk Raj (1905–), Indian novelist. He made his name with the powerful protest novel *Untouchable* (1935), which was followed by other studies of the Indian poor in *Coolie* (1936) and *Two Leaves and a Bud* (1937). His Lalu Singh trilogy, *The Village* (1939), *Across the Black Waters* (1940), and *The Sword and the Sickle* (1942), follows the fortunes of a young Sikh during World War I. The best known of his later works is *The Private Life of an Indian Prince* (1953).

ānandalahārī *plucked drum.

Andean culture *South American Indian art.

Andersen, Hans Christian (1805–75), Danish writer of tales for children. He travelled widely and wrote prolifically, but his fame is based on the 168 tales he wrote between 1835 and 1872, many of them based on disguised autobiography: he felt an outsider in society and regretted his inability to form normal loving relationships. Among his best-known tales are 'The Ugly Duckling', 'The Emperor's New Clothes', and 'The Little Mermaid'.

Andrea del Sarto (Andrea d'Agnolo di Francesco) (1486–1530), Italian painter. Apart from a visit to France from 1518 to 1519, he lived in Florence all his life. He was outstanding as a *fresco decorator, as a painter of altar-pieces, and as a portraitist, famous both as a superb draughtsman and subtle colourist. Andrea's pupils included his biographer Vasari, who both made and marred his reputation by describing his works as 'faultless', but representing him as a weakling. Such a negative attitude is unfair to Andrea, who was a great artist but has been overshadowed by some of the giants who were his contemporaries.

Andrić, Ivo (1892–1975), Serbo-Croat novelist. A career diplomat who served in the capitals of Europe, Andrić found his main inspiration as a writer in his native province of Bosnia. Two of his three novels, *Bosnian Story* (1945) and *The Bridge on the Drina* (1945), are set in Bosnia and take the history of the province as their theme. Andrić's restrained use of language heightens the epic power and breadth of the novels. He was awarded the Nobel Prize for Literature in 1961.

Andrzejewski, Jerzy (1909–83), Polish novelist. His work confronts sometimes controversial moral issues: the

wartime stories *Night* (1945) deal with betrayal, the Jews, Auschwitz; the novel *Ashes and Diamonds* (1948), describes the first confused days of peace. Later works include *The Inquisitors* (1956) and *The Gates of Paradise* (1960).

Angelico, Fra (Guido di Pietro) (*c*.1400–55), Italian painter of the *Renaissance. He was a Dominican friar (his nickname means 'the angelic friar') and painted only religious subjects, his work being famous for an inspired directness of religious feeling. However, the spiritual quality of Angelico's work has sometimes obscured the fact that he was also a highly professional artist—one of the most progressive of his day in his mastery of new Renaissance ideas such as *perspective. His reputation rests primarily on the series of *frescos he carried out for his own friary, San Marco, in Florence. Many of the frescos are in the friars' cells and their radiant beauty was intended as an aid to meditation. Angelico painted panel pictures as well as frescos, and this aspect of his work is also well represented at San Marco, now a museum devoted to his work.

Angelou, Maya (Marguerite Johnson) (1928–), US poet, autobiographer, short-story writer, and dramatist. She won international acclaim with her powerful autobiographical work *I Know Why the Caged Bird Sings* (1970) and its sequels, which recount the struggle towards social and spiritual liberation of black women in the American South. In *All God's Children Need Travelling Shoes* (1986)

This exquisite depiction of the 'Annunciation' is one of the frescos with which Fra **Angelico** decorated the friars' cells in San Marco, Florence. The cells are otherwise almost completely bare and the paintings seem to float on the walls like miraculous visions. With their pale, chaste colours, their inspired simplicity of composition, and their freedom from the accidents of time and place, they attain a sense of blissful serenity.

she recounts her return to Ghana in search of the pillaged past of her tribe. Her poetry, written in a sensuous and lyrical style, is collected in *Poems, Maya Angelou* (1986).

Angkor Wat *Khmer art.

Anglo-Saxon art, the art and architecture of the north European tribes whose arrival in Britain began during the 5th century AD. Their conversion to Christianity (597) was to inspire some of the finest expressions of Anglo-Saxon culture, which continued to flourish until the Norman Conquest (1066). Many of their ecclesiastical buildings were, doubtless, constructed of wood and have not survived; early stone churches, often attached to monasteries, were characteristically small, with thick walls, narrow, rounded arches, and tiny windows. Arcades of arches decorated the walls, which were built of rough-hewn stones. A revival of learning initiated in 7th-century Northumbria by the founding of monasteries on the island of Lindisfarne and at Jarrow led to a flowering of manuscript decoration in which the abstract ornamentation of the native Anglo-Saxon metalwork tradition, characterized by bright colouring and interlaced patterns, was fused with Celtic decoration of curvilinear form. The Viking invasions which began in the latter half of the 9th century saw the destruction of this great monastic heritage, but Anglo-Saxon art experienced a second flowering in the second half of the 10th century, notably in Wessex, when the so-called Winchester school of illumination predominated. It was characterized by the use of rich colours, expressive poses and gestures, and heavy draperies. The masterwork of this period is the Benedictional of St Aethelwold, now in the British Museum. Relatively few examples of ivory or stone sculpture survive, although those that do are often of high quality, among them the angels at St Lawrence Church, Bradford on Avon, and the rood screen at Romsey. The Norman invasion brought England into the mainstream of *Romanesque art, but Anglo-Saxon traditions survived to influence Norman art throughout the 12th century.

Anglo-Saxon literature *Old English literature.

Angry Young Men, a catch-phrase dating from the mid-1950s loosely applied to certain British playwrights and novelists who held radical or anarchic political views. It is sometimes said to derive from the title of the autobiography *Angry Young Man* (1951) by the Irish writer Leslie Paul. The phrase gained widespread popularity after the production of John *Osborne's play, *Look Back in Anger* (1956). The anti-hero of the play, Jimmy Porter, is the epitome of the Angry Young Man and the play became a mouthpiece for a group of young men from working-class backgrounds who had been to university and subsequently found themselves not only alienated from their own family backgrounds but opposed to the political and social attitudes of bourgeois society. Other writers in the category include Kingsley *Amis, John Wain (1925-), Colin Wilson (1931-), Alan Sillitoe (1928-), and John Braine (1922-).

animation (on film), photographing of individual drawings and replaying them in rapid succession to give the illusion of movement. Each drawing in an animated sequence is minutely different from the one before, and

Anglo-Saxon art is now known mainly through architecture and manuscript illumination, but notable pieces of carving also survive. This ivory, dating from *c.*1150, shows the deposition from the cross. (Victoria and Albert Museum, London)

the camera stops after each has been photographed. Though animation was first displayed in 1892, before the invention by the *Lumière brothers of moving pictures, the latter vastly increased its potential. By 1908 the most common form of animation, the film cartoon, had begun to appear, coming into full flower in 1928 with the advent of sound and the work of Walt *Disney. Animation later developed in Europe, especially Poland, Czechoslovakia, and Yugoslavia, but with the spread of television it has become more common on the small screen (mainly in advertising). Animation can also be achieved by filming puppets and silhouettes: Lotte Reiniger (1899-1981) adapted the techniques of *shadow plays for this purpose.

Anouilh, Jean (1910-87), French dramatist. Anouilh classifies his plays as either light-hearted or serious, though a fundamental pessimism underlies them all. His characters struggle for personal integrity, limited by the

taboos of society and the constraints of family background, unable to find solace even in the fulfilment of love. Representative titles from more than thirty plays written during a period of over forty years include *Antigone* (1944), *La Répétition* (1950), *L'Alouette* (1953), and *Pauvre Bitos* (1956). Anouilh's plays are less experimental than those of his contemporaries Genet and Ionesco, employing clearly organized plot and eloquent dialogue.

anthem, an elaborate hymn, the Anglican equivalent of the Roman Catholic *motet. The first Elizabethan anthems were derived from metrical psalm settings and were therefore very simple. Gradually they became more elaborate and *polyphonic, taking on the expressive qualities of the *madrigal. There developed verse anthems, which introduced passages for solo voices to contrast with the normal four- or five-part choir. The full anthem employed the choir only, with or without organ or instrumental accompaniment. During the Restoration period (after 1660) anthems often employed elaborate orchestral accompaniments and acquired something of the vocal display of *opera. The great period of the anthem includes such composers as Byrd, Weelkes, Gibbons, Purcell, Blow, and Handel. The word is also used in the general sense of a special 'hymn', as in a *national anthem.

anthology, a collection of poems or of prose passages by different authors. The most popular anthologies, like F. T. Palgrave's *Golden Treasury of Songs and Lyrics* (1861), have had a significant influence upon public tastes in poetry. An important collection known as the *Greek Anthology*, compiled chiefly by Constantinus Cephalas (AD *c*.920), contains thousands of poems from as early as the 7th century BC.

Antonello da Messina (*c*.1430–79), Italian painter from Messina in Sicily. He was one of the first Italian painters to master the new technique of *oil painting and he played a major role in popularizing it. His 16th-century biographer Giorgio Vasari said that he was a pupil of Jan van Eyck (then credited as the 'inventor' of oil painting), but it is unlikely that he visited northern Europe, and he probably learnt the technique in Naples, which was then artistically dominated by the Netherlands. Antonello painted religious subjects and portraits, and in his work he successfully combined the Netherlandish passion for exquisite detail with the Italian tradition of clarity and dignity of form. His work was particularly influential in Venice, notably on Giovanni Bellini.

Antonioni, Michelangelo (1912–), Italian film director, whose almost plotless films depict the unsatisfactory nature of modern relationships. He achieved international fame with *The Adventure* (1960). One of the cinema's leading aesthetes, he established an unmistakable style through which he disclosed a new kind of beauty in 20th-century urban architecture. His next two films, *Night* (1961) and *The Eclipse* (1962), are often considered to complete a trilogy, and *The Red Desert* (1964), his first colour film, was stylistically similar. He then made three films in English: the faster-paced *Blow-up* (1966), set in 'swinging' London; the California-based *Zabriskie Point* (1970); and *The Passenger* (1975), his last notable film, in which a television newsman in North Africa adopts a dead man's identity.

Apelles (*fl.* 4th century BC), Greek painter, born at Colothon on the island of Cos. He was court painter to Philip of Macedon and his son Alexander the Great, and in antiquity he was considered the greatest of all painters, celebrated for his mastery of *chiaroscuro and composition. No pictures by him survive, but his works were much discussed by classical authors, and their accounts inspired several major Renaissance artists to try to emulate them.

aphorism, a statement of some general principle, expressed memorably by condensing much wisdom into few words, often in the form of a definition: 'Hypocrisy is a homage paid by vice to virtue' (La Rochefoucauld). Aphorisms are also known as maxims.

Apollinaire, Guillaume (Wilhelm Apollinaris de Kostrowitzki) (1880–1918), French poet of Polish-Italian descent. His poems, which are written without punctuation, are a conscious attempt to be resolutely modern in both form and subject. *Zone*, from his first collection, *Alcools* (1913), evokes the Eiffel Tower, cars, planes, and gas-lights in the streets of Paris; while many of the poems in *Calligrammes* (1918), including 'La cravate et la montre' and 'Il pleut', are set out so as to give a visual representation of the subject upon the page. Apollinaire coined the term 'surrealist' and was acknowledged by the *Surrealist poets as a precursor.

aquatint, an engraving process for producing prints from a metal plate invented in about the middle of the 18th century. An aquatint produces finely granulated tonal areas and resembles a brush drawing or water-colour. A metal plate is sprinkled with acid-resistant resin, which is fused to the plate by heating, and when the plate is immersed in an acid bath (as in *etching) the acid bites between the tiny particles of resin and produces an evenly granulated surface. The design is created by drawing on the plate with acid-resistant varnish. It has been much used for reproducing water-colours, but also as an original creative technique by artists such as Goya and Degas.

arabesque, a scrolling or interlacing plant form, the most typical motif of Islamic decorative art. The motif is found in Hellenistic art, notably in Asia Minor. Its Islamic form first appeared about AD 1000 and thereafter it became the stock-in-trade of the Muslim artist, for whom it had a particular appeal since Islam precludes the representation of living creatures on religious buildings. The arabesque assumed complicated convolutions which were often disposed symmetrically, while the plant form itself became schematic and abstract. The term is applied by extension to the combinations of flowing lines interwoven with flowers and fruit and fanciful figures used in illuminations and by Renaissance decorators. In dance it describes a ballet dancer's position in which one leg is extended horizontally backwards and the arms are outstretched. In music it is usually a short, florid piece of composition.

Arabic literature. Though we have fragmentary indications of the existence of some form of Arabic from the 9th century BC onwards, extant Arabic literature dates back only to the first half of the 6th century AD, roughly a hundred years before the rise of Islam. The earliest material is all poetry in three well-developed

types: *rajaz*, a primitive verse-form with short rhyming lines; the *qiṭ'a* 'occasional piece', of relatively short length, and the longer and more imposing *qaṣida* 'ode', generally sixty to eighty lines long, which probably had its origins in the piecing together into one poem of a number of *qiṭ'a*. The *qaṣida* and *qiṭ'a* are composed in lines made up of two hemistichs or half-lines, normally with both hemistichs rhyming in the first line and thereafter with the rhyme only at the end of the line. Each poem is composed in a single metre. A dozen *metres were current in pre-Islamic times; later the number increased to sixteen. The range of themes which has dominated Arabic poetry until fairly recently is well defined: lament, boasting, praise, satire, war, descriptions of animals and natural phenomena, revelry, and a general philosophic pessimism about life. A special feature of the *qaṣida* is the *nasīb*, an elegiac prelude in which the poet recalls his attachment to his erstwhile beloved. The most famous pre-Islamic poems are the seven Mu'allaqāt, and the most important and influential poets were *Imru al-Qays, 'Antara, Labīd, and al-A'shā. Three forms of prose are known to have existed in pre-Islamic times: story-telling (*qiṣa*) was extremely popular and widespread. There were also sermons (*khuṭba*) delivered by religious figures, and rhymed prose (*saj'*) uttered by soothsayers. All three forms are to be found in the *Koran, revealed AD 610–32, the greatest work in Arabic, a book not only of crucial religious significance but also of the highest literary merit. The Koran and Islam determined the future course of Arabic literature. Most authors were scholars writing on didactic subjects: history, law, all aspects of religion, language, and, later, geography, medicine, and sciences, and it is in such fields that the greatest writers in Arabic are to be found.

In the Islamic period imaginative prose developed from the story-telling of old, from the new stories and fables coming from Persia and India in such collections as *Kalīla wa-Dimna* (see *panchatrantra), and from the *risāla* 'epistle' genre that emerged in the Umayyad period (656–750). The first epistles were on practical subjects such as advice

This 9th-century Abbasid Koran is written in Kufic script on vellum. One of the earliest scripts to be developed for written works of **Arabic literature**, Kufic has a monumental style which reflects the quasi-talismanic religious significance attached to the written word of God. (Private collection)

to rulers or to courtiers. The range of subjects was then extended to the semi-factual, often treated for amusement rather than edification. The great artist in this field was al-Jahiz (d. 869), who wrote not only epistles but also much longer works in the same style, such as the *Kitāb al-Hayawān* (Book of Animals). Anecdotal literature of the kind we find in the *Thousand and One Nights* was also immensely popular, but none of it achieved literary status until the work of al-Tanukhī (d. 994). A younger contemporary, al-Hamadhānī (d. 1008), devised a new genre, the *maqāma*, of dramatic anecdotes written in rhymed prose, the most popular exponent of which was *al-Harīrī (d. 1122). The prophet Muhammad did not approve of poetry, and it fell into disfavour for several decades after his death. Then the ancient traditions were revived, though on a very different social basis, in Syria and Iraq by poets such as al-Akhṭal (d. c.710). The second half of the first Islamic century also saw the rise of two forms of amatory poetry: the first, vivid and direct, was developed in Mecca by 'Umar ibn Abī Rabī'a (d. c.711). The second, idealizing hopeless love, was first depicted in the poetry of Jamīl (d. 701), who made Medina his home. Slightly later, wine poetry developed as a separate genre, its foremost exponent being *Abū Nuwās (d. c.814). This contrasted with the simple, ascetic poetry of Abū'l-'Atāhiya (d. 826). In general, however, poetry was in decline, due to a growing preoccupation with showy form rather than content. Occasionally there are poets whose genius transcends these preoccupations, most notably *al-Mutanabbī, the blind al-Ma'arrī (d. 1057), and Ibn al-Fāriḍ, the greatest Arab mystic poet (see also *Sufi literature). For the most part, Arabic literature in Spain followed the traditions of the east, as can be seen in the work of its greatest prose writer, the polymath Ibn Ḥazm (d. 1064) and its leading poet, Ibn Zaydūn (d. 1071). However, two stanzaic forms of verse, the *muwashshah* and the *zajal*, originated in Spain. The *muwashshah* is of special interest as some fifty poems end with a *kharja* (*envoi* or final stanza) that is wholly or partly in an early Spanish dialect. Classical Arabic literature has no epic and no drama, though the medieval period saw the rise of *shadow plays. Modern Arabic literature developed as the product of this century and is influenced by Western forms such as the novel, the short story, and drama, genres alien to classical tradition, which are now major vehicles of creative expression. Poetry has also acquired new free verse-forms in addition to the neoclassical. Of the many successful writers three Egyptians have won special eminence: the critic, autobiographer, and novelist Taha Husein (d. 1973), the dramatist Tawfīq al-Hakīm (d. 1987), and the novelist Neguib Mahfouz, winner of the 1987 Nobel Prize for Literature. (See also *Persian literature, *Turkish literature.)

Arabic music *West Asian music.

Arbus, Diane (1923–71), US fashion photographer and journalist. After her divorce from Allan Arbus, with whom she had enjoyed a successful photographic partnership, she became increasingly fascinated by the physically and mentally deformed. She transformed her obsession into powerful, direct, flashlit, monochrome portraits, which influenced a whole generation of photographers.

arch, in architecture and engineering, an upward-curved or pointed arrangement of blocks of stone or other rigid

The Arch

keystone

voussoir

lintel

soffit springer

springing line impost

span

arch construction

corbelled arch

round arch

horse-shoe arch

pointed arch

tiers-point arch

equilateral arch

ogee arch

nodding ogee arch

four-centred arch

three-centred arch

materials used to span a gap and support a structure above it; the term is also applied to similar features used decoratively. In a traditional masonry arch the individual wedge-shaped blocks are called voussoirs and the central one is the keystone. The blocks support each other, and the downward pressure of the superstructure is partially converted into outward thrust, which requires substantial abutment from a wall or pillar; if this is not strong enough the arch collapses. With modern materials such as steel and reinforced concrete, however, the stresses can be so distributed that massive supports are not needed, even for very wide spans. The arch was known to many ancient peoples, but they used it mainly for utilitarian purposes such as drains, and the Romans were the first to exploit it as a major element of architectural design. They used it to cover much wider spans than were possible with the simple post and lintel constructional system (two uprights supporting a flat slab) favoured by the Greeks, and they made it a key element of the decorative vocabulary of their architecture. The semicircular arch of the Romans continued to be dominant in European architecture until it was superseded in the 12th century by the pointed Gothic arch, which was stronger structurally and more versatile aesthetically.

Archer, Thomas (*c*.1668–1743), English architect. His output was small, but his buildings are important in being the only ones by an English *Baroque architect to show evidence of first-hand study of contemporary continental, particularly Italian, architecture. Archer's architectural training is unknown, but he travelled abroad 1691–5 and presumably saw the work of *Bernini and *Borromini. His finest works are the north front of Chatsworth, Derbyshire (1704–5), and the London churches of St Paul, Deptford (1713–30), and St John, Smith Square (1713–28), which are vigorous and idiosyncratic in style.

Archipenko, Alexander (1887–1964), Russian-born sculptor who became a US citizen in 1928. Archipenko was one of the most inventive of modern sculptors, experimenting with new materials and reviving the practice of painting sculpture. He was one of the first to apply the principles of *Cubism to sculpture, analysing the human figure into geometrical forms and opening parts of it up with holes and concavities. In moving away from a sculpture of solid form towards one of space and light he influenced the course of modern art.

Arcimboldo, Giuseppe (1527–93), Italian painter, active in his native city of Milan and also in Prague, where from 1562 to 1587 he was court painter to the Holy Roman Emperors Ferdinand I and Rudolf II. He specialized in grotesque symbolical compositions of fruits, animals, landscapes, or various inanimate objects arranged into human forms. His paintings, though much imitated, were generally regarded as curiosities in poor taste until the *Surrealists revived interest in such 'visual punning'.

Aretino, Pietro (1492–1556), Italian poet, prose writer, and dramatist. An outspoken critic of the powerful, he was one of the most influential writers of his day. In addition to five vigorous comedies depicting lower-class life he left a unique dossier of letters which are of great biographical and topical interest. His tragedy, *The Horatii* (1545), is considered by some the best Italian tragedy of the 16th century.

aria (Italian, 'air'), a musical term used since the 17th century to describe an extended vocal solo in an *opera, *oratorio, or *cantata. By the early 18th century operatic arias had taken on a regular A–B–A form, consisting of a main section, a contrasting middle section, and a repeat of the main section. The repeat was usually varied by the singer with impromptu ornamentation. Because the repeated section was not written out, but merely indicated by the words *da capo* ('from the beginning'), this type of aria became known as the da capo aria. The formal rigidity of the da capo aria gradually gave way to shapes that varied according to the nature of the dramatic moment. Although arias have never entirely died out, later 19th-century practice tended to merge them into a general lyricism so that they became difficult to distinguish as such.

Ariosto, Ludovico (1474–1533), Italian poet. Ariosto is principally known for his epic poem *The Frenzy of Orlando*, started *c*.1506, completed in 1532. Written in the metrical form of the *ottava rima*, it is ostensibly a reworking of the legends of Charlemagne and the Christian knights' war against the Saracens, but it is transformed into a brilliant satire of the chivalric tradition, as Ariosto pursues a dozen narrative threads with technical mastery.

Aristophanes (*c*.450–*c*.385 BC), Greek comic poet. Of his plays, eleven have survived complete, and there are titles and fragments of many more. A master of fantasy and *satire, he ridicules contemporary figures, including philosophers and the protagonists of the Peloponnesian War. His most notable productions include *Acharnians*, a comedy about the War, and *Clouds*, where Socrates is attacked as a teacher of amoral *rhetoric. In *Lysistrata* the women of Greece, by refusing sex to their husbands, bring about peace, while *Frogs* portrays the descent of the god Dionysus to Hades and his judgement in favour of *Aeschylus in a competition with *Euripides for the primacy in the art of writing *tragedy. Aristophanes' characters speak a fast-moving, colloquial, and often obscene language; but he is also a master of a varied lyric style. (See also *chorus, *comedy.)

Aristotle *Greek literature.

Arlen, Harold (Arluck, Hyman) *musical.

armonica *glass harmonica.

This woodcut portrait of Ludovico **Ariosto** is from an edition of his *Frenzy of Orlando* published in 1532. One of the greatest poems of the Renaissance, *Orlando* was immensely popular; it went through dozens of editions in Italian before the end of the century and was memorably translated into English by Sir John Harington (1591). (British Library, London)

arms and armour, personal weapons and protective clothing used in combat or for ceremonial purposes, being regarded both as objects of beauty as well as of practical use. In Europe armourers have invariably been workers in metal, but in other parts of the world materials such as wickerwork, bone, and coconut fibre have been used. Outside Europe, the richest traditions of arms and armour have been in the Japanese and Indo-Persian cultures, in which metal (in the form of both mail and plate) is combined with leather and padded and studded textiles. European armour reached its highest peak of development in the 15th and 16th centuries, when plate armour, which had gradually replaced mail, encased the whole body in an ingeniously articulated suit. The finest armours were made in Germany and Milan, and the main English centre of production was Greenwich, where Henry VIII established workshops. Henry's own armours, however, were intended more for the tournament than the battlefield, because by the 16th century firearms were becoming so effective that armour could not be made proof against bullets without being excessively heavy. Cavalry continued to wear breast and back plates until the early 18th century, however. Among weapons, the sword occupies pride of place as the symbol of knighthood, justice, and power. Certain towns—notably Toledo in Spain in the 16th and 17th centuries—have been famous for their production, and in Japan the blades of the great swordsmiths are regarded with an almost religious veneration.

This armour for man and horse, made at Landshut in Germany in about 1480, is in a style known as Gothic, so-called because the pointed forms and rippling surfaces resemble those of Gothic architecture. **Arms and armour** reached a peak of beauty at this time that has never been excelled. (Wallace Collection, London)

Armstrong, Louis ('Satchmo') (1900–71), US *jazz trumpeter and singer. He first played the cornet at 14, while on remand in the Coloured Waifs Home. For a time he played in and around New Orleans, before joining King Oliver's Creole Jazz Band in Chicago. He played second cornet on Oliver's historic recordings of 1923, then formed his own 'Hot Five' in 1925. The recordings made by Armstrong between 1925 and 1928 changed the face of jazz, shifting the focus from ensemble playing to the solo improviser. Armstrong continued to develop as an artist until around 1946; after this he did little new work, though he made many commercial recordings and appeared in over fifty films.

Arne, Thomas Augustine (1710–78), British composer, violinist, and singing teacher. His gift was essentially melodic and found its natural outlet in the many operatic entertainments he wrote for the London theatres and pleasure gardens. Such works as 'Rule, Britannia', from the patriotic *masque *Alfred* (1740), and his settings of Shakespeare have attained the status of national songs. His greatest success was the Italian-style opera *Artaxerxes* (1762), but the English-style opera *Thomas and Sally* (1760) is more typical of his genius. He also wrote concertos, sinfonias, and sonatas.

Arnold, Malcolm (Henry) (1921–), British composer and trumpet-player. His skill as a craftsman is as evident in his many film scores (including that for *The Bridge on the River Kwai*) as in his orchestral output, which includes seven symphonies and numerous concertos. His style is basically *tonal and rejoices in lively rhythms, brilliant orchestration, and an unabashed tunefulness.

Arnold, Matthew (1822–88), British poet and literary critic. He was the eldest son of Thomas Arnold, the reformist headmaster of Rugby School. For thirty-five years he was an inspector of schools, and supported the concept of state-regulated secondary education. His first volume of poems (1849) contained 'The Forsaken Merman'. While continuing to publish poetry (including 'Dover Beach', 'The Scholar-Gipsy', 'Tristram and Iseult', 'Sohrab and Rustum', 'Balder Dead', and 'Thyrsis') he increasingly turned to prose, writing essays on literary, educational, and social subjects. With such works as *Essays in Criticism* (1865), and *Culture and Anarchy* (1869), he became established as the leading critic of his day. Arnold criticized the provincialism, philistinism, sectarianism, and materialism of Victorian England and argued in favour of a more intellectual curiosity and a more European outlook. He had much influence on later critics, notably T. S. *Eliot and F. R. *Leavis.

Arnolfo di Cambio (d. *c.*1302), Italian sculptor and architect. His only certain work as an architect is the original design of Florence Cathedral (subsequently much altered), but several other important Florentine buildings have been attributed to him, notably by *Vasari. They include the church of Sta Croce and the Palazzo Vecchio, and if they are indeed Arnolfo's work he ranks as one of the greatest architects of the Middle Ages. As a sculptor, his most important surviving work is the tomb of Cardinal de Braye (d. 1282) in S. Domenico, Orvieto.

Arp, Jean (Hans) (1887–1966), French sculptor, painter, and poet. In 1912 in Munich he exhibited with

the *Blaue Reiter group, and in 1915 in Zurich he was one of the founders of the *Dada movement. During the 1920s, living at Meudon near Paris, he was associated with the *Surrealists. In the 1930s he turned to sculpture and produced what are now his best-known and most admired works: sensuous abstract compositions that convey a suggestion of organic forms and growth without reproducing actual plant or animal shapes.

arpeggione, a rare bowed stringed musical instrument built and tuned like a guitar, but played like a cello. It had six strings and frets on the fingerboard. It was invented in about 1823 by Johann Georg Staufer in Vienna. Schubert's superb sonata for the instrument has ensured its recognition.

Ars Antiqua, Ars Nova, Latin terms meaning 'ancient art' and 'new art' in music, used by French and Italian theorists in the 14th century to distinguish between the notational systems and composition practices of the 12th and 13th centuries and the technical advances of the 14th century. The Ars Antiqua style was based upon *plainsong and *organum, and restricted itself to triple metres. The Ars Nova style, as exemplified by such composers as Machaut, explored a greater variety of rhythm and independent part-writing. A typical musical form is the *isorhythmic *motet.

Artaud, Antonin (1896–1948), French actor, director, and poet. He was best known for his advocacy of the Theatre of Cruelty, which was defined in his essays *Le Théâtre et son double* (1938) and demonstrated in his direction of his own play *Les Cenci* (1935). Using gestures, movement, sound, and rhythm rather than words, it depicted behaviour no longer bound by normal restraints, aiming to shock the audience into realizing the underlying ferocity and ruthlessness of human life and releasing their own inhibitions. Artaud's ideas were adopted by such playwrights as *Orton and *Genet and were apparent in *Barrault's adaptation of Kafka's *The Trial* (1947); their most commercially successful exposition was the British director Peter *Brook's 1964 production of *The Persecution and Assassination of Marat as Performed by the Inmates of the Charenton Asylum under the Direction of the Marquis de Sade* (known as the *Marat/Sade*) written by the German dramatist Peter Weiss (1916–82). Artaud was also interested in surrealist plays, some of which he produced at the Théâtre Alfred Jarry, which he co-founded.

art deco, a style in the decorative arts which was defined by the Exposition Internationale des Arts Décoratifs et Industriels held in Paris in 1925. Although applied principally to the decorative arts and interior design of the 1920s and 1930s the term can be extended to analogous styles in architecture and painting. Concentrating on stylishness tuned to domestic use and popular consumption, it is characterized by geometric patterning, sharp edges, and flat, bright colours, and often involved the use of enamel, chrome, bronze, and highly polished stone. The simplicity of the style can be seen as classicizing in spirit, attested by the Egyptian and Greek motifs which were often adopted (for example, the schematized Egyptian scarab). Although it led to a re-confirmation, in both Europe and the USA, of the role of the craftsman-designer, popularization of the style often resulted in the mass production of less refined objects.

art direction, design of scenery and costumes for the cinema. When the camera was static, perspective scene painting on theatrical lines was adequate for films. The use of mobile cameras from the 1920s required more solid settings, and the advent of colour further increased the art director's problems. With the growth of outdoor *camerawork after World War II, skilled art direction was needed to 'improve' real locations, which might otherwise seem inferior to studio ones. The art director works closely with the director and cameraman to create the required atmosphere. The term 'production designer', sometimes used to describe the art director, indicates the scale of his responsibilities.

art history, the study of the history of the fine arts and of the applied arts. The term can embrace a variety of intellectual approaches, from the cataloguing of museum collections, where the primary object is to establish a body of factual information about each object, to philosophical musings on the relationship of art and society or the nature of beauty. It also includes the process of attribution: the assignment to an artist of a work of uncertain authorship, based on stylistic or written evidence (such as letters or dealers' records). As an academic discipline, art history developed in Germany in the 19th century, but its origins stretch back much further. Various Greek and Roman writers commented on the history of the arts, notably *Pliny the Elder in his encyclopedic work *Natural History* (1st century), and the 15th-century Florentine sculptor *Ghiberti wrote a manuscript called *Commentaries* that includes a survey of ancient art and the first artist's autobiography to have survived. The man who put art history on the map, however, was *Vasari, whose *Lives of the Artists* (1550) inspired many later collections of biographies. Vasari said that he aimed at 'investigating the causes and roots of styles and why the arts improved or declined', and this idea of art following an evolutionary pattern of decay and revival proved immensely influential. In the 18th century a new approach was initiated by *Winckelmann, who regarded art as the most noble manifestation of a nation's soul. Winckelmann played a major role in establishing Germany as the home of art-historical studies, and it was there, during the 19th century, that two contrasting approaches to the subject developed: on the one hand the analysis of the formal qualities of a work of art was seen as paramount; on the other, the work was studied in its historical context, with emphasis on subject-matter. In the 20th century art history has moved from being a somewhat élitist subject to one that is a popular part of the school curriculum. (See also *iconography.)

art nouveau, decorative style flourishing in most of western Europe and the USA from about 1890 to World War I. It was a deliberate attempt to create a new style in reaction to the academic 'historicism' of much 19th-century art, its most characteristic theme being the use of sinuous asymmetrical lines based on plant forms. Primarily an art of ornament, its most typical manifestations occurred in applied art, decoration, and illustration, but its influence can also be seen in the work of many painters and sculptors. The style takes its name from a gallery called L'Art Nouveau opened in Paris in 1895. However, the roots of the style were in Britain, where the *Arts and Crafts Movement had established a tradition of vitality in the applied arts, and it spread to

The staircase of Horta's Hotel Tassel in Brussels (1893) shows **art nouveau** at its boldest and most inspired. The curvilinear patterns are based on plant forms; Horta said 'I discard the flower and the leaf, but I keep the stalk.' He designed every detail of his buildings himself to ensure unity of effect.

the Continent of Europe chiefly from London. The style was truly international, the most celebrated exponents ranging from *Beardsley in Britain to *Mucha, a Czech whose most characteristic work was done in Paris, and *Tiffany in the USA. Leading art nouveau architects included *Mackintosh in Scotland, *Gaudí in Spain, *Guinard in France, and *Horta in Belgium.

Arts and Crafts Movement, British social and aesthetic movement of the latter half of the 19th century that aimed to reassert the importance of craftsmanship in the face of increasing mechanization and mass production. It had its basis in the ideas of *Pugin and *Ruskin, the most influential of the writers who deplored the effects of industrialization, but it was left to William *Morris to translate their ideas into practical activity. His hand-made products (books, furniture, textiles, wallpaper, and so on) were successful aesthetically, but his ideal of producing art for the masses failed. Nevertheless, he influenced craftsmen, teachers, and propagandists (such as C. R. Ashbee, who founded the Guild of Handicraft in 1888), and in the early years of the 20th century the ideals of the Arts and Crafts Movement spread abroad, notably to Germany, Austria, the Low Countries, and Scandinavia, where the Danish silver designer George Jensen was one of the key figures. After

World War I the movement was transformed by the acceptance of modern industrial methods, but it has had an enduring legacy on 20th-century design.

Ashcan School, a group of US painters active from about 1908 until World War I who painted urban realist subjects. It was inspired largely by Robert Henri; other artists associated with the movement included George Wesley Bellows and Edward *Hopper. They often painted slum life and outcasts, but they were interested more in the picturesque aspects of their subjects than in the social issues involved and they are now seen to have differed less from contemporary academic painting than they themselves believed.

Ashcroft, Dame Peggy (Edith Margaret Emily) (1907–), British actress, the greatest of her generation, renowned for her superb diction. She has played most of Shakespeare's heroines, notably Juliet (1935), with John Gielgud and Laurence Olivier playing Romeo successively. She has also excelled in Chekhov productions, in Ibsen, and in a wide range of modern plays.

Ashton, Sir Frederick (1904–88), British dancer and choreographer. He trained with *Massine and *Rambert, who encouraged his first choreographic work. He joined *de Valois's Vic-Wells Ballet in 1935 and stayed with the company (it became the Royal Ballet) for the rest of his working life, employed as its director from 1963 to 1970. His style is quintessentially English because of its lyrical and pastoral qualities, to which he adds a personal wit and elegance. Characters and situations form the basis of ballets such as *Façade* (1931), *La Fille mal gardée* (1960), and *Enigma Variations* (1968), while abstract works giving attention to the ballet technique and to moods are epitomized by *Symphonic Variations* (1946) and *Monotones* (1965).

Asplund, Gunnar (1885–1940), the outstanding Swedish architect of the 20th century. He was a pioneer of the *Modern Movement in his country, but his work also drew on Scandinavian tradition. His style was noble and graceful, and his finest work, the Woodland Crematorium at Stockholm South Cemetery (1935–40), is one of the undisputed masterpieces of modern architecture. Although starkly minimalist in form, it has a classical serenity recalling Greek architecture and is perfectly attuned to its landscape setting.

assemblage, a term coined in the 1950s by Jean *Dubuffet to describe works of art made from fragments of everyday materials such as household debris. The term is an imprecise one and has been applied to two-dimensional as well as three-dimensional objects, from photomontage at one extreme to complete room environments at the other.

Assyrian art, the art and architecture of Assyria, a kingdom (situated in what is now Iraq) that established one of the greatest empires of the ancient Near East. During their early history the Assyrians seem to have been dominated by the more powerful *Sumerian and *Babylonian civilizations. The empire reached its peak under Sennacherib (705–681 BC), who rebuilt the ancient city of Nineveh, bringing an elaborate system of canals into the city from the hills and introducing a network of

streets and squares. Excavations show that the buildings were grandiose and lavishly adorned with painted and sculpted decorations. Only fragments of the paintings have been preserved, but a considerable amount of sculpture survives, the finest collection being in the British Museum. The Assyrians were an extremely warlike people and their art was overwhelmingly devoted to glorifying their kings and their armies; the most characteristic type of work was a sequence of stone slabs carved in low relief with military or hunting scenes (the human figures are fairly stiff, but the animals, particularly the lions, are imbued with a magnificent sense of sinewy energy). This type of 'narrative relief', arranged around state rooms or courtyards, was the invention of the Assyrians and their most significant contribution to world art. The other distinctive type of Assyrian sculpture was the Lamassu, a colossal winged beast with a human head used in pairs to flank the entrance to palaces. Collections of tablets, many of them in letter form, on the subjects of literature, religion, and administration, as well as on other branches of ancient learning, have been found in the 7th-century BC palace of Ashurbanipal. The Assyrians also worked in bronze, using moulds to cast their figures, jewellery, and objects such as arrow-heads. They decorated furniture with delicately carved ivories, and engraved small scenes on precious stone for use on cylinder seals. They made finely moulded pottery of a very high quality. Their civilization collapsed when their capital, Nineveh, was captured by Babylonians, Scythians, and Medes in 612 BC.

Astaire, Fred (Frederick Austerlitz) (1899–1987), US dancer and choreographer. He worked in *musicals on stage and film, and as a highly talented tap dancer he took the genre to a new level in films such as *Top Hat* (1935) and *Shall we Dance?* (1937). He created memorable partnerships, most notably with Ginger Rogers, using dance as a romantic symbol of love.

Asturias, Miguel Angel (1899–1974), Guatemalan writer. He wrote poetry and short stories, but is best known for his novels. Having studied anthropology in Guatemala and Paris, he was familiar with myths, particularly those of Mayan culture, and used them effectively in many of his prose works. His best-known novel, *The President* (1946), a study of a society dominated by evil personified in a dictator, was influential on later Latin American novelists in its mixture of realism and fantasy. He won the Nobel Prize for Literature in 1967.

Atget, Eugène (1856–1927), French architectural photographer. Atget became a photographer at the age of 41, taking pictures of Parisian life and architecture as reference material for painters. With the simplest equipment, he aimed to make the most straightforward and accurate records. Discovered by Berenice *Abbott, his pictures came to be recognized as far more than mere documents. Atget's work is a prime example of how photographs intended for one purpose can serve another for later generations, who find in them a nostalgic beauty.

atonality, the absence of a readily identifiable musical *key, music in which all twelve notes of the chromatic *scale are used without reference to a tonal centre. Atonality is foreshadowed in the highly chromatic music of mature Wagner (as in *Tristan und Isolde*), where rapid

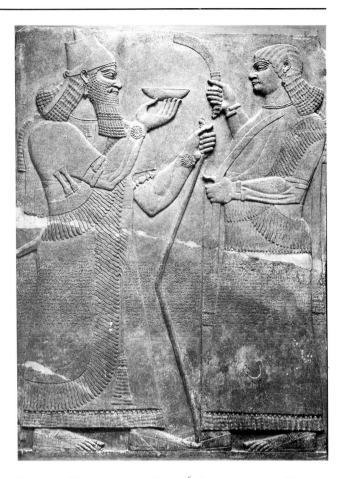

Typical of **Assyrian art**, this relief carving shows King Ashurnasirpal flanked by a human attendant. The relief is one of a series found at the Assyrian palace in the royal city of Calah or Nimrud on the River Tigris (c.865–860BC), where the state apartments were decorated with relief friezes celebrating the invincibility of the king. The inscriptions, all identical, list the king's accomplishments. (British Museum, London)

and frequent modulation (see *harmony) weakens the sense of key. However, the first truly atonal works were written by Schoenberg, in about 1908–9. Other early atonal composers were his pupils Webern and Berg. The search for a structural justification for atonality, to replace that developed over the centuries for tonal music, led to *Schoenberg's proposal of the twelve-note *serial technique in about 1920–1. (See also *tonality.)

'Attār, Farid al-Din (c.1119–c.1200), Persian poet. By profession a pharmacist and doctor, he was a prolific writer who wrote a *divan* or collection of lyrical poems and a number of long poems which were in the philosophical tradition of Islamic mysticism or Sufism. The best known is the *Logic of the Birds*, an allegorical work about thirty birds who set out to find their king, the Simurgh. He also wrote a prose work outlining the biographies and sayings of famous Muslim mystics. (See also *Sufi literature.)

Atwood, Margaret (1939–), Canadian poet, novelist, and short-story writer. In eleven poetry collections, including two volumes of *Selected Poems* (1976 and 1986), she has contributed a memorable voice to modern poetry with her startling imagery and her ironic, elliptical

examinations of the individual confronted by a threatening environment, and by the various myths that support us, including that of romantic love. Her tense, abbreviated style is also evident in her seven novels, in which she examines the roots of a woman's relations with others and with the world—with a sexist society in her first novel, *The Edible Woman* (1969), with nature in *Surfacing* (1972), with a bleak future world in *The Handmaid's Tale* (1985), and with her past in *Cat's Eye* (1988).

Aubrey, John (1626–97), English antiquarian and biographer. Aubrey's *Miscellanies* (1696), a collection of stories and folklore, was the only work published in his lifetime. He is chiefly remembered for his *Brief Lives* (1898, ed. Andrew Clark) of eminent people, which are a lively and varied mixture of anecdote, first-hand observations, folklore, and erudition, giving a valuable and entertaining, though at times inaccurate, portrait of an age.

Auden, W(ystan) H(ugh) (1907–73), British poet, who took US citizenship in 1946. The timely sense of menace in his early collections, notably *Look, Stranger!* (1936), made him the leading young poet of the 1930s, and his mastery of many verse-forms is evident in later collections, especially *Another Time* (1940) and *The Shield of Achilles* (1955). From about 1940 the Marxist inclination of his early verse (much of which he rewrote) tended to be replaced by Christian themes, but his democratic rebelliousness and his Freudian diagnosis of modern unease remained. 'Letter to Lord Byron' (1937) is his outstanding

W. H. **Auden** (*left*) is seen with two friends who were also leading literary figures: Christopher Isherwood (*centre*) and Stephen Spender (*right*). Auden and Isherwood collaborated several times in the 1930s, on three verse-plays and on an account of a journey to China entitled *Journey to a War* (1939).

work of comic verse. A disciplined poetic craftsman, he shows a tolerant, humane approach to ethics and politics.

Audubon, John James (1785–1851), US painter and naturalist. The son of a French sea captain, he received drawing instruction from David in France. After moving to the USA in 1803 he worked as a naturalist, hunter, and taxidermist, also earning some money as a portraitist and drawing master. His combined interests in art and ornithology grew into a plan to make a complete pictorial record of all the bird species of North America. His great work, *The Birds of America*, was published in Britain in four volumes of hand-tinted *aquatints in 1827–38. It is now one of the most prized of all printed books.

Augustan Age (English and French), a literary term applied in Britain to the early and mid-18th century when writers such as *Pope, *Addison, *Swift, and *Steele admired and imitated their Roman counterparts who flourished under the Emperor Augustus (27BC–AD14). This period was notable for the perfection of the *heroic couplet, a preference for wit and elegance, and for intellectual rather than emotional satisfaction. The tradition survived in Britain throughout the greater part of the 18th century, notably in the writings of *Johnson, *Sheridan, and *Goldsmith, who wrote in the weekly periodical the *Bee* an 'Account of the Augustan Age in England' (1759). In French literature the term is applied to the period of *Corneille, *Racine, and *Molière.

Auric, Louis Les *Six.

Ausdrucktanz *Modern dance.

Austen, Jane (1775–1817), British novelist. She was greatly stimulated by her extended and affectionate family, and apart from occasional visits to London, Bath, Lyme Regis and her brothers' houses, her life was externally uneventful. She never married. Her writings focus on the social life and manners of the country gentry, portraying them vividly and with affectionate irony. Her treatment of unexceptional people in everyday life gave a distinctly modern character to the art of the novel. Her reputation rests on six major novels: *Pride and Prejudice* (1813); *Mansfield Park* (1814); *Emma* (1816); *Persuasion* (1818); *Northanger Abbey* (1818), in which she parodies the refined susceptibilities of the *Gothic novel; and *Sense and Sensibility* (1811). Other novels include *Lady Susan* (a short novel-in-letters written about 1793), *The Watsons*, and *Sanditon*, both unfinished. Sir Walter Scott criticized her for the narrowness of her themes but praised her 'exquisite touch which renders ordinary commonplace things and characters interesting'. Today she is regarded as one of the greatest writers of the English novel.

Australian art, art and architecture in Australia from the time of British settlement in 1788. For a century after this, Australian art followed European models (and many of the leading artists came from Europe), but a distinctive national school of landscape painters emerged in the 1880s—the Heidelberg School, so called because the members, led by Tom Roberts, worked together at Heidelberg in Victoria. They worked in the open air and captured the light, colour, and atmosphere of the Australian landscape. In the 20th century several Australian artists have combined this freshness of outlook and in-

spiration from their native country with influence from European *modernism. Three of the best known of them have done some of their finest work in series based on Australian history or tradition: Albert Tucker, whose *Images of Modern Evil* derives partly from his study of Surrealism; Arthur Boyd, noted for his Expressionistic *Love, Marriage and Death of a Half-Caste* cycle; and Sir Sidney *Nolan, famous above all for his pictures of the bushranger Ned Kelly. In architecture, the most famous and original monument is Sydney Opera House (1957–73), designed by the Danish architect Jorn *Utzon and his chief engineer Ove Arup. (See also *Aboriginal art.)

autobiography, a written account of the author's own life which concentrates on personal development rather than just describing (as in a memoir) people and places encountered. Predominantly a Western form, the autobiography reveals an increasing individualism in European and American culture, to the point at which everybody who is famous is now expected to write one. Autobiographies hardly existed in ancient times, the outstanding exception being St Augustine's *Confessions* (AD c.400), a remarkable psychological account of religious crisis and conversion. This pattern of conversion reappears in several 17th-century works such as Bunyan's *Grace Abounding to the Chief of Sinners* (1660) and later in a secular philosophical form in Wordsworth's poetic masterpiece, *The Prelude* (1850), and in J. S. Mill's *Autobiography* (1873). The modern age of autobiography may be dated from Jean-Jacques Rousseau's *Confessions* (1781–8), in which the frankness of self-revelation was unprecedented. Benjamin Franklin had earlier founded a distinctively American tradition of success story in his *Autobiography* (1766). The growth of autobiography in the West has gone hand in hand with that of the *novel: many novels are either autobiographies in disguise, or borrow the autobiographical form of confession, as in Charlotte Brontë's *Jane Eyre: An Autobiography* (1847).

automatism, a method of producing paintings or drawings in which the artist suppresses conscious control over the movements of the hand, allowing the subconscious mind to take over. Although the idea was anticipated by some earlier artists, automatism in its fully developed form is associated particularly with the *Surrealists and the *Abstract Expressionists, especially *action painters such as Jackson Pollock.

Avedon, Richard (1923–), US photographer. After being a photographer in the Marines, Avedon worked for *Harper's Bazaar* and *Vogue*. Inspired by the example of *Munkacsi, he specialized in capturing movement in still pictures of fashion, theatre, and dance. His later, gloomy portraiture included controversial studies of his father dying of cancer.

Avercamp, Hendrick (1585–1634), Dutch painter, famous for his drawings and paintings of the winter landscape. With their delightfully observed skaters, tobogganers, golfers, and pedestrians, his works give a vivid picture of sport and leisure in the Netherlands around the beginning of the 17th century. Avercamp's work enjoyed great popularity; his imitators included his nephew and pupil Barent Avercamp (1612–79).

Aztec art, the art and architecture produced in the Valley of Mexico during the hegemony of Tenochtitlán and its confederated and allied communities in about the 15th century AD and up to the Spanish conquest (1521). The architecture (see *Central American and Mexican architecture) was admired by Spanish invaders for its regularity and symmetry, enhanced by the grid-plan settings. Cortés considered Tenochtitlán a finer city than Seville, yet it was razed and only 'provincial' examples remain. Early colonial plans and paintings of royal dwellings emphasize the orderly aesthetic. Aztec sculpture is skilled and expressive; carving in relief was used to depict stories of the gods and historical scenes on slabs and ritual vessels. Free-standing sculptures, such as the statuette of a cross-legged female in Basle and the large basalt head of a male in a skull-cap in Mexico City possess realism and evocative power. Sculptors also worked in a distinctive form: monoliths carved in high relief, often with extrusions suggestive of limbs, favoured for depicting the network of attributes which each Aztec deity combined. Survivals of woodwork, goldwork, ceramics, featherwork, and lapidary art are also fine.

This huge figure of the earth goddess Coatlicue illustrates **Aztec art** at its most brutally powerful. Dating from the late 15th century, it was unearthed in Mexico City in 1792. Symbolic of the earth as destroyer as well as creator, the goddess has a necklace of human hearts and a skirt of writhing snakes (her name means 'serpent skirt'). (National Museum of Anthropology, Mexico City)

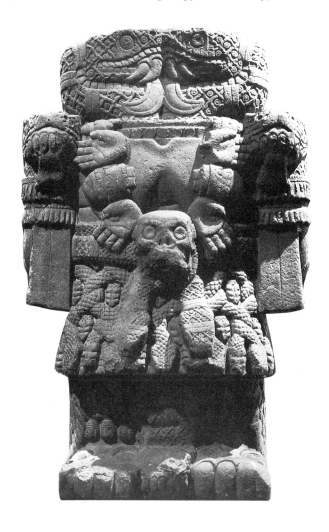

B

Babel, Isaak (Emmanuilovich) (1894–1941), Russian writer. His early short stories, collected in *Red Cavalry* (1926), present, with concentrated economy, the brutality and heroism of the post-revolutionary Russian Civil War as observed by an alienated intellectual. Babel was arrested in 1939 and died in a prison camp in Siberia.

Babits, Mihály (1883–1941), Hungarian poet, novelist, and essayist. He was the most erudite Hungarian writer of his age, combining classical scholarship with an interest in modern philosophy. His poetry is concerned mainly with the role of the individual in a confused world, while his novels such as *The Children of Death* (1927) explore psychological problems. As essayist and editor he influenced a whole generation of younger writers.

Babylonian art, the art and architecture of Babylonia, a kingdom of the ancient Near East; its capital was Babylon, the ruins of which are near the town of Al Hillah in Iraq. The city was probably founded in the 4th millennium BC, and it became the centre of a great empire in the 18th century BC under its king Hammurabi. The early Babylonians were the direct inheritors of the *Sumerian civilization, which inspired the art of their first dynasty. From the 17th century BC, Babylonia underwent a long period of domination by other powers, and from 722 to 626 BC was ruled by *Assyria. Having helped to bring about Assyria's downfall, Babylon entered its period of greatest power and prestige. Nebuchadnezzar II, king from 605 to 562 BC, rebuilt his capital as one of the greatest cities of antiquity, and was probably responsible for the famous Hanging Gardens of Babylon, which were laid out on elevated terraces and ingeniously irrigated by pumps from the River Euphrates. The Babylonians were great traders and were renowned for their love of luxury. Their buildings were often ambitious in scale, but because building materials were poor (mainly sun-dried brick) very little of them survives above ground. An example is the famous ziggurat (tiered temple) of Babylon of which only the foundations survive. The best idea of the splendour of Babylonian architecture can be gained from Babylon's Ishtar Gate (*c.*575 BC), a sumptuous structure of coloured glazed bricks, reconstructed in the Staatliche Museen, East Berlin. The other Babylonian arts were much influenced by the Sumerians and included terracotta plaques, cylinder seals, ivories, and, where the material was available, stone carvings. In 539 BC Babylonia was conquered by the Persians and was never again an independent force. (See also *Gilgamesh, epic of.)

Bach, Carl Philipp Emanuel (1714–88), German composer and harpsichordist. The second and most famous surviving son of J. S. *Bach, he was taught by his father, but also undertook extensive law studies and only settled to music in 1738, when he was engaged by the future King Frederick the Great of Prussia as accompanist to the royal chamber music. By 1768 he was the most famous keyboard-player and teacher in Europe and left Berlin to become director of music in Hamburg's five principal churches. Despite the considerable quantity of church music arising out of his Hamburg years, he is important for his many keyboard works, chamber music, and orchestral sinfonias. He made a significant contribution to the development away from the *Baroque *polyphony of his father towards the *sonata principle that was to dominate the *Classical period.

Bach, Johann Christian (1735–82), German composer, the youngest son of J. S. *Bach. He was taught by his father and, after 1750, by his brother Carl Philipp Emanuel. From 1754 to 1762 he studied and worked in Italy, becoming organist (1760) at Milan Cathedral and gaining success as an opera composer. It was in this capacity that he came to London where, apart from a period (1772–8) when he worked concurrently in *Mannheim, he remained for the rest of his life. Though he wrote for the London theatres, he made his greatest mark with the subscription concerts he gave with his friend Carl Friedrich Abel (1723–87). J. C. Bach contributed significantly to the development of the new *sonata principle. He had a strong feeling for orchestral colour and a flair for attractive melodic invention, which greatly influenced the young Mozart.

Bach, Johann Sebastian (1685–1750), German composer and organist. The most outstanding member of a vast family of 16th–19th-century musicians, he was born at Eisenach, where he received his early training from his father (d. 1695) and from his elder brother, Johann Christoph. In 1703 he took up his first important post as organist and choirmaster at Arnstadt, leaving in 1707 for a similar post at Mühlhausen. In 1708 he became court organist and chamber musician to Duke Wilhelm Ernst of Saxe-Weimar, where he remained until 1717, when he accepted the post of Kapellmeister (musical director) at the court of Prince Leopold of Anhalt-Cöthen. He left Cöthen (the most congenial of all his posts) in 1723 to become Kantor (director of music) at St Thomas's School and Church, Leipzig, where he remained for the rest of his life. Bach married twice: his cousin Maria Barbara in 1707 and, after her death in 1720, the 20-year-old Anna Magdalena Wilcken, daughter of a court trumpeter. Of his twenty children, four became outstanding musicians. Bach's compositions always reflect the demands of the post he occupied: church *cantatas (mostly *chorale-based), *motets, organ works, and chorales when in service to the church; chamber and orchestral works when at Weimar and Cöthen. Chief among his works are the Mass in B minor (1747–9), the *Magnificat* (1728–31), the *St John* and *St Matthew Passions* (performed in 1724 and 1727), all of which were inspired by his devout Protestant beliefs. Among his other great works are the six *Brandenburg Concertos* (completed 1720), the two volumes of forty-eight preludes and fugues known as *The Well-Tempered Clavier* (completed 1742), the Goldberg Variations (1742), and the final demonstrations of his extraordinary contrapuntal (see *counterpoint) skills: the *Musical Offering* (1747) and *The Art of Fugue* (1745–50). Admired in his day but soon forgotten, the magnitude of his genius was not fully appreciated until the 19th century. (See also *Baroque music.)

Bacon, Francis, 1st baron Verulam and Viscount St Albans (1561–1626), English politician and philosopher.

Acclaimed in Europe as the pioneer and leader of experimental philosophy, he was of particular influence during the *Enlightenment. His *Essays* (1597–1625) and other writings mark him as a master of English prose.

Bacon, Francis (1909–), British painter. He was self-taught as an artist and destroyed much of his early work. In 1945, however, he became overnight the most controversial painter in post-war Britain when his *Three Studies for Figures at the Base of a Crucifixion* (1944) was exhibited in London. Featuring twisted and distorted figures set against a vivid orange background, this is typical of Bacon's work in evoking a nightmarish world of fear, horror, and revulsion that shocks and disturbs the spectator with its emotional power. The impact of his pictures derives not only from their subject-matter— usually single figures in isolation or despair—but also on his handling of paint, by means of which he smudges and twists faces and bodies into ill-defined jumbled protuberances suggestive of formless, slug-like creatures. Bacon has built up a reputation as one of the giants of contemporary art, with a style that is uniquely his.

Baez, Joan (Chanders) *popular music.

bagatelle, a short, lightweight instrumental piece in music, usually for keyboard: a mere trifle. The term is first found in 1717 in one of Couperin's keyboard suites. Beethoven's three sets of keyboard bagatelles (not all of which are 'trifling') gave the term greater currency. Webern wrote Six Bagatelles for string quartet (1913).

bagpipe, a reed musical instrument blown via a bag, which may be inflated either by mouth or by means of bellows. There are two basic varieties: those with a conical shawm chanter or melody pipe, and those with a cylindrical (clarinet ancestor) chanter. The former are usually loud outdoor instruments; many of the European examples of the latter are quiet indoor instruments. Both are designed to give a continuous supply of air without having to learn the technique of taking breath while not interrupting the sound. *Drone pipes are often added and a few bagpipes have more than one chanter; the so-called Irish Union pipe or uilleann pipe, has extra pipes, or regulators, with keys providing chords for accompaniment. Bellows-blown pipes allow pipers to sing to their own playing. Bagpipes, which are now associated especially with Scotland, Northumberland, and Ireland, are also found elsewhere in Europe, with many different regional types; they are also widespread in the Middle East and northern India.

Bai Juyi (772–846), Chinese poet of the Tang dynasty (618–907), who achieved fame as a writer of verse in a low-key, near vernacular style that was popular throughout China and in Korea and Japan. The themes of his poems include nature and friendship, but many refer to his political career.

Baker, Dame Janet (Abbott) (1933–), British mezzo-soprano singer. Although extremely versatile, her operatic repertoire stretching from Monteverdi to Kate in Britten's *Owen Wingrave*, Baker is perhaps most associated with roles in 18th-century opera, notably by Handel and Rameau. An intense and intelligent singer,

Baker is an impressive interpreter of *Lieder*, British and French song, and oratorio.

Bakst, Léon (Lev Semuilovich Rosenberg) (1866–1924), Russian painter and *set designer. Associated with *Diaghilev's magazine *The World of Art* from 1899, he became one of the most influential members of the Diaghilev circle and the Ballets Russes. He designed the décor for their productions such as *Carnaval*, *Shéhérazade* (both 1910), *Spectre de la rose* (1911), *L'Après-midi d'un faune*, *Daphnis and Chloë* (both 1912), and *The Sleeping Princess* (1921). His stylized set and costume design brought to Europe a riot of oriental colour.

Balakirev, Mily *Five, The.

balalaika, a Russian folk instrument with three strings and a triangular body, played like a *banjo. It has a long neck with frets on the fingerboard. The belly is flat and the back is made from several flat pieces of wood, each meeting at an angle. The tuning is usually to the E, E, and A above middle C. In the 19th century a full family was created, with sizes down to double bass, and balalaika orchestras became popular in Russia and elsewhere.

Balanchine, George (1904–83), Russian-born dancer and choreographer. He trained at the Imperial Theatre, and danced in Europe before joining *Diaghilev's Ballets Russes in 1924, where he was principal choreographer. He started the School of American Ballet in New York in 1934 (a company, *American Ballet Theater, was formed in 1939) and became director of *New York City Ballet in 1948. Plotless ballets with minimal costume and décor, performed to *Classical and *Neoclassical music characterize his choreography, which emphasizes the primacy of movement as the *danse d'école*. Neoclassical works to Stravinsky's music as in *Agon* (1957) are common, but so too are more romantic ballets such as *Serenade* (1934) to Tchaikovsky's music.

Baldwin, James Arthur (1924–87), US novelist, short-story writer, dramatist, and essayist. With his first novel, *Go Tell It On The Mountain* (1953), which drew on his background as the son of a preacher in Harlem, New York, he was hailed as the successor to Richard *Wright as the leading black American novelist. *Giovanni's Room* (1956) and other novels reinforced this reputation, but his collections of essays were often more highly regarded, particularly those published during the US civil rights movement: *Notes of a Native Son* (1955), *Nobody Knows My Name* (1961), and *The Fire Next Time* (1963).

Balla, Giacomo (1871–1958), Italian painter and sculptor, one of the leading artists of the *Futurist movement. Balla was concerned with expressing movement in his works, but unlike most of the other leading Futurists, he was not interested in machines or violence, his work tending towards the witty and whimsical. After World War I Balla stayed true to the ideals of Futurism when his colleagues abandoned them, but he turned to a more conventional style in the 1930s.

ballad, a folk song, generally with a repeated melody, which tells in a direct and dramatic manner some story usually derived from a tragic incident in local history or

This detail from an oil painting by Nicolas Lancret shows the **ballerina** Marie Camargo in 1730. She is said to have shortened the skirt of the ballerina's traditional costume to allow more liberty for movement, and created a fashion for shoes '*à la Camargo*'; her fame was such that the chefs of the day named several dishes after her. (Musée des Beaux Arts, Nantes)

legend. The story is told simply, often with vivid dialogue, in *quatrains with alternating four-stress and three-stress lines, the second and fourth lines rhyming. In Britain, ballads emerged in Scotland and England from the 14th century, and have been imitated since the 18th century by poets outside the folk-song tradition; notably by Coleridge in 'The Rime of the Ancient Mariner'.

ballade, an Old French lyric verse form, usually consisting of three 8-line *stanzas with an additional half-stanza, each ending with the same line as a refrain. In the 14th century, Guillaume de Machaut set many of his *ballades* to music; but the most celebrated examples were written in the 15th century by Villon. In music, the term can refer either to a folk-song (*ballade* being the German word for *ballad) or to a kind of composition for piano in a narrative style, as in some works by Chopin, Brahms, and others.

ballerina, a woman *ballet dancer, especially one taking leading roles in classical ballet. The prima ballerina is the star dancer of a company. In general, this recognition of the importance of the dancer reflects the method of composition or *choreography and the importance of indi-

vidual interpretation in all forms of dance. The focus on the female at the expense of the male, however, is a phenomenon of the 19th-century movement towards *Romanticism in dance, emphasizing the spiritual and sensual virtues of woman. Prime examples of technical virtuosity and expressive power were Marie Camargo (1710–70) and Marie Sallé (1707–56) and ethereal lyricism and sensual dramatic qualities were displayed by Marie Taglioni (1804–84) and Fanny Elssler (1810–84). In the 20th century prominent interpreters of both Romantic and Classical works, often emerging from *Diaghilev's Ballets Russes revival, have been the Russian dancer Anna Pavlova (1881–1931), who toured with her own company; Tamara Karsavina (1885–1978), famous in the Ballets Russes; Alexandra Danilova (1903–), a member of Russian and US companies; Galina Ulanova (1910–) of the Bolshoi Ballet; Alicia Markova (1910–), attached to British companies; Margot Fonteyn (1919–) of the Royal Ballet; and Alicia Alonso (1917–) of American Ballet Theatre and Cuban Ballet. Natalia Makarova (1940–) has, like so many of her predecessors, crossed the boundaries between Russia and Western Europe, and Suzanne Farrell (1945–) of New York City Ballet is a notable exponent of the American tradition. One of the principles of *modern dance was the creation of work in a non-hierarchical manner that continues into *postmodern dance. Roles are less frequently identified by specific characters' names, hence the opportunity for the development of an individual part is less. Soloists are rarely mentioned as such, and all performers are equal within the *dance company.

ballet, a theatrical form of dance typically combining dance steps with music, set, and costume in an integrated whole. The dance is usually based on a narrative (in which case it might include *mime) or on the movements typical of the genre (the *danse d'école*). The lavish, and extremely long, Italian court spectacles of the Renaissance were often based on allegorical sources. They developed into the French *ballet de cour* under Louis XIV to the music of composers such as Lully and Rameau. By establishing the first dance academy in 1661 and the Paris Opera Ballet in 1669, Louis XIV was responsible for encouraging the acceptance of dance as a professional art. In the early to mid-18th century *ballet d'action* attempted to unite the story-telling function with an increasingly codified vocabulary of mime and movement in a more realistic portrayal of events. *Weaver in London and *Noverre in Stuttgart and Vienna were the chief exponents in a Europe-wide development which culminated in Taglioni's *Robert le Diable* in 1831 and *Bournonville's *La Sylphide* in 1836. Initially the dance movement was restricted to small steps and graceful gestures of the arms with the emphasis on intricate floor patterns and groupings. The steps were formalized by *Blasis in the early 1800s through an analysis of the *five positions of the feet, and the positions for arms, trunk, and head; these remain the basis of the *danse d'école* (the academic school style of classic ballet) and of ballet in the 20th century. The development of ballet from this

A poster by **Bakst**, *right*, showing the Russian dancer Nijinksy in *L'Après-midi d'un faune* (1912). Bakst's innovatory work, which unified set and costume design, created a sensation in Paris. (Bibliothèque Nationale, Paris)

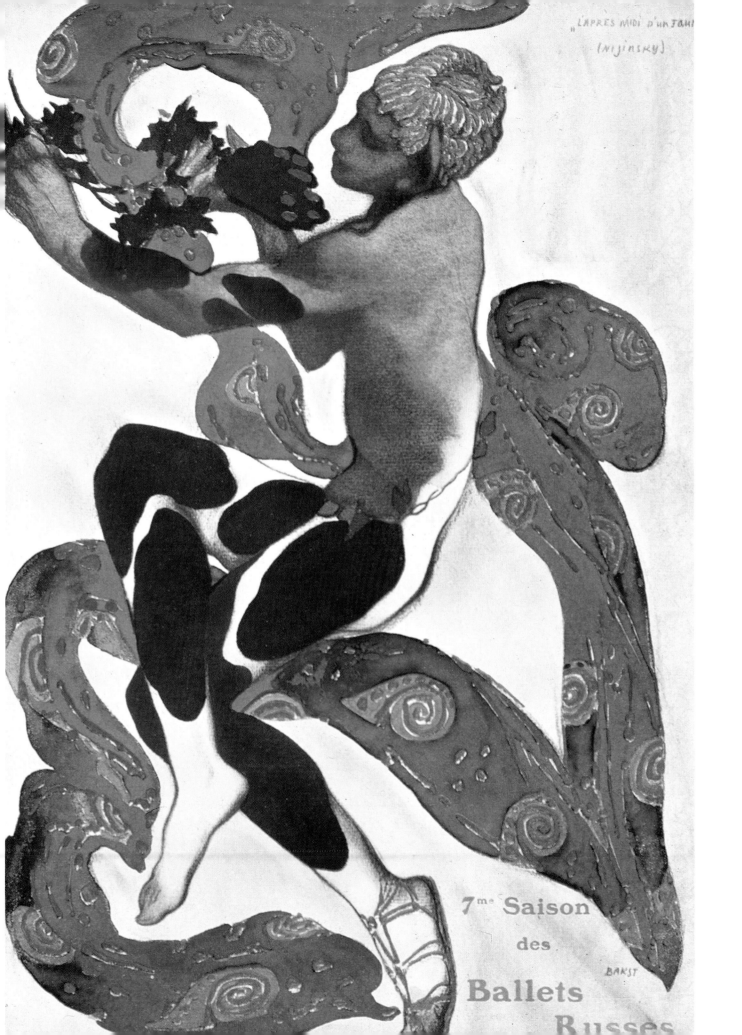

"L'APRES MIDI D'UN FAUNE
(NIJINSKY)

7me Saison

des

BAKST

Ballets

Russes

Some common ballet positions and movements

The five positions

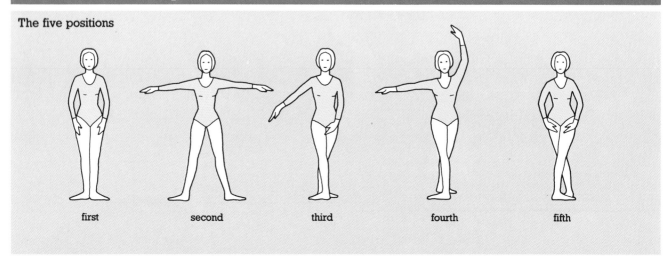

first second third fourth fifth

Positions of the body, attitude, and arabesque

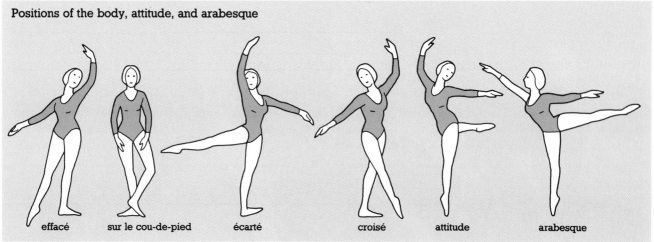

effacé sur le cou-de-pied écarté croisé attitude arabesque

Pirouette Cabriole

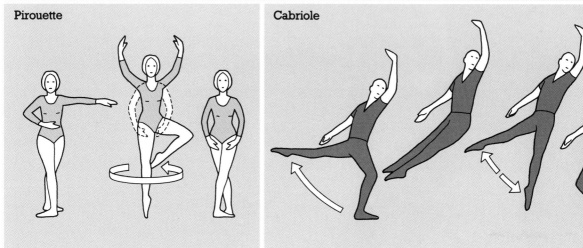

point might be roughly divided into the mid-19th-century romantic ballets, the Russian classics of the latter part of the 19th century, and the Ballets Russes of *Diaghilev, which act as a bridge to the *modern and *postmodern ballets of the 20th century. The romantic ballets have characteristics common to *Romanticism across the arts, of the creation of an ethereal, idealized world. Dancing on point and the use of gauzy white floating fabric helped to create this illusion. Its highest point was undoubtedly reached in the Paris Opéra productions of the 1830s, while Copenhagen developed its own brand of middle-class ballet romanticism and London actively participated in the international ballet boom. Russian ballet owes its origins both to a romantic use of the folk or character dances of the 19th century and to the techniques of ballet. It flourished under Tsarist patronage and, with the arrival of the *choreographer *Petipa in 1847, the Imperial Ballet developed the Classical form to perfection. Ex-

traordinary precision, fleetness of foot, and lightness of movement typify *Classicism in dance. The major development under Petipa was the refinement and perfection of the technique in solos and *pas de deux (duets) and in manipulating a large corps de ballet through complex geometric designs. Exotic settings and fantastical themes continued to be common, allowing mime to develop further its own code of gestures. The Sleeping Beauty (1890) is one of the archetypal works of dance Classicism. The Western European revival of ballet in the 20th century is credited to the Russian impresario Diaghilev through the Ballets Russes *dance company, which first toured Europe in 1909. His ability to bring major choreographers (*Fokine, *Massine, *Nijinsky, *Nijinska) together with composers (*Stravinsky, Fauré, Prokofiev, Satie) and painters (Benois, *Bakst, Roerich, Picasso) to collaborate on works such as The Firebird, Petrushka, and The Rite of Spring heralded a new age. Colourful Russian and oriental spectacles were set alongside works reflective of experimental modern art in what were sometimes seen as outrageous avant-garde programmes.

Although the Ballets Russes performed in London it was not until the middle of the 20th century that a distinctive style emerged in Britain. In the 1920s the formation of schools and companies by Rambert (Ballet Rambert, now *Rambert Dance Company) and *de Valois (the *Royal Ballet and Sadler's Wells Royal Ballet) was the start of a development based initially on Ballets Russes works. Later, revivals of ballets from the Romantic and Classical periods joined the repertoire, but always with new or 'modern' choreographies. Some of these new

The family of the Italian artist Giuseppe Bibiera (1696–1756) dominated European stage design for over a century. In this ink-and-wash drawing of a **ballet de cour** he shows the beginnings of the diagonal stage set. The cherubs decorating the fountain and the statues flanking the sides would probably have been live children and women. (British Museum, London)

works owed allegiance to Romantic inspiration, perhaps seen particularly in *Ashton's treatment of themes, just as much as to modern movements in art. Modernism in dance, however, is reflected in works such as *Tudor's Dark Elegies, which reveal universal emotions in an *Expressionist manner through movement, rather than facial expression. *MacMillan is the British choreographer who continues this development within the Royal Ballet company repertoire through psychological studies, sometimes of historical characters. Bournonville took the French Romantic ballet to Denmark and established a repertoire which has remained intact. Classicism in ballet shows direct continuation from Petipa to *Balanchine, the Ballets Russes choreographer who established an American style of ballet. Balanchine's Neoclassical works, often using *Stravinsky scores, for example Apollo (1928) and Agon (1957), became the hallmarks of American ballet. Balanchine (with the writer Lincoln Kirstein) founded *New York City Ballet in 1948 to perform his own works. His dances, produced over a long career, range from the austere to the Romantic, from Neoclassical abstraction to Broadway *musicals. Balanchine's interest in the development of musical theatre in America was shared by many other choreographers: Agnes *de Mille and Jerome *Robbins contributed Oklahoma (1943) and West Side Story (1957) to the genre. This eclecticism, revealed in the incorporation of *jazz dance elements into ballet, continued later with *modern dance. Some of the characteristics of this newer genre are now seen in modern ballet, for example in MacMillan's Gloria (1980), which deals with the horrors of war. (See also *dance notation.)

ballet companies *dance companies.

ballet de cour, a form of court entertainment, performed exclusively by aristocratic amateurs, which had its greatest flowering between 1580 and 1660. Derived from the *intermedii of the Italian Renaissance, the ballets

de cour consisted of spectacles produced in the private theatres and sometimes the grounds of royal palaces, in which the king and his court performed before invited audiences. The *ballet* consisted of a series of mythological one-act dramas in dance form, accompanied by instrumental music. The costumes and décor were sumptuous and the stage machinery created spectacular technical effects. *Le Balet Comique de la Reine* (1581) is considered to be a forerunner of the *ballet de cour*. In *Le Ballet de la nuit* (1653), the 14-year-old Louis XIV appeared as the sun god, Apollo, from which he gained his title, the Sun King. An earlier related court entertainment in England was known as the *masque.

Ballet Rambert *Rambert Dance Company.

Ballets Russes *dance companies; *Diaghilev, Serge.

ballroom dancing *social dance; see also *rumba, *samba, *tango, *waltz.

Baltic literatures, literature of Estonia, Latvia, and Lithuania. The first known printed vernacular books in all three Baltic states were the Lutheran and Catholic catechisms of the 16th century. In the 19th century an upsurge in patriotic feeling, similar to that expressed in *Finnish literature, inspired the strongly nationalistic *Romantic poetry of writers such as Friedrich Reinhold Kreutzwald (1803–82), Lydia Koidula (1843–86), and Antanas Baranauskas (1834–1902). This trend merged into a period of Realist writing in the plays of August Kitzberg (1856–1927), and the short stories of Rudolfs Blaumanis (1863–1908). Neo-romanticism and *Symbolism in the writings of Jānis Rainis (1865–1929); and Vydūnas (Vilius Storasta; 1868–1953) respectively, were established forms at the turn of the century, and developed further in the wake of the 1905 revolution by members of the Young Estonia group such as Gustav Suits (1885–1956). The Nazi occupation and annexation of the states by the Soviet Union in 1944 drove many writers into exile. Initially writers at home, constrained by the dogmas of *Socialist Realism, could only discuss certain aspects of political life, but gradually they began to look at a wider range of social subjects. Under the influence of *perestroika* émigré writings have begun to appear officially within the three states, re-forming single national literatures. There has been a move away from novels to the more immediate essay form, and to accounts of recent history such as *The Tellings of the Truth* (1988), by the Lithuanian Stasys Kašauskas. Amongst younger writers there is a return to idealist, Christian principles, for example *Memoirs of a Young Man* by the Lithuanian Ričardas Gavelis. (See also *Polish literature.)

Balzac, Honoré de (Honoré Balssa) (1799–1850), French novelist and short-story writer, one of the great French literary figures of the 19th century. He wrote in total some ninety-one novels and tales which together provide a panoramic picture of French life ranging from the peasantry and the provinces to the aristocratic salons of the capital. Among the most famous are *Eugénie Grandet* (1833), *Le Père Goriot* (1834), *Les Illusions perdues* (1837–43), *La Cousine Bette* (1846), and *Le Cousin Pons* (1847). In the collected edition of 1842–8 the novels were grouped together under the title *La Comédie humaine*, which portrays in all over two thousand characters, some of whom, like

the criminal Vautrin, appear in more than one book. Balzac's greatness does not lie in his style, which is at times laboured and overburdened with detail; rather he has the gift to enter imaginatively into the psychology of his characters, often through the observation of minute incidents. His theme is primarily the corrupting power of money and the overriding force of self-interest. The strength of his visionary power reveals Balzac's debt to the *Romantic movement of the early 19th century, while the care which he took in documenting, for example, the legal and financial background to his novels shows him to be a forerunner of *realism.

Bandello, Matteo Maria (1485–1562), Italian short-story writer. He wrote a collection of 214 *Novelle* (Novels), which made him the most popular short-story writer of his day. His stories, though not stylish, give an excellently observed picture of the Italian bourgeoisie: materialistic, amoral, usually lecherous. They were a frequent inspiration to English, French, and Spanish dramatists, notably to Shakespeare for *Romeo and Juliet*, *Much Ado About Nothing*, and *Twelfth Night*, and Webster for *The Duchess of Malfi*. His style strengthened the establishment of the vernacular as the literary Italian language of the day.

bandora, a wire-strung plucked musical instrument invented by John Rose in 1562. It has a flat or slightly curved back and an elaborately curved outline, with wire frets on the fingerboard. The six double courses or pairs of strings were plucked with the fingers, not a plectrum. It was used in the theatre and as a *continuo instrument in consort music (music for small instrumental groups), and was popular up to the end of the 17th century.

banjo, a plucked stringed musical instrument of Afro-American origin with a drum-like resonator, the belly of which is made of skin or plastic. Banjos were first made by slaves on American plantations, possibly on the model of instruments such as the West African *banja*, remembered from their homelands. By most accounts these were made of half a gourd with sheepskin nailed on to it. The earliest banjos had no frets, but fretted fingerboards are now normal. The standard banjo has five strings; the skin belly and wire strings produce a loud ringing sound heard in *folk music and traditional *jazz.

Barber, Samuel (1910–81), US composer. Such works as *Dover Beach* (1931), for baritone and String Quartet (1931), established him as an effective composer working in a conservative, romantic idiom. His *Adagio for Strings* (1936) has become a popular classic, but his operas *Vanessa* (1957) and *Antony and Cleopatra* (1966) were less successful. *Knoxville: Summer of 1915*, an extended song for soprano and orchestra composed in 1947, shows him at his best.

Barbizon School, a group of French landscape painters named after a village in the Forest of Fontainebleau, where its leader Théodore *Rousseau and others, including *Millet, Narcisse-Virgile Diaz (1807–76), and Charles-François Daubigny (1817–79), settled in the 1840s. Influenced by 17th-century Dutch painters and by English landscapists such as *Constable, their aim in art was to achieve freedom from academic convention, especially by painting directly from nature, though, unlike the later *Impressionists, the Barbizon artists usually

painted only studies in the open air, their pictures being completed in the studio.

barcarole, a piece of music that imitates the songs sung by Venetian gondoliers. The accompaniment (in 6/8 or 12/8 *time) suggests the gentle rocking of the gondola. The form is found in operas (such as Offenbach's *Les Contes d'Hoffmann*) and in purely instrumental works, such as Mendelssohn's *Songs without Words*.

bard (originally a composer of eulogy or satire), a poet of the ancient Celts whose role it was to celebrate national events, especially heroic victories. The bards occupied a separate social status with hereditary privileges which, in Wales, were codified into distinct grades in the 10th century. They became extinct in Gaul relatively early but continued in Ireland and Scotland until the 18th century and in Wales to the present day, occupying a central position in the contest of poetry and music known as the Eisteddfod (Welsh, 'session', revived in 1822). In modern Welsh usage a bard is a poet who has taken part in the Eisteddfod.

Barocci, Federico (*c*.1535–1612), Italian painter. His work, mainly of religious subjects, is characterized by great sensitivity of feeling and remarkable beauty of colouring, subtle pastel tints predominating. With this extreme delicacy, however, went a splendid vigour of design and brushwork. Barocci is generally considered the greatest and most individual painter of his time in central Italy, the freshness and vigour of his work setting him apart from the prevailing *Mannerism and heralding the *Baroque.

Baroque art, a term applied to European art and architecture of the 17th and 18th centuries or, more specifically, to certain aspects of it. The word 'Baroque' has a complex history and has been used in various ways. It was coined at a time when much 17th-century art was out of favour and was originally a term of abuse, suggesting the idea of grotesqueness (it may derive from a Portuguese word for a misshapen pearl). In serious art-historical writing the term now describes the dominant style in European art between the *Mannerist and *Rococo styles, that is, from about 1600 to the early years of the 18th century. From the Mannerist style the Baroque inherited movement and fervent emotion, and from the *Renaissance style solidity and grandeur, fusing the two influences into a new and dynamic whole. This style originated in Rome and is associated with the Roman Catholic counter-reformation, its salient characteristics of overt rhetoric and dynamic movement being well fitted to expressing the self-confidence of the reinvigorated Roman Catholic Church. When the style spread outside Italy, it took root most deeply in other Catholic countries. It had little effect in Britain, for example. In painting, two great Italian artists stand at the head of the Baroque tradition—*Caravaggio and Annibale *Carracci, both of whom produced their most influential works in Rome in the last decade of the 16th century and the first decade of the 17th century. Italian painting of the late 16th century had generally been artificial and often convoluted in style, but Caravaggio and Carracci painted with a new solidity and weightiness. In architecture the most important figure in the creation of the Baroque in Rome was Carlo Maderna (1556–1629), who broke away from

Mannerism to create a style of great lucidity and forcefulness. His key work, the façade of the church of Santa Susanna in Rome, dates from 1603. The major figure in the development of Baroque sculpture was Gianlorenzo *Bernini, whose first masterpieces in the new style date from around 1620. Cornaro Chapel (1645–52) in the church of Santa Maria della Vittoria blends painting, sculpture, and architecture in an emotional way that is considered quintessentially Baroque. Bernini's greatest Italian contemporaries, in the period that is sometimes called the High Baroque, were the architect *Borromini and the painter and architect Pietro da *Cortona. Slightly later was Andrea Pozzo (1642–1709), whose ceiling painting, *Allegory of the Missionary Work of the Jesuits*, in the church of Sant' Ignazio in Rome marks the culmination in Italy of the Baroque tendency towards overwhelmingly grandiose display. In the 17th century Rome was the artistic capital of the world, attracting artists from all

The ceiling of the church of Il Gesù in Rome sums up the rhetorical splendour, religious fervour, dynamic energy, and illusionistic skill typical of **Baroque art**. The central painting, *The Adoration of the Name of Jesus* (1674–9), is by Bernini's protégé Gaulli, and the stucco figures that are so brilliantly combined with the painted decoration are by Bernini's pupil Raggi.

over Europe, and the Baroque style soon spread outwards from it. It underwent modifications in each of the countries to which it migrated, as it encountered different tastes and outlooks and merged with local traditions. In some areas it became more extravagant (notably in Spain and Latin America, where a lavish style of architectural ornamentation called *Churrigueresque developed), and in others it was toned down to suit more conservative tastes. In Roman Catholic Flanders it had one of its finest flowerings in the work of *Rubens. However, in neighbouring Holland, a Protestant country, the Baroque had less impact, although *Rembrandt, for example, went through a distinctively Baroque phase in his early maturity, when his work was often extremely lively and dynamic. In France the Baroque found its greatest expression in the service of the monarchy rather than the church. Louis XIV was a lavish patron and he realized the importance of the arts as a propaganda medium in promoting the idea of his regal glory. His adviser in artistic matters was Charles *Lebrun, who led the army of artists and decorators who worked on Louis's palace at Versailles. With its grandiose combination of architecture, sculpture, painting, decoration, and landscaping, Versailles represents one of the supreme examples of the Baroque fusion of the arts to create an overwhelmingly impressive whole. Baroque art favoured the theatrical effect created by the dramatic use of lighting, false perspective, and trick painting used for stage production. The Baroque style made little appeal to sober British taste. In English architecture the Baroque spirit flourished briefly and idiosyncratically in the work of *Vanbrugh and *Hawksmoor in the early 18th century, and some of *Wren's later work comes close to this style as demonstrated by the feeling for large-scale work evident in his magnificent designs for St Paul's Cathedral (1675–1710) and the Greenwich Hospital (begun 1696). It was soon succeeded by the more sedate style of *Palladianism. In all areas the Baroque merged imperceptibly into the lighter *Rococo style that followed it. The period of transition was particularly fruitful in Central Europe, notably in Dresden (destroyed by Anglo-US bombing in 1945), Vienna, and Prague.

Baroque music (c.1600–c.1750). Music composed from about 1600 to the death of J. S. *Bach in 1750 has one simple feature in common: it was built on a *continuo line, a bass that was used by players—particularly of keyboard and plucked instruments—to generate an essentially improvised accompaniment. This allowed a freedom of expression that was particularly important to both composers and performers. The technique existed before 1600 and was still being used in the time of Haydn and Mozart, but the years 1600–1750 saw its main and most rigorous cultivation. It made possible the rise of *opera, which took root, after some earlier experiments, at Venice in the late 1630s: throughout the Baroque era, a very large part of the opera repertory was actually written merely as a melody line (whether played or sung) and continuo bass, though performed with larger forces. Although only the operas of *Monteverdi, *Cavalli, and *Handel, have been widely performed in modern times, opera was the most prominent music in the Baroque period. Instrumental music, and particularly the rise of the *concerto, similarly benefited from the virtuosity and freedom of this *stile moderno*; but they drew just as strongly on the church tradition, the *stile antico* inherited from

Renaissance *polyphony, because this was well known to all keyboard players. A mix of the two traditions fuelled the later German style and particularly that of J. S. Bach, a man whose organ music and church cantatas remain the most powerful testimony of Baroque music.

Barrault, Jean-Louis (1910–), French actor, director, and manager. The study of *mime has played an important role in the development of his technique. In 1946 he and his wife, the actress Madeleine Renaud, formed their own troupe at the Théâtre Marigny in Paris. As an actor Barrault, elegant and outwardly nonchalant, gives the impression of strong passions firmly controlled by disciplined intelligence and physically sustained by the strenuous exercise of mime. As a mime-actor he is best known through his appearance as Deburau in *Carné's film *Les Enfants du paradis* (1945).

Barrie, Sir J(ames) M(atthew) (1860–1937), British dramatist and novelist. His literary career began with a series of stories and novels in the 'Kailyard' or 'cabbage patch' tradition which portrayed a romantic image of village life in Scotland. His most successful plays are his sentimental comedy *Quality Street* (1901), and *The Admirable Crichton* (1902), a comedy about a manservant cast away on a desert island with his employers. Barrie is best remembered for his celebrated children's play *Peter Pan* (1904) about a boy who would not grow up.

Barry, Sir Charles (1795–1860), British architect. He was the pioneer and chief exponent of a rich Italianate style, reviving the classicism of the Renaissance palaces of Rome and Florence, that became highly popular in the Victorian period. The Travellers' Club (1830–2) and the Reform Club (1838–41), in Pall Mall, London, are his best-known works in this vein. His most famous work is the Houses of Parliament (1839–52), but while Barry was responsible for the overall composition, the *Perpendicular Style detail is by *Pugin. Two of Barry's sons were architects, and a third, Sir John Wolfe Barry, was engineer of Tower Bridge, London.

Barry, James (1741–1806), Irish painter who moved to London in 1764, influenced by the great masters of the Renaissance. His most important work, the series of paintings on *The Progress of Human Culture* (1777–83) shows, however, that his ambitions outstripped his talent. Barry's portraits are now considered more successful than his history paintings.

Bartók, Béla (1881–1945), Hungarian composer and pianist. Early compositions, notably the symphonic poem *Kossuth* (1903), reflect his sympathy with the movement for Hungarian independence, and from 1904 (with *Kodály) he was increasingly concerned with the collection and study of Hungarian and Romanian *folk music. These researches, coupled with the influence of *Debussy, freed his music from German models and he soon developed a distinctive style: rhythmic, percussive, tonally free, and harmonically astringent. The opera *Duke Bluebeard's Castle* (1911) and the ballets *The Wooden Prince* (1917) and *The Miraculous Mandarin* (1919) helped establish his reputation as a leading, if controversial, composer. Between the Wars he toured Europe and the USA as a concert pianist, but with the collapse of Hungary to Nazi Germany he fled to the USA (1940),

Taken in 1908, this photograph shows the composer **Bartók**, *centre*, with a group of Hungarian peasants. Equipped with his phonograph, he was at work collecting folk music. Bartók collected and studied some 10,000 folk-songs, which were an important influence on his own music.

where, in comparative obscurity, he completed his last works, including the ebullient Concerto for Orchestra (1943). Six string quartets (1908–39), together with three piano concertos (1926, 1931, 1945), two violin concertos (1908, 1938), the Music for Strings, Percussion and Celesta (1936), and the Sonata for Two Pianos and Percussion (1937) form the core of his achievement.

Bartolommeo, Fra (Baccio della Porta) (*c.*1472–1517), Italian painter. He worked in Florence for virtually all his career. His work has much in common with that of *Raphael, and the solemn restraint and graceful dignity of his mature paintings make him one of the purest representatives of the High *Renaissance style. Typically his paintings are of static groups of figures in subjects such as the Virgin and Child with Saints.

Baryshnikov, Mikhail (Nikolayevich) (1948–), Russian dancer and choreographer. He joined the Kirov Ballet in 1967, moved to the West in 1974, and is now Artistic Director of American Ballet Theatre. His extraordinary physical abilities, coupled with a sense of humour, inspired new roles, and film work extended his career across a broad field.

baryton, a stringed musical instrument, with six bowed strings tuned like a bass *viol, and many sympathetic strings behind the neck that could be plucked by the left thumb to accompany the bowed melody. Haydn wrote many works for baryton, a favourite instrument of his employer, Prince Nikolaus Joseph Esterházy.

Bashō (Matsuo Bashō) (1644–94), Japanese poet and travel-writer. He was a major influence on the development of *haiku, but is also well known for his travel essays beginning with *Records of a Weather-Exposed Skeleton* (1684), written after his first journey west to Kyoto and Nara. The most famous, *Narrow Road to the Deep North* (1694), records a trip to the backward northern region of the main Japanese island, Honshū.

Basie, Count (William) *jazz.

basilica, an architectural term originally applied to a large meeting hall used by the Romans in public business. Such halls were often rectangular in shape, with long colonnades dividing the interior into a central 'nave' flanked by an 'aisle' on each side. The name 'basilica' was adopted for early Christian churches that imitated this arrangement. In a different sense the word is applied to certain Roman Catholic churches that enjoy special privileges conferred by the pope and more loosely to any especially large, important, or venerable church.

bas relief *relief.

Bassano, Jacopo (*c.*1517–92), the most illustrious member of a family of Italian painters. Apart from a period training in Venice in the 1530s, Jacopo worked in Bassano, his home town near Venice, all his life, and his work has an earthy vigour and often a distinctive rustic flavour that proclaim his provincial roots. He specialized in religious paintings, but he often treated biblical themes in the manner of rural *genre scenes, portraying people who look like local peasants and depicting animals with real interest. In this way he helped to develop the taste for paintings in which the genre or *still life element assumes greater importance than the ostensible religious subject. He was the son of a painter and had four painter sons himself, the best known being **Leandro** (1577–1622), who was an accomplished portraitist.

basset horn, a tenor *clarinet with an extended range. The lowest written note on all normal clarinets is E below middle C; the basset horn has an extension to low C. On 18th- and early 19th-century instruments, this extension was made by drilling three bores in one piece of wood, down, up, and down again, leading to the bell, but modern instruments are straight, with an upturned bell. Because the bore diameter is hardly any larger than that of the clarinet, the extra length gives it a rather hollow tone colour, much liked by Mozart.

bassoon, a bass double-reed musical instrument, one of the orchestral woodwind family. It is over $1\frac{1}{2}$ metres (5 ft) long with the reed placed on a curving metal 'crook'. Down to the bottom of the butt (the thick part at the bottom) it functions like any other woodwind instrument. The tube then comes up again to the bell as an extension from the low F to the bottom note B♭, with the relevant keys controlled by the two thumbs. The first bassoons, invented in France in the late 17th century, had three keys, but by 1800 six keys were standard. Thereafter, the mechanism divided: the French system was perfected by Jean Nicolas Savary and the German, devised by Carl Almenräder, by the Heckel family. Today the more reliable German system is used everywhere, even though the French had a livelier tone quality.

bathos, a lapse into the ridiculous by a poet aiming at elevated expression. Whereas anticlimax can be a deliberate poetic effect, bathos is an unintended failure. Pope named this stylistic blemish from the Greek word for 'depth', meaning a jarring descent from the elevated to the commonplace, an anticlimax.

batik, a method of textile dyeing originating in South-East Asia. The areas of fabric that are not to be dyed are covered with melted wax, which is later removed by immersion in boiling water. The process can be repeated to produce multicoloured or blended effects. Many of the traditional patterns had ancient symbolic meanings and reflected the social position of the owner. Batik was brought to Europe by Dutch traders in the 16th or 17th century and was adopted by Western craftsmen in the 19th century. The bold, exotic patterns typical of batik have also been imitated by other printing processes.

Batoni, Pompeo (1708–87), Italian painter, the last great Italian artist in the history of painting in Rome. His early success was as a painter of religious and mythological works, but he is now famous above all for his portraits. Many distinguished visitors to Rome were painted by him, with Englishmen on the Grand Tour often portrayed against ancient ruins.

The technique of **batik** has been used for over 200 years in Java to produce textiles such as this elaborately patterned cloth dating from the mid-19th century.

This portrait of **Baudelaire** (c.1847) by his friend Gustave Courbet captures the moodiness and intensity of his personality: 'I don't know how to finish this portrait of Baudelaire,' Courbet said, 'as every day he looks different.' (Musée Fabre, Montpellier)

Baudelaire, Charles (1821–67), French poet. Little appreciated in his own lifetime, he is now considered a major figure in 19th-century French literature. His collection of poems entitled *Les Fleurs du mal* brought about his prosecution for offences against public morality when first published in 1857. In it he contrasts man's aspirations towards the ideal with the disillusion which he experiences in his daily existence. Seeking beauty not in abstractions but in the sordid reality of Parisian life, especially in the *Tableaux parisiens*, the poet discovers reflections of the Beyond in all creation ('correspondances'). But, overcome by disgust, he rebels against God and looks for the release of death which will allow him to see behind the façade of existence. The poems, which exhibit mastery in the handling of rhyme and rhythm, contain a colourful exoticism inherited from the *Romantics, yet are based on observations of real life executed in a perfectly chiselled form that anticipates the characteristic style of the *Parnassians. At the same time the power of suggestion arising from his theory of 'correspondances' foreshadows *Rimbaud and the *Symbolists. Baudelaire also wrote prose poems, usually grouped under the title *Le Spleen de Paris* (1857 onward), and works of criticism whose standing has increased with time.

Bauhaus (German, 'building house'), a school of architecture and design, founded in Weimar in 1919 by Walter *Gropius and closed by the Nazis in 1933. Although short-lived, the Bauhaus was enormously important in establishing the relationship between design and industrial techniques. Gropius envisaged a unity of all the visual arts, fostering the idea of the artist as craftsman and forming a close relationship with industry. The characteristic Bauhaus style was impersonal, geometric, and severe, but with a refinement of line and shape that came from a strict economy of means and a close study of the nature of materials. Many Bauhaus products (notably Marcel Breuer's tubular steel chair) were adopted for large-scale manufacture. Several of the most illustrious artists of the 20th century taught at the Bauhaus, notably

*Mies van der Rohe (director 1930–2), *Kandinsky, and *Klee. The emigration of staff and students caused by Nazism ensured the international spread of Bauhaus ideas. (See also *functionalism.)

Bausch, Pina (1940–), German dancer, choreographer, and director. She performed with German and American dance companies before becoming Director of the Wuppertal Dance Theatre in 1973. She continues the European and American Expressionist movements in dance with modernist works in the highly dramatic mode of *modern dance theatre dealing with psychological trauma arising from relationships. They include a version of the *Rite of Spring* (1975), *Bluebeard* (1977), and *Carnations* (1982).

Bax, Sir Arnold (Edward Trevor) (1883–1953), British composer. He achieved fame through a series of highly romantic, *Impressionistic tone-poems based on Celtic folklore: *In the Faery Hills* (1909), *The Garden of Fand* (1916), and *Tintagel* (1919). Between 1922 and 1939 he wrote seven symphonies as well as three string quartets and four piano sonatas. He was knighted in 1937 and appointed Master of the King's Music in 1942. Bax's music is extremely lyrical and its rich scoring is highly effective and sumptuous in its harmonies.

Bayeux Tapestry, a celebrated piece of embroidered linen fabric (actually not a tapestry; see *embroidery) depicting the Norman Conquest of England in 1066. It is about 70 m. (231 ft.) long—the last section is lost—and 50 cm. (19½ in.) wide, and is arranged somewhat in the manner of a strip cartoon, with one episode succeeding another in more than seventy scenes. Perhaps made to the order of William the Conqueror's half-brother, Bishop Odo of Bayeux in Normandy, it was displayed for centuries in the cathedral at Bayeux and is now housed in the former Bishop's Palace there.

Baylis, Lilian (Mary) (1874–1937), British theatre manageress, founder of the Old Vic Theatre (1912), which became the only London theatre permanently staging Shakespeare, as well as other classics. In 1963 it became the temporary home of the *National Theatre. She also reopened Sadler's Wells Theatre in 1931, making it the home for the Vic Wells Ballet (later the Royal Ballet) and the English National Opera.

Beardsley, Aubrey (1872–98), British illustrator. Although he died young of tuberculosis, he was prolific and had already become a well-known, controversial figure in the art world. He had little formal training and his style was highly original, using vivid contrasts of black and white and grotesque figures to create a sense of menacing decay and depravity. Some of his work was frankly pornographic, and like *Wilde—whose *Salome* he illustrated (1894)—he was regarded as a leading figure of the 'decadent' *aesthetic movement of the 1890s. The linear sophistication of his draughtsmanship also places him among the masters of *art nouveau.

Beatles, The (1956–70), English pop group. Formed in Liverpool in the late fifties by John Lennon (1940–80), Paul McCartney (1942–), and George Harrison (1943–), The Beatles were joined in 1962 by the drummer Ringo Starr (Richard Starkey) (1940–). In the same year they achieved national then international popularity under the management of Brian Epstein (1935–67). Their songs, mostly by Lennon and McCartney, initially blending *rhythm and blues and *rock and roll, became increasingly sophisticated, and their novel use of electronic, studio-produced sound was highly influential in the mid- and late sixties.

Beat Movement, a term used to describe a group of US writers, usually based in San Francisco or New York, which included the novelist Jack Kerouac (1922–69) and the poets Allen *Ginsberg, Gregory Corso (1930–), and Lawrence Ferlinghetti (1920–). William *Burroughs, though older and frequently living abroad, had strong links with the Beats. Their writing first received national attention with the publication of Ginsberg's booklet *Howl and Other Poems* (1956) and Kerouac's autobiographical *On the Road* (1957), which remain the Movement's most famous works. Reacting against the middle-class values of the 'tranquillized Fifties', they celebrated states of ecstasy achieved with the aid of sex, drugs, jazz, or danger. They were influenced by existentialism, but often had leanings towards oriental mysticism. Rejecting an

Allen Ginsberg, a central figure of the **Beat Movement**, reached large audiences with readings of his poetry, such as this one at the Albert Hall in London in 1965. By the 1960s the ideas and attitudes of the Beatniks, notably their disillusionment with society's materialism and militarism, had spread outside the USA and were absorbed into the life-styles of cultural groups such as the hippies.

impersonal, academic literature, they returned the personal statement to the centre of the work, and wrote in a free and hectic vernacular style. Walt *Whitman and Henry *Miller were predecessors they admired.

Beaton, Sir Cecil (1904-80), British photographer, diarist, and designer. In the 1920s, inspired by picture postcards of fashionable actresses, Beaton began photographing his family with a simple camera. Persuading such celebrities as William Walton and Edith Sitwell to submit to his picturesque fantasies, he soon became famous himself. During a number of visits to Hollywood, he learned to master studio lighting, and in 1939 was asked to photograph Queen Elizabeth (wife of George VI). He became virtually the 'Photographer Royal' for three decades, a 20th-century equivalent of the great state portraitists of the past. After the war (during which he took some memorable propaganda photographs), Beaton's fashion pictures in particular became simpler and less mannered. He began to design for the theatre, achieving notable success with sets and costumes for the stage and film versions of *My Fair Lady*.

Beaumarchais, Pierre-Augustin Caron de (1732-99), French dramatist. His comedies *Le Barbier de Séville* (1775) and *Le Mariage de Figaro* (1781, but banned by Louis XVI until 1784) were among the most successful plays of the 18th century. They brought laughter back to the theatre after the rather serious bourgeois drama, derived from the dramatic theories of *Diderot, which had flourished during the preceding decades. The plays constitute two parts of a trilogy in which the most important character is the valet Figaro, whose many adventures incorporate elements taken from Beaumarchais's own life. As the cunning servant who outwits his master, Figaro's role has many antecedents in French and classical drama, but he had become, particularly in

A scene from Samuel **Beckett's** *Waiting for Godot*, one of the most influential plays of the post-war period. It portrays two tramps, as they await the arrival of a mysterious person called Godot who never comes. They are diverted by the arrival of the whip-cracking Pozzo and the oppressed and burdened Lucky (shown here). Beckett uses their situation as a metaphor for the human condition as one of ignorance and futility.

the latter play, a spokesman for popular resentment at the injustices of 18th-century society. The plays inspired two comic operas, *The Marriage of Figaro* by Mozart (1786) and *The Barber of Seville* by Rossini (1816).

Beaumont, Sir Francis (c.1584-1616) and **Fletcher, John** (1579-1625), English dramatists. They collaborated from 1605 in about sixteen plays, at first for the Children of the Queen's Revels and then mainly for the King's men, then at the Globe and Blackfriars Theatres. Beaumont's superior faculty in the construction of plots is discernible in their joint productions, including *Philaster* (1609), *The Maids Tragedy* (1610), and *A King and No King* (1611). *The Knight of the Burning Pestle* (c.1607), thought to be Beaumont's alone, is a high-spirited burlesque of knight-errantry, satirizing middle-class *naïveté* about art. Fletcher also collaborated with *Massinger, William Rowley (c.1585-1626), *Middleton, *Jonson, and others, including *Shakespeare in *The Two Noble Kinsmen* (1634) and in *Henry VIII* (1613). The major plays of which he was the sole author are *The Faithful Shepherdess* (c.1610), a pastoral with passages of great poetic beauty, *The Humorous Lieutenant* (1619), *The Wilde Goose Chase* (1621), *The Woman's Prize* (1604-17), and *Rule a Wife and Have a Wife* (1624).

Beauvoir, Simone de (1908-86), French novelist and essayist. From 1929 she was the companion of Jean-Paul *Sartre and her writing gives expression to the existentialist philosophy which they shared. She reached a wide public with her book on women's rights, *Le Deuxième Sexe* (1949) and *Les Mandarins* (1954), a novel describing existentialist circles in post-war Paris. However, her most enduring contribution to literature may be her memoirs, notably the first volume, *Mémoires d'une jeune fille rangée* (1958), which have a warmth and descriptive power lacking in her fiction.

Beaux-Arts, École des, the chief official art school of France, established as a separate institution in 1795. It dominated the teaching, practice, and criticism of art in France throughout the 19th century and into the 20th century, controlling the path to traditional success with its awards and state commissions. Teaching remained conservative until after World War II. Architecture was taught at the École des Beaux-Arts from 1819, and the term 'Beaux-Arts style' is applied to buildings expressing its official taste. Essentially this was academic and grandiose, and as with *Victorian architecture, Beaux-Arts architecture was long condemned as stuffy and pretentious. Now, however, it is being treated seriously again, for the best French architects of the period—such as Charles *Garnier—were no less spirited and original than their other European contemporaries in their reinterpretation of past styles.

bebop *jazz.

Beckett, Samuel (Barclay) (1906-89), Irish dramatist, novelist, and poet. Born into a Protestant, Anglo-Irish family, he settled in Paris (1937), where he formed a lasting friendship with James Joyce. His stories describing episodes in the life of a Dublin intellectual, Belacqua Shuah, were published in *More Pricks than Kicks* (1934). His first novel *Murphy* (1938) was written in English, but his trilogy, *Molloy* (1951), *Malone Dies* (1958), and *The*

Unnameable (1960), and several subsequent works were all first written in French. They consist of desolate, obsessional, interior monologues, with flashes of black humour. He achieved high acclaim with the Paris production of *En attendant Godot* (1952; *Waiting for Godot*, 1955). Beckett became widely known as a playwright associated with the Theatre of the *Absurd. Subsequent plays include *Endgame* (1958), a one-act drama of irascibility, frustration, and senility; *Krapp's Last Tape* (1958); *Happy Days* (1961); *Breath* (1969), a thirty-second play projecting a pile of rubbish, a breath, and a cry; and *Not I* (1973), delivered by a protagonist of indeterminable sex of whom only the mouth is illuminated. Beckett's *Collected Poems in English and French* appeared in 1977. He was awarded the Nobel Prize for Literature in 1969.

Beckford, William (*c*.1760–1844), British writer. He was a man of great wealth who spent large sums in collecting works of art and in the building of Fonthill Abbey, an extravaganza designed by *Wyatt in the *Gothic Revival style, where he lived from 1796 until forced to sell by his creditors in 1822. He is remembered as the author of *Vathek* (1782), one of the most successful of the oriental tales that were fashionable at the time. His two books on travel display his power of description and ironic observation of customs and manners.

Beckmann, Max (1884–1950), German *Expressionist painter and graphic artist. At the beginning of his career he was artistically conservative, but his experiences in World War I completely changed his outlook and style. His work became full of horrifying imagery and distorted forms, and its combination of brutal *realism and social criticism led him to be classified with the artists of the *Neue Sachlichkeit* ('New Objectivity'). Beckmann did indeed exhibit with them in 1925, but he differed from contemporaries such as Dix and Grosz in his concern for allegory and symbolism. His paintings were intended as depictions of vices such as lust, sadism, cruelty, rather than as illustrations of specific instances of these qualities at work. In 1932 Beckmann's work was declared 'degenerate' by the Nazis, and in that year he began *Departure*, the first of a series of nine great triptychs, in which he expressed his philosophy of life and society. He was dismissed from his teaching post in Frankfurt in 1933, and finally settled in the USA in 1947.

Beethoven, Ludwig van (1770–1827), German composer whose career spanned the transition from *Classicism to *Romanticism in music. Born in Bonn, the son and grandson of musicians, he received his first lessons from his father. Intermittent work as a court musician for the Elector of Cologne led to an official appointment (1784–92), during which time (1789) he took over responsibility for the family, his mother having died and his father having taken to drink. In 1792 he left Bonn for Vienna, to become a pupil of Haydn and to establish himself as a composer and virtuoso pianist. In this he was singularly successful, finding aristocratic patrons who were to support him for the rest of his life. By 1801, however, he had become aware of an increasing deafness and by 1802 he was resigned to his disability, which worsened progressively over the next seventeen years. His growing deafness led him to abandon his career as a concert pianist, and he plunged ever deeper into composition—the Third ('Eroica') Symphony (1803)

This miniature of **Beethoven** by the Danish artist Christian Horneman was painted in 1803, not long after his realization that he was to lose his hearing completely. In a moving testament addressed to his brothers, he recorded his despair at his impending deafness, his devotion to his art, and his resolve to submit to fate. (Beethovengeburtshaus, Bonn)

marked a turning-point in his development. His career thereafter is the record of his growth as a composer: from the Haydn–Mozart influences in his First Symphony, through the titanic Third and Fifth Symphonies, to the intense self-communion of the last piano sonatas and string quartets. The experimental side of his work can be seen in his thirty-two piano *sonatas, which prepare the way for each stage of a development made manifest in his nine symphonies (1800–24) and eighteen string quartets. Beethoven's music is noted for its intense rhythmic power, its capacity for developing the simplest thematic cells into immense structures, and the profound humanity of its emotional utterance.

Behn, Afra (Aphra) (1640–89), English novelist, poet and dramatist. After the death of her husband she was imprisoned for debt and became the first Englishwoman to support herself by her writing. She became an intelligence agent in the Dutch Wars (1665–7), adopting the pseudonym Astrea, under which she later published her poems. Among the best known of her many plays are *The Rover* (1677–81), *The City Heiress* (1682), and *The Lucky Chance* (1686), which explores one of her favourite themes, the unhappy consequences of arranged and ill-matched marriages. In her best remembered work *Oroonoko* (1688), perhaps the earliest English philosophical novel, she deplores the slave trade and Christian hypocrisy, holding up for admiration the nobility and honour of its African hero.

Behrens, Peter (1868–1940), German architect and designer. A versatile artist who began his career as a painter, he joined the firm of AEG in 1907 and designed everything from factories to stationery. This marks the beginning of industrial design as a specialist field, showing a desire to humanize technology. As an architect Behrens was a pioneer of the *Modern Movement in Germany; his most famous work is the AEG Turbine Factory in Berlin (1908–9), a massive, bold structure of concrete, iron, and glass. Behrens was an influential figure, and his pupils included *Gropius, *Le Corbusier, and *Mies van der Rohe.

Béjart, Maurice (1927–), French dancer, choreographer, and company director. He trained in Paris and London, danced with several European companies, and in 1953 started his own company which became the Ballet of the Twentieth Century in 1959. He developed a popular expressionistic form of modern ballet, tackling vast themes. His works include *Firebird* (1970) and *Kabuki* (1986).

bel canto (Italian, 'beautiful song'). A style of singing favoured by Italian *opera, in particular, in the work of *Bellini and *Donizetti, in the 18th and early 19th centuries that was fluid and lyrical, beautiful in tone and flawless in technique. Now cultivated by singers who wish to do justice to the music of this period.

Bellini, family of Italian painters who played a dominant role in Venetian artistic life. **Jacopo Bellini** (c.1400–c.70), the founder of the family's fortunes, was the father of Gentile and Giovanni. He was trained by *Gentile da Fabriano and by the middle of the century he had a flourishing workshop in Venice with his two sons, but his major paintings have disappeared and most of those that survive are fairly simple and traditional representations of the Virgin and Child. His artistic gifts are better seen in two remarkable sketchbooks, one in the British Museum, and the other in the Louvre. Together they contain more than 200 drawings, which are notable particularly for their interest in unusual *perspective effects. **Gentile Bellini** (c.1429–1507) took over as head of the studio. Like his father, he was greatly admired in his time, but many of his major works have perished. They included erotic scenes painted for the harem of Sultan Mehmed II when Gentile worked at the court in Constantinople in 1479–81; his portrait of Mehmed, however, survives in the National Gallery in London. His most famous works today are two huge religous canvases in the Accademia in Venice, which are remarkable for the rich amount of anecdotal detail they contain of contemporary Venetian life. **Giovanni Bellini** (c.1430–1516) was the greatest artist of the family and helped to transform Venice from an artistically provincial city to one that rivalled Florence and Rome in importance. The major influences on his formative years were those of his brother-in-law *Mantegna and that of Antonello da Messina, who was in Venice in 1475–6. Like Antonello, Bellini was one of the early masters of the technique of *oil painting. Relatively few of his works are dated, but the general course of his development is fairly clear, as he moved from the severe linear style of his early work to one of warmth in which colour and light were the primary means of expression. He was remarkably inventive pictorially and one of his innovations was to bring together figures and landscape in perfect harmony, so that the landscape is not merely a backdrop but an essential part in creating the mood of the picture. His favourite subject was the Virgin and Child, and only Raphael has rivalled his subtle variations on the theme. He was Painter to the Venetian Republic from 1483 until his death, and he influenced most of the leading artists of the next generation, including Giorgione and Titian, who trained in his workshop.

The Agony in the Garden (c.1460) is one of Giovanni **Bellini**'s early masterpieces. He already showed an unrivalled feeling for colour and atmosphere—the rosy glow of the dawn horizon is a particularly beautiful piece of observation. The subject is Christ's 'agony' on the night before his crucifixion. (National Gallery, London)

Bellini, Vincenzo (1801–35), Italian composer. Born in Sicily into a family of musicians, he composed his first successful opera, *The Pirate*, in 1827. He wrote eleven operas, which were enormously successful throughout Europe. Chief among them are *The Sleepwalker* (1831), *Norma* (1831), and *The Puritans* (1835). Bellini was the master of soaring, ecstatic melody characteristic of the *bel canto* style which, when wedded to the *Romantic plots of the time, can have a most powerful effect. His pure melodic style greatly influenced Chopin.

Belloc, (Joseph-Pierre) Hilaire (1870–1953), French-born British poet, essayist, historian, and novelist. A prolific writer and devout Roman Catholic, he wrote essays, reviews, and books attacking and satirizing Edwardian society, collaborating with G. K. *Chesterton in writing against socialism. He was elected as a Liberal member of parliament in 1906 but became disillusioned and abandoned politics in 1910. He wrote historical biographies and numerous travel works, including *The Path to Rome* (1902). Today he is best known for his comic verse, included in such volumes as *The Bad Child's Book of Beasts* (1896) and *Cautionary Tales* (1907).

Bellotto, Bernardo (1720–80), Italian painter, the nephew, pupil, and assistant of *Canaletto and his most skilful follower. In 1747 he left his native Venice and spent the rest of his life working at various European courts, notably Dresden and Warsaw. He called himself Canaletto and this caused confusion (perhaps deliberate) between his work and his uncle's, particularly in views of Venice. Bellotto's work, however, is more sombre in colour than Canaletto's and his depiction of clouds and shadows brings him closer to Dutch painting.

Bellow, Saul (1915–), US novelist, short-story writer, and dramatist. Born in Canada of Russian parents, his early fiction is diverse in approach and subject-matter, ranging from short works with few characters like *Dangling Man* (1944), *The Victim* (1947), and *Seize the Day* (1956), to the expansive picaresque of *The Adventures of Augie March* (1953) and the African fantasy of *Henderson the Rain King* (1959). *Herzog* (1964) concerns the intense revelation of the life and experiences of a middle-aged Jewish intellectual, who is led through neurosis almost to suicide and emerges 'pretty well satisfied to be, to be just as it is willed'. The works which follow it—*Mr Sammler's Planet* (1969), *Humboldt's Gift* (1975), *The Dean's December* (1982)—tend also to focus on intellectuals confronting present-day urban reality. He won the 1976 Nobel Prize for Literature.

bells, open-mouthed vessels made of any resonant material, whether wood, ceramic, or metal, struck on or near the rim by an internal or external clapper or a separate striker. Bells may be hung from the vertex or top, as in a church tower, or may rest upon the vertex, as with the Indian tuned tea-bowls, or have handles fixed to it as with handbells and African iron bells. Bells are used for many purposes, the commonest being rituals, signalling, and hanging round animals' necks. Sets of bells are played as a *carillon or used for change ringing. Because church bells are so large and heavy, for orchestral purposes their sounds are imitated as well as possible by instruments such as *tubular bells, bell-plates, or electronic simulation. The word is also used to describe the flared, or occasionally bulbous, end of the tube of a wind musical instrument.

belly-dancing *Islamic dance.

Bely, Andrey (Boris Nikolayevich Bugayev) (1880–1934), Russian writer. With his friend Aleksandr *Blok, Bely was a leader of the younger generation of Russian *Symbolists. He began with lyric poetry and musical prose, abstract and transcendental. A note of social awareness comes into his work from about 1905, but aesthetic and religious values remain paramount; Bely became a committed anthroposophist and follower of Rudolf Steiner in 1914. His masterpiece in prose is the *modernist novel *Petersburg* (one-volume publication 1916), and in verse, the long poem *The First Encounter* (1921). He returned to Russia in 1923 after a trial emigration, and continued writing novels and memoirs, and revising his poetry, until his death.

Bengali literature, literature in the Bengali language spoken in Bangladesh and the Indian state of West Bengal. The *Caryāpadas*, 12th-century Buddhist verses, are the earliest Bengali texts, followed by Krittibas's 15th-century *Rāmāyaṇa*, which is still popular, as is Kashiram Das's 17th-century *Mahābhārata*. The greatest work of Bengali *Bhakti literature was Chandidas's *Praise of Lord Krishna* (15th century). The ecstatic devotion preached by the mystic Chaitanya (1485–c.1534) inspired thousands of verses to Krishna from the 16th century onwards. Verse eulogies of Hindu goddesses were an enduring tradition, such as Mukundaram's *Eulogy of the Demon-Slaying Goddess* (c.1590), Ketakadas's 17th-century *Eulogy of the Snake Goddess*, and Bharatachandra Ray's popular *Eulogy of the Food-Giving Goddess* (1752). Bengali prose developed with the Baptist missionaries of Serampore and the founding of Fort William College, where Ramram Basu wrote the first creative Bengali prose-work, the biography *The Deeds of King Protāpaditya* (1801). The first true Bengali novelist was Bankimschandra Chattopadhyay (1838–94). The poet Michael Madhusudan Duff (1824–72) introduced blank verse and created the first Bengali epic, *The Death of Meghnād* (1861). Modern Bengali drama began with Ramnarayan Tarkaratna's *The Kulin Brahmin all for Prestige* (1854), condemning child-marriage, and Dinabandhu Mitra's *The Indigo Mirror* (1860) on the plight of indigo-workers. Rabindranath *Tagore (1861–1941) dominated Bengali poetry and prose-writing for half a century. Saratchandra Chattopadhyay championed women's rights in novels like *Śrīkānta* (named after its chief character) (1917–33), while Bibhutibhushan Bandyopadhyay portrayed rural society in *Pather Pañchali* ('Song of the Road') (1929). Muslim Bengali literature ranges from the 17th-century Daulat Kazi and Saiyad Alaol to the 20th-century Kazi Nazrul Islam and Jasimuddin.

Bennett, (Enoch) Arnold (1867–1931), British novelist, dramatist, and critic. At the age of 21 he embarked on a versatile literary career, publishing stories in Dickens's magazine *Tit-Bits* (1890) and in the *Yellow Book* (1895). Bennett's fame rests on the novels set in Staffordshire in the Potteries of his youth (since amalgamated to form the city of Stoke-on-Trent), which he recreated as the 'Five Towns'. They include *Anna of the Five Towns* (1902) and *The Old Wives' Tale* (1908). All portray with irony and affection provincial life in documentary detail. They were

This portrait of Alban **Berg** was painted in about 1910 by his teacher, the composer Arnold Schoenberg, who was also a talented artist. Berg revered Schoenberg and dedicated four of his twelve major works to him, but his own work is characterized by a bitter-sweet romanticism very different from Schoenberg's more stringently atonal compositions. (Museum der Stadt Wien)

followed by the popular Clayhanger series (*Clayhanger*, 1910; *Hilda Lessways*, 1911; *These Twain*, 1916; *The Roll Call*, 1918). As well as many other novels (including *Riceyman Steps* (1923) set in a London suburb), he also wrote short stories, plays, and *The Journals of Arnold Bennett, 1896–1928*.

Beowulf, the most important epic in *Old English literature and the first major poem in a European vernacular language. It survives in a 10th-century manuscript but is generally dated to the 8th century when Anglo-Saxon England was being won over from paganism to Christianity. The poem, which represents the fusion of Norse legend and history and Christian belief, describes two major events in the life of the Scandinavian hero Beowulf. In the first, the young Beowulf fights and kills the water monster Grendel, the scourge of the Danish king Hrothgar and his followers; he then kills Grendel's mother. In the second, set fifty years later, Beowulf, by now the ageing King of the Geats of southern Sweden, confronts the dragon who threatens his people with destruction. In the combat both the dragon and Beowulf are mortally wounded. The poem is over 3,000 lines long and is written in strongly accentual *alliterative verse.

Berent, Wacław (1873–1940), Polish novelist. Though a marine biologist, he devoted himself to writing, influenced by Nietzsche, whom he translated. He experimented with narrative and time, reconstructing the past in *Rotten Wood* (1903) and *Living Stones* (1918), set in the Middle Ages. *Winter Wheat* (1911) describes one night in Warsaw in 1904, when war is announced.

Berg, Alban (1885–1935), Austrian composer. Before becoming a pupil of *Schoenberg in 1904, Berg's musical education was slight. Under Schoenberg's guidance, however, he made rapid progress, readily assimilating his master's exploration of *atonality. Despite a delight in structuring his music in complex intellectual patterns, he was fascinated by the emotional climate of late *Romanticism. His music, even at its most experimental, had a surface glamour that won him admirers when Schoenberg himself had few. His most important works include two operas, *Wozzeck* (1922) and *Lulu* (Acts I and II produced in 1937, and the complete opera in 1979), the Lyric Suite (1926), and the Violin Concerto (performed posthumously in 1936). The operas in particular exploit a heady eroticism that is typical of the bitter-sweet, world-weary *Expressionist art of contemporary Vienna.

Bergman, Ingmar (1918–), Swedish film and theatrical director. His work has probably been influenced by his strict upbringing as a Lutheran pastor's son. By 1944 he was director of the City Theatre, Hälsingborg. In the following year he directed his first film, for which, as for his later films, he also wrote the script, though he was not widely noticed until *Smiles of a Summer Night* (1955). His bleak view of the human condition, and especially that of women, was enshrined in a series of austere, complex films which made him one of the world's great film-makers. The best included *The Seventh Seal* (1957), an allegory, set in the Middle Ages, of the human search for religious faith; *Wild Strawberries* (1957), in which an old man reviews his past; *Persona* (1966); and *Cries and Whispers* (1972). His theatrical career, which continued in parallel, included periods as Leading Director of the Royal Dramatic Theatre, Stockholm (1963–6) and of the Residenztheater in Munich. Among his later films were *Autumn Sonata* (1978), about the relationship between a famous pianist and her daughter, and *Fanny and Alexander* (1983), which depicted family life rather more warmly than hitherto.

Berio, Luciano (1925–), Italian composer. Though his early work was influenced by *Stravinsky, he soon began to experiment with *serial and *electronic techniques. Later works explore *indeterminacy and the use

of spoken texts (entire, or broken into phonetic sounds) as the basic material for composition. In 1955 he set up the first Italian studio for the study of electronic music at Milan. Under his guidance this rapidly became an important centre for artistic experiment.

Berkeley, Busby (1895–1976), US director and choreographer. He was known for his flamboyant stagings of dances in Hollywood films, sometimes using the camera to move among the dancers. He was famous on *Broadway in the 1920s and then in the 1930s in *Hollywood for such films as *Gold Diggers of 1933* and *Lady be Good* (1941).

Berkeley, Sir Lennox (1903–89), British composer. He studied with the renowned music teacher Nadia Boulanger in Paris (1927–32), where he also came directly under the influence of *Ravel, *Stravinsky, and *Poulenc. The pronounced *Neoclassical qualities of his music distinguish it sharply from that of his British contemporaries and is best seen in such works as the *Serenade for Strings* (1939) and the orchestral *Divertimento* (1943). In addition to four symphonies, he has had much fine chamber music and a full-length opera, *Nelson* (1954).

Berlin, Irving (Israel Baline) (1888–1989), US composer. The son of poor Jewish immigrants, he achieved international success with the song 'Alexander's Ragtime Band' (1911). His first complete score, *Watch Your Step*, followed in 1914. From 1935 he wrote for Hollywood, including the Fred Astaire–Ginger Rogers film *Top Hat*, *On the Avenue*, and *Holiday Inn* (which contained the best-seller 'White Christmas'). Successful *musicals followed: *Annie Get Your Gun* (1946) and *Call Me Madam* (1950).

Berliner Ensemble, theatre company associated with the plays of *Brecht, established in East Berlin in 1949. There Brecht directed the plays written during his US exile. The company achieved international fame and its style of production and acting—designed to encourage audience detachment and inhibit emotional involvement—became known as 'Brechtian' and was very influential. After Brecht's death in 1956 his widow Helene Weigel took over as director, and the company later extended its repertoire to include other playwrights, including Shaw and Wedekind.

Berlioz, (Louis-) Hector (1803–69), French composer. Despite an early passion for music, he obeyed his father and studied medicine before finally (1826) attending the Paris Conservatoire. He used his unrequited passion for the Irish actress Harriet Smithson as inspiration for the *Symphonie fantastique* (1830)—a *programmatic work of exceptional power and originality. Never securing a permanent post, he was obliged to combine composition with work as a critic and conductor. His music is generally conceived on the grandest scale and seldom fails in power and imagination. His exceptional skill in orchestration greatly influenced Liszt and Wagner. Berlioz's works are often programmatic, and are indebted to *Romantic literary themes: the symphony *Harold in Italy* (1834) draws on Byron's work, and the choral symphony *Romeo and Juliet* (1839) is one of several works inspired by Shakespeare. He never heard a complete performance of his greatest achievement, the epic five-act opera *Les Troyens* (1858), based on Virgil's *Aeneid*.

Bernanos, Georges (1888–1948), French novelist. Like *Mauriac in his own generation and *Claudel and *Péguy some years earlier, he wrote from a position of convinced Roman Catholicism. His two major novels, *Sous le soleil de Satan* (1926) and the *Journal d'un curé de campagne* (1936), both revolve around a parish priest who, armed with a childlike simplicity which was of central importance to Bernanos, is able to combat evil and despair in the world. Among Bernanos's polemical works *Les Grands Cimetières sous la lune* (1937) is a notable exposition of his humanitarian values.

Bernhardt, Sarah (1845–1923), French actress and theatre producer, renowned for her beautiful voice. Her outstanding performances included the title roles in Racine's *Phèdre* and Shakespeare's *Hamlet* (in which she played the prince). She also managed several theatres, including the Théâtre Sarah-Bernhardt, was an accomplished painter, and wrote poetry and plays.

Bernini, Gianlorenzo (1598–1680), Italian sculptor, architect, and painter, the outstanding figure of Italian *Baroque art. He was the greatest sculptor and one of the greatest architects of the 17th century, and with his buildings, fountains, and statuary he has had a more profound effect on the city of Rome than any other artist. The son of a sculptor, Pietro Bernini (1562–1629), he was remarkably precocious and an unrivalled virtuoso of

The centre-piece of **Bernini**'s Cornaro Chapel in Santa Maria della Vittoria, Rome, is his sculpture, *The Ecstasy of St Teresa*, which shows to the full his virtuoso skill in marble-cutting and his ability to convey intense emotion; he considered it his most beautiful work.

marble cutting. When his patron Maffeo Barberini became Pope Urban VIII in 1623 he was established as virtually the artistic dictator of Rome. His first great work for St Peter's was the *Baldacchino* (or canopy) (1624–33) over the high altar. During the pontificate of Innocent X (1644–55) Bernini was out of papal favour, but at this time he created the work that perhaps best sums up the ideals of Italian Baroque art—the Cornaro Chapel, with its famous marble group of *The Ecstasy of St Teresa* (1645–52), in the church of Santa Maria della Vittoria in Rome. This is not large by the standards of some of Bernini's works, but it combines architecture, sculpture, and painting into a breathtaking decorative whole. He returned to work on St Peter's in 1655, designing the huge piazza in front of the church (1656–67) that is one of the great sights of Rome. In 1666 he visited Paris to design the east front of the Louvre for Louis XIV, but his plans were abandoned and little came of the visit. Back in Rome he continued active to the end of his long life, and his late works became intensely spiritual, reflecting his own deeply religious character. His work went out of favour in the Neoclassical period but in the 20th century his reputation has again risen to the highest level.

Bernstein, Leonard (1918–), US composer, pianist, and conductor. In 1943 a concert with the New York Philharmonic launched a spectacular conducting career that has taken him all over the world. His music, which combines jazz and classical techniques with great effect, includes the ballets *Fancy Free* (1944) and *On the Town* (1944), and the musicals *Candide* (1956) and *West Side Story* (1957), as well as 'serious' works such as the 'Jeremiah' Symphony (1943) and *Mass* (1971).

Bertolucci, Bernardo (1940–), Italian film director. He made his first film at twenty-two, and established himself as a major director in 1970 with two brilliant films, *The Spider's Stratagem* and an adaptation of Moravia's novel *The Conformist*. His next film, *Last Tango in Paris* (1972), was attacked as obscene because of its brutal and unorthodox treatment of sex. *1900* (1976) followed the fortunes of an Italian family and their servants through the first seventy years of the 20th century. After *The Moon* (1979), about a US opera singer's problems with her son, and *Tragedy of a Ridiculous Man* (1981), he branched out in a totally new direction. *The Last Emperor* (1987) was a big-budget American film, shot in China, telling the story of Pu Yi, the last emperor of China. It won nine Academy Awards, including Best Film.

bestiary, a description of animal life in verse or prose, in which the characteristics of real and fabulous beasts are given edifying religious meanings. This kind of *allegory was popular in the Middle Ages, surviving in some later children's books.

Betjeman, Sir John (1906–84), British poet and conservationist. His first collection of verse, *Mount Zion* (1931) was followed by many others including *New bats in old belfries* (1945) and his blank verse autobiography *Summoned by Bells* (1960). His poems are often affectionately humorous comments on provincial and suburban life, written in traditional rhyming stanzas, but other poems show a darker side, reflecting a lifelong depression and fear of death, against which strongly held religious beliefs offered

no adequate protection. He was also noted for his championship of Victorian and Edwardian art and architecture and for his guidebooks to the English countryside. He was appointed *Poet Laureate in 1972.

Beuys, Joseph (1921–86), German sculptor, draughtsman, and *performance artist, regarded as one of the most influential leaders of avant-garde art in Europe in the 1970s and 1980s. He was appointed Professor of Sculpture at the Art Academy in Düsseldorf in 1961, but was dismissed in 1972 after his teaching methods had aroused conflict with authority. The protests that followed included a strike by his students, for by this time he had become something of a cult figure. His best-known works were probably his performances (see *happening).

Bewick, Thomas (1753–1828), British *wood engraver, active for most of his life in Newcastle upon Tyne. There he had a flourishing business, with many pupils who established a local tradition in wood engraving. Bewick revived the art, transforming it from a humble reproductive medium to a means of creative expression. He is famous above all for his illustrations of animals and country life, notably in his celebrated books *A General History of Quadrupeds* (1790) and *A History of British Birds* (2 volumes), (1797 and 1804).

Bhagavadgītā (Sanskrit, 'Song of the Lord'), a Hindu philosophical poem inserted into the *Mahābhārata*. The poem consists of 700 Sanskrit verses divided into 18 chapters. It was probably written in the 1st or 2nd century AD. The Pāṇḍava chief Arjuna, revolted by the prospect of killing his kinsmen in battle, seeks guidance from Krishna, disguised as his charioteer. Krishna urges Arjuna to fulfil his caste duties as a warrior selflessly and, revealing his divinity, preaches absolute devotion (*bhakti*) to the all-loving Supreme Being incarnated from age to age to save mankind. This is the first clear presentation of this doctrine in Hindu texts, moving away from the priestly sacrificial cult of the *Vedas to a devotional Hinduism open to all.

Bhakti literature, medieval Indian writing inspired by devotion (*bhakti*) to the Hindu god Vishnu, a way of salvation first propounded in the *Bhagavadgītā*. Bhakti literature began in southern India with the mystical Tamil hymns of the Āḻvār saint-poets (7th–10th centuries AD), but by 1500 had permeated all the Indian vernacular literatures. Poets like Kabīr (1430–1518) and the Sikh Guru Nanak (1469–1539) preached devotion to a universal God neither Hindu nor Muslim. Most Bhakti literature, however, concerned Vishnu's incarnations as Rama and Krishna. The greatest Rama devotee-poet was Tulsi Das (1532–1627), writing in Hindi. Krishna devotion was more widespread in northern and eastern India, from the Bengali poet Chandidas (15th century) to the Hindi poetess Mīrābāī (1498–*c*.1573), who expressed intense longing for God. In western India the most important Bhakti poets were the Marathis Nāmdev (*c*.15th century) and Tukaram (1608–49), and the Gujarati Narsimha Mehta (*c*.1500–80).

Bharata-nāṭyam, important solo dance tradition from south India, especially amongst Tamils, performed by women. The programme consists of seven items, proceeding from the simple *alārippu*, an invocation to the

deity and audience, through complex virtuoso dances, to the concluding *śloka*, a recitation of a short Sanskrit verse. Accompaniment is provided by a singer, a drum, a wind instrument, and a dance-master: the latter recites rhythmic compositions. This style was formerly performed by temple dancers: women who were dedicated to the service of the deity. It is said to follow the precepts of the earliest Indian treatise on music and dance, the *Nāṭya-śāstra* (early centuries AD), attributed to Bharata, after whom the style is named.

Bialik, Chaim Nahman (1873-1934), Hebrew poet. He was born in Volhyina, a region historically joined to Lithuania, Poland, and finally Russia. He is one of the most distinguished figures in modern Hebrew literature. His poetry, written in a Hebrew freed of its classical rigidity, depicts a variety of themes: life in Eastern Europe, nostalgia for the landscapes of his childhood, lyric love poetry, the conflict between traditional Judaism and modern secularism, prophetic pessimism, and the hope for national revival. Regarded as the poet of the Jewish national renaissance, Bialik castigated his people for their helplessness in the face of persecution ('In the City of Slaughter', 1904). He was a noted essayist and story-teller, and translated major works from European languages.

Biber, Heinrich Ignatz Franz von (1644-1704), Bohemian composer and violinist. Regarded as the most outstanding virtuoso violinist of his generation, his finest works are for that instrument and include sixteen 'Mystery' Sonatas (completed 1676)—meditations on the Mystery of the Rosary (Roman Catholic devotional prayers). He also wrote operas, sacred music, and music for chamber ensemble. He used high positions, new modes of bowing, multiple stopping, and unconventional tunings to produce the illusion of *counterpoint: in this he was an important precursor of J. S. Bach.

Biedermeier, a term applied to German, Austrian, north Italian, and Scandinavian art and interior decoration between *c.*1815 and *c.*1850. The name derives from a fictional character called Gottlieb Biedermeier, who personified the solid yet sentimental qualities of the bourgeois middle classes, and the art to which he has lent his name eschewed flights of the imagination in favour of simplicity, functionality, and domestic comfort.

big band, a specialized form of dance band. The classic big band consisted of four trumpets, three or four trombones, five saxophones (two alto, two tenor, one baritone), and a rhythm section of piano, double bass, and drums. Unlike true *jazz, the music of the big bands was arranged by a skilled orchestrator; and while improvisation might play a part, the results were essentially due to well-rehearsed team-work. The band led by Fletcher Henderson, established in 1923 as an ordinary dance band, was the first to develop the big-band sound, but the big band reached its greatest popularity during the period 1930-45 in the hands of such inspired composer-arranger bandleaders as Duke *Ellington, Benny Goodman, Count Basie, Woody Herman, and Glenn Miller.

Bihzād, Kamāl al-Dīn (*c.*1455-1535/6), Persian painter. There is little firm information about his career and few certain works survive, but he is regarded as marking the highpoint of the great tradition of *Islamic

A German secretaire (a writing desk in which papers can be locked up) in the **Biedermeier** style. Made of walnut and birch-root veneer, with bronze mounts, it dates from about 1815–20 and displays the solidity and unpretentious charm characteristic of Biedermeier furniture. (Städtisches Museum, Flensburg)

miniature painting. He worked mainly in Herat (famous for its miniaturists), but after the city was captured by the Safavids in 1510 he moved to Tabriz and perhaps Bukhara. Among the works accepted as being from Bihzād's own hand are miniatures in a manuscript of *Sa'dī's *Būstan* in the National Museum, Cairo (1488), and in two manuscripts of Nizami's *Khamsa* in the British Museum, London (1493 and 1494-5). They show the purity of colour, vigour of design, and delightful observation of the everyday world and court life typical of his style.

Bildungsroman, a kind of novel which follows the development of the hero or heroine from childhood or adolescence into adulthood, through a troubled quest for identity. The term ('formation-novel') comes from

Germany, where Goethe's *Wilhelm Meister's Apprenticeship* (1795–6) set the pattern for later *Bildungsromane*. Many outstanding novels of the 19th and early 20th centuries follow this pattern: Dickens's *David Copperfield* (1849–50) or Charlotte Brontë's *Jane Eyre* (1847), for example. A sub-category known as the *Künstlerroman* describes the formation of young artists, as in Joyce's *A Portrait of the Artist as a Young Man* (1916).

binary form, a term in music to describe a simple two-part form consisting of two balancing sections of an AB structure. The first section generally modulates to a closely related *key, while the balancing section makes the return journey. This form is found in simple songs and in short keyboard works such as Bach's 'Two-part Inventions'.

biography, a written account of some other person's life and character. The earliest biographers were Greek and Roman historians in the 1st and 2nd centuries AD: Tacitus wrote lives of Roman emperors, as did Suetonius in his fascinatingly gossipy *Lives of the Caesars*, while *Plutarch's *Parallel Lives* of Greek and Roman statesmen was used by Shakespeare for his Roman plays. Sufi Islamic literature and European medieval writings abound in accounts of saints' lives (hagiography), but the Italian Renaissance discovered a new kind of subject in *Vasari's *Lives* (1550) of artists. In Britain, biography developed in the hands of *Aubrey and Izaak *Walton in the 17th century, and became a significant literary form with *Johnson's *Lives of the English Poets* (1779–81); Johnson's own life was recorded by *Boswell in *The Life of Samuel Johnson* (1791), the most celebrated of all biographies. The many lengthy biographies written in the 19th century were often hampered by demands of respectability and piety, but these inhibitions were lifted by *Strachey, whose witty irreverence in *Eminent Victorians* (1918) and *Queen Victoria* (1921) launched a new period of growing interest in biographies. Among the highest achievements in recent years are Richard Ellmann's *James Joyce* (1959) and *Oscar Wilde* (1987).

Birtwistle, Sir Harrison (1934–), British composer. He was a member (1952–60) of the New Manchester Group, formed to study and perform advanced types of contemporary music. Birtwistle's music often has strong ritualistic aspects and is sometimes very violent. Such works as *The Triumph of Time* (1972) and the opera *The Mask of Orpheus* (1983) have placed him in the forefront of British 20th-century music.

bistre, a transparent brown pigment made by boiling the soot of burned wood. It was used, particularly in the 17th century, for pen-and-ink drawings or as a wash for water-colours. Rembrandt and Claude are among the artists who used it most successfully. The slightly greenish tinge of bistre distinguishes it from the more reddish *sepia.

bitonality, the simultaneous use of two *keys in musical performance (more than two constitutes polytonality). Brief examples of bitonality can be found in the music of Stravinsky, Holst, and many 20th-century composers. Milhaud and Ives, however, took the practice to greater and more consistent lengths. In small doses the effect can be wonderfully mysterious and evocative.

Bizet, Georges (Alexandre César Léopold) (1838–75), French composer. He completed his first important opera, *Les Pêcheurs de perles*, in 1863, but his second, *La Jolie Fille de Perth* (1866), enjoyed a greater success. *Carmen*, the last and finest of his seven completed operas, failed when it was first produced in 1875, probably because its story was considered too improper by the audiences of the day. It was the first *opéra comique* (i.e. with a spoken dialogue) to portray an anti-heroine and to have a tragic ending. Bizet's music is distinguished by its unfailing flow of sparkling melody, its sharpness of characterization, and its brilliant orchestration.

Björling, Jussi (1911–60), Swedish tenor singer. After his Stockholm debut in 1930 as the Lamplighter in Puccini's *Manon Lescaut*, Björling's warm and appealing voice soon secured him the role of Ottavio in Mozart's *Don Giovanni*. Throughout Europe, and as a member of the New York Metropolitan company for almost twenty years, Björling sang the Italian, French, and Russian opera repertory with excellent taste.

Björnson, Björnstjerne (1832–1910), Norwegian playwright, novelist, and poet. His early prose work depicts Norwegian peasant life with unprecedented realism (*Synnøve Solbakken*, 1857, *The Fisher Girl*, 1868), and he achieved early and lasting success as a dramatist, overshadowing his contemporary Ibsen for much of his life. The trilogy *Sigurd Slembe* (1862) portrays Norwegian history, but later plays deal with contemporary problems (*The Editor*, 1875, *A Glove*, 1883, *Beyond Our Power I*, 1883). Perhaps his best play is *Paul Lange and Tora Parsberg* (1898), a tragedy about a man's vain struggle against intolerance. Björnson was a prolific polemicist, and extremely influential in Norwegian public life and Scandinavian cultural debate. A poem of his became the National Anthem, and he won the Nobel Prize for Literature (1903).

Blackmore, R(ichard) D(oddridge) (1825–1900), British novelist. His fame rests largely on his novel *Lorna Doone* (1869), set in the 17th century on Exmoor, where an outlawed family, the Doones, terrorize the countryside. His works include volumes of poems, translations from Theocritus and Virgil, and thirteen other novels. These pastoral tales are sometimes wordy and ill-constructed; their excellence lies in their descriptions of lovingly observed climate, wildlife, and vegetation.

Blake, William (1757–1827), British poet, painter, and engraver. Through his personal mythology, Blake expresses in his poems a mystic sense of energy of the universe and a protest against hypocrisy and constraint in conventional religion and art. He marks a rejection of the Age of Englightenment and heralds the dawn of *Romanticism. His two best-known books of short poems were *Songs of Innocence* (1789) and *Songs of Experience* (1794; containing 'Tyger! Tyger! burning bright'), noted for their powerful imagery and rhythms combined with the simplicity of their language. He was trained as an engraver and engraved the texts of his own poems with their accompanying and often interwoven illustrations. *The Marriage of Heaven and Hell* (engraved *c*.1790–3) consists of a sequence of paradoxical aphorisms in which Blake turns conventional morality on its head. Other pieces reflect his personal interpretation of the French Re-

volution and political authority. In *Jerusalem* (1804–20) and elsewhere there is evidence of Blake's personal vision of Christianity. Subsequent poets, among them Swinburne and Yeats, have been much influenced by Blake's intuitive creed of contraries. In spite of encouragement from his patrons, both his art and his poetry failed to find a sympathetic contemporary audience, and his last years were passed in obscurity.

blank verse, unrhymed lines of iambic *pentameter: 'Was this the face that launch'd a thousand ships, | And burnt the topless towers of Ilium?' (Marlowe). It is a very flexible English verse-form which can attain rhetorical grandeur while echoing the natural rhythms of speech. First used in about 1540 by Henry Howard, Earl of Surrey, it soon became both the required metre for dramatic poetry and a widely used form for narrative and meditative poems. Much of the finest verse in English—by Shakespeare, Milton, Wordsworth, and Tennyson—has been written in blank verse.

Blasis, Carlo (1797–1878), Italian dancer, choreographer, and teacher. He danced in France, Italy, London, and Russia. He became Director of the Dance Academy in Milan in 1837 and is primarily known as the author of noted treatises on the codification of *ballet technique (1820, 1828) which remain of central importance.

Blaue Reiter, Der (The Blue Rider), a loosely organized group of *Expressionist artists, formed in Germany in 1911, and with Die *Brücke the leading modern art movement in Germany before 1914. The name derives from the title of a picture by *Kandinsky; other leading members of the group included Paul *Klee and Franz *Marc. Though its members differed widely in artistic outlook, they shared a desire to express spiritual values in their work. The group disintegrated with the outbreak of World War I.

Bliss, Sir Arthur (Drummond) (1891–1975), British composer. After active service throughout World War I, Bliss became known as a very 'advanced' composer, much influenced by Stravinsky and Ravel. Such works as *A Colour Symphony* (1922) and the choral symphony *Morning Heroes* (1930) confirmed his importance, as did a series of lively ballets, beginning with *Checkmate* (1937). Later works, such as the opera *The Olympians* (1949), were more romantic in manner. He was appointed *Master of the Queen's Music in 1953.

Blixen, Karen (1885–1962), Danish writer of short stories, novels, and memoirs, who wrote mainly in English, under the name of 'Isak Dinesen'. She managed a coffee plantation in Kenya (1914–32); after it failed she returned to Denmark, where she devoted herself to writing. *Seven Gothic Tales* (1934), characterized by mystery, fantasy, melodrama, irony, and parody, made her famous overnight. In later stories, her wit and wide range of reference were tempered by resignation: *Winter's Tales* (1942), *Last Tales* (1957), *Anecdotes of Destiny* (1958), *Ehrengard* (1963). Her idyllic but ultimately tragic autobiography, *Out of Africa* (1937), was made into a successful film (1985).

Bloch, Ernest (1880–1959), Swiss-born US composer. He first visited the USA (as a conductor) in 1916. He

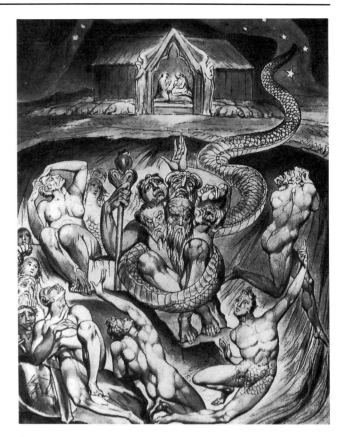

The pictures of William **Blake** were often inspired by the poetry of John Milton, this watercolour being one of a set of six illustrations (1809) to his ode 'On the Morning of Christ's Nativity'. It refers to verse xviii, in which 'The old Dragon under ground [Satan] . . . wroth to see his kingdom fail | Swinges the scaly horror of his folded tail.' (Whitworth Art Gallery, Manchester)

took US citizenship in 1924, but also worked in Europe. His first mature works, such as the popular rhapsody for cello and orchestra, *Schelomo* (1916), explore the world of traditional Jewish music. Later compositions, such as the *Concerto Grosso No. 2* (1952), adopt a more astringent, *Neoclassical stance. In the USA he was much admired as a teacher of composition: he taught amongst others Roger Sessions and Richard Rodgers.

Bloemaert, Abraham (1564–1651), Dutch painter and *engraver. He worked mainly in Utrecht, where he was the leading painter for many years and an outstanding teacher, training a whole generation of artists. A good learner as well as a good teacher, he rapidly assimilated the new ideas that his pupils (Honthorst and Terbrugghen, for example) brought back from Italy. For a while he adopted the style of *Caravaggio and he also assimilated some of the stylistic features of the *Carracci. He is best known for historical subjects, but his most original works are his landscape drawings.

Blok, Aleksandr (Aleksandrovich) (1880–1921), Russian poet, the most important poet of Russian *Symbolism. Born into the intellectual élite of St Petersburg (now Leningrad), his poetry was suffused with the spirit of French Symbolism, which was introduced to Russia in the 1890s. His poetry was always a spiritual quest for the ideal, made manifest in a series of powerful female images.

The **blues** singer and guitarist Huddie Ledbetter ('Leadbelly') built up a vast repertoire of songs, many of them from his long periods in gaol. In 1933 the ethnomusicologist John Lomax discovered Leadbelly, and recorded many of his songs for the US Library of Congress. Late in his life Leadbelly found commercial success and a new audience among white jazz fans.

Loss of faith in his ideal, disillusionment following the Russo-Japanese War, and disappointment in the failure of the 1905 revolution are all reflected in Blok's later verse. The lyric cycles of 1906–16 achieve unprecedented heights of passion in a search for the meaning of Russia's destiny and that of the poet himself. His last great work in verse, *The Twelve* (1918), was the culmination of his searchings and visions. He worked for the Bolshevik government in various administrative capacities, but he died exhausted and disappointed at the outcome of events.

Bloomsbury Group, the name given to a group of British writers, artists, and thinkers. They met from 1905 to the later 1930s, in Bloomsbury, London, at the houses of Clive and Vanessa Bell, and of Vanessa's sister, Virginia Stephen, later Virginia *Woolf. Other major figures in the group included the Fabian writer Leonard Woolf, Lytton *Strachey, the art critic Roger Fry, the painter and designer Duncan Grant, the economist J. M. Keynes, the novelist E. M. *Forster, and the novelist and critic David Garnett. Its members, many of whom were in revolt against the restrictions of Victorian aesthetic and social conventions, profoundly affected the development of art and literature in Britain.

Blow, John (1649–1708), English composer and organist. Trained as a chorister of the *Chapel Royal, he served as organist of Westminster Abbey (1668–79, 1695–1708). On becoming a Gentleman of the Chapel Royal (1674)

he succeeded the lutenist and composer Pelham Humfrey as Master of the Children, at which time Henry Purcell served his apprenticeship under him. More than 100 anthems by Blow have survived, as well as fourteen settings for services, some secular songs, and ceremonial music. His delightful *masque *Venus and Adonis* (*c.*1684) is important as a precursor of English opera, being the first dramatic work in which the whole text is set to music without dialogue or irrelevant musical entertainment.

blues, a type of black American song, taken up by *jazz musicians in the 1920s but with much older folk roots, and an ancestry going back to African origins. Words and music were originally improvised on a simple, fixed-harmonic, twelve-bar basis. Characteristic of the music are the 'blue' notes, in which the third, the seventh, and (more rarely) the fifth notes of the *scale are slightly lowered or 'bent', giving the music its distinctive bitter-sweet quality. The pitch or intonation of blue notes is not fixed precisely, but varies according to the instinct of the performer. Blues structures and formulae have also been developed as purely instrumental music, just as the words and music of the sung blues has been developed by professional composers and lyricists. The true blues is, as much as anything, a state of mind: cynical, disillusioned, but defiant in the face of adversity. The singing style can be harsh with raw emotion, as in the work of such remarkable blues singers as Bessie Smith and Billie Holiday. The so-called 'country' blues is quieter and more meditative than the harsh 'city' blues.

Boccaccio, Giovanni (1313–75), Italian novelist, poet, and humanist, son of a Florentine merchant. He was a friend and admirer of *Dante and endeavoured, apparently with little success, to interest *Petrarch in his fellow poet. In 1348 he witnessed the Black Death in

This detail of a portrait of **Boccaccio** by Andrea del Castagno was originally part of a fresco on famous men and women commissioned by the Carducci family in 1448 to decorate their villa near Florence. Together with his friend Petrarch , Boccaccio was among the first in the Renaissance to appreciate the literature of ancient Greece. (Cenacolo di Sant' Apollonia, Florence)

Florence. His most famous work, the *Decameron* (1348–58), is a collection of tales supposedly told by a group of ten young people fleeing from the pestilence. Boccaccio is an important figure in the history of narrative fiction and has provided inspiration to major writers in most periods of literature, including Chaucer, Shakespeare, Dryden, Keats, Longfellow, and Tennyson.

Boccherini, Luigi (1743–1805), Italian cellist and composer. Famous in his teens as a virtuoso cellist, he resembled *Haydn in his style of composition. He wrote a large quantity of chamber music (nearly fifty string trios and over 100 each of string quartets and quintets). His famous minuet (one of the best known pieces of classical music) is from the String Quintet in E major.

Boccioni, Umberto (1882–1916), Italian painter, sculptor, and art theorist, the most energetic member of the *Futurist group. He advocated a complete break with the art of the past and was concerned with the production of emotionally expressive works and the representation of time and movement. He believed that objects have a kind of personality of their own, revealed by 'force lines' with which the object reacts to its environment. His ideas led him to almost pure abstraction, and his theories on sculpture were extremely forward-looking, including the advocacy of materials such as glass and electric lights.

Bodenwieser, Gertrud (1886–1959), Austrian dancer, teacher, and choreographer. She toured Europe with her own dance company and emigrated to Australia in 1938. An exponent of *Ausdrucktanz*, the German Expressionist dance movement, her works range from the dramatic through the lyrical to mechanical portrayals of early *modernist dance concerns.

Boiardo, Matteo Maria (c.1434–94), Italian poet. Born Count of Scandiano, near Modena, he was in the service of the Duke of Este. Inspired to celebrate the glories of medieval chivalry, Boiardo embarked on his epic *Orlando in Love*, which he abandoned shortly before his death. The poem skilfully weaves together the threads of numerous legends surrounding Charlemagne and the Paladins. Though it does not stand comparison with *Ariosto's *The Frenzy of Orlando*, it remains a work of great inventiveness.

Boileau, Nicolas (1636–1711), French poet. His early reputation rested upon his verse *Satires* and *Epistles*, notable among which are 'Satire VI' on the inconveniences of life in Paris and 'Epistle XII', which shows his sympathy for Jansenist theological doctrine. He is remembered as the codifier of the literary doctrines of French classicism, supremely in the *Art poétique* (1674), where he advises the would-be poet to cultivate clarity and reason, virtues introduced into poetry by *Malherbe. Boileau became embroiled in the *Quarrel of the Ancients and Moderns (1687), in which he defended the superiority of ancient over modern literature, and in 1693 published an important volume of reflections on his own translation of *Longinus' treatise *On the Sublime*.

Böll, Heinrich (Theodor) (1917–85), German novelist and short-story writer. In his early works Böll was concerned to reveal the futility of war. He satirized the moral and spiritual emptiness of post-war Germany, which had embraced materialism and failed to face up

to its Nazi past in his novels *The Bread of Those Early Years* (1955) and *The Clown* (1963). Experimentation with narrative techniques is most obvious in *Billiards at Half-past Nine* (1959), *Group Portrait with Lady* (1971), and *The Lost Honour of Katharina Blum* (1974), the last a scathing indictment of journalistic and judicial malpractice. Böll won the Nobel Prize for Literature in 1972.

Bolshoi Ballet Company, one of the two major Russian ballet companies, based at the Bolshoi Theatre in Moscow. Ballets were staged at the theatre from 1776, but the present company developed after the Revolution (1917). Until the late 1940s it was secondary to the *Kirov, but the dancer Galina Ulanova and choreographer Leonid Lavrovsky were seconded there and the Bolshoi school started producing its own great dancers. When it appeared in the West in 1956 its acrobatic, dramatic style caused a sensation. Yuri Grigorovich became director in 1976, bringing ballets like *Spartacus* (1956) into the Bolshoi's repertoire.

bone carving, the art of carving or incising various types of animal bone. Bone can be used for some of the same kinds of work as *ivory, but allows little more than surface treatment because of its large soft core. It is associated mainly with prehistoric and primitive peoples, but there are some fine examples of Anglo-Saxon carving in whalebone and Japanese *netsuke are often carved in bone.

bone china, a type of *porcelain made with the addition of bone ash (the powdery remains of burnt bones) to the clay. The ash gives bone china a pure white colour that is considered desirable in porcelain and it became popular within a short period of the technique being devised. The first patent was taken out in 1748 by Thomas Frye, co-founder of the Bow porcelain factory, and the process was used at the French Sèvres factory shortly afterwards. It was perfected in about 1800 by Josiah Spode II, son of the founder of one of the most famous Staffordshire pottery works. Bone china is still something of an English speciality, and is used particularly for tableware.

bongos, a pair of small drums played with the fingers and used predominantly in Latin American music. Cylindrical in shape and with a single head or skin (nowadays often of plastic), they are fixed together and usually held between the knees, or sometimes fixed to a stand. They are normally tuned a fourth apart. The playing technique is elaborate in rhythm, pitch, and tone quality, the pitch being quite widely variable by hand pressure, while tone variation can be achieved by using rim shots and by changing the way in which the fingers strike the skins.

Bonington, Richard Parkes (1802–28), British painter, active mainly in France, where his family moved when he was 15. Although he died young of tuberculosis, his work was highly regarded and influential in France. Though his range was wide—including scenes from medieval history and romance—he is best known for his landscapes. These show great freshness and spontaneity and a beautifully fluid touch, whether he was painting in oils or watercolour.

Bonnard, Pierre (1867–1947), French painter and graphic artist. In the 1890s Bonnard was a leading

member of the Nabis, a group of artists who rejected naturalistic depiction and painted in bright non-naturalistic colours. After about 1900, however, his work, while still richly coloured, became more traditional and he is regarded as one of the champions of the ideals of the *Impressionists in the 20th century. With his lifelong friend Edouard *Vuillard, he is best known for intimate domestic scenes (the term *'Intimisme' is sometimes used to refer to the work of the two men in this vein).

bookbinding, decorative, the art of enclosing the pages of a manuscript or printed book in a covering that is ornamental rather than merely protective. The art originated in the monasteries of the Coptic Church in Egypt, perhaps as early as the 2nd century AD, at a time when the codex (manuscript book) was taking over from the roll or scroll, which had been stored in a cylindrical container. Leather-covered boards decorated with stamped or incised patterns were used by the Coptic craftsmen, but much more elaborate and expensive materials were soon being employed in the West. From as

An illustration from an English edition (1672) of Comenius's *The Visible World in Pictures*. Divided into 150 chapters, the book was a landmark in children's **book illustration**, and was translated into most European languages as well as Arabic, Turkish, Persian, and Mongolian. (Bodleian Library, Oxford)

early as the 4th century, gold, precious stones, ivory panels, and enamel plaques were used by monastic craftsmen to decorate the heavy wooden boards fitted with clasps that were necessary to keep the vellum sheets, on which manuscripts were written, from buckling. From about the 7th or 8th century, leather became the normal material for all but the most expensive bindings. Gold tooling became the normal form of decoration in the later 15th century, and the great 16th-century French bibliophile Jean Grolier popularized the practice of stamping book covers with names and mottoes as a mark of ownership. The style of decoration varied greatly from this time onwards, reflecting trends in the other visual arts, but geometrical, interlace, and floral patterns have been particularly popular. Before the 19th century it was the normal practice for publishers to issue their books in sheets, so that booksellers or their customers could have them bound to their own requirements. From the 1820s, however, publishers began issuing books in simple cloth covers, known as trade bindings, the start of modern practice. Detachable paper jackets for books became widespread during the 20th century. These jackets created a recognizable 'house style' for publishers and in Britain many distinguished artists (including John Piper and Graham Sutherland) have worked in this area. Fine binding has continued as an art, particularly in France, which has a rich history of bookbinding.

book illustration, the art of adorning printed books with pictures and decorative motifs. The earliest printed books were modelled closely on *illuminated manuscripts, with spaces left blank for illustrations to be added by hand, but by the end of the 15th century *woodcut illustrations—particularly in Italy—had attained a high level of mastery. Woodcut is inherently suitable for book illustration, since the impression is taken from the surface of the block, which can be made the same thickness as the standard height of type. However, copper *engraving, though it required a separate printing process, allowed greater detail, and it became the standard method of book illustration from about the mid-16th century to the end of the 18th century. Colour printing first became common in the 18th century. In the 1790s Thomas *Bewick popularized *wood engraving, which became the most common method until it was superseded by various photo-mechanical processes at the end of the 19th century, although *lithography and *aquatint were used for more expensive publications. In the 20th century many noted artists have returned to older techniques, such as *etching or woodcut, for the illustration of luxury editions.

In the West there is also a long history of producing illustrated books for children. Early books intended for children were for instruction rather than enjoyment, and the first picture book designed exclusively for children is generally regarded as being *Orbis Sensualium Pictus* by the Moravian-born educational reformer John Amos Comenius (Jan Komenský; 1592–1670), which was published in Germany in 1658 and translated into English the following year as *Comenius's Visible World*. Consisting of pictures illustrating Latin sentences, with translations into the vernacular, this was reprinted and adapted for two centuries and was the prototype of the modern illustrated school textbook. Pictorial ABC books became popular in the 18th century, but it was not until the 19th century that children's books began to be conceived as

entertainments, and colour was used extensively. The classic age of children's book illustration was the late 19th and early 20th centuries, when artists such as John Tenniel (who illustrated *Carroll's 'Alice' books), Kate Greenaway, Beatrix *Potter, and Arthur Rackham flourished. One of the major developments since then has been the use of a cartoon-like graphic style, which was introduced in the USA between the two World Wars.

booth, portable theatre which during the Middle Ages provided travelling companies with an adequate stage, supplanting the adapted inn-yards, barns, or makeshift rooms which were at first the only places available for theatrical productions. Booths consisted originally of tents housing a small stage on which were presented short sketches interspersed with juggling and rope dancing. Portable buildings, easily dismantled and re-erected, later made their appearance, becoming more elaborate as time went on. Some of the more successful showmen contrived to build up a front of gaudily painted canvas flats, sometimes with a platform outside on which the performers could appear to tempt the audience in. This was a particular feature of the French fairground theatres, which evolved from the early booths, and the first permanent fairground theatres in Paris—which had no counterpart in England—had large balconies for the performance of introductory parades. The plays were necessarily simple, farces or strong drama based on popular legends, stories from the classics, the Bible, or history. The booths lasted longest for the accommodation of puppet shows, and the portable stage of the Punch and Judy show is a vestigial remnant of this.

Booth, Edwin Thomas (1833-93), US tragic actor. He sustained a reputation as a tragedian rivalled only by Edmund Kean. Best known for his Shakespearean roles, he was acclaimed on both sides of the Atlantic as the leading Hamlet of his day, and is generally regarded as the foremost US actor of his century. He reached the peak of his career in the years 1869-74 in performances given in Booth's Theatre, which he built in New York City. His habitual melancholia was aggravated by the shock following the assassination of President Lincoln by his youngest brother, John Wilkes Booth.

Borges, Jorge Luis (1899-1986), Argentinian poet, essayist, and short-story writer. His earliest collection of poems, *Fervor de Buenos Aires* (1923), was inspired by his native city. An extraordinary intellectual capacity fed by wide reading of philosophy, theology, and literature from many cultures and ages is demonstrated in his essays published as *Inquisiciones* (1925), *Discussion* (1932), and other collections, and stories. His best-known collections of fantastic stories, *Ficciones* (1944) and *The Aleph* (1949), for the first time reveal his intellectual world, with its own language and system of symbols, and earned him international fame. Subsequently, he continued to write despite the onset of blindness, which forced him to abandon the composition of long texts and to dictate shorter works. Favourite Borges themes include labyrinths, mirrors, the circularity of time, and dualities in human nature. The clarity of his thought and his capacity to undermine our basic assumptions are dazzling. He is probably the most influential intellectual and literary figure ever to have come from Latin America. *Labyrinths* (1962) is an anthology of some of his best-known works.

Borromini's church of San Carlo alle Quattro Fontane, Rome, begun in 1638, was his first independent commission, and he showed great ingenuity in coping with the small, irregular site on which he had to work. The undulating wall surfaces are typical of the way in which he introduced a revolutionary sense of movement into architecture.

Borobudor *Indonesian art.

Borodin, Alexander (Porfiryevich) (1833-87), Russian composer. Borodin studied science and eventually (1864) became Professor of Chemistry at St Petersburg. Composition remained a part-time activity and many works were left unfinished. His reputation rests on the Symphony No. 2 in B minor (1869-76), the String Quartet No. 2 in D (1881), the orchestral *In the Steppes of Central Asia* (1880) and, most important of all, the opera *Prince Igor* (completed by Rimsky-Korsakov and Glazunov for performance in 1890). (See also The *Five.)

Borromini, Francesco (1599-1667), the most original of Italian *Baroque architects. Almost all his work is in Rome, where he lived from 1619. Unlike those of his two great Roman contemporaries, Bernini and Pietro da Cortona, Borromini's commissions were fairly modest, and his genius was expressed through an extraordinarily inventive interplay of subtle but vigorous forms, rather

than through sheer grandeur or richness. The two buildings that best represent his style are the churches of S. Carlo alle Quattro Fontane (begun 1638) and S. Ivo della Sapienza (1642–60), which display the vibrant, undulating rhythms and sense of fantasy typical of his work. Most of his other commissions were not carried out as he intended. His work was enormously influential on the development of Baroque architecture, but it was in Central Europe rather than Italy that his ideas were most fruitfully developed. He was strongly criticized in some quarters in his lifetime, and with the *Neoclassical reaction against Baroque and *Rococo 'licentiousness' he was enshrined as the chief villain of architectural history— an anarchist and corrupter of taste. It is only in the 20th century that he has become widely regarded as one of the greatest architects of all time.

Borrow, George (Henry) (1803–81), British writer. He travelled widely in Britain, Europe, and Asia and produced several works in which he mingles fact with fiction. *The Bible in Spain* (1842) gives a vivid account of his adventures in a country racked by civil war. In *Lavengro* (1851), as in *Wild Wales* (1862), he meets gypsies, tinkers, and murderers, and tells the reader much of his comparative study of languages; he continues these adventures in a sequel, *The Romany Rye* (1857). His works are marked by a *picaresque quality with vivid portraits

of the extraordinary personages he encounters, and by his idealization of an open air and vagrant life.

Bosch, Hieronymus (Jerome van Aken) (*c.*1450–1516), Netherlandish painter, named after the town of 's Hertogenbosch (in French, Bois-le-Duc) in northern Brabant, where he seems to have lived throughout his life. Bosch, who had a prosperous career, was an orthodox Roman Catholic, but the paintings for which he is famous are so bizarre that in the 17th century he was reputed to have been a heretic. None of forty or so paintings is dated, and it has been difficult to establish a chronology for his work. It is generally agreed that the more conventional pictures are from early in his career; the majority of his paintings, however, are completely unconventional and the product of one of the most extraordinarily vivid imaginations in the history of art. They concentrate on man's cruelty and folly, and Bosch's greatest works swarm with disturbing fantasy creatures— half-human, half-animal. His basic themes are sometimes

This is a detail from the right wing, representing Hell, of Hieronymus **Bosch**'s largest painting, *The Garden of Earthly Delights* (*c.*1500–10). The left wing represents Paradise, and the central panel shows mankind's sinful activities. Although Bosch represents such hideous, nightmarish monsters, his paintings are remarkable for their beautiful glowing colour and superbly fluid technique. (Prado, Madrid)

quite simple, but they are heavily embellished with subsidiary themes and symbols, evoking the power of temptation, the horrors of evil, and the fearful consequences of sin. His work was widely known through prints during his lifetime and he had several imitators. In the 20th century his work has become extremely popular, and the Surrealists have claimed him as a forerunner.

Boswell, James (1740-95), Scottish diarist, lawyer, and biographer. During his travels through Europe he met Voltaire and Rousseau; the zeal for the cause of national liberty with which they inspired him resulted in *An Account of Corsica* (1768). Boswell first met Samuel *Johnson in 1763; their travels in Scotland in 1773 are vividly related in *Journal of a Tour of the Hebrides* (1785). The remainder of his life was devoted to the pursuit of a legal and political career and to producing *The Life of Samuel Johnson* (1791), the most felicitous biography in the English language, which gives a vivid and intimate portrait of Johnson, and an invaluable panorama of the age and its personalities. The *Private Papers of James Boswell from Malahide Castle* (1928-34) fill eighteen volumes.

Both, Jan (*c*.1618-52), Dutch landscape painter. He lived in Italy from about 1637 to 1641 and became one of the best-known exponents of the type of Italianate landscape painting that was highly popular in his lifetime and (especially with British collectors) in the 18th century. His pictures often feature peasants driving cattle or travellers gazing on Roman ruins in the light of the evening sun, and warm, rosy lighting is one of the characteristics of his style.

Botticelli's *Primavera* (*c*.1478) is one of the most puzzling as well as one of the most beautiful paintings of the Renaissance. The 16th-century art historian Giorgio Vasari described the subject as 'Venus as a symbol of spring [Italian, *primavera*] being adorned with flowers by the Graces', but scholars have continued to debate the exact meaning of the various figures. (Uffizi, Florence)

Botticelli, Sandro (1445-1510), Italian painter, one of the most notable artists of the *Renaissance. He was a pupil of Filippo *Lippi, whose graceful linear style he raised to new heights. Apart from a visit to Rome in 1481-2, when he worked on frescos on the walls of the Sistine Chapel in the Vatican, almost all his career was spent in Florence. Little is known of his life there, but he was patronized by the greatest families in Florence as well as by the civic authorities and some of the city's most prestigious churches. Most of his pictures are of religious subjects, but he also painted portraits, mythological scenes, and allegories, and (unusually for the time) he made drawings intended as finished works of art in their own right. His most famous and original works are his mythological paintings, and he was the first artist since antiquity to paint mythological subjects on a scale and with a dignity hitherto reserved for religious works. Chief among them are two great masterpieces in the Uffizi in Florence, *Primavera* (*c*.1478) and *The Birth of Venus* (*c*.1485)—supremely graceful works that have become so famous that they are practically symbols of the Renaissance. Botticelli's late works are usually more solemn and intense; in the last decade of his life his style was considered out of date and he died poor and neglected. It was only in the second half of the 19th century that he was rediscovered and his refined, elegant figures became an inspiration for the Pre-Raphaelites and a major source of influence on *Art Nouveau*.

Boucher, François (1703-70), French painter, engraver, and designer. He was one of the greatest artists of the *Rococo period and his work embodies the frivolity of French court life in the middle of the 18th century. He accumulated several honours, including the post of King's Painter (1765). He was also the favourite painter of Louis XV's most famous mistress, Madame de Pompadour, of whom he painted several memorable portraits. His work ranged in scale from huge decorative schemes for the royal châteaux at Fontainebleau, Versailles, and elsewhere to designs for fans and slippers. Sometimes it shows the effects of over-production, but his best work

has irresistible charm and great brilliance of execution, qualities he passed on to his most important pupil, Fragonard. Towards the end of Boucher's career French taste changed towards the severe Neoclassical style and his work was attacked for its artificiality.

Boudin, Eugène (1824–98), French painter. He was the son of a sailor and lived mainly near the coast of northern France, his work consisting principally of beach scenes and seascapes. A strong advocate of direct painting from nature, he is regarded as a link between the generation of *Corot and the *Impressionists; he was particularly influential on the young Monet (they met in about 1858) and exhibited at the first Impressionist exhibition in 1874.

Boulanger, Nadia (1887–1979), French conductor and teacher of music. After studying with Fauré at the Paris Conservatoire she gained a considerable reputation as a conductor and champion of early music (particularly Monteverdi), finally becoming famous as a teacher of composition. Much influenced by the ideals of *Fauré and *Stravinsky, her teaching methods concentrated on *counterpoint exercises and a close analysis of music of all periods. Her pupils include Aaron Copland, Virgil Thomson, Lennox Berkeley, and Jean Françaix. Her sister **Lili Boulanger** (1893–1918) was a talented composer.

Boulez, Pierre (1925–) French composer, conductor, and musical theorist. His music developed rapidly through *atonality and the liberating example of non-Western music to the total serialization (see *serialism) of duration, timbre, and loudness, as well as pitch. His first masterpiece in this manner is the orchestral *Le Marteau sans maître* (1955). Later works, such as *Pli selon pli* (1962) explore *aleatory techniques. Work in the theatre led to his development as a conductor, during which time his compositional output declined. In 1974 he became director of the Paris *computer music studio, Institut de Recherche et de Coordination Acoustique-Musique (IRCAM), which in turn led to fruitful experiments in the manipulation of new sounds. Boulez has also been a leading propagandist of the post-Webern *serialist movement, with books such as *Boulez on Music Today* (1971).

Boulle, André-Charles (1642–1732), French furniture-maker and designer, the most famous of Louis XIV's reign. A fine craftsman in wood and metal and a versatile designer, he was appointed royal cabinet-maker in 1672 and created much of the sumptuous and costly furniture for the palace of Versailles, ending the domination of foreign furniture-makers at the French court. He perfected the use of tortoiseshell and brass *marquetry, which became known as Boulle (or Buhl) work, and his style was highly influential, four of his sons continuing his business until the mid-18th century.

Boullée, Etienne-Louis (1728–99), French architect. He had a successful career as an architect, but little of his work survives and he is now remembered mainly for a series of designs for monuments and public buildings on a scale so vast they could never have been constructed (the drawings are in the Bibliothèque Nationale, Paris). They use severe geometrical elements with stark boldness and are among the most imaginative works of *Neoclassicism. Although they were unpublished, they in-

fluenced Boullée's many pupils. He wrote a treatise on architecture, but this was not published until 1953.

Bournonville, August (1805–79), Danish dancer, choreographer, and director. He trained at the *Royal Danish Ballet School and later danced in Paris, partnering Taglioni, the archetypal Romantic *ballerina. He returned to Copenhagen in 1830 as director, and presented *La Sylphide* in 1836 in a version that has endured to the present day. He championed the male dancer in an era of female adulation and brought warmth and humanity to the often exaggeratedly mysterious atmosphere of Romantic *ballet. His dances are characterized by leaps, fast footwork, and long continuous phrases of dance steps within the tradition of Romanticism in dance.

bouzouki, a plucked stringed instrument used in Greek café music. During the Ottoman period, the Turks introduced the *bozuk* into Greece, a medium sized *saz with three pairs or courses of strings. It is thus an urban instrument rather than a folk instrument common to the whole country. Since the late 1940s it has acquired a fourth course of strings and it now resembles a *mandolin with a very long neck and geared tuning pegs. It has become internationally known through tourism, films, and through occasional use by Greek composers.

bow (in music), a band of horsehair attached to both ends of a stick, drawn across strings to make them sound; rosin (distilled oil of turpentine, solidified to a cake) makes the hair sticky, so that it grips the string. Early bows in about AD 1000 were curved like the archer's and thus held the hair taut. As bows became straighter, methods of keeping the hair taut and away from the stick changed, culminating in the screw frog, a block between the stick and the hair at the handle, tightened with a screw. François Tourte perfected the modern bow *c*.1785, with an inward camber or curve that greatly strengthened it.

bow, musical, the simplest, perhaps the first, of all stringed instruments. With mouth bows, altering the mouth capacity, as on *jews harps, resonates upper harmonics of the string selectively for making soft melodies. With gourd bows, by more or less closing the opening of a gourd or other vessel tied to the stave against the player's body, separate upper harmonics can again be sounded. A string tied to the stave provides two fundamentals; stopping the string near one end provides another. The commonest way of playing is tapping the string with a light stick. Others are plucked and some rubbed, either with a smaller bow on the string or with a stick across notches on the stave. The rarest method is blowing on a flattened quill linking the bowstring to the stave, as with the *lesiba* or *!göra* of South Africa.

bow harp, a form of *harp without a forepillar best known in Africa and Burma, and in ancient times from Egypt to India. The ordinary bow harp has a neck curving away from the resonator, as in many African and ancient Egyptian harps. The resonator usually has a skin belly, with the strings tied to a wooden spine below it. When the neck curves over the resonator it is an arched harp, as in Burma.

boy actors' companies, acting troupes of choirboys who performed in London in the 16th and early 17th

centuries, and were an important element in the life of its 'private' (i.e. enclosed) theatres. Among the most notable companies were the Children of the Chapel, who were attached to London's *Chapel Royal and played regularly at court from about 1517. In 1600 they were installed as a fully professional company in the Blackfriars Theatre, where they enjoyed a popularity which drew audiences away from the adult companies. The boy companies' repertory eventually included works by most contemporary dramatists except Shakespeare. By about 1615 the vogue for boy actors had come to an end. Individual boys continued to play all women's roles in the public theatres until after the Restoration (1660), when women were finally accepted on the British stage.

Boyce, William (1711–79), British composer and organist. In 1736 he became composer to the *Chapel Royal, and in 1757 was made *Master of the King's Music. He wrote extensively for the church, court, and stage, but in his last years turned, through increasing deafness, to musicology and the publication of an important collection, *Cathedral Music* (1790). Boyce was the leading British representative of the late *Baroque style as in his *Eight Symphonyes* (1760) and *Twelve Overtures* (1770).

Boyd, Martin A'Beckett (1893–1972), Australian novelist. His novels examine ironically the tensions between old and new cultures among upper-class Anglo-Australians; some are based on his upbringing in Melbourne. He shows a strong interest in character in his family sagas, which include *The Montfords* (1928), *Lucinda Brayford* (1946), and *The Cardboard Crown* (1952).

Brahms, Johannes (1833–97), German composer and pianist. Born in Hamburg to a poor but musical family, Brahms was obliged to earn his living by playing in taverns while he studied piano and composition. He gave his first solo recital in 1848, and in 1853 joined the violinist Eduard Reményi in a series of concert tours. In that same year he met Robert Schumann, who quickly recognized his genius, though it was not until he settled in Vienna (1862) that his reputation as a composer began to spread. The performance of his *German Requiem* (1868) consolidated his importance. Although in terms of its emotional content Brahms's music has strong *Romantic characteristics, he upheld the *Classical principles of order and moderation and was widely regarded as the most vital inheritor of the *Beethoven tradition. In this he was at variance with the progressive tendencies of *Liszt and his followers, signing a manifesto against their 'new music' in 1860. He soon came to be regarded as the natural, but reluctant, opponent to *Wagner. In effect his convictions involved a strict adherence to the *sonata principle, observance of the classical laws of *tonality and harmonic progression, and the avoidance of all *programmatic elements—including the merely colouristic use of the orchestra. This powerful restraint can be seen in his four Symphonies (1876, 1877, 1883, 1886), two Piano Concertos (1859, 1881), a Violin Concerto (1879), and a large and varied amount of chamber music. He wrote over two hundred songs and was a master of keyboard writing.

Brain, Dennis (1921–57), English player of the French horn. Brain was principal horn with the Royal Phil-

harmonic and Philharmonia Orchestras. A frequent concerto soloist, the subtlety of his musicianship evident in his performances of Mozart and Strauss, Brain was regarded as the finest virtuoso of his day. Britten composed the *Serenade for Tenor, Horn, and Strings* (1943) for him.

Bramante, Donato (1444–1514), the most important and influential Italian architect of the High *Renaissance. He began his career as a painter and his interest in *perspective and *trompe-l'oeil can be seen in his first building, Sta Maria presso S. Satiro in Milan (c.1480), in which he creates an illusion of deep recession in the choir, which in fact is only a few inches deep. When the French invaded Milan in 1499 Bramante moved to Rome, where his style became much more solemn and majestic, leading his contemporaries to declare that he was the first to revive the grandeur of ancient Roman architecture. His greatest commission, the most important in Christendom, was the designing of the new St Peter's (begun in 1506). Bramante's plans were changed by his various successors, but he set the scale for the mighty enterprise, and the four massive central piers he built committed those who followed him to his idea of a huge central *dome. The style of Bramante's own work can best be seen in the Tempietto (a small circular chapel on the supposed site of St Peter's death), dating from about 1502. Generally regarded as the first High Renaissance building, this is

In spite of its small scale, **Bramante**'s Tempietto ('little temple') (c.1510) commemorating the site of St Peter's martyrdom in Rome, is the most complete embodiment of the High Renaissance style in architecture. No building since the ancient world had displayed such a sense of Roman gravity and formal perfection.

remarkable for its dignity and perfect proportioning, and has a grandeur out of all relation to its size.

Brancusi, Constantin (1876–1957), Romanian sculptor who worked mainly in Paris, where he settled in 1904. In his early years in Paris he was influenced by *Rodin, but from 1907 he turned from modelling to carving in stone, and he abandoned a naturalistic approach for one in which forms were simplified almost to the point of abstraction. Brancusi also worked in bronze, and from about 1914 began to make woodcarvings. These are different in spirit from his other works, having a rugged, fetishistic power that relates them to the tradition of Romanian folk art. He had an immense influence on 20th-century sculpture, both in inspiring a move towards abstraction and in showing how to utilize to the full the qualities of the materials with which he worked.

Brandt, Bill (1904–83), British photographer, born in Germany. He was one of a number of important photographers who studied with Man *Ray in Paris in the late 1920s. In England in the 1930s, he took up documentary photography, working for several French and English magazines, and publishing his first book, *The English at Home* (1936). A foreigner's coldly analytical view of the British class structure, it shows how photographs can serve as anthropological evidence. Brandt's famous series of photographs taken in the London Underground during the blitz stand comparison with Henry *Moore's equally disturbing Shelter drawings. His subsequent books reveal

Photographed in 1946, a Lancashire boys' **brass band** is here seen on the march. The Stalybridge Old Band, founded in 1814, claims to be the earliest in Britain. In the USA the Boston Brass Band was founded in 1835, while in German-speaking lands almost every municipality has had its *Posaunenchor* of brass instruments since the mid-19th century.

his growing interest in the aesthetic possibilities of the medium, and a disquieting abstract vision, deriving in part from his antique wooden Kodak camera and a lens with a very small aperture. By the 1970s he had become perhaps Britain's most respected artist-photographer.

branle (Italian, 'brando', English, 'brawl'), originally a French medieval dance derived from the *carole. It existed in many forms, but was essentially a dance with combinations of steps, interspersed with little hops and performed by a linked line of dancers travelling sideways. The quick or slow sideways stepping and the closing of the feet brought about characteristic changes of level, and it was these rhythmic patterns which later became the basis of many other dances. Branles varied from being slow and grave to energetic and lively and were often performed successively as contrasting dances.

Braque, Georges (1882–1963), French painter, with *Picasso the joint creator of *Cubism. Initially a house painter, his father's trade, he took up art seriously in 1900. In 1907, having passed through a brief *Fauvist phase, he discovered the work of *Cézanne and began painting in a geometrically analytical manner. In the same year he met Picasso and until the outbreak of World War I they worked in close collaboration, each being regarded as equally important in the development of Cubism. After the war, in which he was seriously wounded, Braque's work diverged from that of Picasso. His style became less angular, making use of graceful curves. He concentrated mainly on *still-life, using subtle, muted colours and sometimes mixing sand with the paint to produce a textured effect. Braque also did much book illustration, and designed stage sets and costumes.

brass, memorial, a funerary monument consisting of an engraved brass sheet mounted on a stone slab. Brasses, which were cheaper than sculptured tombs, were probably first introduced during the early 13th century, and had their greatest popularity in England, where more than seven thousand survive from the late 13th to the late 16th centuries. They have been of importance as a source of information on the evolution of medieval armour and costume.

'Brassaï' (Gyula Halasz) (1899–1984), Hungarian photographer. After studying painting in Budapest and Paris, 'Brassaï' (he took his pseudonym from his native village) started photography at the suggestion of *Kertész. His favourite subject was Parisian nightlife, but he also made some compelling portraits, especially of artists.

brass band, a combination of musical instruments found throughout Europe, especially popular in Germany and central Europe. In Britain it normally consists of cornets, tubas, tenor horns, baritones, flugelhorn, euphonium, and trombones, with percussion. The history of the British brass band derives partly from the old city 'waits' or street singers and partly from the military wind-band. Competitions began in about 1818 and now centre around Manchester's British Open Championship (founded in 1853) and London's National Brass Band Championship (1860). Much of the brass band material consists of arrangements of light classics, but original works by Elgar (*Severn Suite*) and Holst (*Moorside Suite*) are commensurate with the exceptional skills of the top bands.

brass instruments, in technical usage all the wind instruments formerly made of that metal though now sometimes of other metals. The term does not include instruments formerly of wood but now sometimes of metal (like the flute), nor metal instruments with reed mouthpieces, like the saxophone. Each instrument has a cup- or funnel-shaped mouthpiece to be pressed against the player's lips, which vibrate within it something like the double reed of the *oboe. The shape of the mouthpiece affects the quality of the tone, a deep funnel-shaped mouthpiece (like the *horn's) giving more smoothness, and a cup-shaped mouthpiece (like the *trumpet's) giving more brilliance. The shape of the bell at the end of the tube also affects the character of the tone, as does the nature of the tube's bore, cylindrical or conical. Brass instruments sound only the natural *harmonics of their tube-length, and can thus only play melodies in the high register; in the lower registers they are limited to fanfares, unless equipped with some device to alter their tube-length. The tube may be shortened by opening finger-holes (cornett and serpent) or lengthened by a slide (*trombone) or valves. Valves were introduced in the early 19th century. By depressing or turning the valve the column of air is diverted into auxiliary tubing and lengthened sufficiently to lower the pitch by a musical interval so that a further harmonic series becomes available. Brass instruments have been included in the orchestra since the earliest days. In the *Classical period the orchestral brass usually included merely two horns and two trumpets. In later Beethoven we find either two or three trombones, and up to four horns. Wagner made great use of brass instruments, adding an extra trumpet, additional horns and trombones, and up to four *tubas, plus a contrabass tuba.

Brathwaite, Edward Kamau (1930–), West Indian poet and historian. His trilogy written in the 1960s and published as *The Arrivants: A New World Trilogy* (1973) explores the Caribbean sense of identity from its African roots, blending oral, written, and musical traditions. A second trilogy on his native Barbados comprises *Mother Poem* (1977), *Sun Poem* (1982), and *X-Self* (1987).

Bravo, Manuel Alvarez (1902–), Mexican photographer. Bravo taught himself to take photographs in 1920, soon receiving encouragement from Edward Weston. At first a Pictorialist, he was soon influenced by *Surrealism, exploring intuitively, poetically, and compassionately the metaphorical symbols beneath the stark religious and political contrasts of his native land.

Brecht, Bertolt (1898–1956), German dramatist, poet, and novelist. In the 1920s Brecht's work was marked by a revolt against bourgeois values, which reached its peak in *The Threepenny Opera* (1928), an adaptation of *Gay's *The Beggar's Opera*, with music by *Weill. After espousing Marxism, Brecht developed his concept of *epic theatre, which aims at the spectator's detachment from the action. This 'alienation effect' is designed to instruct and, by reducing the emotional involvement of the spectator, to stimulate a critical scrutiny of reality. In exile (1933–47), first in Switzerland, then in the USA, Brecht produced his finest plays, *Mother Courage and her Children* (1941), *The Good Woman of Setzuan* (1943), *The Life of Galileo* (1943), and *The Caucasian Chalk Circle* (1948). In them Brecht reveals his concern for justice and human goodness; his Marxist reading of social conflict underlines the comic or tragic potential of the characters. Returning to Germany, Brecht founded his own theatre company, the *Berliner Ensemble, in East Berlin (1949).

Breton, André (1896–1966), French poet and literary theorist. He was the leader of the *Surrealists and published manifestos on surrealism in 1924, 1930, and 1934. During the 1930s he rejected the association of Surrealism and communism but remained throughout his life a political radical. His works include *Nadja* (1928), a semi-autobiographical novel, *Les Vases communicants* (1932), a theoretical work on the understanding of dreams, and an edition of his collected poetry (1948). He founded several literary reviews, including *Littérature*, *Minotaure*, and *VVV*, which were vehicles for his ideas on literature.

brickwork, construction using bricks—small rectangular blocks of dried or baked clay bound together with mortar. Bricks have a very long history in building; they were used certainly as long ago as 3000 BC and possibly much earlier. Primitive bricks were simply dried in the sun, but brick kilns were being used in the 3rd millennium BC. The Romans were great builders in brick,

A scene from a production of **Brecht**'s *Mother Courage* at the Deutsches Theater, Berlin, with his wife Helene Weigel in the title role. Brecht's plays discard the notion that drama should seek to create the illusion of reality and call for highly stylized acting.

but after the fall of their empire its use declined until about the 13th century. Brickwork has the advantages over stonework of comparable quality that it requires less labour and is usually much cheaper whilst being just as strong and resistant to decay or fire. Although it has often been covered with a facing of more luxurious material, brickwork can also be highly attractive, by reason of its colour, texture, or patterning. Fine brickwork has often flourished, particularly in areas where good stone is lacking; in northern Germany, for example, many Gothic churches were built in a style known as Backsteingotik ('brick Gothic'). In England, Tudor brickwork is particularly admired for its mellow beauty.

Bridges, Robert (Seymour) (1844–1930), British poet. Apart from several volumes of verse, anthologies, and plays, he wrote two important essays on the study of speech rhythms: *Milton's Prosody* (1893) and *John Keats* (1895), as well as the words for musical settings by Parry. His poetry, noted for its refined simplicity and perfection of form, reached its culmination in *The Testament of Beauty* (1929), setting out his spiritual philosophy in alexandrines. He was appointed Poet Laureate in 1913.

British Film Institute, organization founded in 1933 to foster the development and appreciation of film as an art. It operates the National Film Theatre in London, which offers members a daily selection of the world's films on its two screens, and also stages lectures. It publishes a quarterly magazine *Sight and Sound*, and the *Monthly Film Bulletin*. Financed by government subsidy, membership fees, sponsorship, commercial activity, and donations, it is also responsible for the National Film Archive, the Museum of the Moving Image, and the annual London Film Festival.

Britten, (Edward) Benjamin (1913–76), British composer, pianist, and conductor. He won his first international success at the 1937 Salzburg Festival with *Variations on a Theme of Frank Bridge*. In that year he met the tenor Peter Pears, who became his lifelong artistic and domestic partner. After a period in the USA (1939–42) he returned to Britain to face a conscientious objector's tribunal. The success of *Peter Grimes* (1945) made him the most important opera composer of his generation. In 1946 he founded the English Opera Group, and in 1948 the Aldeburgh Festival. He wrote copiously for both, including chamber opera (*Albert Herring*, 1947; *The Turn of the Screw*, 1954) and full-scale operas (*Billy Budd*, 1951, revised 1960; *A Midsummer Night's Dream*, 1960; *Death in Venice*, 1973). The *War Requiem*, combining the Latin mass with war poems by Wilfred *Owen, was written for the consecration (1962) of the rebuilt Coventry Cathedral; it is probably his masterpiece. Britten was as comfortable writing for children and amateurs (*Noye's Fludde* of 1957 is his best work of this kind) as he was for the most sophisticated professional. Basically conservative, he was nevertheless able to use the traditional ingredients of music in a way that was wholly new and individual.

Broadway, street running north–south of Manhattan Island, New York, at one time synonymous with US theatrical activity, its many famous theatres clustering round the district. It has flourished since the mid-19th century, and in its heyday in the 1920s numbered about eighty theatres. The high cost and consequent un-

adventurousness of Broadway productions led, after 1952, to the establishment of smaller theatres away from the area ('off-Broadway'), where lower overheads enabled risks to be taken with experimental drama. There are now also 'off-off-Broadway' theatres which continue to stage less expensive and more daring productions.

Broch, Hermann (1886–1951), Austrian novelist and essayist of Jewish parentage, living in the USA from 1938. His novels are permeated by philosophical reflection and cultural criticism. The trilogy *The Sleepwalkers* (1930–2) records the disintegration of values in late 19th- and early 20th-century Germany from 'romantic' adherence to outmoded convention, through the 'anarchy' of shattered ethical beliefs, to the triumph of materialistic 'objectivity' (in fact unscrupulousness). Political developments after 1918 are indirectly reflected in *The Guiltless* (1950) and *The Tempter* (1952). Broch's best-known work is *The Death of Virgil* (1945), which questions the value of a literature that satisfies aesthetically but serves neither an ethical function nor the cause of ultimate truth.

Brodsky, Iosif (Aleksandrovich) (1940–), Russian poet and essayist. Recognized by Anna Akhmatova as outstanding among a brilliant generation of Leningrad poets, but not by official literary circles, he was arrested in 1964 as a 'parasite', exiled to the north, released, and emigrated in 1972. He has been a US citizen since 1977. His poetry is intellectual, formally ingenious, and packed with cultural references (*A Part of Speech*, 1978). He is an accomplished essayist (*Less than One*, 1985). Brodsky was awarded the Nobel Prize for Literature in 1987, and late that year his work began to be published in the Soviet Union.

Brontë, Charlotte (1816–55), **Emily** (1818–48), and **Anne** (1820–49), British novelists and poets. Their Irish-born father became rector of the parish of Haworth in Yorkshire in 1820, where his wife died in 1821, leaving him with five daughters and a son, Patrick Branwell. After a period at a boarding school, when the two eldest daughters, Maria and Elizabeth, died of consumption, the girls were educated largely at home. An isolated childhood on the edge of the Yorkshire moors intensified their imagination. Their experience of the world beyond the rectory was limited, apart from brief spells as governesses and teachers, and a visit to Brussels by Emily and Charlotte to study languages and school management. In 1846 a joint publication of their poems appeared under the names Currer, Ellis, and Acton Bell (the pseudonyms respectively of Charlotte, Emily, and Anne). Charlotte is remembered for her romantic masterpiece *Jane Eyre* (1847), for *Shirley* (1849), and *Villette* (1853). She was the most noted of the sisters and her writings have received widespread praise for their depth of feeling and courageous realism. Emily is established as the true poetic genius of the three, remembered for her personal visionary poems and for her masterly novel *Wuthering Heights* (1847). Anne's first novel *Agnes Grey* (1847), which reflects her experiences as the governess of two contrasting families, was followed by *The Tenant of Wildfell Hall* (1848), which portrays a violent drunkard, to some extent drawn from their brother Branwell, a talented painter whose wildness and intemperance caused much distress to his family. All the Brontë sisters died young, Charlotte soon after her marriage to her father's curate, Arthur Bell Nicholls.

Bronze Age art, the art of the stage of human culture when metals (copper and then bronze) were first used regularly in making tools and weapons. The term is a very general one, as this phase of human development (between the *Stone Age and the *Iron Age) began and ended at widely differing times in various parts of the world. In Crete (see *Minoan art) the Bronze Age had begun by about 3200 BC, and bronze artefacts seem to have been made even earlier in Thailand. In some areas the Bronze Age coincided with the development of great civilizations, notably in China, Egypt, the Mediterranean, and the Middle East, and apart from metalwork the arts of the time included architecture on a grandiose scale, stone sculpture, and painting. However, in other areas, for example Britain, Bronze Age culture was much less advanced. Early bronze technology began in Britain *c*.1800 BC, and may be associated with immigrants named the Beaker folk (after the shape of their drinking vessels). The ability to organize society is shown by the addition to Stonehenge of a circle of bluestone monoliths transported from the Prescelly mountains in south-west Wales. In the Middle East the Bronze Age developed into the Iron Age from about 1200 BC; in southern Europe from about 1000 BC, and in northern Europe from about 500 BC. Bronze was not used in the New World until about 1100 AD, among the Incas. (See also *Mycenean art.)

bronzework, a general term for artefacts or decorative work made from bronze, an alloy of copper (usually about 90 per cent) and tin, often also containing small amounts of other metals such as lead or zinc. It has been used since prehistoric times in various parts of the world, and in the Middle East and the Mediterranean area it became an important material in the second millennium BC. From Greek and Roman times it has been the metal most commonly used in cast sculpture, and it has also been used for—among much else—bells, drinking vessels, mirrors, weapons, architectural ornament, and coins ('copper' coins are usually bronze). Its popularity and versatility come from its strength, durability, and the fact that it is easily workable—both hot and cold—by a variety of processes. The colour of bronze is affected by the proportion of tin or other metals present, varying from silverish to a rich, coppery red, and its surface beauty can be enhanced when it acquires a patina (an incrustation—usually green—caused by oxidation and occuring naturally with age). (See also *Chinese bronzes.)

Bronzino, Agnolo (1503–72), Italian *Mannerist painter. He spent most of his career in Florence, as court painter to Cosimo de' Medici. He followed the style established by *Michelangelo, but without the crude energy his work appeared more as elegant posturing. His best-known work is an allegorical painting, *Venus, Cupid, Folly, and Time,* in the National Gallery, London, but his greatness lay in his portraits: their formal, unemotional style stresses the social status of the sitter rather than probing his or her character, and had a long lived influence on European Court portraiture.

Brook, Peter Stephen Paul (1925–), British theatrical director, famous for his innovatory productions. As early as 1946 he directed Shakespeare's *Love's Labour's Lost* with *Watteau-style costumes at Stratford-upon-Avon. His most famous productions include Anouilh's *Ring Round the Moon* (1950), Shakespeare's *Titus Andronicus*

(1955, with Olivier), and *A Midsummer Night's Dream* (1970) with circus trappings. His production of Peter Weiss's *Marat/Sade* (1964) epitomized *Artaud's Theatre of Cruelty. In 1970 he moved to Paris, founding the International Centre for Theatre Research.

Brooke, Rupert (Chawner) (1887–1915), British poet. He won a scholarship to King's College, Cambridge, where he soon established himself as a literary figure. Some of his poems appeared in the first two volumes of *Georgian Poetry* and his collection, *Poems 1911,* was widely acclaimed. A breakdown led him in 1913 to travel in the USA, Canada, and the Pacific, particularly Tahiti where he wrote several poems. In 1915, as an officer in the Royal Navy, he died of blood poisoning on the way to the Dardanelles. The ecstatic reception of his five 'War Sonnets' made him the nation's poet of the war, a reputation further enhanced by the posthumous publi-

Donatello's famous statue of David (*c*.1440) is one of the outstanding pieces of Renaissance **bronzework** and the first free-standing nude statue to be made since classical antiquity. (Bargello, Florence)

cation of *1914 and Other Poems* (1915) which caught the mood of romantic patriotism of the early war years. His handsome appearance and untimely death contributed to the popularity of his work among young people in the interwar period. He is now chiefly valued for his lighter verse, his sonnets, and his Tahiti poems.

Brouwer, Adriaen (*c.*1605-38), Flemish painter. He spent much of his short working life at Haarlem in Holland (where he was probably a pupil of Frans *Hals) and was an important link between the Dutch and Flemish schools. In both the countries in which he worked he played a major role in popularizing low-life *genre scenes; his most typical works represent peasants brawling and drinking. Although his subject-matter was usually humorously coarse his technique was delicate and sparkling, and Rembrandt and Rubens were among the admirers of his work. In addition to his peasant scenes Brouwer painted some outstanding landscapes.

Brown, Ford Madox (1821-93), British painter and designer. He was born at Calais and trained in Antwerp, Paris, and Rome before settling in England in 1845. His meticulous and detailed—if rather overwrought—style, vivid colouring, passionate sincerity of approach, and preference for literary subjects made him a major influence on the *Pre-Raphaelites, whom he befriended (Rossetti was briefly his pupil). In 1861 Brown was a founder member of William *Morris's company, for which he designed stained glass and furniture.

Brown, Lancelot (1716-83), British landscape designer, known as 'Capability Brown' because he would tell his patrons their estates had great capabilities. Developing the ideas of William *Kent, he became the principal exponent of the new natural style which ousted the formal tradition of the 17th and early 18th centuries. His aim was to create the illusion of a natural landscape by introducing winding lines, by planting trees in apparently random clumps, and by forming irregular lakes to replace the straight canals of the earlier period. He succeeded so well that his work (the most famous examples are at Blenheim Palace and Chatsworth) is sometimes mistaken for natural landscape. Brown was also an accomplished architect; some of this side of his practice was carried out in collaboration with his son-in-law Henry *Holland. (See also *garden art.)

Brown, Trisha (1936-), US dancer and choreographer. She was an initiator of the *postmodern dance movement in the early 1960s, the founder of the improvisational group Grand Union, and of her own company in 1970. Her works range from dances in unusual spaces or based around, for example, climbing equipment, to works built from small gestures repeated in accumulating sequence. Latterly her dances use larger but always finely articulated movements which flow easily and endlessly from dancer to dancer.

Browne, Sir Thomas (1605-82), English writer and physician. He is remembered for his distinctive wit, his rich prose style, and his eloquent musings on mortality. He won immediate fame with *Religio Medici* (printed, without his permission, in 1642), a journal about the mysteries of God, man, and nature and enhanced with citations from classical philosophers, historians, and poets.

His most ambitious work, *Pseudodoxia Epidemica* (1646; commonly known as *Vulgar Errors*) established him as a man of learning. His *Hydriotaphia* or *Urne-Buriall* (1658) has been called the first archaeological treatise in English, and is particularly noted for the beauty of its sonorous prose. He spent most of his life in Norwich, where, in his capacity as a doctor of medicine, he acted as witness in the condemnation of two women as witches (1664).

Browning, Elizabeth Barrett (1806-61), British poet. A semi-invalid from youth, in 1845 she began her correspondence with Robert *Browning which culminated in their secret marriage and elopement to Italy in the following year. Her *Poems* (1844) received such acclaim that she was widely canvassed as Wordsworth's successor as Poet Laureate, but her progressive social ideas and audacious metrical experiments were considered unconventional. *Sonnets from the Portuguese* (1850) reflect her developing love for Browning. Her major work, the verse novel *Aurora Leigh* (1857), speculates with wit and force on social responsibilities and the position of women, with vivid sketches of the English countryside and luminous Italian landscapes. The stridently political *Poems before Congress* (1860) injured her popularity. Some of her best-known lyrics are contained in her posthumously published *Last Poems* (1862).

Browning, Robert (1812-89), British poet whose work is marked by a strong psychological interest in human emotions and motives. His experiments in form and content and his technical virtuosity have considerably influenced modern poets, notably Eliot and Pound. The success of *Paracelsus* (1835), a blank-verse dramatic poem, led to friendship with the actor Macready, who played the title role in Browning's blank-verse play *Strafford* (1837). *Dramatic Lyrics* (1842) and *Dramatic Romances and Lyrics* (1845) contained some of his most accomplished poems but achieved little public success. In 1846 he married Elizabeth Barrett (see *Browning, Elizabeth Barrett), who was to inspire some of his finest work. *Men and Women* (1855) included some of his most successful dramatic monologues and his love-poem, 'Love Among the Ruins'. *Dramatis Personae* (1864), a collection of poems, reflects his grief at his wife's death. His greatest triumph was *The Ring and the Book* (1868-9), a series of dramatic monologues, a form in which Browning excelled.

Bruce, Christopher (1945-), British dancer and choreographer. He trained at the Rambert School, joining the company in 1963. He has choreographed for the Rambert Dance Company and other European companies. His works blend *modern dance and ballet styles. They deal with emotional relationships (*George Frideric*, 1969), are sometimes intensely theatrical (*Cruel Garden*, 1977, with Lindsay Kemp), or emphasize social and political themes (*Ghost Dances*, 1981).

Bruch, Max (Karl August) (1838-1920), German composer. In 1891 he became Professor of Composition at the Berlin Academy, where he remained until his retirement in 1910. Though once admired as the composer of large-scale choral works (*Odysseus*, 1872), he is now chiefly remembered for his Violin Concerto in G minor (1868)—a work of singular beauty in the *Mendelssohn tradition.

Brücke, Die (The Bridge), a group of German *Expressionist artists founded in 1905 by Ernst *Kirchner in Dresden. Its members sought to achieve 'freedom of life and action against established and older forces' (the name, Die Brücke, indicated their faith in the art of the future, towards which their own work was to serve as a bridge); their aims, however, remained vague. Their most lasting achievement was the revival of graphic arts, in particular the *woodcut with its characteristically strong contrasts of black and white, bold cutting, and simplified forms. The group moved to Berlin in 1910 and broke up in 1913.

Bruckner, (Joseph) Anton (1842–96), Austrian composer and organist. His discovery of *Wagner's music in 1863 proved a liberating experience and by 1864 he had come into his own as a composer with the Mass in D minor. Despite his growing fame as a composer (consolidated in 1885 with the performance of his Seventh Symphony), and his reputation as an organ recitalist of international importance, Bruckner remained tentative and uncertain about his gifts—often accepting well-meant advice, so that his nine symphonies now exist in several versions. Though influenced by Wagner, he did not share that composer's sense of dramatic display. His music moves instead along leisurely, contemplative lines, achieving its effects through the sheer monumentality of its slowly unfolding *sonata forms.

Bruegel, Pieter (c.1525–69), the greatest Flemish artist of the 16th century and the founder of a dynasty of painters that extended into the 18th century. Bruegel was an outstanding draughtsman as well as a painter, and in his early career he earned his living mainly as a designer of engravings. In 1551 he became a master in the Antwerp painters' guild and soon afterwards made a journey to Italy. He was unmoved by the wonders of ancient and Renaissance art, but the experience of crossing the Alps

Brunelleschi's Foundling Hospital in Florence (begun 1419) is often cited as the first Renaissance building. It uses the forms of Roman architecture, but Brunelleschi has greatly simplified them, giving his building a sense of graceful lightness rather than massive strength.

left a permanent mark on him. He made some marvellous drawings of mountain scenery in which he showed the combination of breadth of vision and loving attention to detail that were later seen in his paintings. Bruegel lived in Antwerp until 1563, when he moved to Brussels, and there his style changed. His early paintings were much influenced by *Bosch and are full of tiny figures, but he later made his figures bigger and bolder. His subjects included scenes of village life and biblical themes, in both of which he displayed his skills in depicting landscape and the details of everyday existence. Bruegel had a considerable reputation in his lifetime and an enormous influence on Flemish painting. Today he is recognized as a profound religious and humanitarian painter. Bruegel had two painter sons who were infants when he died. **Pieter Brueghel** (the Younger) (the sons kept the 'h' in their name) was known as 'Hell Brueghel' because scenes of hell and fires were among his favourite subjects. He also reworked many of his father's peasant subjects. Pieter the Younger's brother **Jan** (1568–1625) was known as 'Velvet Brueghel' because of his skill at depicting rich and delicate textures. He was rated the finest flower painter of his day and also painted lush landscapes. Jan often collaborated with other artists, notably his friend Rubens. The children and grandchildren of Jan and Pieter continued the family tradition, but with diminishing talent.

Brunelleschi, Filippo (1377–1446), Italian architect, the founder of *Renaissance architecture. He trained as a goldsmith in Florence and early in his career worked as a sculptor. It is said to have been his defeat by Ghiberti in the competition (1401–2) for the new baptistery doors for Florence Cathedral that turned him to architecture, but his first buildings were begun almost two decades after this. They include (all in Florence): the Foundling Hospital (begun 1419); the churches of S. Lorenzo (begun c.1425) and S. Spirito (begun c.1436); and the Pazzi Chapel of Sta Croce (begun 1433). These buildings show Brunelleschi's mastery of classical detail, partly inspired by visits to Rome, but they are not archaeological in spirit; rather thay have a lucid, airy harmony that is Brunelleschi's own. His most famous work is the *dome

of Florence Cathedral (1420-36), which shows *Gothic influence in its use of pointed forms, but makes use of Roman constructional techniques to span the huge space it covers; it was far and away the greatest engineering feat of its time. Brunelleschi was a friend of Donatello and Masaccio, his greatest contemporaries among sculptors and painters, and the co-founders of the Renaissance style. Like them he was a pioneer of perspective, but the two panels on which he is said to have demonstrated his innovations have disappeared.

Brussels tapestries, *tapestries woven at factories in Brussels, which, during the 16th and 17th centuries, was one of the most important centres in Europe for this art. The industry was well established by the late 15th century, and the technical excellence of Brussels craftsmen was reflected in Pope Leo X's decision to send Raphael's cartoons of the Acts of the Apostles there to be woven into tapestries for the Sistine Chapel (1516-19). This marked a turning-point in the history of the art, for henceforth the designer of the tapestry was accorded greater status than its weavers. Rubens provided numerous cartoons for the weavers, and was a major factor in the continuing international success of Brussels tapestries. After the reorganization of the *Gobelins factory in 1662 the leadership in tapestry production moved to Paris, though Brussels continued to produce large numbers of tapestries during most of the 18th century.

Brutalism, an architectural term, coined in 1954, describing the powerfully raw and chunky late style of *Le Corbusier and of his contemporaries who were influenced by it. The most characteristic feature of the style is the use of *béton brut* (French, 'concrete in the raw'), that is, concrete that is left just as it is after the removal of the shuttering (the framework into which it is poured). Sometimes wood with a pronounced grain was used for the shuttering to emphasize the sense of toughness.

Buddhist art, art and architecture in the service of Buddhism. Buddhism was made the national religion in India by the emperor Aśoka (see *Mauryan art) in the 3rd century BC, and from India it spread over much of Asia; it is still a major force in many parts of the continent, but ironically there are now few Buddhists in India, where the religion barely survived the Muslim invasions in the 13th century. Buddhism soon attracted a strong following among wealthy merchants, who erected *stupas to venerate the Buddha's memory, and this became one of the most characteristic forms of architecture throughout the Buddhist world. Other typical forms of Buddhist architecture are the rock-cut shrine (as at *Ajaṇṭā), hollowed out of the side of a mountain or cliff, often with elaborate façades and pillared halls, and the monastery, which in India took on a fairly standard form, with small cells arranged around a courtyard. Initially there was reluctance to depict the physical form of the Buddha, his presence being indicated by symbols such as his footprints. However, at *Gandhāra and *Mathurā, at about the same time (c. AD 100), he was first shown in human form, and the statue of the Buddha, ranging in size from colossal figures carved from the living rock (see *Sri Lankan art) to small bronzes, became one of the most characteristic forms of Buddhist art. He is generally shown standing or seated in the lotus position and is often in monastic garb.

Aspects of the Buddha are conveyed by *mudras (hand positions), indicating specific virtues or incidents in his life. As well as the Buddha himself, Bodhisattvas were frequently represented; these were people who had attained enlightenment, but refrained from remaining in a state of Nirvāṇa (absolute blessedness) so as to help others to attain it. There were also many minor 'gods' in the Buddhist pantheon, some borrowed from Hindu mythology, so Buddhist iconography can be exceedingly complex, not least when Buddhism mingled with native religions, as for example in *Tibetan art. There were various schools of Buddhist thought, of which Zen Buddhism was particularly influential in China and Japan. Zen Buddhism asserts that enlightenment is attained through meditation, self-examination, and intuition, rather than through studying the scriptures, and its influence on Oriental art is seen in the idea of the unity of all things, notably in the reverence and awe for the natural world found in Chinese landscape painting (see *Chinese painting) and in other works by the great Zen Buddhist monk artist *Muqi.

Buddhist literature *Sanskrit literature, *Pali literature.

In early **Buddhist art** Buddha was represented by symbols: footprints indicated his presence, a standing woman (his mother) his birth, a tree the Enlightenment, a wheel the Doctrine and the First Sermon, and a stupa his death. However, this Buddha from Gandhara in present-day Pakistan, reflects Greco-Roman influence in the development of a way of showing the standing Buddha. (Indisches Museum, Berlin)

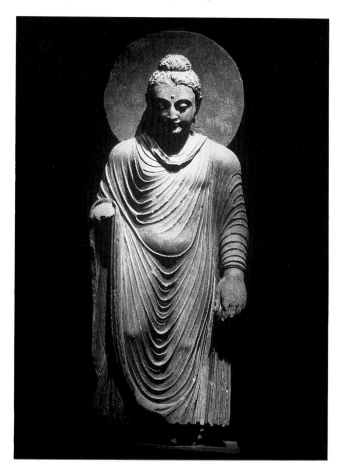

Buddhist monastic dance (*'cham*), the ritualistic dance performed in Buddhist monasteries in Central Asia. The dancers wear elaborate masks and costumes and are accompanied by musicians playing horns and drums. They perform visual representations of the benign forces of religion overcoming the evil powers of demonic spirits. Their steps and body movements are highly stylized and the rhythmic beat of the dance is accented by a measured stamp of the foot.

Buddhist music, music of the rituals and festivals of Buddhism. This has developed with much variation throughout South, South-East, and East Asia since its origins in 6th-century BC India. From its earliest history the choral chanting of sacred texts has been an essential part of Buddhist liturgy. Chants are learnt by repetition, though obscure *notations exist in Japan, Tibet, and Korea. The two basic forms are sutra, a simple syllabic recitative, and *gāthā*, using more elaborate melodies. The main Buddhist instruments—the *ghanṭā* (handbells), *śaṅkha* (conch trumpet), *vīṇā* (arched harp or lute), *tāla* (cymbals), and various types of drums, bells, and gongs—developed in importance from the 3rd century BC to the 7th century AD, as the religion became richer in ceremony. Today stringed instruments are rarely used, and ritual assemblies are often dominated by oboes, trumpets, and drums. Instruments chiefly accompany chanting, though they are also used in Buddhist pageants and processions marking significant days. Purely instrumental music is rare.

bugle, a brass musical instrument without valves used for military signalling. *Bugle* was the Old French term for oxhorn, and large semicircular oxhorns were used in the 17th century and were copied in metal in semicircular shape in the Hanoverian armies of the 18th century. By the early 19th century an instrument of more modern appearance, with a single coil of tubing, was usual. The modern instrument, more closely folded twice round, was in use by the time of the Crimean War. In 1810 Joseph Haliday patented a bugle with five keys, capable of playing any melody, and the key bugle remained popular to the end of the century. After valves were invented in 1815, they were applied to the bugle, creating the flugelhorn, and larger members of the family down to the bass *tuba.

Bulgakov, Mikhail (Afanasyevich) (1891–1940), Russian dramatist, novelist, and short-story writer. He became a professional writer with the success of his early short stories, some of which are autobiographical (*A Young Doctor's Notes*, 1925–6), while others use elements of the fantastic to explore ethical problems (*The Heart of a Dog*, published in the Soviet Union 1988). His Civil War novel *The White Guard* (1925–7) explores the post-revolutionary predicament of the intelligentsia and professional classes; it formed the basis of his play *Days of the Turbins* (1926), which became and remains a staple of the Moscow Arts Theatre repertory. In the 1930s Bulgakov encountered increasing difficulties during the Sovietization of cultural life. He worked on his most original novel, *The Master and Margarita*, from 1929 until his death; it was published in the Soviet Union only in 1966.

Bull, John (*c.*1562–1628), English composer, organist, and organ-builder. He joined the Children of the *Chapel Royal in 1574, returning to his native Hereford as cathedral organist in 1582. Of his skill as a player there can be no doubt—his variations on the *Walsingham* tune represent a peak in the writing of virtuoso virginal music and test finger dexterity to the full—but his skill as a composer is as great. His interest in *counterpoint is shown in a set of 120 canons, most of them on the plainsong *Miserere*. This skill informs many of his compositions, especially the great A minor *In nomine* with its complex rhythmic proportions. He was also a fine composer of linked *pavans and *galliards, which are treated less as music for dancing than as miniature variation sets; similarly, his arrangements of Dowland's *Piper's Galliard* glow with a dark passion. His virtuosity is never empty show but is used to express that intellectual melancholy common to both music and verse in the Jacobean period.

bull-roarer (thunderstick, whizzer, etc.), an ancient musical instrument comprising a flat piece of wood, typically about 15–30 cm. (6–12 in.) long, tied, through a hole at one end, to a long piece of string; when whirled above the head it produces a roaring or screaming sound. It is still used by various peoples throughout the world (see, for example, *African music, European *folk music, *Papua New Guinean music), and is often used in important rituals.

bumbass, a bowed one-string musical instrument, usually with an inflated bladder as a resonator, though a small drum, as with the Polish devil's fiddle, or even a tin can, as with the Dorset humstrum, were also used. The string is usually bowed with a notched stick, occasionally with a proper bow, and it is not fingered, so that the sound is a rhythmic drone. The rhythm is reinforced by beating the instrument on the ground while it is played, and often strengthened by bells or cymbals fixed to the stick.

Bunin, Ivan (Alekseyevich) (1870–1953), Russian poet and novelist. He attained wide recognition after 1900 for his short stories and *novellas, stylistically exquisite, elegiac, and sensuous, dealing mainly with the provincial gentry (*Dry Valley*, 1912), and also reflecting his extensive foreign travels. *The Gentleman from San Francisco* (1915) is his supreme early achievement. Bunin emigrated in 1920 and lived thereafter in France; his creative powers were undiminished, and reached new heights with the largely autobiographical novel *The Life of Arsenyev* (1927–33) and the novellas of *Dark Avenues* (1943). He was the first Russian to win the Nobel Prize for Literature, in 1933. His works began to be published extensively in the Soviet Union in the 1960s.

Buñuel, Luis (1900–83), Spanish film director. The influence of *Surrealism can be seen in much of his work, and especially in his first two films, the twenty-four-minute *Un chien andalou* (1928) and *L'Age d'or* (1930), both made in France in collaboration with *Dalí. After the documentary *Land Without Bread* (1932) he made no further films until 1947, when he began to direct in Mexico, where he made such notable films as *The Young and the Damned* (1950), about children in a Mexico City slum, and *Nazarín* (1958). The anti-clerical *Viridiana* (1961), with its famous tramps' 'Last Supper', was shot in Spain, but banned there. His later films (mainly French or French/Italian) continued to attack religion and

bourgeois morality and included *Diary of a Chambermaid* (1964), *Belle de jour* (1966), in which an upper-class woman becomes a prostitute in the afternoons, *The Milky Way* (1969), and *The Discreet Charm of the Bourgeoisie* (1972).

bunraku *Japanese theatre, *puppetry.

Bunyan, John (1628–88), English writer and non-conformist preacher. A man of deep religious convictions, in 1653 he joined a Nonconformist church in Bedford, preached there, and came into conflict with the Quakers, against whom he published his first writings. He was arrested in 1660 for preaching without a licence and imprisoned in Bedford until 1672. There he wrote *Grace Abounding to the Chief of Sinners* (1666), his impassioned and tormented spiritual autobiography. During a second period in prison, in 1676, he probably finished the first part of his greatest work, *The Pilgrim's Progress* (1678–84), an *allegory of salvation remarkable for the beauty and the simplicity of its language.

Burbage, Richard (*c*.1567–1619), English actor, the greatest of *Elizabethan theatre. He was the leader of the Chamberlain's (later the King's) Men, the group of actors for which *Shakespeare wrote most of his plays. They appeared at the first permanent playhouse (The Theatre) built by Richard's father James in 1576, then from 1599 at The Globe, which Richard and his brother Cuthbert built on the south bank of the River Thames. Though short and fat, he created many of Shakespeare's greatest roles, including Hamlet and Richard III. He also played leading roles in plays by Jonson and others.

Burges, William (1827–81), British architect and designer, one of the most original exponents of the *Gothic Revival. Like the *Pre-Raphaelite painters, with many of whom he was friendly, he developed a romantic vision of the Middle Ages, partly inspired by his extensive continental travels. His architecture, furniture, stained glass, metal-work, and jewellery are all notable for his historicist attention to detail, and are characterized by sumptuous decorative effect. Burges inherited wealth from his father and was not a prolific architect. His masterpieces are the 'restorations' (in fact reconstructions) of Cardiff Castle (1868–81) and the nearby Castell Coch (1875–81), undertaken for the immensely wealthy 3rd Marquess of Bute, who shared Burges's medievalist vision.

Burgess, Anthony (1917–) (also called Joseph Kell, b. John Burgess Wilson), British novelist, critic, and composer. His years in the colonial service in Malaya and Borneo inspired his first three novels, known collectively as the Malayan Trilogy (1956–9). These established him as a writer of great verbal invention, displaying a flair for pastiche and satirical social comment. *A Clockwork Orange* (1962; film version by Stanley *Kubrick, 1971) is an alarming vision of violence, high technology, and authoritarianism. He has written critical works, numerous reviews, film and television scripts, and a biography of Shakespeare; he has also composed orchestral works. His best-known later novel is *Earthly Powers* (1980).

Burgundian school, the title given to artists and musicians of the Burgundy region of eastern France, especially during its golden age in the late 14th and early 15th centuries. Burgundy's period of greatest importance began in 1363 when Philip the Bold was created Duke of Burgundy. Under Philip and his successors, Burgundy acquired large areas of north-eastern France and the Low Countries. Its capital, Dijon, was one of the most thriving cultural centres in Europe, attracting artists such as the great *Netherlandish sculptor Claus Sluter (d. 1406), almost all of whose surviving work can still be seen there. Sluter led the way from the *International Gothic style, which had one of its finest flowerings in Burgundy, to a more solid, naturalistic style that formed the basis of much Flemish art in the 15th century. Choir schools flourished in the major cities, attracting such major composers as *Dufay and Gilles Binchois (*c*.1400–1460). Sophisticated *chansons were composed by the church musicians, lending their work a characteristically warm style that distinguished it from the more intellectual *Ars Nova.

burlesque, a kind of *parody which ridicules some serious literary work either by treating its solemn subject in an undignified style, or by applying its elevated style to a trivial subject, as in Pope's 'mock epic' *The Rape of the Lock* (1712). Often used in the theatre, burlesque appears in Shakespeare's *A Midsummer Night's Dream*, mocking theatrical interludes in the Pyramus and Thisbe play, while *The Beggar's Opera* (1728) by Gay burlesques Italian opera. In the US a **burlesque** is a sex-and-comedy entertainment originally intended for men only. (See also *vaudeville.)

Burlington, Lord (Richard Boyle, 3rd Earl of Burlington) (1694–1753), English architect and patron. He was the leading figure of *Palladianism, promoting it through his own buildings, his publication of the designs of *Palladio and Inigo *Jones, and his patronage of artists such as his friend William *Kent. Burlington's masterpiece is Chiswick House (*c*.1723–9), a villa he built for himself; although based on Palladio's Villa Rotonda and impeccably correct in detail, it is much fresher than most Palladian buildings. He was regarded as an arbiter of taste, and although highly influential, was attacked for his dogmatism by Hogarth in his satirical engravings.

Burmese art. Burma is bordered by India and China, but it is cut off from them by formidable mountain ranges, and although there has been influence from both countries, Burma has a distinctive cultural and artistic tradition. *Buddhism (adopted from India in about the 5th century AD) has been the main religious force, but there has also been widespread worship of nature-spirits (*nats*). Several distinct peoples have influenced Burmese art, notably the Mon of lower Burma, the Pyu of central Burma, and the Burmese (or Burmans) of upper Burma. The earliest artistic survivals of Burma are extensive remains of brick architecture near Prome, built by the Pyu from about the 6th century AD. The central artistic impulse came from the Burmans, however. By the 9th century they controlled the strategic city of Pagan, and in the 11th, 12th, and 13th centuries it was the centre of a great architectural flowering, stimulated by widespread conversion to Buddhism. Pagan grew rapidly and the remains of over 5,000 temples can be traced today scattered over a 41 sq. km. (16 sq. mile) site east of the Irrawaddy River. The temples were richly decorated in stucco and glazed tiles on the exterior, with mural painting on the interiors. Sculpture, although important

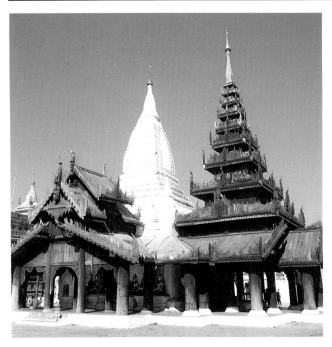

It is related that a spirit commanded King Anawrahta to build monasteries and shrines in penance for killing his older brother. This was the inspiration for the foundation of Pagan, a complex of religious buildings outstanding in **Burmese art**. Shown here is the Shwe Zigon Temple compound (12th–13th century).

at Pagan, appears to have played a subordinate role. Large-scale images were typically constructed of brick with a stucco render and were rarely of the quality seen in contemporary bronzes or mural painting. In the small bronzes which survive can be seen the contending influences of the indigenous Mon and Indian Pala styles. The standard representation of the Buddha is in the 'earth touching' attitude, a posture which allows little scope for invention. Examples of Burmese ceramics survive from at least the 9th century, and excavations of Pagan period temples (11th–13th century) have revealed terracotta and glazed wares. Glazed tiles, including reliefs depicting Buddhist stories, are an important part of Pagan architecture, and kilns for the production of glazed wares have been discovered there. In 1287 Burma was invaded by the Mongols and building activity at Pagan largely ceased, although descendants of the Pagan rulers continued to govern. In the south the Mons established an independent state at Pegu and under King Dhammaceti (reigned 1472–92) built a temple complex richly decorated with glazed ceramic tiles. Kilns for producing glazed wares were found at Pegu and it is also associated with the trade in the large glazed storage jars (*martabans*), famous from the middle of the 14th century. The emergence of the courts of Amarapura and Mandalay (1783–1885) stimulated the production of decorative arts such as fine goldwork and elaborately carved teak, often lacquered and gilded, and a flamboyant style of wooden architecture. After three Anglo-Burmese wars in the 19th century, Burma became a province of British India from 1887 to 1937 and achieved independence in 1948. Decorative arts have continued to flourish in the 20th century. Mandalay and other centres continued to produce low-fired glazed wares for both domestic and temple use into modern times.

Burmese literature. Earliest examples of writing are found on stone inscriptions of the 12th to 14th centuries. From the mid-15th to the 18th century verse writing dominated Burmese literature and was the preserve of the royal court. The earliest dated poetic work is the *Cradle Song of the Princess of Arakan* of 1455. Classical verse was composed in four-syllable lines with a complicated climbing rhyme. Within this form, various genres developed such as *maw-gun* (commemorating a notable event), *ei-gyin* (cradle songs extolling a king's lineage and greatness), and *pyo* (long poems on religious themes). Two illustrious monk poets were Shin Thi-la-wun-tha (1453–1518) and Shin Rat-hta-tha-ra (1468–1530). The minister Padei-tha-ya-za (*c.*1683–1754) produced much innovative literature, writing *pyo* on non-religious subjects and the first court play, *The Drama of Maniket the Flying Horse.* The foundation of the new Kon-baung dynasty in 1752 and the Burmese conquest of the Thai capital, Ayutthaya, in 1767 stimulated much literary activity and new forms. In the 19th century a more secular literature developed and humorous and satirical elements were introduced, particularly in a form of long narrative poem called *yagan* and in dramas, *pya-zat*. Two famous 19th-century playwrights were U Pon-nya and U Kyin U, whose plays were popularized by the spread of printing and were published in large editions from the 1870s. The first Burmese novel, *Mr Yin Maung and Miss Me Ma*, was written by James Hla Gyaw in 1904, and by the 1920s many adapted and original novels had appeared. They increasingly reflected an awareness of social problems and the growth of Burmese nationalism. In the 1930s members of a literary movement called *Hkit-san* (Testing the Age) developed a clear prose style, while poetry similarly became freed from conventional forms and themes. In Burma's post-independence period from 1948 the most flourishing literary form is the short story.

Burne-Jones, Sir Edward (1833–98), British painter, illustrator, and designer. He was a pupil of *Rossetti, and like him favoured medieval and romantic subjects. His style, characterized by dreamy, elongated figures, also owed much to the example of *Botticelli. After 1877 he became famous, with, unusually for a British artist, a remarkably wide following abroad. His ethereally beautiful women, like the more sensuous types of Rossetti, were much imitated at the end of the century. Some of Burne-Jones's finest work was done in association with William *Morris, notably as a designer of stained glass and tapestries and as an illustrator of books produced by the Kelmscott Press.

Burney, Fanny (Frances) (1752–1840), British novelist. Her three major novels (*Evelina*, 1778; *Cecilia*, 1782; *Camilla*, 1796) take as their theme the entry into the world of an inexperienced young girl of beauty and understanding, and her exposure to circumstances and events that develop her character. In 1786 Fanny Burney was appointed Keeper of the Robes to Queen Charlotte. In 1793 she married the exiled French General D'Arblay with whom she was interned by Napoleon in France. Her journals and letters give a vivid account of her times and the distinguished circles in which she moved.

Burns, Robert (1759–96), Scottish poet. In his youth he worked as a labourer on his father's Ayrshire farm. The early experience of poverty and injustice increased

his belief in the equality of men and led him to become an ardent supporter of the French Revolution in its early days. His *Poems, Chiefly in the Scottish Dialect* (1786) were an immediate success and Burns found himself fêted by the literary and aristocratic society of Edinburgh. He collaborated with the musicologists James Johnson and George Thomson in collecting Scottish songs. His best poems include his satires 'Holy Willie's Prayer' (1799), 'The Twa Dogs' (1786), and 'The Jolly Beggars' (1786). His songs, many of which were published in *The Scots Musical Museum* (1787–1803), include the ever popular 'Ye Banks and Braes', 'O my luve's like a red, red rose', and 'Auld Lang Syne'. He was encouraged to write in the rhetorical and sentimental fashion of the day and in this mode he wrote 'The Lament', 'Despondency', and 'Address to Edinburgh'. After his unsuccessful return to farming life in 1788 he became an excise officer in Dumfries (1791) and published his last major poem, 'Tam o' Shanter'. Burns wrote with passion, and with equal facility in the Scots dialect and English, on themes of country life, love, and animals, and with a deep sympathy for the oppressed. His popularity with his fellow countrymen is reflected in celebrations held by Scotsmen all over the world on 'Burns' Night', 25 January, his birthday.

Burroughs, William S(eward) (1914–), US novelist. A leading writer of the *Beat Movement, in 1959 he published *The Naked Lunch*, a disturbing phantasmagoria evoking the experience of a drug addict, which was rapidly followed by other novels, such as *The Soft Machine* (1961), with the same experimental technique. After years of apparent creative decline he produced a trilogy composed of *Cities of the Red Night* (1981), *The Place of Dead Roads* (1984), and *The Western Lands* (1987).

Burton, Robert (1577–1640), English writer and clergyman. Apart from a few minor works in Latin he left only one work, *Anatomy of Melancholy* (1621), which is structured to resemble a medical work but in effect is an affectionate satire on the inefficacy of human learning and endeavour. Burton finds 'melancholy' to be universally present in mankind and quotes a wide range of authors, making his book a masterpiece of anecdote and erudition. The work inspired *Keats's narrative poem 'Lamia'.

Busoni, Ferruccio Dante Michelangiolo Benvenuto (1866–1924), Italian-born composer and pianist, who settled in Germany. He conducted his own *Stabat Mater*, at the age of 14, in 1878. By the time he was 20 he was celebrated as a virtuoso. In 1894 he settled in Berlin, where he gave important concerts of contemporary music and championed the works of *Liszt. His own music was extremely adventurous, coming at times close to *atonality. His operas *Turandot* (1917) and *Doktor Faustus* (produced posthumously, 1925) are much admired; his editions and transcriptions of Bach less so.

bust, a representation of the head and upper portion of the body. The term most commonly refers to sculptured portraits, but it can also be applied to paintings, drawings, or engravings. The Egyptians, convinced of life after death, made vivid polychrome busts of the dead. The Greeks often combined portraits with herms, that is, squared pillars with heads on top. The art of the Romans is particularly rich in portrait busts.

Butcher, Rosemary (1947–), British dancer and choreographer. She trained at Dartington College of Arts and in the USA with *postmodern dance choreographers, returning to form her own company (1976). She bases her teaching and choreography on shared explorations of tasks using ordinary movement. Her concerns for space within dance lead to works such as *Flying Lines* (1985) and *Touch the Earth* (1986), performed in non-theatrical venues in a minimalist style. Her work has been a seminal influence on British postmodern dance.

Butler, Samuel (1835–1902), British novelist and travel writer. He achieved success with his satirical anti-utopian novel *Erewhon* (1872); its sequel *Erewhon Revisited* appeared in 1901. He produced a series of works of scientific controversy, many of them directed against Darwinism. He was pre-eminently a *satirist, who waged war against the torpor of thought, the suppression of originality, and the hypocrisies and conventions that he saw around him. His largely autobiographical novel, *The Way of All Flesh* (1903), is an ironic and witty study of the stultifying effects of Victorian family traits and attitudes.

Buto dance *East Asian dance.

Butterfield, William (1814–1900), British architect, one of the most individual exponents of the *Gothic Revival. He was a deeply religious man, and apart from some work for schools and colleges he designed mainly churches. His mature style is vigorous, even aggressive, using hard, angular forms and patterned, coloured brickwork, thereby breaking with the more historicist approach of contemporaries such as *Pugin. All Saints, Margaret Street, London (1850–9), and Keble College, Oxford (1867–83), are his best-known works. His buildings continue to arouse strong differences of opinion: admirers think that his work has great originality and conviction, while detractors find it harsh and uncouth.

buttress, a structure, usually of stone or brick, projecting from or built against a wall to strengthen the wall or counteract pressure from a vault. At its simplest the buttress is merely a pile of masonry, but in *Gothic architecture buttresses were often as aesthetically striking as they were structurally sophisticated. Many French Gothic cathedrals, in particular, feature a rich array of flying buttresses; in this form, an *arch (or segment of an arch) of masonry springs from the upper part of a main wall and leads outward to a vertical buttress rising against and above the side aisles. Flying buttresses were often enriched with tracery and other decoration.

Buxtehude, Dietrich (c.1637–1707), Danish-born composer and organist, who settled in Germany. In 1668 he was appointed organist of the Marienkirche in Lübeck (one of the most important posts in Germany), where he remained for nearly forty years. His fame was such that the young J. S. Bach walked 200 miles to hear him play. His compositions consist mainly of church music, among them about 120 sacred vocal pieces which include cantatas, oratorios, chorales, and arias. His organ works represent a perfect fusion of the complex *contrapuntal North German style and the brilliant French style of Johann Froberger (1616–67). His ability to fuse scholarly subtlety with virtuoso brilliance greatly influenced other composers, Bach in particular.

Byrd, William (1543–1623), England's foremost composer during the reigns of Elizabeth I and James I. A pupil of Thomas *Tallis, he served as organist and master of the choristers at Lincoln Cathedral (1563–73) and in 1570 was sworn in as Gentleman of the *Chapel Royal. He was almost certainly a practising Roman Catholic throughout his life, evading persecution only on account of his acknowledged excellence as a composer. Byrd's music, which includes outstanding settings for both the Latin and English liturgy, *motets, polyphonic songs with instrumental accompaniment, *consort music for viols, and many keyboard pieces, represents the high point of English *polyphony. He was an innovator in both form and technique, and his music has great emotional power.

Byron, George Gordon, 6th Baron (1788–1824), British poet and satirist. In 1798 he inherited the barony and an ancestral Nottinghamshire mansion, Newstead Abbey. His first volume of poems, *Hours of Idleness* (1807), was attacked in the *Edinburgh Review*; Byron responded with his satire *English Bards and Scotch Reviewers* (1809).

In the 6th to 8th centuries Ravenna was the main centre of Byzantine power and **Byzantine art** in Italy. It has several well-preserved buildings of the period, notably the church of San Vitale (526–47) shown here, which has some of the most beautiful of all Byzantine mosaics.

His travels during 1809–11 to Spain, Malta, Albania, and Greece provided material for *Childe Harold's Pilgrimage* (1812–18), which presents in the pilgrim the prototype of the truly 'Byronic Hero', aloof, cynical, and rebellious; on publication of the first two cantos (1812) Byron was lionized by aristocratic and literary circles. After a series of much-publicized love affairs he lived with his half-sister Augusta Leigh, whose daughter (born 1814) was probably his. His marriage to Annabella Milbanke in 1815 ended the same year, after the birth of their daughter Ada. Amid mounting debts Byron left England in 1816, ostracized and embittered. He lived briefly in Geneva with the *Shelleys and Claire Clairmont (who bore Byron a daughter, Allegra, in 1817), wrote *The Prisoner of Chillon* (1816), the poetic drama *Manfred* (1817), and finally settled in Italy. In Venice he wrote the satirical poem *Beppo* (1818), finding in *ottava rima* a new ironic colloquial style which he fully developed in *Don Juan* (1819–24), an epic satire of great wit and irony, much admired by Goethe. He now became deeply attached to Teresa, Countess Guiccioli, and involved with the Italian nationalist cause. A new interest in drama led to several poetic dramas, including *Sardanapalus* (1821), and *Cain* (1821). Byron's poetry, although condemned on moral grounds, exerted great influence on *Romantic poetry, music, the novel, opera, and painting in Britain and Europe. He was passionate for the cause of Greek lib-

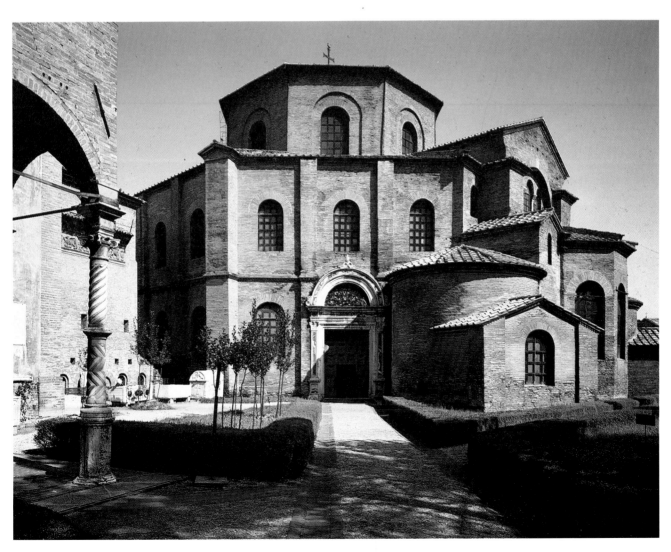

eration from the Ottoman Turks, and gave generously to the insurgent Greeks. He sailed to Missolonghi in mainland Greece, where he set up the 'Byron brigade', but before he saw any serious fighting he died of fever. His influence on later artists, more as a hero figure than because of his work, has been immense.

Byzantine art, the art and architecture produced in or under the influence of the Eastern Roman (Byzantine) Empire. Constantinople (on the site of the ancient city of Byzantium) was founded in AD 330 by Constantine, and remained Christian (Byzantine) until taken by the Ottoman Turks in 1453. Byzantine art extended beyond the political or geographical boundaries of the empire, penetrating into the Slav countries; in certain areas, for example Russia, where the Eastern Orthodox Church flourished, its tradition continued long after the collapse of the empire. In architecture the Byzantines evolved a new style for churches from two types of *Roman building: the three-aisled, flat-roofed *basilica, and the domed and vaulted buildings such as the pantheon. The Byzantines produced a cruciform plan, and then placed a *dome above the central crossing. They completed the transformation by rounding the east end to form either a single apse or, more often, three apses. Most Byzantine churches are comparatively small, but the finest of them all, the great church of Hagia Sophia, in Constantinople, erected by Justinian in the 6th century, is vast. The interiors of Byzantine churches were often sumptuous: the lower parts of the walls were panelled with rare marbles, and the upper parts were covered with *mosaics and wall-paintings. Apart from churches, the most imposing works of Byzantine architecture are immense subterranean cisterns and defence works designed to withstand sieges. The cisterns were vaulted and domed, the roofs supported by great columns surmounted by capitals. During a siege Constantinople depended on them for its water supply. Byzantine religious paintings were governed by clearly defined rules, each scene being allotted its particular place in the decorative scheme. The pose and gesture, even the colour of the vestments, was also exactly prescribed. The artists, generally monks, were expected to remain anonymous. Innovation was forbidden, and artistic genius was concentrated on the emotional and symbolic as well as the decorative use of colour, and on the intensity of feeling expressed in the work. The Byzantines developed the art of religious pictures or *icons, painted on panels, for either devotional or ritualistic use. The style of these was much the same as in the wall paintings, with figures arranged frontally and flat. Much fine painting is also to be found in illuminated manuscripts, sumptuously bound, either in tooled leather, carved boards, or ivory panels, or in worked metal ornamented by jewels, *cloisonné enamel, or carved ivory plaques. Elaborately and finely carved ivory was used for caskets, mounts, and figures. Metal-work varied from vast metal doors set up in the sanctuaries, to crosses, reliquaries, ecclesiastical plate, and a great variety of secular jewellery. The Byzantines excelled in cloisonné enamel, outlined by tiny gold wire threads. Their woven silks and brocades, bearing fiercely vital animals facing each other in stylized design, intricate geometric patterns, or exuberant floral motifs, rank with the finest in the medieval world. The splendid embroideries in gold thread and coloured silks, their ceramics and glass, and other minor arts carry the vivid stamp of their genius.

cabaret, entertainment, often but not necessarily musical, provided in restaurants, at night-clubs, and at official dinners. Cabaret began in 1881 with the establishment of the Chat Noir in Paris, where a series of amateur actors and musicians satirized the conventions of bourgeois society. The master of ceremonies played a central role. Its many imitators toured widely and were particularly influential in Germany (especially Berlin), where the 'Kabarett' developed into leftist political centres, reaching their peak in the 1930s. Hitler's domination of Europe put an end to cabaret as a serious art-form. The cabaret was revived in post-World War II France, Germany, Austria, and the USA (where it is usually called a night-club), but its popularity has waned. In Britain and the USA an alternative cabaret circuit has developed on the theatrical fringe, where improvised political and social satire flourish.

cabinet-making, the craft of producing fine wooden furniture. The term is not usually used with precision, since several types of craftsmen could be involved in the production of one piece of furniture—including gilders and upholsterers—but the cabinet-maker was concerned particularly with joining and *veneering.

cadence, a harmonic progression in music involving two *chords that acts as a method of punctuating the progress of a composition by marking its end, or the end of a section or phrase. There are four cadences in common use: two, the perfect and plagal cadences, have a feeling of finality; the other two, as their names suggest, are less conclusive: the interrupted and imperfect cadences imply that more is to follow. In early music, such as plainsong, the cadence is a purely melodic formula.

Cage, John (1912–), US composer. In 1937 he developed a strong and continuing interest in music for dance, exemplified by his collaboration with the Merce *Cunningham Dance Company. He was responsible for developing the 'prepared' piano (1938), changing the sound of the instrument by inserting objects between the hammers and the strings. Cage has experimented with many compositional methods. A central concern has been the use of chance techniques (*Music of Changes*, 1951), but *electronic music, and environmental sounds are also part of his work. He has been at the centre of the US avant-garde for several decades, and has probably had a greater influence on world music than any other 20th-century US composer.

Calder, Alexander (1898–1976), US sculptor, painter, and designer, principally famous as the inventor of the 'mobile', a pioneering type of *kinetic art. He trained as an engineer and took up art in his mid-20s. His early works included wire sculptures and in 1931 he made his first abstract moving construction. Originally Calder's mobiles were moved by hand or a motor, but in 1934 he began making the unpowered mobiles—responsive to the faintest air currents—for which he is most widely known.

They consisted typically of flat metal parts suspended on wires. Mobiles became a popular item of interior decoration, but Calder himself sometimes worked on a huge scale. He also painted *gouaches and designed rugs and *tapestries.

Calderón de la Barca, Pedro (1600–81), after Lope de *Vega the most influential Spanish dramatist of the 17th century. He studied with the Jesuits and at Salamanca University, saw military service, and became a priest (1651). He wrote over 110 full-length plays (*comedias*), many of which were performed in the public theatres between 1627 and 1640. Two of the best known are *The Mayor of Zalamea* (*c*.1642), about honour, and *Life is a Dream* (1636), on the contrast between true and false values. From 1648 Calderón wrote plays mainly for the court theatre, and *autos sacramentales*, one-act religious plays performed in the streets during the annual Corpus Christi processions. Calderón's work, which is markedly didactic, is typified by the stress on theme over characterization, complexity of language, conceptual depth, and tight organization of structure.

Caldwell, Erskine (Preston) (1903–), US novelist and short-story writer. He used the 'poor whites' of the South as the basic subject-matter for fiction which combined grotesque humour with realistic depiction of social deprivation and injustice. His most vivid achievement was *Tobacco Road* (1932), which shows a rich sense of folk humour, indignation at social inequities, and a lusty bawdiness. Numerous popular novels and short stories followed, including *God's Little Acre* (1933).

Callaghan, Morley *lost generation.

Callas, Maria (Cecilia Sophia Anna Kalogeropoulos) (1923–77), US soprano singer of Greek parentage. From the 1940s, Callas's lyrical and dramatic interpretation of classical coloratura roles was revelatory (see *voice). A member of La Scala, Milan (1950–8), her vivid portrayals of, for example, Bellini's *Norma*, Puccini's *Tosca*, and Violetta in Verdi's *La Traviata* are unforgettable. She revived some unfamiliar Italian operas and has left a legacy of more than twenty complete opera recordings.

calligraphy, the art of producing beautiful handwriting. Usually the term refers to writing in ink or similar materials, but it is sometimes extended to certain types of epigraphy (inscriptions on durable materials, particularly stone). The earliest surviving examples of calligraphy are in Egyptian papyri of the third millennium BC, and the art has been practised in most civilizations since then. It is in the Far East and the Islamic world, however, that calligraphy has assumed the greatest importance and had its richest flowering. In China calligraphy has for centuries been accorded pride of place among the arts. Because of the complexity of the Chinese writing system (in which thousands of characters express a word or an idea rather than a sound) mastery was confined to the highly educated; the ability to write a beautiful hand was an essential requirement for obtaining prestigious posts in the civil service and was a necessary accomplishment for the gentleman-scholar. The most famous calligraphers were not necessarily professional scribes, but often men who were highly distinguished in other fields—poets and even

emperors. There were two main traditions: the regular and angular northern style, which derived from stone inscriptions; and the southern style, with its flowing lines and elegant brush-strokes. It was the southern style that was adopted as the classic Chinese type of calligraphy. Its most illustrious exponent was Wang Xizhi (AD 306–65), whose work was so admired that it is said that even in his lifetime a few lines by him or even his signature were paid for in gold. Spontaneity was the guiding principle and calligraphy was judged by the vitality of the line, the shape of the individual characters, and the overall composition of the page. Much Chinese painting was based on the same aesthetic principles, particularly pictures of bamboo and landscapes executed in ink and wash. In Japan calligraphy evolved later but became just as highly esteemed as in China. Chinese words, called *kangi* in Japanese, began to be used in Japan in about the 7th century as an instrument of the transmission of Buddhism (many monks were outstanding calligraphers). It was unthinkable to adopt the Chinese language wholesale, however, so a new script, called *hiragana*, was developed for native writings. It is graceful in appearance and was sometimes called *onnade* (woman's hand) in Japanese. To cultivate a steady hand some Japanese calligraphers are said to have trained with their right hand supported by a cord attached to the ceiling, so they developed a feel for moving the brush at a fixed distance from the paper. Japanese calligraphers generally worked with the paper on the floor, whereas Chinese calligraphers supported it on a table. In the Islamic world calligraphy has been just as important as in the Orient, but for religious rather than aesthetic reasons. The Islamic conquerors who converted vast areas in the 7th and 8th centuries spread the Arabic language as well as their Muslim faith, for the *Koran was thought to be the directly dictated word of Allah. Thus the written word of God was treated with enormous respect and the most loving workmanship was thought appropriate to copying and propagating it. Early Arabic scripts were formal and angular, but later more flowing types were used. The great Islamic calligraphers included Yāqūt al-Mustaʿsimī (d. 1293), who devised the sloping nib. Muslims made extensive use of calligraphy in embellishing buildings, metalwork, pottery, and textiles. An angular type of script called kufic was also much used in architectural ornamentation, and it infiltrated Europe, where it was used, purely decoratively, in Romanesque and Gothic art. In the West calligraphy has never assumed the same importance as in the East, but it nevertheless had a superb flowering in medieval manuscript *illumination. With the invention of printing the need for skilled handwriting declined, but professional writing masters flourished from the 16th to the 19th century, producing many instructional manuals. Often these included drawings of animals, specimens of ornament, and so on, composed of pen-strokes and flourishes. This tradition came to an end in about the middle of the 19th century, but there was a revival of interest in calligraphy in the early 20th century, spearheaded by the British designer and teacher Edward Johnston, whose *Writing and Illuminating, and Lettering* (1906) was highly influential.

Callimachus (*c*.305–*c*.240 BC), Greek poet and scholar. He was appointed cataloguer to the royal library at Alexandria, the most important in the Hellenistic world. His prolific poetry, learned and highly polished, had a

profound influence on Latin literature. Only fragments of his writings remain, though papyrus discoveries since 1910 have enlarged modern knowledge of his texts.

Calvino, Italo (1923-85), Italian short-story writer and novelist. He published his first novel, *The Path to the Nest of Spiders* (1947), an account of the Italian Resistance, at the age of 23. His short stories include the trilogy *Our Ancestors*, written in the 1950s, *Difficult Loves* (1958), and *If on a Winter's Night a Traveller* (1979). While Calvino, especially in his stories, shows himself an acute observer of intimate human psychology, his novels are steeped in fantasy, which he regards as integral to human experience.

calypso, a type of West Indian popular song, originating in Trinidad and Tobago. A form of folk-song whose words comment on newsworthy topics in a humorous and, if necessary, critical way, and whose music is typically played by *steel bands. Calypso music is syncopated and repetitious. It usually has choruses in which everyone joins. There is a body of some fifty standard calypso tunes, but the words are improvised afresh as the occasion demands. More recently a new form, soca, has arisen from a meeting of soul and calypso styles.

Cambodian literature, literature written in the Khmer language in Cambodia. A large corpus of the literature is inscriptional and the earliest Khmer inscription is dated AD 611. The inscriptions of the great city and temples of Angkor, capital of Cambodia from the 10th to the 15th century, have been particularly studied. Cambodia possesses two great epics, the *Poem of Angkor Vat* composed in 1620, and the *Ramakerti* (based on the Indian *Ramayana*), of which the main story dates from the 16th and 17th centuries, and the later part from the mid-18th century. The story of Rama narrated in this epic has pervaded all Cambodian art-forms: sculpture, *shadow plays, and dance-drama. Cambodia also has a large body of traditional folk stories (*rioen bren*) and verse fiction, the latter mostly dating from the 18th and 19th centuries. The verse work *The Conch Shell Story* is the oldest such work, written in 1729. Much of this literature is inspired by *Jataka (stories of the Buddha's previous lives) of which the last ten *Jataka* and the extra-canonical cycle of fifty *Jataka* are particularly popular. The Thai *Traibhumi* ('Three Worlds') cosmological text has also been an important influence on Cambodian literature. Another form of literature is *cpap*, short didactic verse works learnt by heart as moral texts in Buddhist schools. All Cambodian writings of the period from the 16th to the mid-19th century are generally classified as Khmer classical literature. In the 19th century French colonial rule introduced printing and some western education to Cambodia, and new literary genres gradually developed. The first modern novel written in prose (rather than in the more traditional verse) was *Suphat* by Rim Kin (1911-59) which was published in 1938. French writers have influenced much modern Cambodian literature, and Chinese epics such as the *Three Kingdoms* have also been adapted and translated. Literature ceased under the regime of the Khmer Rouge (1975-9), and little is known of literary developments during the Vietnamese occupation of Cambodia (1979-89).

Camden Town Group, a group of British painters including Harold Gilman (1876-1919), Spencer Gore

(1878-1914), and Robert Bevan (1865-1925). Formed in 1911, it took its name from the drab working-class area of London made popular as a subject by *Sickert, their prime inspiration. Their subjects included street scenes, landscapes, portraits, and still lifes; their use of bold, flat colour showed the influence of *Post-Impressionism. The group merged with a number of smaller groups in 1913 to form an exhibiting society called the London Group.

cameo, a small carving (often a portrait) cut in relief on a gemstone or similar surface. Often a banded or multicoloured stone, such as agate, is used, so as to exploit the different layers of colour—with, for example, one colour for the background and another for the carving. The cameo was highly popular among the Greeks and Romans, particularly for jewellery; it was revived during the Renaissance, and again in Victorian times.

camerawork (cinema), process by which the camera is manipulated to produce the picture required by the director. The latter's conceptions can often be enhanced by the lighting cameraman (or cinematographer), who heads the camera crew; the camera is actually worked by the camera operator. The camera can pan (move in a horizontal plane), tilt (in a vertical plane), track (move on a mount to 'track' the action) or zoom (appear to move towards or away from the scene while remaining stationary). Camerawork is thus capable of extreme precision, and each shot must be assimilated into the style of the whole by the cinematographer. The work of an outstanding cinematographer such as Gregg Toland (1904-48) on such films as Ford's *The Grapes of Wrath* (1940) and Welles's *Citizen Kane* (1941) shows how the camera can be used to create emotional involvement.

Cameron, Charles (c.1743-1812), British *Neoclassical architect. Born in Scotland, he was active mainly

A 4th-century Roman **cameo** showing an emperor (either Honorius or Constantine II) with his wife. As is usual with cameo portraits, the lighter vein of the stone is used for the figures and the darker colour for the background. The intricate silver mount is probably a later addition to the cameo. (Rothschild Collection, Paris)

in Russia, where he settled in about 1778 and remained for the rest of his life. He was employed by Catherine the Great on various projects at the palace of Tsarskoe Selo, near St Petersburg. His style was similar to that of Robert *Adam, but less refined. Cameron's early career is obscure, but he was in Rome in 1768, and in 1772 published the drawings he made there as *The Baths of the Romans*, a scholarly textbook of classical ornament.

Cameron, Julia Margaret (1815–79), British portrait photographer. Born in India, Mrs Cameron met the distinguished astronomer-scientist Sir John Herschel in 1837, and it was he who sent her the first photograph she ever saw. The Camerons retired to England, soon settling on the Isle of Wight. Here Julia took up photography late in 1863 to 'amuse' herself during her husband's visits to his coffee plantations in Ceylon (now Sri Lanka). Her large and intensely dramatic 'close-ups' of such eminent Victorians as Carlyle, Darwin, Tennyson, and Herschel himself are among the most powerful of their time. She also photographed costumed *tableaux* illustrating contemporary literature, notably Tennyson's *Idylls of the King and Other Poems*. Of several surviving presentation albums of her pictures, that dedicated to Herschel is the best known.

Camões, Luís de (c.1524–80), Portuguese poet. A major lyric poet, whose work is characterized by his mastery of a wide range of verse-forms, he espoused *Renaissance Platonic ideas of absolute love and spiritual and aesthetic perfection. His major work is *The Lusiads* (1572), the Portuguese national epic, describing Vasco da Gama's journey round the Cape of Good Hope to India, but essentially a glorification of Portuguese achievements. Camões draws on a variety of sources—classical mythology, ancient history, chronicles, travellers' tales—as well as his own experience, to give the entire history of Portugal. *The Lusiads* is a work of great formal beauty with many memorable sequences, including the councils of the gods, the Old Man of Belém, the description of the sea-spout, and the final evocation of the Isle of Love, combining pagan mythology and Christian ideals.

Campbell, Colen (1676–1729), Scottish architect, one of the key figures of *Palladianism. In 1715 he published the first volume (two more followed in 1717 and 1725) of his lavishly illustrated *Vitruvius Britannicus*; this was ostensibly a review of modern British architecture, but it was heavily biased against the 'affected and licentious' *Baroque style and in favour of 'antique simplicity'. It was as much a personal advertisement as a manifesto (it contained several of his own designs), but it became the most important pattern-book of Palladianism. It brought him success and he died rich; Lord *Burlington was among his patrons. Campbell's most important work was Wanstead House, Essex (c.1714–20, destroyed), the prototype of the large Palladian country house. His best surviving building is Mereworth Castle, Kent (1722–5), closely based on *Palladio's Villa Rotonda.

Campbell, Mrs Patrick (Beatrice Stella Tanner) (1865–1940), British actress of wit, beauty, and passion. She reached the front rank after creating two of Arthur Pinero's most famous heroines—Paula in *The Second Mrs Tanqueray* (1893) and Agnes in *The Notorious Mrs Ebbsmith* (1895). Other roles included Mélisande in Maeterlinck's

Pelléas et Mélisande (1898), which she repeated in French in 1904 to Sarah Bernhardt's Pelléas. George Bernard Shaw created for her the role of Eliza Doolittle in *Pygmalion* (1914).

Campin, Robert (d. 1444), Flemish painter. He was the leading painter of the Northern Renaissance, practising in the Flemish municipality of Tournai. The Campin/Flémalle pictures are revolutionary in their sense of three-dimensional solidity and their naturalism, placing the artist alongside Jan van *Eyck as the founding father of the Early Netherlandish School of painting. Campin was almost certainly the teacher of Rogier van der Weyden.

Camus, Albert (1916–60), French novelist, dramatist, and essayist. He is best known for his novels *L'Étranger* (1942) and *La Peste* (1947), which give expression to his concept of the absurd, the view that the universe and human existence are intrinsically meaningless. *La Peste*, a graphic account of a city shut off from the outside world during an outbreak of plague, has also been seen as an *allegory describing France under the German occupation of 1940–4. In his essay *Le Mythe de Sisyphe* Camus claims that even in an absurd universe happiness becomes possible once man accepts that life has no meaning other than what he gives to it. In certain respects these views suggest the existentialist philosophy of *Sartre, though Camus criticized existentialism for itself taking the place of those metaphysical explanations of life which it sought to displace. Camus and Sartre also differed politically for, in his essay *L'Homme révolté* (1951), Camus maintained that progress towards political and social justice could come about only through a process of gradual revolt, not the total revolution advocated by Sartre and the Marxists. His confidence in humanity showed itself most clearly in his last novel, *La Chute* (1956). Camus was awarded the Nobel Prize for Literature in 1957.

Canadian painting. In the 17th, 18th, and early 19th centuries, French and British influences dominated. Other European settlers brought a multiplicity of aesthetic traditions which found expression in the heritage of Canadian *folk art. In the 19th century the Irish-born Paul Kane (1810–71) and the Dutch-born Cornelius Krieghoff (1815–72) painted genre scenes, in the West and in Quebec respectively, that are highly valued today. it was not until 1911 that a truly Canadian group of like-minded artists appeared, inspired by the northern Ontario landscape, which they painted with bold brushwork and in brilliant colours. They included J. E. H. MacDonald, Lawren Harris, Tom Thomson, Frank Carmichael, Frank Johnston, Arthur Lismer, A. Y. Jackson, and F. H. Varley. In 1920 they formed the Group of Seven (minus Thomson, who died in 1917). In 1927 a contact with Harris helped another well-known Canadian painter, Emily Carr (1871–1945), reach her peak in creating powerful expressionist paintings of the British Columbia forest landscape. Working outside the Group was perhaps the most distinguished Canadian painter, David Milne (1882–1953), whose glowing watercolours and oils conveyed an exhilarating technical mastery. Since World War II numerous Canadian painters have gained international reputations, including Paul-Émile Borduas (1905–60), Jean-Paul Riopelle (1923–), Jack Bush (1909–77), Alex Colville (1920–), and Michael Snow (1929–).

Canaletto (Giovanni Antonio Canale) (1697–1768), Italian painter, the most famous of all painters of town views. He began his career as a scene painter (his father's profession), but he turned to *veduta* (view) painting in 1719–20 during a visit to Rome, where this kind of picture was becoming fashionable. In Venice he found a ready market among British visitors, principally young noblemen on the Grand Tour. When France declared war on Britain in 1744, however, continental tourism ceased; Canaletto moved to London in 1746 and remained there (with a single brief visit to Venice) until 1756. At first he was highly successful, painting mainly views of London, but his popularity waned as his work became rather mechanical. Nevertheless his influence in Britain was great, as it was in Italy and elsewhere (his nephew Bernard *Bellotto took his style to central Europe). His pictures still form the popular image of Venice, and although in the later part of his career his work suffered the effects of overproduction, he never lost his gift for striking composition.

Candela, Félix (1910–), Spanish-born architect who settled in Mexico in 1939 after fighting on the losing Republican side in the Spanish Civil War (1936–9). In his adopted country he has established a reputation as one of the outstanding exponents of concrete construction in the 20th century. His speciality is shell vaulting, in which the concrete is reduced to a thin membrane, enabling large spans to be covered economically. The buildings on which he has worked include the Church of Santa Maria Miraculosa (1954–5) and the Olympic Stadium (1968), both in Mexico City.

Canetti, Elias (1905–), novelist and dramatist, born in Bulgaria of Spanish Jewish descent, writing in German. His novel *Auto-da-Fé* (1935, expanded 1963) concentrates on the doomed attempt of the aloof, narrow-minded intellectual to avoid contamination by the material world. Besides three dramatic parables, *The Wedding Feast* (1932), *Comedy of Vanity* (1950), and *Their Days are Numbered* (1956), an essay on Kafka, and three volumes of autobiography, Canetti's other outstanding work is *Crowds and Power* (1960), a behavioural study of crowds and dictators, which seeks to synthesize the insights of history, psychology, anthropology, and mythology. Canetti was awarded the Nobel Prize for Literature in 1981.

Cano, Alonso (1601–67), Spanish sculptor, painter, and architect. His career was spent mainly in his native Granada, in Seville, and in Madrid, where he worked for Philip IV. His work tends to be serene, and it is best represented in Granada Cathedral, which has several examples of his painting and his superb painted wooden statue of the *Immaculate Conception* (1655). Cano also designed the façade of the cathedral, one of the most original works of Spanish *Baroque architecture.

Canaletto's paintings are valued not only as works of art, but also as matchless records of the topography of Venice. This painting, *The Upper Reaches of the Grand Canal* (c.1738), preserves a view that has now changed greatly, most of the buildings on the right-hand side having been demolished to make way for the railway station. (National Gallery, London)

canon, in music, a device in *counterpoint which occurs when a melody in one voice (or part) is imitated exactly in another voice, or voices. Thus the voices overlap and the melody is made to echo itself. Imitations may occur at any *pitch, and can be 'strict' (exact) or 'free'. Canon is often associated with other forms of contrapuntal ingenuity. Thus the double canon involves two canons at once, each for a pair of voices. Canon by augmentation occurs when the imitating voice employs notes that are longer than the original. Canon by diminution reverses the procedure. In canon cancrizans ('crab' canons) the imitating voice gives out the melody backwards, and in infinite canon the end is made to dovetail with the beginning so that the composition can (in theory) go on forever. In canon by inversion the imitating voice is a mirror image of the original. Simple infinite canons for popular singing are known as rounds or catches.

Canova, Antonio (1757–1822), Italian sculptor, the most famous sculptor of the *Neoclassical movement. He worked in Venice before settling in Rome in 1781. His early work was in a lively, naturalistic vein, but in Rome his style became much graver and grander. He was employed by a galaxy of European notables, including Napoleon—one of his most famous works is a reclining nude figure of Napoleon's sister, Pauline Borghese (1805–7), and one of his most spectacular works is an enormous nude marble statue of Napoleon himself. Canova also worked for the papacy, and after Napoleon's defeat in 1815 was sent by Pius VII to Paris to recover works of art looted from Italy by the French. His reputation suffered after his death, his work disliked by devotees of Romanticism, and it is only fairly recently that his greatness has again been acknowledged.

cantata, in the general sense, a musical work that is 'sung', as opposed to one that is 'sounded' by instruments (the *sonata). In the 17th century the cantata was a short work for several voices: a series of *arias and recitatives, linked by a common dramatic theme and with an instrumental accompaniment. Those that dealt with secular subjects were known as chamber cantatas (*cantata da camera*). Church sonatas (*cantata da chiesa*) dealt with sacred matters. By the 18th century the chamber cantata had become more operatic in style and content. Church cantatas had become more like miniature *oratorios and were of particular importance to the Protestant composers of Germany, such as Schütz and J. S. Bach. In their hands the use of the *chorale as a basis of cantata composition became of prime importance. Such works, to sacred and secular texts, involved soloists as well as chorus, and though designed for performance with an orchestra, could often be effectively accompanied by the organ or pianoforte.

canticle, the musical setting of words from the Bible, other than the psalms, used as part of the liturgy or fixed form of public worship used in churches. In the Anglican Book of Common Prayer the term is applied only to the Benedicite, but custom allows it to be applied also to the Benedictus, Magnificat, Nunc Dimittis, and Te Deum, as well as to certain psalms such as the Venite and Jubilate. In recent years Benjamin Britten has used the word to describe an extended song to a religious text not intended for use in church—such examples as *Abraham and Isaac* (1952) are virtually miniature operas.

The frontispiece to William Billings's *New England Psalm Singer*, published in Boston in 1770. The circle of music shows a **canon** for six voices, to be sung over a ground bass. The heyday of the canon in classical music was over by the 17th century, but the form remained widespread in popular music, both religious and secular.

cantus firmus *plainsong.

canvas, a woven cloth used as a painting surface stretched over a wooden frame. Linen is used for the best-quality canvas, and other materials used are cotton, hemp, and jute. These materials readily absorb paint, so are coated with a suitable substance ('priming') to prevent this before being used. Canvas came into use in the 15th century, and it began to take over from wooden *panels as the most popular 'support' for portable paintings around 1500 in Italy, later in northern Europe. Canvas is cheaper and easier to manufacture and transport than well-seasoned wooden panels.

canzona, a musical term used in the 16th century to describe a type of Italian vocal composition similar to the *madrigal, but simpler in style. The term also describes a type of instrumental composition of the same period, which either transcribes the vocal composition directly or imitates its general characteristics. The instrumental canzona became particularly important in the 17th century among such composers as Gabrieli and Frescobaldi, often becoming complex in structure and exploring the possibilities of solo and tutti, orchestral and vocal contrast. Such compositions gradually evolved into the *sonata. The term is also used in 18th- and 19th-century opera to describe a short *aria.

Cao Xueqin *Dream of the Red Chamber.

Cao Yu (1910–), Chinese dramatist. Cao Yu was one of the first Chinese playwrights to produce Western-influenced spoken drama rather than traditional opera and his *Thunderstorm* (1933) and *Sunrise* (1935) were popular, particularly in Shanghai. *Thunderstorm* is the tense story of twenty-four hours in the life of a self-made businessman and his family and reflects the conflict between the generations in revolutionary China.

Capa, Robert (Andor Friedmann) (1913–64), Hungarian photo-journalist. Capa's most famous picture shows a soldier being killed in the Spanish Civil War (often said to be staged rather than real). He went on to cover four more wars, eventually being killed by a landmine on assignment in Indo-China. His memorials, apart from his pictures, are the photographers' co-operative Magnum (of which he was a co-founder) and New York's Institute of Contemporary Photography, established by his elder brother Cornell.

Čapek, Karel (1890–1938), Czech writer. His works are warnings against man's misuse of science and his desire to master life. They were much admired by, among others, Shaw and Chesterton. They include the plays *RUR—Rossum's Universal Robots* (1921), from which the word 'robot' is derived and which describes the elimination of humanity by robots, and *The Macropoulos Secret* (1922), on the discovery of a drug capable of prolonging life (turned into an opera by Janáček), as well as the novels *Krakatit* (1924) about the invention of an all-powerful explosive, and *War with the Newts* (1936), about giant newts at first exploited by men but finally taking over the world. *The Insect Play* (1922), written in collaboration

This painting from a family album (c.1775) shows a group of musicians rehearsing a **cantata**. The continuo parts are taken by the cellist, harpsichordist, and bassoonist, with violins, oboes, and horns accompanying the three singers. A figure before a closed score with the title '*Lobet ihr Knechte des Herrn*' (Give praise, ye servants of the Lord), has assumed the role of conductor. (Germanisches Nationalmuseum, Nuremberg)

with his brother Josef, is an allegory satirizing human pretentiousness, greed, and militarism. The trilogy *Hordubal* (1933), *The Meteor* (1934), and *An Ordinary Life* (1934) explores problems of truth and human personality.

capital, in architecture, the crowning feature of a column, forming a transition between the shaft of the column and the member it supports. Capitals are often more or less elaborately carved with figurative or decorative elements (and sometimes painted) and in classical architecture the various types of capitals mark the most obvious distinctions between the different *Orders.

Capote, Truman (1924–84), US novelist, short-story writer, and journalist. His reputation rests largely on his early work, which includes two novels set in his native South, *Other Voices, Other Rooms* (1948), about a homosexually inclined boy painfully groping towards maturity, and *The Grass Harp* (1951), about innocent people, old and young, escaping social restraint by living in a treehouse. His novella about a New York playgirl, *Breakfast at Tiffany's*, was published in 1958. *In Cold Blood* (1966) examines a notorious multiple murder: the technique he uses here is seen as a seminal combination of document and fiction.

cappella (Italian, 'chapel'), in choral music *a cappella* means 'in a church style' (that is to say, unaccompanied), and *maestro di cappella* means 'director of church music'. The German equivalents are Kapelle and Kapellmeister. 'Chapel', as in *Chapel Royal, can also refer to the salaried musicians serving a church or noble household.

Capra, Frank (1897–), US film director, born in Sicily. His optimistic films eulogize ordinary people, who were shown as more decent and honest than the figures of authority with whom they came into conflict. He won Academy Awards for best director for *It Happened One Night* (1934), his first big success; *Mr Deeds Goes to Town* (1936), about an innocent from the provinces in New York; and *You Can't Take It With You* (1938). Equally successful were *Lost Horizon* (1937), about the incursion of some kidnapped aircraft passengers into a Utopian community, and *Mr Smith Goes To Washington* (1939), in which an honest young senator outfaces government power. Capra's six post-war films were less successful, though *It's a Wonderful Life* (1946), *State of the Union* (1948), and *A Hole in the Head* (1959) had considerable merit. The first of these, in which a real 'guardian angel' shows a would-be suicide how much he has to live for, was very much in his pre-war mould.

capriccio (Italian, 'caprice') in music, a term applied at random to describe a light, fanciful vocal or instrumental piece. It is also used of certain 16th-century Italian *madrigals and, later, such keyboard pieces as employ *fugal imitation. In all its usages the term suggests music that is fantastical and capricious. Richard *Strauss's last opera (1942)—a playful study of the relative importance of words and music in opera—adopted the term as a very apt title.

In art, a term applied to any fantasy subject, but most commonly used of a type of townscape in which real buildings are combined with imaginary ones or are shown with their locations rearranged. Such pictures were particularly popular in the 18th century, Canaletto and Francesco Guardi being noted exponents. Goya's etchings

Los Caprichos, issued in 1799, illustrate how wide-ranging the term 'caprice' can be, for they feature savagely satirical attacks on social customs, with strong elements of the macabre.

Caravaggio, Michelangelo Merisi da (1571–1610), the most original and influential Italian painter of the 17th century. His early works were usually small pictures of non-dramatic subjects, with half-length figures, a preponderance of *still-life details (which Caravaggio painted superbly), and a frankly homo-erotic character. The direction of his career changed completely when he was given his first important public commissions in Rome: three paintings on the life of St Matthew (1599–1602) in the Contarelli Chapel of San Luigi dei Francesi, and *The Conversion of St Paul* and *The Crucifixion of St Peter* (1600–1) in the Cerasi Chapel of Santa Maria del Popolo. These astonishingly original works show how forcefully Caravaggio broke with the prevailing *Mannerist style, for his figures, emerging from gloomy shadow into bright light, convey an intense sense of physical presence. Henceforth Caravaggio devoted himself almost exclusively to religious works. He was often criticized for his down-to-earth approach in showing religious figures as real people; but this feature of his work, as well as his dramatic handling of light and shade, was enormously influential, the artists who flocked to Rome from all over Europe at this time carrying his ('Caravaggesque') style back to their own countries. Caravaggio was notoriously violent and in 1606 he fled Rome after killing a man in a brawl. His final years were spent in Naples, Malta, and Sicily.

Carducci, Giosuè (1835–1907), Italian poet and literary critic. Born in Tuscany, he was Professor of Italian Literature at Bologna from 1860 to 1904. In 1906 he was awarded the Nobel Prize for Literature. In addition to being an influential literary critic, he was a revolutionary poet both in the political content of much of his verse and in his experiments with form, much of which harked back to *Foscolo's classicism. In *Iambs and epodes* (1867–9), *Barbarian Odes* (1877–89), and *New Rhymes* (1861–7), his

Caravaggio's *The Lute Player* was painted for Cardinal del Monte, an important patron during the earlier part of the painter's career. The play of light and shade, with the use of a shaft of light to illumine the painting from the left, is characteristic of his mature work. (Hermitage, Leningrad)

poetry, when not over-rhetorical, beautifully evokes place and mood.

Caribbean music, music of the islands of the Caribbean or West Indies, including the Bahamas, the Greater Antilles (Cuba, Jamaica, Hispaniola, and Puerto Rico), and the Lesser Antilles. The Caribbean was first inhabited by South American Indians in the first millennium AD; between 1510 and 1834 slaves were imported from the West African coast. After the abolition of slavery, indentured labourers were imported from Asia, especially from northern India (to Trinidad) and southern India (to Martinique), with the result that Indian culture and folk music is still current in a number of islands. Though peoples of African origin are numerically dominant, the music of the islands thus results from nearly five centuries of fusion of peoples and cultures of European, African, and Asian descent. The musical genres of different religious cult groups show many striking connections with African musical systems. *Congolese words are used in the songs of the Jamaican Kumina cult, and Nigerian Yoruba religious practices are combined with Roman Catholic and Baptist beliefs in the Trinidadian Shango cult. Much of the polyrhythmic playing in drum ensembles resembles African techniques, but there seems to be less emphasis on drums as melodic instruments. The call and response patterning of much Caribbean music and its pervasive use in ritual, work, and play, is typical of sub-Saharan Africa; but the textures of Caribbean polyphony and the roles of individual composers and of solo performances seem to be different.

Amongst contemporary dance forms, limbo dancing is said to date from the time of slavery, while the quadrille was imported into the Caribbean from Europe during the same period. Cuban dances such as the *danzón* and *rumba*

Max Beerbohm's **caricature** here captures some of the most noteworthy artists and writers of the 1890s. The artist's witty and whimsical comments on *fin de siècle* literary London cunningly exploit his very lack of skill as a draughtsman.

are akin to *Latin American dances in their combination of Spanish and African elements; early in the 20th century they were exported to ballrooms in the USA and Europe. Street dancing is an important part of the carnival season, which runs from New Year's Day to the first day of Lent. The most common carnival music forms are Trinidadian *calypso and *steel band music, and Jamaican *reggae.

caricature, a form of art, usually portraiture, in which characteristic features of the subject represented are distorted or exaggerated for comic effect. Its invention is usually credited to Annibale *Carracci, who flourished in the late 16th and early 17th centuries, although other forms of grotesque or ludicrous representation were known earlier (and are sometimes loosely called caricature)— famous examples are Leonardo da Vinci's drawings of grotesque heads. Several notable 17th-century artists, Bernini for example, were brilliant caricaturists, but only as a sideline, and it was not until the 18th century that the professional caricaturist emerged. Political caricature as we know it today developed in the last three decades of the 18th century, *Gillray and *Rowlandson being great exponents at this time in Britain, and *Daumier in France. George *Cruikshank produced gentler, less satirical caricatures in the early Victorian period in the UK, while the weekly *Punch* cartoon institutionalized political caricature for the middle-class home. Political caricature still flourishes, for example in the work of Gerald Scarfe in *Punch* and *Private Eye* in the UK, in the satirical magazine *Krokodil* in the Soviet Union, and the newspaper *Le Canard enchaîné* in France.

carillon, a chime of *bells so arranged that melodies can be played on it. Originating in the Low Countries but also popular elsewhere, it is played either by a *carillonneur* using a 'keyboard' of rods struck with the fist, or *mechanically by a pinned barrel. Recently, electronic imitations have been introduced.

Carlyle, Thomas (1795–1881), Scottish historian and political philosopher. His semi-autobiographical philosophical work, *Sartor Resartus* (1833–4), shows the influence of Richter and the German Romantic school. In 1826 he married Jane Welsh (later famed for her brilliant letters), and in 1834 they left Scotland for London, where Carlyle wrote his celebrated *History of the French Revolution* (1837). In *On Heroes, Hero-Worship and the Heroic in History* (1841) he outlined his view that great men in the past shaped destiny through the genius of their spirit. In *Chartism* (1840) he attacked the consequences of the Industrial Revolution; in *Past and Present* (1843) he exalted the feudal past and paternalistic government. During his lifetime his influence as a social prophet and critic was enormous; in the 20th century his reputation waned, partly because his ideas were interpreted as foreshadowings of fascism.

Carmina Burana ('Songs of Beuern'), a collection of late 12th-century Latin and German lyrics discovered in Munich in 1803 among documents from the Bavarian Benediktbeuern monastery. They form part of the tradition of Goliardic songs, the poetry of the 'wandering scholars' or Goliards. The lyrics celebrate love, wine, and the life of the vagabond. They represent a reaction against the medieval ascetic ideal of the church. Some were set to music in 1937 by the Bavarian composer Carl *Orff, in a secular choral cantata.

Carné, Marcel (1909–), French film director, whose best films were made in collaboration with the scriptwriter and poet Jacques Prévert (1900–77). Their films together included *Quai des brumes* (1938), about a doomed love affair, and *Le Jour se lève* (1939), in which a man who has murdered from sexual jealousy is besieged all night by the police. Both films combine contemporary reality with a poetic approach, which in their next two films was applied to a historical subject. The first, *Les Visiteurs du soir* (1942), is a kind of fairy-tale set in the 15th century. The second, *Les Enfants du paradis* (1945), set in the 19th century and with a theatrical background, includes an unforgettable performance by *Barrault, and is one of the most haunting films ever made. Carné's partnership with Prévert ended in 1948; though he made many more films they were not of the same standard.

Caro, Sir Anthony (1924–), British sculptor. In 1951–3 he was assistant to Henry *Moore, but after meeting David *Smith in 1959, he began making sculpture using prefabricated metal elements, painted in rich colours. They were often large and sprawling, and he is considered to have originated a new sculptural outlook, using the ground as his base in order to involve the spectators more intimately in the space occupied by the sculpture instead of segregating it on a pedestal or plinth. His work has been highly influential on younger sculptors.

carole or carol, an early dance form and the type of song deriving from it. Circle or ring dances originated in pre-history and were probably performed around central objects as part of ritualistic and celebratory activities. The dancers moved around in a circle or in and away from the centre. By the early Middle Ages a distinct form had developed into a type of song that was also danced. Most carols have religious texts, though some, such as the 'Agincourt Song' sung after the 1415 victory, were purely secular. When the Christmas season developed as a public holiday in the nineteenth century, new carols (Christmas hymns) were written as part of the festivities. Many have achieved the status of folk-song.

Carolingian art, the art and architecture of the reign of Charlemagne (800–814), the first Holy Roman Emperor, and of his successors until about 900. Charlemagne's reign was noteworthy for reforms in many fields; his guiding principle was a renewal of the culture of the Roman empire, and this was felt in the arts no less than in administrative, judicial, and religious matters. His capital at Aachen (Aix-la-Chapelle) became the centre of a cultural revival. The most important Carolingian building to survive largely intact is his Palatine (imperial palace) Chapel at Aachen (792–805), which shows the sturdiness of Carolingian architecture and its dependence on early Christian precedents. The chief innovation in Carolingian architecture was the 'westwork', a porch at the west end of a church flanked by towers. Little survives of Carolingian mural paintings or mosaics, but several manuscripts contemporary with Charlemagne are known, showing a classical, naturalistic figure style, but also at times a vivid expressiveness. There is no surviving large-scale sculpture, but Carolingian ivory carving and metalwork (on book covers, for example) reached a high level. Carolingian art had great influence on *Ottonian and *Romanesque art. In music, the reign of Charlemagne was marked by the so-called Carolingian reform which led to an attempt to fix liturgical chant, hitherto a flexible and continuously evolving art, in writing.

Carpaccio, Vittore (*c*.1450–*c*.1525), Italian painter, regarded as second only to Giovanni *Bellini as the outstanding Venetian painter of his generation. His fame rests primarily on two great cycles of paintings: *Scenes from the Life of St Ursula*, executed in the 1490s, and *Scenes from the Lives of St George and St Jerome*, painted for the Scuola di San Giorgio degli Schiavoni in Venice in 1502–7 and still in its original position. They show his characteristic gracefulness, sense of fantasy, and sharp eye for anecdotal detail.

carpets and rugs. The two words are not usually strictly differentiated, but are vaguely indicative of size, rugs being smaller than carpets. In the West it was not until the 18th century that they became common as floor coverings (rushes and rush matting were generally used for this purpose), but they have also been used in many other ways—to cover beds, tables, and other pieces of furniture,

This carved ivory panel, part of a diptych known as *Genoels Elderen*, shows the Annunciation in the upper half and Mary's visit to her cousin Elizabeth in the lower half. The panel displays the Roman influence so significant in **Carolingian art**, as in the angel (*above, left*), although it is modified by local traditions which elongate the figures and emphasize vertical lines by patterning. (Musées Royaux d'Art et d'Histoire, Brussels)

This sumptuous carpet is known as the Ardabil Carpet as it came from the shrine at Ardabil in north-western Iran. Dated 1539–40, it is superb example from the greatest period of Persian **carpets and rugs**. William Morris described it as 'the finest Eastern carpet which I have seen'. (Victoria and Albert Museum, London)

gold thread were also used for particularly luxurious products. Oriental rugs were common in Europe by the 15th century, and were being imitated by the 16th century. Folk traditions such as those in Scandinavia and the Middle East still produce carpets using centuries-old techniques and designs. The first great European carpet factory—the Savonnerie—was founded by Louis XIII in Paris in 1626, and other famous factories include Aubusson in central France (celebrated also for *tapestries), Axminster in Devon (founded 1755), and Wilton in Wiltshire (founded c.1740). All carpets were made on handlooms until the 1840s, when power-looms made it possible to mass produce them, revolutionizing the industry.

Carr, Edwin (James Nairn) (1926–), New Zealand composer. He began composing after attending London's Guildhall School of Music in the 1950s, where other New Zealand composers included Robert Burch, David Farquhar, Larry Pruden, and Ronald Tremain. The influence of Stravinsky is evident in his *Blake Cantata* (1952) and his Symphony (1981). Other works include the opera *Nastasya* (1969–72), based on Dostoyevsky's *The Idiot*.

Carr, John (Carr of York) (1723–1807), British architect. He had an extensive practice in the north of England, concentrating mainly on domestic architecture, but also designing and altering churches, public buildings, and bridges. His work, essentially *Palladian in style, was unoriginal but assured, and he had high standards of craftsmanship (he was a stone-mason by training). Late in his career he was influenced by the elegant style of Robert *Adam in his interiors.

Carrà, Carlo (1881–1966), Italian painter. He was a prominent member of the *Futurists (whom he joined in 1909), and visits to Paris in 1911 and 1912 introduced *Cubist influence into his work. In 1915 he met de *Chirico and turned to *Metaphysical painting, although his work was generally without de Chirico's sinister feeling. Carrà broke with de Chirico in 1918 and abandoned Metaphysical painting, devoting himself to trying to recapture the monumental grandeur of early Italian painters such as *Giotto and *Masaccio and becoming an influential teacher.

Carracci, family of Italian painters from Bologna, the brothers **Agostino** (1557–1602) and **Annibale** (1560–1609) and their cousin **Ludovico** (1555–1619). They transformed Bologna from something of an artistic backwater to the centre of some of the most important developments in 17th-century Italian painting. In about 1582 they opened a teaching academy, in which stress was laid on drawing from life, and their encouragement of a solid, naturalistic art encouraged the move away from the rather vapid *Mannerism that prevailed in late 16th-century Italian art towards the more robust *Baroque style. In 1595 **Annibale** settled in Rome, where he painted his masterpiece, the ceiling of the Farnese Gallery (1597–1600) in the Farnese Palace. Featuring mythological scenes, it is a gloriously exuberant but also deeply thought-out work that was the foundation of much Baroque decoration. Annibale was an extremely versatile artist: he was the inventor of *caricature as we know it and of the type of picture known as 'ideal *landscape'. In 1605 he began to suffer from depression and did little work in his final years. In the 17th and 18th centuries the Farnese Ceiling was

for example, as wall hangings, and as the curtains of tents. In the East, where they originated, they are also used as part of religious ceremonial—prayer rugs on which to kneel during devotions. The earliest extant carpets come from Central Asia and date from the 5th century BC, but there is evidence that they were being made some two thousand years earlier. A large area of the East is renowned for skill in carpet-making, stretching from Turkey through Persia as far as China, but the most prized of all carpets are perhaps those made under the *Safavid dynasty (1502–1736) in Persia, whose splendour of colour and intricate beauty of design have never been surpassed. Wool is the most common material of carpets, but camel and goat hair were much used in oriental examples, and silk and

ranked on almost the same level as *Michelangelo's work in the Sistine Chapel and *Raphael's Vatican frescos, but in the 19th century his reputation plummeted. Today he is judged alongside his great contemporary Caravaggio. **Agostino** is remembered as a teacher and engraver, whose studies of the human body were used for instruction in art academies for two centuries. **Ludovico** ran the academy in Bologna after his cousins went to Rome. He was an uneven painter, but capable of great emotional depth. All three Carracci were brilliant draughtsmen.

Carroll, Lewis (Charles Lutwidge Dodgson) (1832–98), British writer and photographer. A lecturer in mathematics at Christ Church, Oxford, he is remembered as the author of the children's classics *Alice's Adventures in Wonderland* (1865), and *Through the Looking-Glass* (1871) written for Alice Liddell, the young daughter of the classicist Henry George Liddell. Both describe a child's dream adventures, and were first illustrated by Sir John Tenniel. Unlike most *children's literature of that period they were neither moralistic nor instructive. Their fantasy, satire, and surrealism make them equally appealing to adults. He also wrote inspired humorous and *nonsense verse, notably *The Hunting of the Snark* (1876). Carroll was a respected portrait photographer. At first a typical Victorian 'lion-hunter', he sought out celebrities to pose for his camera, but he later concentrated on photographing children, particularly little girls. He excelled in getting them to look relaxed: his masterpiece is a study of Alice Liddell as a 'beggar girl'. Carroll gave up photography in 1880 and his lectureship a year later, presumably to concentrate on writing, the greatest of his talents.

Carter, Elliott (Cook) (1908–), US composer. His early work shows the influence of Stravinsky and *Neoclassicism, which he gradually shed in favour of a much more passionate and rhythmically complex style, derived in part from an admiration of Charles *Ives's methods and a study of medieval and non-Western techniques. In his mature works, instruments engage in an exuberant dialogue of great intensity, as if characters in an abstract drama. His most important works include the Double Concerto (1961), the Piano Concerto (1965), Concerto for Orchestra (1969), A Symphony of Three Orchestras (1977), and four string quartets (1951, 1959, 1971, 1986).

Cartier-Bresson, Henri (1908–), French photojournalist. Cartier-Bresson studied painting and literature before becoming a photographer in 1931, inspired by the work of Martin *Munkacsi. After making films in the late 1930s (notably with Paul *Strand and Jean *Renoir), he became caught up in the war, escaping from a German prisoner-of-war camp and photographing for the Resistance, from 1943 to 1945. After the war, he became a freelance and helped to found the Magnum Photos co-operative in 1946. This supplied to the media global coverage by some of the most talented photo-journalists of his time. Cartier-Bresson refuses to allow the shape of a picture to be altered (or 'cropped') after it has been taken, and his approach to photography sometimes appears overly pure and theoretical. This is belied, however, by the emotional warmth often found in his shots of ordinary people in everyday situations (he has also taken portraits of many celebrities). In recent years Cartier-Bresson has returned to painting; but he is probably still the 20th century's most revered photographer.

cartoon, a full-size drawing made for the purpose of transferring a design to a painting or tapestry. Cartoons were an essential part of the process of making stained glass, and were used in painting by the early 15th century. The design was transferred either by pressing heavily along the outlines with a pointed metal implement called a stylus or by rubbing powdered charcoal through a series of pinpricks—a process called 'pouncing'. In the 19th century proposed designs for frescos in the Houses of Parliament in London were parodied in the magazine *Punch*; thereafter the word came to mean a humorous drawing or parody.

Caruso, Enrico (1873–1921), Italian tenor singer. Caruso's international fame dates from 1902, when he sang Rodolfo in Puccini's *La Bohème* with *Melba at Monte Carlo. Between then and 1920 he sang thirty-six roles, appearing over 600 times in New York. The first tenor to make records, Caruso's voice is resonant and almost baritonal (see *voice), and, though not stylistically impeccable, is regarded among the greatest.

caryatid, a carved female figure clad in long robes and serving as a column. Caryatids were first used in Greek architecture, the most famous examples being on the Erechtheum in Athens (*c*.421–407 BC), and again came into prominence with the Greek Revival of the 19th century. The male equivalent of the caryatid is the atlas; the term 'canephorae' is applied to caryatids with baskets on their heads.

The Erechtheum in Athens has a porch in which six **caryatids** take the place of columns. The name means 'woman of Caryae', a town in Sparta, and the device may derive from the postures assumed in the local folk dances at the annual festival of Artemis Caryatis. The original figures have been removed for safe keeping and replaced with copies.

Casals, Pablo (1876–1973), Spanish cellist, conductor, composer, and pianist. Starting his career in Barcelona cafés, Casals performed as a soloist throughout Europe from the late 1890s, and from 1901, when he toured the USA, was regarded as the world's greatest cellist. Forming a notable trio with the pianist Alfred Cortot (1877–1962) and the violinist Jacques Thibaud (1880–1953), Casals was forced to leave Spain in 1936, and refused to return after the Spanish Civil War.

Cassatt, Mary (1844–1926), US painter and print-maker who worked mainly in Paris (where she settled in 1866) in the circle of the *Impressionists, and particularly with *Degas. Cassatt is renowned for her delicate depictions of everyday life, particularly her paintings of mothers with children, and she was an outstanding print-maker and pastellist. She came from a wealthy family and exercised an important influence on US taste by urging her rich friends to buy Impressionist works.

castanets, wooden *clappers, a pair for each hand, characteristic of Spanish music, and of orchestral music with a Spanish flavour, where traditionally they are made of chestnut wood or *castaña*. The left-hand pair is lower pitched than the right. The two shells of each pair are linked together with cord, tightened round the thumb so that the shells are sprung apart and can be struck together with the fingers. In orchestras, one pair of shells is attached to a handle, with a plate between them, which makes the playing technique easier. Very similar instruments were used in ancient Egypt, and they are related to the *clappers used in much European *folk music.

Castiglione, Baldassare (1478–1529), Italian courtly writer. A Mantuan nobleman and diplomat, he was in the service of the dukes of Urbino and of the papacy. His four volumes, *The Book of the Courtier* (1528), which had widespread influence, take the form of conversations which set out the necessary attributes of the perfect Renaissance courtier and the noble lady.

casting, the process of making a mould from a statue or similar object and reproducing the original in a material such as *bronze or plaster of Paris that can be shaped into the mould. Casting may be used to make a copy of a finished work or to create the permanent version of a work that the sculptor has modelled in some fragile material such as clay. There are various methods of casting, the *cire-perdue technique being the best known. The practice of casting the head and limbs separately releases the bronze sculptor from the constraint of block size faced by the stone sculptor.

castrato, a type of male soprano or contralto *voice achieved by castration before puberty, in great demand in Italy for opera in the 17th and 18th centuries. The voice had a special brilliance and the singer often became very wealthy through the adulation accorded him. Castrati parts were written as late as 1824 (Meyerbeer's *The Crusader in Egypt*) and the voice survived in the Vatican Chapel well into the late 19th century. The last castrato was Alessandro Moreschi (1858–1922), who in old age made a number of recordings. The practice of castration was finally banned by the Vatican in 1903.

catch *canon.

catharsis, the effect of 'purgation' or 'purification' achieved by tragic drama, according to Aristotle's argument in his *Poetics* (4th century BC). Aristotle wrote that a *tragedy should succeed 'in arousing pity and fear in such a way as to accomplish a catharsis of such emotions'. There has been much dispute about his meaning, but Aristotle seems to be rejecting *Plato's hostile view of poetry as an unhealthy emotional stimulant. His metaphor of emotional cleansing has been read as a solution to the puzzle of the audience's pleasure in witnessing the disturbing events enacted in tragedies.

Cather, Willa (Sibert) (1873–1947), US novelist and short-story writer. She used her knowledge of the lives of the immigrant families of the Midwest as the basis for a series of novels, beginning with *O Pioneers!* (1913), *The Song of the Lark* (1915), *My Ántonia* (1918), and *One of Ours* (1922). Later novels like *Death Comes for the Archbishop* (1927) and *Shadows on the Rock* (1931) reflect her interest in history and religion.

Catullus, Gaius Valerius (c.84–54 BC), Latin poet. Born in Verona, he spent much time in Rome. His surviving work covers a wide range of topic and metre. Most memorable are the twenty-five lyrical poems reflecting a stormy relationship with a woman addressed as 'Lesbia', probably the fashionable Clodia. But he writes with equal directness of the death of his brother, the excitement of composing poetry, and the malpractices of various contemporaries. His minor epic on the wedding of Peleus and Thetis is untypical of an *œuvre* that is usually brief, personal, and passionate. He also translated the work of *Sappho and *Callimachus. He prepared the way for the development of Roman love *elegy, but his lyric pieces had no real heirs till the rise of the Romance languages; he was admired and imitated by Renaissance poets.

Cavafy, Constantine (Konstantínos Pétrou Kavafis) (1863–1933), Greek poet. A native of Alexandria, he was fascinated by the Asian Greek culture from the Hellenistic period onward. His poems, predominantly on historical and homosexual erotic themes, are suffused with an ironic awareness of the instability of life and the limits of human knowledge. They also reflect on the nature and power of art, particularly poetry. Cavafy is notable for his laconic but musical style and for his development of the dramatic monologue as a poetic form.

Cavalcanti, Guido (c.1260–1300), Italian poet. Born in Florence, he was a close friend of *Dante, and the leader of the *dolce stil nuovo* ('sweet new style') school of poets, characterized by the dominant theme of love, the idolization of woman, by a propensity to philosophy, and by a stylistic grace and directness of diction. The passion in Cavalcanti's verse anticipates *Petrarch.

Cavalier Poets, the name given to a group of English poets in the time of Charles I, noted for their lyrical poetry and courtly behaviour. It included Thomas Carew (c.1594–1640), Richard *Lovelace, Sir John Suckling (1609–42), Edmund Waller (1606–87), and Robert *Herrick (who was not a courtier). Their lyrics, similar in tone and style, were distinguished by short lines, fluent and idiomatic diction, and urbane and graceful wit. Typical themes were love, honour, the transience of beauty, loyalty to the king, and gallantry.

This early 18th-century celadon-glazed bowl, decorated with moulding under the glaze, was made in China. **Celadon** wares were prized for their beauty and resemblance to jade, and also because, according to superstition, a celadon dish would shatter or change colour if poisoned food were put into it.

Cavalli, (Pietro) Francesco (1602–76). Italian composer, organist, and singer. An advantageous marriage, and an appointment as one of the organists to St Mark's (for which he composed a number of motets, settings for masses, duets and trios, and a requiem), encouraged him to attempt *opera, and he soon became one of the most distingushed operatic composers of his day. Such works as *Ormindo* (1644) and *Calisto* (1652) have figured largely in the recent revival of interest in operas of this period.

cave painting, European, painting executed on cave walls and roofs during the Palaeolithic (Old Stone Age) period. Almost all the known cave paintings are in south-western France and northern Spain. The paintings are often deep in the cave systems, away from the areas used as dwellings, and may have magical or religious significance, one theory being that the animals painted there (humans rarely appear) were depicted in connection with hunting rites. The best-known cave paintings are at Altamira in Spain (discovered 1879) and at Lascaux in France (discovered 1940), dating from about 12,000 BC to 15,000 BC. They are extremely vivid, conveying the beauty and energy of animals with great force and economy, in a narrow range of earthy colours. The paints used were ochres and manganese oxides, charcoal and iron carbonate, as well as soot. The powdered colours were mixed with fat or other binding mediums and then applied to the walls.

Cecchetti, Enrico (1850–1928), Italian dancer and teacher. Famous as a teacher, he worked in St Petersburg with Diaghilev, and then independently. He developed a systematic method of teaching ballet technique emphasizing the use of the shoulders and a lyrical, flowing quality, that is still taught today.

celadon, a rather imprecise term applied to certain Chinese ceramic wares characterized by greyish-green glazes and to similar wares produced in Japan and Korea. The colour—somewhat resembling jade—is caused by the use of a ferrous oxide glaze. Celadon ware, particularly southern celadon, which is associated with the Sung dynasty (960–1279), was widely exported and was highly prized in the West.

celesta, a small upright keyboard instrument invented by Auguste Mustel in Paris in 1886. The hammers strike metal plates, the sound being amplified by a wooden resonating box behind each plate; there is a sustaining pedal like that of the piano. It appears quite frequently in the orchestra. Perhaps its most famous use, well suited to the sweet sound, is in 'The Dance of the Sugar Plum Fairy' in Tchaikovsky's ballet *The Nutcracker*.

Cellini, Benvenuto (1500–71), Italian sculptor, goldsmith, metalworker, and writer. He was the most renowned goldsmith of his day and he also holds a distinguished place among *Mannerist sculptors, but his fame depends less on the quality of his artistic work than on his autobiography (first published 1728), a work of gusto in which he boasts of his feats in art, love, and war. Early in his career he worked in Rome, then from 1540 to 1545 he was in France in the service of King Francis I, for whom he made a famous gold salt-cellar, the most important piece of goldsmith's work to survive from the Italian Renaissance. The remainder of Cellini's career was spent in Florence, where he turned to large-scale sculpture, producing in his bronze Perseus (Loggia dei Lanzi, 1545–54) one of the most famous sights of the city.

cello (violoncello), historically the bass of the *violin family. Its vast range—in solo works the note C, for example, may be sounded in five different octaves—and its huge expressive powers render the cello the great solo instrument of the family after the violin itself. A little over twice the size of the violin, its great depth of body is nearly four times that of a violin, bringing the internal air-resonance frequency down to nearly a twelfth lower,

namely close to G (if the *f*-holes are on the wide side this may rise to above A). The strings are thicker than violin strings and under about twice the tension. They require a stouter *bow, about 25 mm (1 in.) shorter and some 25 per cent heavier, with the band of hair wider to about the same degree. Though the cello, being held downwards, has its strings the opposite way round from those of the violin (that is, the top string to the left as the player sees it, not to the right) the principles of bowing are, broadly speaking, similar. The instrument seems to have been first seriously developed in the late 17th century in Cremona, and some 63 cellos made by Antonio Stradivari (*c.*1644–1737) still exist. From the 18th century the cello developed into a virtuoso solo instrument: concertos have been written for it by many composers including Boccherini (himself a cellist), Beethoven, Schumann, Saint-Saëns, Elgar, and many others. There have been many outstanding cellists, perhaps the greatest being *Casals, though *Rostropovich rivals him for this position.

Celtic art, the art of the Celts, ancient peoples of central and western Europe; in pre-Roman times they inhabited much of Europe, including Britain, Gaul, parts of Spain,

This 8th-century bronze crucifixion plaque was perhaps originally a book cover. The smooth face of Christ contrasts with the manuscript-like decoration of the other surfaces, which are ornamented with the interlacing motifs typical of **Celtic art**. Stephaton and Longinus stand by Christ's sides, and oddly awkward angels flank his head. (National Museum of Ireland, Dublin)

Germany, and Czechoslovakia. A distinctive type of Celtic art, named after La Tène in Switzerland, first developed in the 5th century BC, expressed mainly in metalwork, a field in which the Celts showed extraordinary skill (see *Iron Age art). They decorated practical objects, such as weapons, armour, cups and flagons, and also made jewellery, chiefly working in bronze and gold and using sophisticated inlay techniques. Motifs were borrowed from many sources, but they were transformed by the Celtic genius for abstract ornament, which took delight in vigorous geometrical and spiral designs, often combined with stylized animal forms. Human figures are rarer, and are always depicted in a rather abstract manner. The Roman conquest tended to submerge native forms in a provincial classicism, and the Celtic tradition survived most strongly in areas on the fringes of Europe, most notably Ireland, outside the Roman Empire. Metalwork skills declined, but with the Christianizing of Ireland Celtic art took on a new lease of life in manuscript *illumination, in which the written text is eclipsed by intricate latticework borders. The most famous of Irish illuminated manuscripts is the Book of Kells, which dates from about 800. After the Romans abandoned Britain in the 5th century, there was an influx of Celtic influence from Ireland, felt particularly in the north of England and most notably in the Lindisfarne Gospels, written and illuminated in the monastery at Lindisfarne, Northumbria, in about 700. In sculpture, Celtic art is most important for the free-standing stone cross, a type that seems to have been unique to Britain and Ireland. Their carving combines Christian subjects with pagan decorative motifs. Although much modified by Scandinavian influence, the Celtic tradition continued to flourish in Ireland until the 12th century, when, following the Anglo-Norman invasion of 1170, the country came much more into the mainstream of *Romanesque art. Vestiges of the Celtic style of ornamentation survived, however, into the 14th century.

Celtic literature *Irish-language literature, *Scottish Gaelic literature, *Welsh-language literature.

Central American and Mexican architecture, the Pre-Columbian architecture of what are now Mexico and Guatemala, for which 'Mesoamerican' is the term preferred by scholars. All the societies which produced monumental architecture in this region seem to have demanded similar functions from their great buildings: service of a theocratic élite; a setting for ritual games and sacrifices; and the needs of earth magic, usually informed by celestial observations. All found these functions best fulfilled by the stone pyramid, steeply stepped, surmounted by a platform and approached by a single or double stairway, symmetrically positioned. Regularity and symmetry were always respected, as, with rare exceptions, were a rectilinear plan and angularity of profile. Pyramids were grouped according to the same principles, sometimes to enclose ball-courts. Most sites also have chambered buildings, sometimes of domestic scale, usually of later date than the pyramids. The aesthetic established by the earliest surviving building—the Sun Pyramid of *Teotihuacán (perhaps *c.*1st century AD)—endured for nearly a millennium and a half despite technical innovations and local and regional variants. The *Maya, for instance, used cemented corbel-vaults to enclose fairly large spaces, and admired a form that was almost a cuboid, topped by lofty superstructures;

at Tula, the *Toltec built cloister-like colonnaded court-yards that seem to have been conceived to create internal volume rather than as external masses, which were the priority of most Mesoamerican architects. Every temple contained a ball-court, where a symbolic ball game was played, though its exact interpretation is unknown. Though admired by Renaissance Spaniards, Mesoamerican architecture exerted little subsequent influence until the 20th century.

Central American and Mexican art. The term is used here to cover what scholars call Mesoamerican art of before the Spanish invasion. In Central America few sites have yielded objects of artistic value, apart from the stone vases of Ulúa and 'Geutar' stone sculptures of Costa Rica (c.9th to 11th centuries), the guardian-spirit statues from around Lake Nicaragua (of uncertain date), the rich funerary goods of Sitio Conte (AD c.500–1000), and the Panamanian goldwork of the 14th and 15th centuries. Little survives from the earliest known Mesoamerican civilizations, which may have flourished as long ago as the 15th century BC. There were builders of large, flat-topped mounds at Ocós. At Xochipala, sculptors in clay perhaps produced the figurines found at that site, noteworthy for expressiveness, creative realism, and rhythmical fluidity. In about the 13th century BC the civilization known as *Olmec, centred in Vera Cruz, began to build monuments which influenced later civilizations. Between the 1st and 3rd centuries AD successor cultures were founded in the Valley of Mexico, southern Mexico, and Yucatán by large-scale builders in stone: the people of *Teotihuacán, the *Maya, and the *Zapotec). These in turn passed through a period of crisis between c.8th and c.11th centuries, perhaps as a result of conquest by warrior peoples from the highlands or deserts. Work of about the 10th century onwards is conventionally designated 'post-classic' by Mesoamericanists, though it includes splendid achievements—notably the 'Toltec-Maya' city of Chichén Itzá (c.11th century); the Toltec centre at Tula (c.12th century); the monumental sculpture of the Huastec (c.13th century); the Mixtec *glyphs (perhaps 13th to 16th centuries); and *Aztec sculpture and goldwork. Unresolved scholarly debate has centred on the relationships of these civilizations with each other and with those of South America and, in particular, on the extent to which similarities are the result of diffusion or cross-fertilization. The most striking feature of the art as a whole is that, while it yields nothing in craftsmanship or expressive power to most Old World cultures, it was produced without the aid of the wheel, of beasts of burden, or metal tools. (See also *Tlatilco.)

Central American and Mexican literature, Mesoamerican literature before the Spanish invasion in the 16th century. Large quantities of manuscripts were burnt by the early Christian missionaries, for fear of the pagan messages they contained. Only two dozen or so of these books survive from pre-conquest times, but the tradition of making them continued for a while under Spanish rule and much of their content was transcribed into books in alphabetic script. This comprises a mixture of prophecy and history; it is recorded in books made of paper and parchment, and murals and carvings. Rather than being bound to a spine, the books (often referred to as codices) were folded like a screen or accordion, in the fashion of some books in early Japanese literature; this technique

allows for concentration on a single page or for several pages to be viewed at the same time. Two main types of script were used: one was the hieroglyphic script (using highly stylized symbols which are pictorial in origin) of the lowland Maya, which also profusely adorns monuments and buildings from the Classic Period (AD c.300–900); the other is the iconographic script (a simpler form of picture writing) shared by the Aztecs and such predecessors of theirs as the Mixtecs of southern Mexico. It is found on monuments and rock carvings, which may date back to 1000 BC or earlier. The core of the Maya books is a calendrical cycle known as the *Count of the Katuns*, which covers thirteen lots of twenty Maya years and ingeniously combines record with forecast, history with prophecy. Present in the hieroglyphic books, this cycle also lies at the heart of the alphabetic books written by the Maya of Yucatán. These were composed in their language up to this century and are known as the *Books of Chilam Balam*. The iconographic books, of which a far larger sample survives, fall into two categories: annals and so-called 'ritual' texts. The annals relate the origins and rise to prominence of such cities as Tenochtitlán, the Aztec capital (Boturini Codex), and Tilantongo, the headquarters of the 11th-century Mixtec hero Eight-Deer. The ritual books are formally much more sophisticated and have posed severe problems for would-be decipherers; they deal with a range of subjects which include childbirth and marriage, warfare and planting, astronomy and tribute, as well as

A view of the Maya city of Chichen Itza, in the Yucátan peninsula, Mexico, with the feathered serpent pillars of the Temple of the Warriors in the foreground and the Pyramid of Kukulcan in the background. It demonstrates the great achievement of **Central American and Mexican art** from the 11th to the 13th centuries.

A page from the 15th-century Fejervary screenfold shows the iconographic style used to convey **Central American and Mexican literature**. The fire god in the centre is being fed on the blood of sacrifice. The trees of the cardinal directions appear on each side, with the tree of the east shown at the top, between the god of the rising sun and the god of the cutting-stone. (Liverpool City Museum, Liverpool)

the magnificent philosophy of evolution later transcribed in alphabetic texts such as the *Popol vuh* of the highland Quiche Maya, a fundamental source that is appropriately known as the 'Bible of America'.

Central Asian music, music of northern Afghanistan, the Soviet republics of Uzbekistan, Turkmenistan, Tajikstan, Kirghizia, and Kazakhstan, Xinjiang (Singkiang-Uighur), and the Republic of Mongolia. Apart from the Persian-speaking Tajiks of Turkestan, most people speak the same Turco-Mongol languages. Historically, the area was a crossroads between West Asian and Chinese civilizations. From the 6th century onwards, when the Silk Road had been established, Central Asian music was imported by the Chinese, especially during the Tang dynasty (618-907). After the Arab invasions and the Islamization of Turkestan in the 8th century, there was two-way traffic in music between West and Central Asia. Urban classical styles reached their peak in Samarkand and Herat under the Timurids (c.1350-1500), and a Persian-Turkic style evolved under the influence of court poet-musicians. During the 19th century the Russians colonized and settled in Central Asia, establishing European genres such as opera and compositions based on local themes. Today, traditional Central Asian music is taught in conservatories in Tashkent (Uzbekistan), Alma-Ata (Kazakhstan), and elsewhere, together with European 'classical' music, and new works are composed in all genres for orchestral and chamber ensembles as well as for soloists. Asian instruments, themes, and musical ideas are also incorporated into compositions for symphony orchestras. In the past, the nomadic Kazakh, Kirghiz, and Mongols had fewer musical styles and instruments than the sedentary peoples, especially the Islamized Turkestani agri-

culturists; but shamanism provided an important setting for musical performance, and horse symbolism was reflected in the horse-head scroll of their spikeless fiddle, and the horse-hair of the bow and the strings. Music was more favourably regarded by the nomadic peoples, and epic recitation, such as the Kirghiz *Manas*, was widely developed. The most characteristic instruments of the sedentary peoples are long-necked *lutes such as the Uzbek *dutar*, spike fiddles such as the Tajik *ghichak*, *shawms, vertical and transverse flutes, large tambourine-like frame-drums, and the short-necked lute or *rebab. Classical music forms derive from courts, such as that in Bukhara, where in the 17th and 18th centuries they organized music into a set of pieces called *Shashmaqam*, or six 'modes' or 'suites', similar to Arab and Persian practice (see *West Asian music). The six *maqam* are: *buzruk, rast, nava, dugah, segah,* and *iraq.* Each *maqam* is subdivided into an instrumental section followed by an elaborate sequence of songs in various poetic metres. Improvisation is no longer a part of *maqam* performance. The vocal music of the many different folk music styles is monophonic, while the instrumental music is often in two parts, either with a *drone or with the second voice at the fourth or fifth. The *quatrain is the most common song structure. Itinerant singers also perfom tales and legends with a sacred Islamic theme or derived from medieval literary romances.

ceramics *Chinese ceramics, *Islamic ceramics, *Japanese ceramics; *creamware, *earthenware, *lustreware, *maiolica, *porcelain, *pottery, *stoneware, *Wedgwood.

Cervantes Saavedra, Miguel de (1547-1616), Spanish novelist, dramatist, and poet. He created the universally known characters, the Knight-errant Don Quixote and his servant Sancho Panza. He wrote mainly in the last twelve years of his life after a career as a soldier which included being held captive by corsair pirates (1575-80), and being imprisoned in Spain for alleged mishandling of government funds. His long poem *The Voyage to Parnassus* (1614) met with little success. Two early plays, *Life in Algiers* and *The Siege of Numancia,* and the later *Eight Comedies and Eight Interludes* (1615), earned him some recognition as a dramatist. The relative failure of his pastoral romance *Galatea* (1585) was followed by the acclaim of his parody of the chivalric romance in *The Adventures of Don Quixote* (1605-15). In his works he explores questions concerning the relationship between reality and illusion in a brilliant variety of literary modes that has made him one of the acknowledged masters of world literature. He also wrote *Exemplary Novels* (1613), a collection of twelve short stories which exhibit the characteristic Cervantine duality of idealism and realism.

Césaire, Aimé (-Fernand) (1913-), French poet and dramatist. Born in the Caribbean colony of Martinique, which he later represented in the French National Assembly, he initiated (with *Senghor) the black cultural self-awareness *négritude* movement in the 1930s. The movement opposed the French policy of assimilation, with its inherent assumption of European superiority. His collection of poems *Cahier d'un retour au pays natal* (1939) is a revolutionary landmark in modern black writing, influenced partly by *Surrealism. His plays, which are polemical and rich in African imagery, include *Une saison au Congo* (1967).

Cézanne, Paul (1839–1906), French painter, with Gauguin and van Gogh the greatest of the *Post-Impressionists and a key figure in the development of 20th-century art. In the 1860s and 1870s he was associated with the *Impressionists, but he never identified himself with them or adopted their aims and techniques. Working with his friend and mentor *Pissarro, he devoted himself to painting landscapes out-of-doors, a technique still considered radical. Rather than trying to capture fleeting impressions of light, he was interested in the underlying structure of nature, and his aims are summarized in two of his sayings: that it was his ambition 'to do Poussin again after nature' and that he wanted to make of Impressionism 'something solid and enduring like the art of the museums'. After the death of his wealthy father in 1886 Cézanne lived mainly at the family estate at Aix-en-Provence, and his financial security enabled him to survive the indifference to his work that lasted until the last decade of his life. After a successful exhibition of his work in Paris in 1895, he greatly excited the attention of young artists and by the time of his death was a much-revered figure. His paintings are principally devoted to certain favourite themes—*still life, portraits of his wife, and above all the landscape of Provence, particularly the Mont Ste-Victoire. In them he combined the grandeur of the French classical tradition with novel representational methods, suggesting form and space not through traditional perspective but through extraordinarily subtle modulations of patches of colour. His late landscapes, which express simultaneously depth and flat design, were the starting-point for the *Cubist experiments of Braque and Picasso, which came only a few years later, and he has had a great influence on other developments in 20th-century art.

Chabrier, (Alexis-) Emmanuel (1841–94), French composer and pianist. Despite early proof of a talent for music, Chabrier was side-tracked into the study and practice of law and did not become a full-time musician until the end of 1880. Though *Wagner's music fired his imagination and ambitions (as in the opera *Gwendoline*, 1885) Chabrier retained a lighter touch; the *opéra comique Le roi malgré lui* (1887), the orchestral rhapsody *España* (1883), and *Joyeuse marche* (1888) have a sparkle and brilliance that are wholly French.

Chabrol, Claude *Nouvelle Vague.

chaconne (Italian, *ciaccona*), a dance in triple time that originated in Latin America, was imported into Spain at the beginning of the 17th century, and came thence to the rest of Europe. The dance employed a traditional sequence of chords, the melodic outline of which was used in Italy as the basis for a set of variations—the bass melody was repeated over and over again while new material was added above. The bass melody could also rise into an upper part. Similar structures underly the passacaglia (also originally a dance) and the ground bass. A refined and developed form appeared in the *ballet de cour* and the opera-ballets of Gluck, Lully, and Rameau.

Chagall, Marc (1887–1985), Russian-born painter and designer who worked mainly in Paris. He was regarded as one of the leading avant-garde figurative painters of his day, and was also active as a book illustrator, and as a designer of stained glass and of sets and costumes for the theatre and ballet. His work was dominated by two rich sources of imagery: memories of the Jewish life and folklore of his early life in Russia; and the Bible. Some of his odd spatial effects derive from *Cubism and his prismatic colour combinations relate him to *Orphism, but he created a highly distinctive style, remarkable for its sense of fairy-tale fantasy. This caused the *Surrealists to claim him as a precursor of their movement, but Chagall said that however fantastic his pictures seemed he painted only direct reminiscences of his early years.

Chaliapin, Fyodor (Ivanovich) (1873–1938), Russian bass singer. Leaving the Imperial Opera, St Petersburg in 1896, Chaliapin joined a Moscow company, where his superb vocal and dramatic abilities matured. Renowned as Ivan in Rimsky-Korsakov's *Maid of Pskov* and especially as Mussorgsky's *Boris Godunov*, he made his international début at Milan in 1901. His considerable versatility stretched from baritone to bass roles (see *voice) in Italian, Russian, and French opera.

chalk, drawing material made from various soft stones or earths. There are three main types: black chalk (made from stones such as carbonaceous shale); red chalk, also called sanguine (made from red ochre or other red earths); and white chalk (made from various limestones). Unlike *crayons or *pastels, which are manufactured products, chalk needs only to be cut to a suitable size and shape to be usable. Chalk drawings are known from prehistoric times, but the medium really came into its own in the late 15th century, notably in the hands of Leonardo da Vinci, who favoured it for drawing.

Chagall's *White Crucifixion* (1938) is not a conventional religious painting but a commentary on contemporary events. The crucifixion is used as a symbol for the suffering of Jews, who at that time were being persecuted by the Nazis. On the left houses are attacked by soldiers and on the right a synagogue is in flames; elsewhere figures flee or lament. (Art Institute, Chicago)

chamber music, a term that originally implied performance in the private salons of the nobility by a small group of instrumentalists or singers, but nowadays applies to music for very small combinations of instrumentalists, regardless of where they are performing. Chamber music implies at least two instruments. The most honoured medium is that of the string quartet (two violins, viola, and cello). Other combinations include the string trio (violin, viola, and cello) and string quintet (usually two violins, two violas, and cello), together with similar combinations that involve an instrument other than strings, such as the piano trio (piano, violin, and cello), the piano quintet (piano, two violins, viola, and cello), and so on. Septets, octets and nonets tend to mix woodwind and strings, though Mendelssohn's Octet (1825) is a double string quartet. The intimate nature of all these combinations, and that of the string quartet in particular, is generally considered to be one of the greatest musical challenges a composer can face. The terms 'chamber orchestra' and 'chamber choir' imply groups of not more than about thirty performers. Chamber concerts began in 1813, when the Müller brothers gave the first public performance of a string quartet.

Chambers, Sir William (1723–96), British architect. He was born in Sweden, the son of a Scottish merchant, travelled in India and China for the Swedish East India Company during the 1740s, then trained as an architect in Paris and Rome, before settling in England in 1755. He was instrumental in the foundation of the Royal Academy. Although less imaginative than that of Robert *Adam, his only serious rival, Chambers's work is always dignified and polished. Throughout his life he remained in touch with French ideas; and he successfully combined French elegance and finesse with the English tradition of sober grandeur. His most famous work is Somerset House in London, a huge complex of government offices begun in 1776 and finished after Chambers's death.

Champaigne, Philippe de (1602–74), Flemish-born painter who became a French citizen in 1629. He trained as a landscape painter and did many fine religious works, but his greatest fame is as a portrait painter. His early work shows influence from the Baroque style of *Rubens, but his style became more sober and classical in line with French artistic trends of the middle of the 17th century. He became involved with the Jansenists (a Roman Catholic sect) in the early 1640s. His most famous work was painted to commemorate his daughter's miraculous recovery from paralysis (*Ex-Voto de 1662*). His nephew **Jean-Baptiste de Champaigne** (1631–81) was also a portrait and religious painter.

change-ringing, a way of ringing church *bells peculiar to Britain. A bell is said to have been 'chimed' when the bell itself remains still while the clapper inside it moves. The bell is 'rung' when it is swung round in a circle by pulling on a rope. A set of church bells is called a 'ring'. The number will vary, twelve being the usual maximum. The different orders of ringing are called 'changes'. With a ring of five bells, 120 changes are possible. With twelve bells the number of changes rises to nearly 480 million. The patterns used in ringing the changes are known by traditional names, such as 'Grandsire Triple', 'Oxford Treble Bob', and so on. The bell itself is linked to a large wheel, around which the bell-rope runs in a groove. The art of change-ringing is an art of timing and, if the changes are very long, can also be something of an athletic feat.

chanson (French, 'song'), a musical term mainly used to describe the *polyphonic settings of a particular type of French verse written during the 14th to 16th centuries. The *chanson* was an ancestor of the *madrigal, though simpler in style and with greater emphasis placed upon the upper voice. Later examples, from the end of the 15th century, were no longer dependent on the original poetic form for their structure. The term is also used to describe almost any kind of verse-repeating solo song of the 17th to 20th centuries.

chanson de geste (French, 'song of deeds'), narrative poem recounting legendary heroic exploits of the time of Charlemagne (742–814). The poems (of which about 100 survive) date from the 11th to the 14th centuries, and were sung to short musical phrases, probably involving repetition, by *trouvères* (see *minstrels). Themes common to them include reflections on feudal society, Christian ethics, the status of women, and the heroism of the Crusaders against the 'Muslim' enemy. The most famous, *La Chanson de Roland* (early 12th century), recounts the death of Roland, one of Charlemagne's knights, with remarkable grandeur and pathos. The *chansons de geste* were predecessors of the verse romances written by *Chrétien de Troyes. They strongly influenced Spanish heroic poetry as well as Italian and German Renaissance epics.

Chantrey, Sir Francis (1781–1841), British sculptor. He succeeded *Nollekens as the most successful sculptor of portrait busts in England, and his enormous workshop also executed statues and church monuments. Once he had become famous he did little of the actual marble cutting himself, leaving this to assistants. He became extremely wealthy, and left the bulk of his fortune to the Royal Academy for the purchase of works of art.

Chapel Royal, the musicians and clergy employed by the English monarch for religious services and, by extension, whatever building these services take place in. Records of the Chapel Royal go back as far as the first year (1135) of King Stephen's reign. The altos, tenors, and basses are known as Gentlemen of the Chapel Royal, and the boys as Children of the Chapel Royal. They are nowadays based at St James's Palace, London.

Chaplin, Sir Charles Spencer ('Charlie') (1889–1977). British actor-comedian and film writer, producer, and director, one of the most notable comedians of all time and a great *mime artist. The son of two music-hall performers, he himself appeared on the stage before he was eight. In the thirty-five *slapstick one-reel films he made for Mack *Sennett and the Keystone Company during 1914 he began to establish the character of the splay-footed tramp, with bowler, baggy trousers, and cane, which became universally popular. His first full-length film, *The Kid* (1920), revealed his pathos and sympathy for the underdog. *The Gold Rush* (1925), *The Circus* (1928), and *City Lights* (1931) were enormously successful; but from then on, unhappy with talking pictures, he made films less frequently. *Modern Times* (1936) had no dialogue, and *The Great Dictator* (1940), which satirized Hitler and marked the tramp's last appearance, was his first film with full sound. Thereafter his popularity declined and he made

Charlie **Chaplin** and his inebriated millionaire acquaint-
ance face an encounter with the law in *City Lights*, one
of his most popular films. Set in the Depression,
it combines comedy scenes with a plot about a blind
flower-girl who recovers her sight thanks to Charlie.

only four more films, of which the sentimental *Limelight*
(1952) was the sole success. He wrote the music for his
last seven films.

charango, the treble *guitar of the Andes with four or
five double or triple courses, set of strings tuned to the
same note. The back may be flat, but is often made of an
armadillo shell, or of wood carved in that shape.

charcoal, charred twigs or sticks used for drawing. Its
use dates back to Roman times and possibly much earlier.
Charcoal is easily rubbed off the drawing surface unless a
*fixative is used, so it has been much favoured for
preparatory work, for example for *cartoons or for out-
lining a design that would be gone over with a more
permanent medium. It has also been used for finished
drawings, however, some artists finding its broad, soft-
edged effects particularly suitable to their style.

Chardin, Jean-Baptiste-Simeon (1699–1779), French
painter of *still life and *genre, in which fields he was one
of the greatest masters of all time. He worked during the
heyday of the elegant, lighthearted *Rococo style, but his
own paintings are completely different in spirit, having a
feeling of deep seriousness in spite of the modest subjects
he depicted. His still-life pictures usually represent objects
from the everyday life of the middle classes to which he
belonged and are painted with unerring simplicity and
directness. His genre scenes are also taken from domestic
life and usually contain only one or two figures, presented
without sentimentality. Much of the beauty of his work
lies in his distinctive technique, subtle textural effects being
captured by the use of richly applied, grainy paint. Late
in life, when his sight was failing, he gave up painting in
oils and turned to pastels, producing some penetrating
portraits. Chardin's work was popular during his lifetime
and he is now one of the most revered artists of the 18th
century.

Charleston, a US ballroom dance of the 1920s, said
to have originated among blacks in Charleston, South
Carolina. It was in fast 4/4 time, with a characteristic
syncopated *ragtime rhythm and involved side kicking
and swinging movements of the body. See also *jazz dance.

Charpentier, Marc-Antoine (c.1645–1704), French
composer. A serious rival of *Lully in his lifetime, he was
associated with *Molière's troupe (Comédie Française),
writing incidental music for its productions until about
1686. It is for the variety and excellence of his sacred
music that he is now remembered. This includes eleven
settings of the mass, ten magnificat settings and over 200
*motets. He was master of a great variety of techniques,
from the rich *polyphony of the old style to the har-
monization of carol tunes in the well-known *Messe de
minuit pour Noël*.

Chateaubriand, Vicomte François-René de (1768–
1848), French novelist and memoir writer. He was, with
Mme de *Staël, a major figure in early 19th-century
French literature. His prose tales, *Atala* (1801) and *René*
(1802), are marked by a vague and melancholic yearning
which became the hallmark of *Romanticism. They were
originally intended to form part of *Le Génie du christianisme*
(1802), a work of Christian apologetics which signalled a
reaction against the rationalism of writers like *Voltaire
and *Diderot. Chateaubriand's memoirs, published post-
humously in 1849–50, are written in the rhythmic, flowing
style which is characteristic of his work.

Chatterton, Thomas (1752–70), British poet. He is
chiefly remembered for his poems purporting to be by an
imaginary 15th-century Bristol monk, Thomas Rowley,
employing a variety of verse-forms, including the ballad.
Notable among them are his Pindaric *ode 'Songe to Ella'
and 'Ælla', and 'An Excelente Balade of Charitie'. In 1770
Chatterton went to London, but within four months,
apparently reduced to despair by poverty, he committed
suicide at the age of 17. The Rowley poems were published
in 1777, and controversy about their authenticity raged
for decades, while Chatterton's own short, tragic life
exercised a powerful effect on the *Romantic imagination.

Chaucer, Geoffrey (c.1343–1400), English poet. Born
in London, he held a number of positions at court and
frequently travelled abroad on diplomatic missions; during
a journey to Italy in 1372–3 he may have met Boccaccio
and Petrarch. His writings develop from an early period
of French influence (culminating in the *Book of the Duchess*,
an allegorical lament, c.1370), through his middle period
of both French and Italian influences, which includes the
dream poems *House of Fame* (c.1374–85), *Parliment of Fowls*
and *Troilus and Cressida* (c.1385), one of the great poems
on love in the English language, to the last period during
which he produced most of his masterpiece, the *Canterbury
Tales* (begun 1387). This consists of a series of twenty-four
linked tales told by a group of superbly characterized
pilgrims (ranging from Knight to Plowman, all introduced
in the *Prologue*), who meet at the Tabard Inn in Southwark,
London, before journeying to the shrine of St Thomas à
Becket at Canterbury. In his heroic *couplets, he es-
tablished the iambic *pentameter as the standard English
metre. Chaucer strongly influenced the development of
*Middle English, and his work is regarded by many as
the starting-point of English literature.

Chavin art *South American Indian art.

Cheever, John (1912–82), US short-story writer and novelist. His *New Yorker* stories satirize the affluent inhabitants of New York's Upper East Side and New England suburbia. Five collections were published from 1943 onwards, and the *Collected Short Stories* appeared in 1982. His earlier novels, *The Wapshot Chronicle* (1957), *The Wapshot Scandal* (1964), and *Bullet Park* (1969), depict the comically raffish lives and eventual decline of a wealthy Massachusetts family during the first half of the 20th century. The prison tale *Falconer* (1977) is a story of human redemption, while *Oh What A Paradise It Seems* (1982) is a novella about an ageing man and his subsequent rejuvenation.

Chekhov, Anton Pavlovich (1860–1904), Russian dramatist and master of the short story. He qualified as a doctor and practised for a while, but abandoned medicine soon after the success of his collected early short stories in 1886. The journalistic humour and trivial subject-matter of these pot-boilers was then replaced by a more serious tone and more weighty themes; however, Chekhov did not lose the lightness of touch and skilled economy of means

Chekhov with his wife, the actress Olga Knipper. A man of great nobility of character, Chekhov was an active humanitarian, whose lesser-known works include a study of the Russian penal colony on the island of Sakhalin, a book that helped to improve convict life. As a doctor he helped to fight two cholera epidemics.

he had learned in his apprenticeship. In the last fifteen years of the 19th century he brought the Russian short story to the high point attained earlier by the novel; among the supreme achievements is 'The Lady with the Little Dog' (1899). Simultaneously, Chekhov was experimenting with dramatic pieces, mainly short. In the four full-length mature plays, *The Seagull* (1896), *Uncle Vanya* (final version, 1897), *Three Sisters* (1901), and *The Cherry Orchard* (1904), as staged by *Stanislavsky at the Moscow Arts Theatre. Chekhov became Russia's greatest dramatist. His plays, which centre on frustrated desires and hopes, delicately avoid melodrama, using understatement, oblique reference, and misunderstanding to achieve dramatic tension. Chekhov's view of human nature and human relationships is elegiac; as in the mature short stories, there are no examples of fulfilled and enduring mutual affection that correspond with social convention. Only the philistine is happy. Hope for a better future is regularly undermined by the pathetic inadequacy of those who express it.

Chénier, André (1762–94), outstanding French poet. An early supporter of the French Revolution, he was executed when he protested against its excesses, and the bulk of his poetry was published posthumously. His best poems, which are imbued with a love of the poetry of ancient Greece, are odes and eclogues grouped under the title *Les Bucoliques*. He was a forerunner of *Lamartine and the Romantic poets in the metrical innovations of his verse and his nostalgia for the glories of the past.

Cherubini, Luigi (Carlo Zanobi Salvadore Maria) (1760–1842), Italian composer. He made his operatic début in 1779, and scored his first great operatic success in 1782. He worked successfully in London (1784–6), but then settled in Paris under royal patronage. He survived the French Revolution and achieved his greatest operatic successes with *Médée* (1797) and *Les deux journées* (The Water Carrier) (1800). In addition to nearly forty operas, Cherubini wrote much sacred music, including two requiem masses (1816, 1838).

Chesterton, G(ilbert) K(eith) (1874–1936), British essayist, novelist, and poet. As a journalist, with his close friend *Belloc, he opposed the agnostic socialism of *Shaw and *Wells. In his first novel, *The Napoleon of Notting Hill* (1904), he develops his political attitudes, glorifying the individual and 'Merry England' and attacking conglomerates, technology, and the monolithic state. These themes echo through his fiction and his many volumes of short stories, the best known of which are those featuring Father Brown, a Roman Catholic priest skilled in the detection of crime by intuitive methods. Chesterton himself became a Roman Catholic in 1922. Much of his vast output is marked by a vigorous celebration of the oddity of life and the character of England.

chiaroscuro, a term used to describe effects of light and shade in a work of art, particularly when they are strongly contrasting. It derives from the Italian words *chiaro* (bright) and *oscuro* (dark). Although it is most commonly used in discussing paintings, it can also be applied to drawings or other works of graphic art. Rembrandt, for example, was an unsurpassed master of chiaroscuro in his drawings and etchings as well as in his paintings. Other artists particularly associated with the use of strong chiaroscuro are Caravaggio and Georges de la Tour.

Chicago School, a term applied to the architects who in the late 19th and early 20th centuries made Chicago the most dynamic centre in the USA in the development of modern architecture, particularly the evolution of the skyscraper. Chicago was almost completely destroyed by fire in 1871 and the city of wood was rebuilt as a city of stone, steel, and glass. The most important new buildings were mainly commercial structures, stores, office buildings, warehouses, and so on, and the economic pressures to build rapidly conditioned the *functionalist approach of their architects. William Le Baron Jenney was the first to use an iron and steel skeleton to construct a multi-storey building (the Home Insurance Building, 1883–5), but the central figure of the Chicago School was Louis *Sullivan.

Chikamatsu Monzaemon *Japanese literature.

children's literature. Children and adults for a long time shared the ancient body of oral folk literature which was later written down and continues to be enjoyed today. The first literature specifically intended for children was educational, and alphabet books became popular with the invention of printing. The most successful of the didactic books inspired by the Puritan movement in Britain and North America was *Bunyan's *Pilgrim's Progress* (1678). This was followed by works written for adults but enjoyed by children, such as *Defoe's *Robinson Crusoe* (1719) and *Swift's *Gulliver's Travels* (1726). In *c.*1765 a collection of nursery rhymes, *Mother Goose's Melody*, was published in England, possibly borrowing the title from Charles Perrault's fairy tales, *Contes de ma mère l'oye* (1697). German fairy tales collected by the brothers *Grimm and first published in 1812 were followed by stories composed by Hans Christian *Andersen in 1835, and Heinrich Hoffmann's surrealist tales in comic verse, *Struwwelpeter* in 1845. Charles *Kingsley's *The Water Babies* (1863) touched on contemporary social problems, but Edward *Lear's *Book of Nonsense* (1846) and Lewis *Carroll's two *Alice* books (1865, 1872) were the first major writings designed for entertainment rather than self-improvement. A realistic portrayal of middle-class family life was recorded in Louisa M. Alcott's *Little Women* (1868), while Mark *Twain's *Adventures of Tom Sawyer* (1876) and R. L. *Stevenson's *Treasure Island* (1883) introduced the adventure tale, and *Kipling's *Jungle Books* (1894–5) brought animal stories into the mainstream of children's literature. The first landmark in poems for children was Stevenson's *A Child's Garden of Verses* (1885). School and 'gang' stories evolved with Thomas *Hughes' *Tom Brown's Schooldays* (1857). Serial publications such as the *Boys' Own Paper* and the *Boys' Own Magazine* were launched in the latter half of the 19th century and were followed by similar publications for girls. Beatrix *Potter's *The Tale of Peter Rabbit* (1900) did much to establish the book in which pictures and text are of equal importance. The 20th century has seen the creation of memorable characters like Billy Bunter (F. Richardson), Dr Dolittle (H. Lofting), Winnie-the-Pooh (A. A. *Milne), Mary Poppins (P. L. Travers), Emil and the Detectives (Erich Kästner), the Moomintrolls (Tove Jansson), Pippi Longstocking (Astrid Lindgren), Tintin (Hergé), Asterix (Goscinny), and Tolkien's Hobbits. Among today's leading writers are Roald Dahl, Leon Garfield, Rosemary Sutcliffe, Tony Ross, Janet and Allan Ahlberg, Judy Blume, the Canadian Monica Hughes and the poets Roger McGough, Michael Rosen, and Ted Hughes. (See also *book illustration.)

The Guaranty (now Prudential) building (1894–5), in Buffalo, New York State was designed by Louis Sullivan, the dominant figure of the **Chicago School**, and is often considered his masterpiece. Although the design is strong and lucid, Sullivan was also a master of decoration, and the building is delicately faced with ornamental terracotta.

Chimū art *South American Indian art.

Chinese art and architecture. China has the longest cultural tradition in the world, with a continuous history of more than 3,000 years. Its art is significant not only because of its beauty and richness, but also because it has been a major source of inspiration for the entire Far East— Japan, Korea, Tibet, Mongolia, and Central Asia. Europe, too, owes many artistic impulses to China (see *chinoiserie), as well as the introduction of various techniques, particularly in pottery and textiles (see *silk). Attitudes towards the arts have been very different in China from those prevailing in the West. The scholarly amateur, for example, has generally been accorded a higher status than the professional, and there has been no distinction between 'fine' and 'applied' arts. Indeed, in China the art of handwriting—*calligraphy—has long been regarded as the noblest form of art. Painting was a development of calligraphy, and even today the two are closely related. The painter, instead of painting his pictures on canvas or wood in oil colours, usually worked on silk or paper in water-colours, and the vitality and rhythm of the brush-strokes were generally more important than naturalism of representation. The sculptor not only worked in stone, wood, or bronze, but also sometimes modelled or

There was a renaissance in **Chinese art** under the Tang dynasty, reflected in the vitality of ceramic production and in the development, in particular, of new glazes. Amongst the most interesting Tang wares are the lifelike tomb figures, such as the guardian figure shown here. Tradition dictated that a tomb be provided with six figures: two demons, two guardians, and two officials. (British Museum, London)

coated his statues in *lacquer, an art-form that originated in China. *Porcelain, also, was first made in China, more than a thousand years before the secret of its manufacture was discovered in Europe in the early 18th century. *Jade is another material that is associated above all with China, being used for ritual objects, ceremonial weapons, jewellery, and small sculptures. In architecture, wood is the most important material. Houses are often of only one storey and spread over large areas, with gardens and courts between the various wings, though palaces, temples, and pagodas are higher. Roofs do not cover only the types of buildings with which they are associated in the West; they are also put over gateways, bridges, walls, and monuments. Several roofs are often piled one on top of the other and the edges bent up in graceful curves, forming one of the most distinctive features of Chinese architecture. After a fairly obscure prehistoric period, the evolution of Chinese art can be divided into five long periods, for which, however, there are no very distinct boundary lines. Definite records date back to the second part of the Shang dynasty (1711–1066 BC), the most important surviving works from

this time being bronze sacrificial vessels of severe form, decorated chiefly with animal motifs that have a religious significance. The second period begins when China was united in 221 BC under the Qin emperor Shi Huangdi, the builder of the Great Wall of China. Objects of bronze and jade are the most important examples of the art of the period; in addition, glazed earthenware vessels and tomb-figures have been found. One of the most important events of the Han period (206 BC–AD 220) was the introduction of Buddhism from India and Central Asia, for Buddhist temples and monasteries became great patrons and repositories of the arts. The best-preserved temples are those which, following Indian prototypes, were hewn into rock faces. They were decorated with sculpture and frescos. These cave temples belong to the third period of Chinese art, the climax of which is reached in the Sui (581–618) and Tang (618–907) dynasties, when China was united after a time of invasions and civil war and all branches of art flourished. The 10th century marks the beginning of the fourth period, which culminated in the Song dynasty (960–1279), when Chinese art reached its peak. The greatest achievement of these centuries was the evolution of pure landscape painting into a major art-form, long before Europe conceived of such a possibility. No less important, however, was the pottery of this period, unsurpassed for nobility of form and beauty of decoration. The last great period of traditional Chinese art covers the reign of the Ming emperors (1368–1644) and the last Chinese dynasty of the Manchu or Qing (1644–1911). Painting and pottery remained at a high level and new porcelain techniques were evolved, notably blue underglaze painting and the use of enamel colours over the glazing. Outstanding skill was shown also in *ivory and *jade carving and in *cloisonné enamel. In the 20th century a combination of Western influence and revolutionary upheaval undermined traditional Chinese art. Since the communist revolution of 1949 avant-garde movements have been branded as 'bourgeois formalism'. However, the revolution also brought a revival of traditional art-forms, with people being taught to value their artistic traditions, and much valuable restoration and discovery of new artistic treasures from the past have resulted.

Chinese bronzes. China has one of the world's greatest traditions in *bronzework and the early ritual vessels for which it is particularly famed are regarded as being among the world's supreme masterpieces of metalwork. Dating mainly from the Shang (18th–12th century BC) and Zhou (c.1066–256 BC) dynasties, such vessels were used in sacrificial ceremonies honouring ancestors. Many different types have been classified, including the *ding* (a tripod), the *pan* (a basin), and the *guang* (an oval-shaped vessel with a lid). The method of casting involved ceramic piece-moulds, as opposed to the *cire-perdue process used in the West. There was considerable variation in the composition of the metal, with often a high proportion of lead in the alloy. This variability has contributed to the rich variety of patina (a surface discoloration occurring naturally with time or artificially induced) for which Chinese bronzes are renowned; their multi-coloured, mottled, and cloudy effects are unparalleled elsewhere. It is not only their beauty for which these bronzes are so highly regarded; to the Chinese they are also of great significance because their inscriptions are unique documents of their history. Decoration is often extremely elaborate and dense and can prove difficult for scholars to

elucidate. Frequent motifs are a *taotie* (a demon or ogre mask), a dragon, birds, oxen, sheep, and goats, and a background of 'thunder' or stylized cloud pattern. Apart from ritual vessels, mirrors are perhaps the field in which Chinese metalwork is richest. One side was polished to reflect an image of the face and the other was decorated with geometrical, animal, or human-like ornamentation, sometimes of magical significance. Superb examples were made from the Han (206 BC–AD 220) to the Ming dynasty (1368–1644). Bronze has also been used for religious statues, incense-burners, and other Buddhist cult objects.

Chinese ceramics, the *pottery and *porcelain of China. China has the greatest tradition of pottery-making in the world. The country's acknowledged pre-eminence stems not only from the sheer beauty and technical accomplishment of its products, but also from the enormous influence they have had in both Asia and the West. The use of the word 'china' as a general term for any porcelain or porcelain-like products shows how closely the country is identified with ceramics. Pottery has been made in China from as early as the 3rd millennium BC. Some early examples are of outstanding quality, with splendid painted decoration, but it is only from the Han dynasty (206 BC–AD 220) that a continuous tradition begins, low-fired, lead-glazed *earthenware being made in large quantities for use in tombs. As well as vessels, tomb models were made, giving a picture of life at the time, with granaries, houses, fish ponds, animals, and games reproduced in clay. High-fired wares were also made, developing into the Yue wares of the Six Dynasties (251–589) and Tang (618–907) periods. These were *stoneware, fired to a temperature of about 1,200°C and covered in a green *celadon-type *glaze, the result of a small amount of iron oxide in the glaze and a reducing atmosphere during firing. Foreign motifs, such as the lotus (from Buddhist imagery) and lion masks (from Sassanian metalwork) often appear on

ceramics of the period. Tang ceramics are noted for the dynamic beauty of their shape and for the brightly coloured glazes used in funerary wares. However, the most important feature of Tang ceramics was the perfection of the fine pottery known in the West as porcelain in the 7th or 8th century. The Song dynasty (960–1279) was the golden age of Chinese ceramics, with famous kilns in both northern and southern China. The simple elegance of form and colour in Song porcelains and stoneware contrasts with the more ornate decorations of the Tang. Jingdezhen, in south-eastern China, became the most important ceramic centre from the Yuan dynasty (1279–1368) onwards. Underglaze cobalt painting started to be used at this time on the porcelain for which this area became famous. The cobalt blue had already been used on earthenware in Persia and Mesopotamia and was imported into China by Muslim traders, thus acquiring the name 'Mohammedan blue'. The Chinese improved control of the blue pigment so that it could be used for detailed brushwork. During the Ming dynasty (1368–1644), this 'blue and white' ware reached an unsurpassed level, particularly in the 15th century. Overglaze enamel colours were introduced in the 16th century, first in combination with underglaze blue (*doucai* or 'contending colours') and later on their own. During the Qing dynasty (1644–1911) 'famille verte' enamels became popular in the reign of Emperor Kangxi (1662–1722) and *'famille rose' in the reign of Emperor Yongzheng (1723–35). The pink used in 'famille rose' enamels was derived from colloidal or opaque gold and was probably introduced from the West by Jesuit monks at court. The ceramic complex at Jingdezhen was managed by able directors during the 18th century and enjoyed court patronage, notably that of the Emperor Qianlong (1736–95), a great art patron and collector. Technical quality was extremely high and there were innovations in monochrome glazes such as the 'sang de boeuf' red, 'tea dust' green, and 'robin's egg' blue. Another important kiln site was in Dehua, Fujian province. This produced the fine white porcelain, left unpainted with a milky glaze, that came to be known as 'blanc de Chine' in the West and was very popular in Europe in the 17th and 18th centuries. Chinese porcelain was such a rarity in the West before the 17th century that pieces were mounted in gold, but thereafter an enormous export trade grew up. Because of its high kaolin (a very fine white clay) content 'blanc de

Under the Ming dynasty porcelain with blue-and-white under-glaze decoration, such as this bowl, became a predominant part of **Chinese ceramic** production. Much of such porcelain was made for export, and the largest surviving collections are in Iran, Turkey, and Indonesia. The rather intricate decoration was not according to Chinese taste, and one 14th-century Chinese writer termed blue-and-white wares 'very vulgar'.

Chine' was difficult to throw and was therefore mostly cast in moulds, creating some of the most beautiful of all porcelain figures. Chinese ceramics from later than the 18th century have generally been regarded as (at best) slick derivatives of earlier types. Certainly they cannot compete with past glories, but imperial wares of the 19th and early 20th century have recently begun to enjoy increased favour.

Chinese dance *East Asian dance.

Chinese decorative arts. The Chinese have excelled in many fields of the decorative arts, but certain of them are associated with China above any other country. China was the first—and for long the only—country in the world to produce *silk. Production began there perhaps as early as 3000 BC and by the Han dynasty (206 BC–AD 220) the material was being exported to Greece and Rome along the Silk Road across Central Asia. The *kesi* or 'cut silk' technique of tapestry weaving was introduced in the Tang dynasty (618–907) and developed in the Song dynasty (960–1279). It was applied to a variety of decorative patterns, featuring floral, bird, and animal subjects. Embroidery was also a field in which the Chinese showed great skill. The earliest examples date from the Han dynasty, and some of the finest are from the Ming dynasty (1368–1644), when a favourite theme was birds, usually the phoenix or mandarin duck, amid highly stylized cloud and landscape forms. Embroidery sometimes used metal threads. Other decorative arts, rather than being native to China, were introduced from the West, for example *cloisonné* enamels, which began to be made in China in the Yuan dynasty (1279–1368). Painted 'Canton' enamels were particularly popular in the Qing dynasty (1644–

1911), for the most part using the *famille rose palette. The flow of influences between East and West was often circular, a prime embodiment of this in the decorative arts being the snuff bottle. Snuff was introduced to China by the Portuguese in the 17th century and soon became highly popular. The Oriental method of taking it was more refined than that prevailing in Europe, a spoon rather than the fingers being used to extract the powder from its container. In the West snuff was generally kept in boxes, but the Chinese favoured miniature bottles, which were made in a great variety of materials and often exquisitely decorated. Porcelain and glass (first made in China as early as the Eastern Zhou dynasty, 770–256 BC) were the most common materials, but virtually any substance that could be made into an airtight container and suitably embellished (including a variety of stones) was used by ingenious Chinese craftsmen for snuff boxes. They were brought back to Europe in great numbers, mainly to be used as ornaments rather than as snuff containers, and have continued to be an extremely popular area for collectors of Chinese decorative arts. Many other types of objects bear witness to the Chinese genius for exquisitely delicate carving on a small scale, notably items for the scholar's desk such as figures of popular gods and immortals. Ivory, wood, bamboo, and rhinoceros horn are among the materials with which Chinese carvers have worked.

Chinese drama. Traditional Chinese drama, a mixture of music, dancing, mime, recitation, and acrobatics, goes back many centuries. It has a code of symbolic gestures and intonations that have been refined to an extreme of stylization. Early recorded performances took place in the Song dynasty (960–1279) capital, Kaifeng. A northern or mixed episodic narrative drama (*zaju*) flourished during the Yuan dynasty (1279–1368): its leading writers were *Guan Hanqing and Wang Shifu, author of *The Western Chamber*. Ming (1368–1644) drama was based on the southern styles of the Suzhou area and its greatest exponents were *Tang Xianzu and Kong Shangren (1648–1718), whose *The Peach Blossom Fan* sets a love story between a poet and a courtesan during the collapse of the Ming dynasty. By the late 18th century Beijing opera, based on traditional stories or historical events rather than original plots, was beginning to supplant these earlier styles. Western-style spoken drama came to China with the 'new culture' that followed the 1919 May Fourth Movement directed towards the emancipation of the individual, and the rebuilding of a modern national society and culture, and attracted a certain amount of interest among educated people. Tian Han (1898–1968) and *Cao Yu were among the pioneer playwrights. *Lao She straddled the divide between pre- and post-1949 China and although better known as a novelist and short-story writer, wrote highly successful plays, including *Teahouse* and *Dragon Beard Ditch*.

Chinese literature (traditional). One of the major literary heritages of the world, it has profoundly influenced the literary traditions of other Asian countries, particularly Japan, Korea, and Vietnam. It has a virtually uninterrupted history of some 3,000 years, a timespan unequalled anywhere else in the world. The sheer quantity is also awe-inspiring: from the Tang dynasty (AD 618–907) alone, over 48,000 poems by more than 2,000 authors have survived. This body of literature has remained familiar to generations of Chinese scholars. The Chinese wrote their

Textiles are among the glories of **Chinese decorative art**. This is a detail of an emperor's marriage robe, dating from the 19th century. It shows the imperial dragon (representing good fortune). Various other symbolic images include the axe, which indicates the emperor's power to punish. (Victoria and Albert Museum, London)

earliest preserved texts on bone and tortoise shell and in inscriptions on bronzes. Later they wrote on silk and wood. Paper was invented in about the 1st century AD, and China also developed (8th century AD) the first printing techniques in the world. Chinese literature has been divided into two streams: the so-called classical or literary style, set by the ancient writers, and the vernacular, consisting of writings in the living tongue of the authors. Among the former are the *Confucian scriptures, history, philosophy, and collected works of poetry and prose. Fiction and drama were largely excluded, as being too trivial. The first major works were the texts of Confucian literature (c.500 BC), among them the *Shijing or Book of Songs (an anthology of poetry which includes the I Ching (Yi Jing or 'Classic of Changes'), a fortune-telling manual which later became popular with Western diviners), the Analects, and The Book of Mencius. All were written in the classical Chinese language, which was to be the vehicle for all recognized literature up to the 20th century, effectively restricting it to a scholarly élite. Non-Confucian philosophical texts such as *Zhuangzi, Mozi, and the Dao De Jing ('Classic of the way and its power'), traditionally ascribed to Laozi, also have considerable literary merit and influence. Some of the finest writing can be found in early historical texts such as the Intrigues of the Warring States, the series of dynastic histories that began with the Historians' Records of Sima Qian and the Han Shu (History of the Han Dynasty), and Chronicles like Sima Guang's Comprehensive Mirror for Aid to Government in the Song dynasty (960–1279). Translations of Tang and Song poetry strongly influenced the modern *Imagist school of English-language poetry. *Chinese poetry was always highly esteemed and the poetic tradition can be traced back to the *Shijing before 600 BC and *Qu Yuan of the 3rd century BC, with a high point during the Tang dynasty represented by *Du Fu and *Li Bai. These two friends were polar opposites, Du the humane Confucian moralist and Li the reckless Daoist. Harmony between man and nature, a constant theme in Chinese poetry, can be seen in the work of Wang Wei of the same period. *Chinese drama was originally a combination of music, mime, and spoken dialogue and developed into a form more like Western opera than spoken word drama. Traditional drama became very popular during the Mongol Yuan dynasty (1279–1368), when Chinese culture was repressed by the invaders and *Guan Hanqing wrote his famous play Injustice to Dou E. *Tang Xianzu of the Ming dynasty (1368–1644) and author of the Peony Pavilion was perhaps the major lyrical playwright of imperial China. There is a tradition of short stories in classical Chinese beginning in the 8th century and culminating in the 17th-century Tales of Liaozhai by *Pu Songling. A centuries-old popular tradition of story-telling on street corners, in the teahouses, and by the river bank just survives today. Fiction, drawing on this tradition, and written in a language much closer to the spoken vernacular of its day, was collected during the Ming dynasty, and it was during this period that the great *Chinese novels such as *Water Margin, with its tales of the daring deeds of an outlaw band, the magical satire *Monkey, and *Romance of the Three Kingdoms emerged. It was during the succeeding Qing dynasty (1644–1911) that this fictional tradition saw its most sophisticated achievements, with *Dream of the Red Chamber and The Scholars. In the 20th century Chinese writers felt that their inherited literary tradition had stagnated and needed radical changes (see *Chinese literature (modern)).

Chinese literature (modern), the literature of modern China, beginning in the years leading up to the May Fourth Movement of 1919: the nationalist movement in which intellectuals grappled with Marxism and liberalism in their search for reform. Its authors committed themselves to write in the vernacular language rather than classical Chinese. They questioned traditional values and Confucianism. They took a great interest in Western literature and made various attempts to copy western styles, not always successfully. Soviet influence was quite marked in the 1920s. The most remarkable figure of the new literature was *Lu Xun; other major writers included Hu Shi, scholar, poet, and the champion of vernacular writing; Ba Jin, the author of the trilogy Family, Spring, and Autumn; Mao Dun, whose Midnight is a realist novel set in Shanghai; Yu Dafu, a short-story writer whose alienated characters are very close to those in the Japanese 'I-novels'; *Lao She; and the poets Wen Yiduo and Xu Zhimo. After Mao Zedong's 'Talks at the Yan'an Forum on Literature and Art' in 1942, in which he decreed that literature existed to serve politics and should be written for a proletarian readership, it became impossible for writers to separate politics from any literary genre. In the 1950s, after the formation of the People's Republic, Chinese writers took Soviet *Socialist Realism as their model. In 1956–7 there was a brief period of flowering of critical literature inspired by the Hundred Flowers Movement of self-criticism, but revolutionary romanticism took over with the Great Leap Forward of 1958, when culture became synonymous with industrial and agricultural expansion. By the time of the Cultural Revolution (1966–76) control over literary activities was complete. Traditional Chinese cultural expression was banned as bourgeois, while modernist writers and artists were purged as anti-socialist. The reform programme which began in 1978 has released great literary forces, beginning with the 'wound' literature from the generation damaged by the Cultural Revolution. Despite evidence of more repressive forces, the 1980s saw a proliferation of literary journals and the emergence of works reflecting the dramatic social and psychological effects of transition from a rural to an urban society.

Chinese music, the music of the people who call themselves Han, living in an area comprising present-day China plus Taiwan and Hong Kong, but excluding the autonomous regions like Tibet. For over 4,000 years music has played an important role in Chinese society. There is a Confucian tradition that sees music in terms of its value to people, and two Confucian texts from the first millennium BC, the Book of Odes and Book of Documents, attest to music's philosophical and educational power. The Han emperor Wudi (156–87 BC) sought to control this power by founding a Bureau of Music, which established the yayue or court ritual music of imperial China. It also maintained the correct *pitch-standards for the 12 lü, pitches of legendary origin derived from the fundamental huangzhong and already by the 3rd century BC organized to produce the Pythagorean *scale, from which the pentatonic and heptatonic scales characteristic of Chinese music were extracted for practical application. In the early 7th century AD the Sui emperor Wendi (581–604) established seven orchestras (later nine under Tang emperors) specializing in different Chinese and various foreign musical styles (such as those from Korea, India, and other neighbouring cultures): these were the source of spectacular ceremonial entertainment (yanyue). The Song

period (960–1279) saw the collection of many ancient Chinese song-texts and the development of *gongche* notation, which used symbols to indicate pitch and symbols for rhythm. This replaced an earlier 6th-century *tablature notation, the *jianzi pu*. Dramatic genres were developed widely in the Ming and Qing dynasties (1368–1911), notably the *gaoqiang* and *kunqu* operas, the former based on folk-song, the latter a synthesis of literary drama and refined musical composition. Both exploited the close correlation between the tonal Chinese language and music to determine melodic shapes and heighten drama. The Ming dynasty is also important for the theoretical works of Prince Zhu Zaiyu, who in the 16th century organized the twelve *lü* into an equal-tempered scale some 100 years before this was done in the West. In the 19th century Beijing opera was consolidated. This combined speech, song, instrumental music, dancing, and acrobatics to enact myths and historical tales in a heavily stylized ritual where gesture and symbols were imbued with great significance. Actors, all male until 1910, were traditionally divided into four types: *sheng*, male roles; *dan*, female; *jing*, warriors or statesmen; and *chou*, the jester. However, many of the above traditions have been discarded by modern revolutionary China, which has witnessed an increasing Westernization of musical culture.

Chinese musical instruments.

Many Chinese instruments are of great antiquity. The large number of ceremonial gongs, bells, and stone and wooden percussion instruments, and also the *zheng* and *guqin* (both *zithers; see *koto*), and *sheng* (a type of *mouth-organ) date back 3,000 years. Amongst stringed instruments, the *sanxian* (a lute, see *shamisen*), *yueqin*, and *jinghu* (bowed lute) are important in operatic genres, while the *pipa, *yangqin* (lutes), and *erhu* (bowed lute) are used in virtuoso solos and ensembles. The most refined instrumental music is the solo repertory of the *guqin*, played by scholars and literati; the pieces, some of which are hundreds of years old, are *programmatic in content, and exploit a wealth of different sonorities and tonal effects, encoded in an elaborate tablature notation. After a period of ideological supression this music, though never widely popular, is once more to be heard in China.

Chinese novel.

Novels appeared in the Ming dynasty (1368–1644) and many were written in a style close to the vernacular rather than the classical Chinese favoured by the scholar élite. The best-known novels of imperial China are *Dream of the Red Chamber*, *Monkey*, *Romance of the Three Kingdoms*, *Water Margin*, and *The Golden Lotus*, a 16th-century chronicle of the conflicts in the life of a merchant's family with unusually frank sexual detail. Others include *The Scholars* by Wu Jingzi (1701–54), a satire on the corruption and shallowness behind the façade of official probity, and *The Travels of Lao Can* written by Liu E in 1904–7 just before the downfall of the Qing dynasty (1644–1911). Modern novelists emerging from the May Fourth Movement included *Lao She and Mao Dun, who chronicled urban social conflict, and Ba Jin, author of the trilogy *Family*, *Spring*, and *Autumn*. Post-1949 novels were constrained by Socialist Realism, but reflect the turmoil of China's revolution. *The Sun Shines over the Sangkan River* by Ding Ling is based on her experience of land reform and Zhao Shuli's *Rhymes of Li Youcai* draws on the same period with a vein of folksy humour.

Chinese painting.

Chinese painting is very different in spirit from that of the West, being primarily an expression of a philosophical attitude rather than a form of decoration or illustration. It was practised mainly by the intellectual élite, who found painting elevating to the spirit and cleansing to the mind. Subjects tend to be calm and reflective rather than dramatic, and the painter brought to his art a deep knowledge not only of the work of earlier painters but also of philosophy and poetry. Collectors and admirers (as well as the artists themselves) sometimes added their own poems or comments to the painting or its mount, and these often increased its interest to the connoisseur. Although there were great individualists and eccentrics such as *Muqi and *Zhu Da, originality counted for little, the same types of subject being treated over and over again. Rather, painters were aware of their position as part of a great tradition and often worked in the style of artists from an earlier generation as a sign of respect. Recognizing such stylistic allusions was an essential part of the enjoyment of the picture. Individuality was greatly valued, however, in the handling of paint. The artist painted with the same type of brush used by the *calligrapher, and the brushwork of a master painter was as fluent and personal as handwriting. Years of disciplined practice were required to obtain complete mastery of the brush, for there could be no overpainting or erasure. Although murals have played a part in Chinese art, painting was most characteristically a private art, pictures being contemplated by the connoisseur in his home rather than publicly displayed. They were fragile objects on paper or silk, and were reverently handled; when not being viewed they were stored in special cases, often of beautiful workmanship. Paintings took various forms: notably the screen (one-panel or folding); the hanging scroll; the hand-scroll, which was gradually unrolled from right to left; the album leaf, a single picture mounted on sheets of stiff paper or bound between brocade covers; and the fan. The painter worked sitting on a low stool or on the floor with his paper or silk laid on a table. Brushes were tipped with the hair of deer, goat, or wolf, and ink was made of soot mixed with resin, dried and moulded into sticks. It was crushed on an ink-stone and mixed with water, the tone of the ink depending on the amount of water used. By skilfully manipulating the tip of the brush the painter could produce a fine or thick line and the ink could also be spread out in a wash. Many pictures were virtually monochromatic and can be regarded as drawings as much as paintings, but the artist also had vegetable and mineral colours at his disposal. Although fragmentary survivals and literary records show that the beginnings of Chinese painting go back much earlier, it is only from about the 5th century AD that a continuous history can be traced. *Gu Kaizhi is the first painter about whom anything is known but the earliest large body of painting to survive comes from a complex of Buddhist cave-shrines at Dunhuang. This is at the Chinese end of the Silk Road, accounting for the foreign influence from Central Asia. Magnificent paradise scenes depict Buddhas and Bodhisattvas amongst brightly coloured landscapes (see

Chinese bronzes show superb technical skill and great richness of invention in decorative treatment. This Shang dynasty (c.1525–c.1027 BC) ritual vessel, *right*, is in the form of a tiger protecting a man. Their bodies are covered with animal motifs relating to a fertility cult. (Musée Cernuschi, Paris)

*Buddhist art). Figure painting continued to be important during the Tang dynasty (618–907), when scenes of court life and historical subjects were much favoured. There was also a good deal of Buddhist wall painting, but this has almost all disappeared, and the Tang period is now regarded as being most important for the rise of landscape painting, a form of art in which China has an unrivalled tradition. The Song dynasty (960–1279) saw the culmination of landscape painting, and under enlightened court patronage the imperial academy of painting attained equal status with the literary academy. Most remarkable of imperial patrons was the Emperor Huizong (1082–1135), who had a superb collection of pictures, sponsored the compilation of a series of artists' biographies, and was himself a painter and calligrapher of considerable stature. He painted various subjects, but is most renowned for pictures of birds and flowers. Still life became particularly popular at this time, with ink pictures of bamboo being so favoured that they developed into a recognized branch of painting of their own. Bamboo assumed such great significance because its pliant but resilient trunk symbolized the perfect gentleman, the superior man who adapted himself with the times but remained unchanging in his inner moral character. In 1260 the Mongols overran China and ruled until 1368. Many scholars, painters, and bureaucrats refused to serve under the foreigners, preferring to escape into the countryside, and the court ceased to be the hub of art. Imperial patronage was reintroduced in 1368 under the Ming dynasty (1368–1644), but the academy never regained its former importance. Professional painters of the Zhe school showed great technical skill, but these were overtaken in importance by the scholar-amateur painters of the Wu school based in Suzhou, of which *Wen Zhengming was perhaps the most illustrious representative. Several of the emperors of the Qing dynasty (1644–1911) were art enthusiasts and they greatly enriched the imperial collections. Technical mastery remained at a high level, but by the 19th century Chinese painting had—as a whole—degenerated into a rather sterile reworking of old formulae. At present, the traditional style of painting is enjoying a resurgence after the oppression of the Cultural Revolution (1966–76), a movement that encouraged revolutionary ideals. Some painters who have been exposed to Western art show ambitious but rather derivative combinations of Western and Chinese methods.

Chinese poetry. Educated people in China were expected to be adept in the arts of poetry, calligraphy, and painting, which complemented each other: a painting would often have a poem written on it in exquisite calligraphy. All Chinese poetry is chanted; traditionally it was sung to the accompaniment of music. The earliest collection of poetry, consisting of temple, court, and folk songs, is the *Shijing ('Classic of Poetry', c.551–479 BC), and *Qu Yuan is the earliest poet known by name. In the courts of the Han emperors (206 BC–AD 220), a rhymed prose form known as *fu* (rhapsody) developed, but by the end of the 2nd century there were also short poems with five-syllable lines based on popular songs. The Tang dynasty (618–907) was the golden age of Chinese poetry, when the likes of *Du Fu, *Li Bai, *Bai Juyi, the Buddhist landscape-painter and nature poet Wang Wei, and the macabre Li He, poet of the supernatural were writing, mostly in *shi* form, with lines of equal length. A new style, the 'long and short line' *ci* began in the late Tang and was developed by Song dynasty (960–1279) poets including

Fan Chengda and *Su Dongpo. After the Mongol suppression of Chinese culture during the Yuan dynasty (1279–1368), classical Chinese poetry saw little new development. Ming (1368–1644) and Qing (1644–1911) poets like Tang Yin (1470–1523) and Yuan Mei (1716–97) lacked the originality and freshness of their predecessors. Modern poetry began after the May Fourth Movement of 1919 and sought to free Chinese culture from traditional restraints; it was heavily influenced by Western styles, but not always successfully. Hu Shi took an interest in *Imagism (which in turn had been influenced by early Chinese poetry) and Guo Moruo read much Walt *Whitman. Wen Yiduo's (1899–1946) *Red Candle* is accessible to Western readers. Poetry since 1949 has not been particularly distinguished, although Mao Zedong and other leaders wrote verse following the example of imperial officials. It is popular, heartfelt, and dramatic, but less likely to last than the work of Bei Dao, Gu Cheng, and other young poets of the 1980s.

chinoiserie, the imitation or evocation of Chinese styles in Western art and architecture. The term is applied particularly to art of the 18th century, when pseudo-Chinese designs in a whimsical or fantastic vein accorded well with the prevailing lighthearted *Rococo style. By the middle of the 18th century the enthusiasm for things Chinese affected virtually all the decorative arts, and there was also a vogue for Chinese-style buildings in garden architecture, one of the most famous examples being Sir William *Chambers's pagoda in Kew Gardens (1763). The taste for chinoiserie faded during the dominance of the *Neoclassical style in the second half of the century, but there was a revival in the early 19th century.

Chippendale, Thomas (1718–79), British *cabinet-maker and furniture designer. He is the most famous name in the history of English furniture, mainly on account of his book *The Gentleman and Cabinet-maker's Director*, which was first published in 1754. This was the first comprehensive book of furniture designs and was immensely influential in Britain and the USA. Many of the designs exemplify the Georgian tradition of solidity and sobriety, but Chippendale also introduced influence from the French *Rococo style and Gothic and Chinese detailing. The amount of furniture that can be certainly identified as coming from Chippendale's workshop is fairly small, so the expression 'a Chippendale chair' means one in the style of the designs in his book, rather than one made by his own hand. His eldest son, Thomas Chippendale the Younger (1749–1822), continued the family firm.

Chirico, Giorgio de (1888–1978), Italian painter, the originator of *Metaphysical painting. This style, which he invented around 1913, evokes a dreamworld. This was achieved partly by unreal perspectives and lighting, partly by the incongruous juxtaposition of realistically painted objects, and partly by the use of strange conventions whereby, for example, tailors' dummies were used instead of human figures. Metaphysical painting was short-lived and had few exponents (apart from de Chirico, *Carrà was the most noteworthy figure), but it was a major influence on *Surrealism. In the 1920s he painted his most powerful and disturbing works, but in 1930 he broke with this style to concentrate on technical works with little of the earlier strangeness, and set himself against modern art.

choir, a balanced group of singers performing, usually, in parts. The choir may be of mixed voices (soprano, alto, tenor, bass), or of male or female voices only. The term was originally applied to church singers, but is now found also in general use for choral societies and the like. The term 'chorus' usually implies an operatic choir.

Chōla sculpture, the sculpture associated with the Chōla dynasty of south India. The dynasty ruled from the mid-9th century until 1279 and its kingdom was mainly on the Coromandel Coast. Its greatest artistic achievement was in bronzes, which were produced for temple worship using the *cire-perdue technique. Many depict the god Shiva, notably in the form of Shiva Naṭarāja—four-armed Shiva dancing within a halo of fire. The finest examples are from the 10th century, combining vitality with serenity and elegance.

Chopin, Fryderyk Franciszek (1810–49), Polish composer and pianist. The son of a French father and Polish mother, he settled permanently in Paris in 1831. After 1838 he withdrew from the concert platform and concentrated upon the composition of piano music of brilliant virtuosity and passionate intensity. Being often based on Polish folk-dance forms and rhythms, his music was rightly perceived to have strong nationalistic significance. Throughout his composing career Chopin explored and exploited the possibilities of the rapidly developing *pianoforte with an intensity and exclusivity that has scarcely been equalled. Despite his far-reaching harmonic innovations, his delight in unusual pianistic textures, and his ability to handle subtle improvisatory forms, such as the *nocturne, *polonaise, and *ballade, the core of his genius lay in his melodies. His much-publicized love affairs (particularly that with the novelist George *Sand), persistent ill-health, and an untimely death have made him the archetypal 'romantic' composer.

Chopin, Kate (O'Flaherty) (1851–1904), US novelist and short-story writer. Born in St Louis, she achieved celebrity as a regional writer with the stories of Creole and Cajun life in Louisiana, collected in *Bayou Folk* (1894) and *A Night in Arcadie* (1897). Her masterpiece *The Awakening* (1899), a novel about a woman's adulterous inclinations, caused a storm of criticism that ended her literary career because readers of the time were shocked by the realistic treatment of morbid psychology in the objective account of mixed marriage and adultery.

chorale, the simple congregational verse-hymn of the Lutheran Church. J. S. Bach's harmonizations are particularly fine. Chorales became an important means of spreading the Lutheran gospel, achieving such popularity and spiritual authority that they came to be used as the basis for extended compositions which were, in effect, meditations upon their religious significance. Chief among these compositions was the chorale prelude, in which the chorale melody is presented, either whole or in stages, in an elaborate web of organ *polyphony that is itself derived from the chorale.

chord, any combination of more than two musical notes sounded simultaneously. Two notes sounded together are called an *interval. The use of chords—their logical progression one to the other—forms the basis of *harmony and helps to define the *tonality of a piece of music.

This **Chōla** bronze depicts Shiva as Nataraja, the lord of the cosmic dance which reveals both his creative and his destructive powers. In his upper right hand he holds the drum which vibrates to announce creation and in his upper left the flame of universal conflagration. His lower right hand is raised in the gesture giving freedom from fear while the lower left points towards his left foot lifted aloft in a gesture of release. His right foot crushes the dwarf Apasmara, the demon of ignorance and materialism. (Musée Guimet, Paris)

Chords are commonly regarded as pleasant (concordant) or unpleasant (discordant), though the degree of their consonance and dissonance is as much a matter of subjective perception as acoustic fact. In general, however, the ear expects a discord to resolve itself on to a concord. This is one way by which music is given a sense of forward movement. When the notes of a chord are played in sequence, from top to bottom, or vice versa, the effect is described as an arpeggio.

choreography, the process of arranging or designing dance. The word is derived from the Greek for dancing (*khoreiā*) and writing (*graphos*), and was originally used by Feuillet to describe his system of *dance notation. Later in the 18th century the word came to mean the art of creating dances, the sense in which it is used today. Thus choreographing is a Western invention. Many forms of dance do not recognize choreographers or 'owners' of certain dances, though individual dancers may create or improvise variations on traditional movements. Choreographers almost never write a 'score' as a composer might, rather they create directly on the dancers, only writing the work down afterwards, if at all. Some choreographers begin with a very clear idea of the movements they want to use: *Petipa constructed tiny models, while *de Valois and *Cunningham plan meticulously on paper. Others

like *Ashton might depend a great deal on the dancers for inspiration, and *modern or *postmodern choreographers may use improvisation to create material, or even in the finished pieces. Music was for hundreds of years the major inspiration for dance, and such 20th-century choreographers as *Balanchine and *Alston still start from a musical score. Many formal choreographic devices are analogous to those used in music, such as motif and development, canon, and repetition. Similarly, form may be derived from narrative or action, as in many *ballet works. In modern and postmodern choreography a new form may be devised for each individual work. Cunningham uses chance methods to determine parts of his choreography, and postmodernists like Trisha *Brown explore the use of accumulation and other rule-based games.

chorus (in Western theatre), in *Greek theatre a group of actors who stand aside from the main action of the play and comment on it, often in general terms. Euripides made less use of the traditional chorus, concentrating some of its functions in one person who was much more closely concerned with the fate of the protagonists. In the comedies of Aristophanes the chorus performs the same function as in the tragedies, but points up the satire of each play by being dressed in some relevant disguise—birds, frogs, wasps—and by being more closely concerned in its comments with the intimate and bawdy aspects of the plot. On the Elizabethan stage the chorus was the speaker of an introductory prologue, a legacy from Euripides handed down via the Roman closet dramas of Seneca. He spoke either at the beginning of the play or before two or more acts. The long gap of sixteen years between the third and fourth acts of *The Winter's Tale* is bridged by 'Time, the Chorus'. The group chorus is used rarely in modern European drama, though an exception is T. S. Eliot's *Murder in the Cathedral* (1935).

In the late 19th-century theatre the chorus was the troupe of supporting singers and dancers in musical comedy, *vaudeville, and *revue. There had always been a number of them to accompany the principal actors in *burlesque, extravaganza, and *pantomime, but it was not until about 1870 that the 'chorus girl' became a player in her own right. At first she was asked to do no more than move gracefully in unison with her companions, often accompanied by fairly static 'chorus boys'. By the 1920s chorus girls were wearing fewer clothes, and reached a high standard of precision dancing. The men in the chorus were often dispensed with at this time, but since World War II, under the influence of the US *musical, both men and women now take a larger share in the plot.

Chrétien de Troyes (*fl.* c.1165–c.1175), French poet. He used traditional Arthurian legends as the substance of verse romances which, unlike the earlier *chansons de geste*, were intended to be read not sung. They are remarkable for the poet's narrative skill and his subtle analysis of emotions, particularly love. In *Le Chevalier à la charrette* (c.1172) and *Yvain* (c.1173) his heroes embody the concept of courtly love derived from *Provençal literature, while *Perceval* (c.1175), more mystical in tone, introduces into European literature the theme of the Holy Grail.

Christie, Dame Agatha (1891–1976), British writer of *detective fiction, who published more than sixty novels. Her international success was achieved by her ingenious plots and by her brisk, unsentimental humour. Her first detective novel, *The Mysterious Affair at Styles* (1920), introduced Hercule Poirot, the Belgian detective who reappears in many subsequent novels; her other main detective is the elderly spinster Jane Marple. She also wrote plays, including *The Mousetrap* (1952), the longest-running play in theatre history, and published novels under the pseudonym Mary Westmacott.

Christine de Pisan (1364–1430), French poet and prose writer. Her poems convey the sadness of her early widowhood, and continue a lyrical tradition based on courtly love, written in the new, rigidly determined *ballade* form which *Villon was to exemplify. Her prose works include the *Dit de la Rose* (1400), which vindicates women from the traditional calumnies of Jean de Meung in the *Roman de la Rose*.

Christus, Petrus (d. c.1472), Netherlandish painter, active in Bruges. He was one of the closest followers of Jan van *Eyck, and was possibly his pupil; he may even have completed some pictures that Jan left unfinished at his death. He was at his best as a portraitist, and set his figures before a window or in a clearly defined interior. His *Madonna with Two Saints* (1457) is the first dated example of the use of geometric *perspective in the north.

chromatic scale *scale.

chromaticism *harmony in music.

Churrigueresque, an extravagant style of architecture and decoration popular in Spain and Latin America in the 18th century, and sometimes used loosely to refer to the Late *Baroque and *Rococo period as a whole in Spanish architecture. The style, named after the Churriguera family of architects, particularly the Madrid architect José de Churriguera (1665–1725), is characterized

A contemporary miniature portrait of **Christine de Pisan**. She sought to express the dignity of woman and wrote several specifically feminist works. At the end of her life she witnessed the early successes of another remarkable woman, Joan of Arc, and her last work was a poem in praise of her, *Ditie en l'honneur de Jeanne d'Arc*. (British Library, London)

by abundant use of barley-sugar columns and extremely florid surface ornamentation which sometimes runs riot to such an extent that it completely obscures the underlying structure. To *Neoclassical taste it was the last word in decadence and it died out completely in the last quarter of the 18th century. The Churrigueresque style found a distinctive flowering in the Spanish New World, particularly in Mexico.

Cibber, Colley (1671-1757), English actor, manager, and playwright. He excelled in comic roles, both of his own works and in *Restoration Comedy. His plays, of which the first was *Love's Last Shift* (1696), balanced comedy with sentiment. His heavily adapted version of Shakespeare's *Richard III* (1700) remained the standard theatre text until the late 19th century. He was joint manager of Drury Lane from 1711. He wrote an *Apology for the Life of Mr Colley Cibber, Comedian* (1740), after his much-ridiculed appointment as Poet Laureate in 1730.

Cicero, Marcus Tullius (106-43 BC), Roman politician, orator, and philosopher. His chequered political career is reflected in his speeches, many of which survive. Cicero was fascinated by the theory as well as the practice of oratory and its branches, such as *rhetoric, and in a series of works expounded the principles of the art. No one, apart from himself, much admired Cicero's poetry; but his letters, especially those to his friend Atticus, which were not meant for publication, give an unrivalled view of contemporary Roman politics and social life, in a style of brilliant variety and vigour. No less remarkable is a series of philosophical works, written as a consolation during years of political inactivity. They are largely based on Greek sources, but, with their dialogue form (based on *Plato), they bring to life the basic philosophical quarrel between hedonistic Epicureans and rigorous Stoics. Cicero found Latin a language ill-suited to abstract exposition, and it is an important part of his achievement that he greatly expanded its vocabulary and developed a fluent and adaptable style that enabled the Christian writers of the 4th century to expound and forward the doctrines of their faith. He has remained an influence on Western thought and literature to this day.

Cimabue (Cenni di Peppi) (c.1240-1302), Italian painter, his unflattering nickname meaning 'Ox-head'. Little is known about his life, but he is said to have been the teacher of *Giotto and so stands at the head of the great Florentine, indeed the whole Italian, tradition of painting. Several major works are traditionally (and plausibly) attributed to him, including the majestic crucifix in Santa Croce in Florence, which was badly damaged in the Florentine flood of 1966. If this and other attributions are correct, Cimabue was indeed the outstanding master of the generation before Giotto.

Cimarosa, Domenico (1749-1801), Italian composer. In 1772 his first opera was produced in Naples, and by the mid-1780s he had become one of the most popular composers of *opera buffa* (comic opera) in Italy. He worked in Russia (1787-91), and Vienna (1791-3), where his masterpiece *The Secret Marriage* was performed (1792). In 1799 he was imprisoned for composing a patriotic hymn in favour of the French Revolution. On his release he left for Venice, where he died while preparing an opera for the carnival season.

cinéma-vérité, unscripted *documentary style of film-making, which aspires to total truthfulness and spontaneity. Originating in the Soviet Union in the 1920s, it developed rapidly in the late 1950s and early 1960s, encouraged by the increase in location filming, the appetite of television for factual material, and the availability of lightweight cameras and sound-recording equipment (which facilitated a closer approach to the subject). In France (where it has been popular with the *Nouvelle Vague), attempts are made to coax the subjects into self-revelation; in the USA (where it is called 'Direct Cinema'), a more self-effacing approach is preferred.

Cinq, Les The *Five.

circus, a spectacle in which animal acts and human feats of daring are performed. The modern circus dates from the late 18th century, when ex-sergeant-major Philip Astley gave horse-riding displays in London in 'Astley's Royal Amphitheatre of Arts', an arena to which he had added a stage for singing, dancing, and pantomime. This form of entertainment proved so popular that similar shows were started elsewhere in Britain and in other countries of Europe, some permanent, others as 'tenting' circuses, with performers (see *clown) and equipment travelling in caravans and wagons. From the early 19th century they were often combined with the travelling menageries and wild animal performances that had become very popular, of which the most celebrated was the combined circus and menagerie owned by the Sangers. The USA was the home of the really big circus. Barnum and his partners opened their first show at Brooklyn in 1871, and combined in 1880 with his great rivals Cooper and Bailey. After losing its popularity in Britain in the early 20th century, the circus enjoyed a revival through the large and elaborate productions of C. B. Cochran (1912) and after World War I by new circuses such as that of Bertram Mills, but circuses are now rare in Britain and the USA. In the Soviet Union, however, the state-subsidized circus continues to flourish.

cire-perdue (French, 'lost wax'), a term in art used to describe a method of hollow metal *casting used by sculptors. A thin layer of wax corresponding to the shape of the final sculpture is encased within two layers of heat-resistant clay or plaster, melted and drained off, and then replaced with molten metal poured into the cavity that the 'lost wax' has created. The technique, found in every continent except Australasia, was used by the Egyptians, Greeks, and Romans, and is still the main means used for traditional *bronze sculpture.

cittern, a plucked musical instrument which, because it has wire strings, a strong construction, and a flat back, held its tuning much better than the lute. It could therefore be picked up and played without lengthy preliminary tuning and was popular for casual music-making from the 15th to 17th centuries. The cittern appeared also in the broken (i.e. mixed) consort of Morley and other composers. Its characteristics are a body tapering in side view, shallower at the base than at the neck, a neck with full thickness only under the treble strings, and vestigial wings at the base of the neck.

Clair, René (René-Lucien Chomette) (1898-1981), French film director. His humorous, ironical films

The great American impresario Phineas T. Barnum, one of whose shows (1887) is illustrated here, brought an unrivalled sense of spectacle to the **circus**. His most sensational coup was buying Jumbo, the biggest elephant in the world, from London Zoo, in spite of national outcry in Britain against the sale.

In this painting by the 17th-century Dutch painter Gabriel Metsu, a woman tunes a **cittern** (c.1600). She is plucking the wire strings with a plectrum, held between thumb and forefinger, while turning a tuning peg with the other hand. (Uffizi, Florence)

contained an element of fantasy. Most of his best-known films date from early in his career, including *Un Chapeau de paille d'Italie* (1927), based on Labiche's farce, *Sous les toits de Paris* (1930), his first sound film, *A nous la liberté* (1931), an attack on the machine age, and *Le million* (1932), a musical. His ten years abroad (1935–45) produced only two notable films, *The Ghost Goes West* (1935) for *Korda, and *I Married a Witch* (1942) in Hollywood. He returned to form in such films as *La silence est d'or* (1947), *La beauté du diable* (1950), *Les belles de nuit* (1952), in which a man dreams about beauties of the past, and *Porte des lilas* (1957).

clappers, almost any pair of objects struck together for musical purposes. Most commonly clappers are sticks, such as the claves, an essential rhythm instrument of *Latin American dance music, or those used with the *didjeridu, but they may be flat pieces of wood, as the orchestral whip or slapstick, or have hollowed surfaces, as the *castanets, or be made of metal or stone, or have jingles attached, as the Indian *kartāl*. Clappers are widely used to provide a rhythmic accompaniment to vocal or instrumental music and dance.

Clare, John (1793–1864), British nature poet. He was deeply attached to his birthplace, Helpstone, in Northamptonshire, where he worked as an agricultural labourer. His successful first volume *Poems Descriptive of Rural Life and Scenery* (1820), was followed by *The Village Minstrel* (1821), *The Shepherd's Calendar* (1827), and *The Rural Muse* (1835). He suffered from fits of melancholy and in 1837 he was pronounced insane and spent most of the rest of his life in an asylum. Now recognized as a poet of great truth and power, he is appreciated for his highly personal evocations of landscape and place. His work, characterized by the use of dialect and idiosyncratic grammar, laments lost love and talent, the death of an earlier rural England, and vanished innocence.

clarinet, a single-reed musical instrument with a mainly cylindrical bore and the reed attached to a mouthpiece. It was almost certainly invented, as an improvement over the earlier chalumeau, by Johann Christoph Denner in about 1710. Early clarinets had only two keys, but by the mid-18th century five were normal, which, combined with the problems of the different fingering for the same note in different octaves, may explain why it did not become a standard orchestral instrument until around 1800. In the 19th century further keywork was devised, as with all the *woodwind. From their early days, clarinets were made in a family of sizes, all of which, except for the *basset horn, had the written E below middle C as their lowest note. The family eventually ranged from a sopranino in A♭ to a contrabass in B♭, two octaves below the normal size.

Clarke, Jeremiah (c.1674–1707), English composer and organist. Little is known of his origins, but by 1685 Clarke was a chorister of the *Chapel Royal. Clarke's work includes church music, songs, odes, incidental music for the theatre, and harpsichord pieces. The best of it has sometimes been mistaken for *Purcell's (including the 'Prince of Denmark's March', better known as the 'Trumpet Voluntary'). He also set to music John Dryden's poem *Alexander's Feast*.

Clarke, Marcus (Andrew Hislop) (1846–81), Australian novelist and dramatist. He emigrated from London in 1863, and later worked as a journalist in Melbourne, also writing pantomimes and melodramas. He is remembered for his powerful novel *For the Term of his Natural Life* (1870–2), about convicts transported to the cruel penal settlement in Tasmania.

Classical music, in popular usage 'serious' as opposed to 'popular' music; more narrowly, Western art music from the Classical period, c.1750–1830. This was the age of the *sonata form—the complete expression of those theories of *tonality that had gradually been built up during the 17th century. The principles of sonata form are to be found in instrumental music of every kind, from the solo sonata to the string quartet, from the solo concerto to the symphony. It can be found even in opera, and had its most accomplished expression in the music of *Haydn, *Mozart, and *Beethoven. In parallel with the development of the sonata principle, ran the development and stabilization of the *orchestra, which now increasingly began to look to the public concert and the paying audience for its support. *Opera, through Gluck's reforming zeal and Mozart's instinctive dramatic genius, shed much of the artificiality it had acquired during the 17th and early 18th centuries and was now concerned to present human nature in convincing terms. By the end of the 18th century the resources of music had reached a point of development that was in perfect accord with its capacity to reveal every shade of human emotion, so that in the art of Beethoven, it was able to reach a pinnacle of achievement that even now seems unassailable.

Classicism in dance, periods in dance history where ideas that derive from Ancient Greece are evident. Classicism represents economy and precision in movement, order and geometric design, grace and ease in performance, adherence to recognized rules and the values of symmetry, proportion, and restraint. The 16th- and 17th-century classical revival in the Italian *intermedii and the French *ballets de cour drew on classical imagery and themes, while *Noverre brought a return to Greek myth in his *Orpheus* (1760). Greek characters and myths provide a rich seam throughout the history of Western theatre dance, recently in *Graham's *Clytemnestra* (1958) and David Bintley's *Choros* (1983). *Petipa, the arch-Classicist, showed the wealth of imaginative possibility in set steps and patterns and was known for the creation of sculptural 'tableaux'. The early 20th-century revival took many forms, from *Duncan's *Iphigenia* (1904) to *Balanchine's *Apollo* (1928), the latter demonstrating a spare neoclassical aesthetic based on Petipa but with distortions created by turned-in feet and hips and unexpected incidents.

Claude Gellée (1600–82), French painter, one of the greatest of all *landscape painters. He is often called Le Lorrain (in France) or Claude Lorrain (in Britain), after his birthplace, though he spent most of his life in Rome. During the 1630s he established himself as the leading landscape painter of the day, working for a distinguished international clientele. His work is therefore exceptionally well documented. Usually his pictures are inspired by the countryside around Rome (the Campagna), which he presents as a world of ideal order and tranquillity. Their ostensible subjects, taken usually from the Bible or Roman poets, are subordinate to the real theme, the mood of the landscape presented poetically in terms of light and colour. His style acquired great grandeur and formality in the 1640s and 1650s, but in his late work forms seem to lose their material solidity and melt into the magical atmosphere. Claude was extremely influential, especially in Britain—not only on painters such as Richard *Wilson and *Turner, but also on landscape gardening, parks being modelled on his pictures.

Claudel, Paul (1868–1955), French dramatist and poet. His conversion to Roman Catholicism in 1886 made a profound impression on his writing. In plays like *Partage de midi* (1906), *L'Otage* (1911), *L'Annonce faite à Marie* (1912), and *Le Soulier de satin* (1925–8), he creates a half-imaginary universe impregnated by a divine presence which draws his characters on to perform deeds of self-sacrifice. His early association with the *Symbolists is revealed in his use of imagery and the free-verse form in which he wrote both plays and poems (for example *Cinq grandes odes*, 1910). He also wrote an oratorio *Jeanne d'arc* (1938) with music by *Honegger.

Claudet, Antoine François Jean (1797–1867), French pioneer photographer. Director of a glass-manufacturing company, Claudet established a London warehouse twelve years before photography was first announced. Purchasing a licence to take daguerreotypes from *Daguerre himself, he opened a portrait studio in 1841. A prolific inventor, Claudet reduced the early long exposures by chemical means, and obtained patents for a darkroom light, a light-meter, the use of artificial lighting and painted backgrounds in the studio, and several other devices—especially for stereo photography.

clavichord, the simplest and one of the most expressive of all keyboard instruments. When a key is depressed, a brass rod or blade (the tangent) mounted on its inner end rises and touches the string, making it sound. When the key is released, the tangent leaves the string and its

The title of this painting by **Claude** is *Landscape with the Marriage of Isaac and Rebekah* (1648), but the depiction of the scene does not correspond to the biblical description of the event, and the artist's real concern is with the beauty of nature; indeed the picture is often known as *The Mill*, in reference to the building in the middle distance. (National Gallery, London)

vibration is stopped by a strip of felt (the listing) wound over the left-hand end of the strings. Thus the finger is in contact with the string while it sounds, and the sound can be varied by pressure on the key. The clavichord was invented *c.*1400 and was widely used, especially as a practice instrument, into the 19th century.

clef *notation.

Clementi, Muzio (1752–1832), Italian-born British composer and pianist. He studied in Rome, where he became the protégé of Peter Beckford (cousin of the novelist William *Beckford). On Beckford's Dorset estate Clementi was able to study (1766–73) and perfect his harpsichord technique. He moved to London in 1774, soon gaining great success as a composer, performer, teacher, and publisher, both in England and in Europe. He is remembered mainly for his keyboard works, which helped to establish a style appropriate to the newly created pianoforte. Some of these keyboard pieces foreshadow later *Romantic music.

clerihew, a form of comic verse named after its inventor, Edmund Clerihew Bentley (1875–1956). It consists of two metrically awkward *couplets, and usually presents a ludicrously uninformative 'biography' of some famous person whose name appears as one of the rhymed words in the first couplet: George the Third | Ought never to have occurred. | One can only wonder | At so grotesque a blunder.

clocks. The evolution of the style and design of clocks can be traced back to the Gothic forms of medieval church architecture. Chamber clocks of the 15th and early 16th centuries were mostly made of iron, with arches, lancet 'windows', pinnacles, and figures in niches, which bore no relationship to their structural needs. The great schools of 16th-century clock-making were centred in southern Germany, of which a wide range of gilded or polished-bronze table clocks, iron and steel lantern clocks, ship clocks, and weight-driven wall-clocks survive. In the 17th and 18th centuries the greatest advances in clock-making took place in France, Holland, and Britain, where the application of a pendulum to control the motion of the clock altered its appearance. Among the great clock-makers of the period was Thomas Tompion of London, who made the noted 'Mostyn' mantle clock, encased in veneered ebony with silver mounts. Baroque clock cases reflect the more classic architectural and sculptural forms, such as in the French 'tête de poupée' clock from a design by A.-C. Boulle, with marquetry and gilded bronze mounts, made

by the Martinot family and now in the Wallace Collection in London. French clock cases of the 18th century were considered as works of art, and the names of their makers, such as Jacques Cafferi, were stamped on them. Neoclassicism was popularized by Robert Adam, Josiah Wedgwood, and Matthew Boulton, who characteristically made gilded bronze cases which were ornamented with Derby porcelain figures, marble bases, and jasperware medallions. A contemporary French long-case clock by Balthazar Lieutaud was veneered in tulipwood and kingwood, and had a dial in enamelled copper. Among notable clock-makers at the court of Louis XVI were Ferdinand Berthoud and Pierre Le Roy. In America, a distinctive family of Massachusetts clock-makers were the Williards, who introduced the 'banjo' wall-clock. Among the makers of American tall clocks which became popular in the early 1800s were Daniel Burnap of Connecticut and Eli Terry. As the 19th century progressed clock-makers began to mass produce both the movements and cases of clocks, and the factory took over from the craftsman.

cloisonné (French, *cloison*, 'partition'), a technique in *enamelwork in which thin strips of metal are attached to the background surface, forming a design made up of various little compartments that are filled with the vitreous enamel paste. The technique was known in the ancient Mediterranean world and has also been much used in China, but it is perhaps best associated with *Byzantine art, particularly with the celebrated 11th- and 12th-century Pala d'Oro (Golden Altar screen) of St Mark's in Venice.

Clouet, a family of French portrait painters descended from an obscure Netherlandish artist, Jean Clouet, who settled in France in about 1460. The more famous **Jean Clouet** (d. *c*.1540) is thought to have been his son. He was royal painter and highly regarded in his lifetime, but no documented works by him are known. A handful of paintings and a number of drawings are, however, attributed to him on fairly good circumstantial evidence, revealing him as a master of the realistic Netherlandish portraiture tradition. His son **François** (*c*.1510–72), who succeeded him as royal painter, is better documented, but still an obscure figure. There are several signed portraits of high quality, but other works are disputed between him and his father (they both used the same nickname, 'Janet', which adds to the confusion).

Clough, Arthur Hugh (1819–61), British poet. Aware of the social and intellectual crisis in 19th-century society, he was tormented by religious and personal doubts, which led him to resign his Oxford fellowship in 1848. His best-known work *The Bothie of Tober-na-Vuolich* (1848), is a narrative poem in *hexameters set in Scotland. His lyrics, including the well-known 'Say not the struggle nought availeth', reflect his spiritual anguish. He died in Florence; Matthew *Arnold, his close friend, wrote the poem 'Thyrsis' to commemorate his death.

clown, a comic character, who, unlike the traditional *fool or the *court fool performs a set routine. In his earliest form he is to be found in ancient Greek theatre and again in *Roman satire and *mime, wearing a pointed hat and patchwork clothes. Clowning was part of the routine of medieval *minstrels, but it was not until the late Middle Ages that professional travelling entertainers

Oleg Popov, a member of the Moscow Circus, is probably the most famous of contemporary **clowns**. He is immensely popular in his native Soviet Union and is well known in the USA and the various European countries in which he has toured. The character he portrays, a gentle little man buffeted by a harsh world, was influenced by Charlie Chaplin's screen tramp.

such as the French *Enfants sans souci* and the Italian *commedia dell'arte* troupes developed. One of the formative elements of the Elizabethan clown was the character of 'Old Vice' of the *liturgical drama. The hallmark of 17th-century stage clowns in Germany was a costume of oversize shoes, waistcoats, pointed hats, and giant neck ruffs. The white-faced clown is said to have been introduced by the French clowns of the same period. Britain's Joseph Grimaldi, one of the greatest of his profession, first appeared in a circus in 1805. In the 1860s a comedian under the name of Auguste introduced the red nose, exaggerated eyebrows, and tufts of hair. The Swiss-born Grock (Charles Adrien Wettach), at the constant mercy of inanimate objects, was a much-loved star of the British *music-hall. Charlie *Chaplin brought the repertoire of the clown into the cinema, while in the Soviet Union, where the *circus remains popular, clowns such as Popov (1930–) achieve national stardom.

Coburn, Alvin Langdon (1882–1966), British photographer born in the USA. First given a camera at the age of 8, Coburn later attended art school in Massachusetts. He studied photogravure in London in 1906, publishing two books of atmospheric gravures: *London* (1909) and *New York* (1910). *Men of Mark* followed in 1913, with a second volume in 1922. He organized the influential 1917 exhibition of 'Old Masters of Photography' (all British) at

the Albright Gallery, Buffalo, and two years later exhibited his first purely abstract photographs—'Vorto-graphs'—in London alongside his paintings.

Cochran, Sir Charles Blake (1872–1951), British theatrical impresario. He was best known for his productions at the London Pavilion between 1918 and 1931, where his 'Young Ladies' of the *chorus became famous. He presented many straight plays, including Reinhardt's production of Vollmöller's *The Miracle* at Olympia (1911; revived 1932); he introduced overseas plays and players to London; and promoted non-theatrical entertainments such as boxing and the *circus.

Cockerell, Charles Robert (1788–1863), British architect, one of the most individual figures of *Neoclassicism. He trained with his father Samuel Pepys Cockerell (a descendant of Pepys the diarist) and worked for *Smirke before travelling widely in the Mediterranean, 1810–17. During this time he became an expert on classical antiquities. His learning is apparent in his architecture, for he regarded himself as heir to the whole classical tradition, admiring *Wren greatly, for example, as well as the Greeks. However, scholarship was to him a servant not a master, and his buildings are bold, rich, and imaginative, without a trace of pedantry. The best known is the building which houses the Ashmolean Museum in Oxford (1841–5).

Cocteau, Jean (1889–1963), French writer. He made innovative contributions in a number of fields: poetry (*Opéra*, 1927), the novel (*Les Enfants terribles*, 1929), drama (*La Machine infernale*, 1934), ballet scenarios (*Parade*, 1917, with sets by Picasso and music by *Satie), and film scripts (*Orphée*, 1950). He shared with the *Surrealists an interest in the subconscious world of dream, sleep, and myth, and, like them, used words to startle the reader into seeing a deeper reality behind familiar appearances.

coda (Italian, derived from the Latin for 'tail'). A musical term used to describe the last few bars of a movement, or section of a movement, which have been extended in such a way as to increase the sense of finality. In Beethoven's symphonies this extension assumes considerable structural importance.

Cohan, Robert *London Contemporary Dance Theatre.

coins, pieces of metal, usually discs, stamped by an authority such as a monarch as a guarantee of value and used as money. Early coins were stamped on only one side, but in about 560 BC the ruler of Athens, Pisistratus, had coins produced with a design on both sides—on one the head of Athena, the patron goddess of Athens, and on the other an owl, the symbol of the city. Since then almost all coins have been imprinted with a head on one side (at first symbolic images, later actual portraits) and a device related to the state for which they were produced on the other. From an aesthetic point of view the most important aspect of coinage is the design of the reliefs on the two sides. Until recently these were carved in *intaglio directly into the face of a metal die by a coin engraver, whose major problem was to produce an artistic and lifelike representation on such a small scale. It is generally agreed that the coins of the ancient Greeks have never been surpassed for beauty of design. One of the last coin

types to be directly engraved was the well-known *St George and the Dragon* by Benedetto Pistrucci (1817). It has been used repeatedly on British coins for nearly 150 years and is an excellent energetic relief. Few mechanically produced coins are works of art due to the inflexibility of modern methods of coin production.

Coleman, Ornette *jazz.

Coleridge, Samuel Taylor (1772–1834), British poet and man of letters. His first published poetry was a series of sonnets to eminent radicals, including William Godwin and Joseph Priestley. In 1797 Coleridge met *Wordsworth and his sister Dorothy. The intense friendship that sprang up between them shaped their lives for the next fourteen years and proved one of the most creative partnerships in English *Romanticism. A selection of their work appeared as the *Lyrical Ballads* (1798), which achieved a revolution in literary taste and sensibility. This period produced Coleridge's major contribution to the Romantic movement: his supernatural poems, 'The Rime of the Ancient Mariner', 'Christabel', and 'Kubla Khan', and his tender and evocative 'Frost at Midnight'. Coleridge spent ten months in Germany (1798–9) studying Kant, Schiller, and Schelling and was instrumental in introducing German thought to England. In 1800 he moved to the Lake District with the Wordsworths but his personal life became increasingly unhappy and his addiction to the opium-based drug laudanum became crippling; much of his anguish is reflected in his last great poem, 'Dejection: an Ode' (1802). His *Notebooks* produced in these years are among his most moving works. After a spiritual crisis Coleridge achieved a rebirth of his Christian beliefs and creative activity. Subsequent works include *Biographia Literaria* (1817), his major work of poetic criticism and philosophy, and other works that develop his critical ideas. His literary criticism of Shakespeare remains among the foremost in the field.

Colette (Sidonie Gabrielle) (1873–1954), French novelist. Her writings portray, with lucidity but no bitterness, stages in the growth and decline of love; they also document the manners of French society around the turn of the century. Among her best-known novels are *Chéri* (1920), *Le Blé en herbe* (1923), and *La Fin de Chéri* (1926). Three autobiographical works, *La Maison de Claudine* (1922), *La Naissance du jour* (1928), and *Sido* (1929), are poetic evocations of her childhood in Burgundy and Provence, revealing her characteristic appreciation of beauty in the natural world.

collage, a pictorial technique in which photographs, newspaper cuttings, and other suitable objects are pasted on to a flat surface, often in combination with painted passages. It first became a serious artistic technique in the early 20th century, and the Cubists, Futurists, Dadaists, and Surrealists all made use of collage.

Collins, (William) Wilkie (1824–89), British novelist. Noted as a writer of mystery, suspense, and crime, his finest work in this genre, the novel of sensation, was *The Woman in White* (1860). With *The Moonstone* (1868), considered the first full-length *detective story in English, he set a mould for the genre. Trained as a lawyer, he excelled at constructing ingenious and meticulous plots and experimented in narrative technique; vivid and

sympathetic portraits of physically abnormal individuals appear in many of his novels. He was a close friend and collaborator of *Dickens, for whose journals he wrote numerous articles and stories.

Collins, William (1721–59), British poet, one of the dominant influences on later 18th-century *lyric poetry. His first book, *Persian Eclogues* (1742), was followed by *Odes on Several Descriptive and Allegoric Subjects* (1746) containing 'Ode to Evening', and 'How Sleep the Brave'; and *Ode on the Popular Superstitions of the Highlands* (1788). Thereafter he suffered increasingly from severe melancholy which deteriorated into insanity. A precursor of 19th-century *Romanticism, his works emphasize imagination and mood, presented in neoclassical form.

colour field painting, a term in art applied to a type of *abstract painting that features large expanses of unmodulated colour, sometimes covering the whole canvas. It came to the fore in the USA in the late 1940s and early 1950s in the work of artists such as Mark *Rothko and Morris *Louis. Some artists developed colour field painting by soaking or staining very thin paint into raw unprimed canvas, so that the paint is integral with it rather than a superimposed layer. The term colour stain painting is applied to paintings of this type.

Coltrane, John (William) *jazz.

A 17th-century Italian painting of the **commedia dell' arte** showing Capitano Babeo and Cucuba. The captain was one of the most familiar characters of the *commedia*, but his image changed over the years. Originally conceived as a complex character—often a sad, unsuccessful lover he became cast as a clown and his role was usurped by the more sophisticated Scaramouche. (Museo Teatrale alla Scala, Milan)

comedy, in the Western tradition, a literary composition, usually dramatic, written chiefly to amuse its audience. A comedy will normally be closer to everyday life than a *tragedy, and will explore common human failings rather than the tragedy's exalted passions and acts. Its ending will usually be happy for the leading characters, involving the downfall of any villains. In another sense, the term 'comedy' was applied in the Middle Ages to narrative poems which end happily: the title of *Dante's *Divine Comedy* (c.1310) carries this meaning. Comic elements can also appear in many kinds of non-dramatic writing; and comedy is an important genre in the cinema. As a dramatic form, comedy in Europe dates back to *Aristophanes in the 5th century BC. His plays combine several kinds of mischief, including the satirical mockery of living politicians and writers. At the end of the next century, *Menander established the form known as New Comedy, in which young lovers went through misadventures surrounded by other stock fictional characters; this tradition was later developed in the *Roman comedy of Plautus and Terence, and eventually by *Shakespeare in England. The great period of European comedy was the 17th century, when Shakespeare, Lope de *Vega, and *Jonson were succeeded by *Molière—comedy's supreme exponent—and by the *'Restoration comedy' of *Congreve, Etherege, and *Wycherley. There are several kinds of comedy, ranging from the idealized love-affairs of Shakespeare's 'romantic comedy' in *A Midsummer Night's Dream* (c.1595) to the *satire in Jonson's *Volpone* (1606) or Molière's *Tartuffe* (1669), and to the sophisticated verbal wit of the 'comedy of manners' in *Wilde's *The Importance of Being Earnest* (1895). Among its minor forms are *burlesque, *slapstick, and *farce.

commedia dell'arte, the popular improvised Italian comedy of the 16th to 18th centuries, as opposed to the

commedia erudita, written Italian drama of the time; *dell'arte* signifies that the actors were professionals—members of the *arte* or actors' guild. It was usually performed by companies of twelve to fifteen, who improvised while conforming to a pre-arranged skeleton scenario, with suggestions for acrobatics, singing, and dancing. Apart from the young lovers, all performers wore *masks, each retaining his own mask (or character), though perhaps changing to an 'older' mask as he grew older. The lovers were opposed by the fathers or guardians, notably Pantalone, who became the English Pantaloon. Other characters included Dottore (Doctor), a pedant, and Capitano (Captain), a braggart. The servants (*zanni*) were a distinctive feature. Shrewd, opportunistic and greedy, they reappeared in various guises in European literature and theatre, providing several characters still familiar today, such as Arlecchino (Harlequin), Pulcinella (Punch), Colombina (Columbine), and Pedrolino (*Pierrot). The companies travelled abroad—to Spain by the 1570s and later to France and perhaps Britain. But by the 18th century improvisation was dying out in Italy, to be replaced by written material. The tradition survived in *puppetry, the *harlequinade, and *pantomime. (See also *mime.)

community architecture, an approach to architectural design in which stress is laid on the architect's responsibilities towards the users of his or her buildings, particularly housing. The idea of community architecture developed in the 1970s and became a recognizable movement in the 1980s, the Prince of Wales and his architectural adviser Rod Hackney being among the champions of the cause. It marked a reaction against the doctrinaire and dehumanizing attitude towards mass housing that had characterized much 20th-century building, encouraging instead consultation with the community, and the consideration of all relevant social conditions.

community dance, developed from North American and French work, this aims to promote dance enjoyment, to increase participation opportunities, and to draw the artist, the education system, and the wider community together. Projects are led by an 'animateur' or community dance worker. Schemes are funded jointly by local authorities, arts associations, and/or local business. Some are based in arts centres, others are peripatetic, covering large rural areas. Dance artists in education projects, linking professional dance to the education system, are also part of the wider community dance concept.

community theatre, a 20th-century movement in drama which seeks to involve the community. It began to flourish in Britain in the early 1970s and is closely allied to *political theatre, usually with a socialist commitment which may also embrace feminism and gay liberation. Community theatre groups, which usually perform in such non-theatrical places as working-men's clubs, public houses, village halls, streets, and open spaces, seek to relate their activities to a locality by presenting material of local interest and by creating a closer rapport with their audiences than is possible in a conventional theatre.

company painting, a term applied to paintings produced by Indian artists in the 18th and 19th centuries for colonial (mainly British) clients; these clients were often connected with the East India Company, hence the name. Major centres of production included Calcutta, Delhi, Lahore, Lucknow, and Patna. The paintings were done in a water-colour technique (usually on paper, but also on other materials such as ivory) and stylistically combined Indian and European conventions. Subjects included landscapes, portraits, animals, plants, and so on. In the 19th century, sets of paintings of subjects such as Indian activities, deities, festivals, monuments, birds, and flowers, became popular; many such sets were sent to relatives in Britain in the days before photography.

Compton-Burnett, Dame Ivy (1884–1969), British novelist. Her novels, noted for their lack of plot, centre on family relationships in large middle-class Edwardian households, ruled by a tyrannical parent or grandparent. In these introverted, semi-isolated households she examines the misuse of power and the violence and misery that follow. She lived quietly in London for most of her life, establishing her career with *Pastors and Masters* (1925), in which she introduced the abrupt, stylized dialogue that characterizes her work. Other outstanding works are *Brothers and Sisters* (1929), *Manservant and Maidservant* (1947), and *A God and His Gifts* (1963).

computer music, music in which computers are used either to work out the details arising out of whatever program is fed into them, or to produce *electronic sound. Thus the computer might calculate the frequency and distribution of a series of events within the structure of a composition and then, in association with a *synthesizer, simulate the required sounds. Effective computer programming depends upon the creative imagination as fundamentally as any ordinary method of composition. Computers are also beginning to find a place in publishing in the production of scores and instrumental parts, the *notation having first been translated into a suitable code. (See also *aleatory music, *20th-century music.)

conceit, an unusually far-fetched or elaborate *metaphor or *simile presenting a surprising parallel between two apparently dissimilar things or feelings: 'Griefe is a puddle, and reflects not cleare | Your beauties rayes' (T. Carew). Under Petrarch's influence, European poetry of the Renaissance cultivated the conceit to a high degree of ingenuity, either as the basis for whole poems (notably Donne's 'The Flea') or as an ornamental device. Poetic conceits are prominent in Elizabethan *sonnets (Sidney's and Shakespeare's especially), in *metaphysical poetry, and in the dramatic verse of Corneille and Racine.

conceptual art, a term applied to various forms of art in which the idea for a work is considered more important than the finished product, if any. The notion goes back to Marcel *Duchamp, but it was not until the 1960s that Conceptual art became a major international phenomenon. Its manifestations have been diverse; most Conceptual artists deliberately render their productions visually uninteresting in order to divert attention to the 'idea' they express. Exponents of Conceptual art see it as posing questions about the nature of art and provocatively expanding its boundaries.

concertina, a small *free-reed musical instrument held in the hands. The hexagonal or square end-plates, one for each hand, are separated by the bellows and carry several rows of buttons, whose function and number vary from

model to model. The German, American, and Anglo-German concertinas produce two notes from each button, one when closing the bellows and the other on opening them. The English concertina produces a different note on each button, the same note on push and on pull. The Duet concertina is similar to the English with a larger bass range. The concertina was an enormously popular instrument from its invention in the early 19th century until it was gradually superseded by the piano *accordian following World War I. Since this time the instrument has again returned to favour, particularly with folk musicians. The Anglo-German concertina is much loved by English folk musicians for its rhythmic capabilities and raucous cheerfulness, and it was from such an instrument that Cecil Sharp noted down morris dances.

concerto, originally a very general term in music used to describe the act of 'playing together'; towards the end of the 17th century it became attached to a distinctive form, the *concerto grosso. During the second half of the 18th century the concerto grosso developed into the concerto as we now know it, a work for soloist and orchestra, usually in three movements. Of these three movements only the first acquired a distinctive form, the second and third being usually a lyrical slow movement (virtually an *aria) and a brisk, cheerful finale (often in *rondo form) in which the material is shared fairly evenly between soloist and orchestra. The first movement, however, combined the 'ritornello principle' of the concerto grosso with *sonata form. Instead of a single exposition it had a double exposition: the first for orchestra alone, with the usual sonata subjects presented entirely in the main *key, the second following on with the same material (with perhaps additional themes) in the 'correct' keys and shared between soloist and orchestra. At important structural moments in the movement, the orchestra would drop its role of accompanist and make some forceful statement on its own, thus echoing the 'ritornello principle' of earlier times. Towards the end of the movement, immediately before the final orchestral outburst, it was customary to allow for a solo cadenza (a passage for solo instrument), often improvised. The great masters of the Classical concerto were Mozart and Beethoven. In the 19th century the double exposition gave way to a single, shared exposition; and the cadenza moved its position to the end of the development section, thus providing a dramatic introduction to the restatement of the main themes. The gradual enlargement of orchestras, the rise of public concert-giving, and the increasing virtuosity of soloists all led to what may fairly be called the Romantic concerto, in which the polite exchange of ideas between equals turned into something of a pitched battle, as in the concertos of Tchaikovsky and Rakhmaninov.

concerto grosso, a musical work in several contrasted movements, in at least some of which a group of soloists (the concertino) was made to contrast with a full band of strings (the ripieno). The alternation between the two groups created the 'concerto style': a pattern of contrasts between soloists and orchestra, loud and soft sounds, lightness of texture and weight. It also gave shape to the movement, beginning with a bold statement by the ripieno orchestra and then alternating between the two groups. The return of the ripieno, usually with the same musical material, gave the form its coherence. Not every movement employed the ritornello principle, but its presence in at least some cases distinguished the concerto grosso from the dance suite, from which the overall pattern of contrasted movements was derived. The great masters of the concerto grosso include Corelli, J. S. Bach, Vivaldi, and Handel. From those examples where the concertino group was reduced to a single instrument came the solo *concerto of the late 18th century.

conch, a shell used as a trumpet, made in parts of Oceania and in East Africa by making a hole in the side, and elsewhere by removing the tip. In many areas it is a ritual instrument, for example in Fiji (where some have a finger-hole), India (where heroes of Hindu epics each have their own conch), Central and South America (where pottery copies are used), and Europe (where conches were used to avert thunderstorms: *Vivaldi wrote a concerto imitating this use). It is also a signal instrument, particularly for fishermen.

concrete painting, a general term applied to those styles of modern painting which repudiate all figurative reference to an object and construct the composition from elementary pictorial elements such as the rectangle or square. The term has been applied to many distinct movements in abstract art including *Constructivism, *Suprematism, and *Neo-plasticism. The work of Ben *Nicholson, with its use of abstract shapes, can also be described as concrete.

concrete poetry *pattern poetry.

The **conch** or shell trumpet is associated particularly with the Pacific islands, but a type has been used in Europe since antiquity. The conch serves primarily for signalling, particularly among fishermen, but it has also been blown to summon councils, to ward off storms, and as a war trumpet. In India conches have been used in Hindu temple rituals and in place of a bugle for barrack calls.

conductor, in music, the person who directs the performance of an orchestra or choir. The idea of a 'conductor' who not only indicates the basic beat, but also the way in which the music is interpreted, is of comparatively recent date. It arose as a necessity alongside the development of the *orchestra and the appearance of music that sought ever more subtle ways of being expressive and meaningful. The early orchestra could be directed from the keyboard by the *continuo-player. Direction later passed to the first violin (still called the 'leader' in Britain and the 'concert master' in the USA), who would indicate with his bow, or by a mere inclination of the head, all that was needed. But by the 19th century orchestras had grown larger, the music was more expressive, and the art of orchestration had become an integral part of composition. The relative weight of sound produced by the different instruments now had to be 'balanced' if the music was to make its proper effect. Someone therefore had to take charge. Conducting with a baton began in Germany in the early part of the 19th century. The baton is mainly used to indicate the beat by a series of universally recognized movements. It can also be used to cue in instruments; to suggest (by amplitude of gesture) the required dynamics; and, by quality of gesture, to indicate the style of interpretation. The conductor's free hand can be used for additional or complementary indications and need not mirror the baton gestures.

The German composer and violinist Louis Spohr (1784–1859), one of the best of the early 'modern' conductors employing a baton, probably used only a piano reduction of the score to conduct from, while *Berlioz was one of the first to conduct from a full score, which showed all the different instrumental parts in the orchestra. *Mendelssohn was an excellent and versatile conductor, but perhaps the first virtuoso was *Wagner. From him stems the tradition of interpretive conducting, whereby the conductor is responsible for projecting his own understanding of the composer's intentions into the performance. Hans von Bülow (1830–94) and Hans Richter (1843–1916), followed by *Mahler and Richard *Strauss dominated the European conducting scene until the arrival of the brilliantly spontaneous Wilhelm Furtwängler (1886–1954), the epic interpretations of Otto Klemperer (1885–1973), and the tyrannic and brilliant Arturo Toscanini (1867–1957). The first English conductors to win wide acceptance: Henry Wood (1869–1944), responsible for the significance of the London Promenade concerts, and the idiosyncratic Thomas Beecham (1879–1961), were followed by Adrian Boult (1889–1983), who studied with Strauss's contemporary Artur Nikisch (1855–1922) and learned from him his unpretentious style. In more recent years, the unrestrained conducting of Leopold Stokowski (1882–1977) and the colourful style and catholic taste of Leonard Bernstein (1918–), have contrasted with the polished perfectionism of Herbert von Karajan (1908–89).

Confucian literature, the body of Chinese literature founded in the 6th century BC and accepted as the basis for Confucian philosophical thought. The first acknowledged Confucian works were the Five Scriptures: the divination manual *Book of Changes* or *Yijing* (*I Ching*), the *Book of Documents*, which provided the ideological basis for Zhou dynasty rule to 256 BC, the *Book of Odes* or *Shijing*, a manual of *Ritual*, and the *Spring and Autumn Annals*, a chronicle of one of the early feudal states. In the Later Han dynasty (AD 25–220) the *Analects*, sayings of Confucius, the *Scripture of Filial Piety*, and the *Mencius*, by a disciple of Confucius, were added to the canon. Four Confucian works, the *Analects*, the *Great Learning*, the *Doctrine of the Mean*, and the *Mencius*, were selected for special use by Song dynasty (960–1279) educationists in 1190; they were known as the Four Books.

Congreve, William (1670–1729), British dramatist. After leaving Trinity College, Dublin, he began to study law, but abandoned this for literature. By 1693 he had achieved fame with his comedy, *The Old Bachelor*. He continued his success with other comedies, including *The Double Dealer* (1693), *Love for Love* (1695), and *The Way of the World* (1700). With these plays he showed himself a master of *Restoration comedy, reflecting the fashionably artificial manners of the day, enlivened by brilliant dialogue and a gallery of humorous characters. His only tragedy is *The Mourning Bride* (1697).

Conrad, Joseph (Jósef Teodor Konrad Walecz Korzeniowski) (1857–1924), Polish-born British novelist. In 1874 he began his career as a sailor, which was to provide much material for his writing. He became a British subject in 1886 and retired from the sea to write, beginning with *Almayer's Folly* (1895). *Nostromo* (1904), set in an imaginary South American republic, explores one of his main themes: man's vulnerability and corruptibility. *The Secret Agent* (1907), and *Under Western Eyes* (1911) show Conrad's ironic scepticism about politics. The sea is the setting for *The Nigger of the Narcissus* (1897), *Typhoon* (1902), and *The Shadow-Line* (1917). Marlow, the narrator of some of his works, provides a pessimistic commentary on the action, notably in *Lord Jim* (1900) and the celebrated novella *Heart of Darkness* (1902). Conrad was a leading influence on *Modernist fiction.

consort, in music, an ensemble of voices and/or instruments. By extension the term also means the music played by such a group, and its performance in public. In Britain the term applies to chamber music from the early 16th to the early 18th century, and most frequently to the 'consort of viols'. A whole consort was one in which all the instruments were of the same family (all strings, all wind, all brass). A mixed group of instruments was known as a broken consort.

Constable, John (1776–1837), British *landscape painter. Unlike his great contemporary *Turner, Constable was slow to achieve recognition: it was not until 1829 that he was grudgingly elected, by a majority of only one vote, a full member of the Royal Academy. In his early years he worked in the tradition of *Gainsborough and 17th-century Dutch painting, but he soon developed an original style based on direct study of nature, representing in paint the changing effects of light and atmosphere. To capture the shifting flicker of the weather he abandoned the traditional polished finish of landscape painters, catching the sunlight in blobs of pure white or yellow and the drama of the storm in vigorous brush-strokes. He worked extensively in the open air, drawing or making sketches in oils, but his large finished pictures were painted in the studio. His finest works are of the places he knew best: Suffolk and also Hampstead, where he lived from 1821; but in his lifetime his genius was more appreciated in France than in Britain. His most famous picture, *The Hay Wain* (1821), was exhibited at

Salisbury Cathedral was one of **Constable**'s favourite subjects. This vigorous sketch, which may well have been painted in the open air, was probably done in 1820 during a lengthy visit he paid to his close friend Archdeacon John Fisher. (National Gallery, London)

the 1824 Paris *Salon; he was a major influence on *Romantic painters such as *Delacroix, on the painters of the *Barbizon School, and ultimately on the *Impressionists.

Constant, Benjamin (1767–1830), Franco-Swiss politician and novelist. He is best remembered for his novel *Adolphe* (1816), a forerunner of the modern psychological novel, which narrates the growth and decline of a passionate relationship which in many ways parallels his turbulent liaison with Mme de *Staël. The unresolved inner agony of the hero, who is unable to free himself from the woman he no longer loves, foreshadows the spiritual malaise that informs the work of *Chateaubriand and *Lamartine.

Constructivism, a Russian movement in sculptural art founded in about 1913 by Vladimir *Tatlin. He was later joined by the brothers Antoine *Pevsner and Naum *Gabo, who rejected the idea that art must serve a socially useful purpose and conceived a purely abstract art-form that explored the aesthetic use of modern machinery and technology and used industrial materials such as plastic or glass. Tatlin was among those who applied Constructivist principles to architecture and design. Pevsner and Gabo left Russia in 1922 after Constructivism had been condemned by the Soviet

regime. They and other exiles had considerable influence throughout Europe and the USA.

contact improvisation *Paxton, Steve.

continuo, short for 'basso continuo', a musical term meaning 'continuous bass'. In the 17th and 18th centuries instrumental music was provided with a 'figured bass' part: the lowest line of the music, complete with figures that indicated the chords to be supplied above. This was interpreted by such instruments as could play chords—harpsichords, organs, lutes, and so on—which usually worked with an instrument, such as the cello or bassoon, that could reinforce the bass line. The continuo group thus supplied a complete harmony at a time when orchestras and instrumental groups could not be relied upon to provide all the necessary parts. The expression 'to play the continuo' simply means 'to interpret the continuo part'.

continuous representation (or continuous narrative), a pictorial convention whereby two or more successive incidents from a story are combined in the same image. In a painting of the martyrdom of a saint, for example, the saint may also be seen in the background performing miracles or shown in other important events from his life. Continuous representation is most common in medieval art, but occasionally occurs later.

contrapposto (Italian, 'set against'), a term in art applied to poses in which one part of a figure twists or turns away from another part. During the Renaissance, it was used to describe a relaxed asymmetrical pose characteristic of much classical sculpture in which the body's weight is

borne mainly on one leg, so that the hip of that leg rises relative to the other. The term is now also applied to paintings. Michelangelo was the acknowledged master of contrapposto, and some of his Mannerist followers devised poses of wilful complexity to demonstrate their virtuosity.

conversation piece (painting), a portrait group in a domestic or landscape setting in which two or more sitters are engaged in conversation or other polite social activity. Conversation pieces are usually fairly small in scale. They were especially popular in Britain during the 18th century, but the use of the term is not confined to British painting or to this period. Notable practitioners included Arthur Devis, Zoffany, and the young Gainsborough.

Cooper, James Fenimore (1789–1851), US novelist. A pioneer of American fiction, his prolific output falls roughly into four categories: sea stories like *The Pilot* (1823); miscellaneous historical romances, such as *The Spy* (1821); the 1840s studies of New York society known as the Littlepage Manuscripts; and, most importantly, the five 'Leather-Stocking Tales' of frontier life. The last group consists of *The Pioneers* (1823), *The Last of the Mohicans* (1826), *The Prairie* (1827), *The Pathfinder* (1840), and *The Deerslayer* (1841). All show white civilization pushing into the wilderness, opposed by the Red Indian, and feature the veteran frontiersman Natty Bumppo, who, as Cooper's *alter ego*, articulates his dismay at the destruction of the American wilderness. He is an archetypal figure in American literature.

Cooper, Samuel (1609–72), the greatest English *miniaturist of the 17th century. He was patronized by Oliver Cromwell and Charles II and had a European reputation. His sitters are presented with force and individuality and his *Baroque sense of design marks a complete break with the tradition of *Hilliard. Cooper's brother **Alexander** (c.1609–60) was also a miniaturist, working mainly in Europe.

Copeau, Jacques (1879–1949), French actor and director. In an effort to reverse the trend towards realism in the theatre he took over the Théâtre du Vieux-Colombier in 1913, presenting mainly Molière and Shakespeare and eventually designing his theatre as a reconstruction of the Elizabethan apron stage, by removing the proscenium arch and introducing simplified scenery. In 1936 he became a director of the Comédie-Française. He edited two *Cahiers du Vieux-Colombier* (1920, 1921), which expressed his theatrical concepts based on a closer relationship between actor and audience. (See also *theatre building.)

Copland, Aaron (1900–), US composer, pianist, and teacher. Wishing to develop a truly 'American' style, he introduced *jazz and *Latin American elements into his music. A series of dance pieces on American subjects, quoting folk-song and exploring a harmonic vocabulary that has a very characteristic 'open-air' quality, brought his name before a wide and appreciative audience. These works (*Billy the Kid*, 1938; *Rodeo*, 1942; *Appalachian Spring*, 1944) have remained popular. His Piano Quartet (1950) showed a return to a more astringent style, incorporating certain aspects of *serialism. Copland's work has embraced all forms and includes three symphonies (1924, 1933, 1946) and an opera, *The Tender Land* (1954). He has also written perceptively on musical subjects.

Copley, John Singleton (1738–1815), the greatest North American painter of the 18th century. By his early twenties he was painting portraits that in their sense of life and character completely outstripped anything previously produced by colonial portraitists. He became extremely successful and in 1775 settled in London, encouraged by the praises of *Reynolds and Benjamin *West. The portraits he painted in Britain were more than a match for those of most of his contemporaries, but in adopting a more fashionable style he lost something of the vigour of his colonial work. He turned to *history painting, taking up West's innovation of using modern dress and showing a gift for composing multi-figure groups that none of his British contemporaries could approach. His success in this field was short-lived, however, and he spent his final years ill and in debt.

copperwork, a general term for artefacts and decorative work made from copper. It was one of the first metals to be used by man, perhaps as early as the 5th millennium BC. As well as being attractive in colour, it is easy to hammer into shape, and its excellent conductivity of heat makes it a particularly useful material for cooking utensils. It can be cast as well as beaten, and has been used in this way for statuary (for example, in ancient Egypt), although it has proved more suitable for this purpose when alloyed with tin to form bronze. Other uses to which copper has been put in the arts include jewellery and architectural decoration.

Coptic art, the art of the native Christians of Egypt (Copts), particularly in the period between the 3rd and 8th centuries. Coptic art, which represents one of the earliest Christian artistic traditions, developed in the Nile Valley and combined traits from the *Hellenistic art of Alexandria with elements deriving from ancient *Egyptian art. Coptic painting includes murals, manuscript illuminations, and tomb portraits buried with the dead. The portraits are often highly realistic, but in other Coptic painting, such as church murals and icons, there is often heavy stylization, with forms simplified and flattened out and strong, bold colours. Similarly in sculpture, the prevailing style was somewhat crude, but vigorous, with characteristically rounded figures. Coptic art seems to have been remarkably democratic, intended for rich and poor alike, and the sincerity of the religious message was more important than technical finesse. The applied arts included pottery and work in bronze for church furnishings such as incense burners, and the Copts attained great distinction in textile manufacture. The Arab conquest of Egypt in 640 brought to an end the most important period of Coptic art. Coptic control of the Ethiopian church until the 20th century produced some distinctive forms of architecture and painting in that country, among them the ancient rectangular church of Debre Damo at Aksum and the Lalibela rock-hewn churches of the 12th and 13th centuries. Ethiopian Coptic churches were characteristically round, consisting of three concentric circles.

coral work, a general term for objects made from coral, a stony substance formed of the skeletons of certain marine creatures. Coral is found in various colours, can be filed and carved to shape, and takes a brilliant polish. It has been used since prehistoric times, mainly for jewellery, but also, for example, for statuettes, for religious objects such as rosaries, and for chessmen. The great age of coral-

carving in the West was the 17th and early 18th centuries, notably in Italy—In China many fine coral-carvings were made during the 19th century, and Tibet and Nepal were centres of quite distinctive carving. A coral branch is one of the Seven Legendary Treasures of Nippon and it is perhaps in Japan that the best work is still being done.

cor anglais (English horn), a musical instrument, a tenor *oboe built a fifth lower, with a bulbous bell. The name is a mystery, for it is neither a horn nor English. It has been suggested that *anglais* should be *anglé* (i.e. angled), but the earliest examples were curved, not angled. The constricted *bell opening gives the tone a hollow sound. It is the only survivor of the various types of tenor oboe of the Baroque period; it was little used in the Classical period, but became popular with the rise of Romanticism, and is available in every orchestra, played by one of the oboists.

Corelli, Arcangelo (1653–1713), Italian composer and violinist, based in Rome for most of his working life. Though he wrote relatively little, Corelli's music gained enormous currency and was influential in establishing the form and manner of the trio sonata and *concerto grosso. He published four collections of twelve trio sonatas (1681, 1685, 1689, 1694), a collection of twelve solo sonatas (1700) and the extremely popular twelve concerti grossi (1714), which include the famous 'Christmas' Concerto, written for the midnight mass. Corelli was one of the first composers to vary the keys in a *binary movement in a meaningful way, and his use of dissonance remains a highly attractive ingredient of his music.

Corneille, Pierre (1606–84), French dramatist, one of the principal writers of the 17th century. His output included *comedies and *tragedies written during the period from 1629 to 1674, though he is chiefly admired for the tragedies first performed between 1637 and 1651, including *Le Cid* (1637), *Horace* (1640), *Cinna* (1640), *Polyeucte* (c.1640–1), *La Mort de Pompée* (1642–3), *Rodogune* (1644–5), and *Nicomède* (1650–1). Corneille inaugurated a type of drama concerned rather with the inner struggles of the protagonists than with external action. His plays are commonly based on the conflict between the opposing claims of duty and love and are written in verse whose heroic grandeur parallels the moral elevation of the subject. In later years this formula found less success with a public whose demand for a more unbridled presentation of passion was being satisfied by the young *Racine.

cornet, a brass musical instrument with three valves, similar in range to the *trumpet but with the tubing narrowing more towards the mouthpiece, resulting in a rounder, less brilliant tone. In about 1825 valves were applied to the coiled continental *posthorn, initially two, and later three, creating the *cornet à pistons*, which retained the posthorn's set of crooks and shanks (additional lengths of tubing, fitting between the mouthpiece and the instrument, to produce a lower pitch) from B♭ down to E. The tone of the cornet is distinctly different from that of the trumpet, and French 19th-century composers contrasted the two instruments in the orchestra. The cornet's main home today is in *brass and military bands.

cornett, a musical instrument combining a miniature trumpet mouthpiece with a wooden tube around $\frac{3}{4}$ metre

(2 ft.) long with finger-holes, the great virtuoso wind instrument of the Renaissance. It also played the treble line in support of choirs and the upper parts in *Turmmusik* or 'tower music', music played from a church, balcony, or town hall tower (a common practice in 16th- to 18th-century Germany).

Corot, Jean-Baptiste Camille (1796–1875), French painter, one of the greatest figures in the history of *landscape painting. In his lifetime he was most successful with fairly traditional works evoking an idealized rustic past and painted in a misty, soft-edged style, but he is now most highly regarded for his more directly topographical work, which displays a luminous clarity and an unaffected naturalness. His directness of vision was much admired by the major landscape painters of the late 19th century, and almost all of them were influenced by him at some stage in their careers. Late in life he turned to figure painting, and did some exquisite female nudes.

Correggio (Antonio Allegri) (c.1489–1534), Italian painter, named after the small town in Emilia where he was born. He was one of the boldest and most inventive artists of the High *Renaissance, working mainly in Parma, where he painted two famous dome frescos, in the church of San Giovanni Evangelista (1520–1) and the cathedral (1526–30). In these two brilliant works he raised to new heights the illusionistic conception used by

Correggio was a versatile painter, his output ranging from ceiling frescos to intimate boudoir pictures such as *The Madonna of the Basket* (c.1525) showing the artist at his most charming. (National Gallery, London)

*Mantegna of depicting a scene as if it were actually taking place above the spectator's head, with steeply foreshortened airborne figures. These dome paintings were highly influential in the *Baroque period, and other aspects of Correggio's art were equally forward-looking. The striking light effects that he often used in his altarpieces again anticipate the Baroque, and his extraordinarily sensuous mythological paintings foreshadow the erotic works of such Rococo masters as Boucher.

Cortázar, Julio (Julio Denis) (1914–84), Argentinian novelist and short-story writer. He moved to Paris in 1951 and subsequently published collections of short stories, novels, and poetry. Many of the stories incorporate elements of play and fantasy, but the best known, *The Pursuer* (1959), with its contrasting but complementary figures of the hot jazz soloist and the cold jazz critic, introduces a persistent theme of the individual's quest for meaning in life. The novel *Hopscotch* (1963) is regarded as his masterpiece. It tells of an Argentine's quest for meaning in Paris and in Buenos Aires, and, in 'optional' chapters, discusses the function of literature in human experience. In later years he became active in the cause of human rights in Latin America.

Cortona, Pietro da (1596–1669), Italian painter, architect, decorator, and designer: a major figure of *Baroque art in Rome. His most famous work as a painter is the huge fresco *Allegory of Divine Providence and Barberini Power* (1633–9) in the Palazzo Barberini in Rome, a triumph of illusionistic skill, with the ceiling apparently opening to the sky and the figures seeming to descend into the room as well as to soar out of it. In other decorative schemes, notably in the Pitti Palace in Florence, where he worked intermittently from 1637 to 1647, Pietro combined painting with elaborate *stucco work in a way that proved highly influential. His masterpiece of architecture is the church of SS. Martina e Luca in Rome (1635–50), the first Baroque church designed and built as a complete unity.

Cosmati work, a type of coloured decorative inlay work of stone and glass that flourished mainly in Rome from about 1100 to about 1300. Small pieces of coloured stone and glass are combined with strips of white marble to produce geometrical designs. Cosmati work was applied to church furnishings such as tombs and pulpits and was also used for architectural decoration. The fashion spread as far as England, for example in the tomb of Henry III in Westminster Abbey (c.1280), executed by Italian craftsmen.

costume, a style of dress, especially as associated with a particular place or time. Throughout history men and women have sought embellishment through clothes and headwear, the quality and detail of the garment being intended to reflect the wearer's wealth and status in society. The clothes of the rich were ornamented with embroidery, fur, and jewels, with emphasis on details such as elaborate sleeves, capes, trails, veils, and headwear. In Western society neck ruffs appeared in the 16th century; in the 17th, high cork heels and silk stockings were worn by both sexes, as were ornamented gauntlet gloves. Men began to wear feathered hats over long hair curling to the shoulders, with full-bottomed wigs appearing around 1630. In the early part of the 18th century women encased themselves in hooped dresses and under extremely elaborate head-dresses. A simpler style spread across

Eminent artists have often been involved in designing theatrical **costume**. Bernardo Buontalenti (1536–1608), who made this drawing, was a multi-talented master of the revels at the Medici court in Florence, producing and designing fêtes, plays, and spectacles of all kinds, including firework displays. (Victoria and Albert Museum, London)

Europe after the French Revolution, when the cheapness of India muslin and light china silk allowed middle-class women to own more clothes than before. Trousers, orginially the sailors' traditional garment, superseded breeches in about 1812. In the mid-19th century women's dresses were supported by crinolines and later by bustles. The real break with the past came after World War I when men's clothes became less formal and women began to wear loose-fitting shifts shortened to the knee. This style has, with seasonal and regional variations, been generally adopted, and the mass production of synthetic fibres has brought fashionable clothes within reach of most. Western-style clothing, often massproduced locally, has increasingly led to its adoption for ready wear by men and women around the world. Among the most widely prevailing regional costumes are the Hindu dhoti for men and sari for women, both consisting of lengths of fine cloth wrapped around the body; the sarong worn with a small jacket or bodice by South-East Asian women; the Japanese kimono, now worn only on formal occasions; and the long black veil or yashmak that covers women who practice the traditional Islamic faith. Climate and comfort often dictate the continued use of regional costumes such as the long white robes of the Bedouin and full trousers or *shalvar* of Middle Eastern peasants. (See also *African costume and textiles.)

Cotman, John Sell (1782–1842), British *landscape painter (mainly in water-colour) and etcher. In 1806 he settled in his native Norwich, where with John *Crome (the Elder) he became the most important representative of the *Norwich School. His early works are classic examples of the traditional English water-colour technique, but taken to new heights of boldness and sureness of hand, shapes sometimes being reduced to almost geometrical simplicity. In later years, however, he lost this freshness as he tried to catch the public fancy with large and gaudily melodramatic water-colours.

cotton and cotton-printing, a soft white fabric made from the fibre of the cotton plant and the various methods that have been used for printing designs on it. The cotton plant is found in both the northern and southern hemispheres, and it has been used to make fabrics since ancient times—archaeological evidence indicates they were produced in India about 5000 years ago and in Peru about 4000 years ago. Cotton was also known to the Romans, but it was not until the Middle Ages that a cotton industry was established in Europe; it appeared first in Spain in the 8th century, introduced by the Moors, and gradually spread eastwards and northwards, reaching Britain in the 15th century. Imported cotton was of better quality, however, and in the 17th century attempts were made in Europe to imitate Indian painted cottons (chintz) by means of printed designs. These early designs—usually lush floral patterns—are called 'block-printed' because they were made from wooden blocks (as in woodcut). In the 1750s engraved copper plates, which permitted finer detail, were introduced to the industry ('plate-printed cotton'). One of the main centres of production was at Jouy near Paris, and the term 'toile de Jouy' (literally 'cloth of Jouy') is often applied to all cotton printed in this way. In the 1780s 'roller-printed cotton', in which the design is printed using engraved metal cylinders, was introduced, and in the early 19th century this superseded plate-printing and was fully developed so that, by the middle of the 19th century, a very wide range of colours could be printed.

counterpoint (from the Latin *punctus contra punctus*, 'point against point', i.e. 'note against note'). In music, counterpoint is the art of combining two or more independent melodic lines. These may differ in rhythm and outline, yet in combination they make perfect sense. Music conceived contrapuntally requires the listener to take in the shape of each melody—to listen 'horizontally'. As the melodies pass one another they produce a vertical harmony. Until almost the end of the 19th century the degree of dissonance permitted in the resultant harmonies was strictly controlled. In 20th-century counterpoint the movement of parts is usually free of harmonic inhibitions. An important aspect of counterpoint is imitation or *canon—the repetition by one voice of a phrase that another voice has just stated. That repetition may be strict (exact) or free (similar, but not exact), and the overall effect is to bind the different strands of a complex texture together. The combination of independent parts, with or without imitation, is known as *polyphony.

country music, with its roots in the rural South of the USA, derived from traditional oral music brought from Europe. The music was first recorded in the 1920s, when it was known as 'hillbilly music'. Initially there were many regional styles, but the nationwide spread of the music through records and the radio helped to forge a recognizable mainstream style. However, in the 1930s regional variations continued outside the mainstream: examples include cajun music (from French-speaking rural Louisiana), Western swing (a blend of hillbilly music with early jazz), honky tonk (an urban sound from Texas), and bluegrass (from the Appalachian mountains). Meanwhile, mainstream country and western continued to develop; in the 1950s and 1960s artists such as Jim Reeves, Johnny Cash, and Patsy Cline spread its appeal to (mainly white) urban communities. More recently artists such as Glen Campbell and Dolly Parton have

This detail of a *toile de Jouy* shows the delicacy of effect obtainable with the copper plate method of **cotton printing**. Illustrating some of the stages that go into manufacturing material, it was designed by the French Rococo artist Christophe Huet in 1783. (Victoria and Albert Museum, London)

developed a style closer to that of *popular music. Country music now has a world-wide audience, and new performers from outside the USA have adopted the style so successfully as to compete with US artists.

Couperin, François (1668–1733), French composer, harpsichordist, and organist. Commonly called 'le Grand', he was the most important member of a musical dynasty that included his uncle **Louis** (*c.*1626–61), a composer, violinist, and skilled keyboard-player, and father **Charles** (1638–79), an organist. In 1693 François was appointed organist to Louis XIV, during whose reign he established himself as the leading French composer, harpsichordist, and keyboard teacher of his day. His very considerable output includes sacred and secular vocal music, organ music, motets, instrumental chamber music and, most important, four books of harpsichord pieces (254 in all), arranged as dance suites, each movement bearing a fanciful, poetic title. Couperin's work attempted to reconcile French melodic restraint with Italian harmonic intensity, and was largely successful.

couplet, a pair of rhyming verse lines, usually of the same length. Chaucer established the use of couplets in English, notably in the *Canterbury Tales*, using rhymed iambic *pentameters later known as 'heroic couplets': a form perfected in the 17th and 18th centuries by Dryden and Pope. Couplets of *alexandrines were the standard verse-form of French drama in the age of Racine. A couplet may also stand alone as an *epigram, or form part of a larger *stanza, or (as in Shakespeare) round off a *sonnet or a dramatic scene.

courante, a dance of French origin, popular in the 17th century. It was quick and in triple time, and was often used as a lively contrast to the *allemande. The courante appears in Italian sources as the *corrente* and in England as the coranto. It is one of the basic movements of the dance *suite.

Courbet, Gustave (1819–77), French painter, the out-standing figure of the *Realist movement. He established his reputation at the 1850 Paris *Salon, where he exhibited three large paintings that treated scenes from everyday life on an epic scale normally associated with grandiose religious or historical subjects. The most famous of the three, *The Burial at Ornans*, showing an interment at a cemetery on a hill outside his home town, was attacked by some critics for its alleged crudity and deliberate ugliness, but it was also hailed for its powerful naturalism. His most famous painting, *The Painter's Studio*, is an elaborate allegory of his own life and also contains subtle political allusions attacking Napoleon III. After the deposition of Napoleon in 1871 Courbet was active in the short-lived Commune (the insurrectionary government in Paris). He was imprisoned and then fled to Switzerland, where he remained for the rest of his life. His work was influential because of his rejection of the traditional notions of idealization in art.

court fool, a member of the Royal Household, also known as the king's jester, not to be confused with the humbler *fool of the folk festivals. His origin has been variously traced to the court of Haroun-al-Raschid, to the classical dwarf-buffoon, and to the inspired madman of Celtic and Teutonic legend. At some point in his career he adopted the parti-coloured costume of his rival, which led to confusion between the two types, but the court fool has nothing else in common with the folk tradition, whose fool is nearer to the *clown. Shakespeare's fools derive from the court fool, already a tradition in his time. In dramatic use they serve as vehicles for social *satire.

courtly love, a modern term for the literary cult of heterosexual love which emerged among the French aristocracy from the late 11th century, with a profound effect upon subsequent Western attitudes to love. The troubadours (*minstrels) of southern France, followed by French and German *romance writers and by *Dante, *Petrarch, and other Italian poets, converted sexual desire from a degrading necessity of physical life into a spiritually ennobling emotion, almost a religious vocation. An elaborate code of behaviour evolved around the tormented male lover's abject obedience to a disdainful, idealized lady. Some of these conventions derive from misreadings of *Ovid, but this form of adoration also imitated both feudal servitude and Christian worship, despite celebrating adultery (as in stories of Lancelot and Guinevere) rather than the then merely economic relation of marriage. *Chaucer treated the cult sceptically, but its influence is strong in 16th-century English *lyrics.

Covent Garden Theatre, the London theatre devoted since the mid-19th century to opera, now known as the Royal Opera House. It opened in 1732 as the Theatre Royal, sharing with *Drury Lane a monopoly of legitimate theatre in London until 1843. In 1773 it presented the first performance of Goldsmith's *She Stoops to Conquer*. Its dramatic heyday was the early 19th century, under the managements of *Kemble and *Macready. It was rebuilt twice after fires in 1808 and 1856.

Coward, Sir Noël (1899–1973), British composer, author, actor, producer. His acting career began in 1911, his first effective song, 'Forbidden Fruit', dates from 1916, and his first play, *I'll Leave it to You*, from 1920. There followed successful comedies (*Hay Fever*, 1925), dramas (*The Vortex*, 1924), revues (*This Year of Grace*, 1928), and operettas (*Bitter Sweet*, 1929). Two comedies, *Private Lives* (1930) and *Blithe Spirit* (1942), are outstanding. His music, inextricably linked to his own brilliant lyrics, ranges from the delicately sentimental to the satirical.

Cowley, Abraham (1618–67), English *metaphysical poet and essayist. During the English Civil War he contributed to the Royalist cause with a satire, *The Puritan and the Papist* (1643). His other works include *The Mistress* (1647), love poems, 'Miscellanies' in *Poems* (1656), which contains the scriptural epic 'Davideis', and 'Pindarique Odes,' which employ the irregular Pindaric *ode that was to influence later poets. His prose works, which combine grace and simplicity with bright rhythmic discourse, include *A Proposition for the Advancement of Learning* (1661) and 'Essays' (1668).

Cowper, William (1731–1800), British poet and hymn-writer. He was subject to bouts of melancholia and insanity, and for consolation turned increasingly to evangelical Christianity. With John Newton, an evangelical curate, he wrote *Olney Hymns* (1779). These were followed by several satires and poems, and by his comic ballad *John Gilpin* (1785). His sympathetic feelings for nature presage *Romanticism. His best-known long poem, *The Task* (1785), stresses the delights of rural life and the poet's own search for peace. Man's isolation, storms, and shipwrecks recur in his works as images of the mysterious ways of God. His letters are considered among the most brilliant in the language.

Cox, David (1783–1859), British *landscape painter, one of the best-known water-colourists of his period. In spite of a certain anecdotal homeliness, his style was broad and vigorous, and in 1836 he began to paint on a rough wrapping paper that was particularly suited to it. A similar paper was subsequently marketed as 'Cox Paper'. He wrote several treatises on landscape painting in water-colour, and frequently in oils.

Coypel, family of French painters, of which **Noël** (1628–1707) was the head. He had a successful career with his academic style based on *Poussin and *Lebrun. His son **Antoine** (1661–1722), the best-known member of the family, went to Rome as a child, when his father was director of the French Academy there, which explains the strong Italian element in his style. This is particularly evident in his finest work, the ceiling of the chapel at Versailles (1708), which is convincingly *Baroque and much more successful than many other of his ambitious works, which tend to combine bombast with pedantry. His half-brother **Noël-Nicholas** (1690–1734) painted charming mythological subjects, but his rather timid personality prevented him from achieving the worldly success of his relatives.

Cozens, Alexander (1717–86), British *landscape draughtsman, the first major British artist to devote himself entirely to landscape. In 1785 or 1786 he published his famous treatise *A New Method of Assisting the Invention in Drawing Original Compositions of Landscape*, in which he explains his method of using accidental blots on the drawing paper to stimulate the imagination by suggesting landscape forms that could be developed into a finished

work. He worked almost exclusively in monochrome, and both his 'blot drawings' and his more formal compositions use intense lights and darks with masterly effect. His son, **John Robert Cozens** (1752–97), was also an outstanding landscape painter in water-colour. He did not compose wholly from imagination like his father, but he often rearranged natural features in the interests of the composition. His finest works have an exquisite sense of poetic melancholy, and his work was admired and copied by artists of the stature of Constable and Turner.

Crabbe, George (1754–1832), British poet. In *The Village* (1783) and in other works he paints precise, closely observed portraits of the cruel realities of country life, making plain his revulsion from the *pastoral, and writing mainly in the *heroic couplets of the *Augustan age. *The Borough* (1810) describes the life, characters, and surroundings of his birthplace, Aldeburgh in Suffolk, where he was curate; two of the Tales, 'Ellen Orford' and 'Peter Grimes' were combined in Britten's opera *Peter Grimes* (1945).

Craig, Edward Gordon (1872–1966), British stage designer and theorist. Originally an actor, he became an innovatory designer. His theory on acting, which involved the actor becoming the director's puppet, and on scenery (including movable screens), are collated in *On the Art of the Theatre* (1911), and had great influence in Europe and the USA.

Cranach, Lucas (the Elder) (1472–1553), German painter. He was court painter to Frederick III (the Wise), Elector of Saxony, and lived in Wittenberg until 1550, when he followed the Elector John Frederick (the Unfortunate) into exile. His career was extremely successful and he became one of Wittenberg's wealthiest and most respected citizens. His paintings were eagerly sought by collectors and his busy studio often produced numerous replicas of popular designs, particularly those in which he showed his skill at depicting female beauty. He excelled at erotic nudes and pictures of coquettish women wearing large hats, sometimes shown as the biblical heroine Judith or the goddesses in *The Judgement of Paris*. Cranach was also a fine portraitist, and in his early works particularly he showed a poetic feeling for landscape. His son, **Lucas** (the Younger) (1515–86), was his pupil and skilful assistant, imitating his father's style so successfully that it is sometimes difficult to distinguish their work.

Crane, Stephen (1871–1900), US novelist, short-story writer, and journalist. His first novel, *Maggie: A Girl of the Streets* (1893), is a pioneering example of *naturalism. His masterpiece *The Red Badge of Courage* (1895) renders the horror and confusion of war through the reactions of an inexperienced soldier. Written without any direct experience of battle, it led to several assignments as war correspondent. The short stories, some of which ('The Open Boat', 'The Blue Hotel') are regarded as classics, are outstanding amongst the remainder of his output.

Cranko, John (1927–73), South African dancer, choreographer, and director. He studied in South Africa and in London, and subsequently choreographed for both the Sadler's Wells and the Royal Ballet companies, his works including *Pineapple Poll* (1951). In 1961 he became director of the Stuttgart Ballet, achieving an international reputation for the company's theatrical and athletic new works. His own choreography is notable chiefly for full-length dramatic works such as *Onegin* (1965) and *Carmen* (1971).

craquelure (French, 'crackling', 'crazing'), the network of small cracks that appears on the surface of a painting when the *pigment or *varnish has become brittle with age. Craquelure is apparent to some extent in all old paintings, but its appearance and obtrusiveness varies with such factors as the materials used, the age of the picture, and the skill of the artist. When the cracks are circular in form, as in Reynolds's *Mrs Siddons as the Tragic Muse* (British Museum, London), it is known as 'rivelling'.

Crashaw, Richard (c.1612–49), English poet. He converted to Roman Catholicism in about 1645, at the time of Puritan rule in England, and spent the rest of his life in exile in France and Italy. His principal work, *Steps to the Temple* (1646) is a collection of religious poems influenced by *Marino and the Spanish *mystics; to this was attached the secular *Delights of the Muses*, containing

The *Judgement of Paris* was one of **Cranach's** favourite subjects, allowing him to display his skill in painting the female nude. Paris (*left*), is asked to judge which of the three goddesses, Hera, Athene, or Aphrodite, is the most beautiful. Cranach shows the scene in contemporary costume: Paris is a knight in armour rather than a shepherd and the three contestants are girlish coquettes, not remote divinities. (Staatliche Kunsthalle, Karlsruhe)

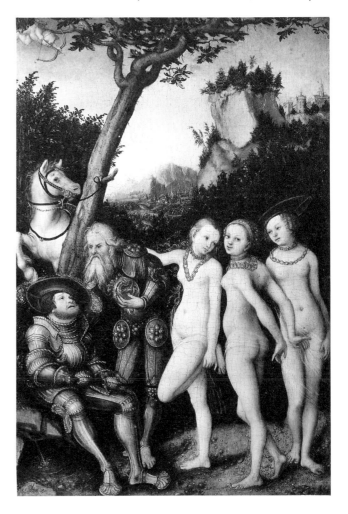

'Music's Duel', in which a nightingale and lute-player contend until the nightingale dies. His elaborately written poems such as the 'Hymne' and 'The Flaming Heart' addressed to St Teresa, reflect the baroque style of the Counter-Reformation in Europe. (See also *Metaphysical poets.)

crayon, a stick of colour made with an oily or waxy binding substance, used chiefly by children. This is the way in which the term is now most generally understood, but in the past the word 'crayon' has been used very vaguely and not clearly distinguished from *chalk or *pastel. In 18th-century usage, a 'painter in crayon' usually meant a pastellist.

creamware, a type of pottery with a cream-coloured body containing flint. It was first made by the Staffordshire potter Enoch Booth in the mid-18th century, and an improved type called 'Queen's ware' was introduced by *Wedgwood in 1765. Creamware was hardwearing and fairly cheap to produce, and it was well suited to painted, transfer-printed, or openwork (pierced) decoration. It soon became very popular in Britain and Europe, and as early as 1770 a factory for producing it was opened in South Carolina in the USA.

crescendo, an Italian musical term meaning 'growing', used in music scores since the early 18th century to indicate a gradual increase in loudness. Its opposite is diminuendo. Both can be abbreviated to cresc. and dim.; or, if the required effect involves only a few notes, replaced altogether by hairpin signs: $<$ or $>$. A crescendo is a gradual increase in tension and excitement. In orchestral music the effect seems to have been first exploited by the Mannheim composers. In later years it found a particularly skilful exponent in Rossini.

crewel work, a type of embroidery, distinguished by the two-ply worsted wool yarn called crewel, often on a twill foundation of linen warp and cotton weft, or sometimes on pure linen or cotton. It dates back to the 16th century, when it was used mainly for bed hangings and curtains. It had its greatest popularity in Britain, from the late 17th century, and then in the USA, where the vogue lasted throughout the 19th century. Crewel work most typically features bold tree designs, with curling leaves and exotic flowers, imitating embroidered hangings from India and China.

Crome, John (1768–1821), British *landscape painter and etcher, was with *Cotman the major artist of the *Norwich School. He spent his life in Norwich, and his paintings show a keen appreciation of local characteristics. Largely self-taught, he was influenced particularly by the great Dutch landscape painters such as *Ruisdael and *Hobbema, and also by *Gainsborough and Richard *Wilson. He is sometimes known as 'Old Crome' to distinguish him from his son **John Bernay Crome** (1794–1842), who was also a painter, but of lesser talent.

crooning, a singing style adopted by US singers of *popular music from about 1930. It was soft and sentimental and relied upon microphones to build up the tone. The technique was introduced by such artists as Rudy Vallee and 'Whispering' Jack Smith and perfected by Bing Crosby, Perry Como, and Frank Sinatra.

This detail of a 17th-century English bed-hanging shows some of the different stitches used in **crewel work**. Designs, often inspired by Indian cottons, were worked in a rich variety of colours, all obtained, in this period, from natural dyes. (Victoria and Albert Museum, London)

Crosby, Bing (Harry Lillis) *crooning.

Crown Film Unit *documentary film.

crown jewels. Among the earliest examples of crowns are those of ancient Egypt, which range from geometric designs to gold coronets of floral wreaths, and silver, gem-set crowns embossed with busts and plumes of the goddess Isis. Early European examples are the mid-7th century votive crowns found at Toledo. Known as the 'Guarrazar' treasures, they are studded with pearls and precious stones set in gold. They carry pendants of jewels or cut-out letters in gold, with gold chains to enable them to be suspended from a ceiling for ceremonial use. Two of the most notable crowns of the early Middle Ages are the Wenceslaus crown in Prague and the so-called Charlemagne crown, now in the Kunsthistorisches Museum in Vienna. The latter bears the insignia of the Holy Roman Emperor with depictions of religious subjects in enamel, surrounded by a border of filigree encrusted with pearls and precious stones. In the 13th and 14th centuries a great number of royal crowns

were made. Among the finest is the crown of Princess Blanche, daughter of King Henry IV of England, worn at her wedding at the age of 10 in 1402. It demonstrates the Gothic style at its most refined, with a garland of long-stemmed fleur-de-lis springing up from narrow circlets of gold and precious stones. The present English collection of crown jewels kept in the Tower of London was made for the coronation of Charles II in 1661. It includes the sword of state, the royal sceptre (containing the Star of Africa, cut from the Cullinan diamond), the ampulla (the container for the holy oil used in anointing), the orb, and the anointing spoon.

Cruelty, Theatre of *Artaud, Antonin.

Cruikshank, George (1792–1878), British painter, illustrator, and *caricaturist. He was the son of a caricaturist, Isaac Cruikshank (c.1756–c.1811), and was precociously gifted, quickly establishing himself as *Gillray's successor as a political cartoonist. The private life of the Prince Regent was one of his first targets. In the 1820s he began to turn to book illustration, in which field his output was immense, including many of the novels of Dickens. Later he took up the cause of temperance, producing moral narratives in woodcut.

crumhorn, a reed musical instrument with a hook-shaped lower end used between about 1480 and about 1640 and now revived. It has a cylindrical bore and is played with a double reed inside a cap with a hole in the top to blow into. The sound is low-pitched and buzzing. The main members of the family were the descant in C, the alto in G, the tenor in C, and the bass in F (this last often being extended to low C). The name comes from the upcurved end (German, *krumm*, 'crooked').

crwth, a bowed stringed musical instrument played like a *fiddle, with the two upright arms and yoke of a *lyre used in Wales until the early 19th century. The bowed lyre was widely used in the early Middle Ages, but was replaced in the 12th century by the *harp. It reappeared as the crowd before 1400, always with a fingerboard and with two *drone strings, either plucked with the left thumb or bowed. The crwth was the final form of this instrument, with a finger board, and three pairs of strings.

crypt, a cell, chamber, or vault beneath the main floor of a church, used as a burial chamber, chapel, etc. Crypts are usually completely underground, but they may be only partly sunk, with the floor above them raised, as at Canterbury Cathedral, where the crypt (which is unusually large) forms a complete lower church. The tradition of crypt-building derives from the practice of the Early Christians of erecting churches above catacombs and the tombs of martyrs. Thus, the original (4th century) St Peter's in Rome was built over the tomb of St Peter, and the crypt of the present church still serves as the burial place of the popes.

Cubism, a movement in painting (and to a lesser extent sculpture) developed by *Picasso and *Braque from about 1907. Cubism made a radical break from the realistic depiction of nature that had dominated European painting and sculpture since the *Renaissance, for Picasso and Braque aimed to depict the permanent structure of objects rather than their appearance at a particular moment and place. They represented subjects from a multiplicity of angles, rather than showing them from a single, fixed viewpoint, so that many different aspects of the same object could be seen simultaneously. Influenced by *African sculpture and the later paintings of *Cézanne, Cubist work up to 1912 is called 'Analytical' Cubism: forms were analysed into predominantly geometrical structures and colour was extremely subdued. In a second phase, known as 'Synthetic' Cubism, colour became much stronger and shapes more decorative, and elements such as stencilled lettering and pieces of newspaper were introduced into paintings and made into *collages. Juan *Gris was as important as Braque or Picasso in this phase of the movement. World War I brought an end to the collaboration of Braque and Picasso, but their work was a major influence on other movements, among them *Futurism, *Orphism, *Purism, and *Vorticism. Certain forms of modern poetry, prose, and music have been called Cubist because of their multi-image structure.

cueca, a lively dance from Chile, which alternates between 3/4 and 6/8 tempo in eight-syllable *quatrains, interspersed with improvised dialogues. It is danced by a couple to the accompaniment of tonic and dominant chords on guitars, punctuated by hand claps of the singers and dancers. The song 'America' from *Bernstein's *West Side Story* is in the style of a *cueca*.

Cui, César The *Five.

cummings, e. e. (Edward Estlin) (1894–1962), US poet. His first published poetry was written in a relatively conventional style, but in *&* (1925) and *is 5* (1926) he started to adopt the techniques he is best known for: vernacular language, tricks of typography and spelling (including lower case for his own name), hybrid verse-forms, and word plays. His verse, collected in *Complete*

Georges Braque's *Bottle and Fishes* (c.1909–12) shows how far **Cubism** had moved along the road to abstraction. The objects are still recognizable, but their forms have been radically fragmented. Braque seems to have worked on the picture, which is exceptionally heavily painted, over a number of years. (Tate Gallery, London)

Poems (1968), celebrates individual vision and experience in a modern age of mass culture and uniformity.

Cunningham, Merce (1919–), US dancer, choreographer, teacher, and director. He danced with the *Graham company (1939–45) and, after a period as a solo dancer, started his own company in 1952. He is one of the major figures in *modern dance who pursued the question of form through chance and indeterminacy. His use of isolated body parts is combined with intricate fast (balletic) footwork and twisted and tilted trunk articulations. He fashioned this vocabulary into an alternative modern dance technique to that of Graham. He is noted for his collaborations with the composer *Cage and painters such as *Rauschenberg and *Warhol, in which each art pursues its independent course. Among his many works are *How to Pass, Kick, Fall and Run* (1965), *Walkaround Time* (1968), and *Duets* (1980). Excerpts from his works are sometimes compiled into Events.

Currier, Nathaniel (1813–88) and **Ives, James M.** (1834–95), US print publishers who went into partnership in 1857 and produced a vast number of 'Colored Engravings for the People' representing almost every aspect of contemporary America. A number of artists were retained by the firm to draw the *lithographs in black and white, and the prints were coloured by hand on a production-line system. The business was carried on until 1907 by the sons of the founders. Currier and Ives prints have all the virtues of good popular art, being unpretentious, vigorous, and colourful.

Cuyp, family of Dutch painters, three members of which gained distinction. **Jacob Gerritsz. Cuyp** (1594–*c.*1651) excelled as a portraitist, his depictions of children being particularly charming. His half-brother **Benjamin Gerritsz. Cuyp** (1612–52) is noted for his biblical and genre scenes, which use light and shadow effects in a manner akin to the early work of *Rembrandt. The most illustrious member of the family is **Aelbert Cuyp** (1620–91), the son and probably the pupil of Benjamin Gerritsz. Aelbert painted many subjects, but he is now remembered as one of the greatest Dutch landscape painters. His finest works—typically river scenes and landscapes with placid, dignified-looking cows—show great serenity and masterly handling of glowing light.

cymbals, bronze plates, either clashed together in pairs, or used singly and struck with a drumstick. Small cymbals were used in the ancient world (the origin of the orchestral 'antique' cymbals), sometimes on the ends of tongs; they were also used in the Middle Ages. Medium-sized instruments came into military bands in the late 18th century with Turkish music, and were occasionally used orchestrally. Larger instruments were used from the mid-19th century. Cymbals are graded in tone for various uses: military, orchestral, suspended, ride (for popular music), crash, etc. Many different styles of cymbal are used throughout Asia. Large Tibetan cymbals have deep domes, whereas the Chinese cymbals have small, high centres and upturned rims. Small, thick cymbals are used in Tibet and elsewhere. Cymbals are used throughout the Islamic world and in India, especially by dancers.

Cyrano de Bergerac, Savinien (1619–55), French writer of fantastic and burlesque romances. He is remembered principally for *L'Autre Monde,* published posthumously in 1656, an extravagant account of an imaginary visit to the moon which is in reality a satire of contemporary France. Some of Cyrano's views, such as his conception of a materialistic universe and his criticism of orthodox religious practices, which were considered subversive in the 17th century, anticipate *Diderot and the *Enlightenment. He is the hero of Edmond Rostand's play *Cyrano de Bergerac* (1897), in which he is portrayed as a gallant lover of grotesque appearance.

Czech literature, the literature of the Czech-speaking part of Czechoslovakia. The beginning of vernacular writing dates to the 9th century, when the greater part of the Bible was translated into literary Slavonic (now known as Old Church Slavonic). The *Legends* that recount the life of St Wenceslas (10th century) are written partly in Czech. Until the late 14th century Czech literature consisted mainly of Latin chronicles such as the *History of Bohemia* by Cosmas of Prague, and Czech hymns, courtly literature such as the *Alexandreis*, and verse satire. A political allegory, *The New Council*, was written by Smil Flaška of Pardubice as a defence of the Bohemian nobility against the crown. The best and most original works of the religious reformer Jan Hus were written in the vernacular, laying the foundation for a new uniformity in Czech orthography and grammar. The defeat of the Czech nobility in the Thirty Years War (1618–48) resulted in a suppression of the Czech language, while its literature survived mainly in ballads and folk tales. The radical Protestant and egalitarian ideas of Peter Chelčický (*c.*1390–*c.*1460) inspired scholars to translate the Kralice Bible (1579–93), whose language became the model for classical Czech. In the 17th century the educational reformer and religious thinker Comenius published, while in exile, one of the supreme achievements of Czech prose literature, the *Labyrinth of the World and Paradise of the Heart* (1631), as well as the first illustrated children's book in any language, *The Visible World in Pictures* (1658). In the 18th century the scholar Josef Dobrovský led a revival of older Czech literature and codified the language. In the 19th century Slavophilism, also expressed in *Slovak literature, inspired the work of the greatest poet of Czech *Romanticism *Mácha. A reaction against this were the satirical writings of Karel Havlíček (1821–56) and the realist novels of Božena Němcová (1820–62). After independence in 1918 the plays and novels of *Čapek achieved world renown, as did *Hašek's satire on war, *The Good Soldier Schweik*. After the Communist take-over in 1948, *Socialist Realism prevailed, but this was superseded by the introspective plays of writers such as *Havel and *Hrabal who chose to remain in their country after the 'Prague Spring' of 1968, and the novels of others such as Milan *Kundera and Arnošt Lustig, who chose exile after 1968. After 1969 the works of many playwrights, poets, and novelists were banned and were published instead by the underground press in the form of 'self-published' or *samizdat* editions, circulated in typewritten and hand-bound form. An alternative culture was thus created, which proved to be culturally more influential than the official one. After the political upheaval of 1989 censorship restrictions on *samizdat* and exiled writers were removed, and their work fused once more into the mainstream of Czech culture.

D

dactyl, a metrical unit (foot) of verse, having one stressed syllable followed by two unstressed syllables, as in the word 'barbarous'; or (in Greek and Latin verse) one long syllable and two short ones. Dactylic *hexameters were used in Greek and Latin *epic poetry.

Dada (French, 'hobby-horse'), a movement in European and US art characterized·by violent revolt against traditional values. It was founded in Zurich in 1915, arising from the mood of disillusionment engendered by World War I. Emphasis was given to the illogical and the absurd, and the importance of chance in artistic creation was exaggerated. According to the most popular of several accounts of how the name originated, it was chosen by inserting a penknife at random in the pages of a dictionary, thus symbolizing the anti-rational stance of the movement. Dada artists did not cultivate a particular style, but went to extremes in the use of buffoonery and provocative behaviour to disrupt public complacency. *Montage, *collage, and the ready-made were among the typical forms of expression, as was the nonsense poem in the field of literature. Dada spread quickly (notably to New York, where Marcel *Duchamp was the leader of the movement), but it did not survive long as an organized movement. Its influence, however, was profound, notably on *Surrealism (particularly in its tendency towards absurdity and whimsicality), *Abstract Expressionism, and *Conceptual art.

Daguerre, Louis Jacques Mandé (1787–1851), French inventor of photography. In 1829 Daguerre—theatrical scenery painter and joint owner of the Paris Diorama—became the partner of Joseph Nicéphore Niepce, who had taken the world's earliest photograph 'from nature' (the 'heliograph') three years before. In 1839 Daguerre at last published a development of Niepce's process. Niepce had died in 1833, so it was Daguerre who reaped honours and riches, and his name was attached to the first practical photograph, the daguerreotype, a 'one-off' direct positive with no negative.

Dalcroze, Jaques *Jaques-Dalcroze.

Dalí, Salvador (1904–89), Spanish painter. In 1929 he joined the *Surrealists in Paris, where his talent for self-publicity rapidly made him the most famous representative of the movement. During the 1930s he painted some classic Surrealist pictures, employing fine draughtsmanship and a meticulous technique to create disturbing, hallucinatory images that he called 'hand-painted dream photographs'. Certain favourite recurring images such as watches bent and flowing as if melting in the sun became almost trade marks. In 1937 Dalí visited Italy and adopted a more traditional style—one of the factors that led to his expulsion from the Surrealist ranks. He moved to the USA in 1940 before returning to Spain in 1955 to live as a recluse. Dalí's output included sculpture, book illustration, jewellery design, and work for the theatre and cinema. His status is controversial, many critics

feeling that he produced little of consequence after the 1930s.

Dallapiccola, Luigi (1904–75), Italian composer and teacher. He was one of the most distinguished composers of his generation and the first Italian to follow the example of *Schoenberg's *serialism. His career began with the six *Michelangelo Choruses* (1933–6). International fame came with the one-act opera *The Prisoner* (1948)—a masterpiece of serialism and a powerful expression of his hatred of fascism. Later works, such as the *Songs of Freedom* for chorus and orchestra (1955), the ballet *Marsia* (1943), and the operas *Job* (1950) and *Ulisse* (1968), were influenced by *Webern and consequently are leaner in texture. Despite his adherence to serial techniques, Dallapiccola's music is essentially lyrical.

damascening, the technique of ornamenting a metal (often steel or brass) by inlaying it with a design in another metal or metals (usually gold or silver). The technique was often used on arms and armour. The word derives from the city of Damascus, which was long famous for its sword blades. Originally the term referred to the process of imparting a 'watered' (ripple) pattern to the surface of the blade.

Dance, George (1741–1825), British architect. He studied architecture in Italy (1758–64), where he absorbed

Magazines such as this played an important role in spreading the ideas of **Dada** (and later of Surrealism). They are also of great value in recording the appearance of Dada works, many of which were produced in unconventional media and have not survived.

the spirit of *Neoclassicism. In 1768 he succeeded his father as Clerk of the City Works, and much of his work involved public and mercantile buildings in the City of London; he was an innovative town-planner, but few of his schemes were fully realized. His masterpiece was Newgate Prison (1770–80, demolished 1902), the massive, severe forms of which perfectly expressed its forbidding function. The austerity and nobility of his style are reflected in the work of his most important pupil, Sir John *Soane.

dance companies. The tradition of groups of dancers training and performing together originated in the Renaissance courts of France and Italy. Louis XIV sought to improve standards of the *ballet de cour by the establishment of the first dance academy in 1661, which led to the distinction between the amateur dancing of the aristocracy and professional dancers. The Académie Royale de Musique was also founded by Louis XIV, and later spawned the Paris Opera Ballet. A distinguished succession of ballet-masters and dancers, including the composer *Lully, the Taglionis, Saint Leon, and *Petipa ensured its reputation, despite periods of mediocrity both before and after the Romantic period. By 1740 an Imperial School of Ballet had been established at the Winter Palace in St Petersburg, and Russian soloists danced in a fully established company. The Moscow Ballet Company (later to become the *Bolshoi Ballet) was opened in 1825, while Russian nobles created their own companies composed of their serfs and drawing on native Russian dance-forms. The Russian Imperial Ballet at St Petersburg became the Maryinsky and then the *Kirov Ballet in 1935, continuing Petipa's emphasis on classical purity of line and elegance, in contrast to the Bolshoi's vivid dramatic, athletic style. Dancers from the Maryinsky and Moscow Ballets formed the backbone of a troupe of Russian dancers, known as the Ballets Russes, organized by *Diaghilev to present a season in Paris in 1909. The Ballets Russes company existed for twenty years and was famous for generating new work and for collaborations between composers, choreographers, and painters. The dispersal of Diaghilev's dancers and choreographers after his death in 1929 encouraged a widespread revival of ballet, particularly in Britain and the USA, where the seeds of new national dance forms were sown. In London in 1930 the Marie Rambert Dancers were formed, and later renamed Ballet Rambert. During the 1960s Rambert changed to become a small modern company, presenting works by new choreographers like *Bruce and *Alston. In 1986 Alston became director of the company, renaming it *Rambert Dance Company. Another major British company founded around the same time was the *Royal Ballet (orginally the Vic-Wells Ballet), set up by Ninette *de Valois, which gave its first performances in 1931. She also established the Royal Ballet Schools and ensured a theatre base for the company at the Royal Opera House. The English National Ballet (formerly London Festival Ballet) emerged in the 1950s from the partnership of the first British *ballerina, *Markova, and Anton Dolin. The company has always pursued a policy of combining the classics with the works of modern choreographers and, through its director Peter Schaufuss, has developed links with another strong European tradition, the *Royal Danish Ballet. The catalyst for the development of American dance was the arrival in New York of the former principal choreographer of

the Ballets Russes, *Balanchine. He established the School of American Ballet in 1934, and in 1948 he and writer Lincoln Kirstein founded *New York City Ballet explicitly to perform Balanchine's work. The company's reputation is based on its definitive interpretations of Balanchine's choreography and its associated neoclassical technique. *American Ballet Theatre, founded in 1939, developed an eclectic transatlantic artistic policy with a wide repertoire of works. Another ex-member of Diaghilev's Ballets Russes was dancer Serge Lifar. In 1929 he became ballet-master of the Paris Opera Ballet, beginning the revival of French dance. *Nureyev is currently artistic director of the Paris Opera Ballet; with the strengthening of its classical repertoire and the formation of an experimental modern group, the company is again of international standing. In Germany the pre-eminent ballet company is the Stuttgart Ballet. Modern ballets were responsible for the revival of the Stuttgart Ballet, in a city where ballets de cour were first performed in the early 1600s. Under the directorship of *Cranko between 1961 and 1973 the company achieved international status with a broadly based repertoire in which expressionistic works by *MacMillan and Cranko's own dramatic choreography contrasted with that of Balanchine. *Modern dance companies are often formed by one choreographer to present their work exclusively. The modern dance pioneers *Wigman, *Graham, and *Humphrey all formed their own companies, while such artists as *Bausch and *Cunningham continue the practice. But broaderbased modern companies have developed, particularly in Europe. One of the earliest was Netherlands Dance Theatre, formed in 1959, which has become an important platform for the work of such choreographers as Anna Sokolow, Glen Tetley, Hans Van Manen, and Jiri Kylian. In Britain the *London Contemporary Dance Theatre was the first dance company in Europe to be based on Martha Graham's work. Recently a new generation of choreographers such as Alston and *Davies has emerged from the company. *Postmodern dance companies are typically 'pick-up' companies with informal arrangements and a sequence of changing dancers. In the USA the Trisha *Brown company is an exception to this, but most US and British postmodern companies are distinguished by a total commitment to the creation and presentation of new work. Two British modern dance companies which have established themselves, albeit with a changing company membership, are Second Stride (founded by Siobhan Davies and Australian choreographer Ian Spink) and the Rosemary *Butcher Dance Company.

dance, medieval, dance in Europe from c.700 to c.1500. As well as the traditional *folk dance forms associated with fertility rites (for example, the maypole dance), and warrior and demoniacal rituals, dancing took place in churches to the accompaniment of music, to celebrate religious ceremonials. In time the dances became secularized and developed into social dance or theatrical spectacle performed by travelling comedians. A form of ecstatic mass dance, the St Vitus's or St John's dance evolved in the 11th and 12th centuries; a wild, leaping dance, its protagonists sang and danced themselves into exhaustion. By the 12th century a form of courtly, paired dance had evolved in Provence to the accompaniment of musical instruments and singing by spectators. Until banned by the Ecumenical Council of Basle in 1445 the

A **medieval dance** is seen here performed at court to the accompaniment of bagpipes and shawm. The long, pointed shoes (*left* and *centre*) worn by both men and women at this time were known as crackowes after the Polish city of Kraków. The shaping of garments to the body had begun at the end of the 13th century, facilitating the graceful, slow movements of the dance. (Biblioteca Casanatense, Rome)

pre-Christian winter saturnalia or Feast of Fools offered, as did similar feast days, an opportunity for men and women to dance in leaping and skipping steps, carrying bells and sometimes wearing masks. The dancers linked hands and danced in a circular, clockwise pattern, often around a focal figure such as a hobby-horse or a green man. In the late 15th century the dance of the 'Seven Virtues and Seven Sins' was presented by priests and their choristers as part of the Corpus Christi festival in Madrid, out of which later allegorical dance-dramas were to evolve.

dance notation, the recording of movement in words, drawings, or symbols. In the late 15th century well-known steps were recorded by single letter abbreviations (such as R for reverence), and during the 16th and 17th centuries dancing masters published manuals describing how steps should be performed. The first developed form

of notation (which he called *choreographie*) was credited to Raoul Feuillet in 1700 and depicted the paths traced by the dancers, adding signs for turns, beats, and other detailed footwork. This technique was inadequate, as it assumed a general knowledge of the dances of the period, but it remains the only system to have reached the non-specialist, with theatre-goers reading the notation of the dances as they were performed, rather as concert-goers refer to musical scores. *Choreographers in the 19th century often resorted to small stick figures (as well as memory) to preserve their work until Vladimir Stepanov's method (1892), analogous to musical notation, allowed for more detailed recording of ballets. Fully workable systems did not evolve until the 20th century. *Laban's kinetography (1928), now called Labanotation, tends to be used for modern dance. It gives sophisticated indications of the direction, spatial dimensions, duration, and quality (hard/soft) of the movement. The Benesh system (1956), also called choreology, is used by most ballet companies. The positions of all the parts of the body are indicated on a five-line musical stave, with signs to indicate duration and the missing third dimension. Another, less common, form of notation is the Eshkol–Wachmann system, developed in Israel in 1958. Modern notation systems, usually in combination with video, can provide complete permanent records of dances. A recent

Two examples of **dance notation**. The Feuillet system, *right*, shows the floor plan for two dancers, while the Laban system, *left*, shows the choreography for five dancers, indicated by the double vertical paths marked B, C1, C2, C3, and C4. A diagonal line indicates that dancer C3, for example, performs the same movements as dancer C1 in the first two bars. The three lower diagrams indicate the positions and movements of the dancers on stage.

innovation that promises to extend the use of notation is the development of computer software to facilitate the writing and learning of notation.

dance of death (*danse macabre*), a theme in art in which living people are led to their graves by a personification of death, typically a skeleton. The human figures are usually arranged in order of social precedence, the idea being to show, in allegorical form, the inevitability of death and the equality of all men in the face of it. The idea of death as a dancer or a fiddler is very ancient; a dance of skeletons has been found on an Etruscan tomb. The theme was highly popular in Europe in the 15th and 16th centuries in virtually all forms of the pictorial arts (for example, the famous woodcuts *Totentanz* designed by Holbein and first published in 1538). Mimed representations of this symbolic dance were carried out in Germany, Flanders, France, and elsewhere. Saint-Saëns's symphonic poem *Danse macabre* (1874) is based on a poem by Henri Cazalis, and in the 20th century ballets have been composed on the theme.

D'Annunzio, Gabriele (1863–1938), Italian poet, dramatist, novelist, short-story writer, and military leader. He led an active life, which included acts of heroic courage during World War I. His opus is vast and uneven, its tenor is generally pagan, evoking the Nietzschean, superman-hero, and setting the tone for Mussolini's fascist regime. Among his best work are the autobiographical novel *The Child of Pleasure* (1898) and his collection of poetry *In Praise of Sky, Sea, Earth, and Heroes* (1899). D'Annunzio ruled the Dalmatian port of Fiume as dictator from 1919 to 1921.

Dante Alighieri (1265–1321), Italian poet, prose writer, literary theorist, moral philosopher, and political thinker. Born in Florence he spent the first half of his life there until political upheaval forced him into exile, seeking refuge in one princely court after another. His Florentine years were marked by his passion for Beatrice Portinari, who died in 1290 aged barely 20, and who remained the inspiration of his poetry and of his Christian devotion for the remainder of his life. This tragic love occasioned the beautiful lyric poems in *The New Life* (c.1293). In exile he wrote two Latin treatises, *Eloquence in the Vernacular Tongue*, of major importance in establishing the Italian vernacular in place of Latin as the literary language, and *On World Government*, which supported the Holy Roman Emperor against the claims of the Pope. *The Banquet* (c.1304–7) is an unfinished philosophical work. *The Divine Comedy* he began c.1308, but did not complete until late in life. A poem in three parts, *Inferno*, *Purgatory*, and *Paradise*, it describes Dante's journey to God, accompanied by *Virgil (symbolizing human reason) to the point where Beatrice (divine grace) must guide him. On his journey he stops to talk to all manner of people, both contemporaries and figures of antiquity and mythology. As he descends through the nine circles of Hell to Satan, trapped in ice at the earth's core, and ascends the

seven-storey mountain of Purgatory, he gradually becomes purged of his sinfulness and ready to be led through a series of celestial spheres to the Empyrean, where God dwells. *The Divine Comedy* is a complete cosmography of medieval lore, and a profound recapitulation of the Christian doctrine of Fall and Redemption, couched in verse which ranges from the majestic to the sublimely beautiful—especially in its imagery. It represents the pinnacle of Italian poetry.

Danube School, a term applied to a number of painters working in the Danube valley in the early 16th century who were among the pioneers of depicting *landscape for its own sake. *Altdorfer and *Cranach the Elder (in his early work) are the best-known artists covered by the term. These two and other landscape pioneers such as Wolfgang Huber worked independently of one another; the term is thus one of convenience rather than an indication of any formal group.

danzón *rumba.

Darío, Rubén (Félix Rubén García Sarmiento) (1867–1916), Nicaraguan poet, journalist, and diplomat. An innovator in poetic imagery, metre, and rhythm, he led the literary movement of *modernism both in Latin America and Spain. He published his first major work, *Blue* (1888), in Chile, a collection of verse and prose which broke with the complex literary idiom of the past in favour of a simpler, more direct language. His *Profane Hymns and Other Poems* (1896) was heavily influenced by

An allegorical portrait (1465) by Domenico di Michelino showing **Dante** against the background of heaven and hell described in his masterpiece, *The Divine Comedy*. On the right is Florence Cathedral. (Duomo, Florence)

the French *Symbolist poetry, but by the time he was to publish his masterpiece, *Songs of Life and Hope* (1905), he had changed direction and was writing modern, socially committed poetry. His work continues to influence Latin American literature today.

Daudet, Alphonse (1840–97), French novelist. He is chiefly remembered for his *Lettres de mon moulin* (1866), humorous sketches of life in Provence, and the three comic Tartarin stories, especially the first, *Tartarin de Tarascon* (1872). Daudet is often linked with *Naturalism, the extreme form of *Realism associated with Zola and *Maupassant, though he writes with more warmth and humour than is typical of that school. He also wrote short stories, including *Les Contes du lundi* (1873), and a play, *L'Arlésienne* (1877), with incidental music by Bizet.

Daumier, Honoré (1808–79), French *caricaturist, painter, and sculptor. He began his career as a political cartoonist in 1830 after learning the process of *lithography, and his attacks on King Louis-Philippe in the left-wing press were so effective that he was sentenced to six months' imprisonment in 1832. When political satire was suppressed in 1835 he turned to social satire, returning to political themes after the 1848 Revolution. He is regarded as the greatest caricaturist of the 19th century, with a remarkable power to interpret mental folly in terms of physical absurdity. His painting and sculpture were less well known in his lifetime, but are now highly regarded. He never made a commercial success of his art, and in the last years of his life he was saved from destitution by the generosity of Corot.

David, Jacques-Louis (1748–1825), French painter, the most outstanding artist of the *Neoclassical movement. He was briefly a pupil of *Boucher and began his

career working in a *Rococo manner, but during the 1770s his style changed radically, particularly after he had lived in Rome (1775–80). Under the influence of the art of ancient Rome his style became heroic and severe, and on his return to France he soon found himself the leader of the reaction from the frivolity of the Rococo towards an art more in tune with the soberer social and moral values that then dominated French life. His themes gave expression to the new cult of the civic virtues of stoical self-sacrifice, devotion to duty, honesty, and austerity. The painting that made his reputation was *The Oath of The Horatii* (1784), which depicts a Roman legend of three brothers who fight for Rome against three enemy champions. David was in sympathy with the ideals of the French Revolution and took an active part in it. Napoleon appointed him his chief painter in 1804 and David glorified his life in a series of pictures that show a move away from the severity of Neoclassicism to a more *Romantic ardour. After Napoleon's defeat in 1815 David went into exile in Brussels. His work weakened as the possibility of exerting a moral and social influence declined, although he remained a superb portraitist. He had many pupils, the most important of whom was *Ingres. His influence on European painting was enormous.

Davies, Sir Peter Maxwell (1934–), British composer. He has combined an interest in *medieval musical techniques with the influence of *Stravinsky and *Schoenberg to produce a very distinctive, often violent, style—as expressed in the operas *Taverner* (1968) and *The Lighthouse* (1979). His music includes three symphonies (1976, 1980, 1984), a violin concerto (1985), and several theatre pieces written for the Pierrot Players (later The Fires of London), which he founded in 1967. In 1970 he settled on the island of Orkney, where he founded (1977) the St Magnus Festival.

Davies, Robertson (1913–), Canadian novelist, playwright, and essayist. He is best known as a novelist for his Deptford trilogy: *Fifth Business* (1970), *The Manticore* (1972), and *World of Wonders* (1975). These are first-person narratives that explore the Jungian significance of intertwined events. They were followed by *The Rebel Angels* (1981), a novel reflecting elements of Davies's life as Master of Massey College, University of Toronto, and *Bred in the Bone* (1985).

Davies, Siobhan (1950–), British dancer and choreographer. She studied at the London Contemporary Dance School and joined the company in 1969. She started her own company in 1981 and with Ian *Spink founded the modern dance company Second Stride in 1982. Study in the USA inspired new directions, and her choreography became more closely associated with abstract *modernism. Works include *The Calm* (1974), *Bridge the Distance* (1985), using a Britten string quartet, and *Wyoming* (1988).

Davis, Miles (1926–), US *jazz trumpeter. As an inexperienced youngster Davis played with Charlie Parker's Quartet, but the fast, aggressive bebop style did not suit his playing, and in 1949 he left Parker. During the early 1950s Davis developed a spare, muted 'cool' solo style that influenced jazz trumpet playing into the 1960s and beyond. He has continued to be a jazz pioneer, developing the modal jazz (in which the notes of a *mode constitute the basis for extended improvisation), and making the first commercially successful jazz-rock record, *Bitches Brew*, in 1969.

Deburau *mime.

Debussy, (Achille-) Claude (1862–1918), French composer. Initially trained for a career as a pianist, he turned to composition, winning the Prix de Rome (1884) with the cantata *L'Enfant prodigue*. Debussy's work came to the notice of the public in 1893 with the performance of the cantata *La Damoiselle élue* and the String Quartet in G minor. These were quickly followed (1894) by an orchestral masterpiece that was revolutionary in style: *Prélude à l'après-midi d'un faune*. Later works include his opera based on *Maeterlinck's Symbolist play *Pelléas et Mélisande* (1895, performed in 1902); the orchestral suites *Nocturnes* (1899), *La Mer* (1905), and *Images* (1912); and two important collections of piano *Préludes* (1910, 1913). Debussy was of prime significance in helping to free 20th-century music from the restrictions of classical form and orthodox harmonic progression. His explorations were influenced by Indonesian *gamelan music and Afro-American *ragtime, and it was through him that the West began to recognize the virtues of such music. His melodic lines are fluid, and often based on unusual

Woman Combing her Hair (c.1885) shows a favourite **Degas** theme: at the Impressionist exhibition in 1886 he sent in ten pictures under the general title 'series of nudes of women bathing, washing, drying, towelling, combing their hair'. He wrote of such works: 'It is the human animal preoccupied with itself, like a cat licking itself. Hitherto the nude has always been shown in poses which take an audience for granted.' (Musée d'Orsay, Paris)

scale patterns; *harmonies are used for the sake of their colour and without regard to their status in the traditional hierarchy of concords and discords; his forms are essentially rhapsodic. Equally subtle is his colouristic treatment of the orchestra. Debussy's avoidance of the clear-cut definitions of Classical procedures gives his music a dream-like quality that equates very closely with the achievements of the great *Impressionist painters.

Decorated style, the second of the three phases into which English *Gothic architecture is conventionally divided, covering the period c.1250–c.1375, between *Early English and *Perpendicular. This classification was devised (by the architect Thomas Rickman in 1817) mainly in terms of window design; in Decorated churches the simple Early English lancets were replaced by wider windows with bar *tracery that developed from simple geometric designs to fanciful flowing patterns. (The terms 'Geometrical' and 'Curvilinear' are often used to characterize this evolution.) Increased ornamentation was seen in other aspects of the Decorated style, in the growing complexity of vault patterns for example, and the period was one of the most inventive and experimental in English architecture. The outstanding works of the Decorated style include the nave of Exeter Cathedral and the nave and west front of York Minster.

Defoe, Daniel (b. Daniel Foe) (1660–1731), English novelist and journalist. Defoe was a master of plain prose and powerful narrative, and had a journalist's eye for circumstantial detail. He produced over 500 books, pamphlets, and journals, and was approaching 60 when he turned to fiction and produced the *Life and Strange Surprising Adventures of Robinson Crusoe* (1719), based in part on the experiences of Alexander Selkirk. It was followed by many other fictional works including *Captain Singleton* (1720), *Moll Flanders* (1722), the story of a London prostitute and thief, *A Journal of the Plague Year* (1722), *Colonel Jack* (1722), and *Roxana* (1724). Defoe had a considerable influence on the evolution of the English novel.

Degas, Edgar (1834–1917), French painter, graphic artist, and sculptor. In 1861 he met *Manet, who introduced him to the *Impressionist circle. Degas exhibited in seven of the eight Impressionist exhibitions and is regarded as one of the leading members of the movement, but he was Impressionist only in certain restricted aspects of his work and like Manet stood somewhat aloof from the rest of the group. He had little interest in landscape, and concentrated on scenes from contemporary life, making certain subjects his own, particularly ballet dancers and horse-racing. He liked to give the suggestion of spontaneous creation, but he did not paint out of doors or directly from nature. In fact, his pictures are carefully worked out; he was more interested in draughtsmanship than the other Impressionists and was aware of his place in the tradition of figure-painting stemming from the Renaissance. In the 1880s his sight began to fail and he worked increasingly in *pastel. About the same time he also took up modelling in wax, his figures being cast in bronze after his death.

Dekker, Thomas (c.1570–1632), English dramatist and pamphleteer. His work is noted for its portrayal of London life and manners, for its sympathy with the poor and the oppressed, and for its bright wit. Many of his plays were written in collaboration with other playwrights, including *Webster, *Massinger, and *Middleton. His domestic comedy *The Shoemaker's Holiday* (1599), was followed by many others, including *Satiromastix* (1602; probably with John Marston (c. 1575–1634)), which was a response to *Jonson's ridicule of Dekker in *The Poetaster*. He also wrote pageants, tracts, pamphlets, and *The Guls Hornebooke* (1609), a satirical book on manners, which gives a valuable account of the London theatres of the day.

de Kooning, Willem (1904–), Dutch-born US painter (and occasional sculptor). He emigrated to the USA in 1926 and became prominent in the *Abstract Expressionist movement. After his first one-man show in 1948 he was generally recognized as sharing with Jackson *Pollock the unofficial leadership of the Abstract Expressionist group. Unlike Pollock, de Kooning usually retained figurative elements in his painting, which is often characterized by frenzied brushwork. His wife, **Elaine de Kooning** (1920–), is a painter and writer on art.

Delacroix, Eugène (1798–1863), the greatest French painter of the *Romantic movement. In 1822 the first picture he exhibited at the Paris *Salon, *The Barque of Dante*, was bought by the government, launching him on a highly successful and prolific career. As in this painting, Delacroix often favoured dramatic subjects drawn from

Delacroix's *Orphan Girl in a Cemetery* is one of the numerous detailed oil studies he made for his huge picture *The Massacre of Chios* (1824), commemorating an atrocity that had taken place in 1822 during the Greek struggle for independence against the Turks. Delacroix was one of many artists and intellectuals throughout Europe who championed the Greek cause. (Louvre, Paris)

literature, and he also had a taste for the exotic, stemming partly from a visit to Morocco in 1832. His other subjects included portraits, noted for their spiritual intensity, and from the 1830s he undertook several great mural decorations in public buildings in Paris. His style is characterized by great energy, emotional fervour, and scintillating colour. His use of colour influenced such diverse figures as Renoir, Seurat, and van Gogh. A dandy, wit, and dashing society figure, Delacroix was also a fine writer, his *Journal* being a marvellously rich source of information and opinion on his life and times.

de la Mare, Walter (1873–1956), British poet and novelist. His themes of childhood and dreams are invested with mystery, fantasy, and occasional melancholy. His volumes of verse for adults include *The Burning Glass* (1945), two visionary poems, 'The Traveller' (1946), and 'The Winged Chariot' (1951), and various *Collected Poems*; and for children the popular *Peacock Pie* (1913). His prose works include *The Memoirs of a Midget* (1921) and the children's story *The Three Mulla-Mulgars* (1910). He also produced short stories, anthologies, and critical works.

Delaunay, Robert (1885–1941), French painter. For most of his career he was devoted to experimenting with effects of colour and he was an important figure in the development of *abstract painting in the second decade of the 20th century. By 1910 he was making an individual contribution to *Cubism, notably with a series of paintings of the Eiffel Tower that combine fragmented forms with vibrant colour. By 1912 his work had become completely abstract and the poet Apollinaire gave the name *Orphism to the style in which he painted. His radiantly beautiful paintings were extremely influential, notably on the German *Expressionists and the Italian *Futurists. The period of Delaunay's greatest achievements was, however, fairly short-lived and after World War I his work became rather repetitive. His wife was the Russian-born painter and textile-designer **Sonia Delaunay-Terk** (1885–1979), who settled with him in Paris in 1910. She worked with him on the development of Orphism, and most of her subsequent work also involved the use of bright colour and abstract forms.

delftware *maiolica.

Delibes (Clement Philibert) Léo (1836–91), French composer. Although he began his career as a church organist, he later found more congenial work in the Paris theatres, first as accompanist and chorus-master of the Théâtre-Lyrique, and then as chorus-master at the Paris Opéra. The first of a long series of operettas appeared in 1856, but it is with the ballets *Coppélia* (1870), based on a story by E. T. A. Hoffmann, and *Sylvia* (1876) that he achieved lasting success. His masterpiece, the opera *Lakmé* (1883), is set in the Orient: it shares the same melodic elegance as the ballets, but on a deeper level.

Delius, Frederick (Theodore Albert) (1862–1934), British composer. In 1897 he settled in Grez-sur-Loing (near Paris) with the painter Jelka Rosen, whom he married in 1903. From 1922 on he was virtually paralysed, and from 1928 could compose only with the help of an amanuensis (a musical assistant who wrote the manuscripts), Eric Fenby. Delius's music is essentially rhapsodic, depending more on its impressionist *harmonies than on obvious melody. Such works as the opera *A Village Romeo and Juliet* (1901) and the choral *Sea-Drift* (1904) show him at his most poetically evocative, while the *North Country Sketches* (1914) reveal a sterner side of his genius.

Delorme, Philibert (or de l'Orme) (c.1510–70), the outstanding French architect of the 16th century. He was an artist of great distinction and originality, but almost all his buildings have been destroyed. In 1533–6 he studied in Rome and he introduced a sophisticated classicism into French architecture. His style, however, was not a mere imitation of Italian motifs; rather he adapted the classical language of architecture to French traditions and materials, and he showed great inventiveness in structure and decoration. The most important of his surviving works are fragments of the château of Anet (c.1550), built for Henry II's mistress Diane de Poitiers. Delorme wrote two influential treatises, *Nouvelles Inventions* (1561) and *Architecture* (1567), in which he reveals himself as a learned man, a skilful engineer, and a pragmatic businessman who stressed the need for thorough consultation with the client.

Delsarte, François (1811–71), French movement theorist who was a seminal influence on the development of US modern dance. His analysis of bodily movement in terms of its reflection of emotional states and moods was seized upon by the expressionistic *modern dancers of the early 20th century such as *Shawn.

Demachy, Robert (c.1859–1938), French pictorialist photographer. After his marriage to a rich American, Demachy was enabled to devote his life to practising and writing about photography. Influenced by *Impressionist painting, he manipulated his prints with gums, oils, and chemicals in order to 'interpret' what was on the negative.

deMille, Agnes (1909–), US dancer and choreographer. Her choreographic style incorporates American folk idiom in popular narrative fusions of *ballet and *modern dance as in *Rodeo* (1942) and *Fall River Legend* (1948). In Broadway *musicals her choreography was pre-eminent in the integration of dance, song, and action, as in *Oklahoma* (1943), and *Carousel* (1945).

deMille, Cecil B(lount) (1881–1959), US producer-director, who played a major role in the development of *Hollywood. He was renowned for his pseudo-biblical and historical spectacles, among the most notable of which was *The Ten Commandments* (1923, remade 1956). There followed *The King of Kings* (1927), *The Sign of the Cross* (1932), *Cleopatra* (1934), *The Crusades* (1935), and *Samson and Delilah* (1949). He also made spectacular films with other backgrounds, including such *Westerns as *The Plainsman* (1937) and *Union Pacific* (1939), and *The Greatest Show on Earth* (1952), about a circus.

De Morgan, William (1839–1917), British pottery designer and writer, a leading figure of the *Arts and Crafts Movement. Like his friend William *Morris, he reacted against the Victorian taste for detailed naturalistic decoration and was a master of bold, flat pattern. His work drew on a variety of influences, notably the lush foliage patterns and rich colours of *Islamic ceramics, but it has a distinct individuality. Tiles were his speciality,

and he also made vases and decorative plates, some employing the technique of *lustre, which he revived.

Demosthenes *Greek literature.

Denis, Maurice (1870–1943), French painter, designer, and art theorist. Early in his career he was a member of the Nabis (a group of artists who disliked naturalism and were interested in colour and linear distortion), and a leading exponent of *Symbolism; later he devoted himself to trying to revive religious art. He made a statement in 1890, 'Remember that a picture—before being a war horse or a nude woman or an anecdote—is essentially a flat surface covered with colours assembled in a certain order', that has often been regarded as the key to contemporary aesthetics of painting and the justification for *abstract art.

De Quincey, Thomas (1785–1859), British essayist and critic. His best-known work, *Confessions of an English Opium-Eater* (1822), written in hauntingly sonorous prose, was a study of his addiction to opium from the euphoric early experience of addiction to the appalling nightmares of the later stages. In 'Suspiria de Profundis' (1845) and 'The English Mail Coach' (1849) he describes how childhood experiences can be crystallized in dreams which may also give birth to impassioned literature. Most of his work, produced under pressure to support his large family, was journalism; it is more remarkable for occasional *tours de force* than for sustained coherence. Among his autobiographical writings, his *Recollections of the Lake Poets* (1834–9) deeply offended Wordsworth and the other Lake District poets.

Derain, André (1880–1954), French painter, sculptor, and graphic artist. One of the creators of *Fauvism and an early adherent of *Cubism, he was near the heart of the most exciting developments in art in Paris in the first two decades of the 20th century, but his work does not approach in quality that of his great contemporaries such as Matisse and Picasso. He also produced numerous book illustrations and designs for the stage.

dervish dance *Islamic dance.

Derzhavin, Gavriil (Romanovich) (1743–1816), Russian poet. His work deals with both civic themes and intimate emotions. His rough, powerful, explicitly personal manner consistently went against stylistic decorum; his *Ode to the Deity* (1784) was translated into many languages and the individual passion in his verse makes him the first great Russian poet.

Desai, Anita (1937–), Indian novelist and short-story writer. Her sophisticated novels of urban India include *Voices in the City* (1965), *Fire on the Mountain* (1977), and *Clear Light of Day* (1980). She has also published children's books, and a collection of short stories, *Games at Twilight* (1978).

Desani, G(avindas) V(ishnoodas) (1909–), Indian novelist, born in Kenya. He is known for his only novel, *All About H. Hatterr* (1948), in which the protagonist's comical search for wisdom is recounted in a unique style, combining several dialects, jargons, and varieties of wordplay. He also wrote a dramatic prose poem, *Hali* (1950).

design, the lines, shapes, or layout of any product, whether for use or show. Most fields of design have been influenced by the struggle between practical and artistic consideration. The theory of *functionalism, which was popular in the early 20th century, maintained that the requirements of use and economy, rather than aesthetic consideration, should determine optimum design—an idea that was particularly influential on *industrial design, but also had an impact on the design of such things as *typography. The term 'design' is now used in such phrases as *interior design or *set design, where it implies a special regard for the requirement of appearance and improvement of marketability by imparting an attractive appearance or one in line with current fashions, within the margins of variation imposed by the requirements of use and economy. The importance of consumer appeal in design is shown by the recent expansion in the field of graphic design (see *graphic art).

detective story, a tale in which an amateur or professional detective solves a puzzling criminal mystery, usually a murder, by investigation and deduction. The elements of a detective story (the eccentric genius faced with an 'impossible' case) were first combined in *Poe's tale 'The Murders in the Rue Morgue' (1841), and the earliest full-length detective novels were Émile Gaboriau's *L'Affaire Lerouge* (1866) and Wilkie *Collins's *The Moonstone* (1868). The appearance of *Doyle's Sherlock Holmes stories, beginning with *A Study in Scarlet* (1887), created a huge following for detective stories, leading to a 'golden age' in the first half of the 20th century: new heroes like Hercule Poirot (Agatha *Christie), Maigret (*Simenon), and Lord Peter Wimsey (Dorothy L. Sayers) appeared, while American authors, led by Hammett and Chandler, challenged the snobbish English amateurs with 'hard-boiled' detectives, and with more realistic 'police procedural' stories. Although partly eclipsed by the rise of spy stories, detective fiction still thrives in the works of Ruth Rendell and P. D. James.

deus ex machina (Latin, 'god from the machinery'), device in *Greek theatre whereby problems were resolved at the end of a play by the intervention of a god who was apparently brought down from Olympus. In fact he was moved by 'machinery' (a crane). The term is now applied to any contrived interposition in a novel, play, or film, and in general to any external, unexpected, last-minute resolution of a difficulty.

de Valois, Dame Ninette (1898–), Irish-born dancer, choreographer, and director. With Lilian *Baylis's support she founded the Vic-Wells Ballet in 1931, later to become the *Sadler's Wells and then the Royal Ballet in 1956. Although a choreographer of some merit, creating *The Rake's Progress* (1935) and *Checkmate* (1937), she is best known for her tenacity in establishing and nurturing the Royal Ballet companies and schools, remaining artistic director of the Royal Ballet until 1963.

devil's fiddle *bumbass.

Devis, Arthur (1711–87), British painter, one of the first artists to specialize in *conversation pieces, though he also painted single portraits. His work was virtually forgotten until the 1930s, but since then it has attained popularity because of the charm of his figures and the

delicate detail of his settings. Most of his clients were from the newly prosperous middle class; his work is thus of considerable interest to social historians.

De Wint, Peter (1784–1849), British *landscape painter of Dutch extraction. Although he was a fine painter in oils, he is best remembered as one of the outstanding water-colourists of his generation and is particularly associated with views of the countryside around Lincoln. His broad washes of colour and bold compositions are in the tradition of *Cotman and *Girtin. De Wint was a popular and influential teacher.

Diaghilev, Serge (1872–1929), Russian ballet impresario and founder-director of the Ballets Russes. In 1898 he became editor of the influential *World of Art* magazine and arranged exhibitions and concerts of Russian art and music, culminating in the 1909 Russian opera and ballet season in Paris. This led to the formation of the Ballets Russes, which existed despite chronic financial problems from 1911 until his death. He brought about a revolution in dance and other arts by inspiring collaborations between world-famous composers such as *Stravinsky and *Satie, and painters such as *Bakst and *Picasso with choreographers such as *Fokine, *Nijinsky, *Nijinska, *Massine, and *Balanchine. (See also *dance companies.)

diatonic scale *scale.

Dickens, Charles (John Huffam) (1812–70), British novelist. His father, a clerk in the Navy pay office, was imprisoned for debt and Dickens, at the age of 12, worked in a warehouse. Painful childhood memories inspired

much of his fiction, notably *David Copperfield* (1849–50), in which his father appears as Micawber. He worked as a court stenographer, became a parliamentary reporter, and began contributing to periodicals: the articles were subsequently published in *Sketches by Boz* (1836). These led to the creation of Mr Pickwick and the publication of *The Posthumous Papers of the Pickwick Club* (1836–7). In 1850 he started the periodical *Household Words*, which published much of his later work. *A Christmas Carol* (1843) and *The Cricket on the Hearth* (1846) were among his series of Christmas books. His other novels, most of which appeared first in monthly instalments, are *Oliver Twist* (1837–8); *Nicholas Nickleby* (1838–9); *The Old Curiosity Shop* (1841); *Barnaby Rudge* (1841); *Martin Chuzzlewit* (1843–4); *Dombey and Son* (1847–8); *Bleak House* (1852–3); *Hard Times* (1854); *Little Dorrit* (1855–7); *A Tale of Two Cities* (1859); *Great Expectations* (1861); *Our Mutual Friend* (1864–5); and *The Mystery of Edwin Drood* (1870, unfinished). He visited the USA twice but his initial favourable impressions turned to disillusion, and his portrayal of American stereotypes in *Martin Chuzzlewit* caused much offence. During these productive years he raised a large family, occupied himself with philanthropic work, amateur theatricals, and public readings of his own works. Through his works and his readings Dickens aroused the Victorian social conscience and captured the popular imagination. His high-spirited humour and his brilliance of caricature (often labelled 'Dickensian') is seldom absent from his work, and he has created the greatest gallery of characters (including Fagin, Scrooge, Uriah Heep, Little Nell) in English fiction.

Dickinson, Emily (Elizabeth) (1830–86), US poet. She lived in seclusion in her father's house in Amherst, Massachusetts, hiding her poems from all but a few friends and never attempting to publish them. These strikingly original lyrics were finally collected in the complete *Poems* (1955); her *Letters* followed in 1958. Written in deceptively simple hymn-like *quatrains, her

An illustration by H. K. Browne ('Phiz') 'Restoration of mutual confidence between Mr. and Mrs. Micawber' which accompanied the 1850 edition of **Dickens**'s *David Copperfield*.

poems condense into surprising imagery an ecstatic and paradoxical response to religion, the puzzle of death, and the revolving seasons.

Diderot, Denis (1713–84), French encyclopedist, novelist, and dramatist. He was substantially responsible for the production of the *Encyclopédie* (1751–72), whose aim was the application of reason to all matters of human interest. He wrote two plays, *Le Fils naturel* (1757) and *Le Père de famille* (1758), illustrating his concept of a new theatrical genre called *drame bourgeois or serious comedy. These have little artistic merit, though his theories exercised some influence on other writers, including *Beaumarchais. Diderot wrote two prose tales, *La Religieuse* and *Jacques le fataliste*, and an imaginary dialogue entitled *Le Neveu de Rameau*, which were published posthumously. He derived his ideas from natural science: he became an atheist, advocated a materialist philosophy, and attempted to found morality on reason. Like *Rousseau, he held that man, born good, was corrupted by society.

didjeridu, the only melodic instrument of the Australian aborigines. It is a trumpet, sometimes of bamboo, more often a wooden tube hollowed by termites, and today sometimes metal or plastic piping. Playing techniques can be extremely elaborate, with continuous breathing combined with speech syllabics, spat overtones, and hummed *drones. The didjeridu is sometimes used with singing and is accompanied by a pair of *clappers or by the player tapping on the instrument.

diptych, a picture consisting of two parts facing one another like the pages of a book and usually hinged. Most popular in the 15th century, the two parts might show two related religious scenes, or, for example, a portrait of the person who commissioned the work on one part facing a picture of the Virgin and Child on the other. The outside surfaces of a diptych were also often painted or decorated, although generally less elaborately than the inner surfaces.

Direct Cinema *cinéma-vérité.

Directoire style, style of decoration and design prevailing in France between the *Louis XVI and *Empire styles. It takes its name from the Directoire (1795–9), the period (immediately before Napoleon came to power) when France was governed by an executive of five *directeurs*, but the style flourished roughly between 1793 and 1804. Decoration was simpler and more consciously classical than in the Louis XVI style, the simplicity being partly the result of the havoc that revolution and war had wrought. As a result of Napoleon's campaigns in 1798–9, there was also a fashion for Egyptian-inspired ornament in this period. The latter part of the Directoire period (1799–1804) is sometimes distinguished as the 'Consulat' style, named after the period when Napoleon ruled as Consul (he became emperor in 1804).

dirge, a song of lamentation in mourning for someone's death; or a poem in the form of such a song. A famous example is Ariel's song 'Full fathom five thy father lies' in Shakespeare's *The Tempest* (1611).

Disney, Walt (1901–66), US animator, the best-known name in film *animation. In 1928 he created the cartoon character Mickey Mouse, who was soon joined by other famous characters such as Minnie Mouse and Donald Duck. In 1929 the 'Silly Symphonies' began, a series of over seventy cartoons whose characters included the Three Little Pigs. The first cartoon in colour appeared in 1933. *Snow White and the Seven Dwarfs* (1937), Disney's first feature-length cartoon, was followed by others such as *Pinocchio* (1940), *Fantasia* (1940), illustrating classical music, *Dumbo* (1941), *Bambi* (1942), *Lady and the Tramp* (1955), and *101 Dalmatians* (1961). He also made several nature *documentaries and in 1950, with *Treasure Island*, began to produce 'live' films for the family market, the most successful of which was the musical *Mary Poppins* (1964). Disney developed a vast worldwide organization, marketing numerous spin-offs as well as films, and in 1955 opened the first Disneyland amusement park, in California.

Disraeli, Benjamin, 1st Earl of Beaconsfield (1804–81), British statesman and novelist. Of Jewish descent, he was Conservative Prime Minister in 1868 and 1874–80. The first success of his literary career was the novel *Vivian Grey* (published anonymously, 1826), which together with *Alroy* (1833) and the autobiographical *Contarini Fleming* (1832) formed his first trilogy; the second was composed of *Coningsby; or The New Generation* (1844), *Sybil; or The Two Nations* (1845), and *Tancred* (1847). A fascination and amused contempt for high society, together with a genuine sympathy for the poor and the oppressed characterized his novels.

divertimento, a musical term coined in the 18th century to describe a suite of movements intended purely to divert. This was usually written for a small group of players, and often designed for performance out of doors. The terms *serenade and cassation imply much the same kind of work. In the 19th century the term was sometimes applied to a selection of 'hit' tunes from an opera. The French word *divertissement* has the same meaning, but it can also mean an entertainment of songs and dances inserted into a larger work, such as an opera or ballet.

Dix, Otto (1891–1969), German painter and printmaker. In the 1920s he was, with George Grosz, the outstanding artist of the *Neue Sachlichkeit* ('New Objectivity') movement, his work conveying his disgust at the horrors of war and the depravities of a decadent society. He was also a brilliantly incisive portraitist. His anti-military stance drew the wrath of the Nazi regime, and his work was branded as 'Degenerate Art'. In 1939 he was gaoled, but was soon released. After the war his work was based on religious mysticism and lost much of its strength.

Dixieland, the popular name for the Southern states of the USA. The name was adopted at the beginning of the 20th century by New Orleans white musicians who imitated black *jazz styles. Groups like Nick La Rocca's Original Dixieland Jazz Band (who first appeared in New York in 1917) played a bowdlerized form of jazz, borrowing colouristic and novelty effects from black jazz. But as later white musicians began to gain a fuller understanding of jazz it became less necessary to distinguish the New Orleans and Dixieland styles. Since the 1940s there has been an international revival of this type of music.

documentary film, film dealing with real people and events. The oldest type of documentary is the newsreel, the first regular series of which began in 1907, and which was developed in the 1920s by the Russian Dziga Vertov (1896–1954). The American Robert J. Flaherty (1884–1951) pioneered the aesthetic use of documentary with *Nanook of the North* (1922) and other films about isolated communities. Documentary was used for a social purpose in Britain in the 1930s in such films as *Coal Face* and *Night Mail* (both 1936), made by the predecessors of the Crown Film Unit, which during World War II produced such documentaries as *Fires Were Started* (1943). In the USA *The March of Time* (1935–51) was a monthly current affairs series; the US Film Service was founded by Roosevelt in 1938. Two remarkable pro-Nazi documentaries—*Triumph of the Will* (1934) and *Olympia* (1938) about the 1936 Olympics—were made by Leni Riefenstahl (1902–). After the war new techniques such as *cinéma-vérité and *Free Cinema extended the bounds of the documentary. *Disney made notable full-length nature films such as *The Living Desert* (1953). Television, however, was increasingly the home of documentary films, and few are now made with the cinema in mind.

documentary theatre, theatre based, usually for propaganda purposes, on fact, as documented in material such as recordings, films, newspapers, official reports, and transcripts of trials. An alternative term (especially in the USA) is the Theater of Fact. Examples of documentary theatre were seen in post-revolutionary Russia, and in the work of *Piscator in Germany in the 1920s. In the 1930s the government-sponsored Living Newspaper in the USA was responsible for six documentary productions on contemporary themes, including *One-Third of a Nation* (1938), a play about the need for cheap housing. Other examples are *Theatre Workshop's production by Joan Littlewood of *Oh, What a Lovely War!* (1963), about World War I, and the Royal Shakespeare Company's production of *US* (1966), about the US Vietnam involvement.

doggerel, monotonously rhymed, rhythmically awkward, and shallow verse. The unscanned verses of William McGonagall (c.1830–1902) are doggerel. Some poets, like Skelton, have deliberately imitated doggerel for comic effect.

dome, a curved roof, hemispherical or approximately hemispherical in shape and generally large in scale: usually it is the crowning feature of a major building. The dome evolved from the *arch and seems to have originated in the ancient Near East where it was a feature of Sassanian architecture. It was first used on a monumental scale by the Romans, most notably in the Pantheon in Rome (AD 120–4), which had an internal diameter of over 40 metres (44 yds.). Constructing a dome on this scale has traditionally posed great structural problems, with massive support needed either from a continuous solid wall or from four or more immense piers. The great domes of the world, such as that of the innovatory Byzantine Hagia Sophia in Istanbul, Sinan's Selimiye mosque in Edirne (western Turkey), Brunelleschi's in Florence, Michelangelo's at St Peter's in Rome, and Wren's at St Paul's in London are triumphs of engineering as well as of art. Modern constructional methods have enabled large domes to be built without enormous supports (see, for example, *Fuller).

Domenichino (Domenico Zampieri) (1581–1641), Italian painter, the favourite pupil of Annibale *Carracci, whom he assisted with his *frescos in the Farnese Palace in Rome. Domenichino continued the classical style of Annibale, and established himself as Rome's leading painter. In the 1620s his style became more *Baroque, but he always remained true to the ideal of clear, firm draughtsmanship that he had learned in the Carracci academy in Bologna. Domenichino was important as an exponent of ideal *landscape painting, forming a link between Annibale Carracci and *Claude. He was a fine portraitist and a superb draughtsman. In the 18th century his reputation stood extremely high, but was eclipsed in the 19th century under the attacks of John Ruskin.

Domenico Veneziano (d. 1461), Italian painter, active mainly in Florence. Very little work by him survives, but his masterpiece, the St Lucy Altarpiece (c.1445), is one of the finest Italian paintings of its time; the central panel is in the Uffizi, Florence. Its delicate beauty of colouring, mastery of light, and airy lucidity of spatial construction are reflected in the work of Domenico's assistant *Piero della Francesca.

Domingo, Placido (1941–), Spanish tenor singer. After major roles in Mexico, the USA, and with the Israel National Opera (1962–5), Domingo remained in world-wide demand. A fine Walther, in Wagner's *The Mastersingers*, Domingo also excels in the heroic roles of Italian opera, notably outstanding as Verdi's *Otello*. Since *Björling's death, Domingo has been the leading lyric-dramatic tenor.

Donatello (Donato di Niccolo) (1386–1466), Italian sculptor. He was the greatest European sculptor of the

The 'Feast of Herod' (c.1425) is a bronze panel on the baptismal font of Siena Cathedral, a project on which **Donatello** worked with three other sculptors, including his former teacher Ghiberti. Donatello was a master at conveying intense emotion and has here shown the varied reactions at the shocking moment when the head of John the Baptist is presented to King Herod.

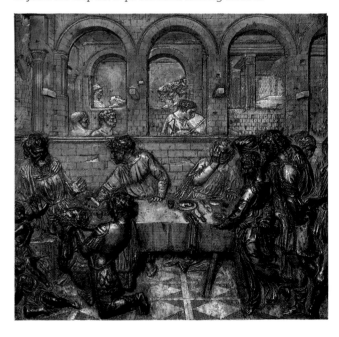

15th century and, with his friends *Alberti, *Brunelleschi, and *Masaccio, one of the remarkable group of artists who created the *Renaissance style in Florence. He began his career as an assistant of *Ghiberti, but he developed a style that was radically different from his master's Gothic elegance. Whereas Ghiberti excelled in linear grace and surface elegance, Donatello was concerned rather with emotional force. He revealed his genius in a series of powerful statues for public buildings in Florence, including the famous *St George* (*c*.1415–17, Bargello, Florence), with its marvellous sense of youthful ardour and valour. With his acute feeling for characterization went a technique of daring originality; he could carve with the utmost delicacy when a work would be seen at close range, but with almost brutal boldness when it had to be seen from a distance. When a statue on a building had to be viewed from below he carefully took this into consideration by adjusting the proportions of the figure. His work had greater influence than that of any other 15th-century artist—on painters as well as sculptors—most notably Michelangelo.

Donizetti, Gaetano (1797–1848), Italian composer. He wrote his first opera at 14 and achieved fame in 1830 with his *opera seria* (tragic opera) *Anne Boleyn*. In all he wrote nearly seventy operas in both Italian and French, including *The Love Potion* (1832), *Lucrezia Borgia* (1833), *Lucia di Lammermoor* (1835), *The Daughter of the Regiment* (1840), and *Don Pasquale* (1843). Their musical style is marked by a strong emphasis on the decorated *bel canto* melody in favour with the musical audiences of his day.

Donne, John (1572–1631), English poet and priest. Of Welsh extraction, he came from a devout Roman Catholic family but renounced his faith in his early 20s. He sailed with the Earl of Essex and with Sir Walter Raleigh on expeditions against Spain, which are described in his poems 'The Storm' and 'The Calm'. After serving various noble patrons, Donne was ordained as an Anglican priest in 1615; he was appointed Dean of St Paul's Cathedral in 1621 and became a celebrated preacher. His later work was mainly religious: the 'Holy Sonnets' and 'Hymns'; the prose 'Devotions'; and the *sermons, which include the famous 'Death's Duel', delivered shortly before his death. Donne is regarded as foremost of the *Metaphysical poets. His poems, whether cynical or idealistic, are constructed with ingenious logical arguments. Their images use intellectual, rather than physical, connections; and their language is both grandiloquent and colloquial, with a 'speaking voice' that accosts the reader, often with startling first lines ('Busy old fool, unruly sun', or 'Batter my heart, three-personed God'). Donne celebrated human relationships in religious or philosophical language, and described man's relationship to God with a dramatized intensity of emotion.

Doré, Gustave (1832–83), the most prolific and successful French book-illustrator of the mid-19th century. Doré's output was so huge that at one time he employed more than forty block-cutters to make the printing blocks from his drawings. His style is characterized by a highly spirited love of the grotesque, but he could also produce more sober work, as with his striking studies of the poor quarters of London, done between 1869 and 1871. In the 1870s he took up painting and sculpture, with less success.

In photographs **Dostoyevsky** often looks nervous or troubled and the remarkable events of his life were such as to leave terrible emotional scars. When he was 18 his father was murdered by his own serfs, an event that haunted Dostoyevsky and goes some way to accounting for his preoccupation with crime and guilt. Ten years later, as a political prisoner, he stood in front of a firing squad, not knowing that a reprieve had already been decided on; his terrifying confrontation with imminent death affected him deeply and was recalled in *The Idiot*.

Dos Passos, John (Roderigo) (1896–1970), US novelist. *Three Soldiers* (1921) drew on his experiences with the medical corps during World War I, while the New York novel *Manhattan Transfer* (1925) rehearsed the experimental techniques of his major work *USA*, an epic trilogy covering the nation's history from 1900 to the 1929 stockmarket crash. It is composed of *The 42nd Parallel* (1930), *1919* (1932), and *The Big Money* (1936).

Dostoyevsky, Feyodor (Mikhaylovich) (1821–1881), Russian novelist. The son of a doctor, he graduated as a military engineer but resigned his commission to devote himself to writing. His earliest works, particularly *Poor Folk* (1846), transform the theme of human suffering amid urban squalor pioneered by *Gogol. In 1849 his participation in a radical intellectual discussion group led to his exile to a penal colony in Siberia (1849–59). During this time he suffered periods of great physical and mental pain, and recurring bouts of epilepsy. Out of this experience came the harrowing *The House of the Dead* (1862). His mature work is characterized by an obsession with morbid psychology, a tendency to view human beings as absurd posturing manikins, a cruel sense of humour, and at the same time a tormenting awareness of the most

profound religious, metaphysical, and moral problems. In terms of technique, the novels have a heightened dramatic quality, achieved through extensive use of dialogue and techniques of suspense, and a masterful ability to set scenes of confrontation. *Notes from Underground* (1864) is a record of personality disintegration. *Crime and Punishment* (1866) explores the problem of the moral prerogatives of the exceptional individual, and is also a brilliant exercise in murder and suspense. In *The Idiot* (1868) Dostoyevsky created his most enigmatic hero, the other-worldly and infirm Prince Myshkin, and surrounded him with a gallery of male villains and rogues, and female saints and sinners. *The Devils* (also published as *The Possessed*, 1871-2) is his cruellest work, a savage mocking of positivist thought, conspiratorial socialism, and progressive ideas. With *The Brothers Karamazov* (1879-80) his unsurpassed ability to clothe ideas in flesh reached its apogee.

double bass, the largest of the violin family. To make notes easier to reach, basses are tuned in fourths, normally *E′–A′–D′–G′*. Music for the instrument is notated an octave higher than the actual pitch. Three-string basses were used in the 19th century, but four strings are normal today, with sometimes a fifth string tuned to low *B″* or *C′*, or the fourth string extended to that note by mechanism. To avoid carving away so much wood, the backs of basses are often flat, not curved, but they are nevertheless large violins, not viols.

Dowland, John (1563-1626), one of the most notable English composers and lutenists of his day. Little is known of his early years, but he spent time in France (where he converted to Roman Catholicism). From 1594, after failing to obtain the post of Queen's Lutenist (possibly on religious grounds), he worked in Germany and Italy, eventually becoming lutenist to the court of Christian IV of Denmark (1598-1606) and to the English court in 1612. Dowland's music, often imbued with a quality of heavy sadness, consists of solo and *part-songs with lute accompaniment, lute dances and *fantasias, psalm harmonizations, sacred songs, and several works for lute and viols—including the famous *Lachrimae or Seaven Teares* (1604). He also composed a collection of *pavans, *galliards (his favourite form), and *allemandes for five-part string *consort. His three *Bookes of Songes or Ayres* (1597, 1600, 1603) mark him out as an outstandingly sensitive and imaginative interpreter of the English language.

Doyle, Sir Arthur Conan (1859-1930), British novelist and writer of detective stories. He is remembered as the creator of the amateur detective Sherlock Holmes (and his colleague Dr Watson), whose ingenious solutions to a wide variety of crimes began in *A Study in Scarlet* (1887) and continued in many tales collected in *The Adventures of Sherlock Holmes* (1892), as well as in his novel *The Hound of the Baskervilles* (1902), and in other works. He wrote a long series of historical novels—including *The Exploits of Brigadier Gerard* (1896, the first of the 'Gerard' tales) and *The Lost World* (1912)—books on public themes, and a history of spiritualism (1926). (See also *detective story.)

D'Oyly Carte *Sullivan, Sir Arthur.

Drabble, Margaret (1939–), British novelist. Her early novels, including *The Millstone* (1963), are mostly realistic examinations of individual dilemmas faced by educated women. *The Ice Age* (1977) is a more ambitious attempt to depict the moral condition of contemporary Britain. She has also edited *The Oxford Companion to English Literature* (1985).

dramatic monologue, a kind of poem in which a single fictional or historical character other than the poet speaks to a silent 'audience' of one or more persons. Such poems reveal not the poet's own thoughts but the mind of the impersonated character, whose personality is revealed unwittingly; this distinguishes a dramatic monologue from a *lyric, while the implied presence of an auditor distinguishes it from a *soliloquy. Major examples of this form in English are Tennyson's 'Ulysses' (1842), *Browning's 'Fra Lippo Lippi' (1855), and T. S. Eliot's 'The Love Song of J. Alfred Prufrock' (1917).

drame bourgeois, a term coined in the 18th century to describe plays about middle-class domestic problems designed for the new middle-class audiences. Their themes avoided the classical extremes of *tragedy and *comedy and, while serious, they usually ended happily. The *drame* was rooted in the *comédie larmoyante* ('tearful comedy') of La Chaussée (1692-1754), but of somewhat higher quality, though it was sentimental and priggish. The novels of Samuel *Richardson were an influence, and *Diderot himself, who invented the term, wrote plays in this genre.

Dravidian literature, the literature of southern India and Sri Lanka, comprising besides *Tamil literature the three younger literatures of Kannada, Telugu, and Malayalam. All three were influenced by *Sanskrit literature in their early development, and Malayalam by Tamil also. Besides *Kavirājamārga* (*c*.850), a treatise on poetics, the oldest Kannada texts are *Jain hagiographies and the *Mahābhārata* reworked by Pampa, Ponna, and Ranna (10th century). The earliest Telugu work is also a *Mahābhārata* with versions by Nannaya (11th century) and Tikkana (13th century), while Malayalam begins with the 13th-century *Rāmacharitam*, retelling the *Rāmāyaṇa*. The Lingāyat sect (12th century) inspired Kannada and Telugu hymns to Shiva by authors such as the sect's founder Basava and the poetess Akkamahadevi. All three languages have a rich *Bhakti literature, notably Telugu's Potana (*c*.1400-75), whose *Mahābhāgavatamu* ('The Great Bhagavata') retold Krishna's boyhood, Kannada's Purandaradasa (1494-1564), and Malayalam's Tuncattu Eruttacchan (17th century), who wrote a *Mahābhārata* and *Rāmāyaṇa*. Under the patronage of the Vijayanagar kings (14th-16th centuries) and later Hindu and Muslim dynasties, Telugu and Kannada poets like Allasani Peddana (*c*.1510-75) and Lakshmisha (17th century) widely imitated Sanskrit literary forms. Malayalam writers such as Kottyatu Tampuran (17th century) provided texts for the famous Kerala *kathakali dance-drama tradition. Although a Dravidian tradition

A detail, *right*, from the central front panel of **Duccio**'s masterpiece, the *Maestà* altar-piece painted for Siena Cathedral. It shows St Agnes, one of ten saints and a company of angels who adore the Virgin and Child. When it was completed in 1311 the great altar-piece was carried in a solemn procession from the painter's workshop to the cathedral. (Museo dell' Opera del Duomo, Siena)

of mixed verse-and-prose writing (*campū*) existed, true prose developed with the spread of Western education in the 19th century. Modern Telugu literature dates from Viresalingam (1847–1919); his *Life of Rajaśekhara* (1878) and *Hariśchandra* (named after its hero) are among the earliest original Telugu novels and plays. The first true Malayalam novel was Appu Netungati's *The Jasmine Creeper* (1887), while M. S. Puttana is regarded as the pioneer of Kannada fiction. The leading 19th-century Malayalam poets were the epic-writer Ullur and the lyricist Kumaran Asan. The first modern Kannada poet was B. M. Srikanthayya, followed by Kuvempu. In the 1920s and 1930s Telugu poets like Duvurri Rami Reddi (1895–1949) were influenced by *Romanticism, while the Malayalam poet Vallathol (1879–1958) was inspired by Indian nationalism. The most acclaimed modern novelists are Malayalam's Takazi Sivasankara Pillai and Kannada's Sivarama Karanta. The outstanding modern Telugu writer is the poet, playwright, novelist, and essayist Visvanatha Satyanarayana.

Dream of the Red Chamber, Chinese novel of the mid-Qing (1644–1911) dynasty. *Hongloumeng* or the *Dream of the Red Chamber*, which has also been translated as the *Story of the Stone*, was written in the vernacular by Cao Xueqin in about 1760, and is considered by some critics as one of the world's finest novels. The central theme is the story of frustrated love between two cousins who live in an enclosed and protected world, but it is also a semi-autobiographical account of the decline and fall of an influential family.

Dreiser, Theodore (Herman Albert) (1871–1945), US novelist. He succeeded Frank Norris as the foremost representative of *naturalism in American fiction with his studies of working girls, *Sister Carrie* (1900) and *Jennie Gerhardt* (1911), and the first two parts of a trilogy featuring a businessman, *The Financier* (1912) and *The Titan* (1914). His best novel, *An American Tragedy* (1925), is the story of a youth of unstable character trapped by circumstances that lead to his execution for murder.

drone, a continuous note of fixed pitch that acts as a permanent bass in some instruments. The best-known example is perhaps the *bagpipe, which has one or more reed-pipes tuned to the tonic or the tonic and dominant of the *key of the instrument. These sound throughout the melody and are heard as the player first inflates the bag. Drones are also characteristic of much Indian music and folk music. The French traditional carol 'Il est né le divin enfant', for example, opens with a typical open-fifth drone accompaniment, entirely appropriate to the words 'ressonez musettes' (resound bagpipes).

drum, strictly a musical instrument with a membrane, traditionally of animal skin but now frequently plastic, which is struck, or through which passes a stick or cord which is rubbed. Various other instruments, although without membrane, are also called 'drum', for example, *slit drum. (See also *frame drum, *friction drum, *kettledrum, *talking drum, and *waisted drum.)

drum chime, a musical instrument, usually a set of *kettledrums, each tuned to a different pitch, and usually played as though they formed one instrument. Drum chimes are found in many areas, the best known being

Ethiopia and Burma. The Burmese *hsaing-waing* is a circular bamboo frame with twenty-one small kettledrums, covering over three octaves in range, suspended round the inner circumference; the player sits in the centre of the ring. The Ethiopian drums appear in many religious paintings, usually showing the drum chime, with a number of drummers, above a layer of clouds.

Drury Lane Theatre, London's oldest surviving theatre, rebuilt three times since it opened in 1663 as the Theatre Royal. It shared with *Covent Garden a monopoly of legitimate theatre in London until 1843. *Dryden was briefly its resident playwright, but its great period was the second half of the 18th century, under the managements of *Garrick, *Sheridan, and *Kemble. Sheridan's *The School for Scandal* opened there in 1777. Sarah *Siddons established her fame there, as did *Kean in the early 19th century. The theatre was noted from the 1880s for its spectacular *melodramas and *pantomimes, and from the 1920s for musical comedies.

Dryden, John (1631–1700), English poet, critic, and dramatist. His mastery of the *heroic couplet is demonstrated in *Heroique Stanzas* (1658), commemorating the death of Cromwell, and in *Astraea Redux* celebrating the restoration of Charles II. He wrote several comedies, but he was at his best with tragi-comedies, often discussing political and philosophical questions, notably *Marriage à la Mode* (1672). In the prologue of his heroic masterpiece, *Aureng-Zebe* (1675), he denounced rhyme in serious drama and his next play, *All for Love* (1678), based on the story of Antony and Cleopatra, was in *blank verse. His celebrated verse *satires include *Absalom and Achitophel* (1681), *The Medall* (1682), *Religio Laici* (1682), a defence of Anglicanism, and *MacFlecknoe* (1682). On the accession of James II, Dryden became a Roman Catholic and his poem *The Hind and the Panther* (1687) defends his new faith. He developed his critical principles in *Essay of Dramatick Poesie* (1668) and in many fluent prologues, epilogues, and poems addressed to his fellow writers. His translations include a version of Virgil's *Georgics* and *Fables Ancient and Modern* (1700). Both in his verse and his prose he displayed lucidity and great zest for his subject. He was made *Poet Laureate in 1668.

drypoint, a method of *engraving on copper, dating from the 15th century, in which the design is scratched directly into the plate with a sharp tool that is held like a pen. A distinctive feature of drypoint is the 'burr' or rough, upturned edge of the furrow made by the cutting tool. This produces a soft, rich quality in the print, but because it soon wears down only a limited number of good impressions can be taken. Drypoint has often been used in combination with other processes; Rembrandt, for example, often touched up his etchings in drypoint.

Du Bellay, Joachim (1522–60), French poet. He was, with *Ronsard, a member of the group of poets called the *Pléiade* who, inspired by the literature of classical antiquity, set out to renew French poetry. Four years in Rome produced in him a nostalgia for the city's vanished past and a yearning for France which crystallized in his two major collections of poems *Les Antiquités de Rome* and *Les Regrets* (1558). *Les Regrets* in particular strike a note of elegy and emotional sincerity which is regarded as anticipating the *Romantic poetry of the 19th century.

Dubuffet, Jean (1901–85), French artist, one of the chief figures in the modern movement to reject traditional techniques and to place untrained spontaneity above professional skill. His pictures often incorporate materials such as sand and plaster, and he also produced sculptural works made from junk materials. He made a large collection of what he called 'Art Brut' (raw art)—the products of children, illiterates, the insane, and indeed anything uninhibited and without pretensions—of which his own work is aggressively reminiscent. He initially caused outrage, but has since been influential.

Duccio di Buoninsegna (*fl.* 1278–1318), Italian painter, the most illustrious artist of the *Sienese School. He is famous as the painter of one of the most celebrated works in the history of Italian art: the altar-piece of the Maestà (the Virgin and Child enthroned in heavenly glory) painted for Siena Cathedral in 1308–11. The panels are remarkable for their exquisite colouring, supple drawing, and superb standard of craftsmanship; and although Duccio's work is much less solid and three-dimensional than that of his Florentine contemporary *Giotto, it has, like Giotto's, a new warmth of human feeling that marks a break with the aloof tradition of *Byzantine art. Duccio's work was highly influential in his native city and elsewhere; as well as the Maestà, the other pictures attributed to Duccio are all panel paintings.

Duchamp, Marcel (1887–1968), French artist and art theorist. Although he produced few works he is regarded as one of the most influential figures in 20th-century art because of the originality of his ideas. In 1912 he invented the 'ready-made' (a term he applied to a mass-produced article selected at random and displayed as a work of art), and soon after this he abandoned conventional means of artistic expression. His 'ready-mades' included a bicycle wheel mounted on a kitchen stool, a bottle rack, and a urinal, which he entitled *Fountain*. He hoped to destroy the mystique of taste, and although he was unsuccessful in this aim ('I threw the bottle rack and the urinal in their faces and now they admire them for their aesthetic beauty', he lamented in 1962), he nevertheless had an enormous influence on *Dada, on *Surrealism, and later on *Conceptual Art.

duct flute, a musical instrument, a flute where the air is guided to the voicing edge by a duct. Most frequently the duct is internal, a block with a narrow windway between the block and the wall of the flute, as with organ pipes, recorders, and flageolets; the duct is sometimes at the back. The Indonesian *suling* has an external duct, with the windway between a ring of palm leaf round the head of the flute and its exterior. One South-East Asian and American Indian duct has an inner obstruction forcing the airstream out of the flute into a windway under a tied-on external block which directs it to the mouth of the flute. With the tongue-duct, the player protrudes the tongue into the otherwise empty head of the flute, thus guiding the air to the voicing edge.

Dufay, Guillaume (*c.*1400–74), French composer who spent much of his working life in Italy. Dufay's surviving compositions include eight settings of the mass (and some settings of single movements), thirteen *isorhythmic motets, hymn settings, and many secular *chansons. He earned his fame less by innovation than by the perfect control he exercised over the accepted elements of composition: the beauty of his melodic lines and the skilful use he made of *canon and imitation.

Du Fu (AD 712–70), generally considered the greatest poet of China. He lived during the Tang dynasty (618–907) and was born into a high-ranking family near the capital Chang'an. As a poet he excelled in all verse-forms, and his writings are characterized by rich and varied language, by a superb command of the rules of prosody, and by a deeply felt humanity. His early poetry celebrates the beauties of the natural world, and regrets the passage of time. An impassioned critic of injustice and of warfare, he himself experienced extreme personal hardship. After

Marcel **Duchamp**'s *Nude Descending a Staircase, No. 2* (1912) was the first of the works in which he showed his talent for outraging the public and often his fellow artists. It was the most notorious exhibit at the Armory Show in 1913 (America's first wholesale introduction to modern art), where it was described by one critic as 'an explosion in a shingle factory'. The multiplication of forms, conveying such a vivid sense of movement, was suggested by photograph sequences taken with high shutter-speed cameras. (Philadelphia Museum of Art)

the An Lushan rebellion he joined the exiled court (757), but later served a local warlord and acquired some land.

Dufy, Raoul (1877–1953), French painter, graphic artist, and textile designer. After passing through *Impressionist and *Fauvist phases, and a period when he was influenced by the art of *Cézanne, he developed the highly distinctive style for which he is famous in the 1920s. It is characterized by rapidly drawn figures on backgrounds of bright, thinly applied colours and was well suited to the glittering scenes of luxury and pleasure he favoured. The accessibility and *joie de vivre* of his work helped to popularize modern art. Dufy was also commercially successful in producing textiles, pottery, and tapestries.

In this late 15th-century French allegorical depiction of music, a young woman plays a **dulcimer** supported by two swans. Beside her are a harp (*left*) and a portative organ (*right*). Behind her, three musicians play pipe and tabor and shawm, (*left*) and bagpipe (*right*), with a group of singers. (Bibliothèque Nationale, Paris)

Dukas, Paul (1865–1935), French composer. He began composing when he was about 13 and he wrote his first important work, the overture *Polyeucte*, in 1892. There followed, most notably, the Piano Sonata (1901), his Symphony in C (1895–6), a symphonic scherzo *L'Apprenti sorcier* (1897), an opera *Ariane et Barbe-Bleue* (1906), and a ballet *La Péri* (1912). All of these works made a considerable impression, but Dukas was both eccentric and hypercritical, destroying or failing to complete the few works he wrote after 1912.

dulcimer, a musical instrument with a flat, usually trapeze-shaped, soundbox and numerous wire strings struck with a pair of light hammers. It seems to have derived from the *psaltery in Europe in the late 15th century, and is still a popular folk instrument, especially in Central Europe. The best-known examples are the Austro-German *hackbrett* and the Hungarian *cimbalom*. It is also used in Central Asia, as the *santūr, and in China, as the *yangqin. The so-called Appalachian dulcimer, much played in folk ensembles, is not another 'hammered' dulcimer but a plucked *zither.

Dumas, Alexandre (Dumas *père*) (1802–70), French dramatist and novelist. He rose to fame originally as a dramatist, the success of his play *Henri III et sa cour* (1829) signalling an important victory for the *Romantic movement. Today he is remembered chiefly as the author of novels, particularly *Les Trois Mousquetaires* (1844) and *Le Comte de Monte-Cristo* (1844–5), which, though tinged with melodrama, are written with great verve and narrative skill. The former is a *historical novel, a genre made popular by Sir Walter Scott and later practised by Vigny and Hugo.

Dumas, Alexandre (Dumas *fils*) (1824–95), French dramatist. He became one of the most successful dramatists of the Second Empire. His play *La Dame aux camélias* (1852), is the story of a courtesan who voluntarily renounces her love for a respectable young man and then dies of consumption. It was based on Dumas's own novel (1848) and inspired Verdi's opera *La Traviata* (1853).

Dunbar, William (*c*.1460–*c*.1513), Scottish poet. He is believed to have been a Franciscan novice, who later became court poet to James IV of Scotland. He is the best known of the *makaris* (Scottish 'maker' or 'poet'), a group of Scottish courtly poets who flourished *c*.1425–1550. His political satire 'The Thrissill and the Rois' (1503) celebrated the king's marriage to Margaret Tudor. His other works include 'The Dance of the Sevin Deidly Synnis' (1507); the 'Lament for the Makaris', a powerful elegy on transitoriness that bewails the deaths of his contemporary poets; the celebrated *satire in *alliterative verse, 'Tretis of the Tua Mariit Wemen and the Wedo'; and 'The Flyting of Dunbar and Kennedie', a virtuoso satiric invective against his professional rival. Dunbar wrote with great artistry in a variety of *stanza forms whose subjects ranged from earthy jokes to caustic *lampoons, moral *allegory, and hymns of religious exaltation.

Duncan, Isadora (1877–1927), US dancer and choreographer, who worked mainly in Europe. A *modern dance pioneer, her work was an innovative mix of Greek-derived notions of beauty and harmony, everyday running, leaping, and walking actions, and rhythms abstracted from nature. Her choreographic subject-matter embraced Greek myths and contemporary social and political events. Her use of classical music was considered both outrageous and revolutionary. An outstanding performer, she created more than 150 works.

Dunstable, John (*c*.1390–1453), English composer, widely considered one of the foremost composers of the time. His surviving music includes two complete masses, many single movements from the mass, and various settings of sacred Latin texts, including many *isorhythmic motets. He was a master of the *polyphonic style of the period, and the perceived 'Englishness' of his music (its freshness and lyricism) greatly influenced his continental contemporaries.

Dürer, Albrecht (1471–1528), German graphic artist and painter, the greatest figure of *Renaissance art in northern Europe. He was the son of a goldsmith and from an early age he was introduced to the world of books and learning. His whole approach to art was highly intellectual, and in his self-portraits he presents himself as a cultured gentleman rather than an artisan. Most of his career was spent in his native city of Nuremberg, but

The Negress Catherine (1521) is one of the drawings made by **Dürer** in the course of a visit to the Netherlands. Dürer's reputation was by this time so great that he was treated as a celebrity and met many important men from various walks of life; Catherine was a servant of João Bradão, one of the economic representatives of Portugal in Antwerp. The drawing is in silverpoint, one of the many techniques in which Dürer excelled. (Uffizi, Florence)

his travels included two journeys to Italy (1494–5 and 1505–7), where he was influenced by the beauty of Venetian painting. He particularly admired Giovanni *Bellini and became deeply interested in problems of proportion and harmony. He was the leading painter in Nuremberg and executed several major altar-pieces, but his greatest fame was as an engraver. Because engravings were easily portable, knowledge of his work became widespread and his prints were influential even in Italy. Technically, he brought engraving to a level of excellence rivalling the richness and textures of painting. Most of his work was on religious subjects, often displaying deep feeling; but his visual curiosity was endless, and particularly in his marvellous drawings and water-colours he displayed a fascination with all aspects of nature comparable to that of his Italian contemporary Leonardo da Vinci.

Durey, Louis Les *Six.

Dürrenmatt, Friedrich (1921–), Swiss dramatist and author of detective stories with an ironic twist. Fascinated by the absurd and the grotesque, Dürrenmatt

introduces into his black comedies *The Visit* (1956) and *The Physicians* (1962) humorous dialogue and situation before allowing a chilling awareness to dawn that the moral issues raised are no laughing matter. The audience is in no position to discard the serious implications behind the absurd events on stage. Dürrenmatt holds tragedy to be irrelevant today—the distance created by comedy affords the only hopeful perspective on moral issues.

Durych, Jaroslav (1886–1962), Czech novelist and poet. His monumental novel *The Erring Quest* (1929, renamed *The Descent of the Idol* in the shortened English version, 1935) is written from the standpoint of ardent yet unorthodox Roman Catholicism; it gives a unique picture of the Thirty Years War and reveals a profound understanding of the spirit of the Baroque era.

Duse, Eleonora (1858–1924), Italian actress, one of the greatest of all time. She came from a theatrical family, played Juliet at 14, and scored early successes as an adult in Zola's *Thérèse Raquin* (1879) and as Santuzza in Verga's *Cavalleria rusticana* (1884), which she created. She championed the plays of D'Annunzio, and her playing of Shakespeare's Cleopatra impressed Chekhov, who may have envisaged her as Arkadina in *The Seagull*. She refused stage make-up, preferring not to disguise her mobile features, and her powerful presence and subtlety enabled her to play emotional roles without histrionics.

Dvořák, Antonín (Leopold) (1841–1904), Czech composer. Born in Bohemia, his peasant background was intensely musical and he trained as a church musician. The publication of the *Moravian Duets* (composed 1876) and the *Slavonic Dances* (1878) for piano duet confirmed him as one of the most popular and important composers of the day. His music belongs to the mainstream 19th-century classical tradition, but is distinguished from that of his closest contemporaries, *Brahms and *Tchaikovsky, by colourful, light-hearted folk elements. His achievement is best seen in the nine symphonies (particularly No. 9 in E minor 'From the New World', 1893); and in concertos for violin (1880) and cello (1895). Among his large-scale choral works the *Stabat Mater* (1877), Mass in D (1887), Requiem (1890), and *Te Deum* (1892) have retained their popularity, but of his ten operas only *Rusalka* (1900) has made much of an impression outside his native Czechoslovakia.

Dyce, William (1806–64), British painter, designer, and art educationist. His work, with its bright colours and naturalistic detail, formed a link between the *Nazarenes and the *Pre-Raphaelites. His design is usually stronger, however, and his high-mindedness more convincing than in the works of either. A favourite of Prince Albert, Dyce carried out decorative schemes at Buckingham Palace and Osborne House on the Isle of Wight. As director of the Government School of Design (1840) he was a pioneer of state art education.

Dyck, Sir Anthony Van (1599–1641), Flemish painter, celebrated as one of the greatest portraitists of all time. He was remarkably precocious, painting in a distinctive style when he was in his teens. He became *Rubens's chief assistant and was influenced by him, but Van Dyck's style was always less robust and more nervously sensitive. In 1620 he worked briefly for James I in London, then

This magnificent black chalk drawing of the architect and stage designer Inigo Jones is one of a series Van **Dyck** made for engraving in a volume of portraits of notable contemporaries entitled *Iconography*. Van Dyck and Jones were the two foremost artists at Charles I's court and the painter has captured a sense of the architect's formidable intellectual strength. (Collection of the Duke of Devonshire, Chatsworth, Derbyshire)

in 1621 he moved to Italy, where he stayed until 1628 and made a name with his grand aristocratic portraits. From 1628 to 1632 he was again mainly in Antwerp, then from 1632 until his death he worked in London as court painter to Charles I, who knighted him. In his English years he concentrated almost exclusively on portraiture; his many pictures of the king, his family, and his courtiers have formed posterity's image of this period in English history. He had an unrivalled ability to invest his sitters with an air of elegant refinement, and his work continued to be a model for society portraitists until the early 20th century.

Dylan, Bob *rock music, *folk music.

Eakins, Thomas (1844-1916), US painter, regarded by most critics as the outstanding US painter of the 19th century and by many as the greatest his country has yet produced. He worked mainly in his native Philadelphia, but trained in Europe, 1866-70, and was particularly influenced by works by *Velázquez and *Ribera. His work was founded on a precise sense of actuality, which he applied to portraiture and *genre pictures: boating and bathing were favourite themes. His career was controversial, and he was forced to resign from his teaching post at the Pennsylvania Academy of Fine Arts in 1876 for allowing a class of both sexes to draw from a completely nude male model. It was only towards the end of his life that he was recognized as a great master. Eakins was a talented photographer and also made a few sculptures.

Early English style, the first of the three phases into which English *Gothic architecture is conventionally divided, covering the period c.1175-c.1275 and preceding the *Decorated and *Perpendicular styles. It is most obviously distinguished from the later styles by the use of simple 'lancet' (tall and narrow) windows, without *tracery. The choir of Canterbury Cathedral (begun 1174) is generally regarded as the first truly Gothic building in England, and Salisbury Cathedral, begun in 1220, is the archetypal example of the Early English style, since, very unusually for an English cathedral, it is remarkably consistent in style throughout.

earthenware, pottery that has been fired at a fairly low temperature, so that the clay has not vitrified (turned glassy); it is therefore slightly more porous and coarser than *porcelain or *stoneware. To make it suitable for holding liquids, and also for decorative reasons, earthenware is almost always glazed, but it is left unglazed in, for example, flowerpots. The oldest known pottery, dating from about 7000 BC, is earthenware. It is still widely used today, particularly for cooking and serving utensils.

East Asian dance, the dance of China, Korea, and Japan. Dancing to musical accompaniment and in magnificent costumes has been recorded in China from c.1000 BC. Common artistic traditions have since then linked the three countries as each developed its form of stylized dance. Frequently the dancer is also the musician; his body positions are regulated by codes of arm and hand gestures set forth in the Nāṭyaśāstra, a treatise compiled in the early centuries AD. Scores of court and folk dances and dance plays exist. Masked dances are especially characteristic of Korea, while in Japan movement is an important part of Kabuki and No theatre (see *Japanese drama). The traditional dancer in China, Korea, and Japan moves in relatively slow and often geometric patterns, scarcely raising his or her feet in the air. A performance of East Asian traditional dance, blended with drama, mine, and music, extends over eight to twelve hours. A recent Japanese development is Buto dance, created in the early 1960s from the work of Tatsumi Hijkata and Kazuo Ono, which combines the *Expressionist dance works of *Wigman with concepts from traditional Japanese dance and culture.

Eastern Orthodox chant *plainsong.

eclogue, a short *pastoral poem, often in the form of a shepherds' dialogue or a *soliloquy. The term was first applied to the 'bucolic' poems of *Virgil, written in imitation of the *idylls of Theocritus; Virgil's work became known as the *Eclogues* (42-37 BC). The form was revived in the Italian Renaissance by Dante, Petrarch, and Boccaccio, and appears in English in Spenser's *The Shephearde's Calender* (1579).

Edda, the name given to two collections of Icelandic literature. The *Elder* or *Poetic Edda* was compiled in the 13th century, and consists of thirty-three poems in *alliterative verse handed down by oral tradition, and dating probably from the 9th to the 12th centuries. It comprises mythological poems, featuring Germanic gods and goddesses, and heroic *lays based on early Germanic history. The *Prose Edda* or *Younger Edda* (c.1223) was written by the Icelandic *skald* or court poet *Snorri Sturluson. It contains a survey in dialogue form of Nordic mythology; a discussion of *skaldic poetry and versification, giving rules and many examples; and a poem in honour of King Håkon and Earl Skuli of Norway, its 102 *stanzas illustrating different *metres. Though many of the poems convey the spirit of the Viking age, they are not historically accurate.

Edgeworth, Maria (1768-1849), Anglo-Irish novelist. Her first publication, *Letters to Literary Ladies* (1795), is a plea for women's education. Her novels on Irish life include *Castle Rackrent* (1800), narrated in dialect by the Irish family servant Thady, which is regarded as the first regional and *historical novel in English; and *The Absentee* (1812) showing sympathy both for the gentry and for the plight of the Irish peasantry. *Belinda* (1801) describes the suffering caused by the loose morality of fashionable society. She also wrote *Moral Tales* (1801) and other stories for children.

Egyptian art, the art of ancient Egypt, particularly in the period from about 3000 BC, when the country was unified as one kingdom, until 30 BC, when it became a Roman province. Art in Egypt appears to have developed from the earliest times in the service of the divine king, who was the chief patron of artistic enterprises. Most of the reliefs, statues, and architecture which have survived were created to sustain the divinity of the Pharaoh, particularly after his death. During the first Dynasty (about 3000 BC) the earliest work of art which we can place definitely is a ceremonial slate palette dedicated by King Narmer in the temple of Hieraconpolis. It is carved with reliefs commemorating the king's victories, the available space being organized so as to tell a story with force and precision. This palette shows in essence all the characteristic features of subsequent Egyptian art. At this time, Egyptian drawing had not discovered perspective, and throughout the rest of its history it was so bound by the authority of the conventions used by the earliest artists that there was little attempt to represent depth and space. During the 3rd Dynasty (about 2800 BC), permanent

This scene, 'Fowling in the Marshes', is from the Tomb of Nakht at Thebes, c.1320 BC (XVIIIth Dynasty). The tomb painting of this period in **Egyptian art** reflects the luxurious way of life of the ruling classes. Hunting and banqueting scenes are common, and beautiful young women are represented abundantly. (British Museum, London)

mortuary buildings in stone, such as the Step Pyramid of Djeser, began to replace perishable mud-brick tombs. From this time Egyptian art took on its monumental character, a development which reached full expression in the 4th Dynasty (2613–2494 BC). The reliefs that decorated the walls of tomb-chapels within the pyramids show scenes of an ideal life which it was hoped the deceased would enjoy in eternity. Impressive as the achievements of the Ancient Egyptians are in the fields of painting, sculpture, and architecture, perhaps the most characteristic expression of their genius is to be found in the applied arts. Egyptian jewellery of the Middle Kingdom (2040–1786 BC) in the form of crowns, pendants, clasps, and mirrors in exquisitely worked gold and silver, inlaid with semi-precious stones, has never been surpassed in taste and execution. Even in prehistoric times great skill was shown in the making of vessels from hard stones, and this craft survived until classical times. Egyptian joinery and woodwork at its best was not equalled until the Italian Renaissance, and the many toilet accoutrements of the New Kingdom (1567–1085 BC) in wood, ivory, and glass, such as were found in Tutankhamun's tomb, are among the most attractive products of the ancient world.

Eichendorff, Joseph Freiherr von (1788–1857), German novelist and lyric poet, one of the great exponents of the *Lied*. Typical of Eichendorff is the notion of the wanderer, for instance the simple optimist hero of his novella *Memoirs of a Good-for-nothing* (1826), who is presented as the opposite of the materialistic philistine. The short story *The Marble Statue* (1819) reveals Eichendorff's

awareness of the sinister aspects of life. His poems, using traditional nature symbols and simple rhythms, appear pantheistic, for he believed that the poet praised God by conveying with immediacy, reverence, and metaphysical longing the wonders of nature. Many of his lyrics were set to music by Schumann and Wolf.

Eisenstein, Sergey (Mikhaylovich) (1898–1948), Soviet film director. His first film, *Strike* (1925), was followed by *The Battleship Potemkin* (1925), about the Russian naval mutiny of 1905, and *October* (1927), about the Russian Revolution of 1917, both silent classics which re-create actual events with *documentary realism (the 'Odessa Steps' sequence in *Potemkin* is an unrivalled *tour de force*). Official disapproval at home disrupted his film-making, but he returned to Russian history in 1938 with *Alexander Nevsky* and then *Ivan the Terrible, Part 1* (1944). Part 2 of the latter, *The Boyars' Plot*, met with Stalin's disfavour and was not shown until 1958; Part 3, *The Battles of Ivan*, was never finished.

electronic music, music produced by electronic means and recorded on tape. Strictly speaking, the term applies only to music derived through a *synthesizer, but nowadays it embraces sounds taken from normal musical or everyday sources that have been recorded on tape and perhaps manipulated in some way (formerly referred to as *musique concrète*). Tape recorder, synthesizer, computer, and microchip have made possible a whole new range of sounds that can be controlled (programmed) in ways that are impossible for conventional instruments and players. (See also *computer music, *twentieth-century music.)

elegy, an elaborately formal *lyric poem lamenting the death of a friend or public figure. In Greek and Latin verse, the term referred to the *metre (alternating *hexameters and *pentameters known as elegiacs) of a poem, not to its content: love poems were often included. But since Milton's 'Lycidas' (1637), the term in English has

usually denoted laments, although Milton called his poem a 'monody'. Two important English elegies which follow Milton in using *pastoral conventions are Shelley's 'Adonais' (1821) on the death of Keats, and Arnold's 'Thyrsis' (1867), which mourns Clough. Tennyson's *In Memoriam: A. H. H.* (1850) is a long series of elegiac verses (in the modern sense) on his friend Arthur Hallam, while Whitman's 'When Lilacs Last in the Dooryard Bloom'd' (1865) commemorates a public figure (Abraham Lincoln) rather than a friend, as does Auden's 'In Memory of W. B. Yeats' (1939). In a broader sense, an elegy may be a poem of melancholy reflection upon life's transience or its sorrows, as in Gray's 'Elegy Written in a Country Churchyard' (1751), Rilke's *Duino Elegies* (1912–22), and many poems by Leopardi.

Elephanta caves, a group of rock-cut caves dedicated to the Hindu god Shiva on the island of Elephanta in Bombay harbour. They date from the 8th or 9th century AD. The temple proper is a large hall with rows of columns 'supporting' the cave roof. It contains a series of huge and spectacular carvings illustrating the legend of Shiva, the most magnificent portraying the god three-headed in his benevolent, serene, and terrifying aspects. The carving, although much damaged, is remarkable throughout for its sensitivity as well as its monumentality. A statue of an elephant, which gives the island its English name, has been removed to Victoria Gardens, Bombay; the Indian name for the island is Gharapuri.

Elgar, Sir Edward (1857–1934), British composer. In 1899 he achieved international fame with the orchestral Variations on an Original Theme ('Enigma'). Despite the initial failure of the oratorio *The Dream of Gerontius* (1900), a setting of Newman's poem, his fame steadily increased through the oratorios *The Apostles* (1903) and *The Kingdom* (1906), the Introduction and Allegro for strings (1905), the First and Second Symphonies (1908, 1911), the symphonic study *Falstaff* (1913), and the concertos for violin (1910) and cello (1919). With the death of his wife, Alice Roberts, in 1920 he virtually ceased composing. His hymn 'Land of Hope and Glory' to the words of Arthur Benson's poem, was adapted from the trio of the *Pomp and Circumstance* March No. 1 in D in 1902. This, together with further compositions of patriotic marches, has earned him a popular place in the heritage of British ceremonial music. His work marks a reawakening of British musical genius, largely dormant since the death of Purcell. Traditional in manner, his music has all the opulence of late *Romanticism and is imbued with a powerful personal melancholy.

Eliot, George (Mary Ann, later Marian, Evans) (1819–80), British novelist. She renounced her early evangelical Christian faith, but remained strongly influenced by religious concepts of love and duty. She became assistant editor on the *Westminster Review* and in 1851 began her notorious relationship with the writer G. H. Lewes (1817–78), a married man with whom she lived until his death. The three stories *Scenes of Clerical Life* (1858) attracted praise for their domestic realism, pathos, and humanity, as well as speculation about the identity of 'George Eliot'. After the publication of *Adam Bede* (1859) she was recognized as a major novelist and sustained this reputation with further novels, including *The Mill on the Floss* (1860), *Silas Marner* (1861), *Romola* (1863), and *Felix Holt* (1866). Her masterpiece *Middlemarch* (1871–2), a sensitive study of moral responsibilities, set in a small provincial town resembling Coventry, is regarded by many critics as the greatest English novel. Her last novel, *Daniel Deronda* (1874–6), displayed her sympathies for Jewish nationalism. Her work is noted for its intelligent and serious exploration of moral problems, and for its development of the psychological analysis that characterizes the modern novel.

Eliot, T(homas) S(tearns) (1888–1965), US poet. Born in Missouri, he became a major figure in English literature from the 1920s onwards. Having settled in the UK in 1915, his first volumes of poems, *Prufrock and other Observations* (1917) and *Poems* (1919), struck a new chord in English poetry. Having founded a quarterly, the *Criterion*, he published in the first issue *The Waste Land* (1922), a

The 'Odessa steps' massacre in **Eisenstein**'s *Battleship Potemkin* is probably the most quoted scene in cinema history. Eisenstein's high reputation is based on comparatively few completed films. Much time was wasted on projects such as the uncompleted *Que viva Mexico!* (1931–2), shot in Mexico, parts of which were extracted by others to make separate films, and *Bezhin Meadow* (1935–7).

This detail of a portrait of T. S. **Eliot** was painted by the novelist Wyndham Lewis in 1938. By this time Eliot was firmly established as a figure of great cultural authority and he is now widely regarded as the most influential poet of the English-speaking world of the 20th century. (Durban Art Museum)

cryptic, complex, and erudite poem in five parts that reflects the fragmented experience of 20th-century urban man. It became a landmark of *modernism, and established him as the voice of a disillusioned, secularized generation. As a director of the publishing firm Faber and Faber from 1925 he built up a list of poets (including Auden, Spender, and Pound) which represented the mainstream of the modern movement in poetry. He became a British subject in 1927 and joined the Anglican Church; *Four Quartets* (1935-42) communicates in modern idiom Christian faith and experience. These preoccupations were reflected in his critical works and developed in part from the concept of 'dissociation of sensibility' which he formulated in 1921. His attempt to revive verse drama resulted in *Murder in the Cathedral* (1935), *The Family Reunion* (1939), *The Cocktail Party* (1950), and other plays. He also wrote a book of children's verse, *Old Possum's Book of Practical Cats* (1939). Eliot was equally influential as critic and poet. Among his many volumes of criticism is *The Sacred Wood: Essays on Poetry and Criticism* (1920). He was awarded the Nobel Prize for Literature in 1948. (See also *literary criticism.)

Elizabethan theatre, English drama and theatre during the reign of Elizabeth I (1558-1603). Before the construction of permanent theatres plays were performed on temporary stages and on *booths; often the action took place in the open air, but sometimes in public buildings such as guild halls, in the houses of noblemen, or in the courtyards of inns. The first permanent playhouse in London was The Theatre (1576-97), which, together with subsequent Elizabethan theatres, reproduced the

main features of the innyard. These theatres were wooden, unroofed, with a platform stage and two or three roofed galleries with seats. A canopy (called the heavens) supported by pillars covered part or perhaps all of the stage. The permanent back wall contained entrance doors for actors. The open balcony at the back of the stage could be used for the appearances of actors, and above it was a hut where the *stage machinery was housed to raise or lower actors or scenery on to the stage. Beneath the stage was a cellar with more machinery, from which 'ghosts' and 'devils' could be transported on to the stage. The spectators could, for the price of one penny, stand around the stage on three sides, or, for sixpence, sit in the galleries. The Globe (1599-1644), in Bankside, Southwark, was the largest and most famous Elizabethan theatre and the most closely associated with *Shakespeare. Performances could be given only in the daylight and during the summer months (during the winter, the roofed Blackfriars theatres were used; these were built within the walls of the old monastery and were therefore private). The Globe met all Shakespeare's requirements, including the display of *pageantry and the performance of music. Both were used by Richard *Burbage's company and by the *boy actors' companies. It was not uncommon for actors and playwrights to hold 'shares' in a theatrical company which, as in Shakespeare's case, brought considerable wealth. (See also *chorus.)

Ellington, Duke (Edward Kennedy) (1899-1974), US *jazz composer, pianist, and bandleader. He played the piano professionally while still in High School; by 1923 he was leading a band in New York. His band developed a distinctive sound, and Ellington began to emerge as a songwriter. From 1927 to 1932 Ellington's band played the Cotton Club in Harlem. This period established him as a composer and arranger of genius: such songs as *Mood Indigo* are among his finest. From the 1940s on, Ellington increasingly wrote longer, concert works. Though these were less successful, his band continued to play interesting jazz until his death.

The London district of Southwark called Bankside, the centre of the **Elizabethan theatre**, is shown in this detail of an engraving of London (made in 1616—the year of Shakespeare's death) and the Globe Theatre is clearly marked. Visual records of the Elizabethan theatre such as this are tantalizingly vague or incomplete, but in 1989 the foundations of both the Rose and Globe Theatres were unearthed, and this discovery has substantially augmented knowledge of the subject. (The Mansell Collection, London)

Ellora caves, a series of rock-cut temples near the village of Ellora in Maharashtra state in the north-western Deccan region of India. They date from the 5th to the 13th century and are mainly Hindu; some are Buddhist and Jain. The largest and most important is the Kailasanath temple (8th century), dedicated to the god Shiva and intended as an architectural replica of his sacred home, Mount Kailāsa. It is profusely decorated with vigorous mythological carvings and is one of India's greatest artistic monuments.

Éluard, Paul (1895-1952), French poet. The poetry of his early years, for example *L'Amour, la poésie* (1929), is primarily lyrical in inspiration. It reveals Éluard's debt to and association with the *Surrealists, though during the 1930s he developed profound communist sympathies, and moved towards a poetry of political involvement, dealing with the sufferings and brotherhood of man. *Cours naturel* (1938) was inspired by the Spanish Civil War and *Poésie et vérité* (1942) by the German occupation of France during World War II.

embroidery, a general term for ornamental stitchwork applied to any kind of fabric using any kind of thread (including hair). Embroidery is an extremely ancient and widespread craft. It was known in the civilizations of Assyria, Babylon, and Egypt, and surviving fragments from the Crimea and central Asia date from perhaps as early as the 4th century BC. It is only from the Middle Ages, however, that complete or well-preserved pieces begin to survive in some number. The *Bayeux Tapestry is one of the masterpieces of its period, but the finest medieval embroidery is generally religious rather than secular. In the 13th and 14th centuries England had such a reputation for its ecclesiastical embroidery that it was prized throughout Europe and known simply as *opus anglicanum* ('English work'). Embroidery has continued to be used in the service of the church, but from the end of the Middle Ages it has been used with equal distinction for secular purposes for costumes, curtains, upholstery, book covers, and so on. Sometimes gold or silver thread, as well as gems, feathers, glass beads or small mirrors, are incorporated in the fabric.

Emerson, Peter Henry (1856-1936), British photographer and critic. Emerson published his first book, *Life and Landscape on the Norfolk Broads*—a collaboration with the painter T. F. Goodall—in 1886. His *Naturalistic Photography* (1889) argued that photographs should not be uniformly in focus. Using 'differential focus', he took pictures with only part of the image sharp. He cited the *Impressionist painters, as well as *Turner and Whistler, as examples of what he advocated: it was *Whistler himself who convinced him that he was confusing art with nature. Emerson recanted in *The Death of Naturalistic Photography* (1890) and returned to his earlier straightforward style. In 1925 he began to award 'Emerson Medals' to photographers he admired, such as Julia Margaret *Cameron and *Hill and Adamson.

Emerson, Ralph Waldo (1803-82), US essayist, lecturer, and poet. After abandoning the Unitarian ministry, he settled in Concord, Massachusetts, where he was a central figure among the *Transcendentalists. The rhapsodic outline of the group's principles in his essay *Nature* (1836) received little attention, but he caused

The Syon cope, dating from the first quarter of the 14th century, is probably the most famous example of the type of medieval ecclesiastical **embroidery** known as *opus anglicanum* or 'English work'. Named after the convent of Syon, to which it once belonged, it is made of linen embroidered with silk and metal thread. (Victoria and Albert Museum, London)

controversy with the important orations 'The American Scholar' (1837) and 'The Divinity School Address' (1838). The publication of his first volumes of *Essays* (1841) and *Poems* (1847), and of *Representative Men* (1850), won him national and international esteem. Emerson was the great thinker of the so-called 'American Renaissance' of the mid-19th century, and his philosophy—idealist, nationalist, optimistic—influenced not only *Thoreau and *Whitman, but also writers like *Hawthorne and *Melville, who rejected his optimism.

Empire style, a style of furniture and interior decoration in France in the first quarter of the 19th century and associated with the personal taste of Napoleon Bonaparte (emperor 1804–14). It was largely the creation of the architects Charles Percier and Pierre-François Fontaine, who decorated Napoleon's state apartments in various residences. Essentially the style was *Neoclassical, with an attempt to copy what was known of ancient furniture and decorative motifs (Napoleon's campaigns inspired an interest in Egyptian decoration). There was also a lavish use of draperies. The Empire style was influential in other European countries and also in the USA. The term 'Second Empire' is applied to French architecture and decoration under Napoleon III (usually known as Louis-Napoleon), the nephew of Napoleon Bonaparte and emperor from 1852 to 1870. There was no dominant style during this period, but rather a tendency to revive various styles of the past in an uninhibitedly ostentatious way. The most famous work of Second Empire architecture is Charles *Garnier's magnificent Paris Opéra (1861–74).

Empson, Sir William (1906–84), British poet and critic. In his poetry he made use of complex analytical argument and imagery drawn from modern physics and mathematics. His volumes of verse, *Poems* (1935), *The Gathering Storm* (1940), *Collected Poems* (1955) show a technical virtuosity combining metaphysical *conceits with metrical complexities. His major critical work, *Seven Types of Ambiguity* (1930), is a study of the meaning of poetry and a classic of modern *literary criticism.

enamelwork, artefacts or decorative work in enamel, a smooth, glossy material made by fusing glass to a

A 16th-century Limoges **enamelwork** plaque with a design closely based on Raphael's fresco of *The Triumph of Galatea* in the Farnesina, Rome. In classical mythology Galatea was a sea-nymph of great beauty; here she is shown being pulled by dolphins in her chariot (an enormous cockle-shell), surrounded by sea-creatures, while cherubs sport in the sky. (Wallace Collection, London)

prepared surface, usually of metal. Though easily fractured, like glass, enamel is extremely durable and gives great brilliance of colour, especially when used in translucent form against a ground of precious material. The colour can come from the use of coloured glass or from the application of colour to plain enamel. Enamelling is thought to be of western Asiatic origin; the Egyptians, Greeks, and Romans made extensive use of it in jewellery. In the Middle Ages—in both Byzantium and western Europe—different enamelling techniques (including *cloisonné) were much used for the decoration of various types of ecclesiastical art, including book covers, reliquaries, and crucifixes. Enamelwork was sometimes executed on a large scale, as in Nicolas of Verdun's pulpit frontal for the abbey church at Klosterneuburg, near Vienna (the 'Klosterneuburg Altar', completed 1181), which features forty-five enamel plaques in an elaborate iconographical programme. Nicolas came from the Mosan region (the area around the River Meuse in present-day Belgium), which in his time was the centre of the highest quality enamelwork. Later in the Middle Ages the French city of Limoges became the best-known centre of production, catering for the mass market and making secular objects such as caskets and rings, as well as objects for religious use. The great days of enamel were over by the end of the 16th century, although it continued to be used for jewellery and decorative work.

enanga, a Ugandan musical instrument: a trough *zither made of a board with one face hollowed. The single string runs to and fro across the hollow, hitched round protuberances at either end of the trough at each crossing. A Ugandan *bow harp is spelt *ennanga*.

encaustic painting, a technique of painting with *pigments mixed with hot wax. It is said to have been perfected in the 4th century BC. The finest surviving examples from ancient times are the mummy portraits from the Faiyum area of Egypt. Methods of encaustic painting varied, but the essence of the technique was to fuse the colours to the painting surface through heat. It fell into disuse around the 8th century AD, probably because it was so impractical.

end flute, a flute that is blown across the end rather than transversely or through a duct. Most end flutes have the end shaped to form a sharp edge, though some retain a plain end, and others, the *notch flutes, have the sharp edge located only at the bottom of a notch. End-blown flutes have all the advantages of freedom of tuning and of dynamic expression of transverse *flutes without needing a stopper at precisely the correct distance from a carefully shaped mouth-hole in the side.

Endō Shūsaku (1923–), Japanese Roman Catholic novelist. Endō, a major literary figure in Japan, missed service in World War II because of illness and many of his stories are set in hospitals. After the war he studied in Lyons and was deeply influenced by French literature. Among his major works are *White Man* and *Yellow Man* (both 1955), which explore attitudes to Christianity, *The Sea and Poison* (1957), and his masterpiece, *Silence* (1966) on the persecution of Japanese Christians in the 17th century. His *Foreign Studies* (1965) examines the seemingly irreconcilable cultural and religious gulf between East and West.

engraving, a term applied in its broadest sense to the various processes of cutting a design into a plate or block of metal or wood, and to the *prints taken from these plates or blocks. However, the word usually applies to one of these processes, that of line engraving. The design is cut into a smooth metal (usually copper) plate with a tool called a burin, and prints are taken by inking the plate and pressing it (usually mechanically) against a sheet of paper. Line engraving produces hard, clear lines, and has been employed chiefly to reproduce works of art. Until the invention of photographic methods of reproduction in the 19th century it was the principal method of reproductive printing.

Enlightenment (or 'Age of Reason'), a term used to describe the philosophical, scientific, and rational attitudes, the freedom from superstition, and the belief in religious tolerance of much of 18th-century Europe. In Germany the *Aufklärung* ('Enlightenment'), which extended from the middle of the 17th century to the beginning of the 19th century, was a literary and philosophical movement that included *Lessing, *Goethe, *Schiller, and Emanuel Kant. The *Yiddish literature of Eastern Europe experienced a new dynamism, while a similarly invigorating freedom of ideas affected writers as far apart as Sweden, Russia, and Britain. In France the Enlightenment was associated with the *philosophes*, the literary men, scientists, and thinkers who were united in their belief in the supremacy of reason and their desire to see practical change to combat inequality and injustice. The movement against established beliefs and institutions gained momentum throughout the 18th century under *Voltaire, *Rousseau, and others. Through the publication of the *Encyclopédie* (1751-76) their attacks on the government, the church, and the judiciary provided the intellectual basis for the French Revolution. In Scotland an intellectual movement flourished in Edinburgh between 1750 and 1800; its outstanding philosophers were Hume and Adam Smith. The *Encyclopaedia Britannica* began in 1768-71 as a dictionary of the arts and sciences issued by a 'Society of gentlemen in Scotland'. In literature, some have seen a connection between the philosophy of the Enlightenment, the growth of literary *realism, and the rise of the *novel. It influenced the *Romantic movement in the arts, partly by releasing the more individualist attitudes in which this movement was based, and partly as the Romantics themselves reacted against the coldly scientific intellectualism which for them the Enlightenment represented.

Ennius, Quintus (239-*c*.169 BC), Latin poet, dramatist, and satirist. The first great Latin poet, he was a prolific writer of tragedy, comedy, satire, and epigrams, but is most celebrated for his epic poem *Annales*, telling in *hexameters (which he introduced into Latin) the story of Rome from the wanderings of Aeneas to his own day. A number of fragments survive; the poem had an influence on *Lucretius and on *Virgil's *Aeneid*.

Ensor, James (1860-1949), Belgian painter and printmaker. He was one of the formative influences on *Expressionism and was claimed by the *Surrealists as a forerunner, but his work defies classification within any school or group. It is characterized by fantastic and macabre imagery, often satirical in intent, involving social or religious criticism. He made much use of carnival masks, grotesque figures, and skeletons, with a gruesome and ironic humour reminiscent of his great Flemish predecessors *Bosch and *Bruegel.

epic, a long narrative poem celebrating the deeds of great heroes, in a grand ceremonious style. The hero, usually protected by or even descended from gods, performs superhuman exploits in battle or in marvellous voyages, often saving or founding a nation, as in Virgil's *Aeneid* (30-20 BC), or the human race itself, as in Milton's *Paradise Lost* (1667). Virgil and Milton wrote what are

This type of **encaustic** funerary portrait was found throughout Egypt, but it is particularly associated with the Faiyum area, south of Cairo. Produced from about the 1st to the 4th century BC, the portraits were painted on canvas or wood and enclosed in the wrapping around the corpse's face. They are among the most vivid and naturalistic portraits from the ancient world, suggesting that the work was done while the subject was still alive. (British Museum, London, on loan from National Gallery)

called 'secondary' epics in imitation of the earlier 'primary' epics of Homer, whose *Iliad* and *Odyssey* (*c*.8th century BC) evolved from an oral tradition of recitation. The Anglo-Saxon poem *Beowulf* (8th century AD) is a primary epic, as is the oldest surviving epic poem, the Babylonian *Gilgamesh* (*c*.3000 BC). In the Renaissance, epic poetry (also known as 'heroic poetry') was regarded as the highest form of literature, and was attempted by Ariosto in *The Frenzy of Orlando* (1532), Tasso in *Jerusalem Delivered* (1575), and Camoës in *The Lusiads* (1572). Other important national epics are the Indian *Mahābhārata* (3rd or 4th century AD) and the German **Nibelungenlied* (*c*.1200). The action of epics takes place on a grand scale, and in this sense the term has been transferred to long, ambitious novels like those of Tolstoy, and to some large-scale film productions.

epic theatre, a form of drama developed in the 1920s by the German dramatists *Piscator and *Brecht, who rejected traditional dramatic structure in favour of a detached narrative (hence 'epic') presentation in a succession of loosely related episodes interspersed with songs and commentary by a narrator. Epic theatre aims to encourage an attitude of critical reflection in the audience, rather than emotional identification with the action. Brecht's major plays *Mother Courage* (1941) and *The Good Woman of Setzuan* (1943) are fine examples.

epigram, a short poem with a witty turn of thought; or a wittily condensed expression in prose. First found in early Greek monumental inscriptions, the epigram was developed into a literary form by Martial, whose *Epigrams* (AD 86–102) were often obscenely insulting. This epigram by Herrick is adapted from Martial: Lulls swears he is all heart, but you'll suppose | By his proboscis that he is all nose. In English, epigrams have been written by many poets since Donne, and are found in the prose of Wilde and Dorothy Parker.

epilogue, a concluding section of any written work. At the end of some plays in the age of Shakespeare and Jonson, a single character would address the audience directly, begging indulgence and applause; both the speech and the speaker were known as the epilogue, as in Rosalind's closing address in Shakespeare's *As You Like It* (1599). Some novels have epilogues in which the characters' subsequent fates are briefly outlined.

epistolary novel, a novel written in the form of a series of letters exchanged among the characters of the story, with extracts from their journals sometimes included. A technique often used in English and French novels of the 18th century, it has been revived only rarely since then. Important examples include Richardson's *Pamela* (1740–1) and *Clarissa* (1747–8), Rousseau's *La Nouvelle Héloïse* (1761), and Laclos's *Les Liaisons dangereuses* (1782).

epitaph, a form of words in prose or verse suited for inscription upon a tomb, although many facetious verses composed as epitaphs have not actually been inflicted on their victims' graves. Epitaphs may take the form of appeals from the dead to passers-by, or of descriptions of the dead person's merits. Many ancient Greek epitaphs survive in the *Greek Anthology* (AD *c*.920), and both Johnson and Wordsworth wrote essays on the epitaph.

epithalamion (or epithalamium), a song or poem celebrating a wedding, and traditionally intended to be sung outside the bridal chamber on the wedding night. Some epithalamia survive from ancient literature, notably by Catullus, but the form flourished in the Renaissance. Spenser's 'Epithalamion' (1595) is the most admired English model, but others were written by Sidney, Donne, Jonson, Marvell, and Dryden. Later examples are those by Shelley and Auden.

epithet, an adjective or adjectival phrase used to define a characteristic quality or attribute of some person or thing. Common in historical titles (Catherine the Great, Ethelred the Unready), 'stock' epithets have been used in poetry since Homer. The 'Homeric epithet' is a compound adjective repeatedly used for the same thing or person: 'the wine-dark sea' is a famous example.

Epstein, Sir Jacob (1880–1959), US-born sculptor who settled in Britain in 1905. He was one of the most controversial artists of his time, his work often arousing violent abuse because of its modernism or on the grounds of alleged obscenity. He studied in Paris (1902–5), where he knew such artists as *Brancusi, *Modigliani, and *Picasso, who all helped to inspire the expressive simplifications of his work and to make him aware of ancient and primitive sculpture, which powerfully influenced his style. One of his most original works is the tomb of Oscar Wilde (1912) in Père Lachaise Cemetery in Paris, featuring a magnificently bold hovering angel inspired by Assyrian sculpture. His public sculptures were regularly attacked, their expressive use of distortion being offensive to conservative critics, but his portrait busts, to which he devoted himself increasingly from the 1920s, were well received and many of the great figures of the time sat for him. (See also *vorticism.)

Erasmus, Desiderius (1467–1536), Dutch scholar, writing in Latin. He produced a new edition of the Greek New Testament and several important translations, but is better known for his *Praise of Folly* (1511), a *satire on theologians suggested by his English friend Sir Thomas More. His *Adages* (1500) is a collection of *proverbs, used later by *Rabelais and other authors. His many editions and translations of the Bible, early Christian authors, and the classics revolutionized European literary culture.

Ernst, Max (1891–1976), German-born artist who became a French citizen in 1958, one of the major figures of *Surrealism. After studying philosophy and psychology and serving in World War I, he became leader of the *Dada group in Cologne in 1919. In 1922 he settled in Paris, bringing with him the Dadaist techniques of *collage and photomontage (see *montage), which were adapted to Surrealist uses. His work, which was always imaginative and experimental, makes brilliant use of irrational and whimsical imagery.

Escher, M(aurits) C(orneille) (1898–1972), Dutch graphic artist. He is well known for prints making sophisticated use of visual illusion, exploiting, for example, the ambiguity between flat pattern and apparent three-dimensional recession. From the 1940s his work took on a *Surrealist flavour as he made brilliant play with optical illusion to represent, for example, staircases that appear to lead both up and down in the same direction.

essay, a short, written composition in prose, which discusses a subject or proposes an argument without claiming to be a complete or thorough exposition. A minor literary form, the essay is more relaxed than the formal academic dissertation. The term ('trying out') was coined by *Montaigne in the title of his *Essais* (1580), the first modern example of the form. Bacon's *Essays* (1597) began the tradition of essays in English, of which important examples are those of Addison, Steele, Lamb, Hazlitt, Emerson, Lawrence, Virginia Woolf, and Orwell. The verse essays of Pope are rare exceptions to the prose norm.

etching, a term applied to a method of *engraving in which the design is bitten into the plate with acid, and also to a print produced from such a plate. The design is drawn on a metal (usually copper) plate that has been coated with a waxy, acid-resistant substance. Where the waxy coating is scratched through with the etching needle the bare metal is exposed, and when the plate is placed in a bath of acid the acid bites only the lines so exposed. It is possible to achieve subtle variations of tone by 'stopping out' part of the design (covering it with a protective varnish). Etching was developed in the early 16th century and reached exalted heights in the hands of Rembrandt. It is still a popular technique.

Etruscan art, the art and architecture of the Etruscans, an ancient people of unknown origin living in central Italy (Etruria corresponds roughly with present-day Tuscany). Etruscan art may be divided into three periods: during the first (*c.*750–*c.*600 BC), the Etruscans looked chiefly for

Etching is the most personal of the techniques for producing prints from a metal plate, for the artist can scratch through the waxy covering of the plate almost as easily as if he were drawing on paper. It thus encourages spontaneity and atmospheric effects. Samuel Palmer, whose *Opening the Fold* is shown here, was one of the outstanding etchers of the 19th century, using the technique to create some of the most poetic landscapes in British art. (British Museum, London)

This bronze sculpture of the Chimera (*c.*350 BC), a mythological fire-breathing monster, is the most noted masterpiece of **Etruscan art**. Taut and lean, the magnificent snarling beast shows Etruscan skill with bronze at its finest. Originally it was perhaps part of a group with a figure of Bellerophon, who slew the monster with the aid of the winged horse Pegasus. The sculpture was discovered in 1553 and the snake's tail was restored by Benvenuto Cellini. (Museo Archeologico, Florence)

their models to western Asia, for Greece had not as yet much to offer them; during the second (*c.*600–*c.*400 BC) they fell under the influence of *Greek art; during the third (*c.*450–*c.*100 BC) their art gradually declined until finally it was swallowed up in *Roman art. The chief products of the first period were bronze pails, jugs, and jars, which were engraved and often decorated with figures of men and animals which had been made separately and then fastened on; gold jewellery in the form of ear-rings, clasps, and necklaces, decorated with granulation (minute dots of gold); and a characteristic grey-black pottery called 'bucchero'. Vast numbers of Greek vases from Corinth, Athens, and elsewhere have been discovered in tombs of the second period, and it seems likely that Greek artists came to Etruria to work.

In addition to the products of the previous period, the Etruscans made statues and statuettes of bronze and also of clay. At this time no good stone was known to them, and in general they used bronze and clay where the Greeks used marble. They executed a certain amount of sculpture, however, in coarse stone. Their temples were much like the Greek temples, but instead of having a surrounding colonnade, they had only a deep porch in front and plain walls at the sides and back. They were made of wood and faced with clay. Clay was also used for making ornamental coffins. Important families frequently had elaborate tombs, the usual form being a communal burial-chamber covered by a large mound. The walls were decorated with paintings, which showed the influence of Greek art. Numerous arts, among them painting, metalwork, and the cutting of seal stones, flourished in the third period.

euphonium, a wide-bore, low-pitched, valved *brass instrument related to the tuba, pitched in 9-foot B♭, a principal melody instrument in the *brass band. In Britain there is a firm distinction between the narrow-bore baritone, the lowest of the cornet family, and the wide-bore euphonium, but elsewhere, especially in the USA, the two terms are almost interchangeable. Orchestrally the euphonium is sometimes indicated as the tenor *tuba, and it makes a good substitute for the small French tuba in C, and also for the 19th-century *ophicléide, for both of which a bass tuba has too heavy a sound. Like the tuba, it is ultimately descended from the *bugle.

Euripides (*c*.485–*c*.406 BC), Greek writer of *tragedies. He wrote plays from 455 BC onwards, producing eighty or ninety in all; nineteen are preserved more or less complete, together with numerous fragments. He was influenced by the sophists of his time, who taught the

A scene from a lost tragedy by **Euripides** is shown on this Greek vase (350–325 BC). Alcemene, *centre*, is shown being sacrificed on the pyre by her jealous husband Amphitryon. His plays have provided a rich ore for later writers, among them Dryden, Molière, and, in this century, Giraudoux. (British Museum, London)

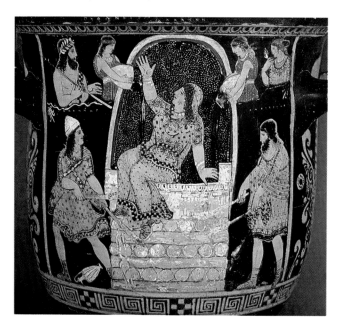

new art of *rhetoric and helped to cast doubt on traditional beliefs: his plays regularly aim to disconcert, especially by bringing discredit on the gods of mythology, and are marked by strong arguments between opposed characters. The criticism found in the satirical play *Frogs* by *Aristophanes that Euripides degraded tragedy by bringing it nearer to the level of ordinary life points to one of his strengths, while Aristophanes' complaint of his misogyny is a conscious misunderstanding of a playwright fascinated by and sympathetic to strong emotion in women. Euripides' characters speak a less elevated language than those of *Aeschylus or even *Sophocles, while his *choruses, however lyrical and musically innovative, are less integral to the plot of many of his plays. The tragedies are extremely varied in theme and tone: *Medea*, portraying a passionate woman who kills her children to spite her errant husband; *Hippolytus*, where Phaedra dies for love of her stepson and brings about his death; and *Bacchae*, a striking portrayal of the arrival of the cult of Dionysus in Greece, are among the most admired.

Evelyn, John (1620–1706), English diarist and man of letters. He was with Robert Boyle a founder-member of the Royal Society (1662) and a man of wide interests which extended from landscape gardening to numismatics, art, and architecture. He is principally celebrated for his *Memoirs* or *Diary*, first published in 1818, which gives an invaluable account of the social, political, and religious life of 17th-century England.

exegesis, the interpretation or explanation of a text. The term is usually applied to the interpretation of religious scriptures (or oracles and visions), but has been borrowed by *literary criticism for the analysis of any poetry or prose. Literary scholars have likewise inherited some of the procedures of biblical exegesis, for instance the decoding of *allegories.

Expressionism, a term used to denote the use of distortion and exaggeration for emotional effect, chiefly associated with the visual arts. In its broadest sense it can be used of any art that raises subjective feeling above objective observation, reflecting the state of mind of the artist rather than images that conform to what we see in the external world. The paintings of the 16th-century artists *Grünewald and El *Greco, who conveyed intense religious emotion through distorted, unnaturalistic forms, are outstanding examples of expressionism in this sense (when used in this way the word is usually spelt with a small 'e'). In a narrower sense, the word Expressionism is applied to a broad trend in modern European art that traces its origin to van *Gogh, who used colour and line emotionally 'to express . . . man's terrible passions'. Among the great artists who represent this type of Expressionism are the Belgian *Ensor and the Norwegian *Munch. In its narrowest sense, the term Expressionism is applied to one aspect of the trend just described—a movement that was the dominant force in German art from about 1905 to about 1930, led by the *Brücke and *Blaue Reiter groups. Expressionism represented a rebellion against the naturalism of 19th-century art, and its insistence on the supreme importance of the artist's personal feelings has been one of the foundations of aesthetic attitudes in the 20th century. Representatives of other art-forms in whose work elements of Expressionism are found include the early works of *Berg

Jan Van **Eyck**'s *The Madonna with Chancellor Rolin* (*c*.1435). (Louvre, Paris)

and *Schoenberg in music, and *Dostoyevsky and *Kafka in fiction. In drama, **Expressionism** was a movement that began in Germany in about 1910, and is best typified in the theatre by the plays of Georg *Kaiser and Ernst *Toller. The Expressionist theatre was a theatre of protest, mainly against the contemporary social order. Most of its dramatists were poets who used the theatre to further their ideas. One of the few dramatists outside Germany to be influenced by Expressionist drama was Eugene *O'Neill, particularly in *The Emperor Jones* (1920) and *The Hairy Ape* (1922).

Eyck, Jan Van (d. 1441), *Flemish painter. He was long credited with being the inventor of *oil painting, and although this idea has been discarded, he did bring the technique to a sudden peak of mastery, and ranks as one of the most influential figures in European art. Jan was court painter to Philip the Good, Duke of Burgundy, from 1425 until his death, and travelled on secret diplomatic missions to Spain and Portugal for his master. Jan's contribution to the central masterpiece of early Netherlandish painting, the great altarpiece of *The Adoration of the Lamb* (completed 1432) in Ghent Cathedral, is uncertain. An inscription on the frame says it was begun by Hubert van Eyck and completed by Jan, but Jan's brother **Hubert** (d. *c*.1426) is such an obscure figure that some scholars have denied that he ever existed. The same glowing effects of colour and jewel-like perfection of detail that it displays are, however, also seen in the paintings that are undoubtedly entirely from Jan's hand, such as the celebrated double portrait *Giovanni Arnolfini and his Wife* (1434). Jan's technique became the accepted model in the Netherlands and rapidly spread elsewhere; within a short time of his death he was famous in Italy as well as in northern Europe.

F

Fabergé, Peter Carl (1846–1920), Russian goldsmith and jeweller of Huguenot descent. Under his management the family business became the most fashionable jewellery house in Europe, a position it held until World War I. Fabergé specialized in precious and semi-precious materials such as gold, silver, lapis lazuli, malachite, jade, and gems which he rendered into masterpieces of flower arrangement, figure groups, animals, and above all the celebrated Easter eggs, opening up to reveal a further present inside, that the emperors Alexander III and Nicholas II gave annually to royal relatives. After the Russian Revolution of 1917 the company was nationalized, and Fabergé died in exile in Switzerland.

fable, a brief tale in verse or prose which conveys a moral lesson, usually by giving human speech and manners to animals and inanimate things. Fables often conclude with a moral, delivered in the form of an *epigram. A very old form of story related to folklore and *proverbs, the fable in Europe descends from tales attributed to Aesop in the 6th century BC. An Indian collection, the *Bidpai*, dates back to about AD 300. La Fontaine revived the form in 17th-century France with his witty verse adaptations of Greek fables; he was followed by Gay in England and Ivan Krylov (1768–1844) in Russia. More recent examples are Kipling's *Just So Stories* (1902), Thurber's *Fables of Our Time* (1940), and Orwell's *Animal Farm* (1945).

Fabritius, Carel (1622–54), Dutch painter. He was *Rembrandt's most gifted pupil and a painter of outstanding originality and distinction, but he died tragically young and only about a dozen works by him are known. His early works were strongly influenced by Rembrandt, but he created his own style marked by cool colour harmonies, which influenced *Vermeer, the greatest of Delft painters. His brother **Barent Fabritius** (1624–73) was also a painter, but of much lesser quality.

facet-cutting *jewellery.

Fachang *Muqi (Fachang).

faïence *maiolica.

Falla (y Matheu), Manuel de (1876–1946), Spanish composer who migrated to Argentina in 1939. Until he came under the influence of the composer and musical scholar Felipe Pedrell in 1902, he was largely self-taught as a composer. Pedrell's enthusiasm for Spanish folksong and masterpieces from the past liberated Falla's own individuality, which soon expressed itself in an opera, *The Short Life* (1905). A period in Paris (1907–15) brought the influence of *Debussy's *Impressionism, evident in the suite for piano and orchestra, *Nights in the Gardens of Spain* (1915), and the ballets he wrote for *Diaghilev (*Love, the Magician*, 1915, and *The Three-Cornered Hat*, 1919). Later works, such as the chamber opera *Master Peter's Puppet Show* (1922) adopted a leaner, *Neoclassical style.

famille rose, famille verte (French, 'pink family', 'green family'), terms applied to *porcelain manufactured in China during the 17th and 18th centuries and decorated in tin-glazed *enamel. Both types influenced European ceramic manufacture. In *famille verte* a translucent green enamel dominates, while the colours of *famille rose* are softer, more varied, and often mixed with white. The terms *famille jaune* and *famille noire* are applied to the less common wares of the same type in which yellow and black predominate respectively. *Famille noire* was probably a later (19th-century) type than the others. All of them were made mainly for export to Europe. The designs are usually made up of floral or animal motifs. (See also *Chinese ceramics, *glaze.)

fan, a hand-held device for producing a current of cooling air. Fans have been used since ancient times in many parts of the world, and have sometimes acquired a cultural role, in religious ceremonies for example, or as adjuncts to the dance. Ancient fans were sometimes mounted on poles carried by slaves, but the best-known type of fan is the small folding kind, which was developed in Japan (perhaps as early as the 7th century AD) and introduced to Europe by Portuguese traders in about 1500. In the West, it reached its peak of artistry in 18th-century France; the 'sticks' were made of materials such as ivory or silver, and the 'mounts' or 'leaves' were sometimes painted by distinguished artists. The fan went out of fashion after about 1900.

fantasia, in the 16th and 17th centuries the instrumental musical equivalent of the *motet. In Britain the term 'fancy' was used to describe adaptations of madrigals, popular tunes, and dances to instrumental music. In the 18th century it was a composition with the characteristics of an improvisation, while in the 19th century it was a short, descriptive mood-piece (as, for example, Schumann's *Fantasy Pieces*), or a selection of operatic tunes. In the early 20th century the term was revived as 'phantasy', to describe a loosely structured *chamber work, usually in one movement. In all these usages there is the implication of freedom from strict form.

Fantin-Latour, Henri (1836-1904), French painter and *lithographer. He is best remembered as one of the outstanding flower painters of his period, but he was also a successful portraitist. Although he was friendly with several of the leading progressive artists of the day, including Manet and Whistler, whom he depicted in group portraits, Fantin-Latour was himself thoroughly traditional in outlook and technique. In his later career his admiration for Richard Wagner led him towards imaginative compositions illustrating his music and that of other Romantic composers.

farandole, a popular dance of the Middle Ages in which the basic circle of the *carole was developed into various floor patterns. The line of linked dancers moved forward, travelling sideways or facing forwards. The leader determined the patterns, taking the line through streets and round houses, interspersing the travelling with special figures such as leading the line into a tight spiral and reversing the direction to unwind, and going through one or more arches made by the raised arms of the dancers. Many *folk dance forms involve similar linked lines of dancers.

farce, a kind of *comedy which inspires hilarity in its audience through an increasingly rapid and improbable series of ludicrous confusions, physical disasters, and sexual innuendoes among its stereotyped characters. Farcical episodes of buffoonery can be found in European drama of all periods since Aristophanes; but as a distinct form of full-length comedy, farce dates from the 19th century, with the works of Eugène Labiche in the 1850s, and of Pinero and Feydeau in the 1880s and 1890s. Brandon Thomas's *Charley's Aunt* (1892) is recognized as a classic of the genre. The 'bedroom farce', involving bungled adultery in rooms with too many doors, has had prolonged commercial success in London's theatres; Orton used its conventions to create a disturbing kind of *satire in *What the Butler Saw* (1969).

Farnaby, Giles (*c.*1563-1640), English composer. He published his *Canzonets to Fowre Voyces* in 1598. His canzonets are pleasing to sing, and include one remarkable experiment in chromatic writing in the famous puzzle-*madrigal 'Construe my meaning'. His vocal music is most attractive, as are his many keyboard pieces—which include *fantasias, *variations, and several 'character sketches', such as 'Tower Hill' and 'Giles Farnaby's Rest'.

Farquhar, George (*c.*1678-1707), English dramatist, born in Ireland. A major *Restoration dramatist, Farquhar began as an actor but after accidentally wounding a fellow player he turned to writing comedies. The greatest of these, *The Constant Couple* (1699), *The Recruiting Officer* (1706), and *The Beaux' Stratagem* (1707), are still regularly staged. They are filled with good humour and mark a transition between the licentiousness and mannerism of Restoration drama and the high tone of the 18th century.

Fatimid art, the art and architecture associated with the Muslim Fatimid dynasty that ruled over parts of North Africa, Egypt, and Syria from 909 to 1171; the name derives from the fact that the caliphs claimed descent from Fatima, Muhammad's daughter. Their capital was Cairo, which they founded in 969, and most of their major buildings are there, notably the Al Azhar Mosque (begun 970), which became the Muslim world's principal seat of learning, and the Al Hakim Mosque (990-1013), now ruined. Forms were generally traditional, but the wealth of the Fatimids meant they could afford the most lavish decoration: the famous painted wooden roof of the Cappella Palatina in Palermo in Sicily (*c.*1143), with its fantastic array of stalactites, is probably Fatimid work. Little remains of Fatimid wall-painting or illustrated books, but they were renowned workers in glass and crystal and in many other crafts.

Faulkner, William (Harrison) (originally Falkner) (1897-1962), US novelist and short-story writer. His first novel, *Soldiers' Pay* (1926), was followed first by *Mosquitoes* (1927) and *Sartoris* (1929), and then by the sequence of works for which he is best known: *The Sound and the Fury* (1929), *As I Lay Dying* (1930), *Sanctuary* (1931), *Light in August* (1932), and *Absalom, Absalom!* (1936). Frequently involving technical experiments such as the use of multiple, confusing narrators, these novels constitute a myth of a doomed South, evoked in an ornate and copious style. Later works of note are *Go Down, Moses* (1942), which includes the hunting tale 'The Bear', and the trilogy about the rise to power of the depraved Snopes

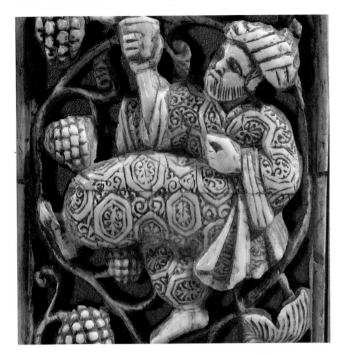

Fatimid ivories such as this detail of an 11th–12th-century panel from a piece of furniture typically show genre scenes such as wine-drinking or hunting. The depiction of grapes and a wine-drinker here is a good example of the religious–secular divide in Islamic society, for though proscribed in a religious context, figural representation and wine-drinking were sometimes shown in items meant for secular use. (Museum of Islamic Art, Berlin)

family, consisting of *The Hamlet* (1940), *The Town* (1957), and *The Mansion* (1960). Faulkner's greatest achievement was the creation of a semi-imaginary world, Yoknapatawpha County, Mississippi, the setting of most of his fiction; his confidence in the larger significance of regional subject-matter, and his structural boldness, served as a model for writers around the world. He was awarded the Nobel Prize for Literature in 1950.

Fauré, Gabriel (Urbain) (1845–1924), French composer and organist. Despite the subtlety of his melodies and the harmonic richness of his style, Fauré was essentially a conservative composer working in the established *Romantic tradition. He is properly regarded as one of the greatest of French song-writers, and is much admired for his chamber and piano music. He wrote an opera, *Pénélope* (1913), a Requiem (1877) of exceptional beauty, and several attractive orchestral works, including the Ballade for piano and orchestra (1881) and the suite *Masques et bergamasques* (1919).

Fauvism, style of painting based on the use of intensely vivid non-naturalistic colours, the first of the major avant-garde developments that changed the face of European art between the turn of the century and World War I. The name 'Fauves' (French, 'wild beasts') was given to the artists who painted in the style because of their uninhibited use of colour freed from its traditional descriptive role. Fauvism reached its peak in 1905–6, and with most of the group of artists involved, including *Derain and *Vlaminck, the style was a temporary phase; only the most important of them, *Matisse, continued to explore the beauty of pure colour. Although short-lived, Fauvism was highly influential, particularly on German *Expressionism.

featherwork, the use of feathers to decorate clothing, tools, and utensils. Featherwork has been practised in a wide area of the world extending from southern and eastern Asia through various Pacific islands to North and South America. It reached its highest development in Polynesia and in the pre-Columbian civilizations of Central America and the Andes. In Britain there was something of a vogue for featherwork panels depicting birds, which were used as wall hangings in the 18th and 19th centuries.

Federal style, a term applied to US architecture, furniture, and decorative arts from about the time of the establishment of the Federal Government in 1789 to about 1830. It is a chronological rather than a stylistic label, as there was no one style at this period, but a common theme running through it was the imitation of contemporary fashion in Britain. The designers associated with the term include the Scottish-born furniture designer Duncan Phyfe and the silversmith Paul Revere. In architecture, the period was marked by a *Neoclassicism looking to Roman rather than Greek inspiration.

Fellini, Federico (1921–), Italian film director. His first success, *The Loafers* (1953), about a group of bored young men in a small town, was—like several of his films—autobiographical. His next two films starred his wife, Giulietta Masina (1920–), and established them both on the international scene: in *The Road* (1954) she played an exploited, mentally retarded waif, and in *The Nights of Cabiria* (1957) a kind but unsuccessful prostitute. Fellini's greatest success was *The Sweet Life* (1960), a jaundiced look at Roman society, in which the main character represented Fellini himself. This was even more true of *8½* (1963), a complex blend of realism and fantasy which reflects the work of a film director. *Juliet of the Spirits* (1965), his first colour film, again featured his wife and was a psychoanalytical study of the character she portrayed; but in *Roma* (1972) and *Amarcord* (1974) he returned to personal experience. More recent films of note are *Casanova* (1976) and *Ginger and Fred* (1986).

Fénelon, François de Salignac de la Mothe- (1651–1715), French theologian and man of letters. He was appointed Archbishop of Cambrai and tutor to the grandson of Louis XIV in 1689. He fell from favour in 1699 when he came under the influence of the unorthodox theological doctrine of Quietism (the condemnation of all human effort) and, in the same year, published a prose romance called *Télémaque*. The book, written in an elegant, poetic style, recounts the imaginary adventures of Telemachus, son of Ulysses, and contains passages of implied criticism of Louis XIV.

Fenton, Roger *war photography.

Ferrabosco, Alfonso, father (1543–88), and son (*c*.1578–1628), Italian-born composers who spent much of their working lives in England. A highly competent composer, both of Latin church music and of Italian madrigals, Alfonso the father revealed a sound knowledge of *counterpoint and an appreciation of chromaticism.

His son served the English court throughout his career, becoming composer to King Charles I in 1626. He was admired as a composer of church music, but his finest work is found in his music for viols, especially the imaginative fantasias and *In nomine* settings in which each performer was expected to show his skill in fast-moving scale passages, broken chords, and the like. With Ben Jonson and Inigo Jones he created lavish court *masques.

Ferrier, Kathleen (Mary) (1912–53), English contralto singer. After her 1943 London début in *Messiah*, Ferrier rose rapidly to a leading position among British concert singers. Whilst Lucretia in Britten's *The Rape of Lucretia* and the title role in Gluck's *Orfeo* were her only operatic roles, the part of the Angel in Elgar's *Gerontius* was perfectly suited to the warmth and expressiveness of her voice.

Feydeau, Georges (1862–1921), French dramatist. He wrote uproariously funny *vaudevilles and *farces, among them *Occupe-toi d'Amélie* (1908) and *Feu la mère de Madame* (1908), which were revived in France some twenty years after his death and are now popular throughout the world.

fiddle, any bowed stringed musical instrument, but more frequently used of folk instruments. The medieval fiddle was large, held either on the shoulder or downwards, often with five strings running over the fingerboard plus two *drone strings to one side. To the *trouvères* (see *minstrel) of the 13th century it was their most important musical instrument. Fiddles vary widely over the world, the simplest (a 'spike-fiddle') having a gourd or bamboo tube resonator (today often a tin or plastic container), spiked through with a neck, to each end of which one or more strings are attached. An example of this is the Chinese *huqin*. Equally strongly constructed fiddles, such as the *sāraṅgī, are carved from a single block of wood. A one-stringed fiddle of Yugoslavia is known as the *gusle*. The more fragile construction of a resonator to which a neck is attached, like the *violin, presupposes a more advanced technology.

Field, John (1782–1837), Irish composer and piano virtuoso, remembered as the inventor of the piano *nocturne, of which he published nineteen between 1812 and 1836. After travelling in Europe with *Clementi, he settled (1803) as a fashionable pianist and teacher in St Petersburg, and later (1821) in Moscow. Field invented a refined, smooth style of playing, as evidenced in his seven piano concertos and numerous piano pieces, in which he dispensed with the supporting string quartets. His work greatly influenced later composers such as *Chopin.

Fielding, Henry (1707–54), British novelist and dramatist. He wrote mainly *satire and *farce, including *Tom Thumb* (1730), a *burlesque ridiculing the grandiose tragedies of the day, and a fierce political satire, *The Historical Register for 1736* (1737), which resulted in the introduction of censorship on the stage and the end of Fielding's career in the theatre. In the preface to his first novel, *Joseph Andrews* (1742), he mocked his rival *Richardson's sentimental novel *Pamela*. His greatest novel, *Tom Jones* (1749), traced the adventures of its high-spirited hero. In Fielding's last novel, *Amelia* (1751),

he used the story of a young wife's love for her inconstant husband to expose numerous social evils of his day. A writer of considerable originality, Fielding devised what he described as 'comic epics in prose', which are in effect the first modern *novels in English. He also wrote several influential legal enquiries and pamphlets, including a proposal for the abolition of hanging, and helped to establish the Bow Street Runners (predecessors of the London police).

figure of speech, an expression which departs from the accepted literal sense or from the usual order of words, or in which an uncommon emphasis is made through sound. Figurative language is a major characteristic of *poetry, and is ever-present (although usually unnoticed) in all other kinds of speech or writing. The ancient theory of *rhetoric named and categorized dozens of such figures, drawing a rough distinction between those (known as 'tropes') which extend the meaning of words, and those which merely affect their order or their impact upon an audience. The most important trope is *metaphor, in which the name of one thing is used to indicate something else resembling it; in *simile, this resemblance is drawn explicitly. Another trope, metonymy, refers to one thing by naming another thing associated with it (like 'the bench' for the judiciary); one of its forms, synecdoche, names a part to mean a whole ('per head', meaning per person) or a whole to mean a part ('Liverpool', meaning one of its football teams). Other important tropes are *irony, overstatement (*'hyperbole'), understatement ('litotes'), and euphemism or circumlocution ('periphrasis'). The minor varieties or 'rhetorical figures' can emphasize a point by placing words in contrast with one another ('antithesis'), or by repeating words in various patterns, changing the order of words ('hyperbaton'), missing out conjunctions ('asyndeton'), or breaking off in mid-sentence ('aposiopesis'); or they can stress the sounds of words, as in *alliteration and punning.

filigree, openwork decoration made of very fine wires and tiny balls of metal soldered into a design. The metal is usually gold or silver, but bronze and other metals have also been used. Filigree has been used in jewellery since Greek and Roman times and has also been employed in a wide variety of small decorative objects.

film. Motion pictures as a form of dramatic art began as sideshows at fairgrounds or as items in music-hall programmes. They were all short and silent, and included slapstick comedy, trick pictures, short romances, and five-minute dramas. Between 1900 and 1914 the length of a performance increased from a few minutes to two hours, and after World War I *Hollywood in California became the chief centre of production. Sound films evolved in the late 1920s and Technicolor in the 1930s. Among the pioneering geniuses of film-making are *Eisenstein and the Germans von *Sternberg, *Lang, and *Murnau, whose development of *Expressionism in the cinema paralleled its evolution in art and drama. In France the films of Jean Vigo (1905–34) introduced a form of *surrealist lyricism. In the USA *Welles created new heights of cinematic drama with *Citizen Kane* (1941), while *Kazan directed some of the great classics of the cinema. In France the *Nouvelle Vague directors evolved an intimate and influential cinema style in the 1960s, while the technical innovations of the *cinéma vérité

allowed inexpensive but notable film productions to be made. In Britain the *Free Cinema group were concerned to bring realism to the feature film. Among internationally acclaimed post-war directors are *Kurosawa, whose works often draw on elements of the Kabuki and samurai traditions, *Bergman, *Buñuel, *Hitchcock, *Tarkovsky, *Truffaut, *Rossellini, *Herzog, and Rainer Werner Fassbinder (1946–82).

film music, music that plays a legitimate part in the action of a film, mainly used as a means of supplying additional emotional or physical atmosphere. In the days of silent films, performances were accompanied by the piano, the music being improvised on the spot or selected in advance from a library of suitable pieces. Larger cinemas employed orchestras, and the more elaborate films came with an appropriate score selected by the film company. Although Saint-Saëns wrote special music for the film *L'Assassinat du Duc de Guise* in 1908, the practice of commissioning film scores arose in the mid-1920s and soon attracted the skills and attention of major composers. Among the many important composers who have written major film scores are Prokofiev, Shostakovich, Vaughan Williams, Walton, Korngold, Bernstein, and Copland. (See also *incidental music.)

fin-de-siècle (French, 'end-of-century'), a phrase often used to refer to the world-weary mood of the arts in Europe in the 1880s and 1890s, when writers and artists like *Wilde, *Beardsley, and the French *Symbolists, under the slogan 'art for art's sake', adopted a 'decadent' rejection of any social or moral function for art. Reacting against *realism and *naturalism, they sought a 'pure' beauty removed from nature and contemporary society.

Finnish literature, literature written in the Finnish and Swedish languages in Finland. Its oldest form, folk poetry in Finnish, was transmitted orally until it was written down in the 18th century. Under Swedish rule (from the mid-12th century to 1809) Swedish remained the language of the educated classes; virtually the only transcribed literature in Finnish was the Bible (1642) and other religious writings. In 1835 the scholar Elias Lönnrot published the *Kalevala* (final form, 1849), a collection of Finnish myths and folk poetry with connective passages of his own that introduced a unifying plot. The poet Johan Ludvig Runeberg (1804–77) wrote in Swedish, evoking the peasant life and character of Finland. With Aleksis Kivi (1834–72) a genuine Finnish literature came into being. His play *The Village Cobblers* (1860) and novel *Seven Brothers* (1870) depict the Finnish people with realism and humour. The rise of nationalism in the mid-19th century and independence from Russia in 1917 led to the founding of the Finnish National Theatre (1872) and a new cultural consciousness. Frans Eemil Sillanpää (1888–1964) saw his characters as integrally fused with their surroundings; he won international acclaim with his novel *Fallen Asleep While Young* (1931) and was awarded the Nobel Prize for Literature in 1939. Väinö Linna (1920–) achieved widespread fame with his war novel *The Unknown Soldier* (1954) and reinforced his reputation with *Under the Northern Star* (1959–62), a long novel of social criticism set against the Finnish Civil War (1918). The most outstanding Finnish poets of this century have written in Swedish: perhaps the best of those writing in Finnish is Paavo Haavikko (1931–).

Finzi, Gerald (Raphael) (1901–56), British composer. His *Dies natalis* for tenor and strings (1939) attracted attention, as did the collections of songs that emerged thereafter—particularly the settings of the poetry of Thomas Hardy. His ear for the music of words was so acute that he was able, at his best, to create within the orbit of pure melody and musical inflexion, a result akin to stylized reading aloud. His few larger works include a clarinet (1949) and a cello (1956) concerto.

Firdausī, Abū al-Qāsim (c.940–c.1020), Persian poet. His most noted work is his *epic poem the *Shāhnāmah* or Book of Kings. Basing himself on earlier accounts of Persian history, Firdausī worked for thirty-five years to describe in poetry the whole sweep of Iranian history. A poem of nearly 60,000 *couplets, it was completed in 1010 and was presented to the celebrated sultan Mahmūd of Ghazna, who gave Firdausī a pittance for his work. One episode from this epic inspired the poem of Matthew Arnold, 'Sohrab and Rustum' (1853).

Fischer-Dieskau, Dietrich (1925–), German baritone singer. Although his career is rich and varied, from his concert and operatic débuts in the late 1940s, at

This 15th-century Persian miniature illustrates an episode from **Firdausī**'s *Book of Kings*. Kay Ka'us is shown in a flying-machine drawn by four eagles in his arrogant and ill-fated attempt to control the cosmos. (British Museum, London)

Bayreuth (1954–6), and involvement in first performances of works by Henze and Britten, he is an outstanding interpreter of *Lieder*. His huge repertoire (including the complete songs of Schubert, Schumann, and Wolf), and vocal control and balance are exemplary.

Fischer von Erlach, Johann Bernhard (1656–1723), the greatest Austrian architect of his period. He worked mainly in Vienna, where he settled in 1685 after spending about 15 years in Italy. Fischer's work inaugurated the Austrian *Baroque style. He was much influenced by *Borromini and other Italian Baroque architects, but his work has an aristocratic, intellectual quality that is his own. His most famous building is the Karlskirche in Vienna (begun in 1716), an extraordinarily original design with a façade featuring a pair of giant replicas of Trajan's Column in Rome. He had scholarly inclinations, and in 1721 published the first illustrated history of architecture, *Outline of Historical Architecture*.

Fitzgerald, Edward (1809–83), British translator and scholar. His fame rests on his paraphrase of a poem by the 11th-century Persian poet 'Omar *Khayyām, *The Rubā́yāt of 'Omar Khayyām* (published anonymously in 1859), preserving its original *stanza form but adapting the *quatrains into a linked theme; the work contains some of the most quoted lines in English poetry.

Fitzgerald, F(rancis) Scott (Key) (1896–1940), US novelist and short-story writer. His novel *This Side of Paradise* (1920) led him to be hailed as the voice of the young generation of the 'Jazz Age', a reputation re-inforced by *The Beautiful and Damned* (1922) and numerous magazine stories. *The Great Gatsby* (1925), his finest novel,

is a sensitive and symbolic interpretation of themes of contemporary life related with irony and pathos to the legend of the American dream. An extended period abroad with his wife Zelda (1899–1948), herself a minor writer, resulted in *Tender is the Night* (1934), a novel seeking to analyse the psychological and spiritual malaise of modern life. His troubled final years were spent in Hollywood, where he was employed as a screenwriter. *The Last Tycoon* (1941), a novel portraying a movie mogul and his industry, was left unfinished at his death.

Five, the, a group of 19th-century Russian composers, who shared the common ideal of creating a distinctively nationalist school of composition. The mentor of the group was Mily Balakirev (1837–1910), who was deeply influenced by Russian folk-song, which he combined with the romantic idiom of his European contemporaries. The other members of the group were *Borodin, César Cui (1835–1918), *Musorgsky, and *Rimsky-Korsakov, though *Glinka also upheld the nationalist cause.

five positions, the five basic positions of the feet in classical *ballet, all of which place the body in perfect equilibrium. In each the legs are turned out from the hip. In first position the heels touch and the feet form an angle of 180 degrees; in second the heels are apart, again with the feet in a straight line; in third the heel of one foot is placed against the instep of the other; in fourth the feet are apart with one in front of the other, either opposite first (*ouverte*) or opposite fifth (*croisée*); in fifth the heel of one foot is placed against the big toe joint of the other. All have corresponding positions of the arms.

flageolet, a musical instrument, a small whistle *flute, blown through a duct. There are two main varieties, the French and the English. The French was invented in about 1580 with four finger- and two thumb-holes, and remained a professional's instrument into this century. The English, essentially an amateur's instrument with six finger-holes, is the precursor of the tin or penny whistle, and a descendant of prehistoric and folk *duct flutes. It was greatly elaborated in the early 19th century, with double and even triple flageolets being produced.

Flagstad, Kirsten (Malfrid) (1895–1962), Norwegian soprano singer. Although virtually unknown outside Scandinavia before 1932, reviews of her Isolde in Wagner's *Tristan and Isolde* in Oslo led to her engagement at Bayreuth (1933). After débuts in New York (1935) as Sieglinde in Wagner's *The Valkyrie*, and London (1936) as Isolde, her standing as an exponent of Wagner's great female roles was unchallenged until her retirement in 1953.

Flamboyant style, the final phase of French *Gothic architecture, so called because its most distinctive feature is elaborate *tracery made up of flowing, flame-like shapes (French *flamboyant*, 'flaming'). The style began in about 1370, was almost ubiquitous in France by the mid-15th century, and gradually gave way to the *Renaissance style in the early 16th century. It encouraged virtuoso effects of stonework, to the extent that decoration sometimes obscures structure, and to many critics it marks a great decline from the earlier phases of French Gothic. Few churches are built entirely in the Flamboyant style; rather it is found mainly in additions to existing struc-

F. Scott **Fitzgerald**, shown here with his wife Zelda, lived out the same type of life that he described in his novels, with glamour, fame, and success being his ruling passions, and he became a symbol of the affluent hedonism of the Roaring Twenties. His excesses burnt him out, however, and his early death from heart-attack was hastened by chronic alcoholism. (Princeton University Library)

The *Fall of Icarus* (*c*.1550) by Pieter Bruegel the Elder, the greatest figure in **Flemish art** in the 16th century. Icarus was a character in Greek mythology who flew with artificial wings made by his father, the inventor Daedalus. The sun melted the wax on his wings when he soared too high and he fell into the sea and drowned. Icarus is only a tiny detail in this picture, which illustrates the Flemish proverb 'Not a plough stands still when a man dies'. (Musées Royaux des Beaux-Arts, Brussels)

tures—façades, towers, etc. Secular buildings were becoming more important at this time, however, and the Flamboyant style can also be seen in civic buildings.

flamenco, a dance indigenous to southern Spain. It originates from the classic Moorish dance (itself influenced by dance from northern India) and from the dance and music of Spanish gypsies. These probably combined in the 15th century, when both Moors and gypsies took refuge from the Christians, and produced a dance of forceful rhythmic footwork and sinuous arm movements. During the 19th century it became a recognized art, with the dance inextricably connected to handclapping, song, and guitar-playing. Improvisation is stressed and there are two main styles, the serious *jondo*, and the light, sometimes humorous *chico*.

Flaubert, Gustave (1821–80), French novelist. His first major novel, *Madame Bovary* (1857), is a portrait of a young woman who cannot come to terms with the limitations of provincial life. Following publication, Flaubert was prosecuted for offences against public morality, but acquitted. *L'Éducation sentimentale* (1869) is an account of a platonic relationship between a young man and an older woman which mirrors his own relationship with Mme Schlésinger. Flaubert rejected the *Romanticism by which he had been influenced in his early years, believing that it distorted reality by an excessive lyricism. He sought instead a more exact portrayal of reality and took great pains in establishing the documentary background to his novels. However, although his novels are often seen as examples of *realism, he was unwilling to associate himself closely with the literary doctrines of

the *Goncourt brothers. His aim was rather to achieve the stylistic detachment characteristic of his major novels and the tales included in *Trois Contes* (1877), and to this end he set himself very high standards, working painfully slowly. Nevertheless his passion, his contempt for the stupidity of the bourgeoisie, as well as the love of the exotic found in two of his other novels, *Salammbô* (1862) and *La Tentation de Saint Antoine* (1874), are continuing signs of a fundamentally Romantic temperament.

Flaxman, John (1755–1826), British sculptor, draughtsman, and designer, one of the leading figures of the *Neoclassical movement. His sculpture includes some large groups with standing figures, but his best work is found in simpler and smaller church monuments, sometimes cut in low relief.

Flemish art, a term applied to the art of the area of Europe corresponding with present-day Belgium and at times to certain other adjoining regions. In the period before the northern Netherlands (present-day Holland) separated from the southern Netherlands (Flanders or Belgium) the north was culturally a satellite of the south, so in the field of 15th- and 16th-century art the terms Flemish and Netherlandish are often used interchangeably. Earlier, Flanders had been ruled by Burgundy, so there is also an overlap between the terms 'Flemish art' and *'Burgundian art'. The history of Flemish art is dominated by painting, which arose from a 14th-century tradition of manuscript illumination. The founding figure of the school of painting, Jan van *Eyck, combined the delicately detailed technique of the miniaturist with a new, searching naturalism; he was the most important pioneer of *oil painting as we now understand it, achieving unprecedented richness of colour and texture, and his technique became a model for Flemish painters into the next century. His successors included Rogier van der *Weyden, who worked mainly in Brussels, and Hans *Memlinc, who worked mainly in Bruges. Standing somewhat apart from the main tradition was Hieronymus *Bosch, the greatest Flemish painter at the turn of the 16th century. In general the Flemish painters of the

16th century did not match the achievements of their 15th-century predecessors, but the great genius of the period, Pieter *Bruegel the Elder, influenced his countrymen well into the 17th century with his brilliantly observed scenes of everyday life. The 17th century saw Flemish art invigorated by the genius of Rubens, who had wide influence. Other outstanding painters of the period were van *Dyck, Jacob *Jordaens, Jan *Brueghel, and David *Teniers the Younger. After the 17th century Flemish art played a fairly minor role in a European context, but there have been isolated modern artists of importance, for example James *Ensor and René *Magritte.

Fletcher, John *Beaumont, Sir Francis.

Floating World (Japanese, *ukiyo-e*), Japanese term to describe the art and literature produced under the influence of the pleasure quarters of cities in Japan during the Tokugawa or Edo period (1603–1867). A rapidly expanding commercial economy enabled rich townsmen to pursue transient sensual pleasure and short-lived fashion where Confucian morality did not intrude. The period is best known for the bright woodblock prints of actors and courtesans, *ukiyo-e*, but also produced writers like *Ihara Saikaku and *Matsuo Bashō.

Florentine art. In the period from the early 14th to the early 16th century, Florence was artistically the most important and innovative centre in Europe. This period coincided with the time of Florence's greatest prosperity (based mainly on banking and the textile trade), and of its greatest pride as an independent city-state. For much of this period the Medici family was a dominant force, and

the great works they commissioned are still everywhere to be seen in the city. Florence was founded in Roman times, however, and has important works from earlier times, notably the baptistery of the cathedral (of uncertain date, but perhaps as early as the 5th century) and the 11th–12th-century *Romanesque church of San Miniato al Monte, famous for its geometrically patterned marble façade. Although Florentine art is highly varied, it is associated particularly with certain qualities, notably clarity of form and intellectual rigour. These were expressed through an emphasis on the importance of draughtsmanship and a scientific concern with the problems of representing three dimensions on a two-dimensional surface. The first great figure in Florentine painting was *Giotto, regarded as the founder of the central tradition of European painting. A century later, in the early 15th century, his innovations were refined by *Masaccio, the first painter to master *perspective. This had been devised by his friend *Brunelleschi, famous above all as the architect of the dome of Florence Cathedral. With another friend, the sculptor *Donatello, Masaccio and Brunelleschi formed an unrivalled grouping of artistic genius, and this set the tone for the rest of the 15th century, during which Florence produced many great artists, including some of the most illustrious names in the history of art—Fra *Angelico, *Botticelli, *Leonardo da Vinci, *Michelangelo. Great artists from elsewhere in Italy, notably *Raphael, also spent significant parts of their careers in the city. By the early 16th century, however, Florence was being rivalled in importance as an artistic centre by Rome and Venice. Great and influential artists continued to work there (for example *Giambologna, the leading sculptor in Europe in the late 16th century), but it never again achieved unquestioned dominance. By the 17th century Florence was more a receiver than a giver of artistic ideas, and imported artists were responsible for some of the best work, notably Pietro da *Cortona in his sumptuous decorations in the Pitti Palace. The decline was complete by the 18th century.

flugelhorn, a valved *bugle used in *brass bands. It is pitched in B♭, like the cornet and trumpet, but has the wide bore of the bugle and thus a broad and rich tone

The Rout of San Romano by Paolo Uccello (*c.*1455) is one of a series of three large panels he painted for the Medici Palace in Florence representing a victory of Florentines over the Sienese in 1432. It shows the patriotic spirit characteristic of **Florentine art**, as well as its splendour. The figure in the elaborate headgear on the white charger is Niccolò da Tolentino, the Florentine commander. (National Gallery, London)

quality. On the continent of Europe it is also used in military bands, with both tenor and soprano sizes in E♭. It makes occasional appearances in the orchestra. It was developed before 1840 by fitting valves to the key bugle instead of the keys, and it was said to be the inspiration for Adolphe Sax's family of *saxhorns.

flute, a musical instrument sounded by blowing across a hole in a tube or *vessel. Some are blown across the end of the tube (see *end flute), others into a *notch or via a *duct. The Western orchestral flute is the transverse or side-blown flute. This is of great age in India and has also a long history in China, where a membrane, covering an extra hole, adds a buzz to the sound. In Japan it is a leading instrument in the No theatre. Elsewhere transverse flutes are comparatively rare outside Europe. They came into Europe through Byzantium in the 10th century. The one-piece flute with six finger-holes was used throughout the Middle Ages and Renaissance, especially by soldiers. A key, for the lowest chromatic note d♯, was added in the late 17th century, and further keys in the late 18th century. Flutes were then made in four pieces or joints and the lowest note was extended from d′ to c′. The flute was brought to its modern form by Theobald Boehm, with two designs in 1832 and 1847: the latter is today's orchestral flute.

Fo, Dario (1926–), Italian playwright, director, and actor. Fo and his wife, the actress Franca Rame, founded the Campagnia Dario Fo–Franca Rame in 1959 to perform their left-wing, anti-establishment theatre, which has its roots in the *commedia dell'arte*. In 1970 Fo and Rame set up the Collettivo Teatrale La Commune which toured factories and other public places. Particularly well known among Fo's plays are *Accidental Death of an Anarchist* (1974) and *We can't pay? We won't pay!* (1974).

Fogazzaro, Antonio (1842–1911), Italian novelist. His works explore conflicts between reason and faith in the light of a liberal Catholicism. His finest novel, *The Little World of the Past* (1896), the first of a tetralogy, describes the fortunes of a young couple caught up in the struggle by Italian patriots to free northern Italy from Austrian domination. It has considerable elements in common with *Manzoni's *The Betrothed*, both in the conflicts described and in the delicate portrayal of every character.

Fokine, Michel (1880–1942), Russian dancer and choreographer. He trained at the Imperial school, St Petersburg, and danced with the Maryinsky Company. He started choreographing in 1905 and made his first work for *Diaghilev's Ballets Russes in 1909 (*Les Sylphides*). This represents his romantic concerns, while *Petrushka* (1911) reveals his Russian sense of drama and characterization. *Shéhérazade* (1911) shows exotic, spectacular form. His theories for modern ballet are enshrined in a letter to *The Times*, 6 July 1914, arguing for a new form of movement for each work, the relationship of dance and mime to the dramatic situation, the use of the whole body, the expressiveness of the group, and the relationship of dance to the other arts as an equal. Fokine's influence on the development of ballet is seminal.

folk art, term describing objects and decorations made in a traditional fashion by craftsmen who have had no formal training and belong to a cultural group that is to

In this engraving after a drawing by Titian in the second half of the 16th century a trio plays on three **flutes**, apparently all at the same pitch. The Renaissance flute was cylindrical in bore, with six finger-holes and no key. The player with his back to us is playing left-handed; the others play right-handed, as all players do today. (Städelsches Kunstinstitut, Frankfurt)

some extent cut off from the artistic mainstream. The term embraces articles of daily use as well as those made for special occasions, such as weddings and funerals. Decorative woodcarving, embroidery, lace, basketwork, mural painting, and earthenware pottery are among the typical products of folk art. Its methods are handed down in the home from generation to generation, and traditional patterns and designs persist with little alteration. Although it may involve considerable manual skill, folk art is generally unsophisticated or even rough-hewn, often with bold colours. The qualities of freshness, spontaneity, and sincerity that the best folk art possesses have caused it to be admired and imitated by sophisticated artists (just as folk music has influenced art music), but attempts to revive or artificially reproduce folk art in the context of modern urban life are rarely successful.

folk dance, ceremonial, country, and step dances, distributed world-wide. Folk forms all over the world frequently have their roots in older fertility rites or work dances, and many of the sophisticated *Indian and *South-East Asian dance forms have emerged from religious ceremony. Among ceremonial dances the sword dance is common in Europe and also appears in India, Borneo, and other areas. Country dances and step dances such as the Irish and Scots jigs and reels were performed for social reasons. The intricate patterns woven with swords were adopted by trade guilds, who substituted their own implements for the weapons. Ritual dances such as the English Morris dance are widespread throughout Europe and extend to India, parts of Central and South

In this detail of an early 17th-century painting 'The Thames with Old Palace at Richmond', a **folk dance** involving a hobby-horse is being performed. The men wear the bell-pads below the knees typical of morris dancers. (Fitzwilliam Museum, Cambridge)

America, and the Middle East. A feature common to all is the animal-man, sometimes bearing deer antlers, masks, and bells fastened to the legs or body. Complex, fast, and rhythmic footwork typifies step forms. Country dances were collected by John Playford (1659) in England and other dancing-masters on the European continent. They consisted of long or circular sets traced with simple walking, running, or skipping steps repeated in a rich variation of the basic patterns. Rustic dances developed into formal court variants such as the *minuet, the quadrille, and the cotillon. In Britain, Cecil Sharp's work collecting folk music and dance steps in the early 20th century prompted a revival of interest, scholarship, and performance. In Scotland the elegance of the French court is reflected in the reel and, although the dances were primarily social and performed by many, interaction with the aristocracy provided a two-way exchange of dance forms. Similarly an interesting relationship emerges between 19th-century step dances performed in clogs, early 20th-century *music hall clog dances, and the later parody in *ballet, for example in *Ashton's *La Fille mal gardée*. This overlapping of styles, contexts, and forms is a recurrent feature of folk dance.

folk festivals (Western), seasonal celebrations connected with the activities of the agricultural year, particularly seed-time and harvest. They appear to have arisen spontaneously from the time of the first organized communities and vary considerably in form. Some consist merely of a processional dance, as in the Morris dance (see *folk dance). The New Year's Eve *Archetringle* at Laupen in Switzerland contains a mock combat between two bands of masked men, one side wearing ribbons and bells reminiscent of Morris dancers; there is more horseplay among the Bavarian Wild Men, who appear on St Nicholas's Day. A rudimentary form of drama is found in the *Mascarade* of the Soule region of south-west

France, which contains elements seen in the most elaborate form of folk festival, covering the life-cycle of birth, death, and resurrection, the *mummers' play. In Britain the simpler forms of folk festival were connected with Plough Monday; May Day; Midsummer Day, with its fires derived from the Celtic festival of Beltane; and Harvest Home, which celebrated the final gathering into barns of the year's grain harvest. Similar festivals are found world-wide. In Europe they survived the rise and fall of Greece and Rome and the coming of Christianity, although the Church, considering them an undesirable pagan survival, tried either to suppress them or to graft them on to its own festivals of Christmas, Easter, and local saints' days.

folk music, a term used widely in Europe, the Americas, India, and some other Asian cultures to distinguish music of rural areas or peasant traditions from art or 'cultivated' (urban) music. While precise definition is difficult, the principal characteristic is that it is transmitted orally, that is, handed down through performance and with no written tradition. As a consequence variations are continually introduced, either through imperfect learning or through the adaptation of material to the changing characteristics of the community, and it is this element of constant reshaping through variation that distinguishes a thriving folk culture. This fluidity makes it impossible to speak of an 'authentic' folk tune, but one speaks rather of tune families, which might contain dozens of closely related tunes. These usually exist within the folk music of a certain group, but occasionally two or more nations share tune families, the specific details of which have become adapted to the local tradition. The link between folk-song and language is particularly strong. Both music and words tend to come into existence at the same time, so that the melody follows the natural rhythm and inflection of the language. Folk-songs therefore have indelible national characteristics. Rapid urbanization in this century has both threatened the traditional environment of folk music and opened it up to a new audience and many new influences, so that we find singers of popular urban cultures, like Bob Dylan, composing songs in the folk style, and the growth of mixed genres

like bluegrass and folk rock (see *country music and *rock and roll). At the same time traditional folk music this century is sometimes used to symbolize the ethnic identity of a minority or oppressed group, or is manipulated for political ends. While traditional folk music displays a profusion of styles, certain characteristics are shared. Folk music celebrates the calendrical cycle and the key events in an individual's life. There are songs to accompany religious events or work, to lull children to sleep, or to narrate stories in ballad or epic form. There is also an extensive body of *traditional dance music, usually accompanied by instruments (but see *mouth music). Songs are usually strophic (that is, the same melody serves a number of verses), with stanzas, usually of four lines, lines of music and text coinciding. Line lengths tend to be consistent in western Europe but more varied in the east, perhaps determining the more irregular rhythms encountered there. Songs are mostly monophonic, that is, simple, unaccompanied tunes, though vocal *polyphony is common in eastern and southern Europe, and heterophony (the singing of a tune by a group of singers, each introducing slight rhythmic and melodic differences) and rounds are also used. Parallel singing at various intervals is also encountered, with thirds used in Spain and Austria, fourths and fifths in eastern and southern Slavic cultures, and seconds and sevenths in Yugoslavia. Polyphony is more common in instrumental music, for example the Norwegian fiddle, the *hardingfele, accompanies itself with *drones. Melodies, typically arch-shaped, use three basic *scales: gapped scales (using intervals greater than a whole tone); pentatonic scales; and modes, making much use of flattened sevenths. A variety of singing styles are encountered, from the tense nasality and highly ornamented style of, for example, North Africa, Italy, and Spain to the more relaxed, unornamented singing of, for example, Russia, Germany, and northern Europe. The many instruments used can be divided into several groups. First are the simplest, oldest instruments, common to many peoples throughout the world, such as *rattles, the *bull-roarer, and the *musical bow. Then there are instruments introduced into Europe from other cultures since the Middle Ages, such as the *banjo and *xylophone from Africa, or the *bagpipes and *shawm from the Middle East. Their usage is often considerably altered, and sometimes a sophisticated repertory has developed, for example the *piobaireachd of the Scottish Highland bagpipes. A third group are instruments developed in imitation of urban ones, such as the washtub bass and the Dolle, a north-west German *fiddle made from a wooden shoe. Finally there are instruments taken directly from European culture, for example, the double bass and clarinet. Even these instruments are often adapted in some way or the manner of playing changes; for example, a violin may have sympathetic strings added, or be played cradled in the arm rather than tucked under the chin. The serious collection of European folk music began only in the later part of the last century, aided in part by the phonograph (invented in 1877), which allowed collectors to record folk material with total accuracy and thus eliminated any tendency to 'correct' it and make it conform to the rules of art music. Pioneering collectors were Cecil Sharp and his assistant Maud Karpeles in Britain and North America, the Australian composer Percy *Grainger in England, *Dvořák in Bohemia and Moravia, and *Bartók

and *Kodály in Hungary and other parts of eastern Europe. A direct result of their work was the conscious integration of folk music within art music by composers like *Vaughan Williams, *Grieg, and Bartók, who used their national folk-songs to create a national style capable of shaking off the hegemony of Germanic music. The result may overlay the original material with undue sophistication, but it is evidence of the power and strength of folk music that it can inspire and influence art music while still existing in a more traditional environment, where it has evolved for hundreds of years.

folly (French *folie*, 'madness' or 'eccentricity'), an ornamental building or structure built purely for decoration, often to provide a focal point for a view. Follies take such forms as towers, temples, fake medieval ruins, and so on, and are often deliberately eccentric. During the Renaissance, garden buildings were sometimes conceived as architectural novelties to amuse the beholder, but it was during the 18th century, with the rise of the *Gothic Revival and the cult of the *Picturesque, that the folly became a specific genre. In a broader sense, the term 'folly' can be applied to any building of outrageous extravagance, particularly one that is inappropriate for its site or purpose, or that ruins the patron with its cost, or that is too expensive to maintain, such as *Beckford's Fonthill Abbey.

Fontainebleau, School of, a term applied to artists working in a style associated with the French court at Fontainebleau in the 16th century. The palace of Fontainebleau, begun in 1528, was the most ambitious expression of Francis I's desire to emulate the great rulers of Italy, and he brought Italian masters to France to direct the building's decoration. They created a distinctive *Mannerist style—elegant, sophisticated, and often voluptuous, characterized by the combination of *mural painting with *stucco ornament, a feature that was widely imitated. The Fontainebleau style was so influential that it left few French artists of the time untouched. In the early 17th century the decorative painting of royal palaces was revived under the patronage of Henry IV. The name Second School of Fontainebleau is usually given to the artists who carried out this work, which was accomplished but lacks the inventive brilliance of the First School.

Fontana, Carlo (1634-1714), Italian *Baroque architect. He worked with Pietro da *Cortona and then *Bernini and became the leading architect in Rome in the late 17th and early 18th centuries, with a hand in almost all the major building projects in the city. His work was accomplished rather than original, his academic version of Baroque taking hold where its more rhetorical manifestations would have been unacceptable. His pupils included *Fischer von Erlach, *Gibbs, and *Hildebrandt.

Fontane, Theodor (1819-98), German novelist. Initially a writer of popular ballads, travel books, and a long historical novel, he went on to write a series of social novels, notably *Entanglements* (1888), *Frau Jenny Treibel* (1893), *Effi Briest* (1895), and *Lake Stechlin* (1898), set in and around contemporary Berlin. Turning his back on the German tradition of the *Bildungsroman*, Fontane explored the tensions of modern society, particularly from the perspective of the middle classes and of women.

His novels are characterized by their unprogrammatic realism, their rejection of romantic solutions, their ironic observation and good-humoured criticism, their skilful dialogue, and their preference for understatement.

fool, the licensed buffoon of the medieval feast of fools, later an important member of the *sociétés joyeuses* of medieval France, not to be confused with the *court fool. The traditional costume of the fool, who is associated with such *folk festivals as the Morris dance (see *folk dance) and the *mummers' play (especially the wooing ceremony), is a hood with horns or ass's ears, and sometimes bells, covering the head and shoulders; a parti-coloured jacket and trousers, usually tight-fitting; and sometimes a tail. He carries a *marotte* or bauble, either a replica of a fool's head on a stick, or a dried and distended bladder filled with dried peas, and he sometimes has a wooden sword or 'dagger of lath', like the 'Old Vice' in the mystery plays.

Ford, Ford Madox (Ford Hermann Hueffer) (1873–1939), British novelist, editor, and critic. He collaborated with Conrad on *The Inheritors* (1901) and other works and published over eighty books of fiction and non-fiction. His masterpiece, *The Good Soldier* (1915), is a finely constructed and complex tale of the relationship of two married couples. As founder and editor of the *English Review* (1908–11), and later as editor of the Paris-based *Transatlantic Review* (1924), his appreciation of originality and quality in the works of *Joyce, *Pound, *cummings, and others, did much to shape the course of 20th-century writing. (See also *literary criticism.)

Ford, John (1586–c.1639), English dramatist. He collaborated with *Dekker and Willam Rowley (c.1585–1626) in *The Witch of Edmonton* (c.1621), and in several plays with other dramatists. Among the plays written by Ford alone are *The Lover's Melancholy* (1629), a romantic comedy (influenced by *Burton's *Anatomy of Melancholy*); the tragedies *Love's Sacrifice* (1633), *Tis Pitty Shee's a Whore* (1633), *The Broken Heart* (1633), and *Perkin Warbeck* (1634), a historical play. His plays are mainly concerned with human dignity, courage, and endurance in suffering; melancholy, torture, incest, and delusion are explored with sincerity in very individual rhythmic *blank verse.

Ford, John (Sean Aloysius O'Feeney) (1895–1973), US film director, renowned maker of *Westerns. His first film, in 1917, was a short Western and he directed such classics of the genre as *Stagecoach* (1939), *My Darling Clementine* (1946), *She Wore a Yellow Ribbon* (1949), *The Searchers* (1956), and *The Man Who Shot Liberty Valance* (1962), which combined a feeling for American landscapes with a concern for their inhabitants. Yet he made outstanding films in other genres, including *The Lost Patrol* (1934), a war film; *The Informer* (1935), one of the best films ever made about the problems of Ireland; *Young Mr Lincoln* (1939); *The Grapes of Wrath* (1940) based on John *Steinbeck's novel about a poor family's trek to California during the Depression; and *The Fugitive* (1947), based on Graham Greene's novel *The Power and the Glory*. He won Academy Awards for direction of *The Informer*, *The Grapes of Wrath*, *How Green Was My Valley* (also Best Film) (1941), and *The Quiet Man* (1952).

Formalism, a style of theatrical direction developed in Russia in about 1905 by *Meyerhold, which survived until the 1930s. The antithesis of the naturalism of the Moscow Art Theatre (see *Stanislavsky), it entailed treating the actor like a puppet whose inner feelings must be suppressed in the interests of symbolism. It was not inappropriate in the climate of experimentation after the Revolution of 1917, though its abstractness and lack of emotional warmth alienated its audience. With the rise of *Socialist Realism, however, which demanded a type of presentation that the workers could understand, Formalism fell into disrepute.

Forster, E(dward) M(organ) (1879–1970), British novelist, essayist, and critic, connected with the *Bloomsbury Group. He attended King's College, Cambridge, where the atmosphere of free intellectual discussion and the emphasis on personal relationships profoundly influenced his work, notably, *The Longest Journey* (1907). Impeccably stylish, Forster's fiction is in the English tradition of the novel of manners, and takes the difficulties of forming human relations as its theme. Travels in Italy and Greece provided material for *Where Angels Fear To Tread* (1905) and *A Room with A View* (1908). *Howard's End* (1910) contrasts the conflicting social and cultural values of two English families. *A Passage to India* (1924) is a picture of society in India under the British Raj and an exploration of the nature of external and internal reality. His own homosexuality nurtured a deep sensitivity to the conventional hypocrisies of the day; homosexual themes dominate *Maurice* (begun 1913, published posthumously in 1971), and some of his short stories.

Foscolo, Ugo (Niccolò) (1778–1827), Italian poet and novelist. Born of Venetian-Greek parentage, he was a supporter of the French Revolution and enlisted in the Napoleonic army. After Napoleon's defeat he chose exile, spending his last eleven years in England. His first novel, the *Last Letters of Jacopo Ortis* (1798), contains a bitter denunciation of Italy's social and political situation. A substantial scholar and critic, his reputation rests principally, however, on his *sonnets, his *odes, and on *Of Sepulchres* (1807), works of lyric beauty and haunting melancholy which reflect his restless, passionate nature. Foscolo, a classicist in the purity of his style, was one of the most significant voices heralding the Risorgimento, the movement to unite and liberate Italy.

Foster Associates, British architectural partnership established in 1967 by Norman Foster (1935–) in collaboration with Buckminster Fuller. With Richard *Rogers (his partner 1963–7) Foster is one of the leading exponents of a 'high-tech' style exulting in modern machinery and technology. His best-known buildings include the aircraft-hangar-like Sainsbury Centre for the Visual Arts at the University of East Anglia (1975–8) and the skyscraper headquarters of the Hong Kong and Shanghai Banking Corporation in Hong Kong (1979), which renounces the smoothness of the *Mies van der Rohe tradition for a mechanistic irregularity.

Fouquet, Jean (c.1420–c.1481), French painter and manuscript illuminator, the outstanding French painter of the 15th century. In the mid-1440s he visited Rome, and his work shows considerable *Renaissance influence, particularly in his confident handling of *perspective. On his return from Italy Fouquet became the leading artist

at the French court. Whether he worked on *miniatures or on a larger scale in panel paintings, Fouquet's art had the same characteristics: clear and powerful draughts-manship and an impressive sense of gravity and poise.

Fowles, John (Robert) (1926–), British novelist. His novels explore the theme of freedom by inventively adapting popular fictional forms: the thriller in *The Collector* (1963), the mystery story in *The Magus* (1966), and the historical romance in *The French Lieutenant's Woman* (1969). These works, like the novella *The Ebony Tower* (1974), have been adapted for the cinema. Others include the 18th-century mystery *A Maggot* (1985).

Fox Talbot, William Henry *Talbot, William Henry Fox.

Fragonard, Jean-Honoré (1732–1806), French painter whose works embody the *Rococo spirit. He was a pupil of *Chardin and of *Boucher before living in Italy from 1756 to 1761 as a prize-winning student. After his return to Paris he soon abandoned his attempts to paint grand historical works and turned to the delicately erotic subjects for which he is famous. Almost all his work was done for private patrons, among them Madame du Barry, Louis XV's most beautiful mistress. Fragonard's delicate col-ouring, witty characterization, and spontaneous brush-work give his work an irresistible verve and joyfulness, ensuring that even his most erotic subjects are never vulgar. Taste, however, turned decisively against him when the Neoclassical style came to the fore and he was ruined by the Revolution, dying in poverty.

frame drum, a drum with a shell shallower than the diameter of the head and usually a single head. Frame drums are used by many peoples, especially those in the Arctic, where it is often a cult instrument. In North Africa and the Middle East it is often a woman's instrument, as it was in biblical times. Frame drums often have rattling elements, such as *tambourine jingles or the internal snares of the North African *bendīr* and the double-headed Portuguese *adufe*, and the suspended *rattles of the Si-berian shaman's drum.

France, Anatole (Anatole-François Thibault) (1844–1924), French novelist and critic. He stands in the rationalist tradition of French literature inherited from *Voltaire in the 18th century and Renan in the 19th. In his early career he wrote poetry in the style of the *Parnassians, but achieved greatest success as a novelist. His characteristic mode is elegantly polished social satire, as for example in *L'Ile des pingouins* (1908), *Les Dieux ont soif* (1912), and *La Révolte des anges* (1914). He also wrote several volumes of childhood reminiscences, including *Le Livre de mon ami* (1885), and essays of literary criticism. He won the Nobel Prize for Literature in 1921.

Franck, César- (Auguste-Jean-Guillaume-Hubert) (1822–90), French composer and organist of Belgian birth. His music was much influenced by the chromaticism (see *harmony) of *Liszt and *Wagner and he was one of the earliest French composers to write *symphonic poems, such as *Les Eolides* (1876) and *Le Chasseur maudit* (1882). His real genius, however, lay in his non-*programmatic works, such as the Piano Quintet (1879), the *Variations symphoniques* for piano and orchestra (1886),

the Violin Sonata (1886), and the Symphony in D minor (1888).

Fredro, Aleksander (1793–1876), Polish dramatist. A nobleman, he fought under Napoleon and late in life wrote about his experiences. In his many mainly verse comedies, such as *Maiden's Vows* (1833) and *Revenge* (1834), he created a collection of witty caricatures, using rapid dialogue to poke fun at human foibles and contemporary social customs.

Free Cinema, movement founded in Britain in 1956 which aimed to steer the British cinema towards subjects relevant to its audiences. Three well-known British dir-ectors helped to found the movement and contributed short films in furtherance of its aims: Lindsay Anderson (1923–), *O Dreamland* (1953), and *Every Day Except Christmas* (1957); Karel Reisz (1926–), *We Are the Lambeth Boys* (1959), and co-director of *Momma Don't Allow* (1955), with Tony Richardson (1928–). Though the movement lasted only three years, it paved the way for several feature films, including Anderson's *This Sporting Life* (1963), Reisz's *Saturday Night and Sunday Morning* (1960), and Richardson's *A Taste of Honey* (1961).

free-reed instrument, a musical instrument in which free reeds vibrate freely to and fro in a closely fitting frame. Instruments with large free reeds are plucked (*Jew's harps), while those with small ones are blown: (*mouth organs, *harmonicas, *harmoniums, and reed organs). In South-East Asia, where this type of reed may well have originated, they are also used on pipes with finger-holes, like any other *reed instrument.

free verse, a kind of poetry which does not conform to any regular pattern of *metre. The length of its lines is irregular, as is its use of *rhyme (if any). Free verse uses flexible patterns of rhythmic repetition, and is now the predominant verse-form in English. It has some precedents in translations of the biblical Psalms and in the poems of Blake, but the pioneers of free verse in English were Whitman, Lawrence, and the poets of *modernism: T. S. Eliot, Pound, and William Carlos Williams.

french horn, a *brass musical instrument used orches-trally since the mid-17th century as the *corno da caccia* (Italian, 'hunting horn'), played with the *bell upwards. Around 1750 players discovered that moving the hand in the bell produced notes other than natural harmonics; this 'hand horn' for which Mozart wrote his horn con-certos, was used until the mid-19th century. Valves were invented in 1815, but tone quality was at first poor due to constricted tubing. Improvements were rapid and valve horns became predominant. Because of the long, narrow air column, with a range high in the harmonic series, horn playing is notorious for its difficulty.

fresco (Italian, 'fresh'), a method of wall-painting in which powdered pigments mixed in water are applied to wet plaster freshly laid on the wall. The paint fuses with the plaster, making the picture an integral part of the wall. Fresco is an ancient technique, going back to classical times, and it is also found in China and India. It had its finest flowering in Italian painting from the time of Giotto up to the 17th century, and in the 18th

The Mexican artist Diego Rivera was a rare modern exponent of the art of **fresco**, and with his brightly coloured murals covered more wall space than any other artist. This detail of his fresco, *La Civilisation Zapothèque* (1942), forms part of a series on the Pre-Columbian history of Mexico he painted for the Palacio Nacional in Mexico City. It shows Zapotec craftsmen engaged in the arts for which their civilization was famed.

century in Tiepolo. It has been memorably revived by the Mexican painter Rivera in the 20th century.

Frescobaldi, Girolamo (1583–1643), one of the greatest Italian keyboard composers and organists of his time. In 1608 he became organist at St Peter's in Rome, and in the same year he published his first volume of keyboard music, containing fantasias that show a remarkable grasp of *counterpoint. A volume of *toccatas and *partitas (1612) demonstrates his gifts as an improviser using unusual harmonies. The *capriccios of 1624 and the magnificent toccatas of 1627 show a considerable stylistic advance. In 1635 he published his most famous volume, the *Fiori musicali*, a collection of music for use in the Mass, which the young J. S. Bach was to copy and study some

sixty years later, and which were to exercise considerable influence on other organ composers such as Buxtehude.

fret, a narrow strip of wood or metal built into the fingerboard of certain stringed musical instruments, such as the guitar and banjo (but not the violin family). A fret raises the string clear of the fingerboard just as the open string is raised, minimizing the damping and allowing the note to ring clearly after being plucked.

Freud, Lucian (1922–), German-born painter (a grandson of Sigmund Freud) who came to Britain in 1931 and acquired British nationality in 1939. Since the 1950s he has built up a formidable reputation as one of the most powerful of contemporary figurative painters, portraits and nudes being his speciality. They are often seen in arresting close-up and his work has great emotional intensity. Early in his career he painted highly meticulously, but later his brushwork became much broader, bringing to his flesh painting a quality of palpability.

friction drum, a musical instrument played usually by rubbing a rosined string or stick fixed in or through the drum head. Some, for example the string lion-roar, are

occasionally used orchestrally; most, like the Flemish stick *rommelpot*, are folk instruments. Indian plucked drums, with the string through the drum head as a resonator, are sometimes confused with friction drums. Really they are string instruments, for the sound is produced by the string whose pitch depends on its tension. This is varied, either by pulling a small drum on the other end, as with the *ānandalaharī* and similar instruments, or by squeezing the arms of the instrument, as with the *gopīyantra*.

Friedrich, Caspar David (1774–1840), landscape painter, one of the greatest German *Romantic artists. He studied at the Copenhagen Academy from 1794 to 1798, then settled permanently in Dresden, where he led a quiet life. He was introspective and often melancholic and pursued with great single-mindedness his vision into the spiritual significance of landscape, discovering solitary aspects of nature: an infinite stretch of sea or mountains; snow-covered or fog-bound plains seen in the strange light of sunrise, dusk, or moonlight. He seldom used obvious religious imagery, but his landscapes convey a sense of haunting spirituality. In 1835 Friedrich suffered a severe stroke and thereafter had to confine himself to the small sepia drawings with which he had started his career. Forgotten at the time of his death, his greatness began to be recognized at the end of the 19th century.

fringe theatre, British theatrical movement (also known as alternative theatre) which provides a home for productions of limited commercial appeal. The term dates from the late 1960s and probably derives from the activities on the 'fringe' of the Edinburgh Festival. There are several dozen fringe theatres in London; they are usually small, and few were built as theatres: mostly they are found in converted warehouses or factories, in basements, or in rooms in public houses. They tend to be transitory, but some have achieved a certain stability. Outside London fringe theatre is housed in arts centres, university and college theatres, and the studio theatres attached to civic theatres, as well as in more makeshift quarters. (See also *community theatre.)

Frink, Dame Elisabeth (1930–), British sculptor and graphic artist. Some of her early sculptures were angular and menacing (showing the influence of *Giacometti), but during the 1960s her figures—typically male nudes or horses and riders— became smoother. She lived in the Camargue for a time, studying the wild horses there, and is noted for animal sculptures. She retained a feeling for the bizarre, however, in the strange goggles that feature in her oversize heads. She is one of the best-known contemporary sculptors.

Frisch, Max (1911–), Swiss novelist and dramatist. Obsessed with the question of identity and existence, Frisch consistently exposes the dangers of absolutism. Influenced by *Brecht and the Theatre of the *Absurd, he calls his play *The Fireraisers* (1958) a '*parable without a moral' because the audience to which it is addressed is deaf to its message. This play and *Andorra* (1961) are harshly critical of the supineness of the bourgeoisie and echo recent European history to challenge the complacent Swiss assumption that 'it couldn't happen here'.

Frith, William Powell (1819–1909), British painter. He achieved great commercial success with his crowded, anecdote-packed scenes of Victorian life, and the three most famous of them still rank among the most familiar images of their age: *Derby Day, Ramsgate Sands,* and *The Railway Station.* Such pictures were so popular in their day that they sometimes had to be railed off from their masses of admirers at the *Royal Academy exhibition. Frith wrote two volumes of autobiography (1887 and 1888) containing much interesting art-world gossip.

Fröding, Gustaf (1860–1911), Swedish poet. Born into a gifted family with a history of mental illness, he became the most influential Scandinavian poet of his day. In *Guitar and Concertina* (1891) he demonstrated a lyric virtuosity that unites colloquial language with rhyme and rhythm; particularly brilliant are the descriptions of his native Värmland and its people. In *New Poems* (1894) and *Splashes and Patches* (1896), the humour is overshadowed by a personal melancholy, social compassion, and search for a personal philosophy which, because of his final mental breakdown, could never be resolved.

Froissart, Jean (*c*.1337–*c*.1410), Flemish poet and court historian. His *Chroniques* are a record of events from 1325 to 1400, principally concerned with the Hundred Years War. He travelled in England and France to collect the material for his narrative, which is unparalleled in its depiction of 14th-century life. His style has great vividness, as in his famous depiction of the burghers of Calais and the battle of Poitiers (1356). Like his contemporaries, Froissart delighted in feats of chivalry and daring but concerned himself little with the morality of the events described. He took pains to ensure, wherever possible, the truth of his narrative, though the *Chroniques* are not always exact history in the modern sense of that term. The work of Froissart and the other medieval chroniclers Villehardouin and Joinville, whose subject was the Crusades, together with the much more sober narrative of Commines (late 15th century), constitutes the greatest contribution to French prose before the Renaissance.

Fromentin, Eugène (1820–76), French novelist. His one novel, *Dominique* (1863), is a masterpiece of 19th-century fiction. It is a psychological study of sublimated love, written at a time when novelists like the *Goncourt brothers were dominated by *Naturalism and the depiction of external reality. Like *Gautier, who admired the work, Fromentin rejected the highly coloured language of the *Romantics, but preserved their sense of the beauties of nature, which he conveyed with delicacy and discretion. Fromentin's travel sketches and art criticism also possess considerable literary merit.

Frost, Robert (Lee) (1874–1963), US poet. A New England farmer as well as a popular poet, his first collections, *A Boy's Will* (1913) and *North of Boston* (1914), included such favourites as the *blank-verse poems 'Mending Wall', 'The Wood-Pile', and the dramatic dialogue in blank verse 'Home Burial'. He confirmed his reputation with *Mountain Interval* (1916), *New Hampshire* (1923), and several subsequent volumes. His poetry is characterized by a mixture of technical skill, Yankee humour and understatement, rustic wisdom, and an acute ear for the speech of his country neighbours.

Fugard, Athol (Harold Lanigan) (1932–), South African playwright, actor, and director of black theatre

groups. He explores the racial policy tensions and in-equalities of South Africa in plays that defy apartheid policy. His works include *The Blood Knot* (1961), *Boesman and Lena* (1968), and *Master Harold and the Boys* (1982).

fugue, a type of contrapuntal, musical composition (see *counterpoint) in which the voices (parts) enter one by one with the same short theme, referred to as the subject. Fugues can be for any number of voices, four being the most frequent. When all the voices have entered, the ex-position (statement of material) is complete and the composition proceeds through an exploratory middle section (the middle entries) to a final statement of the thematic material (the final entries). In the exposition, as soon as one voice has stated the subject and the second voice takes over, the first voice continues with a counter-subject, which then passes to the second voice as the third takes over the subject. It is the interplay between subject and counter-subject that forms the chief point of interest in the fugue. Subject and counter-subject are inevitably related (since they have to combine with each other), so that the fugue, in essence, involves a complex discussion of one fundamental musical idea.

Fuller, Loie (1862—1928), US dancer and cho-reographer. A forerunner of modern dance in America, she explored the possibilities of fabric, electric light, and sculptural extensions to the human body in creating movement pre-figuring the use of modern technology.

Fuller, R(ichard) Buckminster (1895–1983), US engineer, architect, philosopher, and writer. He was a brilliant inventor who believed that technology should be used to solve social problems and benefit mankind. His inventions include an electric car and the factory-assembled Dymaxion (dynamic plus maximum efficiency) House, but he is probably best known for his geodesic *domes. These are lightweight structures of standardized interlocking polygonal units (usually of metal or plastic) forming an effectively spherical shape. They enabled large spaces to be enclosed with great efficiency—in line with Fuller's ideals of using the world's resources with max-imum purpose and least waste. His book *Operating Manual for Spaceship Earth* (1969) was influential on the environ-mentalist movement in the 1970s.

functionalism, a doctrine (applied particularly in archi-tecture) that the design of an object should be deter-mined solely by its function, rather than by decorative considerations, and that anything perfectly designed for its purpose will be inherently beautiful. Although aspects of the idea of functionalism can be traced back to Greek antiquity, it was not until the 20th century that it became an aesthetic creed, expressed, for example, in *Le Corbusier's dictum that 'a house is a machine for living in'. In building, form has always followed function to a great extent, but in the context of modern architecture, the term 'functionalism' implies particularly that con-structional elements should not be disguised and that ornament should be eschewed. The many different styles of architecture that might claim to be functionalist—from the organic romanticism of Frank Lloyd *Wright to the cool elegance of *Mies van der Rohe—show that the term can be interpreted in different ways. Functionalism exerted great influence on *industrial design, particularly at the *Bauhaus. It has been a stimulating influence on

many designers, but has also resulted in much arid work.

furniture. Furniture has been made of a wide variety of materials (wood, metal, textiles, glass, plastics) and decorated in many ways, including painting, gilding, carving, and inlay with semi-precious materials. The most common material for furniture, however, has been wood, and because this material is easily subject to decay, little furniture survives from early times. For knowledge of furniture in the ancient world we are mainly dependent on representations in art and literary descriptions, although there were some remarkable finds of Egyptian furniture in Tutankhamun's tomb and examples of bronze and marble furniture survive from Roman times. It is only from about 1400 that furniture survives in sufficient quantity to be able to trace a continuous history. From the 16th century pattern-books of various kinds helped the international spread of styles and motifs. Dozens of different kinds of wood have been used in furniture-making, but certain varieties have dominated at par-ticular times. Oak was the characteristic wood of the Middle Ages, but later finer, more decorative varieties came to be preferred, especially after the introduction of veneering in the 17th century. Mahogany, which began to be imported to Europe from the West Indies in the 1720s, is the classic wood of the 18th century. The Industrial Revolution brought with it the general com-mercial production of furniture. With the foundation of the Century Guild in Britain in 1882 there began a revival of craftsmanship through the *Arts and Crafts Movement. In the 20th century the leaders in modern design have been Scandinavia and Germany, while the *Bauhaus furniture, based on mechanized production and the use of new materials, set a standard of creative design in Europe and the USA. Modern furniture ranges from bent tubular steel to moulded plywood, soft and hard plastics, and refined sculptural forms in wood.

Fuseli, Henry (Johann Heinrich Füssli) (1741-1825), Swiss-born painter, draughtsman, and writer on art, one of the outstanding figures of the *Romantic movement. He settled in London in 1779. His work was inspired by literary themes (notably from Shakespeare and Milton) and he displayed an extremely vivid imagination, tending towards the horrifying and the fantastic. Although in-fluential in his lifetime, his work was neglected after his death until the *Expressionists and the *Surrealists rediscovered him.

Futurism, Italian art movement founded in 1909 by the poet Filippo Tommaso Marinetti. It was originally a literary movement, but the dominant figures were painters and it also embraced sculpture, architecture, music, the cinema, and photography. The aim of the movement, which was outlined in various manifestos, was to break with the past and to celebrate modern technology, dynamism, and power. The rendering of movement was one of the key concerns of Futurist painters, and their work at times approached abstraction. As an organized movement Futurism did not last much beyond the death of *Boccioni and the end of World War I, but it had wide influence, notably in Russia, where there was a Russian Futurist movement, and also in Britain, on *Vorticism. The *Dadaists also owed something to it, particularly in their noisy publicity techniques.

Furniture: the development of the chair in western Europe

Portuguese Gothic c.1470

English carved wood c.1550

English back-stool 17th century

Louis XIV 17th century

English wing-chair c.1740

English Windsor chair
mid-18th century

French gilt c.1768

English Regency chair c.1810

English papier-mâché chair
c.1850

Bentwood fireside armchair
1860s

Mies van der Rohe
'Barcelona' chair 1929

Modern version of
19th century Italian
Chiavari chair

Gabo, Naum (Naum Neemia Pevsner) (1890–1977), Russian-born sculptor who became a US citizen in 1952, the most influential exponent of *Constructivism. The brother of the sculptor Antoine *Pevsner, he began using the name Gabo in 1915, at the time when he began to make geometrical constructions. In his later years he was much honoured and had many prestigious commissions. He was one of the earliest artists to experiment with *kinetic sculpture and to make serious use of semi-transparent materials.

Gabriel, Ange-Jacques (1698–1782), French architect. He came from a long line of architects, succeeding his father, Jacques Gabriel (1667–1742), as First Architect to the king in 1742 and enjoying the personal favour of Louis XV. Gabriel is generally regarded as the greatest French architect of the 18th century, the dignity and masterly refinement of his work perfectly expressing the good taste of his time. His most famous building is the exquisite Petit Trianon (1761–8) in the grounds of the palace at Versailles. He could also work commandingly on a monumental scale, however, as in his layout of the Place de la Concorde in Paris (begun 1755).

Gabrieli, Giovanni (c.1553–1612), Italian composer and organist. He was the nephew of the composer and organist **Andrea Gabrieli** (c.1533–86), and like him became organist of St Mark's, Venice (1585). His music consists mainly of *motets, a handful of *madrigals, and much instrumental music. He developed the idiomatic use of instruments, made the contrasts of sound and texture more acute, and increased the use of dissonance. Many of his works (vocal and instrumental) exploit the idea of groups of performers arranged antiphonally, the spatial effect of sounds coming from different directions. The contrasts that his compositions created between loud and soft, voice and instrument, contributed significantly to the evolution of the *concerto grosso.

Gaelic literature *Scottish-Gaelic literature, *Irish-language literature.

Gainsborough, Thomas (1727–88), British portrait and *landscape painter, one of the most outstanding figures in British art. He was born in Suffolk, and spent most of his early career in East Anglia, painting local merchants and squires. In 1760 he moved to Bath, where his sitters were drawn from higher levels of society and his style became correspondingly more elegant, inspired particularly by van *Dyck. In 1774 he settled permanently in London, where he became a favourite painter of the royal family and the chief rival of *Reynolds. Gainsborough always maintained that while portraiture was his profession, landscape painting was his pleasure, and he often created imaginative compositions from studio arrangements of twigs and pebbles. He also produced a number of works called 'fancy pictures'—delicately sentimental rural *genre scenes. The most notable feature of pictures by Gainsborough is the brushwork, which has

Two noble couples dance the **galliard** in this late 16th-century engraving by Hans Asper. They are accompanied by musicians, one playing the viol, and the other playing pipe and tabor simultaneously. (Kunstsammlungen Veste Coburg)

a wonderfully fluid brilliance. Contrary to the normal practice of the time, and despite a large output, he hardly ever employed an assistant to paint the draperies or other 'subsidiary' parts of his portraits, so they all bear the mark of the individuality of his hand.

Gałczyński, Konstanty Ildefons (1905–53), Polish poet. Inventive with language, he wrote memorable poetry which reflected his anarchistic life-style: *Poetical Works* (1937), and his attempts to come to terms with post-war Poland: *Lyrical Verses* (1952). In *Ten Songs* (1953) he sums up his work, which could be both grotesque and tenderly personal.

Gallé, Émile (1846–1904), French glass-maker and (from the 1880s) furniture designer, one of the outstanding exponents of the *art nouveau style. He opposed the revival of historical styles, but he did not subscribe to functionalist theories or the social doctrines of the *Arts and Crafts Movement; rather he sought novel decorative patterns from the organic forms of nature. In glass-making he experimented with opaque and semi-translucent glass and won international fame for his vases decorated with plant forms and floral motifs. In furniture he inaugurated a revival of *marquetry.

galliard, a lively dance of Italian origin, first appearing in print around 1529–30 but presumably dating from earlier times. Usually in triple time and featuring a five-step pattern, it was a very energetic dance which, although performed by a couple, was virtually a solo performance for the man. The dance was composed mainly of leaps, jumps, and turns and was a vehicle for a display of masculine virtuosity, skill, and stamina. It is often paired and contrasted with the slower *pavan. A variant of the galliard, the volta, was danced at the court of Elizabeth I.

Galsworthy, John (1867–1933), British novelist and dramatist. He published several novels and stories which

showed his interest in the effects of poverty and the constraints of convention, before embarking on the sequence of novels (*The Man of Property*, 1906; *In Chancery*, 1920; *To Let*, 1921) collectively known as *The Forsyte Saga* (1922), tracing three generations of the Forsyte family; a second sequence of three further novels appeared as *A Modern Comedy* (1929). His career as a dramatist began with *The Silver Box* (1906), in which he employed a favourite device of two parallel families, one rich, one poor. It was followed by others on social and moral themes, including *Strife* (1909), and *Justice* (1910). Galsworthy received the Nobel Prize for Literature in 1932.

gamelan, a Javanese orchestra, the best-known being an ensemble of bronze percussion instruments: sets of bronze bars on stands, *sarons* which play the nuclear melody, and *genders* which decorate it; there are also kettle-gongs resting on stands (*bonangs*), elaborating the melody, and *kenongs*, which punctuate it; hanging *gongs and *kempuls*, both punctuating instruments; *xylophones (*gambangs*), which elaborate further; fiddle (*rebab); *duct flute (*suling*); drums (*kendang*), which direct the ensemble, and singers. Most instruments are duplicated, one set being tuned to each of the Javanese scales, *pelog* and *slendro*. (See *Indonesian music.)

Gance, Abel (1889–1981), experimental French film director. His best-known work, *Napoléon vu par Abel Gance* (1927), is a four-hour film of great technical innovation, with audacious camerawork and using a triple screen in some scenes. His other films include the powerfully pacifist *J'accuse* (1919), in which he first demonstrated the rapid cutting which was to become so influential, and *La Roue* (1922), a triangle drama involving father and son.

Gandhara sculpture, a school of Buddhist sculpture associated with the region of this name, formerly part of India and now in north-western Pakistan and eastern Afghanistan. It flourished particularly in the 1st to 4th centuries AD. Situated astride the Indus River, with Peshawar and Taxila as its main cities, the region was a cultural crossroads; it marked the eastern limit of Alexander the Great's campaigns, and Gandhara sculpture was influenced by *Hellenistic and *Roman art, especially in the portrayal of drapery, hair, and the human body. Possibly this humanistic tradition was one of the reasons why Gandhara witnessed some of the first depictions of the Buddha in human rather than symbolic form. However, a similar though unrelated development occurred contemporaneously in *Mathura. Gandhara sculpture has mostly been recovered from *stupas and monastery chapels. It includes single figures and narrative scenes. Early work was mainly in grey-blue schist, but *stucco was extensively used from the 3rd century AD. Invasion by the Huns in the 5th century brought the great period of Gandhara sculpture to an end. (See also *Buddhist art.)

Gandon, James (1743–1823), British architect, active mainly in Ireland, where he was the leading architect of his period. The most distinguished pupil of *Chambers, his style is similar to his master's in its dignity, its learning, and its slightly French air (Gandon was in fact of French descent). His two most famous works are among Dublin's main landmarks, commandingly sited on the River Liffey:

A traditional **gamelan** orchestra in Java plays at a shadow-puppet show. Although Indonesia has been subject to many diverse cultural influences, the gamelan tradition probably originated and developed in Indonesia itself, and remains popular today at a range of occasions, from weddings to concert performances.

the Custom House (1781–91) and the Four Courts (1786–1802). Gandon established new professional standards in Ireland and was highly influential there. He was co-author of two supplementary volumes to Colen *Campbell's *Vitruvius Britannicus* (1769 and 1771).

García Lorca, Federico (1898–1936), Spanish poet and dramatist. Lorca became the foremost among the constellation of inter-war poets known as the *Generation of '27, and ranks among the greatest of 20th-century poets. He was an excellent painter, a precocious composer, and an accomplished pianist: his musicality is reflected in the colour, tonality, and rhythm of his poetry. Much of his early work concentrated on his native Andalusia (*Impressions and Landscapes*, 1918), the music and folklore of that region (*Poems of the Cante Jondo*, 1921–2), and its gypsies (*Gypsy Ballads*, 1928). In 1929–30 he visited North America and Cuba and conveyed his horror at the brutality of mechanized civilization in the jarring images of *Poet in New York* (published 1940). On his return to Spain in 1931 he started a travelling theatre company sponsored by the new Republic, which brought drama to peasant and worker audiences and brought him invaluable theatrical experience. As a playwright, Lorca attempted historical drama and *farce before achieving success with *tragedy. The three rural tragedies with Andalusian settings, *Blood Wedding* (1933), *Yerma* (1934), and *The House of Bernarda Alba* (1936), have assured Lorca's place as a major playwright. At the outbreak of the Spanish Civil War Lorca went to Granada, where he was executed without trial by the Nationalists.

García Márquez, Gabriel (1928–), Colombian novelist and short-story writer. A journalist by profession, he is a central figure in the 'magical realism' movement in Latin American literature. His first short stories led to his best-known novel *One Hundred Years of Solitude* (1967). Written in a dense, convoluted style and using trance-like imagery, it relates the history of a fictional Colombian village, Macondo, and of the family who founded the settlement and are destroyed with it. It can be read on

A portrait of Federico **García Lorca** painted by his friend Pablo Serrano in 1935, the year before he was murdered by the Nationalists during the Spanish Civil War. His work is rooted in the culture of the southern Spanish region of Andalusia, with its mixture of gypsy and Arab influences. His early death and his lyrical, romantic style have secured Lorca's lasting popularity.

many levels: as the history of a nation (Colombia) or as the reflection of human experience. Subsequent novels include a *satire on Latin American military dictators, *The Autumn of the Patriarch* (1975) and tale of a murder for honour, *Chronicle of a Death Foretold* (1981). Márquez was awarded the Nobel Prize for Literature in 1982.

Garcilaso de la Vega (*c.*1501–36), Spanish Renaissance poet. He was inspired by his devotion to a Portuguese woman, Isabel Freyre, to write poetry of high lyric quality through which he spread the new Italianate poetic forms in Spain. His output of *elegies, *canciones*, *sonnets, and *eclogues, though small, was highly influential. Eclogues II (1533), I (1534–5), and III (1536) employ the *pastoral convention to express the sufferings of unrequited love and the grief occasioned by Isabel's death. Characterized by their carefully structured form and exquisite language, they express both love and melancholy, and are among the finest written in Spanish.

garden art, the cultivation of land for ornamental purposes rather than for utility. Garden design was already highly developed among the Egyptians by the second millennium BC (representations of elaborate gardens occur in their paintings and sculpture) and the most celebrated gardens of antiquity, the Hanging Gardens of Babylon (see *Babylonian art), probably dated from the

6th century BC. The Romans too had imposing formal gardens, often terraced and adorned with fountains, statuary, and topiary (shrubs clipped into ornamental shapes). In other parts of the world entirely different traditions evolved, notably in China (which has the longest continuous history of garden design in the world) and in Japan. The attitude to gardens has generally been more spiritual in the East than in the West, and they have been seen as a means of seeking communion with nature. Arrangements are often simple and economical, with rocks (and in Japan raked sand) playing a major part; whereas in English one speaks of 'planting' a garden, a common phrase for garden-making in China translates literally as 'piling rocks and digging pools'. Horticulture was also highly developed too among the Pre-Columbian cultures of Latin America (the *conquistadores* reported that the Incas had parks, gardens, and zoos served by sophisticated irrigation systems) and in the Islamic world. The English word 'paradise' is derived from a Persian word meaning 'enclosure' or 'park', and the state of blessedness promised by the Koran as a reward to the faithful is conceived as an ideal garden. Typically, the Islamic garden was a calm retreat from the turbulence, noise, and dust of the everyday world, with cascades, pools, and fountains cooling and moistening the air. The Crusaders brought back Eastern ideas and plants to Europe during the Middle Ages, and medieval miniatures depict walled gardens of refined beauty, but it is only from the Renaissance that a continuous history of garden design can be traced in the West. From the 16th to the early 18th century, gardens were often highly formal and grandiose—prime examples being those of André *Le Nôtre. However, in the mid-18th century, initially in England, there was a move towards informality, led by 'Capability' *Brown. His successor, Humphry *Repton, coined the phrase 'landscape gardening', and the term is sometimes confined to the art of laying out parkland so that it imitates natural scenery; however, it is often used for any decorative cultivation on a large scale. The similarly imprecise term 'landscape architect' was first used slightly later, and professional associations of landscape architects were established in the USA and Britain in 1899 and 1929 respectively. Modern garden design is extremely varied, one of the leading exponents being the Brazilian artist Roberto Burle Marx (1909–), whose work makes use of brightly coloured exotic trees and shrubs arranged as sculptural groups within free-flowing patterns.

gargoyle, a spout in the form of a grotesque figure either human, animal, or monstrous, projecting from a cornice or parapet and allowing the water from the roof gutters to escape clear of the walls. There are many examples on Gothic cathedrals and churches throughout Europe, bearing witness to the lively imagination of medieval craftsmen. In the 14th and 15th centuries sculptures similar to gargoyles but not serving their function were used to decorate walls, and the term gargoyle is sometimes loosely applied to these. With the introduction of lead drainpipes in the 16th century gargoyles were no longer necessary, but examples were occasionally made in lead.

Garnier, Charles (1825–98), French architect. His reputation rests almost entirely on one building, The Paris Opéra (1861–74). One of the most prominent buildings

in Paris, this has a rhetorical splendour in keeping with its purpose and a self-confident swagger perfectly expressing the official taste of the time and the vigour with which the capital was being rebuilt. The style is neo-*Baroque, with a lavish display of luxurious materials and sculpture. Garnier also designed the Casino at Monte Carlo (1878–9), which was influential on similar buildings for expensive pleasure resorts.

Garrick, David (1717–79), British actor and theatrical manager. Of Huguenot descent, he was a small man with great mobility of expression. He was unsurpassed in his playing of tragic heroes, and excelled equally well in comedy. As an actor, Garrick was opposed to the declamatory and elaborate style fashionable at the time, and developed a more natural way of speaking. As a manager, he introduced concealed stage lighting and naturalistically painted backdrops, and also stopped the practice of admitting audiences to the stage. He wrote many plays, including *Miss in her Teens* (1747).

Gaskell, Elizabeth Cleghorn (b. Stevenson) (1810–65), British novelist. Both her father and her husband, William Gaskell, were Unitarian ministers. Her first novel, *Mary Barton* (1848), with its cast of working-class characters reflecting the poverty of the unemployed in the industrial towns of early Victorian Lancashire, attracted the attention of *Dickens, who subsequently published much of her work in his periodical *Household Words*. Her other major novels include *Cranford* (1853); *Ruth* (1853), which shocked many readers by its sympathy for 'fallen women'; *North and South* (1855), contrasting the values and habits of rural southern England and the industrial north; and her masterpiece *Wives and Daughters* (1866), which observes the habits, loyalties, prejudices, and petty snobberies of a rural hierarchy. In her works she displays her concern for social reconciliation and tolerance. She also wrote short stories and a biography of her friend Charlotte *Brontë (1857).

Gaudí y Cornet, Antoni (1852–1926), Spanish architect and designer active mainly in Barcelona. He was one of the greatest exponents of *art nouveau and one of the most original figures in the history of architecture, creating a style without precedent or parallel. His work owed something to *Gothic and *Moorish architecture, but was unconventional and deliberately provocative in its spatial freedom, its fantastic, voluptuous forms, and its bizarre decoration: 'organic' towers like anthills, columns placed out of line, twisted roofs, and surfaces with broken china set into thick mortar are all part of his style. Gaudí's masterpiece is the church of the Sagrada Familia in Barcelona, begun in 1882 in a conventional *Gothic Revival style, but taken over by Gaudí in 1883 and transformed into a startlingly expressive vision of almost nightmarishly weird forms. It was unfinished at his death. Gaudí also designed furniture and fittings for his buildings. His style was too personal to be imitated and he was not firmly established as one of the giants of modern architecture until long after his death.

Gaudier-Brzeska, Henri (1891–1915), French sculptor and draughtsman, who worked in England from 1911 to 1914 before being killed during World War I. As a sculptor he first imitated *Rodin before developing a highly personal manner of carving in which shapes are radically simplified. In England, *Epstein alone was producing sculpture as stylistically advanced at this time. In his lifetime Gaudier-Brzeska was appreciated by only a small circle, but since his death he has become widely recognized as one of the outstanding sculptors of his generation. He also did some splendid animal drawings.

Gauguin, Paul (1848–1903), French painter, sculptor, and print-maker, with *Cézanne and van *Gogh the most important of *Post-Impressionist artists. In the early 1870s he took up painting in his spare time, and after meeting *Pissarro in 1874 he began making a collection of *Impressionist pictures. He exhibited with the Impressionists from 1880 and in 1883 became a full-time artist. His work failed to sell and, leading a restless and poverty-stricken life, he abandoned his family. From 1886 until 1890 he spent much of his time at Pont-Aven in Brittany, where he was the major figure of an artists' colony, but he also visited Panama in 1887–8 and in 1888 spent a short time at Arles with van Gogh, a visit ending in a disastrous quarrel when van Gogh suffered one of his first attacks of madness. Having had a taste for colourful, exotic places since his childhood in Peru (his mother's native country), and regarding civilization as a 'disease', he longed to 'become one with nature', and in 1891 left France for Tahiti. Apart from a period (1893–5) when he was forced back to France by poverty and ill health, he remained in the tropics for the rest of his life,

Stourhead Park in Wiltshire is one of the finest examples of 18th-century **garden art**, a field in which England excelled at this time. The grounds were laid out from 1741 by the banker Henry Hoare II, who inherited the estate from his father, and include a chain of lakes, a grotto, and temples. In 1762 Horace Walpole called Stourhead 'one of the most picturesque scenes in the world'.

Where Do We Come From? What Are We? Where Are We Going To? is **Gauguin**'s largest picture and one of the central works of his career. He painted it in Tahiti in 1897, when he was ill, impoverished, and devastated by the news of his daughter's death, intending it as his final testimony to the world before committing suicide (he took poison, but survived). It is an allegory of human life and destiny, reading from the right (the baby) to the left (the old woman brooding on death). (Museum of Fine Arts, Boston)

from 1895 to 1901 in Tahiti again and from 1901 in the Marquesas Islands, where he died. Despite illness, poverty, and depression that led him to attempt suicide, Gauguin painted his finest works in the South Seas. He wove native myths into profound visions of the human condition and abandoned the naturalism of the Impressionists to use colour in flat, contrasting areas, emphasizing its decorative or emotional effect. His reputation was established when 227 of his works were exhibited in Paris in 1906; his influence on 20th-century art has been enormous.

Gautier, Théophile (1811–72), French poet, novelist, and journalist. As a young man he was an ardent supporter of *Hugo and the *Romantics, but soon abandoned the effusive emotion and overt humanitarianism of that movement in favour of a doctrine of 'art for art's sake', which placed the highest value on beauty, achieved through the perfection of form and expression. These views, first expressed in the preface to his novel *Mademoiselle de Maupin* (1835), were shared in some measure by *Baudelaire and *Flaubert and make Gautier a precursor of the *Parnassians. His poetic masterpiece, *Emaux et Camées* (1852), is a collection of finely chiselled short poems, often borrowing themes from the fine arts, which capture fleeting impressions and momentary observations. Notable pieces from this collection are 'Symphonie en blanc majeur' and 'L'Art' (first included in the edition of 1858), a statement of his artistic doctrine. Gautier also wrote articles of literary and art criticism, and accounts of his travels, including *Voyage en Espagne* (1845).

gavotte, a French dance in duple *time, beginning on the third beat. Originally a folk dance, it was absorbed into the repertory of *ballet de cours* in the 16th century, and became one of the optional movements in the Baroque dance *suite. Its steady, lively rhythm allowed the development of intricate steps and gestures of the arms.

Gawain and the Green Knight, Sir, one of four *alliterative poems by an unknown author dating from the second half of the 14th century. It is one of the most admired poems in *Middle English, for the richness of its language, its graceful descriptions, and its entertaining and mysterious story, which tells the Arthurian legend of the knight Gawain. The poem is closely linked in style and dialect to the *elegy 'Pearl', in which an *allegorical vision of great beauty reconciles the poet to his daughter's death and place in paradise.

Gay, John (1685–1732), British poet and dramatist. His early works were in imitation of *Pope. He found his own voice in *The Shepherd's Week* (1714), a series of poems in mock-classical style, which introduced real rustics into a pastoral setting. Success came with *The Beggar's Opera* (1728) a *ballad opera, in which political *satire is eclipsed by the glamour of Captain Macheath and the realistic scenes of the underworld; this and its sequel *Polly* (1729) contain some of his best-known ballads. His *Poems* appeared in 1720 and *Fables* in 1727. He wrote the libretti of Handel's operas *Acis and Galatea* and *Achilles*. His *Beggar's Opera* was later adapted by Bertolt *Brecht and Kurt Weill as *The Threepenny Opera* (1928).

Geminiani, Francesco (Xaverio) (1687–1762), Italian composer and violinist. After studying in Milan, and in Rome with *Corelli, he worked in theatre orchestras in Lucca and Naples, becoming accepted as a virtuoso of exceptional ability before settling in London (1714–47). His last years were spent mainly in Dublin. Geminiani's music (violin sonatas and concerti grossi) is notable for the expressive qualities of its melodies and the brilliance of its virtuoso figuration. His example helped to establish the Baroque violin as a legitimate solo instrument.

Generation of '98, a term given to a group of writers in early 20th-century Spain. It derives its name from the moral and cultural rebirth that was to rise out of Spain's defeat by the USA in 1898. A broad list of its members would include Angel Ganivet (1865–98) (precursor), Unamuno, Manuel Machado (1874–1947), Pío Baroja (1872–1956), Martínez Ruiz (Azorín) (1874–1967), who

popularized the term, Ramiro de Maeztu (1875-1936), *Ortega y Gasset, Jacinto Benavente (1866-1954), and Ramon del Valle-Inclán (1869-1935), with Ramón Pérez de Ayala (1880-1962) as a related writer. Initially, regeneration was sought both through the adaptation of ideas from abroad and through the quest for the 'soul of Spain' in its people, history, culture, and landscape, especially that of Castile as in Machado's *Fields of Castille*, (1912) and in essays such as Azorín's *The Route of Don Quixote*, (1905). At the same time, these writers sought their own identity, and the search became one for authentic values. This philosophical dimension is apparent in the fiction of the period, which deviates from traditional *realist narrative in that the focus is on the crisis of the single protagonist who invariably fails in his existential quest, as in Baroja's *The Tree of Knowledge* (1911). In their insistence on the individual crisis and in their search for a national character, these writers ignored social and economic questions and, despite their undoubted literary achievements, made little impact on Spain's underlying problems.

Generation of '27, a group of Spanish writers, principally poets, prominent in the inter-war years. The title refers to 1927, when several members of the group (Gerardo Diego, Dámaso Alonso, and José María de Cossío), published works to celebrate the tercentenary of the death of the poet *Góngora. Among other writers associated with the group are *Jiménez, *García Lorca, and *Alberti. The school introduced new subjects, new words, and had scant respect for traditional *rhyme and *metre. Its writings were both anti-*realist and anti-*Romantic, serving pure aestheticism.

Genet, Jean (1910-86), French dramatist and novelist. His life of crime led him to prison where, in 1942, he began to write novels exalting his own immoral values and subsequently dramas on more positive, existentialist themes. It was his plays, *Les Bonnes* (1947), *Le Balcon* (1956), *Les Nègres* (1959), and *Les Paravents* (1961) that brought him to prominence. These reject the western tradition of realism and imitate the stylized conventions of eastern drama.

genre, the French term for a 'type' or recognizable category within any form of art: the Western in cinema, or the ode in poetry, are examples of genres, which have certain predictable features peculiar to them. The term may be used for the broadest categories (in literature: poetry, drama, fiction) or for the most specialized (sonnet, farce, ghost story). In painting, the term has a different meaning: a kind of picture representing a scene of everyday life, often domestic, as in much of the finest Dutch art of the 17th century.

Gentile da Fabriano (*c*.1370-1427), Italian painter. He was one of the foremost Italian artists of his day, but most of the work on which his contemporary reputation was based has been destroyed. His most important surviving work is the altar-piece of the *Adoration of the Magi* (1423), which was painted for the church of Santa Trinità in Florence, and establishes him as one of the greatest of all exponents of the *International Gothic style. His influence was felt by many artists, notably *Pisanello, Jacopo *Bellini, and Fra *Angelico.

Gentileschi, Orazio (1563-1639), Italian painter. He settled in Rome in about 1576 and became one of the closest and most gifted of *Caravaggio's followers. His work lacks the power and depth of his master, but is distinguished by its stateliness and grace. In 1621-3 Gentileschi worked in Genoa, then after a period in Paris he settled in England in 1626 and became a court painter to Charles I. He helped to spread the Caravaggesque style, but by the end of his career he had long abandoned the strong *chiaroscuro associated with it and was painting in light colours. His daughter **Artemisia Gentileschi** (1593-*c*.1652) was one of the greatest of Caravaggesque painters. Precociously gifted, she built up a European reputation and lived a life of independence rare for a woman of the time. Artemisia's powerful style is seen at its most typical in paintings of *Judith and Holofernes*: her depiction of a woman violently decapitating a man has been seen as pictorial 'revenge' for her own sufferings.

George, Stefan (1868-1933), German lyric poet. The greatest formative influences on his work were *Mallarmé and the French *Symbolists. His conception of *l'art pour l'art* saw the beauty of poetry in the sensual, especially aural, presentation of a selective vocabulary in disciplined organization. The themes of his poems are chiefly landscape, friendship, and art. Consciously writing for an élite, he published in 1895 his collection of verse, the *Book of the Shepherds*. *The Seventh Ring* (1907) celebrates his encounter with Maxim, a 15-year-old boy whom George saw as an incarnation of the godhead and who was to epitomize for him the renewal of civilization. The tone of his later poetry passes to the prophetic, apocalyptic, and monumental in his volume *The New Kingdom* (1928). His work, which evokes the vision of a new Germany, was exploited after 1933 by the Nazis, but George rejected any association with them and died in self-imposed exile in Switzerland.

A study for **Géricault**'s painting *The Raft of the Medusa*. The disaster of the shipwreck was caused, many thought, by government incompetence and Géricault's painting caused a political sensation. One of Géricault's most original traits was his predilection for investing contemporary incident with epic massiveness. (Louvre, Paris)

Georgian architecture, a general term for British architecture from the accession of George I (1714) to the death of George IV (1830). This period encompassed a wide range of styles and taste in architecture, with labels such as *Palladianism, *Neoclassicism, *Gothic Revival, *Chinoiserie, and *Regency. However, the term 'Georgian' is most commonly used to characterize the restrained good taste typical of the period, which developed from the *Queen Anne style. It is applied most readily to the simple red-brick house with regularly spaced windows, white paintwork, and a pedimented doorway so common in the period, and also to the somewhat grander terraces and crescents laid out in cities such as Bath and the New Town of Edinburgh. The word 'Georgian' is applied to architecture in the USA as well as in Britain, and also to furniture, decoration, and so on.

Georgian poetry, a term applied to the poetry of British writers during the reign of George V (1910–36), usually of a *pastoral nature and largely traditional. Though drawing inspiration from *Wordsworth, it lacked his visionary depth. *Georgian Poetry*, a series of five *anthologies, was published between 1912 and 1922; the early volumes brought a fresh vision to the tired poetry of the time and were widely successful. The first volume included Rupert *Brooke, John *Masefield, D. H. *Lawrence, Walter *de la Mare, and John Drinkwater (1882–1937). Later volumes included Edmund Blunden (1896–1974), Siegfried *Sassoon, Robert *Graves, and Isaac Rosenberg (1890–1918). The quality of poetry in the later volumes deteriorated and several poets (notably Graves, Sassoon, and Blunden) objected to being labelled 'Georgian' in the company of lesser writers. The term has subsequently acquired its mildly pejorative sense of superficiality and rural veneer.

Géricault, Théodore (1791–1824), French painter, one of the most important figures in the development of *Romanticism. He was a passionate admirer of *Rubens, whose work he copied in the Louvre, and was influenced by *Michelangelo and *Baroque art. The heroic, muscular style that he developed was seen in the picture with which he made his name and for which he is still most famous, *The Raft of the Medusa* (1819). It depicts the ordeal of the survivors of the shipwreck of the *Medusa* in 1816. It treated a contemporary event on a scale previously reserved for subjects taken from religion, mythology, or the great events of history. Géricault is also known for his paintings featuring horses and for an extraordinary series of portraits painted of mental patients in the clinic of his friend Dr Georget, one of the pioneers of humane treatment for the insane. Géricault's powerful, vigorous work, full of ardour and movement, had an enormous influence, most notably on *Delacroix.

German literature, the body of literary work written by the German-speaking peoples of Europe. Despite a substantial amount of religious writing in the 8th and 9th centuries, a continuous literary tradition in the German language began only in the 11th century, when a lay audience emerged for secular works reflecting the courtly ethos to which they aspired. Their desire for romances and for courtly love lyrics (*Minnesang*) was satisfied at the high point of medieval German literature between 1150 and 1250 notably by *Gottfried von Strassburg, Hartmann von Aue (*c.*1165–1210), *Wolfram von Esch-

enbach, and the lyric poet *Walther von der Vogelweide. Although Germany produced a number of Renaissance and humanist authors, their influence remained limited: the literature of the Middle Ages in all its variety remained popular up to the 16th century, until the controversies of the Reformation and the influence of Martin Luther (1483–1546), whose idiomatic prose style marks the beginning of a new age in the history of the German language and its literature. The 17th and 18th centuries are marked by critical attempts to improve and refine German literature. This resulted initially in a literature influenced by French practice and combined with Baroque rhetorical virtuosity. The most readable author of the period is *Grimmelshausen. Through the work of *Lessing, *Klopstock, and *Wieland, German literature finally found its own voice, culminating in the plays of the *Sturm und Drang* movement and then in the mature classicism of *Goethe and *Schiller, whose genius influenced many authors throughout the 19th century. Reaction to these models came firstly from *Romantics, who built partly on impulses from *Sturm und Drang*, concentrating on the irrational, fantastic and even subconscious: the *Schlegel brothers, Ludwig Tieck (1773–1853), Wilhelm Heinrich Wackenroder (1773–98), *Novalis, and *Hoffmann; and secondly from *Junges Deut-

The first-edition cover of the song 'Bess you is my Woman' from George **Gershwin**'s *Porgy and Bess.* A love story set in the sleazy poverty of the black tenement section of the Charleston waterfront known as Catfish Row, the opera combines jazz and 'serious' music in a way that was unprecedented at the time of its composition. Gershwin spent a summer in South Carolina researching black musical traditions before he started work on the opera. (Museum of the City of New York)

schland, a multifarious grouping of writers including Heinrich *Heine, with more radical political interests. The 19th century produced notable prose-writers, including Gottfried *Keller, Wilhelm Raabe (1831–1910), Adalbert Stifter (1805–68), and Theodor Storm (1817–88), whose realism was developed further and given a sharp critical edge by Gerhart *Hauptmann and Hermann Sudermann (1857–1928). The lyric poet Stefan *George was chiefly responsible for the revival of German poetry at the close of the 19th century. Of the literary groups critical of the moral emptiness and hypocrisy of bourgeois society in the early 20th century, most significant were the *Expressionists, Georg Heym (1887–1912), Georg *Kaiser, August Stramm (1874–1915), Georg Trakl (1887–1914), and *Wedekind. Reaching its height during World War I, the movement declined in the 1920s, suffering an abrupt end in 1933 when the Nazis drove into exile or silenced within Germany almost every author of significance. In Rainer Maria *Rilke Austria produced one of the great poets of the 20th century. The post-World War II development of German literature was complicated by the addition of ideology to the political divisions that existed in the German-speaking world. In the German Federal Republic (West Germany) the initial post-war restorative tendencies gave way to criticism of German complacency of the 'economic miracle' and the reluctance to face the Nazi past. This was led by the dramatists Wolfgang Borchert (1921–47), Rolf Hochhuth (1931–), and the novelists Alfred Andersch (1914–), Siegfried Lenz (1926–), Günter *Grass, and Heinrich *Böll. In the 1960s the sense of crisis which dominated the literary scene, encouraging a political social and artistic radicalization of literature, was expressed in the documentary literature of Günter Wallraff (1947–), the novels of Nicolas Born (1937–79), Max von der Grün (1926–), and in the plays of Tancred Dorst (1925–) and the Austrian Peter Handke (1942–). The literary scene in the German Democratic Republic (East Germany) was, until the political rapprochement between the two republics in 1989, affected by phases of cultural repression and relaxation. A dominant theme of East German literature, whether critical of the regime or not, has been the position of the individual in a socialist society and his or her attitudes to the capitalist society beyond the Berlin Wall. This manifested itself in the writings of Christa Wolf (1929–), Hermann Kant (1926–), and Ulrich Plenzdorf (1934–). A number of writers were banished or sought exile in the West: Sarah Kirsch (1935–), Botho Strauss (1944–), and Erich Loest (1926–), though not all survived, artistically speaking, the transplantation.

Gershwin, George (1898–1937), US composer and pianist. The son of emigrant Russian Jews, his first successful song, *Swanee*, was published in 1919. *Rhapsody in Blue*, scored originally for jazz band and piano (1924) greatly advanced his reputation as a serious composer, confirmed by the Concerto in F (1925) and the symphonic poem *An American in Paris* (1928). He·wrote successfully for film and for the Broadway *musical theatre, often with his brother **Ira** (1896–1983) as librettist, his life's work culminating in the opera *Porgy and Bess* (1935), based on the novel *Porgy* by DuBose Heyward. Though Gershwin's ability to structure large-scale works was limited, this was more than offset by his outstanding melodic gifts and pungent, *jazz-based harmony.

gesso (Italian, 'chalk'), a brilliant white preparation of *chalk (or a similar substance) mixed with glue, much used in the Middle Ages and Renaissance to coat *panels or *canvas and prepare them for painting upon. In the 20th century the term 'gesso' has come to be loosely used of similar substances to that described, and in reference to sculpture it often refers to plaster of Paris.

Gesualdo, Carlo, Prince of Venosa (c.1561–1613), Italian composer and lutenist. Gesualdo lived most of his life in Naples. His *madrigals and *motets were highly individual, for he used dissonance for dramatic effect, introduced notes outside the basic scale for emotional intensity, and indulged in sudden changes of tempo. His work marks a transition from *Renaissance style to the dramatic expression of the *Baroque era.

Ghiberti, Lorenzo (1378–1455), Italian sculptor, goldsmith, designer, architect, and writer. He came to prominence in 1401 when he won a commission to make a pair of bronze doors for the baptistery of Florence Cathedral. The doors were completed in 1424, and in 1425 he was asked to make a second pair for the same building, which occupied him until 1452. These two great works, the earlier featuring twenty-eight scenes from the life of Christ and various saints, the later consisting of ten large panels of Old Testament subjects, were made in a large workshop in which many illustrious artists, notably *Donatello and *Uccello, had at least part of their training. The refinement of Ghiberti's work places him in the *International Gothic tradition, but in his interest in *perspective and classical sculpture he also represents a transition to *Renaissance ideals. He also made statues, designed stained glass windows for Florence Cathedral, and was involved in the building of its dome. He left a large, incomplete manuscript *Commentaries*, which is a major source of information on 14th-century Italian art and contains his autobiography.

Ghirlandaio, Domenico (1449–94), Italian painter. His style was solid, prosaic, and rather old-fashioned, but he was an excellent craftsman and had one of the most prosperous workshops in Florence, which he ran in collaboration with his two younger brothers, **Benedetto** (1458–97) and **Davide** (1452–1525). Ghirlandaio worked on frescos in Pisa, San Gimignano, and Rome (in the Sistine Chapel) as well as in Florence, and his studio produced numerous altar-pieces. His frescos are noteworthy for the way they include anecdotal details of the life of his times (he often included portraits in his religious works) and are of historical and social interest. He also painted portraits. Ghirlandaio's son and pupil **Ridolfo Ghirlandaio** (1483–1561) was a friend of *Raphael and a portraitist of some distinction, whose most famous pupil was *Michelangelo.

Giacometti, Alberto (1901–66), Swiss sculptor and painter. He lived in Paris for much of his career and in 1930, after a period of restless experimentation, joined the *Surrealist group. Until 1935 Giacometti made witty Surrealist constructions, but then he reverted to more traditional work based on the human model. It was not until about 1947 that he developed the highly distinctive and original style for which he is famous, characterized by emaciated, extremely elongated figures who evoke a

Giacometti's sculpture *Man Pointing* (1947) is an example of the elongated, skeletal figures by which he is best known. The mature style of this work was possible only after he had expressed himself in, and abandoned, Cubist, Constructivist, and Surrealist forms. (Tate Gallery, London)

sense of isolation or tragic gloom. His figures seemed to capture the spiritual malaise of the post-war world and his work was influential on sculptors in the 1950s in particular. From this time on Giacometti's reputation as a painter began to increase. Most of his paintings and drawings are portraits of his family and friends.

Giambologna (1529-1608), Flemish-born Italian sculptor, also known as Giovanni Bologna and Jen Boulogne. He was the greatest sculptor of the age of *Mannerism, and exercised widespread influence in Europe. In about 1554 he went to Italy to study, and after spending two years in Rome he settled in Florence, where he was much patronized by the Medici family. His work there included a series of marble figure groups that, in their mastery of complex twisting poses, mark one of the highpoints of Mannerist art. Giambologna was a master of bronze as well as marble, notably in his equestrian statue of Duke Cosimo I de' Medici in the Piazza della Signoria, Florence, a work that set a pattern for similar monuments all over Europe. Equally influential were his bronze statuettes, which were reproduced almost continuously up to the 20th century.

Gibbon, Edward (1737-94), British historian. While on a visit to Rome he conceived the plan for what has become the most celebrated historical work in English literature, *The History of the Decline and Fall of the Roman Empire* (1776-88), which traces the connection of the ancient world with the modern, encompassing such subjects as the establishment of Christianity, the Teutonic tribes, the conquests of Islam, and the Crusades. The work is distinguished by the author's great erudition and elegant and lucid prose style, and is enlivened by ironic wit.

Gibbons, Grinling (1648-1721), Dutch-born wood-carver and sculptor who settled in England in about 1667. He was discovered by the diarist John Evelyn, who introduced him to Charles II and Sir Christopher *Wren, who employed him on decorations at Hampton Court Palace and St Paul's Cathedral. His speciality was carving decorative garlands and festoons of fruits, flowers, shells, and so on, a field in which he showed unsurpassed virtuoso skill. Gibbons also worked in marble and bronze, but with much less distinction than as a woodcarver.

Gibbons, Orlando (1583-1625), English composer, one of the last great figures of the English *polyphonic school. He became a Gentleman of the *Chapel Royal and in due course (c.1605) its organist. In 1623, in addition to his duties as 'one of the musicians for the virginalles to attend in his highnes privie chamber', he was appointed organist of Westminster Abbey. One of the most versatile composers of his generation, Gibbons was a serious *madrigalist, eschewing the frivolous pastoral style of the Italian-influenced Weelkes and Wilbye in favour of a moralizing, strictly contrapuntal (see *counterpoint) manner in the tradition of the *consort song. His sacred music was written exclusively for the Anglican church, and his best work is found in some large-scale *anthems.

Gibbs, James (1682-1754), British architect who trained in Rome with Carlo *Fontana, the leading architect of the day there. His continental training set him apart from his British contemporaries and he remained an individualist, independent of the rigorous *Palladians and the highly charged *Baroque school of *Hawksmoor and *Vanbrugh, although he had certain features in common with each. His style was eclectic and sophisticated, continuing to some extent the tradition of *Wren. The overall quality of Gibbs's large output is extremely high, without generally showing any great originality. Occasionally, however, he produced an altogether exceptional design, as with his church of St Martin-in-the-Fields in London (1722-6), which combined a temple-front portico with a steeple in a completely novel way. It was the most influential church design of the 18th century, particularly in America, where it was known through Gibbs's *A Book of Architecture* (1728). Gibbs's masterpiece, however, is the Radcliffe Camera in Oxford (1737-48), a circular library of immense authority.

Gide, André (1869-1951), French novelist and essayist. As a young man he rejected the constraints imposed by his Protestant background, and, for the generation following World War I, symbolized its rebellion against conventional values. His fiction is divided into three categories: *soties*, such as *Les Caves du Vatican* (1914), so called because of the farcical treatment of the theme;

récits, including *L'Immoraliste* (1902), *La Porte étroite* (1909), and *La Symphonie pastorale* (1919), in which Gide combines economy of presentation with a sophisticated (often ironic) use of first-person narrative, and a single novel, *Les Faux-Monnayeurs* (1926), which explores themes such as authenticity and which in some ways anticipates the highly self-conscious manner of the *Nouveau roman*. His other works include an account of his early years, *Si le grain ne meurt* (1926), travel writing, and literary criticism, all marked by the characteristic elegance of his style.

Gielgud, Sir (Arthur) John (1904–), British actor and director, the leading classical actor of his day. In 1929 he joined the Old Vic Company to play Hamlet, his greatest role. Other famous roles included John Worthing in Wilde's *The Importance of Being Earnest* (1930, 1939), Joseph Surface in Sheridan's *The School for Scandal* (1937), and Raskolnikov in Dostoyevsky's *Crime and Punishment* (1946). A consummate and versatile artist, he is as much at home with modern drama as with the classical masterpieces, and has had a distinguished career in film. He has supported modern playwrights such as Christopher Fry, Alan Bennett, David Storey, and Harold Pinter, and has directed numerous plays.

gigue, a dance or tune, a courtly version of the English jig, imported into France in the mid-17th century. It was played in lively triple or duple *time, with rhythms that were predominantly dotted. The Italian version (*giga*) tended to be much quicker. The gigue was the customary closing movement of the Baroque dance *suite.

Gilbert, Sir Alfred (1854–1934), British sculptor and metal-worker, famous for his Shaftesbury Memorial Fountain in Piccadilly Circus (1887–93) surmounted by the figure of Eros. He moved into self-imposed exile in Bruges in 1909, after going bankrupt, but returned to Britain in 1926 at the request of George V to complete the tomb of the Duke of Clarence in St George's Chapel, Windsor Castle, which he had begun in 1892, now regarded as one of the most important examples of the *art nouveau style. Gilbert's reputation suffered after his death, but interest in him has recently revived.

Gilbert, W. S. *Sullivan, Arthur.

gilding, the technique of decorating a surface with a very fine layer of gold. The metal can be beaten into extremely fine sheets (known as gold foil or gold leaf) and this can be applied to various surfaces by means of an adhesive. Silver-gilt is silver that has been covered with a thin layer of gold. Gilding has been used to embellish wood and other materials from ancient times throughout the Near and Far East, in Egypt, Greece, and Rome, and in the Pre-Columbian civilizations of Latin America. Apart from decorating furniture of all types, gilding has been used to embellish picture frames, to enrich sculpture and architecture, in the illumination of manuscripts, and in other types of painting.

Gilgamesh, epic of, Babylonian work of some 3,000 lines written in cuneiform on twelve clay tablets in *c.*2000 BC, and discovered among the ruins of Nineveh. It tells of the friendship of Gilgamesh, King of Uruk, and Enkidu, and of the king's search for the plant that gives eternal life. He finds the plant, but while he sleeps, a serpent steals it, and the spirit of Enkidu returns to describe the afflictions that await man in the underworld. (See also *Babylonian art.)

Gill, Eric (1882–1940), British sculptor, engraver, typographer, and writer. A convert to Roman Catholicism, Gill tried to revive a religious attitude towards art and craftsmanship, and was an advocate of a romanticized medievalism. In sculpture he was a leader in the movement for the revival of direct carving (as opposed to modelling), and his work usually has an impressive simplicity of conception. He illustrated many books and also designed typefaces, including 'Gill Sans-serif', that are among the classics of 20th-century *typography.

Gillespie, Dizzy *jazz.

Gillray, James (1757–1815), one of the greatest of British *caricaturists. Despite doing some social satires he was mainly a political cartoonist, and in this field was unrivalled in his day. The subjects of his attacks included the two main British political parties (Whigs and Tories), the royal family, and Napoleon, his work showing great fecundity and vividness of imagination as well as biting wit. In 1811 his career was cut short by insanity.

Giordano, Luca (1634–1705), Italian painter. His work was varied in subject-matter, although he was primarily

The chalice of Abbot Suger of St Denis (*c.*1140), worked in gold, silver **gilding**, and sardonyx, and studded with precious gems and pearls. The richness of the chalice reflects Abbot Suger's importance as adviser to King Louis VI of France. Powerful and fair-minded, Suger presided over administrative reforms and inspired the rebuilding of his abbey church in the new Gothic style. (National Gallery of Art, Washington DC)

Sleeping Venus is one of only a handful of paintings that are accepted as original works by **Giorgione**; according to a reliable contemporary source it was left unfinished at his death and completed by Titian (who was probably responsible for the landscape). It has been an exceptionally influential design, the precursor of reclining nudes by some of the most illustrious names in European painting. (Gemäldegalerie, Dresden)

a religious and mythological painter, and he absorbed a host of influences, reputedly being able to imitate other artists' styles with ease. He worked mainly in Naples, but also in Florence, Venice, and Spain. His work was highly influential in Italy, and his open, airy compositions and light, luminous colours presage painters such as *Tiepolo.

Giorgione (Giorgio Barbarelli or Giorgio da Castel-franco) (*c.*1476–1510), Italian painter. Almost nothing is known of his life and only a handful of paintings can be confidently attributed to him, but he holds a significant place in the history of art. He achieved almost legendary status soon after his early death from plague, and ever since he has captured the imagination in a way that few other artists can match. His fame is explained by the fact that he initiated a new conception of painting. He was one of the earliest artists to specialize in small pictures for private collectors rather than public works for civic or ecclesiastical patrons, and he was the first painter who subordinated subject-matter to the evocation of mood: even well-informed contemporaries sometimes did not know what was represented in his pictures, and they have continued to pose intriguing puzzles for modern scholars. He was probably a pupil of Giovanni Bellini and he developed his soft and mellow style in the direction of a dreamy romanticism, which in turn cast a spell over many of his contemporaries, including his friend *Titian, who after Giorgione's death completed some pictures he had left unfinished. In the generation after his death Giorgione's work was widely imitated, an additional source of confusion for scholars.

Giotto di Bondone (*c.*1267–1337), Italian painter and architect. Giotto, one of the most illustrious names in the history of art, is regarded as the founder of the central tradition of Western painting because his work broke away from the flat conventions of *Byzantine art and introduced a new and convincing sense of pictorial space. No surviving painting is strictly documented as being by him, but it is agreed that the fresco cycle in the Arena Chapel in Padua (*c.*1305–6) is by Giotto, and this alone secures his fame as one of the greatest painters of all time. Most of the frescos represent scenes from the life of the Virgin Mary and events from the Passion of Christ. The figures are about half life-size, but their three-dimensionality and physical presence give them majestic power. They possess an energy and vitality that the flat, linear style of Byzantine art never could have achieved. The other major fresco cycle associated with Giotto's name is that on the Life of St Francis in the Upper Church of San Francesco at Assisi, but whether or not he painted this is one of the most controversial issues in the history of art. There are some frescos attributed to him in Santa Croce in Florence, but they are in poor condition. Among the panel paintings attributed to him the most important is the large and majestic Ognissanti Madonna in the Uffizi in Florence. Due to of his great fame as a painter, Giotto was appointed architect to Florence Cathedral in 1334; he began the campanile (bell tower), but the design was altered after his death. His influence on *Florentine painting was enormous.

Giraudoux, Jean (1882–1944), French dramatist and novelist. His early success came as a novelist, but he was encouraged to write for the theatre by the actor-producer Louis Jouvet, whose theatre is the setting for Giraudoux's play *L'Impromptu de Paris* (1937). Some of his plays, for example *Amphitryon 38* (1929) or *Intermezzo* (1933), are built around plots of little substance, which are sustained by his stylistic virtuosity. Others, like *Siegfried* (1928), adapted from Giraudoux's own novel, or *La Guerre de Troie n'aura pas lieu* (1935), are serious discussions of ethical issues. Although they appear to be literary rather than dramatic these plays are, in fact, successful on stage. Giraudoux's use of mythical or half-imaginary settings reveals his link with the *Symbolists, though his blend of elegance, irony, and verbal dexterity recalls *La Fontaine.

Girtin, Thomas (1775–1802), British landscape painter in *water-colours. In his short life he revolutionized water-colour technique; before him water-colours were essentially tinted drawings, but Girtin used strong colour in broad washes. He was influenced to some extent by J. R. *Cozens, but went beyond him in the grandeur with which he created effects of space, the power with which he suggested mood, and the boldness of his compositions. *Turner acknowledged his friend's greatness with the words 'If Tom Girtin had lived, I should have starved.'

Gislebertus (*fl.* early 12th century), French *Romanesque sculptor. One of the great geniuses of medieval art, his name has survived only because he carved his signature on his sculpture of *The Last Judgement* (*c.*1125–35) above the west doorway of Autun Cathedral, a masterpiece of expressionistic power. The unusually prominent position of his signature (beneath the feet of the central figure of Christ) suggests that his greatness was appreciated in his own time. On stylistic grounds most of the rest of the carved decoration of the cathedral is attributed to him. It includes more than fifty capitals, which vividly display his fecundity of imagination and range of feeling. Gislebertus' work had considerable influence on other churches in Burgundy, and his ideas influenced the development of French *Gothic sculpture.

Gissing, George Robert (1857–1903), British novelist. Noted for the realism and documentary portrayal of the sufferings of the Victorian middle-class poor, he explores the themes of failure and the blighting effects of poverty on creative endeavour. His best-known novel, *New Grub Street* (1891) (see *Grub Street), describes the jealousies and intrigues of the contemporary literary world. Other works include *The Nether World* (1889), *Born in Exile*

This representation of 'The Lamentation', showing Christ's body mourned by his mother after the Crucifixion, is one of the most celebrated of **Giotto**'s frescos in the Arena Chapel in Padua. The tragic intensity is overwhelming; no artist has surpassed Giotto's ability to express the essence of a story with gestures and expressions of unerring conviction.

(1892), and the partially autobiographic *Private Papers of Henry Ryecroft* (1903), the imaginary journal of a recluse.

Giulio Romano (*c.*1499–1546), Italian painter and architect. He was *Raphael's chief pupil and assistant in Rome and one of the major figures of *Mannerism. In 1524 he moved from Rome to Mantua and remained there for the rest of his life, dominating artistic affairs at the court of the ruling Gonzaga family. The great monument to his genius is the Palazzo del Tè, begun in 1526 for Federigo Gonzaga. This was one of the first Mannerist buildings, deliberately flouting the canons of classical architecture as exemplified by *Bramante in order to shock and surprise the spectator. The same tendency is seen in Giulio's witty and exuberant fresco decorations in the palace, notably in the Sala de' Giganti. His style owed much to *Michelangelo as well as to Raphael, and proved widely influential.

Glasgow School, a term applied to two quite distinct groups of Scottish artists working mainly in Glasgow in the late 19th and early 20th centuries respectively. The earlier group (also known as the 'Glasgow Boys') was a loose association of painters who were in revolt against the conservatism of the *Royal Academy and were advocates of open-air painting. The later and more important group created a distinctive version of *art nouveau. Its most important member was *Mackintosh.

Glass, Philip (1937–), US composer. An interest in Indian music led him to develop a type of *minimal music in which small rhythmic figures are repeated and made to evolve over a long period with powerful hypnotic effect. The melodic figures are themselves simple, as are the harmonic structures through which they move. His work is at its most effective in such operas as *Einstein on the Beach* (1976) and *Satyagraha* (1980).

glass harmonica (or armonica), an elaboration of the musical glasses, invented by Benjamin Franklin in 1761. A series of glass bowls, of gradually diminishing size and fine-tuned by grinding, are nested within each other and mounted on a spindle, which is turned by a pedal-operated crank, with just enough of each bowl projecting from the last to be accessible to the player's fingers. Water in a trough keeps the rims of the bowls moist so that they will sound when rubbed. Mozart wrote a quintet (K. 617) for glass harmonica and other instruments in 1791.

glassware. The early history of glass is obscure, but it was probably invented in western Asia or Egypt in the third millennium BC. Beads were perhaps the first glass articles to be made, and vessels are not certainly known to have been made of glass until about 1500 BC. The first glass objects were made by moulding, but glass-blowing was invented in the 1st century BC and revolutionized the craft, enabling a much wider range of vessels to be made, often in thinner, clearer glass, and at much greater speed. The molten glass is shaped by blowing air into it through a tube; by means of swinging and rolling the tube and manipulating the glass with pincers and other tools, it can be worked into a great variety of forms. Glassware was brought to a high degree of sophistication by the Romans, notably in the Portland Vase (British Museum) made in the reign of Augustus (27 BC to AD 14). The art of glass-making declined after the break-up of the Roman

and after losing ground somewhat to other areas in Central Europe in the 18th century, 'Bohemian glass' again achieved a high reputation in the 19th century. In Britain, Bristol and Newcastle upon Tyne are two of the places most noted for glassware, particularly that of the 18th century. In the USA notable glass-makers include Louis Comfort *Tiffany and the *New England Glass Company. The term 'studio glass' is applied to products made by independent craftsmen.

glaze, a glass-like coating applied to pottery to make it watertight and to give it a smooth, glossy finish. The essential ingredient of glazes is sand, technically silica, which is combined with a fluxing agent, the purpose of which is to cause the glaze to melt and adhere to the pottery at a manageable temperature, since silica by itself would require a temperature that would melt the clay. Generally, the type of fluxing agent used gives the glaze its name, for example lead glaze and tin glaze. Apart from its practical function, glazing provides a medium for decorative effect, and many different techniques have been evolved for embellishing pottery by, through, or on glazes. Painted or printed decoration can be applied either before or after glazing ('underglaze' and 'overglaze' decoration respectively). Underglaze decoration is permanent, but only a few pigments can resist the heat of the firing process, so the colour range is more limited than with overglaze decoration. In painting, a glaze is a layer of paint so thin and transparent that its colour is modified by the colour or surface underneath it. The effect of an undercolour seen through a glaze, with the light reflected back, is one of special depth and luminosity. From the 15th century to the 19th century most *oil paintings were an elaborate structure of glazes and *scumbles, but artists now favour more direct methods.

Glazunov, Aleksandr (Konstantinovich) (1865–1936), Soviet composer. He completed a highly successful First Symphony when he was aged 16. From 1899 he taught composition at the St Petersburg Conservatory, becoming its director in 1905. Though he adapted to the 1917 Revolution, he eventually settled (1928) in the West. Glazunov is best known for his ballet music, particularly *Raymonda* (1896–7) and the orchestral piece *Chopiniana* (1895) (later the music for the ballet *Les Sylphides*). He also completed eight symphonies, several concertos, and many shorter orchestral, choral, and chamber works.

glee *partsong.

Glinka, Mikhail (Ivanovich) (1804–57), Russian composer. He became acutely aware of Russian *folk music long before experience of Western music convinced him that he should become a composer. In 1836 his opera *A Life for the Tsar* (later retitled *Ivan Susanin*) scored an immense success. Its strong folk elements, evidenced again in the orchestral *Kamarinskaya* (1848) and to a lesser degree in his second opera *Ruslan and Lyudmila* (1842), based on a poem by Pushkin, made him a natural leader of the *Romantic movement in music. (See also the *Five.)

Globe Theatre *Elizabethan theatre.

glockenspiel, a musical instrument with steel bars laid out like a *xylophone, played with mallets of wood,

An enamelled Venetian goblet of about 1480. Venice was famous for the beauty of its coloured **glassware** such as this as well as for transparent 'crystal' glass. The secrets of manufacturing it were jealously guarded; glassworkers enjoyed great privileges, but were virtually prisoners of the state, and some who fled the Venetian Republic are said to have been murdered abroad by hired assassins. (Victoria and Albert Museum, London)

Empire, until it was revived within the world of Islam from the middle of the 8th century. The Egyptians discovered a new means of decorating glass once it had cooled by painting it with metallic 'lustre'. In Mesopotamia the facet-cutting and boss-cutting familiar from Sassanian times continued. The crowning achievement of the Islamic world in this art was its enamelled and gilt-glass in the form of drinking beakers, bottles, mosque lamps, and other objects. These enamelled glasses of the 13th and 14th centuries are among the most sumptuous ever produced. The art of making clear, colourless glass (crystal glass) was discovered in Venice in the 15th century. With this material the Venetian craftsmen of the first half of the 16th century produced forms of great beauty, which were to make it famous as the greatest of all glass-making centres. Subsequently, many other places have become noted for glass-making. Bohemia, for example, had a large number of factories that took up Venetian innovations in the 16th century,

ceramic, hard plastic, or brass. Keyboard glockenspiels have been used but are inefficient and poor in tone quality; works written for them such as Paul Dukas's *L'Apprenti sorcier* are now played on normal instruments. Marching glockenspiels for military bands are fitted to a lyre-shaped frame on a pole. Various names have been used for the instrument, including harmonica, in Saint-Saëns's *Carnival des animaux*, and in the USA, bells.

Gluck, Christoph Willibrand von (1714–87), German composer. He made his début as an opera composer in Milan in 1741. After eight successful Italian operas he worked, less successfully, in London, and later settled in Vienna in 1752. In 1762, in collaboration with the poet Raniero Calzabigi (1714–95), he produced the first of his 'reform' *operas, *Orpheus and Eurydice*. Shorn of vocal excess and courtly conventions, it aimed at 'simplicity, truth, and naturalness'. Further operas followed: *Alceste* (1767) and *Paris and Helen* (1770) for Vienna, *Iphigénie en Aulide* (1774), *Armide* (1777), and *Iphigénie en Tauride* (1779) for Paris. Gluck's contribution to opera lay in his ability to weld together arias, chorus, and pantomime with each detail contributing to the total effect.

glyphs, the name given by Mesoamericanists to signs used to convey meaning in Pre-Columbian manuscripts and in some murals and carvings. Examples recorded can be classed in two groups: Mixtec, the conventions of which were followed by Nahua-speaking peoples, and *Maya. In Mixtec sources, ideographs (characters symbolizing a concept) generally represent names and dates. Status, kinship, time, and events such as marriages, war and migration are conveyed by pictorial relationships as well as some further ideographs, such as curling lines emanating from a character's mouth, which indicate speech or authority, or closely grouped dots, which indicate a libation of pulque or, by extension, drunkenness. The Mixtec system is essentially representational and mnemonic. In the Maya system, ideographs are mixed with symbols expressing the sound of the word, yielding a more flexibly exploitable form of writing, confined in surviving examples to historical, calendrical, and astronomical subjects. (See also *Central American and Mexican literature.)

Gobelins, the most famous of all *tapestry manufactories, named after Jean and Philibert Gobelin, 15th-century scarlet-dyers, whose works were situated on the outskirts of Paris. In or near these buildings some tapestry looms were set up in the first decade of the 17th century, and in 1662 the buildings were bought by *Louis XIV and reorganized as a factory producing furnishings for the royal palaces. The factory closed in 1694 and although it reopened in 1699, thereafter it made only tapestries. It was temporarily closed during the Revolutionary period, but reopened again by Napoleon. Carpets as well as tapestries continue to be produced there to this day.

Godard, Jean-Luc *Nouvelle Vague.

Goes, Hugo van der (d. 1482), the greatest Netherlandish painter of the later 15th century. He worked in Ghent and then Brussels, where he entered a priory as a lay brother in 1475. In 1481 he suffered a mental breakdown and he died the next year. His only securely documented work is his masterpiece, a large triptych of the Nativity known as the Portinari Altarpiece (Uffizi, Florence, c.1474–6), commissioned for a church in Florence. It shows remarkable skill in the way it reconciles grandeur of conception with loving observation of detail, and it exercised a strong influence on Italian painters with its masterly handling of the oil technique.

Goethe, Johann Wolfgang von (1749–1832), German poet, novelist, dramatist, and natural philosopher. A writer of the first rank, Goethe's œuvre ranges from *Sturm und Drang subjectivism to the conscious harmony of classicism. It includes *lyric, *epic, and *ballad poetry, drama, novels, shorter tales, and autobiographical works. His literary reputation was established with the publication of *Götz from Berlichingen* (1771–3), a play in the Shakespearian tradition portraying a manly, autonomous hero worn down by a degenerate age. This was followed by *The Sorrows of Young Werther* (1774), the sensationally successful novel of the hypersensitive outsider for whom the world has no place. Between his move to Weimar (1775) and his first visit to Italy (1786–8) Goethe developed a greater stability and moderation and an appreciation of Mediterranean openness and classical values, seen in the erotic poetry of the *Roman Elegies* (1788–90). In his verse play *Iphigenia on Tauris* (1779–86) the tortured mind of Orestes is healed, and the exemplary honesty of the heroine conquers violence and deceit, while in *Torquato Tasso* (1780–9) the subjectivity and sensitivity of the

A drawing by Angelica Kauffmann of a scene from **Goethe**'s verse-play *Iphigenia in Tauris*. It was first performed in 1779, but this scene is from a reshaped version performed at Weimar in 1802; Goethe himself played Orestes (the central figure here). In Greek mythology Iphigenia was a princess offered as a sacrifice to enable the Greek fleet to sail to Troy. According to one version of the legend, the goddess Artemis saved her life and carried her off to the land of the Tauri (the Crimea) to be her high priestess. (Goethe Nationalmuseum, Weimar)

alienated hero find release in poetic expression and are counterbalanced by the tolerant nobility of the Princess. Friendship with *Schiller in the 1790s led to the verse *idyll *Hermann and Dorothea* (1796–8) and the completion of the novel *Wilhelm Meister's Apprenticeship* (1795–6), which presents a confident view of the possibility of personal development towards social responsibility and became the model of the German *Bildungsroman*. The symbolic novel *Elective Affinities* (1809), however, reveals a greater sense of tragic vulnerability, as the elemental force of love threatens the ordered world of marriage and is barely controlled by sacrificial renunciation. Goethe's masterpiece, the two-part drama *Faust*, occupied him intermittently from the 1770s until 1831. It reflects the developing vision of a lifetime, with its comedy and tragedy, pathos, wit, and satire. The hero's ceaseless striving to experience all aspects of life, his thirst for knowledge, and his presumptuous challenge to the powers of evil, conspire in his downfall, yet serve a divine purpose, complementing the power of love to lead to ultimate salvation. Best known as a man of letters, Goethe also had a distinct talent for drawing, and became a successful theatre director. His knowledge of art and of science was comprehensive and profound. He is sometimes referred to as the last universal man.

Gogh, Vincent van (1853–90), Dutch painter and draughtsman, with *Cézanne and *Gauguin the greatest

A Wheatfield with Cypresses (1889) is one of several paintings featuring such trees that van **Gogh** painted when he was a patient at the asylum for the insane at Saint-Remy. He was surprised that no-one had been moved to paint cypresses before, as he said their form was 'as beautiful in line and proportion as an Egyptian obelisk'. (National Gallery, London)

of *Post-Impressionist artists. During his lifetime he sold only one picture and waged a grim battle against poverty, alcoholism, and insanity. Although his career lasted only ten years, his output was prodigious (about 800 paintings). His early works deal mainly with the life of peasants and are sombre in colour and mood. After he moved to Paris in 1886, however, he was influenced by *Impressionism and Japanese woodcuts (see *ukiyo-e*) and his work became lighter and featured a broader range of subjects, including landscapes, portraits, and still lifes. While the Impressionists were interested in colour as a means of reproducing the appearance of the natural world, van Gogh used it for symbolic or expressive purposes, and painted with vigorous swirling brush-strokes. In 1888 he settled at Arles, where he produced an enormous amount of work but suffered recurrent nervous crises, with bouts of hallucination and depression. He was joined by Gauguin, but they quarrelled, precipitating the episode in which van Gogh cut off part of his own ear. In the last seventy days of his life he painted seventy pictures before shooting himself. His fame grew rapidly after his death, and the emotional intensity of his work has had an immense influence on 20th-century art from *Fauvism and *Expressionism onwards. Van Gogh's brother Theo, a picture-dealer, was a loyal support to him, and their correspondence provides valuable information about his life.

Gogol, Nikolay (Vasilyevich) (1809–52), Russian humorist, dramatist, and novelist. He was born in the Ukraine, and his early short stories present colourful, colloquially written pictures of the life and customs of that area. The stories were collected in *Evenings on a Farm near Dikanka* (1831–2), and *Mirgorod* (1835). Gogol wrote these stories after he had moved to the capital, St Petersburg (now Leningrad). The theme of the great city,

in which supernatural forces play an even more menacing role than among rural people, enters his work in the later stories, among them the masterpieces 'The Nose' (1835) and 'The Overcoat' (1842). He became an important dramatist with his satirical comedy *The Government Inspector* (1836), exposing corruption and pretentiousness in a provincial town. His greatest work is the novel *Dead Souls* (Part 1, 1842). Again using a provincial setting, he presents a series of grotesque caricatures, whose spiritual emptiness is exposed by an even emptier hero, the confidence trickster Chichikov. Gogol was increasingly troubled by the dark, perhaps even satanic, view of human nature that came through in his literary works. He restlessly sought spiritual comfort, but eventually he burned the rest of *Dead Souls*, and died deranged.

golden section (or golden mean), a *proportion in which a straight line or rectangle is divided into two unequal parts in such a way that the ratio of the smaller to the greater part is the same as that of the greater part to the whole. The proportion has been discussed since classical times and is supposed to possess inherent aesthetic value because it corresponds with the laws of nature or the universe. It was much studied during the *Renaissance, and the great mathematician Luca Pacioli wrote a book on it illustrated with drawings by Leonardo.

Golding, William (Gerald) (1911–), British novelist. Golding creates the quality of a *fable in his works by presenting isolated individuals or groups in extreme situations, which reveal man in his basic condition. He established his reputation with his first novel, *Lord of the Flies* (1954), a *parable which depicts a group of schoolboys stranded on a coral island and reverting to savagery. Subsequent novels include *The Inheritors* (1955), set in the last days of Neanderthal man, and *Pincher Martin* (1956), describing the guilt-filled reflections of a man wrecked after his ship is torpedoed. *The Spire* (1964) reiterates Golding's vision of man as a creature that 'produces evil as a bee produces honey'. His *Rites of Passage* (1980) won the Booker Prize, and in 1983 he was awarded the Nobel Prize for Literature.

Goldoni, Carlo (1707–93), Italian comic dramatist. He was a lawyer until 1748, when demand for his plays enabled him to become a full-time writer. Enormously productive (149 *comedies) he moved to Paris in 1762 to work as dramatist and tutor to Louis XV's princesses, though his best plays are those written in Venetian dialect. He died a pauper in Paris, a victim of the French Revolution. Goldoni revolutionized the Italian theatre, weaning the public away from the stock characters and situations, improvisation, and buffoonery of the *commedia dell'arte*, to provide a genuine comedy of character, observed from life, in the manner of *Congreve and *Goldsmith.

Goldsmith, Oliver (*c.*1730–74), Anglo-Irish poet, dramatist, and novelist. He is best known today for his *comedy *She Stoops to Conquer* (1773), which plays on the confusions arising from a private house being mistaken for an inn. His most famous poem, *The Deserted Village* (1770), is a nostalgic lament for village life as it declines under economic pressures. His novel *The Vicar of Wakefield* (1766) tells of the complex misadventures of a vicar's family, and also contains the humorous 'Elegy on the

The salt-cellar made by Benvenuto Cellini for Francis I of France. An exceptional example of **goldwork**, it is fashioned from gold, enamel, and precious stones, and Cellini has left accounts of how he made it and what the various figures represent. The two principal figures depict the Ocean (in the person of Neptune) and the Earth (personified by a beautiful woman). (Kunsthistorisches Museum, Vienna)

Death of a Mad Dog' and the song 'When lovely woman stoops to folly'. Goldsmith was a member of *Johnson's Literary Club.

goldwork. From the earliest times gold has been one of the most prized of metals. As well as its beauty it is valued for its durability (it does not tarnish or corrode) and the ease with which it can be worked. Its softness means that it is often alloyed with other metals, such as copper and silver. Gold has been regarded as a symbol both of divinity and of royalty. Many religious objects, such as medieval crosses and reliquaries, were made from gold, while in ancient Egypt all gold was the property of the pharaoh. In Egypt gold was used in the funerary arts to cover mummies or tomb objects, resulting in such famous artefacts as the gold mask of Tutankhamun. The Cretans used gold for drinking cups adorned with scenes in relief, and the Greeks covered their statues in gold and precious stones. Many of the Pre-Columbian civilizations of South America were famed for their goldwork, particularly the Mixtecs of Mexico and the Incas of Peru, who paid religious tribute in the form of worked gold, treated as a gift to the sun god. By the 16th century goldsmiths were working to supply the rich with elaborately designed domestic objects such as the famous golden salt-cellar made by *Cellini for King Francis I of France. Styles in goldwork reflected the current fashions in design, such as the heavy and ornate Baroque work of the 17th century, which in turn was replaced by simpler more classical styles as tastes changed.

Gombrowicz, Witold (1904–69), Polish novelist and dramatist. In his first novel, *Ferdydurke* (1937), and the plays *Princess Ivona* (1938) and *The Marriage* (1953), he established the major preoccupations of his work, which are questions of immaturity and forms of behaviour. He saw the individual as struggling against sterile adherence

to form, his best weapon being to adopt the immature stance of the adolescent. In Argentina when World War II broke out, Gombrowicz began there to confront certain unflattering characteristics of Polishness in *Transatlantic* (1953) and his idiosyncratic *Diary* (1953–68).

Goncharov, Ivan (Aleksandrovich) (1812–91), Russian novelist. The hero of his masterpiece *Oblomov* (1859) embodies one of the great myths of the Russian man, presenting him as lazy, impractical, and fatalistic; this created a literary archetype recognized the world over.

Goncourt, Edmond (1822–96), and **Jules** (1830–70) **de,** French novelists and historians. They originally collaborated on historical works, including *La Femme au XVIIIᵉ siècle* (1863), and then turned the same technique of meticulous observation and exact documentation to the writing of novels. The most famous of these, *Germinie Lacerteux* (1864), is both a portrait of contemporary society and a psychological case-study based on the life of their own servant. The work of the Goncourt brothers is usually associated with the literary doctrine known as *realism, though it may also be seen as a forerunner of the later concept of *Naturalism. The Prix Goncourt was founded in 1903 by the will of Edmond Goncourt. It is the most important of the 1,500 literary prizes given each year in France.

gong, a bronze disc with turned-back rim, with either a flat face, usually then of indefinite pitch like the orchestral tam-tam, or with a central boss. Tam-tams seem to have originated in Central Asia and were perhaps known in ancient Greece and Rome. They travelled also to China and came thence into 19th-century Europe. Bossed gongs, always tuned to definite pitches, reached their peak of development in Java, where the great gong *ageng* and many smaller gongs make up the classical *gamelan. Gong orchestras are widespread in South-East Asia, though few are as carefully made and tuned as the Javanese. Chimes of tuned gongs are occasionally used in Western orchestras also.

Góngora y Argote, Luis de (1561–1627), Spanish poet. His early poetry is elegant and original, but his fame rests primarily on his mature works, which include *Panegyric for the Duke of Lerma* (1609), *The Tale of Polyphemus and Galatea* (c.1613), and the unfinished pastoral poem *The Solitudes* (1613). He introduced a baroque style (*gongorismo*) into Spanish literature through the Latinization of vocabulary and syntax, a play on classical allusions, and an extended use of *metaphor and complex *conceits. Rediscovered by *García Lorca and the *Generation of '27, Góngora has greatly influenced modern Spanish poetry. He is now acclaimed for his mastery of varied poetic forms, as well as for the longer poems of his maturity in which theme, language, tone, and structure are skilfully matched and controlled.

Goodman, Benny *big band, *jazz.

gopura, a term in Indian architecture for an elaborate gateway in the surrounding wall of a Hindu temple. Found mainly in the Deccan and south India, they were originally fairly small, but from about the 12th century they grew to be enormous, tiered, pyramid-like structures covered with elaborate carving.

Gordimer, Nadine (1923–), South African novelist and short-story writer. Her first collection of stories, *The Soft Voice of the Serpent* (1953), showed a precise psychological observation. Her later work is increasingly concerned with racial politics, notably in *A Guest of Honour* (1970), set in a newly independent African nation, and in *July's People* (1981), which envisages a future civil war.

Gorky, Arshile (Vosdanig Manoog Adoian) (1905–48), US painter, born in Turkish Armenia, who emigrated to the USA in 1920. He settled in New York, where in the 1940s he became involved with the circle of immigrant *Surrealists who had fled from Europe. Gorky has been called the last of the great Surrealists and the first of the *Abstract Expressionists; his work in the 1940s contributed to the emergence of a specifically American school of abstract art. At the peak of his powers, however, he suffered a series of misfortunes, and committed suicide.

Gorky, Maksim (Aleksey Mikhaylovich Peshkov), (1868–1936), Russian short-story writer and novelist. Of humble provincial birth, as a youth he wandered over Russia, working at many trades. In the 1890s he began publishing short stories based on his experiences, and achieved international fame. 'Twenty-Six Men and a Girl' (1899) encapsulates the central idea of all his work: that the strong, self-aware individual can overcome moral and physical misery. The heroine of *Mother* (1906) is Gorky's most poignant embodiment of the struggle between the heroic human spirit and its degrading environment; the trilogy *Childhood* (1913), *Out in the World* (1916), and *My Universities* (1923) tells of his self-liberation. An early Marxist and active sympathizer with the Russian revolutionary movement, he lived in Italy from 1905, returning to Russia in 1917 to help the literary intelligentsia oppose Lenin's dictatorial methods during the years of upheaval; he then spent most of the 1920s abroad. Returning in 1928, he became the first Chairman of the Union of Writers (1934) and the figurehead in Stalin's regimentation of literary life. He helped to consolidate the literary doctrine of *Socialist Realism, which was to turn Soviet writers into political propagandists.

Gossaert, Jan (Mabuse) (c.1478–c.1533), Netherlandish painter, active mainly in Antwerp. In 1508–9 he visited Rome, and his work thereafter was transformed by his experience of Italian art. He had a high reputation in his day, and a generation after his death the Italian biographer *Vasari acclaimed him as the first 'to bring the true method of representing nude figures and mythologies from Italy to the Netherlands'. *Dürer, rather more perceptively, said he was better in execution than invention.

Gosse, Sir Edmund William (1849–1928), British critic, scholar, and biographer. His father was a puritanical and authoritarian Christian, portrayed by his son in his masterpiece *Father and Son* (1907). He was translator for the Board of Trade for some thirty years, and librarian at the House of Lords (1904–14). Much of his scholarly work was devoted to Scandinavian literature and he was the first to introduce *Ibsen's name to England. He wrote biographies of Thomas *Gray, *Congreve, and *Donne. Vivid and intimate pen portraits of his literary contemporaries are to be found in his many critical writings.

A scene from the original production of **Gorky**'s *The Lower Depths* at the Moscow Art Theatre in 1902, directed by Konstantin Stanislavsky, who appears, *left*, as Satin. On the right is Olga Knipper, Chekhov's wife, as Nastya. A study of the wretched lives of derelicts, it is perhaps Gorky's best-known play and has frequently been revived. (Bakhrushin Theatre Museum, Moscow)

Gothic, the style of architecture and art that succeeded *Romanesque. It originated in France in the mid-12th century, spread rapidly to other countries, and lasted into the 16th century in many areas, particularly in northern Europe. The word was originally a term of abuse; it was coined by Italian artists of the *Renaissance to denote the type of medieval architecture which they condemned as barbaric—implying, quite wrongly, that it was the architecture of the Gothic tribes who had destroyed the classical art of the Roman Empire. The Gothic style is still characterized chiefly in terms of architecture, and by three features in particular: the pointed arch (as opposed to the round arch of Romanesque architecture); the rib *vault, in which transverse arches springing from the wall of the building support (or appear to support) the ceiling; and the flying *buttress, a type of external support that is not placed solidly against a wall, but is instead connected to it by an arch. None of these features was first used in the Gothic period (they are all found in late Romanesque architecture), but when employed together they created a new type of skeletal structure and a sense of graceful resilience that was different in spirit from the massive solidity of Romanesque buildings. Another highly characteristic feature of Gothic architecture that developed slightly later was the use of *tracery, decorative stonework in window openings or applied as ornament to wall surfaces. Window tracery, in fact, evolved in such distinctive and elaborate ways that its variations (or absence) have often been used as the most convenient method of classifying the different stages of the development of Gothic architecture. Whereas Romanesque architecture evolved gradually in several countries simultaneously, the birth of the Gothic style can be located precisely in time and place. The key work was the rebuilding of the abbey church of Saint-Denis, just outside Paris, between 1140 and 1144. The reconstruction of the abbey was carried out for Abbot Suger, one of the greatest

patrons of the Middle Ages. Only a small part of Suger's rebuilding survives intact, the ambulatory of the choir, but it is one of the most revolutionary structures in the history of European architecture. The heaviness of the Romanesque style has been completely abandoned, and the graceful columns, arches, and ribbed vaults create a remarkable feeling of airiness and elegant poise. Whereas in Romanesque churches the windows were openings pierced through a thick wall, here the windows have been enlarged to such an extent that they form a translucent wall supported by a framework of stone. It is astonishing that Suger's masons managed to bring the elements of the new style together with such total assurance. Saint-Denis was succeeded, in the following three-quarters of a century, by a series of great cathedrals in the Paris region that brought the Gothic style to its most sublime heights. Chartres, begun in about 1194, is sometimes considered the supreme example of a Gothic cathedral, because its glories include not only architecture but also sculpture and *stained glass of the highest quality. Many critics, however, consider that Amiens Cathedral (begun 1220) ranks even higher in architectural terms and marks the climax of French Gothic. The windows are now so large and the stonework so taut and membrane-like that the walls look like translucent, almost weightless curtains. Later French Gothic became more decorative in the *Rayonnant and *Flamboyant styles. Gothic spread from France to most parts of Europe and it took on distinctive forms in many countries. In Germany, for example, some of the finest Gothic churches (such as Cologne Cathedral) are very close to French models, but in northern Germany there was an independent tradition of brick churches in a simple but impressive style called *Backsteingotik*. In Italy the Gothic style took less firm root than elsewhere, and (with the conspicuous exception of Milan Cathedral) Italian churches of the period generally eschew the elaborate tracery, forests of buttresses, and spiky pinnacles of their northern counterparts, preferring instead broad relatively unadorned masses, the large areas of plain wall surface inside often being covered with *fresco paintings. Secular buildings as well as churches were designed in the Gothic style, and Belgium made a particularly rich contribution to this field with buildings such as the Cloth Hall in Bruges, celebrated for its towering belfry. Some of the earliest important English Gothic buildings (such

The nave of Bourges Cathedral (c.1190–1275), one of the finest buildings of the great period of **Gothic** art in France, contemporary with such masterpieces as the cathedrals at Amiens, Chartres, and Reims. These buildings show astonishing daring and technical mastery in raising soaring vaults over slender supports and they have a lucid grandeur of design that was later submerged in a love of decoration.

as the choir of Canterbury) were strongly influenced by French architecture, but England soon developed an extremely rich tradition of its own. Conventionally English Gothic is divided into three stages: *Early English, which began in about 1180; *Decorated, which began to take over in the late 13th century; and *Perpendicular which began in about 1330 and lasted well into the 16th century. The Perpendicular style, so called because of the predominating vertical lines and rectilinearity of its tracery and decorative panelling, was unique to England. Its greatest monument is the Chapel of King's College, Cambridge. English Gothic architects were virtuosi in wood as well as stone, two great masterpieces being the octagonal lantern at Ely Cathedral and the hammerbeam roof at Westminster Hall in London. The term 'Gothic' has much less precise meaning when it is applied to painting or sculpture than it has when it is used in architectural contexts, although a swaying elegance is often considered typical of Gothic figures, which are generally much more naturalistic and less remote than those of the Romanesque period. There were great sculptural ensembles (particularly around portals) at several cathedrals (notably Chartres and Reims), and the characteristic *gargoyles, but the most typical sculptural product of the age was probably the standing figure of the Virgin and Child, notably in ivory. In late Gothic Germany woodcarving reached great heights of beauty and elaboration. Gothic painting is seen at its best in manuscript illumination, and in stained glass which

reached its peak as an adjunct to Gothic architecture. Panel painting came more into its own with the development of the late branch of the style known as *International Gothic, which flourished at the turn of the 14th and 15th centuries. Among the other arts in which the Gothic period excelled were *embroidery and tapestry. (See also *International Gothic, *Gothic Revival).

Gothic novel, a story of terror and suspense, usually set in a gloomy old castle or monastery (hence 'Gothic'). The heyday of the Gothic novel in Britain lasted from the publication of Horace *Walpole's *The Castle of Otranto* (1765) to the 1820s. The leading Gothic novelist was Ann *Radcliffe, whose *Mysteries of Udolpho* (1794) had many imitators. She was careful to explain away the apparently supernatural occurrences in her stories, but other writers, like M. G. Lewis in *The Monk* (1796), made free use of ghosts and demons. The fashion for such novels, ridiculed by Jane *Austen in *Northanger Abbey* (1818), gave way to a vogue for *historical novels, but it contributed to the new emotional climate of *Romanticism. The claustrophobic, sinister atmosphere of later 19th-century fiction is often based on Gothic novels, which can also claim to have inspired modern *science fiction through Mary *Shelley's partly Gothic *Frankenstein* (1818).

Gothic Revival, a movement in architecture and associated arts in which the *Gothic style of the Middle Ages was revived. Beginning in the mid-18th century, it was partly of literary origin and partly a breakaway from the rigid *Palladian rules of architectural design then prevailing. Initially, Gothic forms were used in a *Rococo spirit for their *picturesque qualities, with no regard for archaeological accuracy. In the early 19th century, however, the Romantic interest in medieval forms and fancies gave way to a more serious approach, as the Gothic style became closely identified with a religious revival; it was advocated by architects such as *Pugin as the only one suitable for churches, as opposed to the 'pagan' *Renaissance style, and churches were built in careful imitation of the constructions of the Middle Ages. Scholarly imitation in turn gave way to more original adaptations, and the Gothic style was much used for civic, commercial, and even domestic buildings as well as churches. The Gothic Revival had its fullest expression in Britain (where the original Gothic style had never entirely died out), but throughout Europe and the USA buildings of all kinds were designed in medieval styles as part of the vogue for revivals characteristic of 19th-century architecture. (See also *Burges, *Butterfield.)

Gottfried von Strassburg (early 13th century), German poet. He is the author of an unfinished *narrative poem *Tristan* (c.1210) which is based on a French version of Celtic legends and is the source of *Wagner's opera *Tristan and Isolde* (1865). Gottfried's work uses the illicit love between Tristan and Isolde, the wife of his uncle, King Mark, for a pessimistic exploration of the situation of individuals searching for perfection through mystical union, in a hostile and restrictive society. Gottfried was a master of rhetorical form, and his verse is the most flexible and mellifluous of any medieval German poet.

gouache, opaque *water-colour. The degree of opacity varies with the amount of white pigment added to the

colour, but in general it is sufficient to prevent the reflection of the paper through the paint, and it therefore lacks the luminosity of transparent water-colour wash. Gouache was used for manuscript illumination, on fans, and for preparatory sketches. The term 'body colour' is sometimes used as a synonym for gouache.

Gounod, Charles (François) (1818–93), French composer. He became a church organist in Paris, and briefly studied for the priesthood, but abandoned these studies in favour of composition. Gounod's musical output includes a series of masses and other sacred works, and two symphonies. However, his reputation, which was once overwhelming, now rests on his operas (in particular *Faust* (1859) based on *Goethe's drama), his songs, and the *Petite Symphonie* for ten wind instruments (1885).

Gower, John (c.1330–1408), medieval English poet, who wrote in English, French, and Latin. In French he wrote *Mirour de l'omme* (c.1376–8), a moral *allegory concerned with the virtues and vices of fallen man, and in Latin, *Vox clamantis* (c.1379–81), an apocalyptic poem containing reflections on the disturbances of the early years of Richard II and the Peasants' Revolt. In English he wrote *In Praise of Peace*, as well as his major work *Confessio amantis* (c.1390), containing 141 stories of courtly Christian love largely derived from classical authors and medieval *romance. It is written in octosyllabic *couplets which he handled with brilliant metrical skill.

This etching is part of **Goya**'s series of sixty-five prints *The Disasters of War*, which he made in 1810–14. These nightmarishly savage scenes depict atrocities committed by both sides and are among the most powerful anti-war statements ever made. Contrary to the conventions of his time, Goya does not show heroics and glory—only mutilation, pain, and death. (Courtauld Institute Galleries, London)

Goya y Lucientes, Francesco José de (1746–1828), Spanish painter and graphic artist. His genius was slow to mature, and he was well into his forties before being appointed a court painter to Charles IV. He was the victim of a mysterious and traumatic illness in 1792–3 which left him deaf, and during his convalescence, 'to occupy an imagination mortified by the contemplation of my sufferings', he painted a series of pictures of 'fantasy and invention' that mark the beginning of the preoccupation with the morbid, the bizarre, and the menacing that was to be such a feature of his mature work. Goya made his living principally as a portraitist (and in this field he ranks among the greatest masters), but his imaginative gifts were brought out most fully by themes involving cruelty and terror. They included scenes from the bullfight and the madhouse, and the French occupation of Spain (1808–14) led him to create scenes of atrocities that are among the most savage anti-war protests ever produced. They include his famous series of etchings *The Disasters of War* (1810–14). The culmination of his career is a series of murals, known as the 'Black Paintings', done for his own house and now in the Prado, Madrid. They depict nightmarish scenes, painted with an almost ferocious intensity and freedom. His output also included cartoons for the royal tapestry factory in Madrid (the major work of his youth), numerous religious paintings, and one of the most famous nudes in the history of art, the *Naked Maja* (c.1800), said to represent the beautiful Duchess of Alba, whose relationship with Goya caused scandalous gossip. After 1815 he virtually retired from public life, and in 1824 he settled in France.

Graham, Martha (1894–), US dancer and choreographer. She studied with Ruth *St Denis and Ted *Shawn and danced with their company before starting on a solo career in 1926. She founded her own school and company in 1927 and 1929 respectively, the most significant *modern dance school and company to emerge from the early 20th century. Her technique arose from a

Martha **Graham** is one of the most original and influential figures in modern dance, outstanding as a dancer, choreographer, and teacher. Small in stature she nevertheless had a commanding and dynamic stage presence. Rather than telling stories, as in traditional dancing, her work explores emotions and psychological situations.

need to give expression to ideas like the mythic and mystical themes of *Primitive Mysteries* (1931), to stories of Greek origin, *Night Journey* (1947), and to American pioneer themes, *Frontier* (1935). For these works she fashioned an abrasive and dramatic technique based on the notion of 'contraction and release', a percussive and spare style. Later works such as *The Witch of Endor* (1965) were more lyrical. Modern dancers such as *Cunningham, Hawkins, and *Taylor trained in her school, danced for the company, and later set up their own companies.

Grahame, Kenneth (1859–1932), British writer. Six of his essays, published as *Pagan Papers* (1893), describe the life of a family of five orphans, who reappear in *The Golden Age* (1895) and in its continuation, *Dream Days* (1898). The sharp observations of the child narrator and the authenticity of childhood vision brought him critical and popular success. His children's classic *The Wind in the Willows* (1908) was based largely on bedtime stories and letters to his son. It was dramatized by A. A. *Milne as *Toad of Toad Hall* in 1930.

Grainger, (George) Percy (Aldridge) (1882–1961), Australian-born US composer and pianist. He settled in 1900 in London as a successful concert pianist, also becoming deeply involved in the revival of interest in the tunes and texts of *folk music. In 1914 he moved to New York, acquiring US citizenship in 1918. In 1938 he inaugurated a research institute studying ethnic music and instruments at Melbourne University. His own music is unconventional and resolutely unacademic, but also highly imaginative. A lifelong search for 'free music' anticipated later *electronic developments.

Granados y Campiña, Enrique (1876–1916), Spanish composer and pianist. As a composer his most lasting success came in 1911 with the piano suite *Goyescas*, descriptive of seven paintings by *Goya. Material from the suite was later (1916) worked into an opera with the same title. Though unmistakably Spanish, his music was less insistently nationalistic than that of Albéniz or Falla.

Grand Guignol, Théâtre du, a theatre opened in Paris in 1899 which featured short, violent sketches. The Guignol was the chief character of the traditional popular *puppet play: the French equivalent of the British Punch and the German Hanswurst, or Kasperl. In Paris the name attached itself to cabarets which specialized in short plays of violence, murder, rape, ghostly apparitions, and suicide. In a modified form these made their appearance in London in 1908 and have been seen sporadically ever since. Its true home now remains in the small theatres of Montmartre.

graphic art, a term used in the context of the fine arts to refer to those arts (drawing and the various forms of *engraving) that rely on line or tone rather than colour as does painting. Some writers, however, exclude drawing from this definition, so that the term 'graphic art' is used to cover the various processes by which *prints are created. In another sense, the term—sometimes shortened to 'graphics'—is used to cover the entire field of commercial printing, including text as well as illustrations. (See also *typography.)

Grass, Günter (Wilhelm) (1927–), German novelist, poet, and dramatist. His early work shows traces of existentialism and the grotesque, elements which can be found in the *picaresque novel *The Tin Drum* (1959). Two further novels also relating to Danzig, Grass's birthplace, *Cat and Mouse* (1961) and *Dog Years* (1963), show him as a committed socialist exploring with technical virtuosity the average German's complicity with Nazism and the complacent atmosphere of West Germany's post-war 'economic miracle'. His recent novels include *The Flounder* (1977), a ribald fable that treats relations between the sexes from prehistoric times to the present, and *The Rat*, which is set in a post-nuclear-war Europe.

Graves, Robert van Ranke (1895–1985), British poet and novelist. His prodigious output includes volumes of verse, essays, fiction, biography, children's works, and translations. His autobiography *Goodbye to all that* (1929) describes his unhappy schooldays, his experiences in the trenches in World War I, and the breakdown of his first marriage; its tone is distinguished by the passionate disillusion of the post-war generation. His many novels include *I, Claudius* and *Claudius the God* (both 1934). His

Collected Poems (1955) confirmed his status as a major poet. His writing is lucid, intense, and epigrammatic and defies classification within any school or movement; his self-imposed exile in Egypt, France, and Majorca distanced him from literary developments in Britain.

Gray, Thomas (1716–71), British poet. A precursor of the *Romantic movement, he spent most of his life in Cambridge. He published several odes before completing 'Elegy written in a Country Church-Yard' (1751), one of the best known *lyrics in the English language, which reflects on the obscure destinies of the villagers buried there and, through them, on the fate of all men. His last major works were the Pindaric *odes on 'The Progress of Poesy' (1757) and 'The Bard' (1757). He lies buried in the churchyard at Stoke Poges, Buckinghamshire, celebrated in his 'Elegy'.

Greco, El (Kyriakos Theotokopoulos) (1541–1614), Cretan-born painter, sculptor, and architect known by his nickname, meaning 'the Greek'. In Crete he was trained in the local tradition of *icon painting, but little is known of his work before he moved to Italy in the 1560s. *Tintoretto and *Michelangelo had a particular influence on his style. In 1577 El Greco settled in Toledo in Spain, where he stayed for the rest of his life, painting a succession of great altar-pieces. His distinctive style features ecstatic figures elongated into flame-like forms; through them he rapturously expressed the awesomeness of great spiritual events. He also excelled as a portraitist, particularly of churchmen, and painted two striking views of Toledo. In addition he designed complete altar compositions, working as architect and sculptor as well as painter. The strangeness of his art has inspired suggestions that he was mad, but his paintings express the religious fervour of his adopted country. After his death he was generally forgotten until the development of *Expressionism in the early 20th century.

Greek and Roman novel, the 'novel' of the classical world, conventionally applied to a number of disparate works from antiquity. In Greece, especially from the 2nd century AD onwards, a type of romantic fiction flourished, in which young people finally marry after prolonged tribulations. *Daphnis and Chloë,* by Longus (2nd–3rd century AD), is made particularly attractive by its pseudo-naïveté and its bucolic setting. In Latin the satirical romance *Satyricon* was written by Petronius Arbiter (probably the courtier of Nero *c.*60 AD), relating the adventures, often unsavoury, of the narrator Encolpius. Equally striking is the *Metamorphoses* ('Golden Ass') of Apuleius (2nd century AD), recounting the difficulties of Lucius, who is turned into an ass but eventually rescued by the goddess Isis. Both books seem to have Greek counterparts, but they are quite different, in their vigour and occasional coarseness, from the surviving Greek novels.

Greek art, the art and architecture of Greek-speaking societies from the beginning of the *Iron Age (11th century BC) to the late 1st century BC. Earlier (*Bronze Age) art of the Greek mainland and islands (with the exception of Crete, where there was a distinct tradition called *Minoan Art) is known as *Mycenean Art, and later Greek art, known as *Hellenistic art, is considered part of the culture of the Roman Empire. Solid bronze statuettes of men, and particularly horses, are the earliest Greek sculpture. The first nearly life-sized statues were made about 650 BC in stone. These statues are stiff and one-dimensional. In the beginning of this, the 'Archaic Period', the sculptor, to avoid cutting the stone deeply, rendered features and muscles as markings on the surface. Sculptors of the 6th and early 5th centuries studied the forms of the body, gradually working out its proportions. Sculpture developed so that a statue was interesting from any angle, instead of only its front or side. Statues were painted throughout the Greek period. Many, buried in the debris after the Persians had sacked the Athenian Acropolis (citadel) in 480 BC, were excavated with their colour still preserved. The victories over the Persians in the early 5th century BC were followed by a graver, grander style, which found characteristic expression in

This marble statue of Hermes with the infant Dionysus is one of the most fascinating examples of **Greek art**. Ancient literary evidence suggests that it is an original work from the hand of the 4th-century BC sculptor Praxiteles, which would make it a survival of the utmost rarity, for the statues that were famous among the Greeks are today known mainly through Roman copies. Certainly it has a delicacy in the modelling of forms and a subtlety of finish far removed from the workmanship seen in most Roman copies, but its authenticity is not established. (Museum of Archaeology, Olympia)

sculpture, as at Olympia. It was a period of increasing naturalism, and the sculptor, certain of his mastery of body forms, turned to representing all forms of action. Myron's Discobolos, an athlete hurling the discus, made in about 450 BC, was originally in bronze, but survives only in Roman marble copies. Indeed most sculptors of this period worked in bronze; hollow bronze casting was invented in the 6th century, but no works remain from earlier than the 5th. Few life-size bronzes survive, except in copies, but we have one, by an unknown sculptor, which must be among the greatest—the bronze statue of Zeus hurling a thunderbolt, found in the sea off Cape Artemisium, and dated about 470-460 BC. *Phidias, between 445 and 432 BC, made the two most famous statues, the Athene of the Parthenon, and the Zeus of Olympia. Both are known only by late copies and descriptions. They were colossal, with ivory flesh and golden garments. The sculptures of the Parthenon show Phidias' largeness of style and design, splendid strength, delicacy, and subtlety. His contemporary, *Polyclitus, in about 440 BC made a statue of a youth holding a spear, embodying what he considered the ideal *proportions of the human figure. In the 5th century emotion was shown in the whole figure rather than in the face, which was generally shown with calm features. Fourth-century sculptors such as *Scopas concentrated on representing intellect and emotion through the face, and this led to the development of *portraiture. Earlier portraits had idealized the subject, representing a type rather than an individual. Drapery became dramatic, with swirling folds, creating complications of light and shade, and indicating different textures. The human body was soft and graceful but lacked the strength and dignity of earlier work. This change is seen in the works of *Praxiteles (mid-4th century BC), who worked mainly in marble. Greek architecture has an equally long and distinguished history. Early Greek temples were small hut-like buildings of rubble or mud-brick, sometimes thatched. Colonnaded temples of stone were rare before the 6th century. The design was simple— a rectangular building on a foundation of usually three steps, with columns (see *orders of architecture) at the porch, at either end, or all round. The Greeks did not use the *arch, their buildings depending for effect on the strong contrast of light and shade on horizontals and verticals. Figure sculpture in the round filled the triangular gable (pediment) at each end of the building, and reliefs were carved on the horizontal beams supported by the columns. The sculpture usually told a story, often that of the god or hero of the place. Pediment figures with elaborate scenes of movement have been preserved from temples at Aegina (early 5th century), Olympia, and the Parthenon (mid-5th century BC). In the reliefs the artists had to solve the problems of showing in a depth of a few inches figures overlapping and receding in space. This was brilliantly achieved on the Parthenon frieze in Athens, where horsemen are shown effectively grouped. Some of these, known as the 'Elgin Marbles' after Lord Elgin, who had obtained permission from the Turkish government to bring them to Britain (1802-12), are now on display in the British Museum in London. Little is left of large-scale Greek wall-painting, except for some remarkable tomb paintings of the 4th and 3rd centuries BC, notably the royal tombs at Vergina, Macedonia. Although the work of painters such as *Zeuxis has left no trace, we can follow its influence in vase painting, an art practised by artists of great skill (see

*Greek vases). The Greeks were adept at other arts: superb examples of bronzework have been found at Vix in central France (c.500 BC), for example. Gem engraving reached a peak of perfection with the work of Dexamenos in the late 4th century, and jewellery of considerable refinement has been found in Magna Graecia (southern Italy) and southern Russia. Greek art did not end with the Roman conquest of Greece, or even with the transition from the ancient to the medieval world; it developed as *Hellenistic art and later as *Byzantine art, and has been at the foundation of the art of western Europe. Its lasting influence is due to its sense of reason and balance, its concentration on humanity, and its sheer beauty. (See also *Hellenistic art.)

Greek literature (ancient), the literature of the ancient and classical eras of Greece. The earliest European literary works are the epic masterpieces the *Iliad* and the *Odyssey*, attributed to *Homer. Among other early *epic poems are those of *Hesiod, which are didactic in tone. Fragments of many other early Greek poets survive, both *elegiac and personal, among the greatest of which are the poems of *Sappho. Lyric poetry (see *Greek lyric poetry), for choral performance, together with the song and dance in the ceremonies honouring Dionysus in Athens, laid the foundations for the *Greek theatre, both *tragedy and *comedy. *Iambic verse was employed especially for invective by poets like Archilochus (7th century BC); the *metre, well suited to more colloquial speech, went on to be the vehicle for the non-choral parts of drama. Elegiac verse was widely employed, for epitaphs and even, as by Solon (c.630-c.560 BC), for political exhortation. Prose was a late development. Herodotus (c.490-430 BC) and Thucydides (c.460-400 BC) are the greatest among a rich tradition of historians whose writings continue to be read for their literary worth. Democracy, introduced in the 5th century BC, brought with it the need to be persuasive in court and public assembly, and the sophists or itinerant professional teachers, whose uniting aim was to expound the new art of *rhetoric, supplied the need. The great age of oratory, however, is the 4th century, the most notable name being that of the Athenian Demosthenes (384-322 BC). At this time, too, literature and philosophy were married to wonderful effect in the dialogues of *Plato, whose pupil Aristotle (384-322 BC) was to create for Western civilization a whole vocabulary of literary, philosophic, and scientific thinking. By this time 'Old Comedy', with its free criticism, gave place in a less libertarian world to the stereotypes of 'New Comedy'. This marked the end of the classical age of Greek literature c.320 BC, though what followed was interesting in itself and important for its effect on *Latin literature, which was developing at the same time. The next period of Greek literature reached its peak in Hellenistic Alexandria, where a number of major writers were employed. *Callimachus' poetry is noted for its brevity, sophistication, and inventiveness in form. Apollonius of Rhodes (3rd century BC), in his long poem on the voyage of the Argonauts, adapted the language of Homer to a romantic epic, while Theocritus (c.270 BC) broke altogether new ground with his *Idylls*, which do not restrict themselves to the *pastoral. He was followed by the biographer and philosopher *Plutarch (AD c.46-126), whose *Parallel Lives* was later to supply, for example, the material for some of Shakespeare's plays. Most Greek poetry which survives from the period after

the Alexandrian Age is in the form of *epigram. An attractive product of later Greek literature was the witty and satirical œuvre of the prose-writer Lucian (AD c.120– after 180) whose *True History* influenced such writers as Rabelais and Swift. A reaction against the extravagance of some Asian Greek oratory initiated a period of 'Atticism', when the restraint and even the vocabulary of the earlier Athenian orators became the norm. Such antiquarianism set its mark on literature for many centuries, affecting both the great Christian writers of the 4th century and their Byzantine successors until the fall of Constantinople in 1453.

Greek literature (modern), the literature of modern, as distinct from classical, Greece. Between the fall of Constantinople (1455) and the War of Independence (1821–6) Greek literature developed in two independent traditions. In Crete (until it fell to the Turks in 1669) and the Ionian islands writers wrote in a form of language close to the spoken language (demotic). Elsewhere literature was mostly cultivated by the Phanariots, the Greek administrative class within the Ottoman Empire, who wrote principally in a form based on classical and church Greek. In the 19th century literature was dominated by Ionian islanders—the poets Dionysios Solomos (1798–1857) and Andreas Kalvos (1792–1869)— who successfully combined Greek preoccupations with aspects of European *Romanticism. But in the 1880s political and cultural nationalism led to the growth of the folklore movement, and mainland poets and prose-writers such as Kostis Palamas (1859–1943) began to write, mostly in demotic, about modern Greece's roots, customs, and conditions. The movement culminated in Palamas's nationalist epics *The Dodecalogue of the Gipsy* and *The King's Flute*. At the same period Greek poetry was being renewed in a very different way in Egypt, by *Cavafy. After the Balkan Wars and the disastrous Greco-Turkish war of 1922, literature could no longer draw on the nationalist aspirations of the previous generation. With the exception of Angelos Sikelianos (1884–1951), a lyrical mystic, the 1920s offered a pessimistic reaction, coupled with an attempt to adapt to an increasingly urban culture. But the so-called 'generation of the '30s' opened up new perspectives in poetry, particularly under the influence of *Surrealism, and sought new ways to understand and explore Greekness. The major, though very different, figures to emerge were *Kazantzakis, *Seferis, and Odysseus Elytis (1911–), who received the Nobel Prize for Literature in 1979. The novel in Greece developed more slowly than poetry. The major novelists of the 1930s, reacting to the experience of war, re-examined their environment and roots. The sufferings undergone by Greece in World War II and the subsequent civil war led to a greater politicization of the novel. Post-war Greek literature has continued this trend towards a greater element of commitment, whether political or social. There has also been more formal experiment in prose fiction, particularly in the work of G. Chimonas (1936–) and Aris Alexadrou (1922–78). Another significant development has been the growth of major women writers in both prose and poetry in the last forty years, reflecting the rapidly changing position of women in Greek society.

Greek lyric poetry, poetry in ancient *Greek literature accompanied by the *lyre. It could be sung by an individual (*monody*) or by a *chorus accompanied by dance as well as music, composed for a religious festival. Around 600 BC *Sappho and Alcaeus, both living on the island of Lesbos, composed lyric poetry to celebrate their emotions and concerns; remarkable fragments of their work survive. The poems of Anacreon (c.570 BC) and the drinking songs (*skolia*) of Athenian aristocrats followed on in the same tradition. Choral lyric reached its peak in the works of Bacchylides (5th century BC) and *Pindar. Their *odes are usually in praise of the god and human involved in the occasion, and contain a moral message. Choral lyric found a secure place in the structure of 5th-century tragedy (see *Greek theatre).

Greek Revival, a movement in architecture expressing a new interest in the simplicity and gravity of ancient Greek buildings: an aspect of the broader movement called *Neoclassicism (see *Greek art). Greek architecture became widely known in western Europe only in about 1750–60 and in the early days of Neoclassicism it was regarded as primitive, few architects caring to imitate it. In the 1790s Greek-style buildings became fashionable, however, and the movement culminated in the 1820s and 1830s. Leading exponents included *Ledoux in France, *Schinkel in Germany, and *Soane in England. Imported to America by *Latrobe, the Greek Revival became something of a national style in the first half of the 19th century.

Greek theatre, the drama of the ancient and classical eras of Greece. It was characteristically performed on a flat, circular space containing the altar of Dionysus, called the *orchestra*, where the *chorus sang and danced and the actors spoke. The *skene* or stage-buildings were at first very simple, and the audience sat on wood or stone seats, rising around the orchestra. Plays were performed in the open air and in daylight. A notable tradition of drama grew up in Athens, where both *comedy and *tragedy were regularly performed at the festival of Dionysus, a god of the fertility of nature associated with religious rites. Poets presented three tragedies (often not connected in theme) and a satyr play (lighter in tone). Prizes were given for the best poet, and the victor was wreathed in ivy. Early developments are obscure, but the Attic poet Thespis (c.534 BC) is said to have made the decisive step of introducing an actor whose role it was to conduct a dialogue with the chorus. The Athenian *Aeschylus is said to have brought in a second actor, *Sophocles a third. Though the choral element remained important, its changing character can be traced in the surviving plays of the three great exponents of tragedy, Aeschylus, Sophocles, and *Euripides. The subject-matter of Greek tragedy is almost always mythological, though occasionally contemporary events could be presented, as in Aeschylus' *Persians*. Action tends to take place off-stage, and is often reported in the speeches of a messenger. Actors and chorus alike wore *masks. The chorus was present throughout the play. Choral and non-choral elements alternate, but there is no fixed structure. Some mechanical devices were used: a derrick or 'machine' could raise characters in the air (hence *deus ex machina, 'god from a machine'), while the *ekkuklema* (a moving platform) could reveal action inside a house. *Aristotle's precepts for the best kind of tragedy, given in his *Poetics*, do not fit many of the surviving plays. In 'Old Comedy' (c.5th century BC), which we can properly judge only from *Aristophanes, and which presented political, lit-

erary, and philosophical parodies interspersed with personal lampooning, the chorus again plays an important part. Its address to the audience in the poet's name, and unconnected with the action of the drama, is known as the *parabasis*, and its grotesque costume, with the phallus *de rigueur* for male roles, symbolizes the irreverence that governed the whole occasion. After a transitional 'Middle Comedy' (c.400–c.320 BC), we come to 'New Comedy', starting in the last part of the 4th century BC and now easier to recapture in the newly discovered *Ill-Tempered Man* of *Menander. It contains little contemporary reference, and its domestic plots and characters are largely stereotyped. There is a regular division into five acts, and the dramatic chorus, once the representative of forces larger than life, has either completely disappeared or become a small band of musicians and dancers who provide light entertainment. Both Greek tragedy and 'New Comedy' had their imitators in Latin (see *Latin literature and *Roman comedy). (See also *theatre.)

Greek vases, decorated clay vessels made by the ancient Greeks from the 12th century BC. Because almost all panel

The **Greek theatre** at Epidaurus (c.350 BC) is the best-preserved building of its type; the stage section is ruined, but the seating for about 12,000 spectators remains. Most Greek cities were built on or near hills, so theatres were generally built in a natural hollow, suitably excavated and terraced. Initially spectators sat on temporary wooden banks, but after an accident in Athens in 499 BC, safer, more permanent seats were introduced.

and wall pictures of the time have been destroyed, vases—which survive in great numbers—are the main source of first-hand knowledge of Greek painting. For the earliest period of Greek art, indeed, vases are virtually the only surviving works. Vases were made in a great variety of shapes and sizes: some of the commonest types are the amphora, used mainly for storing wine; the hydria, a water-jug; the krater, used for mixing wine and water; and the lekythos, an oil-bottle. The earliest type of decoration on Greek vases consisted of geometric bands; these came to incorporate stylized plant, animal, and figural decoration, and eventually the human figure came to be the dominant motif, often illustrating scenes from Greek legend. There were two main techniques of Greek vase-painting: black-figure and red-figure. In the former, which originated in Corinth in the 7th century BC, the figures were painted in black pigment or sometimes by overpainting in red or white. In the red-figure technique, the background was painted black, leaving the figures in the unpainted red colour of the pottery. Details of the figure could thus be added with a brush rather than incised through the black paint, allowing much greater flexibility and subtlety of treatment. Because of this advantage the red-figure technique, which developed in Athens from about 530 BC, rapidly superseded the black-figure technique.

Green, Henry (Henry Vincent Yorke) (1905–73), British novelist. His first novel, *Blindness* (1926), appeared when he was still an Oxford undergraduate, but he is better known for *Living* (1929), about factory life in Birmingham, and *Loving* (1945), set in an Irish country house. He is noted for his strangely poetic and colloquial style.

Greene, (Henry) Graham (1904–), British novelist and dramatist. Preoccupations with moral dilemma (personal, religious, and political) and with divided allegiance characterize his work. His output, which spans half a century, includes the novels *The Power and the Glory* (1940), *The Heart of the Matter* (1948), set in Sierra Leone where Greene had worked for the Foreign Office in World War II, *The End of the Affair* (1951), and *The Captain and the Enemy* (1988), set in wartime London and revolutionary South America. Other works of fiction which he classified as 'entertainments' include *Brighton Rock* (1938), the first of his novels with a strong Roman Catholic message (he was converted to Catholicism in 1926), and *Our Man in Havana* (1958), set in pre-Castro Cuba. *The Third Man* (1950), a mystery melodrama, was originally written as a screenplay and filmed in 1949. His plays include *The Complaisant Lover* (1959). He has also written short stories, books of reportage and travel, children's books, and autobiography.

Greuze, Jean-Baptiste (1725–1805), French painter, enormously successful with sentimental and melodramatic *genre scenes. He also found a good market for titillating pictures of young girls, which contain thinly veiled sexual allusions under their surface appearance of mawkish innocence. With the swing of taste towards *Neoclassicism his work went out of favour; he sank into obscurity following the Revolution in 1789 and died in poverty.

Grieg, Edvard (Hagerup) (1843–1907), Norwegian composer and pianist. He trained at Leipzig and later in

Greek Vases

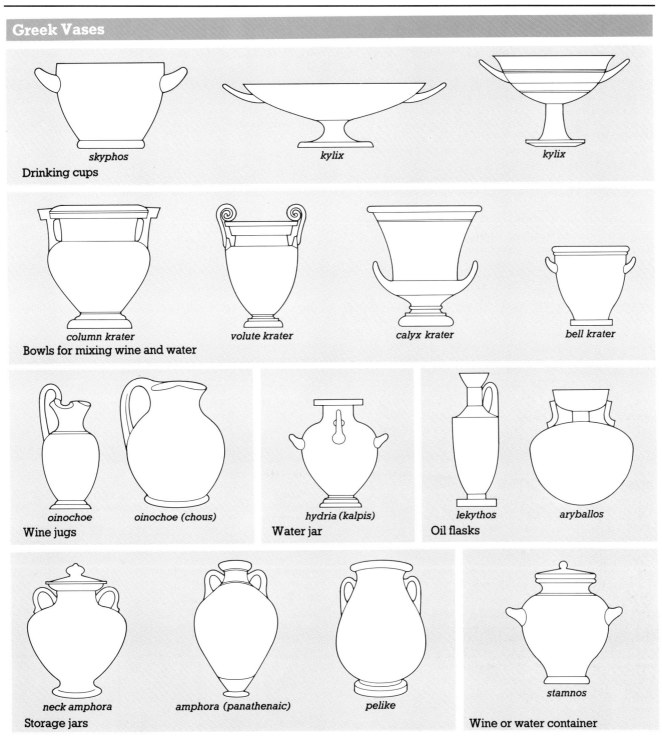

skyphos kylix kylix

Drinking cups

column krater volute krater calyx krater bell krater

Bowls for mixing wine and water

oinochoe oinochoe (chous) hydria (kalpis) lekythos aryballos

Wine jugs Water jar Oil flasks

neck amphora amphora (panathenaic) pelike stamnos

Storage jars Wine or water container

Copenhagen. In 1864 he spent the summer with the violinist Ole Bull, and later worked with the composer and *folk music enthusiast Rikard Nordraak. These experiences fired his imagination and from 1866 he set himself the task of creating a national style—partly through the music he wrote, and partly through the recitals he gave in partnership with his wife, the singer Nina Hagerup. Despite the popularity of his Piano Concerto (1868) and the *suites of incidental music to *Sigurd Jorsalfar* (1872) and *Peer Gynt* (1875), his finest work is to be found in his songs and short piano pieces.

Griffith, D(avid) W(ark) (1875–1948), US film director, one of the great figures of the early cinema. In around 450 films made between 1908 and 1913 (mostly fifteen-minute one-reel films) he abandoned the theatrical type of presentation hitherto favoured for a fluid, cinematic use of the camera, moving it about and bringing it closer to the actors, whom he also trained to behave more cinematically. He began making feature-length films in 1914, and the spectacular *Birth of a Nation* (1915), about the American Civil War, was one of the most ambitious films ever made, gaining the cinema a new respectability. His next film, *Intolerance* (1916), used four separate stories to drive its message home. *Hearts of the World* (1918) had a World War I background, combining a fictional story with *documentary material. In 1919, with *Chaplin and others, he founded the United Artists

Corporation, which released his *Broken Blossoms* (1919), a touching *melodrama set in Limehouse, London's Chinese quarter. After *Isn't Life Wonderful?* (1924), a naturalistic film about contemporary Germany, Griffith's career went into decline. He made his last film, *Abraham Lincoln*, in 1931, only a year after his first sound film, and died in obscurity.

Grillparzer, Franz (1791–1872), Austrian dramatist and poet. His plays, mostly on historical and mythological subjects, explore the tragic ambivalence of human action and will and their interaction with an unsympathetic society. He was belatedly recognized as perhaps the greatest tragedian of the Austrian stage. Most notable among his works are *Sappho* (1818), on the irreconcilability of art and life; his patriotic drama *King Ottokar: His Rise and Fall* (1825), which explores the proximity of inevitable failure and apparent success; his classical tragedy *The Waves of Sea and Love* (1831); and his comedy *Woe Betide the Liar* (1838). His verse play *A Dream is Life* (1834) was influenced by the popular Viennese theatre and by Mozart's *Magic Flute*. In 1823 he wrote *Melusina* as a libretto for Beethoven; another contemporary, Franz Schubert, set his poem *Berthas Lied* to music (1819).

Grimm, Jacob (1785–1863), and his brother **Wilhelm** (1786–1859), German writers and scholars, pioneers of German nationalism. The brothers' work must be seen against the background of contemporary *Romantic notions of the nature of the German people, dashed hopes of German unification in 1815 and 1848, and accelerating social change. For the Grimms German nationhood was vested in its language, and the study of its history and literature was an expression of patriotic unity. Their famous collection of folk-tales, *Children's and Household Tales* (1812–15, revised 1819), known in the English-speaking world as *Grimm's Fairy Tales*, is an attempt to identify and preserve the original spirit of the people in a changing world. The same notions underlie their many editions of medieval literary texts, among them Jacob's *German Grammar* (1819–22), which initiated the historical study of the German language, and the brothers' *German Dictionary* (1852, completed 1961).

Grimmelshausen, Johann Jakob Christoffel von (1622–76), German satirical novelist. Of the massive literary output of the 17th century his novel *The Adventurous Simplicius Simplicissimus* (1668–9) is one work which remains outstandingly alive. It is narrated with vivacity and humour, drawing on an original and erudite combination of indigenous, *picaresque, and other foreign literary traditions which offer a specifically German view of the Thirty Years War (1618–48) in which Grimmelshausen himself had served. *Simplicissimus* is also an *allegory of the development of the Christian soul, in which the simple hero, having attempted to gain a material foothold in a chaotic world, realizes his folly and turns to God. The best known of Grimmelshausen's other writings is *Runagate Courage* (1670), on which Bertolt *Brecht based his play *Mother Courage* (1938–9).

Gris, Juan (1887–1927), Spanish painter, sculptor, graphic artist, and designer, active mainly in Paris, where he settled in 1906. Almost all his serious painting belongs to the *Cubist movement, though his work was generally more calculated than that of *Picasso or *Braque, and

he is regarded as the chief originator of the 'synthetic' type of Cubism. In the 1920s his style became more fluid. His output included a number of book illustrations and numerous designs for stage sets (see *set design) and costumes, notably for the great Russian ballet impresario *Diaghilev.

grisaille (French, *gris*, 'grey'), a painting done entirely in shades of grey or another neutral greyish colour. Grisaille is sometimes used for underpainting or for sketches (Rubens often painted sketches in grisaille), and in the Renaissance it was used for finished works imitating the effects of sculpture. The earliest known use of grisaille is in Giotto's series of *Virtues* and *Vices* (*c.*1305) in the Arena Chapel in Padua.

Gropius, Walter (1883–1969), German-born architect, designer, and teacher. He became a US citizen in 1944, and was one of the most internationally influential figures in modern art and design. He worked with *Behrens and practised independently as an architect before founding the *Bauhaus in 1918. He was Director until 1928, then resumed his architectural practice in Berlin, before leaving Germany in 1934 because of the rise of Nazism. After working in England for three years, he settled in the USA, where he became professor of architecture at Harvard. He remained active to the end of his long life and had an extensive list of notable buildings to his credit,

The Fagus Factory (1911) at Alfeld-an-der-Leine was **Gropius**'s first important commission, and it is a revolutionary building. The supporting structures of the wall are recessed, so the windows seem to form a transparent skin around the building, a treatment that was to become one of the standard patterns of modern architecture.

among them the Fagus Works (1911) and the Bauhaus itself at Dessau (1925–6). His buildings are characterized by an uncompromising use of modern materials (he was one of the pioneers in the use of a glass screen to form an entire outer wall of a building), but also by lucidity and gracefulness. His whole approach to design was influential: he believed it should be a response to the needs and problems of society, utilizing to the full the resources of modern technology and expressing the ideal of a humane, integrated community.

Grosz, Georg (1893–1959), German-born painter and draughtsman. From 1917 to 1920 he was prominent among the *Dada group in Berlin and during the 1920s he became a leading exponent of *Neue Sachlichkeit* ('New Objectivity'). He denounced a decaying society in which gluttony and depraved sensuality exist alongside poverty and disease; prostitutes and profiteers are frequently depicted in his work. In 1933, despairing of the political situation in Germany, he moved to the USA, where his work declined in quality.

grotesque, a term in art originally applied to a type of mural decoration—painted, carved, or moulded in stucco—incorporating floral motifs, animal and human figures, and masks, combined into fanciful and playful schemes. This type of ornamentation was used in Roman buildings and was revived during the Renaissance; the buried ruins in which examples were discovered were called *grotte* ('caves' or 'grottoes'), hence the name. By extension, the term has come to be applied to any bizarre, distorted, or incongruous representation.

Group f.64, a US-based association of photographers (1932–5). It created a new style of clearly defined and sharply detailed photography, in revolt against the soft-focused, academic photography then fashionable. The name refers to an aperture setting which facilitates this style. Its members included Edward *Weston and Ansel *Adams; the exhibition staged by the Group in 1932 marked a turning-point in US photography.

Grub Street, a street in London (now renamed Milton Street) off Chiswell Street by Finsbury Square, which was occupied in the 18th century by impoverished writers who turned out third-rate poems, reference books, and histories to make a living. The term now covers any such underworld of literary penury, as in *Gissing's novel *New Grub Street* (1891). Its writers are known as 'hacks': an abbreviation of 'hackney', a hired horse.

Grünewald, Mathis (c.1470–1528), German painter. Grünewald's work forms a complete contrast to that of his contemporary Dürer. Whereas Dürer was an intellectual imbued with Renaissance ideas and had limitless visual curiosity, Grünewald concentrated exclusively on religious themes, in particular the Crucifixion. His most famous treatment of it is the central panel of his masterpiece, the Isenheim Altarpiece (c.1512–15) in Colmar. The intensity with which Grünewald represents Christ's physical sufferings, his expressively distorted body convulsed with pain, makes this one of the most unforgettable images ever painted. At the end of his career Grünewald's fortunes declined. It was not until the advent of *Expressionism in the early 20th century that his few surviving works began to arouse widespread interest.

Guan Hanqing (c.1241–1322), Chinese dramatist of the Yuan dynasty (1279–1368), considered by many critics to be the greatest playwright of the Chinese classical theatre. Guan was an actor and theatre-manager born in Beijing, said to have written over sixty plays, although only seventeen survive. Many of his plays portray women of low social standing, who suffer deprivation and injustice. His sympathy with his characters is reflected in his best-known play, *Injustice to Dou E*, about a widow executed after confessing under torture to a murder she had not committed. His style is simple and direct, making his plays accessible to theatre audiences.

Guardi, Francesco (1712–93), Venetian painter, the best-known member of a family of artists. Apart from *Canaletto, he is the most famous painter of Venetian *veduta* ('views'), but unlike Canaletto he had little worldly success. He produced work on a great variety of subjects, and for much of his career his personality was largely submerged in the family studio, which handled commissions of every kind. He died in poverty, and appreciation of his genius came only in the wake of *Impressionism, when his vibrant and rapidly painted works were seen as having qualities of spontaneity and atmosphere lacking in Canaletto's more deliberate and sharply defined works. His brother **Gianantonio** (1699–1760), who was head of the Guardi studio, may also have been an artist of stature, but it is difficult to isolate what he painted himself, and the highly original paintings representing *The Story of Tobit* in the church of Sant' Angelo Raffaele in Venice are attributed to him by some critics and to Francesco by others.

Guarini, Guarino (1624–83), Italian architect. The spiritual heir of the great *Borromini, Guarini was a priest, a philosopher, and a mathematician, facts relevant to his architecture, for his buildings combine geometrical complexity with a sense of spiritual exaltation. He built churches in places as far apart as Lisbon, Messina, Paris, and Prague, but almost all his surviving work is in Turin. His most famous buildings are the Chapel of the Holy Shroud (1667–90) in Turin Cathedral and the church of S. Lorenzo (1668–87), celebrated for their breathtaking openwork domes of interwoven arches. Guarini also designed secular buildings, notably the Palazzo Carignano in Turin (1679–83), which has a spectacular curved façade. Among Guarini's many learned publications was the architectural treatise *Civil Architecture*, posthumously published in 1737; this helped to spread his influence, which was strongest in Central Europe.

Guercino, Il (Giovanni Francesco Barbieri) (1591–1666), Italian painter. His nickname, meaning the squinter, was given to him because of an eye defect. In his early work he drew on north Italian sources to create a highly individual style characterized by dramatic lighting, strong colour, and broad, vigorous brushwork. In 1621–3 he worked in Rome, painting the famous ceiling fresco of *Aurora*, a bravura triumph of *Baroque illusionistic decoration, in the Casino of the Villa Ludoviso. His later works can be remarkably similar to Guido *Reni's, calm and light in colouring, with little of the lively movement of his early style.

Guimard, Hector (1867–1942), French architect and designer, France's leading exponent of *art nouveau. His

In Vermeer's painting *The Guitar Player*, a young girl plays a Baroque **guitar**, plucking the five double courses, or pairs, of gut strings with her fingers. The sound-hole is covered with perforated parchment that is, like its architectural counterpart, known as a rose, and the borders of the sound-board and the neck are inlaid with purfling of thin strips of ebony and ivory. (The Iveagh Bequest, London)

finest building is the Castel Bérenger (a block of flats) in Paris (1894–8); Guimard was much influenced by *Horta, and here, as in Horta's Hôtel Tassel in Brussels, he unified architecture, furniture, and decoration with flowing scrolls of vegetal ornament. Guimard is most widely known not for buildings, however, but for his entrances to Paris Métro stations (mostly *c.*1899–1900), in which he used cast iron in imaginative plant-like forms.

güiro, a scraper used in Latin American music. Usually made from a gourd with notches cut in one surface, which are scraped with a stick or similar implement. Bamboo and other tubes are sometimes used instead of gourds. It is included, as *râpe* (French, 'rasp'), by Stravinsky in *The Rite of Spring*.

guitar, a plucked musical instrument, today usually with six strings. Early guitars had four courses or pairs of strings, the highest single, the others double, tuned in a fourth, a third, and a fourth. A further course was added a fourth higher, and then another a fourth lower, creating the 18th-century instrument. The 19th-century guitar was radically redesigned, with six single strings, and the

modern body-shape was created by Antonio de Torres Jurado (1817–92). Francisco Tárrega (1852–1909) is held as the founder of the modern school of the classical guitar, carried further by *Segovia. Today there is a wide diversity of types, some played with a *plectrum, from the steel-string and the twelve-string folk guitars to electric and now electronic instruments. Electric guitars can, through a variety of accessories, produce a wide range of sounds, all recognizably those of a plucked string. Electronic instruments, with a midi-computer, can imitate any other instrument. In addition, there is a considerable range of local guitar types around the world.

Gu Kaizhi (344–405), Chinese painter. He is the earliest identified Chinese painter of whose work we have visual evidence; several later copies survive and a handscroll in the British Museum in London, *Admonitions of the Instructress to the Court Ladies*, is just possibly an original work by him. It illustrates a text made up of advice to concubines on behaviour at court, and the style is delicate, wispy, and subtle. There is almost no indication of spatial setting, the artist relying on the tension between the figures to hold the picture together.

Gupta art, the art and architecture associated with the Gupta dynasty (*c.*320–*c.*550), which ruled over all of northern India and parts of central and western India. Founded by Chandragupta I, the Gupta dynasty brought peace and prosperity to a vast area and witnessed a great flourishing of the arts; indeed the Gupta period is often characterized as the 'golden age' of Indian culture. In architecture the temple assumed the form that it was to retain in essence for centuries, and in sculpture the emphasis was on statues of Buddha and Bodhisattvas (see *Buddhist art). Figures were characteristically severe and majestic with uncluttered surfaces, emanating a sense of great spiritual power. In painting the Gupta period is represented through the great cave paintings at *Ajanta and the minor arts also flourished, Gupta gold coins being particularly outstanding. Literature and the dance, too, reached high levels under the Gupta dynasty, which was brought to an end by invasions by the Huns in the 6th century.

Habimah (Hebrew, 'stage'), a Jewish theatrical company founded in Moscow in 1917 to promote the revival of Hebrew in Russia. It became famous in 1922 with its production of Ansky's *The Dybbuk*. The company made a world tour in 1926, returning to new headquarters in Berlin. It visited Palestine in 1928 and settled in Tel Aviv in 1932, where it was designated a National Theatre in 1958.

Hāfiz, Shams al-Dīn Muhammad (1325–90), Persian poet. Little is known of his life other than that he was born and lived all his life in Shiraz, Southern Iran. He is generally considered the greatest master of the *ghazal* or sonnet in Persian literature, and his collection, or *dīvān*, is held in high esteem in Iran. It has been translated into all the major European languages, and the German translation of 1812 greatly influenced Goethe's collection of poems, 'Der West-östliche Divan' (1819).

Haggard, (Sir Henry) Rider (1856–1925), British writer. Southern Africa provided the setting for his most celebrated novels, *King Solomon's Mines* (1885), *Allan Quatermain* (1887), and *She* (1887). In all he wrote thirty-four adventure novels variously set in Mexico, Iceland, Egypt, and Turkey.

Hague School, group of Dutch painters including the brothers Jacob, Matthijs, and Willem Maris and Anton Mauve who worked in The Hague between about 1860 and 1900. The group is particularly associated with *landscapes and beach scenes, but its members also painted street scenes, views of everyday life, and church interiors. They had a special interest in sensitively recording light and atmospheric effects, and in this they looked back to the great Dutch landscapists of the 17th century and also showed something in common with the *Barbizon school and the *Impressionists.

haiku, a form of Japanese *lyric verse which encapsulates a single impression of a natural object or scene, within a particular season, in seventeen syllables arranged in lines of five, seven, and five syllables. Arising in the 16th century, it flourished in the hands of *Bashō and Buson (1715–83). During the Tokugawa or Edo period (1603–1867) it was known as a *hokku*, the introductory stanza of a *haikai no renga* sequence (see *renga), but it became a separate form in the modern period under the influence of Masaoka Shiki (1867–1902). The haiku convention, whereby feelings are suggested by natural images rather than directly stated, has appealed to many modern Western imitators, especially *Pound and his followers.

Hall, Sir Peter (Reginald Frederick) (1930–), British theatre and opera manager and director. Among his most memorable productions was the first English-language staging of Beckett's *Waiting for Godot* (1955). His best known productions include *The Wars of the Roses*, a cycle of plays based on the three parts of Shakespeare's *Henry VI* and *Richard III*. He has produced many new plays by avant-garde European and British writers. He was managing director of the Royal Shakespeare Company (1960–8) and director of the *National Theatre (1973–88).

Hals, Frans (*c*.1581–1666), Dutch painter, the first great artist of the 17th-century Dutch School and one of the most famous of all portraitists. In 1616 he came to prominence with his first great work, the life-size group portrait of *The Banquet of the Officers of the St George Militia Company*. In its vigorous composition and characterization this picture broke free from the rigid conventions of the group portrait. Like another celebrated Hals picture, *The Laughing Cavalier* (1624), it demonstrates to the full his broad brush-strokes and his remarkable ability to capture a sense of fleeting movement and expression and thereby convey a compelling feeling of vivacity. From the 1630s his work began to grow more sober and restrained, and in some of his late masterpieces he approaches *Rembrandt in depth of characterization and sombre grandeur. Destitute in his last years, his reputation did not long outlive him and it was not until the late 19th century that his genius was widely recognized.

Hammerstein, Oscar, II *Rodgers, Richard.

Hamsun, Knut (1859–1952), Norwegian novelist, dramatist, and poet. His early novels of the 1890s (*Hunger*, 1890, *Mysteries*, 1892, *Pan*, 1894) embody his theories of the 'unconscious life of the soul', reflecting the turbulent inner conflict of modern man, and written with haunting lyrical intensity. In later works (including *Segelfoss Town*, 1915, and *Growth of the Soil*, 1917, for which he won the Nobel Prize for Literature in 1920) he turned to social issues, attacking modern capitalist decadence and celebrating the ideal of the noble peasant. His extreme conservatism led him to support Hitler, but the rich inventiveness of his later works (like the 'August' trilogy, 1927–33) is unaffected by his political bias.

Handel, George Frideric (1685–1759), German-born composer, who spent most of his working life in Britain. His first operas, *Almira* and *Nero*, were successfully produced in 1705. Invited to Italy, he soon established himself as a leading composer of Italian *opera. In 1710 he left Italy to become Kapellmeister (director of music) to the Elector of Hanover (who in 1714 became King George I of England). He made his first visit to London in 1711, where *Rinaldo*, written for the occasion, proved a sensational success. He returned to London in 1712, this time for good. For a while he dominated the London stage with his operas. However, increasing financial difficulties forced him to bring his operatic ventures to an end (1736) and exploit the less costly field of the *oratorio. Though not all his oratorios were successful (not even *Messiah* (1742) initially), the popularity of *Saul* (1739), *Samson* (1743), *Judas Maccabaeus* (1747), and *Joshua* (1748) restored his fortunes and he died a wealthy man. The growing fashion for *Baroque music has now enabled more of his instrumental music to reach a wide audience. *The Water Music* and *Music for the Royal Fireworks* are now often given in their original form. The *concerti grossi of Op. 6 are now seen as the summit of a tradition begun by *Corelli, whose 'classical' balance and emotion Handel enlivened. His extraordinary musicianship inspired admiration from other musicians—Mozart re-

Painted between 1730–35, Philippe Mercier's portrait was owned by the composer **Handel** until 1748. Unlike many other artists, Handel enjoyed a high reputation and some prosperity during his lifetime, and his music never really went out of fashion after his death, especially in Britain, his adopted country. (Private Collection)

orchestrated several of his oratorios—and the younger generation of British composers had difficulty in breaking away from his style.

Han Yu (768–824), Chinese essayist and poet of the Tang dynasty (618–907). Han was a *Confucian scholar who advocated a simpler, freer, and more direct prose and poetry style based on models from the Han dynasty (206 BC–AD 220) and earlier. In his most famous essay, 'Memorial on the Bone of the Buddha', he attacked Buddhism as a foreign religion, criticizing the emperor for paying respect to the supposed finger of the Buddha. His own essays, for example 'On Man' and 'On the Way', are among the most beautiful written in Chinese.

happening, a form of entertainment, often carefully planned but usually involving some degree of spontaneity, in which an artist performs or directs an event combining elements of theatre and the visual arts. The term was coined by the US artist Allan Kaprow in 1959, and happenings became a popular means of artistic expression in the 1960s, often involving spectator participation. Happenings are related to Performance Art; the two terms are sometimes used more or less synonymously.

hard-edge painting, a term applied to a type of painting (predominantly abstract) in which forms, although not necessarily geometrical, have sharp contours and are executed in flat colours. The term was first used in 1958 and it is applied mainly to the type of painting that emerged in the USA as a reaction to the spontaneity of *Abstract Expressionism.

hardingfele (or hardanger fiddle), a Norwegian folk *fiddle preserving many features of the earliest violins, including a short, straight neck and a very highly arched body, which is usually well decorated with inlay and carving. There are usually four sympathetic strings below the bowed strings. Tunings are varied to suit the music being played.

Hardouin-Mansart, Jules (1646–1708), French *Baroque architect, the great-nephew of François *Mansart, with whom he collaborated early in his career. Hardouin-Mansart was the most successful architect of *Louis XIV's reign, for although his work was less inventive and subtle than that of his great-uncle, he had a feeling for grandiose display that matched the king's artistic taste, and he was an excellent administrator, capable of controlling the vast royal building works at Versailles. His work there includes the Hall of Mirrors (Galerie des Glaces) and the Chapel, but his masterpiece is the splendid domed Church of the Invalides in Paris (1679–91).

Hardy, Thomas (1840–1928), British novelist and poet. The son of a stonemason, he was born in Dorset, where he spent much of his life. Here, and in the surrounding counties (which he named 'Wessex') he set many of his novels. He abandoned his career as an architect's assistant after the success of his fourth novel *Far from the Madding Crowd* (1874). The theme that underlies many of his novels is man's struggle against an indifferent cosmic force that inflicts suffering upon him. This is at times relieved by his humorous and sympathetic presentation of rural characters. His other major novels include *Under the Greenwood Tree* (1872), *The Return of the Native* (1878), *The Mayor of Casterbridge* (1886), *The Woodlanders* (1887), and *Tess of the D'Urbervilles* (1891). He enjoyed the praise of London's literary and aristocratic society but was mortified by the criticism of reviewers about his 'pessimism' and 'immorality'. *Jude the Obscure* (1896), a story (in Hardy's words) 'of deadly war waged between flesh and spirit' caused a literary uproar and he wrote no more fiction. His epic drama *The Dynasts* (1904–8), combining verse and prose, centres on the tragic figure of Napoleon. Most of his poems and novels reveal Hardy's love and observation of the natural world, often with symbolic effect. He experimented with rhythms and verse-forms, and his *Collected Poems* (1930) contains over 900 poems. He also published volumes of short stories, including *Wessex Tales* (1888). He married twice, first Emma Lavinia Gifford and after her death Florence Dugdale, herself a writer of children's books.

Harīrī, Muhammad ibn al-Qāsim al- (1054–1122), Arab philologist and poet. His fame rests on his set of fifty *maqāmāt* or dramatic anecdotes written in rhymed prose that Arabs commonly consider to be second only to the *Koran in literary merit. Each *maqāma* is an independent discourse in rhymed prose, with some verse, featuring the doings of a *picaresque rogue Abū Zayd.

Their popularity is due not only to the author's extraordinary mastery of language and allusion but also to the general wit of his discourses and the everyday character of the events that he describes.

harlequinade, a play in which Harlequin plays the leading role. As a theatre form it originated in the fusion of the Italian *commedia dell'arte* with the dumbshows of the actors at the Paris fairgrounds, where dialogue was forbidden. Harlequinade was an important element in the development of the English *pantomime. It originally consisted of story-telling dances in which Harlequin, a quick-witted, unscrupulous servant, dressed usually in a patched suit, soft cap, and small black cat-faced mask, played the leading role. He was later transformed into the persecuted lover, fantastically dressed in a silken suit of brightly coloured diamond patches, and retaining from his origins his black mask and his magic wand, or bat (see *slapstick). In the 19th century Grimaldi made the purely English character *clown into the chief personage, and to ease the burden on the dancers the harlequinade was preceded by a fairy-tale. As Harlequin's importance lessened and the fairy-tales became longer, the harlequinade dwindled into a short epilogue to what became the present English pantomime. It was finally abandoned completely.

harmonica, a mouth-blown *free-reed musical instrument, also called a *mouth organ or blues harp by folk musicians, invented by Christian Buschmann about 1821 and developed by later makers. Simple harmonicas are diatonic; chromatic instruments have a slide which, when pressed in, blocks off the basic row of reeds and opens access to a second row a semitone higher. Both models have reeds for the common chord sounding on blow, and the other notes of the scale sounding on draw; players block the unwanted reed chambers with the tongue to sound notes one by one or in particular chords.

harmonic flute, a flute without finger-holes, sounding only the overtones of the harmonic series. Most are short enough that players stop the distal end with a finger, producing the overtones of a stopped flute, odd-numbered harmonics of a fundamental an octave lower than that of the open flute. By interlocking that series with the open-tube harmonics, players can produce a complete harmonic series from a tube half the length of an open flute. Some harmonic flutes are end-blown, for example the Romanian *tilinka*. Others are duct-blown, for example the Norwegian *selje-fløyte*, a seasonal flute made of a tube of bark in the spring, though nowadays a plastic version is used all year round. Much larger harmonic flutes, nearly 3 metres (about 10 feet) long, are played in pairs, blown transversely in alternation, in New Guinea as ritual instruments.

harmonics, a term used to describe the lesser vibrations produced by voices or instruments that add colour to the main note. Voices and instruments produce their sound when something is made to vibrate—the vocal cords, a column of air, a stretched string. Each main vibration contains a series of lesser vibrations. Thus a string vibrates along its whole length, and also in halves, thirds, quarters, fifths, and so on. The main note that we hear is that of the whole vibrating string, the first harmonic. The lesser vibrations (harmonics, overtones, or partials) produce

With his famous diamond-patterned costume, Harlequin is the most distinctive character of the *commedia dell' arte*. He is athletic, witty, and amorous; this painting by Goya, *Strolling Players* (1793) shows the characters of the **harlequinade**. (Prado, Madrid)

their own sounds, though these are largely overshadowed by the first harmonic. The harmonics enable us to distinguish between the sound of different voices or instruments. Each emphasizes different harmonics and therefore has a characteristic timbre. Harmonics follow a mathematical progression, and as the series rises the intervals between them grow smaller, as shown in the example of the harmonic series of the note C.

1st 2nd 3rd 4th 5th 6th 7th 8th 9th 10th 11th 12th 13th 14th 15th 16th

*Pitches evolved in this way are said to be acoustically 'pure'. So too are the intervals that arise between them. Western music, however, has preferred to make slight adjustments away from acoustically pure tuning in order to enjoy the advantages of equal *temperament. In comparison with the 'tempered' tuning of the piano, the 7th, 13th, and 14th harmonics actually sound slightly flat, and the 11th slightly sharp. Individual harmonics can be made to stand out clearly by damping down the first harmonic. Thus if a violinist bows an open string and simultaneously touches it at the half-way point, the

sound of the second harmonic (an octave above the first) will be heard—a delicate, silvery note. Touched a third of the way along, the same open string will produce the third harmonic, and so on.

harmonium, a musical instrument, a reed-organ blown by the player with a pair of pedals. It is often used as a substitute for a church organ, with *free-reeds instead of pipes, especially in chapels and small churches. The harmonium was also popular for domestic use. Strictly the harmonium blows air past the reeds, as opposed to an American organ, which sucks air past them. Instruments vary in size from small and portable for outdoor services to large and ornate, with as many stops and ranks of reeds as a church organ has pipes.

harmony (in music), the art of using *chords, involving not only the way in which individual chords are constructed, but also their relationship. This aspect of music only began to be codified into a specific 'grammar' with the establishment of a system of *tonality during the 17th century; harmonies began to be thought of as entities in themselves, as distinct from being the vertical outcome of horizontal lines in combination: *polyphony giving way to homophony. Such vertical combinations of notes as seemed pleasant to the ear were known as concords. Those that seemed less pleasant were discords. Both were linked by accepted methods of progression that stemmed, ultimately, from the harmonic series. Discords always needed to be 'resolved' on to concords, and concords moved in stately progression from one to the other. Fundamental to this practice was the idea of diatonic harmony—chords built from the notes of the major or minor *scale. Chords involving notes outside the scales were said to be chromatic. It was only when chromatic harmonies began to be accepted as the norm, at the end of the 19th century, that the tonal system was undermined and new ways of explaining music (such as *serialism) had to be found.

harp, a plucked musical instrument with strings rising vertically from the resonator to an arm or neck. A forepillar may hold the arm from the resonator, but many regional harps are open, with either a curved or an acutely angled arm. Harps were perhaps the earliest stringed instruments of civilization, possibly even older than *lyres. Arched harps may be seen as a development from the musical *bow; they have a curved wooden neck, a hollowed-out soundbox with a skin belly, and under this, pressing upwards against it under string tension, a stick holding the strings. Such harps are today played by singers in central Africa, often held with the neck pointing away, and deep-sounding with their low-tension strings. India knew arched harps in the later centuries BC; one type has survived in the Nuristan area of Afghanistan and another in Burma. The European harp, with a sloping soundbox, strings tuned at the neck above, and a rigid column in front, can first be made out in pictures and carvings of the 9th and 10th centuries AD. The medieval harp was small, often placed on the knee between the player's arms, and had about 19 strings. Renaissance harps were a little larger, with 24 to 26 strings from F to G upwards. They seem often to have been fitted with 'brays'—wooden soundboard-pins shaped in an obtuse angle for the string to buzz against the tip. In Spain as early as 1378 (about the time of the

development of the chromatic keyboard instruments) one reads of a 'double harp' (*arpa doble*). This later came to signify a harp with a second row of strings to provide accidentals. The 'double harp' was also made in Germany up to the mid-18th century, but in that country, from the late 17th century, greater use was made of the single-row harp with hand-turned 'hooks' of stout iron wire for the semitones—like those of the present so-called Celtic harp. In the 18th century various pedal mechanisms were invented, each controlling all the strings of one note name. In 1810 Sébastien Érard patented his double-action harp in which each pedal has three positions: this became the basis of the modern concert harp. The present Celtic harp derives its size and shape—with the column out-curved in older Irish and medieval style—from the 'portable Irish harp', produced in Dublin about 1819 by the maker John Egan as a drawing-room successor to the old professional Irish harp. 'Bardic' or 'knee harps' (Gaelic *clàrsach*) are based on the medieval Irish and Scottish models. The Welsh triple harp was known in Italy around 1600 and adopted by the Welsh harpists in the 17th century, replacing an older single-strung harp and becoming their normal instrument, until almost wholly replaced by the pedal harp after the mid-19th century.

harpsichord, a keyboard musical instrument. A wooden jack resting on each key jumps up so that a quill, set in a tongue, plucks the string. As the jack falls back, the tongue tips, preventing the quill plucking again. During the 16th century two distinctive types of harpsichord developed, the bright-sounding Italian and the rather richer Flemish. By the 18th century, French, German, and English harpsichords were also established, each with a characteristic tone quality; thus Bach, Couperin, Scarlatti, and Handel each wrote for different sonorities. Mechanisms also developed. Contrasting tone qualities were available using two keyboards (double-manual), several rows of jacks, and several ranks of strings, usually two ranks in unison (8'), one an octave higher (4'), and occasionally in Germany one an octave lower (16'). The 8' ranks, one on each manual, had different tone qualities, and an extra row of jacks plucked the upper 8' near its bridge, producing a sharp nasal sound (lute stop). A batten, fitted with little pieces of buff leather, could be slid against one 8', muting the sound (buff or harp). These effects could only be produced by moving a stop with the hand, and thus changes were normally made only between movements.

Harris, Joel Chandler (1848–1908), US author of children's fiction and short stories. He published the first of his Uncle Remus stories in 1879. These verses and tales were based on the folklore of former plantation slaves, told in dialect by the story-teller Uncle Remus. The central animal characters, led by Br'er Rabbit and Br'er Fox, are noted for their humorous dialogue and homely wisdom. Harris also wrote stories set in Georgia for adults.

Harris, Roy (1898–1979), US composer. His large output includes sixteen symphonies, written between 1933 and 1979, of which the Third (1937) made a particularly strong impression. His music is stark and forceful, highly contrapuntal (see *counterpoint), and often based on American folk idioms and Protestant hymn tunes.

Hart, Lorenz *Rodgers, Richard.

Hašek, Jaroslav (1883–1923), Czech novelist and short-story writer. His satirical masterpiece, *The Good Soldier Schweik* (1920–3), recounts the *picaresque adventures of the archetypal survivor, Švejk, a private serving in the Austro-Hungarian army, who feigns idiocy in order to prevail over the inhumanity of the military machine. In Prague Hašek edited anarchist publications (1904–7); he was drafted into the Austrian army in World War I and was captured by the Russians. He was briefly a member of the Czech liberation army, but later joined the Bolsheviks and wrote Communist propaganda.

hatching, the use of finely spaced parallel lines to suggest shading. The technique is found mainly in drawing and *engraving, but it is also used, for example, in *tempera painting. When crossing sets of parallel lines are used, the term cross-hatching is used.

Hauptmann, Gerhart (1862–1946), German dramatist, poet, and novelist. A consistent use of dialect and a refusal to shirk unpleasant realities places him at the forefront of German *Naturalism. Hauptmann characteristically introduces outsiders—the idealist Alfred Loth in *Before Dawn* (1889), the 'new woman' Anna Mahr in *Lonely People* (1891), and the soldier Moritz Jäger in *The Weavers* (1892)—as catalysts to critical situations, thus initiating events that are sound in theory but in practice catastrophic. Hauptmann also produced an effective and popular comedy written in the Berlin dialect, *The Beaver Pelt* (1893). He was awarded the Nobel Prize for Literature in 1912.

Hausmalerei (German, 'home painting'), a term applied to factory-made products (mainly pottery and enamel, but also glass and silver) decorated by independent artists working in their own homes or studios and not always with the manufacturer's approval. This type of work flourished mainly in Bavaria, Silesia, and Bohemia during the 17th and 18th centuries, and many Hausmaler of the period are known by name.

Havel, Václav (1936–), Czech dramatist. His first play, *The Garden Party* (1963), uses the technique of the Theatre of the *Absurd to satirize post-war Czechoslovak society. *Largo Desolato* (1984) and *Temptation* (1985) continue his preoccupation with the individual at odds with a pervasive bureaucracy, while *Letters to Olga* (1989), based on letters addressed to his wife from prison, reflects on the interior life of the individual under state socialism in Eastern Europe. An active campaigner for human rights he suffered frequent imprisonment by the authorities and his writings were banned. In 1989 he was in the vanguard of the peaceful revolution that caused the overthrow of the Communist regime and its replacement by a multi-party system, and late in the same year he was elected as President of his country.

Hawksmoor, Nicholas (1661–1736), English architect, with *Vanbrugh the outstanding figure of the brief *Baroque period in Britain. Unlike Vanbrugh, a brilliant 'amateur', Hawksmoor was a thoroughly trained professional, a rarity in England at this time. He was *Wren's assistant for many years, and also provided expertise for Vanbrugh at Castle Howard and Blenheim. A man of humble origins and modest nature, Hawksmoor was slow in establishing an independent career, but there is nothing hesitant about his buildings, which are bold, dramatic, and highly original, using the forms of classical architecture with energetic freedom. He combined something of the monumental grandeur of Roman buildings with the daring vigour of the Gothic style, as in Christ Church, Spitalfields (1714–29), one of six churches he built in London. Hawksmoor also did work on royal buildings and country houses, and designed university buildings in Oxford and the west towers of Westminster Abbey. His genius was little appreciated until the 20th century.

Hawthorne, Nathaniel (1804–64), US novelist and short-story writer. After bringing out his first collection of stories, *Twice-Told Tales* (1837), he worked in the Boston Custom House (1839–41) and briefly joined the experimental commune at Brook Farm; in 1842 he took a house in Concord, Massachusetts, the centre of the *Transcendentalist movement. *Mosses from an Old Manse* (1846), his second collection of stories, was hailed as a work of genius by *Melville, whom he later befriended. It was followed by a period of great creativity: his masterpiece, *The Scarlet Letter* (1850), a sombre romance of conscience and the tragic consequences of concealed guilt; *The House of the Seven Gables* (1851), tracing the legacy of the Puritan era as far as the 19th century; and *The Blithedale Romance* (1852), which makes comic use of his Brook Farm experiences. He also produced *The Snow Image and Other Twice-Told Tales* (1851) and two books for children before becoming US Consul in Liverpool (1853–7). Two further years were spent in Italy, and they resulted in *The Marble Faun* (1860), a novel about American artists in Rome. For Hawthorne America was a land of ghosts, and he was unable to share the *Transcendentalist optimism of contemporaries like *Emerson and *Thoreau. His work seems old-fashioned in its fondness for *allegory, modern in its darkness and psychological acuteness. Many of his short stories are classics, and he is recognized as a leader in the development of the *short story as a distinctive American genre.

Haydn, (Franz) Joseph (1732–1809), Austrian composer, one of the most highly skilled musical craftsmen of all time. Born in modest circumstances, he received his first musical training as a chorister and in 1740 was chosen for the choir of St Stephen's Cathedral, Vienna, where he remained for twenty years. In 1761 he entered the service of the aristocratic Magyar family of Esterházy, directing all the musical activities in their palace of Esterháza at Eisenstadt, and composing church, opera, chamber, and orchestral music in great quantity, as well as 108 symphonies. His originality of thought, rich sense of harmony, and thematic development, are to be found particularly in his sixty-seven string quartets. The early pieces are suites of simple movements, but later works are balanced sets of four contrasted movements, built symphonically from closely argued themes and employing every device available to music. On the death of Prince Nikolaus Esterházy (1790) Haydn retired to Vienna. Visits to London in 1791–2 and 1794–5 (crowned by the twelve 'London' symphonies) were particularly successful and aroused his interest in choral music. In collaboration with the amateur musician Baron von Swieten he composed two *oratorios in the English as opposed to the Italian manner, that is, giving an important role to the choir rather than writing in a predominantly *opera seria*

A performance of **Haydn**'s opera *The Unforeseen Encounter* in the castle of his patron Prince Nikolaus Esterházy in Hungary. The figure at the keyboard (*far left*) is probably the composer himself directing his work; this gouache was painted between 1766 and 1790. (Deutsches Theatermuseum, Munich)

manner, based on the aria. *The Creation* was completed in 1798, and *The Seasons* in 1801.

Haydon, Benjamin Robert (1786–1846), British painter. His ambition was to paint historical and religious works in the grand manner, but his talents fell far short of his ambitions and his real monument is his autobiographical writings, which give a detailed picture of English cultural life in his day as well as of his disturbed mind. Haydon was closely linked with the *Romantic movement in literature, and painted portraits of Keats and Wordsworth. In 1846 he shot himself in his studio.

Hazlitt, William (1778–1830), British essayist and critic. Influenced by *Coleridge and encouraged by Charles *Lamb, he embarked on a prolific and versatile career that included painting and journalism. He was a supporter of the French Revolution and of Napoleon and showed a deep concern for the social conditions of his own country. Notable among his works are his literary criticism, *Characters of Shakespeare's Plays* (1817); *Lectures on the English Comic Writers* (1819); *Political Essays* (1819); and *Liber Amoris* (1823), an account of his obsessive love for Sarah Walker. Many of his best essays, noted for their forceful style, were written during this period and were published in his two most famous books, *Table Talk* (1821) and *The Plain Speaker* (1826). At the height of his powers as a critic he published *The Spirit of the Age* (1825), a selection of incisive portraits of his contemporaries.

Heaney, Seamus (Justin) (1939–), Irish poet. His early poetry is rooted in the Derry farmland of his youth,

as in *Death of a Naturalist* (1966) and *Door into the Dark* (1969), which express complex feelings in homely images. His later, densely written work broods on the cultural implications of words and on the interweaving of politics and tradition, as in *Wintering Out* (1972), *North* (1975), and *Field Work* (1979). *The Government of the Tongue* (1989) discusses the role of the poet in an authoritarian society. In the year of its publication he was elected Professor of Poetry at Oxford University.

Hebbel, (Christian) Friedrich (1813–63), German dramatist and poet. Hebbel locates the essential conflict of *tragedy not in specific moral transgression but in the very assertion of the self against the universal will. In his prose play *Judith* (1840) the heroine's tragedy lies in the realization that offended womanhood rather than divine commission motivates her murder of Holofernes. In *Agnes Bernauer* (1851) the heroine's adherence to the validity of her love leads to her political murder. In the domestic tragedy *Maria Magdalena* (1843) the heroine's death is caused not by her offence against the morality of a patriarchal society but as a result of her acquiescence in its most restrictive demands.

Hebrew literature, literature written in the Hebrew language and produced uninterruptedly since at least the 12th century BC. From *c.*1200 BC to AD *c.*200, historical, legal, ethical, and liturgical works were compiled to create the Old Testament of the Bible. Later the main juridical and religious laws were committed to writing in the *Mishnah* (AD *c.*200), itself expanded into the *Gemarah* and ultimately the *Talmud*, which was written down in the 4th and 5th centuries AD. After AD *c.*220 Hebrew became a literary language only. The centre of Jewish culture moved first to North Africa, then to Muslim Spain (7th to 15th centuries), where both the liturgy and secular poetry in Hebrew were raised to a level of excellence by poets including Solomon *Ibn Gabirol and Yehuda Halevi (*c.*1080–1140). The Judeo-Arabic school reached

its zenith with Moses ben Maimon (Maimonides, 1135–1204), who formulated a code of rabbinic law, the *Mishneh Torah*. In the 16th and 17th centuries Poland emerged as a major centre of Jewish learning. The period from the mid-18th century saw the renaissance of secular Hebrew literature during the *Haskalah* (Hebrew Enlightenment) in Germany, Galicia, and Russia, where *Bialik was the dominant figure, the flowering of Hebrew poetry and journalism and, in the late 19th century, the revival of Hebrew as a spoken language. From the 1880s the centre of Hebrew literature shifted from Europe to Palestine (after 1948 Israel), where new literary styles based on the living language steadily developed. The major Hebrew writer of this period was *Agnon. The gradual maturing of society in Israel has allowed a wide range of themes to be developed. Yehuda Amichai (1924–) writes with a strong lyrical strain; Nathan Zach (1930–) writes elegant urban poetry; David Avidan (1934–) has experimented with innovative forms; Amos Oz (1939–) moulds current political and social conflicts into eloquent prose; while Abraham B. Yehoshua (1936–) allows reality to penetrate his studies and novels.

Heifetz, Jascha (1901–87), Russian-born violinist, assuming US citizenship in 1925. Taught by his father, Heifetz made his public début aged five. While still a student he played Tchaikovsky's concerto with the Berlin Philharmonic Orchestra (1912). After his US début in 1917, his position among the greatest violinists was secured, renowned for technical perfection but not ostentatious display. He commissioned a concerto from Walton in 1939.

Heine, Heinrich (Harry Heine) (1797–1856), German poet and essayist. His career difficulties and Jewish background contributed to his sense of alienation from German society. His early poetry is partly *Romantic, and uses the *Lied* form to express isolation and yearning for unrequited love. None the less, his satirical tendency often leads him to deflate his feelings and dream-visions. His first collection, *Book of Songs* (1827), remains the best known, partly because so many of its lyrics have been set to music. His collection in prose and verse, *Travel Sketches* (1826–31), juxtaposes apparently sincere nature-description with *satire upon contemporary affairs, a mode culminating in the politically more radical anti-Prussian mock epic *Germany: A Tale of Winter* (1844). After 1831 Heine lived virtually in exile in Paris, suffering from a debilitating paralysis that rendered him bedridden from 1848 onwards. The illness intensified his wit and irony, evident in the emotionally more complex volume of poems *Romanzero* (1852), where his pain is treated without self-pity or stridency. The hallucinatory, nightmarish perception of human existence is maintained in *Poems 1853 and 1854* (1854), which included the touching poems to 'la mouche', Elise Krinitz, who inspired the spiritual love that lightened the last months of his life.

Hellenistic art, a term applied to *Greek and Greek-inspired art and architecture from the late 4th to the late 1st century BC. In the Hellenistic period, when Greek civilization spread over the Mediterranean and Near East, some works such as the Venus de Milo (*c.*150 BC) continued earlier traditions. The Victory of Samothrace (*c.*200 BC) is full of life and grand in conception. A lively feeling for movement and emotion is shown in the Great Frieze of battling gods and giants on the Great Altar of Zeus at Pergamum (3rd century BC), now in Berlin, and in the Laocoon group, which is probably considerably later, in the Vatican. The painting of the Hellenistic period is well known from tombs in southern Russia, Macedonia, and Alexandria, as well as from copies found at Pompeii and Herculaneum. Interest in perspective and elaborate colour schemes continued, and a new interest developed in still life and landscape, not yet as a scene in itself, but as a setting for figures. Pictures were also executed in lively and decorative mosaic. Portraiture was introduced into art at this time. The features of rulers appeared on coins. These, with gems, and small works in ivory and precious metals, are in design and execution among the finest Greek works of art.

Heller, Joseph (1923–), US novelist. A New Yorker, he served in the US Air Force during World War II and subsequently exploited the experience in writing *Catch-22* (1961), a 'black humour' satire on military life and its bureaucratic rulings. The title has lent its name to a new phrase in the English language meaning a set of circumstances in which one requirement is dependent upon another, which is in turn dependent on the first: 'If he flew [more missions] he was crazy and didn't have to,

This portrait of Seamus **Heaney** (1974) is by Edward McGuire. Heaney is widely regarded as the finest Irish poet since W. B. Yeats and he is also a distinguished prose writer, who comments illuminatingly on the work of other writers and on the nature of the poetic craft. (Ulster Museum, Belfast)

but if he didn't want to he was sane and had to.' His second novel, *Something Happened* (1974), exposes a dark view of the life of a business executive, disgusted with what he does and is. *Good as Gold* (1979) is a farcical treatment of Jewish family life and of the Washington political scene; *Picture This* (1988) follows Heller's theme of money and war, pursuing the link between commerce and conflict through the ages.

Helmholtz resonator, an acoustical chamber devised by the scientist Hermann von Helmholtz (1820–94) to isolate single pitches in complex tones, as a globular vessel with two orifices, the smaller fitting the ear, the larger admitting sound. The pitch which it resonates is governed by the vessel's volume and fine-tuned by the area of the larger hole. It is thus the inverse of a *vessel flute, for it receives sound whereas the latter emits it.

Helpmann, Sir Robert (1909–86), Australian dancer, actor, and choreographer. He studied with Pavlova and de Valois, and was one of the first dancers of the Vic-Wells Ballet, known for his comic and dramatic roles. His own choreography includes *Hamlet* (1942), *Miracle in the Gorbals* (1944), and *Elektra* (1963). He returned to direct the Australian Ballet in 1965.

Hemingway, Ernest (Miller) (1898–1961), US novelist and short-story writer. He settled in Paris in 1921, where he wrote *In Our Time* (1925), stories largely dealing with a boyhood spent out of doors, and *The Sun Also Rises* (1926), the definitive novella of the expatriate *lost generation. His reputation was further enhanced by the novel *A Farewell to Arms* (1929), and the story collections *Men Without Women* (1927) and *Winner Take Nothing* (1933). Later works include non-fiction studies of bull-fighting and big-game hunting, and the Spanish Civil War novel *For Whom The Bell Tolls* (1940). The success of the novelette *The Old Man and the Sea* (1952), a parable of a man against nature, led to his receiving the Nobel Prize for Literature in 1954. He committed suicide in 1961 after years of silence and illness. One of the most influential writers of the century, Hemingway created in his early work a distinctive, taut dialogue, and a style in which rhythmical patterns emerge from vernacular language; the surface of his prose suggests, without directly expressing, an intense underlying emotion.

Henderson, Fletcher *big band.

Henry, O. (William Sydney Porter) (1862–1910), US short-story writer. He became a prolific and popular author after a period in gaol, turning out tales of great technical skill which were often based on the lives of ordinary New Yorkers, notably in his collection *The Four Million* (1906).

Henryson, Robert (also spelt Henderson) (*c*.1424–*c*.1506), Scottish poet. Described as a schoolmaster of Dunfermline, he is, with *Dunbar, often referred to as a 'Scottish *Chaucerian'. His *Testament of Cresseid*, an eloquent work of rhetorical craftsmanship, was written as a sequel to *Chaucer's *Troilus and Criseyde*. It gives a grim, tragic, and moralizing account of Cresseid's end. His other important works are *Morall Fabillis of Esope* and *Robene and Makyne*, a pastoral in which he employs the speech and humour of the Scottish peasantry.

Henze, Hans Werner (1926–), German composer. His early music combined the *Neoclassicism of Hindemith and Stravinsky with *serialism and touches of *jazz. As music director of the Wiesbaden State Theatre (1950–3) and composer of such operas as *Boulevard Solitude* (1952), *Elegy for Young Lovers* (1961), *The Bassarids* (1965, a re-working of Euripides' *Bacchae*), *We Come to the River* (1976), and *The English Cats* (1982), he proved himself a true man of the theatre. Seven symphonies (1947–84) and numerous concertos have confirmed his international standing. In 1953 he settled in Italy, his music becoming richer and more lyrical. Later works, such as *The Raft of the Medusa* (1968), express, powerfully and even violently, his strong Marxist sympathies.

Hepplewhite, George (d. 1786), British cabinet-maker and furniture designer. No furniture by him has been identified and his fame depends on his book of designs, *The Cabinet-Maker and Upholsterer's Guide* (1788). This contains almost three hundred designs representing the style used by furniture-makers of the time. It sums up the *Neoclassical taste of the time in pieces that are characterized by the use of light and elegant lines, shield-backed chairs, and a restrained application of classical ornament.

A design for a bed illustrated in George **Hepplewhite**'s influential pattern-book *The Cabinet-Maker and Upholsterer's Guide* (1788). The elegant lines and slender tapering forms are typical of Hepplewhite's style. His book made no claim to originality, but it epitomized the taste of his time.

Design for a Bed *Pl. 97*

Hepworth, Dame Barbara (1903–75), British sculptor, one of the most important figures in the development of *abstract art in Britain. She worked in various materials, including bronze, but she always had a special feeling for carving wood and stone. Her early sculptures were quasi-naturalistic, but by the early 1930s her work had become entirely abstract. At this time she worked in close harmony with Ben *Nicholson (her second husband) and Henry *Moore; unlike Moore's, her work was not representational in origin, but she attained a subtle synthesis between geometric and organic forms. By the 1950s she was internationally famous and had many prestigious commissions. From 1939 she lived in St Ives in Cornwall.

Herbert, George (1593–1633), English religious poet. A friend of John *Donne, he was ordained deacon (c.1624) and canon of Lincoln Cathedral (1626), and he finally became rector of Bemerton near Salisbury. *The Temple: Sacred Poems and Private Ejaculations* (1633) contains nearly all his surviving English poems (he also wrote poetry in Greek and Latin). He is noted for the subtlety of his writings, and for his attempt to express the complications of the spiritual life; his poems are marked by simplicity, unusual imagery, rhythmic skill, and metrical invention. He is now accepted as one of the greatest *Metaphysical poets. His major prose work, *A Priest to the Temple* (1652, as part of his *Remains*), gives a picture of a typical country parson.

Herbert, Zbigniew (1924–), Polish poet. The eponymous character first introduced in *Mr Cogito* (1974) experiences the moral dilemmas of contemporary man, themes present in Herbert's poetry since *Chord of Light* (1956). The essays *Barbarian in the Garden* (1962) reflect his interest in European culture and history.

Herman, Woody *big band, *jazz.

Herodotus (c.490–425 BC), Greek historian. His account of the Persian wars earned him the title 'the father of history', since he wrote on a scale and with a comprehensiveness that had never been attempted before. His style is simple, clear, and graceful, and his narrative has great charm.

heroic couplet, a rhymed pair of *iambic *pentameter lines in poetry, called 'heroic' from their use by Dryden in heroic (*epic) verse and drama. An important English verse-form first used by Chaucer, the heroic couplet was perfected by Dryden and Pope into a balanced, polished medium sharing the qualities of *epigram.

Herrick, Robert (1591–1674), English poet and cleric. He was ordained priest in 1623 and apparently moved in the London literary circles of *Jonson. While living in Devon he developed an appreciation for English folklore and lyrics. Among his most outstanding poems are 'Corinna's Going A-Maying', the 'Nuptiall Song', and 'To the Virgins, to make Much of Time', which includes his best-remembered line 'Gather ye rosebuds while ye may'. A *Cavalier poet, deeply influenced by classical writers such as *Horace and *Catullus, his secular poems are mostly exercises in miniature: highly polished with meticulous use of syntax and word order on the theme of love, transience, and death. The 17th-century English composer Henry *Lawes set some of his poems to music.

Herzog, Werner (1942–), West German film director. His complex, allegorical films, written and produced by himself, express a personal vision in striking, ambivalent, sometimes repulsive images. His characters are usually exceptional in some way—perhaps through talent or physical deformity—and are never fully revealed. He first attracted attention with *Even Dwarfs Started Small* (1970), about a rebellion of dwarfs, and two of his best-known films are *Aguirre, Wrath of God* (1973), describing a 16th-century *conquistador*'s search for gold, and *The Mystery of Kasper Hauser* (1974), a supposedly true story set in the 1820s, of a foundling's attempt to escape from a state of nature. Later films included *Nosferatu the Vampire* (1978), *Fitzcarraldo* (1982), in which opera is performed in the jungle, *Where the Green Ants Dream* (1984), and *Green Cobra* (1987), about slavery.

Hesiod (c.700 BC), one of the earliest Greek poets. Only two surviving poems are likely to be his, both in *hexameters. The *Theogony* deals with the mythology of the gods and Zeus' rise to supremacy. The *Works and Days* describes peasant life, with a strong moralizing element and some personal detail.

Hesse, Hermann (1877–1962), German novelist, poet, and short-story writer. He was posthumously elevated to a cult figure in the English-speaking world for the celebration of Eastern mysticism and search for self-realization in his work. A Neo-Romantic lyricism, rejection of society, love of nature, and vagabond existence characterize his first novel, *Peter Camenzind* (1904). Psychology and experimental form combine in *Steppenwolf* (1927) to provide a critique of society's superficiality, and a semi-autobiographical study of the hero's mid-life crisis, and his acceptance of his divided self and the imperfections of life. *The Glass Bead Game* (1943) depicts a problematic utopia, from whose sterile spirituality the hero escapes into everyday life, only to meet his immediate death. Hesse received the Nobel Prize for Literature in 1946.

hexameter, a verse line consisting of six metrical units ('feet'). Greek and Roman poets used *dactylic hexameters in *epic poetry, and for *elegies and *satires. This *metre was later imitated by Goethe and Pushkin, but does not easily fit the stress-patterns of English, although Longfellow and Clough attempted long poems in English hexameters.

'high-tech' style *Foster Associates.

Hikmet, Nazim (1902–63), Turkish poet. Hikmet returned to Turkey in 1924 a convinced Marxist, after two years studying in Moscow. Arrested for working on a leftist magazine in Turkey, he escaped to the Soviet Union, where he was influenced by *Futurists such as Mayakovsky, and worked with *Meyerhold. Hikmet wrote his poems in forcefully colloquial Turkish, introducing *free verse and a range of innovative imagery. His *Epic of Sheikh Bedreddin* (1936) and *Human Landscapes from my Country* (1941) portray a powerful range of Turkey's past and present.

Hildebrandt, Johann Lucas von (1668–1745), Austrian architect. He was born in Genoa and his style is more Italianate than that of *Fischer von Erlach, to whom he ranks second in renown among Austrian *Baroque

architects. Compared with Fischer's, Hildebrandt's buildings are elegant and graceful with a charm and vivacity that are considered typically Viennese; most of his best buildings are in Vienna, his masterpiece being the Belvedere Palace (1714–24). He was primarily a palace builder, but he also designed churches that look forward to the intricate spatial conceptions of Balthasar *Neumann.

Hill, David Octavius (1802–70), and **Adamson, Robert** (1821–48), Scottish portrait photographers. In 1843 Hill, Secretary of the Royal Scottish Academy of Fine Arts, determined to paint a grand commemorative picture of the Establishment of the Scottish 'Free Church'. He was introduced to the young Adamson, who had just opened a photographic studio in Edinburgh, and the partners began to record the nearly 500 faces of the reverend and other gentlemen involved, using Fox *Talbot's calotype process, which in Scotland was free of patent restrictions. Altogether they took 2,000 or so portraits (outdoors, in sunlight, despite their studio look); many believe them to be the first true masterpieces in photographic history. Adamson was no mere technician: his paper prints have survived better than most others of the period, and Hill's photographs taken after Adamson's premature death are comparatively dull.

Hilliard, Nicholas (1547–1619), English *miniaturist. He trained as a jeweller and was appointed Court Miniaturist and Goldsmith by Elizabeth I. His jeweller's training shows in the exquisite craftsmanship of his work, but his miniatures are memorable also for the characterization of each sitter. Many of the great Elizabethans sat for him, including Drake, Ralegh, and Sidney. After the turn of the century his position as the leading miniaturist in the country was challenged by his former pupil Isaac *Oliver.

Hindemith, Paul (1895–1963), German composer and instrumentalist. His early *Expressionist works, such as the one-act opera *Murderers, the Hope of Women* (1919), gave way to a drier, *Neoclassical style (as in the opera *Cardillac*, 1926) and then to something altogether more lyrical, as in his operatic masterpiece *Mathias the Painter* (1935), from which he also derived an important symphony. Attacked by the Nazis, he left Germany (1937), settling in the USA (1940) and then Switzerland (1953). Hindemith was much concerned to write music that would be of use to amateurs and the community in general, and to establish a coherent musical grammar that would explain contemporary musical developments in terms of *tonality and the immutable laws of acoustics.

Hindi literature, literature in Hindi, the national language of India, spoken particularly in the north Indian plain. The literature began (AD *c.*1000) with verse romances of Rajput chivalry. The most famous is Cand Bardāī's *The Lay of King Prithviraj* (14th century), glorifying Pṛthvīrāj Cauhān, King of Delhi. Muslim mystic poets also produced allegorical romances, most notably Jayasi's *Padmāvat* (named after its heroine) (*c.*1540), describing King Ratansen's love for Princess Padmavati of Sinhala. Hindi *Bhakti literature began with the monotheistic Kabīr (1430–1518). Devotion to Rama is epitomized by the *Rāmcaritmānas* ('The Lake of the Acts of Rama') of Tulsīdās (1532–1627), the greatest vernacular version of the *Rāmāyaṇa*. Krishna-devotion is best seen

The Shore Temple in the southern (*dravida*) style at Mahabalipuram (or Mamallapuram) near Madras in southern India, dedicated to the god Shiva. It was built at the beginning of the 8th century by the Pallava king Rajasimha and marks the transition in **Hindu art** from the earlier tradition of rock-cut architecture to structural stone-building.

in the verses of Surdas (*c.*1483–1563) and Mīrābāī (1498–*c.*1573). From the early 17th century poets like Keśavdās (1555–1617) and Bihārī Lāl (1603–63) imitated classical Sanskrit forms to depict love and physical beauty. Standard Hindi prose (Kharībolī) evolved with pundits at Fort William College (founded 1800) such as Lallūjī Lāl, whose *The Ocean of Love*, retelling Krishna's childhood, proved extremely popular. Modern Hindi literature proper began with Bharatendu Harishchandra (1850–83), poet, playwright, novelist, and essayist. In the 1930s the Chayavad movement of mystical romanticism developed with the poets Nirala, Pant, Mahadevi Varma, and Jayashankar Prasad, author of the epic *Kāmāyanī* (named after its heroine). The fiction-writer Premchand (1880–1936) vividly depicted village life in short stories and novels like *The Gift of a Cow*. (See also *Sanskrit literature.)

Hindu art, art and architecture in the service of Hinduism. Hinduism has an extremely complex mythology. In artistic terms the main gods are Shiva, the god of destruction and reproduction, and Vishnu, the preserver. Each of them takes many different forms. Shiva, for example, is often represented as a phallic pillar (lingam) and Vishnu has several earthly incarnations, most notably as Krishna, whose love-life forms one of the staple subjects of Indian art. There are other major gods and a host of minor and local deities. Images of them are found wherever Hindus worship, from wayside shrines to great pilgrimage centres. The earliest Hindu buildings to survive are from the *Gupta period, although earlier examples in wood presumably existed. Stone is the normal material for major buildings, although brick is also known. Hindu architecture generally uses upright supports and cross-members as the basic constructional devices, with arches and domes being eschewed. Wall surfaces were often

extremely richly decorated with sculpture, such beau-tification being an attempt to recreate the celestial en-vironment of the gods. The heart of a Hindu temple is typically a sanctuary where an image of the god to which it is dedicated is enshrined; in northern India this is surmounted by a tower-like structure called a *sikhara, and in southern India by a smaller structure called a vimana. Outside is a columned hall (mandapa) where devotees gather. These buildings are often set within a court, which may contain subsidiary shrines, including that of the god's consort, and also further mandapa. The court is typically entered by a towered gate (*gopura), and nearby there is usually a water-tank for ritual ablutions. Hindus, like Buddhists, also built rock-cut temples, as at *Ellora, where instead of being tunnelled into a rock face, the temple has been created—amaz-ingly—by carving downwards from the top of an immense block of stone, and at *Elephanta. The sculptural dec-oration of Hindu temples (as at *Khajuraho) is often explicitly erotic, *mithuna (love-making couples) being a recurring motif. Sexual love was seen as a manifestation of divine power and a way in which the self could be transcended through union with another. The great age of Hindu art was over by the 17th century, when the main artistic impulse had passed to Islam (see *Mughal art), but there was a splendid late flowering of Hindu painting in the courts of north-west India (see *Rajput painting).

Hine, Lewis Wickes (1874-1940), US journalistic photographer. When Hine photographed immigrants on New York's Ellis Island in 1905, he was an amateur. He soon turned professional, documenting social dep-rivation—especially of children—in words and pictures. He was among the first to prove the power of photographs to achieve reform.

Hiroshige Ando (1797-1858), Japanese painter and print-maker of the *ukiyo-e school. He is famous mainly as a landscapist, but his views usually contain prominent human activity and his great popularity stems largely from the warmth and humour with which he depicts the people he met on his travels around the country. Among his best-known works is the series 53 Stages of the Tokaido Road, published in 1833. His prints were among the first by Japanese artists to be seen in the West and were influential on van *Gogh among others.

Hispano-Moresque ware, *lustreware produced in southern Spain from the 13th century to the 15th century, when this territory was under the domination of the Moors. The pottery, which combined European and Islamic motifs, was the first of artistic importance to be made in the West since Roman times and was influential on the development of Italian *maiolica.

historical novel, a *novel in which the action takes place a generation or more before the time of writing, and in which some attempt is made to depict accurately the customs and mentality of the period. The central character, real or imagined, is usually entangled in divided loyalties within a larger historic conflict. The pioneers of this *genre were Edgeworth, Scott, and Cooper; Scott's many historical novels, starting with Waverley (1814), influenced not only Dickens and Thack-eray but the entire European tradition of novel writing.

Outstanding 19th century examples include Hugo's Notre Dame de Paris (1831), Dumas père's Les Trois Mousquetaires (1844), Flaubert's Salammbô (1862), and Tolstoy's War and Peace (1863-9). Historical novels have remained popular, especially the kind known as historical or 'costume' romances, like Margaret Mitchell's Gone With the Wind (1936): these are usually more romantic than historical. Some recent historical novels, like Vidal's Lincoln (1984), come very close to *biography.

history painting, a term in art applied to scenes representing actual historical events, and to scenes from legend and literature of a morally edifying kind. From the Renaissance to the 19th century it was generally accepted by artists and critics that history painting was the highest branch of the art. It was traditionally treated in the 'Grand Manner'—that is, with rhetorical gestures, lofty sentiments, and figures either nude or clad in 'timeless' draperies. It was only in the late 18th century that contemporary costume began to be used for history painting, the US artists Benjamin West and John Sin-gleton Copley leading the way, initially against strong criticism.

Hitchcock, Sir Alfred (1899-1980), British film dir-ector, the cinema's 'master of suspense', and probably

In **Hitchcock**'s North by Northwest, Cary Grant is pursued by an aeroplane, at first assumed to be engaged in crop-spraying. Hitchcock was expert at handling chases: the same film ends with a chase down the face of Mount Rushmore.

the best-known director of all time. He excelled in all branches of the cinematic art and was a brilliant story-teller. His career covered fifty years, from the silent *The Lodger* (1926) to *Family Plot* (1976). His early British films included *The Man Who Knew Too Much* (1934) (which he remade in 1956), *The Thirty-Nine Steps* (1935), and *The Lady Vanishes* (1938). His Hollywood career began with *Rebecca* (1940) (Academy Award for best film). Outstanding among his other US films were *Notorious* (1946); *Strangers on a Train* (1951), in which two strangers arrange to perform murders for each other; *North by Northwest* (1959); *Psycho* (1960), with its famous shower murder; and *The Birds* (1963), a film in which birds turn against human beings. Hitchcock's constant search for new challenges was shown in *Lifeboat* (1944), set entirely within the boat; *Rope* (1948), his first colour film, filmed in one room in a series of prolonged takes; and *Rear Window* (1954), shot from the viewpoint of a man confined to a chair. Hitchcock's portly figure was famous from his practice of making brief appearances in his own films.

Hittite art, the art and architecture of the Hittites, an ancient people of Anatolia (the Asian part of Turkey), who built a great empire in the 2nd millennium BC. Hittite artists worked in their own native variety of metals such as bronze, copper, silver, gold, and iron, then a very precious metal, and could carve stones both in the round and in relief, often carving for preference on the living rock. But the main part of their art was apparently executed in the service of religion, and depicts gods and goddesses (for example, the rock-carved reliefs at the Great Sanctuary of Yazilikaya near Bogazköy); gateway figures of guardian lions and sphinxes (for example, at Catalhüyük or at Bogazköy); and scenes of cult or mythology, as at Carchemish: only rarely and in a limited form do we see narrative representations of human activities, as, for example, the musicians and hunting scenes on the palace walls at Catalhüyük, *c.*1400 BC. The minor arts are represented by vases, perhaps ritual in purpose, in the form of animals. The Hittites' pottery was made on the wheel, with fine red burnished walls, sometimes with painted decoration over a slip. They were exceptionally skilled in goldwork. In the British Museum is a set of minute figures of a king, deities, and sacred monsters carved out of lapis lazuli and encased in gold. They were originally attached to a golden garment woven of strands, each threaded with tiny golden beads forming real 'cloth of gold'. Hittite architecture is best known from Bogazköy, where massive city walls and great stone substructures of temples and other buildings remain. They also developed the heavily fortified double gateway, decorating this sometimes with a bottom course of slabs, ornamented in relief with mythical or magical groups or single figures of gods, men, or monsters, with a preference for making every slab a self-contained scene. Of the internal appearance of Hittite buildings we know nothing, though at Bogazköy and Atchana there are remains of wall-paintings executed in *fresco strongly recalling, and possibly connected with, the brilliant, highly developed use of the same art in Crete (see *Minoan art). (See also *Iron Age art.)

Hoban, James (*c.*1762-1831), Irish-born architect who settled in the United States after the American Revolution. Hoban is best known as the architect of the White House in Washington DC (1793-1801), the façade of

which he based on a design illustrated in James *Gibbs's *Book of Architecture*. Hoban carried out several other federal commissions in Washington, and was one of the superintendents of the construction of the Capitol.

Hobbema, Meindert (1638-1709), Dutch landscape painter, the only documented pupil of Jacob van *Ruisdael. Some of his pictures are very like Ruisdael's, but his range was narrower and he concentrated on a few favourite subjects—particularly water-mills and trees round a pool—which he painted again and again. After 1668 he seems to have painted only in his spare time; his most famous work, *The Avenue at Middelharnis*, dates, however, from 1689. His work was very popular with British collectors and painters; *Gainsborough was among the artists influenced by him.

Hockney, David (1937-), British painter, draughtsman, print-maker, photographer, and designer. Hockney achieved international success by the time he was in his mid-20s and has since consolidated his position as the best-known British artist of his generation. Since the late 1970s he has lived in the USA. His phenomenal success has been based not only on the flair and versatility of his work, but also on his colourful personality, which has made him a widely known figure. His early paintings, often almost jokey in mood, gained him a reputation as a leading *Pop artist, but in the late 1960s he turned to a weightier, more traditionally representational manner. He is a fluent draughtsman and has been much acclaimed as a book illustrator. In the 1970s he achieved success as a stage designer and recently has worked much in photography.

Hoffmann, Ernst Theodor Amadeus (1776-1822), German writer, composer, and music critic. Although Hoffmann's first love was music, he is best remembered for his literary works. Exploring the dichotomy between artistic calling and philistine society, his grotesque and bizarre tales belong to the later period of German *Romanticism. The best known are *The Golden Pot* (1813) and *The Maid of Scuderi* (1818). His one completed novel is *The Devil's Elixirs* (1813-16), which shows horror stretched to the point of insanity. The unfinished *Philosophy of Life of the Tom-cat Murr* (1819-21) maintains a subtle balance between dark, irrational elements and a palpable reality. Hoffman is the central figure in the opera *The Tales of Hoffmann* (1881) by *Offenbach.

Hoffmann, Josef (1870-1956), Austrian architect and designer. He was a pupil, assistant, and disciple of Otto *Wagner, and one of the pioneers of the *Modern Movement in Austria. His mature style was based on the right angle and other primary geometric forms, but it was extremely elegant and refined, rather than severe. Hoffmann designed numerous Austrian government pavilions for exhibitions throughout Europe and many houses in Vienna, but his best-known work is in Brussels— the Palais Stoclet (1905-11).

Hofmannsthal, Hugo von (1874-1929), Austrian poet, dramatist, and essayist. His early work is characterized by a luxuriant aestheticism and a *fin-de-siècle melancholy. In *The Tale of the 672nd Night* (1895) and the drama *The Fool and Death* (1900) he expresses his sense of the dangers of aestheticism; in the so-called 'Chandos Letter' (1902)

he records a loss of faith in the ability to communicate ideas or give coherence to the world. After 1900 he concentrated on the theatre, adapting plays from such diverse traditions as the classical in *Elektra* (1904) and the medieval in *Everyman* (1911). He collaborated with Richard Strauss on several operas, notably *Rosenkavalier* (1911) and *The Woman without a Shadow* (1916). Nostalgia for the Habsburg empire and adherence to traditional values colour his social comedies *The Difficult One* (1921) and *The Incorruptible* (1923). His tragedy *The Tower* (1925–7) deals with the possibility of overcoming tyranny without brutality or the loss of humane values. He was co-founder with Max *Reinhardt and Richard *Strauss of the Salzburg Festival (1917).

Hogarth, William (1697–1764), English painter and engraver. He was trained as an engraver, but in the 1720s also turned to painting. In the early 1730s he invented and popularized the use of a sequence of anecdotal pictures 'similar to representations on the stage' to satirize social abuses. The best known is probably *A Rake's Progress* (*c*.1735, eight scenes), portraying the punishment of vice in an entertainingly melodramatic fashion. Engravings of each series were extremely popular, and were so much pirated that Hogarth succeeded in having a copyright act passed in 1735 to protect him from profiteers. His satire was directed as much at pedantry and affectation as at immorality, and he saw himself as a defender of native virtues against a fashion for French and Italian mannerisms. This no-nonsense approach also characterizes his forthright portraits, while his treatise *The Analysis of Beauty* (1753), argues that the views of the practising artist should carry more weight than the theories of learned connoisseurs. Hogarth was the most important British artist of his generation: the quality and originality of his work freed British art from its domination by foreign artists.

Hogg, James (1770–1835), Scottish poet, known as the 'Ettrick Shepherd', after the place of his birth. His poetic gift was discovered by *Scott, to whom he had sent his poems, and he became popular during the revival of the *ballad that accompanied the *Romantic movement. He made his reputation as a poet with *The Queen's Wake* (1813), verse-tales in various styles and including the narrative ballads 'Kilmeny' and 'The Witch of Fife'. In 1824 he published *The Private Memoirs and Confessions of a Justified Sinner*, a macabre psychological novel.

Hokusai Katsushika (1760–1849), Japanese painter and print-maker, the most illustrious of the *ukiyo-e* artists. Versatile, prolific, and fervently devoted to his art, he excelled at every subject, including landscapes, animals, plants, theatre scenes, and erotica. His richness of imagination, warmth of human feeling, and mastery of technique place him among the greatest artists of any time or place. His most celebrated works are the *36 Views of Mount Fuji*, showing Japan's most famous natural feature from various viewpoints and in various weather conditions. In the later 19th century his work became well known in the West and was particularly influential on the *Post-Impressionists, who were impressed by his boldness of form and vividness of colour.

Holbein, Hans (*c*.1497–1543), German painter and designer. He trained in Augsburg with his father, Hans

Holbein the Elder (*c*.1465–1524), and in his early career worked mainly in Basle. There he became the leading artist of the day, both as a painter (mainly of religious works) and as a designer of book illustrations. The disturbances of the Reformation meant a decline in patronage in Basle, however, and in 1526 he moved to England, settling there permanently in 1532. He worked mainly as a portraitist, and as court painter to Henry VIII he created a superb gallery of portraits of the king and his courtiers, both in paintings and in a marvellous collection of shrewdly characterized drawings in the Royal Collection at Windsor Castle. He also did many designs for decorative work which introduced the *Renaissance style of ornament into England. In his last years he turned to *miniature painting, to which his exquisitely detailed craftsmanship was well suited, and he was a major influence on Nicholas *Hilliard, the greatest of English miniaturists.

Holberg, Ludvig, Baron (1684–1754), Dano-Norwegian dramatic poet and man of letters. The outstanding Scandinavian literary figure of the *Enlightenment, he is best remembered today for the comedies he wrote for the first native-language Danish theatre in

This drawing by **Holbein**, inscribed 'M Souch', represents either Mary Zouch, a maid-of-honour to Queen Jane Seymour, or Joan (née Rogers), the wife of Sir Richard Zouch (the 'M' may stand for 'Mistress'). It is in various coloured chalks reinforced with ink and shows the delicacy of technique and subtlety of characterization typical of Holbein's drawings of the English court. (Royal Collection, Windsor Castle)

the 1720s. Comedies of character like *The Political Tinker* and *Jeppe of the Hill* (both 1722) are still popular today. His attitude to learning and authority was often humorous and daringly irreverent in an age of absolute monarchy. He published, under the pseudonym of Hans Mikkelsen, the mock-heroic *epic poem *Peder Paars* (1719–20). He wrote several volumes on the history of Denmark–Norway, and of moral philosophy, for example, the novel *Niels Klim's Subterranean Journey* (1740) and *Epistles and Moral Thoughts* (1744–54).

Hölderlin, Friedrich (1770–1843), German *lyric poet and novelist. Today ranked among the greatest of German poets, he succeeded in synthesizing the spirit of ancient Greece, the *Romantic views of nature, and an unorthodox Christianity in his writings. *Hyperion* (1797–9), an epistolary novel set during the revolt of the Greeks against the Ottoman Turks (1770), is a lyrical expansion of his belief in a new Greek Christ, symbol of spiritual regeneration, who will overcome the fragility and alienation of human existence. Using mainly the *hexameter and the *ode, Hölderlin's supple, condensed lyricism is dignified and elevated, but impassioned.

Holiday, Billie *blues.

Holl, Elias (1573–1646), German architect, active mainly in his native Augsburg, where he became city architect in 1602. Holl had travelled in Italy in 1600–1 and he held a position somewhat comparable to Inigo *Jones in England in introducing a regular *Renaissance style to his country. Of the many buildings he designed in Augsburg the most notable is the Town Hall (1616–20, destroyed in World War II and rebuilt), a tall, austere block with very plain classical detailing. Holl was a Protestant in a predominantly Roman Catholic city and was dismissed from his office for religious reasons in 1631; he was reinstated in 1632, but dismissed finally in 1635.

Holland, Henry (1745–1806), British architect, the son of a master builder of the same name. In 1771 he entered into partnership with his father's friend Lancelot *Brown. His first major work was Brooks's Club (1776–8) in St James's, London, the success of which immediately led to other commissions from members of the Whig aristocracy. He was particularly patronized by the Prince of Wales, for whom he remodelled Carlton House in Pall Mall, 1783–96 (later demolished). Holland also did alterations at several country houses (notably Althorp and Woburn Abbey) and from 1771 he was involved in the entrepreneurial development of the area in Chelsea around Sloane Street and Cadogan Square, known as Hans Town. His work, though lacking originality, was elegant, tasteful, and well planned.

Hollar, Wenceslaus (or Wenzel) (1607–77), Czech engraver and water-colourist. His output was very large and he portrayed a variety of subjects, but he is best known as an engraver of topographical views. After meeting the English connoisseur the Earl of Arundel in Cologne in 1636, Hollar settled in London, and his views of the city form an invaluable record of its appearance before the Great Fire of 1666.

Hollywood, a district of Los Angeles, USA, which became synonymous with the American film industry and a particular style of glossy, professional, usually escapist film-making. The site was used by *deMille for his first directorial assignment, *The Squaw Man* (1914). Its ideal climate attracted others, and it became the world's centre for film production. By the 1950s, however, television was discouraging cinema-going and film-makers were increasingly filming abroad, where costs and taxation were lower. Hollywood now makes films mainly for television.

Holman Hunt, William *Hunt, William Holman.

Holst, Gustav (Theodore) (1874–1934), British composer. Like *Vaughan Williams, Holst clarified an early Germanic style through the study of English *folk music. He leapt to fame with the powerful orchestral suite, *The Planets* (1916). A strong tendency to mysticism expressed itself in his choral masterpiece *The Hymn of Jesus* (1917). Later works, such as the overture *Egdon Heath* (1927), grew even more austere. The one-act chamber opera *Savitri* (1908) is outstanding among his compositions. Some of his most characteristic and powerful music is in the choral works such as the *Choral Fantasia* (1930) and the *Ode to Death* (1919), and in his solo songs such as the Welsh folk-song settings for unaccompanied chorus (1930–1). His part-song *This Have I Done for My True Love* (1916) has become part of the canon of English carol-singing.

Holub, Miroslav (1914–), Czech poet and essayist. A research immunologist by profession, his cool, intellectual, and anti-sentimental poems on contemporary civilization show a preoccupation with ethical reflections. In his many volumes of poetry, such as *Achilles and the Tortoise* (1960), and *On the Contrary* (1981), optimism alternates with irony and scepticism.

Homer, the principal figure of ancient *Greek literature. He seems to have lived before 700 BC, probably in Ionia (present-day western Turkey). Tradition suggests that he was blind, and may well have sung at the courts of kings as bards do in his *epic poem the *Odyssey*. How far his original words correspond to the texts we now possess is unknown, but it seems clear that the basis of the poem, together with that of his *Iliad*, was oral: working within an elaborate tradition, a bard could improvise *hexameter poetry marked by much use of repeated phrases, lines, *epithets, and even paragraphs. At the same time, the poems as we have them are impressively unified, despite their great length. The *Iliad*, while recounting the enmity between Achilles and Agamemnon, encapsulates much of the mythology surrounding the ten-year war at Troy; vigorous scenes of warfare are set off by tender pictures of domestic life. Similarly the *Odyssey*, while recounting Odysseus' return to Ithaca and his revenge on the suitors of his wife, is set against a wider background of the return of the Greek heroes, and gives much detail of other phases of Odysseus' life, at Troy and elsewhere. Written in a simple and lofty style, the structure of this poem is especially intricate, with a long flashback in which Odysseus tells the story of his wanderings. Not all scholars believe that the poems are the work of one man, but there is general agreement on their consummate excellence, which places them among the great works of Western literature. The poems were a model for *Virgil's *Aeneid*.

Homer, Winslow (1836–1910), one of the greatest US painters of the 19th century. His favourite subject was the sea, and from 1883 he lived in isolation at Prout's Neck on the Maine coast, where he painted pictures representing the grandeur and solitude of the ocean and the contest of man with the forces of nature. Homer had visited Paris in 1867 and been impressed with *Manet's work, but he explored the rendering of light and colour outdoors in a way different from the *Impressionists, using a firm construction of clear outlines and broad planes of light and dark. He was a superb water-colourist, using the medium with the force and authority of oil.

homophony *polyphony.

Honegger, Arthur (1892–1955), Swiss composer. He achieved success as a composer with the powerful stage oratorios *Le Roi David* (1921) and *Jeanne d'Arc au bûcher* (1935), the delightful orchestral suite *Pastorale d'été* (1920) and, in 1928 and 1933 more notoriously, with two brutally realistic orchestral works: *Rugby* (the portrait of a game of football) and *Pacific 231* (the portrait of a steam locomotive). His delight in bold *counterpoint and clear-cut *Neoclassical forms, to be seen particularly in his five symphonies, stemmed from a reverence for J. S. Bach.

Honthorst, Gerrit van (1590–1656), Dutch painter of religious, mythological, and *genre scenes and of portraits. In about 1610 he went to Rome, where he fell under the spell of *Caravaggio's art. He became known as 'Gherardo delle Notti' (Gerard of the Night Scenes) due to his skill in painting candlelight scenes, and on his return to the Netherlands in 1620 his work contributed to Utrecht becoming a stronghold of the Caravaggesque style. In the last three decades of his career he abandoned this style and achieved international success as a court portraitist.

Hooch, Pieter de (1629–84), Dutch painter. He created a small number of tranquil masterpieces that give him a place among the finest Dutch genre painters. They represent figures in a room or courtyard engaged in everyday tasks and have a lucidity of composition and sensitivity in the handling of light that recalls his great Delft contemporary *Vermeer. After de Hooch moved to Amsterdam in the early 1660s, however, his subjects became grander and his work lost its magic.

Hopkins, Gerard Manley (1844–89), British poet. At Oxford he was deeply influenced by John Henry Newman and the religious fervour of the Oxford Movement. After he converted to Roman Catholicism in 1866 he became a Jesuit and renounced poetry, burning most of his youthful poems. In 1874 he was sent to St Beuno's College in North Wales to study theology. There, encouraged by his Superior, he once more began to write poetry. Moved by the death of five Franciscan nuns in a shipwreck, Hopkins composed his masterpiece, 'The Wreck of the *Deutschland*'. Other notable poems include 'The Windhover' and 'Pied Beauty'. After his ordination he was sent to work as a priest in Liverpool, where he felt oppressed by 'vice and horrors' and a sense of his failure as a preacher. In 1884 he became professor of Latin at University College, Dublin, where he wrote his profoundly tragic 'Dark Sonnets', which begin with 'Carrion Comfort' and express his sense of exile, spiritual aridity,

Courtyard with an Arbour in Delft (1658) exemplifies the sense of peaceful well-being evoked by much 17th-century Dutch painting and which Pieter de **Hooch** sums up more completely than any other artist. The same models, virtually the same setting, and the same feeling of pleasant domesticity occur in other paintings by de Hooch. (Fitzwilliam Museum, Cambridge)

and artistic frustration. In his work Hopkins developed his theories of natural beauty, using the terms 'inscape' (the individual or essential quality of the object) and 'instress' (the force of 'inscape' on the mind of the observer). A skilful innovator, he sought to unite the rhythm of his verse with the flow and varying emphasis of spoken language by using 'sprung rhythm' (a combination of regularity of stress patterns with freely varying numbers of syllables). The posthumous publication of his *Poems* by his friend Robert *Bridges in 1918 has established him as a major poet in the English language.

Hopper, Edward (1882–1967), US painter, active mainly in New York. He first worked as a commercial illustrator, but he began to win recognition as a painter in the 1920s. His work usually features anonymous, non-communicating figures who express the loneliness of life in a large city. He explored a visual world that no earlier artist had seriously considered—a world of concrete and glass, motel rooms and filling stations, soulless offices and cafeterias—and created from it some of the most poignant images in 20th-century US art.

Horace (Quintus Horatius Flaccus) (65–8 BC), Latin lyrical poet. He enjoyed the support of the Roman statesman Maecenas (also *Virgil's patron), and the Emperor Augustus, and produced a wide body of work. His early *lyric poems, the *Epodes*, are invectives in the tradition of the Greek Archilochus. More notable are the four books of *Odes*, poems in lyric metres in the tradition

of *Sappho, though much influenced by the Alexandrian poetry of *Callimachus and others. Masterfully constructed in a verse that shows Latin brevity at its best, they cover an enormous range of topics, though love, politics, philosophy, the art of poetry, and friendship predominate. The poet's personality, wry and self-deprecating, comes over more consistently in the *Satires* and *Epistles*, both written in a relaxed *hexameter verse that echoes the rhythms of conversation. Particularly notable are the *Epistle to Augustus*, on literary themes, and the companion *Epistle to the Pisones*, the so-called *Art of Poetry*, remotely descended from Aristotle's *Poetics*, which had great influence on poetic practice and theory in the 17th and 18th centuries.

horn, any wind instrument sounded by applying buzzing lips to a hole in a tube. Some are made of horn, but ivory, shell, wood, bamboo, gourd, pottery, or metal are used as often. The earliest horns were probably animal horns and *conches. Most are end-blown, but in Africa, Oceania, parts of tribal India, South America, and Bronze Age Ireland, horns have also been blown from the side of the tube. Ivory horns were often status symbols in Africa, but they and horns of other materials are also widely used for music and signalling. Ivory horns, called olifants, were also used in Europe in the early Middle Ages, sometimes replacing a written charter as a symbol of land ownership or rights of usage, but usually, and also in the Renaissance, as status symbols. In ancient Egypt, Israel, Greece, and Rome, horns of bronze and other metals were used. The only other horns of similar antiquity which have survived are the Scandinavian bronze *lurs* and the slightly later Irish bronze horns. In medieval European iconography, short horns, presumably cow horns, can be seen in the *Bayeux Tapestry, and longer horns, of wood or metal, in Anglo-Saxon and Mozarabic manuscripts. Coiled horns, ancestors of our *French horn, appear from the 16th century onwards.

Horniman, Annie (Elizabeth Fredericka) (1860–1937), British theatre patron and manager, pioneer of *repertory theatre. In 1904 she founded the Abbey Theatre, Dublin. From 1908 to 1917 she supported a repertory company at the Gaiety Theatre, Manchester. The more than 200 plays presented included many new works, the playwrights connected with the theatre, such as Harold Brighouse (*Hobson's Choice*, 1916) and Stanley Houghton (*Hindle Wakes*, 1912), being known as the Manchester School. Though the enterprise was financially unsuccessful it gave a strong impetus to the repertory movement.

hornpipe, a single-reed musical instrument with a horn bell and often also a horn fixed over the reed to keep it dry. The reed is a cane tube with a vibrating tongue cut from its surface, like the *drone reeds of a Highland *bagpipe; hornpipes are also often bagless chanters blown by mouth. Two British examples are the Welsh pibcorn and Scots stock-and-horn. Some hornpipes, such as the Basque *alboka* and Tunisian *zukra*, have two pipes, fixed side by side, often with different numbers of finger-holes in each.

The **hornpipe** is also an energetic dance popular in the late 17th and 18th centuries. It was originally performed in triple *time; later, when associated with the Navy, a simple duple time was used.

hornwork, artefacts and decorative work made from the horns of cattle and other animals. Horn can be softened by gentle heating and pressed into shape, and it has been used for a variety of small objects. John Obrisset, a French Huguenot who worked in London in the first quarter of the 18th century, was renowned for his snuff-boxes made of horn and tortoiseshell. One of its most common uses (on account of its transparency) was in making a children's elementary reading aid called a hornbook—a page bearing the alphabet or a religious text held in a frame with a sheet of horn covering the paper or parchment to preserve it. They were common until the 18th century. In the 19th century there was a fashion for furniture incorporating horns or antlers.

Horowitz, Vladimir (1904–89), Russian-born pianist, assuming US citizenship in 1944. Making his international reputation with concerts in Berlin in 1925, Horowitz gave début performances in Britain and the USA in 1928. A remarkable pianist, his career was frequently interrupted by illness and retirement. A virtuoso of the highest rank, Horowitz seemed sometimes to complicate the composer's intentions, but was a magnificent interpreter of Liszt and Prokofiev.

Horta, Victor, Baron (1861–1947), Belgian architect and designer, one of the outstanding exponents of *art nouveau and one of the pioneers of *modernism in Belgium. His first major work was the Hôtel Tassel (a house, not a hotel) in Brussels (1892–3), in which he made extensive use of iron, both as a structural material and for decorative purposes. He designed every detail of his buildings down to the light fittings, which are characteristically in the form of flowers, to achieve a complete unity of effect, with flowing curves everywhere. His most innovative building was the Maison du Peuple (a meeting hall) in Brussels (1896–9, destroyed), which had the first iron and glass façade in Belgium. After World War I, Horta's style became more austere and conventional.

Housman, A(lfred) E(dward) (1859–1936), British poet and scholar. His best-known work, *A Shropshire Lad* (1896), was a series of sixty-three nostalgic *lyrics largely in *ballad form and often addressed to a farm-boy or soldier. Many of his earlier poems, preserved in notebooks, appeared in later volumes; his *Collected Poems* were published posthumously in 1939. *Praefanda* (1931) is a collection of bawdy and obscene passages from Latin authors. His lecture 'The Name and Nature of Poetry' (1933) illuminates the process of poetic creation.

Howells, Herbert (Norman) (1892–1983), British composer. His early work includes songs and orchestral and chamber music, written in a rhapsodic, pastoral style that owed much to *Vaughan Williams and *Delius. The success of his highly personal requiem *Hymnus Paradisi* (1950) renewed his interest in liturgical music, of which he became the foremost English practitioner. He is a master of complex contrapuntal textures, soft dissonance, and a quality of sensuous spirituality.

Howells, William Dean (1837–1920), US novelist and literary critic. Like his friend Henry *James, he first made his name with 'international novels' set in Europe, but his most admired works, *The Rise of Silas Lapham* (1885)

and *A Hazard of New Fortunes* (1890), deal with the problems of the machine age. In his later years he championed the trend towards realism in the novel represented by Hamlin Garland (1860–1940), Frank Norris (1870–1902), and Stephen *Crane.

Hrabal, Bohumil (1914–), Czech novelist and short-story writer. In his works eloquent and eccentric characters reveal themselves in highly original language. His novel *A Close Watch on the Trains* (1965) tells of an adolescent during World War II, while *Dancing Lessons for Older and Advanced Pupils* (1968) is a single-sentence monologue by an elderly man. In *How I Waited Upon the English King* (1984, not published in Czechoslovakia), a resourceful survivor narrates his exploits before, during, and after World War II alienated from the world around him.

Hudson River School, a name applied to a group of US landscape painters including Washington *Allston and Thomas Cole (1801–48), active from about 1825 to about 1875, who were inspired by pride in the beauty of their homeland. As well as the Hudson River valley, they painted the Catskill Mountains and other remote and untouched areas of natural beauty, often on a grandiose

scale. Their patriotic spirit won them great popularity in the middle years of the century, but later taste has often found their work overblown. Painters of a similar outlook who found their inspiration in the far West are known collectively as the Rocky Mountain School.

Hughes, Ted (Edward J. Hughes) (1930–), British poet. An obsession with the cunning and savagery of animal life and a sense of the beauty of the natural world are themes which dominate much of his work, including his first volume of poems *The Hawk in the Rain* (1957). In *Crow* (1970) he introduced the central symbol of the crow which recurs frequently in his verse; through the dark vision of the predatory bird he reflects the legends of creation and birth. Later volumes include *Cave Birds* (1975), *Season Songs* (1976), and *Moortown* (1979). In *Remains of Elmet* (1979) and *River* (1983) he shows his interest in topographical poetry. In 1956 he married the US poet Sylvia *Plath. He was appointed *Poet Laureate in 1984.

Hughes, Thomas (1822–96), British novelist. He is remembered as the author of *Tom Brown's Schooldays* (1857), evoking Rugby School which he attended when Dr Thomas Arnold was headmaster. In the character of the tyrannical Flashman, Hughes condemned the bullying in public schools and advocated a form of 'muscular Christianity' which saw Christian principles allied to physical courage, the love of sport, and patriotism, a combination that had much impact on late 19th-century public-school ethos. Other works include *Tom Brown at Oxford* (1861), biographies, memoirs, and sermons.

Hugo, Victor (1802–85), French poet, novelist, and dramatist. In range and quantity he was the greatest

A contemporary illustration of the first night of Victor **Hugo**'s *Hernani* at the Comédie Française in 1830, one of the most famous occasions in the history of French theatre. Traditionalists, determined to crush the play, packed the expensive seats, but they were outclapped and outshouted by the hordes of Hugo admirers—young artists, musicians, and writers—who ensured the success of the play that was to herald a new age of Romanticism in drama. (Musée Victor Hugo, Paris)

French poet of the 19th century. His poetry exhibits great rhythmical diversity, breaking away from the regularity of the *alexandrine, which had dominated 17th- and 18th-century verse. Hugo's poetry prior to the mid-1840s is primarily lyrical, a well-known poem from this period being 'Tristesse d'Olympio' from the collection *Les Rayons et les ombres* (1840), which displays a characteristic note of pathos. The later collections are more openly philosophical, but scattered through them are some of his finest poems. *Les Châtiments* (1853) is full of satirical invective against the usurpation of political liberty in France. *Les Contemplations* (1856), a nostalgic review of his own life, includes the poem 'A Villequier' inspired by the death of his daughter Léopoldine. *La Légende des siècles* (1883), containing the well-known poem 'Booz endormi', is a historical account of the spiritual progress of mankind. Hugo's ideas on drama are set out in the preface to his play *Cromwell* (1827) and include the view that the theatre should express both the grotesque and the sublime of human existence, the real and the ideal. The success of *Hernani* (1830) signalled the triumph of *Romanticism over the dramatic conventions which had governed French theatre since the time of *Corneille and *Racine. His novels, notably *Notre-Dame de Paris* (1831) and *Les Misérables* (1862), are written with great verve and demonstrate his concern for social and political issues.

Hummel, Johann Nepomuk (1778–1837), Austrian composer and pianist. Outstanding as a child prodigy, he embarked in 1788 on concert tours that took him all over Europe. Returning to Vienna in 1793 he built up a reputation as a composer and teacher, and later (1804–11) entered the service of Prince Miklós Esterházy. A spectacularly successful return to the concert platform (1814) was followed by an appointment as grandducal Kapellmeister (director of music) at Weimar (1818). Enormously prolific, he is now remembered for his fluent but somewhat conservative piano music.

Humperdinck, Engelbert (1854–1921), German composer. He came under the influence of *Wagner, whose *Parsifal* he helped prepare for performance (1882). He became famous as the composer of two operas which successfully blended the simplicity of folk-like tunes with all the paraphernalia of Wagnerian harmony and orchestration: *Hansel and Gretel* (1893), and *King's Children* (1910). His incidental music to *Reinhardt's spectacular production of *The Miracle* (1911) was also admired.

Humphrey, Doris (1895–1958), US dancer, choreographer, and teacher. She studied a range of dance styles before joining Ruth *St Denis to learn an early form of *modern dance. She formed a group with Charles Weidman in 1928 and toured with performances of her own choreography. Her dances were often concerned with form and based on musical structures, but reveal also a concern for humanistic values. Her movement vocabulary resulted from what she called 'the arc between two deaths', the standing position and the lying position, movement between which results in a sensation of falling or recovering. Her works include the music-based *Air for the G String* and the abstract mood piece *Water Study*, both made in 1928. In contrast, *With my Red Fires* (1935–6) and *Day on Earth* (1947) are both passionate and humanistic. Her writings represent a fully developed theory of the modern dance.

Hungarian literature, literature written in the Hungarian language which may be divided into two main periods. The first is from about 1200 to the late 18th century. In verse the outstanding figures are two soldier-poets, the lyricist Bálint Balassi (1554–94) and the epic writer Miklós Zrínyi (1620–64). Cardinal Péter Pázmány (1570–1637) was a master of Baroque prose style. The Enlightenment and Joseph II's political reforms initiated the second period. Writers and literature assumed the role of political opposition. Thus the romantic pessimism of the poet Mihály Vörösmarty (1800–55) and the revolutionary ardour of *Petőfi reflect the political atmosphere leading to the 1848 revolution. Its defeat resulted in a period of introspection characterized by the psychological novels of Zsigmond Kemény (1814–75), Imre Madách's *The Tragedy of Man* (1862), and the ballads and epics of János Arany (1817–82). The romantic novels of Mór Jókai (1825–1904) offered escapism; those of Kálmán Mikszáth (1847–1910) criticized Hungarian society. The demands of 20th-century readers were met by the journal *Nyugat* (1908–41), which rejuvenated literary activity and attracted new talent. *Ady, *Babits, the poet and novelist Dezső Kosztolányi (1885–1936), the social novelist Zsigmond Móricz (1879–1942), and the humorist Frigyes Karinthy (1887–1938) were among its leading contributors. The dramas of Ferenc Molnár (1878–1952) proved popular abroad. The post-war Communist regime initially stifled cultural development, provoking the literary ferment which led to the 1956 revolution. Several writers, including the socialist Tibor Déry (1894–1977), were later imprisoned, while others left Hungary. Of the younger writers, László Nagy (1925–78) is perhaps the most significant.

Hunt, William Holman (1827–1910), British painter, co-founder of the *Pre-Raphaelite Brotherhood in 1848 and the only member of the Brotherhood to remain faithful to its ideals throughout his career. His work is remarkable for its minute precision and its didactic emphasis on moral or social symbolism, and from 1854 he made several journeys to Egypt and Palestine to ensure accurate settings for his biblical scenes. Most of his works are now regarded as failures (his colouring tends to be painfully harsh and his sentiment mawkish), but the strength of his convictions commands respect. His autobiographical *Pre-Raphaelitism and the Pre-Raphaelite Brotherhood* (1905), although somewhat biased, is the basic source-book of the movement.

hurdy-gurdy, a musical instrument with strings rubbed by a wheel, instead of a bow. One or two strings are stopped by pressing wooden blades against them with the fingers; others are *drones. The instrument is thus a stringed equivalent of the *bagpipe. It derived from the earlier forms such as the 11th-century organistrum and the 13th-century symphony. It was one of the aristocratic 'folk' instruments of Marie Antoinette's court, but after the Revolution of 1789 it reverted to folk use, and is still found over much of Europe.

Huston, John (1906–87), US film director. Early in his career he combined critical and popular success in four outstanding films, for all of which he was also involved in the screenplay: *The Maltese Falcon* (1941), his first film, a classic of the detective genre; *The Treasure of the Sierra Madre* (1948) (Academy Award for best director), about

In this stone carving at the Cathedral of Santiago de Compostela, Spain, two monks are playing an organistrum, the earliest type of **hurdy-gurdy**. The instrument was used by the clergy to teach singing in choir-schools in the 11th and 12th centuries. One man cranks a handle to turn the wheel (beside the fingers of his other hand) that 'bows' the strings; the other turns the keys.

Eyeless in Gaza (1936), reflecting his growing involvement with pacifism. He left England for the USA in 1937, partly in search of a new spiritual direction. There his deepening interest in mysticism and parapsychology culminated in *The Doors of Perception* (1954) and *Heaven and Hell* (1956), which describe his experiments with the drugs mescalin and LSD.

hymn, a song or poem set to music in praise of a divine or venerated being. Hymns from India, the Sanskrit *Rig-veda*, survive from *c.*1200 BC (see *Sanskrit literature), and Greek hymns from about the 7th century BC. Christian hymns in the West (in Latin, until the Reformation) date from St Ambrose in the 4th century, the major English writers being Watts and *Wesley in the 18th century. What is thought to be the first Protestant collection of hymns and psalms in the vernacular was published by the Bohemian Brethren in Prague in 1501. The title 'hymn' is sometimes given to a poem on an elevated subject, like Shelley's 'Hymn to Intellectual Beauty' (1816), or praising an historical hero, like Mac-Diarmid's 'First Hymn to Lenin' (1931). (See also *spiritual.)

hyperbole, exaggeration for the sake of emphasis: a figure of speech not meant literally. An everyday example is the *simile 'old as the hills'. Hyperbolic expressions are common in plays of Shakespeare's time, in the inflated style of speech known as bombast.

greedy gold prospectors; *The Asphalt Jungle* (1950), a superb crime story centring on a jewel robbery; and *The African Queen* (1952), probably his most popular film. Huston's other films, though impressive in their diversity and technical finesse, seldom achieved the same success. *The Red Badge of Courage* (1951) was a notable war film; *The Misfits* (1961), scripted by Arthur Miller, was a study of failure set against a rodeo background; *Fat City* (1972) was about unsuccessful boxers. He filmed biographies of Toulouse-Lautrec (*Moulin Rouge*, 1953) and Sigmund Freud (1962); plays by Maxwell Anderson (*Key Largo*, 1948) and Tennessee Williams (*The Night of the Iguana*, 1964); and made a valiant effort to transfer *Moby Dick* to the screen (1956). The best of his later films were *The Man Who Would be King* (1975), based on Rudyard Kipling's tale; *Wise Blood* (1979), about religious mania; *Prizzi's Honour* (1985); and his last film, *The Dead* (1987), based on a story by James Joyce.

Huxley, Aldous (Leonard) (1894–1963), British novelist and essayist. A mixture of *satire and earnestness, of apparent brutality and humanity, is characteristic of his novels. His first novel *Crome Yellow* (1921), a country-house satire, earned him a reputation for precocious brilliance and cynicism. His other novels include *Antic Hay* (1923), set in the decadent society of post-war London; *Point Counter Point* (1928), in which his close friend D. H. *Lawrence appears as Rampion; *Brave New World* (1932), an indictment of mechanistic values; and

I

iambic verse, the commonest type of English verse, consisting of metrical units ('feet') known as iambs: these have one unstressed syllable followed by one stressed syllable, as in the word 'beyond'. The most important English form is the ten-syllable iambic *pentameter, which is unrhymed in *blank verse and rhymed in *heroic couplets; the eight-syllable iambic tetrameter is also a common English verse line. In Greek and Latin verse, iambs consist of one short syllable followed by one long syllable, and are found mainly in dramatic dialogue.

Ibert, Jacques (François Antoine) (1890–1962), French composer. The *Impressionistic orchestral suite *Escales* (1922) reflects his travels in the Mediterranean area. He later worked in Rome as director of the Académie de France (1937–60). Of his seven operas, the witty *Angélique* (1926) has proved the most popular. Though his style is eclectic it is basically *Neoclassical in conception: elegant, humorous, and designed to please.

Ibn Gabirol, Solomon Ben-Judah (*c*.1020–*c*.1070), Spanish-Jewish philosopher and poet. Born probably in Malaga, he was the most outstanding of Hebrew secular and religious poets during the Jewish Golden Age in Moorish Spain. He fused the heritage of Hebrew literature contained in the Bible, Talmud, and other rabbinical writings with that of the dominant Arab culture of Andalusia, drawing in the *Koran, Arab poetry (see *Arabic literature), philosophy, and ethics. His major philosophical work, *The Fountain of Life*, originally written in Arabic, was in the 12th century translated into Latin under the name of Avicebron. The Hebrew version appeared in the 13th century. Ibn Gabirol's Neoplatonist conception of the universe as a product of the divine will influenced the medieval Franciscan school of Scholastics, but was rejected by the Dominicans, including Thomas Aquinas. In his *The Royal Crown*, a long meditative poem, he describes the splendours of the universe, the smallness of man, and the divine grace that infuses both. His secular poetry includes love poems, wine songs, portraits of nature and praise of the seasons, as well as panegyrics about his noble patrons.

Ibsen, Henrik (Johan) (1828–1906), Norwegian dramatist and poet, creator of the modern *realist prose drama. He wrote many plays in the 1850s and early 1860s while directing the recently established theatre in Bergen and, later, the Norwegian Theatre in Christiania (now Oslo), but acquired a world-wide reputation with plays written in Italy and Germany from 1864 to 1891. His first successes were the poetic dramas of ideas *Brand* (1866) and *Peer Gynt* (1867), but from 1869 onwards Ibsen turned to social dramas, perfecting an analytical technique whereby the dramatic action, usually concerning an individual in conflict with the narrowness and complacency of contemporary society, is triggered as past events are gradually revealed. *Pillars of Society* (1877), which established Ibsen's reputation, attacked hypocrisy and praised individualism and refusal to compromise. *A*

Doll's House (1879), which provoked a major literary controversy, depicts a woman's rebellion against and final breaking away from the 'man-made' society in which she is confined. *Ghosts* (1881) shows how another woman's compromise with the demands of convention, undertaken for the sake of her family, leads to tragedy for all. Ibsen's later plays became increasingly symbolic. In *The Wild Duck* (1884), the wounded duck symbolizes the delusions of characters as ideals and idealists are exposed as inadequate; the title-character in *Hedda Gabler* (1890) is a woman whose lust for life, denied any outlet, turns inward and becomes self-destructive; and Solness in *The Master Builder* (1892) is punished for sacrificing human qualities to ambition. *When We Dead Awaken* (1899), described by Ibsen as the epilogue of his writing, depicts a sculptor who places his art above his personal fulfilment, and realizes too late that by denying the latter he has destroyed the former. Ibsen's plays pose questions, but seldom provide answers beyond a deep scepticism of political, social, and artistic ideals taken to excess. Few playwrights have matched his mastery of dramatic technique.

icon (Greek, *eikon*, 'likeness'), an image of a saint or other holy personage particularly of the Byzantine Church

According to tradition, the first **icon** depicted the Virgin and Child and was painted by St Luke the Evangelist. This famous example, 'The Virgin of Vladimir', was probably brought from Constantinople to Russia in the 1130s. It has become the most venerated of Russian icons. (Tretyakov Gallery, Moscow)

and the Orthodox Churches. Icons are generally images that are regarded as sacred in themselves and capable of aiding contact between the worshipper and the person portrayed. They vary considerably in size and appearance, but most typically they are fairly small *panels featuring the head of Christ or another holy figure. Often they feature wide, staring eyes that have an almost hypnotic effect on the worshipper. They are still produced in the Orthodox world.

iconography, the branch of *art history dealing with the identification, description, classification, and interpretation of the subject-matter of painting, sculpture, and the graphic arts. The term 'iconography' can also be applied to collections or the classification of portraits, so one can refer to 'the iconography of Queen Victoria', meaning the study of the representations of her.

idyll, any short poem describing an incident of country life in terms of idealized innocence and contentment; or any such episode in a poem or prose work. The term is virtually synonymous with *pastoral, as in Theocritus' *Idylls* (3rd century BC). The title of Tennyson's *Idylls of the King* (1842–85), a sequence of Arthurian *romances, bears little relation to the usual meaning. Browning, in *Dramatic Idyls* (1879–80), seems to understand the term to mean any self-contained poem.

Ihara Saikaku (1642–93), realistic, unsentimental Japanese poet and popular writer of the Tokugawa or Edo period (1603–1867). He was from Osaka, probably from a merchant family and made his early fame as a prolific virtuoso *haiku poet. He then turned to fiction and works such as *Life of an Amorous Man* (1682) and *Five Women who Loved Love* (1686) are frank portrayals of foolish, amorous heroes, prostitutes, and the exploits of *nouveaux riches* merchant families. (See also *floating world.)

Iliad *Homer.

illumination, a term in art applied to the decoration of manuscripts with paintings and ornaments, an art that can be traced back as far as the ancient Egyptians and which flourished particularly in the Middle Ages. The decorations can be classified into three main types: miniatures, or small pictures, which sometimes occupy a whole page; initial letters; and borders. The initials and borders sometimes contained devotional and domestic scenes, but were often composed of purely decorative, floral motifs. The art of illumination declined with the invention of the printed book in the 15th century, although early printed books sometimes have illumination added by hand.

illusionism, a term which generally refers to the use of pictorial techniques such as *perspective, foreshortening, and *trompe-l'œil to deceive the eye (if not the mind) into believing a painted object is a real one. In architecture and stage scenery similar techniques can be used to make three-dimensional constructions seem more extensive than they are.

Imagists, members of an Anglo-American poetic movement which lasted roughly from 1910 to 1917, and represented a reaction against *Romanticism. The aim was poetry in which the image was central rather than ornamental. Other key features included a preference for

The *Book of Durrow*, made at the monastery of Durrow in about 680, is the first of the great manuscripts from the golden age of Irish **illumination**. It is a Gospel Book (also called an Evangeliary), containing the text of the four gospels. This page shows St John's symbol, an eagle. As with other Irish books of the period, the decoration consis mainly of boldly elaborate interlace patterns. (Trinity College Library, Dublin)

*free verse over metrical forms; a stress on economy and exactness; the use of the language of common speech; and a 'dry, sophisticated' quality. An English group influenced by the radical philosopher T. E. Hulme, led by Richard Aldington, was joined by the Americans Ezra *Pound and Hilda Doolittle ('H. D.') (1886–1961) in 1912. In 1914 Pound edited the anthology *Des Imagistes*, which also contained poems by D. H. *Lawrence, James *Joyce, William Carlos *Williams, and Amy *Lowell. Lowell, who had arrived in England in the same year, then took over the movement, producing a number of anthologies called *Some Imagist Poets* (1915). For the leading writers, Imagism was only a stage in their development.

impasto, a term in art describing thickly applied paint retaining the marks of the brush, knife, or other instrument of application. The textural qualities it creates

can be one of the most personal aspects of *oil painting, and impasto is also a feature of certain types of *acrylic; it is not possible, however, with *water-colour or *tempera. Rembrandt is one of the great artists particularly associated with rich impasto.

Impressionism, a movement in painting originating in the 1860s in France and regarded as perhaps the most momentous development in 19th-century art. The Impressionists were not a formal group with clearly defined principles and aims but an association of artists, linked by a community of outlook, who banded together for the purpose of exhibiting. The central figures involved in the movement were *Cézanne, *Degas, *Manet, *Monet, Camille *Pissarro, *Renoir, and *Sisley, and their commitment to Impressionism varied considerably. Manet was much respected as a senior figure, although he never exhibited with the group. The Impressionists reacted against academic teaching and conventions and were also in revolt from the basic principle of *Romanticism, that art should convey intense personal emo-

Monet, the most devoted exponent of **Impressionism**, worked on a series of paintings of Rouen Cathedral from 1892 to 1895, using a makeshift studio next to the Cathedral during his visits to Rouen and finishing the pictures in his own studio at Giverny. He represented the cathedral at various times of the day and in various weather conditions to show how a scene's appearance changes according to the prevailing light. (Metropolitan Museum, New York)

tion. They were interested in the objective recording of contemporary life, trying to capture an 'impression' of what the eye sees at one particular moment. Landscape is considered the theme most typical of the Impressionists, but they painted many other subjects. Degas depicted subjects such as horse-races, ballet-dancers, and laundresses, and Renoir is famous for his pictures of pretty women and children. The Impressionists' desire to look at the world with freshness and immediacy was encouraged by photography and by scientific research into colour and light. In trying to capture the effects of light on varied surfaces, particularly in open-air settings, they transformed painting, using bright colours and sketchy brushwork that seemed bewildering or shocking to traditionalists. The name 'Impressionism' was coined derisively, when it was applied after the first Impressionist exhibition, held in Paris in 1874, to a picture by Monet, *Impression: Sunrise* (1872, stolen from the Musée Marmottan in Paris in 1985 and now listed by Interpol as one of the ten 'most wanted artworks missing'). Seven more Impressionist exhibitions were held between 1876 and 1886; after the final one the group broke up, only Monet continuing rigorously to pursue Impressionist ideals. Although Impressionism was at first greeted with hostility and many of its practitioners had to endure financial hardship early in their careers, it began to win critical acceptance in the 1880s and its influence was enormous—much of the history of late 19th-century and early 20th-century painting is the story of developments from it or reactions against it. The word 'Impressionist' has been applied to painters outside France—for example Philip Wilson *Steer in Britain—who painted in a style influenced by the French movement. By extension, the term has also been applied to literature in which the author attempts to convey his own impression rather than an objective description. The term has also been borrowed by musicologists to describe music which attempts to convey an idea of immediate experiences which are intangible and fleeting. In particular it has been applied to the works of *Debussy, such as his *Prélude à l'après-midi d'un faune* (1892–4) and the piano piece *Reflets dans l'eau* (1905). In this context it refers to the free use he made of dissonant chords, asymmetrical melodies, fluid rhythms, unusual scale formations, and subtle orchestral coloration. He used such innovative techniques to lend his music an apparent spontaneity and to avoid sharp contrasts. (See also *Neo-Impressionism and *Post-Impressionism.)

Imru' al-Qays, pre-Islamic Arab poet, thought to have died c.550, though details of his life are sketchy. He is the earliest major Arab poet whose work has survived in any quantity. He is considered to be the pioneer of the *qaṣida* (formal ode), and is renowned for his exquisite diction, the variety of his imagery, and the flow of his verse. The Prophet Muhammad is alleged to have described him as 'the leader of the poets into Hell-fire'.

Inca art *South American Indian art.

incidental music, music written for a play, either as atmospheric background or as part of the action itself. *Overtures and entr'actes also come within this definition. Some examples have become concert works in their own right: Mendelssohn's music for Shakespeare's *A Midsummer Night's Dream*, Grieg's for Ibsen's *Peer Gynt*, Beethoven's

overture for Goethe's *Egmont*. *Film and television music also fall into this general category.

incunabula (Latin, *cunae*, 'cradles'), a collective term for printed books published during the earliest period of *typography, from the invention of printing in Europe in the 1450s to the end of the 15th century. Incunabula tend to be rare, and the number a library possesses is often used as a rough guide to its importance. The British Library in London has about 10,000, estimated to be about a quarter of all those published.

indeterminacy (in music), a term used to describe music over which the composer has to some degree relinquished control, perhaps by leaving some aspects to chance or to the performer's decision. Techniques which involve chance in the process of composition have been used, for example, in the work *Music of Change* (1951) by Cage, whose performance was largely determined by the results of tossing coins. Other examples of indeterminate music are to be found in the works of Lutosławski, Stockhausen, and Henze. (See also *aleatory music.)

Indian art, the art and architecture of the Indian subcontinent (present-day India, Pakistan, and Bangladesh) or more broadly of India and the adjacent areas that have been part of its cultural sphere (in this wider sense, *Sri Lankan, *Nepalese, and *Tibetan art are included in the definition). The earliest Indian art belonged to the *Indus Valley civilization of about 2500–1500 BC, but after that there was a long gap before the next major artistic impulse—*Mauryan art, which flourished mainly in the 3rd century BC. Ashoka, the greatest of the Mauryan rulers, was a convert to Buddhism, and this religion and Hinduism provided the inspiration for most Indian art until the coming of Islam, although a third religion native to the country, Jainism, has also played a part. Two early traditions are represented by *Gandhara art and *Mathura art, but early Indian art reached its peak slightly later in the *Gupta era, the finest flowering of which was in the 5th century AD. Painting (notably at *Ajanta) and sculpture attained new heights and the great age of temple building was firmly established. The temple continued to be the chief focus of artistic endeavour in India, and in splendour and beauty of decoration many examples can compare with the great Romanesque and Gothic cathedrals of Europe: *Elephanta, *Ellora, and *Khajuraho are among the most illustrious. Traditional values in Indian art, however, were threatened and eventually overthrown by the Muslims, who conquered virtually all of the vast subcontinent beween the 11th and 15th centuries, bringing India into the sphere of *Islamic art. The highpoint of Islamic art in India came with the *Mughal dynasty, which in the period from about 1550 to about 1650 included among its rulers three celebrated patrons of the arts. One of them, Shah Jahan, was responsible for the most famous of all Indian buildings, the Taj Mahal at Agra (built from 1632 to 1649), the exquisitely pure forms of which contrast with the superabundant decoration characteristic of Buddhist and Hindu temples. Exchanging gifts was important in Mughal court life and this encouraged the decorative arts to flourish in luxury articles such as carpets, jewellery, and inlaid weapons. With the decline of the Mughal empire, the British emerged as the dominant power among the European nations who had been a presence in India since the arrival of the Portuguese navigator Vasco da Gama in 1498. By the mid-18th century much of the country was under British control; government was intitially in the hands of the East India Company, but after the Indian Mutiny of 1857 the control of the whole country passed to the British crown (1858). Indian painting produced for European patrons, known as *Company painting, is often attractive, but the finest artistic expressions of the period of European rule were in architecture. Many major cities boast huge Victorian public buildings that are as impressive as virtually anything of the same type in Britain; usually they are in historicist styles such as *Gothic Revival, but sometimes with features or detailing inspired by Indian tradition. The culmination of the taste for the grandiose came with Sir Edwin *Lutyens's designs for the new capital at New Delhi (1913 onwards), an inspired fusion of British and Indian traditions. The most famous artistic monument created since India became independent in 1947 is *Le Corbusier's new town of Chandigarh (1950 onwards). Among modern Indian artists the best known is the painter Jamini Roy (1887–1974) who has successfully combined influences from European modernism with ancient traditions. (See also *Buddhist art, *Hindu art, *Jain art.)

Indian dance. India has a strong classical dance tradition, as distinct from traditional or *folk dance-forms related to hunting, agricultural, and social rituals of a particular community. The four major classical dance styles are *Bharatānātyam, *Kathak, *Kathakali, and *Manipuri, although two others, Odissi and Kuchipudi

One of the many varied forms of **Indian dance** is shown here. This detail of a Mughal miniature (*c*.1561) shows dancing girls and musicians performing at a marriage entertainment at the court of Sultan Akbar. (Victoria and Albert Museum, London)

were recognized in 1958. All trace their ancestry to Bharata Muni's *Nāṭyaśāstra, a comprehensive treatise on nāṭya (dramatic art that is also dance), and to the *Vedas, the oldest scriptures of Hinduism. The dances are a combination of two basic styles: abhinaya, a mimed representation of a song or story from Indian classical mythology; and nṛtta, 'pure' or abstract dance, where composed sequences of rhythmically complex movements are performed to vigorous drum accompaniment. Two temperaments—tāndava, the forceful male energy of the god Siva, and lāsya, the tender grace of Shiva's wife Parvati—are represented in the various forms. Bharatānāṭyam and Manipuri have a lāsya character, Kathakali is predominantly tāndava in mood, while Kathak combines the two. In the 20th century Indian classical dance-forms are widely taught in small academies and training centres. Dance-forms that draw on Western *ballet and *modern dance forms have also developed since the 1930s, when Uday Shankar choreographed Western-style ballets that drew on the classical Indian styles. Indian dancers working in Britain are also experimenting with new ideas, notably conveying modern themes using the vocabulary of Indian classical dance. (See also *mudrā.)

Indian literature, literature of the Indian subcontinent. In written form it derives primarily from the languages of the Indo-Aryan and Dravidian families, while the Tibeto-Burman and Austric languages such as Manipuri or Santali are rich in folk-songs and oral literature. The oldest Indian literature is Indo-Aryan, the hymns of the *Vedas, some of which date from the middle of the 2nd millennium BC. With the scientific codification of the language in the 5th century BC, *Sanskrit literature proper began with the *Mahābhārata and *Rāmāyaṇa epics, and during the early centuries AD classical Sanskrit poetry, drama, and prose emerged under Gupta patronage. Through works such as the epics and the *Purāṇas, Sanskrit literature profoundly influenced not only all the later vernacular literatures of the subcontinent but also, as Hindu culture spread overseas, South-East Asian literatures such as Thai and Balinese. Through later Mahāyāna Buddhist works such as the Diamond Sūtra, Sanskrit literature permeated Central Asia and further eastwards. Indian folk-tales in Sanskrit like the *Pañchatantra have, through various translations, been absorbed into European literature. The non-Brahmanical religions of ancient India did not use the 'refined' Sanskrit for their sacred writings but the spoken language of the masses, the 'unrefined' Prakrit, of which various dialects developed. Hence the *Pāli literature of early Hīnayāna Buddhism, from which the *Jātakas proved particularly popular throughout South-East Asia, and *Jain literature in Ardhamāgadhī Prakrit. There was also some secular literature composed in Prakrit, since by convention Sanskrit dramatists used it for the speech of lower-caste and female characters. From 600 AD onwards, the Prakrits underwent further simplification into what is termed Apabhraṃśa, a variety of which was used by a few Jain poets in Gujarat and Rajasthan. After about 1000 the modern Indo-Aryan literatures began to emerge, such as Assamese, *Bengali, and Oriya in eastern India, *Hindi in the centre, and Rajasthani, Marathi, and Gujarati in the west. The *Dravidian literature of southern India, written in Tamil, Telugu, Malayalam, and Kannada, has distinctive traditions of its own. *Tamil literature can be traced back to the first centuries AD and its early styles of epic and love poetry are quite unlike those of Sanskrit. Later, however, all Dravidian literature, including Tamil, was heavily influenced by Sanskrit literary forms and traditions. The vernacular Indian literatures, whether Indo-Aryan or Dravidian, show a remarkable degree of uniformity in their development. Initially bardic poetry and versions of the Sanskrit classics predominated, but it was the rise of devotional *Bhakti literature which first established the vernacular literary tradition as something quite distinct from the Sanskritic. From the 14th to the 17th centuries Bhakti literature was the dominant creative force in all the Indian vernaculars. The arrival of Muslim rule in India brought with it the Perso-Arabic literary tradition, and the mystical writings of Sufi saints were particularly influential. *Persian literature flourished at the Muslim courts of India until increasingly supplanted by *Urdu literature from the 17th century onwards. With the spread of Western education under the British in the 19th century, the Indian vernaculars acquired a modern prose style which led in turn to the introduction of European literary forms such as the novel, the short story, and the essay alongside poetry and drama revitalized by the mingling of the Western with the Sanskrit traditions.

Indian music, music of the Indian subcontinent, divided into two classical traditions: the North Indian or Hindustani (as used in Pakistan, north India, and Bangladesh) and the South Indian or Carnatic (followed in south India and Sri Lanka). Despite many differences between the two, certain general characteristics are shared, such as the essential texture, consisting of highly ornamented melody, multiple *drone and complex rhythmic accompaniments, and an emphasis on virtuoso improvisation. The most ancient surviving music is that of the Sāmaveda, highly melismatic chants (that is, many notes to each syllable) for the sacred Sanskrit hymns of the *Veda which are over 4,000 years old. Non-Vedic art music emerged nearly 2,000 years ago, when it was associated with dance and poetry. The *Nāṭyaśāstra classified melodies into modal groups or jāti, and was influential throughout India. In the Bṛhaddeśī of Mataṅga (8th–10th centuries) the concept of ragas (modes) was first developed, refined with much sophistication over ensuing centuries. A series of invasions between the 12th and 16th centuries by Central Asian peoples brought Islam to India: an influence discerned in the absorption of Muslim instruments such as lutes, *shawms (including the *shahnāī), and *kettledrums into north Indian culture (see West Asian music). Western rulers of the last two centuries have had little influence on Indian music. The twin essentials of Indian music are its organization by raga and tāla. Many different ragas were extracted from each same basic *scale by listing small differences such as frequent, infrequent, or omitted notes, so that the Saṅgītaratnākara, a mammoth text on the theory of music, written in the 13th century, could list over 200 ragas. Each raga was also considered to have an individual musical and aesthetic characteristic, and was associated with a particular deity, sentiment, season, even time of day at which it should be performed. A simultaneous development was the emergence of the ālāpa, a method of improvisation that set out systematically the characteristics of the rāga being performed, and used today as the basis of extended improvisation. The three basic types of scale in use today are diatonic, scales using

augmented seconds (from Perso-Arabic traditions), and scales with consecutive semitones, used only in the south. The octave was theoretically divided by ancient theorists into twenty-two microtones, but this has no modern practical application. The rhythmic organization of Indian music is highly complex. Rhythm is either unmeasured, for example during the improvised *ālāp*, which opens a performance, or measured, as used in fixed compositions and improvised variations on them. Measured rhythm is expressed in terms of equally spaced beats, the number of beats in a measure, usually between four and sixteen, being determined by the rhythmic pattern (or *tāla*). Each *tāla*, which is assigned a particular name, divides up the total number of beats into a variety of asymmetric groups, for example the *Tīvrā* divides seven beats into 3+2+2. Apart from the first beat of the measure (the *sam*), stress can fall at any point, and complex cross-rhythms ensue, the drum providing a rhythmic counterpoint to the melody. Typically, pieces begin with an improvised prelude, proceed with a traditional composition set in raga and *tāla*, and end with virtuoso variations on these, in which the first phase of the composition serves as a refrain. Performers such as Ravi *Shankar have extended the appreciation of Indian music beyond the subcontinent.

Indian musical instruments. The most highly regarded 'instrument' is the voice, which in performance uses a variety of glissandos (movement through a succession of notes), vibratos (slight variations in pitch to lend tone), and much ornamentation, techniques all imitated on instruments. Plucked string instruments are next in importance, examples being the long-necked lutes *vīṇā, *sitar, and the *tambura* (used to play the *drone) and *sarod*, the short-necked lute (see *rebab). Bowed instruments include the *dilrubā* and *esrāj* (small-boned sitars), and the *sārangī*, an instrument of Central Asian origin used especially to accompany the verse. Amongst wind and brass instruments, transverse bamboo flutes are of great antiquity and are associated with the god Krishna, while curved horns and straight trumpets are used in folk and religious ceremonies. The playing of percussion instruments, especially drums, such as the *mṛdaṃga* and *tabla, is a great art-form in India, and they are indispensable to classical and much folk music.

Indonesian art, the art and architecture of Indonesia, a large group of islands in South-East Asia including Java and Sumatra. Remains of Stone Age and Bronze Age culture have been found on several islands, and stone inscriptions indicate the presence of an Indianized culture in Indonesia by at least the 4th century AD. By the late 7th century the kingdom of Srivijaya, probably centred around Palembang in southern Sumatra, is mentioned in Chinese and Arab sources as a major commercial centre controlling much of the East–West maritime trade, but only a few brick temples survive. Bronze images, principally of Buddhist deities, chronicle their religious allegiance. These sculptures, like those to be found in the Thai peninsula at this period, reflect in part the Pallava style of southern India. In the course of the 8th century the centre of power shifted to central Java with the emergence of the Sailendra dynasty (*c.*775–856), patrons of Buddhism who maintained close links with the Pala rulers of eastern India. Their major legacy is the 'temple-mountain' of Borobudor (*c.*800), which is the greatest

surviving monument of Buddhism and one of the world's supreme religious sites. It consists of a step-pyramid on a square platform rising through eight terraces to a *stupa pinnace. Borobudor and the other Buddhist temples in central Java were embellished with decorative and narrative reliefs and housed free-standing sculptures, principally representations of the Buddha and attendant Bodhisattvas (see Buddhist art). Small-scale metal sculptures also survive, mostly in bronze, but also in precious metals, which follow the monumental stone sculptural tradition. By the middle of the 9th century it appears that Hinduism was ascendant, as the great temple complex at Prambanan, dedicated to Shiva, testifies. The temple monuments of central Java reveal much about the religious concerns of the Sailendras and set the style for the later Hindu-Javanese arts which emerge after power shifted to east Java in the 11th century. The richest legacy of this region are the brick temple towers (*candi*) of the Majapahit kingdom (13th–late 15th century) with their distinctive *kala* face reliefs, and the bronzes, both ritual utensils and images, associated with the ritual life of the temples. Much of the stone sculpture of this period is stiff and formal, lacking the naturalism which graced earlier Javanese art. The later courtly arts of Java are linked with the palace (*kraton*) rather than the temple and reflect, in part, the overlaying of Chinese and Islamic influences on Hindu-Javanese tradition.

A view of the upper terraces of Borobudor, one of the great monuments of **Indonesian art**, which culminates in a central stupa. The ten levels of the temple represent stages in the pilgrim's path from ignorance to enlightenment. Thus the austerity of the upper circular terraces, corresponding to a spiritually advanced state, contrasts with the rich sculptural ornamentation of the lower levels, depicting scenes of worldly distraction.

Indonesian literature, the traditional poetry and prose writings in Sundanese, Javanese, and other languages of the peoples of Indonesia, and modern writing in Indonesian. Many themes and forms have been borrowed and adapted from *Indian literature, whose influence is particularly strong upon old Javanese literature. The sophisticated Javanese poetic genre called *kakawin* includes subjects adapted from the Indian *Mahābhārata* *epic as well as from Buddhist sources. The 14th-century Javanese work the *Description of the State* is, unlike other *kakawin*, not predominantly mythological but a description of the Javanese kingdom of Majapahit. An important Javanese prose work is the *Pararaton* ('Book of Kings') which has a strong historical content. In 'modern' Javanese literature, which has flourished from the early 18th century, there are many long works called *babad*, of which the most important is the *Chronicle of the Land of Java* relating the history of Java. Indonesian literature incorporates much from Muslim traditions as well as from Indian, and often has a strongly mystical element. Other sources of inspiration have come from models and story-cycles in *Persian and *Arabic literature, for example from the *Thousand and One Nights*. Much historical literature takes the form called *hikayat*, of which the *Story of Aceh*, telling the history of Iskandar Muda (1607-36), Sultan of Aceh, is a typical example. In the 19th century the influence of contact with the West is apparent in works by the Javanese writer Ranggawarsita, while the emergence of a vernacular press and, in the early 20th century, the growth of nationalism contributed to the modernization of Indonesian literature. After World War II writers of the *Angkatan 45* (Generation of '45) group pioneered a new style and saw themselves as part of a world culture. Indonesian literature in the post-war years became increasingly polarized along political lines and, following the attempted communist coup of 1965, many writers were imprisoned. Among the last to be released from prison in the late 1970s was the outstanding writer Pramoedya Ananta Toer. Many writers accused of leftist associations are still under restrictions and writers and the press in general operate a degree of self-censorship. (See also *Malay literature.)

Indonesian music, music from the 3,000 inhabited islands stretching from Sumatra in the west to Irian Jaya in the east, and with a population of 150 million people distributed through more than 300 cultural groups speaking almost as many languages. Indonesian music, not surprisingly, demonstrates great cultural diversity. Nevertheless, its most famous and characteristic music is *gamelan music, sophisticated ensemble music primarily for *gongs, developed from before the 7th century AD. The dominant gamelan tradition is from central Java and its modern practice dates from around the 17th century, when two basic types of royal court orchestra—the loud and soft ensembles—were merged. Ensembles consist of various types of gongs combined with other percussion and melody instruments and vocalists. Two different tuning systems (*laras*) are used: *slendro* and *pelog*, with respectively five and seven fixed pitches to the octave, though *pelog* in practice yields a number of pentatonic *scales. A tablature notation developed in the 19th century (*kraton*) has been replaced this century by the *kepatihan* system, which uses numbers to represent notes. Usually only the *balungan* (fixed melody) is notated. All the instrumental parts are derived from this fixed melody,

each player interpreting and elaborating it according to the speed and form of the music and the technique of his instrument, from fast embellishments in the higher pitched instruments to infrequent punctuation on the deepest gong. The result is a complex polyphonic texture, static yet full of movement, and with a calm and refined beauty. Gamelan music is used in concerts, accompanies many social gatherings, *shadow plays and dances, as well as being used in Hindu temple ceremonies. Central Javanese gamelan music spread most notably to west Java (Sunda) and Bali, where it was adapted and modified. Of the gamelan ensembles of the Balinese tradition, some are clearly related to the Hindu-Javanese ceremonial court ensembles, others add instruments such as *jew's harps or bamboo instruments, while in some groups metallophones are tuned slightly apart, producing a shimmering sonority. In the 20th century *gamelan gong kebyar*, an energetic and virtuosic orchestral style which uses abrupt contrasts of tempo, dynamics and texture, has developed rapidly, and replaced older types of gamelan. Sundanese gamelan ensembles generally employ fewer instrumentalists and feature more prominently the female vocalist. (See also *South-East Asian music; *South-East Asian dance.)

industrial architecture, a general term applied to buildings designed in the service of large-scale industry. Although major commercial buildings (such as warehouses) were erected earlier, the term 'industrial architecture' is generally confined to buildings dating from the time of the Industrial Revolution in the 18th century. Mechanization, particularly the development of steam power, greatly increased the production of goods, and new types of building were needed for their manufacture, transport, and storage, and for the administration of business. Early factories, foundries, and similar buildings were often built in a simple utilitarian style; they would scarcely have been thought of as architecture at the time, but they are now often admired for their rugged strength. Some buildings continued in this tradition in the 19th century, but with the Victorian passion for reviving historical styles there was also a tendency to make, for example, a brewery look like a castle (see *Victorian architecture). Railway stations are often particularly good examples of the way in which new technology behind the scenes was combined with highly ornamented historicism on the show façades. The vast iron and glass train shed at St Pancras Station, London, for example, a marvel of Victorian engineering, is hidden behind the pinnacles and towers of Sir George Gilbert *Scott's Midland Grand Hotel, *Gothic Revival at its most sumptuous. In the 20th century, however, following the lead of figures such as *Behrens, industrial architecture has moved overwhelmingly in the direction of simplicity, *functionalism, and cost-effectiveness. The health and welfare of the occupants is (or should be) another major consideration in modern industrial buildings.

industrial design, the design of products made with machines or tools in organized industry, as opposed to the works of individual artists and craftsmen. Although the term did not come into use until much later, the concept of industrial design was born with the decline in craftsmanship following the Industrial Revolution—the Royal Society of Arts was founded in London as early as 1754 to encourage a union of 'Art and Commerce'.

However, as industrialization increased, it became clear to many critics that the overwhelming majority of manufacturers put the quantity of goods produced before the quality. In the UK the poor quality of goods displayed at the Great Exhibition held in London in 1851 persuaded many artists (particularly the members of the *Arts and Crafts Movement) that industry and art were incompatible. In the early 20th century the real breakthrough came, with designers working totally in harmony with the methods of machine mass-production. The key developments took place in Germany, where in 1907 *Behrens joined the firm of AEG, marking the beginning of a desire within large-scale industry to humanize technology. In the same year was founded the Deutscher Werkbund (German Association of Craftsmen), which promoted the ideas of *functionalism and abolition of ornament. These ideas were developed during the 1920s at the *Bauhaus, which has had an enormous influence throughout the world. In the 1930s industrial design became established as a profession, and in the fiercely competitive markets of the modern world the appearance of a product has become of great importance in attracting customers. The extent to which industrial design has entered into everyday life can be gauged from the example of Raymond Loewy (1893–1986), the most successful US designer of his period; in the 1950s it was estimated that 75 per cent of all Americans came into daily contact with at least one of his designs, which include such classics as the Lucky Strike cigarette packet (1940) and the Pepsodent toothpaste packet (1945) in addition to cars, electrical goods, and many other products. Recently, the subject of ergonomics—the scientific study of human efficiency in the working environment—has become of great importance in industrial design, products such as office furniture, for example, being made so that it can be used with optimum effectiveness, comfort, and safety.

Indus Valley art, a term applied to the artistic products of an enigmatic civilization that flourished in the valley of the River Indus and its tributaries (in present-day Pakistan) from about 2500 BC to about 1500 BC. Nothing is known of its origin or the reasons for its decline, but archaeological excavation has revealed that it was artistically highly sophisticated for its date. The main sites at Mohenjo Daro and Hareppa were major urban centres, each more than 5 km. (3 miles) in circumference, with citadels, granaries, and baths (perhaps used for sacred ablutions) as well as houses. Buildings were of fire-burnt bricks. Works of art excavated include stone sculpture, terracotta figurines, a large number of engraved seals, and some outstanding bronze and copper figures. All of these are on a small scale, showing human figures and animals with great liveliness; no large-scale public art survives.

infinite canon (perpetual or circular canon), a form of musical structure in which each voice, having reached the end of the melody, begins again and so indefinitely.

Ingres, Jean-Auguste-Dominique (1780–1867), French painter, *David's most important pupil and one of the foremost exponents of *Neoclassicism. He went to Rome as a prize-winning student in 1807 and remained in Italy until 1824. While he was there the works he sent back to France were often criticized for the way in which

he was considered to have distorted forms for the sake of sinuous elegance, so that on his return to Paris in 1824 he was surprised to find himself acclaimed as the champion of 'official' academic art against the rising tide of *Romanticism. He was appointed director of the French Academy in Rome in 1834. In 1841 he returned to France, again acclaimed as the upholder of traditional values in art. His preferred subjects were grandiose historical and religious themes, but he was also one of the greatest portraitists of his day and painted some superb nudes. In spite of his role as the guardian of classical rules and precepts, it was his personal obsessions and mannerisms that made him a great artist, and his profoundest influence was on other masters of line, such as *Degas and *Picasso.

inro, a small medicine case carried attached to the sash of the kimono as part of the traditional male Japanese costume. Originally such cases held seals, but they were adapted for holding medicine in about the 17th century. They are made of several sections fitted on top of one another, and are usually decorated with *lacquerwork, the most splendid examples having all the resources of this luxury craft bestowed on them, including embel-

The Valpinçon Bather (1808) is one of **Ingres**'s most memorable depictions of the female nude. Although the precision of outline and immaculately smooth handling are typical of Neoclassicism, the sensuous response to the subject is entirely personal to Ingres. (Louvre, Paris)

An early 19th-century Japanese **inro** depicting a bloodcurdlingly fierce-looking mythological character, Shoki the demon-quaker, against a background of eggshell-mosaic lacquer. Like many other inros, this example is signed by the craftsman who made it, Koma Kansei. (Victoria and Albert Museum, London)

lishment with gold. Like *netsukes, inros became popular with Western collectors in the 19th century.

intaglio (Italian, 'incision'), a term in art to describe engraved or incised work in which the design is sunk beneath the surface of the material, the opposite of *cameo, in which the design is in relief. It is a very ancient technique dating back to Babylonian seals of about 4000 BC. The form makes it particularly appropriate for seals, and 'an intaglio' often means an engraved gem in which figures or other devices are carved into the stone so that when pressed upon wax it produces a likeness in relief. In the graphic arts, 'intaglio printing' refers to any process of print-making in which the parts of the plate or block that will take the ink are incised into it, for example *etchings.

interior design, the planning and decoration of the interiors of buildings, including architectural planning as well as surface finishes and furnishing and fittings. The terms 'interior design' and 'interior decoration' are often used more or less interchangeably, but it is useful to distinguish between them; interior design is a more inclusive term, dealing at its broadest with the analysis of space requirements in large buildings such as hotels and offices, whereas interior decoration suggests the embellishment of a pre-existing environment. Since the Renaissance, architects have often been supported on major buildings by teams of craftsmen—carvers, joiners, stuccoists, and decorative painters—and in the 17th century the *Gobelins factory supplied virtually everything necessary for the furnishing of the royal palaces of Louis XIV. However, it was only in the 18th century, particularly with the work of Robert *Adam, that architects began to impose their design conception on every aspect of a building—plasterwork, carpets, furniture, and so on. Today interior designers tend to belong to one of two groups: those who are specialists within large architectural firms; and those who concentrate on domestic design for individual clients. However, there are no precise boundaries and the architect, the furniture designer, and the industrial designer all play their parts in interior design.

intermedio, a musical interlude performed between the acts of a play. Developed in Italy in the 16th century, it was usually presented in the form of light allegorical tableaux. The music consisted of songs accompanied by large and varied instrumental ensembles, sometimes with ballet; the whole was often conceived for vast forces with an elaborate *mise-en-scène*. In time the intermedio came to assume more prominence than the play itself, and was one of the elements that led to the concept of *opera.

intermezzo, musical term which by the 18th century had come to mean a short comic opera performed between the acts of a serious opera. In the 19th century it meant an orchestral interlude separating the scenes or acts of an opera, and has since then come to embrace a short movement in a symphony, concerto, or sonata, or a short piano piece. (See also *intermedio.)

International Gothic, a style in painting, sculpture, and the decorative arts that spread over Europe between *c*.1375 and *c*.1425. The style was characterized by aristocratic elegance and delicate naturalistic detail and was formed by a mingling of elements from Italian and northern European art, encouraged by the cultural rivalry of major courts and the increasing freedom with which major artists travelled. Lombardy, Burgundy, and Bohemia were among the areas in which the style flourished, and major exponents included *Gentile da Fabriano, *Pisanello, and the *Limburg Brothers. Elements of the style are present in the work of several of the leading artists of the early Italian *Renaissance, such as Fra *Angelico, *Ghiberti, and *Uccello. In Britain, the finest example is the celebrated Wilton diptych, which testifies to how genuinely international the International Gothic style was, for although it clearly comes from the hand of an artist of the highest rank, authorities disagree as to whether he was English, French, or Italian.

interval (in music), the distance in pitch between any pair of notes in the scale. The smallest interval acknowledged by Western music (though not by other

civilizations and cultures) is the semitone. The size of an interval is reckoned numerically, beginning with the unison and progressing through the second, the third, and so on, to the octave. Intervals larger than the octave are known as compound intervals. It is also necessary to define the quality of the interval. All seconds, thirds, sixths, and sevenths are either major or minor—the minor version always having one less semitone than the major (C to A flat, as opposed to C to A natural). Unisons, octaves, fourths, and fifths are said to be perfect. If a major interval is increased by a semitone it is said to be augmented (C to A sharp, as opposed to C to A natural). When a minor interval is reduced by a semitone it is said to be diminished. Perfect intervals can also be augmented or diminished in the same way.

Intimisme, a term in art applied to a type of intimate domestic *genre painting particularly associated with *Bonnard and *Vuillard from about 1900 onwards. By this time both men were moving away from the experimental work of their youth in favour of a more naturalistic, more or less Impressionist, approach, and their own homes, family, and friends figured prominently among their favourite subjects.

Inuit literature, literature of the Inuit (Eskimo) people. The unique polar environment of the Inuit infuses their literature, which ranges from shamanist chants to extended creation narratives. Particularly notable are texts,

Costume designs for gods and signs of the zodiac by Bernardo Buontalenti for a Florentine **intermedio** of 1589. The *intermedio* originated in 16th-century Italy as a short, light, musical entertainment interpolated between sections of classical plays, the earliest recorded example being seen at Florence in 1539. (Biblioteca Nazionale, Florence)

such as the Raven Cycle, versions of which they share with the *North American Indians, which celebrate the dramatic contrast between summer and winter, the arctic day and night, and which highlight the urgent need to find food in the blank world of snow and ice.

Ionesco, Eugène (1912–), French dramatist of Romanian birth. He is often associated with the so-called Theatre of the *Absurd. In *La Cantatrice chauve* (1950) he portrays the banality of everyday existence, basing the platidudinous dialogue through which he conveys the alienation of the individual on the formal phrases of the textbook he was using to learn English. *Rhinocéros* (1960), less negatively, defends the individual against the dehumanizing force of totalitarianism. His ubiquitous fear of death finds its fullest expression in his masterpiece, *Le Roi se meurt* (1962). Ionesco produces almost *Surrealistic effects by his use of props and settings to externalize his characters' anxieties.

Ireland, John (Nicholson) (1879–1962), British composer and pianist. His music reflects the influence of Debussy and Ravel and found its most persuasive outlet in songs and piano pieces. His second Violin Sonata (1917) made a considerable impact, as did his Piano Concerto (1930) and two *Impressionistic programme works: *The Forgotten Rite* (1913) and *Mai-Dun* (1921). The light-hearted overture *Satyricon* (1946) revealed a less introspective side of his nature.

Irish-language literature, the literature written in the Celtic language of Erse Gaelic. It was first recorded in the Roman alphabet in the 8th century, but earlier verse has been preserved in manuscripts. The earliest datable Irish poem is Amra Choluim Chille, a eulogy in praise of Saint Colum Cille (d. 597). The Ulaid cycle, a

group of legends and tales dealing with the heroic age of the Ulaids, a people who gave their name to Ulster, was recorded from oral tradition between the 8th and 11th centuries. Outstanding in Irish literature, they are preserved in the 12th-century manuscript, the *Book of the Dun Cow*, and narrate the high deeds of Conchobar, King of the Ulaid, Cu Cuchulainn, a boy warrior, Medb, Queen of Connaught, and the doomed lovers, Noise and Deidre. (The latter story has been retold in the 20th century by W. B. *Yeats and J. M. *Synge.) After the 12th century the hereditary *bards perfected the art of eulogistic and ornamental poetry. Tales and *ballads centring on the deeds of the legendary Finn MacCumhaill (MacCool) were recorded in manuscript in *The Interrogation of the Old Man* (c.1200), and have remained a vital part of Irish folklore. The gradual infiltration of a Norman and English aristocracy and the intense hardships suffered under British rule undermined the old literature which was preserved only as a folk tradition. *Satire flourished, and the old poetic metres were abandoned in favour of the vernacular. By the middle of the 19th century literary activity in Gaelic had all but ceased, but the revival of the language has since played a significant part in modern Irish nationalism. In the 20th century works in Gaelic have been published, and novels such as Flann *O'Brien's *At Swim-Two-Birds*, published in English (1939), translated into Gaelic (1956), and his second novel *An Béal Bocht*, published in Gaelic (1941), as well as Brendan Behan's *Giall* (1957) (*The Hostage*; 1958) have received popular acclaim.

Irish Literary Revival, a renaissance of Irish literary culture and nationalism which began in the last quarter of the 19th century and continued to flourish until the 1920s. The movement drew on the heritage of *Irish-language literature. Early pioneers were Sir Samuel Ferguson (1810–86) who stimulated interest with his translations of works based on Irish legend (such as *Lays of Western Gael*, 1865); and Douglas Hyde (1860–1949) whose translations from Gaelic and *A Literary History of Ireland* (1892) were influential. The leading figure of the movement was W. B. *Yeats, whose poems such as *The Wanderings of Oisin and other poems* (1889), were inspired by traditional and nationalist themes. He expressed the mysticism of the Irish in *The Celtic Twilight* (1893), a collection of stories which gave a name to the Irish Revival movement. In 1899 Yeats, Augusta, Lady Gregory (1852–1932), and Edward Martyn (1859–1923) founded the Irish Literary Theatre to encourage Irish drama. This subsequently became the Irish National Theatre Society, which in 1904 acquired the Abbey Theatre, Dublin where J. M. *Synge's play *The Playboy of the Western World* caused outrage and riots in 1907. The Abbey Theatre also staged plays by Yeats and *Shaw, while *O'Casey's controversial play *The Plough and the Stars* (1926) provoked a nationalist riot. George Russell ('A.E.') edited *The Irish Homestead* from 1905 to 1923, which encouraged interest in Irish literature and culture, as did the *Dublin University Review*. Other poets, including *Joyce, Padraic Colum (1881–1972), James Stephens (1882–1950), and Oliver St John Gogarty (1878–1957), contributed to the new literary stature of Irish writing.

Iron Age art, the art of the stage of human culture when iron took over from bronze as the most important metal used in making tools and weapons. The *Hittites were the first people to produce iron on a commercial scale (by the 15th century BC), and when their empire collapsed in about 1200 BC their techniques soon spread to other parts of the Near East and then to Europe. The beginning of the Iron Age is thus conventionally placed at about 1200 BC, and by about 1000 BC most of Europe had made or was making the transition from bronze to iron, although the former continued to be used for artefacts and decoration. The Italian peninsula became an important cultural and artistic centre, first with the Villanovian civilization whose burial rites inspired decorated, biconical pottery urns for the ashes of the dead, and later with the *Etruscans, whose influence spread into the surrounding areas. In central and eastern Europe a metal art with geometrical abstract ornamentation was developed. The Hallstatt culture, so-called after a burial site of this name, produced polychrome pottery and characteristic bronze buckets that were severely geometric in style. It was superseded by the La Tène culture with its typical curvilinear decoration. The characteristic *Celtic art-form was established, with its S-shaped spirals and circular patterns. Its finest work is a remarkable mixture of abstract and figurative representation. In Asia, including India and China, Iron Age art was developed in the first millennium BC; it did not become fully established in Egypt until about the 3rd century BC. In Africa bronze had never been adopted, so the Iron Age culture there immediately followed the *Stone Age. In America, the use of iron was introduced by European settlers.

ironwork, decorative objects, particularly architectural ornamentation, made of iron, one of the most widely distributed of metals and one of the most useful in the service of mankind. The malleability of iron varies with the impurities present, especially the amount of carbon; the type used in most decorative work is called wrought iron, which has a very low carbon content and can be hammered by the blacksmith into elaborate shapes. Iron

The great French ironworker Jean Tijou, who lived in England between 1688 and 1712, did much work for Sir Christopher Wren, including these railings at Hampton Court Palace. His **ironwork** is among the most splendid ever made. He published a book of his designs in 1693 that helped spread his style among English ironworkers.

was used ornamentally by the Greeks and Romans, but because it is so susceptible to rust, very little early work survives. From about the 12th century, however, many magnificent examples of decorative ironwork survive. It was much used for grilles, gates, stair-rails, and balconies, the great age of the art extending into the 18th century. Among the most renowned of all craftsmen in wrought iron was Jean Tijou (French-born but active in England), who did superb work at St Paul's Cathedral in London, Hampton Court Palace, and elsewhere, working in an opulent but dignified style. In the 19th century wrought iron was largely superseded by cast iron, which contains more carbon and is consequently more brittle, but has the advantages of being cheaper to produce and less subject to corrosion. Wrought iron has continued to be used for high quality work, however, and enjoyed something of a revival at the end of the 19th century, during the heyday of the Arts and Crafts Movement and the art nouveau style.

irony, a subtly humorous perception of inconsistency, in which an apparently straightforward statement or event is undermined by its context so as to give it a very different significance. In various forms, irony appears in many kinds of literature, from the *tragedy of Sophocles to the satire of Swift. At its simplest, in 'verbal irony', it involves a discrepancy between what is said and what is really meant, as in its crude form, sarcasm. The more sustained 'structural irony' in literature involves the use of a naïve or deluded hero or narrator, whose view of the world differs widely from the true circumstances recognized by the author and readers; literary irony thus flatters its readers' intelligence at the expense of a character (or fictional narrator). A similar sense of detached superiority is achieved by 'dramatic irony', in which the audience knows more about a character's situation than the character does, foreseeing an outcome contrary to the character's expectations. 'Cosmic irony' is a view of people as the dupes of a cruelly mocking Fate, as in the novels of Hardy, for example, *Tess of the D'Urbervilles*.

Irving, Sir Henry (John Henry Brodribb) (1838–1905), British theatrical actor-manager. He achieved fame overnight in 1871 at the Lyceum in *The Bells*, a *melodrama adapted from Erckmann Chatrian's *Le Juif polonais*. With his Hamlet of 1874 he reached the peak of his profession, where he remained for thirty years. With *Terry as his leading lady he was actor-manager at the Lyceum from 1878 to 1899, making it the most prestigious theatre in the country. He was the first actor to be knighted.

Irving, Washington (1783–1859), US short-story writer and historian. His early contributions to the satirical essays and poems *Salmagundi* (1808), were followed by the *burlesque *History of New York* (1809), in which, under the name of Diedrich Knickerbocker, he satirizes the methods of contemporary historians. He is better known for *The Sketch Book* (1820), a successful collection of sketches and tales, including 'Rip Van Winkle' and 'The Legend of Sleepy Hollow', which was to make him the first American author to be known abroad. Later he served as a diplomat in Spain and wrote several books on the country. Returning to the USA, he published works on the Western frontier, including *A Tour of the Prairies* (1835), and later turned to biographical and historical studies.

Irzykowski, Karol (1873–1944), Polish critic and novelist. He began his only novel, *The Hag* (1903), in 1899, well before the publication of Freud's first work on psychoanalysis, yet in it he explores conscious and subconscious motivations for human behaviour. His most important work of criticism was *The Struggle for Content* (1929).

Isherwood, Christopher (1904–86), British novelist and dramatist. His concern with the role of the intellectual in a tyrannical society is reflected in *Mr Norris Changes Trains* (1935) and *Goodbye to Berlin* (1939), a series of sketches featuring seedy expatriates living through the decay of the Weimar republic and the rise of Hitler's Nazism. Reissued in 1946 as *The Berlin Stories*, they were dramatized by John Van Druten as *I am a Camera* (1951) and adapted as a Broadway musical (*Cabaret*, 1966). He wrote several verse-plays in the 1930s with *Auden. Together they went to the USA in 1939 and became American citizens in 1946. Other works include the novel *Down there on a Visit* (1962); *Christopher and His Kind* (1977), an account of his homosexual experiences; and translations of Hindu classics.

Islamic art and architecture, the artistic expression of nations and peoples professing the faith of Islam, which was founded in the early 7th century AD in Arabia and spread with great rapidity. It contains stylistic variants which are the result of regional, ethnic, and political influences. These styles nevertheless conform to an underlying unity in their use of the Arabic script and geometric ornament in decoration and in the religious requirements of their architecture. While powerful political groupings have tended to foster schools of art and thereby created dynastic styles, religious architecture draws on a group of models which can claim to be universal. The focal point of Islamic religious life is the congregational mosque or *masjīd*, literally the place of prostration. The pattern for early mosque architecture was set by Muhammad's house in Medina, built after his migration from Mecca in AD 622 as a place of meeting and worship. It was a fortified courtyard house, looking inwards for protection, with a veranda for shade on the north and south sides and living rooms on the east. As the congregation increased, the veranda was enlarged by adding more columns, and this type was developed into the many-columned mosque with arcades on three sides of an open courtyard. As prayers are said facing Mecca, an important component of the mosque is the indication of the *qibla* or direction of prayer by the *mihrāb*, an ornate niche in the appropriate wall, first introduced in the mosque at Medina (707–9). Other components include the minaret, first introduced in the mosque of 'Amr (Cairo, 673), for the call to prayer, and areas for ritual washing (*ziyāda*), often outside the main mosque. Important optional elements include the dome or *qubba*, which had special significance as a symbol of the heavens and divinity, especially in the Dome of the Rock in Jerusalem (685–91). This was built by the *Umayyads at the place from which Muhammad undertook his *mirāj* or night journey to heaven, and as an alternative focus of pilgrimage. In *Ottoman mosques of 16th-century Istanbul, the *dome became highly prominent, inspired by the 6th-century

Byzantine church of Hagia Sophia. An important building type which was widely imitated in the Islamic world is the four *īwān* plan. The *īwān*, borrowed from Sassanian architecture, is a square or rectangular room, completely open at one end and covered by a deep, elliptically arched roof, four ends of which are usually arranged around an open courtyard. Originating in Khorasan, the cruciform plan was used in the construction of *madrassahs* (religious colleges), mosques, and domestic buildings. In mosques two opposing *īwānāt* form the entrance and the prayer hall. The side *īwānāt* are usually for teaching and are often not emphasized. In Iranian mosques the main *īwānāt* are often faced with tall, tiled rectangular frames (*pīshtāq*), flanked by minarets. The *madrassah* itself, widely emulated in the Islamic world, became an instrument of *Seljuk and Ayyubid state policy. Standing examples are the Mustansiriyya (Baghdad, 1234) and the Ince Minareli *madrassah* (Konya, 1258), where, because of the inclement weather, the central courtyard is domed. Although generally discouraged by Islam, the building of funerary monuments became widespread. One of the earliest known is the hexagonal Qubba al-Sulaybiya (862), built in Samarra for an Abbasid Caliph. In Central Asia square, brick, domed mausolea, such as that of the Samanid dynasty in Bukhara (before 942), are ethnically Turkish in origin. In Seljuk Iran, a fashion for round, fluted and polygonal, often isolated, tomb towers developed, culminating in the massive, domed tomb of Sultan Oljaitu in Sultaniyeh (1305-13) and influencing the mausolea of the *Timurids and *Mughals. In Mamluk Cairo domed mausolea were often built in association with pious foundations, usually in urban contexts. Other typically Islamic institutions such as the monastic mosque

or *khāngāh*, introduced into Egypt by the Ayyubid Saladin (1093), and the Ottoman *külliye*, a religious philanthropic assemblage, each acquired a specific architectural form, as did trading institutions like caravanserais (inns for travellers). Although there is no special Koranic proscription against representing human figures, tradition prohibits their depiction and so these are never found in religious buildings. The walls of the Umayyad fortress of Mshatta in Syria (744) were decorated with friezes of interlaced vines and animals, the latter omitted where it forms the outer wall of a mosque. In mosques, decoration was restricted to floral, geometric, and *calligraphic designs from an early date, as in the Dome of the Rock in Jerusalem (685-91). Early coinage of the Umayyad period used figurative decoration derived from both Byzantine and Sassanian models, but this was abandoned in the coinage reform of 'Abd al-Mālik in 696. This proscription was largely maintained on coins, until the secular movements of the 19th and 20th centuries. Three major periods of development can be distinguished in traditional Islamic art. Firstly the period of the classical inheritance which saw borrowings from the Sassanids (see *Persian art) and from the classical and Byzantine worlds in Syria, Mesopotamia, and Spain. This is seen in the Umayyad palace of Khirbāt al-Mafjar (c.743), in the use of mosaic, marble wall coverings, stucco decoration, and wall painting. The second phase is marked by the eastern influence of the Turkish peoples of Central Asia and Iran, up to and including the Seljuk period. Turkish traditions had already influenced some aspects of *Abbasid art, such as the use of seated figures on monochrome *lustrewares, and carving styles. In architecture, decorative brickwork and the use of the *muqarnas* or stalactite vault also probably spread from the east. The third phase introduces colour into the external decoration of buildings. In Spain, North Africa, Egypt, and Syria coloured stone *ablaq* was used architecturally, and in Persia and Central Asia coloured tile and tile mosaic emerged in the Seljuk period. Strong Chinese influence was felt particularly in miniature painting and *ceramics throughout the Islamic world after the Mongol conquests

This interior of the Hajj terminal in Saudi Arabia is an example of the successful blending in modern **Islamic architecture** of advanced technology and traditional local forms, in this case the tent. The terminal was designed by Fazlur Rahman Khan for the firm of Skidmore, Owings & Merrill in Jeddah; it serves as a focus for thousands of pilgrims on their way to Mecca.

of the 13th century, especially in Egypt and Iran. European influence became a factor from the 16th century, particularly in painting. Traditional styles and techniques continued in the decorative arts, but by the 19th century the quality of Islamic art as a whole had declined greatly. In architecture Western styles were imported and became dominant in the 20th century, but, particularly since the 1970s, there has been a reaction against such 'aesthetic imperialism' in favour of buildings that express national traditions and are culturally and functionally suited to their environment. This movement has been stimulated by the Aga Khan Awards for Architecture, presented every three years since 1980. The Egyptian architect-philosopher Hassan Fathy, one of the leading opponents of the acceptance of Western ideals and technology, argues the case for a separate Islamic aesthetic in his book *Architecture for the Poor* (1973). Fathy's work, lucid, elegant, and unpretentious, has most characteristically been in mud brick, reinvigorating ancient building methods, but other Islamic architects have sought to combine traditional forms with modern technology. In Iraq, Rifat Chadirji has combined the powerful forms of Louis *Kahn with the geometric brick patterning of his native tradition. Foreign architects designing for Islamic countries have likewise recently tried to harmonize Eastern and Western ideas. The *Skidmore, Owings and Merrill partnership has been particularly active in the Middle East, one of their most striking designs being the Hajj Terminal at King Abdul Aziz International Airport at Jeddah, built in the early 1980s, which has a vast tent-like roof supported on steel poles. (See also *Islamic ceramics, *Islamic decorative arts, *Islamic miniature painting.)

Islamic ceramics. The Islamic world has an extremely rich tradition in pottery; as well as producing vessels of many kinds, craftsmen made ceramic tiles for the decoration of mosques, tombs, and other buildings. Pottery was made in Egypt, Mesopotamia, Iran, Turkey, and Syria, the first important developments taking place during the 9th century in the *Abbasid capitals of Baghdad and Samarra, when local potters attempted to imitate Chinese porcelains by covering buff-coloured earthenware vessels in a tin glaze. Use of colour in glazes and underglaze decoration became one of the outstanding characteristics of Islamic pottery in general. Decorative motifs such as animal and human figures, floral and foliate ornament, and *calligraphy were employed to striking effect by Islamic potters. The technique of lustre glazing (see *lustreware) was probably invented by Islamic potters, and the technique was certainly perfected in the Islamic world as the numerous surviving examples of lustreware from various centres of production testify. Vessels were usually thrown on a potter's wheel, although sometimes moulds were used, particularly when relief decoration was added. Designs were sometimes also made by scratching through the clay body or slip with a sharp instrument, a technique known as *sgraffito*. From Mesopotamia lustreware spread to Egypt by the late 10th century, and *Fatimid potters produced outstanding wares, while potters in Khorasan, in eastern Iran, produced (10th–13th century) distinctive wares of a red body covered in a thick white slip which was then decorated in black with bold calligraphic inscriptions or strongly stylized animal motifs. After the fall of the Fatimid dynasty in 1171 the technique of producing lustre passed quickly to Iran and Syria. In addition to lustreware,

Made in Kashan, northern Iran, and dated 1207, this bowl is an early example of the Persian lustreware which developed in **Islamic ceramics**. It shows a polo-player mounted on horseback against an elaborately decorative background of stylized birds and leaves, a typical subject for this type of pottery. (Victoria and Albert Museum, London)

centres such as Rayy and Kashan in northern Iran produced distinctive pottery known as Minai wares, in which underglaze decoration of courtly scenes was embellished with finer details over the glaze of the first firing, and then given a second firing, resulting in an enamelled effect, with some of the qualities of a miniature painting. Imitation of Chinese porcelain resulted in delicate wares decorated in blue and black designs under a clear glaze. In Syria 13th-century production in Raqqa was outstanding for the assured drawing of vigorous designs of animals, birds, or fish, executed in a range of blackish or purplish colours under a transparent glaze. Some of the most distinguished ceramic work produced under the Seljuk (13th century) rulers of Anatolia and Timurids (14th and 15th centuries) in Iran was tilework, sometimes lustre, sometimes in a range of brilliant blues, used for architectural decoration. Under the *Safavid (1502–1722) dynasty of Iran and Ottomans (16th–20th centuries) in Turkey (see *Iznik) the use of coloured decorative tilework in architecture was further developed and refined. A somewhat distinct tradition was that of *Hispano-Moresque ware in Spain.

Islamic dance. Dance as an entertainment has traditionally been considered as a profession for the low-born and, as a result of Islam's restrictions on women, the art evolved into an almost male monopoly. Women entertainers (*ghawazi*) were in the past considered little better than prostitutes; in the Arab world they continue to specialize in the erotic art-form of the belly dance. Dervish dancing is performed by male members of certain Sufi religious groups. Practised for more than seven centuries, this takes the form of a whirling dance accompanied by music, whose purpose is to glorify God

and seek spiritual perfection by shedding one's own identity in the dance itself.

Islamic decorative arts. There is no real distinction in Islamic art between 'fine' and 'decorative' art, for painting and sculpture do not hold pride of place as they traditionally have done in the West. Thus most Islamic religious art would be classified in the West as decorative (a term that usually carries the implication of 'minor') even though it represents the highest aspirations of Islamic inventive genius. As the Islamic world has embraced such a huge geographical span over so many centuries, Islamic decorative arts are extremely varied. There are, however, certain areas in which Islamic craftsmen have set standards that have been unexcelled anywhere. Textiles and metalwork are perhaps the two most outstanding examples. Islamic textiles have long enjoyed world-wide prestige and Persian *carpets and rugs are universally acknowledged to be the most beautiful ever made. In metalwork Islamic craftsmen have produced superb examples of virtually every type of object in precious metals (silver and gold) as well as steel, brass, and bronze. As Islamic tradition prohibits the representation of living things on religious buildings and furniture, craftsmen and artists have traditionally resorted to geometric, *calligraphic, and floral themes. They developed highly intricate techniques of inlay and were masters at creating lustrous surface finishes. Arms and armour were wrought with consummate skill, the sword blades of Toledo and Damascus (see *damascening) being regarded as the finest in the world. Among other fields in which Islamic craftsmen have excelled are *rock crystal and *jade carving, glass, ceramics (see *Islamic ceramics), and woodwork. The pulpit of carved wood (known as a *minbar*) was one of the most important features of the mosque and often received the finest attentions of Islamic craftsmen, who sometimes used ivory inlay on it.

Islamic literature *Arabic literature, *Persian literature, *Sufi literature, *Turkish literature, *Urdu literature.

Islamic miniature painting. Islamic tradition prohibits the representation of living things on religious buildings or furniture, but human and animal figures appear in Islamic paintings in a secular, specifically a courtly, context. Battles, hunting scenes, and illustrations to literature are among the themes that have predominated. The early history of Islamic painting is obscure, and it is only from the early 13th century that anything like a continuous history can be traced. Baghdad was the first major centre of production, but the city was sacked by the Mongols in 1258 and other centres replaced it in importance. Iran has the richest tradition of illumination in the Islamic world, Herat, Isfahan, Qazvin, Shiraz, and Tabriz being among the cities where it has particularly flourished. The late 15th and early 16th centuries mark the high point of Iranian painting. This was the time of activity of Bihzād (c.1455–1516), one of the most illustrious figures in Islamic art. Only a very small amount of work survives that can be attributed to him with any confidence, but he had many pupils who continued his style, which was marked by exquisite draughtsmanship, beautifully clear colouring, and vivid characterization. As with all Islamic painting, the emphasis is on outline rather than mass (reflecting the fundamental importance of *calligraphy in Islamic art), and colours are flat and used decoratively rather than naturalistically. In the 16th century, however, European influence began to affect Islamic painting, notably in portraiture. Some of the finest late examples of Islamic miniatures, including portraits, belong to *Ottoman and *Mughal art.

Islamic music, music composed and performed within the Islamic faith. Since music is traditionally proscribed in Islamic society because of its secular connotation instruments are not used in orthodox ritual, and vocal performance is considered to be recitation, not song. Within the mosque is the call to prayer of the muezzin, varying from single-note calls to melismatic chants, in which a number of notes are sung on one syllable, and the important chanting of the Koran by a soloist, which varies between stylized speech and simple recitative, though some traditions employ ornamentation derived from the *maqām* system of Arabic classical music (see *West Asian music). These chants are orally transmitted and hence regional variations are found. Outside the mosque one finds hymns of praise for the Prophet (*na'at*) and songs sung during the journey to Mecca and the month of the pilgrimage (*hajj*) and in Ramadan, the month of fasting. Chanting with drum accompaniment is used in the Shi'ite Muslim *ta'ziya*, a mystery play. The ecstatic rituals of the Sufi communities involving the dervish dance (see *Islamic dance), songs and hymns, and reed-pipes, flutes, and drums, are now largely restricted.

isorhythm, a technique in which a rhythmic pattern is repeated over and over again within an evolving *melodic line. The applied rhythm thus acts as a structural device. Isorhythmic techniques are found in the masses and *motets of the 14th and 15th centuries.

Italian literature. The first significant works of Italian literature were St Francis of Assisi's Cantico del Sole (12th century) and the *Landi* of Jacopone da Todi (c.1230–1306). At this time writing in the vernacular was rare; only Latin was considered a suitable language for works destined to endure. By the late 13th century the religious themes which had dominated literature were beginning to be supplanted by secular interests and by the love *lyrics of the troubadours (see *minstrel), which were in their turn to be perfected in the *dolce stil nuovo* ('sweet new style') poets centred in Tuscany, whose vernacular *sonnets, *canzones*, and *ballads celebrate a spiritual and idealized view of love. Among its members are Guittone d'Arezzo (c.1230–1294), Guido *Cavalcanti, and above all *Dante Alighieri, whose works, in *The New Life* and especially in *The Divine Comedy*, marked the culmination of the medieval tradition. *Petrarch, the first poet of the Renaissance, established in his *Canzoniere* (Lyric Poems) a new standard for the sonnet and love lyric. Other poets in the lyric-elegiac tradition which was to flourish in the 15th and 16th centuries include *Poliziano, Lorenzo de' Medici (1449–92), *Michelangelo, and Vittoria Colonna (1492–1547). Virtually all these poets came from Florence or Tuscany and they established Tuscan as the literary language of Italy. The other principal poetic tradition, for the *narrative poem, stemmed from the store of Carolingian chivalric *epics. *Boiardo started weaving them together in a rich heroic narrative, *Orlando in Love*, heedless of the sardonic populist medley, *The Greater

Morgante by Luigi Pulci (1432-84), while *Ariosto composed the brilliant satire of the chivalric tradition, *The Frenzy of Orlando*. The heroic epic of the Renaissance reached its culmination with *Tasso's *Jerusalem Delivered*. In prose, it was *Boccaccio in the *Decameron* who established a new standard for the *short story, a genre important thereafter in Italian literature. The vernacular, too, gradually displaced Latin as the medium for humanist scholarship—the language of the historians *Machiavelli and Francesco Guicciardini (1483-1540), of the artists *Alberti and *Vasari, of philosophers and poets including Giovanni Pico della Mirandola (1463-94), Pietro Bembo (1470-1547), Giordano Bruno (1548-1600), and Tommaso Campanella (1568-1639), as well as of *Castiglione and Giovanni della Casa (1503-56).

With the Counter-Reformation and the foreign domination of Italy, literature echoed the *Baroque's search for a formal, surface beauty of expression, as in the poetry of Gabriello Chiabrera (1552-1638) and *Marino. In the theatre, dominated by the improvisation of the *commedia dell'arte*, fresh life was restored in the 18th century by *Goldoni's new comedy of manners and by *Alfieri's classical tragedies. A new note of passion, of commitment, of savage irony returned in the poetry of *Parini, *Foscolo, and *Carducci; in *Leopardi Italy found the voice of a lyrical emotion largely absent since Petrarch. The serious foundation of the Italian novel subsists in the works of *Manzoni, *Fogazzaro, and *Verga, who also enhanced the tradition of short-story writing. The latter was to continue its flowering in the 20th century with *Pirandello and *D'Annunzio, Natalia Ginzburg (1916-), and *Calvino. Pirandello's contribution to the revival of the Italian theatre was followed by that of Ugo Betti (1892-1953) and Dario *Fo. The poets have undergone foreign influences and sought new ways of relating art to experience; among the best have been *Pascoli, D'Annunzio, *Montale, *Quasimodo, *Ungaretti, and *Pasolini. Breaking out of a narrow provincialism, Italian novelists have faithfully mirrored their society and reflected it to a world-wide audience, especially in the novels of *Svevo, Carlo Emilio Gadda (1893-1973), *Vittorini, *Pavese, *Moravia, Ignazio Silone (1900-78), and Primo Levi (1919-87), who is also renowned as an essayist and autobiographer.

Ives, Charles (Edward) (1874-1954), US composer. Ives's compositions draw on every kind of musical material—marches, hymns, parlour songs—using them in an entirely free way in a collage of conflicting sounds, often wildly dissonant and virtually *atonal. Most of his works, such as his Second ('Concord') Sonata (1915) and the evocative orchestral *Three Places in New England* (1914), reflect the influence of 19th-century New England literature and philosophy. He wrote four symphonies, the last (completed in 1916) being the finest. Ives's work has a quality of visionary innocence—as if he was inventing music from scratch. Perturbed by his own discoveries he composed nothing after 1926, and it was not until the 1930s that his originality attracted public recognition.

ivorywork, artefacts and decoration made from ivory—the hard, smooth, creamy white substance forming the main part of the tusks of elephants and some other animals. Elephant and walrus tusks have been the commonest sources of ivory, but the term has also been used to embrace rhinoceros horn, stag horn, bone, and the teeth of various animals, including the crocodile. Ivory has been used since prehistoric times for utilitarian and decorative purposes and can be worked with saws, chisels, drills, and rasps. In the ancient world it was classed with gold and precious stones as a luxury material, and the Greeks used it for colossal statues of gold and ivory, the ivory simulating the flesh. In the Middle Ages it was particularly favoured for standing figures of the Virgin Mary, the shape of the tusk being used to indicate the pose, but the art of statuary in ivory declined fairly steadily after the 14th century. Ivory has also had many uses in the decorative arts—as mounts on furniture, for example, and for a wide range of small objects, including boxes, fans, and chess pieces. It is also used for inlay. There is now widespread opposition to the use of ivory since elephants are threatened with extinction.

Iznik ware, pottery and tiles produced mainly at Iznik in western Anatolia for the imperial *Ottoman court. The great period of production was from the mid-16th to the mid-17th century. Using a body of white clay covered in a thick, transparent lead *glaze, potters executed naturalistic underglaze designs of flowers and *arabesques, some showing Chinese influence, in a range of colours, from olive green, purple, and grey in the earlier period to a rich sealing-wax red and brilliant turquoise in the heyday of production. Designs were supplied by court workshops and tiles were specially ordered to decorate the interiors of the magnificent mosques being built at this time by architects such as *Sinan, and also in the sultans' apartments and the harem of Topkapi Palace in Istanbul. However, by 1648 a contemporary noted a mere nine workshops in Iznik compared to over 300 at the beginning of the century, and subsequent attempts to revive the industry met with failure.

J

Jacobsen, Arne (1902–71), Danish architect and designer. Jacobsen worked in a severely modern style, in accordance with his dictum, 'economy plus function equals style'. Internationally renowned as an industrial designer, Jacobsen carried out many of his important commissions in Denmark, including the SAS building (1959), Copenhagen's first skyscraper. His design for St Catherine's College, Oxford (1964) is a good example of the stark simplicity of his style.

jade carving, the making of ornaments, utensils, and other objects from either of two hard, semi-precious stones—jadeite and nephrite—both of which are commonly called jade. The stones are so hard (they cannot be cut with steel) that they have to be laboriously worked with abrasives. The two minerals are unrelated in chemical composition, but similar in appearance; jadeite, the rarer and more prized stone, has a glassy lustre, while nephrite (sometimes called 'true jade') is more oily in appearance. They vary in colour, but green is the colour most associated with the material. They have been worked since prehistoric times in various parts of the world, but China has by far the richest tradition in the medium. Perhaps the most impressive collection of jade objects was found in the Mancheng tombs excavated in the district of Hebei in 1968. These included royal burial suits made from over 2,000 pieces of finely carved jade sewn together with gold and silver thread. Jade was used for weapons, bowls, and bottles, among other objects. Jade vessels of unbelievable thinness and translucence were a notable feature of *Mughal art in India, including Shah Jehan's cup with a delicately carved ibex-headed handle. Jade

Jade was held in the highest esteem by the Chinese, ranking above gold or precious stones. In the early period jade was used for ritual purposes, particularly burial. Elaborate rites evolved with six jade emblems to honour the cosmic deities. The example of Chinese **jade carving** shown here dates from the Song period (960–1280) and, as was fashionable then, imitates a Chinese bronze vessel. (Private collection)

was unknown in Europe until after the discovery of America, where it was a prized material in the Aztec and Maya cultures. The Maori people of New Zealand carve jade pendants called *hei-tiki* (*hei*, 'to hang', and *tiki*, 'image of man') in the form of representations of ancestors.

Jain art, the art and architecture of Jainism, a religion that originated in India in the 6th century BC in opposition to the overdeveloped ritualism of Hinduism. Jainism has remained a fairly small sect mainly confined to India. The Jains accepted various Hindu gods and goddesses but chiefly venerated twenty-four (mostly legendary) teachers, of whom the last was Mahavira (also called Vardhamana and Jina), the founder and major prophet of the religion. Vardhamana and the other *tirthankaras* (teachers) are the central figures of Jain iconography, and it is often only in iconographical details (the particular symbols by which figures are identified) that Jain art can be clearly distinguished from *Buddhist or *Hindu art. Jain architecture in particular is very similar to Buddhist architecture; little survives from before the 7th century AD (the Jains were often persecuted and their temples were probably destroyed during these times). The most typical form of Jain sculpture is the bronze figure donated to a temple as a 'good work'. Often the figures have inscriptions on the reverse mentioning the name of the donor, the temple to which it was given, and so on. Jain painting is found as temple murals and as manuscript illustrations; there was a flourishing school of miniature painting centred in Gujarat in the 12th to 16th centuries, patronized by wealthy Jain merchants.

Jain literature, literature in both Prakrit and Sanskrit consisting of religious teachings, commentaries, philosophy, and narrative tales and legends. Jainism as a religion and philosophy was founded in India by Mahavira, a contemporary of the Buddha, in the 6th century BC. His teachings advocating non-violence and self-purification were initially transmitted orally in Prakrit, the spoken language, rather than Sanskrit. Gradually portions were lost and a council met (*c.*280 BC) at Pataliputra (modern Patna) to reconstruct the Jain canon. Mahavira's teachings were codified into twelve sections (*Aṅgas*), the most important containing the *Pūrvas*, dealing with the cycle of birth and death. Only the Shvetambaras (white-robed) Jains accepted this. The naked Digamabara Jains declared the original canon lost and produced their own scriptures, the *Shaṭkhaṇḍāgama* ('The Six-Part Doctrine'). The Shvetambara canon was finally written down after another council at Valabhi (Gujarat) in the 5th century AD, new material being added to form the *Upāṅgas*. (See also *Indian literature.)

James, Henry (1843–1916), US novelist and short-story writer. His family travelled extensively in Europe during his adolescence, and he returned there in the 1870s, eventually settling in London. In *Roderick Hudson* (1876) and *The American* (1877) he discovered the 'international theme' of Americans in Europe, which is the subject of much of his work, including the popular success *Daisy Miller* (1878) and the masterpiece *The Portrait of a Lady* (1881). In the following years he published *The Bostonians* (1886), a satirical novel of New England reformers and philanthropists; made a catastrophic attempt to become a dramatist; and produced notable short novels like *The Spoils of Poynton* (1897) and *The Turn of the Screw* (1898).

Other works of this middle period include *The Princess Casamassima* (1886), *The Tragic Muse* (1895), and *The Awkward Age* (1899). The last two decades of his life were spent in Rye, Sussex, where he wrote the stylistically elaborate novels of his 'late manner': *The Wings of the Dove* (1902), *The Ambassadors* (1903), and *The Golden Bowl* (1904). In all he wrote eighteen novels and some long novellas, several volumes of short stories and literary criticism, and a three-part autobiography. As a young man in Paris, James met writers like *Turgenev and *Flaubert who inspired him to bring an unprecedented degree of artistic sophistication to American fiction: an intense concern for formal organization and narrative technique, a new richness of style, a greater depth of characterization and psychological analysis. His principal legacy was to suggest that Europe was the natural subject of American literature, causing a generation of writers, including such figures as *Stein, *Eliot, *Hemingway, and *Fitzgerald to become expatriates.

Jāmī, 'Abd al-Rahmān (1414–92), Persian poet and mystic. He is associated with the city of Herat in Afghanistan and is considered the last of the great Persian poets for the excellence of his prolific output. He produced many prose works in Islamic philosophy and mysticism, or Sufism. But he is best known for his three collections (*dīvān*) of lyric poetry and his seven long *masnavi* poems entitled *The Seven Thrones*. Many of the latter were based on themes well used in Persian poetry, like the story of Joseph and Potipher, the Arab lovers Leyla and Majnun, and the wisdom of Alexander the Great.

Janáček, Leŏs (1854–1928), Czech composer. He worked as director of the Organ School in Brno (1881–1924). His early music was influenced by *Dvořák, but gradually it took on a character of its own through the study, begun in 1885, of the *folk music of his native Bohemian and Moravian highlands. By the time he had completed his first important opera, *Jenůfa* (1904), the folk-song influence had been completely integrated into his style, as had his theories about 'speech melody'—the natural rhythm and rise and fall of ordinary speech, heightened into musical themes and melodies. Success, achieved after a revival of *Jenůfa* in 1916, coupled with a late, one-sided love affair, prompted an astonishing upsurge of creativity. The operas *Katya Kabanová* (1921), *The Cunning Little Vixen* (1923), *The Makropulos Case* (1925), and *From the House of the Dead* (1928), a setting of incidents from Dostoyevsky's prison-camp novel, together with the Sinfonietta (1926), the *Glagolitic Mass* (1926), some lyrical piano pieces, and two string quartets (1923, 1928), all testify to an outstanding originality.

Japanese architecture, the architecture of Japan from ancient times to the present day. Evidence of buildings from Neolithic times survives in the form of models of houses buried in tombs, but it is not until after the introduction of Buddhism in the 6th century AD that a continuous tradition can be traced. As with the Buddhist religion, architecture in Japan has been strongly affected by the influence of China (see *Chinese art and architecture), using wood as its main building material and the column as the main structural element (Japan has an abundance of trees, and wooden buildings are particularly suitable for a country prone to earthquakes). Japanese

The Golden Pavilion, Kyoto, was built in 1397 as a residence for the military ruler Ashikaga Yoshimitsu and was later transformed into a temple. It was burnt down in 1950, but has been completely restored, even to the gold leaf. The setting is superb, for it is part of a paradise garden, intended as a park for Buddha to walk in. This sensitive integration of building with landscape is characteristic of much **Japanese architecture**.

architecture, however, tends to be less grandiose than Chinese and to pay greater attention to the integration of a building with its surroundings, whether garden or natural scenery. This consideration has been particularly important in the siting of Shinto shrines (Shinto is the ancient native religion of Japan, predating Buddhism); they were often located in beautiful places that had an air of grandeur or mystery, suggesting the nearness of the gods. In essentials, Japanese traditional architecture has changed little over the centuries, and continuity has been preserved by the fact that some religious structures have been periodically rebuilt in exactly the same form for ritual purposes. Buddhist temples were often built as monastic colleges and had numerous types of building within a compound; the *to* or pagoda housing a holy relic; the *kondō*, housing images of the deities worshipped at the temple; the *korō* or drum- or bell-tower; the *kyōzō* or *sutra* (scriptural narratives) or storage hall; the *kōdō* or lecture hall; the *sōbō*, or dormitories; and the *jikidō* or dining hall. Carpentry was brought to great heights of mastery, and the beauty of Japanese buildings depends as much on the subtle curvature of the roofs as on any decorative treatment, which included the painting of

pillars and beams and the use of gilding. The high point of Buddhist architecture in Japan was reached in the Todaiji monastery in Nara, which was founded in 745 and marks the adoption of Buddhism as a state religion by the imperial house. The Hall of the Great Buddha, dedicated by the Emperor Shomu in 752 (reconstructed in 1709), is still the largest wooden building in the world, and the rest of the complex was executed on a similarly ambitious and costly scale. Japanese domestic architecture, on the other hand, is noted for its simplicity and exquisite refinement. Sliding panels of wood or rice-paper flexibly sub-divide the living area into a series of airy spaces. A space is sometimes set aside within the house for the tea ceremony, associated with contemplation and the cultivation of the arts, but tea-houses are often separate pavilions in the garden. The relationship of house to garden is traditionally very important to the Japanese, with the veranda serving as a transition space. Palaces were modest by Western or Chinese standards but, following the introduction of European firearms in the 16th century, a number of huge and imposing castles were built (there was incessant civil war at this time). They were constructed on massive stone bases and had multi-storey central towers. Himeji Castle is the most impressive. From the mid-17th to the mid-19th century Japan pursued an isolationist policy, with virtually no contact with the West, but from the 1860s it began to industrialize along Western lines and adopt the European architectural tradition. Frank Lloyd *Wright designed the Imperial Hotel in Tokyo (1916–20, destroyed) and the International Style of the *Modern Movement was adopted in the 1930s. It was not until the 1950s that Japan began to make a distinctive contribution to modern world architecture. Since then, with a building boom reflecting the country's remarkable economic revival after World War II, Japan has become an acknowledged centre of excellence and originality in modern design. *Tange is the outstanding figure in modern Japanese architecture, his work reconciling the influence of *Le Corbusier with traditional Japanese forms. Among Tange's pupils, the most distinguished is perhaps Arata Isozaki (b. 1931), whose major works include the Tokyo Globe Theatre (1988).

Japanese ceramics, the pottery and porcelain of Japan. The history of ceramics in Japan is long and distinguished, China being the only country that can claim a richer tradition. Japanese potters have often been influenced and stimulated by Chinese and Korean ceramics, but have also made many distinctive and original contributions. In particular, many Japanese potters have eschewed the anonymous perfection typical of Chinese ceramics, seeking instead a hand-made quality that expresses the individual personality of the creator. Accidental effects and irregularities were encouraged, and cracked and heavily fissured *glazes were deliberately induced, to give the feeling that the pottery was a 'natural' object rather than an artefact. These considerations were especially pronounced in wares made for the tea ceremony, which from the 15th century played a major role in Japanese cultural life. It was an aesthetic ritual conducted according to strict rules of etiquette and with an almost religious air of veneration (tea-drinking had in fact been introduced to Japan by Buddhist monks), and it is because of the great importance attached to the tea ceremony that pottery became a special cult in Japan.

Ceramics from the Neolithic Age provide the earliest evidence for culture in Japan (see *Japanese visual arts); these were fairly crude, but sophisticated pottery has been made in Japan since the 6th century AD. *Porcelain has been made in Japan since the early 17th century, when suitable clay for manufacturing it was discovered at Arita. Many different places in Japan have produced ceramics, but Kyoto (the capital city from 794 to 1868) has been the most important creative centre. It was there that *raku ware was developed in the 16th century and there in the 18th century that *Kenzan, the most famous of Japanese potters, lived and worked. His influence, particularly as mediated through the Japanese-trained Bernard *Leach, has endured into the 20th century, helping to create the *studio pottery movement. The vigorous tradition of Kenzan represents only one facet of Japanese pottery, however, for many wares have been extremely refined and exquisitely decorated, not least those aimed at the Western market. The term 'Imari Ware' is applied to the richly decorated porcelain that was exported to the West from the port of Imari from about 1600 (it is also sometimes called 'Arita Ware', as Arita was the main centre of manufacture). The types

The 17th-century stoneware sake bottle illustrates the hand-made quality prized in **Japanese ceramics**. The thick, crackled brown glaze and the slightly asymmetric proportions of the bottle are considered to be expressions of the individuality of the craftsman. (Victoria and Albert Museum, London)

exported included blue and white wares and Kakiemon ware, named after the porcelain-maker Sakaida Kakiemon (1596-1666), who is credited with introducing overglaze enamel painting from China to Japan in 1644. Kakiemon ware has fairly sparse, asymmetrical decoration, sometimes in the form of sprigs of foliage and little quails. It was enormously popular in the West, so much so that imitations and adaptations by the leading European factories are much commoner than Japanese examples.

Japanese dance *East Asian dance.

Japanese drama. The classical Japanese theatre as it is known today dates from the late 14th century. It consists of three elements—No, Kabuki, and the puppet theatre, *jōruri*. No (meaning 'accomplishment') is a form of lyric drama with dancing, noble in tone and sonorous in language. Each programme consists of five plays (including a god play and a warrior play). The subject-matter is mainly taken from *Japanese classical literature, which includes the novels and the drama of court life and war romances, as well as a large corpus of lyric poetry. The No actors (all male) are accompanied by a chorus and an orchestra of drums and flute. Kabuki and the *jōruri* puppet theatre evolved in the 17th century. Livelier and more popular in their appeal, they provided entertainment for the expanding merchant class. Kabuki, like No, is part acted and part danced (dance forms the major part of an actor's training for both). Kabuki actors—once again all male—are trained from childhood, and their art lies in their ability to express emotions through stylized movements of their whole body. As well as the *shamisen, two types of *clappers are used to orchestrate the performance and highlight the climaxes. Kabuki playwrights are entirely under the actors' control, and a Kabuki programme consists of acts from different types of play, such as historical or domestic drama, and dance pieces. The rise of the puppet theatre was encouraged by the increased complexity of puppets and improvements in puppet manipulation. The action of the puppets is accompanied by musical recitative, and by the playing of the shamisen. The most notable Japanese playwright, Chikamatsu Monzaemon (1653-1725), wrote both puppet and Kabuki plays, but his best work was for the puppet theatre. His plays divide mainly into domestic and historical. The *puppet theatre declined after the middle of the 18th century and is now known as bunraku, since it can be seen regularly only at the theatre of that name in Osaka. No and Kabuki are still regularly performed, together with new types of theatre such as *shimpa*, which combines elements of Kabuki with less exaggerated acting and the use of actresses; the less commercial *shingeki*, presenting Western plays and realistic plays about modern Japan; and an avant-garde movement.

Japanese literature. Although Japanese was not written till the 6th century, there was a considerable oral tradition before that. Writing began when Chinese characters were introduced, but although the influence of *Chinese literature on Japanese culture was very great, the Chinese writing system was far from ideally suited to the Japanese language. In 710 Nara became the first permanent capital of Japan, and two years later the *Kojiki* (Record of Ancient Matters) was finished. In 720 the *Nihon Shoki* (Chronicles of Japan) appeared, and the

A scene from a *kyogen*, a distinctive feature of **Japanese drama** consisting of a farce or comic interlude performed between the individual plays of a No sequence to relieve the emotional tension. *Kyogen* are performed in ordinary costume without masks and every object of popular fun finds a place, including the boaster, the glutton, and the drunken, dishonest, impudent, or stupid servant.

Man'yōshū collection of poetry, which included both *tanka and long poems (*chōka*), was compiled some time after 760. The Heian period (794-1185), named after the then capital now known as Kyoto, produced the *Kokinshū* ('Poems Old and New'; 905), using the newly developed *kana* script in which it was easier to write the native language, and Ki no Tsurayuki's *Tosa Diary* (935), an account of a journey which began a new diary genre in Japanese literature. The two classic works of Heian literature, however, are The *Tale of Genji* and The *Pillow Book of Sei Shōnagon*. Medieval Japan was plagued by civil wars and out of this came The Tale of the Heike, the saga of the rise and fall of the Taira (Heike) clan. In the 14th and 15th centuries, No drama (see *Japanese drama), underpinned by Zen Buddhism and linking this world to its departed spirits, became popular.

In the Tokugawa period (1603-1867), Japan entered a period of isolation, and the city of Edo (later Tokyo) grew in economic and cultural importance. The art and literature of the *Floating World became popular, as witnessed by the stories of *Saikaku, while the pre-eminent poet was *Bashō, and the dramatist Chikamatsu Monzaemon (1653-1725) wrote historical and domestic tragedies for the puppet theatre. Modern Japanese literature can be dated from the Meiji Restoration (1868), and the first modern Japanese novel, Futabatei Shimei's *Ukigumo* ('Floating Cloud'), the story of a clerk, unsuccessful because he is not sycophantic, appeared in 1887-9. Akutagawa Ryūnosuke (1892-1927) gave a modern psychological edge to traditional Japanese stories such as *Rashōmon*, which Kurosawa later adopted in his famous film. Two other important late Meiji novelists were *Natsume Sōseki and *Mori Ōgai (1862-1922), whose

Dancing Girl (1890) was the first of the influential auto-biographical novel genre. Kawabata Yasunari (1899-1972) won the Nobel Prize for Literature in 1968, and his *Snow Country* (1935-47), *Thousand Cranes* (1949-51), and *House of the Sleeping Beauties* (1939) all deal with guilt and the psychology of the erotic. Major writers of modern Japan include *Tanizaki Jun'ichirō, *Mishima Yukio, and Ōe Kenzaburō (1935-). (See also *Japanese poetry.)

Japanese music. Japanese musicians have adapted musical styles of the Asiatic mainland and produced their own distinctive tradition, which includes several outstanding art-forms. Before the 6th century AD the state religion Shinto developed rituals containing music and dance, which were taken over by courtly ceremonies. These used a wide variety of metal and wooden percussion instruments, the six-string zither wagon, and bamboo *flutes. In the 7th to 9th centuries Japan imported from Tang China courtly and solo art music (*tōgaku*), the system of modes, and the *biwa*, a lute closely related to

In this early 18th-century Japanese print two Kabuki actors are shown dressed in the costumes of wandering minstrels. The actor on the right plays the *shamisen*, while the actor on the left plays the *kokyu*. The comparatively newly introduced *shamisen* became the most important instrument in **Japanese music** of the Tokugawa or Edo period (1603-1867). There was a large repertoire of narrative and lyrical music for it, and it was also used to accompany the new dramatic forms of Kabuki and *bunraku*. (Museum of Fine Arts, Boston)

the *pipa*. From this time also dates the earliest notated music: tablatures for instrumental music and neumes (symbols indicating melodic shapes) for vocal genres. The arts flourished in the Heian period, 782-1184 (based at present-day Kyoto), when court song and official court music (*gagaku*) were widely developed. Buddhist chant (*shōmyō*) was also introduced (see *Buddhist music). By the end of the 12th century Japanese musicians had simplified the Chinese mode system and developed a Japanese system of naming the twelve fixed pitches. New musical genres of the late 12th to the early 17th centuries—during which period a military leader (shō-gun) and a warrior (samurai) ruling class replaced the imperial court—included the chanting of ballads to the accompaniment of heikebiwa (a four-string lute), and No, a theatrical entertainment combining music, drama, dance, and poetry. No reached a definitive form between the 14th and 16th centuries, with the composition and adaptation of 2,000 dramas by Kanze Kannami Ki-yotsugu (1333-84), his son Kanze Zeami Motokiyo (1363-1443), and their followers. Performance was stand-ardized in comprehensive instructions covering singing and acting, the order and classification of the dramas, and the staging on a square platform, on two sides of which sat the musicians and the chorus. The Tokugawa or Edo period (1603-1867) saw the development of solo and chamber music for the *koto, the *shakuhachi, and the *shamisen. Two new scales were introduced, as was the popular theatre Kabuki and the puppet drama bunraku (see *Japanese drama), in which a singer-narrator, accompanied by a shamisen-player, recited tales typically bloodthirsty or romantic in nature using puppets of half human size. The reinstatement of court drama and dance accompanied the restoration of power to the Meiji emperor in 1868. Melodies from the Heian period were revived and dressed in colourful orchestral textures, which featured the loud double-reed pipe hichiriki and the *mouth-organ shō. In the 20th century Japanese musicians have cultivated Western classical music to a high degree; Japanese composers have been influenced, however, by their traditional music and have composed for both Japanese and Western instruments.

Japanese poetry. Some Japanese poetry has always been written in Chinese, but *haiku and *tanka are relatively free of Chinese influence. There are poems in early Japanese literature, including the *Kojiki* ('Record of Ancient Matters'), and the *Man'yōshū*: the major collection of this period. The greatest exponent of haiku was the Tokugawa-period writer *Bashō and interest in this form continued throughout the Meiji period (1868-1912) and into the present day. Tōson (1872-1943) pioneered modern poetry, and today Japan has several schools of modernist poets. (See also *Japanese drama, *Japanese literature.)

Japanese visual arts, the fine and applied arts of Japan from prehistory to the present. For much of its history Japan has been strongly influenced by the art of the Asian mainland, notably China, but it has been selective in what it has absorbed from other cultures and has transformed its borrowings into distinctive native styles. As a broad generalization, Japanese art tends to be more direct and sensuous than *Chinese art, and its exponents have been proud of their skills as craftsmen (often hereditary) rather than would-be artistic philo-

sophers. Painting, sculpture, print-making, ceramics, *lacquerwork, swordsmithing, and textiles are among the arts and crafts in which the Japanese have particularly excelled. Japan was probably populated as long ago as 30,000 BC, but the earliest recognizable culture did not develop until the 5th or 4th millennium BC. The earliest known art was monochromatic pottery decorated with a twisted cord pattern (*jomon*), and the period *c*.4500 BC to *c*.200 BC is named after this, the Jomon period. This Neolithic Jomon culture was succeeded by Bronze Age developments, stimulated perhaps by invaders from Korea who brought metalworking techniques with them. The most characteristic aspect of Bronze Age culture in Japan is called Yayoi, after a neighbourhood of Tokyo where extensive remains have been found. Ceremonial bronze bells called *dotaku*, mirrors, and swords are typical of the Yayoi culture (*c*.200 BC–AD *c*.250). The succeeding era is known as the Haniwa period (3rd to 6th centuries AD) after the clay figures (*haniwa*) placed in the great burial mounds that are its most characteristic feature. All these stages of Japanese art can be referred to collectively as pre-Buddhist, for the introduction of Buddhism from the mainland in the 6th century had an enormous effect and marks the beginning of Japan's mainstream artistic development. Buddhist temples were furnished with sculptures, murals, manuscripts, silks, banners, and other works of art, and private individuals had similar artefacts in miniature—in the shape, for example, of portable shrines. Early Buddhist sculpture was in various materials, including wood, bronze, and terracotta, and was strongly influenced by Chinese prototypes. Examples survive from the 7th century. A breakaway from Chinese influence began in the 9th century and crystallized in the tradition of painting known as *Yamato-e*. This term, meaning 'Japanese-style painting', refers to the painting of hand-scrolls in an idiom quite distinct from the Chinese tradition of ethereal landscape; Japanese artists chose instead secular themes and used bold outlines and strong colours. Popular stories, romances, and biographies were favourite subjects, notably the *Tale of Genji*, which is often considered the earliest novel in the world. Practitioners of *Yamato-e* included members of the Tosa School, a school of court artists founded by Tosa Mitsunobu (1434–1525). At the same time, however, Chinese influence reasserted itself in a style of ink painting reflecting the other-worldly ideals of Zen Buddhism. The outstanding exponent of this style was the painter-priest *Sesshu, who gave it a distinctively Japanese slant. From the 15th to the 19th centuries there were a number of schools of painting that mingled Chinese and Japanese elements, of which the most important was the Kano school, founded by Kano Masanobu (*c*.1434–*c*.1530). The dynasty of artists he established were official painters to the shōguns (military dictators) and their work expressed the prevailing political and moral ideals. They also represented a tradition of professional training, as opposed to the Chinese ideal of the scholar-amateur. Many Kano paintings are in the form of folding screens, a type particularly associated with Japanese art. Landscapes were among the most popular subjects, but they were distinct from Chinese prototypes, being much more solid and firmly drawn. At the same time as official art was flourishing in the Kano school, a much more informal tradition of popular print-making developed known as *ukiyo-e*, with *Hiroshige, *Hokusai, and *Utamaro as its most splendid representatives. Their lively observation of everyday life

One of the twelve sacred generals in the To-ji, Kyoto. The figure dates from the Momayama period (1573–1614) when castle-building, in particular, flourished. Vigorous and assured sculpture such as this is as much part of **Japanese visual art** as more tranquil and reflective work.

has its counterpart in the most characteristic form of sculpture of the time, *netsukes. The renewal of contact between Japan and the West in the second half of the 19th century had momentous consequences for both European and Japanese art, but the aesthetic benefit was mainly one way. Many avant-garde European artists (such as the *Post-Impressionists and *Whistler) were influenced by various aspects of Japanese art but the Westernization of Japanese art produced little that was memorable. In the 20th century both Western and traditional styles have been practised, and although Japan has played a fairly marginal role in the mainstream of modern art (an exception is that Japanese artists were among the pioneers of *happenings), technical accomplishment has remained high. The pride which the Japanese take in skill in the arts and crafts is witnessed by the designation of eminent practitioners as 'Living Treasures of Japan'. Those so honoured, performing artists as well as painters, sculptors, potters, and so on, are given an annual allowance for life and are revered figures. (See also *calligraphy, *inro, *Japanese architecture, *Japanese ceramics.)

japanning *lacquerwork.

Jaques-Dalcroze, Emile, (1865–1950), Swiss music teacher and theoretician who developed a system termed 'eurhythmics' for translating rhythm into movement. He taught many of the dancers of the period, such as Rambert (see *Rambert Dance Company) and *Wigman.

Jarry, Alfred (1873–1907), French poet and dramatist, whose *Ubu-Roi* is now considered the founding play of the avant-garde theatre, and a seminal influence on French *Surrealism and on the Theatre of the *Absurd. Written when Jarry was 15 years old and first performed in 1888 as a marionette play, it was given its first live stage production in 1896. A savagely funny, anarchic revolt against society and the conventions of the nat-uralistic theatre, it scandalized audiences and still has considerable impact. Père Ubu, vicious, cowardly, coarse, pompously cruel, and unashamedly amoral, is a farcical prototype of the later anti-hero of the 20th century. Many of the marionette elements in the play became common currency in the work of playwrights like *Genet and *Ionesco and directors like *Brecht and Roger Planchon (1931–): the use of masks, skeleton sets, crude pan-tomime, and stylized speech to establish character, gross farce and slapstick elements, placards indicating scene changes, cardboard horses slung round actors' necks, and similar unrealistic props.

Jasperware *Wedgwood, Josiah.

Jātakas ('Birth-stories'), stories of the previous lives of the Buddha in various animal and human forms. There are traditionally 550 'birth-stories' in *Pali literature illustrating the Buddhist virtues, the earliest composed by the 3rd or 2nd century BC, but many others were added later. Some show similarities with the *Pañchatantra and even with *Aesop's *Fables*.

Jawlensky, Alexei von (1864–1941), Russian painter. He left Russia in 1896 and settled in Munich, where he met *Kandinsky and became associated with the *Blaue Reiter*. Although he had much in common with this group, he developed a markedly individual style, fusing elements from modern French painting (particularly *Fauvism) with Russian traditions of *icon painting and peasant art. Like Kandinsky, Jawlensky was obsessed by a belief in the correspondence between colours and musical sounds, but he always based his abstractions on nature. His later works often have a mystical feeling.

jazz, a type of *popular music which developed in the Southern states of America around the end of the 19th and beginning of the 20th century, principally in New Orleans and largely in the hands of black musicians. Although certain outstanding practitioners, such as Fer-dinand 'Jelly Roll' Morton, claimed to have invented it, hundreds of musicians contributed to its evolution. Be-cause the term jazz is so broad, no one characteristic can distinguish it from other styles. However, common characteristics are an emphasis on improvisation, a rhyth-mic 'swing' resulting from small departures from the regular pulse, and an emphasis on individuality of instru-mental or vocal sound. Musical elements that went into the evolution of jazz include the hymn tunes of 19th-century revivalist meetings; white imitations of slave

King Oliver's Creole Jazz Band in Chicago, 1923. King Oliver is the trumpeter, Louis Armstrong is at the front playing slide trombone, and the pianist is Lil Hardin, later to become Lillian Armstrong. Oliver was the only black **jazz** artist to record extensively in the early twenties. Many of these early recordings became classics of the genre.

music, as in the black-face minstrel shows popular from the 1830s; the *blues and work songs of the black slaves; and the syncopated rhythms of *ragtime. Instruments such as the clarinet, trumpet, and trombone, discarded by army bands after the US Civil War (1861–5), were taken up by the emancipated slaves and, together with such simple 'minstrel' instruments as the *banjo, became the basis of a new sound. Because it arose out of a black oral tradition the early history of jazz is obscure. Most New Orleans musicians name Buddy Bolden as the earliest jazz player, though there were two musicians of that name in New Orleans at the time. Although it began as a black music, jazz was initially brought to a wider public by white musicians. The Original Dixieland Jazz Band were a white New Orleans group who became immensely popular in New York playing *Dixieland music. In 1917 they made the first jazz recordings, and by the end of that year jazz was becoming a nationwide phenomenon. As jazz gained popularity it became possible for black musicians to make records. Of great importance were the early recordings (1923) of Joseph 'King' Oliver, who numbered among his players the trumpeter Louis *Arm-strong. Armstrong's imaginative playing marked the emergence of the soloist as a shaping influence on the way jazz developed, as 'Jelly Roll' Morton and Bessie Smith had respectively influenced the development of ragtime and blues. As jazz spread to Chicago and New York, and thence to London, Paris, and the rest of Europe, it became more ambitious and sophisticated. The 'arranger' came into existence, scoring the music in such a way that improvisation (the life-blood of the style) was still possible within the context of the written score. The typical seven-piece ensemble now began to develop into the *big band, and with it came the first of the great jazz composers: Edward 'Duke' *Ellington. The carefully thought-out big band style led to the development of a much smoother style of playing, less subject to the raw emotions of improvisation. This style became known as swing. Typical swing bands were led by virtuoso players

such as the clarinetists Benny Goodman, Artie Shaw, and Woodrow 'Woody' Herman, and the pianist William 'Count' Basie. In its turn, swing was overtaken in the 1940s by a more rhythmic style of jazz known as bebop, so called after the practice of imitating its sound by vocalizing meaningless, onomatopoeic syllables ('scat' singing). Among the leading exponents of the new style were the saxophonist Charlie 'Bird' *Parker, the trumpet-player John 'Dizzie' Gillespie, and the pianist Thelonious Monk. 'Bop' was in some respects a return to the principles of early jazz, in that it reacted against big band commercialism and laid a greater emphasis on spontaneity and solo virtuosity. In the 1950s the rise of *rhythm and blues and *rock and roll led to a decline in jazz audiences. Jazz continued to develop, but along several pathways. Some musicians moved towards a blending of jazz and classical styles; this cool or West Coast jazz involved such musicians as Miles *Davis and Gerry Mulligan; it was further developed by John Lewis's Modern Jazz Quartet. Miles Davis and saxophonist John Coltrane later introduced modal playing, in which modal scales (see *mode) were used as the basis for improvisation. In the late 1950s such players as Ornette Coleman and Cecil Taylor abandoned scales altogether and began to play 'free' jazz. Free jazz has continued as a minority form, and more recent groups such as the Art Ensemble of Chicago have brought it to a wider audience. In the late 1960s Miles Davis was once again at the forefront of a new development in jazz, fusing jazz idioms with elements of rock music. In the 1970s and 1980s there has been an increasing use of electric and *electronic instrumentation in jazz. Many jazz groups have evolved with multinational personnel, and this has led many musicians to incorporate the music of other countries into their work: Chris MacGregor's group Brotherhood of Breath, for example, draws on South African music. Other groups show a wider eclecticism: Carla Bley's opera on record, *Escalator Over the Hill*, uses different styles of jazz, Western art music, and folk-song from various parts of the world. Jazz styles from all earlier periods continue to flourish, and the term now covers a range of music in which no clear mainstream is discernible.

jazz dance, a popular form of North American vernacular dancing performed to *jazz music. During the early decades of the 20th century African and Caribbean dance elements were incorporated into White dancing in musical shows. Early forms such as the *Charleston used the bent knees, swinging hips, and isolated shoulder and torso movements associated with African dance but in a Westernized version. In common with jazz music, the elements of jazz dance are difficult to disentangle, partly because of their improvisational character. Balletic and modern dance movements also appear in later forms, but there now seem to be two, often conflated, versions: African jazz dance (which remains as true as possible to its African elements), and North American jazz dance (which borrows from existing Western theatre forms). Jazz dance is highly popular at a participatory level in the Western world. In musical shows and films such as *Cabaret* (1972) it appears as the main form of dance. Its impact is clear in the work of ballet *choreographers such as *Balanchine and in much *modern dance.

Jefferies, (John) Richard (1848–87), British novelist, essayist, and naturalist. He is remembered for his works

about country life in Wiltshire written in a descriptive, poetic prose. *Hodge and His Masters* (1880) is a classic record of Victorian countrymen. This was followed by *Bevis, the Story of a Boy* (1882), an outstanding evocation of a country childhood drawn from Jefferies's own boyhood in Wiltshire. His autobiography, *The Story of my Heart* (1883), tracing the development of his unorthodox and atheistic beliefs, caused some literary scandal.

Jencks, Charles *Post-Modernism.

Jensen, Johannes V(ilhelm) (1873–1950), Danish novelist, essayist, and poet. He made his mark with *Himmerland Stories* (1898–1910), collections of tales immortalizing his home region of North Jutland. *The Fall of the King* (1900–1) his best-written work, is a *historical novel full of exuberant fantasy and rich poetry. More uneven is the six-volume novel cycle *The Long Journey* (1908–22), a history of mankind counterbalancing the Bible, mythology, and saga with an idealized Darwinian vision of human development. The eleven volumes of stories and essays *Myths* (1907–44), in similar vein, gained him the Nobel Prize for Literature (1944).

jet ornaments, small decorative objects, particularly jewellery, made of jet, a hard, black, lustrous stone (a form of lignite) similar to coal, but capable of being elaborately carved. Used since prehistoric times, it has always been thought to be able to ward off evil, and so was much used for making amulets, particularly in medieval Spain. There the art of jet carving flourished in Santiago de Compostela, where figures of saints and rosaries were sold to the pilgrims to the famous shrine. Jet carving was also important in Whitby, northern England, in the early 19th century. By the middle of that century card-cases, paper-knives, busts, seals, and many other ornaments were being made; it was also used for inlaying in alabaster.

jewellery, decorative objects worn as adornments on various parts of the body. Jewellery has been made from a great variety of materials including precious metals, gemstones, *amber, bone, *coral, glass, *jet, *shell, wood, and more recently plastic. It has also involved the use of many techniques, such as gem-cutting, *enamelling, *filigree, and so on. From the earliest times people have lavished skill and wealth on jewels for personal adornment. An elaborate four-string necklace of beaten gold leaf and precious stones was found in a royal grave at Ur in Sumeria, perhaps 4,000 years old. The jewellery of the ancient Egyptians is also of very high quality, for example the beautiful pieces in gold and lapis lazuli discovered in Tutankhamen's tomb. The finest Greek jewellery belongs to the Classical period of 475 to 330 BC. Diadems were made of embossed strips of gold, while ear-rings were often made in the form of spirals, with the thin end passing through the ear and the other end ornamented with an animal or human head. The Romans followed Greek patterns but made greater use of precious stones, including emeralds, pearls, sapphires, and uncut diamonds. They also made great use of *cameos in their jewellery. The Inca peoples of what is now Peru had distinctive ear-plugs, worn within holes pierced in the ear-lobes. They varied in size and material according to status, those of royalty being some 15 cm. in diameter. The men of this civilization also wore gold arm-bands,

Jewellery reached great heights of complexity and sophistication in the ancient world. This Minoan pendant, dating from about the 17th century BC, portrays a nature god standing among lotuses holding a water-bird in each hand. The two curved, serpent-headed objects behind him are perhaps hunting bows. (British Museum, London)

while women wore necklaces of shells. Anglo-Saxon jewellery (*fl.* 7th century AD) was famous for the fine quality of the goldwork and *cloisonné* enamel, a good example being the Alfred Jewel now in the Ashmolean Museum, Oxford. Much of medieval jewellery was made for the Church, especially for fastening ecclesiastical robes and regalia. Later jewellers found employment at the royal courts (see *crown jewels). The Renaissance brought a different kind of jewellery, based on more classical motifs and personal to the wearer: Henry VIII had a jewel with the initials H and K for himself and his wife Katherine of Aragon. In the 17th century jewellers became increasingly skilful in the cutting of stones, and used less interesting settings. The craze of the Napoleonic era (1804–14) for imitating the dress of the ancient world led to a new fashion for cameos, worn as brooches or on bracelets. Towards the end of the 19th century the precious stone became increasingly important and the setting of less account. Around the turn of this century the *art nouveau style had an important influence on jewellery design, the guiding spirit being *Lalique, who made jewellery based on the naturalistic forms of flowers, winged insects, and the human figure made from gold, ivory, horn, mother-of-pearl, and enamel. *Tiffany's designs combined the art nouveau styles with the Byzantine and Oriental traditions that had strongly influenced him. One of the most important recent developments in jewellery for the mass market has been the introduction of plastic, which allows the use of a very wide range of colours.

jew's harp, a plucked musical instrument, in fact neither Jewish nor a harp. Western models, and the Indian ones from which they derive, have a steel reed, or feather, between the arms of a bowed frame. The free end of the feather is upturned and is plucked by thumb or finger.

The frame is held between the teeth and overtones of the reed's fundamental are produced by varying the mouth capacity, and amplified by breathing past the reed. In South-East Asia, where they probably originated, jew's harps are either a single piece of metal or more often bamboo, with the reed cut out of the piece, as a greatly enlarged form of the blown free reed. In New Guinea they are a curved bamboo segment, with the reed cut from the segment. Both are plucked by pulling a piece of cord attached through the hinge end of the reed.

Jhabvala, Ruth Prawer (1927–), novelist and screen-writer, born in Germany but resident for many years in India. Her many novels, including *Heat and Dust* (1975) and *Baumgartner's Bombay* (1988), explore encounters between European and Indian cultures. She has written several fine screenplays for the film director James Ivory, including *Shakespeare Wallah* (1965), adaptations of Henry James's novels *The Europeans* (1979) and *The Bostonians* (1984), and a version of her own *Heat and Dust* (1983).

Jiménez, Juan Ramón (1881–1958), Spanish poet. He stands between the *modernism of *Darío, whose emphasis on subjectivity and individuality influenced his work, and *García Lorca and the other poets of the *Generation of '27. While his output of poetry was prodigious, he is best remembered for *Platero and I* (1914), a children's volume of some 137 prose poems. He was awarded the Nobel Prize for Literature in 1956.

Joachim, Joseph (1831–1907), Hungarian violinist and composer. After studying in Vienna (1841–3), Joachim went to Leipzig where he was taught by *Mendelssohn. In 1849 he became leader of the Weimar court orchestra, under *Liszt. A superb interpreter of the classical concerto, especially that of Beethoven (for which he wrote cadenzas), Joachim was the dedicatee and first player of Brahms's concerto.

John, Augustus (1878–1961), British painter and graphic artist. As a young and brilliant draughtsman John was identified with all that was most independent and rebellious in British art. In the years immediately before World War I he painted some ambitious figure compositions showing an awareness of advanced French art, but increasingly he turned to portraiture. He painted many famous personalities, but the bravura of his early work often degenerated into mere flashiness, and the second half of his long career added little to his achievement, although he remained a colourful figure.

John, Gwen (1876–1939), British painter. She was the sister of Augustus *John, but his complete opposite artistically, as she was in personality, living a reclusive life and favouring introspective subjects. For most of her life she lived in France, where she was a pupil of *Whistler, adopting from him the delicate greyish tonality that characterizes her work. Most of her work consists of single figures, usually young girls or nuns (she was deeply religious), painted with great sensitivity and unobtrusive originality. She was little known in her lifetime, but her reputation now stands higher than her brother's.

Johns, Jasper (1930–), US painter, sculptor, and print-maker. He has been closely associated with *Rau-

schenberg, and they are considered to have been largely responsible for the movement from *Abstract Expressionism to the types of *Pop art and *Minimal art that succeeded it. Much of his work has been done in the form of series of paintings representing commonplace two-dimensional objects, for example *Flags*, *Targets*, and *Numbers*, and his sculptures have most characteristically been of equally banal objects, such as beer cans.

Johnson, Philip (1906–), US architect and writer on architecture. His book *The International Style* (1932), written in conjunction with the architectural historian Henry-Russell Hitchcock, is regarded as a fundamental work on the *Modern Movement. In the 1940s he turned to architectural practice, working in the fastidiously elegant style of *Mies van der Rohe, with whom he collaborated on the Seagram Building, New York (1954–8), possibly the most beautiful of all skyscrapers. Later, Johnson's work became more experimental, and in the 1970s he became one of the leaders of *Post-Modernism, notably with his AT&T building in New York (1978–83).

Johnson, Samuel (1709–84), British poet, lexicographer, and critic. His student days at Oxford were marred by poverty and he left prematurely, without a degree. He contributed articles and poems to the *Gentleman's Magazine*; in 1750 he started his own journal the *Rambler*, followed by the *Idler*. Among his best-known poems are *London* (1738), reflecting on the city's vices and the oppression of the poor, and *The Vanity of Human Wishes* (1749), both in imitation of *Juvenal. His *Dictionary of the English Language* (1755) was the first major English dictionary to use illustrative historical quotations, and represented the first attempt to standardize the pronunciation and spelling of the English language. His philosophical romance *Rasselas* was written in 1759. The preface to his edition of Shakespeare (1765) is regarded as one of his finest works of critical prose. His famous expedition to Scotland, recorded in *A Journey to the Western Islands of Scotland* (1775), was followed by his classic *The Lives of the Most Eminent English Poets* (1777–81), which remains a landmark in the history of literary taste. *Boswell's *Life of Johnson* portrays his brilliant conversation, his eccentricities, his generosity, and his humanity. His profound but melancholy religious faith is revealed in his diaries and meditations.

Jones, Inigo (1573–1652), English architect and stage designer. Jones was one of the greatest of English architects and certainly the most influential, for he introduced a pure classical style based on the work of *Palladio to a country where *Renaissance influence had previously been fairly superficial. He revolutionized theatre design in Britain when, from 1605, he undertook the *set design for a series of court *masques, introducing the Italian picture-stage framed in the proscenium arch. He used revolving screens in the Italian manner, with backcloths, shutters or flats painted and arranged in perspective and able, by means of mechanical devices, to present to the audience different facets of a solid structure. The principal writer of the masques was Ben *Jonson, with whom Jones had a notorious running feud about the rival claims of words and spectacle. Jones made two visits to Italy (*c.*1600 and 1613–14) and it was after the second that he began to be employed by the crown as an architect as well as

a designer. Most of Jones's buildings have been altered or destroyed, but his two finest surviving works, the Queen's House at Greenwich (1616–35) and the Banqueting House in Whitehall (1619–22), with its painted ceiling by *Rubens, are among the masterpieces of English architecture. His immediate influence was confined mainly to court circles, as his style was too advanced and subtle to be generally imitated, but he was an inspiration to *Wren and a hero to exponents of *Palladianism such as *Burlington and *Kent.

jongleur, a medieval travelling entertainer, a combination of *minstrel, conjuror, *clown, and acrobat. Descendants of the *mime of Roman times, *jongleurs* formed a link during the theatreless Middle Ages between the earlier pagan drama and the emergent *liturgical drama. They were vagabonds working sometimes in groups and sometimes independently, and included both sexes. They are not to be confused with the *trouvères*, who were attached to particular households and whose material was more uplifting and sometimes used by the *jongleurs*.

Jonson, Ben(jamin) (*c.*1572–1637), English dramatist and poet. His first important play *Every Man in his Humour*

Ben **Jonson** collaborated with Inigo Jones on court masques from 1605 until 1631, when their quarrelling brought the partnership to an end. This design by Jones is for Queen Henrietta Maria's costume in *Chloridia* (1631), the last masque on which he worked with Jonson. Its subject was the transformation of the nymph Chloris into Flora, the goddess of flowers, through the love of Zephyrus (the west wind). (Trustees of the Chatsworth Settlement)

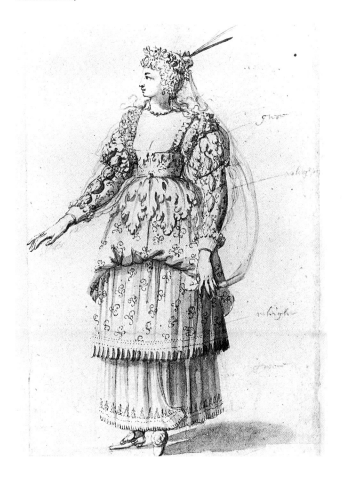

(1598) introduces his comedy of humours in which various characters are dominated by a particular 'humour' or passion. His tragedies, *Sejanus* (1603) and *Catiline* (1611) are on Roman themes. His greatest plays are the comedies *Volpone* (1605-6), *Epicene* (1609-10), *The Alchemist* (1610), and *Bartholomew Fair* (1614), which earned him a royal pension. Some of his finest lyrics appear in the *masques he produced for the court of James I from 1605 with stage scenery by Inigo *Jones. He introduced the antimasque, a prelude to the main action which by contrast served to highlight the central theme. His non-dramatic verse includes *Epigrams* (1616), *The Forest* (1616), which contains the song 'Drink to me only with thine eyes', and *The Underwood* (1640). His collection of observations on life and letters, *Timber: or Discoveries*, was published posthumously in 1640 and is among his major prose works. He presided over a literary circle which met at the Mermaid Tavern; it included Shakespeare, Bacon, Donne, and many younger writers known as the 'tribe of Ben'. Of Shakespeare he was to say on his death, 'I loved the man, and do honour his memory, on this side idolatry, as much as any.' In both his religious and secular poems Jonson wrote in a variety of forms with a classical, unadorned clarity and with great depth of feeling.

Jooss, Kurt (1901-79), German dancer, choreographer, teacher, and director. He studied ballet before meeting *Laban, with whom he then worked. His best-known work, *The Green Table* (1932), 'a dance of death in eight scenes', is a powerful work showing how the horrors of war affect ordinary people. With the rise of Nazism Jooss left Germany for Dartington Hall in Britain, where his group Ballets Jooss toured extensively. He returned to Essen in 1949 to re-establish his school and company. His works continue to be mounted by his daughter Anna Markard. The synthesis of *ballet and *modern dance styles mark his choreography, as does his concern with dramatic versions of social events.

Joplin, Scott (1868-1917), US pianist and composer. Little is known of his early career, but after working in various musical capacities he formed his own band (Chicago, 1893) and began to write down his piano compositions. 'Maple Leaf Rag' (1899) established his reputation, and its many successors earned him the title 'The King of *Ragtime'. Though not successful during his lifetime, his ragtime opera *Treemonisha* achieved recognition in 1972 as part of a general revival of interest in his music.

Jordaens, Jacob (1593-1678), *Flemish painter, etcher, and tapestry designer. After *Rubens's death in 1640, Jordaens became the leading figure-painter in Flanders. His style was heavily indebted to Rubens, but was much more earth-bound, characterized by thickly applied paint, strong contrasts of light and shade, and colouring that is often rather lurid. He is particularly associated with large canvases of hearty, rollicking peasants, but his prolific output included many other subjects.

Josquin Desprez (*c*.1440-1521), Franco-Flemish composer, perhaps the most talented, versatile, and influential composer of his time. He was a prolific composer—some eighteen masses, 100 *motets, and approximately 70 secular pieces have been attributed to him. Though he did not break radically with tradition, Josquin brought an intensity and human warmth to the art of music. He pioneered the use of free imitation (particularly in the motet), which dispenses with the conventional backbone of a *plainsong *cantus firmus* or fixed melody. Those motets which do not use plainsong as their basis often treat the material in unusual *canons (*inviolata*), as a motto (*Salve Regina*), or intermittently as a kind of *leitmotiv. His *chansons reflect the growing taste for lightweight, racy, and sometimes erotic texts, and he was one of the earliest composers to borrow extensively popular melodies, which he worked in canon into his settings.

Joyce, James (Augustine Aloysius) (1882-1941), Irish novelist and poet. Educated at a Jesuit boarding school and University College, Dublin, he soon became dissatisfied with the constrictions and what he considered the bigotry of Irish Roman Catholicism and left Ireland in 1904. Thereafter he lived mainly in Trieste, Zurich, and Paris with Nora Barnacle, whom he married in 1931. His collection of short stories *Dubliners* (1914) was greeted with enthusiasm by *Pound, who greatly encouraged Joyce's career. His next important work, the autobiographical novel *A Portrait of the Artist as a Young Man* (1914-15), introduces Stephen Dedalus, who reappears in his masterpiece, *Ulysses* (published in Paris by Sylvia Beach, 1922). This work, a gentle *parody on Homer's *Odyssey*, employs a variety of techniques, and ranges from extreme realism to fantasy; it deals with a day in the life of an 'everyman' figure, Leopold Bloom. Together with *Finnegans Wake* (1939), which presents the story of a Dublin tavern-keeper, Chimpden Earwicker, it revolutionized the form and structure of the *novel, decisively influenced the development of the *stream of consciousness, and pushed language and linguistic experiment to the limits of communication. Both works have produced a mass of critical commentary. Joyce also wrote two collections of poems, *Chamber Music* (1907) and *Pomes Penyeach* (1927), and a play *Exiles* (1918).

Juvenal (AD *c*.60-*c*.127), the last and greatest writer of Roman *satire. The main (but not invariable) subject of his sixteen surviving satires is the darker side of human life and of imperial Rome; their style is forceful, rhetorical, and often lofty. He had considerable influence on later poetry; in English this is best seen in *Johnson's poems 'London' and 'The Vanity of Human Wishes'.

K

Kabuki *Japanese drama.

Kafka, Franz (1883–1924), Austro-German novelist and short-story writer. The son of a prosperous Jewish businessman in Prague, Kafka's works create a world of private myth, where, with dreamlike logic, events are recorded with sobriety and exactitude, tinged with grotesque humour. Although his vain attempts to escape domination by his father, documented in *Letter to His Father* (1919), contributed to his obsession with the theme of guilt and self-doubt and with figures of authority, his writing betrays a more fundamental metaphysical fear, uncertainty, and alienation. Life offers his heroes merely a choice of evils; it demands justification of self and status or provokes an endless search for meaning, which is re-enacted in the reader's frustrated attempts at unambiguous interpretation. In his short story *The Judgement* (1912) a son's compliance with a death sentence passed on him by his father reveals the hollowness of his social success and the validity of his initial self-doubt. With relentless logic *The Metamorphosis* (1915), a story in three sections, pursues the effect on an entire family of the hero's impossible metamorphosis into an insect. The transformation itself is thought to represent either the hero's willing servility or his hitherto suppressed rebellion against the worlds of work and family. Kafka's three novels, all unfinished, were published posthumously (against the author's wishes) by Max Brod. The most important are *The Trial* (1925), in which the unexplained arrest and trial of the hero provide a picture of the workings of inscrutable authority and of the individual's desperate attempt to deny the guilt of his own existence, and *The Castle* (1926), which describes a further search for self-justification and a doomed quest to penetrate the secret of some supposedly higher authority, which appears merely an inaccessible, muddled bureaucratic machine.

Kahn, Louis (1901–74), Estonian-born US architect, based mainly in Philadelphia, where he studied and taught at the University of Pennsylvania (he was appointed professor of architecture in 1955). From the 1950s he came to prominence with a series of buildings, many for universities and educational institutions, in which he moved beyond the smooth elegance of the *Modern Movement to a style that, while still strongly geometrical, was more bold and rugged. The Yale University Art Gallery (1951–3) and the Kimbell Art Musuem, Fort Worth, Texas (1966–72), are among his best-known works. He had wide influence through his writing and teaching as well as his buildings.

Kaiser, Georg (1878–1945), German *Expressionist dramatist. Concerned with the need for an ethical renaissance to reassert humane values, Kaiser uses trenchant and impassioned language to convey his characters' search for a spiritual fulfilment which few find: the cashier in *From Early Morning to Midnight* (1916) and the millionaire's son in the trilogy *Gas* (1917–20) are broken by society's reluctance to change. In *The Burghers of Calais* (1914),

generally regarded as his best work, six individuals achieve spiritual equilibrium through self-sacrifice. After the Nazis banned his plays (1938), Kaiser went into exile in Switzerland. His last work was a mythological trilogy in which he reaffirms his self-confidence and his belief in regeneration.

Kālidāsa (b. AD *c*.400), Sanskrit poet and dramatist. He flourished during the reigns of Chandragupta II and Kumaragupta I (AD 375–455), the heyday of ancient Indian courtly culture. Only six works can definitely be ascribed to Kālidāsa, his earliest poem perhaps being *Meghadūta* ('The Cloud Messenger') with its lyrical descriptions of Indian nature and landscape. Among the finest works of *Sanskrit literature are his two epic poems: *The Birth of Kumara* on Shiva and Parvati's courtship and the birth of their son, the war-god Kumara, and *The Lineage of Raghu*, thought to be his last composition, a history of the Raghu dynasty inspired by the *Rāmāyaṇa*. Of Kālidāsa's plays, *Malavika and Agnimitra* is a comedy of court love-intrigues, while *Urvashi won by Valour* portrays the ancient love-story of Pururavas and Urvasi. His masterpiece, much admired by Goethe, is Śakuntalā (named after its heroine), in which a king, cursed to forget his wife, finally recognizes her again by the token of a ring.

kalimba *sansa.

Kandinsky, Wassily (Vasily Vasilyevich) (1866–1944), Russian-born painter and writer on art who

This woodcut by **Kandinsky** was used as the cover for the first issue of the *Blaue Reiter Almanach*, published in 1912 (a second number was planned, but never appeared because of the outbreak of war). The almanac is a collection of essays and illustrations, many of the pictures showing the wide-ranging artistic sympathies of Kandinsky and his colleagues; they include, for example, children's drawings and African sculpture.

became a German citizen in 1927 and a French citizen in 1939: one of the most important pioneers of *abstract art. He abandoned a promising university career teaching law and in 1896 went to Munich to study painting. From 1908 he began to eliminate the representational element from his work; and between 1910 and 1913, in a series of pictures he called *Compositions*, *Improvisations*, and *Impressions*, he arrived at pure abstraction, using colour and line freely with vigorous expressive power. From 1911 he was a prominent figure in the *Blaue Reiter, but on the outbreak of war in 1914 he returned to Russia, where he was appointed to several distinguished academic posts. In 1921, however, being out of sympathy with ideals in the newly created Soviet Union according to which fine art was subordinated to *industrial design, he left his homeland for Germany and took up a teaching post at the *Bauhaus, remaining there until it closed in 1933. He then settled in France. He was influential not only through his paintings but also through his writings, which show his interest in mysticism.

kantele, a musical instrument, a Finnish *zither, originally carved from solid wood but now usually built up from slats. It has the same position in the Finnish *Kalevala* epic as the lyres of Orpheus and Apollo in Greek legend. In the 19th century and earlier the kantele had only five strings, but more have been added recently. It is played with a *plectrum or the fingers. Similar instruments are called *kannel* in Estonia, *kokle* in Latvia, *kanklės* in Lithuania, and *gusli* in Russia; early examples have been found in Gdańsk and Novgorod.

Karsh, Yousef (1908–), Canadian portrait photographer. Born in Armenia, Karsh learned photography in Boston, Massachusetts, from John Garo. His magnificent portrait of Winston Churchill appeared on a *Life* magazine cover in December 1941. It was the beginning of Karsh's international reputation as the greatest modern photographer of masculine heroes.

Kasprowicz, Jan (1860–1926), Polish poet. He was Poland's first outstanding writer of peasant origin. The *Hymns* in *To a Dying World* (1902) are free verse expressions of conflict in creation, using the form of medieval penitential hymns. He adopted a naïve folk style in *Book of the Poor* (1916) and *My World* (1926).

kathak, a major classical dance form from northern India, performed by men and women for entertainment or religious functions. It developed from the 15th to the 18th centuries, deriving some of its theory from dance treatises like the *Natyashastra, and elaborated by connection with north Indian classical music and dance-dramas expressing moods of love and devotion to Krishna. In the basic stance the dancer stands straight, one arm held vertical, the other extended at the level of the shoulders. Gliding movements of the neck, wrists, and eyebrows are also used; angular movements are excluded. The feet, which have about 100 tiny bells attached to them, execute intricate rhythmic patterns at high speed, the rest of the body remaining motionless, and sequences of rapid pirouettes are assisted by the flowing skirts of the costume. Musical accompaniment is provided by drums, *sarangi (a bowed string instrument), and a singer. Major 20th-century performers include Shambhu Maharaj, Sunder Prasad, Gopi Krishan, and Sitara Devi.

kathakali, a form of *Indian classical dance originating in the 17th century in Kerala, in the extreme south. Kathakali relates stories from the *Ramayana and other religious texts through dance-drama, accompanied by singing and by instrumental music with an emphasis on percussion. Most characters wear towering headgear, billowing skirts, and elaborate make-up in which different characters are represented by different facial colours. The dance comprises sequences of delicate and vigorous movements. In the latter not just the hands, but also neck, face, eyes, and eyebrows are all important. Performances generally take place at night and in the open air. Traditionally the roles are played by men. Outstanding kathakali performers include Guru Chandu Pannikar and Krishnan Kutty.

Kauffmann, Angelica (1741–1807), Swiss painter. Having formed her style in Rome, she lived from 1766 to 1781 in London, where she enjoyed great professional and personal success. In 1768 she became a founder member of the Royal Academy, and was a close friend of its President, Sir Joshua *Reynolds. She worked initially as a portraitist, but then devoted herself more to historical scenes and to decorative work for Robert *Adam and other architects. She married the decorative painter Antonio Zucchi in 1781 and returned to Rome, where she continued her successful career.

kaval, an *end-blown flute widely used in Turkey and the Balkans by virtuoso performers, probably deriving from the Arab *nāy. It is commonly accompanied by a *drone, either hummed by the player, which greatly alters the tone character of the flute, or played on another *kaval* by a colleague.

Kawabata Yasunari *Japanese literature.

Kayagŭm *koto.

Kazan (Kazanjoglous) Elia (1909–), US film and theatrical director, of Greek parents, born in Turkey. He became a major stage director in the 1940s, coming into prominence with his staging of Thornton Wilder's *The Skin of Our Teeth* (1942). He was particularly associated with the two leading US playwrights of the time: Arthur *Miller and Tennessee *Williams. *Gentleman's Agreement* (1947) dealt with anti-Semitism, and *Pinky* (1949) with racial prejudice. After the film of *A Streetcar Named Desire* (1951) he began to show an increased awareness of the possibilites of film in *Viva Zapata!* (1952). With *On the Waterfront* (1954), about corruption among New York longshoremen, his mastery of the medium was complete. Other important films were *East of Eden* (1955), depicting the agonies of adolescence, *Baby Doll* (1956), scripted by Tennessee Williams, about a child bride in the Deep South, and *A Face in the Crowd* (1957), which attacked the misuse of television to create worthless idols. In 1964 he announced his desertion of the theatre and his preference for films, but he made only three more, the last a poorly received version of Scott Fitzgerald's *The Last Tycoon* (1976).

Kazantzakis, Nikos (1883–1957), Greek poet and novelist. He was born on Crete, and the island is a recurrent focus in his writing. His work reveals a complex and ever-evolving set of intellectual influences (including

Bergson, Nietzsche, Lenin, and Buddha). He himself saw the core of his work as the short metaphysical volume 'The Ascetic' and his modern epic poem 'The Odyssey', which embodies a doctrine of heroic but nihilistic liberty. However, he is best known for his novels, notably *The Life and Manners of Alexis Zorba* (1946), *Christ Recrucified* (1948), and *The Last Temptation of Christ* (1955), and for his autobiography *Report to Greco* (1961), where his ethical and metaphysical preoccupations found their most convincing literary expression.

Kean, Edmund (1789-1833), British Shakespearian actor. He reintroduced a naturalistic style of acting that relied on movement and on the beauty of the language rather than on the exaggerated, melodramatic delivery then in fashion. His revolutionary, romantic interpretation of the great tragic roles in Shakespeare quickly outmoded the artificial, declamatory style of its leading exponent, John *Kemble.

Keaton, Buster (Joseph Francis) (1895-1966), US film actor-comedian, director, and scriptwriter, in the silent era rivalled only by *Chaplin. He began appearing in *vaudeville with his parents in an act that combined acrobatics with miming. He entered films in 1917 and began making dozens of films with the comedy star Roscoe ('Fatty') Arbuckle. He graduated to starring roles in 1920 with *The Saphead*. As actor, co-screenwriter, and co-director he continued to make short films for the next three years, developing a character which was to become famous: the calm, dead-pan young man in conflict with mechanical monsters. In 1923 he began to appear in full-length films, most of which he directed or co- directed. They included *Our Hospitality* (1923); *Sherlock Junior* (1924), in which he played a cinema projectionist who dreamed about intervening in the on-screen events; *The Navigator* (1924), his biggest success, set in a deserted ocean liner; *Go West* (1925); *Battling Butler* (1926); and *The General* (1926), in which, in authentic American Civil War settings, the eponymous railway engine was stolen and chased. In 1928 he abandoned independent production to work for MGM; his career plummeted when the spoken dialogue displaced pantomime. Beset by personal problems and conflict with the studio, he continued to appear mostly in short films. In his last twenty years he gradually rebuilt his career, appearing in films such as *Sunset Boulevard* (1950) and *Limelight* (1952).

Keats, John (1795-1821), British poet. In 1816 he qualified as an apothecary, but gave up medical practice in favour of his literary pursuits. His long narrative poem *Endymion* (1818) was attacked by the critics as the writing of an ignorant apothecary's apprentice. During 1818-19 he reached his creative heights and wrote some of his greatest poems, all published in 1820. These include 'The Eve of St Agnes', with its rich and vivid imagery and heightened atmosphere of passion; 'Isabella, or The Pot of Basil'; 'La Belle Dame sans Merci', much admired by the Pre-Raphaelites; 'Ode to a Nightingale'; 'Ode on a Grecian Urn'; 'To Autumn'; 'Lamia', inspired by *Burton's *Anatomy of Melancholy* which reflected Keats's recurring preoccupation with the relationship between the real and the ideal, between art and life; and the unfinished epic poem *Hyperion*. Suffering from tuberculosis, he left for Rome in 1820, where he died. Keats is regarded as one of the principal figures of the *Romantic movement.

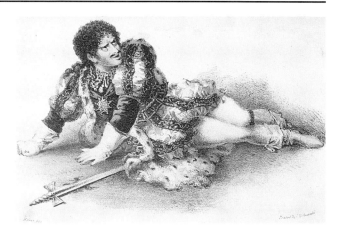

Edmund **Kean** is shown in this lithograph as Richard III. His intensely passionate style, which relied much on facial expression, appealed to the age of Romanticism; Coleridge wrote that 'to see him act is like reading Shakespeare by flashes of lightning'.

His letters (published 1848 and 1878) were, in T. S. Eliot's words, 'the most notable and most important written by any English poet'.

Keller, Gottfried (1819-90), Swiss poet, writer of short stories and novels. He is best known for his collections of stories *The People of Seldwyla* (1856 and 1874). Each story is based upon an obsession, but the moralizing is tempered by irony and humour. The collection is remarkable for its range of comic technique and moods. *Green Henry* (1854-80), a partly autobiographical novel which exists in two distinct versions, is optimistic in its view of human development, whereas *Martin Salander* (1886) is pessimistic about the effects of social and political complacency in a society that is beginning to disintegrate.

Kelly, Gene (1912-), American dancer, choreographer, and film director. He appeared in musicals in the 1940s and achieved success with *An American in Paris* (1952). He has choreographed extensively for both stage and film in the popular *musical genre.

Kemble, John Philip (1757-1823), British actor and theatre manager. The son of strolling players, he was the brother of Sarah *Siddons. He began his London career with Hamlet at Drury Lane in 1783 and ended it with Coriolanus in 1817, two of the tragic roles in which he excelled. He acted in the declamatory and statuesque style then in fashion, but his career on the stage waned when his rival, Edmund *Kean, introduced a more naturalistic interpretation of dramatic roles. He managed *Drury Lane and later *Covent Garden, where his reforms improved the status of the theatrical profession.

Kent, William (1685-1748), English architect, interior designer, landscape gardener, and painter. He began his career as a painter and in 1709-19 worked in Rome. There he met Lord *Burlington and returned with him to England; from then until Kent's death they were inseparable partners in the conversion of Britain to *Palladianism. Kent gradually abandoned painting (which was never his greatest talent) and worked as an architect, interior decorator, and garden designer. His

most important building was Holkham Hall in Norfolk (begun 1734), where the entrance hall is one of the richest and most splendid works of the period. In general he excelled more at interiors than exteriors, often designing the furniture as well as the decoration, anticipating the way in which Robert *Adam created complete interior ensembles. As a landscape designer he was important in pioneering the informal style later developed by 'Capability' *Brown.

Kenzan (Ogata Kenzan) (1663–1743), the most famous of Japanese potters, also a painter, poet, calligrapher, and lacquerer. His work is varied in style, but often combines the simplicity of form required for the tea ceremony with a bold sense of decoration reflecting the influence of his brother, the painter Ogata Korin (1658–1716). As with other notable Japanese potters, Kenzan's name was handed on from master to favourite pupil. Bernard *Leach, through whose work Japanese ceramics had a great influence on the *studio pottery movement, studied with Kenzan VI and himself was given the title Kenzan VII. (See also *Japanese ceramics.)

Kern, Jerome (David) (1885–1945), US composer. He received a thorough musical training in New York and Heidelberg, but gained practical experience as a song-plugger and by contributing songs to other people's shows. Success came with *Very Good, Eddie* (1915), *Oh Boy!* (1917), *Sally* (1920), *Sunny* (1925), *Roberta* (1933) and, greatest of all, *Show Boat* (1927), which established a new, wholly integrated type of operatic *musical. From 1939 he lived in Hollywood, contributing such outstanding songs as 'The Way you Look Tonight' (*Swing Time*, 1936) and 'Long Ago and Far Away' (*Cover Girl*, 1944).

Kerouac, Jack *Beat Movement.

Kertész, André (Andor) (1894–1985), Hungarian photographer. Born in Budapest, Kertész took his first photograph at the age of 16. Its sophisticated visual sense derived from a childhood love of magazine illustrations and several years of taking photographs 'in his head'. As a World War I soldier, he took a camera to the front line; after being wounded, he took pictures in and around military hospitals. In 1925 he went to Paris, getting to know many artists and holding his first exhibition in 1927. Wanting to be unobtrusive, Kertész always preferred small cameras. His 'candid' photographs were soon in demand for the illustrated news magazines and in 1936 he went to New York to work for a picture agency, intending to be there for a year. Trapped by World War II, he stayed for the rest of his life, working mainly for such publications as *House and Garden*. In 1962, after major surgery, he decided to give this up and take photographs only for himself. Throughout the next twenty years he became internationally famous for impeccably composed, humane, and witty slices of real life—'little happenings' as he called them.

kettledrum, a drum with a closed, often hemispherical, shell as a body. The term derives from the cauldron, or cooking pot, with a skin over the opening. Kettledrums are used worldwide, often in pairs and made of pottery, metal, or wood, the latter in Africa sometimes carved as a human trunk and legs. Small Middle Eastern kettledrums, *naqqāra*, were imported into Europe by returning Cru-

saders, and were known as nakers; they were common throughout medieval Europe. Larger kettledrums, played on camel-back in the Turkish armies, were taken up by late 15th-century European potentates and became *timpani.

key, in musical composition, a general adherence to the notes of the major and minor scales. There are twelve major keys: one for each of the semitones available in the chromatic *scale of Western music. Each has a relative minor key that shares the same general pitch area, but whose scale starts on a different note. Thus the scale represented by the 'white notes' of the piano and which has C as its tonic (starting note) is the key of C major. A white-note scale starting on A is the key of A minor. The tonic note of the minor key is always three semitones below that of its relative major key. Each major key contains seven steps. Two are semitones and five are tones. These are arranged as two identical four-note sequences, linked by a tone. These tone–tone–semitone sequences are known as tetrachords. The example below shows the tetrachords for the scale of C major.

A similar, but slightly more complex, principle governs the construction of minor scales. This invariable scale-structure explains the system of key relationships that underlies the idea of *tonality. Keys are in their nearest relationship one with the other when their scales share every note but one. The new note is introduced in order to preserve the tone–tone–semitone structure of the tetrachords. This relationship exists between keys whose scales start on tonics that are five notes apart. Thus the keys immediately related to our C major example are G above and F below. In the key of G major the scale

This detail of an illustration from Sandford's *History of the Coronation . . . of James II and Queen Mary* (1687) shows a drummer playing a pair of Baroque timpani or **kettledrums**, carried on the back of an assistant. The instruments are covered by royal banners.

requires an F sharp in order to preserve its hexachord pattern, while F major requires a B flat. Keys are thus related to each other in a continuous cycle of fifths, and each key is identified by the number of sharps or flats required for the maintenance of the tetrachords. These are usually grouped at the beginning of each line of music in the form of a key signature (see example below, which shows the cycle of major keys, with their relative minors).

| C maj. | G maj. | D maj. | A maj. |
| A min. | E min. | B min. | F♯ min. |

| E maj. | B maj. | F♯ maj. | C♯ maj. |
| C♯ min. | C♯ min. | D♯ min. | A♯ min. |

| C maj. | F maj. | B♭ maj. | E♭ maj. |
| A min. | D min. | G min. | C min. |

(seldom used)

| A♭ maj. | D♭ maj. | G♭ maj. | C♭ maj. |
| F min. | B♭ min. | E♭ min. | A♭ min. |

The key signature may be changed during the course of a composition, when the tonality changes. It may also be contradicted, briefly, by the use of accidentals (new sharps, flats, or naturals applied to individual notes). The process of passing from the note-area of one scale into the note-area of another is known as modulation. Reference to the piano keyboard will show that the keys of C sharp major and D flat major involve the same notes, as do C flat major and B major. These keys are said to be enharmonic versions of each other—they sound the same but have different notation.

The word **key** is also applied to the levers on woodwind instruments that enable the player to obtain different notes more easily. The complete set of levers is known as the keywork.

keyboard, a set of levers ('keys') which, when struck by the player's fingers, set in motion the mechanism of such instruments as the organ, harpsichord, and piano. The keys correspond to the twelve notes of the chromatic scale and are grouped in two rows: a lower row of seven 'white' keys for the diatonic scale of C major, and an upper row of five 'black' keys, grouped in sets of two and three, for chromatic notes necessary to complete the other scales. Early keyboards often employed a 'short octave' arrangement for the lowest registers, whereby certain rarely used chromatic notes were omitted from the tuning and their corresponding 'black' keys made to operate diatonic notes. The complete diatonic octave was thus compressed into a shorter span that enabled the left hand to tackle larger intervals. The colour of the keys, though now universally black and white, has been a matter of fashion. In the 17th and 18th centuries the present-day black and white arrangement was often reversed.

Keystone Kops *Sennett, Mack.

Khachaturian, Aram (Ilyich) (1903–78), Soviet composer. Of Armenian descent, Khachaturian attracted international interest with his Piano Concerto (1936). His ballets *Gayane* (1942, containing the popular 'Sabre Dance') and *Spartacus* (1954) have come to be performed all over the world. His finest music is richly romantic and reflects the influence of Armenian folk-song.

Khajuraho, the site of a vast group of temples in the Madhya Pradesh province of central India. Khajuraho was a capital of the Chandella dynasty and the temples were built in the 10th and 11th centuries; originally there were about eighty of which about a quarter are still standing. The most famous is the Kandarya Mahadera temple, dedicated to the Hindu god Shiva, which has one of the world's greatest groupings of architectural sculpture, including many beautiful erotic scenes.

Khayyām, 'Omar (d. 1132), Persian poet. Originally he was most famous in the Iranian world as an astronomer and mathematician. But he was also known as the master of the minor poetical form of *rubā'āt* or *quatrains, and his work has always been admired for its polished excellence. His wider fame is due to the inspired English translation, or interpretation, of his poems by Edward *Fitzgerald.

Khmer art, the art and architecture of the ancient kingdom of Khmer in Cambodia, which emerged in the second half of the 6th century AD and prospered from the 9th to the 13th century. Khmer culture was based on Indian ideas of social organization borrowed from Java, central to which was the concept of the king as personification of a god (Devaraja cult). The large-scale sandstone temple complexes at which state rituals were performed were designed to resemble the sacred mountain, the abode of the gods, and the temple-mountain analogy was used to identify the king's authority as divinely sanctioned. The gods most widely worshipped in ancient Cambodia were the Hindu deities Shiva, Vishnu, and Harihara (a combined form of these last two deities), but Buddhism also became widely practised, and an increasingly hybrid religion emerged. The popularity of particular deities is chronicled through the surviving sculptures, both free-standing and relief. Representations of these deities in stone and bronze (large-scale bronze-casting was practised with great skill) were installed in state-sponsored and private temples throughout the kingdom and sculptures of snakes (*nagas*), lions, and warriors (*dvarapalas*) were erected as temple-guardians. These sculptures are derived from Indian prototypes, but are in a distinctly Khmer style, the figures being graceful and slender, with softly smiling lips and deeply arched eyebrows. The surfaces of Khmer temples are typically decorated with low-relief narratives depicting both episodes from the great Indian religious epics such as the *Mahabharata* and scenes from the life of the ruler and his people. These are the richest source available for an insight into the daily life of ancient Cambodia. Far and away the most important Khmer temple is Angkor Wat, near the capital of Angkor Thom. Probably the world's largest religious structure (almost 2.6 sq. km. or 1 sq. mile), it was begun in the reign of Suryavarman II (1113–50) as his dynastic temple and mortuary shrine, and is

This example of **Khmer art** shows a sandstone statue (c.10th century) representing Brahma, the supreme Being, God of wisdom and guardian of the vedas. Three of his four heads are visible in the photograph, with sacred threads on his arms and wrists. (Musée Guimet, Paris)

the supreme example of the Khmer concept of the temple as sacred mountain. Dominating the structure are five huge acorn-shaped towers and the sculptural decoration is astonishingly rich and abundant. The carving indicates that the temple was dedicated to Vishnu, with whom the king may have aspired to be identified. Angkor was finally abandoned in 1431 and, despite reoccupation by Khmer royalty in the 16th century, never regained its artistic momentum. Later Khmer art tends to reflect the influence of *Thai art, particularly in its temple architecture. Khmer ceramics are made in shapes inspired by metal vessels, with a rich iron-brown/black glaze. Examples have mostly been excavated in the vicinity of Khmer temples of the 12th and 13th centuries, both in Cambodia and in north-eastern Thailand, once part of the Khmer kingdom. Many of the forms, such as the balaster jar, incense burner, and conch-shell vessel are associated with the ritual life of the temple. Production appears to have ceased with the collapse of the Khmer empire. Some Cambodian pottery pre-dating the Khmer kingdom has also been excavated, associated with the earlier Fu-nan kingdom of the Mekong Delta region. (See also *Buddhist art, *Hindu art, *Indian art.)

kinetic art, term describing art incorporating real or apparent movement. In its broadest sense the term can be used to encompass a diverse range of phenomena, including cinematic motion pictures, but most usually it is applied to sculpture incorporating motors or driven by air currents, such as Alexander *Calder's mobiles. The term was first used in an artistic context in 1920, but it was not until the 1950s that the phrase 'kinetic art' became established as a recognized addition to critical classification.

Kingsley, Charles (1819–75), British novelist and poet. An Anglican clergyman, he was a founder-member of the Christian Socialist movement which set out to counter the evils of industrialism through Christian ethics. His interest in social reform is expressed in his didactic novels *Alton Locke* (1850), *Yeast* (1851), and *Two Years Ago* (1857); he also published the anti-Catholic historical novel *Westward Ho!* (1855). His most lasting success is the children's book *The Water-Babies* (1863), which shows his love of the underwater world and, through many vividly realized creatures, his philanthropic concerns.

Kipling, (Joseph) Rudyard (1865–1936), British novelist, short-story writer, and poet. Born in India and educated by foster-parents and at boarding-school in England, he later returned to India as a journalist (1882–9). His collections of articles and poems include *Plain Tales from the Hills* (1888), which observes the customs of both Indians and the British Raj, and *Soldiers Three* (1890). Many of his short stories are concerned with cruelty and the supernatural, such as 'The Man Who Would be King', or with man's isolation. Regarded as the 'poet of empire', his views were reflected in such well-known poems as 'The White Man's Burden', 'Mandalay', 'Gunga Din', and 'If'. Much of his best verse was collected in *Barrack-Room Ballads* (1892). Kipling's books for children, *Stalky & Co* (1899); *The Jungle Book* (1894), about Mowgli, a child brought up by wolves; *Just So Stories* (1902); and *Puck of Pook's Hill* (1906) continue to be read, as is his masterpiece *Kim* (1901), about an English boy's adventures as a spy among the natives of North-West India. In 1907 he was the first British writer to receive the Nobel Prize for Literature.

Kirchner, Ernst Ludwig (1880–1938), German painter, sculptor, and graphic artist. He was the dominant figure of the *Brücke group, and his finest works mark one of the high points of German *Expressionism. His style had much in common with that of the *Fauves, but was more emotional, revealing the influence of *Munch. Particularly noteworthy are his series of street scenes, done in Berlin in the years immediately before World War I, which powerfully express the pace and morbidity of city life. Later he turned mainly to painting landscapes and scenes of mountain peasants, his work gaining in serenity what it lost in vigour. It was declared degenerate by the Nazis in 1937 and he committed suicide the following year.

Kirov Ballet, Russian ballet company based at the Kirov Theatre, Leningrad. Until the Revolution it was called the Maryinsky and was the principal company in Russia. *Petipa and *Fokine choreographed for it, and dancers Tamara Karsavina, Anna Pavlova, and *Nijinksy were trained at its school. After the revolution Agrippina Vagonava became ballet director; she maintained the classical purity and elegance which are still the Kirov's hallmarks. *Nureyev, Natalia Makarova, and *Baryshnikov were all members of the company and its current stars include Attynai Assylmouratova and Faroukh Rusimatov. Its current director, Oleg Vinogradov,

is looking to Western choreographers to expand the repertoire.

Kitāb al-Aghānī, an Arabic literary encyclopedia compiled by Abū al-Faraj al-Iṣfahānī (d. 967). It is a twenty-volume survey of Arab poets and musicians down to the time of the compiler. One of the most delightful works in Arabic, it is the chief source of information on early Arab culture.

kitchen-sink drama, a term applied in the London theatre after John *Osborne's *Look Back in Anger* (1956) and after the staging of plays by Arnold *Wesker, to using working-class settings rather than the drawing-rooms of polite comedy. It was used somewhat contemptuously, and as modern dramatists enlarged their settings to cover many different places it fell out of use as being no longer appropriate. (See also *'Angry Young Men'.)

kitsch (German, 'trash'), a term applied to art that is considered vulgar, tawdry, or pretentious, especially work designed to have a popular, sentimental appeal. It has been most often applied to mass-produced commercial atrocities such as cheap tourist souvenirs, but it can also be used in connection with 'serious' art, for example Andy Warhol's silk-screen prints of Campbell's soup cans.

Klee, Paul (1879–1940), Swiss painter and graphic artist, one of the great figures of 20th-century art. He spent most of his early career in Munich and became involved with the *Blaue Reiter in 1911. In 1914 he

Old Man is the title of this enigmatic head by Paul **Klee**, painted in 1922. The whimsical expression, disarming simplicity of presentation, and delicate beauty of colouring are typical of Klee's subtle, poetic, and imaginative style. He greatly admired the directness of vision found in children's drawings. (Öffentliche Kunstsammlung, Basel)

travelled to Tunisia, a visit that awakened in him a sense of colour that was to be one of the glories of his work. During World War I he served in the German army, then in 1921 became a teacher at the *Bauhaus, remaining until 1931. In 1933 he was forced by the Nazis to leave Düsseldorf and returned to Switzerland. His work was included in the Nazi exhibition of degenerate art in 1937. Klee was deeply troubled by contemporary events (as well as by illness from 1935) and his late works are sometimes sombre and intense. His output was highly varied, moving freely between figuration and abstraction, absorbing countless influences and transforming them through his unrivalled imaginative gifts. He was equally a master of oils and water-colour (sometimes he combined the two in one picture) and was a superb draughtsman. His work explores the fantasies and fears of mankind with a joyous spirit that is unequalled in 20th-century art.

Kleist, Heinrich von (1777–1811), German dramatist and writer of short stories. His works, predominantly tragic, are based on the belief that knowledge is illusory and events are usually misunderstood by humans and controlled by a remote, apparently arbitrary Fate. The moral laws behind existence thus appear inscrutable. The theme of the conflict of reason and emotion lies at the heart of all his work; it appears in *The Broken Pitcher* (1808), one of the finest German comedies, but is more obvious in *The Schroffenstein Family* (1803), a re-working of the Romeo and Juliet *tragedy, and *Penthesilea* (1808), a work which contains some of Kleist's most powerful poetry. *Prinz Friedrich von Homburg* (1810) conveys his admiration for Prussia, and discusses the concepts of heroism and cowardice, of dreaming and action. Kleist's short stories are distinguished by their dramatic compactness and narrative skill in handling extreme situations of violence and disorientation.

Klimt, Gustav (1862–1918), Austrian painter and graphic artist. After an early *Impressionist phase Klimt came under the influence of *Symbolism and *art nouveau and created a highly distinctive style of lush sensuality. He painted large allegorical works and female portraits; the figures themselves are treated more or less naturalistically, but they are embellished with richly decorative patterns recalling butterfly wings or peacock feathers. They are often erotic but pessimistic in feeling and his work sometimes caused violent controversy. Klimt was regarded as the leading avant-garde artist in turn-of-the-century Vienna (he founded the Vienna *Sezession), and his work was highly influential, notably on *Kokoschka and *Schiele.

Klopstock, Friedrich Gottlieb (1724–1803), German poet. His reputation was established by the first three cantos of *The Messiah* (1748, completed 1773), an epic poem on the passion of Jesus Christ and salvation of Man modelled on Milton's *Paradise Lost* (1667). A bold and original manipulator of language, he used classical metres and free rhythmic structures to describe themes such as love, friendship, and the infinity of Divine creation, achieving thereby an unprecedented emotional expressiveness of the German language.

Kneller, Sir Godfrey (1646–1723), German-born painter who settled in England in the mid-1670s and became the leading portraitist there in the late 17th and

early 18th centuries. The finest portraits from his own hand are excellent, but his studio turned out much slick and mechanical work. He is best known for portraits of the members of the fashionable Kitcat Club.

Kochanowski, Jan (1530–84), Polish poet. The lyrical *Songs* (1586), modelled on *Horace, reveal how he enriched Polish poetic diction, influencing many subsequent generations of Polish writers. When he virtually retired from court life to the country, to lead a life he idyllized in *St John's Eve* (c.1575), he wrote the first Polish classical drama, *The Dismissal of the Grecian Envoys* (performed 1578) and a poetic version of the Psalms, *The Psalter of David* (1579). The death of his young daughter Orszula led him to express his grief and crisis of faith in an extraordinarily personal cycle of *Laments* (1580).

Kodály, Zoltán (1882–1967), Hungarian composer and educationalist. With *Bartók he became deeply involved in the collection and study of *folk music, while at the same time attempting to stimulate an interest in contemporary music. Both composers were indebted to folk-song as the basis for their own style. International success came in 1923 with the choral work *Psalmus Hungaricus*, and was followed by the equally successful opera *Háry János* (1926). Later works include the orchestral *Dances of Marosszék* (1930), *Dances of Galánta* (1937), and 'Peacock' Variations (1939); and the *Missa brevis* (1944). From 1925 Kodály was much occupied in laying the foundations of a Hungarian national scheme for musical education, for which he wrote a graded series of imaginative singing and sight-reading exercises, based on folk-song. This 'Kodály Method' rapidly gained international acceptance.

Kokoschka, Oskar (1886–1980), Austro-Czech painter, graphic artist, and writer who became a British subject in 1947. Throughout his long life he was unaffected by modern developments and pursued his own highly personal and imaginative version of pre-1914 *Expressionism. His varied output included portraits, large allegorical decorative paintings, and a particular kind of town view seen from a high viewpoint. His writings include an autobiography (1971) and several plays.

A 12th-century Korean bowl with a celadon (grey-green) glaze. Medieval ceramics are among the chief glories of **Korean art**, and this type of sparsely decorated celadon ware—beautifully proportioned and exquisitely finished—is particularly esteemed. (Victoria and Albert Museum, London)

Kollwitz, Käthe (1867–1945), German *Expressionist graphic artist and sculptor. She concentrated on tragic themes, much of her work being intended as social protest—against, for example, the working conditions of the urban poor. Many of her best works were devoted to the mother and child theme, and most of the later ones were pacifist in intention (her son was killed in World War I and her grandson in World War II). Her work conveys both power and poignancy and represents one of the high points of Expressionist art.

Komisarzhevsky, Fyodor (Fyodorovich) (1882–1954), Russian-born theatrical director and designer. Influenced by the naturalistic theatre of *Stanislavsky, he produced plays and operas in Russia from 1907, but after the Revolution of 1917 moved to Britain and then to the USA. In 1926 he directed a notable Russian season, including Chekhov's *Uncle Vanya* and *Three Sisters*. In the 1930s there followed a series of Shakespeare productions at Stratford-upon-Avon, such as *Macbeth* (1933) in 20th-century dress, with aluminium scenery.

kora, a musical instrument, the bridge-harp or harp-lute, used by the professional bards of the Manding peoples of West Africa. There are 21 strings, 11 on the left and 10 on the right side of the bridge, which stands upright, on the skin belly of the large hemispherical gourd body.

Koran (Qur'ān), the Holy Scripture of the Muslims, who believe it to be Allah's word revealed to his messenger Muhammad (570–632) through the angel Jibril or Gabriel over the period 610–32. It consists of 114 *sūras* (chapters) of varying length, each *sūra* being composed of a number of *āyas* (normally translated as verses because assonance is involved, although the Koran is a prose work). The early revelations are highly charged and rhetorical, but the style becomes more relaxed with the passing of time. The contents are diverse, particularly prominent themes being the omnipotence of Allah, the duty to believe in Allah alone, descriptions of the Day of Judgement, heaven, and hell, stories of the Prophets, and, in the latest phase, social legislation. Much of the power of the Koran lies in the Arabic and does not come across in translation.

Korda, Sir Alexander (Sándor Kellner) (1893–1956), Hungarian-born British film producer and director. He had already directed numerous films in Hungary and elsewhere when in 1932 he founded London Film Productions, making a series of high-quality films which attracted international talent and greatly enhanced the prestige of the British cinema. He directed *The Private Life of Henry VIII* (1933) and *Rembrandt* (1936) and produced such films as *Catherine the Great*, *The Scarlet Pimpernel* (both 1934), *Sanders of the River*, *The Ghost Goes West* (both 1935), *Things to Come* (1936), and *The Four Feathers* (1939). After a break during World War II the company began production again. The last film Korda directed was a version of Oscar Wilde's play *An Ideal Husband* (1947), but his productions included *Reed's *The Fallen Idol* (1948) and *The Third Man* (1949), and *Lean's *The Sound Barrier* (1952) and *Hobson's Choice* (1954). The company disbanded on Korda's death.

Korean art, the art and architecture of Korea. A peninsula situated between China and Japan, Korea has

often acted as a cultural crossroads and its art has frequently been treated as a poor relation of that of its two great neighbours. Certainly Korean art has been decisively influenced by China, but the Koreans are one of the most creative people of Asia, their finest work being characterized by an effortless grace and vitality. Unfortunately, Korea's war-torn history has led to the destruction of a great deal of the country's art. Few ancient buildings are left standing, for example, even though temples and fortifications were often built of granite, rather than wood. Korea's documented history goes back to the 12th century BC, when it was colonized by the Chinese, and the first native Korean state emerged in the 1st century BC. The time from then until AD 668 is known as the Period of the Three Kingdoms, when Korea was divided into Koguryo in the north, Paekche in the south-west, and Silla in the south-east. Many tombs survive from this period, and in spite of widespread looting, some of them have yielded goldwork of superlative quality. Others contained mural paintings. In 668 Korea was united under the rule of Silla, and this inaugurated the finest age of the country's art, the Great Silla period, which lasted for 250 years (668–918). Buddhism provided the basis for a cultured society centred on the capital Kyongju, and impressive remnants of temple architecture and sculpture survive, notably the cave temple of Sukku-lam. Stone-carving reached high levels and the bronze-casters of the Great Silla period were famed throughout the East for their temple bells, the finest surviving example being the great bell at Kyongju, made in 770. The ruling dynasty was deposed in 918, inaugurating the Koryo period, which lasted until 1392 and during which the capital moved to Songdo (now Kaesong) in 938. Numerous temples and monasteries were built during this period, but little large-scale work survives. Some superb bronzework remains, however, in the form of mirrors and ornaments, and Korean ceramics reached their peak during this period, matching even the finest products of China. In particular the *celadon ware made during the Koryo period is generally regarded as being among the most beautiful pottery ever created anywhere in the world. The Yi dynasty superseded the Koryo dynasty in 1392 and lasted until 1910, when Korea was annexed by Japan. The new dynasty replaced Buddhism with Confucianism as the state religion, and art became pre-dominantly secular. In 1592–8 a Japanese invasion dealt a severe blow to the arts, causing widespread destruction and forcing many Korean potters into captivity in Japan, where they played a major role in creating the Japanese porcelain industry. Korea produced a number of fine painters in the 17th and 18th centuries who added lustre to the national tradition. Chinese influence was strong, but Korean painters created distinctive features of their own, showing for example a special talent for portraying domestic animals. The most illustrious name in Korean painting is Chong Son (1676–1759), who brought a new vitality and freshness to the portrayal of landscape. IIe travelled the country visiting famous places and painting what was called 'real landscape', using a vigorous technique that broke with the restrained Chinese tradition. More recent Korean art has been less distinguished, although modern folk arts have won high praise. The national economy has shown a revival since the Korean War of 1950–3, and there was a massive building campaign in Seoul (capital of Korea from 1392 and of South Korea from 1948) for the Olympic Games held there in 1988. (See also *Buddhist art, *Chinese art, *Japanese visual arts.)

Korean music, a form of East Asian music performed in Korea. Though influenced for centuries by *Chinese musical traditions, Korea has maintained its own distinctive style in north-east Asia. Chinese influence is apparent from the Three Kingdoms period (57 BC–AD 668), with early native Korean instruments, such as the six- and twelve-string *zithers kŏmun'go and kayagum (see *koto), related to the Chinese qin and zheng (see *Buddhist music), and with the introduction of *Buddhism and Confucianism and their attendant music and rituals. This continued during the Great Silla period (668–918), when music was categorized as hyangak (native music) or tangak (Tang, later any Chinese music). In the Koryŏ dynasty (918–1392) Confucian ritual music was imported from China and is still performed, though in a Koreanized style. Chinese music lessened in importance in the early years of the Yi dynasty (1392–1910), from which time also dates the oldest surviving notation, and musical settings of poems written in the newly developed Korean alphabet. These show the characteristic pentatonic scales and triple metres of later Korean music. Court music is divided into various genres, including ceremonial orchestral music, aristocratic chamber music (including the vocal solo kagok), and 'folk music'—actually sophisticated solo genres for instruments (sanjo) or voice (the one-man opera p'ansori). The National Classical Music Institute was founded in 1951 to preserve traditional music.

Korngold, Erich Wolfgang (1897–1957), Austrian-born US composer. His ballet The Snowman (1910) was followed in 1916 by a remarkable first opera Violanta. His masterpiece, The Dead City (1920), conquered the world's operatic stages. In 1934 he settled in Hollywood, becoming one of the most imaginative and fluent composers of film music; the scores for Robin Hood and Anthony Adverse received Oscars. Korngold's music is highly chromatic (see *harmony), sumptuously scored, and romantic to the point of decadence.

koto, zheng, and **kayagüm,** musical instruments, the long *zithers of Japan, China, and Korea. A bridge under each string allows scales to be set by moving bridges rather than retuning strings. Pitches are varied by depressing the strings behind the bridges. The kayagüm is plucked with the flesh of the fingers, the zheng with fingernails, and the koto with artificial nails. The Chinese qin differs by not having bridges and by making more use of harmonics, whose positions are indicated by spots set into the soundboard; its use and repertoire are very ancient.

Krasicki, Ignacy (1735–1801), Polish poet. An acute observer of human follies, he employed various styles and succinct language with wit and irony in the mock-heroic Mouse-iad (1775), Fables and Parables, Satires (1779), and the first Polish novel, the Utopian Nicholas Try-All (1776).

Krasiński, Zygmunt (1812–59), Polish dramatist. His major work, the play The Undivine Comedy (1835), is concerned with the universal problem of divine intervention in historical processes, and seems to anticipate an organized revolution that would destroy the aristocracy to which he belonged. His other literary achieve-

ment is a vast correspondence that reveals an acute perception of contemporary political and cultural affairs.

Kreisler, Fritz (Friedrich) (1875–1962), Austrian-born violinist and composer, assuming US citizenship in 1943. Having studied in Vienna and Paris, and toured the USA (1888–9), Kreisler abandoned, then resumed, his career before his brilliant technique and unmistakable vibrato (controlled vibration of the string) brought him international fame. He was the dedicatee and first performer (1910) of Elgar's concerto. He composed many charming violin miniatures, attributing some to composers such as Tartini.

Kubrick, Stanley (1928–), US film director, an outstanding talent whose infrequent films usually provoke critical discussion. He attracted favourable comment with *The Killing* (1956), and after *Paths of Glory* (1957), a study of military callousness during World War I, he was seen as a major director. The spectacular *Spartacus* (1960) was taken over from another director; after its completion he moved to Britain. *Lolita* (1962), adapted from Nabokov's novel, was followed by three extraordinary films: *Dr Strangelove: How I Learned to Stop Worrying and Love the Bomb* (1964), a black comedy about the build-up to a nuclear war; *2001: A Space Odyssey* (1968), a beautiful and technically advanced *science fiction film; and *A Clockwork Orange* (1971), about teenage violence in the future. In sharp contrast to these prophetic visions, *Barry Lyndon* (1975) was a period piece, a visually beautiful adaptation of Thackeray's novel. *The Shining* (1979) was his contribution to the horror genre, and *Full Metal Jacket* (1987) a belated comment on the Vietnam War.

Kundera, Milan (1929–), Czech writer. His poems, 'The Last May' (1955) and 'Monologues' (1957), as well as his novels *The Joke* (1967) and *Life is Elsewhere* (1969), were condemned by the Czech authorities on account of their 'political deviation' and eroticism, and he was expelled from the Communist Party in 1970. In 1975 he emigrated to France, where he published *The Unbearable Lightness of Being* (1984) and *The Art of the Novel* (1988). His writings employ a mixture of eroticism and cynicism to expose the self-deception of the individual in his search for a personal fulfilment.

Kurosawa Akira (1910–), Japanese film director, a powerful and impressive artist whose individuality is stengthened by his involvement in script and editing. His early films made him well known in Japan, but his twelfth, *Rashomon* (1950), a strikingly photographed film about subjective perceptions of reality, marked a break-through in the West, not only for him but for Japanese films as a whole. His popularity was increased by several samurai sword-fighting films such as *The Seven Samurai* (1954), *The Hidden Fortress* (1958), and *Sanjuro* (1962). He also made films on a more intimate scale, including *Living* (1952), about an old man dying of cancer, and *Red Beard* (1965), about a young doctor. Other films were based on foreign classics: Dostoyevsky's *The Idiot* (1951), *Throne of Blood* (adapted from *Macbeth*), and Gorky's *The Lower Depths* (both 1957). His infrequent later films—*Dersu Uzala* (1975), *Kagemusha* (1980), and *Ran* (1985)—have confirmed his status as a master. The themes of several of his films have been reworked in the West, notably *The Seven Samurai* as *The Magnificent Seven* (1960).

Laban, Rudolf von (de Varaljas) (1879–1958), Hungarian dancer, choreographer, and dance theoretician. He founded a school in Munich in 1910 and worked in many German cities until the threat of war necessitated leaving Germany for Britain in 1938. He was the single most important figure of the Central European *modern dance movement (*Ausdrucktanz*), spanning theatrical development and theoretical exposition of movement, and creating a *dance notation system (kinetography or Labanotation) based on his analysis. He has influenced approaches to movement in education, therapy, industry, and in the notation of dances in the theatre.

Labrouste, Henri (1801–75), French architect. In opposition to the prevailing *Beaux-Arts ideals, he was a

Needlepoint **lace** evolved from decorative embroidery which filled small openings in fabric, to sumptuously intricate work such as this example of early 18th-century French needle lace, known as *point de France*. The lace shown here was made at Argentan, where Louis XIV's minister Colbert set up a state lace factory in the 17th century. (Victoria and Albert Museum, London)

leading advocate of rationalism in architecture, believing that buildings should serve human purposes rather than demonstrate aesthetic principles. His masterpiece is the Bibliothèque Ste-Geneviève in Paris (1843–50), the principal feature of which is a vast reading-room with exposed iron columns and roof. It was the first major public building in which iron was used in such a way. Labrouste made similar use of the material in his other major work, the main reading-room of the Bibliothèque Nationale in Paris (1859–68).

La Bruyère, Jean de (1645–96), French satiric moralist. His single book, *Les Caractères* (1688), is a study of the social types and institutions of late 17th-century France. It consists of separate remarks varying in length from maxims to extended portraits through which there emerges a pessimistic and conservative view of man. His moralistic stance as an observer of society's vices parallels the satirical intent of *Molière in his comedies of manners.

lace, a delicate decorative openwork fabric. Lace may be made from many kinds of thread, including cotton and silk, but the most usual is fine white linen. There are two distinct types of lace: bobbin lace, in which threads are twisted or knotted together to form a solid pattern standing out against a net-like background; and needle lace, the oldest type, which is created by drawing the linen threads to create the pattern of the lines. In addition, net can be embroidered to make lace. Popular from the late Middle Ages as an ornament to costume, lace was in demand in most of Europe. In the 16th and early 17th centuries lace was distinguished by geometric, wiry designs, reflecting Renaissance ornament, which were replaced by large-scale sweeping patterns in the Baroque period. The Italian supremacy in lace production passed to France at the end of the 17th century. The Netherlands, Spain, and Britain have also been home to flourishing traditions of lace-making.

Laclos, Pierre Choderlos de (1741–1803), French novelist. He is remembered as the author of *Les Liaisons dangereuses* (1782), a portrait of contemporary libertinage. The novel shares the moral ambiguity of *Prévost's *Manon Lescaut*, in that it purports to have a moral aim whilst indulging the taste for the licentious. Like Rousseau's *La Nouvelle Héloïse*, it is written in letter form (see *epistolary novel), a device which was employed to give an appearance of realism to a work of fiction; it also becomes the vehicle of a brilliant technique of multiple narrative presentation.

lacquerwork, the decoration of objects, usually of wood or metal, with successive layers of a varnish called lacquer, forming a hard, lustrous, and extremely durable skin. Lacquerwork originated in China and is an ancient craft; fragments survive from as early as the 7th century BC and by the Han dynasty (206 BC to AD 220) its use was widespread. Bowls, vases, and even coffins were made with beautiful painted decoration, mainly in red and black. China, together with Japan, has continued to have the richest tradition of lacquerwork. In the Orient, the varnish used is the sap of the tree *Rhus vernicifera*, purified by straining and heating. This was laid on in a series of coats, sometimes as many as several dozen, each one being allowed to dry and harden before the next was applied. The final surface, ground smooth and highly

The technique of **lacquerwork** has been developed to a high level of sophistication in Japan, as in this cabinet (c.1860). Lacquer can be coloured to obtain varied effects, for example by adding cinnabar for red, and iron acetate for deep black, and it can also be carved, or even enhanced by adding relief designs in gold leaf. (Mallett & Sons (Antiques) Ltd.)

polished, could be decorated by an artist using one or more of various techniques, including sprinkling the surface with flaked or powdered gold. In addition to being decorated on the surface, lacquer can be carved or incised and the varnish itself can easily be coloured with various additives. From about 1600 articles decorated with lacquer such as cabinets, chests, and screens, began to be imported to Europe from the Far East on a fairly large scale, and as with porcelain, attempts were soon made to imitate them. The sap used in the Orient was not available in the West, so a substitute was used, made from the resin of an insect (*Coccus lacca*) dissolved in alcohol. (Various names were given to this substance, the best known being shellac.) The technique of imitating lacquerwork with this substitute is known as japanning. It had a European vogue in the 18th century for furniture and other wooden objects and also for various items of metalware—teapots, trays and so on. In America, where the fashion also spread, such metalwork is known as toleware (from the French *tole*, sheet metal). Lacquerwork continues to flourish in the Soviet Union, the village of Palekh, north-east of Moscow, being the best-known centre of production.

La Fayette, Marie-Madeleine, Comtesse de (1634–93), French novelist. Her novel *La Princesse de Clèves* (1678) is often considered the first modern French novel, abandoning the improbable adventures of earlier prose

*romances, such as d'*Urfé's *L'Astrée*, in pursuit of that verisimilitude which was to become the concern of 18th-century novelists. It is written with the stylistic restraint characteristic of French classicism.

La Fontaine, Jean de (1621–95), French poet. His fame rests principally upon his *Fables*, published in 1668, 1678–9, and 1694. These are drawn from sources both ancient (Phaedrus, *Aesop) and modern, though La Fontaine uses them as the starting-point for observations on human nature—often quite astringent ones—in which he ranges across all classes of society. La Fontaine sided with *Boileau and the Ancients in the literary *Quarrel of the Ancients and Moderns, though he disavowed the idea of slavish imitation.

Lagerkvist, Pär (Fabian) (1891–1974), Swedish novelist, poet, and dramatist. His novels explore the ambiguities of life, the fear of death, and the problem of good and evil. *The Dwarf* (1944), set in Renaissance Italy, deals with man's destructiveness; *Barabbas* (1950) heralded a series of novels whose central concern is man's search for God. Lagerkvist's poetry collection *Angest* (1916) is startling in its emotional intensity and forceful language and he developed into one of Sweden's greatest *lyric poets. He was awarded the Nobel Prize for Literature in 1951.

Lagerlöf, Selma (1858–1940), Swedish novelist. The first woman to receive the Nobel Prize for Literature (1909), her writings, often based on legends and sagas, are vividly descriptive and lyrical. Among her most notable works translated into English are *Jerusalem* (1901–2), *The Story of Gösta Berling* (1891), and the children's book which won her world-wide fame, *The Wonderful Adventure of Nils* (1906–7).

Lalique, René (1860–1945), French jeweller and glass-maker, one of the outstanding exponents of the *art nouveau style. He abandoned the conventions of the day, creating dynamic, sinuous, asymmetrical patterns of plant and insect forms. Most of his later career, particularly after World War I, was devoted to glass production; he made a great variety of objects, including light fixtures, jewellery, screens, vases, and mascots for cars at two factories he established in France.

Lalo, Edouard- (Victoire-Antoine) (1823–92), French composer. He remained in relative obscurity working as a teacher and violinist until the 1870s, when his *Symphonie espagnole* (1875) for violin and orchestra made a favourable impression. His third opera, *Le roi d'Ys*, was begun during this period; it reached the stage in 1888 and was an overwhelming success. It is generally regarded as his masterpiece.

Lamartine, Alphonse de (1790–1869), French poet, one of the greatest French *Romantic poets. His collection of poems entitled *Méditations poétiques* (1820), containing such well-known pieces as 'Le Lac' and 'Le Vallon', signalled the re-emergence of a lyricism largely stifled since the days of *Malherbe. He transcribed that unsatisfied longing known as the *mal du siècle* which his generation inherited from *Chateaubriand. Like *Hugo, he believed in the prophetic role of the poet, and from 1833 to 1849 was active in the Republican cause.

Lamb, Charles (1775–1834), British essayist, literary critic, and poet. He is best known for his 'Essays of Elia', a series of miscellaneous articles which appeared in the *London Magazine* between 1820 and 1823. After his older sister Mary, in a fit of insanity, killed their mother, Lamb took charge of her and entered into a long-standing literary collaboration with her which was to include *Tales from Shakespeare* (1807), a re-telling of the plays for children. He contributed *essays, articles, and poems to the major periodicals of the day under the pseudonym of Elia. His *Specimens of English Dramatic Poets who lived about the time of Shakespeare* (1808), a selection of much-edited Elizabethan drama, drew attention to that period.

Lamming, George (1927–), West Indian novelist. His first novel, *In the Castle of My Skin* (1953), is set in his native Barbados, and follows the growing awareness of a village boy. *The Emigrants* (1954) examines West Indians migrating to Britain. His later novels, notably *Natives of My Person* (1972), are more poetic and symbolic, exploring West Indian identity through imaginary voyages.

lampoon, an insulting written attack upon a real person, in verse or prose, usually involving caricature and ridicule. Among English writers who have indulged in this maliciously personal form of *satire are Dryden, Pope, and Byron. The laws of libel have restricted its further development as a literary form.

Ländler *waltz.

Landor, Walter Savage (1775–1864), British poet and prose writer. A sense of control and formality characterizes much of his verse which is in sharp contrast to that of other *Romantic poets. His skill as a lyricist is demonstrated in his *epic poem *Gebir* (1798), an oriental tale. He is remembered for his *Imaginary Conversations of Literary Men and Statesmen* (1824–9), a prose work with dialogues concerning political, social, and literary questions, which range from classical antiquity to the 19th century.

landscape gardening *garden art.

landscape painting, the art of depicting natural scenery in painting. Although Western examples of landscape painting by the Romans survive from Pompeii, it was not until the 16th century that landscape began to emerge as a distinctive subject in European art. The German Altdorfer is generally credited with being the first artist to paint a pure landscape and it was in northern Europe that interest in the subject chiefly developed. From being a highly stylized art, using conventional arrangements of trees, rock-forms and so on, it became one of naturalistic depiction—17th-century Dutch painting marks one of the high points of naturalistic landscape, particularly in the works of *Ruisdael, *Hobbema, *Seghers, and *Rembrandt. At the beginning of the 17th century Annibale Carracci invented the ideal landscape, a grand and highly formalized arrangement suitable as a setting for small figures from serious religious, historical, or mythological subjects, a tradition carried on by Claude and Poussin. Other approaches also emerged, however, notably in the work of Romantic artists such as Friedrich and Turner, who explored the awesome, mystical, and poetic aspects of nature. In the late 19th century the Impressionists established landscape as probably the single

most popular category of painting. In modern painting landscape has also been the basis for Surrealist fantasy or abstract compositions. (See also *Chinese painting, *Japanese visual arts.)

Landseer, Sir Edwin (1802–73), British painter, sculptor, and engraver of animal subjects. Though his work delighted the Victorian public, his reputation has since declined, for although he had great skill in depicting animals, his sentimental and moralizing compositions do not appeal to modern taste. In his last years he suffered from bouts of madness aggravated by alcohol. His father John (1769–1852) and his brother Thomas (1795–1880) were engravers.

Lanfranco, Giovanni (1582–1647), Italian painter, active mainly in Rome and Naples. In the 1620s he overtook *Domenichino as the leading *fresco decorator in Rome, and with *Guercino and Pietro da *Cortona he ranks as one of the founders of the mature *Baroque style of painting. His most important work is the *Assumption of the Virgin* (1625–7) in the dome of San Andrea della Valle in Rome, in which he took to new extremes the dynamic type of illusionistic foreshortening practised by *Correggio. It became a model for illusionistic decorators throughout Europe. From 1633 to 1646 Lanfranco worked in Naples and had a great influence on painters there.

Lang, Fritz (1890–1976), Austrian-born US film director. He established his reputation in Germany with a series of films including *Dr Mabuse the Gambler* (1922), a two-part film about a criminal mastermind in decadent contemporary Germany; *Die Nibelungen* (1924), based on the Siegfried legend, also in two parts; and *Metropolis*

The massive sets needed to create **Lang**'s vision of the future in *Metropolis* almost bankrupted its producers; but it remains a landmark in cinema history. Lang was more successful in his later Hollywood career than most European directors, though his lack of independence caused him frequent frustration.

(1927), a bleak look at a dehumanized city of the future. His first sound film was *M* (1931), a classic study of a child-murderer. *The Testament of Dr Mabuse* (1933) attracted the attention of Goebbels, who invited him to supervise Nazi Germany's film-making. Lang rejected the offer and moved to the USA; his first American film was *Fury* (1936), a study of lynch-law. Notable among his other American films were *You Only Live Once* (1937), in which a man is wrongfully executed; the anti-Nazi *Hangmen Also Die* (1943), co-authored with Bertolt Brecht; *The Woman in the Window* (1944), about ill-fated sexual desire; *Rancho Notorious* (1952), the best of his three Westerns; and *The Big Heat* (1953), a crime melodrama. After leaving the USA in 1956 he made only two more films, both in Germany, the second being a contemporary Mabuse film, *The Thousand Eyes of Dr Mabuse* (1960).

Langland, William (c.1330–c.1400), English poet, presumed author of 'Piers Plowman' (c.1367–70), one of the major poems of *Middle English literature. It exists in three versions and is an *allegory of mankind's predicament on earth. The first part contains the poet's vision of society under Lady Meed (love-of-gain) and of Piers 'ploughing his half-acre', beset by the seven deadly sins, on his pilgrimage to Truth. In the remainder of the poem the nature of Truth is examined in the life of Dowel (Do-Well), and Piers comes to personify the individual Christian in his search for self-knowledge, grace, and charity. The poem is written in colloquial, simple English, using simple symbols and images while maintaining the religious orthodoxy of medieval Christian doctrine.

Lao literature. The classical literature of Laos, written in both prose and poetry, contains many epics, of which the most famous is the *Prah Tak Prah Lam*, a much adapted Lao version of the Indian *Ramayana. Popular literature consists of oral legends, stories, and poems. Modern Lao literature only originated in the 1960s and reflected the political divisions within Laos. A revolutionary style of literature which praised the people's struggle against the US and the pro-Western regime based at Vientiane emerged and, with the establishment of

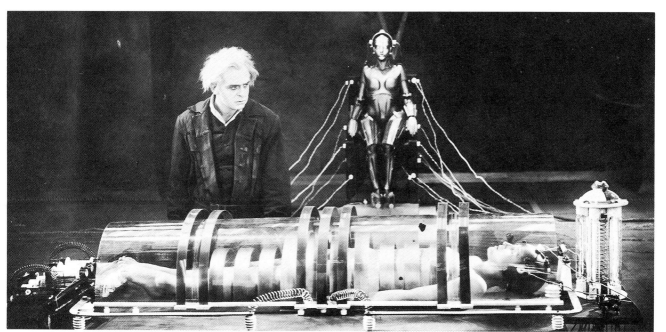

the Popular Democratic Republic in 1975, predominated. The numerous Dai minority peoples who inhabit Laos also possess a rich and diverse Buddhist literature of their own, preserved for the most part in manuscript form.

Lao She (Shu Qingchun) (1899–1966), Chinese novelist and dramatist. He taught in London in the 1920s and was deeply influenced by *Dickens, *Conrad, and *Swift. He is best known for his later novels, which were more concerned with patriotic and social themes. His masterpiece is the novel *Xiangzi the Camel* (1936), which recounts the tragic story of a rickshaw-puller in Beijing. An unauthorized and bowdlerized English translation entitled *Rickshaw Boy* appeared in 1945 and became a best-seller in the West.

Larkin, Philip (Arthur) (1922–85), British poet and novelist. Larkin's poems acquired a distinctive voice in *The Less Deceived* (1953), which was followed by *The Whitsun Weddings* (1964). He spent the latter part of his life as librarian at Hull University, and there is a melancholy comedy in his observations of provincial urban life and the presentation of himself as out of date and disillusioned. Throughout his work contemporary speech rhythms and vocabulary are adapted to an unobtrusive metrical elegance. The *Collected Poems* appeared in 1988.

La Rochefoucauld, François duc de (1613–80), French classical author. His *Maximes* (1665, fifth enlarged edition 1678) are terse, highly polished observations on human nature which undermine the concept of disinterested virtue and the power of the will which *Corneille had depicted in his plays. La Rochefoucauld substitutes a pessimistic picture of man in which subconscious self-love lies behind every action. His views reflect the changing moral climate of the later 17th century, also seen in the work of Mme de *La Fayette.

Lassus, Orlande de (1532–94), Franco-Flemish composer. He travelled widely, joining the court of Duke Albrecht V of Bavaria in 1556. As head of his musical establishment he turned the court at Munich into the most famous musical centre in Europe, while he himself was acknowledged as one of the greatest composers of the day. In 1555 he began to publish his works, showing an extraordinary versatility in his compositions of elegant and serious *madrigals, of baudy *villanelle*, French *chansons* or part-songs, German *lieder*, and Latin *motets. In 1568 he appeared as an actor in the traditional *commedia dell'arte*. His enormous output includes at least sixty settings of the mass, four settings of the passion, over one hundred settings of the magnificat, settings from the Book of Job, the Penitential Psalms, and the Lamentations of the Prophet Jeremiah. He stands, together with *Palestrina, as one of the great masters of Renaissance choral *polyphony.

Latin American literature, the literature of Central and South America, written in Spanish or Portuguese. The literature of the conquest (1492–1600) and of the colonial period (to *c.*1810) is in the form of chronicles, histories, letters, religious pieces, polemical tracts, and epic poetry. Fiction, banned by the Spanish, only emerged after independence. The most popular form of literature was poetry, and its supreme exponent was the Mexican nun Sor Juana Inés de la Cruz (1648–95). In the 19th century literature initially reflected European fashions, but some original works did begin to appear, such as the literary sketches, *Peruvian Traditions*, of Ricardo Palma (Peru, 1833–99). By the end of the century a great novelist, Machado de Assis (Brazil, 1839–1908), and an outstanding poet, *Darío, had appeared. The former's *Dom Casmurro* (1899) ranks alongside any 19th-century European novel, and the latter founded a poetic movement, *modernismo* (*modernism), from French models but with sufficient freshness to be influential in Spain itself. The 20th century has seen Latin American literature grow in vitality as the century has progressed. In poetry the outstanding authors are *Vallejo, *Neruda, and Octavio Paz (Mexico, 1914–). The short story has reached inspired levels in, for example, the work of *Borges and *Cortázar. The novel, of high quality since the 1930s and increasingly successful since the so-called 'boom' of the 1960s, has its major exponents in Carlos Fuentes (Mexico, 1929–), *García Márquez, and *Vargas Llosa.

Latin American music, the music of South America, a mixture of native Indian music (see *American Indian music), transported African elements (see *Afro-

A Peruvian harp-player. **Latin American music** is marked by the presence of instruments such as this harp, a derivative of the Spanish renaissance harp brought to South America by the *conquistadores*. The mingling of Hispanic music with native Indian traditions has produced a uniquely lively music.

American music in South America), and imported European traditions, each region and country of South America having its own distinct voice due to the relative strength of each tradition in the mixture. Taken as a whole, the Indian element in South American music is relatively weak, and restricted to highland areas with large native populations, for example parts of Mexico and Peru. The African component is stronger, especially in the Caribbean and Brazil, while the European element is everywhere and in every aspect a major influence. The advanced civilizations of South America quickly adapted to the instruments and music the Europeans brought with them from the 16th century onwards. Sacred *polyphonic compositions were imitated throughout the 16th and 17th centuries, both by Spanish-born or Spanish-descended composers like Juan Gutiérrez de Padilla (1605–73), active at Puebla, Mexico, and Gutierre Fernández Hidalgo (1553–c.1620), who worked at various centres in South America, including Cuzco, the Inca capital, but also by Indian composers like Don Juan de Lienas (c.1620–50), who worked at Mexico City. The Roman Catholic churches and cathedrals in the major centres provided the ideal setting for their music. Secular forms like the *villancicos*, in popular Spanish dance-song, sometimes accompanied by the *vihuela, were also widely imitated, Juan de Araujo (1646–1712) composing a large number. Opera was an important genre of the 18th and 19th centuries, the earliest extant New World opera being *The Purple of the Rose*, written by Torrejón y Velasco (1676–1728) and first performed in 1701. Many theatres and opera houses were built and much pride was taken in a flourishing artistic tradition. In the early 20th century Latin American composers capitalized on exotic local elements, incorporating them successfully into their works: for example, the Mexican Carlos Chávez (1899–1978) used Indian themes and subjects, and José Pablo Moncayo (1912–58), also from Mexico, wrote orchestral works with a strong folk element. Later 20th-century composers for the most part spurned such Latin American colour and followed more mainstream musical developments. The foremost 20th-century South American composer is *Villa-Lobos, who combines traditional rhythmic and melodic elements with European Classical music. The Argentinian composer Alberto Ginastera (1916–83) combined the influence of Indian folk music and Western composers such as *Bartók in his music. The folk music of South America is also indebted to European models. The many varieties of guitar found throughout Latin America, such as the *cuatro (a guitar with four doubled strings varying in size from that of a standard guitar to that of a ukelele), and *charango, are adaptations of European instruments, while the simple chordal harmony employed is also European. Even the most characteristic rhythm of Latin America—a fast alternation of the time signatures 6/8 and 3/4—is of Spanish derivation.

Latin American popular dance. Spanish colonization of South America from the 16th century onwards introduced many European dance-forms to the continent. The Spanish also brought with them many African and Asian slaves, and the rhythmic sophistication of their cultures had a strong influence on South American dance and music. The fusion of African, Asian, and European forms with the indigenous Amerindian dance has created a vigorous and colourful popular dance culture, which flourishes especially during carnival (the week before Lent). Dances like the *cueca, *samba, congo, salsa, and *tango have been exported to the ballrooms of Europe and North America, beginning with the tango in 1910.

Latin literature, the literature of the Roman republic (c.500–c.44 BC), imperial Rome (c.30 BC–AD c.400), and medieval Europe. Little or no Latin writing untouched by *Greek literature has been preserved. The first work of note was the adaptation of *Homer's *Odyssey* (3rd century BC) by the slave Livius Andronicus. Drama, firmly based on *Greek theatre and *epic poetry, developed during the 2nd century BC. *Ennius introduced the *hexameter into Latin with the *Annals*, a poem on the history of Rome. The greatest of Roman dramatists was Plautus (c.254–184 BC), who adapted his plays from the 'New Comedy' of the Greek theatre. As in Greece, prose developed later than poetry. Annalistic history grew gradually from the records of the priests, but Greek influence was also crucial. The first Roman histories were in Greek, and the first known history in Latin, Cato the Elder's *Origins* (c.149 BC), was influenced by Greek writers. Terence (c.185–159 BC) adapted Greek themes for his own polished and urbane comedies. Oratory, an important weapon in Roman republican politics, took on Greek sophistication and rhythms from the time that the tribune Gaius Gracchus (d. 121 BC) delivered his speeches, reaching its peak in the work of *Cicero in the next century. This period produced some of the greatest figures in Latin literature: *Catullus wrote some of the finest lyric poetry, employing the hexameter for mythological subjects, as well as experimenting in the elegiac couplet, while *Lucretius showed how poetry could accommodate philosophy, and Sallust brought a new style and dignity to the writing of history. The fall of the republic did much to stifle the art of oratory and of historical writing, and the classic Augustan period is marked mainly by the poetry of *Ovid, the later work of *Virgil, the lyrics of *Horace, and the maturity of Roman *elegy. It was followed by the writers of the Silver Age, notably Stratius (AD c.45–96), whose epic *Thebaid* influenced Dante and Chaucer. The literature of this period is preoccupied with wit, epigram, and melodrama. In the 1st century AD this manner put its mark on epic poetry, most notably in *Lucan, but it also affected the tragedy and prose of *Seneca. Classical Latin is rounded off at the start of the second century by two mordant writers, *Juvenal, who perfected *Roman *satire, and by the sceptical historian *Tacitus. Apart from the extraordinary writings of Apuleius (2nd century AD) (see *Greek and Roman novel), there is little of note until Christianity brought new inspiration. Latin literature survived in Africa and Europe through the so-called Dark Ages of the 5th and 6th centuries in hymns and other religious verse, notably the influential *allegory *Psychomachia* (c.405) by the Spanish poet Prudentius; in the philosophical reflections of Boethius, whose *Consolatio* (c.524) was later translated by Chaucer; and in the historical writings of the English monk Bede (673–735). From the end of the 11th century a reawakening of Latin poetry began in France, stimulating the production of secular verses by wandering scholars, notably in the *Carmina Burana. Important Latin prose works of the late Middle Ages include the letters of the philosopher and scholar Peter Abelard (1079–1142), the theological writings of Thomas Aquinas (c.1225–74), and the very popular mystical work *De*

Imitatione Christi (*The Imitation of Christ*) by Thomas à Kempis (1380–1471). The learned humanists of the 16th century, led by Erasmus (c.1467–1536), wrote significant Latin works, including *Utopia* (1516) by the statesman and scholar Sir Thomas More (1478–1535). In the next century the English poets *Milton and *Marvell wrote some of their poems in Latin.

La Tour, Georges de (1593–1652), French painter. It is uncertain whether he gained his knowledge of *Caravaggio's style by visiting Italy or by some other means, and very few of his pictures are dated, making it difficult to follow his stylistic development. Recently, moreover, it has been suggested that some of the paintings attributed to the early part of his career may even be forgeries. The acknowledged masterpieces of his maturity, however, are religious pictures of an extraordinary majesty and solemnity, often lit by a single candle and displaying the utmost sensitivity in the treatment of light.

Latrobe, Benjamin (1764–1820), English-born architect who settled in the USA in 1796. He was the first professional American architect and the leading pioneer and chief exponent of the *Greek Revival style in his adopted country. His major works include Baltimore Cathedral (1805–18), a *Neoclassical building that marked a clear break with the American tradition of church building, previously inspired by *Wren and *Gibbs, and the remodelling of the Capitol in Washington after it was burnt by the British in 1814. His work there included *capitals in which the usual acanthus leaves were replaced by American plants such as corncobs and tobacco leaves.

Lawes, Henry (1596–1662) and **William** (1602–45), English composers. Henry Lawes was sworn in as a Gentleman of the *Chapel Royal in 1626 and was appointed one of King Charles I's musicians 'for the lutes and voices' in 1631. His reputation rests upon his songs, of which over 400 exist. Some were written for the court *masques, such as Milton's *Comus* (1634), and some form part of the first English opera *The Siege of Rhodes* (1656). He published three books of *Ayres and Dialogues* (1653, 1655, 1658). His brother William also wrote vocal music and made important contributions to the masque, but his greater reputation derives from his chamber music: suites and trio sonatas for viols, consisting of a series of dance movements, often preceded by an elaborate fantasia.

Lawrence, D(avid) H(erbert) (1885–1930), British novelist, poet, and critic. He was born near Nottingham, the son of a miner and an ex-teacher. He qualified as a teacher, and in 1912 met Frieda Weekley (*née* von Richthofen) with whom he eloped to Germany. Together they travelled widely for the remainder of his life, and their relationship was to form the underlying theme of much of his later fiction. His first major novel *Sons and Lovers* (1913), set in a Nottinghamshire coal-mining village, reflects his early life and strong attachment to his mother. *The Rainbow* (1915) is a study of the 'recurrence of love and conflict' within a rural family, but it was officially banned as obscene. His next novel, *Women in Love* (1921), diagnoses the self-destructive mood of his time and is usually regarded as his most important work. His other novels include *The Lost Girl* (1920), *Kangaroo*

(1923), based on his visit to Australia, and *The Plumed Serpent* (1926), set in Mexico, concerning a girl's search for a mystical rebirth. His last novel, *Lady Chatterley's Lover*, completed in Italy when Lawrence was already dying of tuberculosis, was printed privately in Florence in 1928 and finally published in an unexpurgated edition in 1960, after its publishers were acquitted in a celebrated obscenity trial. Lawrence believed that modern man had alienated himself to the extent of losing his ability to experience life in depth. His work, in which he stresses the mystic power of sexual experience, shows a sensitive response to the natural world. In his poems, collected in *Complete Poems* (3 vols., 1957), he tried to free himself from the constraints of formalism. He also wrote plays, essays, outstanding short stories, travel books (notably *Etruscan Places*, 1932), and many critical works.

Lawrence, Sir Thomas (1769–1830), the outstanding British portrait painter of his generation. He was devoted to the memory and example of *Reynolds and in some respects he was the last of the great portrait painters in the 18th-century tradition. In others he was a *Romantic, responding to the glamour of the period through which he lived, and his fluid and lush brushwork won the admiration of French painters such as Delacroix.

Laxness, Halldór (Gudjónsson Kiljan) (1902–), Icelandic novelist. Influenced by Catholic, communist, and socialist ideas, he later developed a more individualistic approach. *Salka Valka* (1931–2), *Independent People* (1934–5), and *World Light* (1937–40), all set in Iceland, feature individuals, in search of independence, struggling against a hostile world. *The Atom Station* (1948) criticizes US bases in peacetime Iceland, and *The Happy Warriors* (1952), a travesty in saga style, attacks modern power politics. Laxness was awarded the Nobel Prize for Literature in 1955.

lay or lai, a term from Old French meaning a short *lyric or *narrative poem; a medieval song-form. The *Contes* (c.1175) of Marie de France were narrative *lais* of Arthurian legend and other subjects from Breton folklore. Cultivated by the troubadours and *trouvères* (see *minstrels), they had several *stanzas, each with a different poetic structure and each therefore set to different music. They provided the model for the so-called 'Breton lays' in English in the 14th century, which include Chaucer's 'Franklin's Tale' and the anonymous *Sir Orfeo*. Since the 16th century, the term has applied to short narrative poems, as in Macaulay's *Lays of Ancient Rome* (1842).

Leach, Bernard (1887–1979), British potter. Born in Hong Kong, Leach spent his early years as a practising potter in Japan, where he absorbed Japanese techniques and ideas on the role of art and the craftsman in society (see *Japanese ceramics). Leach returned to England in 1920, and set up a pottery in St Ives, Cornwall with his Japanese associate Shoji Hamada (1892–1978). He pioneered the *studio pottery movement by establishing in the West the Japanese notion that the potter was a creative artist rather than merely a skilled craftsman. His *A Potter's Book* (1940) sets out his deeply philosophical views on art and life and influenced a generation of western potters. Leach's pottery shows strong Japanese and Oriental influence, being strong and simple in form, with its beauty depending much on the rich subtlety of

the *glazes combined with the occasional vigorously incised or splashed motif.

Leacock, Stephen Butler (1869–1944), Canadian humorist. The author of over 60 books, he is best known for many collections of humorous sketches, parodies, and essays, beginning with *Literary Lapses* (1910), and including *Sunshine Sketches of a Little Town* (1912), *Arcadian Adventures of the Idle Rich* (1914), and *My Discovery of England* (1922). He also wrote biographies of his masters, Twain and Dickens.

Lean, David (1908–), British film director. Already a highly professional editor, he co-directed *In Which We Serve* (1942) with Noël Coward, and then directed films of Coward's plays *This Happy Breed* (1944) and *Blithe Spirit* (1945). A Coward one-act play, *Still Life*, provided one of his best films, *Brief Encounter* (also 1945), a sensitively made story of middle-aged romance. Two famous Dickens films, *Great Expectations* (1946) and *Oliver Twist* (1948), further enhanced his reputation. *The Sound Barrier* (1952) had spectacular flying scenes and *Hobson's Choice* (1954) was an excellent adaptation of Brighouse's play. After *Summer Madness* (1955), about a single woman's unhappy love affair in Venice, he turned to more spectacular, epic-style productions. *The Bridge on the River Kwai* (1957) and *Lawrence of Arabia* (1962) both won Academy Awards for Best Film and Best Director; they were followed by *Doctor Zhivago* (1965) and *Ryan's Daughter* (1970), which were attacked by the critics. Discouraged, he made no further films until *A Passage to India* (1984), based on the novel by E. M. Forster.

Lear, Edward (1812–88), British writer of humorous verse and landscape artist. The youngest of twenty-one children, he suffered from epilepsy and melancholia. He began his career as a zoological draughtsman and in 1832 his *Illustrations of the Family of the Psittacidae* appeared. Commissioned by the Earl of Derby to make drawings of his private menagerie, he produced his first *Book of Nonsense* (1845) for the earl's grandchildren. This was the first of many volumes of *nonsense verse in which linguistic fantasy and humorous drawings, combine with occasional touches of melancholy. *Nonsense Songs, Stories, Botany and Alphabets* (1871) contains the well-known 'The Owl and the Pussy-Cat' and 'The Jumblies'. In the 20th century his reputation as a landscape painter (especially in water-colour) has risen steadily.

leathercraft, the creation of artefacts from animal skins that have been made smooth and flexible by various processes. It is one of the oldest crafts known to man, its origins dating back to the Stone Age. Leather can be crafted in a great variety of ways. The most basic skill is cutting, which can be used as a means of decoration: a remarkable example comes from ancient Egypt *c*.1500 BC, in the form of gazelle skins cut into a fine network with an uncut border around the edge. Shoes similarly decorated by cutting leather were made by the Romans and in medieval Ireland. Hard inflexible leather can be moulded once it has been soaked in water, to make such objects as armour, saddles, drinking vessels, bottles, quivers, and various boxes and containers. Such objects were decorated with embossed designs, which were impressed onto the leather while wet. Another form of ornamentation is tooling, involving the use of patterned

brass tools, which are heated. The design may be traced on the surface of the leather and is then lightly impressed with the heated tools. Gold may then be put on the surface and pressed on using the tools. This form of decoration has been used particularly for leather bookcovers. Leather can also be dyed or embroidered to create a stunning variety of clothes and shoes.

Leavis, F(rank) R(aymond) (1895–1978), British *literary critic. As a lecturer at Cambridge University and co-editor (1932–53) of the quarterly journal *Scrutiny*, the vehicle of the 'new Cambridge criticism', he, in collaboration with his wife, **Q(ueenie) D(orothy) Leavis** (1906–81,) established a new critical approach that upheld strict intellectual standards and attacked what appeared to be the dilettante élitism of the *Bloomsbury group. *New Bearings in English Poetry* (1932) championed the poetry of *modernism against the Victorian tradition. Turning to fiction in *The Great Tradition* (1948) he reassessed the works of Jane Austen, George Eliot, Henry James, and Joseph Conrad. Leavis saw a close correlation between an author's moral position and his literary achievement, and introduced a new seriousness into the study of English literature.

Lebrun, Charles (1619–90), French painter and interior decorator. In 1642 he went to Rome, where he was influenced by the theories of *Poussin, but on his return to Paris his own style developed in a more illusionistic *Baroque manner. In 1662 he was made court painter under Louis XIV, and as such he was responsible not only for the Galerie d'Apollon at the Louvre (1661) but also for much of the grandest decorative work at Versailles. In 1663 he was made director of the reorganized Academy of Painting and Sculpture, imposing a codified system of orthodoxy in matters of art and taste: his lectures laid the basis of official French academicism, attempting to impose rules of artistic creation in the spirit of Poussin's classicism.

Leconte de Lisle, Charles-Marie-René (1818–94), French poet. He was born on Réunion Island in the western Indian Ocean, but lived almost continuously in France after 1837 and became the leader of the *Parnassians. The preface to his *Poèmes antiques* (1852) contains a statement of his poetic ideals in reaction against *Romanticism and stressing the need for impersonality and discipline; the poems themselves are mostly of Greek or Indian inspiration, presenting a heroic ideal from which civilization has declined. His *Poèmes barbares* (1862) draw on Nordic, Egyptian, and biblical sources, and contain an exotic streak characteristic of Parnassian poetry.

Le Corbusier (Charles-Edouard Jeanneret) (1887–1965), Swiss-born architect, interior designer, painter, and writer who became a French citizen in 1930. His pseudonym, adopted in 1920, derived from the name of one of his grandparents and was a pun on his facial resemblance to a raven (French, *corbeau*). Through his buildings, designs, and prolific literary output he has probably had a greater influence on 20th-century architecture than any other man. He saw architecture in terms of the problems and potentialities of modern industrial society, and he was particularly interested in town-planning, prefabrication, and the use of standardized building elements. Early in his career he worked

Le Corbusier's Pavillon Suisse (1930–2) was built as a dormitory for Swiss students at the Cité Universitaire in Paris. The rectangular slabs raised on chunky concrete pillars were the model for similar blocks all over the world.

in the office of Auguste Perret (1874–1954), a pioneer in the use of concrete in architecture, and in Germany with Peter *Behrens, but he was to a large extent self-taught, his ideas being developed in the course of extensive travels. In the 1920s and 1930s he was one of the leaders of the *Modern Movement, designing a series of highly influential houses—white, cubic, and often raised on *pilotis* (stilt-like pillars) that leave the ground floor open. After World War II, however, he turned from this smooth, elegant, rationalist style, to a much more massive, sculptural, and expressive style which soon became equally influential. The Unité d'Habitation at Marseilles (1947–52), a huge housing block with its own shops, and the pilgrimage chapel Notre-Dame-du-Haut at Ronchamp (1951–5) are perhaps his most famous works in this vein. Le Corbusier's enormous international reputation ensured that many commissions came from outside France, and his largest project was the layout (1950–1) of the new city of Chandigarh in India. He also designed several of the major buildings there. As a painter Le Corbusier is noted as one of the founders of *Purism. (See also *functionalism.)

Ledoux, Claude-Nicolas (1736–1806), French architect. Ledoux began his career as a designer of charming, elegant houses, but then became one of the most original and powerful exponents of *Neoclassicism and the *Greek Revival. He is similar to his contemporary *Boullée in his imaginative powers and his feeling for starkly simple geometrical forms. His buildings included a series of forty-six massive toll-gates surrounding Paris of which four survive, notably the Barrière de la Villette (1784–9). His most remarkable building is the salt works at Arc-et-Senans near Besançon (1775–9), almost frighteningly austere and powerful. Ledoux's career was ended by the Revolution, during which he was imprisoned and wrote an architectural treatise, published in 1804. It contains many visionary ideas, including plans for an

ideal city to be laid out around his salt works. Ledoux's work had wide influence.

Le Fanu, Joseph Sheridan (1814–73), Irish novelist. His early novels were in the tradition of Walter *Scott and it was not until the 1860s that his main output of ghost stories, mysteries, and supernatural tales began. They include *The House by the Churchyard* (1861), *Uncle Silas* (1864), *Guy Deverell* (1865), and a remarkable collection of stories, *In a Glass Darkly* (1872). His reputation has steadily risen and he now occupies a place of his own in the field of the sinister and macabre.

Léger, Fernand (1881–1955), French painter and designer. In about 1909 he became associated with the *Cubists, but his curvilinear and tubular forms contrasted with the fragmented forms preferred by Braque and Picasso, and after 1917 he became associated with *Purism. Léger created a colourful style in which—inspired by the beauty of machinery, with its complex but harmonious arrangement of interlinking geometric shapes—he celebrated modern technological culture with considerable verve. His strong, flat colours and heavy black outlines are particularly distinctive. During World War II he lived in the USA, and after his return to France in 1945 his painting reflected his political interest in the working class. He also undertook large decorative commissions, including designs for tapestries and stained-glass windows.

Lehár, Franz (Ferenc) (1870–1948), Austro-Hungarian composer and conductor. He worked in the theatre, and then (1890–1902) as a military bandmaster, achieving success with individual waltzes, such as 'Gold and Silver' (1902). In 1905, however, he became world famous with his eighth *operetta, *The Merry Widow*. A whole series of successful operettas followed, including *Frasquita* (1922), *Paganini* (1925), and *The Land of Smiles* (1929). His last stage work, *Giuditta* (1934), brought operetta nearer to opera, but was not a lasting success.

Leighton, Frederic (Lord Leighton of Stretton) (1830–96), British painter and sculptor, one of the dominant figures of Victorian art. He was President of the Royal Academy from 1878 and on the day before his death he was raised to the peerage, the first English artist to be so honoured. His varied output included portraits and book illustrations, but he is best known for his beautifully drawn and opulently coloured paintings of classical Greek subjects.

leitmotif (German, 'leading motive'), a musical theme associated with a person, object, or emotion in *opera and *programme music. An invention of the 19th century, it is used to great advantage in *Wagner's music-dramas, where a network of such themes enables him to weave a coherent symphonic commentary on the action, spread out over many hours. Through the leitmotif a composer can provide detailed information in purely orchestral terms, thus in an opera, a theme that has already been established as representing 'hatred' may reveal the true thoughts of a villain who appears smiling blandly.

Lely, Sir Peter (1618–80), painter of Dutch origin who spent almost all his career in England and was naturalized in 1662. He painted Charles I and Oliver Cromwell, but

he is associated chiefly with the court of Charles II, who appointed him Principal Painter in 1661. With the aid of a team of assistants he maintained an enormous output, and his bewigged courtiers and fleshy, sleepy beauties clad in silks have created the popular image of Restoration England. Much of his work is repetitive but he was a fluent and lively colourist and had a gift for impressive composition. His tradition of society portraiture, developed by *Kneller, endured for almost a century until it was challenged by *Hogarth.

Lem, Stanisław (1921–), Polish novelist. He studied medicine, and in his science fiction combines scientific expertise with discussion of moral and psychological issues. In early works such as *Astronauts* (1951) the emphasis is on technical details, but from *Solaris* (1961; *Tarkovsky film 1973) meditative elements predominate.

Lemercier, Jacques (c.1582–1654), French architect. His major patron was Cardinal Richelieu, for whom he designed his most famous building, the church of the Sorbonne in Paris (1635–42), which, especially in its dome, reflects Lemercier's knowledge of Italian architecture. For the cardinal Lemercier also designed the enormous château (almost totally destroyed) of Richelieu and the adjacent town of the same name, which still survives as a fine example of regular town-planning.

Le Nain, Antoine (d. 1648), **Louis** (d. 1648), and **Mathieu** (1607–77), French painters. The three brothers were born at Laon but had all moved to Paris by 1630. Little is known of their careers, and the assigning of works to one or the other of them is one of the most controversial issues in art history. They are said to have sometimes collaborated; such paintings as are signed bear only the surname, and of those that are dated none is later than 1648, when all three were still alive. The finest and most original works of the Le Nain brothers—powerful and dignified scenes of peasants—are conventionally given to Louis; Antoine is credited with a number of small-scale and richly coloured family scenes; and a more miscellaneous group, chiefly portraits and group portraits, are attributed to Mathieu. Some religious scenes are generally considered works of collaboration.

L'Enfant, Pierre-Charles (1754–1825), French-born American architect, engineer, and soldier. He enlisted in the American Revolutionary Army in 1776, and was made a major of engineers in 1783. His first significant architectural work was the remodelling of New York's old city hall (1787, destroyed) to serve as the US Congress and in 1789 he was asked by George Washington to prepare the layout for the new capital city, Washington DC. L'Enfant was dismissed in 1792, partly because of his high-handed attitude, but his grandiose plan, with its splendid formal vistas, was followed in essentials.

Le Nôtre, André (1613–1700), French landscape gardener, one of the most famous of all practitioners of *garden art. In 1637 he succeeded his father as royal gardener, and from the 1650s he designed, altered, or enlarged gardens for some of the greatest châteaux in France. His grandiose style, characterized by formal arrangements and magnificent unbroken vistas, and exemplified above all by the enormous park at the palace of Versailles, dominated European garden design until the rise of the more naturalistic English style (associated particularly with Lancelot *Brown) in the 18th century.

Leonardo da Vinci (1452–1519), Italian artist, scientist, and writer. He was one of the greatest painters of the *Renaissance and probably the most versatile genius, being also an anatomist, engineer, mathematician, musician, naturalist, and philosopher, as well as an architect and sculptor. His scientific ideas generally remained hidden in his notebooks and it was as an artist that he had the greatest effect on his contemporaries. He was trained in *Verocchio's studio in Florence, but his first major commission, *The Adoration of the Magi* (Uffizi, Florence), was left unfinished when he moved to Milan in 1481 or 1482. He stayed in Milan until 1499, working mainly at the court of Duke Ludovico Sforza. The major work of his Milanese period is the mural of *The Last Supper* (c.1495–7) in the monastery church of Santa Maria delle Grazie, which, in spite of its poor condition, has powerfully influenced successive generations of artists and writers. Until 1506 Leonardo worked mainly in Florence, and probably during this time painted the *Mona Lisa*, a work now so famous that its originality, subtlety, and naturalness of pose and expression tend to be overlooked. From 1506 to 1516 he was based in Milan and Rome. In 1516, at the invitation of Francis I, he retired to France, where he died. Leonardo's output as an artist was small and he left a high proportion of his works unfinished, but his influence was enormous, in his own time and in succeeding centuries. Stylistically, he brought new naturalism to painting through his mastery of light and shade, and his noble compositions ushered in the High Renaissance. He was the greatest and most prolific draughtsman of his time, and his marvellous drawings (mainly in the Royal Collection at Windsor Castle) are the finest testimony to his extraordinarily powerful and wide-ranging imagination.

Leopardi, Giacomo (1798–1837), Italian poet, scholar, and philosopher. The greatest Italian *Romantic poet, his richly suggestive *lyrics (*canti*, 1845) were written between 1816 and 1837. In 1824 he turned his attention to philosophical prose, notably the ironical dialogues *Moral Tales* (1827). The 'cosmic pessimism' of his poems is often attributed to chronic illness, but it was also an intensely intellectual and even scholarly development. His creative work is based on the tension between past and present, childhood innocence and adult awareness of insignificance, illusions and their loss. This gave rise to a wistful poetry of images he called 'vague', in that they evoke memory: the present is too precise to be beautiful.

Lermontov, Mikhail (Yuryevich) (1814–41), Russian poet and novelist. Steeped in European *Romanticism, especially the works of *Byron, and exposed to the atmosphere and legends of the Caucasus, he had marked out his characteristic territory by the age of 18 in a series of civic, philosophical, and nature *lyrics, and in obsessively redrafted long poems, which include *The Demon* and *The Novice*. Lermontov also turned to prose and in *A Hero of our Time* (1840) produced a pioneering psychological novel, a study from many viewpoints of Pechorin, the proud, isolated, selfish intellectual. Lermontov's work, which has a strong misogynistic tinge, was fundamentally concerned with the problem of individual freedom and the possibilities for social engagement of the

outstanding individual. Moody and petulant, he was, like his great contemporary Pushkin, killed in a duel.

Leśmian, Boleslaw (1877–1937), Polish lyric poet. He was one of the first writers to adapt *symbolism and *expressionism to Polish verse. Of Jewish origin, he was educated at Kiev and wrote in both Russian and Polish. He was a lawyer by profession; in his poetry he attempted to depict man's co-existence with nature, expressing his own existential philosophy in *Orchard at the Crossroads* (1912), *The Meadow* (1920), *The Shadowy Drink* (1936), and *Woodland Tale*, published posthumously in 1938.

Lessing, Doris May (1919–), British novelist. Her quintet, *Children of Violence* (1952–69), a *Bildungsroman*, traces the history of Martha Quest from childhood in Rhodesia through post-war Britain to an apocalyptic ending in AD 2000. Her ambitious novel *The Golden Notebook* (1962) was hailed as a landmark in feminist literature. Later novels, *Briefing for a Descent into Hell* (1971) and *Memoirs of a Survivor* (1975) enter the realm of 'inner space fiction', exploring mental breakdown and the collapse of society.

Lessing, Gotthold Ephraim (1729–81), German poet, dramatist, and critic. Lessing's most significant contribution to German letters lies in the field of dramatic art: in his periodical *Hamburg Dramaturgy* (1767–8) and earlier works he rejected the conventions of French classicism on the German stage in favour of the Greek classical traditions and Shakespeare. In his own plays he introduced *blank verse to German drama and effectively founded the modern German dramatic tradition: *Miss Sara Sampson* (1755) established the domestic tragedy on the German stage; in *Minna from Barnhelm* (1767), a topical work set during the Seven Years War, he rejected a comedy of types for greater realism and nuance of characterization. In 1766 Lessing published his treatise on aesthetics, *Laokoon, on the Limits of Painting and Poetry*, a study of the nature of art-forms, which with more specialized works helped to create an understanding of classical culture in 18th-century Germany. A second domestic tragedy, *Emilia Galotti* (1772), an attack on princely despotism, and *Nathan the Wise* (1779), a powerful plea for balance and tolerance, make him a powerful German proponent of the *Enlightenment.

Le Vau, Louis (1612–70), French architect. He lacked the subtlety and refinement of his great contemporary *Mansart, but he was highly efficient and able to organize teams of craftsmen to great effect. These qualities were particularly evident in his masterpiece, the château of Vaux-le-Vicomte, built for Nicolas Fouquet, Louis XIV's finance minister. Begun in 1657, it was being roofed by the end of 1658, and the lavish decorations were complete by 1661; *Lebrun did the paintings and *Le Nôtre designed the gardens. The building is clumsy in some of its details, but the overall effect is magnificent, and Le Vau had a feeling for *Baroque rhetoric unsurpassed among his French contemporaries. Vaux was the model for Versailles, where Le Vau and his collaborators worked when the palace was remodelled from 1669. Le Vau designed the garden front (later altered by *Hardouin-Mansart). His other works included the east front of the Louvre in Paris, although other architects were involved and Le Vau's exact share in the design is uncertain.

Lewis, C(live) S(taples) (1898–1963), British literary scholar, critic, and novelist. His critical works include his early publication *The Allegory of Love* (1936). Among Lewis's popular religious and moral writings is *The Screwtape Letters* (1940), which purports to be advice from one devil to another on the art of temptation. He also wrote 'space fiction' with a strong Christian flavour (*Voyage to Venus*, 1943, reworks the story of the Garden of Eden), and the *Narnia* series of novels, including *The Lion, the Witch, and the Wardrobe* (1950), for children. *Surprised by Joy* (1955) is his spiritual autobiography.

Lewis, (Harry) Sinclair (1885–1951), US novelist, short-story writer, social critic, and dramatist. His best work was written before he received the Nobel Prize for Literature in 1930, in the satirical studies of a complacent middle-class, middle America represented by the novels *Main Street* (1920), set in a small town in Minnesota, and *Babbitt* (1922), a satirical portrayal of an 'average' American businessman. Later works include *Arrowsmith* (1925), *Elmer Gantry* (1927), a satire on a hypocritical preacher, *Dodsworth* (1929), and *It Can't Happen Here* (1935), in which Lewis imagines a future fascist uprising in the USA.

Lewis, Wyndham *Wyndham Lewis, Percy.

Leyster, Judith (1609–60) and **Molenaer, Jan Miense** (c.1610–68), Dutch painters. Both belonged in their youth to the circle of Frans Hals which made Haarlem one of the great centres of Dutch painting. As husband and wife they collaborated so closely in each other's work that it is sometimes difficult to differentiate their paintings. Leyster is at her best in small *genre pieces. Among her best-known paintings is the *Gallant Proposal* (Mauritshuis, The Hague). Her monogram includes a star, a play on 'Ley/ster' (lode star). Molenaer's work ranges from pictures of the crude, indecorous activities of peasants to small, exquisitely finished portraits, and domestic scenes of well-to-do families. In accordance with the general development of Dutch painting from c.1625 to 1650 Molenaer's early works have a grey-blond tonality and wide range of colour, whereas the later ones have less variety of colour and tend to be a brownish tone.

Li Bai (701–62), Chinese poet of the Tang dynasty (618–907). Li Bai was a friend of the poet *Du Fu, rivalling him for the title of China's greatest poet. In many ways his opposite, he was a romantic, who wrote of the joys of friendship, wine, nature, and, with regret, of the passage of time. He became increasingly interested in the study of Daoism and of alchemy. According to popular legend

Leonardo da Vinci was the supreme portraitist of his age; no previous artist had captured so convincingly the quality of a living individual. This exquisitely graceful picture, *right*, which is known as 'The Lady with an Ermine' (c.1485), almost certainly represents Cecilia Gallerani, the mistress of his patron Ludovico Sforza, the ruler of Milan. Ludovico used the ermine as one of his emblems, and the Greek word for the animal 'galen', forms a pun on Cecilia's surname. (Czartoryski Museum, Cracow)

he drowned when he attempted to seize the moon's reflection in the water while drunk.

Lichtenstein, Roy (1923–), US painter, sculptor, and graphic artist, one of the most famous and successful exponents of *Pop art. In common with other Pop artists he adopted the images of popular commercial art, but he did so in a highly distinctive manner. Taking his inspiration from comic strips, he blew up the images to a large scale, reproducing the primary colours and dots of the cheap printing processes. His work shows impressive compositional skill as well as energy and humour. His later work has included sculpture in polished brass.

Liebermann, Max (1847–1935), German painter and graphic artist. He visited France in the 1870s and was an important figure in introducing modern French trends into German painting. His subjects included portraits, landscapes, and scenes of rural life, and with Lovis Corinth he was regarded as one of the foremost German *Impressionists.

Lied, a musical term usually reserved for songs in the German language with a piano accompaniment that is as important as the vocal line. Though intimate in scale, *Lieder* are likely to be thought-provoking. The musical setting may repeat for each verse, or change according to the demands of the poem (through-composed). The *Lied* is essentially a product of the *Romantic movement and was popular with such composers as Schubert, Schumann, Brahms, Wolf, Mahler, and Richard Strauss. The terms *Liedercyclus* and *Liederkreis* indicate a song-cycle.

Lievens, Jan (1607–74), Dutch painter and graphic artist. Already established as a painter in Leiden at the age of 13, he worked there from about 1625 to 1631, in close collaboration with his friend *Rembrandt, and they were regarded as equally gifted. Lievens, however, did not sustain his early brilliance, which had been expressed in great boldness of imagination. In his later career he worked mainly as a portraitist, his elegant and facile style, somewhat influenced by van *Dyck, bringing him great commercial success.

Ligeti, György (Sándor) (1923–), Hungarian composer. His early studies were interrupted by World War II, and later his most advanced music, influenced by *Schoenberg and *Webern, was banned in Hungary. When the 1956 Soviet invasion made the political situation even worse, he emigrated to the West. In such works as *Atmosphères* (1961) he removed melody, harmony, and rhythm as distinct features, replacing them with an overall cluster of sound. The *Requiem* (1965) elaborates this idea in terms of a highly complex evanescent counterpoint, though later works, such as the *Double Concerto* (1972), go some way towards rediscovering melody.

lighting, stage, the means of lighting a theatrical performance. Daylight was virtually the only source of theatre lighting until roofed theatres were introduced into Renaissance Italy. The first artificial lighting of stage and auditorium was provided by chandeliers, candle sconces, and torches. Concealed lighting was directed on to the stage by reflectors on the backs of the wings; and later footlights were used. Coloured lights were produced by

A 13th-century pen-and-ink portrait by Liang K'ai of **Li Bai** chanting a poem. Boastful and exuberant in character, Li Bai none the less fulfilled the ideal of writing poems 'like lotus flowers standing in a pool of clear water, naturally captivating and needing no artificial trimming', and he managed to combine the two qualities most prized in Chinese poetry: romantic abandonment and artistic restraint. (Tokyo National Museum)

placing lights behind containers of coloured liquids. The chandeliers above the stage dazzled the audience and were removed by David *Garrick from Drury Lane in 1765 and at much the same time in France. It was not until the 19th century, at Henry *Irving's insistence, that

auditorium lights were extinguished during a performance. The coming of gas in the early 19th century transformed theatre lighting. Though criticized as garish and greatly increasing the risk of fire, gas afforded far more flexibility. Gas points could be added where required, and each set of lights could be individually adjusted. Limelight, created by heating lime by a gas jet, gave off a mellow light that could be used to imitate the light of the sun or moon and as a spotlight. The electrification of theatres in the 1880s led to the development of modern stage lighting. Lighting units and dimmers became increasingly refined and easy to operate, and the spotlight became the most important element, floodlighting seldom being used. Remote control was introduced in the 1930s. In the 1940s some theatres introduced light consoles, resembling organs, and in the 1960s lighting systems became computerized. Stage lighting has achieved great subtlety in suggesting mood and scene, creating both natural and non-naturalistic effects by such means as colour changes, shadows, and film slides.

Limburg (or Limbourg) brothers, family of Netherlandish manuscript illuminators, **Herman**, **Jean** (Jannequin), and **Paul** (Pol), active in the early 15th century. In 1402 Jean and Pol were working for Philip the Bold of Burgundy, and after Philip's death in 1404 all three brothers worked for his brother, Jean, Duc de Berry, one of the most generous patrons in the history of art, for whom the Limburgs produced one of the supreme masterpieces of manuscript *illumination, the *Très Riches Heures du Duc de Berry*, begun in about 1413 and left unfinished at their deaths. With its exquisite ornamentation and beautifully observed naturalistic detail it is one of the archetypal works of the *International *Gothic style. They remained in his service until all three died in 1416, presumably victims of an epidemic.

lion roar *friction drum.

Lind, Jenny (Johanna) (1820–87), Swedish soprano singer. Dissatisfied with her voice after her 1838 Stockholm début, Lind went to Paris to study. Meyerbeer commended her to Berlin where she sang Bellini's *Norma* (1844). Her 1847 London début, as Alice in Meyerbeer's *Robert le Diable*, was a triumph. She excelled in brilliant coloratura (see *voice) roles, notably as Amina in Bellini's *The Sleepwalker*.

Lipchitz, Jacques (1891–1973), Lithuanian-born sculptor who worked mainly in France (taking French nationality in 1925) and the USA. He moved to Paris in 1909 and became one of the first sculptors to apply the principles of *Cubism in three dimensions. During the 1920s his style changed, as he became preoccupied with the interpenetration of solids and voids. In his later years, an internationally renowned figure, he returned to greater solidity of form, using tortuous bloated shapes in a desire to express spirituality.

Lippi, Filippino (c.1457–1504), Italian painter, the son and pupil of Filippo Lippi. After the death of his father when he was about 12, his training was taken on by *Botticelli, whose sweet and graceful style he continued, but in a somewhat more restless and nervous manner. He was popular and prolific, painting altar-pieces and

This altar-piece by Filippino **Lippi**, *The Virgin and Child with St Jerome and St Dominic*, comes from a chapel dedicated to St Jerome in the church of San Pancrazio, Florence. It probably dates from about 1485, when the church was dedicated. It well illustrates the gracefulness and tenderness of Lippi's style and his loving attention to detail. (National Gallery, London)

frescos and working successfully in Rome as well as Florence, but (as with Botticelli) his style was outdated by the time of his death. His finest work is considered to be the fresco cycle on the lives of St Philip and St John (1495–1502) in the Strozzi Chapel of Santa Maria Novella in Florence. Here his imaginative gifts come out in his taste for picturesque, dramatic, and even bizarre effects.

Lippi, Fra Filippo (c.1406–69), Italian painter. He took vows as a Carmelite in 1421, but was a reluctant monk and had a scandalous affair with a nun, Lucrezia Buti, who bore him a son (the painter Filippino Lippi) and a daughter before the couple were allowed to marry. As a painter Lippi was one of the most outstanding artists of his generation, said to have been inspired to become a painter by watching *Masaccio at work. His early work owes much to Masaccio's example in its sense of physical substance, but from about 1440 his style became more linear and graceful. He is renowned above all for his tender portrayals of the Virgin and Child, which are sometimes in the form of tondos (circular paintings), a format he was among the first to use. He was also an accomplished fresco painter. His work influenced many painters, notably *Botticelli.

Li Qingzhao (1084–c.1151), China's greatest woman poet. She lived in the Song dynasty (960–1279) and produced seven volumes of essays and six volumes of poetry, of which fragments alone remain. Her early lyric poetry, written to music in the characteristic *ci* form, reflects her happy early married life. This turned into poignant melancholy after the death of her husband and

the nomad invasions which brought about the downfall of the Song dynasty.

lira, a term used for a number of bowed, stringed musical instruments, among them the Greek and Turkish *fiddles, but pre-eminently for the *lira da braccio*, the 15th- to 16th-century precursor of the *violin. This was the size of a large viola, with five fingered strings and two *drones. A larger instrument, the *lira da gamba* or *lirone*, resembled a bass *viol but with many more strings. It was designed for playing chords as a *continuo instrument and remained in use into the 17th century.

Lissitzky, El (Lisitsky Lazar Markovich) (1890–1941), Russian painter, designer, and graphic artist. He was one of the leading Russian avant-garde artists of his day and one of the most important channels for spreading the ideas of *Constructivism and *Suprematism in Western Europe. From 1923 to 1928 he lived in Switzerland and Germany, and after his return to Russia he devoted himself mainly to *typography and industrial design. He designed several propaganda and trade exhibitions, and his dynamic techniques of photomontage (see *montage), printing, and lighting had wide influence.

Liszt, Franz (Ferenc) (1811–86), Hungarian composer and pianist. His phenomenal pianistic powers created a musical sensation, but he was persuaded to retire from the concert platform in 1847 by Princess Carolyne Sayn-Wittgenstein. Work as a composer and conductor now taking precedence, he settled in Weimar as Kapellmeister (director of music) to the ducal court (1848–61). Here he championed contemporary music, particularly that of *Wagner. (Wagner lived with and eventually married Liszt's daughter Cosima, and his music was greatly influenced by that of Liszt.) Liszt's compositions ranged from a vast body of virtuoso piano music to the twelve *symphonic poems (a term which he invented), which exploit the idea of thematic metamorphosis. They include *Les Préludes* (1848), *Mazeppa* (1851), and *Orpheus* (1854). Two programmatic symphonies (see *programme music), on Dante's *Divine Comedy* (1856) and Goethe's *Faust* (1857), explore the same technique. His 'Hungarian' works are mainly based on gypsy elements. Liszt moved to Rome in 1861, where he took minor orders in the church and composed two oratorios: *St Elizabeth* (1862) and *Christus* (1867). His later piano works anticipate many 20th-century techniques and he must be regarded as one of the most innovative composers of the period.

literary criticism, the reasoned discussion of literary works, an activity which may include some or all of the following procedures, in varying proportions: the defence of literature against moralists and censors, classification of a work according to its *genre, interpretation of its meaning, analysis of its structure and style, judgement of its worth by comparison with other works, estimation of its likely effect upon readers, and the establishment of general principles by which literary works (individually, in categories, or as a whole) can be evaluated and understood. From the Renaissance to the 18th century, much criticism was concerned with applying abstract rules, derived from Aristotle, for the correct literary 'imitation of Nature', but modern criticism in English traces its origin from the more flexible kinds of appreciation pioneered by *Dryden, *Johnson, *Coleridge,

and *Arnold. Contrary to the everyday sense of criticism as 'fault-finding', much modern criticism assumes that the works it discusses are valuable; the functions of judgement and analysis having to some extent become divided between the market (where reviewers ask 'Is this worth buying?') and the educational world (where academics ask 'Why is this good?'). The growth of academic criticism in the 20th century has brought with it a profusion of different schools of thought in criticism, very broadly divisible into those which approach the literary work as a self-contained entity to be analysed in isolation from 'external' factors (American 'New Critics' of the 1940s, for instance, influenced by T. S. *Eliot and *Empson), and those which insist on discussing literature in terms of related spheres of interest (psychology, politics, sexual differences, *biography, history, the social structure) which they refuse to regard as 'external'. Further disagreements about the nature of criticism itself, such as whether it can or should become objective description rather than subjective opinion, remain largely unresolved. (See also *Leavis, *Longinus.)

lithography, a method of printing from a design drawn directly on to a slab of stone or other suitable material, invented in 1798. The process is based on the antipathy

Toulouse-Lautrec was one of the greatest of all exponents of **lithography**, which he used for prints as well as posters, such as this poster for Divan Japonais, a popular cabaret in Montmartre. It shows Jane Avril, a well-known dancer of the time, seated next to the music critic Edouard Dujardu. Lithography contributed greatly to the development of the poster, for it enabled large, brightly coloured images to be produced more cheaply. (Victoria and Albert Museum, London)

of grease and water, the design being drawn with a greasy crayon on the stone. After it has been chemically fixed, the stone is wetted and then rolled with oily ink, which adheres only to the greasy drawing, the rest of the surface, being damp, repelling the ink. Prints can then be taken in a press. Many distinguished artists of the 19th century worked in the lithographic technique, notably Daumier.

liturgical drama, medieval drama performed within or near a church, initially at Easter but later also at Christmas. The plot was provided by the events of Christ's birth and death. The antiphonal singing of the original drama was later interspersed by other music with appropriate texts (*tropes*); the latter often consisted of dialogue, chanted rather than spoken. Incidental dance and processions were also performed. As liturgical drama evolved it encompassed subjects outside the liturgy (though always religious) and characters not in the Scriptures. There were no 'actors' apart from priests and choirboys; the dialogue was in Latin and the congregation played no part in the singing. Gradually the connection of liturgical drama with the church was broken as the plays became sponsored by the laity and were performed in the vernacular speech. They survived until the 15th century, when they were superseded by *mystery and *passion plays.

Living Theatre, an experimental theatre group formed in 1951 in New York. It used improvisation and collective creation to develop striking forms of speech and movement with which to expound its attitudes of non-violence and opposition to authority. Its work is exemplified by *The Connection* (1959), about drug addiction, by Jack Gelber, and Kenneth Brown's *The Brig* (1963), based on his experiences in a military prison.

Lloyd Webber, Andrew (1948–), English composer. With the librettist Tim Rice (1944–), Lloyd Webber composed a number of commercially successful musicals, from the catchy *Jesus Christ Superstar* (1970), to the popular *Evita* (1978). In the eighties, he has applied his pastiche style to the record-breaking *Cats* (1981), based on T. S. Eliot's poems, the roller-skating *Starlight Express* (1984), the melodramtic *Phantom of the Opera* (1986), and a requiem (1984).

locks and keys, devices for securely fastening doors, drawers, lids and so on. Locks and keys are of various types, but the essential principle involved in them is of a lever (the key) acting on a bolt in the lock to move it in or out of the secured position. The Egyptians were using huge wooden locks and keys about 4000 years ago; they were mounted on the inside of the door, the arm being inserted through a hole. The Romans introduced the keyhole, making it possible to fasten and unfasten the lock from the outside. It was also the Romans who introduced the portable padlock. From the point of view of skill in design and decoration (rather than ingenuity in terms of security) the great age of the locksmith lasted from the 15th to the 18th century. In the 17th and 18th centuries apprentices were often required to submit a finely worked lock and key to qualify as masters in the guild, and these 'apprentice locks' are often particularly fine examples of virtuosity in steelworking.

Loesser, Frank (Henry) *musical.

Loewy, Raymond *industrial design.

log drum *slit drum.

Lomonosov, Mikhail (Vasilyevich) (1711–65), Russian poet, political reformer, and polymath. Of humble northern origin, he came to Moscow and then St Petersburg (now Leningrad), where he was taken up by the German founders of the Academy of Sciences and sent abroad to study. He returned in 1740 to lay the foundations of achievement in poetry, verse theory, grammar, and many other fields of scholarly and scientific endeavour. At his death his notes, outlining his humanitarian ideas, were suppressed by Catherine the Great, and his complete *Works* were published only in 1950–7.

London Contemporary Dance Theatre (LCDT), British modern dance company, which first performed in 1967 as the Contemporary Dance Group. It was the first dance company in Europe to be based on *Graham's work; the company's artistic director and major choreographer Robert Cohan (1925–) was a leading soloist with the Martha Graham Company before moving to Britain, and the associated London School of Contemporary Dance, from which the company draws most of its members, teaches mainly Graham technique and ballet. LCDT's repertoire consists almost entirely of new works, mostly by Cohan or by younger choreographers. Over the last decade the style of the company's work has broadened to include *jazz dance elements and vernacular dance of street and city origins.

London, Jack (John Griffith) (1876–1916), US novelist, short-story writer, and journalist. The son of a poor San Francisco family, he exploited the experiences of a shifting many-sided life in his popular fiction: the Klondike and Yukon in the collection of short stories *The Son of the Wolf* (1900); a spell as a sailor in the novel *The Sea-Wolf* (1904); the political struggles of the oppressed in *The Iron Heel* (1907); and literary success in *Martin Eden* (1909). *The People of the Abyss* (1903) is a celebrated report on the London slums, and *The Call of the Wild* (1903) and *White Fang* (1906) are powerful tales about dogs which explore the ambivalent attractions of wilderness and civilization.

Longfellow, Henry Wadsworth (1807–82), US poet. His literary début was with the travel sketches of *Outre-Mer* (1833–4), which he followed with the autobiographical romance *Hyperion* (1839). He gained a wide readership through his second volume of verse *Ballads and Other Poems* (1841), which included 'The Wreck of the Hesperus', 'Excelsior', and 'The Village Blacksmith'. This popularity was sustained by a succession of *narrative poems with historical subjects: *Evangeline* (1847); the Indian saga *Hiawatha* (1855) in unrhymed trochaic tetrameters which were derived from the Finnish epic *Kalevala*; and *The Courtship of Miles Standish* (1858). He set great store by the religious trilogy *Christus* (1872). A highly-respected figure on both sides of the Atlantic, Longfellow made Americans aware of the European literary tradition, and Europeans aware of the existence of an American literature.

Longhena, Baldassare (1598–1682), Italian architect, the chief exponent of the *Baroque style in Venice, where

This staircase hall (1643–5) at the monastery of San Giorgio Maggiore in Venice is, apart from his masterpiece Santa Maria della Salute, **Longhena**'s most imposing and original work. This design was highly influential on Baroque architecture in Central Europe.

he built many churches and palaces. His masterpiece is the church of Sta Maria della Salute (1631–87), which, with its great dome supported by massive scrolled buttresses, is one of the chief landmarks of Venice, dominating the entrance to the Grand Canal. The interior, octagonal in plan, is less rich and vigorous than the exterior, its stately harmony showing Longhena's debt to *Palladio.

Longhi, Pietro (1702–85), Italian painter, best known for small *genre scenes of life in Venice. These charming and often gently satirical scenes were very popular and much duplicated by pupils and followers, but Longhi does not seem to have been patronized by English visitors to Venice—the type of client who made up most of the business of his contemporary *Canaletto. His son **Alessandro** (1733–1813) was a successful portraitist.

Longinus, the name bestowed by a scribe's error on the author of the Greek critical treatise on the Sublime, one of the great seminal works of *literary criticism. Perhaps written in the 1st century AD, the author discusses with perception a wide variety of figures of speech in prose and verse. His critical analysis of what constitutes literary greatness shows concern with the moral function of literature, and impatience with pedantry. The period of its greatest influence extends from *Boileau's French translation (1674) to the early 19th century.

Loos, Adolf (1870–1933), Austrian architect, a pioneer of *modernism. Although he worked mainly in Vienna, from 1893 to 1896 he was in the USA, where he was influenced by *Sullivan and the *Chicago school. Rejecting the decorative tradition of *art nouveau and the Vienna *Sezession, Loos developed a style of extreme *functionalism and rationalism (in 1908 he wrote an article called 'Ornament and Crime'). His best-known work is the Steiner House in Vienna (1910–11), austerely geometrical and one of the first private houses built of concrete. Loos was in charge of municipal housing in Vienna in 1920–2, and in 1923–8 lived in Paris, where he associated with the *Dadaists.

Lorca *García Lorca, Federico.

Lorenzetti, Pietro (fl. 1320–48) and **Ambrogio** (fl. 1319–48), Italian painters, brothers. They were among the outstanding Italian artists of their time, but their lives are poorly documented—both are assumed to have died in the Black Death of 1348. They worked independently, but shared a certain affinity of style, the weightiness of their figures (showing the influence of *Giotto) setting them apart from the graceful tradition of Sienese art exemplified by *Duccio and Simone *Martini. Ambrogio was the more innovative of the brothers, and his greatest work, the fresco series representing *Good and Bad Government* (1338–9) in the Town Hall at Siena, is one of the most remarkable achievements in 14th-century Italian art, breaking new ground in the naturalistic depiction of landscape and townscape. Pietro's work is noted for its emotional expressiveness. Both brothers painted panel pictures as well as frescos.

lost generation, the name applied to the disillusioned intellectuals and aesthetes of Europe and the USA of the years following World War I, who rebelled against former ideals and values but could replace them only by despair or a cynical hedonism. The remark of Gertrude *Stein, 'You are all a lost generation', addressed to *Hemingway, was used as a preface to the latter's novel *The Sun Also*

Rises, which brilliantly describes an expatriate group typical of the 'lost generation'. Other expatriate authors of the period to whom the term is generally applied include *cummings, *Fitzgerald, *Pound, and the Canadian novelist Morley Callaghan (1903–).

Lotto, Lorenzo (*c*.1480–*c*.1556), Italian painter. He is said to have trained with *Giorgione and *Titian in the studio of Giovanni *Bellini, but he had a highly personal style, and stands somewhat apart from the central Venetian tradition. His work draws on a wide variety of sources and is extremely uneven, but at the same time shows acute freshness of observation. He is now perhaps best known for his portraits, in which he often conveys a mood of psychological unrest, but he worked mainly as a religious painter.

Louis XIV ('Louis Quatorze') style. style of decoration and interior design prevailing in France during the latter part of the reign of Louis XIV, who became king as a child in 1643 and was effective ruler from 1661 to 1715. Reflecting the grandeur and pomp of Louis's court, the style was highly formal and massively rich; the costliest materials were used freely, but colours tended to be sombre. Louis's palace at Versailles was the greatest monument to the style, but much of the finest furnishing and decoration there has been destroyed. (See also *Boulle, *Lebrun, *Le Nôtre, *Le Vau.)

Louis XV ('Louis Quinze') style, style of interior decoration and design in early 18th-century France, more or less equivalent to the *Rococo style in painting. It coincided only very roughly with Louis's reign (1715–74), emerging around 1700, reaching its peak from about 1720 to about 1750, and being long outmoded by the time of his death.

Louis XVI ('Louis Seize') style, style of interior decoration and design prevailing in France from about 1760 to the Revolution of 1789. Its development thus antedates the reign of Louis XVI (1774–92), after which it is named. The style marked a reaction against the frivolity of the *Louis XV style and a return to greater solidity and sobriety.

Louis, Morris (1912–62), US painter, considered the main pioneer of the movement from *Abstract Expressionism to *colour field painting. His manner changed fundamentally in 1954, when he began using thinned acrylic paint poured on to unprimed canvas, acting as a stain rather than an overlaid surface of pigment. The flow of the colour was controlled by moving the canvas or the scaffolding to which it was loosely stapled. His work was highly influential on American painting.

Loutherbourg, Philippe-Jacques de (1740–1812), French painter who settled in Britain in 1771. He painted a variety of subjects, but is best known for his landscapes. He also designed stage sets and invented a peep-show called the 'Eidophusikon' (1781), a system of moving pictures, lights, and coloured gauzes on a small stage-set, which imitated views in and around London to the accompaniment of appropriate music. It impressed artists as distinguished as Reynolds and Gainsborough, encouraging the latter to experiment with artificially lit paintings on glass.

Lovelace, Richard (1618–*c*.1657), English poet. He was one of the *Cavalier poets associated with the Royalist cause during the English Civil War. An heir to great estates in Kent, he lost most of his wealth during his lifetime. His *lyrics have a deftness of touch in their rhythms and varied verse-forms. Among them are 'To Althea from Prison' (written from the Gatehouse Prison, Westminster, and including the lines 'Stone walls do not a prison make | Nor iron bars a cage') and 'To Lucasta, Going to the Wars' ('I could not love thee, Dear, so much | Loved I not honour more').

Lowell, Amy (Lawrence) (1874–1925), US poet and literary critic. A member of a distinguished Massachusetts family, she joined in 1913, and later led, the group of poets known as *Imagists, editing several anthologies with the title *Some Imagist Poets*. Her own work is marked by technical experiments, notably the *free-verse form 'polyphonic prose'. She wrote three critical studies, *Six French Poets* (1915), *Tendencies in Modern American Poetry* (1917), and *John Keats* (1925).

Lowell, James Russell (1819–91), US poet, essayist, and satirist. Harvard Professor, editor of the *Atlantic Monthly* and *North American Review*, he was also a versatile author, with a reputation established by the works he produced in 1848: *Poems . . . Second Series* and the verse satires *The Biglow Papers*, opposing the Mexican War, and *A Fable for Critics*, on the contemporary literary scene. He became one of the country's most respected men of letters, with later works including the second series of *The Biglow Papers* (1867) and the *blank-verse poem *The Cathedral* (1869), in which he attempts to find refuge in a depersonalized deity, 'so far above, yet in and of me'.

A commode (decorative chest of drawers) in the opulent **Louis XIV style**. It is by André-Charles Boulle, the most notable French furniture-maker and designer of this period, and is a type of furniture that he possibly invented and certainly played a major part in developing.

Lowell, Robert (Traill Spence Jr.) (1917–77), US poet. A member of the leading Bostonian Lowell family, he was gaoled for refusing to serve in World War II. His second collection *Lord Weary's Castle* (1946), which reflected the influence of *Yeats and T. S. *Eliot, was highly praised. After *Life Studies* (1959) he became known for a form of 'confessional poetry' which caused controversy when it revealed his manic-depressive tendencies and aspects of his married life; *Notebooks* (1969), *History* (1973), and *The Dolphins* (1973) continue in this mode. Other works include *For the Union Dead* (1964) and *Near the Ocean* (1967); the poetic adaptations of Baudelaire in *Imitation* (1961); and the three verse-dramas collected as *The Old Glory* (1965).

Lowry, L(aurence) S(tephen) (1887–1976), British painter. He lived all his life in or near Manchester and worked for a property company, his painting being done in his spare time. His highly individual pictures typically feature firmly drawn backgrounds of industrial buildings bathed in a white haze against which crowds or groups of stick-like figures are contrasted. There is considerable divergence of opinion on his status, some critics considering him a great artist, while others dismiss him as a minor talent although interesting as a social commentator.

Lowry, (Clarence) Malcolm (1909–57), British novelist. As a young man he was influenced by *Conrad and went to sea, travelling to East Asia. His first novel *Ultramarine* (1933) was followed by further travels in Europe, the USA, and Mexico; he settled in Canada, but returned to England before his death. Like many of his characters, Lowry was an alcoholic, given to superstition. His autobiographical novel *Under the Volcano* (1947) explores the alcoholic self-destruction of a British ex-consul in Mexico; it is his best work, and a tragic masterpiece. A sequel, *Dark as the Grave Wherein my Friend is Laid*, was published posthumously in 1968. His *Selected Poems* appeared in 1962.

Lubetkin, Berthold *Tecton.

Lubitsch, Ernst (1892–1947), German-born US film director. He had become famous through his German films when, in 1922, he moved to the USA, where his polished, witty, often amoral comedies were said to have the 'Lubitsch touch'. His first sound film, *The Love Parade* (1930), was a musical, as were *Monte Carlo* (also 1930), *The Smiling Lieutenant* (1931), *One Hour With You* (1932), and *The Merry Widow* (1934). Of his best comedies, *Trouble in Paradise* (1932) took a benign view of theft, *Design for Living* (1933) of a *ménage à trois*, and *Bluebeard's Eighth Wife* (1938) of serial marriage; in *Ninotchka* (1939) a female Soviet Communist was seduced by Paris; and *To Be or Not to Be* (1942) satirized the Nazis through the tribulations of a troupe of actors in occupied Poland.

Lucan (Marcus Annaeus Lucanus) (AD 39–65), Latin poet. Nephew of the younger Seneca, his unfinished *epic, the *Pharsalia* or *Belum Civile*, describing the civil war between Caesar and Pompey, is melodramatic and brilliantly phrased, with rhetorical speeches and unflagging appeal to the emotion of the reader.

Lucas van Leyden (1494–1533), Netherlandish engraver and painter, born and mainly active in Leiden.

He was remarkably precocious, producing mature work when he was still in his early teens, and his output was large. He made etchings and woodcuts as well as engravings and was a prolific draughtsman, ranking as one of the greatest figures in the history of the graphic arts. His contemporary fame rivalled that of *Dürer, who was the main influence on his work. Lucas, however, was less intellectual in his approach, tending to concentrate on the anecdotal features of the subject. His status as a painter is less elevated than as an engraver, but he was one of the finest Netherlandish painters of his period, showing vivid imaginative powers, marvellous skills as a colourist, and deft and fluid brushwork.

Lucretius (Titus Lucretius Carus) (*c*.94–*c*.55 BC), Latin poet. Virtually nothing is known of his life. His one great poem, *De Rerum Natura* (*On the Nature of Things*), written in *hexameters, is a masterpiece of ancient didactic poetry. Lucretius passionately recommends the philosophy of Epicurus, whose views on the atomic nature of universe and soul alike, and on the psychology of feeling, he expounds in six books. There are memorable set pieces, as on the evils of religion and the passion of love. A convinced materialist, whose goal is to give men peace of mind by removing fear, Lucretius' combination of philosophical zeal and poetic sublimity is unequalled in Latin.

Ludwig, Christa (1924–), German soprano and mezzo-soprano singer. Ludwig's 1946 operatic début in Frankfurt as Orlofsky in Johann Strauss's *Fledermaus* was followed by performances throughout Germany, in Vienna, New York, and London. Ludwig established herself as a leading singer of the day with her interpretations of Octavian in Strauss's *Rosenkavalier*, Eboli in Verdi's *Don Carlos*, Leonore in Beethoven's *Fidelio*, as well as in Mozart operas and *Lieder*.

Lully, Jean-Baptiste (1632–87), French composer, one of the most influential of his time. Though born in Italy, he was taken to France in 1646. His talents as a dancer and violinist eventually attracted the attention of Louis XIV, into whose service he was recruited in 1653. Collaboration with *Corneille and *Molière further advanced his career and in 1672 he acquired a royal prerogative over the performance of virtually all musical entertainment in France, which was characterized by its large element of dancing. With Philippe Quinault as his librettist he now produced a series of *operas and court *ballets (see also *opéra-ballet). His finest operas, such as 'La Nuit' (1653), which included the famous *Ballet de la Nuit*, an archetypal *ballet de cour, *Alceste* (1674), *Thesée* (1675), *Amadis* (1684), and *Armide* (1686), are noted for their fidelity to the French language. The ceremonial solemnity of his church music, in particular of his grand *motets, which effectively exploit the contrasting sonorities of solo and full orchestral groups, was appropriate to the grandeur and theatricality of the palace of his royal patron at Versailles.

Lumière, Louis (1864–1948), French cinema pioneer, whose father made photographic products. In 1895, with his brother **Auguste** (1862–1954), he patented the Cinématographe, which made possible the exhibition of moving pictures rather than the illusion of movement created by *animation. (Edison's Kinetoscope of 1894

could also record movement, but could not project it.) During the next five years Lumière produced films (mostly of current events) in enormous numbers. Yet he could see no future for his invention, and it was left to *Méliès and others to develop the potential of the new medium.

Luo Guanzhong *Water Margin, *Romance of the Three Kingdoms.

lustreware, pottery with an iridescent metallic surface. There were various ways of obtaining the metallic effect, the most common of which involved painting the already glazed pottery with pigments containing metallic oxides and then refiring. Different metals produced different results, copper giving a rich ruby red, for example. Lustreware was invented in about the 7th or 8th century AD probably by Muslim potters in Mesopotamia. There is a long and distinguished tradition of lustre pottery in several Islamic centres (see *Islamic pottery), culminating in the Spanish *Hispano-Moresque ware. Lustreware is difficult to produce; apart from Spain it went out of fashion by about 1600, but the technique was revived by William *de Morgan in the 19th century.

lute, a plucked stringed musical instrument. Generically it is any instrument with integral neck and resonator and strings running parallel with the resonator, but in Western music the term is used specifically of an instrument with

a resonator resembling a halved pear, which was, in the Renaissance, hailed as 'Queen of Instruments All'. The lute, in this latter sense, derived in the 13th century from the Arab *ūd*, which is still widely used, plucked with a *plectrum, in North Africa, the Middle East, and the Balkans. By the 15th century the lute had four double courses (pairs of gut strings). A fifth was added before the end of the century, and players changed to finger-plucking, which made polyphonic playing much easier. From about 1500 a sixth course was added, establishing a tuning of 4th, 4th, 3rd, 4th, and 4th, covering two octaves, with a single uppermost course tuned to g′ or a′. This remained the standard size, but by the 17th century there was a range of sizes, from a small instrument with a top string tuned to c″, to basses with extended necks carrying unstopped strings. The latter had various names—archlute, chitarrone, and theorbo—and were mainly *continuo instruments. The mean, or standard, lute was both a solo instrument and an accompanist to singers and other instrumentalists. It was a favourite instrument throughout the 16th and 17th centuries, surviving well into the 18th, during these later periods with a different tuning from the old. During the later 18th century it was used less, and all but vanished in the 19th. It was revived in its old splendour as part of the mid-20th century early music revival. Lute music is written in *tablature, the advantage being that the player can more easily change from one size or tuning of lute to another better suited to the range of voice or instrument being accompanied.

In Costa's painting *The Consort* the central figure is seen playing a **lute** with one single and four double courses. On the table lie the instruments of the other players: a small fiddle and a recorder. English lute music was famous for its excellence throughout Europe, one of the most impressive of all Renaissance pieces being John Dowland's 'Lachrimae'. (National Gallery, London)

Lutoslawski, Witold (1913–), Polish composer. During World War II he earned his living as a café pianist. His earliest compositions employed a *Neoclassical style, but a powerful First Symphony (1947) went further and was banned on account of its near *atonality. In deference to political pressures, he began to follow a less controversial, folk-based style, exemplified in the Concerto for Orchestra (1954). A later change of political climate allowed him to turn back to the exploration of atonal techniques once more, as in the highly contrapuntal *Funeral Music* for strings (1958). He later used *aleatoric procedures, as in *Venetian Games* (1961). Since the mid-1950s Lutosławski has appeared widely as the conductor of his own works and has been much admired as a teacher and lecturer. His Third Symphony (1983) is one of the most popular modern works of its kind.

Lutyens, Sir Edwin (1869–1944), the foremost British architect of the early 20th century. His early buildings, mainly country houses for wealthy clients, owe a strong debt to *Shaw and the *Arts and Crafts Movement, with a romantic use of vernacular styles and materials. At this period he worked closely with the garden designer Gertrude Jekyll, for whom he designed Munstead Wood in Surrey (1897–9). After the turn of the century, however, his style became weightier, more formal, and more classical, and he was increasingly concerned with public buildings. His greatest commission was for designing the layout of New Delhi (1912–31) and its dominant building, the Vice-Regal (now Presidential) Palace, a masterly blending of European and oriental forms conceived on a scale of imperial grandeur. After World War I Lutyens was employed to design many war memorials, the most famous of which is the Cenotaph, London (1919–20).

Lu Xun (1881–1936), Chinese short-story writer and essayist, the most important writer to have emerged in 20th-century China. He had a classical Chinese education and studied medicine in Japan, but abandoned this to become a full-time writer and political activist. His best-known works are *Diary of a Madman*, modelled on a story by Gogol, and *The True Story of A Q*, the tale of a downtrodden, self-deceiving farm labourer whose life reflects the condition of China during the 1911 Revolution.

lyre, a stringed musical instrument with two arms and a cross-bar forming a yoke. The plane of the strings is parallel to the belly of the resonator. It was of high antiquity in Mesopotamia and the Near East and was the instrument of King David in the Bible and the bards of ancient Greece (see *Greek lyric poetry) and the early Middle Ages. Homeric epics, and those such as Beowulf, were chanted to the lyre, not spoken. With the adoption of *harps as principal instruments before 1200, the lyre fell into disuse, but reappeared around 1400, when it was often bowed instead of plucked, with a fingerboard running up the centre of the yoke. This form developed into the *crwth. Lyres are still used in East Africa, whither they probably travelled from Hellenistic Egypt. Some, such as the Sudanese and Egyptian *kissar*, are small, with gourd or wooden resonators, deriving from the Greek *chelys* and *lyra* with tortoise carapace; others, such as the Ethiopian *beganna*, are bigger with heavy wooden resonators, akin to the Mesopotamian lyres. The most important Greek lyre, the *kithara*, was the professional singer's instrument.

lyric, any fairly short poem expressing the personal mood, feeling, or meditation of a single speaker (who may sometimes be an invented character, not the poet). Lyric poetry is the most extensive category of verse, especially since the decline (since the 19th century in the West) of the other principal kinds: *narrative and dramatic verse. In ancient Greece, a lyric was a song for accompaniment on the lyre (see *Greek lyric poetry), but the current sense has prevailed since the Renaissance. Lyrics may be composed in almost any *metre and on almost every subject, although the most usual emotions presented are those of love and grief. Among the common lyric forms are the *sonnet, *ode, *elegy, *haiku, and the more personal kinds of *hymn.

Lysippus (*fl.* mid- and late 4th century BC), Greek sculptor. He was one of the most noted and prolific artists of the ancient world, but nothing is known to survive from his own hand. However, there are numerous Roman copies that are almost certainly derived from his sculptures, and it is clear that he was an outstandingly original and influential artist. He introduced a more slender figure type than that current and his work was also noteworthy for its attention to surface detail, which gave it a vivid naturalism. He was official portraitist to Alexander the Great (who is said to have let no other sculptor portray him) and several copies of his portraits of Alexander survive. Lysippus worked exclusively in bronze, but the copies of his work are mainly in marble.

This Greek vase shows the two types of **lyre** current in the ancient world. On the right is the *lyra* or *chelys* with its characteristic tortoiseshell sandbox, and on the left the *kithara*, or concert lyre, played by bards such as Homer. The lady in the centre plays a harp, while the figure to the left holds a pair of reed pipes. (British Museum, London)

Mabinogion, the, a collection of Celtic stories of which the Four Branches of the Mabinogi are the most outstanding. The title, derived from the Welsh word *mab*, 'youth', and subsequently applied to 'tales of youth', was given by Lady Charlotte Guest to her translation (1838–49) of the stories. They are taken from *The Red Book of Hergest* (1375–1425) and form part of a cycle of legends of ancient Irish and Welsh mythology and later myths, including the Arthurian legend, in Roman and Christian Britain.

Mabuse *Gossaert, Jan.

Macaulay, Thomas Babington (1800–59), British historian. His essay on Milton for the *Edinburgh Review* in 1825 brought him instant fame, and for the next 20 years he wrote many articles on historical and literary topics for the journal. His great work *History of England* (1849–55) was notable for its declamatory style, its thorough research, and its biting wit. His descriptive power was one of his great assets, as was the narrative momentum he was able to achieve. The *History*, one of the great best-sellers of the century, has never since gone out of print.

McCullers, Carson (Smith) (1917–67), US novelist and short-story writer. Her reputation is largely based on three novels set in her native South: *The Heart is a Lonely Hunter* (1940), *Reflections in a Golden Eye* (1941), and *The Member of the Wedding* (1946), dramatized by the author in 1950. They concern the loneliness, and quest for love and identity, of outsiders in small communities—adolescents, sexual outcasts, a deaf-mute. The novella which gives its title to the collection of stories *The Ballad of the Sad Café* (1951), dramatized by Edward Albee in 1963, continues these themes.

MacDiarmid, Hugh (Christopher Murray Grieve) (1892–1978), Scottish poet and critic. He was influenced by *Joyce's linguistic experiments in *Ulysses* and wrote lyrics in 'synthetic Scots', an amalgam of Scottish dialects taken from *ballads and other literary sources. In this mode he wrote poetry of great delicacy with detailed observations of nature. His masterpiece, *A Drunk Man Looks at the Thistle* (1926), is a mystical visionary poem presenting the poet's own image of place (Scotland) and time. Passionately devoted to Scottish independence from England, he was a founder of the Scottish National Party, and a communist. With his *First Hymn to Lenin* (1931), he initiated the leftist verse of the decade. He also wrote some remarkable poems in a Scottish form of English, but returned to standard English in *Stony Limits* (1934). His later work comprises a series of linguistically dense poems amounting to a modern *epic of the Celtic consciousness.

Mácha, Karel Hynek (1810–36), Czech poet. He is considered to be the greatest poet of Czech *Romanticism. *May* (1836) traces the revolt of the individual not only against society but against the order of the universe. The poem, which was not well received at the time, has exercised a continuing influence on Czech poets and critics in the 20th century. His unfinished poems, sketches, and novels show a mastery of the newly revived Czech literary language.

Machaut, Guillaume de (*c*.1300–77), French composer, associated with Rheims for most of his life. Although a cleric, Machaut wrote relatively little church music and it is for his secular songs that he was admired. He greatly expanded their length in comparison with earlier examples by *Adam de la Halle and L'Escurel, and introduced much more complex textures. They include simple settings (*lais* and *virelais*) and *polyphonic settings (*ballades and *rondos), all of which combine beauty with ingenuity. Perhaps the most famous of his songs is the rondo *Ma fin est mon commencement*, in which the second voice sings the music of the first voice backwards. His music is noted for its full use of the new rhythms and more flexible notation developed in the 14th century; they are true examples of the *ars nova style, with many syncopations, small note values (the minim appears for the first time) and complex repetition of the tenor part in diminished note values. His only surviving mass (the Notre-Dame Mass) is the earliest known setting for four voices.

Machiavelli, Niccolò (1469–1527), Italian statesman and political theorist. He was involved in political intrigue in the Florentine republic, and turned his experience to advantage in his writings, which include *The Art of War* (1517–20). His comedy *Mandragola* (*c*.1518) is a powerful *satire. His best-known work was *The Prince* (1513), an impassioned work of propaganda aimed to rouse Italians to a new sense of civic unity in face of foreign interlopers.

Mackenzie, Sir (Edward Morgan) Compton (1883–1972), British novelist and dramatist. He lived at various times in the Channel Islands, Capri, and Scotland, all of which provide settings for his many novels and plays. The best known are *Sinister Street* (1913–15) set in Oxford, and *Whisky Galore* (1947) a fictional account of a ship loaded with whisky and wrecked off the Island of Eriksay, which was later made into a successful film. An ardent Scottish Nationalist, he also produced books of travel, biography, essays, poems, and an entertaining biography *My Life and Times* (1963–71).

McKim, Mead, and White, New York-based US architectural firm founded in 1879 by Charles Follen McKim, William Rutherford Mead, and Stanford White. It was for many years the best-known architectural firm in the USA, with hundreds of buildings to its credit. Success initially came with houses and country clubs, but it then became renowned mainly for public buildings, in which it championed a monumental classical revival style, reflecting McKim's training at the École des *Beaux-Arts in Paris. The firm's works include Boston Public Library (1888–95) and Pennsylvania Railway Station in New York (1904–10).

Mackintosh, Charles Rennie (1868–1928), British architect and interior designer, the leader of the Glasgow School of *art nouveau and one of the most original and influential architects of his time. His furniture design and

The staircase and hall at Hill House, Helensburgh (1902), one of the two country houses designed by Charles Rennie **Mackintosh**. The restraint and austerity are typical of the graceful functionalism which characterizes Mackintosh's work. Mackintosh was responsible for the entire interior, down to the pewter fire tongs and poker.

interior decoration, often done in association with his wife, Margaret Macdonald (1865-1933), showed the characteristic calligraphic quality of art nouveau but avoided the exaggerated floral ornament often associated with the style. As an architect he worked in a clear, bold, rational style that did not, however, exclude an element of fantasy. His fame rests to a large extent on his Glasgow School of Art (1897-9) and its library block and other extensions (1907-9), but his interior decoration was perhaps most spectacularly expressed in the four Glasgow tea-rooms designed with all their furniture and equipment for Catherine Cranston (1897-c.1911, now mainly destroyed). Mackintosh's work was much exhibited on the continent of Europe and was extremely influential, so much so that the advanced style of the early 20th century was sometimes known there as 'Mackintoshismus'.

Mackmurdo, Arthur H. (1851-1942), British architect, interior designer, and writer. In two-dimensional design he was a pioneer of *art nouveau, but his architectural work was in a different spirit, showing a clarity of structure and independence from past styles that made him one of the most advanced figures of the 1880s and a forerunner of *Voysey. In 1882 he founded the Century Guild, a group of artist-craftsmen inspired by the ideas of *Ruskin and *Morris, and in 1884 he launched *The Hobby Horse*, a magazine that became a focal point for the *Arts and Crafts Movement. Mackmurdo gave up architecture in 1904 and devoted much of his later career to writing on economics.

MacMillan, Sir Kenneth (1929-), British dancer, choreographer, and director. He worked for both Sadler's Wells companies in the 1940s and 1950s, and was ap-

pointed resident choreographer (1965), and director of the *Royal Ballet (1970-7). He works also for *American Ballet Theatre. His dramatic skills and depth of characterization are shown in works like *Romeo and Juliet* (1965) and *Mayerling* (1978), although he has also made plotless works like *Diversions* (1961). He represents the expressionist direction of modernism in ballet and finds suitable subject-matter in historical characters such as *Anastasia* (1967).

MacNeice, (Frederick) Louis (1907-63), Irish poet. Both his childhood in Northern Ireland and his classical scholarship influenced his work. MacNeice's poetry shows an exceptional virtuosity of technique, using accented vowel correspondences, internal rhymes, half-rhymes, and ballad-like repetitions. At a time when poetry was much politicized, he remained non-aligned, but none the less attempted to make sense of the interactions of public and private life. *Letters from Iceland* (1937) was written with W. H. *Auden; *Autumn Journal* (1938) was a long verse meditation on the Munich crisis; *Modern Poetry* (1938) makes a strong plea for poets to 'cut a middle course between pure entertainment and propaganda'. During World War II MacNeice joined the BBC and wrote radio documentaries and parable-plays such as *The Dark Tower* (1947), with music by Britten.

Macready, William Charles (1793-1873), British actor, manager, and diarist, contemporary and rival of Edmund *Kean. A leading figure in the reform of the techniques of production and acting, he imposed the principle of theatrical unity based on the central concepts of the playwright. He re-established some of the text of Shakespeare in its original form, partially purging the adaptations introduced by Colley *Cibber. His theories on the production of drama and of styles of acting opened the way to the art of the modern theatre.

madrigal, a musical composition for several un-accompanied voices. The words are usually secular and light-heartedly amorous, though sometimes touching

upon deeper feelings. Pastoral, allegorical, and satirical subjects are also to be found. The madrigal is mainly *contrapuntal in style, involving much imitation in a sequence of contrasted but overlapping sections that follow the content of the poetry. The madrigal took shape in 16th-century Italy, achieving its finest flowering in the work of Marenzio, Gesualdo, and Monteverdi. It also took root in England, following the publication in 1588 of an Italian collection, *Musica transalpina*. Byrd, Morley, Gibbons, Wilbye, and Weelkes are among the many British composers who, inspired by the lyric poetry of the period, made outstanding contributions to this genre. The word madrigal had also been used in 14th-century Italy to describe a type of pastoral song for two or three voices.

maestà (Italian, 'majesty'), term in art used to describe a representation of the Virgin Mary and the infant Jesus in which the Virgin is enthroned as Queen of Heaven, surrounded by a court of saints and angels. The most famous example is the altar-piece painted by Duccio for Siena Cathedral in 1308-11.

Maeterlinck, Maurice (1862–1949), Belgian poet, dramatist, and essayist. He lived much of his life in Paris and was associated with the *Symbolists. He is chiefly

For centuries **madrigal** singing such as is shown on this 16th-century Italian painting, *Le Concert champêtre; le Chant,* was enjoyed as domestic music-making or on formal occasions. Its performers strove for a pure, clear sound to express many of the deepest emotions through music. (Hôtel Lallemant, Bourges)

remembered for his plays, most of which were produced at the Théâtre de l'œuvre, the home of symbolist drama. The most famous of these, *Pélleas et Mélisande* (1892), which was set to music by *Debussy in 1902, displays a simplicity and suggestive power shared by his principal collection of poetry, *Serres chaudes* (1889), and such essays as *La Vie des abeilles* (1901) and *La Mort* (1913).

Magnum Photos *Cartier-Bresson.

Magritte, René (1898–1967), Belgian painter, one of the outstanding artists of the *Surrealist movement. His work is characterized by startling and disturbing juxtapositions of the ordinary, the strange, and the erotic, and he had a repertory of obsessive images that appear again and again. He repeatedly exploited ambiguities concerning real objects and images of them (many of his works feature paintings within paintings) and between inside and out of doors, day and night. For the fertility of his imagination, the unforced spontaneity of his effects, and not least his rare gift of humour, he ranks as one of the very few natural and inspired Surrealist artists.

Mahabalipuram or Mamallapuram, a village in Tamil Nadu state, south-east India, on the Coramandel Coast, the site of a group of rock-cut shrines, some of them in caves, others hewn from hillocks. Built by the Pallava kings in the 7th and 8th centuries, the temples feature outstanding sculptural decoration. Because of the towering pinnacles of some of the temples, the site is sometimes called 'Seven Pagodas'.

The demon brothers Sunda and Upasunda fighting with raised clubs for the nymph Tilottama who stands between them being pulled both ways while others sit enthralled by the fatal contest. This rendering of the well-known story from the **Mahābhārata** is carved in relief on a pediment in the 10th-century temple of Banteay Srei (Kampuchea), the high-point of Khmer architecture and sculpture in the pre-Angkor period. (Musée Guimet, Paris)

Mahābhārata ('The Great Story of the Bharatas'), one of the two great *epics of *Sanskrit literature in India. Comprising 110,000 *couplets, it is probably the longest single poem in world literature. Its central theme is the struggle between two families of cousins, the Kauravas and the ultimately successful Pandavas, for control of Kurukshetra, the region north of Delhi. Woven around this story are various unconnected elements—myths, legends, folk-tales, and philosophical pieces, including the *Bhagavadgītā. The Mahābhārata is not the work of a single poet but representative of the whole range of ancient Indian bardic poetry, probably compiled between 400 BC and AD 400.

Mahler, Gustav (1860-1911), Austrian composer and *conductor. He had a very successful conducting career from 1880, specializing in the operas of Mozart, Weber, and Wagner. His first important composition, the cantata *Das klagende Lied*, was completed in 1880. Mahler's compositions consist of nine large-scale symphonies (1888-1909) (plus a detailed sketch for a tenth); a number of song-cycles, including *Lieder eines fahrenden Gesellen* (1885), *Des Knaben Wunderhorn* (1892-8), and *Kindertotenlieder* (1904); and *Das Lied von der Erde* (1909), a song-cycle with orchestral accompaniment. His Second, Third, Fourth, and Eighth Symphonies also involve large choirs and solo voices. Though his music is rooted in the grammar of late *Romanticism it constantly strains towards new sound-horizons in an effort to express powerful feelings of nostalgia and anxiety. Although it took some time to gain acceptance outside Austria and Germany, his music has had a considerable influence on later composers.

Mailer, Norman (1923–), US novelist, essayist, and journalist. His celebrated war novel *The Naked and the Dead* (1948) was followed by many others, from the Hollywood satire *The Deer Park* (1955, dramatized 1967) to the lengthy Egyptian fantasy *Ancient Evenings* (1983); but his reputation and celebrity are largely due to a mixture of journalism and autobiography, dealing with such topics as the Kennedy presidency, the 1960s anti-war movement, women's liberation, boxing, and the Apollo space programme. *The Executioner's Song* (1979) is a non-fictive novel about a convicted murderer.

Maillol, Aristide (1861-1944), French sculptor, painter, graphic artist, and tapestry designer. After 1900 he worked mainly as a sculptor, and from about 1910 received a constant flow of commissions. With only a few exceptions, his sculptures portray the female nude. His figures are weighty and solemn, often shown in repose, with simple poses and gestures. He consciously continued the classical tradition of Greek and Roman sculpture, but at the same time gave his work a quality of healthy sensuousness. He ranks as the most important figure in the transition from Rodin to modernist sculpture. Apart from sculpture, his finest achievement is found in his book illustrations, which helped to re-establish the art of fine book design in the 1920s and 1930s.

maiolica (or majolica, from its reputed place of origin, Majorca), a type of tin-*glazed earthenware decorated with bright colours over a white ground, popular during the Renaissance. Maiolica decoration often featured figurative scenes, many of them more or less freely adapted from engravings. There were factories in several Italian cities, and the fame of Italian maiolica led to the establishment of centres of production in northern Europe during the 16th century. The tin-glazed earthenware of northern Europe was known as faïence, after the Italian city of Faenza. Towards the middle of the 17th century the Dutch faïence industry became concentrated in Delft, hence the name 'delftware' to describe Dutch blue and white maiolica. Tin-glazed earthenware was also made in Bristol in the 17th and 18th centuries.

make-up (theatrical). Little is known about make-up in classical times, since most of the actors wore *masks. Two extremes of make-up used in later times were the gilding of God's face in *liturgical drama, and the elaborate painting of the actors' faces in the Kabuki plays of Japan (see *Japanese drama). In the open-air theatre of the Elizabethans there is evidence of some form of character make-up—black for Negroes, umber for sun-burnt peasants, red noses for drunkards, chalk-white for ghosts. Before the introduction of modern grease-paints, all make-up was basically a powder, compounded with a greasy substance or with some liquid medium, which was often harmful to the skin, particularly if white lead was used in its composition. Powder make-up also had the disadvantages of drying up and so hindering the mobility of the actor's features, or of melting and streaking

in the heat. Gas lighting led to changes in the art of making-up, and although the paints used were still powder-based, some form of grease was used as a foundation. A revolution in make-up was achieved in the second half of the 19th century by the introduction of grease-paint, invented in about 1865 by Ludwig Leichner, a Wagnerian opera-singer. He opened his first factory in 1873, and his round sticks, numbered and labelled from 1 to 54, were soon to be found in practically every actor's dressing-room. As well as the thick sticks of grease-paint which the actor was instructed to use over a slight coating of cocoa butter, which was also used to clean the face afterwards, there were thin sticks, or liners, used for painting in fine lines. The introduction of electric light again caused fundamental changes in theatrical make-up, which has also more recently been influenced by the techniques of film and television.

Malamud, Bernard (1914–), US novelist and short-story writer. Born in Brooklyn of immigrant Russian parents, he was one of the large group of Jewish-American writers who came to prominence in the 1940s and 1950s. His subjects are various, including a comic treatment of baseball in terms of a myth in *The Natural* (1952); a family grocery store in *The Assistant* (1957), in which the main character searches for the good life; a Western campus in *A New Life* (1961); and anti-Semitism in Tsarist Russia in *The Fixer* (1967). *The Tenants* (1971) treats conflicts between a white and a black writer, *Dubin's Lives* (1979) is about a famous author's marriage and love affair, and *God's Grace* (1982) is a pseudo-biblical fable about a man who begins a new civilization among apes.

malapropism, a confused, comically inaccurate use of a long word or words. The term comes from the character Mrs Malaprop (after the French *mal á propos*, 'inappropriately') in *Sheridan's play *The Rivals* (1775): her bungled attempts at learned speech include a reference to another character as 'the very pine-apple of politeness', instead of 'pinnacle'. This kind of joke, though, is older than the name: Shakespeare's Dogberry in *Much Ado About Nothing* (c.1598) makes similar errors.

Malay literature, poetry and prose writings in the Malay language, distributed over the Malay peninsula and archipelago. Much literature traditionally existed in oral form and has only comparatively recently been recorded in writing. The two most important verse-forms are the *pantun*, consisting of four lines rhymed ABAB, and the *syair*, a long, often *epic, poem narrating legendary and historical events. Among the genres of prose are *kitab*, didactic Islamic literature, *adab*, stories of the prophet Muhammad and of Muslim saints and heroes, and *hikayat*, epics with strong romantic and historical elements, of which the most famous is the *Story of Hang Tuah*. The *Malay Annals* are considered to be a literary masterpiece. Munshi Abdullah, author of *Story of Abdullah* (1849) and other works, is regarded as the first modern Malay writer, although his writing did not inspire a new literary movement. Modern novels and short stories first appeared in the 1920s, and often addressed contemporary social and moral issues. After World War II, the Singapore-based writers group *Asas 50* (Generation of '50) were influential. Although much drama is performed in Malaysia, little has been published.

Malevich, Kasimir (Severinovich) (1878–1935), Russian painter and designer. Early in his career he was influenced by *Impressionism and *Futurism, and created a distinctive style by combining these styles with Russian themes and motifs. Desiring, however, 'to free art from the burden of the object', he launched a movement called *Suprematism in 1915. He used only basic geometrical shapes and a severely restricted range of colour, culminating in 1918 with a series of *White on White* paintings showing a white square on a white background. Thereafter he virtually abandoned abstract painting for teaching, writing, and making three-dimensional models that were important for the growth of *Constructivism. His work was at odds with the ideals of the newly created Soviet Union and he died in neglect, but he had immense influence in western Europe on both painting and commercial design.

Malherbe, François de (1555–1628), French poet. Official poet to Henri IV from 1605, he reacted against the linguistic exuberance of *Ronsard and the Renaissance verse-forms of the Pléiade group, and was credited by *Boileau with inaugurating the poetic diction which characterized 17th-century literature. His preference for order and clarity has led most readers to feel that, like most of the poetry of the 17th and 18th centuries, it is cold and excessively formal.

Mallarmé, Stéphane (1842–98), French poet. He was a leader of the *Symbolists, many of whom, between 1885 and 1894, met at his home each week. His earlier and more accessible poems, 'Les Fenêtres' and 'Brise marine' evoke an idealism reminiscent of *Baudelaire; his mature masterpiece 'L'Après-midi d'un faune' inspired an orchestral prelude by Debussy. Mallarmé's poems, which include an experimental piece entitled 'Un coup de dés', are frequently obscure, for he sought primarily

An Italian **maiolica** roundel (1525) showing the Three Graces. Maiolica was once known as Raphaelle-ware since it was thought the young Raphael had painted plates. (Victoria and Albert Museum, London)

a suggestive power achieved through rhythm and symbol and did not court popular success.

Malle, Louis *Nouvelle Vague.

Malory, Sir Thomas (d.1471), English writer, the author of *Le Morte d'Arthur*, a long prose narrative retelling the legends of King Arthur. Malory's identity remains uncertain, but his work was completed 1470, and printed by Caxton in 1485. It follows various sources, mainly French, and is the standard source for later versions in English of the *romances that have been retold many times throughout Europe: the exploits of the Knights of the Round Table, the quest for the Holy Grail, the loves of Launcelot and Queen Guinevere and of Tristram and Iseult. Malory's prose is direct and fast-moving, enlivening even the more fantastic episodes, and achieving a dramatic simplicity, as in Launcelot's last parting with Guinevere, or the lament for his king. (See also *Middle English literature.)

Malraux, André (1901–76), French novelist. His novels exploit the potential of some of the 20th century's most dramatic events, the Spanish Civil War (*L'Espoir*, 1937), and the early days of the Chinese communist uprising (*La Condition Humaine*, 1933). In several respects he anticipates the existentialism of *Sartre, for it is through consciously chosen action that his characters confer meaning on their existence. Art alone, says Malraux in a work of criticism, *Les Voix du silence* (1951), achieves a permanence denied to man.

Mamluk art, the art and architecture associated with the military caste, originally Turkish slaves (Arabic, *mamluk*, slave), who ruled Egypt from about 1250 to 1517 and at times had dominion over Palestine and Syria. The Mamluks acquired immense wealth through trading, and were great builders. Stylistically their buildings were conservative, but they were superb stonemasons and sometimes used contrasting coloured stones to create decorative effects. Their love of decoration is evident in their highly ornamented minarets and elaborate portals. The old quarters of Aleppo, Cairo, Damascus, and Jerusalem are among the places with extensive Mamluk remains. Mamluk wealth also helped luxury crafts to flourish, metalwork, woodwork, and glass being fields in which Mamluk skill was particularly renowned.

Mandelshtam, Osip (Emilyevich) (1891–1938), Russian poet and literary critic. He emerged as one of the leading post-*Symbolists with *Stone* (1913); in *Tristia* (1922) he struck a new note in Russian poetry, characterized by dense metaphors, the suppression of logical links, and an abundance of cosmopolitan cultural references. He was out of tune with post-Revolutionary literary and intellectual life, and published no books of poetry after 1928. In 1934 he was arrested for reading an *epigram on Stalin to a small circle of friends, and exiled for three years. He began writing poetry again, committed to memory by his wife Nadezhda and published abroad more than twenty years after his death. Mandelshtam was re-arrested in 1938, and died in a prison camp. Rehabilitated in 1956, he was substantially republished in the Soviet Union only in the 1970s. He is immortalized in his widow's two volumes of memoirs, *Hope Against Hope* (1970) and *Hope Abandoned* (1974).

mandolin, an Italian stringed musical instrument. There are numerous varieties: Vivaldi and other early composers wrote for the Milanese mandolin, which has six pairs of gut strings plucked with the fingers; today the best known is the Neapolitan, which has four pairs of wire strings, is tuned like a violin, and plucked with a *plectrum. Both have rounded backs, the Neapolitan being the deeper. A Sicilian variant of the Neapolitan has a flat back, and was the origin of the American mandolin, which also has a flat back and usually an arched belly.

mandora, a name, with variants such as mandore, pandore, mandola, and so on used for a variety of small treble *lutes, most with rounded backs (though the Spanish *bandurria* usually has a flat back), from the 16th century onwards. Some were ancestral to the *mandolin.

Manet, Édouard (1832–83), French painter and graphic artist, one of the most important figures of 19th-century art. The modernity of his work outraged critics and he was unwillingly cast in the role of an artistic rebel. His *Déjeuner sur l'herbe* (1863), showing a naked woman having a picnic with two clothed men, was refused by the official *Salon in 1863, and was the most abused work at the *Salon des Refusés*, set up specially in that year for such rejected paintings. Two years later his *Olympia*, showing a naked courtesan gazing blatantly out at the spectator, was even more furiously attacked when it was exhibited at the official Salon. Manet was denounced not only for his subject-matter, but also for his bold technique, which flouted academic conventions; because of his freshness of approach, however, he was looked upon as an

This enamelled glass Egyptian mosque lamp made for the **Mamluk** Sultan al-Malik al-Nāshir dates from the early 14th century. Glass-making flourished under the Mamluks, particularly in Syria which inherited the earlier Roman tradition. (Ashmolean Museum, Oxford)

inspiration by the *Impressionists. He adopted their practice of painting out of doors and in the 1870s his work became freer and lighter under their influence. Apart from modern-life themes, Manet painted a great variety of other subjects and was also an outstanding etcher and lithographer. His approach was completely undogmatic and his pictures often seem to be more concerned with the act of painting than with the ostensible subject, although in some works he comments obliquely on current political issues. It is partly in this freedom from the traditional literary, anecdotal, or moralistic associations of painting that he is seen as one of the founders of 'modern' art.

Manipuri, classical *Indian dance from the valley of Manipur in the Assam hills, an area that remained isolated from outside influences until the 1920s. Female Manipuri dancers move with slow, undulating rhythms, the immobility of the face being characteristic and in sharp contrast to the other classical forms. The Manipuri drummer is male, and dances in a frenzied, energetic fashion to the rhythms of his drum. Atomba Singh and Amubi Singh are notable 20th-century performers.

Mann, (Luiz) Heinrich (1871–1950), German novelist, dramatist, and short-story writer; elder brother of Thomas *Mann. While his early works deal with the artistic outsider or the quest for self-fulfilment, a strong democratic commitment infuses his mature writings. In *Professor Unrat* (1905, filmed as *The Blue Angel*, 1930) and *Man of Straw* (1918) he exposes the corrupting force of authority and subservience in *fin-de-siècle* Germany. Deprived of his German citizenship by the Nazis (1933), he went into exile in France, where he wrote *Henri Quatre-Romane*, two novels on the life of Henry of Navarre, which are generally held to be the summit of his achievement.

Mann, Thomas (1875–1955), German novelist and writer of short stories and essays. His elder brother was Heinrich *Mann. His first novel, *Buddenbrooks* (1901), traces the decline of a family of merchants through four generations, as sound business practice gives way to refined aesthetic sensibility. It was for this work that Mann received the Nobel Prize for Literature in 1929. In numerous shorter works he explores the position of the writer, whose creativity depends on a renunciation of full participation in life. *Tonio Kröger* (1903) traces the consequences of the neglect of safe, acceptable habits; *Difficult Hour* (1905) explores an episode from the life of Schiller; while *Death in Venice* (1912; film by Visconti, opera by Britten) depicts the sacrifice of a man's identity and sense of dignity in exchange for the superior experience of beauty and art. *The Magic Mountain* (1924) follows the tradition of the *Bildungsroman* in that it shows the maturing, through error, of a man's character. It is an eloquent and complex commentary on the introverted civilization contained within a sanatorium, the symbol of a sick Europe. In the 1920s Mann's earlier support of German authoritarianism yielded to an acknowledgement, expressed in the story *Mario and the Magician* (1930), of the danger presented both by the fascist dictator and the intellectual coward. Exiled from Germany after 1933, he wrote a biblical tetralogy, *Joseph and His Brothers* (1933–43); a semi-fictional portrait of the elderly Goethe, *Lotte in Weimar* (1939); and *Doktor Faustus* (1947), in which a composer's creative impasse is interwoven with

both the legend of Faust and the degeneration of Germany in Mann's lifetime. Deprived of his German citizenship in 1936, Mann became a citizen of the USA in 1944, and spent the last years of his life in Switzerland.

Mannerism (Italian *maniera*, style or stylishness), a term used in the study of the visual arts. It was popularized by the writings of the 16th-century artist and biographer *Vasari, who used it as a term of praise, signifying qualities of grace, poise, and sophistication. From the 17th century, however, most critics thought that the Italian art of the mid- to late 16th century marked a decline from the peaks reached during the High *Renaissance by Leonardo, Michelangelo, and Raphael, and the term 'Mannerism' came to describe an art characterized by artificiality, superficiality, exaggeration, and distortion. From being a stylistic label the term expanded its meaning to become a period label, so that 'Mannerism' came to designate the style adopted by some schools of Italian art—in particular the Roman—between the High Renaissance and *Baroque from about 1520 to about 1600. The origins of Mannerism are generally traced back to the late works of Raphael when he was moving away from the supremely clear and balanced idiom of the High Renaissance to a more complex and emotional style. Apart from emotionalism, the qualities associated with Mannerist art include elongation of the figure, strained *contrapposto poses, unusual or bizarre effects of scale, lighting, or perspective, and vivid, sometimes harsh or lurid, colours. In sculpture, the archetypal Mannerist was *Giambologna, whose elaborate twisting poses and smoothly flowing and polished forms were immensely influential. Benvenuto *Cellini is also numbered among the leading Mannerist sculptors, as well as representing the highpoint of Mannerist virtuosity in goldsmiths' work. *Michelangelo was much the greatest sculptor of the age, but although some critics characterize his work (or certain examples or aspects of it) as Mannerist, others consider him so original and personal that he lies outside categorization. Mannerism in architecture is generally as difficult to define and isolate as it is in painting and sculpture, but it is often taken to involve the deliberate flouting of the accepted rules and conventions of classical architecture. Michelangelo, who was extremely inventive and free in his handling of architectural ornament, is often cited as the fountainhead of Mannerist architecture, but the first great Mannerist building is generally agreed to be *Giulio Romano's Palazzo del Tè in Mantua (begun 1526), in which Giulio wilfully and wittily handles the decorative features in such a way that certain blocks of stone seem to have slipped out of their rightful place. Outside Italy, the term 'Mannerism' is most readily applied to the School of *Fontainebleau in France. Other non-Italian art that has been called Mannerist includes much work by 16th-century Netherlandish artists (many of whom visited Italy and took back only partially digested ideas) and the ecstatic paintings of El *Greco in Spain. In the fields of literature and music, the term 'Mannerism' is even more loosely and controversially applied than it is with art and architecture. Writing characterized by ornateness, involved syntax, and the use of far-fetched images has sometimes been dubbed Mannerist, the best-known English exemplar being the prose romance *Euphues* (two parts, 1578 and 1580) by John Lyly, a work that gave rise to the term Euphuism, meaning a highly artificial and affected

literary style. In music the term 'Mannerism' has been applied, for example, to the Italian madrigal composer Carlo *Gesualdo, whose work is characterized by unusual harmonies, sudden changes of tempo, and vivid expression.

Mannheim School, the name given, for convenience, to the group of conductors, violinists, and composers associated with the electoral court of Mannheim in south-western Germany, in the 18th century, in particular the court of Prince Carl Theodor of Mannheim between 1742 and 1778. By the middle of the 18th century the court orchestra was acknowledged to be the finest in Europe, and the Mannheim composers, who also played in it, were thus able to use its resources as a testing ground for experiments which greatly contributed to the development of the early *symphony. The composers include Johann *Stamitz and his sons Karl and Anton, Ignaz Holzbauer, Franz Xaver Richter, and Johann Christian Cannabich. The Mannheimers were famous for their orchestral discipline: precision of attack, uniform bowing, and attention to dynamic detail.

Mansart, François (1598–1666), the greatest French architect of the 17th century, who like his contemporary *Poussin in painting represents the French classical spirit

Mantegna's painting of *The Agony in the Garden* (c.1460) is similar in composition to a version of the same subject of about the same date by Giovanni Bellini (*see p. 43*); both pictures, in fact, derive from a drawing of the subject by Mantegna's father-in-law (Giovanni's father) Jacopo Bellini. The two paintings are very different in style, however; Mantegna's has a ringing clarity, whereas Giovanni's is much more atmospheric. (National Gallery, London)

at its purest and most elevated. Mansart completed few buildings because he refused to accept even the most reasonable restrictions from his patrons or to keep to an agreed plan, leading frequently to his dismissal. The only building where he seems to have been allowed a completely free hand was his masterpiece, the château of Maisons (now Maisons-Lafitte) near Paris (1642–6). Its patron went as far as allowing Mansart to pull down part of the building during construction so that he could revise his design. It displays to the full the typical characteristics of his style: grandeur, lucidity, subtlety, refinement and precision of detail, and a kind of severe luxuriousness depending on sheer quality of workmanship rather than richness of materials. Among the architects influenced by his work was his great-nephew Jules *Hardouin-Mansart.

Mansfield, Katherine (Kathleen Mansfield Beauchamp) (1888–1923), New Zealand-born short-story writer. After 1903 she lived mainly in England. Her first collection of stories, *In a German Pension* (1911), was published the year she met the critic and essayist John Middleton Murry, whom she married in 1918 and in whose magazine, *Rhythm*, some of her stories, many of them based on her New Zealand childhood, were published. *Bliss, and other stories* (1920) and *The Garden Party and other stories* (1922) were the only other collections published before she died of tuberculosis. Her stories vary from the long, delicate evocations of family life ('Prelude') to short, pointed sketches ('Poison'). Posthumous publications include two collections of stories, letters, and extracts from her journal.

Mantegna, Andrea (1431–1506), Italian painter, one of the most famous artists of the early *Renaissance. His

distinctive style was characterized by sharp clarity of drawing, colouring, and lighting, a passion for archaeology and the ancient world, and a mastery of *perspective and foreshortening unequalled in the 15th century. In 1460 Mantegna moved from Padua to Mantua as court painter to the ruling Gonzaga family. His greatest work is the *fresco decoration of the Camera degli Sposi (bridal chamber) in the Gonzaga palace, where he painted illusionistic architecture that appeared to extend the real space of the room. This was the first time since antiquity that such a scheme had been carried out and Mantegna's work became the foundation for much subsequent decorative painting in this vein. His other great work for the Gonzaga was a series of nine paintings on *The Triumph of Caesar* (c.1480–95). He was also an engraver and one of the first artists to use prints to spread knowledge of his work.

Manueline style, a style of architectural decoration found only in Portugal and named after King Manuel I, with whose prosperous reign (1495–1521) it roughly coincided. Merging *Gothic, *Moorish, *Renaissance, and possibly Indian influences it was characterized by richly encrusted carved ornamentation, the most common feature being a twisted rope motif, used for tracery, vault ribs, columns, pinnacles, and so on. The style also spread to the decorative arts.

Man'yōshū, Japanese classical poetry collection. The twenty books and over 4,500 poems in this *Collection of Ten Thousand Leaves* date from earliest times up to AD 759. They are popular as the earliest example of a Japanese literary voice before major influences from Chinese culture became apparent.

Manzoni, Alessandro (1785–1873), Italian novelist and poet, author of the novel *The Betrothed*. In a long series of painstaking revisions from its first published version (1825–7) to its final form (1840–2), it forged from Tuscan the literary Italian which, after the unification of Italy (1870), became standard Italian. It is also remarkable for its powerfully characterized historical reconstruction of 17th-century Lombardy under Spanish domination and ravaged by the plague. Manzoni also wrote two historical tragedies in verse, *The Count of Carmagnola* (1820) and *Adelchi* (1822), which deal with the relationship between oppressed and oppressors, and the role of divine providence in history. He was the subject of the great Requiem Mass by Verdi.

Maori art, the art of the Maori people of New Zealand, who settled there about 1,000 years ago. Archaic Maori art reflects its eastern *Polynesian origins, with a restricted range of geometric and rectilinear forms, often decorated with chevrons, spikes, and edge-notches. Small amulets, necklaces, and pendants of stone and bone are most common, along with cave paintings in the South Island. Gradually, later classic Maori art developed a wider range of bold, curvilinear forms, expressed in woodcarving, jade-work, and body tattoo. The women's arts of plaiting and weaving continued the earlier angular geometric patterns on mats and cloak borders. War canoes, dwelling houses, storehouses, and smaller items were all decorated with high-relief ancestral figures. Gods were only rarely represented. Two major regional carving styles evolved, slightly separated in time. The earlier style

of sinuous, intertwined figures produced with stone tools became concentrated in northern and western areas, reaching its greatest development just before European settlement. In the later 19th century, the central and western style of straight, full-fronted figures flourished, encouraged by the introduction of metal tools. By the 1870s, large, fully carved meeting houses became the main vehicle for Maori arts, as they still are today.

A panel from the Te-Hai-Ki Turanga meeting house, showing an ancestress breastfeeding her child. Skill at woodcarving is one of the main features of **Maori art**, the elaborate treatment of the surface being typical. (National Museum of New Zealand, Wellington)

A panel from the Alexander sarcophagus (c.325–300 BC), probably carved for a client king in Phoenicia, and excavated in 1887 from the royal burial-ground of Sidon. The **marble** relief shown here represents a hunting scene in realistic detail. (Archaeological Museum, Istanbul)

Maori music, the music of New Zealand's indigenous people, who migrated from eastern Polynesia about 1,000 years ago in several waves. Maori music is predominantly vocal, consisting mainly of unison group singing either recited or sung. In the former, words are chanted in a rapid monotone, as in the *pātere*, traditionally sung by slandered women, the *karakia*, intoned spells, and the strongly rhythmic *haka*, posture war dances (which are further characterized by shouting, jumping, and facial distortion). Sung-style chants have melodies using small steps within a narrow range and are mainly strophic (that is, the same melody serves a number of verses). Examples are *waiata tangi*, laments for the dead; *waiata aroha*, and *waiata whaiāipo*, love songs; *pao*, short, extemporized songs about everyday life; and the *poi*, a spectacular dance with sung accompaniment, in which women swing decorated balls on strings. Instruments include the *pahū*, a large *slit drum, the *pūtātara*, a shell trumpet used for signalling, the wooden war trumpet *pūkāea*, and the flutes *kōauau* and *nguru*, used to accompany *waiata*.

maqām *West Asian music.

maracas, a pair of *rattles used in Latin American music. They are made from gourds, with a stick as the handle, with the seeds left inside to rattle or with pellets such as small stones inserted. Coconut shells are sometimes used instead, and nowadays plastic is common. Proper maracas are always made so that one is lower pitched than the other.

Maratta, Carlo (or Maratti) (1625–1713), Italian painter, the leading painter in Rome in the latter part of the 17th century. He was an heir to the classical tradition of *Raphael, but his work also has the rhetorical splendour of the *Baroque style, shown in the many altar-pieces he painted for Roman churches. Maratta was an accomplished fresco painter and the finest portraitist in Rome.

marble, a hard, crystalline rock formed when limestone has been subjected to great heat and pressure; it can take a high polish and has been much used in sculpture and architecture. Certain types of marble have been particularly prized by sculptors. Among the Greeks the favourite was the close-grained Pentelic marble, quarried at Mt. Pentelicon in Attica; it is from this that the sculptures of the Parthenon are carved. The pure white Carrara marble, quarried at Carrara, Massa, and Pietra Santa in Tuscany, is the most famous of all sculptors' stones and was the favourite material of Michelangelo.

Marc, Franz (1880–1916), German painter, a founder of the *Blaue Reiter group and one of the most powerful and inspired of *Expressionist artists. A man of deeply religious disposition, Marc was troubled by a profound spiritual malaise, and through painting he sought to uncover mystical inner forces that animate nature. His ideas were expressed most intensely in paintings of animals, for he believed that they were both more beautiful and more spiritual than man. Using non-naturalistic, symbolic colour and simplified, rhythmic shapes, he aimed to paint animals not as we see them, but as they feel their own existence. By 1914, under the influence partly of *Cubism and *Futurism, his paintings had become almost entirely abstract, as in the celebrated *Fighting Forms* (1914). He was killed in action in World War I.

Marceau, Marcel (1923–), French actor, the finest modern exponent of *mime. In 1945 he joined the company of *Barrault, but a year later abandoned conventional acting to study mime, basing his work on the character of the 19th-century French *Pierrot and evolving his own character, Bip, a white-faced clown with sailor trousers and striped jacket.

march, music designed to help keep groups of marching people in step, often in 2/2 time. The military march began as a simple drum beat that enabled soldiers to keep in step. Fife tunes were added later, and the instrumentation developed through the 17th-century wind band to the full military band of the present day. Marches, concert or military, generally follow the three-part ABA form known as march and trio, the trio being more lyrical in style than the main march. The concert march, scored for symphony orchestra, is usually

more subtle than the practical military march. The US composer John Philip Sousa (1854–1932) was a famous composer of marches; his output during his career as a band-leader numbered more than 130. His style displays melodic inventiveness and great rhythmic vigour.

Marenzio, Luca (c.1553–99), Italian composer famous as a composer of *madrigals, *villanelle*, and *canzonette*. They are noted for their expressive word-painting and the intensity with which they convey emotion. In 1588 Marenzio entered the service of the Medici in Florence, where he composed the music for the second and third *intermedii of *La pellegrina*. In 1589 he returned to Rome, and in the 1590s he spent some years at the Polish court.

marimba *xylophone.

marine painting, painting of scenes relating to the sea or shipping. It was in the 17th century that marine painting first became an independent subject for artists. Initially it was a Dutch speciality: Holland at this time won its independence from Spain, and pictures of the ships that represented the country's strength appealed greatly to national pride. The most famous of Dutch marine painters, Willem van de Velde the Younger, moved to England with his father in 1672 and they founded the great tradition of marine painting in England, of which Turner was the outstanding representative.

Marino, Giambattista (1569–1625), Italian poet, best known for his *Adone* (1623), a long poem on the love of Venus and Adonis. The term *marinismo* (or sometimes *secentismo*) denotes the flamboyant style of Marino and his 17th-century imitators, with its extravagant imagery, excessive ornamentation, and verbal *conceits.

Marivaux, Pierre Carlet de Chamblain de (1688–1763), French dramatist and novelist. He rejected the stylistic virtues of absolute clarity and simplicity enunciated by *Boileau in favour of a more subtle, individual style, which came to be known as *marivaudage*. His best-known plays, including *La Double Inconstance* (1723), *Le Jeu de l'amour et du hasard* (1730), and *Les Fausses Confidences* (1737), offer a close analysis of the growth of love from its birth until the moment of avowal. His two major novels, *La Vie de Marianne* (1731–42) and *Le Paysan parvenu* (1734–5), both unfinished, reflect the increasing importance of sentiment in 18th-century literature.

Marlowe, Christopher (1564–93), English dramatist and poet. He was involved in political intrigues and in several violent incidents that culminated in his murder in a tavern at the age of 29. An admired literary figure, he gave new strength and variety to *blank verse in English drama, preparing the way for *Shakespeare, on whose work his influence is stamped. His tragedy *Tamburlaine the Great* was probably first produced in 1587. *The Tragicall History of Dr Faustus* (c.1593), the first dramatized version of the legend of the scholar who sells his soul to the devil, is more a series of detached scenes than a finished drama. *The Famous Tragedy of the Rich Jew of Malta* (c.1592) is uneven in quality, and degenerates into caricature. *Edward II* (1594) is the most mature of his plays. Marlowe's unfinished work *Hero and Leander* (1598) is an erotic poem in *heroic couplets of outstanding grace and eloquence.

Marot, Clément (1496–1544), French poet. He belonged to a circle of court poets, many of whom shared his moderate reformist leanings, and eventually left France for Italy as a result of the persecution of Protestants. His religious concerns bore fruit in his translations of the first fifty psalms of the Bible (1543), which became the basis for the Protestant Psalter. His use of medieval forms such as the *rondeau* (see *rondo) and *ballade recalls *Christine de Pisan and *Villon, but later in his career he shows signs of Italian and classical influences.

marquetry, in furniture-making, a *veneer made of pieces of wood or other suitable materials (ivory, for example) shaped and fitted together to form a design. If the design forms a regular geometric pattern it is called parquetry. Marquetry originated in Germany and the Low Countries in the 16th century and spread to France and Britain in the 17th century.

Martial (Marcus Valerius Martialis) (AD c.40–c.104), Latin poet, originally from Spain. His early poem on *Spectacles* commemorates the building of the Colosseum in Rome, but he is best known for twelve books of *epigrams, mostly in elegiac *couplets, reflecting all facets of Roman life, and marked by witty realism and coarseness. In his day he was widely read, and known, he claimed, even in Britain.

In the 17th century Dutch craftsmen used the rare tropical woods found along the Dutch trading routes to bring the art of **marquetry** to new heights. The cabinet (c.1690) by Jan van Mekeren, one of the best-known craftsmen in the style, is typical in the marquetry pictures of flowers in vases and comparatively simple outline, contrasting with the wealth of decoration. (Victoria and Albert Museum, London)

Martin, John (1789–1854), British *Romantic painter and mezzotint engraver, celebrated for his scenes of cataclysmic events, crowded with tiny figures, and placed in vast architectural settings. Martin made mezzotints not only as a means of reproducing his paintings, but also (unusually) as original compositions, notably as illustrations to the Bible and Milton's *Paradise Lost*, subjects to which his vividness and grandiloquence of imagination were ideally suited. Some critics dismissed his work as sensationalist and after his death his reputation declined, though in the 1970s he once again became fashionable.

Martin du Gard, Roger (1881–1958), French novelist. His best-known work, *Les Thibault*, tells the story of two brothers whose private lives are set in the context of the years leading up to World War I. Its themes are the complexity of personal relationships, death, agnosticism, and pacifism. The novel is in seven separate parts, following the form of the cyclical novel used by *Rolland and *Romains among the author's contemporaries and previously by *Balzac and *Zola. He was awarded the Nobel Prize for Literature in 1937.

Martinů, Bohuslav (Jan) (1890–1959), Czech composer. A prolific composer, his works range over almost every musical genre. All his important work dates from after his studies with *Roussel in Paris. He is best known for the *Surrealist opera *Julietta* (1937) and for the six symphonies he wrote between 1942 and 1953. Fear of Nazi persecution took him to the USA (1941), but his last years were spent mainly in Italy and Switzerland.

Marvell, Andrew (1621–78), English poet, politician, and satirist. As a young man he had friends among Royalist supporters of Charles I and was identified with the *Cavalier poets, but his 'Horatian Ode' (1650) shows his admiration for Oliver Cromwell as well as his respect for the executed king. During the Commonwealth he was an active political writer in the Puritan cause; in 1657 he became Latin Secretary to the Council of State, and in 1659 he was elected Member of Parliament for Hull, a post he held until his death. After the Restoration, Marvell turned to verse *satire. His *lyric poems (which were revived in the 19th century by Charles Lamb, and in the 20th by T. S. Eliot) show a classical mastery of rhythm and rhyme, and are distinguished by their clear and dignified language, though his use of *conceits places him among the *Metaphysical poets. Among his best-known poems are 'The Garden', with its description of the author's mind at peace amid nature, and the fine love poem 'To His Coy Mistress'.

Masaccio (Tommasso di Ser Giovanni di Mone) (1401–28), Italian painter. Although he died very young he brought about a revolution in painting and can be considered one of the founding fathers of *Renaissance art. His work recaptured the gravity and grandeur of *Giotto, but whereas Giotto set his figures in space intuitively, Masaccio solved the problem of creating a completely coherent and consistent sense of three dimensions on a two-dimensional surface. His achievement was based on his mastery of the new science of *perspective and his use of a single constant light source to define the structure of the body and its draperies. Before his death in Rome, which was so sudden that there were rumours of poisoning, Masaccio left three great

Mask carving is an important art in Japan, and wooden masks such as these from the No Theatre of the Kongo School, Kyoto, complement the beauty of the actors' elaborate robes. Most costumes are based on the court hunting dress evolved during the 9th and 13th centuries.

works to posterity: a polyptych (multi-panelled altarpiece) of 1426 for the Carmelite church in Pisa; a fresco cycle on the life of St Peter in the Brancacci Chapel of Santa Maria del Carmine, Florence (c.1425–8); and a fresco of the *Trinity* in Santa Maria Novella, Florence (probably 1428).

Mascagni, Pietro (1863–1945), Italian composer. The brutal realism and uninhibited tunefulness of his one-act opera *Cavalleria rusticana* (1890) took Italy by storm and it soon conquered the world's opera houses. Later works, such as *L'amico Fritz* (1891) and *Iris* (1898), were altogether finer and more imaginative. Mascagni died discredited by his association with Mussolini's fascism and disillusioned by his failure to match the success of his first opera.

Masefield, John (Edward) (1878–1967), British poet and dramatist. After a happy early childhood in Herefordshire (described in *Grace Before Ploughing*, 1966), he enrolled in the Merchant Navy, deserted ship, and wandered in the USA. Back in England, he published his poems of the sea, *Salt-Water Ballads* (1902), followed by many other best-selling books of poems, novels, and plays; they include the long, realistic narrative poems such as *Dauber* (1913), which reflects the ceaseless struggle of the visionary man against materialism, and *Reynard the Fox* (1919), which paints a picture of rural life in England. His children's story *The Midnight Folk* (1927) remains popular. Masefield became *Poet Laureate in 1930.

mask, a covering for the face with openings for the eyes and mouth. Originally made of carved wood or painted linen, later of painted cork, leather, or canvas, and later still of papier-mâché or lightweight plastics, masks in the theatre derive from the use of animal skins and heads in primitive religious rituals. In the Greek theatre, masks served, in an all-male company, to distinguish between

the male and female characters and to show the age and chief characteristic of each—hate, anger, fear, cunning, stupidity. In tragedy the mask gave dignity and a certain remoteness to demi-gods and heroes, and also enabled one actor to play several parts by changing his mask. In comedy the mask helped to unify the members of the chorus (who wore masks of such creatures as frogs, birds, horses, etc.) and served as an additional source of humour, particularly with the comic masks of slaves. The Roman theatre took over the tragic masks from the Greeks (though not in the mime), adopting the later exaggerated form with a high peak over the forehead. The golden masks worn by God and the archangels in some versions of the medieval mystery play may have been a survival of the Greek tragic mask or an independent discovery of the new European theatre; but the devils' masks, though often comic in intention, seem by their horrific animal forms to be linked to early primitive religious usage. The comic actors of the *commedia dell'arte* always wore masks, usually the small black 'cat-mask' which left the lower part of the face bare. Otherwise masks, which continued to be an essential feature in the No play of Japan and in other Far Eastern theatres, were discarded in Europe, and they are seldom seen on stage, though they are sometimes used for special effects. (See also *African masks and masquerades, *make-up (theatrical).)

Masolino da Panicale (c.1383–c.1447), Italian painter. His career is closely linked with that of *Masaccio, but the nature of the association remains ill-defined. They worked together on the decoration of the Brancacci Chapel in Santa Maria del Carmine in Florence (c.1425–8). After Masaccio's death Masolino reverted to the more decorative style he had practised early in his career. At his best he was a painter of great distinction.

masonry, a term that can in its broadest sense be applied to any kind of stonework, *brickwork, or concrete construction, but which is usually more specifically applied to high-quality stonework. A great many different kinds of stone have been used in masonry, often what was available locally, but sometimes transported over long distances. The craft was brought to a high level of accomplishment in ancient times, and both the Greeks and the Incas built complex stone structures without the use of mortar, relying on extreme precision in the cutting and fitting of the blocks. Ashlar is masonry in which the blocks are carefully squared and laid in horizontal courses with fine joints, presenting a smooth surface. Rubble masonry, in contrast, consists of irregularly shaped stones.

masque, a spectacular kind of indoor performance combining poetic drama, music, dance, song, lavish costume, and costly stage effects, which was favoured in England in the first half of the 17th century. Members of the court would enter disguised, taking the parts of mythological characters, and enact a simple *allegorical plot, concluding with a dance joined by members of the audience. Shakespeare included a short masque scene in *The Tempest* (1611), and the music for Milton's masque *Comus* (1634) was written by Henry *Lawes. At the courts of James I and Charles I the highest form of the masque proper was represented by the quarrelsome collaboration of *Jonson with the designer Inigo *Jones from 1605 to 1631 in the hugely expensive *Oberon* (1611) and other works.

mass, the principal service of the Roman Catholic Church, in which bread and wine are consecrated and consumed. There are two types of mass: the High Mass, which is sung, and the Low Mass, which is spoken. The most important parts of the High Mass are the five sections that never vary, and are said to constitute the Ordinary of the mass. They are: *Kyrie eleison* ('Lord have mercy'); *Gloria in excelsis Deo* ('Glory be to God on high'); *Credo in unum Deum* ('I believe in one God, the Father Almighty'); *Sanctus* and *Benedictus* ('Holy, holy, holy, Lord God Almighty' and 'Blessed is He that cometh in the name of the Lord'); and *Agnus Dei* ('Lamb of God, that takest away the sins of the world, have mercy on us'). These texts, and their traditional *plainsong, were established during the 7th to 11th centuries and have been set to music by composers ever since. The Proper of the mass consists of those parts that vary from season to season. They are always sung to plainsong. The Protestant equivalent of the mass is the Office of Holy Communion. The parts that are set to music (always in the vernacular) are the *Kyrie*, *Credo*, *Sanctus*, and *Gloria*. Settings of the mass achieved their greatest devotional intensity during the *polyphonic period (roughly 1300 to 1600). Settings made in the 17th and 18th centuries, though musically fine, tended to be too beholden to the secular fashions of the day to be entirely satisfactory as vehicles for liturgical observance. Certain examples, such as Bach's B minor Mass and Beethoven's *Missa Solemnis*, transcend both fashion and liturgy.

Massenet, Jules (Émile Frédéric) (1842–1912), French composer. His first performed opera was heard in 1867 and success came in 1872 with his sixth opera, *Don César de Bazan*. Of his thirty-four operas, the most successful were *Hérodiade* (1881), *Manon* (1884), *Werther* (1892), *Thaïs* (1894), and *Le Jongleur de Notre-Dame* (1902). Together with *Puccini and Richard *Strauss, Massenet dominated the operatic stage at the turn of the century. His style was elegant but essentially conservative, relying for its effects on charm of melody and a somewhat sentimental choice of subject-matter. He also composed many fine songs and several effective orchestral works.

Massine, Léonide (Fedorovich) (1896–1979), Russian dancer and choreographer. He joined the *Bolshoi Ballet in 1912 and then the Ballets Russes in 1914, under *Diaghilev. He was known as a character dancer as well as a *choreographer, taking the lead male role in many new productions such as Fokine's *Legend of Joseph* (1913). He choreographed *Parade* (1917), *The Three-Cornered Hat* (1919), and a version of *The Rite of Spring* (1930) with Martha *Graham. He directed Ballets Russes de Monte Carlo (1938–43), and developed theories of choreography, a system of *dance notation, and worked on a new form of the symphonic ballet (*Choreartium*, 1953).

Massinger, Philip (1583–1640), English dramatist. The chief playwright of the King's Men (Shakespeare's old theatrical company), his plays are noted for their social realism, satire, and comedy. They include *A New Way to Pay Old Debts* (c.1625), in which he expresses his indignation at the economic oppression practised by extortionate financiers; *The Maid of Honour* (c.1621), and *The Bondman* (1623), both tragi-comedies; and his great tragedy *Believe As You List* (1631), a study of the recurring conflict between nationalism and imperialism. He also

collaborated with the playwright John Fletcher (see *Beaumont).

Massys, Quentin (Matsys, Metsys) (*c*.1465–1530), Netherlandish painter, active mainly in Antwerp. He continued the traditions of Netherlandish art, but his work also shows *Renaissance influence and he may have visited Italy. As well as religious pictures, he painted satirical pictures of bankers, tax collectors, and avaricious merchants, and he was a fine portraitist, instituting a new type—the scholar in his study—that was influential on *Holbein among others. He had two painter sons, **Jan** (1509–75) and **Cornelis** (1513–79).

Master of the Queen's (King's) Music, the only surviving music post in the British royal household. It was established in the reign of Charles I, when the holder was the head of the king's private band of strings. Since 1893 the post has been given to some eminent musician who may do as much, or as little, as he chooses in return for the recognition, which carries virtually no pay.

Mathura art, art associated with the town of this name (modern Mutt'a) on the River Jumna in north-west India, which in the first centuries AD was a capital of the Kushana dynasty and had an important school of sculpture. There were quarries nearby and the mottled red sandstone was used for cult images that were widely exported in northern India. Buddha figures are shown standing or seated (the latter being more common), often with a single curled top-knot of hair. Haloes with scalloped edges are a distinctive mark, and foreshadow the dense decoration of haloes seen in *Gupta figures. It is uncertain whether Mathura or *Gandhara can claim the distinction of first representing Buddha in human form. (See also *Buddhist art.)

Matisse, Henri (1869–1954), French painter, sculptor, graphic artist, and designer. In the late 1890s he began to adopt the light colours of the *Impressionists and paint with increasing freshness and spontaneity. He came to prominence in 1905, when he and a group of friends exhibiting in Paris were dubbed the *Fauves ('wild beasts') because of the violent brightness of their colours. He was influenced by the *Cubists and his style became more austere, but in the 1920s he returned to the luminous serenity and delight in colour that characterized his work for the rest of his long career. From 1917 he spent much of his time on the French Riviera, and the luxuriously sensual works he painted there—nudes, still lifes of tropical fruits and flowers, and glowing interiors—are irradiated with the sun and colours of the South. He also made sculptures and book illustrations, and in his final years, when he was bed-ridden, he used brightly coloured cut-out paper shapes to create abstract compositions. One of his greatest works is the decoration of the Chapel of the Rosary at Vence in southern France (1949–51), for which he designed every detail, including the priests' vestments, a gift to the nuns of the adjacent convent who had nursed him during an illness.

Maugham, W(illiam) Somerset (1874–1965), British novelist, short-story writer, and dramatist. His first novel, *Liza of Lambeth* (1897), drew on his experience of slums and cockney life when he was a medical student. His novels include *Of Human Bondage* (1915), a largely auto-

The bold draughtsmanship, love of vivid colours, and strong decorative sense which marks much of **Matisse**'s work is displayed in his *The Red Room or Dessert: Harmony in Red* (1908–9). Matisse developed a large-scale decorative and figurative style of his own, and resolutely resisted adopting any of the principles of Cubism. (Hermitage, Leningrad)

biographical work about a lonely boyhood and a painful progress towards maturity, *The Moon and Sixpence* (1916), suggested by the life of Paul *Gauguin, *Cakes and Ale* (1930), and *The Razor's Edge* (1944). *A Writer's Notebook* (1949) shows him as detached, observant, and worldly.

Maupassant, Guy de (1850–93), French short-story writer and novelist. His most famous tale *Boule-de-suif* (1880), about a prostitute's life during the Franco-Prussian war, brought him immediate success and allowed him to devote himself to writing. His stories, written in a simple, dispassionate style, often describe provincial or lower-middle-class life behind which there often lies an understated sensuality. Their mood is bleak, their outcome often horrific. The preface to his finest novel, *Pierre et Jean* (1888), tells how he learned the craft of writing from *Flaubert and became associated with *naturalism.

Mauriac, François (1885–1970), French novelist. His novels reflect a religious, but generally pessimistic, view of life, depicting characters who struggle against brooding passions from which they find little release. As in his most famous novel, *Thérèse Desqueyroux* (1927), the setting is frequently south-west France, where the summer heat and the claustrophobia of the pine-forests intensifies the characters' emotional drama. Mauriac was awarded the Nobel Prize for Literature in 1952.

Mauryan art, the art associated with the Maurya dynasty, which ruled over a large area of northern India from *c*.325 BC to *c*.183 BC, under the emperor Ashoka (d. *c*.235 BC), the greatest of the Mauryan rulers. The empire extended to cover almost the entire Indian subcontinent. Ashoka was a great conqueror, but on his conversion to Buddhism (which he made the state religion of India) he renounced violence and became an enlightened ruler. He erected numerous monasteries and *stupas, but the main

artistic survivals of his times are highly polished stone columns, some more than 15 metres (*c*.50 ft.) high, originally surmounted by sculptured animals and inscribed on the base with edicts and pious exhortations. One of the finest examples is the lion column at Lauriya Nandangarh, near Nepal, erected in 243 BC. Excavations at Ashoka's capital Pataliputra (near modern Patna) bear out ancient accounts of its size and magnificence. Although so little survives of Mauryan art it is of great significance in marking the first flowering of native Indian civilization, unequalled before the *Gupta dynasty. (See also *Buddhist art.)

mausoleum, a large and stately tomb, particularly one in the form of a building. The term derives from Mausolus (d. 353 BC), Persian satrap (provincial governor) in Caria in Asia Minor, who planned for himself a splendid tomb, erected at Halicarnassus (now in Turkey) by his wife after his death. Built of white marble and richly decorated by some of the leading sculptors of the day, amongst them *Scopas of Paros, it was regarded as one of the Seven Wonders of the World. It was destroyed by an earthquake in the Middle Ages, but some of the sculpture survives in the British Museum. Other famous mausoleums include the Taj Mahal at Agra in India, built by the emperor

Most famous of the monuments of the Mughal rulers of India, the Taj Mahal brings to a pinnacle of grace and refinement the influence of Iran on Indian Islamic architecture. The Taj Mahal ('crown of the palace'), 1632–48, was built as a **mausoleum** for Mumtaz Mahal, beloved favourite wife of Shah Jahan, and is the unquestioned masterpiece of Mughal architecture.

Shah Jahan in honour of his favourite wife, who died in 1631, and Lenin's tomb in Red Square, Moscow (1925).

Maxwell Davies, Sir Peter *Davies, Sir Peter Maxwell.

Mayakovsky, Vladimir (Vladimirovich) (1894–1930), Russian poet and dramatist. Born in the Caucasus, he came to Moscow in 1906, involved himself in underground revolutionary activity, and studied art. Repeatedly jailed for subversive activity, he was a leader of the iconoclastic *Futurists (*A Slap in the Face of Public Taste*, with Khlebnikov and others, 1912). His early long poems dramatize his own personality (*A Cloud in Trousers*, 1915). He versified the myths of the Revolution in long poems like *Okay!* (1927), and *At the Top of my Voice* (1930). The intimate strain in his work culminates in the great tragic love poem *About This* (1923). Increasingly alienated from Soviet life, he directed his satirical plays *The Bed-Bug* (1928) and *The Bath-House* (1929) against post-revolutionary philistinism. Denied a visa to travel abroad, he committed suicide.

Mayan art, the art and architecture of a Maya-speaking civilization which flourished in the Yucatán peninsula and in Guatemala from *c.* 1st to 12th centuries AD. Maya architecture varied in detailed solutions and methods of construction: in the most southerly sites, wooden superstructures were preferred to stone while elsewhere in building work of the 9th century, cores of rubble replaced the methods of building in huge blocks followed in earlier practice. The essential aesthetic, however, remained constant: regularity and external symmetry were unremittingly pursued; imposing height was sought, wit-

These terracotta figurines (*c.*700–900 AD) are grave-offerings from Jaina, an island cemetery in the Gulf of Campeche, Mexico. Among the most delicate examples of **Mayan art**, they give a vivid picture of contemporary ceremonial costume. (Museum of Fine Arts, Dallas)

nessed by towers, roof-combs, and flying façades; the corbel-vault (a support jutting out from the wall), strengthened with mortar, was the universal method for enclosing space; and everywhere the monumental style—largely confined to buildings of ritual importance—was dominated by stepped platform pyramids, perforated by interior chambers. Relationships between buildings were ruled by symmetry and signs derived from the earth. Interiors were richly adorned with low reliefs, incised with stone chisels in a style which probably derived from the mural, ceramic, and bark-manuscript painting which the Maya also practised. Throughout the thousand years of Maya painting and carving, curvilinear silhouettes predominate, often accompanied by hieroglyphic inscriptions which obey the same conventions. Free-standing sculpture is rare, and usually modelled in clay or stucco; carved stelae (upright slabs or pillars), however, are common on most sites. (See also *Central American and Mexican architecture.)

mazurka, a traditional Polish dance in triple time with a dotted rhythm on the first beat and a strong accent on the second. In performance it requires a proud bearing and it is characterized by stamping, clicking heels, and the 'holubiec', a unique turning step. It has been used on many occasions within ballets to convey national character. It was introduced into the concert hall by Chopin as one aspect of his nationalism, his version necessarily being more varied and refined than the traditional peasant dance.

mechanical musical instruments, instruments sounded by a mechanism, rather than by human hands. On the musical box a mechanism turns a barrel with pins inserted into it in appropriate places, which pluck metal tongues, similar to those of a *sansa. Pinned barrels are also used on *organs: each pin activates a lever, which admits air to the appropriate pipe. An identical mechanism was used on street pianos, save that the levers activated hammers. Similarly, pinned barrels have been used since the 16th century on mechanical *carillons. A different, more complex mechanism, permitting variation

of loudness and touch, was used on the pianola, and on some fairground organs: a roll of paper, or folded card, is perforated with holes through which a puff of air operates the appropriate hammer or pipe. The purpose of mechanical instruments is to permit a non-musician to 'play' an instrument; barrel organs were used in churches for want of an organist. The pianola was designed for people to reproduce in the home the performance of professional pianists; until the advent of long-playing discs and tape recorders, only piano rolls allowed continuous performance for more than about four minutes.

medal, a small, flat piece of metal bearing a design commemorating a person, place, or event. They often bear designs on both sides—one of them almost always a portrait, the other an image related to it. Medals are generally made of gold, silver, bronze, or lead, and they can be made in a variety of ways, including being cast or struck from a die like a *coin. Although there are precedents of a sort in Roman art, the medal as we know it was invented in Renaissance Italy. The first was made by *Pisanello to commemorate the visit of the Byzantine

This 14th-century Italian miniature 'Music and her Attendants' illustrates Boethius's treatise on mathematics. In the centre the figure of Music plays a portative organ while around her musicians play some of the principal instruments of **medieval music** (*top left to bottom right*): fiddle, psaltery, lute, tambourine, clappers, bagpipes, shawm, nakers, and trumpets. (Biblioteca Nazionale, Naples)

Emperor John VIII to Italy in 1438. As well as being the first medal-maker, Pisanello is generally regarded as being the greatest, his designs having astonishing vigour and strength for work on such a small scale. Hans Schwarz (1492–c.1535) of Augsburg, who deserves acknowledgement as the first German master, provides excellent examples. In Nuremberg the leading master was Matthes Gebel (fl. 1523–74), whose medal of Albrecht Dürer (1528) is a superb portrait of the great artist. France also had many fine medallists, among them Jean Warin (c.1604–72), who made an excellent portrait medal of Cardinal Richelieu. Later the art of medal-making declined, and the medal became a device for the commemoration of history and the celebration of valour. Recent years have seen a great revival of interest in medals. Modern artists have introduced irregular shapes, altered surfaces, and novel patterns.

medieval music (c.700–c.1500). The music that survives from the European Middle Ages falls primarily into three categories. First, church chant or *plainsong: the main 'Gregorian' repertory perhaps dates back to the 6th century but is not clearly documented before the 9th. It is entirely monophonic (that is, a single vocal line without accompaniment) and covers a wide variety of styles, many of which continued to be used until the present century. Second, early church *polyphony (or part-music): the earliest substantial polyphonic repertory is in the 'Winchester Troper', copied shortly before the Norman conquest in 1066; but the finest music is in the great Parisian repertory of Notre Dame from the years around 1200. Much of this music has one voice singing chant, with up to three added voices, sometimes of truly amazing floridity: the composers Leoninus (documented 1179–1201) and Perotinus (fl. c.1190–1210) appear to have been the leaders here. From the 13th century we have the first evidence of the *motet, an extraordinarily concentrated style of music in which up to four different texts, sometimes both sacred and profane, are sung simultaneously. The third main repertory is in the songs of the Provençal troubadours, the northern French trouvères, the German Minnesinger, and related poets in other languages, c.1100–1300. Here the texts are well preserved, but the music—again monophonic—survives in a form that raises considerable questions about how it was performed. Whether or not it included any of the wide range of instruments that can be seen in pictures and are described in the literature, this repertory gives the clearest indications of the enormous amount of information that has been lost. *Minstrels wrote down nothing, but it seems likely that the lost unwritten music was often highly sophisticated.

medium, a term in art used in its broadest sense to describe the various methods and materials of the artist; thus painting, sculpture, and drawing are three different media, and bronze, marble, and wood are three of the media of sculpture. In a more restricted sense, the word refers to the substance with which pigment is mixed to make paint, for example, water in water-colour painting, egg yolk in tempera, and linseed oil in oil painting.

Meistersinger *minstrel.

Melanesian art, the art of the Melanesian people, inhabiting islands in the south-western Pacific, including

Two wooden figures from the Sepik River Valley area of New Guinea. Wooden sculpture represents the finest flowering of art in New Guinea; the island's creative tradition is the richest in **Melanesian art** and artists have lavished attention on everything from huge meeting houses to small items of personal adornment. (Private collection)

the island of New Guinea, as well as a wide fringe of smaller islands to the north and east. Although their wood carvings, masks, and house decorations survive, the developed arts of body painting and the constructions of ephemeral materials cannot be captured. Art was linked to religious beliefs and huge ceremonial houses were built and spectacular rituals staged, which were occasions for magnificent display of both object and performer. Carvings, paintings, and masks were of basically human form but with all sorts of exaggerations and references to powerful animals and spirits. Melanesian art became much appreciated in the West in the 20th century; there is little of it left in the islands, although a good deal of carving for the tourist trade persists.

Melba, (Dame) Nellie (Mrs Helen Porter Armstrong (b. Milhall)) (1861–1931), Australian soprano singer. Following her 1887 operatic début in Brussels as Gilda in Verdi's *Rigoletto*, Melba had a series of London triumphs, followed by appearances in Paris, Milan, and New York.

She toured the USA with her own company (1897-8). Her final operatic performance in 1926 as Mimi in Puccini's *La Bohème* was recorded. Her voice is notable for its purity and brilliant agility.

Méliès, Georges (1861-1938), French film director and producer, who developed the medium beyond the stage reached by *Lumière. Beginning by recording insignificant happenings, he proceeded to make films based on books, plays and, especially, fantasy and trick photography, an area in which he was profoundly influential; his most famous film was *A Trip to the Moon* (1902). He built the first studio in France in 1897, and his films were so popular in the USA that in 1903 he established his trademark Star-Film there to prevent piracy. His failure to adjust to public taste, however, led to eventual bankruptcy. Over a thousand of his films were destroyed, and only about a hundred remain.

melodeon *accordion.

melodrama, a popular form of sensational drama which flourished in the 19th-century theatre, surviving in different forms in modern cinema and television. The term, meaning 'song-drama' in Greek, was originally applied to plays or scenes accompanied by music, as in opera. In early 19th-century London, many theatres were only permitted to produce musical entertainments, and from their simplified plays the modern sense of melodrama derives: emotionally exaggerated conflicts of pure maidenhood and scheming villainy in a violent plot of suspense. Well-known examples are Douglas Jerrold's *Black-Ey'd Susan* (1829), the anonymous *Maria Marten* (c.1830), and *Sweeney Todd, the Demon Barber of Fleet Street* (1842); the Irish playwright Dion Boucicault wrote several melodramas in the 1850s. The turn of the century saw spectacular melodramas staged at Drury Lane, with shipwrecks, earthquakes, and horse-racing. Similar plots and simplified characterization in fiction can also be described as melodramatic.

melody, any succession of musical notes, varying in pitch, with a recognizable and organized shape. Melody is the horizontal aspect of music, as opposed to its vertical aspect, *harmony. Rhythm is an important element of melody: a change of rhythm can completely disguise a well-known tune. The music of many cultures has concentrated on melodic development, while harmony is a relatively modern invention and by no means universally adopted. Being closely associated with words (as in folk-song), melody reflects the characteristics of language and thus often conveys a sense of national identity.

Melville, Herman (1819-91), US novelist, short-story writer, and poet. As a young man he sailed as a cabin boy to Liverpool, and in 1841 went on the whaler *Acushnet* to the South Seas, jumping ship at the Marquesas and returning in 1844. He drew on his adventures in *Typee* (1846), *Omoo* (1847), *Mardi* (1849), *Redburn* (1849), and *White-Jacket* (1850). These were largely successful, but *Moby-Dick* (1851), his massive experimental account of a whaling voyage, failed commercially, as did the anguished study of artistic impotence *Pierre* (1852), the historical romance *Israel Potter* (1855), the story collection *The Piazza Tales* (1856), and *The Confidence-Man* (1857), a sardonic comedy set aboard a Mississippi steamer. During

the American Civil War he turned to poetry, and published three collections and the long poem *Clarel* (1876), without attracting much attention. In 1866 he became a Customs Inspector in New York. He retired in 1885, and died in obscurity. The novel *Billy Budd, Sailor* was found in his papers and published in 1924; it was later used as the basis for an opera by Britten (1950-1). Melville's major creative phase lasted only ten years, but in it he produced several classic tales of life at sea and encounters with primitive societies, powerful short fiction like 'Benito Cereno' and 'Bartleby the Scrivener', and, in *Moby-Dick*, one of the greatest 19th-century novels in any language. Written in a rich, rhythmical prose, it has a solid basis in a brilliantly handled realistic narrative, and traces of an original documentary purpose. The story of Captain Ahab's pursuit of the white whale is a literary myth, with commentaries which speculate on all manner of topics, from metaphysical enigmas to man's exploitation of nature.

Memlinc (or Memling) (c.1430-94), Netherlandish painter, active in Bruges. His softened and sweetened version of the style of Rogier van der *Weyden (who is said to have been his teacher) made him the most popular Netherlandish painter of his day. Memlinc's paintings are quiet, restrained, and pious, his style changing very little during his career. He painted many portraits and showed rather more originality in this field than in religious painting. There is a museum devoted to him in Bruges.

Menander (c.342-c.290 BC), the leading writer of *comedy in the Hellenistic period of *Greek theatre. An Athenian, he wrote 100 plays, of which one complete play (*The Ill-Tempered Man*) has come to light, together with substantial fragments of several others. His plays deal with domestic situations and his verse stays close to colloquial speech.

Mencken, Henry Louis (1880-1956), US journalist, critic, and essayist. He became literary critic of *The Smart Set* in 1908 and was co-editor of this lively periodical from 1914 to 1923. His essays were published in six volumes entitled *Prejudices* (1919-27). His most important work of scholarship is *The American Language* (1919), a discussion of English in the USA, noting specifically US expressions and idioms. He also wrote three volumes of autobiography *Happy Days* (1940), *Newspaper Days* (1941), and *Heathen Days* (1943), as well as much literary criticism and biographies of literary figures.

Mendelsohn, Erich (1887-1953), German-born architect who became a British citizen in 1938 and settled in the USA in 1941. Early in his career he was a leading proponent of *Expressionism in architecture, his masterpiece in this vein being the Einstein Tower (an observatory and laboratory) at Potsdam (1919), the bizarre, sculpturesque forms of which caused a sensation. Later his forms became more regular and simplified, although still bold, as in his De La Warr Pavilion (a sea-side pleasure pavilion) at Bexhill in Sussex (1933-6), one of the first outstanding works of the *Modern Movement in England (Mendelsohn had left Germany because of the rise of Nazism in 1933). Mendelsohn also worked in Israel (then Palestine) in the 1930s, and his late work in the USA included several synagogues.

Mendelssohn-(Bartholdy), (Jakob Ludwig) Felix (1809–47), German composer, pianist, and conductor. In 1825 he completed the String Octet (one of the most remarkable feats of precocity in the history of music) and in the following year capped that achievement with the overture *A Midsummer Night's Dream*. Travels in Britain (1829) and Italy (1830) further broadened his experience and gave rise, incidentally, to such works as *The Hebrides* overture ('Fingal's Cave') (1832) and the 'Italian' Symphony No. 4 (1833). He founded and taught at the Leipzig Conservatory, and in 1841 became the first director of the Berlin Academy of Arts. Such works as the oratorio *Elijah* (1846) and the Violin Concerto (1844) became instant classics. Mendelssohn's style has been considered superficial by some critics, and he has been called a classic case of youthful genius spoiled by success. However, many of his later works, such as the Violin Concerto, are fine pieces. He was very interested in the music of *Bach, which had been neglected since that composer's death, and gave the first 'modern' performance of the St Matthew Passion in 1829.

Mengs, Anton Raffael (1728–79), German painter and writer on art. He spent much of his career in Rome, where he was one of the pioneers of the *Neoclassical style. His contemporary reputation was enormous, but his historical and allegorical works now seem very flimsy, and his portraits are regarded as much more distinguished. In 1761–9 and 1773–7 he was court painter in Madrid, and it is an indication of the move in taste towards Neoclassicism that his dull and sterile frescos were preferred to those of as great a painter as *Tiepolo.

Menotti, Gian Carlo (1911–), Italian-born US composer. *Amelia goes to the Ball* (1935) established him as a successful opera composer, and his importance in this field was consolidated by such works as *The Medium* (1945), *The Telephone* (1946), *Amahl and the Night Visitors* (1951), and most particularly *The Consul* (1949). His style is basically *tonal and depends upon unabashed melody, piquant harmony, and a flair for theatrical effect.

Menuhin, Sir Yehudi (1916–), US-born violinist of Russian parentage, becoming a British subject in 1985. A child prodigy, Menuhin studied with the Romanian composer and violinist George Enescu (1881–1955) before his 1927 New York début. In 1932 he recorded Elgar's concerto, the composer conducting. Bartók wrote his solo violin sonata for him (1942). Among the most notable modern violin virtuosi, he has directed the Bath Festival and founded a school for young musicians.

Meredith, George (1828–1909), British novelist and poet. His first major novel, *The Ordeal of Richard Feverel* (1859), a romantic comedy with a tragic ending, won him the friendship of *Carlyle and the *Pre-Raphaelites. His success continued with the comedies, *Evan Harrington* (1861) and *The Adventures of Harry Richmond* (1871). His best-known novel, *The Egoist* (1879), examines the self-delusion and final humiliation of a self-centred aristocrat. Meredith's feminist beliefs are seen in the strength portrayed in many of his female characters, notably in *Diana of the Crossways* (1885). He published several volumes of experimental verse, including *Modern Love* (1862), a series of fifty sonnets which reflect his own disillusion with marriage, and *Poems and Lyrics of the Joy of Earth* (1880).

Mérimée, Prosper (1803–70), French short-story writer and novelist. His two most famous works are *Colomba* (1840), about a Corsican vendetta, and *Carmen* (1847), the latter inspiring *Bizet's opera of that name. Mérimée's characters display the passion of the *Romantic hero, but, as in the work of his friend *Stendhal, this is tempered by a concern for realism which manifests itself in the author's economy of style and his use of local colour. Mérimée was one of the masters of the short story in 19th-century French literature.

Messiaen, Olivier (1908–), French composer. The constant theme in all his music has been the expression of a profound religious faith. Early works, such as *L'Ascension* (for orchestra, 1933, or organ, 1934) and *La Nativité du Seigneur* (1935) are notable for their harmonic sweetness and complex textures. The last work of this type is the remarkable ten-movement *Turangalîla-symphonie*, completed in 1948. Experiments with *serialism followed, while bird-song provided the inspiration for such later works as *Oiseaux exotiques*, for woodwind and percussion (1955). The oratorio *La Transfiguration de notre Seigneur Jésus-Christ* (1969) and the opera *Saint François d'Assise*

Taken in 1961, this photograph shows **Messiaen** at work notating birdsong. He had been interested in its wide melodic range since his days as a student at the Paris Conservatoire and he used it transcribed almost note-for-note in several compositions.

(1983) stand as the summation of his development. Messiaen's music is more concerned with the elaboration and decoration of musical themes than with their dynamic development. Its consequent static qualities bring it close in manner to the practices of oriental music.

metamorphosis of themes *symphonic poem.

metaphor, a *figure of speech in which one thing, idea, or action is referred to by the name of another, suggesting some common quality shared by the two. In metaphor, this resemblance is assumed as an imaginary identity rather than directly stated as a comparison: referring to a person as 'that pig' is metaphorical, whereas 'he is like a pig' is a *simile. The use of metaphor to create new combinations of ideas is a major feature of *poetry, but much of our everyday language is also made up of metaphorical words and phrases which pass unnoticed, as 'dead' metaphors.

Metaphysical painting, a style of painting invented by Giorgio de *Chirico in about 1913 and practised by him and a few other Italian painters, most notably Carlo *Carrà, until about 1920. The style is characterized by images conveying a sense of mystery and hallucination, often involving the use of tailors' dummies or statues in place of human figures. It had a strong influence on *Surrealism, though its concentration on depicting uninhabited cities was peculiar to itself.

Metaphysical poets, a description used for a group of 17th-century British poets who share certain characteristics of expression, notably *Donne, *Herbert, *Crashaw, *Cowley, *Vaughan, *Traherne, and *Marvell. They are distinguished by their habitual use of conceits (elaborate and surprising metaphors): these are frequently taken from science or technology, rather than from nature or conventional mythology; a famous example is Donne's comparison of parted lovers to a pair of geometrical compasses: ('Thy soul, the fixed foot, makes no show | To move, but doth, if the other do . . .'). The poems often use an intimate or argumentative tone, and the natural language of a 'speaking voice'. The poets so grouped differ considerably in temperament, but much of their poetry shares the themes of strongly personal religious love, and (as with Donne) with idealized human love, as well as with paradoxes and ingenious persuasions. The Metaphysicals were largely ignored until the revival of their reputation in the 20th century, notably by T. S. *Eliot, who saw in them an admirable integration of thought with feeling.

method acting *Stanislavsky.

metre (or meter), the regular but variable rhythmic pattern in verse lines. In English and other Germanic languages this pattern is based on combinations of stressed and unstressed syllables, but in some other languages it is the length ('quantity') of syllables (as in Greek and Latin or Arabic and Persian) or the number of syllables in a line (French, Japanese) which counts. Different metres are distinguished by the kind of metrical unit ('foot') which predominates in the poem: in English, *iambic metres such as the iambic *pentameter are commonest, although trochees (reversed iambs), *dactyls, and anapaests (reversed dactyls) are sometimes used instead.

metronome, a device for setting the *tempo of a musical composition by reference to the number of beats per minute. This can be as simple as a pendulum whose swing varies with its length, or more sophisticated, like the 19th-century clockwork Maelzel Metronome or the present-day battery-operated electronic version, which can tick or flash as required. The composer places a 'metronome mark' at the head of the score as a guide to the preferred speed, but the wise interpreter does not necessarily take the mark as sacrosanct.

Metsu, Gabriel (1629–67), Dutch painter, active in his native Leiden and later in Amsterdam. He painted various subjects, including portraits, still-lifes, and mythological scenes, but he is best known for his *genre pictures. One of his best-known works, *Mother and Sick Child*, is often compared with *Vermeer. His work displays carefully balanced composition and colour schemes, and his observation of people and still-life details are charming.

Meyerbeer, Giacomo (1791–1864), German composer. He made his mark first as a pianist and only began to achieve success as an opera composer during a visit to Italy (1816–24). His sixth Italian opera, *The Crusader in*

The Letter Reader (c.1665) is one of Gabriel **Metsu**'s finest paintings and is also a reflection on the place of art in 17th-century Dutch society. The servant who has delivered the letter pulls back a curtain covering a picture (they were often hung like this) so that she may examine it. Paintings were indeed so abundant in 17th-century Holland that they could be enjoyed by all levels of society rather than being the preserve of the rich and privileged. (Collection of Sir Alfred Beit, Blessington, Ireland)

The *Creation of Adam* is the most famous of the nine scenes from Genesis that form the central part of **Michelangelo**'s Sistine Ceiling. Mighty figures of prophets and sibyls who foretold Christ's birth are at the sides of the ceiling, while the central scenes are flanked by beautiful nude youths, whose exact significance is uncertain. In completing such a huge task virtually unaided in only four years (1508–12) Michelangelo demonstrated heroic powers of physical endurance as well as matchless genius as an artist.

Egypt (1824), brought him international fame. He then set out to conquer Paris by writing the kind of spectacular Grand Opera that was currently in vogue. In achieving this end, through *Robert le diable* (1831), *Les Huguenots* (1836), *Le Prophète* (1849), and *L'Africaine* (1865), he outdid all his rivals. Meyerbeer's operas have a genuine grandeur and are notable for their stirring melodies, ingenious orchestration, elaborate choral effects, and sheer theatricality.

Meyerhold, Vsevolod (Emilyevich) (1874–1942), Russian theatrical director, who played a major role in the emergence of Soviet theatre. He was active before the Revolution of 1917, when he introduced a stylized '*Formalism' into his productions. His system of Bio-Mechanics, in which actors were required to suppress their individuality and the settings were minimal, gave rise to some exciting productions, notably of *Mayakovsky, but was eventually condemned by the Stalinist regime. His theatre was closed and he was arrested; he is presumed to have died in imprisonment.

mezzotint, a method of *engraving that produces tonal areas rather than lines; the term also applies to a print made by this method. A copper plate is roughened with a tool called a rocker, which raises a 'burr' on the surface. The design is formed by scraping away the burr where

the light tones are required and by polishing the metal quite smooth in the highlights. When the plate has been inked and then wiped, the ink is retained where the plate is rough and will print an intense black, but where it has been smoothed less ink is held and a lighter tone occurs. Mezzotint was invented in the Netherlands in the mid-17th century and soon spread to England, where it became an extremely popular method for reproducing portraits. The technique became virtually extinct in the later 19th century with the development of photography.

Michelangelo Buonarroti (1475–1564), Italian sculptor, painter, architect, draughtsman, and poet, one of the greatest figures of the *Renaissance. He was apprenticed to *Ghirlandaio in Florence, though the greatest influence on his formative years was the work of *Giotto and *Masaccio, on which he drew avidly. In 1496 he moved to Rome and there produced his first masterpiece, the celebrated *Pietà* (completed 1499) in St Peter's. On his return to Florence in 1501 he consolidated his reputation with the huge statue of *David* (1501–4), which has become a symbol of Florentine civic pride. In 1505 he returned to Rome, where he embarked on two vast commissions for Pope Julius II. The first was for a tomb for the Pope, but little came of Michelangelo's originally grandiose plans, and only the figure of *Moses* (1513–16) is by his own hand. Julius's other commission was for the decoration of the Sistine Ceiling in the Vatican (1508–12). It was this sublime work, full of figures of superhuman grandeur, that definitively established Michelangelo as the most famous artist of the age. After a period in Florence from 1516 to 1534 Michelangelo returned to Rome, to paint the *Last Judgement* on the altar wall of the Sistine Chapel (1536–41). It is a work entirely different in spirit from his ceiling *frescos, with massive (rather than graceful) figures of awesome power. In this period he worked increasingly as an architect; his

achievements included directing, from 1546, the re-building of St Peter's and designing its great *dome. His poetry, first published by his grand-nephew in 1623, offers an insight into Michelangelo the man, as he explores his faith, art, and the notion of love. He was regarded by his contemporaries with awe and with *Leonardo and *Raphael he created the idea of the artist as genius.

Michelozzo di Bartolommeo (1396-1472), Italian *Renaissance architect and sculptor. As a sculptor he worked for *Ghiberti (on both sets of doors for the Baptistery of Florence Cathedral) and in partnership with *Donatello, but he is more important as an architect. He was one of the leading figures of the generation after *Brunelleschi and the favourite architect of the Medici family, for whom he designed, among other works, the Palazzo Medici (now the Palazzo Medici-Riccardi) in Florence (begun 1444). His most beautiful work is the library at the convent of S. Marco in Florence (c.1440), a light, airy, and graceful building that became a model for the style throughout Italy. Michelozzo travelled widely and was influential in spreading the Renaissance style.

Mickiewicz, Adam (1798-1855), Polish poet, born in Lithuanian Poland. The direct language and lyrical treatment of folk elements in his *Ballads and Romances* (1822) marked the beginning of Polish *Romanticism. In 1823 Mickiewicz was arrested during a tsarist campaign against Lithuania's liberal educational system, and was deported to Russia. An increasingly mature style is revealed in two cycles of *sonnets (1826), of which the *Crimean Sonnets* are among the finest works in Polish. An actual journey through that exotic landscape mirrors a journey of inner development. When the censor was alerted to his long poem *Konrad Wallenrod* (1828), a tale of patriotic revenge, Mickiewicz felt compelled to leave Russia, eventually to settle in Paris. The strong emotions aroused by the 1830 uprising resulted in a poetic drama of symbolic significance to this day: *Forefathers Part Three* (1832), in which a prisoner is transformed, through divine and diabolic intervention, into a man with a messianic mission to save Poland. Mickiewicz's last important work was the epic idyll *Pan Tadeusz* (1834), set in the recent Napoleonic past, in the traditional world of Lithuanian country life.

Middle Eastern music *West Asian music.

Middle English literature, the term used to describe English literature during the period between about 1100 and 1500. During this time the language lost its inflections and incorporated Norman French vocabulary and structure. Middle English literature is varied and international in character. From the French influence of the trou-badours or aristocratic poet-musicians came the code of *courtly love and rhyme, which co-existed with a freer style of *alliterative verse. Many long *romances come from both French and Anglo-Saxon sources, among them 'King Horn', 'Havelok the Dane', and 'Amadis of Gaul'. Layamon's *Brut* (c.1200) is a nationalist *epic. The first of many continental-style debate poems, 'The Owl and the Nightingale', in which the two birds debate the virtues of the monastic and the secular ways of life, dates from before 1250, and is the ancestor of *Chaucer's 'Parliament of Fowls'. The 'alliterative revival' includes a debate poem 'Winner and Waster' (c.1353), and *Langland's moral

The Seagram Building, New York was designed by **Mies van der Rohe** with Philip Johnson, Kahn and Jacobs in 1958, and is one of his most important works in the United States. Its spare and concentrated elegance typifies Mies's style.

allegory, 'Piers Plowman'. *Pearl*, a richly-patterned poem using rhyme and alliteration and meaningful on several symbolic levels, is probably by the same hand as *'Gawain and the Green Knight'. These poems are in the north-west Midlands dialect, which is less close to modern English than the London English of Chaucer. The code of chivalry of King Edward III (1327-77) may have created the interest in the Celtic legends of Arthur and Gawain that gave rise to many romances which *Malory was to collect in prose. The religious works of the hermit Richard Rolle (c.1300-49) influenced the evolution of prose style. The *Travels* of Sir John Mandeville (c.1356) was a popular series of unlikely traveller's tales. Chaucer's contemporary John Gower (c.1330-1408) wrote the *Confessio Amantis*, a collection of *exempla* or moral stories told in lucid style. After Chaucer came the autobiographical poems of Thomas Hoccleve (c.1368-1426), the enormous output of John Lydgate (c.1370-1449), and the Scots *Henryson, *Dunbar, Gavin Douglas (1475-1522), and James I (1394-1437). The *morality plays and *mystery cycles of the early 16th century are of a high literary value, particularly those of Yorkshire, as are very many lyrics and carols, including 'Alysoun' and 'Sumer is icumen in' (c.1250).

Middleton, Thomas (c.1580–1627), English dramatist. He collaborated with *Webster, *Dekker, William Rowley, and others and wrote many successful comedies on London city life including *A Chast Mayd in Cheape-side* (c.1613) as well as *pageants and *masques for city occasions. His political *satire *A Game at Cheass* (1624) was suppressed by James I on account of its covert allusion to Spain and the Jesuits, and caused him to be summoned before the Privy Council. Middleton is now known for his two great tragedies, *The Changeling* (with Rowley, 1622) and *Women Beware Women* (c.1621).

Mies van der Rohe, Ludwig (1886–1969), German-born architect and furniture designer who emigrated to the USA in 1938 and became an American citizen in 1944. One of the supreme architects of the 20th century, Mies was also a highly influential designer. His work, mainly in steel and glass, is distinguished by classical poise and elegance, masterly refinement of detail, and an insistence on the highest standards of craftsmanship; one of his famous aphorisms is 'I would rather be good than original'. Early in his career he worked with *Behrens (at the same time as *Gropius and *Le Corbusier) and in the 1920s he was one of the key figures of the *Modern Movement. From 1930 to 1933 Mies was director of the *Bauhaus, and in 1938 he became professor of architecture at the Armour Institute (now Illinois Institute) of Technology in Chicago, for which he designed a new campus. Most of his buildings are in the USA, including a pair of apartment blocks at Lake Shore Drive, Chicago (1948–51), and the Seagram Building in New York (1954–8, designed in association with Philip *Johnson), skyscrapers that have been much imitated but never equalled in their lucid precision. One of his last great works was for his native country, the Gallery of the Twentieth Century in Berlin (1962–8). As a designer Mies was best known for his furniture, notably the steel and leather 'Barcelona chair' (so-called because it was designed for the German pavilion at the 1929 International Exposition in Barcelona), which is still produced commercially.

Mighty Handful *Five, The.

Milhaud, Darius (1892–1974), French composer. He became famous as one of Les *Six, with such ballets as *Le boeuf sur le toit* (1919) and the jazz-inspired *La création du monde* (1923). His energetic, eclectic style gave rise to a vast quantity of music, including 15 operas, 17 ballets, 18 string quartets, 12 full-scale symphonies, and 6 chamber symphonies.

Millais, Sir John Everett (1829–96), British painter and book-illustrator. He became a co-founder of the *Pre-Raphaelite Brotherhood in 1848. From the 1850s he was the most popular painter of the day, rivalled in worldly success only by Lord *Leighton, whom he succeeded as President of the Royal Academy. His style changed greatly as his career progressed: he abandoned the highly serious, morally uplifting themes of his Pre-Raphaelite days for subjects that met the public demand for sentiment and a good story, and developed from minutely detailed handling to broad and fluent brushwork. In much 20th-century criticism he has been represented as a youthful genius who sacrificed his artistic conscience for money, but Millais (although he enjoyed his success) was anything

but a cynic, and the merits of his later works are again being recognized.

Millay, Edna St Vincent (1892–1950), US poet. She published several collections of verse after her celebrated début in *Renascence and Other Poems* (1917). She favoured traditional poetic language and forms (particularly the *sonnet) at a time when other young American poets, part of the international *modernist movement, were overturning these conventions. The tone and subject-matter of her works of the 1930s and 1940s, for example *The Murder of Lidice* (1942), reflect an increasing maturity.

Miller, Arthur (1915–), US dramatist. After first attracting attention with *All My Sons* (1947), he produced a sequence of powerful plays: the classic study of American failure *Death of a Salesman* (1949); the re-creation of the 17th-century Salem witch-hunt in *The Crucible* (1953); and the Brooklyn family melodrama *A View From the Bridge* (1955). All are tragedies which subject to examination the values of the community and the individual. With some exceptions, the plays after the apparently confessional *After the Fall* (1964) were less successful. Miller also wrote a novel, short stories, theatre essays, and *The Misfits* (1960), a film-script for his second wife, the actress Marilyn Monroe. *Timebends* (1987) is his autobiography.

Miller, (Alton) Glenn *big band.

Miller, Henry (1891–1980), US novelist and essayist. Of his two best-known autobiographical novels, *Tropic of*

Arthur **Miller**, author of some of the most acclaimed plays in 20th-century American literature. His work is intensely serious, dealing with the pressures of family and society and with the failure of human relationships.

Cancer (1934) covers the emotional and intellectual life of a US expatriate in Paris, *Tropic of Capricorn* (1939) his adolescence in America: their sexual frankness prevented publication in the USA before 1960. *The Rosy Crucifixion* is a semi-fictional memoir consisting of *Sexus* (1945), *Plexus* (1949), and *Nexus* (1960). Otherwise his extensive writings are a miscellany of memoirs, literary criticism, essays, travel sketches, and lengthy correspondence with other authors. *The Colossus of Maroussi* (1941), an unconventional travel account in search of the spirit of Greece, emphasizing people, not sites, consumed in 'a world of light', was seen by some of the *Beats as seminal to their movement.

Millet, Jean-François (1814–75), French painter and graphic artist. His early pictures were conventional mythological and anecdotal *genre scenes and portraits, but from the late 1840s he turned to those scenes of rustic life from which his name is now inseparable. He emphasized the serious and even melancholy aspects of country life and the solemnity of toil (he came from a peasant family). Much of his career was spent in poverty, but his work began to bring him success in the 1860s and his most famous picture, *The Angelus* (1859), became perhaps the most widely reproduced painting of the 19th century. In 1849 he settled at *Barbizon, remaining there for most of the rest of his life. Late in his career he turned increasingly to pure landscape.

Milne, A(lan) A(lexander) (1882–1956), British poet, novelist, and dramatist. He was a regular contributor to *Punch* and began a successful career as a playwright with *Mr Pim Passes By* (1919), *The Dover Road* (1921), and *Toad of Toad Hall* (1929, a dramatization of *Grahame's *Wind in the Willows*). His large output of plays, novels, poetry, short stories, and essays has been overshadowed by his classic books of children's verse, *When We Were Very Young* (1924) and *Now We Are Six* (1927), and the stories *Winnie-the-Pooh* (1926), and *The House at Pooh Corner* (1928), written for his son, Christopher Robin, about his toy animals.

Milosz, Czeslaw (1911–), Polish poet and essayist. His pre-War verse, such as *Three Winters* (1936), written in his native Lithuania, contains a sense of impending doom. Later poetry, including *Where the Sun Rises and Sets* (1974), for which he received the Nobel Prize for Literature in 1980, confronts moral and philosophical questions. Soon after settling in France he wrote *The Captive Mind* (1953), essays analysing how writers functioned in Stalinist Eastern Europe. The novel *The Issa Valley* (1955) evokes childhood in Lithuania. In 1960 he emigrated to the USA.

Milton, John (1608–74), English poet, scholar, and pamphleteer, best known for his *epic poem *Paradise Lost* (1667). Among his early poems are the *ode, 'On the Morning of Christ's Nativity' (1629); 'L'Allegro' and its companion poem 'Il Penseroso' (*c*.1631), the *masque *Comus* (1637), and *Lycidas* (1637), a *pastoral *elegy on the death of a fellow-student. The Civil War then overtook his life, and from 1641 to 1660 (apart from a few masterly *sonnets in the grand style which include the noble 'On His Blindness' and 'On the Late Massacre in Piedmount') he worked as a Puritan for the cause of the Commonwealth with a succession of political pamphlets and

*polemical writings in both English and Latin: on divorce (which he supported on grounds of incompatibility), on education, on the freedom of the press (*Areopagitica*, 1644), and in defence of England's republican policies. By the age of 43 he was totally blind, and from then on his poems were dictated to his daughters, nephews, and disciples, among them Andrew *Marvell. At the Restoration in 1660 he went into hiding briefly, was arrested, fined, and released. His great work *Paradise Lost*, completed in 1667, is an epic in *blank verse on the biblical story of man's fall from grace. In it he proves himself a supreme master of the rhythm and sound of language. *Paradise Regained*, its successor, appeared in 1671. In it Milton recounts how Christ overcame the temptation of Satan. In the same year he composed *Samson Agonistes*, a powerful blank-verse drama modelled on Greek tragedy in which Samson, 'eyeless in Gaza at the mill with slaves', renews his spiritual strength and once more becomes God's chosen champion. After his death Milton's reputation grew steadily and his influence on 18th-century poets was immense.

mime, to play a part with mimic gestures, usually without words. Even at its highest level the mime differs from more conventional forms of drama by its preoccupation with character-drawing rather than plot, a necessary consequence of its more or less improvised nature. In Ancient Rome it became a spoken form of popular, farcical drama with music, which was played without masks. The distinctive *costume of the Roman mime-player was a hood which could be drawn over the head or thrown back, a patchwork jacket, tights, and the phallus; the head was shaven and the feet bare. The popular mimes, which all but drove other forms of spoken drama from the stage under the Roman Empire, were sub-literary, unmetrical, and largely impromptu, with dialogue in prose which the chief actor was free to cut or expand at will. The sordid themes and startling indecency of the language, action, and near-nudity of the actors and actresses, judged by some later fragments which have survived, seem to have been characteristic of the Roman mime. In the 5th century the Church excommunicated all performers in mime for burlesquing the sacraments and for their indecency. The Middle Ages had their mime-players, who may have taken over from the *pantomimus, the last representative of classical drama, something of their traditions, and handed them on to their descendants in the modern world. The actors of the *commedia dell'arte relied heavily upon mime, and it is an essential part of ballet. The work of Jean Gaspard Deburau (1796–1846), which culminated in the famous mime-play *L'Enfant prodigue*, popularized mime in France in the 19th century and the vogue for it spread to Britain. Again a more general interest in the subject was aroused by the performance of *Barrault as Deburau in the film *Les Enfants du paradis* (1945). Modern mime has nothing in common with the Roman mime, and approximates far more closely to the art of the Roman *pantominus, being entirely dependent on gesture and movement, usually accompanied by music, but wordless. An outstanding exponent of mime in the 20th century has been Marcel *Marceau. In recent years a new form of mime has developed, particularly in the work of Philippe Gaulier and Monica Pagneaux at the Le Coq School in Paris, in which dialogue is not prohibited but arises out of improvisation and is subservient to the physical component.

miniature, a very small painting, particularly a portrait that can be held in the hand or worn as a piece of jewellery. The word is also applied to manuscript *illuminations. The small portraits that we now call miniatures were known as 'limnings' or 'pictures in little' during the Elizabethan period, the time when the art—in the hands of Nicholas Hilliard—had its finest flowering. They were usually painted on vellum, occasionally on ivory or card. Miniature portraiture continued to flourish until the mid-19th century, when photography virtually killed the art. (See also *Islamic miniature painting.)

minimal art, a trend in painting and more especially sculpture, arising during the 1950s, in which only the most basic geometric forms were used. Minimal art is associated particularly with the USA, and its impersonality is seen as a reaction against the emotiveness of *Abstract Expressionism. Carl Andre is a leading exponent and his works have been controversial.

minimal music (minimalism), a term applied to a type of music that emerged in the 1960s and involves the repetition of brief musical figures in a simple harmonic field. The US composers Steve *Reich, Terry Riley (1935-), and Philip *Glass are particularly associated with this kind of music, which is in part a reaction against the intellectual aridity of the work of some of their contemporaries. The hypnotic effect of incessant repetition, in which figures gradually evolve over a long time-span, suggests the influence of oriental music.

The art of painting **miniature** portraiture known as 'limning' in Elizabethan England was brought to a high point by Nicholas Hilliard. He became court painter to Elizabeth I and made many portraits of her, of which this, with her favourite lute, is one. (Courtauld Institute, London)

Minnesinger *minstrel.

Minoan art, the art of ancient Crete, so named after the legendary King Minos. It developed from c.3000 BC and continued to about 1100 BC. The evidence of early Minoan pottery suggests strong trade contacts with Egypt during the early Minoan period (c.3000–2000 BC), though it is not clear whether the Minoan civilization originated with immigrants or grew from the previous Neolithic culture (see *Stone Age art). Minoan civilization enjoyed its greatest prosperity from c.2200 to 1450 BC. It was a sophisticated society with the beginnings of a bureaucracy that used written tablets. Minoan palaces were of complex design, each centred on a large courtyard, with many staircases, smaller courtyards, and rooms for cult worship. Magnificent *frescos adorned the walls. Metalworking, gem-engraving, seal stones and jewellery-making reached high artistic standards. Pottery, sometimes of little more than egg-shell thickness, was adorned with formal but highly effective floral designs in colour on a black ground. The palaces at Knossos and Phaestus suffered destruction c.1700 BC either through war or as a result of an earthquake, but were rebuilt. The exquisite freshness of the earlier painting was succeeded by a more grandiose style, which depicts, among other themes, the religious ceremonial of catching a bull by the horns and leaping over it. The delicate pottery was replaced by great wine jars and vases patterned with dark brown or red varnish on a light ground, with naturalistic floral or marine designs or running spirals. A further destruction occurred c.1500 BC, and soon after that the massive eruption of the volcano on Thera (Santorini), which overwhelmed much of Crete. Invaders from Greece finally brought an end to the Minoan Empire. Evidence of its culture was first revealed by the archaeologist Sir Arthur Evans in 1900.

minstrel, a blanket term for the professional entertainers of the 11th to 17th centuries, as opposed to the church musicians. The French minstrels were called *jongleurs*, while in Germany they were *Gaukler* and in Britain gleemen. Minstrels were of several types. *Jongleurs* were entertainers, including musicians, who travelled throughout Europe, from the 11th to the 13th centuries. Troubadours were poet-musicians of the South of France (Provence) and adjoining areas of Italy and Spain in the 11th to 13th centuries. Their songs are commonly on the theme of *courtly love, and their language was Old Provençal or *Langue d'Oc* (see *Provençal literature). Many were of noble birth. *Trouvères* were poet-musicians of northern France, writing in the *Langue d'Oïl* dialect. They were similar to the troubadours, but existed at a slightly later date. *Minnesinger* were the German equivalent of the troubadours in the 12th to 14th centuries. The word *minne* means 'courtly love'. Later came the *Meistersinger*, guilds of amateur musicians, among them Hans *Sachs, that flourished during the 15th, 16th, and 17th centuries in Germany as a middle- and lower-class continuation of the aristocratic *Minnesinger*. Waits were street musicians in medieval England who acted as town watchmen, marking the hours of day by sounding instruments. By the 16th century they had formed themselves into town bands. Some also sang—hence the term has come to be used to describe Christmas carollers.

minuet, a stately dance in triple time, which originated as a popular dance but was taken up and refined by the

A pottery statuette of a priestess with snakes, an example of **Minoan art** dating from about 1700–1600 BC. It is one of several of a similar kind excavated from the Palace of Knossos, Crete. The priestess is shown in a rigid, trancelike pose, possibly an indication that she is 'possessed' by a reptilian divinity. (Archaeological Museum, Heraklion)

French court in the 17th century. It was a couple dance in which many of the movements brought the partners to face each other, whereas in most court dances the dancers performed to an audience and therefore often looked towards the spectators seated around them. In a minuet the couple moved through set figures performing circling movements around each other, presenting right and then left hands. The minuet was crucially important as a court ritual, since in performing it the dancers not only displayed the grace, elegance, and style of their dancing, but were also judged on their breeding, social status, education, and social manners. It became one of the optional movements of the Baroque dance *suite, and thus gained entry into the symphony as a standard third movement. This in turn was supplanted by the Beethoven *scherzo. The minuet is normally in AABA form: the B section is a contrasting minuet, that was originally in three-part harmony, hence the title minuet and trio.

miracle play *mystery play.

Miró, Joan (1893–1983), Spanish painter, graphic artist, and designer. From 1919 he spent much of his time in Paris, though always maintaining close links with Spain. He is particularly associated with the *Surrealists, whose manifesto he signed in 1924. Throughout his life, whether his work was purely abstract or retained figurative elements, he remained true to the basic Surrealist principle of releasing the creative forces of the unconscious mind from the control of logic and reason. However, he stood apart from the other members of the movement in the variety and geniality of his work, which shows none of the superficial devices often characteristic of the Surrealists. In 1940 he returned to Spain and thereafter lived mainly in Majorca. He continued active into his eighties and enjoyed world-wide fame in the later part of his career.

misericord (Latin, *misericordia*, 'compassion'), a bracket projecting from the underside of a hinged tip-up seat of a choir stall in a large Christian church, used to provide support for participants during the standing parts of long services. Misericords were often enriched with carving (see *woodwork), and since they were seldom seen, they do not necessarily conform to traditional ideas of church decoration. Indeed, the carvers often seem to take great delight in indulging their own fancies—in scenes, for example, of domestic life or of animals parodying human activities. The earliest known decorated misericords date from about 1200; the practice generally died out during the Renaissance, but in Britain it continued into the 17th century.

Mishima Yukio (1925–70), Japanese novelist and right-wing activist, whose writings and life reflect the conflict between the traditional Japanese values and Westernization. His novels include the revealing *Confessions of a Mask* (1949), which contained significant homosexual elements, and *Temple of the Golden Pavilion* (1956), based on a fire at a Kyoto temple. His final work, the tetralogy *Sea of Fertility* (1965–71), was completed just before his public suicide by *seppuku* or ritual disembowelling with his sword.

Mistral, Frédéric (1830–1914), French Provençal poet. He was the leader of a movement called *le Félibrige*, whose object was the revival of *Provençal language and literature. His own masterpiece, *Mirèio* (1859), a poem about rural life, inspired Gounod's opera *Mireille* (1864). His example encouraged the revival of Catalan and stimulated interest in regional literature elsewhere.

mithuna, a term (Sanskrit, 'pair') used to describe the amorous couples, usually shown embracing or in sexual union, on Indian temples. They convey auspiciousness and power as well as, more obviously, fecundity.

mobile, term coined by Marcel *Duchamp in 1932 to designate certain sculptures by Alexander *Calder; they consisted typically of flat metal parts suspended on wires and moved by a combination of air currents and their own structural tension. The term has been extended to cover other sculptures of this type, with which many sculptors and interior decorators have since experimented, some of them using motors to provide the movement. Jean *Arp suggested the name 'stabiles' for Calder's sculptures that were non-moving but otherwise similar to his mobiles.

Mochica culture *South American Indian art.

mode, in music, a way of ordering the notes of a *scale. A system of church modes dominated European music up to about 1600. The earliest description of these modes, from the 8th century, lists only eight modes, but with the evolution of *polyphony in the 15th century the number grew to twelve. The modes were said to be based on scales used by the ancient Greeks, but scholars now believe that the church modes were evolved independently. The Ionian and Aeolian modes have survived as the major and minor scales. In folk and non-Western music, the term mode indicates not so much a scale as a collection of characteristic phrases, motifs, and formulas peculiar to one mode and not found in others. The Arabic *maqām* and South Asian rāga systems contain scores of different modes, which underlie a largely improvisatory practice. In jazz, the term mode is applied to scales other than the major and minor that may serve as the basis for an improvised solo.

modern art, a general term applied to avant-garde art of the late 19th and 20th centuries. It is applied to art that is or was outside the range of appreciation of the general public, by virtue of its questioning or abandoning of traditional techniques, subjects, or ideas. Various dates have been suggested as convenient points to mark the beginning of modern art. Among them are 1855, when *Courbet expressed his unconventionality and hatred of authority by organizing a pavilion of his own work at the Paris Universal Exhibition, and 1863, the year of the Salon des Refusés. This was an exhibition held in Paris to show work that had been refused by the selection committee of the official *Salon, many artists having protested at being rejected. It drew huge crowds, who came mainly to ridicule, and *Manet's *Déjeuner sur l'herbe* in particular was subjected to furious abuse. Artists now began to organize their own exhibitions (notably the *Impressionists in 1874) and art dealers became of

The Ballet Rambert in *Dangerous Liaisons* (1985), choreographed by Richard Alston. Reacting against the formality of classical ballet and the banality of show dancing, **modern dance** uses free and expressive body movements.

increasing importance. For most people the phrase 'modern art', however, suggests the 20th century, and its beginnings may be plausibly located in the fertile period between the turn of the century and World War I. In the late 19th century the notion that painting and sculpture were concerned with recognizably representing natural appearances was seriously undermined by artists such as *Gauguin and *Munch, and in the early 20th century was completely overthrown by a series of revolutionary movements, notably *Fauvism, *Expressionism, and *Cubism (which were among the first of the many 'isms' in which modern art abounds). Cubism was the most radical and influential of these movements, for it stimulated many other developments and was one of the main sources of *abstract art. A movement that, in its very different way, proved equally far-reaching in its implications, was *Dada, which was founded during World War I and began questioning the nature and validity of art. Such questioning has been one of the keynotes of modern art, and in it lie the roots of *conceptual art, in which ideas are considered of greater importance than the finished 'product'. Despite the seeming confusion of modern art, the traditional easel painting continues to hold its place, and the human figure still remains the central concern for many artists. In the field of architecture, modernism is generally thought to reside in the development of a *functional style, largely or entirely stripped of historical ornament. Late 19th-century US architects such as *Richardson and *Sullivan are placed in the vanguard of this movement. However, the term *Modern Movement (or 'International Style' or 'International Modern') is used in a more specific way. It refers to a style developed in the 1920s by *Le Corbusier, *Mies van der Rohe, *Gropius, and other architects, characterized by cubic shapes (with white usually the dominant colour), large windows, often arranged in horizontal bands, and a spartan absence of detailing. The term '*Post-Modernism' refers to recent architecture that rejects such functionalism and borrows from historical styles, sometimes ironically.

modern dance, a theatre dance sharing the revolutionary assumptions of *modernism across the arts. It

rejected *ballet, flowered between 1910 and 1945, but continues to the present. Early signs are found in the work of the American dancer-choreographers *Duncan and *St Denis. The first European *Expressionist dances were seen in the *Ausdrucktanz of *Laban, *Jooss, and *Wigman in Germany in the 1920s. Ausdrucktanz differed from US modern dance in two respects. Firstly, it attracted both sexes, resulting in a wider dynamic range than in the female-dominated American modern dance. Secondly, prevailing artistic and cultural influences were highly relevant. The German *Expressionists' radical innovations and Laban's links with the *Bauhaus exemplify this. Ausdrucktanz was an intense, emotional style. Academic classicism was replaced by dance based on everyday actions, individual psychological states, and a liberated technique. By the mid-20th century the Americans *Graham and *Humphrey emerged as the major figures in modern dance. Their distinctive ways of moving were tempered by abstraction. Greek myths, psychological states, political comment, and reflections on the mechanization of modern society were common themes, but the most important was the emotional statement. Ballet was regarded as inadequately expressive, and modern dance took 'natural' actions of walking, running, and breathing, exemplified in Graham's 'contraction and release' and Humphrey's 'fall and recovery'. The later trend towards abstraction, seen in the work of *Cunningham, introduced compositional principles of chance derived from the composer *Cage. Cunningham's compositional work provided the starting-point for the *postmodern dance movement of the early 1960s. Latterly, the European tradition has been revived in the dramatic works of Germany's Pina *Bausch. Alienation of the individual from the group and within male–female relationships provide her expressionistic subject-matter.

modernism, a general term applied retrospectively to the wide range of experimental trends in the arts of the early 20th century. At its broadest, the term embraces *Cubism and *Surrealism in visual arts, the music of *Stravinsky, and the *Modern Movement in architecture, as well as the innovations in literature to which it is more frequently applied. Modernist literature is characterized by a rejection of the 19th-century consensus between author and reader; the conventions of *realism, for instance, were abandoned by *Kafka and the writers of the *nouveau roman. Many writers saw themselves as an avant-garde disengaged from bourgeois values, and disturbed their readers by adopting complex and obscure forms and styles. In fiction, the accepted continuity of chronological development was upset by *Conrad, *Proust, and *Faulkner, while *Joyce and *Woolf attempted new ways of tracing the flow of characters' thoughts in their *stream of consciousness styles. In poetry *Pound and T. S. *Eliot, using *free verse instead of traditional *metres, replaced logical thoughts with fragmentary images. *Pirandello, *Brecht, and *Ionesco opened up the theatre to new forms of abstraction. Modernist writing often expresses a sense of cultural disintegration following World War I. In English, its landmarks are Joyce's Ulysses and Eliot's The Waste Land (both 1922).

Modern Movement, a term that can in its broadest sense be applied to any progressive architecture from about 1900, but which more specifically is applied to a particular style or outlook that dominated the work of some of the leading architects in Europe and elsewhere from the 1920s. In this more restricted sense the term is synonymous with the labels 'International Modern' and 'International Style'. The characteristics of the style are rationality and clarity of design, with clean lines, generally cubic shapes, and a conscious renunciation of all historical references. Buildings were typically of steel frame construction, with large expanses of glass, the windows often being arranged in horizontal bands. Wall surfaces, external and internal, were often white. The leading architects of the Modern Movement included *Gropius, *Le Corbusier, and *Mies van der Rohe. In the USA the Modern Movement found its exponents in the works of Louis *Sullivan and others of the *Chicago school. It was the dominant force in progressive architecture until the 1950s, when it was challenged by the more expressive *Brutalism and later by *Post-Modernism. (See also *Functionalism.)

modern music *twentieth-century music.

Modersohn-Becker, Paula *Worpswede School.

Modigliani, Amedeo (1884–1920), Italian painter, sculptor, and draughtsman. He worked in Paris from 1906, having laid the foundation of his style in Italy with his study of *Renaissance art, and he is often seen as the spiritual heir of *Botticelli because of the linear grace of his work. With few exceptions his paintings are portraits or female nudes and his sculptures are heads or crouching figures. Common to virtually all his work are extremely elongated, simplified forms and a superb sense of rhythmic vitality, but there is a great difference in feeling between, for example, his sculpted heads, which have the primitive power of the African masks that inspired them, and his sensual nudes, which were censured for their open eroticism.

The Penguin Pool (1933) at Regent's Park Zoo in London was designed by the Russian-born Berthold Lubetkin, who was one of the most potent forces in establishing the **Modern Movement** in Britain. The clean, uncluttered forms are typical of the movement, but the taut interlocking ramps (which the penguins use as promenades or diving platforms) are highly original—a novel solution to an unusual design problem.

modulation *key.

Moholy-Nagy, László (1895–1946), Hungarian-born painter, designer, sculptor, photographer, and writer on art. In Berlin in 1920 he co-founded the *Constructivist movement, and took up photography. From 1923 to 1928 he taught at the *Bauhaus, where he became known for his 'photograms' (lens-less photographs similar to the early experiments of Fox *Talbot) and almost equally abstract camera photographs exploiting unusual viewpoints, especially from high above the ground. When Hitler came to power Moholy-Nagy emigrated to Holland, and then moved to London, where he became involved in making films and designing furniture, advertising, and exhibitions. In 1937 he went to the USA to join *Gropius in the creation of the New Bauhaus (later the Chicago Institute of Design) and designed, among other things, the famous Parker '51' fountain pen. He became a US citizen in 1944. Moholy-Nagy's first wife, **Lucia**, born in Czechoslovakia, had collaborated in his photography from the beginning, and in the thirties she took some striking portraits in London. In 1939 she published *The History of Photography*, marking the 100th anniversary of the invention of photography: the first truly popular account of the subject.

Molière (Jean-Baptiste Poquelin) (1622–73), French comic dramatist. In 1658, after touring the provinces for thirteen years, Molière established himself in Paris as an actor, dramatist, and manager of his own troupe. His output from that time until the end of his career ranged from simple farces to elaborate productions including ballets for performance at court. But he is best remembered for comedies of manners like *Le Misanthrope* (1666) and *Les Femmes savantes* (1673), which satirize the foibles and fashions of his day, and comedies of character like *L'Avare* (1668) and *Le Malade imaginaire*, which ridicule extreme types, such as a miser or a hypochondriac. Molière's originality was to unite a profound insight into human nature with a gift for the comic, and his primary aim, as set out in *La Critique de l'École des femmes* (1663), was to please his audience. He incurred the displeasure of the Church for plays like *L'École des femmes* (1662), *Le Tartuffe* (1664, but banned until 1669), and *Dom Juan* (1665), though he maintained that he attacked not true faith and morality but religious hypocrisy.

Mon *Burmese art, *Thai art.

Mondrian, Piet (1872–1944), Dutch painter, one of the most important figures in the development of *abstract art. In his early career, part of which he spent in Paris, he was influenced by a variety of styles, including *Cubism; but although his work was tending towards abstraction it still remained based on images in the natural world. In 1917, in Holland, however, he founded the periodical *De *Stijl*, which became the mouthpiece for a new kind of rigorously geometrical painting that he named *Neo-Plasticism. In this he limited himself to rectangular shapes and a range of colours consisting of the three primaries (blue, red, and yellow) plus black, white, and grey. In 1919–38 Mondrian lived in Paris, then in 1938–40 in London before finally settling in New York. In the USA he developed a more colourful style, with energetic rhythms that reflected his interest in jazz

Molière is seen on the extreme left of this anonymous French painting (*c*.1670) in which he joins *farçeurs* and masked actors a generation removed from him in time. Molière was a complete man of the theatre, writer, actor, director, and stage manager, and single-handed he raised French comedy (previously considered a mere trifle) to the level of great drama. (Comèdie Française, Paris)

and dancing. His work had a profound influence not only on abstract artists, but also on much advertisement, decorative, and industrial art from the 1930s onwards.

Monet, Claude (1840–1926), French painter, often regarded as the foremost exponent of *Impressionism; one of his pictures, *Impression: Sunrise* (1872), gave the movement its name. As a youth in Le Havre he was encouraged to paint landscapes out of doors by *Boudin, and in 1859 he moved to Paris, where he formed friendships with *Pissarro, *Renoir, and *Sisley, who shared a desire to paint directly from nature. In 1870–1, with Pissarro, he took refuge in Britain from the Franco-Prussian War, then moved to Argenteuil, a village near Paris, where he and his friends painted some of the famous works of the Impressionist movement. After a period of extreme poverty, he began to achieve a moderate success. In 1883 he settled at Giverny, where he made an ornamental lilýpond which served as the theme for his *Nymphéas* pictures. In early paintings he experimented with the tonal values used by *Manet (*Le Pont neuf*, 1870), but later he abandoned this for the representation of light and hue, in which he was the most consistent of all the Impressionists. From about 1870 he restricted himself almost completely to landscape and to rendering harmonies of colours in varying conditions of light. Among the most celebrated are the series of Rouen Cathedral painted at different times of day in different lights (1892–4), and the waterlily pictures which prepared the way for the set of murals he did for the Musée de l'Orangerie towards the end of his life.

Mongolian literature. The earliest works of literature in Mongolian are historical epics and chronicles. The imperial chronicle *The Secret History of the Mongols* (*c*.1240), which deals especially with the life of Chinggis (Genghis)

Khan, incorporates traditional stories. The historical chronicles the *Golden Button* (*c.*1655) and the *Jewelled Button* (1662) place the Mongol empire in a Central Asian context. Like *Tibetan literature, Mongolian writing was deeply influenced by Buddhist translations, and in the 18th and 19th centuries by *Chinese literature in Mongolian translation, including the *Romance of the Three Kingdoms*, a novel of enchantment and romance. Modern Mongolia is divided between the Inner Mongolian Autonomous Region of China, where literature is heavily influenced by Chinese models, and the Mongolian People's Republic, with writers and poets like Dashdorjiya Natsagorj and Ts. Damdinsürün producing socialist literature broadly sympathetic to the Soviet Union and critical of the feudal past.

Monk, Thelonious (Sphere) *jazz.

Monkey (Journey to the West), Chinese novel of the Ming dynasty (1368-1644). *Monkey,* or more accurately *Journey to the West,* is an often comic sequence of episodes written in the vernacular, loosely based on the historical pilgrimage of the monk Tripitaka (Xuan Zang) to India in the 7th century in search of Buddhist scriptures. The version often attributed to Wu Cheng'en (*c.*1500-80) introduces Monkey, who acquires magic powers, a pig, and a shadowy sand sprite as the monk's spirit companions and also satirizes heavenly and earthly bureaucracy.

monody, a particular kind of vocal style developed around 1600 as a reaction against elaborate *polyphony. Monody sought to convey the rhythmic values and meaning of words with the greatest clarity and accuracy. The vocal line therefore avoided the regular patterns of 'tunefulness' and aimed to become melodic speech. It was accompanied in the simplest possible way with a few supporting chords. The monodic style became the basis of early *opera.

monologue, an extended speech uttered by one speaker. Most *lyric poems can be regarded as monologues. Other varieties include the *dramatic monologue and the dramatic *soliloquy. Some modern plays in which only one character speaks, like Beckett's *Krapp's Last Tape* (1959), are known either as monodramas or monologues. In prose fiction, the 'interior monologue' is a representation of a character's unspoken thoughts, sometimes rendered in the style known as *stream of consciousness.

montage, a pictorial technique in which cut-out illustrations, or fragments of them, are arranged together and mounted; the term is also applied to the picture so made. Montage differs from *collage in that it uses only ready-made images and in that the images are chosen for their subject-matter—the technique has been much used in advertising, for example, and in political satire. The term 'photomontage' is applied to montage using photographs only. In cinematic usage, the term 'montage' refers to the assembling of separate pieces of film into a sequence or a superimposed image.

Montaigne, Michel (Eyquem) de (1533-92), French essayist. Generally regarded as the inventor of the modern '*essay', a genre which he fashioned out of the late medieval 'compilation', transforming it into a personal test of ideas and experience. His *Essais* (1580-95) ori-

ginated as simple commentaries upon quotations from his favourite authors, especially Plutarch, but soon developed into a self-portrait of the author revealing, through a direct and lively style, his opinions on many subjects. Montaigne's motto 'Que sais-je?' and the lack of trust in human reason which he displays, for example in the famous *Apologie de Raimond Sebond*, caused succeeding generations to see him primarily as a sceptic. However, within the complexity of his thought can be discerned other important strands, notably a Stoic belief in the power of will to govern action and an Epicurean trust in nature. His subtle analysis of human nature opened the way for the moralists of the 17th century, while Voltaire and other writers of the *Enlightenment saw in him a model of the philosophical tolerance which they advocated.

Montale, Eugenio (1896-1981), the greatest Italian poet of the 20th century, recipient of the Nobel Prize for Literature in 1971. He draws on an extreme range of language from the prosaic to the lyrical—from naval and biological terminology to the dialect of Genoa, his native city—and on all the strains in Italian literary tradition, recovering 'dead' words, coining new ones, and subjecting every word to intense multiplicity of meaning. This linguistic engagement means that he rejected the aloof 'Petrarchan' role for the poet, although his wariness of moral keys has often attracted the accusation of apoliticality. Among his main books of poems are: *Cuttlefish Bones* (1925), *Occasions* (1932), *The Storm and Others* (1943-54), and *Diary of 1971 and 1972* (1973).

Montesquieu, Charles de Secondat, baron de (1689-1755), French political philosopher and man of letters. In 1721 he published the *Lettres persanes,* a fictional account in letter form of the visit of two Persians to Paris. The tale provides him with a vehicle to criticize the abuses of church and state in contemporary France. His other major claim to fame is his treatise *De l'Esprit des lois* (1748), a comparative study of the origin and nature of the laws governing society, showing his preference for the system of constitutional monarchy established in Britain. Both these works reveal Montesquieu's kinship with the early *Enlightenment through his use of comparative methodology and his application of the spirit of free enquiry to matters of politics and religion.

Monteverdi, Claudio (Giovanni Antonio) (1567-1643), Italian composer. He published his first compositions when he was 15. Two books of *madrigals followed (1583, 1587), so that by the time he was 20 he was established as a composer of importance. In about 1592 he entered the service of the Duke of Mantua and thus came into contact with some of the finest musicians of the time. In 1601 he became the Duke's *maestro di cappella* (director of music). Two books of madrigals published in 1603 and 1605 show how far advanced he was in the art of making his music express a wide range of emotions. But it was his first *opera, *The Legend of Orpheus,* written for Mantua in 1607, that established him as one of the greatest composers of all time. In one stroke he showed how the diverse elements of solo song, recitative, chorus, and orchestral interlude might be organized into a coherent pattern; how emotion might be portrayed in music, and how characters could be convincingly brought to life. A second opera, *Ariadne*

(1608), now mostly lost, proved equally successful. Monteverdi left Mantua in 1612 and in 1613 became *maestro di cappella* at St Mark's, Venice. Further opportunities to write opera came in 1637 with the opening of the first public opera house. Only two of his four later operas have survived: *The Return of Ulysses to his Country* (1641), and *The Coronation of Poppea* (1642): both are masterpieces. Monteverdi's skill as a dramatist and his flair for handling expressive harmonies and powerful melodic lines can be seen also in his church music, which includes the Mass and Vespers of 1610, and in the 1641 collection *Moral and Spiritual Maze*, which includes a Mass, two Magnificats, and some thirty motets.

Montgomery, L(ucy) M(aud) (1874–1942), Canadian author of children's fiction. She achieved world-wide success with *Anne of Green Gables* (1908), based on her childhood and on the rural life and traditions of Prince Edward Island. Seven sequels, tracing Anne's life from girlhood to motherhood, were less successful.

Montherlant, Henri de (1896–1972), French novelist and dramatist. He first gained recognition for his novels, *Les Bestiaires* (1926), *Les Célibataires* (1934), and *Olympiques* (1938), which glorify physical beauty and prowess. His major work of fiction is his cycle of four novels, which include *Les Jeunes Filles* and *Pitié pour les femmes* (both 1936). Written in limpid, elegant prose, it is a sardonic attack on women as willing tools of a successful libertine. A series of historical plays written between 1942 and 1965 reveal his preoccupation with pride and self-mastery, sensual pleasure, and an austere form of Christianity.

Moore, George (Augustus) (1852–1933), Anglo-Irish novelist. Having studied painting in Paris he returned to England in about 1880 and embarked on revitalizing the Victorian novel with *naturalist techniques gleaned from *Balzac, *Zola, and the *Goncourts. His first novel, *A Modern Lover* (1883), set in Bohemian society, was banned by the circulating libraries: an experience which spurred Moore to fight against bigotry and censorship. His other novels include *A Mummer's Wife* (1885) and *Esther Waters* (1894). He also published volumes of short stories and autobiographical works, including *Hail and Farewell* (1911–14), tracing the history of the *Irish Literary Revival.

Moore, Henry (1898–1986), British sculptor and graphic artist, one of the greatest sculptors of the 20th century. Discovery of African and Pre-Columbian art in the 1920s led him to reject modelling for direct carving in stone and wood, working the material sympathetically and allowing natural qualities of grain and texture to influence form. During the 1930s he achieved critical recognition as the leading avant-garde sculptor in Britain. His work at this time was influenced by European developments such as *Surrealism, but although he produced some purely abstract pieces, his work was almost always based on forms in the natural world—often the human figure, but also, for example, bones, pebbles, and shells. The reclining female figure and the mother and child were among his favourite themes. As an official War Artist (1940–2) he produced a series of poignant drawings of people sheltering from air-raids in London underground stations. Subsequently his reputation grew rapidly and from the 1950s he carried out many public commissions in Britain and elsewhere. In his later career bronze took over from stone as his favoured material and he often worked on a very large scale.

Moore, Marianne (Craig) (1887–1972), US poet. Her first collection, *Poems*, appeared in 1921, and from 1925 to 1929 she edited *The Dial*, then the leading literary magazine of American *modernism. Her poems are witty, occasionally obscure, original in form—imaginary gardens with real toads in them, in her famous description of the 'genuine'. The *Collected Poems* were published in 1951, and her so-called *Complete Poems*, all she wished to preserve, in 1967. She published a verse translation of *The Fables of La Fontaine* in 1954.

Moore, Thomas (1779–1852), Irish poet and musician. He is chiefly remembered for his *Irish Melodies* (1807–34), a collection of 130 poems set to his own music and that of Sir John Stevenson, with occasional adaptations of 18th-century Irish tunes; among the most familiar are 'The Minstrel Boy' and 'The Last Rose of Summer'. His 'oriental' verse tale *Lallah Rookh* (1817) became internationally famous. His many satirical works include *The Fudge Family in Paris* (1818) and portray the politics and manners of Regency London.

Moorish art, the Islamic art of North Africa and Spain. Islamic rulers dominated Spain from the 8th century until they were finally driven out in 1492. Two outstanding buildings date from this period: the mosque of Cordoba (now a cathedral) and the Alhambra palace in Grenada. begun in 785, the monumental mosque of Cordoba is exceptional for its dome, supported by a series of intersecting ribs, and the unusual double arches which create an effect of lightness and delicacy in the ornate interior. The Alhambra palace, behind its massive walls, represents the pinnacle of decorated delicacy, with its surfaces covered in elaborate stucco-work, tiles, and wood carving. Ivory carvings, textiles, and the polychrome *lustreware known as *Hispano-Moresque ware are among the other achievements of the Muslim dynasties of Spain. In North Africa the massively imposing Great Mosque of Qairawan, Tunisia (founded 724, mainly dating from 836) set the style of the earlier period, followed by the restrained religious building of the 13th century in Morocco. (See also *Fatimid, *Mamluk, and *Umayyad art.)

Mor, Anthonis (Antonio Moro) (c.1517–c.1576), Netherlandish portrait painter. A pupil of Jan van *Scorel, he had a successful career as a court portraitist, working in England, Germany, Italy, Portugal, and Spain. His work varied little throughout his career; his composition is simple and strong, and his grasp of character firm but undemonstrative. He had great influence on the development of royal and aristocratic portraiture, particularly in Spain, where his ceremonious but austere style proved ideally suited to the rigorous etiquette of the court.

morality play, a kind of religious drama popular in England, Scotland, France, and the Netherlands in the 15th and early 16th centuries. Morality plays are *allegories, in which personified virtues, vices, diseases, and temptations struggle for the soul of Man as he travels from birth to death. They instil a simple message of

Christian salvation, but often include comic scenes, as in the lively obscenities of *Mankind* (*c*.1465). The earliest surviving example in English is the long *Castle of Perseverance* (*c*.1420), and the best known is *Everyman* (*c*.1510). Most are anonymous, but *Magnyfycence* (*c*.1515) was written by John Skelton. Echoes of the morality plays can be found in Elizabethan drama, especially Marlowe's *Dr Faustus* (*c*.1593) and the character of Iago in Shakespeare's *Othello* (*c*.1603), who resembles the sinister tempter known as the 'Vice' in morality plays.

Moravia, Alberto (Alberto Pincherle) (1907–), Italian novelist. He played a major part in shaping neo-realism in Italian fiction after World War II. His first novel, *The Time of Indifference* (1929), portrays a middle-class society sick with a moral inertia which favoured the rise of fascism. *Two Women* (1957), the most lyrical and complex of his novels, deals with the close of the war, when Italy was occupied by both Germans and Allies. *The Woman of Rome* (1947) and *Roman Tales* (1957) draw on the language and culture of the Roman working classes in order to criticize middle-class values. Other full-length

This view of the Court of the Myrtles from the palace of the Alhambra in Spain (*c*.1369), probably the greatest monument of **Moorish art**, well illustrates the use of decoration, particularly calligraphic, in Islamic architecture. The tile panels, carved doors, use of stucco, and arched doorways leading from shaded inner rooms are typical Islamic treatments of form, surface, and space.

novels, notably *The Conformist* (1951) and *1934* (1983), explore the psycho-sexual basis of politics. His stark, unadorned style is used to powerful effect to convey the social alienation and loveless sexuality of his characters.

Moreau, Gustave (1826–98), French painter, one of the leading *Symbolist artists. He had a strong feeling for the bizarre and developed a style that was highly distinctive in subject and technique. His preference was for mystically intense images evoking long-dead civilizations and mythologies, treated with an extraordinary lush sensuousness, his paint encrusted and jewel-like. Although he had some public success, private means allowed him to pass much of his life in seclusion. In 1892 he became a professor at the École des *Beaux-Arts in Paris and proved an inspired teacher, bringing out his pupils' individual talents rather than trying to impose ideas on them. His favourite pupil was *Rouault, who became the first curator of the Moreau Museum in Paris, left by Moreau to the nation on his death.

Mori Ōgai (1862–1922), Japanese novelist and critic. He studied medicine in Japan and Germany, where he became familiar with European literature. He translated Hans Christian Andersen into Japanese and wrote many short stories, historical novels, and biographies. *The Dancing Girl* (1890) is autobiographical and was the first of the genre known as 'I-novels'; *Vita Sexualis* (1909) describes the eventual triumph of intellect over passion.

Morisot, Berthe (1841–95), French *Impressionist painter, much influenced by *Manet, whose brother she married in 1874. She is said to have persuaded Manet to experiment with painting in the open air. After Manet's death in 1883 she came under the influence of *Renoir. She strongly opposed conventional academic teaching and championed Impressionist ideals, exhibiting in seven out of the eight Impressionist exhibitions. She specialized in gentle domestic scenes, painted in a delicate, feathery technique, and was also a noted marine painter and water-colourist.

Morley, Thomas (*c*.1558–1602), English composer, writer, and publisher. In 1592 he was sworn in as a Gentleman of the *Chapel Royal, and thereafter published both his own compositions and Italian works, so that the vogue for *madrigals, *balletts* (a 16th-century type of Italian dance song) and *canzonets* became firmly established. He also wrote anthems, motets, and other sacred music in English and Latin, as well as solo songs, keyboard, lute, and *consort music. From 1598 until his death he had a monopoly of music publishing in England. His delightful *A Plaine and Easie Introduction to Practicall Musicke* (1597) throws important light on Elizabethan musical theory and practice. In 1601 he assembled and published an anthology in praise of Elizabeth I, *The Triumphes of Oriana*.

Morris, William (1834–96), British writer, painter, designer, craftsman, and social reformer. Morris was a remarkably versatile craftsman and a designer of genius, who, with his unerring feeling for flat pattern and simplified natural forms, revolted against the fussiness and pretentiousness characteristic of much Victorian design. In 1861—with *Burne-Jones, *Rossetti, and others—he founded the manufacturing and decorating firm of Morris

Kelmscott Manor in Oxfordshire was the country home of William **Morris** and is furnished with many examples of his work. This bed, Morris's own, is Elizabethan, but the hangings were designed by Morris and embroidered by his daughter, May.

& Co., producing furniture, tapestry, stained glass, fabrics, wallpaper, carpets, and much more. The company was based on the idea of a medieval guild, in which the craftsman both designed and executed the work. As a socialist Morris wished to produce art for the masses, but there was an inherent flaw in his ambition, for only the rich could afford his products. However, his work bore lasting fruit in Britain (in the *Arts and Crafts Movement) and abroad in the emphasis it laid upon the social importance of good design and fine workmanship in every walk of life. He also had an important role in the *private press movement through his founding of the Kelmscott Press. As well as being an outstanding figure of his day in the decorative arts, Morris was also a prolific writer of political tracts, poetry, and prose romances.

Morris dance *Folk dance.

Morton, (Ferdinand) Jelly Roll *jazz.

mosaic, the art of making patterns and pictures by arranging coloured fragments of glass, marble, or other suitable materials and fixing them into a bed of cement or plaster. Though simple mosaics were made in the Neolithic period, the oldest surviving pictorial scenes are in Macedonia, made by the ancient Greeks. These were mostly in black and white with the addition of pale green and red, and depicted mythological subjects and scenes from Homer. The Romans used mosaic particularly for pavements, and examples survive throughout the empire, such as that at Chedworth, Gloucestershire in the UK. They also created wall mosaics, of which many beautiful examples were preserved at Pompeii and Herculaneum. The early Christian period (4th–9th centuries AD) was a time of rapid development in the art, the richest mosaics from this period being at Ravenna, Italy, at that time the capital of the Roman empire in the West. The mosaics of the emperor Justinian in S. Vitale (AD 530–50) reveal a new understanding of the art. In later Byzantine churches of the 12th to 14th centuries mosaics were again of high quality, and as pilgrims and crusaders spread the fame of Byzantine mosaicists they were summoned to decorate more distant churches, such as the series for the church of Santa Sophia in Kiev. Byzantine artists came to Venice in about 1100 and the Cathedral of St Mark contains work by Greek mosaicists. The art of the mosaic flourished during the Renaissance. In Rome the Chigi chapel in Sta Maria del Popolo was decorated by the Venetian mosaicist Luigi da Pace with a mosaic of the Creation (1516) after a cartoon by Raphael. More recently the expense of carrying out mosaic has limited its use, though some excellent modern examples exist, such as the library of the National University in Mexico City (1951–3).

Moses, Grandma (Anna Mary Robertson Moses) (1860–1961), the most famous of US *naïve painters. She took up painting seriously only in the 1930s, but she had an exhibition in New York in 1940 and thereafter her work achieved widespread popularity for its brightly coloured freshness and charm. She produced more than a thousand pictures (working on three or four at a time, painting first the skies and last the figures), her favourite subjects being scenes of what she called the 'old-timey' farm life she had known in her youth.

mosque *Islamic art and architecture.

These early Christian **mosaics** are in the vault of Sta. Costanza in Rome, a church built in the mid-4th century as a mausoleum for Constantia, the daughter of Constantine, the first Christian Roman emperor. The delightful birds and flowers seem to be entirely pagan (recalling Roman floor mosaics), but the design has been interpreted as an obscure Christian allegory. Mosaic was a luxury art, often, as here, making lavish use of gold.

motet, a short, unaccompanied *polyphonic setting of sacred words. It came into existence in the 13th century when new words (*mots*) were added to the lively upper parts in certain cadences (*clausula*) in which the main lower part moved in the slow notes of *plainsong. The motet reached its greatest development in the music of Palestrina, Victoria, Byrd, Tallis, and their contemporaries, being in effect the sacred counterpart of the *madrigal. During the *Baroque period the motet sometimes acquired an instrumental accompaniment. In the Anglican service the motet was replaced by the *anthem.

mother-of-pearl ornamentation, decorative work using mother-of-pearl, the iridescent lining of the shell of the oyster and similar marine creatures. It has been used since ancient times in West and East in a wide variety of ways: in jewellery, architectural ornamentation, inlay for furniture and musical instruments, and many kinds of small decorative objects.

Motherwell, Robert (1915-), US painter, collagist, and writer on art, one of the pioneers and principal exponents of *Abstract Expressionism. He is unusual among Abstract Expressionists in that his work was essentially abstract from the beginning of his career, but there is often a suggestion of figuration in the large amorphous shapes in his pictures, as well as underlying inspiration from literature, history, or his personal life. His output as a painter is large, and he has also shown great energy as a writer, teacher, and lecturer.

Moussorgsky, Modest *Musorgsky.

mouth music, the singing of dance tunes to sequences of improvised nonsense syllables, used to accompany dances in the absence of instruments. *Puirt a beul* of the Scottish Highlands and 'diddling' of the Lowlands are examples, the latter also being sung competitively in some rural areas. 'Scat' singing in *jazz is also closely related.

mouth-organ, a *free-reed musical instrument such as the *harmonica. Asian mouth-organs have bamboo pipes as resonators, the Chinese *sheng* and Japanese *shō* have these arranged in a circle with each reed, in the foot of each pipe, in a wind chamber. The Laotian *khāēn* has its pipes in a double raft, with the reeds in a wind chamber part-way down. Asian mouth-organs are so constructed that a pipe will only sound when a hole in it is closed with a finger, or with wax as a *drone.

Mozart, (Johann Chrysostom) Wolfgang Amadeus (1756-91), Austrian composer whose music is perhaps more widely respected and loved than that of any other man. The son of a professional violinist and composer, he was the most astonishing prodigy in the history of music. Taught by his father, Leopold, he was already a capable composer and performer at 5 years of age, and by 15 he had well over a hundred substantial works to his credit. His development was enormously helped by a series of concert tours, beginning in 1762, which took him to Germany, France, England, and Italy, and brought him into intimate contact and equal competition with the finest musicians of the day. In 1771 he settled with his father to work at the court of the Archbishop of Salzburg, but continued to tour and accept

Of the seven children born to the violinist Leopold Mozart and his wife Anna Maria (pictured above), only two survived: Wolfgang Amadeus and his sister Nannerl, here playing a duet. The high-spirited letters that **Mozart** wrote to Nannerl and that have coloured popular interpretation of his character are no more bawdy than those of their contemporaries in Salzburg and Prague.

important commissions from further afield. Profound disagreements with the archbishop led him to seek his fortune as a freelance composer, pianist, and teacher in Vienna from 1781. For the most part he was successful—though, with his wife, Constanze, and his two sons to support, the last few months of his life were beset by money troubles. He also received a mysterious commission for a requiem mass, to be delivered secretly (the request came from a nobleman who wanted to pass it off as his own work). By this time, however, Mozart had fallen ill; he never finished the Requiem, which was completed by his pupil Süssmayr after Mozart's death. There is no historical evidence to corroborate the story that he was poisoned by *Salieri. Mozart's operas *Idomeneo* (1781); *The Abduction from the Seraglio* (1782); *The Marriage of Figaro* (1786), with text by Lorenzo da Ponte after Beaumarchais's comedy; *Don Giovanni* (1787), with libretto by da Ponte; *Così fan tutte* (1790); *The Clemency of Titus* (1791); and *The Magic Flute* (1791), with text by Emanuel Schikaneder after the story 'Lulu' from a collection of oriental fairy tales, are rightly considered among the greatest of all time. Mozart excelled in every aspect of musical composition, and produced important works in every musical field. His forty-one symphonies are notable, particularly the last three (the G minor, E flat, and C major 'Jupiter'). The twenty-seven piano concertos and twenty-six string quartets are outstanding. In his music extraordinary technical skill is allied to an unrivalled range of emotional intensity and a profound understanding of the human condition: each separate element in equilibrium and held within the bounds of classical restraint.

mṛdaṁga, a double-headed barrel-shaped drum, used in north and south Indian music, with heads tensioned by leather thongs. The right-hand head is tuned with blocks or wedges under the thongs, while the left is tuned by hand pressure in performance. Both heads and playing technique are similar to, and were probably the origins of, those of the pair of drums known as the *tablā.

Mucha, Alphonse (1860–1939), Czech painter and designer, best known for his luxuriously flowing poster designs, which rank among the masterpieces of *art nouveau. Some of the finest were made in Paris in the 1890s for the celebrated actress Sarah Bernhardt, for whom he also designed sets, costumes, and jewellery. He was also successful in the USA, where he made four journeys between 1903 and 1922. In 1922 Mucha returned to Czechoslovakia, where his work included designing banknotes and stamps.

mudrā (Sanskrit, 'sign' or 'gesture'), a term used in India and adjacent areas to describe the ritualized gestures of the hands and fingers, notably in sculpture and dance. Such hand positions, regulated by iconographical treatises, may denote a specific attitude (for example, meditation or preaching) or may indicate a specific moment in a legend. They are also used by officiants during religious services. (See also *Indian dance.)

Mughal art, the art and architecture of the Muslim dynasty of Indian emperors founded by the former Timurid ruler Babur (see *Timurid art) in 1526. The last Mughal emperor was exiled by the British after taking part in the Indian Mutiny of 1857, but the empire had already begun breaking up more than a century before this. Culturally it was at its peak in the late 16th and early 17th centuries, when there were three successive emperors (father, son, and grandson) who rank among the world's great patrons: they were Akbar (ruled 1556–

An 18th-century Indian painting of a princess in her garden with peacocks. The Deccani and **Mughal art** styles developed in the late 16th century from a combination of elements: Persian skill in composition and draughtsmanship, native Indian colouring and naturalism, and realism from European paintings brought to India by the Portuguese. (Victoria and Albert Museum, London)

1605), Jahangir (ruled 1605–27), and Shah Jahan (ruled 1627–58). Akbar built the city of Fatehpur Sikri (he also had courts at Delhi and Agra) and set up a workshop of painters (some imported from Persia) that initiated the superb Mughal tradition of book illustration. Books were used as an instrument of state policy, for histories of Akbar's reign were circulated among rebellious factions as an aid to unification. Jahangir, indolent and luxury-loving, commissioned paintings of scenes from his own life and also encouraged portraiture. Mughal painting reached its peak during his reign, and Mughal architecture achieved its chief glory under his son Shah Jahan, who commissioned the celebrated Taj Mahal (1630–48) as a *mausoleum for his favourite wife, Mumtaz Mahal. As with Mughal painting, there is strong Persian influence in the Taj Mahal, but its sheer perfection of proportion and detail place it in a class by itself.

Muir, Edwin (1887–1959), British poet. He spent his early life in Orkney and then moved to Glasgow. From 1921 he was in Europe for four years, translating (with his wife Willa Anderson) German works, particularly those of Kafka. *First Poems* (1925) was followed by other collections including *Collected Poems 1921–1951* (1952). The imagery in his verse is rooted in the Scottish landscape of his childhood, in myth, the Bible, and the classics; a recurrent theme is the dream journey through time and place, and a sense of subdued menace underlies many of his quiet, orderly poems (as in 'The Horses'), which at times creates an apocalyptic effect.

Mulligan, Gerry *jazz.

mummers' plays, the best known of the British *folk plays, mainly associated with Christmas. The extant texts (numbering over 3,000) fall into three categories. The first and largest, the Hero-Combat plays, contain a duel between St George and a pagan knight. The second, the Sword Play, features a slaying with swords by a group of dancers, and in the third, the Wooing Ceremony play, the two main characters are women, played by men. Death, resurrection, and the *fool recur in all three. The faces of the cast were often blackened with soot. They were performed regularly until the mid-19th century, and may still be encountered occasionally.

Munch, Edvard (1863–1944), Norwegian painter, lithographer, etcher, and wood engraver. In 1885 he made the first of several visits to Paris, where he was influenced by the *Impressionists and *Symbolists, and above all by *Gauguin's use of simplified forms and non-naturalistic colours. Munch had a traumatic childhood, and in his paintings he gave expression to the neuroses that haunted him. Certain themes—jealousy, sickness, the awakening of sexual desire—occur again and again, and he painted extreme psychological states with a conviction and an intensity that sometimes bordered on frenzy. From 1892 to 1908 he lived mainly in Germany, and was one of the fountainheads of German *Expressionism. An exhibition of his work in Berlin in 1892 caused such an uproar that it had to be closed. In 1908 he suffered what he called 'a complete mental collapse', and after recuperating returned permanently to Norway. He made a conscious decision to devote himself to recovery, even though he realized that his mental instability was part of his genius, and the anguished intensity of his work disappeared,

The *Dance of Life* (1899–1900) is part of a series of pictures that **Munch** called the 'Frieze of Life'—'a poem of life, love, and death'. In this scene the dancing couples represent physical desire, but the mournful figure (*right*) is a reminder of the transitoriness of sexual pleasure and of the loneliness that can exist in the midst of passion. Munch showed unprecedented acuteness and subtlety in showing how the powerful emotions of sexual desire and fear can combine to produce tortuous mental conflicts. (National Gallery, Oslo)

replaced by a more extroverted outlook through which he exalted the positive forces of nature.

Munkacsi, Martin (Márton) (1896–1963), Hungarian photographer. In 1923 Munkacsi photographed an old man and a soldier fighting in a street in Budapest. His picture was used as evidence in a widely reported trial, and the publicity soon brought Munkacsi so much work that he claimed he was the highest-paid photographer in the city. Eighteen years later, now in New York, he claimed he was the highest-paid photographer in the USA. Employed by Carmel Snow, new editor of *Harper's Bazaar*, to take his first fashion photographs, he brought to them a totally novel sense of reality and movement. The photographers who acknowledge the influence of Munkacsi's exuberant spontaneity include *Avedon and *Cartier-Bresson. He suffered a heart attack in the war, and his work declined thereafter.

Muqi (Fachang) (d. *c*.1270), Chinese painter. He was a Zen Buddhist monk living in a temple at Hangzhou and little is known of his life. His contemporaries evidently did not appreciate him, but he is now one of the most celebrated Chinese painters, revered for the sense of profound significance with which he imbued even the simplest subjects. Almost all his surviving paintings are in Japan, where he was initially more highly regarded. They include two masterpieces in the Daitoku-ji, Kyoto: a triptych showing a white-robed Bodhisattva (see *Buddhist art) flanked by a crane and a monkey with her

baby; and *Six Persimmons*, in which the humble fruits are scrutinized with such intensity that they acquire a cosmic significance, the minimalist forms suggesting the sudden, irrational experience of Zen illumination. All Muqi's pictures are virtually monochromatic and painted with inspired spontaneity.

mural, a painting, usually large, on a wall or for mounting on a wall as a permanent part of the decoration of a building. An ancient art-form practised by the Minoans and Greeks, the classic technique for mural painting is *fresco, but other methods suitable for damp climates have been used especially in northern Europe. The most successful alternative has been simply to paint in oils on canvas and glue the canvas to the wall. This technique, known as marouflage, was used by Pierre Puvis de Chavannes, the most successful muralist of the later 19th century, whose pale colours deliberately imitated the effect of fresco. In Asia the traditional method of wall-painting is with glue or dry plaster, but the fresco technique was known there in the 11th and 12th centuries, as a technical examination of mural paintings at Tanjore in India has revealed.

Murdoch, Iris (Jean) (1919–), Irish-born English novelist and philosopher. Her highly individual novels show a preoccupation with the nature of good and evil, the sacred and the taboo, with sexuality and Freudian determinism. They include *Under the Net* (1954), her first novel; *The Bell* (1958), set in a lay community; *A Severed Head* (1961); *The Sea, The Sea* (1978, Booker Prize), about a theatre director and his childhood love; and *The Philosopher's Pupil* (1983). Her plots combine comic, macabre, and bizarre incidents in a highly patterned symbolic structure. Her philosophical works include studies of Sartre and Plato.

Murillo, Bartolomé Esteban (1617–82), Spanish painter. He worked for almost all his career in his native Seville, where he displaced *Zurbarán as the leading painter in the 1640s. His early work was in a sombre

naturalistic vein influenced by Zurbarán, but his mature style was quite different, featuring idealized figures, soft, melting forms, delicate colouring, and sweetness of expression and mood. He painted two main types of picture: religious scenes appealing to popular piety and *genre scenes of beggar children that have a similar sentimental appeal. His rare portraits are much more sombre and intellectual. Murillo's fame in the 18th century and early 19th century was enormous, but as tastes changed he was dismissed as facile and sugary. Now that his own work is being distinguished from that of his countless imitators interest in his art has revived.

Murnau, F(riedrich) W(ilhelm) (Plumpe) (1888–1931), German film director, whose high reputation rests on a small number of films. He achieved prominence with *Nosferatu: a Symphony of Terror* (1922), based on Bram Stoker's *Dracula*, which incorporated technical effects such as negative images. His most important German film was *The Last Laugh* (1924), a silent film without subtitles, which portrays an old man's desolation on being demoted after a heart attack. It broke new ground with its mobile use of the camera. After two impressive films based on stage originals—Molière's *Tartuffe* (1925) and Goethe's *Faust* (1926)—he moved to the USA, where his film *Sunrise* (1927) was hailed for its superb visual impact. *Four Devils* (1928), about trapeze artists, was a remake of the 1925 German film *Variété*, and *City Girl* (1930) was a companion piece to *Sunrise*. *Tabu* (1931), set in the South Seas, was his greatest success.

musical, a play with music and song as the principal feature. Evolving in the USA during the 1920s, the musical was stronger on plot and had generally more dramatically integrated music than its immediate predecessor, the 'musical comedy'. The first musical of real importance was Jerome Kern's *Show Boat* in 1927. The same year saw the coming of sound to the cinema; a proliferation of film musicals followed, initially dependent on the stage for source material. Composers such as *Gershwin, *Porter, *Berlin, Richard *Rodgers, and Harold Arlen, followed and challenged Kern's model, and their work was in turn adapted to Hollywood. Meanwhile, musicals were being written especially for the big screen, the spectacular direction of Busby Berkeley opening up new possibilities exploited in the dance musicals of *Astaire and Ginger Rogers in the 1930s, such as *Top Hat* (1935), and of *Kelly, especially *On the Town* (1949), *An American in Paris* (1951), and *Singin' in the Rain* (1952). As stage musicals such as Frank Loesser's *Guys and Dolls* (1950) and Bernstein's *West Side Story* (1957) became increasingly sophisticated and almost operatic, musicals in which the choreography is central to the plot transferred with great success from *Broadway to the screen, notably *Cabaret* (1972), directed and choreographed by Bob Fosse.

Musical glasses *glass harmonica.

music-hall, a type of entertainment which flourished in Britain during the second half of the 19th and early 20th centuries. The music-hall originated in the 'saloons' of London taverns set apart for 'sing-songs'. In 1852 the first purpose-built music-hall, the Canterbury, was opened. At first the entertainment took place on a simple stage at one end of a hall furnished with tables, chairs,

and a bar. This eventually gave way to the elaborate two- or three-tier auditorium with a fully equipped stage; by this time they were known also as 'palaces of variety'. They provided a varied programme of up to twenty-five 'turns': singers, dancers, comedians, acrobats, jugglers, even dramatic sketches. The early music-halls had a chairman who controlled the proceedings and (unusually for the times) employed women singers and later *comédiennes*, as well as their male counterparts. Some of the music-halls, such as the Alhambra, graduated to *revue

A poster advertising *Top Hat* (1936). Fred Astaire and Ginger Rogers made nine other **musicals** together; these ten films are among the most popular and important made in the genre. Astaire's seemingly effortless dances were an inventive mixture of tap, ballroom, and ballet. His partnership with Rogers had a special chemistry, and his singing inspired some of the finest songs of Kern, Gershwin, Berlin, and other songwriters.

and the *musical, but many remained the home of twice-nightly variety. The many talented music-hall stars included the singer Marie Lloyd (1870–1922), known for her *double entendres*, the comedians Dan Leno (1860–1904) and George Robey (1869–1954), and Vesta Tilley (1864–1952), the best of the male-impersonators. At the turn of the century and into the first quarter of the 20th century the British music-halls were the only venues available for dancers. Dan Leno started his theatrical career as a champion *traditional dancer, a reflection of the eclectic nature of dance in the music-halls, which ranged from virtuoso performances of step and clog dancing to pared down extracts from the ballet repertoire. At the Alhambra and Empire Theatres in London ballet was a regular item on the programme and, since both theatres maintained their own ballet companies, complete ballet programmes were also given. These usually consisted of spectacular productions with dance interspersed between elaborate tableaux-vivants based on mythological stories or nationalistic themes. Adeline Genée, a respected Danish-British ballerina, and Phyllis Bedells, one of the first British ballerinas, both performed regularly at the Empire Theatre. With the advent of the cinema, the popularity of the music-hall waned. (See also *vaudeville.)

musicology, the analytical study of music, past and present. The musicologist aims to study the workings of music—how others have composed and performed it—and is not primarily concerned with any direct, practical application. Among the main musicological areas are analysis, editorial work, ethnomusicology, psychology and aesthetics, and the sociology of music. Musicology has contributed greatly to our understanding (and ability to perform) the music of the past, and our appreciation of the values of different musical cultures. Though many earlier music historians (such as Dr Charles Burney) and music theorists (such as Rameau) contributed to our understanding of the art of music, musicology as a science was first established in Germany towards the middle of the 19th century, and is now a respected discipline.

Musil, Robert (1880–1942), Austrian novelist, short-story writer, and essayist. His first literary success, the short novel *The Confusions of Young Törless* (1906), explores adolescent sexuality and rational and intuitive modes of experience. His short stories appeared under the title *Unions* (1911) and *Three Women* (1924). From the 1920s onwards Musil concentrated on his vast, uncompleted novel *The Man without Qualities* (1930–43), in which narration and discursive reflection interweave to give an ironic yet sympathetic view of the former Habsburg empire, and of a central character who is full of potential, but 'without qualities'.

musique concrète, a term coined by Pierre Schaeffer in 1948 to describe a composition assembled from previously recorded sounds. The sounds may be natural (leaves rustling in the wind) or human-made (cashiers rustling bank-notes). Strictly speaking the sounds should not be modified by electronic means, but the original purity of purpose has been blurred as *electronic music has gained ground.

Musorgsky, Modest (Petrovich) (1839–81), Russian composer. Although he had failed to complete various earlier operatic projects, the first version of his opera *Boris

A portrait of **Musorgsky** by Ilya Repin painted in 1881, a few days before the composer's death. An obituary commented 'Musorgsky died at the height of his creative power and talent', and indeed alcoholism crippled his heroic aim of creating an art which was to illuminate the life of many.

Godunov was completed in 1869. Revised in 1874, a complete performance was given in that year; it proved to be his masterpiece. However, its success did not have the effect that might have been expected, for Musorgsky was by now drinking heavily. He left two incomplete operatic projects, *Khovanshchina* and *Sorochinsky Fair*. Both were completed by *Rimsky-Korsakov and Liadov (1886 and 1913), but from about 1908 onwards there was growing dissatisfaction with Rimsky-Korsakov's versions of these and other works, and since then much of Musorgsky's music has been republished in its original form. Two remarkable song-cycles, *Sunless* (1874) and *Songs and Dances of Death* (1877), his popular *St John's Night on a Bare Mountain* (1867), and the piano suite *Pictures at an Exhibition* (1874), testify to Musorgsky's powerful, if rough-edged, originality. (See also The *Five.)

Musset, Alfred de (1810–57), French poet, dramatist, and novelist. His poetry displays the lyricism characteristic of the *Romantic movement, but his best pieces, for example *Les Nuits* (1835–7), have a sharper note of bitterness than is found, for example, in the work of *Lamartine. Notable among his plays, which were mostly written to be read, is *Lorenzaccio* (1834), which most nearly captures that Shakespearian richness of texture advocated by *Hugo. His novel *Les Confessions d'un enfant

du siècle (1836) is based on his stormy relationship with George *Sand.

al-Mutanabbī, Abū al-Tayyib (915–65), Arab poet. Born in Iraq, he spent most of his life in Syria, becoming court poet in Aleppo 948–57. He then spent eight years in Egypt before being killed on his way back to Iraq. He is considered to be the greatest writer of formal Arabic poetry in the Islamic period. His self-glorification is unappealing, but his linguistic virtuosity and his general poetic skill earned him a reputation that has lasted to the present.

Muybridge, Eadweard (Edward James Muggeridge) (1830–1904), British photographer and inventor. Emigrating to the USA at the age of 22 (and changing his name to sound more 'Anglo-Saxon'), Muybridge became a professional photographer in California, taking hundreds of views of the Pacific Coast and Yosemite National Park. Leland Stanford, millionaire governor of California, commissioned him to photograph his favourite horse at full gallop. Having obtained a recognizable silhouette in 1872, he returned to his experiments in 1877, constructing a huge apparatus with twelve cameras actuated by electromagnets at specific intervals. Later, he doubled the number of intervals, setting them off by trip threads under the horse's hoofs. Muybridge went on to photograph many animals, publishing his famous *Human and Animal Locomotion* in 1887. His Zoopraxiscope was the most successful machine for showing movement until Edison introduced his Kinetoscope in 1888.

Mycenaean art, Greek art in the Late *Bronze Age (*c.*1580 BC–*c.*1120 BC), named after the city of Mycenae, the site of the most important remains of the period. Usually the term embraces the art not only of the mainland, but also of the Greek islands with the exception of Crete, which had its own artistic tradition called *Minoan. Mycenae was the dominant city in the Aegean and controlled much of the eastern Mediterranean, and its architecture was on an extremely ambitious scale. The most distinctive building type was the beehive-shaped tomb, the most notable example of which is the 'Treasury of Atreus' in Mycenae (early 13th century BC); its dome remained the largest in the world until the Pantheon in Rome was built some 1500 years later. The other celebrated structure in Mycenae is the Lion Gate (*c.*1250 BC), so called from its carved figures of lions, the first monumental stone sculptures in *Greek art. The Mycenaeans were a warlike people, and they developed the fortified citadel with its royal palace at the heart of the city, a feature that influenced the development of the later Greek polis with its acropolis. They decorated their buildings with frescos and incrustations of alabaster and lapis lazuli, as well as with sculpture; the wealth of their civilization is witnessed in the gold funeral masks and the inlaid gold weaponry, utensils, and ornaments of their kings. Ivory imported from Egypt was a favourite medium, and their pottery, of stylized design, often depicts military or hunting scenes. The Mycenaean civilization was destroyed by Dorian invaders in about 1100 BC.

mystery play, a popular dramatic representation of scenes from the Old and New Testaments, performed in many towns across Europe from the 13th to the 16th centuries (and, later, in Roman Catholic Spain and Bavaria). They seem to have developed gradually from aspects of the Easter Mass in Latin (see *liturgical drama) into civic occasions in the local languages, usually enacted on Corpus Christi, a holy feast day from 1311. Several English towns had 'cycles' of mystery plays, in which wagons stopping at different points in the town were used as stages for the various episodes, each presented by a trade guild (then known as a 'mystery'). A full cycle, like the forty-eight plays enacted at York, would represent the entire pattern of Christian redemption from the Creation to Doomsday. Other cycles survive from Chester, Wakefield, and the unidentified 'N-town'; the plays of the anonymous 'Wakefield Master' are the most celebrated, notably the *Second Shepherds' play*. In Islam, there is the Shi'ite passion play (*ta'ziya*), usually performed during the mourning month of Muharam, especially for the commemoration of the murder of Husain. The play re-enacts in emotive detail the tragic death of Husain, and is often accompanied by street processions and public expressions of grief, such as self-flagellation.

Mystics, the, a description applied to Spanish mystical writers of whom St Teresa of Avila (1515–82) and St John of the Cross (Juan de Yepes, 1542–91) are the most notable. Their work, linked to a process of spiritual ferment and reform within the Roman Catholic Church, testifies to a deep-felt spiritual condition. St Teresa, a Carmelite nun, led a life of extreme asceticism, and became involved in the controversial reforms of her Order, founding many convents throughout Spain. *Life* (1588), her autobiography, *The Mansions* (1588), which describes the various stages of mystical experience culminating in union between the soul and Christ, *Book of the Foundations* (1610), together with other prose works, poetry, and many letters, record her experiences. St John of the Cross, also a Carmelite, joined the reform, which led to his nine-month imprisonment in a Toledo monastery (1576 and 1577), where he composed some of his finest poetry. His three major poems, *The Dark Night of the Soul*, *The Living Flame of Love*, and *The Spiritual Canticle*, lyrically communicate his mystical experience through the *allegory of human love, as he explains in the later commentaries. Among the many lesser-known Spanish mystical writers are Bernardino de Laredo (1482–1540), Juan de Avila (1500–69), and Alonso de Orozco (1500–91).

Mytens, Daniel (*c.*1590–1647), Dutch-born painter almost all of whose known career was spent in England. He worked for James I and Charles I, dominating court portraiture until the arrival of van *Dyck in 1632. Mytens introduced a new elegance and grandeur into English portraiture, especially in his full-lengths, but he was outclassed by van Dyck and he returned to the Netherlands in about 1634. His great-nephew, **Daniel Mytens** (the Younger) (1644–88), also a portraitist, was probably the best known of the many other artists in the family.

N

Nabokov, Vladimir (Vladimirovich) (1899-1977), Russian-born US novelist and short-story writer. Brought up in St Petersburg, he left Russia in 1919 and later lived in Berlin and Paris, writing fiction in Russian under the name V. Sirin. His first novel in English, *The Real Life of Sebastian Knight*, appeared in 1939, and in the following year he emigrated to the USA. His witty, ingenious, stylized, and erudite novels include *Lolita* (1955), a farcical and satirical novel of the passion of a middle-aged sophisticated European émigré for a 12-year-old American nymphet; *Pale Fire* (1962), a satirical fantasy encounter between poet and madman; and *Ada or Ardor* (1969), a witty parody of a family chronicle. *Conclusive Evidence* (1951) revised as *Speak, Memory* (1966) is a brilliant poetic autobiography.

Nadar (Gaspard Felix Tournachon) (1820-1910), French photographer. Nadar was a Parisian journalist and caricaturist before he took up photography in 1853 in partnership with his brother Adrien. In 1860 he opened his own studio in the Boulevard des Capucines, to which his flamboyance and position in the city's cultural life brought many famous sitters. In 1874 he lent this studio to the *Impressionists for their first exhibition. Always eager to experiment, Nadar took the first aerial photographs (from a balloon), built the world's largest balloon, photographed in the sewers and catacombs of Paris, and, as early as 1860, equipped his studio with electric light. He also participated in the world's first photographic interview—with the scientist Eugène Chevreul—taken in 1886 by his son Paul, who succeeded Nadar when he retired in that year.

Naipaul, V(idiadhar) S(urajprasad) (1932–), West Indian novelist. His early novels, notably *The Mystic Masseur* (1957) and *A House for Mr Biswas* (1961), cast an ironic eye on his native Trinidad. Later works display a bitterly pessimistic mood, especially in *Guerrillas* (1975), a novel about Caribbean revolutionaries, and in *A Bend in the River* (1979), set in Africa. His non-fictional writings include *An Area of Darkness* (1964), his controversial account of India. His younger brother, **Shiva Naipaul** (1945-85), was also noted for his Trinidadian novels *Fireflies* (1970) and *The Chip-Chip Gatherers* (1973), for his essays, and for the African travel book *North of South* (1978).

naïve art, term applied to painting (and to a much lesser degree sculpture) produced in more or less sophisticated modern societies but lacking conventional representational skills. Colours are characteristically bright and non-naturalistic, perspective non-scientific, and the vision childlike or literal-minded. Interest in the freshness and directness of vision of outstanding naïve artists such as Henri *Rousseau developed in France in the early years of the 20th century, and since then many other naïve artists, for example Grandma *Moses in the USA, have won critical recognition.

naker, naqquāra *kettledrum.

Narayan, R(asipuram) K(rishnaswami) (1906–), Indian novelist and short-story writer. His first novel, *Swami and Friends* (1935), introduced the fictional town of Malgudi, in which several later novels are set, including *The Man-Eater of Malgudi* (1962) and *The Vendor of Sweets* (1967). He examines the Indian middle class with an ironic eye in his novels and short-story collections from *An Astrologer's Day* (1947) to *Under the Banyan Tree* (1985).

narrative verse, poetry which tells a story. The three chief forms of narrative verse are the *epic, the *ballad, and the verse *romance. Like dramatic verse, it has tended to decline in importance since the middle of the 19th century, relative to the larger body of *lyric poetry.

Nash, John (1752-1835), British architect, the most prolific and successful of the Regency period. Of Anglo-Welsh parents, he practised at first in Wales, obtaining commissions there and in Ireland. Up to the age of about 50 he worked mainly as a designer of fashionable country houses in a remarkable range of styles. They were in the *Picturesque spirit and Nash often worked in collaboration with the landscape gardener Humphry *Repton. From 1811, however, he concentrated on his masterpiece, the layout of Regent Street and Regent's Park in London. His work in Regent Street has been

Ivan Generalić painted *Under the Pear Tree* on glass in 1943, adding to Yugoslavia's already rich tradition of **naïve art**. Like many exponents of the genre he had little formal education, leaving primary school to work on his parents' land, and taking paper along to draw when he had a free moment. After World War II Generalić's home village of Hlebine became the centre of a school of Yugoslav peasant painting.

largely destroyed and only a part of his scheme for the park was completed, but his sweeping, palatial streets such as Carlton House Terrace and Cumberland Terrace form the finest piece of town-planning in London. They are in stucco-fronted brick (a treatment they helped to popularize) and are sometimes weak in detail, but as scenic effects they are magnificent. For George IV he also redesigned Buckingham Palace (built for the Duke of Buckingham in 1703 and then named Buckingham House), and the Marble Arch, and reconstructed Brighton Pavilion (1823) in a mixture of oriental styles.

Nash, Ogden (1902–71), US author of light verse. Nash claimed that he was indebted to the 'Sweet Singer of Michigan' (Julia A. Moore, 1847–1920), humorously employing the mannerisms of her bad verse. Collections of his poems appeared regularly after his début with *Hard Lines* and *Free Wheeling* (both 1931). His work displays remarkable technical skill, and ranges in tone from acid satire to genial nonsense (see *nonsense verse).

Nash, Paul (1889–1946), British painter and graphic artist. In the 1920s and 1930s he was influenced particularly by *Surrealism and often concentrated on mysterious aspects of the landscape. He was an official War Artist in both World Wars, painting some of the finest pictures to be inspired by the conflicts, and he was regarded as one of the finest book-illustrators of his time. He also designed stage scenery, fabrics, and posters, and was a photographer and writer. His brother **John** (1893–1977) was also a painter and illustrator.

national anthem, a hymn, song, or march authorized by government as the official expression of patriotic sentiment in words and music. The oldest national anthem is the British 'God Save the (King) Queen'. Its origins and authorship are obscure, but its popularity dates from the landing of the Young Pretender, 1745, when it was introduced in London theatres and widely taken up as an expression of loyalty to King George II. At least twenty nations have, at one time or another, borrowed the tune as their national anthem—its virtues being its brevity, dignity, and practical vocal compass. Other national anthems have been written in direct imitation of its solemn, hymn-like style—most notably the original Austrian national anthem, 'Gott erhalte Franz den Kaiser', composed by Haydn in 1797 (and later incorporated in his 'Emperor' Quartet, Op. 76, No. 3). From the mid-19th century this was sung in Austria and Germany to the words 'Deutschland, Deutschland, über Alles' and adopted, in 1922, by the German Nazi Party. It is now used (with different words) by the German Federal Republic—Austria having adopted a new anthem, 'Land der Berge, Land am Strome'. Russia's first national anthem, 'God Save the Tsar' (composed in 1833 by L'vov), was also clearly influenced by the British example. After 1917 the USSR adopted the 'Internationale', which two French workers had written in 1871. It was replaced in 1944, on Stalin's orders, by 'Gimn Sovietskovo Soyuza' ('Anthem of the Soviet Union'), but is still used as the unofficial anthem of many socialist and some communist parties. The Japanese national anthem 'Kimigayo' (Reign of our Emperor), officially adopted in 1888, has words by an unknown 9th-century poet and is sung to a traditional court melody. On the other hand, the USA's national anthem, 'The

This detail of a painting by the brothers Lesueur (18th–19th centuries) shows citizens enthusiastically joining in 'La Marseillaise', the French **national anthem**. Sung by the revolutionary masses as they stormed the royal palace of the Touileries, the anthem was suppressed for a time by Napoleon and again by the Bourbon monarchy, who feared the inflammatory message of its words and music. (Musée Carnavalet, Paris)

Star-spangled Banner' (adopted in 1931), uses the tune of a drinking-song, 'To Anacreon in Heaven', by the British composer John Stafford Smith (1750–1836), and words written in 1814 by Francis Scott Key as he watched the unsuccessful bombardment of Fort McHenry by the British. In 1974 Australia declared the 19th-century patriotic song, 'Advance Australia Fair' to be its national anthem, with 'Waltzing Matilda' coming second in a public opinion poll as an additional national song. The second oldest national anthem, Spain's 'Marcha real', dates from 1770. It has no words, and is an example of the march-anthem favoured by some countries. Other countries, such as the United Arab Emirates, content themselves with simple fanfare-like flourishes. But whatever the style of anthem, it is an expression of national pride, and sometimes—as with the officer, Rouget de Lisle's song 'La Marseillaise', officially adopted by France in 1795—of revolution.

national theatre, a permanent, state-subsidized theatre. The oldest national theatre is the Comédie-Française in Paris, founded in 1680 by Louis XIV; this was followed by five other French national theatres. Other long-established national theatres are to be found in Denmark (1772), Austria (1776), Sweden (1788), Holland (1870), Finland (1872), and Norway (1899). The Abbey Theatre, Dublin (1904) began to receive an annual subsidy from the newly formed Free State Government in Ireland in 1925. The Greek National Theatre dates from 1930; in 1961 it was supplemented by the National Theatre of Northern Greece. The Belgian National Theatre was established in 1945. The British National Theatre (first suggested by *Garrick) was founded only in 1961, and moved into its own premises on the South Bank of the Thames in 1976. The building, designed by Denys Lasdun,

is a vast complex housing three theatres (the Lyttelton, the Olivier, and the Cottesloe). Its first director was Laurence *Olivier, who was succeeded by Peter *Hall in 1973. The Royal Shakespeare Company, formed in 1961, virtually ranks as a second national theatre. The *Habimah is the national theatre of Israel. In Eastern Europe national theatres have survived in Hungary (1840), Romania (1854), Yugoslavia (1869), Bulgaria (1907), and Czechoslovakia (1920). The Moscow Art Theatre was founded by Stanislavsky and Vladimir Nemirovich-Danchenko (1859–1943) in 1898; it is now a state theatre dedicated to Maxim Gorky.

Natsume Sōseki (1867–1916), Japanese novelist and student of English literature. He moved from a traditional style to become one of the acknowledged masters of the colloquial style. *I am a Cat* (1905) is an episodic satire on ineffectual character seen through the eyes of a cat; *Botchan* or *The Young Master* deals with the clash between the samurai values of the older feudal warrior class and the modern Meiji world (1867–1912); and the central theme of *Heart* (1914) traces the relationship between an old man and a young boy.

naturalism, a more deliberate kind of *realism in *novels and plays, influenced by a view of human beings as passive victims of natural forces and social environment. As a literary movement, naturalism was initiated by the brothers *Goncourt with their novel *Germinie Lacerteux* (1865), but led by *Zola, who claimed a 'scientific' status for his studies of impoverished characters miserably subjected to hunger, sexual obsession, and hereditary defects in *Thérèse Raquin* (1867), *Germinal* (1885), and many other novels. Naturalist fiction aspired to a sociological objectivity, offering detailed and fully researched investigations into unexplored corners of modern society: railways in Zola's *La Bête humaine* (1890), the department store in his *Au Bonheur des Dames* (1883), while spicing this with a new sexual sensationalism. Other novelists associated with naturalism include *Daudet and *Maupassant in France, *Dreiser and Norris in the USA, and *Moore and *Gissing in Britain. *Ibsen's play *Ghosts* (1881), with its stress on heredity, encouraged a number of experiments in dramatic naturalism by *Strindberg, *Hauptmann, and *Gorky. The term 'naturalistic' in drama often has a broader application, denoting a very detailed illusion of real life on the stage, as in *Stanislavsky's work, especially in speech, costume, and sets.

Nātyaśāstra, the earliest Indian treatise on theatre, dance, and music. It is attributed to Bharata (AD c.200) and shows the performing arts had already developed fully in India. The earliest surviving Sanskrit plays are fragments from the 2nd century AD. The *Nātyaśāstra* classifies plays into ten types and maintains that the aim of drama is to evoke a particular sentiment (*rasa*) in the mind of the audience. Emotional content was therefore more important than plot or characterization. Acting and dancing were closely linked, Indian drama having probably originated in ritual miming song and dance performed during religious festivals.

nāy, a musical instrument, the *end-blown flute of the Arab world, usually made of reed or cane, and found, often in other materials such as wood or metal, in almost all the cultures influenced by Islam.

Nazarenes, a group of young, idealistic German painters of the early 19th century who believed that art should serve a religious or moral purpose and desired to return to the spirit of the Middle Ages. The nucleus of the group was established in 1809 when six students at the Academy of Fine Arts in Vienna formed an association called the Brotherhood of St Luke, named after the patron saint of painting. The name Nazarenes was given to them derisively because of their affectation of biblical dress and hairstyles. They wished to revive the working environment as well as the spiritual sincerity of the Middle Ages and they lived together in an almost monastic fashion. One of their aims was the revival of *fresco painting, and they received two prestigious commissions in this field in Rome that made their work internationally known. Stylistically they were much indebted to *Perugino, and their work, though clear and prettily coloured, is often insipid. The Nazarenes broke up as a group in the 1820s, but their ideas were influential—the studio of the best-known member of the Brotherhood, Friedrich Overbeck (1789–1869) (the only one to remain permanently in Rome), became a meeting place for artists from many countries. Ford Madox *Brown and William *Dyce were among the British artists who knew him, and these two form a link between the Nazarenes and the similarly idealistic *Pre-Raphaelites.

needlework *embroidery.

Nègre, Charles (1820–80), French photographer. Nègre arrived in Paris in 1839 as an art student. His teacher was Paul Delaroche, and his classmates included Fenton, Le Gray, and Le Secq, themselves destined to become famous photographers. Nègre began taking daguerreotypes in 1844, but turned to photography on paper for his finest successes—though even these were intended as studies for his paintings. In 1852, however, he found his true forte by beginning to document the great buildings of Paris. Returning to the South he continued to work on the architectural views which, together with those of Chartres Cathedral, are his masterpieces. He experimented with photogravure, as being more permanent than conventional prints, and patented his own process in 1856. In 1863 he retired to a drawing master's position in Lyon, but continued to produce portraits and Riviera views until he died.

négritude movement *African literature, Aimé *Cesaire, Léopold *Senghor.

Nekrasov, Nikolay (Alekseyevich) (1821–77), Russian poet and journalist. His satirical and sentimental lyrics expose the author's acute social conscience as he observes rural and urban injustice and misery. Nekrasov was at the same time an inventive master of verse-form. His long poems include the folkloric *Red-Nosed Frost* (1863–4) and the unfinished panorama of Russian village life after the emancipation of the serfs, *Who Lives Happily in Russia?* begun in 1863. Nekrasov was the most important literary editor of his time; he worked tirelessly to publish and publicize the works of his great contemporaries in the face of unrelenting censorship and personal squabbles.

Neoclassicism, the dominant artistic movement in European art and architecture in the late 18th and early

David's *The Oath of the Horatii* (1784) is one of the purest examples of the severity of form and loftiness of ideals typical of **Neoclassicism**. The theme of the picture is patriotic duty versus personal feeling. The three Horatii brothers, young Roman warriors, swear to their father that they will defeat the three Curiatii brothers, the champions of the enemy state, Alba. To the right, the Horatii sisters lament—one of them is in love with one of the Curiatii. (Louvre, Paris)

19th centuries, characterized by a desire to re-create the spirit and forms of the art of Ancient Greece and Rome (see *Greek and *Roman art). A new and more scientific interest in Classical antiquity was one of its features and this was greatly stimulated by discoveries at Pompeii (where excavations began in 1748) and at Herculaneum. In France it permeated what are known as the *Louis XVI style, the Régence, the *Directoire, and the *Empire. In Britain it was reflected in the *Adam style, *Hepplewhite and *Sheraton in furniture, and it constituted one of the main elements of the *Regency. The main theorists of the movement were J. J. *Winckelmann in Germany and in France Antoine Quatremère de Quincy, whose book *An Essay on the Nature and Means of Imitation in the Fine Arts* was published in English in 1837. Neoclassicism was most successful, perhaps, in architecture, as in the works of the Adams brothers, John *Nash, and Alexander 'Greek' Thompson in Britain, Langhans in Germany, Jean-François Chalgrin, Alexandre-Théodore Brongniart, and *Ledoux in France, and Andreyan Zakharov in Russia. Important among the pioneers in architecture were Ange-Jacques Gabriel in France, who built the Place de la Concorde in 1754 and whose Petit Trianon at Versailles was regarded as the most perfect example of 'Attic' in French architecture, and *Soufflot, who was instrumental in introducing the new Classicism into plans for reconstructing Paris. In painting its chief initiator was

A. R. *Mengs, who influenced such artists as Benjamin *West from the USA, Gavin Hamilton from Scotland, and (through Joseph-Marie Vien) its greatest exponent, *David in France. Among sculptors whose work was of wide general influence were *Canova, *Thorvaldsen, Jean-Baptiste Pigalle, Jean-Antoine Houdon, and John *Flaxman. The movement spread to the USA with the work of such artists as the sculptors Hiram Powers and Horatio Greenough and the painter John Vanderlyn. In the decorative arts Neoclassicism repudiated the asymmetry of *Rococo, substituting for it a strict axial symmetry, and relying mainly on motifs of Classical origin such as medallions, trophies, urns, tripods, and masks. It influenced the design of textiles, plate, and interior decoration, and among its most successful furniture designers were Hepplewhite and Sheraton. In his interior designs Adam introduced the simple, rectilinear forms which in the 1770s and 1780s were popular through much of Europe. The great period of Neoclassical taste in ceramics and silverware extended from *c*.1770 to 1820. In ceramics Josiah *Wedgwood produced in his new 'basaltes' ware, a simple and elegantly sober pottery admirably adapted to the Neoclassical interior. In metalwork, Robert Adam designed domestic objects for Matthew Boulton, a pioneer in *Sheffield Plate, which found its fullest flowering in the Neoclassical style. Romantic interest in medieval forms and fancies, which was partly literary in origin, led to the *Gothic Revival that was to supersede Neoclassicism. (See also *Greek Revival.)

Neoclassicism in music is a style which, in a conscious and usually ironic manner, adopts techniques, gestures, or forms from music of an earlier period. The term is used particularly of early 20th-century composers who rejected the Romantic expressiveness of late 19th-century composers such as Wagner, and looked instead to 17th- and 18th-century works for their inspiration. *Stra-

vinsky's works echo many of the *Classical composers: his *Oedipus rex* (1926–7) looks back to Handel in its general shaping and its massive choruses; the Capriccio for piano and orchestra (1928–9) is reminiscent of Weber; while the 'Dumbarton Oaks' Concerto (1937–8) returns to Bach's concerto forms. The influence of Stravinsky's Neoclassical scores was felt by many composers in Paris between the wars, among them *Poulenc, *Martinů, *Honegger, *Szymanowski, and *Copland. The movement in France was light-hearted and often ironic in its imitation of earlier composers. In Germany its leading proponent was Paul *Hindemith, who wrote many concertos and chamber pieces which have a vigour and directness not shared by contemporary Parisian music.

Neo-Impressionism, a movement in French painting that was both a development from *Impressionism and a reaction against it. Like the Impressionists, the Neo-Impressionists (of whom *Seurat was far and away the most important) were fundamentally concerned with the representation of light and colour, but whereas Impressionism was spontaneous, Neo-Impressionism was based on scientific principles and resulted in highly formalized compositions. By using dots of pure colour carefully placed next to each other on the canvas (a technique called *pointillism) the Neo-Impressionists hoped to achieve a more luminous effect than if the same colours had been physically mixed together. Seurat's paintings do indeed convey a vibrating intensity of light, which he combined with a magnificent solidity and clarity of form, but in the hands of lesser artists the approach often produced works that look rigid and contrived. Neo-Impressionism, which was launched at the final Impressionist exhibition in 1886, was a short-lived movement, but it had a significant influence on several major artists of the late 19th and early 20th centuries, notably *Gauguin, van *Gogh, *Matisse, and *Toulouse-Lautrec.

Neolithic art *Stone Age art.

Neo-Plasticism, the term coined by Piet *Mondrian for his style of austerely geometrical abstraction. He restricted the elements of pictorial design to the straight line and the rectangle (the right angles in a strictly horizontal–vertical relation to the frame) and to the primary colours (blue, red, and yellow) together with white, black, and grey. In this way he sought to achieve expression of an ideal of universal harmony.

Neo-Romanticism, a term applied to a movement in British painting and other arts, in the period from about 1935 to 1955, in which artists looked back to certain aspects of 19th-century *Romanticism, particularly the 'visionary' landscape tradition of *Blake and Samuel *Palmer, and reinterpreted them in a more modern idiom. The best known of these painters and illustrators are Paul *Nash, John *Piper, and Keith Vaughan. The term has also been applied to certain painters working in France in the 1930s who typically painted dreamlike imaginary landscapes with mournful figures.

Nepalese art, the art and architecture of Nepal, a land-locked kingdom in the Himalayas. Culturally it has drawn heavily on its southern neighbour India, but it has a vigorous artistic tradition of its own and Nepalese artists have been influential in Tibet and in China, where a Nepalese bronzeworker called A-ni-ko was controller of the imperial studios under Kublai Khan in the 13th century. Natural and man-made disasters (earthquakes, invasions, civil wars) have taken a heavy toll of Nepalese art and few major works survive from before the 15th century. Almost all Nepalese art has been done in the service of religion. Buddhism (Buddha was born in Nepal) and Hinduism have mingled with an animistic religion of spirits and demons to produce a highly complex iconography. The most important region of the country culturally is the Katmandu Valley (Katmandu is the capital), which is fertile and comparatively densely populated. Nepal has excellent timber and much of the architecture is in wood. Temples are essentially Indian in inspiration, but sloping roofs with up-turned corners reflect Chinese influence. Sculpture is the art at which the Nepalese have chiefly excelled, using stone, bronze and other alloys, and occasionally terracotta, as well as wood. Guardian figures in the shape of lions or terrifying deities are placed at entrances to buildings; windows and door frames are covered with reliefs, statues flank the stairs leading to temple entrances, and the temples themselves are replete with images. The quality of such sculpture is often extremely high. Nepalese painting includes *tankas* (temple banners), murals, and book illustrations. Among the decorative arts, ritual objects such as temple bells hold pride of place among a host of items in wood, copper, and brass, sometimes lacquered, gilded, or studded with precious or semi-precious stones.

Neruda, Pablo (Neftalí Ricardo Reyes Basoalto) (1904–73), Chilean poet, diplomat, and political leader. Prolific from his early youth onwards, he published over thirty

This 19th-century bronze of Garuda, a bird with golden wings, worked in gilded bronze is a fine example of the elaborate craftsmanship of **Nepalese art**. The bird stands on a dying *naga*, or serpent. (Private collection)

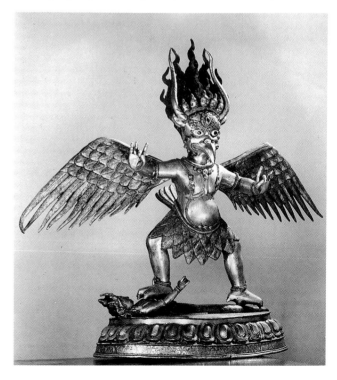

volumes of poetry. These include love poetry, such as *Twenty Love Poems and a Song of Despair* (1924) and *One Hundred Love Sonnets* (1959); three collections of *Elementary Odes* (1954–9) on intentionally simple topics; and public poetry on political themes in *General Song* (1950), an ambitious attempt to portray American history from a South American and communist viewpoint. He was awarded the Nobel Prize for Literature in 1971. A political activist, he supported the communist president Allende and was Chilean ambassador in Paris in 1970. He died during the week of the Chilean coup in 1973. He wrote memoirs in verse, *Memorial to the Black Island* (1964), and in posthumously published prose, *I Confess that I have Lived* (1974).

Nerval, Gérard de (1808–55), French poet. He was associated with the extravagant behaviour and Republican sympathies of *Gautier and the second generation of French *Romantics. His interest in mysticism found expression in *Les Chimères* (1854), a collection of sonnets in which his use of image and allusion anticipates *Symbolism and *Surrealism. Among his prose works *Sylvie* (1853) is a rustic idyll and *Aurélie* (1855) an account of the periods of derangement from which he suffered, and which led to his suicide.

Nervi, Pier Luigi (1891–1979), Italian architectural engineer, one of the most innovative designers of the 20th century. He worked mainly in reinforced concrete, and combined structural ingenuity with aesthetic sensitivity, in many of his buildings spanning wide spaces with graceful lattice-like vaults. His major works include three stadiums in Rome for the 1960 Olympic Games and the structure of *Ponti's Pirelli Building in Milan (1955–9).

Nestroy, Johann Nepomuk (1801–62), Austrian comic dramatist, the outstanding exponent of the Viennese *Volksstück* (play in local dialect intended for popular audiences). He wrote more than eighty comedies and farces with lively musical embellishment, which combine slapstick with social comment on middle-class attitudes. Nestroy's happy endings are predictable but they never quite offset the sharp barbs in his dialogue. His appeal is lasting: the musical *Hello Dolly!* and Tom Stoppard's *On the Razzle* derive from one of his plays. His three-act farce *Love-stories and Matters of Marriage* (1843), based on an obscure English original, is constructed around three parallel courtships, each complicated by difference of class or wealth. Nestroy's caustic satirical and parodistic wit established a new and more modern tone in the *Volksstück* and exercised a dominant influence on the contemporary theatre.

Netherlands Dance Theatre *dance companies.

netsuke, a small toggle used in Japan as an attachment for fastening articles (such as a tobacco pouch or *inro) to the sash of the man's kimono, a garment that traditionally had no pockets. They became popular in the 17th century and were originally simple bamboo rings, but more elaborate designs began to be made in the 18th century, using ivory and many other materials. The finest are superb examples of miniature sculpture, generally in the form of human or animal figures. With new customs of dress in the 19th century, they ceased to be everyday accoutrements, but netsukes continued to be made for

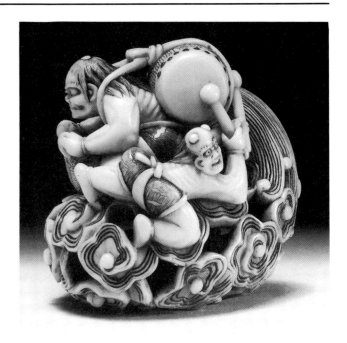

A **netsuke** showing Raiden, the Japanese god of thunder, raising a storm. He is depicted as a demon-like creature carrying a drum upon which another demon beats. Although the carving is tiny, it well depicts the sense of furious energy unleashed by the terrifying god. He was said to be fond of eating human navels; the only protection against him was hiding under a mosquito net. (Victoria and Albert Museum, London)

Western collectors, with whom they had become—and remain—very popular.

Neumann, Balthasar (1687–1753), German architect. He was the greatest master working in central Europe at the time of its most glorious architectural flowering—the period of transition from *Baroque to *Rococo. Neumann is associated particularly with Würzburg, where in 1714 he enlisted in the artillery of the prince-bishop; throughout his career he remained a soldier as well as an architect. His most famous work is the prince-bishops' palace at Würzburg—the Residenz; he began it in 1719 and it occupied him for the rest of his career, work stopping and starting with the reign of successive prince-bishops. *Tiepolo's famous fresco decoration was carried out just before Neumann's death. Neumann's large output included many palaces and churches, the greatest of which is the pilgrimage church of Vierzehnheiligen ('Fourteen Saints') near Bamberg (begun 1743). Like the Residenz, this is sumptuous, stately, spatially exhilarating, and heartwarming in the beauty of its detail and craftsmanship.

neumes *notation.

Neutra, Richard (1892–1970), Austrian-born architect who settled in the USA in 1923. Neutra had studied with Adolf *Loos in Vienna and worked with Erich *Mendelsohn in Berlin. He helped to introduce the *Modern Movement to the USA. His finest works are a series of luxurious Californian houses of the 1920s, 1930s, and 1940s, in which he employed the principles of the *Modern Movement, but adapted to local traditions,

particularly in the choice of materials. The best known is the Lovell House, Los Angeles (1927–9), the building that made his reputation. His later work, including some large-scale commercial buildings, was less memorable. Neutra was also a prolific writer on architecture.

New England Glass Company, US glass manu-factory, founded in 1818 in Cambridge, Massachusetts. It began by making clear lead glass, but from the middle of the 19th century it became well known for ornamental pieces, sometimes engraved or coloured: *amberina*, a pale amber blending into ruby, was one of the colours patented by the company (1883). After a change of ownership in 1878, the company moved in 1888 to Toledo, Ohio, where it is still active as the Libbey Glass Company. In terms of both quantity and quality it is among the most important glass companies in the USA.

New English Art Club, an artists' society founded in London in 1886 in reaction against the conservative attitudes of the Royal Academy of Arts. The artists involved (including *Sickert and others who later formed the nucleus of the *Camden Town Group) were much influenced by French painting, particularly *Impres-sionism. In its early years the Club included most of the outstanding painters in Britain, but it declined in importance after World War I.

New York City Ballet, American ballet company formed by writer Lincoln Kirstein and choreographer *Balanchine. Kirstein persuaded Balanchine to move to the USA in 1934 as director of the School of American Ballet. From this arose the American Ballet in 1935, which after various transformations (Ballet Caravan, 1936; Ballet Society, 1946) became the resident company of the New York City Center for Music and Drama, mounting chiefly works by artistic director Balanchine and co-director *Robbins. The company rapidly gained an international reputation, combining European tradition with American contemporaneity. It moved to the New York State Theater at the Lincoln Center in 1964.

New York School, a general term applied to the innovatory painters, particularly the *Abstract Ex-pressionists, who worked in New York during the 1940s and 1950s at a time when the city replaced Paris as the world capital of avant-garde art.

Nezval, Vítězslav (1900–58), Czech poet, novelist, and dramatist. His early poems reflect the proletarian ideology of post-World War I Prague, but he soon developed his own idiom and became a virtuoso, producing a stream of original images with elements of *Dadaism and dec-adence. He was a poet fascinated by the city, cruel and alluring women, night, and death. A friend of André *Breton and Paul *Eluard, he came to represent the *Surrealist movement in Czechoslovakia, but abandoned it when it was condemned by the official communist line on art.

Ngugi wa Thiong'o (James Ngugi) (1938–), Kenyan novelist and dramatist. He came to prominence with his early novels *Weep Not, Child* (1964), *The River Between* (1965), and *A Grain of Wheat* (1967), which deal with the struggle for Kenyan independence. His most ambitious novel, *Petals of Blood* (1977), shows a stronger note of protest against post-Independence corruption. His political plays in the Gikuyu language led to his detention (1978) and exile.

Nibelungenlied (*c*.1205), commonly used title for a German heroic *epic poem written in Austria. It is based on pre-Christian *sagas and was exploited by *Wagner in *The Ring of the Nibelung* (1876). Written in more than 2,300 rhyming four-line stanzas, the work utilizes many of the techniques of an oral poetic tradition. The narrative was transferred from the original pagan Germanic to the Christian courtly world of its 13th-century public. The anonymous poet simultaneously affirms the civilized val-ues of this martial society and demonstrates their fragility by questioning the moral justification of the heroic acts of nearly all the protagonists. The *Nibelungenlied* is intensely tragic: its motif is one of inevitable doom and the decline of all happiness to grief.

Nicholson, Ben (1894–1982), British painter and maker of painted reliefs, one of the most distinguished pioneers of *abstract art in Britain. He was the son of the painter **Sir William Nicholson** (1872–1949), from whom he inherited a feeling for simple and fastidious still lifes, which occupied much of his early work and showed him responding to the innovations of *Cubism. In 1933 Nicholson made the first of a series of white reliefs using only right angles and circles, the most uncompromising examples of abstract art that had been made by a British artist up to that date. In 1932 he married the sculptor Barbara *Hepworth and from 1939 to 1958 lived with her in St Ives, Cornwall, where they became the centre of a local art movement. He later lived in Ticino, Switzerland, where he continued to experiment with new textures and planes of colour.

niello, a term referring to a black compound (typically sulphur, silver, lead, and copper) used as a decorative inlay on metal surfaces; to the process of making such an inlay; and to a surface or object so treated. The craft flourished particularly in early Renaissance Italy, and above all in Florence, where it was influential on the development of line *engraving, the two techniques having much in common. There was a revival of interest in niello in the 18th and 19th centuries in Russia, where it was known as Tula-work, from the name of one of the towns notable for craftsmen practising it. Typically it was used to decorate small luxury items (known as nielli) such as silver snuff-boxes, cups, boxes, knife handles, and belt buckles. Niello work is still produced in India and the Balkans.

Nielsen, Carl (August) (1865–1931), Danish com-poser. He earned a living as a violinist and teacher, drawing attention to himself as a composer with the Little Suite (1888) for strings. The success of his early chamber music and First Symphony (1894) led to a state pension (1901) that enabled him to compose full-time. There

Sir Sidney **Nolan** is the most notable figure in Australian art and is particularly renowned for his many paintings on the life of the bushranger Ned Kelly. This picture, *Glenrowan, right*, shows Kelly at Glenrowan in Victoria. Nolan's style is highly individual, as is his search for new materials and media to express his art. (Private collection)

followed five more symphonies (1902–25), concertos for violin (1911), flute (1926), and clarinet (1928), as well as songs and choral works. Nielsen's free handling of tonality and his powerful use of rhythm, combined with contrapuntal skill and abundant melodic invention, made him one of the most effective symphonists of his day.

Niemcewicz, Julian (1758–1841), Polish dramatist, poet, and novelist. He was active at crucial periods in Poland's history. His comedy *Return of the Deputy* was performed (1791) while he was a Deputy to the parliament of Poland himself, to influence voting on a new constitution. *Under their Vine and Fig Tree* (1965) describes his extensive travels, especially in the USA, his home for some years.

Niemeyer, Oscar (1907–), Brazilian architect. With his early mentor Lúcio Costa he ranks as his country's leading modern architect, and they are famed for their work on the new capital city Brasilia (1957–79). Niemeyer was strongly influenced by *Le Corbusier, but his work also introduces references to Brazil's tradition of colonial Baroque art, sometimes including decoration in the form of Portuguese-style ceramic tiles known as *azulejos*. In spite of such colour, his work often has a quality of restrained dignity.

Nijinska, Bronislava (Forminitsha) (1891–1972), Russian dancer and choreographer. Sister of Vaslav *Nijinsky, she studied in St Petersburg and later became a soloist with the Maryinsky company before joining the *Diaghilev company as a dancer (1909–14). After a period in Russia she returned to the Ballets Russes in 1921 to become Diaghilev's principal choreographer, the only woman to achieve this status. She was noted for the modern, stark realism of her ballets, as in the ritualistic *Les Noces* (1923).

Nijinsky, Vaslav (Formich) (1888–1950), Russian dancer and choreographer. He trained in St Petersburg, and joined *Diaghilev's Ballets Russes (1909–17). As a dancer he was known for his athleticism in *Fokine's *Spectre de la Rose* (1911), his characterization in *Petrushka* (1911), and for choreographic and interpretive powers in *L'Après-midi d'un faune* (1912). He was an innovative choreographer; the distorted, inturned movement and violent rhythms of *Le Sacre du printemps* (1913) to Stravinsky's score outraged Paris, although it was in tune with the *modernist movement. Mental illness ended his career prematurely.

Nilsson, (Märta) Birgit (1918–), Swedish soprano singer. Nilsson's international reputation as a leading Wagnerian soprano dates from 1954–5, with her Brünnhilde in *The Ring* at Munich. Her vocal and dramatic abilities continued to develop, and she was sensational as Puccini's *Turandot* in Milan in 1958. By the mid-sixties she was an unrivalled interpreter of Wagner, as well as of several roles in operas by Richard Strauss.

No *Japanese drama, *Japanese music.

nocturne, a musical composition that suggests a romantic view of the night. In the 18th century compositions known as *notturni* were played as evening entertainments. In the 19th century the Irish pianist and composer John

*Field used the term to describe short piano pieces of a dreamy, romantic nature. Such pieces involve an expressive melody accompanied by the ripple of broken chords in the left hand. *Chopin's examples are particularly fine and, like Field's, owe much to the *bel canto* singing style of Italian opera. Other composers have also used the term for music with night associations. Debussy's *Three Nocturnes* are orchestral tone-pictures; Britten's *Nocturne* is a song-cycle to poems about night.

Nolan, Sir Sidney (1917–), Australian painter. In the early 1940s he gave the first signs of his originality of vision when he painted a series of landscapes that capture the heat and emptiness of the Australian bush. In 1946 he began a series of paintings on the notorious bushranger Ned Kelly, and it was with these works that he made his name. He has returned to the Kelly theme throughout his career, and he has also drawn on other events from the history of his country, creating a distinctive idiom to express his Australian subject-matter and memorably portraying the hard, dry beauty of the desert landscape. Technically, his work is remarkable for the lush fluidity of his brushwork: he sometimes paints on glass or other smooth materials.

Nolde, Emil (1867–1956), German *Expressionist painter and graphic artist. From 1905 to 1907 he was a member of the Die *Brücke, but he was essentially an isolated figure. He was well travelled, at times living like a hermit, and was a deeply religious man. He is most famous for his pictures of Old and New Testament subjects, in which he expresses intense emotion through violent colour and grotesque distortion. Most of his pictures, however, were landscapes, and he was also one of the 20th century's greatest flower painters.

Nollekens, Joseph (1737–1823), British sculptor, the son of an Antwerp painter of the same name (1702–47). He settled in London in 1733. From 1760 to 1770 he worked in Rome, making a handsome living copying, restoring, faking, and dealing in antique sculpture. He also made a few portraits, and on his return to England it was chiefly as a portraitist that he built up his great reputation and fortune. His finest portraits are brilliantly characterized, but there are many inferior studio copies. He also made statues in a slightly erotic antique manner and had a large practice as a tomb sculptor.

Nono, Luigi (1924–), Italian composer. An innate sense of Italian lyricism is married in his works to strict *serialism and a passionate commitment to left-wing politics. Among his most powerful works are the orchestral *Meetings* (1955) and the opera *Intolerance* (1960). Later works, such as *The Illuminated Factory* (1964), have involved the use of *electronics in a mixed-media context.

nonsense verse, a kind of humorous poetry which amuses by deliberately using strange, non-existent words and illogical ideas. Its masters in English are *Lear and *Carroll. Classics of the *genre are Lear's 'The Owl and the Pussy-Cat' (1871) and his limericks, along with the songs in Carroll's *Through the Looking-Glass* (1871), including 'The Walrus and the Carpenter' and the celebrated 'Jabberwocky'. This poem carries the use of nonsense words to its limit, although two of them, 'burble' and 'chortle', have passed into the language.

Norman, Jessye (1945–), US soprano singer. With her 1969 operatic début in Berlin as Elisabeth in Wagner's *Tannhäuser*, and her 1972 performances as Verdi's *Aida* (Milan) and Cassandra in Berlioz's *Les Troyens* (London), Norman established herself as a notable figure on the international operatic stage. A singer of great vocal beauty and musicianship, she is a noted interpreter of German and French song.

North African music, the traditional music of Africa north of the Sahara desert and Atlas mountains. The music is extremely difficult to define since the region is so vast, there are no written records, and it is hard to extrapolate generalizations from the few historical references or modern field recordings available. Archaeological and historical evidence points to the importance of music from an early date. A rock engraving of a harpist, dating from the 18th century BC, exists at Saqqâra, Egypt, while in the 5th century BC Herodotus wrote of women singing at religious ceremonies. Some ancient traditions have survived to the present day, for example curved percussion sticks used by Libyan mercenaries in the 2nd millennium BC are still in use in the Nile-Congo area. Though the region has suffered invasion from many groups, including Romans, Vandals, Byzantines, and Turks, it is Arabic music that has exerted the most influence. This is especially noticeable in the Mediterranean coastal towns. Arab folk music was described in the early 20th century by the Hungarian composer and folk-music collector Béla Bartók, who wrote of its rhythmic complexity (involving syncopations and cross-rhythms), the vibrato trillings and gurglings of its vocal performance, the invariable use of percussion instruments in accompaniment, and the performance of suites of instrumental and vocal pieces in imitation of the suites of Arabic art music (see *West Asian music). The harsh singing tone and use of vibrato (rapid slight variation of pitch to lend tone) seem to be features of many areas, including the Senegalese countries, which use forms of pentatonic *scales, found also in Morocco. Forms of lutes, harps, drums, and flutes are found throughout the region, as is the one-string Tuareg bowed fiddle, played originally by women of the nobility. The 18th-century traveller James Bruce wrote of the terrifying nature of the Abyssinian trumpets when used in war; nowadays the use of trumpets and drums is mostly ceremonial. (See also *frame drum and *sistrum.)

North American Indian art, the traditional art of the native Indians of North America, who traditionally lived mainly in small tribal units, with hundreds of distinct languages and widely differing life-styles. Their art shows a corresponding diversity, reflecting differences not only in environment and availability of raw materials, but also of ideology. Most Indian art consisted in the decoration of everyday objects, such as clothes, pottery, and weapons, The most common are of the painting and sculpture developed in the service of ritual and memorial. The most famous expression of this aspect of Indian art is the totem-pole—a carved and painted log made by various tribes of the North. The animal and spirit creatures adorning the totem-pole represent family lineage, and the poles serve various purposes—as grave-markers, for example, or as symbols of welcome. Timber was abundant in these regions, and the Tlingits, who lived in what is now southern Alaska, are particularly noted for woodwork,

including architectural carving (unlike most Indians, they built houses, of vast dimensions, near the fishing grounds that were the basis of their livelihood). For the Indians of the Plains (such as the Crow and Sioux), in contrast, the buffalo was the means of livelihood, and its skin was used for almost everything they possessed, including clothes, shields, and tepee covers. Such articles were often painted and adorned with featherwork. A third tradition is represented by the Indians of the South-west, notably the Navaho and Pueblo, who led a more settled life, based on farming, and adopted more sophisticated arts such as silversmithing (from the Mexicans) and weaving (Navaho blankets are famous). They also made sand or dry paintings—stylized, symbolic pictures produced by trickling charcoal, pollen, or crushed stones of various colours on to a background of smooth sand—depicting

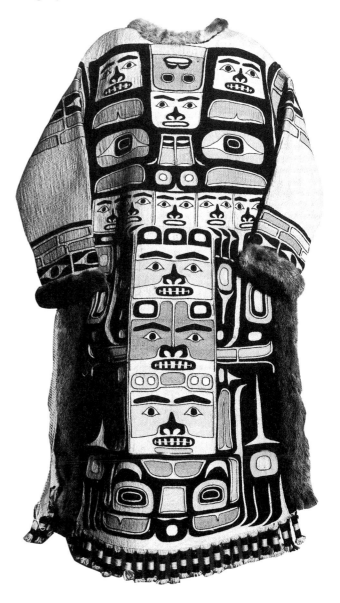

A man's shirt made by the Tlingit tribe of Alaska in the late 19th century; it is woven of mountain goat wool and trimmed with otter fur. The Tlingits have one of the most distinctive traditions of **North American Indian art**; the repeated faces represent the brown bear, the most common motif in their art. (Portland Art Museum, Oregon)

gods, lightning, rainbows, plants, animals, or other symbols.

North American Indian literature, the literature of the native Indians of North America. Archaeological evidence increasingly suggests that tribes separated by language and habitat shared literary perceptions and ways of representing such phenomena as the passage of time. The famous Winter Counts of the Sioux and the Plains Indians (of which some six dozen are known) echo features of the east-coast Woodland chronology, of which the most extensive example extant is the *Walam Olum* of the Lenape Algonkin Indians. In the south-west, an area linked with Mexico long before the European invasion, the sand-paintings which accompany the Chants or Ways of the Navaho bear striking resemblances to pages from the screenfold books of *Central American Indian literature. Still awaiting decipherment and adequate description is the considerable corpus of texts transcribed in the Cherokee writing system, designed by the warrior and scholar Sequoyah (*c*.1760–1843) in the early 19th century. (See also *Inuit literature.)

Norwich School, an English regional school of landscape painting associated with the Norwich Society of Artists, which was founded in 1803 under the presidency of John Sell *Cotman; it was the first provincial institution to hold regular exhibitions. The members of the school were almost all landscape painters who particularly favoured Norfolk scenery.

Norwid, Cyprian (1821–83), Polish poet. During his lifetime his poetry went unrecognized and very little was published. In *Promethidion* (1851), a dialogue on beauty, art, and the dignity of manual labour, Norwid employed the rhythms of ordinary speech. He consciously experimented with poetic form in the collection *Vade-mecum* (completed 1866), and with colloquial verse in *A Dorio ad Phrygium* (written *c*.1872). At a time when newspaper production was increasing, he voiced fear of 'print pollution'. Recognition only came in the 20th century, and his work has since influenced Polish writers.

notation (in music), any system for writing down music. Except in the field of folk music, the Western world has always regarded the musical work as being the unique creation of an individual composer and given the performer the secondary task of interpreting it according to a more or less exact notation. The practice of many other cultures has been quite different. Here the emphasis has been (and is) placed on the performer's ability to improvise in a sophisticated and highly organized way. Although some aspects of the music may be memorized, the final effect depends upon the performer's on-the-spot creative ability. In these circumstances notation is largely unnecessary, for the music is always being created afresh. In Western society this approach to composition is mainly confined to *jazz, though some avant-garde composers have explored the same idea in their *aleatory compositions. The earliest attempts to notate the music of Western Europe date from the 7th century, though it was not until the 11th that any reasonably efficient system was devised (see *solmization). The first method, inherited from the ancient Greeks, assigned an alphabetical letter to each note to remind the performer of something already learned by rote. A more useful step came with the

Standard western notation

Notes Rests

One semibreve:

equals two minims:

or four crotchets:

or eight quavers:

or sixteen semi-quavers:

a dot increases the value of a note by half:

stave treble clef alto clef tenor clef bass clef key signature (E flat major) time signature accidentals

Four clefs: each showing middle C

invention of neumes—signs written above the words to be sung that indicated whether the notes were to rise or fall. Neumes gradually became more complex, some standing for certain fixed groups of notes (they survive today as conventional signs for trills and turns). The next step (in the 10th century) was to place the neumes at different heights above the words according to the relative pitch of the notes. Heightened neumes thus provided a rough outline of the melody. Eventually a horizontal line was added to represent one particular note. Neumes placed above the line represented higher notes, neumes placed below were lower notes. The first *pitch to be singled out was F, and the horizontal line was coloured red. Soon a yellow line was added to represent C, then another and another until a four-line grid had been established. Each line, and each space between the lines, now stood for a different note. We use the same grid today (though now with five lines) and call it a staff or stave. We also add a clef (a *key or 'clue') to one or other of the lines to establish its pitch-identity, rather than rely on lines of different colours. All that was needed now was information about the relative duration of the notes. The simple neumes began to change shape, some developing 'heads' and 'tails', others being replaced by square and diamond shapes. These are the ancestors of our crotchets and quavers. Further signs were added, including sharps and flats, which, when placed before a note, would indicate that the pitch was to be raised or lowered one semitone. In early music these signs were known as *musica ficta* (Latin, 'false music') and were used to avoid certain awkward intervals in the melodic line. They later became the key signatures of *tonal music, and accidentals when they were used during the course of a piece to contradict the prevailing key. The practice of dividing music into bars of equal length came about towards the end of the 15th century. Bars were first used in choral scoring to show how the notes in the different *voice-parts related to one another, and were not at first included in the independent vocal parts used by the singers themselves. In the 20th century composers have been forced to invent new signs to represent new ways of playing instruments and new types of sound (natural and *electronic). Performers often have to learn the notation of each new score before they can play it. Notation, however, is only the blueprint for music. Only the performer's powers of sympathetic interpretation can make it come alive.

notch flute, an end-blown flute with a notch, either v-shaped or u-shaped with a rounded or square bottom, into which players direct the air-stream. The notch is inherently more efficient than the plain end of simple *end flutes, and notch flutes are found in many parts of the world.

nouveau roman (French, 'new novel'), a term, first used by Jean-Paul Sartre, employed to describe the work of a group of French novelists who came to prominence during the 1950s. The authors usually thus classified are Alain Robbe-Grillet (*La Jalousie*, 1957), Michel Butor (*La Modification*, 1957), Nathalie Sarraute (*Le Planétarium*, 1959), Claude Ollier (*La Mise en Scène*, 1958), Robert Pinget (*L'Inquisitoire*, 1963), Jean Ricardou (*La Prise de Constantinople*, 1965), and Claude Simon (*Histoire*, 1967). For the new novelists any authorial interpretation is arbitrary: there is no ultimate meaning behind existence, only the subjective experience of individuals. Their novels treat the world of things with detachment and are frequently dislocated in their presentation of time and plot; many are also characterized by a high degree of aesthetic self-consciousness.

Nouvelle Vague (French, 'New Wave'), a group of French film directors who in the late 1950s began to react against the established French cinema and to make more individual films. Some of its members—*Truffaut, Claude Chabrol (1930-), and Jean-Luc Godard (1930-)—had written for the film review *Cahiers du cinéma*, which promoted the same ideas; but the first films in this category were Louis Malle's (1932-) *Ascenseur pour l'échafaud* (Frantic) and *Les Amants* (both 1958)—the latter being considered extremely erotic. Chabrol, whose films often depicted violence in a *petit bourgeois* setting, directed *Le Beau Serge* (1958) and *Les Cousins* (1959). Truffaut made *Les Quatre Cents Coups* (1959) and Alain Resnais (1922-) broke new ground with *Hiroshima mon amour* (1959), which moved constantly between past and present, and *L'Année dernière à Marienbad* (1961), a virtually plotless film set in a sumptuous dreamworld. Godard was another innovator, who in *A bout de souffle* (Breathless, 1960) used hand-held cameras, jump-cuts, and real locations. For a time in the early 1960s many new directors were at work; but the movement's influence soon waned, and its leading directors—apart from Godard, the most politically committed—gravitated to the commercial cinema.

'Novalis' (Friedrich, Freiherr von Hardenberg) (1772–1801), German poet and novelist. His works and theories influenced the *Romantic movement in Germany, France, and Britain. His celebrated mythical romance, the unfinished novel *Heinrich von Ofterdingen* (1802), outlines the hero's search for the secret of art, 'the Blue Flower', in order to transform the world into one of beauty through the power of imagination. *Hymn to Night* (1800) comprises six developing *odes in *free verse, in which the poet celebrates death as a mystical re-birth in the presence of God.

novel, an extended fictional story in prose, with at least one character involved in some form of plot or sequence of events; normally, several characters are presented in relationships with one another within a social setting. Even these minimal specifications, however, have sometimes been disregarded, since the novel is the most flexible and unregulated of literary *genres: unlike other narrative forms such as *epic or *ballad, it is bound by no rules of structure, style, or subject-matter, and has often freely borrowed its forms from other kinds of writing like *autobiography, history, journalism, or *travel writing. This flexibility has made it the most important and popular literary genre in the modern age. Novels may be distinguished from *romances by their more realistic characters and events, and from *novellas by their length, but the boundaries here are indistinct. Although there are some precedents in the ancient world (see *Greek and *Roman novel), the fully developed tradition of the novel in the West is relatively young: it is usually dated back to the first part of Cervantes's *Adventures of Don Quixote* (1605). La Fayette's *La Princesse de Clèves* (1678) began the distinguished line of French novels. The first significant novel in English was Behn's *Oroonoko* (c.1688), but Defoe's *Robinson Crusoe* (1719) is often regarded as the

origin of the modern tradition. The classic period of the novel was the 19th century: the age of Austen, Balzac, Dickens, Melville, Flaubert, George Eliot, Tolstoy, Dostoyevsky, and Zola. In the 20th century, *Faulkner conducted radical experiments with the genre, but modern reports of the 'death of the novel' have been greatly exaggerated. Among the many specialized forms of novel are the *detective, *epistolary, *Gothic, *historical, and *picaresque varieties, and the *Bildungsroman.

novella, a short prose fiction; from the Italian word for 'novelty'. The tales in Boccaccio's *Decameron* (1349–53) are the most celebrated early *novelle*. Goethe revived the form in 1795, and it has remained an important *genre in German literature, known as the *Novelle*. In English, the term refers to stories which are mid-way, in length and complexity, between a *short story and a *novel, focusing on a single chain of events with a surprising turning point. Conrad's *Heart of Darkness* (1902) is a fine example; James and Lawrence also wrote novellas.

Noverre, Jean-Georges (1727–1810), French ballet-master, dancer, choreographer, and dance-theorist. He travelled and worked widely in Europe, developing a theory of the importance of *mime and dramatic action in dance (*ballet d'action*). He published a series of *lettres sur la dance* between 1760 and 1807 directed towards the elevation of ballet from its position as a mere *divertissement* to a serious art-form. According to Noverre, there should be a perfect integration of words, music, choreography, and *set design, the whole designed to convey a story.

Nureyev, Rudolf (Hometovich) (1938–), Russian dancer, director, and choreographer. He studied in Leningrad and became a soloist with the *Kirov Ballet. In 1961 he obtained political asylum in the West and in the following year made his début with the *Royal Ballet. His partnership with Margot Fonteyn was legendary, as was his virtuosity and expressiveness as a dancer. His first major production as choreographer was *La Bayadère* with the Royal Ballet (1963), followed by many productions of the classical ballets, as well as the first production of Henze's *Tancredi* (1966). Subsequently he danced and choreographed for many European companies, becoming ballet director of the Paris Opera Ballet in 1983.

nursery rhyme, a traditional verse or verses chanted to infants by adults as an initiation into rhyme and verbal rhythm. Most are hundreds of years old, and derive from songs, *proverbs, riddles, *ballads, street cries, and other kinds of composition originally intended for adults, which have become almost meaningless outside their original contexts. Their origins are often obscure, but several, such as 'Humpty-Dumpty' and 'Hush-a-by-baby' are claimed to make covert references to political or social events. The earliest surviving printed collections are *Tom Thumb's Pretty Song Book* (1744) and *Mother Goose's Melody* (c.1765).

nyckelharpa, the Swedish keyed fiddle with keys like the *hurdy-gurdy to stop the strings, but a separate bow. The most common are the simple *harpa*, with only one melody string and only partly chromatic; the *kontrabasharpa*, with two melody strings and fully chromatic; and a more recent chromatic *harpa* with three melody strings, fully chromatic over a wider range. All have at least one *drone string and several sympathetic strings.

objet trouvé (French, 'found object'), a term applied to an object found by an artist and displayed as it is, or with only minimal alteration, as a work of art. The practice began with the *Dadaists and *Surrealists. Marcel *Duchamp gave the name 'ready-made' to a similar type of work in which the object chosen for display is a mass-produced article selected at random.

oboe, a soprano woodwind musical instrument played with a double reed, invented around 1660–70 as an indoor replacement for the *shawm. The early oboe's broad, comparatively gentle sound meant that parts might often be played by more than one oboist. The bore later became narrower, especially in France, the sound approaching the piercing sweetness of the modern oboe. Since the oboe responded well to cross-fingering (closing one or more finger-holes below the lowest open hole to flatten the *pitch by a semitone), as late as 1800 two keys sufficed, but keywork became more complex in the 19th century; leaders in this development were the Triéberts, father and son. There were two other important sizes of Baroque oboe, an alto in A (the *oboe d'amore*), and tenors in F of several types. One was identical with the treble but larger; another, with a bulb *bell, was the ancestor of the *cor anglais; the third, with a flared bell, was presumably that called the *oboe da caccia*.

O'Brien, Flann (Brian O'Nolan or Ó Nuallain) (1911–66), Irish novelist. For many years he contributed a weekly satiric column under the name of 'Myles na Gopaleen' to the *Irish Times*. His first novel, *At Swim-Two-Birds* (1939), is an inventive and exuberant work giving a multi-dimensional exploration of Irish folklore, heroic legend, humour, and poetry and of the nature of fiction, much influenced by *Joyce. Other novels include *An Béal Bocht* (1941, in Gaelic; translated into English as *The Poor Mouth*, 1973) and *The Third Policeman* (1967).

ocarina, a musical instrument, an egg-shaped *vessel-flute invented by Giuseppe Donati in Italy in the 1860s, with two thumb- and eight finger-holes, and a duct mouthpiece extending to one side. It is commonly made in earthenware, but porcelain examples exist. It is usually regarded as a toy, but instruments have been made in sets of different sizes, sometimes with a tuning-plunger, and ocarina bands were popular in the late 19th and early 20th centuries in Europe and the USA, where the instrument was also called a sweet potato.

O'Casey, Sean (1880–1964), Irish playwright. His early plays, *The Shadow of a Gunman* (1923), *Juno and the Paycock* (1924), and *The Plough and the Stars* (1926), are tragi-comedies and deal realistically with the rhetoric and dangers of Irish patriotism, with tenement life, self-deception, and survival. He moved to England in 1926 after a rift with *Yeats and the rejection by the Abbey Theatre of *The Silver Tassie* (1928), an experimental anti-war play which introduced the *Expressionism of his later works.

occasional verse, poetry written for a special occasion. Poetic forms associated with the term include the *epithalamion, the *elegy, and the *ode. Occasional verse may be serious, like Marvell's 'An Horation Ode upon Cromwell's Return from Ireland' (1650) and Whitman's 'Passage to India' (1871), or light, like Cowper's 'On the Death of Mrs Throckmorton's Bullfinch' (1789). The major modern writers of occasional verse in English are Yeats ('Easter, 1916') and Auden ('September 1, 1939', 'August 1968', 'Moon Landing').

Oceanian music, music of the islands inhabited by the peoples of the central and southern Pacific Ocean. Despite huge cultural differences common threads unite music throughout the region. Traditional vocal music is mostly monophonic (consisting of a single melody sung in unison), led by a song leader in a call and response fashion. In north Malekula this is accompanied by a vocal *drone, in Micronesia parallel movement at the fourth is common, while more sophisticated *polyphony exists in the Loyalty Islands, the Solomon Islands, and Fiji, where voice parts have their own distinct names, from the descant *vakasalavoavoa* to the bass *druku*. Nineteenth-century Christian missionaries discouraged local traditions and introduced hymns, now popular, especially throughout Polynesia, and sung in two-, three-, or four-part harmony. Melanesian melodies commonly have triadic or pentatonic structures, while in Micronesia

This illustration from Sydney Parkinson's *A Journal of a Voyage to the South Seas* (1773) shows a performance on the nose flute, one of the principal instruments of **Oceanian music**.

and Polynesia melodies usually have a small range, slides and ornaments between notes being considered of more importance than the melody notes themselves. Music accompanies both everyday social activities and special occasions such as various initiation rites. In Micronesia and Polynesia music is closely integrated with poetry and dance, hand and arm movements of line and sitting dances decorating (Micronesia) or illustrating (Polynesia) the sung text. A number of instruments are found throughout the whole region, such as *conch-shell trumpets, nose flutes, hourglass drums, *stamping tubes, and *rattles. Instruments particular to one region include the huge *slit-drum of Vanuatu, the base of which is buried in the ground and the top carved with a human face; *panpipes, highly distinctive in the Solomon Islands and cultivated with much sophistication by the 'Are'are people of Malaita; and the tall *pahu*, cylindrical drums of Polynesia. Micronesians generally use fewer instruments and employ body-percussion.

Ockeghem, Johannes (*c.*1410–97), Franco-Flemish composer. In *c.*1452 he joined the music chapel of King Charles VII of France, remaining in royal service for the rest of his working life. He is best known today for his masses, fourteen of which survive. These range in structure from the conventional settings based on a *cantus firmus* (see *plainsong) to others constructed entirely of *canons, some of which were capable of being sung in any of the church *modes. His style is characterized by its rich *contrapuntal texture, in which the various voices are of more or less equal importance. Fewer than ten of his *motets survive, as well as some twenty *chansons.

O'Connor, Flannery (1925–64), US novelist and short-story writer. She was born in Georgia, and spent most of her life in the South. Her attraction to grotesque subject-matter was intensified by her preoccupation with locating godliness in a contemporary world in which it could only appear in distorted forms. Her novels are set in Tennessee, and deal with religious fanatics: *Wise Blood* (1952) with a young man who founds a church without Christ; *The Violent Bear It Away* (1960) with a boy seeking to baptize another. Her reputation is based on the short stories collected in *A Good Man is Hard to Find* (1955) and *Everything That Rises Must Converge* (1965). The *Complete Stories* were published in 1971.

ode, an elaborately formal *lyric poem, often in the form of a lengthy ceremonious address to a person or abstract entity, always serious and elevated in tone. There are two different classical models: *Pindar's public odes praising athletes, and *Horace's more privately reflective odes. Pindar used lines of varying length in a complex three-part structure based on the dances of the dramatic *chorus, whereas Horace wrote in regular *stanzas. Close English imitations of Pindar are rare, but a looser 'irregular' ode with varying lengths of stanzas was introduced by Cowley's 'Pindarique Odes' (1656) and followed by Dryden, Wordsworth (in 'Ode: Intimations of Immortality' (1807)), and Coleridge. More Horatian in mood and regularity of structure are the celebrated odes of Keats, notably 'Ode on a Grecian Urn' and 'Ode to a Nightingale' (both 1820). The leading writers of odes in Europe include Ronsard, Leopardi, and Schiller.

Odyssey *Homer.

Oehlenschläger, Adam Gottlob (1779–1850), Danish poet and dramatist. His poem 'The Golden Horns' (1802) was strongly influenced by the German Romantics and introduced *Romanticism into Danish literature. Oehlenschläger's masterpiece is *Aladdin* (1805), an exuberant treatment of the oriental fairytale in the style of Romantic drama. *Baldur the Good* (1807) is based on Nordic mythology; a similar theme was treated in ballad form in the trilogy *Helge* (1814) and *The Gods of the North* (1819). His *lyric poetry has remained more popular than his dramatic verse.

O'Faolain, Sean (1900–), Irish novelist and short-story writer. He is best known for his short stories evoking missed opportunities and characters limited by their background (as he felt himself to be by provincial Cork). His first collection, *Midsummer Night Madness and other stories* (1932), was followed by three novels (*A Nest of Simple Folk*, 1934; *Bird Alone*, 1936; and *Come Back to Erin*, 1940), all dealing with the frustrations of Irish society and the doomed aspirations of Irish nationalists; several biographies; memoirs (*Vive moi!*, 1964); and critical works. His later stories tend to be dryer and more humorous in tone.

Offenbach, Jacques (1819–80), German-born French composer. The success of his tiny theatre in Paris, the Bouffes Parisiens (1855), enabled him to move to larger premises and write works on a larger scale. Such *operettas as *Orphée aux enfers* (1858) and *La Belle Hélène* (1864) proceeded to conquer the world with their humour, satire, and unfailing flow of memorable tunes. His serious lyric-opera *Les Contes d'Hoffmann* was orchestrated and provided with recitatives by Ernst Guiraud, and produced posthumously in 1881.

O'Hara, John (Henry) (1905–70), US novelist and short-story writer. After his début with *Appointment in Samarra* (1934), an ironic, toughly realistic treatment of the fast country-club set of a Pennsylvania city, he produced a succession of sharply-observed novels and short stories. They are diverse in their choice of material, but certain subjects recur: crime; the private lives of the rich; troubled marriages; Hollywood; the world of bars, nightclubs as in *Pal Joey* (1940); and the theatre.

oil painting, painting with *pigments mixed with certain types of oil, which harden on exposure to the air. Linseed oil is the best known, but poppy oil and walnut oil have also been used. It was long believed that oil painting was invented by Jan van *Eyck, but it is now known that its origins are older and obscurer. Van Eyck, however, showed the medium's flexibility, its rich and dense colour, its wide range from light to dark, and its ability to achieve both minute detail and subtle blending of tones. Since the 16th century oil colour has been the dominant painting medium in Europe. Its success has been largely on account of its versatility for it can attain any variety of surface from violent *impasto to porcelain smoothness. In the 20th century *acrylic has become a serious rival to oil paint.

Oistrakh, David (1908–74), Russian violinist. Having won the prestigious Brussels Competition (1937), Oistrakh's international career was interrupted by the war, and his French, British, and US débuts were delayed until the mid-fifties. He was the dedicatee and first performer of Shostakovich's First (1955) and Second (1967) Concertos. A brilliant interpreter of the 19th-century concerto, he was one of the greatest violinists of his day.

O'Keeffe, Georgia (1887–1986), US painter. One of the pioneers of *modernism in the USA, she was a member of the cirle around the photographer and gallery owner Alfred *Stieglitz, whom she married in 1924. She is best known for her near-abstract paintings based on enlargements of flower and plant forms, works of great elegance and rhythmic vitality, whose sensuous forms are often sexually suggestive. Her inspiration derived from the landscapes and natural forms of the American South-West and New Mexico.

Okudzhava, Bulat (Shalvovich) (1924–), Russian poet and novelist. He saw active service in World War II, then worked as a teacher. In about 1960 he began performing lyrical, anti-heroic songs to his own guitar accompaniment; they circulated on privately made tape-recordings, and he soon became one of the most popular Russian poets ever. He has also written a series of novels dealing with 19th-century Russian history.

Old English literature, a term used for the writings in the dialects spoken by the Anglo-Saxons who colonized England (AD *c*.450), until their conquest by the Normans (1066). Both its vocabulary and inflections come from West Germanic (which also gave rise to Dutch and German), as does its characteristic *alliterative verse. A typical line of verse is in two halves, each with two main stresses, and usually the stressed syllables of three of these main words share the same initial consonant: '*h*reoh and *h*eorogrim *h*ringmael gebraegd'.

The first poem of known date to survive is Cædmon's *Song of Creation* (*c*.657–80). The influence of King Alfred (871–99), whose programme of education included starting the *Anglo-Saxon Chronicle*, a historical record of England up to its conversion to Christianity, means that most of this literature is in the West Saxon tongue and dates from the 10th and 11th centuries. Alfred's translation of Boethius's *Consolation of Philosophy* and other Latin works is also of great importance. The most significant Old English poem *Beowulf* blends the Christian tradition with Saxon mythology. In *The Battle of Maldon* (*c*.1000), which is based on contemporary events, a conflict between duty and glory leads Byrhtnoth to disaster through his 'ofermod' (pride). The devotional poem 'The Dream of the Rood' is narrated by the Cross itself, and uses an ingenious web of imagery as a declaration of faith. The largest extant collection of Old English poetry is to be found in the Exeter Book (*c*.940). It contains 'The Wanderer', a religious *allegory with a secular setting, which tells of a man whose lord has died, and who is left in desolation. The personal loneliness broadens in 'The Seafarer' and 'The Ruin', where Roman ruins emphasize the transitoriness of life. The Exeter Book also gives ninety-five riddles, a characteristic literary genre. In about AD 1000 the prose of the monk Ælfric and the archbishop Wulfstan, in sermons and saints' lives, becomes intricate and flexible, using rhythm and alliteration freely. All literature of this period was either written by monks or copied by them; the church was the centre of education and culture.

Laurence **Olivier** (*seated*) with Dennis Quilley in a scene from the 1971 National Theatre production of Eugene O'Neill's *Long Day's Journey into Night.* Although best known for his Shakespearian roles, Olivier was extremely versatile and made memorable appearances in many modern plays as well as in numerous films.

Old Vic, the theatre on London's Waterloo Road, which opened in 1818 as the Royal Coburg and was renamed the Royal Victoria in 1833. It originally presented *melodramas, but became a temperance music-hall in 1880. From 1912 until her death in 1937, it was managed by Lilian Baylis, who made it the leading centre for productions of Shakespeare. Bombed in 1941, it reopened in 1950, continuing its fine Shakespearean tradition as part of a more varied programme. In 1963 it became the temporary home of the *National Theatre until its transfer to the South Bank in 1976.

Oliver, Isaac (*c*.1568–1617), English *miniaturist of Huguenot origin, his father (a goldsmith) being a refugee from religious persecution in France. Oliver trained under Nicholas Hilliard and later became his main rival, finding much patronage at court after the turn of the century. His style was more naturalistic than that of Hilliard, using light and shade to suggest three dimensions and generally dispensing with the emblematic adornments beloved of the Elizabethan age. Oliver's son, **Peter** (1594–1647), was also a miniaturist.

Oliver, King (Joe) *jazz.

Olivier, Laurence (Kerr) (Lord Olivier of Brighton) (1907–89), British actor, director, and manager, one of the greatest actors of his time. As a classical actor he gave outstanding performances in the plays of Shakespeare. He made some Hollywood films, including *Wuthering Heights* (as Heathcliff) (1939) and Hitchcock's *Rebecca* (1940). After war service he returned to the Old Vic as co-director (1944–9). He also directed, produced, and starred in three outstanding Shakespeare films—*Henry V*

(1944), a cinematic masterpiece influenced by *Eisenstein's *Alexander Nevsky*; *Hamlet* (1948), the first British production to win an Academy Award; and *Richard III* (1955). He was the first director of the British *National Theatre company (1963–73), directing its first production, *Hamlet.* His most notable modern role was the second-rate music-hall comedian Archie Rice in John Osborne's *The Entertainer* (1957), which he also filmed (1960).

Olmec art, the art of the early inhabitants of the southern part of Vera Cruz, and the widespread style derived from it. The chief importance of Olmec art lies in the antiquity and vast scale of some of its earliest forms. Some scholars regard Olmec as the 'parent' culture of Mesoamerica (see *Central American and Mexican Art). Characteristics of the style are its sculptural basis and the predominance of favoured types—a jaguar type and a human type with a squat head. The earliest sites, at San Lorenzo, Cobata, La Venta, and Tres Zapotes, yielded the oldest monumental sculpture of Mesoamerica—colossal heads, usually of basalt, with Olmec features (*c.* 13th to 5th centuries BC). Similar types are exhibited in relief-carved stelae, or monumental slabs. To the Olmec culture some lively sculptures of the 7th to 5th centuries BC have been ascribed, including a vital jade wrestler now in Dumbarton Oaks, Washington DC, and the renowned seated athlete of basalt, in Mexico City. These ascriptions are inspired by stylistic resemblances in cruder figurines from Olmec sites.

Omega Workshops, decorative arts company founded in London by Roger Fry in 1913. Fry hoped the workshops would bring modern art into touch with daily life and also provide regular work for talented young artists (including Vanessa Bell, Duncan Grant, *Wyndham Lewis, and Henri *Gaudier-Brzeska). They produced ceramics, furniture, textiles, and other products, although in general the work consisted of decorating manufactured objects rather than designing objects from scratch. Bright colour predominated in the designs, many of which were abstract. The products were sometimes vigorous and fresh, but the craftsmanship was often amateurish. Fry was no businessman, and the workshops closed—a financial failure—in 1919. Though the workshops failed, it none the less influenced the subsequent development of English *industrial design.

O'Neill, Eugene (Gladstone) (1888–1953), US dramatist. His first works for the theatre were one-act plays based on his experiences at sea and among outcasts and oppressed people in many places. He established his reputation with the rural drama *Beyond the Horizon* (1920), and then, influenced by German *Expressionist theatre, wrote a sequence of plays on the theme of tragic frustration, set in modern American backgrounds, in which he experimented with different genres. His works include *The Emperor Jones* (1920), *The Hairy Ape* (1922), *All God's Chillun Got Wings* (1924), *Desire Under the Elms* (1924), the innovative *Strange Interlude* (1928), in which he attempted to create a dramatic technique using the *stream-of-consciousness method, in a nine-act tragedy of frustrated desires, and his reworking of *Aeschylus in *Mourning Becomes Electra* (1931). After he was awarded the Nobel Prize for Literature in 1936 no new plays were produced until the 1946 staging of *The Iceman Cometh,* which shows a gathering of failed dreamers who sym-

bolically portray the loss of illusion and the coming of death. *A Long Day's Journey Into Night* (1956), an autobiographical tragedy written in 1940, was the first of his posthumously produced and published plays. It was to assure his reputation as the most important US playwright of his generation.

onomatopoeia, the use of words which seem to imitate the sounds they refer to (whack, fizz, crackle, hiss); or any combination of words in which sound echoes sense, such as 'The murmur of innumerable bees' (Tennyson). This *figure of speech is often found in *poetry, sometimes in prose.

Op art, a type of abstract art that exploits certain optical phenomena to cause a work to seem to vibrate, pulsate, or flicker. Many of the devices employed by practitioners of Op art are based upon the well-known visual illusions to be found in standard textbooks of perceptual psychology, and the Op artist seeks maximum geometrical precision to evoke an exactly prescribed retinal response. The style developed in the mid-1960s, and leading exponents include Victor *Vasarely and Bridget *Riley.

opera, a dramatic performance or composition of which music is an essential part. Although music has been used in association with drama since the days of ancient Greece, the idea of conveying a story entirely in terms of

words and music belongs to the very end of the 16th century. Drawing in part on the Italian *intermedio* or musical interlude, its evolution is usually credited to a group of poets, musicians, and intellectuals who met as a Society (the Camerata) in Florence from 1580. Among their speculations was the use of music in Greek drama, and it was in the hope of emulating ancient practice that opera (an abbreviation for *opera in musica*) was invented. The earliest surviving example, *Eurydice* (1600), has music by Guilio Caccini (*c*.1545–1618) and Jacopo Peri (1561–1633). The words (the libretto) were by Ottavio Rinuccini (1562–1621). Written in a simple *monodic style that avoided the confusions of *polyphony, these early operas, performed in private theatres, were little more than dramas retold in melodic speech (recitative), interspersed with ballet. Monteverdi, the first opera composer of genius, made it into a cohesive art-form. His first opera, *Orpheus* (1607), uses recitative but supplements it with instrumental interludes, choruses, *arias (solo songs), duets, and ballets, thus enlisting a much greater variety of musical resources in the expression of drama and emotion while at the same time giving the overall structure a degree of genuine musical coherence. Over the next few decades opera gained in popularity, and theatres designed specifically for opera began to be opened (the first was in Parma in 1618). The traditions that Monteverdi had established in his work were carried on by his pupil *Cavalli. Other composers, however, worked in a more spectacular style, in which the emotional burden of the opera was expressed in long arias, often with a da capo or reprise in which the singer could embellish the melody. In France opera took longer to gain popularity. The first major operatic composer was *Lully. He established the *tragédie héroique*, with simpler librettos, more choral writing, and a more restrained vocal style than in Italian opera. *Tragédie héroique*, which grew out of the

Panini's painting *Concert donné en l'honeur de la naissance du Dauphin* (1729) shows the elaborate scenic effects which were at least as much a part of baroque **opera** as the music itself. Winches, gears, and ropes contrived to show celestial clouds or the fires of hell, while the stage was shaken by errupting volcanoes and underwater battles.

early *opéra-ballet and was derived ultimately from the *ballet de cour, governed the style of French opera until the middle of the 18th century. Meanwhile in Rome at the beginning of the 18th century, a group of noblemen and dramatists sought to purify the operatic tradition, writing a series of librettos on uplifting themes. The most important librettist in this opera seria style was Pietro Metastasio (1698-1782). Opera seria soon dominated most of the rest of Europe except for France, where *Rameau's opera-writing was revitalizing the tragédie héroique. Some of the finest works in the opera seria style were written in London by *Handel. Because opera seria librettos excluded any comic elements, alternative comic opera forms soon developed. Many of these forms were, strictly, *operetta rather than opera, but in Italy the more sophisticated opera buffa style was sung throughout, with a much greater variety of style and form than in serious opera. Change in opera seria came in 1762, when *Gluck demonstrated in Orpheus and Eurydice a series of 'reforms' suggested by the poet Raniero de Calzibigi. The da capo aria was dropped in favour of a variety of song-like structures that did not hold up the action so definitely; the orchestra was allowed to play a stronger role than that of mere support to the voices; chorus and dance found an appropriate place; and, above all, the plots were concerned with the drama of genuine human relationships. *Mozart, too, was a reformer—not through conscious theory, for he was quite happy to take the conventions of Italian opera to a high point in Idomeneo as late as 1781—but rather through the sheer force of his musical and dramatic genius. In such operas as The Marriage of Figaro (1786) and Don Giovanni (1787) his understanding of human nature, and capacity to find music to express it, has proved unsurpassed. After Mozart the divisions between opera seria and the various forms of opera buffa became blurred. With the 19th century, opera began to show stronger national characteristics. Italian opera, in the hands of *Rossini, *Bellini, and *Donizetti, remained true to vocal melody (see *bel canto) and finally achieved its apotheosis in the passionate dramas of *Verdi. Germany, through the example of *Weber and responding to the spirit of *Romanticism, veered towards folklore and fantasy. It also laid greater emphasis on the role of the orchestra. This line of development culminated in *Wagner's music-dramas, which dispensed with aria and recitative in favour of a seamless web of music, conceived symphonically from a network of *leitmotifs. Wagner's theory of music-drama was also an attempt to 'reform' opera—particularly the type favoured in France and exemplified in the works of *Meyerbeer. Known as 'Grand Opera', such works were replete with elaborate arias and ensembles, magnificent choruses, ballets, and spectacular scenic effects. Their plots, usually on some historical or quasi-historical event, were melodramatic and sensational. Overt nationalism, reflecting folk music and folkloristic subjects, came to the fore in the second half of the century in composers from Russia (*Glinka, *Musorgsky, *Borodin, *Rimsky-Korsakov and, to a lesser extent, Tchaikovsky), and Czechoslovakia (*Smetana, *Dvořák and, later, *Janáček). And at the end of the century a taste for realistic, low-life subjects, first manifest in Bizet's Carmen (1875), took root among Verdi's heirs and successors—particularly *Mascagni and *Puccini. In Germany, meanwhile, Richard *Strauss began where Wagner left off with music-dramas of an expressionist type (Salome, 1903-5) but gradually relaxed his style in favour of something more lyrical and restrained. By the end of the century most opera had abandoned any obvious division between aria and recitative, replacing it with a more or less continuous musical texture able to assume either function as the dramatic situation required. This was, in effect, a logical compromise between German and Italian methods—as suitable for a *Massenet as it was for a *Korngold. In the same spirit of intelligent compromise, opera in the 20th century has embraced many styles, from the *atonality of *Berg's Wozzeck (1925) to the *jazz of *Gershwin's Porgy and Bess (1935), the *impressionistic reticence of *Debussy's Pelléas et Mélisande (1902) to the astringent *Neoclassicism of *Stravinsky's The Rake's Progress (1951). And as an art-form there can be no doubt that it is as alive as ever, and has enjoyed a spectacular growth in popularity in recent years.

opéra-ballet, a spectacular, lyric form of theatre, in which dancing and singing are of equal importance. It developed at the end of the 17th century out of the earlier court spectacles (see *ballet de cour), largely under the influence of Jean-Baptiste *Lully, who took over the Paris Opera in 1672 and composed several successful examples of the form. It developed further in works like *Rameau's Les Indes Galantes (1735) and continued until the mid-19th century. *Ballets were also used in other operatic forms. Italian opera used dance for festive endings, and much of the grand opera in the 19th century had music especially composed for ballet sequences—the French productions of Verdi's The Troubador, for example (1857 and 1894), and of Wagner's Tannhäuser (Paris, 1861). Most opera houses have some kind of ballet company attached to perform these ballets.

operetta, a light-hearted, small-scale *opera. Spoken dialogue is used to link the *arias and ensembles. Operettas range in complexity from simple plays-with-music to works that involve most aspects of true *opera, other than recitative (melodic speech). Among the notable composers of operetta are *Offenbach, Johann *Strauss, *Lehár, and *Sullivan. The German Singspiel, the Spanish zarzuela, the British ballad opera, and the French opéra comique are forms of operetta, though they all have specifically national characteristics. Similar also is the musical comedy of the early 20th century and the present-day *musical, the difference being largely that of period style and the precise amount and weight of music involved.

ophicléide, a keyed brass musical instrument invented by Halari in 1817 as a bass key-*bugle to replace the *serpent (as the name, French-Greek for keyed serpent, suggests). It was widely used in orchestras and military bands in the 19th century, but was eventually replaced by the *tuba.

Ophüls (Oppenheimer), Max (1902-57), German-born French film director. Of his early German films the best was Liebelei (1932), a tragic romance based on Schnitzler's play. Anti-Semitism drove him first to France and then, in 1941, to the USA, where his films included Letter from an Unknown Woman (1948), a touching tale of infatuation set in turn-of-the-century Vienna; and two untypical suspense films, Caught and The Reckless Moment (both 1949). For the last phase of his career, in France,

he returned to the past. *La Ronde* (1950), his most popular film, based on another Schnitzler play, was a series of linked sexual encounters in which the same protagonist appeared in the first and last; *Le Plaisir* (1952), was based on tales by Maupassant. *Lola Montès* (1955), his last (and only colour) film, used his favoured flashback device to tell the story of the courtesan's decline. Ophüls's superb camerawork atoned for his sometimes novelettish plots.

oratorio, the religious equivalent of *opera, involving stories usually adapted from the scriptures, set to music for solo singers, chorus, and orchestra, and designed to be sung without scenery or costumes in a concert hall or church. Oratorios originated in the plays given in the Oratory of St Philip Neri in Rome during the second half of the 16th century, and developed alongside opera after 1600. The first true oratorio was *Cavalieri's *Representation of Soul and Body* (1600). Later contributors to its development include *Carissimi, Alessandro *Scarlatti, *Schütz, *Handel, *Haydn, *Mendelssohn, *Elgar, and Tippett. As oratorio developed, the chorus assumed more and more importance. This in turn led to the establishment of amateur choral societies. Until the end of the 18th century, oratorio was regarded as an alternative to opera (opera could not be performed during Lent).

Orcagna, Andrea (Andrea di Cione) (*c.*1308–*c.*1368), Italian artist, painter, sculptor, architect, and administrator. His only certain work as a painter is the altar-piece of *The Redeemer with the Madonna and Saints* (1354–7) in the Strozzi Chapel of Santa Maria Novella in Florence, the most powerful Florentine painting of the period, with resplendent colours and awesomely remote figures. As a sculptor and architect he is known through one work, the tabernacle in Or San Michele, Florence (1359). Orcagna was also chief architect of Siena Cathedral from 1358 to 1362, supervising the mosaic decoration of the façade, and was an adviser on the construction of the cathedral in Florence.

orchestra, a body of musical instruments grouped together in families with a view to achieving a balanced sound. The orchestra may be a large group of mixed instruments (the standard *symphony orchestra of ninety players or more), or a small group (such as a *chamber orchestra of sixteen to thirty players). It can consist of strings only (the string orchestra), though for historical reasons groups of woodwind and/or brass are often spoken of as bands. By the end of the 17th century the *polyphonic style had all but given way to homophony—music conceived primarily as a dominant melodic line, supported on pillars of *harmony rising from a firm bass line. This, coupled with the fact that melodic lines could now be projected against a background of harmony, made possible what we now think of as a typical orchestral style. Initially not all orchestras could run to a sufficient number of instruments; moreover, it was helpful to the performance if a keyboard player (often the composer himself) was available to act as a unifying *continuo agent, since there were as yet no *conductors. Little by little the 18th-century orchestra began to take shape (see *Mannheim School), until by the end of the century it was fairly generally established that it should consist of a balanced group of strings; two each of woodwind; two horns and two trumpets; and a pair of kettledrums. By this time the continuo was no longer thought of as an essential binding agent. The history of the orchestra in the 19th century is largely one of expansion and consolidation. Much of this was made possible by a radical change or adaptation in the construction and playing mechanism of instruments to meet the acoustic requirements of a larger auditorium. By the end of the century a typical orchestra generally employed over 100 players as compared to the 40 or so that would have been usual in the 1820s. In recent years composers have begun to specify unorthodox layouts in order to emphasize particular features of their music—often conceived with spatial or theatrical effects in mind. It is important to remember that non-Western cultures have also developed quite different, but equally sophisticated, orchestras of their own. The Chinese court orchestra (see *Chinese music), with its various forms of flute, drum, bell, and zither, and the Javanese *gamelan ensembles of gongs, bronze bars, and drums are but two examples.

orchestration, the art of scoring music for an *orchestra or band, or of arranging music that was originally composed for another medium. When writing orchestral music, composers think directly in terms of orchestral sound. In this sense orchestration is an integral part of composition. Music conceived in terms of specific orchestral colour may lose much of its effect when transcribed for different instruments. Orchestration assumed an increasing importance in the art of composition from the mid-18th century onwards.

Orders of architecture, in classical architecture a term applied to five distinct units of design categorized chiefly by means of the type of column used. Each Order in its entirety consists of the column, plus its base, plinth, or pedestal (if any), its *capital, and its entablature (the decorative horizontal member that surmounts it). The Greeks had three Orders, getting progressively slimmer and more richly decorated: Doric, Ionic, and Corinthian, named after regions of Greece in which they are said to have been first used. The Romans added two more: Tuscan, a starker form of Doric; and Composite, the richest of all, which combines features of Ionic and Corinthian. Each Order was thought to have a particular character that made it particularly appropriate for certain types of buildings or certain positions in buildings. Thus Tuscan was rather grave and serious, while Composite was festive. When Orders were superimposed in buildings of two or more storeys, the 'heavier' more sober Orders always went below the 'lighter', more decorative ones—the Colosseum in Rome is a fine example. The Orders were discussed by *Vitruvius, and from the Renaissance their proportions and detailing were codified and illustrated in numerous architectural treatises. They were regarded as the heart of classical architecture, and study of the Orders formed part of most architectural training in the West until well into the 20th century.

Orff, Carl (1895–1982), German composer and educationalist. In 1924 he helped found the Munich Güntherschule for gymnastics, music, and dance, which led to the development of Orff-Schulwerk (1930), through which he expounded his ideas for a practical course of music study. The simple tunes and hypnotically repetitive rhythms of such theatre-pieces as *Carmina burana* (1937) and *Catulli carmina* (1943), based on medieval poems, brought him immense popularity.

The Orchestra

18th-century orchestra (based on the Dresden opera orchestra 1767)

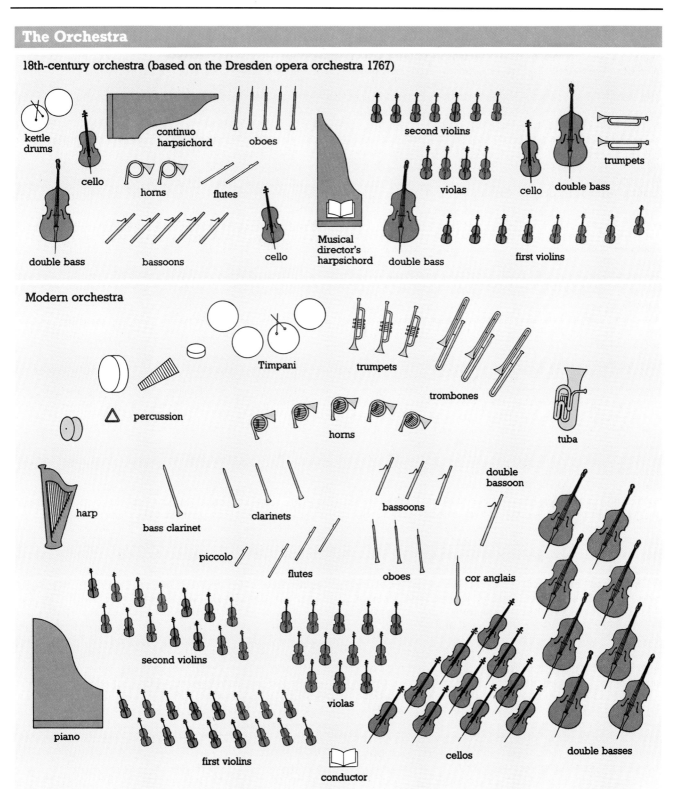

kettle drums

cello

continuo harpsichord

oboes

horns

flutes

double bass

bassoons

cello

Musical director's harpsichord

double bass

second violins

violas

cello

double bass

trumpets

first violins

Modern orchestra

Timpani

trumpets

trombones

percussion

horns

tuba

harp

bass clarinet

clarinets

bassoons

double bassoon

piccolo

flutes

oboes

cor anglais

second violins

violas

double basses

piano

first violins

conductor

cellos

organ, a keyboard musical instrument sounded by air in pipes. On small organs, from their invention in around 250 BC in Alexandria to the medieval *portative organ, when *keys were depressed, tracker-rods moved perforated plates to admit air to pipes. In the 15th century, further rods linked the keys through greater distances to pallets (air reservoirs) at the foot of the pipes. Stops, which control which row of pipes sound, were used on the surviving Roman organ at Budapest in Hungary, but knowledge of this device was lost, and instruments such as the large 11th-century organ at Winchester appear to have produced a general roar, with all the pipes for any one key sounding all the time. When stops were re-invented, in the 15th century, the disadvantage of the tracker action was that as further ranks of pipes were added to increase or alter the sound, the action grew heavier. The pneumatic lever, perfected before 1840, alleviated this problem, and the tubular-pneumatic

action, replacing trackers by tubes down which air could travel, allowed the organ keyboards to be separated from pipework; the invention of the electro-pneumatic action in 1861 allowed still further separation. All early pipes were flues, similar in principle to *duct flutes. The regal, with small beating reeds, existed by 1500, and was followed by pipes with reeds. By the early 1600s, Baroque organs, with the separate sections of *Hauptwerk, Brustwerk, Positive*, and *Pedal*, were firmly established. Pedals were rare in Britain until the 19th century. In that century organs grew ever larger, but since the 1920s there has been a tendency to return to late 17th-century specifications, allowing improved performance of Baroque music but precluding the playing of much 19th-century organ music.

organum, the earliest form of *polyphony, known since the late 9th century. In the earliest type of organum all the voices moved in parallel. The melody (*plainsong) was therefore being sung simultaneously at different pitches, beginning with octaves and then embracing fourths and fifths. This would seem to suggest that organum probably arose quite naturally out of people with different voice ranges attempting to sing the same melody. The movement of organum parts eventually (12th century) became freer, so that the parallel effects were no longer strictly maintained. This freedom led, in turn, to the development of *counterpoint as we know it. A 15th-century version of organum, involving parallel thirds and sixths and particularly loved by British composers, such as John Dunstable, is known as fauxbourdon or faburden.

ormolu (from French *dorure d'or moulu*, 'gilding with gold paste'), a form of gilded *bronzework used in various ways in the applied arts, particularly for the ornamentation of furniture. The term is often used rather loosely, but strictly ormolu is made by mixing powdered gold with mercury, brushing the resulting paste on to the bronze, and then firing the object so treated to make the mercury evaporate, leaving a layer of gold on the surface. It was an expensive procedure, used for luxury objects and reached its highest technical and artistic level in 18th-century France. Apart from furniture, it was used for candlesticks, chandeliers, clock-cases, and so on.

ornamental motif, a distinctive pattern or adornment, especially one that is repeated throughout a design or is found in more or less the same form in many different designs. Such motifs take many different forms and may be natural in origin (for example, the lotus motif much used in Egyptian, Buddhist, and Hindu art) or geometrical (for example, the cross). Often they have symbolic meaning: the lotus, for example, symbolized eternity, fecundity, and resurrection; and the cross (although now inseparably identified with Christianity) has been in widespread use since prehistoric times, often with unknown significance. Ornamental motifs are particularly important in Islamic art, since representations of the human form are prohibited in religious art, which favours stylization over naturalistic depiction. In architecture ornamental motifs are sometimes of structural origin. For example, the triglyph (a decorative stone block repeated at regular intervals in the frieze above the columns in many ancient Greek buildings) is said to derive from the ends of beams, which, when the buildings were made of wood, had projected in these positions.

The apogee of **organ** building was reached during the high Baroque in Central Europe. Magnificent organs are to be found in cities such as Weimar, Prague, and Leipzig, as well as in small village churches and cathedrals, such as the one at Passau where this organ was built in 1731.

orpharion, a wire-strung plucked musical instrument regarded in the late 16th and early 17th centuries as interchangeable with the *lute. It had seven, eight, or nine double courses (pairs of strings), like the contemporary lutes. The back was flat and the ribs followed the same elaborately festooned outline as on the *bandora, which was a larger instrument of the same family. The bridge and the wire frets were splayed further apart under the bass strings, which could thus be longer than the trebles. Orpharion necks were longer than lute necks, allowing a wider range on each string.

Orphism (or Orphic Cubism), a movement in French painting that developed out of *Cubism in about 1912. The word 'Orphism' was applied to the movement by the writer Apollinaire, and the reference to Orpheus, the singer and poet of Greek mythology, reflected the desire of the artists involved to bring a new element of lyricism and colour into the austere intellectual Cubism of Picasso, Braque, and Gris. Among the leading practitioners were Robert *Delaunay and Frank Kupka (1871–1957), who made colour the principal means of artistic expression and were among the first to paint totally non-representational pictures, seeing an analogy between abstract art and music. Orphism was short-lived, but it was particularly influential on German painting.

Ortega y Gasset, José (1883-1955), Spanish philosopher and essayist. One of the most brilliant stylists of this century, his ideas dominated the Spanish intellectual world from 1910, when he became professor of philosophy at Madrid. He was associated with the *Generation of '98, and in 1923 founded the influential magazine *Revista de occidente*, which introduced northern European ideas to Spanish intellectuals. His many academic works span the disciplines of philosophy, theology, literary criticism, and political theory, the best known being *The Revolt of the Masses* (1929), in which he argued that mass democracy could lead to domination by mediocre minds, and proposed instead leadership by an intellectual élite.

Orton, Joe (John Kingsley Orton) (1933-67), British playwright. His comedies are cynical, stylish, and brutal, with an emphasis on corruption. As a homosexual, he mocks conventional morality and authority with a mischievous humour. After writing several successful plays, including *Entertaining Mr Sloane* (1964), *Loot* (1965), and the posthumously performed *What the Butler Saw* (1969) (see *farce), he was battered to death by his lover Kenneth Halliwell, who then committed suicide.

Orwell, George (Eric Arthur Blair) (1903-50), British novelist and essayist. Born in Bengal, he served with the Indian imperial police in Burma (1922-7), which provided material for his first novel (*Burmese Days*, 1934). He resigned to escape the constrictions of imperialism and worked in Paris and London in fairly severe poverty, described in *Down and Out in Paris and London* (1933). His next two novels (*A Clergyman's Daughter*, 1935; and *Keep the Aspidistra Flying*, 1936) were followed by a visit to the north of England which resulted in his evocative account of unemployment and working-class life (*The Road to Wigan Pier*, 1937). His experiences fighting for the Republicans in the Spanish Civil War intensified his political commitment and produced *Homage to Catalonia* (1938). He became increasingly a political writer, a democratic socialist who avoided party labels. His two most popular works were his political satires, *Animal Farm* (1945), about the failure of communism, and *Nineteen Eighty-Four* (1949), a prophetic novel of one man's struggle against the totalitarianism and mechanistic society of the future. He died of tuberculosis a few months after its publication. His plain, colloquial style made him an effective journalist and pamphleteer; his *Collected Essays, Journalism and Letters* appeared in 1968.

Orzeszkowa, Eliza (1841-1910), Polish novelist. Her home in eastern Poland provided rich material for her rather didactic works. She wrote on women's position in society, *Marta* (1873); Jewish communities, *Meir Ezofowicz* (1878); peasant life, *The Boor* (1889), and presents a panorama of country life in *By the River Niemen* (1888).

Osborne, John James (1929-), British playwright. He made his name with *Look Back in Anger* (1956), which proved a landmark in the history of the British theatre and a major contribution to the image of the *Angry Young Man. It was influential in its use of social milieu, its iconoclastic social attitudes, and in its exploration of sado-masochistic relationships. It was followed by further impassioned and energetic plays including *The Entertainer* (1957), *Luther* (1961), and *Inadmissible Evidence* (1964). *A Better Class of Person* (1981) describes his suburban

childhood, his experiences as a journalist, and his life as an actor in repertory.

Ostade, Adriaen van (1610-85), Dutch painter, active in his native Haarlem, where he is said to have been a pupil (at the same time as *Brouwer) of Frans *Hals. He painted many subjects, but like Brouwer is best known for lively scenes of peasants carousing or brawling. Ostade was successful and much imitated, notably by his brother and pupil **Isaak** (1621-49), who was also a fine painter of winter landscapes and whose early death cut short a career of great promise.

Ostrovsky, Aleksandr (Nikolayevich) (1823-86), Russian dramatist. Ostrovsky's plays deal with the social problems facing his urban contemporaries, especially the merchant class (*The Storm*, 1860); distinguished by their *realism, they dominated the 19th-century Russian theatre and remain among the most frequently performed stage pieces in the Soviet Union.

ottava rima, a poetic *stanza of eight lines rhyming ABABABCC, usually employed for *narrative verse. In its original Italian form, pioneered by Boccaccio and perfected by Ariosto, it used lines of eleven syllables; but the English version is in *iambic *pentameters. It was introduced into English by Wyatt, and later used by Byron in *Don Juan* (1819-24) as well as by Keats, Shelley, and Yeats.

Ottoman art. The Ottomans emerged in the early 14th century in western Anatolia, and went on to establish a vast empire with its capital in Istanbul. The finest early Ottoman architecture was built in Bursa and Edirne, in western Turkey, the first capitals. Buildings such as the Green Mosque in Bursa (1419-24) reflect the earlier *Seljuq tradition of building, but have a more intimate character and more lavish use of interior tilework in a range of brilliant blues and greens. After the conquest of

The potteries of the Anatolian lakeside town of Iznik produced pottery and tiles which are perhaps the best-known works of **Ottoman art**. Panels of tiles such as this one, dating from the 17th century, were used, often sparingly, to highlight architectural features in mosques such as the *miḥrāb*, or occasionally in luxuriant profusion to cover whole walls and rooms. (Victoria and Albert Museum, London)

Istanbul (Byzantine Constantinople) in 1453, Ottoman architecture was influenced by *Byzantine buildings such as Hagia Sophia, and the great imperial mosques erected by *Sinan show a preoccupation with constructing a massive dome and centralizing the interior space which remained an important concern even in the later years of the empire when a Europeanized 'Baroque' style became fashionable. As well as the ceramics produced at *Iznik, the Ottoman court workshops supervised the production of magnificent *silks, velvets, and *carpets. There was a distinctively Ottoman style of miniature painting, rooted in the tradition of *Islamic miniature painting, but with a down-to-earth boldness and vividness well suited to the illustration of preferred subjects such as battle campaigns and very different from the more fanciful Persian style.

Ottonian art, a term, deriving from the dynasty founded by the Emperor Otto the Great, applied to art of the Holy Roman Empire in the 10th century and most of the 11th century. Developed on German soil, the Ottonian style revived large-scale bronze-casting and life-size sculpture, but the most typical sculptural products of the period were in ivory and metalwork, notably for book covers and altar reliefs. The earliest surviving over-life-size medieval sculpture in wood, the Gero Crucifixus (969–76) in Cologne Cathedral, dates from this period. In Hildesheim, Bishop Bernward commissioned monumental bronzes for his cathedral, notably the doors (1015) with vividly told biblical scenes in high relief. A few outstanding wall-paintings and a rich store of illuminated manuscripts also survive from the period, Ottonian illumination being notable for the pre-eminence given to the human figure, which is often imbued with strong expression and marked by exaggerated gestures. Church architecture adopted and further developed a *Carolingian type of *basilica with east and west choirs and transepts, or with an elaborate western apse. It was characterized by a fortress-like exterior with groups of towers and massive walls pierced by relatively small windows. Ottonian art was widely influential and was one of the sources out of which *Romanesque grew.

Ousmane, Sembène (1923–), Senegalese novelist and film director. His first novel, *Le Docker noir* (1956), reflects his experiences as a trade union leader in Marseilles, while *Les Bouts de bois de Dieu* (1960) is based on the 1947 rail strike in French West Africa. Among other films, he has directed the screen version (1974) of *Xala*, his *satire on the new African élite.

overture, a one-movement orchestral introduction to an *opera, *oratorio, or play; also a concert work in the same form. The first such pieces were little more than elaborate fanfares (as in Monteverdi's *Orpheus*, 1607), but as opera itself developed the overture took on the characteristics of a dance *suite. Two types of overture eventually emerged: one, to be found in Lully's operas, followed a slow–fast–slow pattern in which the opening section made especial use of pompous, dotted rhythms, the middle section was fast and fugal, and the concluding section was a moderately slow dance. This form was known as the French overture. The other form, the Italian overture, was established in the operas of Alessandro Scarlatti and followed a fast–slow–fast pattern; it began *fugally. In both cases the alternative title 'sinfonia' was

The bronze doors of Hildesheim Cathedral (1015) are the most ambitious monuments of **Ottonian art**. Each of the two doors was cast in one piece, the first time since the Romans that such large and elaborate sculptures had been made in this way. There are eight panels on each door representing scenes from Genesis and the life of Christ. The panels shown here depict the creation of Eve.

used, thus establishing the overture as an ancestor of the *symphony. The overture of the second half of the 18th century took on the formal characteristics of *sonata form, with an introductory slow section inherited from the French overture. Gluck was the first composer to link the overture thematically and atmospherically to the opera that followed, but Italian composers were usually content to produce lively music that would silence the audience's chatter, sometimes designing their overtures as a medley of the 'hit' tunes to come. In such examples as Weber's *Freischütz* (1823), the thematic link is carried to the point where the overture is virtually a musical synopsis of the opera. In this instance the overture foreshadows the *symphonic poem. Concert overtures, also frequently programmatic in content, became popular in the 19th century, while at the same time the purely operatic overture was sometimes replaced by a less formal prelude, as in Wagner's music-dramas. Operas in the 20th century have usually dispensed with the overture altogether.

Ovid (Publius Ovidius Naso) (43 BC–AD 17), the youngest and most productive of the great Latin poets who wrote under Augustus. He gave up public life for poetry, but was exiled by the emperor in AD 8 to Tomis on the Black Sea. He wrote fluently, almost always in *elegiac *couplets, which he brought to a new pitch of point and wit. He was fascinated by the theme of love, which he

treated gaily and sensuously; it dominates the superficially personal *Amores*, the *Heroides* (letters by mythological heroines to their lovers), the *Ars Amatoria* (which gives precepts for winning one's girl), and the *hexameter *epic the *Metamorphoses*, which hangs a brilliant series of stories from Greek and Roman myth on the thread of bodily transformation. He also wrote a poetical calendar covering the first six months of the year, known as the *Fasti* and a lost tragedy, *Medea*. Later in life his exile dominated his poetry, and the *Tristia* and *Letters from the Pontus* have a more sombre tone. Yet on the whole Ovid's work is marked by a wonderful cheerfulness and fluency of invention, which captivated the Middle Ages and is still attractive today.

Owen, Wilfred (1893–1918), British poet, one of the most important poets of World War I. Already a scrupulous craftsman, he was much encouraged in his poetry by contemporaries such as *Graves and *Sassoon, with whom he found himself recuperating in a military hospital. Most of his best work was written during the last year of the war. He was killed in action in France, a week before the armistice. His poems have a bleak and indignant realism ('What passing bells for these who die like cattle?') and emotional drama (' "I am the enemy you killed, my friend" '). Several of his poems were used for *Britten's *War Requiem* (1962).

oxymoron, a *figure of speech which combines two usually contradictory terms in a compressed paradox: 'bittersweet', 'living death'. Oxymoronic phrases, like Milton's 'darkness visible', were especially cultivated in 16th- and 17th-century poetry.

Paderewski, Ignacy Jan (1860–1941), Polish pianist, composer, and statesman. Having studied in Warsaw (1872–83) and Vienna (1884–7), Paderewski's 1888 concert début in Paris was the start of a demanding international career. He composed a number of nationalistic works, including the opera *Manru*, as well as the more familiar *Humoresques de Concert* for piano. Paderewski took an active part in the Polish fight for self-determination, and was briefly his country's Prime Minister (1919).

paean, a song or chant of triumphant rejoicing, usually after a military victory. Originally hymns of thanksgiving to the Greek god Apollo, paeans were extended to other gods and to military leaders. Pindar developed the paean into a literary form.

Pagan *Burmese art.

Paganini, Niccolò (1782–1840), Italian violinist and composer. From the age of 13, Paganini toured throughout Europe and composed difficult pieces to demonstrate his virtuosity. In Paris in 1833 he commissioned *Berlioz to write a viola piece but rejected the resulting work, *Harold in Italy*, because it gave him too little to play. He pioneered the virtuosic use of string techniques, such as pizzicato (plucking), as well as unusual styles of bowing.

pageant, a brilliant spectacle, especially an elaborate parade; a play performed in the open. In medieval times the word referred to the carts representing guilds in civic processions as well as to *booths or pageant wagons, which staged scenes from religious plays in different locations. In Tudor times the word described elaborate, sometimes movable structures of wood and canvas used in *masques. In the 20th century pageants are open-air shows, sometimes processional, and usually celebrating a historical or legendary event. Notable among these are the processions associated with the Chinese New Year and with the Hindu god Vishnu. In the latter an idol of the deity rides in procession on an enormous *jagannath* or juggernaut (see *rath) pulled by devotees.

Pagnol, Marcel (1895–1974), French playwright, film director, and writer. He is best known for *Marius* (1931), *Fanny* (1932), and *César* (1936), a film trilogy based on his own plays for which he wrote the screenplays, also producing the last two and directing *César*. Enormously popular for their humour and the affectionate depiction of their Marseilles characters, they were remade in other languages and even transformed into a Broadway *musical. Forming his own company in 1934, he wrote, directed, and produced his own films, all set in Provence, the best known being *La femme du boulanger* (1938).

paint, a substance for decorating or protecting a surface, consisting typically of a liquid mixture of *pigment (colouring matter) and *medium (oil, water, etc.) that dries to form a hard coating. The nature of the medium determines the qualities and appearance of the paint. In

In the West, the **pageant** reached a peak of artistry with the procession held in Brussels in 1615 to mark a royal wedding. This detail of the painting, *Isabella's Triumph* by van Alsloot shows a mythical king of Africa surrounded by boys dressed as parrots or popinjays. In addition to guilds and religious orders the cavalcade included giants, dragons, decorated floats, and figures from classical mythology. (Victoria and Albert Museum, London)

*oil painting the medium is a vegetable oil; in *tempera it is egg yolk (or sometimes the whole egg); and in *water-colour the medium is usually gum arabic, which is soluble in water. Water is also used in *fresco as the liquid in which the pigment is suspended, but here the medium is really the plaster to which the paint is applied. *Pastel does not use any medium as such, just gum or resin to hold the powdered pigments together. It is sometimes classified as a paint but more usually as a drawing material. Synthetic dyes were invented in 1856 while modern technology has seen further important developments including synthetic pigments.

Palaeolithic art *Stone Age art.

Palestrina, Giovanni Pierluigi da (*c*.1525–94), Italian composer. He received his early training in Rome as a choirboy at Santa Maria Maggiore and by 1544 had become organist at the Cathedral in Palestrina (which may have been his birthplace). In 1555 he was admitted to the pope's official musical chapel (Cappella Sistina), but was forced to resign because he was a married man. Palestrina's immense output includes secular and religious *madrigals, *motets, hymns, and many settings of the mass and the magnificat. Though his work has become accepted as the model for diatonic, strict *counterpoint, pure of purpose and more genuinely 'religious' than that of his more adventurous contemporaries, it is none the less music of great beauty and expressive power and represents the last great peak of vocal *polyphony.

palette, the flat board, usually rectangular, ovoid, or kidney-shaped, with a hole for the thumb, on which artists arrange their paints ready for use. Palettes first appeared in the 15th century; before this time individual containers (sometimes shells) were used for mixing colours. For *oil painting, mahogany is traditionally considered the best material for palettes; for water-colour and miniature painting, materials such as ivory and porcelain have been used. The term 'palette' also refers to the range of colours characteristic of an artist; Caravaggio has a dark or restricted palette, Monet a bright or rich palette.

Pali literature, literature written in the north Indian language of that name, comprising principally the Buddhist canon. The teachings of the Buddha (6th century BC) were originally preserved orally, the canon known as the *Tipitaka* ('three baskets' of wisdom) established at three great councils, the last under the Mauryan Emperor Ashoka's patronage *c*.250 BC. The *Vinayapitaka* ('The Pitaka of Conduct') enshrines the rules of discipline for the Buddhist order. The *Suttapitaka* ('The Pitaka of the Sermon') contains the Buddha's sermons, including the most popular text in the entire canon, the *Dhammapada* ('The Verses on Virtue'), the quintessence of the Buddha's teaching in 423 verses, and the *Jātakas. The *Abhidhammapitaka* ('The Pitaka of Metaphysics'), later than the other two, comprises seven books of Buddhist philosophy. According to tradition, the *Tipitaka* was written down during the 1st century BC. Besides the canon and its many commentaries, other important early Pali works from Sri Lanka are the *Milindapanha* ('The Questions of Menander'), the Graeco-Bactrian King Menander's questions to the sage Nagasena on Buddhist philosophy, and the *Mahavamsha* ('The Great Lineage'), a historical chronicle relating Buddhism's spread to Sri Lanka.

palindrome, a word (like 'deed', 'eye', or 'tenet') which remains the same if read backwards; or a sentence or verse in which the order of letters is the same reading backwards or forwards, disregarding punctuation and spaces between words: 'Madam, I'm Adam'.

Palissy, Bernard (*c.*1510–*c.*1590), French potter. He is renowned for his 'rustic wares', which were dishes and bowls ornamented with snakes, lizards, frogs, fish, and foliage. Palissy was outstanding for the fineness of his wares and for his rich polychrome *glaze colours. He was brought to Paris in 1566 by Catherine de' Medici. He died in prison, persecuted as a Protestant heretic. Little pottery survives from his own hand, but his work was much imitated for some two centuries after his death.

Palladianism, a style of architecture based on the buildings and publications of the 16th-century Italian architect Andrea *Palladio. In its most general sense the term 'Palladian' can be applied to any building inspired by Palladio (for example, those of Inigo *Jones), but 'Palladianism' usually refers to a movement that dominated British architecture from about 1715 to about 1760 (1715 is a convenient symbolic starting-point as it was the year of publication of the first complete English translation of Palladio's *Four Books of Architecture* and of the first volume of Colen *Campbell's *Vitruvius Britannicus*). During this period Palladio was admired by influential figures such as Lord *Burlington and William *Kent, and the exuberant *Baroque style associated with Wren (in his late years), Vanbrugh, and Hawksmoor gave way to one characterized by symmetry, methodical regularity,

Holkham Hall in Norfolk, one of the grandest of **Palladian** houses in Britain. It was designed by William Kent for Thomas Coke, Earl of Leicester and was begun in 1734. The large central portico is a particularly common feature of the movement.

and classical correctness of detail. There was a political as well as a stylistic dimension to the movement, for Palladianism was associated with the Whig aristocracy (supporters of the House of Hanover) to whom the Baroque style smacked of Roman Catholicism and the deposed House of Stuart. In Britain Palladianism was almost entirely confined to domestic architecture; interiors were often richly decorated compared with the sober exteriors. Inherent in Palladianism was the notion that architectural design should be governed by reason and the application of rules; it thus tended to stifle individuality, but on the positive side it helped to spread a tradition of sound classical design throughout the country. In Britain Palladianism began to merge with the more severe and archaeologically spirited *Neoclassicism in the 1760s, but at about the same time it was taken up in America, where it enjoyed a long and fruitful popularity. Thomas Jefferson, better known as the author of the Declaration of Independence and third President of the USA, was one of the most distinguished American Palladian architects.

Palladio, Andrea (Andrea di Pietro) (1508–80), Italian *Renaissance architect, born in Padua and active mainly in Vicenza. Through his buildings and his publications Palladio has been probably the most influential figure in Western architecture (see *Palladianism). He began his career as a stonemason, but in the 1530s he became a protégé of Count Giangiorgio Trissino, a humanist poet and scholar, who furthered his education and encouraged in him an intellectual approach towards architecture. (It was Trissino who gave him the name Palladio, derived from the Greek goddess of wisdom.) Palladio visited Rome with Trissino twice in the 1540s, making a thorough study of Roman architecture; this bore fruit not only in influence on his own buildings, but also in his guide to the city's ancient monuments, *The Antiquity of Rome* (1554), which remained a standard guide for two centuries.

Palladio's large output consisted mainly of palaces and villas in and around Vicenza for the great families of the region. His most famous building is the Villa Capra (or Villa Rotonda), begun in 1566, which has a portico in the form of a Roman temple front on each of its four sides. Palladio was the first to use the temple front in domestic architecture, and like other of his innovations it soon became part of the standard repertory of architectural forms. Late in his career, Palladio also worked much in Venice, designing the churches of S. Giorgio Maggiore (begun 1566) and Il Redentore (begun 1576). In 1570 he published *The Four Books of Architecture*, which contained illustrations of many of his buildings and helped to spread his fame. His buildings, elegant but vigorous, grand but human in scale, were regarded by many of his admirers as unsurpassable models.

Palmer, Samuel (1805–81), British landscape painter and etcher. He had experienced visions from childhood, and his meeting with William *Blake in 1824 intensified his mysticism. In 1826 he moved to Kent, where he was the central figure of a group of artists called 'the Ancients' who looked upon Blake as a figurehead. There he produced his greatest works—landscapes charged with a sense of fecundity, Christian symbolism, and other-worldly beauty. In 1832 what he called his 'primitive and infantine feeling' for landscape began to fade and by the end of the decade, after returning to London in 1835, the break with his visionary manner was complete. His later paintings were more conventional, but in his etchings some of his early genius remained.

Pañcatantra ('The Five Treatises'), a collection of Indian beast-fables. They were composed by Vishnusharman (c. 2nd century AD) to teach princes how to act in war and peace, win and divide friends, and avoid impetuousness. Various later Sanskrit versions prove their continuing popularity. They influenced the *Jatakas and Western European literatures through the Arabic translation, *Kalila and Dimnah*.

panegyric, a public speech or poem devoted to the prolonged, effusive praise of some person, group of people, or public body (a government or army, for example). This branch of *rhetoric was particularly cultivated in ancient Greece and Rome.

panel, a painting surface of wood, metal, or other rigid substance, as distinct from *canvas. Until the adoption of canvas from the 15th century, nearly all movable paintings produced in Europe were executed on wood. Varieties of wood used for panels included oak, poplar, and pine. The panel was well seasoned and then coated with some material such as *gesso before it was suitable for painting on. Other materials that have been used for panels include copper (especially favoured for small-scale work), slate, and millboard (compressed cardboard). In the 20th century artists have used plywood and other synthetic materials.

panelling, a decorative treatment of walls (and also ceilings, doors, and furniture) consisting of a regular series of flat compartments of wood framed and linked together by narrower (in width) but thicker (in depth) strips of wood so that they do not warp or split. Panelling was used in ancient times, but it was not until the Gothic period that it became a leading feature of interior design. Wood panelling reached a peak of elaboration in the traceried panels of late medieval northern Germany and the Low Countries. The linenfold pattern was invented in Flanders during the 15th century, a stylized imitation of curtaining. Panelling was usually of oak, pine, or figured hardwoods that could be laid in thin sheets. In the 18th century oak was replaced largely by deal, and thereafter the painted panel predominated. In the 20th century many other woods and also synthetic materials have come into use.

panpipes (or syrinx), a musical instrument, a series of tubes, each of different length, blown as *end-flutes or via *ducts, usually fixed together in a raft or bundle. (The name derives from the myth of Pan and the nymph Syrinx, who became a clump of reeds to escape him.) Some peoples, for example the Lithuanians and the South African Venda, have a player for each tube. The instrument is used world-wide, the bundle panpipe being commonest in Oceania, the raft being common elsewhere. The instrument plays an important role in the folk music of the Andes (see *American Indian music), and in Romania, where country gypsy bands once used the instrument, modern virtuoso players achieve great popularity. The prevalence of the panpipes in contemporary folk music is shown by Mozart's use of the instrument in his opera *The Magic Flute*.

pantomime, a British theatrical entertainment which derives its name (though not its character) from the Roman *pantomimus*. Associated with Christmas, it developed from the *harlequinade. Traditional fairy-tales form the basis for a mixture of songs, dances, *slapstick, topical jokes, male and female impersonation, magic, and spectacle. The word was also used for the *mimed Pierrot plays of Jean-Gaspard Deburau, based on the *commedia dell'arte* masque.

pantomimus, the name given to a performer popular in Imperial Rome, who by movement and gesture alone represented the different characters in a short scene based on classical history or mythology, sung in Greek by the *chorus accompanied by musicians. The *pantomimus* wore the *costume of the tragic actor—a long cloak and a silken tunic—and a *mask with no mouthpiece, changing it when necessary. As many as five masks could be used in one scene. The art of the *pantomimus* dealt exclusively with tragic or clandestine passions, although unlike its rival the Roman *mime it was never coarse or vulgar.

papier mâché (French, 'chewed paper'), a material made of pulped paper mixed with glue (and sometimes sand), which can be moulded when moist and hardens when baked to form a strong but light substance that can be polished and painted. It is used in a great variety of ways: for household objects such as trays and boxes; for light furniture (sometimes inlaid with mother-of-pearl); for window displays and theatrical decorations; for architectural mouldings imitating plasterwork; and even as a building material. Papier mâché is of oriental origin and became popular in the West in the 17th century.

Papua New Guinean music, the music of the eastern part of the island of New Guinea and many off-shore islands in the south-west Pacific. The main form is group

Papua New Guinean music relates to many of the important rituals of tribal life. Here, the men of Amongavi village on the Kariwari river play sacred flutes after a head-hunting ceremony.

singing led by a song leader to accompany most activities of daily life. Spectacular feasts, including singing and dancing, known as 'sing-sings', are associated with a variety of ceremonies, such as the rites of passage of an individual, courting, and rituals enacted before tribal warfare. Another traditional form of singing is wailing or keening—songs of lamentation to mourn the dead. Instruments, generally made and played by men, are intricately decorated and are used in many contexts. The *garamut*, a wooden *slit-drum made in various sizes, has ends shaped like a crocodile head, bird, or human figure, and accompanies songs and transmits messages between villages. The transverse *flute is considered sacred and only to be seen by initiated males. Other instruments include *conch-shell trumpets, decorated wooden horns (played in the Sepik region, and either blown or sung through), *panpipes, *bull-roarers, bamboo *stamping tubes, *rattles, and a string instrument made by slitting a thin strip of the surface away from a length of bamboo and inserting a wooden bridge beneath it.

parable, a brief *allegory in which a moral or lesson is illustrated, usually through a *metaphor, in a simple story. The forty parables attributed to Jesus of Nazareth in the Christian gospels are the foundation for the Western tradition of allegorical teaching.

Paracas culture *South American Indian art.

Parini, Giuseppe (1729–99), Italian poet and prose writer. Born to genteel poverty in Lombardy, he reluctantly became a priest, and entered a noble household as tutor. Sensitive to the attendant humiliations endured by the humbly born, Parini brought moral commitment back into Italian poetry. He achieved success with his Horatian *Odes* (1795), and with his masterpiece *The Day* (1763, 1765, 1801), a *satire on the superficiality and selfishness of the aristocracy of his day. In Milan he met the young Mozart, who composed an operatic score for his play *Ascanio in Alba* (1771).

Paris, School of, a very general term applied to those movements in modern art including *Fauvism, *Cubism, and *Surrealism that had their focus in Paris, although many of their exponents were from countries other than France. The term reflects the intense concentration of artistic activity, supported by critics, dealers, and connoisseurs, that made Paris the world centre of advanced art during the first forty years of the 20th century, after which time it was replaced by New York. In the context of manuscript illumination, the term 'School of Paris' is applied to the artists who, during the reign of Saint Louis (Louis IX, 1226–70), made Paris the leading centre of book illustration in Europe.

Paris Opera Ballet *dance companies.

Parker, Charles (Charlie, 'Yardbird', 'Bird') (1920–55), US *jazz saxophonist and composer. Parker grew up in poverty in Kansas City. He was largely self-taught, but was working professionally by the age of 17. While a soloist with Jay McShann's band in New York in 1941, Parker met trumpeter Dizzy Gillespie and other musicians who were experimenting with new ideas in jazz. The new ideas took form in the jazz style known as bebop. Parker was its leading exponent and probably the greatest jazz improviser on saxophone. He recorded his best work between 1945 and 1947. Alcoholism, drug addiction, and personality problems made his later performances increasingly erratic, although he continued to produce work of genius up to 1953.

Parker, Dorothy (Rothschild) (1893–1967), US humorist, short-story writer, and poet. Brought up in New York City, she acquired an almost legendary reputation for the malicious and sardonic *bons mots* of her writing and conversation. Her poetry, collected in *Not So Deep as a Well* (1936), and her short stories, collected in *Here Lies* (1939), are characterized by brilliant concision, flippant cynicism, and caustic variations of themes such as frustrated love and cheated idealism in modern living.

Parmigianino (Girolamo Francesco Mazzola) (1503–40), Italian *Mannerist painter and etcher, born in Parma, from which he takes his nickname. He painted important frescos in Parma before moving to Rome in 1524. There his sophisticated style became grander and more graceful under the influence of Raphael and Michelangelo. He is said to have neglected his work because he became infatuated with alchemy, but his late paintings show no falling-off in his powers, but rather an extreme refinement. He seems to have been the first Italian artist to produce original etchings from his own designs, and

his extraordinarily elongated and tapering figures were influential in France as well as Italy. As well as religious pictures, he painted some superb portraits.

Parnassians, a group of French poets active after about 1860. The name is taken from the title of a literary magazine, *Le Parnasse contemporain*, first published in 1866, in which some of their poems appeared. Parnassian poetry was the counterpart of scientific positivism deriving from the theories of Auguste Comte, and *realism in the novel as practised particularly by *Flaubert. It rejected the extreme lyricism and looseness in form associated with the *Romantics, stressing visual beauty captured through formal perfection. Its subjects were typically landscapes, themes from Greco-Roman antiquity, or metaphysical speculations frequently of a pessimistic nature. *Gautier's theory of 'art for art's sake' and *Baudelaire's stress on formal perfection can be seen as precursors of the movement, which was led by *Leconte de Lisle and numbered Sully-Prudhomme (1839–1907) and Heredia (1842–1905) among its adherents. The Parnassians were an early influence on *Mallarmé, *Verlaine, and *Symbolist poetry.

parody, a mocking imitation of the style of an artistic work or works, usually literary. Parody is related to *burlesque in its application of serious styles to ridiculous subjects, to *satire in its punishment of eccentricities, and even to *literary criticism in its analysis of style. Aristophanes parodied the styles of Aeschylus and Euripides in *The Frogs*, while Cervantes parodied medieval *romances in *Don Quixote* (1605). Poets in the 19th century, especially Wordsworth and Browning, suffered numerous parodies of their works. Max Beerbohm's *A Christmas Garland* (1912) is a celebrated series of parodies.

Parry, Sir (Charles) Hubert (Hastings) (1848–1918), British composer, teacher, and writer. The success of his cantata *Scenes from Prometheus Unbound* (1880) established him as a leader in the modern renaissance of English music, to which he contributed five symphonies, much chamber music, and a set of Symphonic Variations (1897). Among his many choral works, *Blest Pair of Sirens* (1887), based on the ode by Milton, is outstanding. His *motets, too, are of high quality, and his 1916 unison setting of Blake's 'Jerusalem' has won a secure place in the repertoire of British ceremonial music.

partita, a musical term. In the late 16th century and the 17th, it referred to one of a set of *variations, as in the titles of a number of volumes of instrumental (especially keyboard) music. Italian and, later, other composers customarily based sets of variations ('parti' or 'partite') on the bass lines of well-known tunes, like the *folia* or *romanesca*. In late 17th-century Germany it came to be an alternative title for a *suite. In the 18th century it could be applied loosely to any sort of multi-movement instrumental piece of the suite or sonata type (e.g. Bach's partitas for solo violin and solo keyboard).

part-song, a work for several voices (male, female, or mixed) usually, but not always, sung without accompaniment. Though part-songs may make use of *counterpoint, the movement of parts is likely to be more restricted and the real interest concentrated in the top line. Part-songs are often verse-repeating. Particularly popular in the 19th century, they paralleled the development of amateur choral societies. Even major composers were happy to write part-songs suitable for choral competitions, while minor composers turned them out in handfuls. The glee, a type of unaccompanied English part-song composed in the 17th, 18th, and 19th centuries, gave rise to new musical genres in Victorian times, such as the comic ensembles in light opera, the close-harmony folk-song arrangement, and the barber-shop quartet popular in the American West of gold-rush days.

Pascal, Blaise (1623–62), French writer and mathematician. After a mystical experience in 1654 he abandoned the scientific work on which his early renown was founded and withdrew to Port-Royal, the home of French Jansenism, which taught the corruption of man and his dependence upon divine grace for salvation. His major work, the *Pensées*, consists of fragments intended for an apology for the Christian religion. These contain profound insights into the grandeur and misery of the human condition, expressed in spare, incisive language.

Pascoli, Giovanni (1855–1912), Italian poet and classical scholar, the major precursor of *modernism in Italian poetry. A socialist sympathizer who preached political anarchy, he was imprisoned for some months in 1879. Nature and simple things often provide his themes, but he draws from symbolism the suggestion of enigma and evanescence. His language spans the range from pure sound (animal- and baby-talk) to the literary conventions of lyric tradition. His *Tamarisks* (1891) is a collection of delicate lyrics; his masterpiece, *Songs of Castelvecchio*, movingly evokes his tragic childhood and celebrates the beauty of nature and family life.

Vaslav Nijinsky and Tamara Karsavina perform the **pas de deux** from *Giselle* in Paris 1910. Since its first performance in Paris in 1841 this *pas de deux* has become a display piece for the ballerinas.

pas de deux, step or dance for two. The term usually applies to dances for a man and woman. In Petipa's ballets the *pas de deux* follows a set order of double work (where the man supports the woman in lifts, turns, and balances) followed by solo variations and coda. In most narrative ballets it expresses the relationship between male and female characters and in *Ashton's ballets hands could be used for a complex and powerful metaphor for love. It may also be a formal display of virtuosity, where the man's strength and sensitivity are used to show off the ballerina's technique.

Pasek, Jan Chryzostom (*c.*1636–*c.*1701), Polish diarist. A minor nobleman, in his *Memoirs* (written 1690–5) he describes in lively, hyperbolic style both the important events and the everyday details of the years 1656–88.

Pasolini, Pier Paolo (1922–75), Italian film director, novelist, and poet. A Marxist who avoided using professional actors, he directed one of the most successful films ever made about Christ, *The Gospel According to St Matthew* (1964). He also made two films based on Greek tragedies, *Oedipus Rex* (1967) and *Medea* (1969); *Theorem* (1968), about a young man's sexual relationships with his host family; and *Pigsty* (1969), partly concerned with bestiality. His later work included three bawdy films based on literary classics: *The Decameron, The Canterbury Tales* (both 1971), and *The Arabian Nights* (1974). He was also the author of grimly realistic novels describing the sordid underlife of Rome in the 1950s.

passacaglia *chaconne.

passion music, musical settings of the Passion or sufferings of Christ on the Cross, according to one of the four Gospels. Its origins may be found in the medieval *mystery play, in which music played a significant part, and in the ancient Holy Week practice of reading the Passion story in church in a more or less dramatic fashion, the words of Christ being sung to *plainsong. Settings of the Passion received a special impetus during the Reformation in the 16th century, when it became the custom to abandon Latin in favour of ordinary language. Thus the Passion settings of Heinrich Schütz are particularly important. Later examples, such as Bach's *St John Passion* (1723) and *St Matthew Passion* (1729), tell the story with great dramatic intensity, using all the resources of chorus, *aria, ensemble, *chorale, and *orchestra.

passion play, a religious play representing the life and crucifixion of Jesus of Nazareth. Performances of such plays are recorded in Europe from the early 13th century. Some formed part of the cycles of *mystery plays, others were performed separately, usually on Good Friday. The most famous example today is the *Passionsspiel* still performed by the villagers of Oberammergau in Bavaria at ten-year intervals; this custom originated in a vow made during an outbreak of plague in 1633.

pastel, a drawing or painting material consisting of a stick of colour made from powdered *pigments mixed with just enough resin or gum to bind them. Pastel is applied directly to paper, and thus the colour as applied represents the final result—no allowance has to be made for changes during drying. Pastel has the disadvantage of being fragile and easily dislodged from the paper. This can be counteracted by using a fixative, though this reduces the brilliance of the colour. Pastel was used for portraits in the 18th century and was revived in the late 19th century by the Impressionists, notably Degas.

Pasternak, Boris (Leonidovich) (1890–1960), Russian poet and novelist. His early lyrics were full of bold metaphors and images of nature; in the 1920s he wrote long poems on subjects from revolutionary history. In the 1930s Pasternak turned to translation, concentrating on Shakespeare, Goethe, and contemporary Caucasian poets. During World War II he went back to *lyric poetry, now simpler and more direct. In 1956 he finished the novel *Doctor Zhivago*, which was an account of the Russian revolution and its aftermath as seen through the eyes of the intelligentsia. Its publication abroad the following year caused a scandal. Pasternak was compelled to refuse the Nobel Prize for Literature in 1958 by the Soviet government. His novel was published in the Soviet Union only in 1988.

pastiche, an artistic work of any kind composed from elements borrowed either from various other artists or from a particular earlier model. The term can be used in a derogatory sense to indicate lack of originality, or more neutrally to refer to works which involve a deliberate and playful imitative tribute to other artists. It differs from *parody in using imitation as a form of flattery, not mockery. The frequent resort to pastiche is an important symptom of self-consciousness in the modern arts.

pastoral, a literary tradition derived from the *idylls of Theocritus and the *eclogues of Virgil, fashionable in Europe from the 16th to the 18th century. Pastoral literature describes the loves and griefs of musical shepherds in an idealized Golden Age of rustic innocence; paradoxically, it is a highly artificial cult of simplicity. The elaborate conventions of pastoral appear in Italian drama of the late 16th century, in Shakespeare's *As You Like It* (*c.*1599), in prose *romances like Sidney's *Arcadia* (1590) and Urfé's *L'Astrée* (1607–27), and in *lyrics like Marlowe's 'The Passionate Shepheard to his Love' (1600). A minor revival of pastoral poetry in the 18th century was superseded by the more realistic country poems of Crabbe, Wordsworth, and Clare, although the pastoral *elegy survived longer.

patchwork, needlework made of assorted small pieces of fabric sewn together at the edges to form a kind of cloth mosaic. This simple and economical method of producing patterned textiles is both ancient and widespread. During the Renaissance, using silks and velvets as its raw materials, it was a sumptuous element in ecclesiastical and secular decoration. The technique is more generally associated with *folk art, particularly (since the 18th century) in the production of patchwork quilts, their cheerful, colourful patterns usually formed from innumerable regularly shaped scraps of printed cotton. Patchwork of irregular shapes is sometimes called crazy patchwork.

Pater, Walter (Horatio) (1839–94), British critic and essayist. His *Studies in the History of the Renaissance* (1873) contains essays on Botticelli and Leonardo, amongst

others. Celebrated for the delicacy of his style and the cultivation of refined artistic sensations, he had an enormous influence on a generation of young writers and was an important theorist of the *Aesthetic Movement of the 1890s. His masterpiece *Marius the Epicurean* (1885) is a fictional biography and study of intellectual and spiritual development, set in the time of Marcus Aurelius.

pattern poetry, verse which is arranged in an unusual shape on the page so as to suggest some object or movement matching the ideas or mood of the words. Pattern poems were known in Greece in the 4th century BC. A well-known English example is Herbert's 'Easter Wings' (1633). Modern poets who have tried this form include Apollinaire, Mayakovsky, cummings, and Dylan Thomas. Since the 1950s, pattern poetry has often been referred to as 'concrete poetry'.

pavan, a dance of Italian origin, possibly from Padua. Popular in the 16th and 17th centuries, it was in duple *time and fairly stately in character. The pavan was usually paired with the quicker-moving *galliard. Their pairing as dances led to the custom of playing them one after the other when such music was performed for purely instrumental purposes. This custom led to the development of the Baroque dance *suite.

Pavarotti, Luciano (1935–), Italian tenor singer. After his 1961 operatic début in Italy, singing Rodolfo in Puccini's *La Bohème*, and his London début two years later in the same role, Pavarotti rapidly became a success, specializing in the *bel canto repertory. With his fine technique and lyric voice he excels in roles such as Romeo in Bellini's *The Capulets and the Montagues* and Radamès in Verdi's *Aida*.

This 'throw' or decorative cover is an unusual example of American **patchwork**, made in 1900 by Rachel Boone Wintersteen, a Quaker from Port Carbon, Pennsylvania. The fan shapes have been made from silks, ribbons, and brocades, emboidered on to a background of dull black satin. (American Museum, Bath)

Pavese, Cesare (1908–50), Italian novelist, poet, translator, and short-story writer. He served a term of exile in southern Italy for anti-fascism, and his short and tormented life ended in suicide. His writing was considerably influenced by American models—he introduced many modern American and British writers to Italy—but is stamped with his own deep sensitivity, most notably in his feeling for the countryside and those who live off it. Among his most moving works is his last novel, *The Moon and the Bonfires* (1950), a bleak, yet compassionate story of a man who returns to the scenes of his youth in the hope of finding his true identity. A collection of his poetry in English, *A Mania for Solitude, Selected Poems 1930–1950*, was published in 1969.

Paxton, Sir Joseph (1801–65), British architect and engineer. He began his career as a gardener and in 1826 was appointed superintendent of the gardens at Chatsworth, the Derbyshire estate of the Duke of Devonshire. At Chatsworth he began designing greenhouses, initially conventional structures, but leading to a huge revolutionary building called The Great Conservatory or 'Great Stove' (1836–40, destroyed); this consisted of an arched metal framework supporting a curved glass roof and some of the supports were mass-produced on a machine Paxton invented. The same principles were taken further in his famous design for the Crystal Palace for London's Great Exhibition in 1851; making use of prefabrication for the first time, the colossal iron and glass structure was built within the remarkably short time of six months. It was destroyed by fire in 1936.

Paxton, Steve (1939–), US dancer and choreographer. One of the founders of the *postmodern Judson Dance Theater and the Grand Union group, he developed a new form of movement, 'contact improvisation', based on giving and taking a partner's weight on various parts of the body. The resultant movement is strongly controlled but soft and relaxed in quality. Most of his works are intentionally short-lived, but *Goldberg Variations* is frequently repeated with new material, a work continually in progress.

Peacock, Thomas Love (1785–1866), British novelist, poet, and satirist. His satirical novels, *Headlong Hall* (1816), *Crotchet Castle* (1831), and *Gryll Grange* (1861) are set in country houses, where eccentrics survey the cultural scene and expound radical theories. In *Nightmare Abbey* (1818) he satirizes the follies of *Romanticism and of his friend *Shelley. His verse includes some touching lyrics such as 'Long Night Succeeds thy little Day' (1826) and 'Newark Abbey' (1842). In his critical essay 'The Four Ages of Poetry' (1820) he proposes the ironic argument that as society progresses, poetry deteriorates; a view which Shelley earnestly refuted in his *Defence of Poetry*.

Peale, Charles Willson (1741–1827), US painter and naturalist, the most distinguished member of a family of artists. In 1775 he settled in Philadelphia, where he became the most fashionable portraitist in the colonies, *Copley having left for Europe in 1774. He fought in the War of Independence, and in 1782 opened an exhibition gallery (the first in the USA) displaying his own portraits of heroes of the Revolution. Several of Peale's children were artists, the most important being **Raphaelle** (1774–1825), one of America's finest still-life painters,

Rembrandt (1778–1860), a gifted though uneven portraitist, and **Titian Ramsay II** (1799–1885), who continued his father's tradition as an artist-naturalist. The family was largely responsible for establishing Philadelphia as one of the country's leading cultural centres.

Pearl *Gawain and the Green Knight, Sir.

pediment, an architectural term applied to a low-pitched gable over the front of a building and by extension to similar forms used decoratively. The type was established in Greek temples, where pediments were often decorated with sculpture (the Parthenon at Athens is the most famous example). The Romans employed pediments which were segmental as well as triangular, and both types were revived during the Renaissance. In the Mannerist and Baroque periods it was common to use broken or interrupted pediments for decorative effect.

Péguy, Charles (1873–1914), French poet and essayist. Many of his writings, for example the essays *Nôtre patrie* (1905) and the poems *Tapisseries* (1912–13) and *Eve* (1914), reflect his patriotic, socialist and, later, religious views. He was influenced by the philosopher Henri Bergson (1859–1941) in reacting against 19th-century positivism (the theory that every rationally justifiable assertion can be scientifically verified) in favour of a dualistic philosophy. Péguy's *free verse form reveals him as an heir of the *Symbolists.

pencil, a writing or drawing instrument consisting of a slender rod of solid marking substance such as graphite (a form of carbon) encased in a cylinder of wood (or less usually metal or plastic). Pencils of predetermined hardness or softness were first produced in the 1790s, by the French scientist and artist Nicolas-Jacques Conté, and it was from then that the pencil became the universal drawing instrument it is today. Until the end of the 18th century the word 'pencil' was often used for a brush, so 'pencilling' could mean 'colouring' or 'brushwork' as well as 'drawing'.

Penderecki, Krzysztof (1933–), Polish composer. He came into international prominence in 1960 with his *Threnody for the Victims of Hiroshima*—a powerful work for string orchestra which explored unusual and expressive sonorities. His *St Luke Passion* (1965) marked a degree of synthesis between tradition and experiment and an extension of his tendency towards ritual drama. Religious preoccupations also inform his operas *The Devils of Loudun* (1968), *Paradise Lost* (1978), and *The Black Mask* (1986). Penderecki is one of the few avant-garde composers able to command the allegiance of a large public.

penillion, traditional Welsh music-making, in which a singer improvises a poem (or makes use of existing words) as a *counterpoint to a well-known melody played on the harp. The harp always starts first with a plain statement of the melody and then accompanies the voice with a set of improvised variations. Singer and harpist (usually the same person) then end together.

penny whistle *flageolet.

pentameter, a verse line of five metrical units ('feet'). In English poetry, this means a line with five strong stresses; the *iambic pentameter is the commonest English *metre. Greek and Latin pentameters were *dactylic, comprising two half-lines of two and a half feet each.

pentimento (Italian, 'repentance'), a term in art describing a part of a picture that has been overpainted by the artist but that has become visible again (often as a ghostly outline) because the upper layer of pigment has become more transparent with age. Pentimenti can be of great interest to the art historian, and they are often used as an argument when the authorship of a painting is in question, since evidence of second thoughts is much more likely to occur in an original painting than in a copy.

Pepys, Samuel (1633–1703), English public official and author of the most notable diary in the English language. Interested in everything, Pepys had the gift of summing up a scene or a person in brilliant and arresting sentences, and with complete honesty. The *Diary* is a record of his life in London from 1660 to 1669, when he stopped writing to safeguard his eyesight. It describes the restoration and coronation of Charles II, the Great Plague, and the Fire of London. Written in Thomas Shelton's Shorthand the *Diary* was not deciphered until 1825; the unexpurgated edition runs to eleven volumes (1970–83).

percussion instruments, all musical instruments that are struck. Many depend on a tensioned skin to sound; others are of materials so hard and rigid that they sound as they stand. The former are commonly called *drums, a term also used for some of the latter. The latter include all the hard percussion instruments such as *xylophones, *cymbals, *bells, and many others, all of which are struck directly, while others are struck indirectly, for example some are shaken so that pellets or other objects strike them or each other (*rattles) and some are scraped (ratchets, struck by tongues as they revolve, and the *güiro, whose corrugations are struck by a rod). Also included among percussion are instruments that are rubbed (*glass harmonica, etc.), and those that are plucked (*jews harps, *sansas, etc.). Percussion players in the orchestra are expected to cope with all these, and also with anything beneath the dignity of other musicians; thus they are responsible for whistles and many other minor instruments. There is an extremely large variety of percussion instruments across the world. The majority are used to give rhythmic impulse to music, but a few, the *talking drum for instance, are used for other purposes.

Pérez Galdós, Benito (1843–1920), Spanish novelist and dramatist. A political and religious liberal, his first major success came in 1873 with *Trafalgar*, the first of forty-six historical novels, the *National Episodes*. In 1881, having written four polemical novels, he began his major literary achievement, the twenty-four novels, *Contemporary Spanish Novels*, which are set almost exclusively in Madrid. Of these *Fortunata and Jacinta* (1886–7) is his acknowledged masterpiece. From 1892 he achieved some success with a number of plays, among which *Reality* (1892) is important in the history of dramatic *realism in Spain.

Performance Art *happening.

Pergolesi, Giovanni Battista (1710–36), Italian composer. Despite persistent ill-health, he wrote assiduously

during his short life and achieved success with both his serious and his comic operas, and with his church music. He is largely remembered for his one-act *intermezzo *The Maid Mistress* (1733), a masterpiece of comic characterization, and his setting of the *Stabat Mater* (1736).

Perpendicular style, the third of the three stages into which English *Gothic architecture is conventionally divided, following *Early English and *Decorated. It originated in about 1330 and lasted well into the 16th century, merging into *Tudor architecture. The name derives from the dominance of straight lines in window tracery and in the decorative panels that spread over wall surfaces, creating great unity of effect. The regular panelling extended also to *vaults in the form known as the fan vault. The greatest masterpieces of the style are three chapels dating from the late 15th and early 16th centuries: St George's Chapel, Windsor Castle; Henry VII's Chapel, Westminster Abbey; and King's College Chapel, Cambridge. The Perpendicular style is unique to England, late Gothic developing in other directions elsewhere in Europe.

Persian art. Known since 1935 as Iran, Persia has been a centre of civilization since the 4th millennium BC. Early artistic finds include a famous series of bronze objects excavated in the mountainous western region of Luristan, probably dating from 1500–500 BC and showing links with *Scythian art. Under the Achaemenid dynasty (559–333 BC) a powerful empire developed, with its ceremonial capital at Persepolis in southern Iran. The substantial remains of the monumental palace there include the great columns which once supported the roof of a massive audience chamber, and a series of low *relief carvings showing processions of courtiers and the like, executed in a formal somewhat static style recalling *Assyrian reliefs. After Alexander the Great conquered the Achaemenid empire (333 BC), there was a period of *Hellenistic influence. The Sassanian period (AD 224–642) was a time of rich artistic activity and innovation. The ruined palaces which survive display accomplished use of features such as *iwanat*, arches, and domes which were to be crucial in the development of *Islamic art. The use of surface decoration, principally carved *stucco, in distinctive symmetric designs, combining fantastic animals with classical elements such as the palmette and acanthus leaf, heralded the later Islamic preoccupation with surfaces covered in swirling *arabesque patterns. Sassanian silver and other metalwork of outstanding beauty survives. Vessels were decorated, by various techniques, with a variety of stylized naturalistic motifs, such as hunting or court scenes, depicted in vigorous detail. The Arab-Muslim conquest in 642 AD initiated a new period. Islamic architectural forms and the use of the Arabic script in decoration (see *calligraphy) combined with the native Persian tradition. Some of the most notable work of the early Islamic period is pottery (see *Islamic pottery). The emergence of the *Seljuq dynasty (1055–1256) marked the beginning of a period of remarkable building activity. The devastation of the Mongol invasions swept away the Seljuq rulers, who were replaced by the Ilkhanid Mongol dynasty (1256–1353), with its capital in Tabriz, in north-western Iran. Painting drew on Chinese and traditional Islamic influences to develop the now familiar style of *Islamic miniature painting in works such as the marvellous Demotte Shāhnāmah, unsurpassed for the expressive power and vigorous drawing of its miniatures. Outstanding among the buildings of the period is the mausoleum of Oljeitu (begun 1305), astonishing for its grandeur of conception and tremendous dome. A new period of patronage of the arts began after the disturbed years of the conquests of Timur (see *Timurid art). The use of turquoise tile decoration in architecture was extended, while miniature paintng entered a golden age of brilliant colouring and harmoniously balanced compositions, as in the work of *Bīhzad. Under the *Safavid dynasty the traditions of Timurid art continued until the reign of Shah Abbas, a great patron of the arts, who transferred the capital to Isfahan, where he laid out a magnificent new city. A nascent over-emphasis on richness of material became more marked under the Qajars (1794–1925). However, interesting Europeanized oil paintings of royalty and other notables, combining European techniques with a Persian subject-matter, date from this period.

Persian literature, literature written in 'modern' Persian. This language is the heir to the language and literature of ancient Iran, but it was profoundly altered by the two centuries of Arab domination that followed the Islamic conquest in AD 642. Iranians contributed enormously to Arabic-Islamic literature and civilization, but their mother-tongue was relegated to the level of a spoken language. The old written language became the dead liturgical language of the Parsees, or those Iranians who had fled to India. With the emergence of independent states in the eastern Islamic world in the early 9th century, a literature began to appear in Persian written in the Arabic script, and suffused with Arabic words and Islamic concepts. Poetry has always been the most important form in Persian literature. Pre-Islamic Persian poetry was probably based on stress. Modern Persian poetry uses a system of *metre taken from the Arabs and called 'arūz. This is a quantitative metrical system based on the length of syllables, and is similar to the metre of Greek and Latin poetry. The 'father of Persian poetry' is generally reckoned to have been Rudaki, who flourished c.859–940 at the Samanid court at Samarkand, in what is now Soviet Central Asia. But the first truly great figure was the 10th-century poet *Firdausī, whose epic poem, the *Shāhnāmah*, or Book of Kings, was based on the largely mythologized Iranian past. Among its many other great names are *'Attār and *Rūmī, both inspired by Islamic mysticism, or Sufism; Nizāmī, Amīr Khusrau of Delhi, and *Jāmī, all inspired by Koranic themes and themes taken from Arabic literature; and *Sa'dī and *Hāfiz, who raised the *ghazal*, or sonnet, to sublime heights. The minor poetic form of *rubā'āt*, or quatrains, popular in the dialect poetry of Bābā Tāhir, (c.1000–55), was perfected by 'Omar *Khayyām. Persian prose enjoyed an extraordinary flowering with works like the guides for princes, such as the *Siyāsatnāmah* of Nizām al-Mulk (1018–92), both of the 11th century. It became an important vehicle for works in religion, philosophy, history, and administration. Some of the greatest Islamic thinkers like al-Ghazālī (1058–1111) and Ibn Sīnā (Avicenna) (980–1037) wrote in Persian, as well as Arabic. Persian was spread by the conquests of nomadic Turkish tribes from Central Asia, who were converted to Islam and civilized through contact with Iran. It became the language of culture far beyond its heartlands to an area stretching from Asia Minor (modern Turkey) to northern and central India. The decline of Persia after the Mongol

invasions of the 13th century, and the wealthy patronage of the Delhi sultanate and the Mughal empire, attracted many poets to India, and an Indian style grew up, characterized by complicated and obscure imagery. The Indian poet Bedil (Bidil) (1644-1721) is still popular in Afghanistan and Central Asia, and the great *Urdu poets Ghalib and Iqbal are also important poets in Persian. In modern times the Iranian world has become divided into new political entities. Iran, Afghanistan, and Tajikistan have developed national literatures which draw on the classical Persian heritage. Modern Iran has produced the great novelist and short-story writer Ṣādiq Hidāyat (1903-51), who is widely known through translations into European languages. (See also *Arabic literature, *Sufi literature.)

Persian music *West Asian music.

perspective, a system for representing spatial recession on a flat or shallow surface. In Western art perspective, variously known as geometric, linear, mathematical, optical, Renaissance, or scientific perspective, was developed in Florence in the early 15th century by *Brunelleschi and put into practice by artists such as Masaccio and *Uccello. It utilizes such optical effects as the apparent convergence of parallel lines as they recede from the spectator to try to create in a picture an illusion of the same kind of spatial relationships that we see in the real world, with objects appearing to diminish in size the further away they are. Such perspective was one of the cornerstones of European art for almost five centuries after its invention. The art of primitive peoples and of some highly sophisticated cultures (for example, the ancient Egyptians and Chinese) tends to ignore or underplay perspective. (See also *aerial perspective.)

Perugino, Pietro (Pietro Vannucci) (c.1445-1523), Italian painter. He worked mainly in Perugia, but also in Rome (he painted frescos in the Sistine Chapel) and Florence. He was a fine portraitist as well as a fresco painter, but he is best known for his altar-pieces, which are gentle, pious, and rather sentimental in manner. At his best, however, he has the authority of a great master, and the harmony and spatial clarity of his compositions and his idealized physical types influenced the young *Raphael, who worked in his busy studio.

Peruvian art *South American Indian art.

Peruzzi, Baldassare (1481-1536), Italian architect, painter, and stage designer, active mainly in Rome, where he settled in 1503. He worked on St Peter's under *Bramante, and became architect to the building after *Raphael's death in 1520. Amongst High *Renaissance architects he ranks almost alongside these two great contemporaries, but his style was very different—sophisticated and delicate rather than monumental and grave. His finest work, indeed the greatest secular building of the High Renaissance, is the Villa Farnesina in Rome (1500-11) which contains Peruzzi's masterpiece in painting, the Sala delle Prospettive, a brilliant piece of illusionist architectural painting that confirms early accounts of his skill in *perspective and stage design. His last work, the Palazzo Massimo alle Colonne in Rome (begun in 1532 and finished after his death), breaks consciously with the regularity of Renaissance architecture and is generally considered one of the first *Mannerist buildings.

Pessoa, Fernando (1888-1935), Portuguese poet. He is best known for his *Messages* (1934), a *Symbolist interpretation of Portuguese history, and for the creation of his three heteronyms, that is, poetic personalities who express different facets of the poet's self: Alvaro de Campos, Alberto Caeiro, and Ricardo Reis. Although different in style and content, the poetry of the heteronyms and of Pessoa himself is united by a common concern with the enigmatic nature of reality. Underlying all the writings of this predominantly intellectual poet are a pervasive scepticism and uncertainty about existence and identity, expressed in terms of paradox, indeterminacy, and evocations of absence and loss.

Peterkiewicz, Jerzy (1916-), Polish poet and novelist. In his early work he drew on his peasant background, and since settling in London he has written poetry in Polish, such as *London Poems* (1965); novels in English (*Isolation*, 1959; *Inner Circle*, 1966); as well as radio plays. His translation of the poetry of Karol Wojtyła (Pope John Paul II) appeared as *Easter Vigil and Other Poems* in 1979.

Petipa, Marius (1818-1910), French dancer, choreographer, and ballet-master. He performed in Europe and the USA before joining the Imperial Ballet at St Petersburg in 1847. From 1862 to 1903 he created about fifty ballets for the Imperial theatres in St Petersburg and Moscow. As his work matured it became the epitome of *Classicism in ballet, synthesizing the best of the French, Italian, and Russian styles. His surviving works form the core of the Classical repertoire: *Bayadere* (1877), *Sleeping Beauty* (1890), and *Swan Lake* (1895).

Petit, Roland (1924-), French dancer and choreographer. His works have a strong sense of theatre and offer rich collaborative possibilities. He spans musical comedy as well as ballet and has worked with many European companies, latterly the Ballet de Marseilles. Although he has staged some revivals of the classics, he is best known for his own choreography, such as the chic *Carmen* (1949).

Petőfi, Sándor (1823-49), Hungarian poet. He disregarded contemporary literary conventions and wrote on everyday rural themes in brief, vivid verse characterized by colloquial language and variety of rhythm. He composed the revolutionary poem 'National Song' (1848) and several epics. His poetry reveals the revolutionary fervour which led him to join enthusiastically in the 1848-9 revolution in which, according to legend, he was to lose his life.

Petrarch (Francesco Petrarca) (1304-74), Italian poet and humanist. One of the earliest and greatest of modern *lyric poets, he remains best known for his *Canzoniere*, mostly *sonnets, written in vernacular Italian between c.1356 and his death, which includes the long series of love poems in praise of Laura, an idealized woman whose identity remains unknown. He was crowned Poet Laureate in Rome in 1341. He was also important as a leader, with his friend *Boccaccio, in the rediscovery of classical antiquity, rejecting medieval scholasticism and

A miniature portrait of **Petrarch** from a manuscript of his *De remediis utriusque fortunae* (Remedies against fortune, good and ill). Most of his works were written in Latin, but those for which he is chiefly remembered are in Italian and his dignified, melodious language became a model for Italian writers for centuries. (Biblioteca Nazionale Marciana, Venice)

insisting on the continuity between pagan and Christian culture. For English poets his chief inspiration lay in his sonnet form, which was adopted by, among others, Surrey, Wyatt, and Shakespeare. Many sonnets were later turned into *madrigals by Monteverdi.

Pevsner, Antoine (1886–1962), Russian-born sculptor and painter who became a French citizen in 1930. He was the elder brother of Naum *Gabo and like him one of the pioneers of *Constructivism. Until he settled in Paris in 1923 he had been a painter, but he turned to sculpture, at first working mainly in plastic and then in welded metal. His work was important in spreading Constructivist ideas to Western artists.

pewterware, articles, particularly eating utensils, made from pewter, an alloy consisting mainly of tin, with a small proportion of copper and sometimes lead. The more lead pewter contains, the lower the quality (and also the greater the risk of contaminating food or drink). Colour, too, is affected by the proportion of lead; when it is entirely absent, pewter can be almost as bright as silver, but otherwise it is grey, sometimes almost black. It has a low melting point and can easily be cast into complex shapes. During the Middle Ages it was extensively used for utilitarian goods, including plates, bowls, drinking vessels and, during the 16th century, it began to be used for similar items intended for decoration, 'display pewter'. In the 19th century new raw materials and techniques made it more or less obsolete for practical purposes, but it continues to be used for decorative wares.

Phidias (*c*.490–430BC), Greek sculptor, with *Praxiteles the most noted artist of the ancient world. No work survives that is certainly from his own hand, but through copies and from the surviving sculpture of the Parthenon at Athens an idea can be gained of his style. He was renowned for two enormous chryselephantine (gold and ivory) cult statues of Athena inside the Parthenon, and of Zeus in the temple at Olympia. The greatest testimony to Phidias' genius is the sculpture of the Parthenon (447–432 BC). Though he could not have carved more than a fraction of the work himself, the finest parts exemplify the harmony and serene majesty that earned him the rapturous praises of ancient commentators and are the most superb relics of *Greek art in its greatest period.

Phoenician art, the art of the Phoenicians, a Semitic people of the ancient world. They are of unknown origin, but had settled in Phoenicia (a Mediterranean region corresponding with parts of Lebanon, Syria, and Israel) by about 3000 BC and possibly earlier. The Phoenicians were a highly civilized people (they invented a system of writing that was the ancestor of the modern alphabet) and a great nation of sea-traders, establishing colonies throughout the Mediterranean, notably at Carthage. They were at the height of their powers from about 1200 BC to about 800 BC and were conquered by the Persians in the 6th century BC. Later the country came under

One of the most important finds of **Phoenician art**, made at Aliseda in Spain, incuded this ear pendant. It is decorated with lotus flowers, palm leaves, and birds, and dates from about the 7th century BC. The Phoenicians were superb metalworkers and jewellers, particularly renowned for their skill with gold and copper. (Archaeological Museum, Madrid)

Greek and then Roman rule. The influence of *Greek art is characteristically shown in the green jasper scarab stones chiefly found in the Carthaginian cemeteries of Sardinia and Ibiza. In Hellenistic times they excelled in elaborately carved marble sarcophagi. The Phoenicians were famous as artists and craftsmen but very little of their work on a large scale has survived. Because of their trading activities, however, smaller Phoenician artefacts were spread widely throughout the Mediterranean world, and many have been found in excavations. They excelled in luxury goods such as jewellery, figurines, glass and alabaster bottles, ivory boxes, and bronze bowls.

photography, history of. Two men have generally been credited with the invention of photography: *Daguerre and Fox *Talbot. Both were primarily interested in its artistic possibilities. The processes which they used had major disadvantages: the calotype was based on fibrous paper, and thus lacked detail; the daguerreotype had no negative and was difficult to reproduce. William Scott Archer's wet collodion process, introduced in 1851, used glass negatives to overcome both problems. It was also made available to all, free of patent restrictions or royalties. George Eastman's 1888 Kodak camera put photography into the hands of the masses, depriving

much of it of any claim to be art, and separating amateurs from professionals. The 1880s also saw the development of ways of reproducing photographs in print: photojournalism and advertising photography were to become important and remunerative professions. At the end of the 19th century the leadership in serious photography passed to the USA, where it has remained since.

Phyfe, Duncan *Federal Style.

pī, a musical instrument, the Thai *shawm. There are three main varieties, *pī nai*, the most important, used in classical music, whose one-piece body bulges centrally, *pī chawā*, with separate bell, probably deriving from the Indian *shahnāī*, and *pī mǫn*, the bell loosely attached with cord, deriving from the Burmese *hnē*.

pianoforte (piano), a *keyboard musical instrument with strings struck by hammers, so called because it plays both piano (softly) and forte (loudly), unlike the *harpsichord: plucking varies little in loudness because the force of the pluck cannot be altered; striking can vary greatly. Bartolomeo Cristofori invented the first true piano around 1700. It met with little success because musical taste was unready for it and light stringing, all that was then available, suits plucking but not hammering. Only after 1750 did musicians prefer pianos to harpsichords, by which time technological advances had brought heavier strings to withstand higher tensions. Increased string tension caused problems, especially in keeping open the gap, through which hammers strike the strings, between the wrest-plank (carrying the tuning pins) and the soundboard. This problem was finally resolved when, in 1825, Alpheus Babcock patented the full iron frame, a solution not generally adopted until after the mid-century. Piano and mechanism types are innumerable. Grand pianos always existed, but square

In this detail of *George, Third Earl Cowper and the Gore Family* by Johann Zoffany we see musicians playing the cello and the square **pianoforte**. This conveniently shaped instrument was the most popular domestic keyboard instrument in Britain and the USA from its invention in the early 1740s until about 1830, when it was gradually supplanted by the upright. The upright became even more popular than the square piano and gained the nickname 'cottage piano' because of its presence in so many rural homes.

pianos (actually oblong) were popular for domestic use for about a century from about 1750, and longer in the USA, because they could stand anywhere in a room. Uprights were introduced late in the 18th century, first as grands bent upright at the wrest-plank, 2 metres (6 ft) or more high, and later in forms familiar today. The first successful mechanism was the Viennese, invented by Andreas Stein in the 1770s and used by Mozart. John Broadwood's pianos late in the 1790s were louder, and one was presented to Beethoven as he grew deafer. Sébastien Érard's more efficient double escapement of 1821 remains the basis of modern actions. Mechanisms, stringing, and hammers (covered originally with leather, but with felt from about 1820) continued to develop. By about 1870 the piano had reached its modern form, but changes, especially to the tone and especially in Japan and the USA, continue. Pianos today frequently have three pedals: the sustaining pedal for raising the dampers from the strings, thus rendering the tone fuller, the sostenuto or half-dampening pedal, and the soft pedal for softening or modifying the tone.

pibcorn *hornpipe.

picaresque novel, a story comprising the adventures of a *picaro* (Spanish, 'rogue'), usually a quick-witted servant who has several masters in succession. The form originated in 16th-century Spain, and was imitated by Grimmelshausen in Germany and by Defoe and Smollett in England. The term is often applied loosely to stories which, instead of a complex plot, follow a sequence of episodes involving an unchanging central character. In this sense, Cervantes' *Don Quixote* (1605) and Fielding's *Tom Jones* (1749) are called picaresque, although they do not fit the stricter Spanish meaning.

Picasso, Pablo (1881–1973), Spanish painter, sculptor, graphic artist, ceramicist, and designer, the most noted, versatile, and prolific artist of the 20th century. Picasso first visited Paris in 1900 and between then and 1904 he alternated between Paris and Barcelona. This time was known as his 'Blue Period', when he took his subjects from the poor and social outcasts, and the predominant mood of his paintings was one of slightly sentimentalized melancholy expressed through cold, ethereal blues. In 1904 he settled in Paris. The period from about 1905 to 1907 is known as his 'Rose Period', when he favoured pinkish colours and his favourite subjects included dancers and acrobats painted in a less austere mood. From this concern with colour and mood he turned to the analysis of form, and with *Braque, whom he met in 1907, he created *Cubism, a movement that rejected the naturalistic tradition of European art and revolutionized painting and sculpture. In the 1920s he painted some of his most solid and classical works (partly inspired by a visit to Italy), but at this time he also experimented with *Surrealism. From about 1925 he began to make more violently expressive works, and this tendency culminated in his most famous painting, *Guernica* (1937) which expressed his horror and revulsion at the German bombing of the Basque capital, Guernica. His sculpture, too, shows his unrivalled powers of invention and as a graphic artist (draughtsman, etcher, lithographer, lino-cutter, and designer for *Diaghilev's Ballets Russes) he ranks among the greatest of the century. His emotional range was as wide as his technical abilities. His work is suffused with

Picasso has exceeded all other artists in volume and diversity of style. Of more than 20,000 works created during a long life-span, the paintings executed in his early twenties such as this *An Old Jew with a Boy* (1903) already show the intensity and commitment that were to remain his hallmarks. (Pushkin Museum, Moscow)

a passionate commitment to life, and no artist has more devastatingly exposed the cruelty and folly of his fellow men or more rapturously celebrated the pleasures of love.

piccolo, a half-size *flute, sounding an octave higher than written. Because it is played in the orchestra by a flautist, its development has paralleled that of the flute save that it has rarely acquired the C-footkeys; its lowest note is normally the d'' a ninth above middle C. There is debate about whether the piccolo, a small *recorder, or a *flageolet was used in the Baroque period.

Picturesque, a term in English art and literature covering a set of attitudes towards landscape, both real and painted, that flourished in the late 18th and early 19th centuries. It indicated an aesthetic approach that found pleasure in roughness and irregularity, and the Picturesque came to occupy a position between the critical aesthetic concepts of the 'Beautiful' and the *'Sublime', having neither the serene order of the first nor the awe-inspiring grandeur of the second. Its most complete exponent in painting was Rosa while the landscape architect 'Capability' Brown deliberately fashioned his picturesque creations to evoke idyllic landscapes. In literature Mrs Radcliffe's works dwell frequently on the Picturesque, and both Austen and Peacock mocked it in

their writings. Although the excesses of the Picturesque theory became a popular target for satire, its exponents made a lasting contribution to our vision, and writers as diverse as Dickens, George Eliot, and Henry James found the term useful.

Piero della Francesca (*c*.1410–92), Italian painter. Now regarded as one of the great Renaissance artists, the obscurity into which he fell after his death reflects the fact that he spent most of his life in his native Borgo San Sepolcro (now Sansepolcro), a small and fairly remote town with no great artistic tradition. He also worked elsewhere, however, notably at the splendid court of Federigo da Montefeltro in Urbino and in Arezzo, where he painted his most famous pictures—a series of frescos on the *Legend of the True Cross* (*c*.1452–*c*.1465) in the church of San Francesco. Piero was a slow and deliberate worker and his style has a solemn meditative grandeur and an almost mathematical clarity of composition. The limpid beauty of colour and light in his paintings is also highly distinctive. Late in life he seems to have given up painting and devoted himself to the study of mathematics and *perspective.

Piero di Cosimo (*c*.1462–*c*.1521), Italian painter, one of the most unconventional of the Florentine artists of the *Renaissance. He painted religious works and portraits, but is best known for a novel type of painting that he made his own—fanciful mythological scenes inhabited by fauns, centaurs, and primitive men. In these he showed a poetical spirit and a marvellous talent for painting animals. According to the biographer Vasari he was an eccentric character, who became a recluse in his later years. *Andrea del Sarto was his pupil.

Pierrot, a stock character in the French and British theatres, based on the comic servant mask of Pedrolino in the *commedia dell'arte*, and featured in the *harlequinade. Simple-minded and awkward, with a whitened face, he wore a long-sleeved loose white garment with a ruff and floppy hat. Pierrot was transformed into a pathetic and lovesick character by Deburau, the French *mime artist. In the late 19th and early 20th centuries Pierrot troupes appeared as organized concert parties on the stage and on pier-pavilions.

pietà (Italian, 'pity'), a painting or other representation of the Virgin Mary supporting the body of the dead Christ on her lap; other figures, such as St John the Evangelist or Mary Magdalene, may also be present. The theme originated in Germany in the early 14th century and it was more popular in northern Europe than in Italy. The most famous of all pietàs, however, is the sculpture by Michelangelo in St Peter's in Rome.

pigment, any substance used as colouring matter, particularly the finely ground particles that when suitably blended with a medium form a *paint. Most pigments are now manufactured synthetically, but were formerly made from a variety of mineral, plant, and animal sources; the brown colour sepia, for example, comes from the 'ink' of the cuttlefish, and ultramarine blue was originally made from the semi-precious stone lapis lazuli.

Pillow Book of Sei Shōnagon, a book of reminiscences of the Japanese imperial court during the Heian period (794–1185). Its author, Sei Shōnagon, served at court for over ten years and her notebooks contain a detailed account of life there through impressions, eyewitness accounts of events, ponderings, and diary entries. The Heian period was remarkable for the quantity of diaries and other writing produced by women, but Sei Shōnagon stands apart from these with her combination of sensitivity, aristocratic disdain of bad taste and bad form, and occasional heartless ridicule of the lower orders.

Pindar (518–438 BC), Greek lyric poet. Of his various works there survive four books of *odes in honour of victories won, chiefly by Greek rulers and aristocrats, in athletic contests. They are usually in the form of choral hymns, written in a grand style; the celebration of victory is seen as a religious occasion. (See also *Greek lyric poetry.)

Pinero, Sir Arthur Wing (1855–1934), British dramatist. His first serious play, *The Profligate* (1889), concerned the double standards for men and women which became a recurring theme for many of his plays, including *Lady Bountiful* (1891), the first of his 'social' plays, and his most lasting success *The Second Mrs Tanqueray* (1893).

Pinter, Harold (1930–), British dramatist. His highly original voice first became apparent in *The Birthday Party* (1958), and many critically acclaimed plays followed, including *The Caretaker* (1960), *The Homecoming* (1965), *Old Times* (1971), *No Man's Land* (1975), and *One for the Road* (1985). His gift for portraying, through realistic dialogue, the many layers of meaning in language, pause, and silence, has created a style known as 'Pinteresque'. His most recognizable themes are nameless menace, erotic fantasy, obsession, jealousy, and mental disturbance. He has written successfully for radio, television, and the cinema. An accomplished actor, he occasionally performs in his own plays.

piobaireachd music (Scots Gaelic, 'piping'; Anglicized as 'pibroch'), the 'great music' of the Scottish Highland *bagpipe, contrasting with the 'small music', represented by military music, airs, and dances. It was developed from the early 16th century as a form of ceremonial music played at highland courts, clan gatherings, and battles, the names of the main classes—salute, lament, march, gathering—reflecting this. In form, *piobaireachd* comprises a highly intricate theme (or ground, *urlar*) and variations on it, involving much elaborate ornamentation. The ancient *notation was *canntaireachd*, in which vocalized syllables represented notes and figurations; this was replaced by staff notation from the early 19th century.

pipa, the Chinese *lute, its shallow body shaped as an elongated half-pear. The short neck carries large hump-backed frets, continuing on the belly as raised strips of bamboo. The four strings are plucked with the fingers. The Japanese **biwa**, deriving from the *pipa*, retains many of its 7th-century characteristics: two small crescent soundholes, frets only on the neck, and being played with a large *plectrum.

pipe and tabor, the original one-man dance band, used throughout Europe from the 13th century. The pipe is played with the left hand, and the *tabor, strapped to

the left shoulder, wrist, or forearm, is struck with the right. The pipe has only three holes, two finger-holes and one thumb-hole, enough to fill the gaps between the overblown harmonics. Tabor rhythms were quite simple, as Thoineau Arbeau shows in his dance treatise *Orchésographie* (1588). The pipe and tabor still survives in France and elsewhere, including South America, whither it was carried by the *conquistadores*.

Piper, John (1903–), British painter, graphic artist, designer, and photographer. During the 1930s he was one of the leading British *abstract artists, but by the end of the decade, disillusioned with non-representational art, he reverted to naturalism. His paintings concentrated on landscape and architectural views in a subjective, emotionally charged style that continued the English Romantic tradition, but in the 1950s he became recognized as one of the most versatile British artists of his generation, noted for his designs for stained glass, textiles, pottery, and for his book illustrations.

Pirandello, Luigi (1867–1936), Italian novelist, short-story writer, and dramatist. His recognition as an innovator in modern drama came in 1921, when he wrote *Six Characters in Search of an Author*, a 'theatre within the theatre'. Together with *Henry IV* (1921) it presents the characteristic Pirandellian contrast between art, which is unchanging, and life, which never remains still. His short stories were collected into *Short Stories Through a Year* (1922–37). By the time he was awarded the Nobel Prize for Literature in 1934 he had achieved a universal reputation. In his prose and plays he attempts to penetrate the masks that people wear in society and lay bare their innermost spirit; he presents intellectual problems in a

Luigi **Pirandello** at work late in life. Some of his finest work lies in his short stories, but his most pervasive influence has been in drama. He had an abiding love for the stage, established his own theatre in Rome in 1925, and later undertook tours with his company in Europe and the USA.

meaningful and tangible way. He has profoundly influenced the existentialist pessimism of *Anouilh and *Sartre, as well as the *absurdist comedy of *Ionesco and *Beckett and the religious verse-drama of *Eliot.

Piranesi, Giovanni Battista (1720–78), Italian etcher, archaeologist, and architect. He was born in Venice but worked for almost all his career in Rome, where he settled in 1740. From 1745 onwards he published *etchings of ancient and modern Rome, known as the *Vedute* ('Views'), and these works won him great popularity and international fame. He often altered the scale of buildings to make them look even grander than they really were. His most original works are a series of etchings of imaginary prisons, a nightmare vision of claustrophobic space and menacing voids. Although he was only a minor figure as an architect, he had an important influence as a writer, championing the superiority of Roman architecture over Greek.

Pisanello (Antonio Pisano) (*c*.1395–*c*.1455), Italian painter and medallist. He worked mainly in Verona and his successful career also took him to Rome and numerous courts of northern Italy. Pisanello was the finest portrait *medallist of his period and arguably of the whole Renaissance. With *Gentile da Fabriano he is also regarded as the foremost representative of the *International Gothic style in Italian painting, though few of his paintings survive. There are still, however, a good many of his drawings in existence, those of animals being particularly memorable.

Pisano, Andrea (*c*.1290–*c*.1348), Italian sculptor and architect. He is best known for his bronze doors for the Baptistery of Florence Cathedral, which preceded the two more famous sets of doors by *Ghiberti. Andrea succeeded *Giotto as architect to Florence Cathedral and in 1347 was appointed master of works at Orvieto Cathedral. His son, **Nino Pisano** (d.1368), followed his father at Orvieto. He was a less distinguished sculptor, but notable as one of the first sculptors to specialize in free-standing life-size statues.

Pisano, Nicola (*fl.* 1258–78) and **Giovanni** (*fl.* 1265–1314), Italian sculptors, father and son. Nicola stands at the head of the great tradition of Italian sculpture as *Giotto stands at the head of the tradition of painting. Like Giotto he broke away from medieval convention and infused his work with dramatic power and richly varied human feeling, drawing much of his inspiration from ancient classical sculpture. His principal works are pulpits for the Baptistery in Pisa (1259) and for Siena Cathedral (1265–8), both of them decorated with biblical scenes and allegorical figures. His last great project was a large fountain for the public square of Perugia (1278), on which he was assisted by his son Giovanni. Like his father, Giovanni's most notable works are pulpits, those of San Andrea, Pistoia (1300–1) and Pisa Cathedral (1302–10). They are modelled on those of his father, but more elegant in style, showing French Gothic influence. Giovanni also made a number of free-standing statues and, from 1283 onwards, designed the façade of Siena Cathedral. This is the most richly decorated of all the great Italian Gothic cathedral façades; its statuary, much of it from his own hand, has tremendous energy and inner life.

Piscator, Erwin Friedrich Max (1893–1966), German theatrical director associated with documentary and *epic theatre, which he used in pursuance of his pacifism and communism, directly influencing *Brecht. In Berlin in the 1920s he pioneered the use of film projection on the stage, and employed elaborate stage machinery. As Director of the West Berlin Freie Volksbühne from 1962 he produced several 'documentary' dramas, including Rolf Hochhuth's *The Representative* (1963).

Pissarro, Camille (1830–1903), French painter and graphic artist, one of the leading figures of the *Impressionist movement. The only artist who exhibited at all eight Impressionist exhibitions, he was looked upon as an inspirational teacher. His large output consisted mainly of landscape paintings, and when—from about 1895—failing eyesight caused him to give up painting out of doors, he produced many town views done from windows in Paris. His son **Lucien Pissarro** (1863–1944) moved to London in 1890 and helped to introduce Impressionist and *Post-Impressionist art to Britain.

pitch, the height or depth of a musical note as perceived by the ear. The pitch of a note is measured by the number of vibrations that take place in a second when a suitable vibrating medium is set in motion. The lower the note, the fewer and slower the vibrations. This rate of vibration is known as the frequency of the note. Most instruments are tuned to note A, set at an internationally agreed concert-pitch of 440 Hertz (vibrations per second). It replaced the standard of 435 Hertz set by the French government in 1859. Before that date pitches differed from place to place. Pitch can be notated in the form of a scale, or described by a series of letter-names (A, B, C, D, E, F, G) or syllables (doh, ray, me, fah, soh, la, te, doh). Many people have the gift of absolute, or perfect, pitch; that is to say, they carry in their minds an accurate memory of the prevailing concert pitch. Most people possess a sense of relative pitch and can relate notes to each other by reference to a given note. (*see p. 352*)

pizzicato, an Italian musical term, usually abbreviated to pizz., which indicates that the strings of instruments that are normally bowed should be plucked with the finger. The term *arco* ('bow') indicates that the normal

method of playing should be resumed. The use of pizzicato came in with the first operas.

plainsong, the traditional ritual melody of the Western Christian Church. In the form in which it is said to have been codified by Pope Gregory the Great (c.540–604) it is known as Gregorian chant. Plainsong developed during the early years of Christianity under the influence of a great many musical sources, including those of the Jewish synagogue and ancient Greece. It consists of a single melodic line, designed to be sung in unison and without accompaniment according to the free rhythms of speech. It is therefore written down without recourse to bar lines. It has its own system of *notation, employing a stave of four lines, instead of the usual five, and the early form of notation known as neumes. During the period of choral *polyphony, plainsong was often woven into the fabric of new compositions in the form of a *cantus firmus* (Latin, 'fixed' or 'given song'), which the other melodic lines would move around and generally make reference to. Even in its early days, however, plainsong was 'developed' by the addition of decorative features (*melismata*) and the interpolation of new words and melodic phrases (*tropes*), with the result that there have been many controversies over the exact nature of its original form and the authentic manner in which it should be interpreted. A similar and equally important body of chant is attached to the rite of the Eastern Orthodox Church, established at Constantinople (the site of ancient Byzantium) in the 4th century. Byzantine notation, developed from the 10th century, involves a series of conventional signs, rather like shorthand symbols, which indicate *pitch, *rhythm, and dynamics (the gradations or amount of volume of sound). The Byzantine rite is widely practised throughout the Near East and in the Slavonic countries, including the Soviet Union.

plasterwork, a general term for architectural decoration of walls and ceilings using a malleable material that hardens when dry. Plaster consists essentially of lime, sand, and water, and in the type known as *stucco, the commonest type for architectural decoration, powdered marble is added. Plasterwork, including the use of *fresco, was highly developed by the Romans and was revived during the Renaissance, when antique buildings were being excavated. Particularly fine plasterwork was made in the Elizabethan period and in the 18th century, when many of Robert Adam's *Neoclassical interiors called for delicate antique-style decoration of ceilings. The various revival styles of the 19th century ensured the continuation of the plasterwork tradition.

The example shows the **pitch** and the corresponding name for various notes. The difference between the same note at different pitches is indicated by the use of capital and lower-case letters and prime marks following the letters.

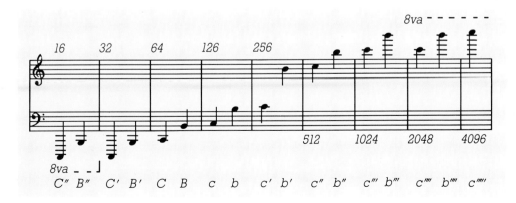

Comparative standard ranges of instruments

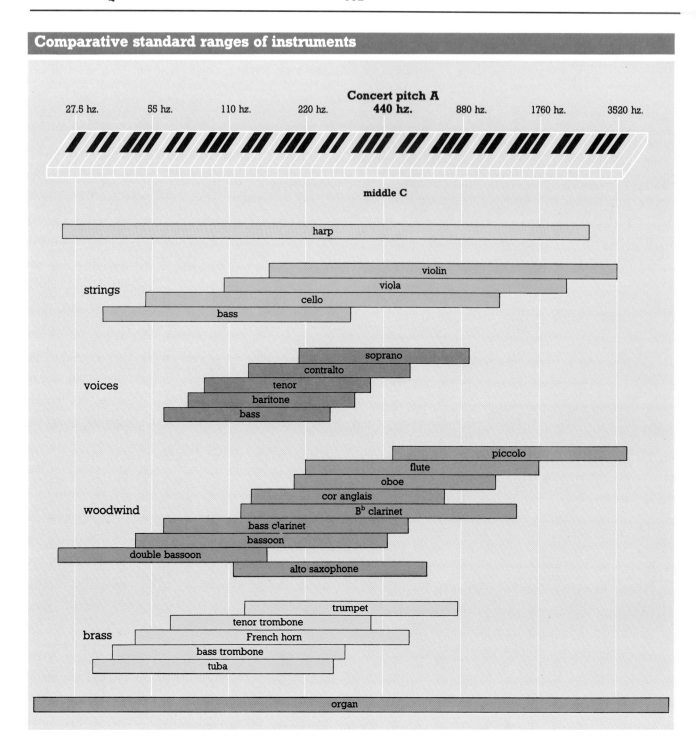

Plateresque, an architectural style found only in Spain in the early 16th century, characterized by extremely lavish ornament, *Gothic, *Renaissance, and sometimes *Moorish in inspiration, unrelated to the structure of the building on which it is used. The term literally means 'silversmith-like', and carving is sometimes so elaborate and fine that it is reminiscent of metalwork rather than stonework. It is as much a sculptural as an architectural style, and some exponents practised both arts.

Plath, Sylvia (1932–63), US poet and novelist. Born in Boston, she studied in the USA, later moving to England where she married the poet Ted *Hughes in 1956. Living alone in London after their separation in 1962, she committed suicide in the following year. Plath published only two volumes of poetry in her lifetime, *A Winter Ship* and *The Colossus* (both 1960), *Ariel* (1965), *Crossing the Water* (1971), and *Winter Trees* (1972) appeared subsequently. She is best known for her death-haunted 'confessional poetry', but her range was more extensive, and her technique more refined, than this term suggests. Her novel *The Bell Jar* (1963), published under the pen-name Victoria Lewis, describes a student's mental breakdown.

Plato (*c*.429–347 BC), Greek philosopher and writer. After the execution of Socrates (399 BC), who exercised a profound influence on his whole life, he is reputed to have travelled widely, returning to Athens to set up the Academy (388 BC), where he taught until his death. His dialogues vary greatly in length and scope and their chronology continues to exercise Platonic scholars. Of especial literary interest are the *Symposium*, in which guests at a party discuss love; the *Protagoras* in which virtue is equated with knowledge; and the *Phaedo*, where the question of immortality is discussed and the conversations held on Socrates' last day are recorded. We also have the *Apology*, which presents a noble defence of Socrates' life and work. The dialogue form reflects the Socratic method of dialectic, in which question and answer lead to the truth by a process in which both speakers share; but Plato increasingly put long speeches in the mouths of his disputants. A notable feature of some dialogues is the poetic 'myth', a symbolic tale or *parable.

Plautus *Roman comedy.

Playfair, William Henry (1790–1857), Scottish architect, the son of the architect James Playfair (1755–94). He was the pre-eminent designer of public buildings in Edinburgh in his day. His most famous works include the National Monument on Calton Hill (in collaboration with *Cockerell, 1824–9, unfinished) and the National Gallery of

The façade of the University of Salamanca (1514–29) is one of the richest and most splendid examples of the **Plateresque** style. Renaissance motifs and Moorish-inspired ornament are applied to a basically Gothic framework. Candelabra, coats of arms, pilasters, and portrait roundels are all part of the lavish scheme.

Scotland (1850–7). These are in the severe *Greek Revival style at which he particularly excelled, but he also used Gothic Revival, Italianate, and Scottish vernacular styles in his domestic and ecclesiastical architecture.

playing cards, rectangular pieces of thin, stiff card (or more recently, plastic), marked with one or more symbols and used in various games, in fortune-telling, and in conjuring. The origin of playing cards is unclear, in spite of much serious research on the subject; they were certainly known in Europe by the 14th century, and they were used several centuries before this in China and other Eastern countries. The earliest cards made in Europe were Tarot cards, which embody an obscure system of occult philosophy, and are used in fortune-telling. A Tarot pack usually consists of 78 cards; the familiar 52-card pack, with its division into 4 'suits', that is standard today originated in France in the 16th century. The modern double-headed ('reversible') court cards (king, queen, and jack) first appeared in 1827, again in France. Early playing cards are often impressive miniature works of art, and some 15th-century examples are important documents in the history of *engraving.

plectrum, in music, something used to pluck strings. Nowadays plastic plectra are standard, but in the Middle Ages quills were used, probably goose for psalteries, lutes, and similar instruments, and crow or birds of prey for harpsichords. In India a wire thimble on the end of the finger plucks the sitār, in Japan and Korea false fingernails of ivory are used on *koto* and *kayagüm*, and large wooden or ivory blades are used on the lutes there and in China. Large plectra were also used on ancient Greek lyres. With present-day guitars the plectrum is usually called a 'pick'.

Pliny, the name of two Latin writers, uncle and nephew. **The Elder** (AD 23–79) produced several books; only the encyclopedic *Natural History* survives. **The Younger** (AD *c*.61–*c*.112), a successful politician, left nine books of literary letters that provide a unique record of contemporary Roman society and attitudes. A tenth book, written as governor of Bithynia (in present-day Turkey), contains one of the earliest pagan accounts of Christians.

plucked drums, musical instruments with the string through the drum head as a resonator; they are sometimes confused with *friction drums. These instruments of the Indian sub-continent are stringed instruments, for the sound is produced by the string, whose *pitch depends on its tension. This is varied, either by pulling a small drum on the other end, with the *ānandalaharī* and similar instruments, or by squeezing the arms of the instrument, with the *gopīyantra*.

Plutarch (AD *c*.50–*c*.120), Greek philosopher and biographer. His surviving works are the *Moralia* ('moral writings'), which consist of more than seventy treatises whose subjects are by no means limited to ethics, and the *Lives*, where Greek and Roman notables are paired and often explicitly contrasted. Among later writers who have relied on his descriptions of the ancient world are Montaigne, Shakespeare, Dryden, and Rousseau.

Poe, Edgar Allan (1809–49), US short-story writer, novelist, poet, and literary critic, now regarded as one of

the great figures of American literature. After brief periods at University and military college he earned a living as a writer and magazine editor, first in the South and later in New York. He suffered throughout his life from poverty and ill health, the latter exacerbated by the death of his young wife. In a brief literary career he produced a succession of classic horror tales, such as 'The Fall of the House of Usher' (1839). He set the standard for the modern detective story in 'The Murders in the Rue Morgue' (1841); and wrote poetry which, through *Baudelaire, profoundly influenced the French *Symbolists. In his essay 'The Poetic Principle' (1848-9) he indicates his conception of poetic unity to be one of mood or emotion, and especially emphasizes the beauty of melancholy. His novel *The Narrative of Arthur Gordon Pym* (1838) describes a sea voyage towards the Antarctic; in his mystical-scientific dissertation *Eureka* (1849) he attempts to establish an all-embracing theory of cosmogony.

Poet Laureate, an honour given to a British poet who is appointed to write poems for state occasions and who receives a stipend as an officer of the Royal Household. The term 'laureate' arose from the practice in medieval universities of crowning with laurel a student who had attained a degree in rhetoric, grammar, and poetry. In its early use the title 'laureate' was conferred upon eminent poets; the poet laureateship follows the custom of kings and chieftains to appoint a court *bard. Ben Jonson and Sir William D'Avenant (1638-68) were successively 'unofficial' poets laureate. Dryden was the first to be given the title officially in 1668. Wordsworth,

Tennyson, Robert Bridges, Cecil Day-Lewis, and Betjeman have been among later holders of the title, which at present is held by Ted *Hughes.

poetry, language sung, chanted, spoken, or written according to some pattern of recurrence which emphasizes the relationships between words on the basis of sound as well as sense: this pattern is almost always a rhythm or *metre, which may be supplemented by *rhyme or *alliteration or both. The demands of verbal patterning usually make poetry a more condensed medium than prose or everyday speech, often permitting unusual orderings of words within sentences, and sometimes involving the use of special words and phrases ('poetic diction') peculiar to poets. Poetry is usually characterized by a more frequent and elaborate use of *figures of speech, principally *metaphor and *simile. All cultures have their poetry, using it for various purposes from sacred ritual to obscene insult, but it is generally employed in those utterances which call for heightened intensity of emotion, dignity of expression, or subtlety of meditation. Poetry is valued for combining pleasures of sound with freshness of ideas, whether these be solemn or comical. The three major categories of poetry are *narrative, dramatic, and *lyric, the last being the most extensive.

pointillism, a technique of painting, used by the *Neo-Impressionists, in which dots (French, *points*) or small touches of pure, unmixed colour are methodically applied to the canvas so that when viewed from an appropriate distance they seem to react together optically, creating more vibrant effects than if the same colours were physically mixed together. *Seurat, the leading pioneer and greatest exponent of the technique, preferred the term 'divisionism'. The two terms are often used more or less interchangeably, but a helpful distinction is to regard 'divisionism' as the underlying optical theory and 'pointillism' as the actual painting technique.

polemic, a verbal or written attack upon some opinion or policy, usually within a theological or political dispute,

Seurat's *Sunday Afternoon on the Island of La Grande Jatte* (1884-6) is the picture that prompted the critic Félix Fénéon to coin the term **pointillism** (French, 'peinture au point'). The dots of colour may fuse in the viewer's eye at the appropriate distance, but it is more accurate to say that they remain visible as optical vibrations, creating something of the shimmering effect experienced in strong sunlight. (Art Institute of Chicago)

sometimes also in philosophy or *literary criticism; a controversial discussion. Notable polemicists in English are Milton, whose *Areopagitica* (1644) attacks censorship, and Thoreau, whose 'Slavery in Massachusetts' (1854) berates upholders of the Fugitive Slave Law.

Polish literature, literature written in the Polish language. Poland possesses the longest unbroken literary tradition of the Slavonic nations, dating from its conversion to Christianity in 966. A few medieval Latin chronicles, vernacular sermons, and Bible translations from the 14th and 15th centuries have survived. From *c.*1520 the spread of humanism influenced the work of poets such as *Kochanowski, who wrote in both Latin and Polish. Of particular importance was the new emphasis by Mikolai *Rej and Lukasz Górnicki (1527–1603) on the vernacular and on national culture. The 1600s were turbulent years of contrasts. Numerous wars generated a fascination with the Orient, reflected, for example, in the epics of Samuel Twardowski (*c.*1600–60) and Waclaw Potocki (1621–96), and in numerous memoirs (see *Pasek), while Jan Andrzej Morsztyn (*c.*1613–*c.*1693) was writing sophisticated occasional verse and Zbigniew Morsztyn (*c.*1628–*c.*1690), a follower of Arianism, a philosophy that denied the divinity of Christ, composed profound and abstract religious writings. The election of King Stanislaw in August 1764 heralded a period of enlightenment and educational reforms. The classical styles of writers such as *Krasicki were modified by the lyrical verse that anticipated the *Romantic movement. The partition of Poland (1772–95) engendered a consuming nationalism which found expression from the 1820s in poetry and drama at home and in exile in the work of *Krasiński, *Mickiewicz, *Norwid, and *Slowacki. The romantic image of Poland's sufferings has dominated its literature to this day. The unsuccessful 1863 uprising provoked reaction against romantic idealism and encouraged a positivist approach that rejected religion and metaphysics, in order to expose the ills of a newly industrialized, changing society. The often didactic novels of *Prus and *Orzeszkowa proved the most useful, popular genre. The positivist interest in science gave way in about 1890 to the Young Poland movement's preoccupation with philosophy, folklore, the occult (Stanislaw Przybyszewski, 1868–1927), and art for art's sake. This was combined with literary and linguistic experimentation in the work of *Berent, *Irzykowski, and *Leśmian. When Poland regained independence in 1918 many writers shed their role as the nation's conscience. In the 1930s the fresh approach to literature of writers such as *Schulz, *Witkiewicz, and *Gombrowicz became more surrealist, grotesque, and pessimistic. *Socialist Realism and political repression largely dominated postwar literature. The current changing political climate of the country is reflected in the writing of, for example, Slawomir Mrożek (1930–), Marek Hłasko (1934–69), Tadeusz Konwicki (1926–), Wiesław Myśliwski (1932–). (See also *Baltic literature.)

political theatre, conscious use of the theatre to make political statements. In its modern form it probably began when actors staged political propaganda in factories during the Russian Revolution of 1917. With notable exceptions (such as Nazi Germany) it has supported the Left; it has played an important role in East European theatre, where playwrights such as Karel Čapek have made use of it. In the USA in the 1930s it was manifested in the work of the Living Newspaper, which like other examples of political theatre used *documentary theatre techniques; and of the socially conscious Group Theatre. The outstanding model of modern political theatre has been the *epic theatre of Bertolt *Brecht. In Britain, *Theatre Workshop was often political, and *fringe playwrights are frequently ideologically committed.

Poliziano, Angelo (Angelo Ambrogini) (1454–94), Italian humanist. One of the foremost classical scholars of the Renaissance, he was professor of Greek and Latin at the University of Florence, and wrote *elegies, *odes, and *epigrams in both these languages. His Italian works include a poem in **ottava rima*, *Stanzas Begun for the Tournament of the Magnificent Guiliano de' Medici* (1475–8), and *Orpheus* (1480), the first secular drama in Italian, characterized by melody and visual imagery of exquisite beauty. His philological acumen, seen at its best in two collections of studies of textual problems (the first and second *Miscellaneorum centuria*), made him one of the founders of modern textual criticism.

polka, a traditional round-dance from Bohemia that became popular in European ballrooms in the early 19th century. It was in quick duple *time, with steps on the first three beats and a small hop on the fourth. The polka figures as a typical Johann Strauss dance, but is also found in the concert music of Smetana and Dvořák. It continues to be used in both folk and ballroom settings.

Pollaiuolo, Antonio (*c.*1432–98) and **Piero** (*c.*1441–*c.*96), Italian artists, brothers, who jointly ran a flourishing workshop in Florence. They are both recorded as being painters, sculptors, and goldsmiths, though it seems probable that Antonio was the more accomplished and innovative artist. The works associated with him reveal an individual mastery of the nude figure in vigorous movement and a pioneering interest in landscape. He is said to have anticipated Leonardo in dissecting corpses in order to study the anatomy of the body. The most famous work associated with the brothers (it may well be a work of collaboration) is the large altar-piece of *The Martyrdom of St Sebastian* (1475).

Pollock, Jackson (1912–56), US painter, a key figure of the *Abstract Expressionist movement. His early work was figurative, but in the early 1940s he adopted an abstract style noteworthy for its restless energy and sense of the mysterious and primitive. In 1946 he began working with the canvas on the floor, the paint dribbled, splashed, or poured across it from all sides, creating a complex network of patterns of immense vitality. During the 1950s he often worked on a very large scale, sometimes using only black paint. In his last years he reverted to a more formal, traditional technique. The public was at first shocked by his work, but his reputation is now secure as the head of the generation of painters who enabled New York to become the world's centre of avant-garde art.

polonaise, a stately processional dance, developed from its peasant origins by the Polish aristocracy during the 17th century. In its stylized 18th-century version the phrase-lengths are short, rhythmic, and repetitive, and start always on the first beat of the bar. Though the Polonaise was popular as one of the movements in the

Baroque dance *suite, a highly refined and much more dramatic version was perfected by Chopin in the 1830s.

Polyclitus of Argos (*fl. c.*450–*c.*420 BC), one of the most famous of Greek sculptors. No original works by him survive, but several are known through Roman copies. He is now best known for his *Doryphorus* (Spear Carrier), a strongly built but lithe nude figure. This was long regarded as a standard for male beauty. In antiquity he was most renowned for his colossal statue in ivory and gold of Hera, sister and consort of Zeus in her temple near Argos; ancient writers compared it favourably with *Phidias' statue of Zeus at Olympia. (See also *proportion.)

The *Doryphorus* (Spear Carrier) by **Polyclitus of Argos** is one of the most notable of ancient statues. The original, dating from about 450 BC, has not survived, but it is known through various copies. Harmony of proportion and mastery of anatomy were two of the overriding concerns of Greek art, and this statue earned itself the sobriquet The Canon (meaning 'rule' or 'measure'), since all other works could be measured against its perfection. (National Archaeological Museum, Naples)

Polynesian art, the art of the indigenous people of the Pacific Ocean islands of Polynesia, stretching from Hawaii to New Zealand and to Easter Island. The earliest expressions of Polynesian art are the stamped geometric designs on Lapita pottery, produced by the ancestors of the Polynesians about 2,500 years ago. The Lapita art principles of bands of repeating motifs divided into design compartments persisted as each Polynesian island group developed its own distinctive styles of stone and wood sculpture, bark-cloth, and body tattoo. Figures of gods in stone and wood became abstract, sometimes decorated with intricate surface patterns. Fine *feather-work and elaborate lashing patterns were a feature in certain islands. Song, dance, and oratory were developed to a high degree. Many of these Polynesian arts did not survive for very long after European contact.

polyphony, music in which several strands of melody are combined simultaneously. Polyphony looks at music in terms of the horizontal. Its opposite pole is homophony, which emphasizes the topmost melody, supported by accompanying *harmonies. Monophonic music (*monody) concerns itself with a single melodic line. The great polyphonic period is usually defined as from about 1200 to 1650, but polyphony has survived to the present day as one of music's essential techniques.

polyptych, a work of art consisting of four or more leaves or panels. Most polyptychs were altar-pieces, and they could be very large and complex, the folding panels sometimes allowing different combinations of pictures to be displayed. Grünewald's famous Isenheim altar-piece, for example, originally had three separate stages, but has now been taken apart so that all the panels can be displayed at the same time. The Ghent altar-piece by Jan van Eyck, however, is still in its folding state, and is opened and closed at fairly frequent intervals so that visitors may see the interior and exterior in turn.

polytonality, the simultaneous use of more than one key in different contrapuntal strands, an effect found in works by Holst, Milhaud, Bartók, and others. The use of only two keys is *bitonality.

Pont-Aven School, a term applied to the group of painters associated with Paul *Gauguin during the period from 1886 to 1890 when he spent much of his time in the Breton town of Pont-Aven. He inspired his followers to move away from the naturalistic depiction of the *Impressionists to a style in which colour is used emotionally to express ideas and feelings rather than appearances. (See also *Synthetism.)

Ponti, Gio (1891–1979), Italian architect and designer. He was one of the pioneers of the *Modern Movement in Italian architecture and also a versatile designer, his work including a rush-seated chair (1951), light fittings, and products of light industry. His masterpiece is the Pirelli Building in Milan (1955–8), one of the world's most elegant and refined skyscrapers. It is built around a concealed structural core by *Nervi.

pop *popular music, *rock music.

Pop art, a movement in art based on the imagery of consumerism and popular culture—comic books, ad-

Easter Island represents the remotest outpost of **Polynesian art**. It is notable for its colossal stone figures, but there also existed a tradition of woodcarving, exemplified by this ceremonial paddle used in dancing. Wood is scarce on the island, and carvings in it are usually quite small and highly finished. Common to wooden and stone figures, however, are distinctive long ears. (Museum für Volkskunde, Berlin)

vertisements, packaging, and images from television and the cinema were among the sources used. The movement began in the mid-1950s and flourished until the early 1970s, chiefly in the USA and Britain. In the USA, where its most famous exponents were Andy *Warhol and Roy *Lichtenstein, it was seen initially as a reaction from the seriousness of *Abstract Expressionism, and artists often used commercial techniques to undermine the idea of the work of art being a unique, hand-crafted piece. Tongue-in-cheek jokiness was often the prevailing mood, although Pop art could also be disturbing or macabre. In Britain, where David *Hockney (early in his career)

and Peter Blake were the leaders, Pop art was generally less aggressive than in the USA.

Pope, Alexander (1688–1744), British poet and satirist. One of the most quoted poets in the English language, he established himself as a master of the *heroic couplet in his 'Essay on Criticism' (1711), a poem on the art of writing. This was followed by his mock *epic poem, 'The Rape of the Lock' (1712, enlarged 1714), a witty *satire on the society of his day. His topographical poem 'Windsor-Forest' (1713), in celebration of the Peace of Utrecht, combines evocative descriptions of landscape with literary and political reflections. The success of his verse-translations of Homer's *Iliad* (1715–20) and *Odyssey* (1725–6) brought him financial independence. He was criticized by the scholar Lewis Theobald for the inaccuracies in his edition of Shakespeare (1725), emended to suit contemporary taste, which led to his selection of Theobald as the hero of his 'Dunciad', a mock heroic satire on dullness. In his satires, 'Imitations of Horace', he defends himself against the charge of malignity and professes to be inspired by love and virtue, but the prologue to 'An Epistle to Dr Arbuthnot' (1735) is one of his most brilliant pieces of *irony and invective, here directed against minor critics. Pope was a member of the Scriblerus Club which included *Gay, *Swift, and John Arbuthnot (1667–1735), his collaborators in *Miscellanies* (1728) in which *Peri Bathous or the Art of Sinking in Poetry* ridicules the pedantry of minor poets.

popular music, mass-disseminated music. Factors contributing to the development of a popular music in the West include the growth in the 18th century of a literate, leisured middle class with the means to become involved in music-making, and new printing methods allowing cheap production of sheet music. Songs from *ballad and comic *operas, simple choral works, *hymns, and a keyboard repertory of familiar tunes and dances were printed as sheet music for home performance. During the 19th century, improvements in transport, expanding urban areas, and an increase in musical literacy made it easier for a piece of music to gain national currency. Music publishing flourished, and many writers emerged whose music catered specifically for the amateur performer. New directions for popular music came from the USA. In 1843 Dan Emmet's Virginia Minstrels visited Europe for the first time. They were enthusiastically received, and 'blackface' minstrel songs soon became a standard element of the *music-hall repertory. It was also around this time that the American Stephen Collins Foster (1826–64) began to write popular songs. Foster confined his music to the simplest elements in order to reach the widest possible audience. Such songs as *Old Folks at Home* and *Jeannie with the Light Brown Hair* have passed into the oral tradition. The 1890s saw the emergence of a new generation of American songwriters and publishers, based around New York's 14th Street in what quickly became known as Tin Pan Alley. They used a more sophisticated musical language than earlier writers, and mostly dealt with urban life. Tin Pan Alley music was strongly rooted in European musical traditions, though later writers absorbed stylistic elements from *ragtime, *jazz, and other popular forms. The early 20th century saw the breakthrough of American music in Europe. Ragtime-influenced music, and the songs of

Performers of **popular music** often create or reflect changing fashions and styles. The taut pose and unadorned costume worn by Madonna indicates an ideal of feminine beauty current in the 1980s; it emphasises freedom of movement, assertiveness, and muscular agility, and replaces the traditionally seductive clothes that suggest rather than state the shape of the body.

Airplane, and The Grateful Dead in California, were early performers of what came to be known as *rock music. Initially the music was associated with the drug culture and social protest, but by the 1970s rock was part of the music establishment. Although early rock and roll had appealed to both black and white Americans, from the 1960s black music followed its own path. In Detroit Benny Gordy Jr. established the Motown corporation, recording such black artists as The Supremes, The Vandellas, Marvin Gaye, and Stevie Wonder. By the early 1960s Motown had more best-sellers in America than the Beatles, and white groups were copying the Motown sound. The style known as *soul music was another type of black music. In the mid-1970s elements of 'pop' soul and the more heavily rhythmic funk gave rise to disco music. Disco became the most widespread music style since rock and roll, appealing to audiences of all types in many countries. Contemporary popular music comprises many genres. The Tin Pan Alley style survives in the music of performers like Barbra Streisand and Barry Manilow; the rock/rock and roll tradition is continued by Bruce Springsteen, U2, and others; Suzanne Vega and Tracy Chapman have revived interest in the urban folk-singer/songwriter, and such black performers as Michael Jackson and Prince perform music rooted in Motown and soul traditions. With the continuing expansion of the popular music market, distinctive musical 'dialects' from different parts of the world have begun to enter the general market: Jamaican reggae, West African highlife and juju, the mbaquanga of southern Africa, and the bhangra beat of British Asians are just a few examples.

porcelain, the finest and most luxurious type of ceramics, usually made from clay and feldspar fired at a high temperature. It is usually white and can be decorated with paints and glazes. An exact definition of porcelain is difficult, and while some authorities regard it as a variety of pottery, to others it is a distinct substance. It is clearly distinguished from earthenware, which is coarser and porous, but not so clearly from stoneware. In China, where porcelain originated, it is defined as pottery that resonates when struck, but in the West the distinguishing factor is usually held to be that it is translucent when held to the light. Porcelain was first made during the Tang dynasty (AD 618–907), and the secret of its manufacture was not discovered in the West until the first decade of the 18th century. Its whiteness, thinness of body, and translucency excited admiration and envy in Europe long before this, however, and pottery imitating porcelain was made, for example by the *Abbasids. The two types—genuine and imitation—are sometimes known as 'hard-paste' and 'soft-paste' porcelain, the terms 'hard' and 'soft' referring to the temperatures of the firing and the consequent hardness of the product; soft-paste porcelain, usually made with clay and ground glass, requires a lower temperature. In about 1708 hard-paste porcelain was first made in Europe, at Meissen in Germany, and by the middle of the 18th century it was being manufactured in many other countries. Different types of porcelain are often named after the factory which produced them, for example Bow, Chelsea, Derby in England, Sèvres, Vincennes in France, Meissen (sometimes called 'Dresden') in Germany. The range of products made with porcelain has been much wider in the West than in the East; apart from vessels of various kinds and tableware, it has been used for figure compositions

such writers as *Kern, *Berlin, *Porter, *Gershwin, and *Rodgers led a Tin Pan Alley domination of popular music that was to last over thirty years. Between the two World Wars, technological innovations had a wide-ranging effect on popular music. *Crooners such as 'Whispering' Jack Smith, Bing Crosby, and Frank Sinatra relied on the microphone to build up the tone of their soft, smooth singing style. Such devices as the radio, the gramophone, and the sound film contributed to the most profound change in the history of popular music, from active performance of music in the home to passive consumption through listening. After World War II the transistor radio and inexpensive gramophone brought the mass dissemination of popular music to a new peak. In the USA the music of Tin Pan Alley was in decline: *country music and *big band jazz were flourishing. In 1955 Bill Haley and the Comets released the record *Rock Around the Clock*, the first example of rock and roll music to gain popularity. Rock and roll music grew directly out of black *rhythm and blues music: its strong dance rhythms, simple lyrics, and declamatory vocal style appealed to a whole new generation. In the mid-sixties a new style emerged, harsher and more heavily electric in sound. The Animals in Britain, and the Byrds, Jefferson

(usually fairly small) and a whole range of articles, including ink-stands, snuff-boxes, cane handles, and chamber-pots.

portative organ, a small medieval *organ. None has survived, nor has any detailed contemporary description, so that our only knowledge comes from the many medieval illustrations, all of which differ in various respects. The portative organ had a small range and was light enough to be carried, usually by a strap over the shoulder, while playing with one hand and pumping bellows at the back or underneath with the other. It is generally assumed that there was no air reservoir and that it therefore had to breathe like a singer between phrases.

Porter, Cole (Albert) (1892–1964), US composer. Born into a wealthy family, he studied at Harvard University and gained experience by writing for amateur shows. He moved to Paris in 1917 and spent three years in the Foreign Legion, then studied briefly with Vincent d'Indy at the Schola Cantorum. International success came with the *musicals *Wake Up and Dream* (1929), *Gay Divorce* (1932), and *Anything Goes* (1934). A serious riding accident in 1937 led to a period of stagnation, from which he emerged in 1948 with his greatest musical, *Kiss me Kate*. His songs and lyrics admirably combine extreme sophistication with infectious memorability.

Porter, Katherine Anne (1890–1980), US short-story writer and novelist. Her short stories collected in *Flowering Judas* (1930), *Pale Horse, Pale Rider* (1939), and *The Leaning Tower* (1944) won her a critical reputation as a stylist who handled complex subjects with economy while subtly penetrating the psychology of her characters. Her only novel, *Ship of Fools* (1962), is set on a passenger boat travelling from Mexico to Bremerhaven in 1931. It is an exploration of the German mind in the 1930s, and an *allegory of the relationship of good to evil, and the voyage of life towards eternity.

portico, architectural term for a large-scale porch, often featuring columns supporting a pedimented roof, and usually forming the principal entrance to a building. They were used in Greek and Roman architecture, revived during the Renaissance (notably by Palladio, who was the first to use the form in domestic architecture), and thereafter became part of the general vocabulary of architectural form. The term 'portico' can also be applied to a walkway with a roof supported by columns.

portraiture, the art of depicting likenesses of individual people, particularly of the face. The earliest surviving portraits of individuals are probably the faces painted on the surfaces of Egyptian sarcophagi. In the Western world, portraiture was well known to the ancient Greeks and was developed by the Romans to become a major art-form, particularly the sculptured *bust. Portraiture became virtually extinct during much of the Middle Ages, reviving in the 15th century when, in both Italy and northern Europe, portraits began to be included in religious compositions (showing the patron or sometimes the artist) as well as appearing as individual works. In Italy 15th-century portraits were often in pure profile, but Leonardo, Raphael, and Titian introduced much greater variety of pose and expression. The secularization of art in northern Europe after the Reformation gave great encouragement to secular portrait painters such as Holbein and the 17th century witnessed a glorious flowering of portraiture at the hands of such masters as Van Dyck, Rembrandt, Rubens, and Velázquez. The 18th century saw Britain's greatest age for the portrait, with Hogarth, Gainsborough, Raeburn, Ramsay, Reynolds, and Romney. Many excellent portraits have been in the form of busts: Jean-Antoine Houdon (1741–1828) was highly regarded and produced busts of many famous contemporaries, including Diderot, Lully, Rousseau, and Voltaire. In Britain Nollekens made busts of Fox and Pitt. Photography posed a major threat in the 19th century, but portraiture has survived, showing continued vitality in the work of such varied modern masters as Jacob Epstein, Graham Sutherland, and Lucian Freud. (See also *miniature.)

Portuguese literature. Early literature was in the form of love ballads collected in books called *cancioneiros*. This form flourished at the court of Alfonso III from 1248, and was related to *Provençal literature. Early prose in the 14th century was based on Celtic legends and was in a form similar to the Breton *lays. The 15th century saw the establishment of an important tradition of historical chronicles, particularly in the writing of Fernão Lopes (c.1380–c.1460). The origins of drama are found in the work of *Vicente in the early 16th century. The poetic tradition was continued by Francisco de Sá de Miranda (c.1485–1558), who introduced many new poetic forms learned during a six-year stay in Italy. This Renaissance flowering of poetry reached its height in the work of *Camões. Portuguese activity on the world stage was reflected in its literature; the tradition of historical writing was continued in the works of such chroniclers as Gaspar Corrêa (c.1495–c.1565), who told of conquests in India. Meanwhile Bernadim Ribeiro (1482–1552) wrote the pastoral novel *The Book of the Young Girl*, one of the earliest novels of European literature. Like Spain, Portugal had an important tradition of mystical writers, one of the foremost being Frei Thomé de Jesus (c.1529–82). The 17th and 18th centuries witnessed the subjugation of Portugal by Spain culturally as well as politically, and in literature the influence of *Góngora was dominant. Nineteenth-century *Romanticism effected a new literary flowering in Portugal, led by the poet and dramatist Almeida Garrett (1799–1854), who concentrated on national themes in such dramas as *The Swordsmith of Santarém*. The historical tradition was revived in the work of Alexandre Herculano (1810–77), while José Maria Eça de Queiroz (1843–1900) wrote novels in the *realist vein. In the 20th century Portugal's foremost poet has been *Pessoa, while the novel has been represented by J. M. Ferreira de Castro (1898–1974), author of *Jungle* (1930) about his work in a Brazilian rubber plantation, and Agustina Bessa Luis (1922–), whose *The Sibyl* (1953) was a complex psychological study.

poster art, the designing of sheets to be printed in multiple copies and displayed in public as announcements or advertisements. Although printed notices of a type have existed since the 15th century, it was not until about 1860 that the poster as we know it today emerged, stimulated by improved printing processes, in particular *lithography, which made it possible to produce brightly coloured images cheaply and easily. The first great masters of the art did their best work advertising the theatre, the

	Typical products	Stylistic features	Other comments
Antwerp potteries Netherlands early 16th century	earthenware and maiolica	strap-work and scrolls	in the 17th century Antwerp was replaced by Delft as the main pottery centre of the Low Countries
Arras porcelain factory France 1770–90	tableware	simple decoration, mainly floral	
Belleek porcelain factory Ireland (County Fermanagh) founded 1857	small white dishes and vases, often shaped like shells	extremely delicate, translucent porcelain with pearly glaze	
Bennington pottery and porcelain factory USA (Vermont) 1793–1858	a wide range of useful and ornamental wares	often used American motifs as in Toby jugs representing noteworthy Americans	called the United States Pottery from 1853 until 1858
Berlin porcelain factories Germany the first founded in 1752	figures, vases, tableware	in the 1760s Berlin produced some of the finest German rococo porcelain	state-run since its acquisition by Frederick the Great in 1763
Bow porcelain factory England (London) c.1744–75	figures, cups, bowls, small items such as ink-wells	figures are often glazed and unpainted; style is English Rococo	with Chelsea the first English porcelain factory; it was bought by the Denby porcelain factory in 1775
Buen Retiro porcelain factory Spain (Madrid) 1759–1808	tableware, vases, figures, and also complete rooms decorated in porcelain for royal palaces	virtually indistinguishable from Capodimonte	founded by Charles III, who transferred the Capodimonte factory to Madrid when he relinquished the throne of Naples on becoming King of Spain
Capodimonte porcelain factory Italy (Naples) 1743–59	tableware and figures, notably peasants and characters from the *commedia dell'arte*; also a complete porcelain room made for the royal palace at Protici	elegant, richly coloured Rococo style	founded by Charles III and transferred by him to Madrid (craftsmen as well as equipment) to form the Buen Retiro factory
Chelsea porcelain factory England (London) c.1745–84	a wide variety of tableware, ornaments, and figures, often based on Meissen prototypes	less impeccably sophisticated than comparable Continental pieces but with a compensating freshness and charm; generally regarded as the best English porcelain	with Bow, the first English porcelain factory; it was acquired by the Derby factory in 1769
Coalport and Coalbrookdale porcelain factory England (Shropshire) founded c.1796	mainly tableware; also reproductions of Meissen and Sèvres	floral decoration was a speciality	after several changes of ownership and name, the factory continues work at Stoke-on-Trent
Copenhagen porcelain factory (Royal Danish Porcelain Factory) Denmark founded 1774	tableware, vases, statuettes (including reproductions of figures by the Danish sculptor Thorvaldsen)	varied	has had a mixed history, but now enjoys a high reputation; it was taken over by the Danish king in 1779 and although sold by the Crown in 1868 it still retains the name Royal Danish porcelain factory
Delft potteries Netherlands 17th century	a huge range of useful and ornamental earthenware, usually decorated in blue and white; tiles were particularly popular; also imitation Chinese red stoneware	floral designs and chinoiserie predominate	Delftware was enormously popular and the terms 'Dutch Delft' is sometimes used to distinguish wares produced in Holland from, for example, 'English Delft'
Derby porcelain factory England founded c.1750	tableware and figures	much influenced by Chelsea, Meissen, and Sèvres; simpler than Chelsea	by the 19th century there were several porcelain factories in Derby, of which the Royal Crown Derby Porcelain Company (1877) still flourishes
Doulton Pottery and Porcelain Company England (London) founded 1815	originally useful articles including sanitary wares; from the 1860s a variety of decorative pieces	employed a great many 'art potters' to create wares specifically aimed at collectors	produced 'Barlow Ware', decorated with animals and other scenes, from early 1870 until c.1900
Dresden porcelain factory:	See 'Meissen'		
Faenza potteries Italy known as early as the 12th century, but important mainly in the 16th century	maiolica		Faenza is still an important centre of pottery production today
Leeds pottery factory England c.1750–1878	tableware (particularly cream-coloured earthenware) and statuettes, including figures of horses	varies from elegantly Neoclassical to much more homely wares	
Limoges pottery and porcelain factories France first factory founded in 1736	Limoges is France's main centre for porcelain production, specializing in tableware	generally unremarkable, but the best 18th-century pieces are similar to simpler Sèvres wares	
Longton Hall porcelain factory England (Staffordshire) c.1750–60	various decorative and useful wares	influenced by Chelsea and Meissen	the first porcelain factory in Staffordshire
Lowestoft porcelain factory England (Suffolk) 1757–c.1800	tableware; also figures of animals and children	generally fairly simple and unpretentious	

	Typical products	Stylistic features	Other comments
Marieberg pottery Sweden 1758–88	faience tableware	exuberantly Rococo	
Medici porcelain factory Italy (Florence) 1575–87	vessels of various kinds	influenced by Chinese porcelain and by contemporary maiolica	Medici porcelain is extremely rare; only about sixty pieces are known, but they include the earliest surviving examples of porcelain (soft-paste) produced in Europe
Meissen porcelain factory Germany (Dresden) founded 1710	virtually every kind of porcelain product	varied, but most famous for its exquisite Rococo pieces	the first European porcelain factory and by common consent the greatest; it still flourishes
Minton's pottery and porcelain factory England (Stoke-on-Trent) founded 1796	a wide range of products	eclectic; made many high-quality imitations of historical styles; large pieces such as fountains, rooms lined with tiles, etc.	Thomas Minton, the founder, is said to have invented the willow pattern; the factory still flourishes
Naples Royal Porcelain Factory Italy 1771–1821	presentation dinner services; figures, including miniature antique statues	Rococo soon giving way to Neoclassicism	under Napoleon it was run by a French firm from 1807
Nevers potteries France first factory founded in 1588	a wide range of faience products	influenced by Italian and Chinese styles; noted for high-quality painting	Nevers is still a pottery centre
Nymphenburg porcelain factory Germany founded 1747	statuettes, tableware, boxes, cane handles	early products include some of the most refined Rococo porcelain	still flourishes; known for the fineness and whiteness of its porcelain
Rockingham pottery and porcelain factory England (Swinton, Yorkshire) c.1745–1842	originally brown stoneware, then a variety of wares	often used a brown glaze that became known as 'Rockingham glaze'; the term 'Rockingham ware' may be given to any products that have a similar glaze.	
Rookwood pottery USA (Cincinnati) founded 1880	decorative objects, mainly vases and jugs	simple, elegant, orientalizing	
Saint-Cloud pottery and porcelain factory France founded late 17th century; closed 1766	a wide range of useful objects, including tableware, boxes, etc.	pieces often have moulded decoration and are sometimes mounted in silver	
St Petersburg Imperial Porcelain Factory Russia founded 1744	luxury products made exclusively for the court	initially rococo, influenced by Meissen, but soon becoming more classical	taken over by the state after the Russian Revolution of 1917
Sèvres porcelain factory France founded 1738	high-quality porcelain of all kinds	always in the forefront of fashion	the most renowned French porcelain factory; originally established at Vincennes, in 1756 it was moved to Sèvres. Taken over by the king in 1759, it became state property in 1793. The factory moved to Saint-Cloud in 1876.
Staffordshire potteries England A group of potteries founded from 17th century onwards	virtually every kind of useful and ornamental pottery and porcelain; rather naive statuettes, including contemporary figures and animals were a 19th century speciality		the region of Staffordshire known as The Potteries, centred on Stoke-on-Trent, continues to be the most important British supplier of ceramics
Strasbourg pottery and porcelain factory France 1720–81	a wide range of faience wares imitating porcelain; it was only from 1752 to 1755 that porcelain was made at the factory		use of enamel colours to decorate faïence was widely imitated
Valencia potteries Spain 14th century onwards	Hispano-Moresque wares, particularly large plates		quality declined after the 16th century, but Valencia is still a pottery centre
Vienna porcelain factory Austria 1719–1864	mainly figures and other decorative items such as vases	initially Rococo, then much more classical	the second European factory (preceded only by Meissen) to make hand-paste porcelain
Wedgwood pottery England (Staffordshire) founded 1759	tableware, vases, plaques, statuettes, busts; best known as wares in Wedgwood blue with antique-style relief decoration in white	elegant and predominantly Neoclassical	the most famous of English potteries; still in family hands
Worcester porcelain factory England founded 1751	mainly tableware and vases; figures are rare and undistinguished; dishes, tureens, etc. moulded like vegetables and leaves	early wares influenced by Chinese porcelain and Meissen; later more varied	the only English porcelain factory with a continuous history from the 18th century; since 1862 it has been called the Royal Worcester Porcelain Company
Zürich pottery and porcelain factory Switzerland 1763–1897	mainly tableware	often charmingly decorated with Swiss landscapes or genre scenes	the leading Swiss factory of its time

The actress Sarah Bernhardt shown as Medea in a fine example of **poster art** by Mucha. The flowing lines and bold forms are typical of Mucha's distinctive style.

two most famous exponents being Toulouse-Lautrec and Mucha, both of them at their peak in Paris in the 1890s. Posters have continued to be used predominantly in the service of commerce, but during World War I they communicated political propaganda. Thereafter, posters entered a boom period, advertising virtually every kind of product, service, and event, some of the finest work being done by well-known artists, including Paul Nash and Graham Sutherland. Since World War II the competition from radio and television and the dominance of photographic images in advertising have reduced artists' contributions to poster design, and the *typography and style of posters has become the preserve of the commercial graphic artist.

posthorn, a valveless brass musical instrument used throughout Europe on mail coaches. In Britain it was a short, straight instrument, a shorter version of the coach horn, which has now become standardized in A♭ for playing Koenig's *Posthorn Galop* (1844) in dance bands. On the Continent of Europe it was a coiled instrument, which can still be seen on postage stamps, post boxes, and so on. In the 18th century crooks (coils of brass tubing inserted between the mouthpiece and the instrument to extend the tube length and thus lower the *pitch to a different *key) were provided for it, and Mozart scored for it in his Serenade K 320 and some dances; this was the ancestor of the *cornet.

Post-Impressionism, a term, coined by the British critic Roger Fry, applied to various trends in painting, particularly in France, that developed from *Impressionism or in reaction against it in the period from about 1880 to about 1905. The ways in which Post-Impressionist artists rejected the naturalism and pre-occupation with momentary effects of Impressionism varied greatly; *Seurat and the *Neo-Impressionists, for example, concentrated on a more scientific analysis of colour; *Cézanne was concerned with pictorial structure; *Gauguin explored the symbolic use of colour and line; and van *Gogh was the fountainhead of *Expressionism.

postmodern dance, a form of dance originating in the USA in the early 1960s that rejected much of the formalism and techniques of *ballet and *modern dance. Dance composition workshops taught by musician Robert Dunn and based on the work of *Cage were held at *Cunningham's New York studios in 1960–2. These workshops brought together many of the early post-modernists, such as Trisha *Brown, David Gordon, Steve *Paxton, and Yvonne Rainer. Dunn organized a concert in 1962 at the Judson Church Hall to show the work of the students. It was the first of many collective performances at the venue, and the main characteristics of postmodern work were apparent in this early concert. Unlike modern dancers the postmoderns drew movement from everyday contexts. Gone was the intensity of focus on individual emotional states and instead an air of impersonality, detachment, and objectivity prevailed. Radical juxtaposition became a key notion. Choreographers worked with painters, writers, and film-makers on chance methods, the use of games, rules, performances in unusual spaces, and improvisation in performance. Hierarchical structures were questioned by co-operative methods of composition and group organization. Variety has always been a hallmark of post-

modernism: the minimalism of early works like Paxton's *Satisfyin' Lover* (1967), which used only walking and sitting, was in contrast to the theatricality of Meredith Monk, who used live and taped music, film, costumes, and props. This remains true of the genre, with movement ranging from *pastiche of other styles to contact improvisation (see *Paxton), and the relaxed, fluid style known as release. Postmodernism did not reach Britain until the 1970s, when the X6 (later Chisenhale) Dance Collective was set up in London and American Mary Fulkerson began teaching at Dartington College of Arts. London's Dance Umbrella Festival provided an early performance platform, and from 1977 *New Dance* magazine was the British postmodern voice.

Post-Modernism, a term coined in the mid-1970s to describe the reaction against the dogmatic and uncompromisingly purist international style of the *Modern Movement in architecture. The prophet of Post-Modernism is the US architect and critic Charles Jencks, whose writings have essentially defined the movement. Post-Modern architects, most of whom had received conventional Modernist training, sought to find a point of conjunction between 20th-century technology and the traditional styles of the past, particularly classicism. In reaction to the austerity of the Modern Movement, architects returned to regional and traditional sources, introducing ornament, colour, and sculpture, often in a hybrid and 'jokey' manner. The archetypal example of Post-Modern architecture is Michael Graves's Portland

James Stirling's New Building at the Staatsgalerie in Stuttgart (1980–3), with its bold forms and strong colour contrasts, is a striking example of **Post-Modernism**. Historical references are more subtle than in many Post-Modernist buildings; the planning, for example, reflects certain Roman ideas. Stirling later designed a Post-Modernist extension for the Tate Gallery in London.

Public Services Building in Portland, Oregon (1980–2), a huge slab, the surfaces of which are enlivened by colour contrasts and ornamental motifs. The term Post-Modernism has also been extended to other forms of art and literature, describing works that reject the theories and practices of modernism.

post-painterly abstraction, a term applied to the work of a generation of US artists who, although they painted in various styles, collectively represented a breakaway from the spontaneity and subjectivity of *Abstract Expressionism. The new trend, which began in about the mid-1950s and included artists such as Morris *Louis and Frank *Stella, was characterized by coolly planned and clearly defined areas of unmodulated colour.

Potter, (Helen) Beatrix (1866–1943), British writer and illustrator of *children's books. She spent a lonely and repressed childhood and youth in London, broken only by annual visits to Scotland and the Lake District. Her small books for children began with illustrated animal stories for the sick son of her former governess in 1893, and she published the first two, *The Tale of Peter Rabbit* (1901) and *The Tailor of Gloucester* (1902), at her own expense. These were followed by *The Tale of Squirrel Nutkin* (1903), *The Tale of Johnny Townmouse* (1918), and others. Written in deceptively simple prose, and imaginatively illustrated with her superb water-colour drawings, they reflect her love and knowledge of the countryside and combine fantasy with humour. *The Journal of Beatrix Potter*, written in code, was transcribed by Leslie Linder (1966).

pottery, articles, particularly vessels, made from clay and baked hard. Pottery making is among the oldest and most widely practised of all the crafts and probably originated independently in more than one place. The earliest known fragments date from about 7000 BC,

and in their most primitive form pots were made from superimposed coils of clay, baked in open fires or perhaps merely dried in the sun (processes still in use in many cultures today). The craft was revolutionized by the invention of the potter's wheel, which probably came into use in the 4th millennium BC. In essence it is a spinning disc (like a record turntable) usually activated by the motion of the potter's feet on a crank; it freed both hands for shaping the clay and the rotary motion reduced the muscular effort needed to shape the raw material to a light guiding touch. By the use of the wheel pots of regular shape could be produced many times more rapidly than by the older techniques of free-hand modelling or strip coiling. An enormously large number of different types of pottery is recognized, classified by material, shape, decoration, and so on, but all pottery can be divided into three basic categories: *earthenware, *stoneware, and *porcelain. (See also *studio potter; Bernard *Leach Bernard *Palissy.)

Poulenc, Francis (Jean Marcel) (1899-1963), French composer. He made a name for himself with his first published composition, the *Rhapsodie nègre* (1917). The success of his Diaghilev ballet *Les Biches* (1924) established an international reputation, which was soon confirmed by such works as the *Concert champêtre* (1928) for harpsichord and orchestra, and the concertos for two pianos (1932) and for organ (1938). Poulenc's gifts as a melodist and his capacity for bringing incongruous musical elements together in a convincing collage, stood him in good stead in his chamber music and many song-cycles. Such works as the opera *Dialogues des carmélites* (1957), the *Stabat Mater* (1950), and the *Gloria* (1959) underline the strength of his Roman Catholic faith as surely as the surrealistic opera *Les mamelles de Tirésias* (1947) confirms the essential seriousness of his apparent frivolity. (See also Les *Six.)

Pound, Ezra (Weston Loomis) (1885-1972), US poet and literary critic. After beginning an academic career in the USA, Pound arrived in Europe as a writer strongly influenced by medieval troubadour and *Provençal poetry. He was later associated with the *Imagists, published translations from the Chinese in *Cathay* (1915), and condemned the degradation of culture in modern civilization in *Hugh Selwyn Mauberley* (1920). He gave assistance to *Tagore, *Eliot, and *Joyce in the anthologies and magazines that he helped to edit. From 1919 onwards his work became dominated by the unfinished *Cantos*, the last of which were published in 1969. They are verse collages filled with esoteric lore and recondite theories that often seem pedantic and confusing, yet they have had a tremendous influence on modern poetry. In 1924 Pound moved to Rapallo, Italy. He admired Mussolini, in whom he professed to find the 'heritage of Jefferson', and during World War II broadcast fascist propaganda which led to his internment by the Allies. He was found unfit to stand trial, and committed to a New York mental hospital from 1946 to 1958. When released, he went to live in Venice. He is now recognized as one of the most important and influential *modernist writers.

Poussin's *Landscape with a Man Killed by a Snake* (c.1648). There does not seem to be a literary source for the picture, and according to a contemporary biographer, Poussin's subject is the effects of terror; the shock of the man who discovers the body is conveyed in a zigzag to the woman with outstretched arms and the fishermen beyond. (National Gallery, London)

Poussin, Nicolas (c.1594-1665), French painter, regarded as the mainspring of the classical tradition in French painting. His early career in France was fairly

undistinguished, but a turning-point came when he went to Rome in 1624; in the 1630s he gave himself up to the passion for the art and civilization of antiquity that was the guiding spirit of his work. The sensuous beauty of *Venetian painting, which had been a strong influence on his early work, gave way to formal clarity and intellectual rigour, and he began to choose themes from the Bible, classical history, or mythology that were heroic or morally uplifting. In 1640 he was recalled to Paris by Louis XIII to work on the decoration of the Louvre, but large-scale official work like this was not to his taste and in 1642 he returned to Rome for good. He preferred to work on fairly modest pictures for a small circle of highly cultured patrons whose interests matched his own. In the late 1640s he took up landscape painting, applying to it the same ideals of almost mathematical lucidity and order, helping lay the foundations for ideal landscape painting for the next two centuries. In his last years, when he had become something of a hermit, his style changed, becoming less rational, and at times showing an almost mystical poetic approach. His work was influential in shaping the official doctrines of the French Academy of Painting and Sculpture (founded 1648), and was an inspiration to *Neoclassical artists, and, later, to *Cézanne, who said that he wanted 'to do Poussin again, from Nature'.

Powell, Anthony (Dymoke) (1905–), British novelist. A distinguished writer of social comedy, his initial reputation as a satirist rests on five books, beginning with *Afternoon Men* (1931), which portray a seedy section of pleasure-loving London. A later sequence of twelve autobiographical and satiric novels, *A Dance to the Music of Time* (named after Poussin's painting), began with *A Question of Upbringing* (1951) and ended with *Hearing Secret Harmonies* (1975). The narrator, Nicholas Jenkins, paints a rich and detailed canvas of literary and artistic society, against which is set the ruthless character of Kenneth Widmerpool, whose pursuit of power carries him from ludicrous beginnings to a position of sinister authority.

Powell, Michael (1905–90) and **Pressburger, Emeric** (1902–88), British film-makers (the latter born in Hungary), whose collaboration in writing, direction, and production created films of great individuality. Their first film, *The Spy in Black* (1939), was followed by films as diverse as the wartime *One of Our Aircraft is Missing* (1942); *The Life and Death of Colonel Blimp* (1943), which spans forty years in the life of its leading character; *I Know Where I'm Going* (1945), a love story set in the Highlands of Scotland; *A Matter of Life and Death* (1946), about a pilot's fantasies after a brain operation, notable for its settings; and *Black Narcissus* (1947), a study of sexual repression in a Himalayan convent. *The Red Shoes* (1948) is perhaps the most shown of all ballet films, while *The Tales of Hoffman* (1951) was based on Offenbach's opera. After their partnership ended in 1956 Powell continued making films on his own.

Powys, John Cowper (1872–1963), British novelist. He grew up in the Somerset–Dorset countryside that had a central place in his writing. His best-known novel is *A Glastonbury Romance* (1932), in which Glastonbury and its legends exert a supernatural influence on the life of the town. This was followed by *Weymouth Sands* (1934) and *Maiden Castle* (1936), both blending powerful characters,

intense relationships, and a strong sense of place. Powys's late writing concentrates on historical themes: the most famous novel is *Owen Glendower* (1940), set in the land of Wales which had become his home. Much controversy centres on his stature as a writer: some regard him as a neglected major novelist, while others find his style to be contrived.

Praetorius, Michael (*c*.1571–1621), German composer and writer on music. As a composer he was enormously prolific—his sacred music, largely based on Protestant hymns and ranging in style from the Venetian polychoral manner (see *polyphony) to quite simple harmonizations, ran to over 1,000 works. Of his equally popular dance music only the collection *Terpsichore* (1612) has survived. He is best remembered for his treatise *Syntagma musicum* (1614–19), which contains much information about contemporary instruments and performing styles.

Pratt, Sir Roger (1620–85), English architect. He designed only a handful of buildings, all of which have been either altered or destroyed. However, he ranks as the most talented and most influential of Inigo *Jones's followers. His major work was Clarendon House in Piccadilly (1664–7), London's first large classical house; although it was demolished as early as 1683, it became the model for country seats throughout Britain. The design shows Pratt's extensive continental travels, for although some of the detailing is inspired by Jones and *Palladio, the steep roof and the architecturally treated chimney-stacks reflect French ideas.

Praxiteles (*fl.* mid-4th century BC), with Phidias the most famous of Greek sculptors. Various works by him described by ancient authors are known through Roman copies, and a marble statue of *Hermes and the Infant Dionysus* in the museum at Olympia is considered by many authorities to be by his own hand. If this is so, it is the only surviving original by a Greek sculptor of the first rank. In antiquity his most famous work was the *Aphrodite of Cnidus*, the first free-standing life-size female nude in Greek art. Praxiteles was a highly influential artist, the tenderness and intimacy of his work marking a decisive move away from the remote idealization of the style of the previous century.

Pre-Columbian art *Central American and Mexican art, *South American Indian art.

predella, a term in art describing a subsidiary picture forming an appendage to a larger one, especially a small painting or series of paintings beneath the main panel of an altar-piece. Originally the step or platform on which the altar was placed, predella panels usually relate in subject to the main picture above them—if a particular saint is shown in the main panel, for example, there may be incidents from his or her life in the predella. When predella panels have been detached from their altar-piece they can sometimes be recognized by their shape, which is often (although not necessarily) very wide in relation to height.

prelude, a piece of music that acts as an introduction to something else. Thus a *suite may commence with a prelude, an *opera may begin with one, or a *fugue may be preceded by one. In the 19th century the term was

used as a title for short piano pieces. Chopin, Debussy, and Rachmaninov, among others, published books of preludes.

Pre-Raphaelite Brotherhood, a small group of young English artists formed in 1848 who took their name from their desire to revive the sincerity and simplicity of early Italian painting (before the time of Raphael). The nucleus was formed by three fellow students—*Holman Hunt, *Millais, and *Rossetti. They chose religious or other morally uplifting themes; their desire for fidelity to nature was expressed through detailed observation and the use of a clear, bright, sharp-focus technique. At first the group was bitterly attacked (their work was thought to be not only unidealized but even sacrilegious in representing biblical characters as ordinary people), but their fortunes improved after the critic *Ruskin publicly defended them in 1851. However, the group had virtually disbanded by 1853, as the individual artists went their separate ways, only Holman Hunt remaining true to the original doctrines throughout his career. Although the group was small and short-lived, it had considerable influence, and curiously it was Rossetti, the least committed to the Brotherhood's ideals, who continued the name. His later work, mainly pictures of beautiful, languorous women, is entirely different from his original Pre-Raphaelite pictures, but the name stuck to them, and

This intensely spiritual picture, *Beata Beatrix* (1864–70), was painted by Dante Gabriel Rossetti as a memorial to his wife, Elizabeth Siddal, who died in 1862 from an overdose of laudanum (possibly deliberate). It expresses Rossetti's love for her as a parallel to the Italian poet Dante's love for the enigmatic Beatrice, his inspiration. Such depictions of beautiful women became a feature of the pseudo-medieval type of **Pre-Raphaelitism** that Rossetti inspired. (Tate Gallery, London)

thus in the popular imagination the term 'Pre-Raphaelite' conjures up the romantic, pseudo-medieval pictures produced by Rossetti and his followers such as *Burne-Jones.

Presley, Elvis (Aaron) *rock music.

Pressburger, Emeric *Powell, Michael.

Prévert, Jacques *Carńe, Marcel.

Prévost d'Exiles, Antoine-François, abbé (1697–1763), French novelist and Roman Catholic priest. He is chiefly remembered for his novel *Manon Lescaut* (1731), which recounts the descent of Des Grieux into vice under the influence of his love for the seductive but wayward Manon. Narrated in the first person by Des Grieux himself, it depicts the moral dissolution of contemporary society and illustrates the cult of sensibility. Through his literary periodical *Le Pour et Contre* (1733–40) and his translations of *Richardson's novels, Prévost fostered the vogue for English literature in 18th-century France. His novel inspired Massenet's opera *Manon* (1884) and Puccini's opera *Manon Lescaut* (1893).

Priestley, J(ohn) B(oynton) (1894–1984), British novelist, dramatist, and critic. His many novels include *The Good Companions* (1929), a *picaresque account of the life of travelling performers, and *Angel Pavement* (1930), a *realist novel of London office life. His best-known plays include his psychological drama with moral overtones, *An Inspector Calls* (1947), and his West Riding farce, *When We Are Married* (1938). His vast output ranged from travel works to the ambitious history of *Literature and Western Man* (1960).

primary colours, in painting, those colours—blue, red, and yellow—that cannot be made from mixtures of other colours. Two primaries mixed together form a *secondary colour*, red and yellow making orange, red and blue making purple, and yellow and blue making green. A related term is 'complementary colour'; blue is the complementary of orange (made up of the other two primaries), red is the complementary of green, and yellow is the complementary of purple.

Primaticcio, Francesco (c.1504–70), Italian painter, architect, and decorative artist, mainly active in France. In 1532 he was called to France by Francis I to work at his palace at Fontainebleau. Together with another Italian, Rosso Fiorentino, Primaticcio provided the main impetus for the distinctive French type of *Mannerism known as the School of Fontainebleau. In particular they developed a type of decorative scheme in which paintings are combined with *stucco ornament. In his later years Primaticcio turned more to architecture and his work helped to introduce *Renaissance elements to France.

primitive art, a term that in its broadest sense has been applied to the art of all societies outside the great Western and Oriental civilizations. Thus Pre-Columbian American art is embraced by the term, even though much of it was produced by peoples who had highly developed cultures. The term has also been used of pre-Renaissance European painting, but this usage is now much less common. In another sense, the word is used more or less as a synonym for *naïve, for example of the works of Henri *Rousseau.

primitivism, a preference for the simpler existence of 'primitive' peoples as opposed to the artificialities of urban civilization. Such nostalgia for lost innocence is found in all ages, but especially in late 18th-century Europe, where it strongly encouraged the emergence of *Romanticism. The most influential primitivist writer was J.-J. *Rousseau, who contrasted the dignity and freedom of the 'noble savage' with the disorientation of the over-cultivated citizen. The popular epic poems of 'Ossian', actually forged in the 1760s by the Scottish poet James Macpherson and passed off as ancient Gaelic works, added to the primitivist climate. In Romantic literature, primitivism appears in *Wordsworth's exaltation of rural sincerity, in *Cooper's Indians and pioneers, in *Melville's South-Sea Islanders, and later in *Lawrence's protest against rationalized industrial society. (See also *primitive art.)

print, a term in art to describe an impression on paper or similar material made from a design cut or otherwise established on a sheet of metal, a wooden block, or other suitable surface. Print processes divide into four groups. In *relief methods, for example *woodcut, the parts that are to print black are left in relief and the other parts are cut away. In *intaglio methods, for example *etching, the principle is the reverse, the ink being held in lines incised into the plate. In surface or planographic methods, such as *lithography and its variants, the design is printed from a flat surface, the inked and non-inked areas being created by the antipathy of grease and water. In stencil methods, for example *silk-screen printing, the principle involved is of brushing colour through a hole cut in one surface on to another beneath. (See also *ukiyo-e.)

private press movement, movement in the late 19th and early 20th centuries, chiefly in Britain, in which individuals set up small publishing concerns to produce handmade books of a high standard of workmanship in typography, printing, and design. Their members were protesting against the low artistic standards and degradation of labour in the printing trade, and were thus allied to the ideals of the *Arts and Crafts Movement. The movement was initiated by William *Morris's Kelmscott Press (founded 1890), famous above all for its edition of Chaucer's works (1896) illustrated by *Burne-Jones. Many of the other private presses, including the Ashendene, Nonesuch, and Golden Cockerell presses, commissioned leading artists (including Eric *Gill, Eric Ravilions, and Reynolds Stone) to work for them, and they stimulated a revival of *wood-engraving for illustration. Private presses still exist, but the movement as such was undermined by improved standards in commercial printing and *typography.

programme music, music which attempts to tell a story, evoke an atmosphere, or in some way illustrate a non-musical event. The term originated with Liszt's *symphonic poems, though the practice of writing descriptive music was established long before that, and received a particular impetus from the needs of *opera to illustrate dramatic situations. Most programme music, however—even that of such a master of description as Richard Strauss—requires to be supplemented by some verbal clue (a title or a 'programme note') if its meaning is to be plainly understood. Music that is not descriptive is said to be abstract.

This Japanese **print** by Ichyosa Kunichika shows a theatrical scene of one actor stabbing another. Japanese prints use the technique of woodcuts to obtain their stylized yet naturalistic effects. (Victoria and Albert Museum, London)

Prokofiev, Sergey (Sergeyevich) (1891–1953), Soviet composer and pianist. He made a considerable impression, both as pianist and as progressive composer, with his First Piano Concerto (1912). His Second Piano Concerto (1913) scandalized audiences and critics with its dissonance and quality of satirical aggression, but his First Symphony (the 'Classical', 1917) charmed them with its witty distortions of 18th-century practices. This mixture of *burlesque and passion came to be a notable part of his style. Prokofiev left Russia at the outset of the 1917 Revolution, moving first to the USA, to Paris in 1922, finally returning to the Soviet Union in 1936. Chief among his works are seven symphonies, six piano concertos and two violin concertos, together with such operas as *The Love for Three Oranges* (1919), *The Fiery Angel* (1923), and *War and Peace* (1943), and the ballets *Chout* (1915), *Romeo and Juliet* (1936), and *Cinderella* (1944). Though certain works achieved great popularity, for example the children's tale *Peter and the Wolf* (1936) and the music for the film *Alexander Nevsky* (1938), he was not immune from Soviet criticism.

prologue, an introductory section of a play, speech, or other literary work; also the name given to an actor

speaking a set of introductory lines in a play. Chaucer's 'General Prologue' to *The Canterbury Tales* describes the various pilgrims before they tell their tales on the journey to Canterbury.

proportion, a term used in the visual arts to describe the harmonious relationship of the parts of a work to each other or of the parts to the whole. Often artists arrive at ideas of proportion intuitively, but there have also been many attempts to discover or work out systematic rules governing it. The Greek sculptor Polyclitus (5th century BC), for example, wrote his *Canon*, a treatise on a mathematical system of porportion, which he embodied in his statue the *Spear Carrier*, and Dürer was the most profound student of proportion among the great artists of the Renaissance, publishing two books on the subject. In the field of architecture, Alberti, Palladio, and Le Corbusier are among the many distinguished figures who have been particularly concerned with theories of proportion. Ideas about proportion have often been linked with notions of cosmic harmony, particularly in the case of the *Golden Section.

Proust, Marcel (1871–1922), French novelist, essayist, and critic, of Jewish descent. He is remembered as the author of one of the greatest novels of all time, *À la recherche du temps perdu* (1913–27). Based on his own life told allegorically and psychologically, the central character, Marcel, recounts his life-story from his childhood holidays with his well-to-do middle-class family in Combray to the salons of the Parisian *fin-de-siècle* élite, which he finally penetrates. The narrative, written in seven sections, evolves on several planes at once. It provides Proust with opportunities to discuss many themes, including love, art, and time's disintegrating action on society. Proust's preoccupation with the subconscious, intuition, and memory owes much to the influence of the *Symbolists, the philosopher Henri Bergson and, later, the psychology of Sigmund Freud. The complexity of the subject is reflected in the long but poetically resonant sentences for which the book is famous. Recognition of the novel's qualities was not immediate: the first volume was rejected by publishers and printed at the author's expense. A revised version appeared in 1917. *À l'ombre des jeunes filles en fleur* received the *Goncourt Prize in 1920. Proust was actively involved, on the side of Dreyfus, in the Dreyfus case of 1897–9, but in later life became almost a recluse, dedicating himself to the completion of his great work. In *Contre Sainte-Beuve* (1954) he explores his own literary aesthetic, defining the artist's task as the releasing of the creative energies of past experience from the hidden store of the unconscious.

Provençal literature, literature from the Occitan- or Languedoc-speaking regions of southern France. Classical Provençal literature was written by troubadours (see *minstrels) from the 11th to the 14th centuries. Relative prosperity and a pleasant climate had favoured the early development of a cultivated and literate feudal society in the south of France, in which the French *lyric poem had its origins. The troubadours, such as Bertrand de Born and Bernard de Ventadour, composed songs and poems of elegant simplicity for court circles in which the daughters of territorial lords played a prominent part. Their poems extolled the ethic of *courtly love (*amour courtois*), which required the man, usually a knight, to serve his mistress with chivalry and devotion. Among important Provençal *chansons de geste* is the long poem *Girart de Roussillon*. Through Eleanor of Aquitaine, wife of Louis VII, and her daughters, the values of courtly love influenced *Chrétien de Troyes and other writers of northern France. The 14th century saw Provençal writing in decline; the dramatic literature of the 15th and 16th centuries consisted of mystery and miracle plays. In the 19th century a revival of interest was stimulated by *Mistral and the foundation of the *Félibrige* movement.

proverb, a short, popular saying of unknown authorship, expressing some general truth or superstition. Proverbs are found in most cultures, and are often very ancient. The Hebrew scriptures include a *Book of Proverbs*. Many poets—notably Chaucer—incorporate proverbs into their works, and others imitate their condensed form of expression: Blake's 'Proverbs of Hell' in *The Marriage of Heaven and Hell* (1793) are, strictly speaking, *aphorisms, since they originate from a known author.

Prus, Boleslaw (Aleksander Głowacki) (1847–1912), Polish novelist. He was a journalist and for nearly forty years wrote sharp, witty *Weekly Chronicles*, revealing a talent for observation, and the compassion and scepticism that informed subsequent works. The early didactic short stories were followed by his first novel, *The Outpost* (1886), about failure and survival set in a Polish village. His most important novel *The Doll* (1890), a portrait of Warsaw, illustrates the need for positive action in a society tainted by romantic idealism. The plot centres on a successful businessman, a scientist *manqué*, who allows himself to be destroyed by an obsessive love. After *Emancipated Women* (1893) Prus took ancient Egypt as the setting in which to discuss the nature of state power, and the organic structure and decay of society, in *The Pharaoh* (1897).

psalm, a sacred song or hymn. The term usually refers to the Hebrew verses in the biblical *Book of Psalms*, sometimes attributed to King David. These psalms, notably in the English translation attributed to Miles Coverdale (*c.*1488–1569) and found in the *Book of Common Prayer* (1662), have had an important place in Christian worship and in English religious poetry.

psaltery, a musical instrument, consisting of a flat soundbox with strings (plucked with fingers or *plectra) running across it. It was widely used in the Middle Ages, from the 10th century in the triangular shape of a harp and, from the 13th century, in an isosceles trapezoid shape with the non-parallel sides curving inwards. A later version halved this, producing a shape identical, in miniature, to the *harpsichord, which is a mechanized psaltery. In the 17th century a harp-like psaltery appeared as the *arpanetta* or *Spitzharfe*, with strings on both sides of the soundbox.

Puccini, Giacomo (1858–1924), Italian composer. His third opera, *Manon Lescaut* (1893), achieved international acclaim and there followed a series of works which immediately dominated the world's operatic stages: *La Bohème* (1896), *Tosca* (1900), *Madam Butterfly* (1904), *The Girl of the Golden West* (1910), *The Swallow* (1917), and the unfinished *Turandot* (performed posthumously in 1926). Puccini's capacity to absorb contemporary musical advances and marry them to soaring vocal lines, deployed

A detail from Hans Memlinc's painting 'Angel Musicians' in which an angel plays a **psaltery**. The instrument existed in a multitude of forms during the Middle Ages and early Renaissance. Its sound was fairly soft, and it was often played with an ensemble of viol, lute, flute, and drum. The *qanun* psaltery was a leading instrument of Middle Eastern classical music from Egypt to Iraq. (Koninklijk Museum voon Schone Kunsten, Antwerp)

with outstanding theatrical effect in personal dramas of great emotional intensity, made him one of the world's most successful opera composers.

Pugin, Augustus Welby Northmore (1812–52), British architect, designer, writer, and medievalist, one of the key figures of the *Gothic Revival and of Victorian design in general. Pugin achieved precocious success as a furniture designer, and after his conversion to Roman Catholicism in 1835 he devoted himself with enormous energy to building churches and houses and designing over a wide field. He believed that the art of a country reflected its spiritual state and that English art had been in decline since the Reformation. This notion was forcefully promulgated in his book *Contrasts* (1836), with which he became famous; it compares the meanness of contemporary buildings with the glories of the medieval (that is, Catholic) past. His ideas were influential on, for example, *Ruskin. Pugin was often hampered by financial constraints in his work, but cost was not a restriction in his work on the Houses of Parliament, and here he created one of the great decorative ensembles of the 19th century. *Barry was responsible for the basic architectural forms, but Pugin designed the exterior and interior ornament, down to details such as inkstands.

Pulci, Luigi (1432–84), Italian poet. A Florentine who frequented Lorenzo de' Medici's court, he is the author

of the *burlesque *epic *Morgante*, started in 1466 and published in its final extended version of twenty-eight cantos in 1483. Like his successors, *Boiardo and *Ariosto, he drew on French chivalric material but injected, in the characters of the giants Morgante and Margutte, his own brand of plebeian humour. The predominantly comic tone of the poem at times alters to express his own deeply felt religious problems in the face of his bitter experience of life. His use of *ottava rima* helped to establish this style in subsequent works of a mock-heroic character.

puppetry, entertainment in which inanimate figures are manipulated by humans to give an impression of spontaneity. The hand or glove puppet is the simplest and most familiar, normally requiring the use of three fingers, the thumb and second finger moving the hands, and the first finger the head. The puppets are held above the head of the puppeteer, who stands inside a booth—as in the British Punch and Judy show—or behind a' screen. Hand puppets are limited in size and gesture, and only two characters can normally be shown at a time. Punch, like the French Guignol (see Théâtre du *Grand Guignol), the German Kasperl, and the Russian Petrushka, derives from the *commedia dell'arte*'s Pulcinella. He was originally a marionette, a type of puppet controlled from above by fine threads attached to the limbs, shoulders, head, and back. These are much less limited than hand puppets and have been used for the performance of full-length plays and operas. There are hand-puppets in China; in India, where they were once very common, they survive mainly in Kerala. Rod puppets, still used in India and Java, are full-length figures. Controlled from below, they are slow and measured in their movements. The *bunraku* puppets of *Japanese drama are about two-thirds life-size; they carry controlling mechanisms in their backs. The (visible) operators work in teams, no puppet being workable by one operator alone.

Among the most striking uses of **puppetry** in the world is the highly stylized Japanese *bunraku* theatre. Here the figures may be operated by as many as three manipulators at a time: the facial movements are controlled by means of strings inside the body and the co-ordination of the artists requires long and devoted training. The text is chanted to the accompaniment of a *shamisen* instrument.

Indian string puppets, now mostly used for the 'dance of the dolls', are manipulated somewhat differently. *Shadow plays are another form of puppetry. Puppets, which date back to Ancient Greece and Ancient Egypt, are today most often encountered in Sicily, Eastern Europe, and the Far East. A form of puppetry used for political *satire is seen on Western television, and puppets are also used to provide children's entertainment.

Purānas ('Purana of the Blessed Lord'), collections of Hindu legends and traditions in Sanskrit. They are regarded as divinely inspired texts, each glorifying a particular god, but are also encyclopedias of secular as well as religious knowledge. Most were composed by AD 1000, but with many additions later. The most popular is the *Bhagavatapurana* ('Purana of the Blessed Lord'), containing the life of Krishna.

Purcell, Henry (1659-95), English composer, organist, and singer. The most outstanding member of a family of musicians, he trained as a chorister of the *Chapel Royal. Purcell contributed many splendid *anthems to the Chapel Royal services and wrote many elaborate choral odes and welcome songs for royal occasions. His personal taste, however, was more for the theatre and he wrote incidental music for many plays, together with five

John Closterman made this chalk drawing of **Purcell** in 1695, the year of the composer's early death at the age of 36. Six years earlier Purcell had written the opera *Dido and Aeneas*, thus introducing the operatic tradition to Britain. He was a prolific composer, but only a fraction of his music is widely known, and there are many riches to be found among the little-performed songs, odes, and church music. (National Portrait Gallery, London)

important semi-operas: *The Prophetess* (1690); *King Arthur* (1691); *The Fairy Queen* (1692); *The Indian Queen* (1695); and *The Tempest* (c.1695); and one true opera, *Dido and Aeneas* (1689). He wrote nine odes for various occasions in the 1690s. In these, as in all his music, he showed remarkable technical skill and creative originality.

Purism, a movement in French painting flourishing from about 1918 to about 1925. The founders and chief exponents were *Le Corbusier (better known as an architect) and Amédée Ozenfant (1886-1966), who was more important as a writer and teacher than as a painter. They thought that *Cubism had developed into a facile, decorative style and advocated a return to its original clarity and order, to create an art in tune with the Machine Age. The paintings they produced in line with this doctrine were predominantly *still lifes—painted in light, clear tones. Although Purism was short-lived and the art to which it gave rise was rather arid, it had a considerable influence in the field of design.

Pushkin, Aleksandr (Sergeyevich) (1799-1837), Russian poet, novelist, dramatist, and short-story writer. Coming from an impoverished noble family, he received the most privileged education available and moved in the highest Russian literary circles in his youth. He made his name with the romantic tale in verse *Ruslan and Lyudmila* (1820). He balked at the civil service career for which his education had trained him, and his rebelliousness and sympathy with what was to become the Decembrist movement led to exile from both Moscow and St Petersburg (now Leningrad) (1820-6). During this period he wrote a series of Byronic tales, including *The Gypsies* (1827). His novel in verse, *Eugene Onegin*, the fountainhead of the Russian tradition, was published in 1833. He introduced Shakespearean features into the Russian drama in *Boris Godunov* (published 1831, staged 1870). Money problems harassed Pushkin throughout his adult life, especially after he married in 1831. He turned to prose partly for commercial reasons, and produced a series of masterpieces, including *The Tales of Belkin* (1830), *The Queen of Spades* (1833), the historical novel *The Captain's Daughter* (1836), and a non-fictional history of the Pugachov rebellion (1834). The four *Little Tragedies* (1830) are the culmination of his dramatic works in verse. In *The Bronze Horseman* (1833) he dramatically embodied the central problem of the individual and the state in Russian history. Pushkin drew together the achievements of 18th-century Russian literature, added his invigorating knowledge of French neoclassical writing, creatively absorbed contemporary *Romantic influences (notably *Byron and *Scott), and developed what has remained the classic Russian verse style: clear and melodious, passionate but controlled, highly regulated in form, relatively unadorned, and sparkling with humane wit. He remains, unchallengeably, Russia's national poet, profoundly influencing Russian cultural life, and providing dramatic settings for operas by Musorgsky, Tchaikovsky, and others.

Pu Songling (1640-1715), Chinese short-story writer of the Qing dynasty (1644-1911). He is best known for his collection mainly of ghost stories, *Strange Tales from Liaozhai* (1766), written in the classical idiom. These include traditional tales he collected and stories of his own creation.

This portrait of **Pushkin** (1827) is by Orest Kiprensky, one of the finest Russian painters of the Romantic period. It was commissioned by another poet, Baron Anton Delvig, and after the Baron's death in 1831 was owned by Pushkin himself. (Tretyakov Gallery, Moscow)

putto (from the Latin, *putus*, boy, child), a representation of a chubby, naked child, sometimes winged, in a work of art. Putti have been a frequent motif of decorative art since classical antiquity and often occur in paintings of the Renaissance and Baroque periods. They derived from a type of figure used in ancient art to represent Eros, the Greek god of love, and a putto has often been used in pictures to represent his Roman counterpart, Cupid. More commonly, however, putti are anonymous subsidiary figures pictured attending classical gods or the Virgin Mary.

Puvis de Chavannes, Pierre (1824–98), French *mural painter. His influence on younger contemporary artists was important, and he was respected by artists pursuing very different aims. His simplified forms, rhythmic line, and use of non-naturalistic colour to evoke the mood of the painting appealed to both the *Post-Impressionists and the *Symbolists.

Pynchon, Thomas Ruggles (1937–), US novelist and short-story writer. His three novels share such themes as the relationships between political power and individual paranoia, history and the present, modern love and modern death. *V* (1963) is set in New York in the 1950s, and in various European cities at critical moments in the 20th century; *The Crying of Lot 49* (1966) in California in the 1960s; and *Gravity's Rainbow* (1973) in London and northern Germany towards the end of World War II, with the leading characters converging in search of the V2 rockets. Like all Pynchon's works, the mood moves from black humour to lyricism, and the dream-like fantasy is marked by labyrinthine interconnections until the reader is uncertain about what is 'real' and what is imagined. *Slow Learner* (1984) collects short stories largely written in the 1950s.

Qajar art *Persian art.

qin *koto.

Quarenghi, Giacomo (1744–1817), Italian-born architect who settled in Russia in 1779 and became Catherine the Great's favourite architect. He was not an original designer, but his prolific output is consistently of a high standard and he ranks among the important exponents of *Neoclassicism in Russia. Many of his finest buildings are in Leningrad, including the Academy of Sciences (1783–7) and the Hermitage Theatre (1782–5).

Quarrel of the Ancients and Moderns, a dispute in French literary history which developed in the latter part of the 17th century between the advocates of imitation of the literature of classical antiquity and the champions of progress and new ideas. *Boileau and *La Fontaine argued for the superiority of classical literature, while Charles Perrault (1628–1703) and others maintained the superiority of modern writers, as representatives of the maturity of the human intellect.

Quasimodo, Salvatore (1901–68), Italian poet, critic, and translator. A powerful voice on modern social issues, his volumes of poetry include *Water and Land* (1930) and *Day after Day* (1947). His dry, sophisticated style is at times expressed in abstruse symbolism and overlaid with Surrealist intonation, which in his later poems changes to simpler language and concrete imagery. He was awarded the Nobel Prize for Literature in 1959. Between 1930 and his death, Quasimodo translated many Greek tragedies, poems from the Latin, plays by Shakespeare and Molière, and the poetry of e. e. cummings and Pablo Neruda.

quatrain, a verse *stanza of four lines, rhymed or (less often) unrhymed. The quatrain is the most commonly used stanza in most European languages. Most *ballads and many *hymns are composed in quatrains in which the second and fourth lines rhyme (ABCB or ABAB). A different *rhyme-scheme known as the 'envelope stanza' (ABBA) was used by Tennyson in *In Memoriam* (1850). The rhyming four-line groups which make up the first eight or twelve lines of a *sonnet are also known as quatrains.

quattrocento, a term (Italian 'four hundred') applied to the 15th century (the 1400s) in Italian art.

Quechua *South American Indian literature.

Queen Anne style, a term applied to an English architectural style considered typical of the reign of Queen Anne (1702–14), or more loosely of the period c.1660–c.1720. It is a style mainly of domestic architecture, characterized by a Dutch-influenced use of red brick in sensible, straightforward, basically rectangular designs, out of which the *Georgian style grew. In the late 19th

century the Queen Anne style was revived, often in a more elaborate and rich way, by Richard Norman *Shaw and other architects. Sometimes the revived style is referred to in inverted commas as 'Queen Anne style' to distinguish it from its inspiration.

Quercia, Jacopo della (*c*.1374–1438), Italian sculptor of the *Sienese school. He was one of the outstanding figures of his time in Italian sculpture, alongside *Donatello and *Ghiberti. His major works included a public fountain for Siena (now, much damaged, in the loggia of the Palazzo Pubblico there), and reliefs on the portal of San Petronio, Bologna, commissioned in 1425 and left unfinished at his death. The figures have a directness and strength that won the admiration of Michelangelo when he visited Bologna in 1494.

Quevedo y Villegas, Francisco Gómez de (1580–1645), Spanish satirist and novelist. Acerbic satire was a characteristic of much of his verse and prose, which included the *picaresque novel *The Life of a Scoundrel* (1626), the satirical *Visions* (1627) of the inhabitants of hell, poems of various types, most of which were published after his death, political and religious works, among them *The Polity of God* (1626–55), *The Life of Brutus* (1644), *The Constancy and Patience of Saint Job* (1641), and pamphlets like *In Defence of Spain* (1609). Quevedo's style employs the then new Baroque style, *conceptismo*, a complicated word-play which involves wit or *conceits.

quilting, a type of needlework in which two layers of fabric are stitched together, usually with a soft, thick substance such as wool between them. The stuffing provides insulation for warmth, and the stitching holds it evenly in place as well as providing an opportunity for artistic expression. Quilting is an old traditional craft that has been popular in most European countries since the Middle Ages. The practice is also widely used in Asia and in the Muslim regions of Africa. It has been largely a *folk art and is still practised in parts of Britain and the USA. Apart from its most familiar role in making bed coverings, it has also been used for warm, light clothing, and in the Middle Ages quilted garments were sometimes worn underneath armour to prevent chafing from the metal. In Britain in the 17th and 18th centuries there was also a vogue for more sophisticated quilted garments.

Quintilian (Marcus Fabius Quintilianus) (AD *c*.35–*c*.100), Roman *rhetorician. Born in Spain, he spent some years in Rome practising advocacy and teaching the art of public speaking. His learning and experience are distilled in *Training of an Orator*, which survived as an admired textbook in the Middle Ages and Renaissance.

Qu Yuan (*c*.340–*c*.278 BC), China's first known poet. Qu is traditionally credited with the authorship of *Songs of the South* (*Songs of Chu*), a collection of elegiac poems from Chu, one of the Warring States. It is quite likely that he wrote *On Encountering Sorrow* (*Li Sao*), an *allegory in which a spiritual quest represents the search for recognition of statesmanlike virtues. His death by drowning when he heard that Chu had been overthrown by the rival Warring State of Qin is still commemorated in China at the Dragon Boat Festival. The genre of poetic writing created by Qu Yuan was cultivated for more than five centuries.

Rabelais, François (*c*.1494–*c*.1553), French humanist and satirist. At one time a Franciscan monk, he is remembered for the satirical stories characterizing the popular giants *Gargantua* (1534) and *Pantagruel* (1532). They are marked by comic inventiveness, ranging from obscenity, wit, and jokes to parody, invective, and fantasy. Rabelais's intellectual curiosity encompasses virtually all the sciences of his age—theology, law, medicine, natural science, politics, military art, and navigation. His knowledge of contemporary life and society is without rival. His command of the vernacular, sustained by an encyclopedic vocabulary and a virtuoso's rhetorical repertoire, and extending beyond French and its dialects to a dozen contemporary languages, remains unique in French literature. His work as a whole seems to rest on a moderate, progressive Protestantism opposed to tyranny, dogmatism, and war. His realism recognizes the physical functions of mankind, affirms its uncorrupted origins, trusts in the effectiveness of virtuous action, and urges gaiety of mind as a supreme good. His influence on English literature has been widespread, though particularly marked on Butler, Swift, Sterne, and Joyce.

Rachel (Elisa Félix) (1820–58), French actress. Born to poor Jewish parents, she was discovered as a street-singer, and from 1838 led a series of important revivals of Corneille's works at the Comédie-Française. A specialist in tragic roles—notably in Racine's *Phèdre*—she was acclaimed as the greatest actress of her day, and toured widely before her early death from tuberculosis.

Rachmaninov *Rakhmaninov, Sergey.

Racine, Jean (1639–99), French dramatist. His first successful play, *Andromaque*, was published in 1667. It was followed by seven tragedies culminating in *Phèdre* (1677). Racine most characteristically draws his inspiration from *Greek literature, though in *Britannicus* (1669) and *Bérénice* (1670) he competed directly with *Corneille by using Roman and political themes usually associated with his great rival. He also wrote *Esther* (1689) and *Athalie* (1691), sacred dramas intended for performance by the girls at the school of Saint-Cyr. Racine's protagonists, reflecting both a Jansenistic and a Greek view of man, are the victims of their fate, and, unlike Corneille's heroes, cannot dominate their passions by an exercise of will. Also unlike Corneille, Racine was content to write within the constraints of the rules of composition (see *tragedy) which were increasingly being imposed on French drama.

racket, a small double-reed musical instrument producing low notes. A series of bores drilled in one piece of wood or ivory are linked together by channels carved in the end caps, so that a single tube zigzags up and down, compressing a long tube into a short space. Renaissance rackets were cylindrically bored like *crumhorns.

Radcliffe, Ann (b. Ward) (1764–1823), British novelist. She was the leading exponent of the *Gothic novel. Her

plots are wild and improbable, but the raptures and terrors of her characters are compelling and she was an expert at maintaining suspense. Her novels in this mode include *The Romance of the Forest* (1791), *The Mysteries of Udolpho* (1794), and *The Italian* (1797).

Raeburn, Sir Henry (1756–1823), British portraitist. He painted directly on to the canvas without preliminary drawings, and his vigorous, bold handling could be extremely effective in conveying the character of rugged Highland chiefs or local legal worthies. He painted some sensitive portraits of women and had a penchant for vivid and original lighting effects; at times, however, his technical facility degenerates into empty virtuosity.

rāga *Indian music.

ragtime, a type of US popular music which flourished from about 1890 to 1920 in parallel with the emergence of *jazz. Its main characteristic is a syncopated melody over a steady beat in the accompaniment, generally in 2/4 time. The word 'rag' suggests the 'ragged' quality of the syncopated melody. Though ragtime is generally associated with piano music and such composers as Scott *Joplin, it also developed orchestral forms, and a song form, as in Berlin's 'Alexander's Ragtime Band'.

Rainer, Yvonne (1934–), US dancer and choreographer. She was one of the founders of the Judson Dance Theater and the Grand Union group. Working collectively in groups, with movements derived from ordinary life, she was deliberately anti-technique and against the mystique of theatre art. Her famous *Trio A or the Mind is a Muscle* (1966) became the hallmark of *postmodernism in dance.

Rajput painting, painting produced at the courts of Rajputana (a region of north-west India coinciding roughly with the present-day state of Rajasthan) from about 1600 until the 19th century. The Rajputs were a warrior people and mainly Hindus; Rajput painting includes many Hindu subjects, notably the legends of Krishna and his love for Radha, but also other subjects such as royal portraits, hunting scenes, and scenes of court life, often in architectural settings. As well as manuscript illustrations in the form of miniatures, Rajput painting included independent portraits and frescos decorating palace walls. Although it was once regarded as an offshoot of *Mughal art, Rajput painting is now known to have had more complex origins, its sources including the manuscript tradition of *Jain art. Whereas Mughal painting was often based on close observation of the natural world, Rajput painting was stylized and often highly poetic in spirit. Its great age came to an end with the influx of European influence from about 1800.

Rakhmaninov, Sergey (Vasilyevich) (1873–1943), Soviet composer, conductor, and pianist. Among his important works are the Second Symphony (1907), the symphonic poem *The Isle of the Dead* (1909), and the choral symphony *The Bells* (1913). The chaos following the 1917 Revolution forced him to leave Russia for Scandinavia; he later (1919–20) began a highly successful career in America as a concert pianist. Rakhmaninov's music represents one of the high points of *Romanticism. The three symphonies and four piano concertos, not to

mention the remarkable Rhapsody on a Theme of Paganini (1934) and the Symphonic Dances (1940), fully deserve the place they hold in the popular repertory.

raku, a type of Japanese pottery invented in Kyoto in the 16th century specifically for the tea ceremony. Raku vessels are made of lead-glazed earthenware and are moulded by hand rather than thrown on a potter's wheel. Some have simple decoration, but generally they depend for their effect on irregularity of shape, expressing the individuality of the maker's hand, and on beauty of colour and texture. Colours of the *glazes include red, green, and cream. The word *raku* means 'enjoyment' or 'felicity', and a seal bearing this word was impressed on many early examples. This distinction is said to have been awarded in the 16th century by Toyotomi Hideyoshi, chief imperial minister of Japan, to the wares of Tanaka Chojiro, the son of the inventor of raku. Chojiro adopted the name 'Raku' for himself, and like that of *Kenzan, it has been handed down from master to favourite pupil to the present day.

Rāmāyaṇa ('The Goings of Rama'), one of the two great epics of *Sanskrit literature. Its 24,000 verses, attributed to Valmiki, narrate Prince Rama's banishment from Ayodhya, his life of exile in the forest, his wife Sita's abduction by Ravana, the demon king of Lanka, the rescue of Sita aided by the monkeys, and their triumphant return home. The nucleus of the story probably existed by 500 BC, but many elements were added later, including identifying the hero Rama as an incarnation of the Hindu god Vishnu. Its enduring popularity is attested by versions in almost every Indian language. The version of the *Rāmāyaṇa* by Tulsidas (1532–1623) is known as *Rāmcharitmānas* and has been called the bible of north India. It remains the pre-eminent book for over a hundred million Hindus, many of whom treat it as their main source of religious inspiration.

Rambert Dance Company (formerly Ballet Rambert), one of Britain's oldest existing companies. It emerged from the teaching work and stage productions of Marie Rambert (1888–1982), a Polish-born dancer and teacher who studied with *Jaques-Dalcroze and worked briefly with *Diaghilev's Ballets Russes before settling in London in 1918. In the 1920s and 1930s Rambert developed a repertory based on new work by *Ashton and *Tudor. After the War the company toured overseas, and promoted work by other new choreographers. In 1966 a series of crises led the company to change direction and it became a modern dance company under the direction of Norman Morrice (1931–). Important choreographers during this later period include Glen Tetley, John Chesworth, Robert North, *Bruce, and *Alston. Alston became the company's artistic director and changed its name to Rambert Dance Company in 1986.

Rameau, Jean-Philippe (1683–1764), French composer. He published his first book of harpsichord pieces in 1706, and further volumes followed when he settled in Paris in 1723. Rameau divided his time between composition and writing on the theory of music. His compositions include keyboard *suites, church music, chamber music, a series of *operas, including *Castor et Pollux* (1737) and *Dardanus* (1739), and *opera-ballets,

including *Les Indes galantes* (1735) and *Les Fêtes d'Hebé* (1739). To meet the demands of his day, every act in Rameau's stage works contains a substantial *divertissement*, affording opportunities for many and varied dances.

Ramsay, Allan (1713–84), British portrait painter, active mainly in London, where he was the outstanding portraitist from about 1740 until the rise of *Reynolds in the mid-1750s. Partly trained in Italy, he brought a sophisticated cosmopolitan air to British portraiture, especially in his portraits of women, which have a French grace and sensitivity. In the 1760s he gradually gave up painting, turning to scholarly and literary pursuits.

Rao, Raja (1909–), Indian novelist and short-story writer. His first novel, *Kanthapura* (1938), looks at the impact of the Independence movement upon a small South Indian village. *The Serpent and the Rope* (1960) traces the spiritual quest of a young Brahmin and his French wife. His stories have been collected in *The Cow of the Barricades* (1947) and *The Policeman and the Rose* (1978).

Raphael's *The School of Athens* (1509–11) shows a gathering of the most famous ancient philosophers (Plato, pointing upwards, and Aristotle are in the centre) and symbolizes the rational pursuit of truth. Previously Raphael had worked on a fairly small scale, and the assurance with which he turned to the most grandiose type of decorative painting was astonishing. (Vatican, Rome)

Raphael (Raffaello Sanzio) (1483–1520), Italian painter and architect, the artist in whose works are found the most complete expression of the ideals of the High *Renaissance. He was highly precocious and was probably *Perugino's junior partner. From 1504 to 1508 Raphael lived mainly in Florence, where his work became more sophisticated under the influence of *Leonardo and *Michelangelo. Many of his most famous paintings of the Virgin and Child belong to this period. In 1508 Pope Julius II called him to Rome, where he was to remain for the rest of his life. He immediately embarked on a highly prestigious papal commission—the fresco decoration of a series of rooms (the *Stanze*) in the Vatican. In the first room, the Stanza della Segnatura, he painted one of his greatest works, *The School of Athens* (1509–11), which shows an imaginary gathering of the most famous philosophers of antiquity in a magnificent architectural setting. Effortlessly combining grandeur and gracefulness, it is considered a supreme masterpiece. For the rest of his career Raphael was in such demand that much of his work, particularly his great decorative schemes, was done with the aid of a team of assistants. The quality of his own workmanship in his later years is generally best seen in his portraits, in which he rivals Leonardo in subtlety of characterization. He also enjoyed considerable status as an architect, succeeding *Bramante as architect to St Peter's in 1514. Despite his premature death at the age of only 37, Raphael was enormously influential in his lifetime and for centuries afterwards.

Rastrelli, Bartolomeo Francesco (1700–71), Italian-born architect who settled in Russia in 1715 and became the leading architect of his day. He was appointed chief architect at the imperial court in 1736 and designed several immense royal palaces in and around St Petersburg (Leningrad), notably the Winter Palace (1754–62). His colourful, ornamented style is in the tradition of Central European *Baroque and *Rococo, but he also introduced traditional Russian motifs, especially in his churches, such as Smolny Cathedral, St Petersburg (1748–55).

rath (or ratha) (Sanskrit, 'chariot'), a term describing a processional car used during Indian temple festivals and *pageants for transporting the image of a deity. The most famous rathayatra ('car festival') takes place at Puri in Orissa, where a massive wooden vehicle with a superstructure of bamboo and textiles is pulled through the streets by thousands of devotees. Such processions enable worshippers who would not normally be admitted to the sanctuary of the temple to have darsana (auspicious sight) of the deity. The word 'rath' is also applied to temples similar in form to the processional chariots or more loosely to shrines seen as a vehicle of the deity.

rattles, all shaken *percussion musical instruments. The basic types are: vessels with internal pellets such as *maracas and pellet bells; vessels with external pellets such as cabacas, gourds with a network of pellets around them; jingles, objects rattling against each other; sliding rattles such as the *sistrum. Many of these can be combined: jingles can be pellet bells strung together or cabacas may have pellets inside also, and some can be single or multiple. They also have many uses: pellet bells are played orchestrally, worn by folk dancers in many areas, and are also called harness bells because of their use on horses and other animals. Rattles are also frequently combined with other instruments, for example with *sansas and other African instruments, miniature cymbals on the *tambourine, and small pellet bells on bows of Aegean *liras.

Rauschenberg, Robert (1925–), US artist, regarded as one of the most important figures in the move away from the *Abstract Expressionism that dominated US art in the late 1940s and early 1950s. In the mid-1950s he began to incorporate three-dimensional objects into what he called 'combine paintings'. His work has included theatre design and choreography and involvement in *happenings, and he has been interested in combining art with new technological developments.

Ravel, (Joseph) Maurice (1875–1937), French composer. His piano study Jeux d'eau (1901) and the orchestral song-cycle Shéhérazade (1903), established his importance as a composer. Though influenced by *Debussy, *Satie, and *Stravinsky, Ravel's music had its own personality—part *Impressionistic, part *Neoclassical, always meticulously wrought and orchestrated with brilliance. It includes the ballets Daphnis et Chloé (1912), La Valse (1920), and Boléro (1928); the one-act operas L'Heure espagnole (1909) and L'Enfant et les sortilèges (1925); songs and song-cycles; piano and chamber music (including the four-handed Mother Goose Suite (1910) for children, later orchestrated); and two piano concertos (1930, 1931), the first being for left hand only.

Ray, Man (1890–1976), US photographer, painter, designer, sculptor, and film-maker. Arriving in Paris in 1921, Ray embarked on a lifetime of restless experiment in the visual arts. An enthusiastic practitioner of *Surrealism, he skilfully used a whole battery of technical manipulations to take advantage of photography's ability to convince the viewer that 'the camera never lies'. Himself inspired by *Stieglitz, he in his turn trained and influenced a number of important photographers, among them Berenice *Abbott and Bill *Brandt.

Ray, Satyajit (1922–), Indian film director. He modernized traditional Bengali literary conventions in his first film—the beautiful and perceptive Pather Panchali (1955), in which he employed non-professionals. It was to form part of a trilogy with The Unvanquished (1956) and The World of Apu (1959). He was born into a family of artists; his grandfather was a well-known painter and his father the author of works that are now Bengali classics. Brought up in the tradition of the Bengali poet *Tagore, he filmed three of Tagore's novels grouped under the title Three Girls. Distant Thunder (1973) treats the great Bengali famine of 1943 in epic style. His first film in the Hindi language, The Chess Players (1977), is equally notable. Ray is in control of every aspect of his work, writing his own scripts and music, and explains the slow rhythm of his films as a reflection of the style of life which he interprets.

Rayonnant style, a term applied to the prevailing style of French *Gothic architecture in the period c.1240 to c.1350. It is named after the radiating (French, 'rayonnant') form of *tracery of rose windows, a type common in the period, and the chief characteristic of the style is the abundant use of bar tracery. Structural logic and clarity mattered less than in the early days of Gothic, and decoration mattered more. The Rayonnant style was taken up in Flanders and Germany and was influential elsewhere, becoming the most international type of Gothic architecture. In France its development was arrested by the Hundred Years War with England and it was eventually superseded by the *Flamboyant style.

realism, the artistic representation of some aspect of everyday life (usually in painting, cinema, drama, or the novel) in such a way as to produce a convincingly lifelike effect. Artists cannot simply reproduce or reflect reality; they have to select and shape, achieving an illusion of fidelity to life by excluding any idealized, supernatural, melodramatic or escapist elements in favour of a 'neutral' depiction of ordinary people in unremarkable surroundings. In the broad sense, realism is a characteristic of many writers and artists, *Defoe and *Vermeer, for instance, before the 19th century, but the novels of *Balzac and the paintings of *Courbet helped to inspire a self-consciously realist trend in late 19th-century French culture, which spread to the rest of Europe and the USA and developed into *naturalism. The novels of *Flaubert, notably Madame Bovary (1857), George *Eliot, and *Tolstoy, and the plays of *Ibsen and *Shaw usually show the best features of realism. In the 20th century, realism tended to be eclipsed by various movements, *Cubism, *Expressionism, *Modernism, and others, which challenged the conventional reproduction of external reality. In Italy, however, an important group of 'neo-realist' film-makers such as *Rossellini had a world-wide impact from the late 1940s with their use of

In *Bonjour Monsieur Courbet* (1854), Gustave Courbet shows himself (*right*) being greeted by his patron Alfred Bruyas and his servant on the occasion of the painter's first visit to Bruyas's home at Montpellier. Courbet, the chief exponent of **realism**, baffled his contemporaries by treating events from the everyday world such as this with a grandeur and seriousness previously reserved for heroic scenes from history, mythology, or religion. (Musée Fabre, Montpellier)

outdoor locations, amateur actors, and 'documentary' styles, which in turn influenced the *cinéma-vérité of the French *Nouvelle Vague.

rebab, a name used in many areas, each for a different variety of stringed musical instrument. Many are bowed, such as the *rebab* of the *gamelan and the Moroccan Berber *ribāb* and *rebab andaluz*, the ancestor of the *rebec. Others, for instance the Afghan *rabāb*, ancestral to the North Indian classical *sarod*, are plucked. It is noteworthy that all peoples who use the name have encountered Islamic influence, and curious that instrument types and shapes vary so widely, the one common feature being a skin belly.

rebec, a bowed musical instrument of the Middle Ages and Renaissance. The body was carved and hollowed from a solid block of wood, with a thin belly of spruce or similar wood laid over the hollow. The back was normally rounded, so that the instrument looked like an elongated half-pear. In the Renaissance rebecs were used principally for dance music, with a family of sizes. The three-stringed treble was the most important, and was one of the ancestors of the violin. Rebecs still exist today as folk instruments, especially in Eastern Europe.

recitative *opera.

recorder, a musical instrument, a *duct-flute. The recorder is a special form of *flageolet, with, in the Renaissance, one thumb- and eight finger-holes, the lowest being duplicated to be accessible to either little finger. Renaissance recorders were in one piece and, initially, cylindrical in bore. By the late 16th century the inversely conical bore, narrowing towards the foot, had been

introduced, resulting in increased range and improved tuning of the upper notes. Around 1660–70 the Baroque form of the recorder was devised at the French court; this was in three sections, head, body, and foot. Because the foot could be turned, the duplicated hole was unnecessary. The conicity was increased, extending the range and improving the tuning. It is this form that is commonly used today. At all periods, the recorder has been made in families from sopranino or smaller to bass, and in the Renaissance to great bass in 8-ft. C.

Redon, Odilon (1840–1916), French *Symbolist painter and graphic artist. For most of his career he worked in black and white, in charcoal drawings and lithographs, developing a distinctive repertoire of weird subjects, including insects and plants with human heads, influenced by the writings of Edgar Allen *Poe. During the 1890s he turned to painting and revealed remarkable powers as a colourist, showing equal facility in oils and pastel, and creating flower paintings and mythological scenes in radiant colours. He was admired by Matisse and the Surrealists.

Reed, Sir Carol (1906–76), British film director. He made his mark with such films as *The Stars Look Down* (1939), the Hitchcock-like *Night Train to Munich* (1940), and *Kipps* (1941), based on H. G. Wells's novel about a draper's assistant. He was praised for his wartime films *The Way Ahead* (1944) and the *documentary *The True Glory* (1945) (which he co-directed). He then made four of his best films: *Odd Man Out* (1947), about the pursuit of an Irish revolutionary; *The Fallen Idol* (1948), in which a lonely child hero-worships the family butler; *The Third Man* (1949), a classic thriller set in ravaged post-war Vienna; and *The Outcast of the Islands* (1951), based on the story by Joseph Conrad. His later work included *The Agony and the Ecstasy* (1965), about Michelangelo, and the film of the stage musical *Oliver!* (1968).

reed instruments, musical instruments whose sound is generated by a reed (usually made from natural plants such as *Arundo donax*, but also of other materials, including metal and slips of wood). Reeds are either beating or free, and beating reeds are either single or double. *Free reeds are so called because they vibrate freely to and fro in a closely fitting slot; unlike all other reeds they are sounded both by blowing and sucking. Single reeds are either a tongue cut in a tube of cane, attached at one end, as on some *bagpipes and *zummāras, or a slip of cane attached to a mouthpiece, as on *clarinets and *saxophones. The tongue beats against the body of the tube, and the slip of cane against the edges of the mouthpiece. Double reeds for *oboes and *bassoons are two slips of cane beating against each other. On many *shawms, double reeds are flattened pieces of plant stem, so that the two sides beat against each other. With all reeds, the vibrations of the reed are transmitted to the column of air inside the instrument, which then produces a musical sound. The art, and difficulty, of playing reed instruments is first to make a reed that responds as desired to the player's breath and which suits the instrument on which it is to be used, and then to control that reed's vibration so that the sounds produced are musical, and not squeaks and squawks. The type of reed used is often immaterial. Even though we conventionally call oboes and bassoons double-reed instruments, single reeds, at-

tached to miniature clarinet-type mouthpieces, can be used on them, and have been since the early 19th century. The behaviour of *wind instruments is controlled by the shape of the bore, not by the type of reed.

Regency style, a term applied to the style of architecture, decoration, costume, and so on, in Britain associated with the time when the future George IV was Prince Regent (1811–20); by extension the term is also used of the period of his actual reign (1820–30) and more loosely for the first three decades of the 19th century. There was in fact no one style during this period; *Neoclassicism (Greek rather than Roman in inspiration) was predominant, but there were also strains of *Gothic, *Rococo, Egyptian, and Chinese (see *chinoiserie) influence, and the building most closely associated with the Prince Regent himself, Nash's remodelling of the Royal Pavilion at Brighton (1815–21), is in an exotic Indian style. Common to all the visual arts of the period, however, was a feeling of elegance and refinement.

Reger, (Johann Baptist Joseph) Max(imilian) (1873–1916), German composer. He wrote large-scale works for the organ (for example, chorale fantasias and the Fantasia and Fugue on B-A-C-H Op. 46), which both rely on and extend the traditions of *Bach. His output of diverse compositions shows a consistent attempt to combine contrapuntal discipline with a renewal of the classical-romantic traditions of *Brahms, and to strengthen the combination with his own bold harmonic and melodic ideas.

reggae *popular music.

Reich, Steve (Michael) (1936–), US composer. His work at the San Francisco tape music centre (1964–5) and the study of West African and Balinese music helped mould his concept of *minimal music, in which the repetition of short phrases in a simple harmonic field creates a hypnotic effect far removed from traditional Western procedures. *Drumming* (1971) and *The Desert Music* for chorus and orchestra (1984) are typical of his style.

Reinhardt (Goldmann), Max (1873–1943), Austrian actor, director, and impresario. His use of *Expressionism in the cinema and on the stage was influential both in Germany and abroad. He produced modern plays such as Ibsen's *Ghosts* and Wedekind's *Spring Awakening* (both 1906) with subtlety and restraint. Yet he also excelled in the manipulation of large open spaces, where his mastery of crowd management could be appreciated. His productions of Vollmöller's *The Miracle* (1911) at Olympia in London and of Hofmannsthal's *Everyman* (1920) outside Salzburg Cathedral are legendary. He also produced Sophocles' *Oedipus the King* at a circus in Berlin (1910).

Rej, Mikolaj (1505–69), Polish Protestant writer. He employed varied verse and prose styles for his didactic, satyrical purposes. The rich language of *The Mirror* (1568), containing 'The Life of an Upright Man', present a colourful picture of 16th-century Poland, poised between the medieval world and the Renaissance.

Rejlander, Oscar Gustave (1813–75), British photographer, probably born in Sweden. Like D. O. *Hill, Rejlander was a painter who at first used photographs to help with his portraits. Anxious to make photographs like paintings, he began to construct them by combining several negatives in one painstakingly assembled print: his most famous example, *The Two Ways of Life*, used over thirty negatives, showing sixteen nude or semi-nude models. Later he concentrated on simpler pictures, mostly whimsical and sentimental but occasionally surprisingly straightforward and modern.

relief, a term in art applied to sculpture that projects from a background surface rather than standing freely. According to the degree of projection, reliefs are generally classified as high (*alto relievo*), medium (*mezzo relievo*), or low (*basso relievo* or bas relief). The name *rilievo stiacciato* is given to a form of very low relief (like drawing in stone) associated particularly with Donatello. The reverse of relief is *intaglio, in which the design is incised and sunk below the surface of the block.

religious drama *liturgical drama; *morality plays; *mystery plays; *passion plays.

Remarque, Erich Maria (Erich Paul Remark) (1898–1970), German novelist. Remarque gained fame and critical prestige with *All Quiet on the Western Front* (1929, filmed 1930), a novel which records the sufferings of war with laconic understatement, from the perspective of the common soldier. Criticized for its underlying pacifism, the novel was one of the books publicly burnt by the Nazi regime in 1933. A sequel, *The Road Back* (1931), depicts the disillusionment of ex-soldiers unable to adjust to post-war society and the collapse of Germany in 1918.

The foremost exponent of the **Regency style** in architecture was John Nash, whose most ambitious work was the development of Regent's Park in London. Park Crescent (begun in 1812) was the first part of his scheme to be built. What we see today is only half of Nash's original plan, for he intended that the crescent should be doubled to form a circus which would have been even larger than Wood's Circus in Bath.

Later novels, written in exile, reflect the life of the refugee or depict the struggle for survival during World War II: *A Time to Love and a Time to Die* (1954), and under the conditions of the concentration camp *Spark of Life* (1952).

Rembrandt Harmensz van Rijn (1606–69), Dutch painter, etcher, and draughtsman, his country's greatest artist. He was born in Leiden and worked there until *c*.1632, when he settled permanently in Amsterdam. There he married the wealthy Saskia van Uylenburgh (whom he immortalized in many tender portrayals) in 1634. From the 1640s, however, his work, especially in religious painting, became more introspective and searching. In 1642 Saskia died, and in the same year he painted his most celebrated work, popularly known as *The Night Watch*, which transformed the traditional Dutch portrait convention into a dramatic presentation of his sitters. His work continued to grow in depth of feeling and freedom of technique and in his last self-portraits, the culmination of an incomparable series that began some forty years earlier, he faces his hardships and losses (his mistress Hendrickje Stoffels died in 1663 and his son Titus in 1668) with dignity and no trace of bitterness. As remarkable as the depth of his work is its great range; most 17th-century Dutch painters were specialists, but Rembrandt painted

This picture, *The Return of the Prodigal Son*, is undated, but it is believed to be one of **Rembrandt**'s last works, and it conveys such tenderness and poignancy that it can stand as a kind of spiritual testimony, summing up his unsurpassed depth of feeling and humanity. The art historian Kenneth Clark described it as 'a picture which those who have seen the original in Leningrad may be forgiven for claiming as the greatest picture ever painted'. (Hermitage, Leningrad)

(and drew and etched) virtually every type of subject, making original contributions in each. He was the greatest teacher of his day, many illustrious artists training with him. After his death his name remained well known, but it was only in the Romantic period that he was recognized as one of the supreme masters of all time.

Renaissance (French, 'rebirth'), a term applied to an intellectual and artistic flowering that began in Italy in the 14th century, culminated there in the 16th century, and greatly influenced other parts of Europe. The notion of a rebirth refers to a revival of the values of the classical world (though an interest in the Latin classics had begun as early as the 12th century). The concept was used as early as the 15th century, and was systematically developed in the 16th century by *Vasari. He held that art had declined in the Middle Ages, had been set on its true path by *Giotto, and had reached its greatest heights with *Michelangelo. The ideal of the 'Renaissance man' (*uomo universale*) arose out of the concept that man was limitless in his capacity for development whether physical, social, or artistic. The idea was brilliantly characterized by *Alberti, himself an architect, painter, scientist, poet, and mathematician, and in *Leonardo da Vinci. *Brunelleschi is considered the first Renaissance architect; out of his interest in Roman remains he created buildings that could be compared with the finest ancient examples. Other major architects included *Alberti, *Bramante, regarded by contemporaries as the most successful architect of the High Renaissance, and *Palladio. In sculpture, the beginnings of the Renaissance are sometimes traced as far back as Nicola *Pisano in the late 14th century, because it was known that he was influenced by Roman sarcophagi. However, it was *Donatello in the early 15th century who thoroughly assimilated the spirit of ancient sculpture rather than simply borrowed motifs from it. *Ghiberti, Michelangelo, and others revealed new possibilities of expression that had been unknown to antiquity. In painting it is harder to define the Renaissance in terms of antique influence because very little classical painting has survived. From classical writings it is known that painters excelled in fidelity to nature, and this became a central concern to early Renaissance painters such as Giotto and *Masaccio, who brought scientific vigour to the problems of representation, while the invention of *perspective assisted in the realistic portrayal of nature. In the 15th and 16th centuries the main centres were Florence, Venice, Rome, and the ducal courts of Mantua, Urbino, and Ferrara. Florence in the period around 1425 was the cradle of the Renaissance (see *Florentine art), but by the early 16th century—the 'High Renaissance'—Venice (see *Venetian art) and Rome were equally important. The Medicis in Florence and the popes in Rome, particularly Julius II and Leo X, were important patrons. The ideals and imagery of the Italian Renaissance did not generally begin to spread to the rest of Europe until about 1500. *Dürer was the outstanding artist of the 'Northern Renaissance', making it his mission to transplant the new Italian ideas on to German soil. Most northern artists imitated only the superficial characteristics of Italian art, and only a few, such as van *Scorel, absorbed something of the order, poise, and dignity associated with the High Renaissance. Out of the art of the High Renaissance there developed a style characterized by a sense of extreme elegance and grace, which was termed *Mannerism.

In literature the Renaissance was led by humanist scholars and poets, notably *Petrarch, *Dante, and *Boccacio in Italy. Poetry and prose began to be written in the vernacular instead of Latin, and the invention of printing contributed to the spread of ideas. Among the notable writers of the Renaissance beyond Italy are Erasmus in the Netherlands; *Montaigne and *Rabelais, and the poets of the Pleiade in France; Lope de *Vega and *Cervantes in Spain; and Edmund *Spenser, Sir Philip *Sidney, *Shakespeare, and Sir Francis *Bacon in Britain. All of these writers gave expression in the fine, classical tones that distinguished the language of the time, and to a new clarity of thought and sensual vitality. The Renaissance profoundly affected the presentation and content of theatrical production. Basing themselves on the architectural works of Vitruvius (*c*.15 BC), *theatre buildings and *set design were constructed according to the principles of Roman theatre. Dramatists introduced classical form and restraint into their works, which were to be codified, notably in France, with greater severity than in classical times. A revival of plays by *Terence in 15th-century Venice was staged before an audience seated in a horseshoe-shaped auditorium facing a proscenium-arch platform, and this was to become the model of theatre-building all over the Western world for the next five hundred years.

Renaissance dance. The ephemeral nature of dance means that no individual works have survived from the early 1400s, but the writings of dancing masters such as Domenico da Piacenza or da Ferrara (*fl. c*.1420–60) and others who worked in the Italian courts, are extant. In the Renaissance the separation of dance into courtly and country forms began. The peasant dances, which marked festive occasions and were often based on pre-Christian dance forms, took place out of doors. They were essentially joyful, highly active, performed by many, and characteristically composed of simple steps derived from basic running, skipping, and leaping actions. In terms of pattern they were all variants of the *carole, the *branle, and the *farandole. The courtly dances were based on country forms, but almost every element of these dances was systematically refined. The community-based peasant dances became couple dances in the court, with the man and the woman having clearly assigned roles. The *basse* or low dance encapsulated Renaissance thinking in terms of the self-confident poise, dignity in performance, and harmonious form and order in the structure and pattern of the parts and the whole. It consisted of single and double steps, slight changes of level, and simple floor patterns. In Italy, the early Renaissance dances gradually developed more intricate footwork and elaborated forms. The numerous *allemandes, *courantes, *galliards, and *pavans of this period stand as testimony to the creative powers of the dancing masters, whose role began to grow in power and importance during this period.

Renaissance music (*c*.1320–*c*.1690). New forms of musical *notation in Europe described around 1320 by Philippe de Vitry (1291–1361) in France and Marchetto da Padova in Italy provided one of the clearest turning-points in the history of music. With their techniques men such as Guillaume de *Machaut, Jacopo da Bologna (*fl.* 1340–60), and Francesco Landini (*c*.1325–97) composed a range of music, particularly secular *polyphony for a courtly culture, that expressed emotions and moods quite

One of a superb pair of tombs of Medici dukes by Michelangelo, representing Lorenzo de' Medici above allegorical figures of Evening and Dawn. The portrayals of the dukes are idealistic rather than realistic and Michelangelo's attitude towards the figures illustrates the new creative freedom of the **Renaissance**, when the idea of the artist as a creative genius, not a hired artisan, was born; asked why he had not produced portraits of the dukes he replied 'In a thousand years' time no-one will know what they looked like'.

as clearly as did the painting of their time: some 400 secular songs survive from 14th-century France, and just over 600 from Italy. Around 1400, the hitherto separate traditions of French and Italian song appear to have coalesced, partly in the hands of Johannes Ciconia (*c*.1375–1412), born in Liège but working mainly in Italy; and the years between about 1420 and 1540 are largely dominated by Franco-Flemish composers who benefited from the opportunities provided by the rich Italian courts. These men were mainly responsible for the evolution from a three-voice courtly song style to the freer Italian madrigal (from about 1530) and related genres in other languages, mostly in four or more voices, bringing sophisticated music to a far wider public. Along with this last development came the rise of written instrumental music: the earliest substantial repertory of independent idiomatic instrumental music was for the lute, starting just before 1500; but there is also a considerable repertory of instrumental part-music from the 16th century, the sur-

viving printed sources evidently aimed at a growing amateur market. Sacred music, which had experienced a decline in the 14th century, appears to have received a new stimulus in the 1420s from the English repertory and particularly *Dunstable whose music was widely admired on the Continent and influenced the most resourceful and fascinating genius of 15th-century music, *Dufay. The major achievement of the later Renaissance in music is the polyphonic mass cycle: after some hesitant starts, this tradition really began around 1450 at the hands of Dufay; in the next generation it was further evolved by *Josquin Desprez, perhaps the most glorious and pure composer of the Renaissance: and the tradition continued through to the 100-odd masses of *Palestrina.

renga, one of the forms of *Japanese poetry. The earliest *renga* date from the 12th century and generally have a set number of verses. They are unusual because the stanzas are mostly composed by several poets in group session. The greatest *renga* master was Sōgi (1421–1508). By the Tokugawa period (1603–1867), when *Ihara was writing, a comic form, the *haikai no renga*, had become popular, and from its opening stanza, the *hokku*, emerged the *haiku, of which *Bashō was the master.

Reni, Guido (1575–1642), Italian painter. He trained with the *Carracci family in his native Bologna and inherited their tradition of clear, firm draughtsmanship. His graceful classical style was also much influenced by the work of *Raphael and by ancient art, which he saw on the several visits he made to Rome. After Ludovico Carracci's death in 1619 Reni became the leading painter in Bologna, running a large and prosperous studio whose products (mainly religious works) were sent all over Europe. His contemporary fame was enormous and in the 18th century many critics ranked him second only to Raphael. He is now particularly admired for his subtle beauty of colouring.

Renoir, Jean (1894–1979), French film director, son of the Impressionist painter Auguste Renoir. Though he made several silent films, his reputation was established in the sound era by films such as *Le Crime de Monsieur Lange* (1936), in which publishing workers form a co-operative, *The Lower Depths* (1936), from Gorky's play, and *La Bête humaine* (1938), a melodrama about a homicidal engine-driver. The short, country-based *Une partie de campagne* (1936) was not released until 1946. His two masterpieces, however, were the pacifist *La Grande Illusion* (1937), about prisoners of war, and *La Règle du jeu* (1939), which cynically portrays the French upper class during a country-house weekend. Of his five American feature films the best was *The Southerner* (1945). *The River* (1950), shot in India and his first colour film, was beautiful; but his subsequent French films, such as *French Can-can* (1955), never equalled those of the 1930s.

Renoir, (Pierre) Auguste (1841–1919), French *Impressionist painter. He started his career as a painter in a porcelain factory, gaining experience with the light, fresh colours that later distinguished his work. In the early 1860s he formed lasting friendships with other artists, notably *Monet, who were to form the nucleus of the Impressionist group. He began to achieve success as a portraitist in the late 1870s, but by this time he thought that he had 'travelled as far as Impressionism could take

me', and a visit to Italy in 1881–2 inspired him to seek a greater sense of solidity in his work. His figures became grander and more formal and he often turned to subjects from classical mythology. In the 1890s Renoir began to suffer from rheumatism, and from 1912 he was confined to a wheelchair, but he continued to work until the end of his life, and in his last years also took up sculpture, directing assistants to act as his hands. Renoir is perhaps the best-loved of the Impressionists, for his subjects—pretty children, flowers, beautiful scenes, above all lovely women—have instant appeal, and he communicated the joy he took in them with great directness.

repertory theatre, strictly a theatre staging a repertoire of plays in rotation, rather than a single play. The system was once adopted in all theatres, but became unpopular with the advent of the touring company and the long run. Unsuccessful efforts were made in Britain at the beginning of the 20th century to revive it, but the term came merely to signify a theatre that presented its own productions for limited runs. In the 1950s and 1960s many repertory theatres were turned into civic theatres funded by local authorities, some of which were then closed during the more stringent economic climate of the 1980s. 'True' repertory is still staged by the Royal Shakespeare Company, the National Theatre, and seasonal theatres in Britain, and by subsidized theatres on the Continent of Europe and elsewhere. Repertory in the USA, where it is called 'stock', followed a similar course, beginning with the Dallas Theater Center in 1959; by the 1980s there were regional theatres in over two-thirds of US states.

Repin, Ilya (Yefimovich) (1844–1930), Russian painter. He joined the 'Wanderers' (*Peredvizhniki*), an influential association of young painters in revolt against the Academy, inspired with ideas of bringing art to the people, who formed the *Realist movement in Russia. Of his later works two became particularly popular: *Ivan the Terrible with the Body of his Son* (1885), and *Cossacks Defying the Sultan* (1891). He was a fine painter and colourist, but what chiefly appealed to his contemporaries was the exciting subject-matter of his pictures. With the introduction of a Socialist Realism (see *Social Realism) in 1932 Repin became established as the model and inspiration for the Soviet painter.

Repton, Humphry (1752–1818), English landscape gardener, the successor to 'Capability' *Brown as the acknowledged leader of his profession. His reconstructions were less sweeping than Brown's and in his later career he used regular bedding and straight paths close to the house, but his parks were carefully informal, as Brown's were. Repton worked for some time in collaboration with John *Nash and occasionally acted as an architect himself; two of his sons, **John Adey Repton** (1775–1860) and **George Repton** (1786–1858), were also architects. A talented water-colourist, Repton was in the habit of making views with flaps, which the client could lift to make a direct comparison between his park in the 'before' and 'after' state. (See also *garden art.)

requiem, the Roman Catholic *mass for the dead, beginning with the Introit *Requiem aeternam dona eis Domine* ('Give them eternal rest, O Lord') sung while a priest approaches the altar for the Eucharist. The text follows

the main outline of the normal mass, but omits the more joyful sections (the *Gloria* and *Credo*) and includes the 13th-century sequence *Dies irae, dies illa* (Latin, 'Day of wrath, day of judgement').

Resnais, Alain *Nouvelle Vague.

Respighi, Ottorino (1879-1936), Italian composer. He was a pupil of *Rimsky-Korsakov, from whom he learned the brilliant orchestral technique that became the hallmark of his style. A capable conductor, teacher, and pianist, he drew attention to himself as a composer through the orchestral tone-poems *Fountains of Rome* (1916), *Pines of Rome* (1924), and *Roman Festivals* (1928), and the three suites of *Antique Songs and Dances* (1917, 1923, 1931). The puppet opera *The Sleeping Beauty* (1922) is probably his operatic masterpiece.

Restoration comedy, a type of social *comedy of manners which flourished in London after the Restoration of the monarchy in 1660. It is characterized by glittering, cynical, licentious, and extravagant language and plot. Women's roles, until then played by boys, were taken by actresses, the most notable among them being Nell Gwynne, the leading comedienne of the King's Company. Restoration comedy is exemplified by the plays of *Congreve, its greatest exponent, *Wycherley, *Farquhar, *Vanbrugh, and Sir George Etherege (c.1634-91). *Dryden also wrote plays in this vein, but was better known for his heroic dramas.

Restoration style, an opulent style of interior decoration introduced to England with the Restoration of Charles II in 1660. Charles and many of his courtiers had spent years in exile on the Continent of Europe, and the Restoration style showed strong influence from the Netherlands and to a lesser extent from France. In general, it brought a new luxuriousness to the sober English tradition, with elegant furniture in veneered walnut, for example, tending to replace the plainer and more solid oak. There was also a fashion for oriental-influenced goods in lacquerwork, porcelain, and textiles.

Revere, Paul *Federal Style.

revue, theatrical entertainment consisting of short, unrelated items, usually alternating between musical and comic. Each member of the cast—unlike the practice in *music-hall or *vaudeville—appeared in several different items. Its popularity dates from the early 20th century, one of its first forms being the British *Pierrot troupe or concert party. The most spectacular were the *Follies* of *Ziegfeld, during the first part of the 20th century. *Beyond the Fringe* (1961) represented a high point of the intimate revues in Britain, possibly because television could deal more rapidly with contemporary issues. The high cost of musical productions brought the more spectacular revues to an end.

Reymont, Wladyslaw Stanislaw (1867-1925), Polish novelist. His writing was uneven, but he fully exploited his considerable descriptive abilities to create his short stories and novels. He drew extensively on personal experience for *Pilgrimage to Jasna Góra* (1895), *Comedienne* (1896), and *The Promised Land* (1899), on the horrors of rapid industrialization. *The Peasants* (1902-9), an epic

A contemporary engraving of a scene from William Congreve's *The Way of the World*, one of the masterpieces of **Restoration comedy**. Such plays were witty, cynical, and amoral, with highly involved plots, the principal theme of which is sexual intrigue, either for its own sake or for money. Standard characters include foppish noblemen, scheming servants, rough-mannered country squires, and sexually voracious young widows. (Victoria and Albert Museum, London)

novel of village life reflected in the relentless passage of the seasons, brought Reymont the Nobel Prize for Literature in 1924.

Reynolds, Sir Joshua (1723-92), British painter and writer on art. In 1768 he became the first President of the newly founded *Royal Academy and through his professional and social prestige he succeeded in raising the status of painting in Britain. Previously it had been considered little more than a skilled craft, but Reynolds (who developed his ideas on the dignity of his calling when studying in Italy as a young man) insisted on the intellectual basis of painting and became a much respected figure in literary circles, Dr Johnson being one of his closest friends. Traditionally *history painting had been considered the highest branch of art and Reynolds tried to elevate portraiture nearer its level by adopting his poses from classical statues and Renaissance paintings.

His ideas on art were presented in the Discourses that he delivered to students at the Royal Academy between 1769 and 1790, which are regarded as being among the classics of art criticism. As a portraitist Reynolds is renowned for his penetrating characterization and for his remarkable versatility.

rhapsody (in music), usually a work in one continuous movement which is fairly free in structure and has the quality of emotional enthusiasm that is implied in our day-to-day use of the word. It is often used to describe works based on a selection of folk-songs, as in Liszt's *Hungarian Rhapsody*, or Vaughan Williams's *Norfolk Rhapsody*.

rhetoric, the use of stylized verbal forms for the most persuasive effect in public speaking or in writing. Although distrusted by Plato, rhetoric was regarded favourably by Aristotle and was cultivated as an important art and science in antiquity, notably by Cicero. It was an essential element of medieval university education, and involved the elaborate categorizing of *figures of speech together with the arts of memory, arrangement, and oratorical delivery. Although the use of the formal device of rhetoric has been discredited to the point that it is considered to be pointless ornamentation, it remains an important technique in the tradition of political and religious public speaking.

rhyme, the identity of sound between syllables or words, usually at the end of verse lines, but sometimes (in 'internal rhyme') within the same line. Normally the last stressed vowel and all sounds following it make up the rhyming element: this can be a monosyllable (*love* / ab*ove*), known as 'masculine' rhyme, or two syllables (as in the 'feminine' rhyme wh*ether* / tog*ether*), or even trisyllabic (*sing to me* / br*ing to me*). Rhyme is not essential to poetry: many languages rarely use it, and in English it finally replaced *alliteration as the structuring principle of verse only in the late 14th century. Some poets use 'eye-rhyme', in which the spellings of two words match, but the sounds no longer do (love / prove). Others, especially in the 20th century, have used 'half-rhyme' or 'slant rhyme', where the vowels do not match (love / leave).

Rhys, Jean (Ella Gwendolen Rees Williams) (*c*.1890–1979), British novelist. Her early novels, including *Postures* (1928; reprinted as *Quartet* in 1969), are usually set in Paris, where she lived for many years. *Voyage in the Dark* (1934) is a first-person account of a chorus-girl and *Good Morning, Midnight* (1939) is the story of a middle-aged woman seeking consolation in her relationship with a gigolo. After some years of silence she published *Wide Sargasso Sea* (1966), drawing on her childhood in Dominica and Jamaica and presenting the life of the mad Mrs Rochester from *Jane Eyre*, which assured her fame.

rhythm, the aspect of music that is concerned with *time. Notes cannot be said to be long or short unless we can measure them against some basic unit of time. This unit of steady time is the beat. It may proceed at any speed, but it is always regular. It may or may not be audible. Beats are commonly grouped in patterns of twos and threes, or some combination or multiple thereof. This grouping is shown in notation by bars, each containing the same number of beats. What tells us how the beats

are grouped is accent: certain notes are stressed more strongly than others. Regular two-, three-, and four-beat groupings are common in Western music, but irregular patterns, such as five (3+2, or 2+3) and seven (3+2+2, 2+3+3, 2+2+3), are equally possible, and are quite common in the music of other cultures. Melodies almost invariably involve note-lengths that are different from the basic beat. Additional rhythmic interest occurs when a strong accent is placed on a normally weak beat, an effect known as syncopation, which is one of the characteristics of jazz. In non-Western music rhythm has always played a much more subtle and complex role, often involving many simultaneous layers of motion and a very fluid rate of change. Some contemporary composers, such as Messiaen and Stockhausen, have been profoundly influenced by this sophisticated approach to rhythm, and it may be said that 20th-century Western composers have treated rhythm with a freedom unknown since instrumental music became associated with regular dance patterns in the late 16th century.

rhythm and blues, the style of music which grew out of the *blues tradition as it developed among black musicians in the northern industrial cities of the USA in the 1950s and 1960s. The typical 'R & B' band was made up of a rhythm section (drums, bass, electric guitar, and piano), and a leading player (either vocalist or guitarist), often with the support of a vocal backing group. Many of the leading performers achieved international recognition, such as B. B. King and Muddy Waters (both guitarists) and Ray Charles and Chuck Berry (vocalists). Rhythm and blues was a significant influence on the early development of rock and roll (see *rock music).

Ribera, José de (1591–1652), Spanish painter, active for all his known career in Italy. He settled in Naples (at the time a Spanish possession) in 1616 and remained there for the rest of his life, becoming one of the most successful painters in the city. In his early career he is usually classed as a follower of *Caravaggio, but although he used a similar strong *chiaroscuro* his work is markedly individual, especially in its vigorous, scratchy brushwork. He gradually moved away from his dark Caravaggesque early style, and his later works are often rich in colouring. Ribera specialized in religious works, but he also painted mythological scenes and a few portraits. He was an accomplished etcher and one of the finest draughtsmen of his day. His work is distinguished by its emotional force and sincerity, whether he was painting a harrowing martyrdom or a scene of tender devotion, and was influential not only in Italy but also in Spain, where much of it was exported.

Ricci, Sebastiano (1659–1734), Italian decorative painter. He is generally considered a member of the Venetian School, but he travelled extensively in Italy and elsewhere before settling in Venice in 1717. His wanderings were a reflection not only of the demand for his work but also of his vigorous love life, for his illicit affairs often compelled him to move in haste and once almost resulted in his execution. Not surprisingly, his work sometimes shows signs of carelessness, but he had a gift for vivid, fresh colouring, and his career was important in spreading knowledge of Italian decorative painting. Little of the decorative work he did in England survives, but there are examples at Chelsea Hospital and Bur-

lington House (now the Royal Academy). He often worked in partnership with his nephew **Marco Ricci** (1676–1730), who was primarily a landscape painter.

Richardson, Henry Handel (Ethel Florence Richardson) (1870–1946), Australian novelist, resident in Britain from 1904. Her novel *The Getting of Wisdom* (1910) is based on her Melbourne schooldays. Her most ambitious work, *The Fortunes of Richard Mahony*, is a trilogy comprising *Australia Felix* (1917), *The Way Home* (1925), and *Ultima Thule* (1929), about the marriage and madness of a doctor, based on her father.

Richardson, Henry Hobson (1838–86), the outstanding US architect of his generation. He trained in Paris at the École des *Beaux-Arts and under Henri *Labrouste, and after returning to the USA in 1865 he embarked on a highly successful and prolific career—although he died fairly young he had a long and varied list of major buildings to his credit. His style was eclectic, based particularly on the *Romanesque, but he reacted against the trivialities of historical revivalism and his works typically have a massive, rugged strength and great individuality. The best known include Trinity Church, Boston (1872–7), and Sever Hall, Harvard University (1878–80). Richardson was a highly influential figure: McKim and White (see *McKim, Mead, and White) were among his pupils, and *Sullivan greatly admired him.

Richardson, Sir Ralph (David) (1902–83), British actor. He established himself as a leading actor with the Old Vic in London in the early 1930s, where he played many leading parts in Shakespeare plays. He played the title roles in Ibsen's *Peer Gynt* (1944) and Chekov's *Uncle Vanya* (1944), and appeared in Sheridan's *The School for Scandal* (1962). He also appeared in plays by contemporary writers, notably with *Gielgud in David Storey's *Home* (1970) and Pinter's *No Man's Land* (1975). He had a successful film career, a famous example being his role in Reed's *The Fallen Idol* (1948), and in his later years enlivened many films with his wittily characterized cameo roles.

Richardson, Samuel (1689–1761), British novelist, one of the founders of the modern novel. A printer by trade, he was asked by two booksellers to produce a series of model letters on the problems and concerns of everyday life. This resulted in his first novel, *Pamela: or Virtue Rewarded* (1740–1), written when he was 50, was parodied by *Fielding (in *Joseph Andrews*) for what he regarded as hypocritical morality. His next novel, *Clarissa: or The History of a Young Lady* (1747–9), was highly successful but criticized for its length and indecency. With his third novel, *Sir Charles Grandison* (1754), Richardson presents a paragon of honour and wisdom. Richardson's interest in analysing character and exploring moral issues in great detail greatly influenced the development of fiction. He anticipated the novel of manners in the late 18th century and counted Jane Austen among the most devoted admirers of his work.

Richler, Mordecai (1931–), Canadian novelist and journalist. He achieved his assured style in his fourth novel, *The Apprenticeship of Duddy Kravitz* (1959), which portrays an unscrupulous, indecently ambitious young Montrealer who, despite his nastiness, takes hold of the reader's interest and even understanding. Richler's gift for outrageous and funny satire reached surreal heights in *The Incomparable Atuk* (1963) and *Cocksure* (1968). Later novels include *St Urbain's Horseman* (1971) and *Then and Now* (1980).

Riley, Bridget (1931–), British painter and designer, the leading British exponent of *Op art. Initially she worked in black and white, but she turned to colour in 1966, by which time she was already gaining an international reputation. Her work shows a complete mastery of the effects characteristic of Op art, particularly subtle variations in size, shape, or placement of units in a pattern. She often works on a large scale, with the aid of assistants.

Rilke, Rainer Maria (1875–1926), Austro-German poet, born in Prague. The keynote of Rilke's work is 'inwardness', his poetry allowing the poet to explore his inner self and explain the mysteries of life. *New Poems* (1907–8) are masterpieces of objective penetration, in which pictorial and visual objects are opened up as the poet immerses himself in their essence and enhances them with inner awareness. In the 1920s Rilke published the ten *Duino Elegies*. An intricate network of imagery and symbolism offering a panorama of human existence, the Elegies, begun in 1912, explore and affirm mankind's role in the world. The grandeur of the Elegies is replaced in the fifty-five *Sonnets to Orpheus* (1923) by a serenity of style and mood as the poet praises the beauty and integrity of creative art, of love and life. No translation can hope to match Rilke's mastery of word and sound manipulation.

Rimbaud, Arthur (1854–91), French poet. One of the most revolutionary figures in 19th-century literature, he was by the age of 16 in full revolt against every form of authority. Expressing the exhilaration of his escapes from maternal discipline and his fascination with cabbalistic and alchemical imagery, his verse was already fiercely independent of religious, political, and literary orthodoxy. By the age of 17 he had written his most famous poem, 'Le Bateau ivre', a hymn to the quest of unknown realities, which became a sacred text for the next two generations of writers. By the time he was 19 his poetic career was over. Between 1871 and 1873—the period of his association with *Verlaine and his sojourns in Britain— he undertook a programme of 'disorientation of the senses' in order to try to turn himself into a voyant or seer. This resulted in his most original work, two collections of prose poems, *Les Illuminations* (1886), which explored the visionary possibilities of this experiment, and *Une Saison en enfer* (1873), recording its moral and psychological failure. The remainder of his life has been described as a prolonged act of passive resistance. Having repudiated poetry, he gave himself up to vagabondage, first in Europe, and later in the north-eastern regions of Africa.

Rimsky-Korsakov, Nikolay (Andreyevich) (1844– 1908), Russian composer. The success of his symphonic poem *Sadko* (1867) led to his appointment as professor of composition at the St Petersburg Conservatory. Thereafter he devoted himself to the cause of Russian musical nationalism as a member of The *Five, to teaching, and to composition. His works include fairy-tale operas such as *The Snow Maiden* (1881), *Sadko* (1896) and *The Golden*

Cockerel (1907); three symphonies; and the brilliant orchestral suite *Sheherazade* (1888).

Rivera, Diego (1886–1967), Mexican painter, the most famous figure in the revival of monumental *fresco painting in the 20th century. He spent the years 1907 to 1921 mainly in Europe and was familiar with modern movements (he painted some excellent *Cubist pictures), but his mature work was firmly rooted in Mexican tradition. He was the leading artist in the programme of murals glorifying the history and people of Mexico initiated by the President in 1921. Painted in a spirit of revolutionary fervour, they were intended to inspire a sense of nationalist and socialist identity in a still largely illiterate population. They can be crude in their attacks on capitalism or their glorification of labour, but Rivera's best work shows his breathtaking vigour and formidable skill. There are examples of his murals on public buildings in Mexico City in addition to a museum of his work.

Robbia, Luca della (*c.*1399–1482), Italian sculptor. In his lifetime Luca had the reputation of being one of the leaders of the *Renaissance style in sculpture, comparable to *Donatello, but he is now mainly remembered as a pioneer of coloured glazed terracotta as a sculptural medium. In particular he invented a type of representation of the Virgin and Child shown half-length in white on a blue background that proved highly popular. The technical formula, which seems to have been kept a secret in the family workshop, soon became the basis of a flourishing business. Unfortunately, Luca's successors tended to sentimentalize his warm humanity.

Robbins, Jerome (1918–), US dancer, choreographer, and director. He studied ballet and modern dance, and danced in *Broadway musicals. In 1940 he joined the *American Ballet Theater, choreographing his first ballet, *Fancy Free*, to Bernstein's music in 1944. His humorous send-up, *The Concert* (1956), and the abstract, waltz- and mazurka-based work *Dances at a Gathering* (1969), are typical of his ballets. He worked with *New York City Ballet from 1949 to 1959 and again from 1969. He collaborated with *Bernstein on his most famous musical, *West Side Story*, in 1957. He choreographs mainly in a character-dance style using modern jazz, show dance, folk, and social dance elements within a ballet framework.

Robeson, Paul (Paul Bustill) (1898–1976), US singer, actor, and political activist. The son of a former slave, Robeson was initially renowned as as actor. He made his concert début in 1925 singing black spirituals. With his rich and sonorous bass-baritone *voice, he won international fame in the London production of the musical *Show Boat* (1928), singing 'Ol' Man River'. As an actor, his characterization of the title role in *Othello* (1943) set an all-time record run for a Shakespeare play on Broadway. Ostracized for his left-wing political views in the 1950s, he did much to further the interests of black Americans, but his visit to the Soviet Union in 1963 as an avowed communist aroused much controversy.

Robinson, Edwin Arlington (1869–1935), US poet. His first collection, *The Torrent and the Night Before*, appeared in 1896. After *Captain Craig* (1902), *The Town Down the River* (1910), and *The Man Against the Sky* (1916) he became established as a popular poet, and in all produced twenty-six volumes, ranging from narrative verse (including an Arthurian trilogy) to lyrics. Perhaps best known for his character portraits, he remained essentially a Victorian writer in style and philosophy.

Robinson, Henry Peach (1830–1901), British photographer. Trained as a painter and draughtsman, Robinson aimed to make artistic photographs by mixing the real with the imaginary. Like *Rejlander, he combined several negatives into a single, complex print, and was a successful commercial portraitist and studio photographer.

rocaille (French, 'rockwork'), a term applied to ornamental rockwork or shellwork and to decoration in other media based on such forms. The term from the mid-16th century was applied to the kind of rugged stonework used in grottoes and fountains, but from about 1730 was used of the more extravagant flights of the *Rococo style, and *rocaille* is now sometimes used more or less as a synonym of Rococo.

Rochester, John Wilmot, 2nd Earl of (1647–80), English poet and satirist, a leading member of a group of 'court wits' surrounding Charles II. The complexity of his poems gives him a good claim to be one of the last important *Metaphysical poets, and with his social and literary verse satires he was one of the first of the *Augustans. An original and powerful satirist, he wrote scurrilous *lampoons, dramatic prologues and epilogues, and miscellaneous poems such as the self-dramatization of 'The Maim'd Debauchee' and 'Upon Nothing'.

rock-crystal carving, the creation of small decorative objects from rock-crystal, a colourless, transparent variety of quartz that is found in many parts of the world. It resembles glass, but it is harder, retains a polish better, and does not cloud with age. It was much used in the ancient world (Egypt, Greece, Rome, and the Middle East) for jewellery and for various types of drinking vessels and ornaments. Since then, the chief flowering of rock-crystal carving has been in Renaissance Italy and Bohemia. It has also been much used in the Islamic world for faceted bowls, goblets and chess pieces, for example. Much early Islamic crystal work found its way to Europe and was mounted and extensively used by the Church. In Mughal times in India, rock-crystal vessels were encrusted with jewels and decorated with typical Mughal flower motifs symmetrically repeated.

rock music (originally rock and roll), a *popular music form originating in the USA in the 1950s. Rock and roll grew out of the black *rhythm and blues music, which in the mid-1950s was being taken up by white *country musicians such as Bill Haley, Buddy Holly, and Elvis Presley. *Rock around the Clock* (1955) by Bill Haley and the Comets, was the first rock and roll record to achieve mass popularity. Within a year of its release rock and roll was a near-universal language among young people. Both black and white musicians achieved commercial recognition, although white artists were generally more successful. However, by the early 1960s, the initial homogeneity of rock and roll was being replaced by pluralism. The US music industry was producing pop music that grafted rock and roll elements on to Tin Pan Alley songs. In 1961 Bob Dylan brought out an album of

satirical, personal songs that spearheaded a new school of urban folk or protest music. Huge audiences were drawn to music festivals at which *folk singers such as Joan Baez took part. In Britain in the early 1960s there was an explosion of musical talent: groups such as the Rolling Stones and The Who played music that drew heavily on rock and roll and black American music. The first of these groups to gain international recognition was the *Beatles. In the mid-sixties a new style emerged, harsher and more heavily electric in sound. The Animals in Britain and the Byrds, Jefferson Airplane, and The Grateful Dead in California, were early performers of what came to be known as rock music. Initially the music was associated with the drug culture and social protest, but by the 1970s rock was part of the music establishment. The late 1970s saw the emergence of a sub-genre of rock, punk, which caught some of the raw energy of rock and roll but did not have such a wide appeal, being largely a British phenomenon. Within a few years punk had given way to new wave bands such as Talking Heads, who used synthesized sounds and Afro-Caribbean rhythms in their music. In the late 1980s videos and compact discs have become as important as records and tapes in promoting and disseminating rock music. Through a broadening of its definition and an assimilation of musical styles, rock has become the predominant form of popular music.

Rocky Mountain School *Hudson River School.

Rococo, a style of art and architecture that emerged in France in about 1700 and spread throughout Europe in the 18th century. It was characterized by lightness, grace, playfulness, and intimacy and was both a development of and a reaction against the weightier *Baroque style. It shared with the Baroque a love of complexity of form, but instead of a concern for solidity and mass, there was a delicate play on the surface, and sombre colours and heavy gilding were replaced with light pinks, blues, and greens, with white also being prominent. The Rococo style was initially mainly one of decoration; the word is said to derive from a combination of *barocco* (Baroque) and *rocaille*, a term applied to fancy rock-work and shell-work for fountains and grottoes. It was originally a term of abuse, meaning tastelessly florid or ornate, but it is now used without pejorative connotations. In painting, the first great master of the Rococo style was *Watteau, and the painters who most completely represent the lighthearted spirit of the mature Rococo style are *Boucher and *Fragonard. Falconet is perhaps the best representative of the style in French sculpture, but generally the Rococo spirit is seen more clearly in small porcelain figures than in large-scale statues (Falconet himself was Director of the famous porcelain factory at Sèvres—other leading factories were at Chelsea and Meissen). In architecture the Rococo style was much more suitable for interior decoration, with asymmetrical curves and pretty decorative motifs prevailing, than for exteriors, but something of its refinement and charm can be seen even in such a regular and relatively unadorned building as *Gabriel's Petit Trianon (1763-9) at Versailles. From Paris the Rococo was disseminated by French artists working abroad and by engraved publications of French designs. Outside France it had its finest flowering in Germany and Austria, where it merged with a still vital Baroque tradition. In churches such as

that of Die Wies by *Zimmerman and Vierzehnheiligen (1743-72) by *Neumann, the Baroque qualities of spatial variety and of architecture, sculpture, and painting work together in a breathtakingly light and exuberant manner. In Italy the greatest exponent of the Rococo style was *Tiepolo, who also helped to carry it to Spain. In Britain the style was confined mainly to the applied arts, such as furniture and silversmithing, but aspects of it can be seen in the painting of *Hogarth, for example, or of *Gainsborough, whose delicacy of characterization and sensitivity of touch are thoroughly in the Rococo spirit. Rococo lasted longest in Central Europe, where it flourished until the end of the 18th century, but in France and most of the rest of Europe the tide of taste began to turn against it in the 1760s. By then it was coming to be considered frivolous, and it was ousted by the severe and serious *Neoclassical style.

Rodgers, Richard (Charles) (1902–79), US composer. A largely self-taught musician, he began by writing for amateur shows, but only found his métier in 1918, when he teamed up with the lyricist Lorenz Hart (1895–1943). Hart's mordant wit admirably offset Rodgers's lyricism and together they achieved work of great charm and sophistication, including *On Your Toes* (1936), *Babes in Arms* (1937) and, most daring of all, *Pal Joey* (1940). In

The pulpit in the church of Die Wies (1745–54) in Bavaria by Dominikus Zimmerman sports curves and embellishments everywhere in a way typical of **Rococo** art. Like many of the outstanding Central European churches of its period, Die Wies is fairly straightforward in form and structure but exceedingly complex in its decoration, which shows superb standards of craftsmanship.

partnership with Oscar Hammerstein II (1895–1960), Rodgers enjoyed even greater success with *Oklahoma* (1943), *Carousel* (1945), *The King and I* (1951), and *The Sound of Music* (1959).

Rodin, Auguste (1840–1917), French sculptor, one of the greatest and most influential artists of his period. In 1878 he caused a sensation with his first major work, *The Age of Bronze*, a male nude which seemed so realistic that he was accused of having cast it from a live model. His reputation established, Rodin was commissioned by the state in 1880 to make a bronze door for a museum of decorative arts. He never finished the huge work—*The Gates of Hell*—in a definitive form, but he poured some of his finest creative energy into it, and many of its nearly 200 figures formed the basis of famous independent sculptures, notably *The Thinker* and *The Kiss*. The exaggerations and distortions of the anatomy and the rough 'unfinished' quality of the modelling, factors that help create great intensity of expression, are taken further in some of Rodin's public monuments, which were often so radical that they caused furious controversy. Although the literary and symbolic significance that he attached to his work has been out of keeping with the conception of 'pure' sculpture that has predominated in the 20th century, his influence on modern art has been immense, for single-handed he rescued sculpture from a period of stagnation and made it once again a vehicle for personal emotions. He was also a prolific draughtsman, some of his later drawings being powerfully erotic.

Rodrigo, Joaquín (1901–), Spanish composer. Blind from the age of 3, he studied in Valencia (1920–3) and with Paul Dukas in Paris (1927–32). His *Concierto de Aranjuez* (1939) for guitar and orchestra is written in a simple, colourful 'Spanish' style that has earned it the status of a modern popular classic. Rodrigo has also composed concertos in a similar style for piano, violin, cello, flute, and so on.

Roethke, Theodore (1908–63), US poet. His first collection, *Open House* (1941), contained intense lyrics, already marked by the plant imagery of growth and decay that pervades all his poetry. In *The Lost Son* (1948), he lyrically presents psychic and physical biographical experiences of the maturing boy and man. After *Praise to the End!* (1951) his writing became increasingly metaphysical in its preoccupations. *The Waking* (1953) and *Words for the Wind* (1958) collect early and late works, showing great variety and sensitivity. Two further volumes followed, as well as a collection of essays and lectures called *On the Poet and his Craft* (1965).

Rogers, Richard (1933–), British architect. With Norman *Foster (his one-time partner) he was one of the leading exponents of a 'high-tech' style fashionable from the 1970s. His most famous work, designed in collaboration with Renzo Piano (1937–), is the Pompidou Centre in Paris (1971–7), a vast mechanistic structure housing the national collection of modern art. The brightly coloured service ducts and pipes of the building are externally exposed, so that the technology of the structure has become the form. It is undoubtedly one of the most famous buildings of its age, but its status is controversial; to some it is an ebullient masterpiece, to others a joke in very bad taste.

Rolland, Romain (1866–1914), French novelist and essayist. He is remembered for the novel *Jean-Christophe* (1906–12), originally published by *Péguy, which tells, through ten volumes, the life-story of a German composer. It provides an opportunity for Rolland to treat many favourite themes, including music, the moral collapse of cultivated society, and the worth of ordinary uneducated people. Early in World War I he lived in Switzerland, from where he wrote his famous essay on pacifism, *Au-dessus de la mêlée* (1915). He was awarded the Nobel Prize for Literature in 1916.

Romains, Jules (Louis Farigoule) (1885–1972), French novelist, dramatist, and poet. His works are the illustration of his theory of *unanimisme*, according to which mankind achieves its fullest expression in the group rather than the individual. His views emerge first in *La Vie unanime* (1908), a collection of poems, and later in *Knock* (1923), his most successful play, about a doctor who persuades a healthy village community that it is in reality ridden with illness. *Les Hommes de bonne volonté* (1932–47), his most memorable work of fiction, paints, through twenty-seven volumes, an essentially optimistic picture of French society between 1908 and 1933.

Roman art, the art of the Roman Empire from *c.*6th century BC to *c.*5th century AD. *Etruscan art and the later stage of *Greek art were the most important of the various roots from which Roman art sprang. Amongst its greatest achievements is architecture. The great advance of Roman over Greek architecture is in the use of the *arch and the *vault. These were first used in engineering constructions such as bridges, aqueducts, and viaducts, and were later used in palaces, theatres, and other buildings. Roman buildings were usually laid out symmetrically on either side of an imaginary central line or axis. The curving walls and vaulted ceilings of the

The Colosseum in Rome (AD 70–82) is the most stupendous single monument of **Roman art** and still evokes awe because of its sheer size and complexity. It is a vast ellipse in shape, and it had seats for some 50,000 spectators at the gladiatorial contests for which it was built.

vast halls of many buildings could only be achieved by the use of bricks and concrete. Symmetrical planning finds its most complete expression in the imperial forum—a large, enclosed square with a temple forming a focal point in the centre of one of the sides. The *basilica, used as a lawcourt, place of assembly, or market-hall, greatly influenced later *Byzantine architecture. No less important were the achievements of Roman architecture in the design of *theatres and *amphitheatres. Two of the most famous Roman buildings are in Rome: the Colosseum (AD 70–82) and the Pantheon (AD 118–28). The former is the largest of all amphitheatres and a building of immensely complex structure. Various materials are skilfully combined in the construction—lava for the solid foundations, and light pumice stone for the vaulting to reduce its weight. The Pantheon, a temple to all the gods, is the best preserved of all great Roman buildings and features a superb concrete *dome. The arch found its purest use in the triumphal gateways. A particular example was the four-sided arch with two passage-ways intersecting at right angles. The walls of rooms were often painted with decorative designs and scenes. Mythical scenes were often copied from Greek models, but the representation of landscape and architecture for its own sake is probably a Roman innovation. Patterns and pictures in *mosaic first appear on floors, but later also on walls in place of paintings. Ceilings were often decorated with relief designs in *stucco. Compared with their splendid architectural achievements the sculpture of the Romans seems somewhat weak and derivative. Portraiture, however, is one of the most characteristic and important achievements of every period of Roman art. Representations of historical scenes frequently appear in bas relief on imperial triumphal monuments, such as Trajan's Column (AD 106–13) and that of Marcus Aurelius (AD 180–92). As well as showing actual events in simplified form, Roman reliefs often include personifications and allegorical figures. The result is a curious mixture of reality and symbolism. In many ways Roman art can be seen as a continuation of *Hellenistic art, and achieved much the same in the minor and luxury arts, silversmithing, glass-blowing and cutting, and the working of precious stones and ivory, and in the major works of sculpture and architecture. (See also *Ottonian and *Carolingian art.)

romance, a fictional story in verse or prose which relates the adventures of idealized characters: a tendency in fiction opposite to that of *realism. The form derives from medieval courtly stories, the most famous being the Arthurian romances, written in the late Middle Ages by Chrétien de Troyes (in verse), Malory (in prose), and many others. Medieval romance is distinguished from *epic by its concentration on *courtly love rather than warlike heroism. Long, elaborate romances were written in the Renaissance by Ariosto, Spenser (*The Faerie Queene*, 1590–6), and Sidney, but Cervantes's parody of romances in *Don Quixote* (1605) helped to undermine this tradition. Later prose romances differ from *novels in their preference for *allegory and psychological exploration rather than realistic social observation, especially in American works like Hawthorne's *The Blithedale Romance* (1852).

Romance of the Three Kingdoms,

Chinese novel, a rousing narrative based on the division and war of the Three Kingdoms period (AD 220–80) and characterized

This relief sculpture (*c*.1st century AD) depicts a scene from **Roman comedy**. Originally actors had been amateurs, but the theatre became an organized profession in Roman times, with recognized star performers. Here an angry father, restrained by a neighbour, chastises his drunken son (*right*) who is egged on by a slave. Masks make clear the role of each character. (Museo Archeologico Nazionale, Naples)

by martial values, and the courage and strategic thinking of its heroes. A fully developed version is said to have been collected and edited by Luo Guanzhong, a 14th-century dramatist, and this was definitively revised by Mao Zonggang in the 17th century.

Roman comedy, the comic plays written in Latin during the Roman republic (*c*.500–*c*.44 BC), and in imperial Rome (*c*.30 BC–AD *c*.400). Most of these are now lost to us, but of those preserved all are by Plautus and Terence and are loosely adapted from the 'New Comedy' of the *Greek theatre. Plautus (*c*.254–184 BC), whose plays are more boisterous in character and tone than their Greek models, wrote in colloquial Latin. His *senarii*, or conversational dialogues, were spoken, but longer passages, the *cantica*, were sung or chanted to the accompaniment of reed pipes. His plots were for the most part minimal, serving as a frame for scenes of pure farce where social conventions were overturned. Plautus' influence revived with the European Renaissance: he was imitated in the Italian *commedia dell'arte* and, with more sophistication, in *Molière's *L'Avare*. The six comedies that Terence (186–*c*.159 BC) wrote during his short life contain few Roman elements. More polished than those of Plautus, Terence achieved an element of suspense in his plots, and allowed his characters to develop in depth. Both his and Plautus' works were to have enduring influence in European drama.

Roman de la Rose, a French poem dating from the 13th century. The first 4,000 lines, written by Guillaume de Lorris (*c*.1205–*c*.1230), relate an allegorical dream in which the lover enters a garden where he strives to gather a beautiful rose, that is, to win the heart of his beloved. The poem, which was left uncompleted when the author died, embodies the aristocratic ethic of courtly love found, for example, in the work of *Chrétien de Troyes. It was continued some forty years later by Jean de Meung

(*c.*1240–*c.*1305), who added a further 18,000 lines written in a more realistic vein and appealing to bourgeois taste. The second part contains a number of didactic passages, including a denigration of women, which was subsequently refuted by *Christine de Pisan. The attitudes to love expressed in the poem, as well as its technique of allegorical personification (see *allegory), exercised an influence over French poets until the time of the Renaissance.

Roman elegy, subjective love poetry in *Latin literature. The Greeks had used the elegiac *couplet (*hexameter and *pentameter alternating) for verse on many subjects, but its employment for personal love poetry seems a largely Roman development, beginning with *Catullus' passionate poems, some hardly more than *epigrams. The main writers of such poetry were Tibullus and Propertius, who both wrote largely in the 20s BC. Tibullus explored both heterosexual and homosexual passion, but Propertius concentrated on a single mistress, Cynthia. Propertius subsequently turned from the love elegy to less personal and more national poetry. When *Ovid took up the genre in his *Amores*, he treated it with some flippancy: man is now a predator, not a brooding introvert, woman not the stern mistress but the cunning prey. The period of the Roman elegy was short-lived, effectively ending with Ovid.

Romanesque, the style of architecture and art that prevailed throughout most of Europe in the 11th and 12th centuries. The term was originally coined in connection with architecture, but by extension it has been used to cover the painting, sculpture, and related arts of the period. It is sometimes used to cover all the developments from Roman architecture in the period from the collapse of the Roman Empire until the flowering of Gothic, roughly AD 500–1200. More usually, however, it is applied to a distinctive style that emerged almost simultaneously in France, Germany, Italy, Spain, and Britain in the 11th century. There were significant variations from region to region, but Romanesque was the first European style to achieve a truly international currency, which distinguishes it from the *Carolingian and *Ottonian styles of the post-Roman period. The most obvious characteristic of the Romanesque style in architecture was a massiveness of scale. Improved building techniques, a church that was recovering from a period of decline and corruption, the development of more elaborate liturgical practices (which required more chapels and larger choirs), and the foundation of monastic orders resulted in ecclesiastical buildings that were more complex and ambitious than those of preceding centuries. Architects looked to Roman buildings to solve the question of how to build stone ceilings or *vaults over the large spaces they created. Initially barrel vaults (built like a tunnel) were used, but these were eventually supplanted by rib vaults, which instead of being of solid, heavy masonry utilized a skeleton-like framework of intersecting arches (ribs) with a comparatively thin and light infilling of stone between them. This invention, first

Pisa Cathedral with its baptistry and campanile (the leaning tower) is one of the most important monuments of Italian **Romanesque** art. The decorative arcades and pilasters of the marble exterior characteristic of Pisan style were probably inspired by Roman and Florentine buildings, but it has been suggested that there was Armenian influence on the building, since Pisan ships were transporting crusaders and pilgrims to the Holy Land at the time of its construction.

used on a large scale at Durham Cathedral in about 1100, revolutionized medieval architecture, enabling much wider spans to be covered by vaults. The need to provide a stable support for vaults encouraged the massive strength of construction and solidity of wall typical of Romanesque architecture. The finest Romanesque churches have a sense of great vigour, not simply of ponderous weight, and are often enlivened by bold decorative motifs, such as zig-zag patterns, cut into the stone. In Italy churches were sometimes built or decorated with multi-coloured marble (as at Pisa Cathedral, with its leaning bell tower), but elsewhere Romanesque buildings were often more severe, particularly German cathedrals such as at Trier and Limburg with their magnificent groups of towers and turrets. Common to Romanesque architecture everywhere was the use of the round *arch (as in Roman buildings), giving way to the pointed arch as the *Gothic style developed. Romanesque architecture in Britain is often called Norman, because it is associated so closely with the Norman conquest of 1066. It is to be found in its purest form in the small Chapel Royal of St John in the Tower of London, built in 1078. The most notable example of Romanesque church architecture on a grand scale is Durham Cathedral, begun in 1093. Castles built of stone made their appearance during the Romanesque period, constructed in the form of keeps or huge central towers that served as the chief living quarters of a castle and the final line of defence. A famous example is the keep at the Tower of London, built for William the Conqueror in 1078–87. Comparatively little large-scale painting, mostly of church murals, has survived (originally the churches of the period would have been alive with colour). Many manuscript illuminations have come down to us, however, and the art of stained glass was perfected during the Romanesque period. There are also some fine Romanesque mosaics, particularly in Italy. A remarkable work of pictorial art of the period is the wall-hanging embroidered on linen, the celebrated *Bayeux Tapestry. The finest examples of Romanesque sculpture emerged at the end of the 11th century and the beginning of the 12th century, with France showing the richest tradition, and *Gislebertus, sculptor at Autun Cathedral in France, is one of the few artists we know by name. In Romanesque painting and sculpture the forms of nature are at times freely translated into linear designs that are sometimes majestically calm and severe and at others agitated by a visionary excitement which can become almost delirious. The decorative arts in gold, silver, ivory, bronze, and precious stones, were often used in making objects for church ritual or containers for holy relics. Many such objects have perished as plunder because of the value of their raw materials, but enough survive to show the superb quality of Romanesque craftsmanship.

Roman satire, the only genre in *Latin literature that appears to have no direct Greek ancestor. The term *satura* seems to imply a medley of diverse materials, and Roman satirists are themselves highly diverse. A form known as 'Menippean' satire combined prose and verse. Petronius' *Satyricon* brought this type close to the *Greek and Roman novel. Lucilius (d. 1021 BC), under the republic, named and savaged contemporaries, and from then on most satire was written in *hexameter verse. *Horace attacked vices rather than individuals, while later *Juvenal, beginning from the evils of imperial Rome, increasingly took the human lot in general as his subject. Styles differ

The painter Friedrich exemplifies more clearly than any other artist the tendency in **Romanticism** to imbue landscape with spiritual meaning. His remark 'the artist's feeling is his law' might be said to sum up the movement. This picture, *Journey above the Clouds*, expresses the Romantic yearning for the individual to lose himself within nature by juxtaposing the solitary figure against dramatic mist-swathed peaks. (Private collection)

correspondingly: Horace gave artistic polish to Lucilius' crude colloquialism, and Juvenal wrote in a high rhetorical vein which is usually appropriate to his material. All three aim, at least on the surface, to correct the follies of men, using philosophy, humour, and sometimes indecency as weapons.

Romanticism, a sweeping but indispensable term applied to the profound shift in Western attitudes to art and human creativity which dominated much of European culture in the first half of the 19th century, and which has shaped most subsequent developments in the arts— even those reacting against it. In its most coherent early form, as it emerged from the 1790s in Germany and Britain, and from the 1820s in France and elsewhere, it is known as the Romantic Movement. Its chief emphasis was upon freedom of individual self-expression: sincerity, spontaneity, and originality became the new standards in the arts, replacing the decorous imitation of classical models favoured in the 18th century. Rejecting the ordered rationality of the *Enlightenment as mechanical, impersonal, and artificial, the Romantics turned to the emotional directness of personal experience and to the boundlessness of individual imagination and aspiration. Increasingly independent of the declining system of aristocratic patronage, they saw themselves as free spirits expressing their own imaginative truths rather than

adorning the household of a noble master. Several found a new audience among an expanding middle-class public eager for emotional sustenance and sensation, and ready to hero-worship the artist as a genius or prophet. The restraint and balance valued in 18th-century culture was abandoned in favour of emotional intensity, often taken to extremes of rapture, nostalgia (for childhood or the past), horror, melancholy, or sentimentality. Some—but not all—Romantic artists cultivated the appeal of the exotic, the bizarre, or the macabre; almost all showed a new interest in the irrational realms of dream and delirium or of folk superstition and legend. The creative imagination occupied the centre of Romantic views of art, which replaced the mechanical rules of conventional form with an organic principle of natural growth and free development. Romanticism drew some of its energies from the associated revolutionary movements of democracy and nationalism, although the 'classical' culture of the French Revolution actually delayed the arrival of French Romanticism, and an element of conservative nostalgia is also evident in many Romantic artists. The emergence of Romanticism can be attributed to several developments in late 18th-century culture, the most significant being the *Sturm und Drang phase of German literature, the influential *primitivism of Jean-Jacques *Rousseau, the cult of sensibility, the *Gothic novel, the taste for the *Sublime and *Picturesque in landscape gardening and tourism, and the revived interest in *ballads and old *romances (from which Romanticism takes its name). The immediate inspiration for the first self-declared Romantics—the German group including the *Schlegel brothers and *Novalis—was the transcendental philosophy of Kant and Fichte, which stressed the creative power of the mind and allowed nature to be seen as a responsive mirror of the soul. This new German thinking spread via *Coleridge to Britain and via Mme de *Staël to France, eventually shaping American *Transcendentalism. English Romanticism had emerged independently with *Blake's then little-known anti-Enlightenment writings of the 1790s and with the landmark of *Wordsworth's 1800 Preface to *Lyrical Ballads*. Romanticism thus began as a literary movement, but achieved a sustained influence on music and a less distinct impact upon painting (see below). By the 1830s the movement extended from *Pushkin in Russia to *Poe in the USA.

In **literature**, Wordsworth in England and *Hugo in France declared an end to the artificiality of older conventions. *Lyric poetry underwent a major revival led by Wordsworth, *Keats, *Pushkin, *Leopardi, *Heine and others; narrative verse took on a new lyricism, but the theatre tended towards the sensationalism of *melodrama. *Hoffmann and *Poe pioneered the tale of terror while the *historical novels of *Scott, *Manzoni, *Hugo, and *Cooper combined bold action with nostalgic sentiment. The astonishing personality of *Byron provided de *Musset, *Lermontov, and other admirers with a model of the Romantic poet as tormented outcast. The growing international cult of Shakespeare also reflected the Romantic hero-worship which, in the writings of *Carlyle and *Emerson, became a 'heroic' view of history as the product of forceful personalities like Napoleon. In **music**, a continuous Romantic tradition can be traced either from *Beethoven (a Romantic hero, although predominantly classical in style) or from *Weber and *Schubert through to *Mahler and Richard *Strauss in the early 20th century, embracing divergent styles ranging from the almost classical purity of *Brahms to the lavish sentimentality of *Tchaikovsky. More a matter of mood than of technique, Romanticism involved closer alliances between music and poetry, in the song-cycles of Schubert and *Schumann, in the rise of 'programme music' (illustrating a story, as in *Berlioz's *Symphonie Fantastique*, 1830), in the 'symphonic poems' of *Liszt, and ultimately in the grandiose 'music-drama' of *Wagner. Using increasingly enlarged orchestras, composers sought an extended range of feeling, stretching tonal harmony to its limits. The new concert-going public which acclaimed the virtuoso performers Paganini (violin) and Liszt (piano) gave rise to the new form of the concert overture (for example, *Mendelssohn's *Hebrides*, 1832), while church music and chamber music declined in importance. The nationalist feeling discerned in *Chopin's Polish mazurkas and Liszt's *Hungarian Rhapsodies* became more pronounced in *Dvořák's use of Czech folk music and in the group of Russian composers known as The *Five. The grammar of music was subject to great pressures by these developments. Old dissonances became acceptable as new harmonies. The concept of *tonality grew weaker, and by the end of the century radically new ways of explaining musical structure were being sought. In **dance** the movement was influential in the mid-19th century and continues into the 20th. The Romantic ballet emerged in *La Sylphide* (1832), with its lyrical and ethereal qualities. Typical features of Romantic ballets are the reference to folk-tales, pastoral scenes, and potent symbols. *Giselle* (1841), the climax of the Romantic vision, demonstrates an unbridgeable gap between belief in simple happiness and the brooding disasters of unrequited love. In the **visual arts**, the boundaries of Romanticism stand out less clearly: the 18th-century taste for natural 'wildness' of mountain scenery and for 'picturesque' ruins preceded any clearly identifiable Romantic school of painting. Indeed there is no unique Romantic visual style as such, only a strong adherence to personal vision, notably in *Turner's use of light and colour, and in the sombre symbolic landscapes of *Friedrich. The controversial French artists *Géricault and *Delacroix stood out as Romantics with the violent energy of their paintings; both admired the quieter Romantic landscapes of *Constable. Other significant Romantic artists include *Fuseli, *Martin, and the poet-engraver Blake. The nostalgia of the *Pre-Raphaelites and of the *Gothic Revival in architecture may also be seen as Romantic.

Romney, George (1734–1802), British painter. His finest works are probably his portraits of young people, where his delicate colour sense and elegant line were used to good effect. In about 1781 he became infatuated with Emma Hart, later Lady Hamilton, whom he painted many times in various guises. Romney failed in his ambition to paint grandiose literary and historical subjects.

rondo, a musical form in which a main section returns several times during the course of the movement. In between these recurring sections are passages of contrasting material. The main section always returns in the same key, and is supplied with a memorable tune. Rondo form is thus an extension of *ternary form, the ABA pattern being developed into an ABACADA shape. A more sophisticated version involves the repetition of

contrasting section B, thus giving a pattern (ABACABA) which is a cross between ordinary rondo and *sonata form. The rondo was frequently used as a cheerful last movement in symphonies up to the time of Beethoven.

Ronsard, Pierre de (1524–85), French poet. He was a leading figure in the group of poets known as the Pléiade, and probably worked with *Du Bellay on his *Défense et illustration de la langue française* (1549), which set out the group's programme for poetic reform. This sought inspiration through an imitation of Greek and Roman literature which sometimes resulted in poetry that was erudite, even obscure. Ronsard was an ambitious poet, writing in many different forms and styles; at his best, he achieves a purity of lyricism in which he typically celebrates the beauties of nature or the brevity of love and life. Among his most famous poems are *Mignonne, allons voir si la rose* from the early *Odes* (1550–3) and *Quand vous serez bien vieille* from the later *Sonnets pour Hélène* (1578).

Rosa, Salvator (1615–73), Italian painter and etcher, active mainly in Rome. He was a flamboyant character—a poet, actor, and musician as well as an artist—and in the 18th and early 19th centuries, when his fame was at its height, he was held up as one of the great role models of *Romanticism, the artist as a rebel against society. He painted various subjects, but he is best known for the creation of a new and highly influential type of wild and savage landscape that contrasted with the serenity of *Claude or the classical grandeur of *Poussin. Rosa is also well known for his macabre scenes, notably of witches.

Rossellini, Roberto (1906–77), Italian film director. He is best known for his two superb neo-realist films: *Rome, Open City* (1945), about the Nazi pursuit of a Resistance leader, and *Paisan* (1947), six episodes during the Allied recapture of Italy. The third film in the trilogy, *Germany, Year Zero* (1947), set in occupied Berlin, was less successful. All three were acted mostly by non-professionals and shot in authentic locations. Rossellini also made four feature films with Ingrid Bergman (1915–82), to whom he was married for a time: *Stromboli* (1949), *Europa '51* and *Voyage in Italy* (both 1952), and *Joan of Arc at the Stake* (1954). Neither these nor his other later films matched his earlier masterpieces.

Rossetti, Christina (Georgina) (Ellen Alleyne) (1830–94), British poet. She was the sister of the painter and poet Dante Gabriel *Rossetti and contributed poems (including 'The Dream') to *The Germ*, the periodical of the *Pre-Raphaelites. A devout High Anglican, her work ranges from poems of fantasy and verses for the young to ballads, love lyrics, sonnets, and religious poetry. It was noted for its technical virtuosity and short, irregularly rhymed lines. A sense of melancholy pervades her work with recurrent themes of delayed or frustrated love and of resignation ('Grown old before my time') as in 'A Dirge' and 'When I am dead, my dearest'. Among her best-known works are 'Up-hill', 'A Birthday', *The Prince's Progress and other poems* (1866), and the anthology *Goblin Market* (1862), which has been variously interpreted as religious *allegory or sexual symbolism.

Rossetti, Dante Gabriel (1828–82), British painter and poet. Born into a highly cultured family he studied at the Royal Academy schools and in 1848 formed the *Pre-Raphaelite Brotherhood with two fellow-students, Holman *Hunt and *Millais, and four other young men. When the Pre-Raphaelites were bitterly attacked, Rossetti withdrew from exhibiting his work, and in the 1850s he turned to water-colours, mainly of romantic medieval subjects, with which he was highly successful. In the 1860s he returned to oils and concentrated on sensuous pictures of beautiful women, his models including Jane Morris, wife of William Morris. Rossetti's poems (published in 1870), like his paintings, are often about women and love, and at the time they were attacked as obscene.

Rossini, Gioachino (Antonio) (1792–1868), Italian composer. The son of theatre musicians, he began his professional career with the one-act comic *opera *The Bill of Marriage* (1810). He established his reputation in 1813 with two operas, the tragic *Tancredi* and the comic *The Italian Girl in Algiers*. He was soon famous throughout Europe, writing nearly forty operas in all, including *The Barber of Seville* and *Otello* (1816), *Semiramide* (1823), and *William Tell* (1829). Ill-health and disillusion led to semi-retirement in 1836, after which he wrote only salon pieces and such works as the *Stabat Mater* (1842) and the *Petite Messe solennelle* (1863).

Rostropovich, Mstislav (Leopoldovich) (1927–), Russian-born cellist, pianist, and conductor, resident in the USA. One of the great cellists of his day, Rostropovich gave the first London performance of Shostakovich's First Concerto (1960). His friend Britten composed the Cello Sonata and the *Cello Symphony* (1963) for him. As a pianist, he frequently accompanies his wife, the Russian-born soprano singer Galina Vishnevskaya (1926–). Rostropovich is also a brilliant operatic and symphonic conductor.

Roth, Philip (1933–), US novelist and short-story writer. His first collection, *Goodbye, Columbus* (1959), set the pattern for a succession of novels featuring observation of Jewish-American mores and contemporary sexuality in a flip, personal style, culminating in the popularly successful *Portnoy's Complaint* (1969), a man's confessions to his psychoanalyst. Later works, such as *Zuckerman Bound* (1985) and *The Counterlife* (1987) show him broadening his range impressively.

Rothko, Mark (1903–70), Russian-born US painter, one of the outstanding *abstract artists of his period. He was largely self-taught, and during the 1930s and 1940s he went through phases influenced by *Expressionism and *Surrealism before turning to complete abstraction and developing his own highly individual style from about 1947. His mature pictures, which are often very large, feature rectangular expanses of colour arranged parallel to one another, usually in a vertical format. The edges of the shapes are softly uneven, giving them a hazy, floating, gently pulsating quality that produces an effect of serene calmness and contemplation. His late works tend to be very sombre in colour, perhaps reflecting the state of depression that led to his suicide. (See also *colour field painting.)

Rouault, Georges (1871–1958), French painter, graphic artist, and designer. In his youth he trained in a stained-glass workshop, an experience which was to

Before a Mirror (1906) is one of **Rouault**'s many powerful pictures of prostitutes, a subject that for him was a symbol of a rotting society. The settings are murky and the feelings conveyed are ones of indignation and revulsion. Like many of Rouault's pictures, this is in water-colour. (Musée National d'Art Moderne, Paris)

influence much of his later work. In about 1898 he underwent an acute psychological crisis, turning to subjects that expressed his hatred of cruelty, hypocrisy, and vice and depicting the ugly and degraded side of humanity with passionate conviction. His pictures of clowns, prostitutes, outcasts, and judges, painted in sombre but glowing colours, initially disturbed the public, but during the 1930s he gained an international reputation. From about 1940 he devoted himself almost exclusively to religious art. Apart from a prolific output of paintings, his work included book illustrations, ceramics, and designs for tapestry, stained glass, and the stage.

Roubiliac, Louis-François (*c.*1705–62), French-born sculptor, active in England for virtually his entire career. He settled in London in the early 1730s, and soon established himself as the leading portrait sculptor of the day. His busts have great vivacity and he showed a remarkable gift for producing lively portraits of men long dead. Roubiliac was also an outstanding tomb sculptor, several notable examples being in Westminster Abbey, showing his vivid imagination as well as his superb craftsmanship. He is generally regarded as one of the greatest sculptors ever to have worked in Britain.

round *canon.

Rousseau, Henri (1844–1910), French *naïve painter. From 1871 to 1893 he worked for the Paris Customs Office and he was nicknamed 'Le Douanier' (customs officer). He took early retirement in 1893 to devote himself full-time to art, but failed to make a successful career of it and died in poverty. His work is remarkable for its innocence and charm and he showed an uncanny ability to retain the freshness of his vision even when working on a large scale. He is best known for his jungle scenes, inspired by visits to the Zoological and Botanical Gardens in Paris, but painted a variety of other subjects, some drawn from everyday life, others from his vivid imagination. His greatness began to be widely recognized soon after his death and he is today considered the greatest of all naïve painters.

Rousseau, Jean-Jacques (1712–78), French philosopher and writer, one of the dominant writers and thinkers of his age. In his *Discours sur les sciences et les arts* (1750) he concludes that the natural man or 'noble savage' is preferred to his civilized counterpart, arguing that the development and spread of knowledge and culture, far from improving human behaviour, has corrupted it by promoting inequality, idleness, and luxury. His novel, *Julie, ou la Nouvelle Héloïse* (1761), is a critical account of contemporary manners and ideas interwoven with the story of a passionate love. *Emile, ou de l'éducation* (1762) is a treatise on education intended to show how a child's naturally virtuous instincts can be developed, not corrupted as Rousseau believed they are by society. In *Du contrat social* (1762) Rousseau applies his trust in human nature to the realm of politics, going beyond the constitutional monarchy admired by *Montesquieu to advocate democracy in accordance with the 'general will' and for the common good. His autobiographical writings, the *Confessions*, three dialogues, and the *Rêveries du promeneur solitaire*, all published posthumously, reveal the persecution mania by which he was dominated. They remain landmarks of the literature of personal revelation and reminiscence. Unlike the other major figures of the *Enlightenment, Rousseau stressed emotion and intuition rather than reason, and was thus a forerunner of Romanticism.

Rousseau, Pierre-Étienne-Théodore (1812–67), French landscape painter, the central figure of the *Barbizon School. He was one of the pioneers of *landscape painting from direct observation of nature. In 1848 he settled permanently in the village of Barbizon, where he was a close friend of *Millet. His early work, depicting nature as an uncontrollable force, was hailed by many of France's leading Romantic painters and writers, but was consistently rejected by the *Salon in Paris (earning him the nickname 'le grand refusé'). Official success came to him after the Revolution of 1848.

Roussel, Albert (Charles Paul Marie) (1869–1937), French composer. A visit to the East (1909) greatly influenced his style, as can be seen in the orchestral suite *Evocations* (1911) and the opera-ballet *Padmâvatî* (1918). The ballets *Le Festin de l'araignée* (1912) and *Bacchus et Ariane* (1930), together with his four symphonies, show his music at its best: richly harmonic (with touches of *polytonality), and with rhythmic qualities that reflect the influence of *Stravinsky.

Rowlandson, Thomas (1756–1827), British *caricaturist. He was a brilliant and prolific social commentator,

creating a memorable and instantly recognizable gallery of social types, satirizing the manners, morals, and occupations of English society. Although his humour was generally bawdy or boisterous, his technique as a watercolourist was deft and fresh, and in spite of his huge output he maintained a remarkable overall quality.

Royal Academy of Arts, London, the national art academy of Britain, founded in 1768 with the aim of raising the status of the artistic professions and arranging exhibitions of works attaining an appropriate standard of excellence. The Academy succeeded in improving the economic and social status of artists, reflecting the prestige enjoyed by its first President, Sir Joshua *Reynolds. Until the late 19th century it was the most influential art institution in Britain, but it then came under attack as a bastion of orthodox mediocrity opposed to creative innovation, and the *New English Art Club was set up to challenge its domination. The Academy still enjoys considerable prestige, however; its annual summer exhibition is a popular social event, and it regularly organizes historical exhibitions of the highest quality.

Royal Ballet, Britain's national ballet company. It began as the Vic-Wells Ballet in 1931 under the direction of *de Valois and with the encouragement of Lilian *Baylis. By 1946 it had moved from Sadler's Wells Theatre to the Royal Opera House and in 1956 was granted a royal charter. Under de Valois and later *Ashton the company and its school were responsible for establishing British ballet, and the lyrical British style. With a repertoire grounded in the 19th-century classics it has staged numerous works by British choreographers and nurtured dancers like *Fonteyn, Antoinette Sibley, and Anthony Dowell. The latter now directs the company.

Royal Danish Ballet, company based at the Theatre Royal, Copenhagen. Ballet appeared at the theatre from 1748 but flourished under Galleotti's direction (1775–1812) and again under *Bournonville (1829–75). The latter's work formed the basis of the repertoire as well as the Danish style, with its fleet footwork and graceful open carriage. After a period of decline, both the company and its Bournonville classics were revived under Harold Lander's direction (1932–51) and new choreographic styles were introduced. It has produced some particularly fine male dancers, including Peter Schaufuss (now the director of the English National Ballet) and Peter Martins.

Rubbra, (Charles) Edmund (1901–86), British composer and pianist. His music is influenced by 16th- and 17th-century composers, and is marked by long, lyrical themes in tireless *polyphony, eschewing anything merely decorative. His output includes concertos, chamber music, and sacred choral pieces, but his main contribution was a cycle of eleven symphonies (1935–79).

Rubens, Sir Peter Paul (1577–1640), the greatest Flemish painter of the 17th century and the outstanding figure in northern European *Baroque art. He trained in Antwerp, but his real artistic education was in Italy, where he was based from 1600 to 1608. In particular, the experience of Rome, with its antique statuary, the great Renaissance frescos of *Michelangelo and *Raphael, and the works of such leading contemporary artists as *Caravaggio and Annibale *Carracci, gave his style

a heroic grandeur then unknown north of the Alps. In 1609 he became court painter to the Archduke Albert and the Infanta Isabella, the Spanish regents in the Netherlands, and he was soon inundated with work. He was able to handle the flood of commissions from all over Europe only because he ran such an efficient studio, employing artists of the calibre of van *Dyck as his assistants. He painted virtually every type of subject, and designed tapestries, book illustrations, festival decorations, sculptures, and architectural work. He visited England in 1629–30 on a diplomatic mission and was knighted by the art-loving Charles I, who commissioned from him the series of ceiling paintings glorifying the reign of his father James I in the Banqueting House in London, the only one of Rubens's large decorative schemes that is still in the position for which it was painted. Although his career was played out on an international stage, Rubens also painted deeply personal pictures, particularly of his two beautiful wives and the children they bore him. His dynamic and colourful style had an overwhelming effect on his Flemish contemporaries, and his posthumous influence has been enormous and widespread.

Rubinstein, Anton (Grigorevich) (1829–94), Russian pianist and composer. Touring and studying in Europe from 1840, Rubinstein settled in St Petersburg (1858) where he founded the Conservatory in 1862. He

This self-portrait of **Rubens** with his first wife, Isabella Brant, the daughter of an eminent Antwerp lawyer, was almost certainly painted to mark their marriage in 1609. It gives a marvellous picture of the artist on the threshold of a career of unprecedented productivity and international success—handsome, vigorous, and dashingly self-confident. (Alte Pinakothek, Munich)

toured the USA (1872–3) and visited Britain several times. One of the greatest pianists of his day, his playing compared with that of *Liszt, Rubinstein was a prolific composer, although only the *Melody in F* for piano is remembered.

Rublyov, Andrey (c.1360–1430), Russian painter. He is the most famous of all *icon painters, but there is little secure knowledge of his life or works. His masterpiece is the celebrated icon of the *Old Testament Trinity* (Abraham's three angels, c.1411). In its gentle lyrical beauty this marks a move away from the Byzantine tradition, and other icons in a similar style have been attributed to Rublyov. He is also known to have painted murals, but none of his authenticated works in this field have survived.

Rudolph, Paul (1918–), one of the leading post-war US architects. He was a pupil of *Gropius at Harvard, and his early buildings reflect *Bauhaus ideas, but he came to develop a more independent sense of form, treating his buildings sculpturally and attempting to find an individual approach appropriate to each building's function. His best-known work is the Art and Architecture Building at Yale University (1958–64) in *Brutalist concrete. His other work has included urban planning, houses, embassies, and government and civic buildings.

Ruggles, Carl (Charles) Sprague (1876–1971), US composer. After studying music at Harvard (1903–7), and working as a teacher and conductor, he settled in New York. The masterly *atonal *polyphonic style of his best work is exemplified by the orchestral piece *Men and Mountains* (1924). He wrote relatively little; his work was idiosyncratic and fiercely independent, like that of *Ives.

Ruisdael, Jacob van (c.1628–82), Dutch landscape painter. He came from an artistic family (Salomon van Ruysdael was his uncle) and began painting mature and distinctive works when he was still in his teens. His output included scenes of watermills and windmills, forests and grainfields, seascapes and winter landscapes; he could conjure poetry from a virtually featureless patch of duneland as well as from a magnificent panoramic view. The emotional force of his work distinguishes him from most of his contemporaries; as with Rembrandt, a landscape for Ruisdael was not simply the depiction of a particular place, but a vehicle for expressing emotional qualities, ranging from the subtlest suggestions of mood to a sense of tragic grandeur. Ruisdael's influence on landscape painting was resounding, not least in England, where he was revered by Gainsborough and Constable.

rumba (rhumba), a *Latin American dance with a strongly African character; it is basically in $\frac{2}{4}$ metre, with syncopated and broken rhythms played with strong percussive effect. The Cubans adapted the original African dance into a ballroom dance called the *danzón*, and with the general outflow of Latin American music to North America and Europe, the modern rumba came into vogue in New York about 1931, the most popular and typical composition to which it was danced being 'The Peanut Vendor'.

Rūmī, Jalāl al-Dīn (1207–73), called Maulāna or Mevlāna, Persian poet and founder of the Mevlevī or 'whirling' dervishes, a Muslim mystical order who are famous for their meditative dance. He was born in Balkh (in modern Afghanistan), but was taken as a child to Turkey, and lived most of his life in Konya, where he is buried. His best-known works are his collection of *ghazals* or sonnets known as the *Dīvān-i Shams-i Tabrīzī*, named after the dervish or Muslim devotee who inspired them, and his huge poem called the *Masnavī-yi ma'navī*, which expresses the philosophy of Islamic mysticism or Sufism through stories.

Runge, Philipp Otto (1777–1810), German painter and draughtsman. As a *Romantic artist he was of a mystical turn of mind and used his work to express notions of the harmony of the universe through symbolism of colour, form, and numbers. He was also an outstanding portraitist, painting in a rigid, sharp, and intense style.

Rushdie, (Ahmed) Salman (1947–), Indian-born British novelist. His first novel, *Grimus* (1975), explored the world of fable and folk-tale, from which the imaginative flamboyance of his later work draws its strengths. His prizewinning *Midnight's Children* (1981) views the development of modern India through the eyes of a telepathic child born at the very moment of Independence. *Shame* (1983) is a fabulous satire on Pakistan's ruling élite. Following his non-fictional account of Nicaragua, *The Jaguar Smile* (1987), his novel *The Satanic Verses* (1988), an ambitious fantasy on good and evil and on the migrant experience, gave rise to an international crisis when Muslim protesters from Bradford to Srinagar burned copies of the book, charging Rushdie with blasphemy against the Prophet Mohammed. The novel was banned in several countries, and Rushdie was forced into hiding in 1989 when the Iranian leader Ayatollah Khomeini pronounced a death sentence against him as a blasphemer.

Ruskin, John (1819–1900), influential British critic and art theorist, also a talented water-colourist. His literary output was enormous and he had a remarkable hold over public opinion, as he showed when he defended the *Pre-Raphaelites in 1851. Although Ruskin worshipped beauty for its own sake, he thought that art, in particular as expressed in the *Gothic style, could be a means of solving social problems, and in the second half of his life he devoted himself much to philanthropic work (using his inherited fortune) and to writing on economic and political questions. His eloquence in linking art with the daily life of the workman had affinities with the views of William *Morris, and he defended the older school of craftsmanship against the new aesthetic in mass production that followed the Industrial Revolution.

Russian art, the art and architecture of Russia and, since 1921, of the Soviet Union. Russian art originated among the Slav-speaking people who settled in the 7th century AD in the great central plain contained by the rivers Dnieper and Volga. In the 10th century the Slav rulers adopted Christianity, which from then on was to form the core of the nation's culture, inspiring its art and directing its thought. Russia in the 10th century centred round the principality of Kiev, its satellite city, Novgorod, and several minor towns. Its people, strongly influenced by *Byzantine art, built churches and monasteries and adorned them with scenes from the scriptures painted on the interior walls of religious buildings as well as upon individual panels and *icons. In architecture, the churches had, like their Byzantine models, three aisles and a dome; but the Russians soon began experimenting

Kasimir Malevich's *Women Harvesting* (1912) dates from one of the most remarkable periods of **Russian art**, when painters and sculptors were in a ferment of revolutionary ideas. It is one of a number of peasant subjects in which Malevich created a highly individual style by combining traditional Russian themes with influence from Western modernism, specifically the 'tubular' forms of Fernand Léger. (Stedelijk Museum, Amsterdam)

with the shape of the dome until, in the 12th century, they had evolved the characteristic onion shape. The more important churches had several domes, although usually not more than three or five, and perhaps as many as five aisles. The arts necessary to the decoration of a church, such as embroidery, metalwork, carving, and bookbinding, also flourished, and followed the Byzantine style. The Mongol occupation of Russia (mid-13th–end 14th century) arrested the growth of Russian art. It revived during the 15th century, when the most important centre of art was Novgorod. Among other architectural innovations was the wooden 'iconostasis' (stand for icons), a screen to separate the altar in the apse from the body of the church. This served as an additional incentive to artists, who were called upon to paint icons for its decoration; and throughout the 14th and 15th centuries, religious paintings of outstanding quality were produced, for example the work of Andrey *Rublyov. In Novgorod, the rigid Byzantine style gave place to a gentleness inspired by slight contact with Italian art. The devotional fervour of the age expressed itself in an elongation of the figures, a delicacy yet forcefulness of colour, and a flowing line which gave an emotional quality to the paintings. In

the 16th century, contacts with the West resulted in a greater variation in style, and foreign and national forms were combined with remarkable felicity. Palaces, fortifications, and churches of delightful imaginativeness sprang up throughout the land. Among the most picturesque were those which re-created the native wooden pyramid style of building in stone and wood. The medieval style of religious painting came to a sudden end when Peter the Great (1682-1725) Westernized Russia and transferred his capital from Moscow to St Petersburg (now Leningrad). Since Russian artists could not instantly produce the secular, Westernized art Peter desired, foreign artists from Holland, Italy, Germany, and France were employed; in the 18th century an alien art was grafted on the national, and in its turn was absorbed and developed. Crafts, on the other hand, were little influenced by Western ideas, but retained their original flamboyance, their intricacy of pattern and their medieval forms. Up to the present century, the Russian countryside was enlivened by the harmonious colours used to offset the splendid carving of door jambs and window surrounds, garden gates and farm carts, domestic utensils, furniture, and toys. In the 19th century artists threw their skill into the social battle for reform, producing numerous paintings with a moral message. This movement was rejected at the turn of the century by a group of artists, known today as 'The World of Art' group, which set out to revive artistic quality under the banner of 'Art for Art's Sake'. They created many paintings of fine quality, and made their influence felt in every branch of art, though perhaps most forcefully on the stage, particularly in ballet, and in the field of book illustration. In the early 20th century

Russian painters, sculptors, and theatre designers were in the vanguard of *abstract art, most notably in the movements called *Constructivism and *Suprematism. All forms of innovative art, *Futurism, for example, flourished in Russia during the first years after the Revolution, but later the state disapproved of experimental art and encouraged *'Socialist Realism'—the didactic depiction of subjects which expressed the aims and ideals of Communism. More recently, the trends in Soviet art have reflected those in the West.

Russian literature, literature written in the Russian language. From its beginnings in the late 10th century until the 18th it was largely the written record of the doctrines and official views of the Eastern Orthodox Church. It used a literary language, Church Slavonic, that was distinct in many ways from the vernacular. It was largely anonymous and conventional, deriving from and depending on Byzantine models: writings about church leaders, hagiography (saints' lives), chronicles, fables, and tales. It was probably the late 12th century that produced the much debated work of Old Russian literature, the epic *The Lay of Igor's Campaign*. From the baptism of Russia in 988 until the invasion of the Tartars in 1237, the centre of literary activity was Kiev. From then until the supremacy of Moscow in the 16th century, literary works were created that reflected the military struggle of the various principalities against the Mongols and other invaders. The Renaissance had no profound cultural effect on contemporary Russia. Secular literature, notably satirical tales, began to appear in the 17th century. It was only with the foundation of St Petersburg (now Leningrad) and the impact of the European *Enlightenment in the 18th century that modern literature began. The 18th century saw the introduction, following French and German models, of neoclassical literature, with its public, didactic intent and ordered hierarchy of genres. *Lyric poetry developed furthest, but longer poems and verse-drama were also prominent; the first attempts at the novel and short story appeared. A vital role was performed by *Lomonosov, who attempted to systematize poetic diction. The first important Russian poet was *Derzhavin, whose civic concerns did not obscure his personal passions. The 18th century saw the first attempts to collect the oral legacy of Russian folklore. The satirical play, *Wit Works Woe* (1822) by Aleksandr Griboyedov (1795–1829) created a gallery of now proverbial characters and some of the most oft-quoted lines in the Russian language. In *Pushkin's work are contained the seeds of subsequent developments in all the genres of the 19th and early 20th centuries. His wide use of folklore and of the living language brought literature within reach of a much wider public, while *Lermontov introduced a darker and more passionate note. Both poets were influenced by western *Romanticism. After this, verse went into a long decline, the novel emerging as the leading and most characteristic genre of the national literature. Of formative influence on later writers were the short stories and novels of *Gogol. The novels of *Tolstoy, *Dostoyevsky, and *Turgenev brought Russia to the forefront of literature and remain its greatest contribution. The scale and scope of realistic composition was refined by *Chekhov in his short stories and dramas, which rank among the masterpieces of European literature. Poetry became pre-eminent with the rise of the *Symbolists in the 1890s. The combination of their

metaphysical search with a rediscovery of the real world in the late Symbolist and post-Symbolist Russian poets born between 1880 and 1895 brought about an unprecedented flowering of poetry; this creative ferment continued through the 1920s. During the Symbolist period *Gorky and other prose writers had kept alive the classic tradition of *Social Realism, and it was this tradition that was drawn upon when Soviet literature, with its mandatory doctrine of Socialist Realism, was created along with the bureaucratization of literature in the 1930s. The imposition of Party controls led to a new specifically Soviet literature, centred in the novel but extending to drama and children's literature, whose task was to give artistic embodiment to the Party's goals and interpretations. However, literary talent was always pitted in creative tension against political dogma, as in the work of *Mandelshtam, Anna *Akhmatova, and *Bulgakov, whose novel, *The Master and Margarita* remains probably the best-known work of that period. Since the Revolution there has been an unbroken tradition of unofficial writing, sometimes 'self-published' (*samizdat*), sometimes sent abroad for publication, and sometimes simply hidden until favourable times come along ('writing for the drawer'). Soviet literature was revitalized with the Khrushchev 'thaw', which began after 1956 and lasted until the mid-1960s and saw the flourishing of the work of writers such as *Yevtushenko. Poetry played a particularly important role in this revitalization; in the form of guitar-accompanied song it survived in a vigorous manner. Under Brezhnev, official literary policy was tightened when it became apparent, principally through the *Solzhenitsyn case, that dissident writers could not be silenced. Increasingly, they were exiled from the USSR. The Leningrad poet Joseph *Brodsky, who has been resident in the USA since 1972, is generally considered to be the most important to have emerged in the Soviet Union since World War II. During the Brezhnev years a deepening stagnation and increasing polarization into official and underground streams developed; the latter including some interesting experimental poetry. The policies of Gorbachev since 1985 have led to a revitalization of literary life, with many previously banned works, including those by emigrés, being permitted publication. Russian literature has throughout been distinguished by its concern for social issues, acting in many ways as an alternative to religious, philosophical, and political debate. Above all, it has furnished a series of heroes by reference to whom the nation has observed and defined its character.

Ruysdael, Salomon van (*c*.1600–70), Dutch landscape painter, active in his native Haarlem. He was one of the most prolific of Dutch painters, specializing in calm, atmospheric river scenes painted in subdued colours, a style which was much imitated.

Rysbrack, John Michael (1694–1770), Flemish-born sculptor. He settled in England in about 1720 and in the 1730s was the leading sculptor in the country, the high point of his career being the monument to William III (1735) in Queen Square, Bristol, generally regarded as one of the finest equestrian statues made in England. From about 1740 he began losing ground to rivals such as *Roubiliac. He was a prolific artist, with a vigorous and dignified style. His output included tombs, statues, portraits, chimney-pieces, and architectural features.

S

Saarinen, Eero (1910–61), Finnish-born US architect. He settled in the USA in 1923, when his father, the architect **Eliel Saarinen** (1873–1950), emigrated. Eliel Saarinen's outstanding building is Helsinki Railway Station (1910–14). From 1937 the two worked in partnership, their buildings including the General Motors Technical Center at Warren, Michigan (1948–56), in a *minimalist rectangular glass-and-steel grid style. In the early 1950s, after his father's death, Eero began to experiment in a highly individual manner, developing a sculptural style, using forms suggestive of organic growth. His masterpiece is the TWA Terminal Building at Kennedy Airport, New York (1956–62), with its curving roof suggesting a bird in flight. Other works included the US Embassy in Grosvenor Square, London (1955–61).

Sachs, Hans (1494–1576), German poet and the most famous of the *Meistersinger* (see *minstrel), commemorated especially in Wagner's opera *The Mastersingers of Nuremberg*. In 1509 he took up the trade of cobbler. For some years he wandered around Germany, but finally settled in Nuremberg in 1516, becoming an influential and honoured member of the guild of German amateur singers, largely artisan. The movement preserved strict artistic codes and encouraged a spirit of competition. Sachs acted as 'marker' or judge of the competitions on many occasions. He wrote a large number of poems and songs, as well as verse-dramas based on Latin models and Shrovetide plays, or moralizing dramas, to educate the populace. He did much to advance the Reformation in Nuremberg and, through the guild's influence, elsewhere in Germany.

sackbut, the English name, used from the 15th to the 18th centuries, for the *trombone, which is Italian for large trumpet. Today the word, derived from the French *saqueboute* ('pull-push'), is used to distinguish earlier models of trombone from later instruments. The sackbut originated in the mid-1400s as an improvement of the medieval slide trumpet with the slide moved from the mouthyard to the front bow. It became an important bass instrument in the Renaissance; especially for accompanying voices and for tower music (music played from the tops of church and town-hall towers, and from balconies), as well as for processional music with cornetts and shawms.

Saʿdī, Muslih al-Dīn (1202–92), Persian poet. He was born and he died in Shiraz, but lived an eventful life with much travel. He wrote highly admired *ghazals* or sonnets that were reproduced in several *divāns*, collections of poetry. He also wrote two famous and influential works, the *Gulistān* or Rose Garden (1257) and the *Būstān* or Garden (1258). The latter is in verse and the former in verse and rhyming prose; both are written in an admirably restrained and lucid style. Both are didactic works teaching through stories, and have greatly influenced Turkish and Urdu literatures.

Safavid art, the art and architecture of the Safavid dynasty in Iran (1506–1736). The early period is characterized by further developments in miniature painting to a style more expressive than the pure work of *Bihzad. The greatest period of Safavid art, however, was under Shah Abbas (1587–1628) who was responsible for a spate of building in the new capital of Isfahan. Round a large central polo ground he built a series of delicately imposing new buildings, including the Masjid-i Shah (1612) with its turquoise dome covered in arabesque designs, and the elegant pavilion of the Ali Kapu, from which the court watched polo games. Under the Safavids the art of the *miniature became ever more refined and elegant. Naturalistic drawings of individual figures became popular, marking the beginning of the decline of miniature painting which gradually lost its vigour and slipped into decadence. The Safavids excelled in the textile arts, weaving exquisitely fine *carpets in floral and arabesque designs, *silks, and velvets with elaborate designs such as hunting scenes.

saga, the Norse name for various kinds of prose tales composed in medieval Scandinavia and Iceland and written down from the 12th century to the 14th. These usually tell of heroic leaders, early Norse kings or 13th-century bishops, or of the heroic settlers of Iceland in the 9th and 10th centuries; others, like the *Vǫlsunga saga*, relate earlier legends. The emphasis on feuds and family histories in some famous sagas like *Njáls saga* has led to the term's application in English to any long story spanning two or more generations, as in Galsworthy's *The Forsyte Saga* (1922).

St Denis, Ruth (Ruth Dennis) (1879–1968), US dancer, choreographer, and teacher. She developed an oriental-inspired form of modern dance performed in exotic costumes. She experimented with 'music visualization', in which dancers' roles were linked to the sound of individual instruments. With Ted *Shawn she started the Denishawn school and company, a major training ground for the next generation of modern dancers, including *Humphrey and *Graham.

Sainte-Beuve, Charles-Augustin (1804–69), French literary historian and critic. He is remembered for his ability to bring to life the authors and texts he studied, which he interpreted in their intellectual and historical context. Notable among his works are the *Causeries du lundi* (1849–69), *Port-Royal* (1840–59), and *Chateaubriand et son groupe littéraire* (1861). He helped to establish the *Romantic movement, whose literary predecessor he found in *Ronsard, and accepted only grudgingly the doctrine of *realism, associated with the *Goncourt brothers, which led literature away from Romanticism.

Saint-Exupéry, Antoine de (1900–44), French aviator and writer. His novels, *Courrier-Sud* (1928), *Vol de nuit* (1931), *Terre des hommes* (1939), and *Pilote de guerre* (1942), are based on his own adventures as an airline and war-time pilot. In each, the plane becomes an instrument which, in moments of danger, brings the pilot a knowledge of himself and a sense of his responsibility to others. Here, as in *Le Petit Prince* (1943), a children's fable for adults, comfortable materialism is shunned in favour of a wider humanism. Saint-Exupéry disappeared on what was to have been his last wartime reconnaissance mission.

Saint-Gaudens, Augustus (1848–1907), US sculptor. Born in Dublin, he was taken to the USA as a child and studied in Paris and Rome. Returning to the USA in 1874 he scored a major success with his Admiral Farragut Monument (1878–81) in Madison Square Park, New York, and thereafter assumed a leading position among US sculptors. His position in the history of American sculpture is important: his warmly naturalistic style turned the tide against *Neoclassicism and made Paris, rather than Rome, the artistic Mecca of his countrymen.

St Ives School, a group of British painters who concentrated their activities in the Cornish fishing port of St Ives. Popular with painters from the late 19th century, it was only after Barbara *Hepworth and Ben *Nicholson settled there in 1939 that a colony of artists was established. Apart from a general interest in painting landscape in an abstract vein, the artists of the St Ives School had little in common. The studio potters Bernard *Leach and Michael Cardew (1901–83) were also based for some time at St Ives.

Saint-John Perse (Alexis Saint-Leger Leger, or Alexis Leger) (1887–1975), French poet. Between 1911 and 1971 he published nine collections of poems, including *Anabase* (1924), *Exil* (1944), *Vents* (1946), and *Amers* (1957). His style is inspired by *Claudel's free-verse form, and depends on rhythm and symbol rather than metre and rhyme. Nature, portrayed allusively rather than descriptively, is frequently used to suggest poetically the infinite spaces of man's inner world. Saint-John Perse was awarded the Nobel Prize for Literature in 1960 and is one of the most widely read French poets of the 20th century.

Saint-Saëns, (Charles) Camille (1835–1921), French composer and pianist. Saint-Saëns had the misfortune to be born with a natural instinct for the classical virtues of clarity and wit in an age that demanded large romantic gestures. Some of his music is, in consequence, rather inflated. His works include the opera *Samson et Dalila* (1877); the Third ('Organ') Symphony (1886); the Piano Concerto No. 4 (1875) and Violin Concerto No. 3 (1880); the *symphonic poems *Le Rouet d'Omphale* (1872) and *Danse macabre* (1874); and the light-hearted *Le Carnaval des animaux* (1886).

Saki (Hector Hugh Munro) (1870–1916), British short-story writer and journalist. He wrote political satire for the *Westminster Gazette* and was correspondent for the *Morning Post* in Poland, Russia, and Paris. He was best known for his short stories, which were collected in *Reginald* (1904) and other volumes, including *Reginald in Russia* (1910), *The Chronicles of Clovis* (1911), *Beasts and Super-Beasts* (1914), and *The Square Egg* (1924). They include the satirical, the macabre, and the supernatural, and often use animals as agents of revenge.

Salieri, Antonio (1750–1825), Italian composer. He settled to a highly successful career in Vienna (1766), becoming court Kapellmeister (director of music) in 1788. Besides sacred and instrumental music of all kinds he composed over forty operas and was to some extent a disciple of *Gluck: *Les Danaides* (1784) and *Tarare* (1787) are his greatest successes in this field. There is a popular but unsubstantiated theory that Salieri poisoned Mozart.

Salinger, J(erome) D(avid) (1919–), US short-story writer and novelist. His small literary output of one novel and thirteen short stories was mainly written in 1948–9; since the 1960s he has spent his life in seclusion in New Hampshire. His best-known work, *The Catcher in the Rye* (1951), is a *picaresque novel that involves a teenager, Holden Caulfield, who escapes from his sheltered world in order to seek adventures in New York; its authentic, teenage idiom, and its rejection of the 'phoney' adult world, made it a symbol for the honesty and purity of youth caught in a world of banality and hypocritical conformity. His remaining fiction is largely concerned with the sensitive Glass family at odds with their materialistic world: *For Esmé—with Love and Squalor* (also called *Nine Stories*, 1953); the double novella *Franny and Zooey* (1961); and the jointly published *Raise High the Roof-Beam, Carpenters*, and *Seymour: An Introduction* (1963).

Salon, the name given to the official exhibition of members of the French Royal Academy of Painting and Sculpture, first held in 1667 and thereafter annually or biennially. As the Salon was the only public exhibition in Paris, official academic art obtained through it a stranglehold on publicity, and during the second half of the 19th century rival Salons began to be organized by progressive artists, including *Courbet and the *Impressionists. In 17th- and 18th-century France, *salons* held in the private houses of women of society were assemblies of artists, writers, wits, and men and women of letters, brilliantly satirized by Molière.

samba, a dance from Brazil. It has two distinct forms: the rural samba, which has African influences and a complicated rhythmic structure; and the urban samba, known as the 'samba-carioca', a more popularized form developed in the dance-halls of Rio de Janeiro. It has a simple step, and combines easily with other dances, as in the samba-*tango and samba-*rumba. There is also a distinct song form.

Sammartini, Giuseppe (Francesco Gaspare Melchiorre Baldassare) (1695–1750), and his brother **Giovanni Battista** (1700–75), Italian composers. Giuseppe was famous as a virtuoso oboist, much admired in England when he came to work at the King's Theatre, London (c.1728). His trio sonatas, *concerti grossi, and overtures, modelled on *Handel, have considerable charm. He was, however, overshadowed by Giovanni, who worked for most of his life in various Milan churches and is of considerable importance in the development of the early *symphony. Giovanni's output also includes many concerti grossi and much chamber music.

sampler, a piece of cloth embroidered with various stitches and designs, either to serve as a model or as a demonstration of the embroiderer's skill. Samplers seem to have originated in the 15th century, though few examples from before 1600 survive, and the 17th century

The graceful curves of arabesque ornament were perhaps most fully developed in **Safavid art**. The dome of the 17th-century Madrasah Mādar-i Shāh in Isfahan, central Iran, shown here, *right*, is sheathed in specially curved turquoise tiles on which an interlocking design of unending complexity leads the onlooker's eye to a vision of paradise.

Only 11 years old when she made this **sampler** in 1774, Hannah Taylor depicts her family, their New England home, and the familiar plants and animals of her childhood. For all its simplicity, sampler-making provided not only aesthetic enjoyment but also a sense of order, structure, and continuity. (American Museum, Bath)

was the great age of the sampler. Often they were made by children being taught needlecraft, and frequently they are embroidered with the name and age of the child, as well as, for example, pious texts and pictures of animals and flowers. Although the sampler flourished mainly in Britain, they were made in many other countries. In the 19th century samplers became coarser and less interesting and the fashion for making them has largely died out.

Sanchi, a site in Madhya Pradesh state, India, noted for a group of Buddhist monuments, including the celebrated Great *Stupa, the finest surviving example of the type. It was probably begun by the emperor Aśhoka (see *Mauryan art) in the 3rd century BC and was later enlarged. It is enclosed by a stone railing with four richly carved gateways erected in the 1st century AD. The sculpture depicts the previous lives of the Buddha, animal life, grotesques, and brackets in the form of female tree-spirits. Later structures include a *Gupta temple.

Sand, George (Aurore Dupin, Baronne Dudevant) (1804-76), French novelist and political journalist. Her early works are *Romantic in inspiration: lyrical, passionate, and ardent in the cause of equality for women. Her protest against social conventions and class restrictions can be found in novels such as *Consuelo* (1842-3).

She wrote several simple, idyllicized romances of country life, among them *François le champi* (1850), which sparked Marcel's discovery of his vocation as a writer in Proust's *À la recherche du temps perdu*. Her unconventional life included a liaison with de *Musset, described by her in *Elle et lui* (1859), and with *Chopin.

Sandburg, Carl (August) (1878-1967), US poet and biographer. He established a reputation as a poet with *Chicago Poems* (1916), which identified him with the colloquial style and vigorous free verse used by other writers then emerging from the Midwest. Later volumes, from *Cornhuskers* (1918) to the panoramic *The People, Yes* (1936), continued in the same mode: verse in the manner of Walt *Whitman, celebrating the lives of ordinary men, and reflecting an openness to all experience and liberal political sympathies. His output also included a collection of US songs and three books for children. His *Collected Poems* (1950) and a six-volume biography of Abraham Lincoln (1926, 1939) were awarded the Pulitzer Prize.

Sandby, Paul (c.1730-1809) and **Thomas** (1721-98), brothers, English topographical water-colourists. Their work is similar in many respects, but Paul was more versatile as well as a better artist, his work including lively figure compositions and an extensive range of landscape subjects. He also sometimes painted in oils, and he was the first professional artist in England to publish *aquatints.

Sanmicheli, Michele (1484-1559), Italian architect and military engineer, active in his native Verona, Venice, and Rome. Fortifications were his speciality, and even his non-military buildings tend to have a feeling of massive strength. His style was indebted to *Bramante and *Raphael, but was more *Mannerist, with striking use of spiral columns and heavy sculptural decoration. Apart from fortresses and gateways, he designed palaces and ecclesiastical architecture. He was a leading architect of his time and influenced his successor *Palladio.

sansa, a musical instrument with a number of flexible tongues, usually made of iron but sometimes of reed, fixed to a board or box and plucked with thumbs and forefingers. Used all over sub-Saharan Africa, either by itself or accompanying singing, it has many names; approximations to *sansa*, *mbira*, *likembe*, and *kalimba* are the commonest. The reeds are normally arranged with the longest in the middle; thus a sequence of consecutive notes lies alternately left and right. The only other area where it is known is the Caribbean, whither it was carried by African slaves.

Sanskrit literature, the early literature of the Indian sub-continent. It begins with the pantheistic hymns and sacrificial formulae of the Aryan invaders of India (c.1500 BC), handed down in compendia (*saṃhitā*) called *Vedas. These were interpreted in relation to the forces of nature in prose commentaries called the *Brāhmaṇas* ('Explanations of Brahman') (c.1000-700 BC) and *Āranyakas* ('Forest-treatises') (c.700-600 BC). In the *Upanishads* ('Sessions imparting secret knowledge') (600 BC and later) ritual exegesis became philosophical speculation, identifying *ātman*, man's individual soul, with *Brahman*, the World-Spirit. The 5th-century BC grammarian Pāṇini codified the language of these later Vedic texts into

George **Sand** wrote some eighty novels which brought her literary acclaim during her lifetime. But her greatest contribution lay in her rejection of the conventions of the day and her open relationships with men whose philosophies and politics she found inspiring.

Torso of Avalokiteshvara, the Bodhisattva (Buddha-to-be) of mercy and compassion, from **Sanchi** in Central India and is identifiable by the antelope-skin worn across the left shoulder. Carved in sandstone in c.900 AD, it was originally one of a pair of Bodhisattva statues flanking a large, seated Buddha in a later Buddhist temple erected near the Great Stupa. (Victoria and Albert Museum, London)

Sanskrit, literally 'refined' for literary expression. The earliest Sanskrit works proper were the great Indian epics, the *Mahābhārata* and *Rāmāyaṇa*, sources for much of later Sanskrit literature and the Indian vernacular literatures. The *Mahābhārata*, composed by several generations of poets (c.400 BC–AD 400), describes the power struggle between two families of cousins, perhaps rooted in historical rivalry between the Aryan tribes. The *Rāmāyaṇa*, a later and more homogeneous work, describe the exile from his kingdom and eventual return of Rama, classical India's archetypal ideal hero. The *kāvya* tradition of court literature, embracing poetry and drama, emerged during the early centuries AD, beginning with the Buddhist poet Aśvaghoṣa (end 1st century). Within elaborate poetic, aesthetic, and metrical laws, Sanskrit poets excelled at verbal ingenuity and technical ornamentation. The 5th-century poet *Kālidāsa is renowned particularly for his two epics, *Kumārasambhava* and *Raghuvaṃśa*. Other important epics were Bhāravi's 6th-century *Arjuna and the Kirāta* and Māgha's *The Death of Śiśupala*, both inspired by the *Mahābhārata*, and Bhatti's 6th-century reworking of the *Rāmāyaṇa*, *Bhatti's Poem*. Lyric poetry also abounded, such as the often erotic single stanzas of Amaru and Bhatṛhari (both 7th century), Bilhaṇa's *The Thief's Fifty Stanzas* (c. 11th century), describing a thief's secret love for a princess, and Jayadeva's 12th-century *The Song of the Cowherd* on Krishna's love for Radha. Sanskrit narrative poetry includes large collections of popular stories, such as Somadeva's 11th-century *Ocean of the Rivers of Stories*. Sanskrit drama, its canons established in the *Nāṭyaśastra*, was performed without scenery, but in costume and using the gesture-language of Indian dance. The earliest surviving complete plays are by Bhāsa, romantic comedies such as *Vāsavadattā the Dreamer*. Kālidāsa's three plays represent the acme of Sanskrit drama, *Śakuntalā* being his masterpiece. *The Little Clay Cart* by Kālidāsa's near contemporary Śūdraka, describing a Brahmin's love for a courtesan, is the most realistic of Sanskrit plays. Viśākhadatta's 6th-century *Rākṣasa and the Signet Ring* is a political drama of Candraguptā Maurya's rise to power, and King Harṣa (7th century) wrote three harem comedies, *Ratnāvalī* (named after its heroine) being the best of them. Second only to Kālidāsa in critical esteem, the 8th-century Bhavabhūti wrote plays full of pathos, a love-story, *Mālatī and Mādhava*, and two works on the life of Rama. The Muslim invasions of India virtually extinguished the Sanskrit theatrical tradition. During the Gupta period (4th–5th centuries), an ornate prose style developed alongside poetry. Daṇḍin's 6th-century masterpiece *The Adventures of the Ten Princes* is a collection of exciting, often humorous and ingenious stories, and Subandhu's *Vāsavadattā* (7th or 8th century) tells of Vāsavadattā's love for Prince Kandarpaketa. Bāna (7th century) wrote *The Deeds of Harṣa*, a biography of his patron King Harṣha, vividly depicting early Indian life, and *Kādambarī* (named after its heroine), relating the adventures of two pairs of parted lovers. The abundant folk-tale and fable literature is epitomized by the 2nd-century *Pañcatantra* collection.

Sansovino, Jacopo (1486–1570), Italian architect and sculptor who worked mainly in Venice, where he was appointed city architect in 1529. In both architecture and sculpture he played a major role in introducing the High *Renaissance style to the city (he had spent several

years in Rome, where he moved in the circle of *Bramante and *Raphael). His most famous work is St Mark's Library (begun 1537), one of Venice's most glorious sights and an inspiration to Palladio, his successor as the city's leading architect; as a sculptor he is best known for the colossal figures of Mars and Neptune (commissioned 1554) on the staircase of the Doge's Palace.

sanṭūr, a musical instrument, the Persian *dulcimer, used over much of the Near East and India, probably deriving from European dulcimers in the 17th century. Multiple courses of thin metal strings pass across bridges resembling chess pawns, one row one-third of the way across the soundboard, the shorter string lengths a fifth above the longer, the other a quarter of the way, with the shorter lengths two octaves above the longer. The strings are struck with light wooden beaters. The *sanṭūr* is an important solo and ensemble instrument wherever it is found, including China (see *yangqin).

Sappho (*fl.* early 7th century BC), greatest of the early Greek lyric poets. Born on the island of Lesbos, the fragments of her poems that have survived are written in her local dialect. She wrote in a great many metres, one of which, the Sapphic, has been called after her. Her poems are characterized by passion, a love of nature, simplicity of style, and control of line. The longest (seven stanzas) is an invocation to Aphrodite over her love for a young girl. She influenced many later writers, among them Catullus, Ovid, and Swinburne.

saraband *suite.

sāraṇgī, a musical instrument, the principal *fiddle of north Indian classical music. The body, carved from a block of wood, has a skin belly. The three bowed gut strings are stopped with a fingernail from the side, often with a glissando from note to note, so that the *sāraṇgī* matches, and frequently accompanies, singers. There are up to thirty-six metal sympathetic strings. The bow is held underhand, the hair tensioned with the fingers.

Sargent, John Singer (1856–1925), US painter. He was born in Florence and in 1885 settled in London, but retained his American citizenship. His style is remarkable for the lush fluidity of his brushwork, based partly on his admiration for Old Masters such as Hals and Velázquez. The elegance of his work brought him unrivalled success, and his portraits convey the glamour and opulence of high-society life with bravura. He loved painting landscape water-colours and devoted much of his energy to ambitious allegorical murals in the Library and Museum of Fine Arts in Boston. In World War I he was an official war artist.

Sartre, Jean-Paul (1905–80), French novelist, dramatist, and philosopher. His name is synonymous with existentialism, a philosophy which acclaims the freedom of the individual human being, and which he shared with his companion, the writer de *Beauvoir. Different emphases exist within existentialism, and Sartre and *Camus quarrelled over points of interpretation. Sartre's view, enunciated in two essays, *L'Être et le néant* (1943) and *L'Existentialisme est un humanisme* (1946), is atheistic: there is no intrinsic meaning to life; the only certainty is the fact of human existence. An initial reaction to life's

absurdity may be despair, but man may, by an act of will, choose a life which is truly free and authentic. Political involvement may follow, as it did for Sartre in his stormy relations with the Communist Party. This is the experience of the central characters in his novel *La Nausée* (1938) and one of his best-known plays, *Les Mains sales* (1948). His other works include fiction: *Le Mur* (1939) and *Les Chemins de la liberté* (1945–9); plays: *Les Mouches* (1943) and *Huis clos* (1943); and an autobiography, *Les Mots* (1963). He declined the Nobel Prize for Literature in 1964.

Sassanian art *Persian art.

Sassetta (Stefano di Giovanni) (*c.*1392–1450), Italian painter. His work continues the traditional values of the *Sienese School in its beautiful colouring and elegant line, but he was also influenced by the *International Gothic style and by contemporary Florentine developments. These influences he combined into a personal style, expressive of his mystical imagination. His most important work was the St Francis altar-piece (1437–44); seven panels from it are in the National Gallery, London.

Sassoon, Siegfried (Lorraine) (1886–1967), British poet and prose writer, known for his anti-war poetry and fictionalized autobiographies. He enlisted in World War I and was seriously wounded in France. He published his anti-war poetry, *The Old Huntsman* (1917) and *Counterattack* (1918), while he was still in the army. He was sent to a military sanatorium where he met Wilfred *Owen, whose works he published after Owen was killed at the front. A strong attachment to the countryside is seen in his post-war works, notably his semi-autobiographical trilogy beginning with *Memoirs of a Fox-Hunting Man* (1928).

Satie, Erik (Alfred Leslie) (1866–1925), French composer. His genius lay in his ability to use extremely simple means, often involving repetition, to produce works of great originality. He also made use of snatches of music-hall songs, jazz, and *objets trouvés* such as typewriters and a revolver. Satie was admired and championed by *Cocteau; they collaborated on a provocatively unconventional ballet, *Parade* (1924). His work had a liberating influence on later composers.

satire, a mode of writing which exposes the failings of individuals, institutions, or societies to ridicule and scorn. Satire is often an incidental element in literary works which may not be wholly satirical, especially in *comedy. Its tone may vary from tolerant amusement, as in Horace, to bitter indignation, as in Juvenal and Swift. Various forms of literature may be satirical, from the plays of Jonson and Molière and the poetry of Chaucer and Byron to the prose writings of Rabelais and Voltaire. The models of *Roman satire, especially the 'formal' verse satires of Horace and Juvenal, inspired some important imitations by Boileau, *Pope, and Johnson in the greatest period of satire, the 17th and 18th centuries, when writers could appeal to a shared sense of normal conduct from which vice and folly were seen to stray. Among modern novelists Waugh and Achebe are noted for their use of satire.

saùng-gauk, a musical instrument, the Burmese arched harp, the only surviving Central and southern Asian *bow harp, whose history goes back several millennia.

The table is deerskin and there are, today, up to sixteen strings tensioned with cord twined round the neck.

saxhorn, a family of valved brass musical instruments, from sopranino in B♭ to subcontrabass in E♭, invented by Adolphe Sax from 1845 onwards. This was the first homogenous family to include cornet, tenor, baritone, and tuba, and although the smaller instruments were initially made in trumpet shape, eventually all were made upright like tubas. The smallest is seldom seen today, and the next two were replaced by cornets, but from the E♭ tenor downwards, the saxhorns are the mainstay of brass and military bands. (See also *flugelhorn.)

saxophone, a single-reed musical instrument of conical bore made, usually, of brass, and invented by Adolphe Sax in about 1842 by combining a clarinet mouthpiece with approximately the tubing and keywork of an *ophicléide. Saxophones were originally made in two sets, from sopranino to contrabass, in F and C for orchestral use and in E♭ and B♭ for military bands. Today, however, only the latter set is seen. The saxophone has been used in well-known British works and in pieces by many German and French composers. It has proved extremely popular in military and dance bands, from which it became important in the more recent jazz combinations and to a lesser extent in popular music.

saz, the long-necked *lute of Turkey, the Balkans, and much of Central Asia. The body is small, shaped like a half-pear though often with a sharp keel at the back, either carved from a solid block of wood or built up in staves. Instruments vary in length from 50 cm (1.5 ft.) to 150 cm (4.5 ft.), with strings in single or multiple courses. Some, such as the Greek *bouzouki, have been extensively modernized. The saz was known in Europe from the 17th century or before.

scale, a series of musical notes arranged stepwise in ascending or descending order of *pitch. The precise size of these steps can vary, as can the permutation of their order. The number of possible scales is therefore considerable. Scales are arbitrary—the convenient codification of musical material as used at any given time and place in the history of music. Western music recognizes two pitch differences: a large step, the tone, and a half-step, the semitone. Other cultures recognize even smaller steps, but for some reason the Western ear is not readily able to accept them. The Western scale is based on the octave, first recognized by Pythagoras in about 550 BC. He found that dividing a string's length in half raised the pitch by an octave and made this the most important relationship. Different divisions in the length of the string gave him the fourth and fifth, and later the intervals between these. A scale that proceeds in twelve equal steps, all semitones, is called a chromatic scale.

The curtain for **Satie**'s circus ballet *Parade* painted by Picasso. The work caused a critical furore with its unconventional form and the inclusion in the orchestra of novel instruments such as a typewriter and a revolver. Satie was imprisoned for eight days for sending a disrespectful postcard to a critic hostile to the work. (Musée Nationale d'art moderne, Paris)

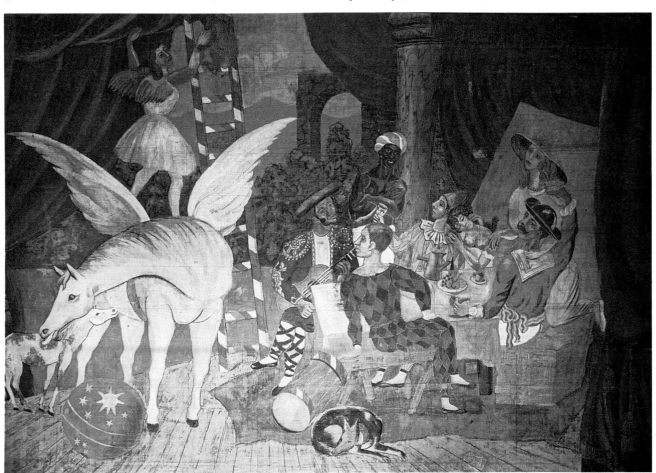

Scales which proceed in seven steps (five tones and two semitones) are diatonic scales. These are reckoned major and minor according to the sequence of tones and semitones (for variations in the exact tuning of the intervals see *temperament). Each step of the diatonic scale is identified by a different name and an appropriate roman numeral, as in the example below, in D major.

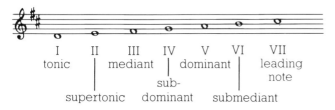

The relationship between different pitches may also be described numerically, from unison to octave, through second, third, fourth, fifth, etc. The starting-note (tonic) of each scale is used to identify the *key it represents and therefore its *tonality. Scales that are not tonal include the five-note pentatonic scale, found in Western folk music as well as non-Western music; the whole-tone scale, which has six pitches; and the many varieties of seven-pitch scales known as *modes.

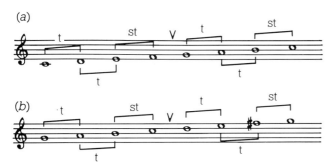

Example (a) is the **scale** of C major, showing the distribution of tones (t) and semitones (st). Example (b) is the related scale of G major. The seventh note, F, is sharpened (♯) in order to maintain the correct tone, tone, semitone relationship.

Scandinavian literature, the literature of Norway, Sweden, Denmark, the Faeroe Islands, and Iceland (see also *Finnish literature). The Icelandic *sagas, for centuries transmitted orally, were written down by Christian scribes between the 12th and 14th centuries and depict in part the myths and legends common to all Germanic peoples. Among the best known are *Egil's Saga* (probably written by *Snorri Sturluson, c.1230) and *Njall's Saga*, written by an unknown poet in the later 13th century. In Iceland and to a lesser extent Norway, *skaldic and Eddic poetry (*Edda) flourished at the same time. The medieval ballads of Denmark rank high in the European tradition, though none were printed earlier than 1591. The literary renaissance flowered in Denmark in the 18th century with the comedies of the Norwegian-born Ludvig *Holberg. The works of the poet and musician Carl Michael Bellman (1740–95) combine realism with humour in a rhythmic, lyrical language; his *Fredman's Epistles* (1790) and *Fredman's Songs* (1791) remain popular in Scandinavia to the present day. Adam *Oehlenschläger was Denmark's greatest Romantic poet, while Esaias Tegnér (1782–1846) was long considered to be his Swedish

counterpart; *Frithiof's Saga* (1825), based on an Old Norse theme, earned him a European reputation. The metaphysical poet Erik Johan Stagnelius (1793–1823) is now considered the most notable of the Swedish Romantics. Johan Ludvig Runeberg (1804–77), who lived in Finland but wrote in Swedish, established himself as the national poet of Finland with his *Tales of Ensign Stål* (1848). The prose writer Carl Jonas Love Almqvist (1793–1866) moved from Romanticism to Realism with his novel *Sara Videbeck* (1839), where his liberal views met with public controversy. Together with his other radical prose works and lyric poetry this earned him a reputation as one of Sweden's leading authors. Hans Christian *Andersen's tales put Danish literature on the world map, and the late 19th century was the high point of Scandinavian literature in modern times. *Ibsen and *Strindberg were key figures in the development of modern drama, while the Danes Jens Peter Jacobsen (1847–85) and Henrik Pontoppidan (1857–1943; Nobel Prize for Literature 1917) and the Norwegians Alexander Kielland (1849–1906) and *Bjørnson produced realistic prose works full of local colour and social criticism. The works of authors like *Hamsun and the Symbolist poet and prose writer Sigbjørn Obstfelder (1866–1900) anticipated the modern psychological novel. In the 1890s the neo-romantic *Fröding was the outstanding poet. *Modernistic poetry in Scandinavia was heralded by influential Finnish poets (writing in Swedish), notably Edith Södergran (1892–1923), but the outstanding modern poets were the Swedes Gunnar Ekelöf (1907–68) and Harry Martinson (1904–78; Nobel Prize for Literature 1974). Scandinavia has produced a number of excellent prose writers in modern times, including *Lagerlöf and *Blixen. William Heinesen (1900–) and Jurgen-Frantz Jacobsen (1900–38) emerged as the leading Faeroese writers (although they both wrote in Danish), and Halldór *Laxness is the greatest Icelandic author of modern times. The Nobel Prize for Literature has been awarded to *Jensen, *Lagerkvist and Eyvind Johnson (1900–76). Johnson, who experimented with new forms and techniques, developed into a fine novelist, his *Return to Ithaca* (1946) and *The Days of His Grace* (1960) being especially noteworthy.

scansion, the analysis of poetic *metre in verse lines, by displaying stresses, pauses, and rhyme patterns with conventional visual symbols. The simplest system, known as graphic scansion, marks stressed syllables (′ or ‾), unstressed syllables (× or ˘), divisions between metrical units or 'feet' (|), and major pauses or 'caesuras' (‖) in a verse line, determining whether its metre is *iambic or *dactylic, and how many feet make up the line. For example, Ĭf mū|sĭc bē | thĕ fōod | ŏf lōve, ‖ plăy ōn (Shakespeare, *Twelfth Night*). Scansion also analyses the rhyme scheme in a poem or *stanza, giving alphabetical symbols to the rhymes: AABB, ABCB, or ABAB in most *quatrains, AABBA in limericks, for instance.

Scarlatti, (Pietro) Alessandro (Gaspare) (1660–1725) and **(Giuseppe) Domenico** (1685–1757), Italian composers. Little is known of Alessandro's early career until his opera *Appearances May Deceive* achieved success in Rome (1679). He moved to Naples (1684–1702) as *maestro di cappella* (director of music) to the Viceroy, continuing his career as a successful *opera composer. A brief return to Rome, where opera was frowned upon by

the Vatican, led to the composition of *oratorios and *cantatas—though he was able to write what is considered to be his operatic masterpiece, *Mithradates Eupator* (1707), for Venice. His last years were divided between Naples and Rome, but his operas were by then seen as old-fashioned and were less successful. Scarlatti's operas helped establish the da capo *aria and the Italian sinfonia form of the *overture. Although Alessandro's son Domenico also composed operas and sacred music, he is remembered for over 500 one-movement keyboard *sonatas. They were written during his time in Lisbon (1719–28) as harpsichord teacher to the Infanta Maria Barbara, or later in Madrid (1728–57), whither he followed the Infanta on her marriage to the Crown Prince of Spain. He was admired as one of the foremost virtuosi of the day, and his sonatas stand as models of ingenious, imaginative keyboard writing.

scat singing　*jazz, *mouth music.

scenery, theatrical　*set design, *stage machinery.

scherzo (Italian, 'joke'). A light-hearted, fast-moving musical movement, which succeeded the *minuet as the standard third movement in *symphonies and *sonatas. Scherzo-like movements can be found in Haydn's music, but it was Beethoven who established the scherzo's symphonic validity. Like the old minuet and *trio, the scherzo usually has a contrasting middle section—the symphonic movement becoming a scherzo and trio. The term has also been used to describe various lively kinds of music, as in Monteverdi's *Scherzi musicali* for voices, and Chopin's one-movement piano scherzos.

Schiele, Egon (1890–1918), Austrian painter and draughtsman. He was influenced by *Klimt and *art nouveau, but soon developed a distinctive style characterized by aggressive linear energy and nervous intensity. His best-known works are his drawings of nudes (including self-portraits), which have an explicit and disturbing erotic power. He died when he was beginning to achieve international acclaim, and has since been recognized as one of the greatest *Expressionist artists.

Schiller, (Johann Christoph) Friedrich von (1759–1805), German poet, dramatist, and historian. Rebelling against his training as a military physician, he composed a series of plays beginning with *The Robbers* (1781), whose terse, impassioned prose and melodramatic theme have close affinities with the *Sturm und Drang* movement. Appointed house poet to the Mannheim Theatre, his play *Love and Intrigue* (1783) was written in realistic idiom and with a strong element of contemporary social criticism. The historical verse-drama *Don Carlos* (1787), intertwining the personal passions of individuals and the fate of nations, marks a new phase in his development. As Professor of History in Jena from 1789 Schiller continued his study of history, writing his *History of the Thirty Years War* (1791–3), as well as a treatise on aesthetics, *Naïve and Sentimental Poetry* (1795–6), and of the philosophy of Kant, all of which led him, encouraged by *Goethe, to his final classical dramas, the historical trilogy *Wallenstein* (1788–9), *Maria Stuart* (1800), *The Maid of Orleans* (1801), and *Wilhelm Tell* (1804). His poetry is one of ideas rather than emotion; his well-known ballads, among them *The Cranes of Ibykus* (1797) and *The Pledge* (1798), are strongly

dramatic. Part of his ode *To Joy* (1785) was set to music by Beethoven in his Ninth Symphony (1824).

Schinkel, Karl Friedrich (1781–1841), German architect, painter, and designer, active mainly in Berlin. Schinkel was the greatest German architect of the 19th century, a brilliant exponent of both the *Greek Revival and the *Gothic Revival styles and also of a functional style free from historical associations. Until 1815, however, when he gained a senior appointment in the Public Works Department of Prussia (from which position he effectively redesigned Berlin), he worked mainly as a painter and stage designer. His paintings are highly *Romantic landscapes, somewhat in the spirit of *Friedrich, although more anecdotal in detail, and his stage designs rank among the greatest of the period, combining the clarity and logic of his architectural style with a feeling of mystery and fantasy. Schinkel's major buildings include the Altes Museum in Berlin (1822–8) and the Nicolai Church in Potsdam (1829–37).

Schlegel, August Wilhelm von (1767–1845), and his brother **Friedrich von** (1772–1829), German scholars and critics, who exercised a major influence on German *Romanticism. Together with the Brothers *Grimm, they stand at the beginning of the study of *art history, literature, and of comparative philology, arguing that an understanding of art is impossible without knowing its history. The translations of Shakespeare for which August Wilhelm was partly responsible are still used on the German stage. Friedrich's *History of Ancient and Modern Literature* (1815) reviews European literature from the Old Testament to his own day, reflecting his notion of the inseparability of a nation's intellectual, spiritual, political, and economic development.

Schnitzler, Arthur (1862–1931), Austrian dramatist and novelist. His psychological dramas dissect *fin-de-siècle Viennese life, with its sexual repressions and social disillusion. The interior monologues of the narratives *Lieutenant Gustl* (1900) and *Miss Else* (1924) draw a picture of self-deceit, social time-serving, and the inferior role of women, while the episodic structure of the dramas *Anatol* (1893) and the cycle of ten dialogues *Reigen* (1900) (filmed as *La Ronde*) confirm duplicity as a way of life.

Schoenberg, Arnold (1874–1951), Austro-Hungarian composer. Apart from early violin lessons and, later, advice from Zemlinsky, Schoenberg was virtually self-taught. Almost from the beginning his music met with opposition and throughout his life he was obliged to teach in order to earn a living. Early works, such as the sextet *Transfigured Night* (1899), *Songs of Gurre* (1900), and the symphonic poem *Pelleas and Melisande* (1903), were written in the shadow of *Wagner's chromaticism, but a gradual increase in dissonance, as in the First Chamber Symphony (1906), coupled with the very free, almost *Impressionistic treatment of harmony and melody in such works as the Five Orchestral Pieces (1909), and excursions into *Expressionism as in the theatre-piece *Expectation* (1909) and *The Lucky Hand* (1913), forced him to conclude that the principles of *tonality were no longer valid. His theory of *atonality governed by the principles of *serialism found its first complete musical expression in the *Five Piano Pieces* (1920–3). In 1933 Schoenberg (who was Jewish) was dismissed by the Nazis from his teaching

post in Berlin. He moved to Paris, and later (1934) to the USA, taking American citizenship in 1941.

Schreiner, Olive (Emilie Albertina) (1855–1920), South African novelist. She is best known for *The Story of an African Farm* (1883), a tragic novel of feminist protest set in the veld in which she grew up. Two other novels, *From Man to Man* (1927) and *Undine* (1929), appeared after her death. Her political views are expounded in *Woman and Labour* (1911).

Schubert, Franz (Peter) (1797–1828), Austrian composer. After singing in the choir of Vienna's Imperial Court Chapel he trained as a teacher. His songs (over 600, which developed the *Lied as a Romantic art-form) and his keyboard music attracted a circle of artistic friends who did much to encourage and sustain him after he had abandoned teaching in 1819. He wrote in all forms, but it is his songs, piano music, symphonies, and chamber music that have claimed the greatest attention. The songs range from simple tunes with simple accompaniments (The Wild Rose, 1815) through tunes with descriptive accompaniments (The Trout, 1817), to elaborate settings in which piano and voice combine to present a drama in miniature (The Erl King, 1823). Such song-cycles as *Winter's Journey* (1827) and *The Beautiful Miller's Daughter* (1823) embrace a whole world of emotion. Equally remarkable is his keyboard music, which ranges from

A sketch by Moritz von Schwind of his friend **Schubert** (*centre*) and companions. Barely two generations separated Schubert from Mozart, but they witnessed the end of traditional patronage by the Church and the nobility. Schubert enjoyed a freedom from both establishments that earlier composers had been denied. (Städtische Galerie, Munich)

simple dances to such masterpieces as the 'Wanderer' Fantasy (1822) and the later sonatas. Schubert's nine symphonies show a similar range of development, beginning in 1813 with works that are indebted to *Haydn and *Mozart and proceeding to a form and manner that is entirely his own in the B minor 'Unfinished' Symphony (1822) and the 'Great' C major Symphony of 1828. His chamber music culminates in the 'Trout' Quintet (1819), the Octet (1824), the String Quartet 'Death and the Maiden' (1824), and the sublime String Quintet (1827). Schubert's music epitomizes the point in time at which classical restraint and moderation was turning towards the poetic sensibilities of *Romanticism, and he thus provides a link between the music of the 18th and 19th centuries.

Schulz, Bruno (1892–1942), Polish short-story writer and artist. He died in the ghetto of the provincial town described in *Cinnamon Shops* (1934) and *Sanatorium Under the Sign of the Hourglass* (1937). His rich prose transformed images of his Jewish childhood into a world at once macabre and magical.

Schumann, Robert (Alexander) (1810–56), German composer. Though his first compositions date from 1822, it was not until he began to take piano lessons from Friedrich Wieck (1829), whose daughter Clara (1819–96) he was to marry, that composition became a serious preoccupation. He was equally attracted to literary work, founding a periodical, *The New Journal* (1834), as a vehicle through which to fight musical philistinism. In 1840 he was finally able to marry Clara and his happiness released a flood of songs, including the magnificent cycles *Woman's Love and Life*, *Poet's Love*, and *Song-Cycles* (all 1840). Symphonies followed from 1841, and then chamber music. Fits of depression, however, soon began to interrupt his creativity. In 1854 he attempted suicide, and was placed in an asylum for the rest of his life. **Clara Schumann**, a remarkable pianist and very capable composer, lived on to support their children and champion his music. Though Schumann's four symphonies (1841, 1846, 1850, 1851), Piano Concerto (1845), and chamber music are greatly to be admired, his genius expressed itself more characteristically in his piano music and songs, which, more often than not, have the intimate quality of autobiography. Such pieces as *Carnival* (1835), a suite of movements expressing the various aspects of his character and subtly contrasting its introvert and extrovert aspects, are among the high points of romantic keyboard literature.

Schütz, Heinrich (1585–1672), German composer. The principal Kapellmeister (director of music) of the royal chapel in Dresden, he was productive in virtually every branch of composition except independent instrumental music. His output of sacred vocal works secured his reputation as the first German composer of truly international stature. In association with Michael *Praetorius he played a major role in introducing into his native country the new Italian styles of the period, thus providing much of the initial impetus for the musical *Baroque in Germany. His *Cantiones sacrae* is a rich collection of Latin *motets. His *Heavenly Choral Music* (1648) contains twenty-nine German motets which demonstrate Schütz's mastery of the *contrapuntal style. In all, around 500 of his works survive; notable among them

Robert and Clara **Schumann** in 1847. Schumann's ambitions as a pianist had been ruined by an attempt to strengthen his fingers which damaged his hand, but he found the life of a professional composer equally taxing and difficult. More resilient than her husband, Clara devoted her life to supporting their family with a series of hugely successful concert tours after his final breakdown.

are the *Seven Last Words of Christ* (*c.*1645), the three Passions, and the *German Magnificat* (1671).

Schwarzkopf, Elisabeth (1915–), Polish-born German soprano singer. After her 1942 Vienna début as Zerbinetta in Strauss's *Ariadne on Naxos*, Schwarzkopf remained there in coloratura (see *voice) roles until 1948. She created the role of Anne Trulove in Stravinsky's *The Rake's Progress* (1951), and is famous for Strauss roles such as the Marschallin in *Rosenkavalier*. A superb interpreter of *Lieder*, Schwarzkopf, together with her husband, the artistic director Walter Legge, conducted master-classes in interpretation at the Juillard School in New York in 1976.

Schwitters, Kurt (1887–1948), German *Dadaist artist and writer. He is best known as the inventor of *Merz*, a nonsense word he gave to a form of art made from refuse, and numerous other forms of *collage. In 1937 he emigrated to Norway, then after the German invasion he fled to Britain in 1940 and lived there for the rest of his life. His major surviving work is an unfinished sculptural composition (what he called a *Merzbau*—'Merz building') in the Hatton Gallery, Newcastle upon Tyne.

science fiction, a prose story which explores the probable consequences of some improbable or impossible transformation of the basic conditions of human (or intelligent non-human) existence. This transformation need not be a technological invention, but may be some mutation of known biological or physical reality: artificial or extraterrestrial life-forms and travel through time are favourite subjects. Science fiction stories may involve Utopian political speculation, or *satire, as in *Zamyatin's *We* (1924), but most rely on the marvellous appeal of fantasy. Several early precedents have been claimed, most plausibly Mary *Shelley's *Frankenstein* (1818), but true modern science fiction begins with *Verne's *Voyage au centre de la terre* (1864) and *Wells's *The Time Machine* (1895). The term science fiction was first given general currency by Hugo Gernsback, editor of the popular *Amazing Stories* magazine from 1926, and is usually abbreviated to SF (the alternative 'sci-fi' is frowned upon by devotees). Once uniformly dismissed as pulp trash, SF gained greater respect from the 1950s, as writers like Asimov, Ray Bradbury, and Arthur C. Clarke expanded its range; among other important writers are J. G. Ballard, Philip K. Dick, Frank Herbert, Ursula Le Guin, *Lem, and Walter M. Miller Jr. SF is also popular in the cinema: notable films include *Lang's *Metropolis* (1927) and *Kubrick's *2001: A Space Odyssey* (1968).

Scopas of Paros (*fl.* mid-4th century BC), Greek sculptor. Little is known about his career, but certain pieces of sculpture, of high quality and in a distinctive style, have been attributed to him. These include three slabs in the British Museum from the Mausoleum of Halicarnassus, on which Scopas is known to have worked. They depict the Battle of Greeks and Amazons and display the intensity of expression and the characteristically deep-set eyes considered typical of his work, which heralds the emotionalism of *Hellenistic sculpture. (See also *Greek art.)

score, the notated form of a piece of music, so laid out as to show all the component parts in relation to one another. Thus the orchestral full score shows all the instrumental parts, starting at the top of the page with the woodwind family and moving downwards through brass, percussion (voices if needed), and strings. A miniature score is a full score in reduced format. A vocal score, of an opera or choral work, shows the voice parts, with the orchestral accompaniment compressed into a piano version for rehearsal purposes. (See also *notation.)

Scorel, Jan van (1495–1562), Netherlandish painter. From 1519 to 1524 he made a tour of the Mediterranean area, in the course of which he became influenced by Italian art. He was the first artist to bring a mature understanding of Italian *Renaissance art to the Netherlands and on his return his countrymen immediately ranked him among their leading artists. He also worked for the courts of France, Spain, and Sweden. His work included religious pictures and portraits, but most of his great altar-pieces have been destroyed. He was highly influential, his pupils including *Mor.

Scott, Sir George Gilbert (1811–78), British architect. A leading advocate and exponent of the *Gothic Revival, Sir George was enormously prolific. As well as designing many new buildings, he restored a great number of medieval churches, including Westminster Abbey and several cathedrals. Although he was a dedicated medieval scholar, he was severely criticized by many for the ruthlessness of his work, in which the medieval fabric was

often replaced with his own design rather than repaired; William Morris founded the Society for the Preservation of Ancient Buildings in 1877 specifically to oppose Scott. Scott also designed secular work, his two most famous buildings being the Albert Memorial (1863–72) and St Pancras Station and Hotel (1868–74) in London. He was the head of an architectural dynasty, among the members of which were his sons **George Gilbert Scott** (1837–97) and **John Oldrid Scott** (1842–1913) and his grandsons **Adrian Gilbert Scott** (1882–1963) and **Sir Giles Gilbert Scott** (1880–1960). The last-named designed Liverpool Anglican Cathedral, Battersea Power Station (1930–4), and the 1924 and 1935 models of the standard General Post Office telephone box.

Scott, Sir Walter (1771–1832), British novelist, poet, historian, and biographer, the first British novelist to become a noted public figure. A lawyer by training, his interest in the oral tradition of the Border tales and *ballads of Scotland was reinforced by the early romantic poetry of France and Italy and by the contemporary German poets including *Goethe (whose *Götz from Berlichingen* he translated). His annotated collection of ballads and tales appeared in *Minstrelsy of the Scottish Border* (1802–3). His first major original work, *The Lay of the Last Minstrel* (1805), a metrical romance, was followed by others, including *Marmion* (1808) and *The Lady of the Lake* (1810), containing many of his best-known songs. In spite of the popularity of his verse-*romances Scott recognized his limitations as a poet and found in the *historical novel a means of expressing his talent for vivid characterization, his wide erudition, his humour, and his realistic portrayal of Scottish life. The best known of the novels are *Waverley* (1814), *Guy Mannering* (1815), *The Antiquary* (1816), *Old Mortality* (1816), *Rob Roy* (1818), *The Heart of Midlothian* (1818), *Ivanhoe* (1819), *Kenilworth* (1821), and *Redgauntlet* (1824), all published anonymously. As well as establishing the form of the historical and regional novel Scott influenced the form of the short story with 'The Two Drovers' and 'The Highland Widow', both in *The Chronicles of Canongate*, 1827. He also published plays, historical, literary, and antiquarian works, editions of Dryden (1808) and Swift (1814), and promoted the foundation in 1809 of the Tory *Quarterly Review*.

Scottish-Gaelic literature, literature in the native tongue of Scotland. Scottish Gaelic remained linked to Irish Gaelic until the 17th century, and early versions of Scottish tales, sagas, and poetry are to be found in the manuscripts of early *Irish-language literature. They are distinctive for their simplicity and terseness of style, and

This portrait by Sir David Wilkie shows Sir Walter **Scott** and his family depicted in the costume of the rural lowlanders he so brilliantly characterized in his novels. Scott was an unpretentious, warm-hearted, and extremely popular man, who loved his life as a country gentleman on his estate at Abbotsford. His prodigious literary output depended on rising very early in the morning so that he could do several hours' work while the rest of the household slept. (Scottish National Portrait Gallery, Edinburgh)

for their colour and richness of imagery. In the Fenian cycle, which became prominent in *c.*1330, the poet sings of nature and love in *ballad-form, and the Fenian legends have survived to modern times. The earliest extensive anthology of heroic tales and ballads written in literary Gaelic was *The Book of the Dean of Lismore*, compiled in the Strathclyde region between 1412 and 1526, and containing works by Scottish and Irish authors from 1310 to 1520. After the rise of Presbyterianism in Scotland in the 16th century, Scottish Gaelic evolved a separate literature. Popular songs in stressed *metres have survived from the early 17th century. These are the work songs or walking songs used as an accompaniment to manual labour. The 17th century saw the high point of Scottish Gaelic literature. Some of the poetry and prose of the period has been preserved in the *Black* and the *Red Books of Clanranald* written by members of the MacMhuirich bardic family, whose work spans nearly 500 years from the 13th century to the 18th. Among the best-known poets of the 17th century were Mary Macleod (*c.*1615-*c.*1706) and the blind harper, An Clarsair Dall. Gaelic printing in the 18th century, greatly influenced by the first Scottish Gaelic book of secular poetry, *Resurrection of the Ancient Scottish Tongue* (1751) by Alexander Macdonald, produced valuable collections of poetry and social satire. Little literature appeared in the 19th century, but a 20th-century movement to free Gaelic poetry from its traditional conventions has kept the medium alive in the works of writers such as Sorley MacLean (1911-).

screen, a term used in various ways in the arts to describe certain types of partition used to rail off a space or separate one part of a room from another. In architecture it refers mainly to grilles across the front of chapels, or to the partition separating the chancel of a church (usually accessible only to the clergy) from the nave—the rood-screen. Both types may be richly decorated. More loosely, the term can refer to any low or pierced wall over or through which one can see. A distinctive form of screen was the Spanish 16th-century *reja* ('grille') in sanctuaries and chapels, constructed in two or more tiers, with spindled balusters of hammered iron. Screens are associated with Islamic, Chinese, and Japanese art (folding screens were used in China more than 2000 years ago) and were often decorated by distinguished painters.

Scriabin, Aleksandr (Nikolayevich) (1872-1915), Russian composer and pianist. His elaborate orchestral works were intended to reveal the mystical, quasi-religious theories in which he had become involved. These include *Le Divin poème* (his Third Symphony), completed in 1904, *Le Poème de l'extase* (1908), and *Promethée, le poème du feu* (1910)—all notable for their languorous harmonies, sumptuous orchestration, and general atmosphere of sensuous abandon. *Mysterium*, planned as an ultimate synthesis of art and belief and intended to herald a period of cosmic regeneration, never came to fruition.

scrimshaw, a general term for any kind of craft work made on board ship by sailors as a leisure activity, and by extension for similar pieces made elsewhere. Scrimshaw includes carving on bone, ivory, shells, and wood, but the most popular type is engraving on whale's teeth. Practical objects included boxes, games-pieces, implements for embroidery and knitting, and many other

items. More luxurious articles, such as walking-sticks and riding-whips, were also made. Scrimshaw was mainly made in the 19th century, and chiefly by American sailors.

sculpture, the branch of art concerned with the production of three-dimensional representational or abstract objects. Techniques used include *stone-carving, *woodcarving, and bronze *casting, as well as the production of pottery and porcelain figures. In the history of Western art sculpture reached a zenith in the work of the ancient Greek sculptors *Praxiteles, *Phidias, and *Scopas. During the medieval period sculpture, much of it ecclesiastical, was largely anonymous, with sculptors rising to prominence again during the Renaissance. In Florence during this period *Donatello and *Michelangelo were the outstanding innovators, and later *Bernini's style epitomized the sculpture of the high Baroque. *Canova and *Thorvaldsen in the 18th century were the two most prominent exponents of a coolly intellectual Neoclassical style. In the 19th century the major figure was *Rodin, whose expressive style owed much to the realist movement in sculpture. The development of modern sculpture was greatly influenced by *African sculpture, with its supernatural orientation and its intention to portray the spirit or feeling instead of producing a naturalistic depiction. Important figures in the modern movement include *Epstein, *Moore, and *Hepworth. Other artists rejected carving and modelling altogether and the movement towards constructions, led by *Picasso and the *Constructivists, set the style for much modern work in the field. *Gabo and *Calder examined the possibilities of *kinetic art such as *mobiles, while the minimalist movement has pared works down to their basic geometrical forms, and other sculptors have experimented with the use of different materials, particularly various metals and more recently vinyl and plastic. Overall, post-war sculpture has been characterized by a multitude of styles and techniques and an absence of closely defined movements. (See also *Buddhist art, *Central American and Mexican art, *Chinese art and architecture, *Hindu art, *Japanese visual arts.)

Sculthorpe, Peter (Joshua) (1929-), Australian composer. Using Aboriginal folklore as a reference point and the music of Bali as an inspiration, he has attempted to create a specifically 'Australian' music. This is best evinced in such pieces as the four orchestral *Sun Musics* (1965-7) and *Sun Music for Voices* (1966). More recent works include the opera *Rites of Passage* (1974).

scumble, a thin layer of opaque or semi-opaque paint lightly dragged or skimmed over a previous layer of another colour in such a way that the lower layer is only partly obliterated and shows through irregularly. Together with the use of *glazes, scumbling allows a range of textural and colouristic effects that ensured *oil paint's dominance over other media. Similar effects can now be obtained with *acrylic. Scumbling is also used in pencil, chalk, or monochrome drawing to soften the lines by rubbing with a stump, etc.

Scythian art, also called Steppes art, the art of the Scythians, a nomadic people originally from Central Asia who formed an empire centred around the area north of the Black Sea (now in the Soviet Union) that lasted from

This silver vase-handle in the form of a wild goat typifies the vitality of **Scythian art**. It is part of a collection known as the Oxus Treasure, found in 1877 on a bank of the Oxus River (now the Amudarya River) in Kataghan province in Afghanistan. This was part of Bactria rather than the Scythian empire, but Scythian goods were widely dispersed through trade. (British Museum, London)

the 7th to the 2nd century BC. Their art centred on the lavish burials accorded their kings and chieftains. Numerous tombs have been excavated, and in some of them objects such as textiles have been preserved by freezing. The finest treasures found in them are objects worked in gold showing vigorous animal designs, in which real or mythical beasts are portrayed. In south-eastern Scythia they often employed Greek craftsmen to produce exquisite pieces of jewellery and drinking vessels, revealing Greek and Scythian life. The Scythians themselves worked in bone, leather, wood, bronze, iron, gold, electrum, and silver. Many of their decorated forms are geometric in design, conveying symbols of magic. Practically all are of superb craftsmanship and compelling force.

Sebastiano del Piombo (c.1485–1547), Italian painter. He was a pupil of Giovanni *Bellini, and his early work was strongly influenced by *Giorgione. In 1511 he moved to Rome, where he remained for the rest of his life. He became a friend of Michelangelo, under whose guidance Sebastiano's work became grander in form whilst losing much of its sensuous beauty of colouring and brushwork. His late work—portraits as well as religious pictures—has a sombre grandeur: after Raphael's death in 1520 he was the leading portraitist in the city.

secondary colour *primary colour.

Seferis, George (Georgios Stylianou Seferiades) (1900–71), Greek poet. He was born in Smyrna, whose destruction in 1922 (in the aftermath of the Greco-Turkish war) left a lasting sense of pessimism in his poetry. His career as a diplomat brought him into contact with European culture, and he consequently became one of the first *modernist poets in Greece. Greekness is central to his poetry, particularly in *Mythistorema* (1935), where the tragedy of modern man is explored in images drawn from Greek myth, history, and landscape. His later collections, such as the three 'Logbooks' and his poem 'The Thrush', extend the breadth and depth of his preoccupations and poetic manner. He was awarded the Nobel Prize for Literature in 1963.

Seghers, Hercules (c.1589–c.1633), Dutch painter and etcher of landscapes, one of the most original figures in Dutch art. Little is known of his life and only about a dozen paintings survive that are confidently attributed to him, most of them mountain scenes. They are usually fairly small, but they suggest vast distances and convey a sense of almost tragic desolation. Only Rembrandt and Ruisdael among Dutch artists attained a similar degree of emotional intensity in landscape painting, and Seghers certainly influenced *Rembrandt, who collected his work. Seghers's etchings are perhaps even more original than his paintings. He experimented with coloured inks and dyed papers, each print being a unique impression.

Segovia, Andrés (1893–1987), Spanish guitarist. Although he studied in Granada, Segovia was largely self-taught. Following his 1924 Paris début, he toured internationally, becoming the central figure in the revival of interest in the guitar as a classical instrument. *Falla and *Rodrigo composed works for him, and Segovia himself transcribed pieces by Bach, Handel, Couperin, and Rameau.

Seifert, Jaroslav (1910–86), Czech poet. After a short phase of writing 'proletarian poetry' and proclaiming his belief in an approaching communist revolution, Seifert turned to poetry freed from all social and moral precepts, and became an exponent of *Dada and *Cubism (*On the Waves of the Wireless*, 1924). In his later poetry, celebrating the joys and beauty of the world, his perspective deepens and his final volumes express with resignation the melancholy of passing life. He was awarded the Nobel Prize for Literature in 1984.

Seljuq art. The Seljuqs were a dynasty with origins among the Turkic tribes of Central Asia who ruled in Iran and part of Anatolia (1055–1256). They were distinguished particularly by their architecture, which was usually of patterned brick, with heavily ornamented façades sometimes enhanced by turquoise tilework. In the superb Friday Mosque at Isfahan in central Iran, the harmonious work of the smaller dome chamber (1088) well illustrates their mastery of the transition between the square base to the circle of the *dome above. The Seljuqs developed the tomb tower, which was sometimes circular, sometimes polygonal, and topped with a conical roof. This remained an important architectural form for the next three centuries in Iran, Central Asia, and Asia Minor. A branch of the dynasty known as the Seljuqs of Rum established itself in Anatolia in the 13th century. Its architecture is related to that of the eastern Seljuqs, but was built predominantly of stone, with elaborately carved flat façades decorated with stylized *calligraphy, *arabesque, and floral patterns or, occasionally, with

paired birds or grotesque animals. The Seljuqs left a remarkable network of fortress-like caravanserais (inns built around a large court) for the use of travellers along the major trade routes of Anatolia.

Seneca the Younger (Lucius Annaeus) (*c.*1–65AD), Roman writer and statesman. Born in Spain, he spent much of his life in Rome, rising to political power under the young Nero. He left nine tragedies on mythological subjects, and a satire on the deification of Claudius, but he is most notable for his prose works: 124 letters; the *Natural Questions*, a treatise on natural science; and a series of essays on philosophical topics, full of point and wit, all marked by an *epigrammatic style that uses *rhetoric to recommend Stoic principles.

Senghor, Léopold Sédar (1906–), Senegalese poet and politician. The leading poet of French-speaking Africa, he evolved the concept of *négritude* in the 1930s, stimulating awareness of African culture as part of the anti-colonial movement which he represented in the French National Assembly after the war. He was the first President of independent Senegal (1959–80). His collections of lyrical poetry include *Chants d'ombre* (1945) and *Nocturnes* (1961).

Sennett, Mack (Michael Sinnott) (1880–1960), Canadian-born US film producer and director, known as the 'King of Comedy'. He was the inspiration behind the Keystone Company from its foundation in 1912 until 1917, developing the use of *slapstick in crazy, irreverent short films almost always involving a final chase, and introducing the legendary Keystone Kops. He worked with notable comedians such as *Keaton and Mabel Normand (1894/5–1930). On leaving Keystone he continued to make short comedy films but his reputation waned in the sound era and he made no films after 1935.

sepia, a brown, semi-transparent pigment made from the ink of cuttlefish and other marine creatures, used for ink drawings and in washes. It was used by the Romans, but its period of greatest popularity was the late 18th and early 19th centuries, when it was favoured especially for topographical drawings—Friedrich was a noted exponent. Sepia's warm, reddish colour distinguishes it from the cooler, more greenish *bistre.

serenade, music intended for performance as night draws on (*sera* being the Italian for 'evening'). The term is generally used to describe works of the *divertimento type, developed towards the end of the 18th century and intended as evening entertainment. Serenades designed specifically for performance out of doors were scored for wind instruments.

serialism (twelve-note technique), a system of musical composition associated with *Schoenberg, whose 'method of composing with twelve notes which are related only to one another' was developed during the 1920s as an explanation of what was giving avant-garde music its sense of 'order' at a time when the old *tonal system had either broken down or been seriously weakened. Instead of the ordered hierarchy of the *key system, serialism treats all twelve notes of the chromatic *scale as being of equal importance. The basis of each composition is a 'series' of twelve chromatic notes, taken in any order, but

without repetition, and formed into a 'note row'. The note row, transposed if necessary, or used in inversion or backwards, and so on, therefore becomes the source of the composition. The notes may be used melodically or harmonically, but a strict sequence must be maintained. It is the order that confirms their identity. Thus, notes 3, 5, and 7, may be heard simultaneously or consecutively, but not before notes 4 and 6 have been sounded. Many composers have found Schoenberg's theory inspiring, but not all have applied it with the same rigour.

Serlio, Sebastiano (1475–1564), Italian architect and architectural theorist, active in France from 1540. He worked as consultant on the building of the palace of Fontainebleau, but is of very minor account as an architect. His importance stems rather from his influential treatise, *Architecture*, published between 1537 and 1551, with other parts appearing posthumously. It was the first architectural publication designed as a highly illustrated handbook rather than a learned treatise and it was used as a pattern-book by craftsmen all over Europe, playing an important part in spreading the *Renaissance style. The many editions published included an English translation in 1611.

sermon, a public exposition of religious (usually Christian) doctrine, also known as a 'homily'. As a literary form, the sermon was developed by Origen and Chrysostom in the 3rd and 4th centuries, becoming a highly elaborate art in the Middle Ages, when it stimulated the emergence of vernacular (non-Latin) literatures. The outstanding later homilists in English were Donne, Lancelot Andrewes

Harīrī's *Maqāmāt* (assemblies of entertaining dialogues), a collection of tales of an elderly stranger called Ibn Zayd, was a bestseller in the medieval Islamic world. The miniature shown here is from a 13th-century manuscript of the *Maqāmāt* from Baghdad, a rare survival of the **Seljuq art** of the book, providing a vivid and satirical view of contemporary life. (Bibliothèque Nationale, Paris)

(1555–1626), and John Henry Newman (1801–90) in England, and Jonathan Edwards in Massachusetts, USA. The techniques of *allegory and *rhetoric cultivated in the Christian sermon tradition influenced many writers from Langland and Chaucer to Emerson and Thoreau.

serpent, a wooden horn with finger-holes, built in sinuous shape. Serpents were used in churches to support the bass voices from around 1600, and in military and other wind bands from about 1740, by which time three keys had been added for chromatic notes. As orchestras grew larger, the serpent was introduced, and it appears in scores up to the middle of the 19th century, after which it was replaced by the *tuba. It survived, often locally made, in church bands and other amateur circles almost to the end of that century.

Sesshu (1420–1506), Japanese painter, considered his country's foremost master of *suiboku-ga* or ink painting. A Zen Buddhist monk, he studied at Zen monasteries during a visit to China (where he was held in high regard) in 1467–8. Although he was influenced by *Chinese art, Sesshu's work was less ethereal, his brush-strokes showing great strength and angular vitality. He began a tradition of Japanese landscape painting based on observation rather than meditative evocation, and he also painted flowers and portraits. Although best known for the vigour of his style, he also worked in a softer manner. (See also *Japanese visual arts.)

The Teatro Olimpico in Vicenza, begun by Andrea Palladio in 1580 and completed after his death by his pupil Vincenzo Scamozzi, was an attempt by one of the greatest architects of the Renaissance to re-create the theatre of the Romans. The permanent **set design** represents an urban scene and achieves a striking sense of recession by sloping the backstage parts upwards to enhance the perspective effect. The use of perspective was the major innovation of the Renaissance period in theatre design.

Sessions, Roger (Huntington) (1896–1985), US composer. His early works were influenced by *Stravinsky, but with the Violin Sonata (1953) he adopted *serial techniques. His most important contribution to American music was the series of eight symphonies composed between 1927 and 1968. He wrote extensively and with penetration on various aspects of music, and was an influential teacher.

set design, design of the settings for theatrical productions. Early productions had no sets, but in the Roman theatre (and possibly the Greek) rotating triangular prisms, *periaktoi*, were sometimes used, each surface of which represented a particular setting. In Renaissance Italy the *periaktoi* were made larger and more numerous, eventually being renamed *telari*, and the new invention of *perspective painting was used by Peruzzi (1481–1537) in painting scenery. Buontalenti (1536–1608) used *telari* with a painted backcloth. The English artist Inigo *Jones incorporated these changes in his *masques, which were performed against elaborate backcloths ranging from the fancifully wild to the formality of gardens, palaces, and colonnaded streets. He also introduced movable flats (painted canvas-covered timber frames) which could be used in pairs (known as wings or shutters), and the 'set scene', which had to be 'set' in advance and was invisible to the audience behind a pair of shutters until they opened. 'Set' and 'flat' scenes (in which the flats slid on and off in view of the audience) alternated in Britain until the end of the 19th century. The public theatres resisted Inigo Jones's reforms until after the Restoration, and it was only under David *Garrick that scenery began to look attractive. In the 19th century architectural authenticity was increasingly demanded, and the box-set, with three walls and a ceiling, was introduced. It superseded the wings and painted backcloth, at least in the non-musical theatre. Later in the century came 'built stuff', three-dimensional replicas of objects such as rostra and porches. The insistence of the Parisian Théâtre Libre, founded in 1887, on giving a literal rendering of real life

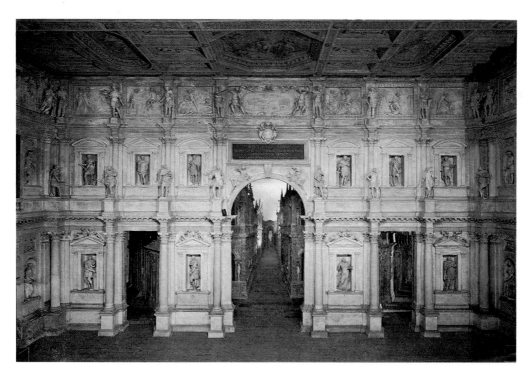

helped to liberate the stage from the artificial prettiness of an earlier epoch. This in turn gave way, especially in France and Germany, to more symbolic, stylized scenery, imaginatively lit by the new electric *lighting. Gordon Craig (1872-1966), *Meyerhold, *Piscator, *Stanislavsky, and *Reinhardt were influential, and Robert Edmond Jones (1887-1954) and Norman Bel Geddes (1893-1958) led the USA to the forefront of scene design. Visual artists like *Picasso, *Braque, *Chagall, *Gris, and *Matisse engaged in set design in the early 20th century, under the auspices of the ballet impresario *Diaghilev. Later 20th-century developments, such as the revolving stage and composite setting—in which several scenes could appear together, at different levels—greatly increased the possibilities for set designers, who also benefited from new materials such as plastics and metal alloys. New methods of staging such as theatre-in-the-round and the use of non-theatrical spaces such as galleries and streets, have posed problems, but are now accepted as part of the wide range of options (still including the box-set) open to the modern designer. (See also *stage machinery.)

Seurat, Georges (1859-91), French painter, the founder of *Neo-Impressionism. His aim was to systematize the method of juxtaposing colours in order to achieve the kind of vibrant effects that the *Impressionists had arrived at intuitively, and the method he evolved was to place small touches of unmixed colour side by side on the canvas, a technique known as *pointillism, producing an effect of greater luminosity than if the colours had been physically mixed together. The first picture in which he fully established his new method was *Sunday Afternoon on the Island of La Grande Jatte* (1884-6), which was shown at the final Impressionist exhibition in 1886 and established him as a leader of the avante-garde. Tragically, he died from meningitis while still a young man. Seurat's work was highly influential, but his followers rarely approached his skill, and still less his level of inspiration, in applying his theories.

Seven Wonders of the World, the seven most spectacular man-made structures of the ancient world, the earliest extant list of which dates from the 2nd century and includes: the pyramids of Egypt (see *Egyptian art); the Hanging Gardens of Babylon (see *Babylonian art); the Mausoleum of Halicarnassus (see *mausoleum); the temple of Diana at Ephesus in Asia Minor, built in 356 BC; the Colossus of Rhodes, a huge bronze statue of the sun-god Helios, sculpted in 250 BC; the statue of Zeus at Olympia (see *Greek art); and the Pharos of Alexandria, a lighthouse built c.250 BC.

Sezession, a general name for several rebel art associations in Germany. During the last decade of the 19th century many of the more advanced German artists found it impossible to exhibit their works through the traditionally minded organizations. Hence they 'seceded', and organized their own exhibition. The first group was formed in Munich in 1892 and was followed by the Berliner Sezession, founded by *Liebermann in 1899. When a number of younger painters were rejected by the Sezession they founded their own Neue Sezession in 1910. The Vienna Sezession, founded by *Klimt in 1897, was concerned with the applied arts and architecture as much as with painting.

shadow plays, a form of *puppetry in which shadows are cast on a screen. The flat, jointed figures, usually worked from below by wires or bamboo rods, pass between the screen and the source of light. The shadow play began in the Far East, in China, India, and particularly Indonesia where it is known as *wayang*, but shadow plays are also performed in present-day Malaysia, Cambodia, and Thailand. The highly stylized shadow puppets are intricately cut from leather and mounted on sticks. Performances can last all night and are conducted by a skilled master puppeteer (*daland*), who manipulates the puppets before a light to cast shadows on a screen, and speaks the dialogues of all the different characters as well as providing the narration. In Indonesia stories based on the *Mahābhārata* and *Rāmāyaṇa* are popular and often performed. Sometimes local and contemporary references are incorporated into the performance, and the shadow play has at various periods been used as a propaganda tool and a means of disseminating government policy. In Turkey the shadow play, known as *Karagöz*, was a popular form of theatrical entertainment, with stock characters based on the various ethnic types of the Ottoman empire. Shadow play was brought successfully to the West, and the Palais Royal in Paris showed *Les Ombres Chinoises* for over seventy years until 1859. The famous shadow play *The Broken Bridge*, which originated in Paris, was also known in London; the shadow play (or Galanty Show) survived there almost into the 20th century, usually in adapted Punch and Judy booths. Lotte Reiniger (1899-1981) adapted the techniques of shadow plays for television and the cinema.

shahnāī, a musical instrument, the *shawm of Indian folk and classical music. Instruments vary from a cone made by stepping pieces of bamboo into each other to the true conical instrument of classical players. Techniques vary similarly, for folk players have the reed wholly in the mouth, whereas classical players now lip it like oboists.

Shaker furniture, a distinctive type of wooden furniture made in the USA in the late 18th and 19th centuries by members of a Christian sect popularly known as the 'Shaking Quakers' or 'Shakers' (they were so called because they trembled when filled with religious ecstasy). The sect was founded in Britain in 1747 and was established in America in 1774. Many of the men were woodworkers and they soon began making furniture commercially. Its style reflected their plain, austere way of life and high ideals of integrity: forms are strong, simple, and functional, without any ornament; materials are of excellent quality; and craftsmanship is impeccable but undemonstrative. It soon gained, and has retained, a high reputation.

Shakespeare, William, (1564-1616), English dramatist and poet. His works, translated and performed throughout the world, have made him the most celebrated and most quoted of English writers. He was born in Stratford-upon-Avon, the son of a glover, and in 1582 he married Anne Hathaway, who bore him three children. He is known to have been active in the London theatre by 1592, but nothing is recorded of his earlier education or working life. As an actor and playwright he worked for the Lord Chamberlain's Men (known from 1603 as the King's Men), the leading company which from 1599 occupied the Globe Theatre, of which Shakespeare was

Of the portraits of **Shakespeare** with any claim to authenticity, the most interesting is this one, known as the 'Chandos' portrait because it used to belong to the Duke of Buckingham and Chandos. According to tradition it was painted by Richard Burbage, the star actor of Shakespeare's company. With his gold earring and plain dress Shakespeare is here depicted less as a literary figure than as the actor and stage-manager beloved 'this side idolatory' by his contemporaries. (National Portrait Gallery, London)

a shareholder. While the plague closed the London theatres (1592-4), he published two narrative poems, the erotic *Venus and Adonis* and *The Rape of Lucrece*. Also probably written in this period was his very fine sequence of 154 *sonnets (published 1609), some of them addressed to a mysterious 'Dark Lady' and to a beautiful young man. Shakespeare is known to be the author or co-author of thirty-eight surviving plays. Dates of composition and first performance cannot be determined exactly, but the accepted approximate dates fall into four phases of Shakespeare's dramatic career. During the first, from some time in the late 1580s to 1594, Shakespeare experimented with different kinds of *comedy in *Love's Labour's Lost*, *The Comedy of Errors*, *Two Gentlemen of Verona*, and *The Taming of the Shrew*; and began his exploration of English history in his first 'tetralogy' (a linked sequence of four plays) comprising *Henry VI* (in 3 parts) with *Richard III*. The bloodthirsty *Titus Andronicus* was his earliest *tragedy. From 1594 to 1599 Shakespeare continued to concentrate on comedies and histories. The comedies of this period—*A Midsummer Night's Dream*, *The Merry Wives of Windsor*, *The Merchant of Venice*, *As You Like It*, and *Much Ado About Nothing*—are mainly in his best-loved 'romantic' vein, while his fuller command of histories appears in the second tetralogy: *Richard II*, *Henry*

IV (2 parts), and *Henry V*. This second period also includes the historical *King John* and a sentimental tragedy, *Romeo and Juliet*. In the third period, from 1599 to 1608, Shakespeare abandoned romantic comedy (except for *Twelfth Night*) and English history, working instead on tragedies and on the disturbing 'dark' comedies or 'problem plays' *Measure for Measure*, *All's Well that Ends Well*, and *Troilus and Cressida*. The tragedies usually regarded as the four greatest are *King Lear*, *Macbeth*, *Hamlet*, and *Othello*, although a second group of tragic 'Roman plays' includes the equally powerful *Antony and Cleopatra*, along with *Julius Caesar* and *Coriolanus*. To this period also belongs the tragedy *Timon of Athens*, possibly written with *Middleton. Shakespeare's final phase, from 1608 to 1613, is dominated by a new style of comedy on themes of loss and reconciliation: *Pericles*, *Cymbeline*, *The Winter's Tale*, and *The Tempest* are known as his late 'romances'. Shakespeare seems to have interrupted his retirement in 1613 to collaborate with Fletcher (see *Beaumont) in *Henry VIII* and *The Two Noble Kinsmen*. Most of the fictional stories in Shakespeare's plays were adapted from earlier plays and romances (including some tales by *Bandello), while his historical dramas are derived from *Plutarch's biographies of Roman statesmen and from Raphael Holinshed's biased account of English history, the *Chronicles* (1577). Shakespeare's unparalleled reputation rests on the plays' memorable and complex characters, their dynamic movement through rapid alternations of short scenes, and above all the extraordinary subtlety and richness of the *blank verse, dense with *metaphors and elaborate in *rhetoric. Since the 18th century Shakespeare has been regarded as the greatest English dramatist, and in the period of Romanticism he came to be venerated as a semi-divine genius, timeless and universal. Modern opinion often prefers to see him as a practical man of the theatre with a highly developed sense of the links between language and political power. (See also *Elizabethan theatre.)

shakuhachi, a musical instrument, a Japanese bamboo *notch flute with thumb- and four finger-holes, despite which it is fully chromatic. Players partly cover finger-holes and shade the *embouchure* or blowing end with the lip to alter the pitch. The shakuhachi was especially associated with Zen Buddhism. Now a virtuoso instrument, it still retains a connection with Zen.

shamisen, a long-necked Japanese *lute used to accompany singing, with three strings and a small, almost square, resonator with catskin belly and back. The large plectrum, the *bachi*, is often made of ivory. The *shamisen* derives from the Chinese *sanxian*, a very similar instrument except that the belly and back are of snakeskin and that the *sanxian* does not have the special nut for the highest string which adds vibrancy to the tone. The Japanese *kokyu* is smaller than the *shamisen* but otherwise similar: it is bowed, not plucked.

Shankar, Ravi (1920–), Indian sitar-player and composer. Taught by his brother, with whose troupe of musicians and dancers he worked, Shankar was director of music for Indian Radio (1940-56). Touring Europe and the USA (1956-7), Shankar's sitar recitals led to the awakening of interest in Indian music in the West. A performer of great sensitivity and musicianship, Shankar composed a sitar concerto, and has continued to tour.

Sharp, Cecil (James) (1859–1924), British ethnomusicologist, who devoted himself to the collection, publication, and performance of the folk dance and folk-song of the British Isles. His collection of nearly 5,000 examples includes many which he had collected in the USA (1916–18). Sharp's example and enthusiasm had a crucial influence on the music of Holst and Vaughan Williams.

Shaw, Artie *jazz.

Shaw, George Bernard (1856–1950), Irish dramatist and critic. He was born in Dublin and moved to London at the age of 20. After working as a theatre and music critic, his first play, *Widower's Houses* (1892) was followed by *Arms and the Man* (1894) and *Mrs Warren's Profession* (1898), which was banned for its frank treatment of prostitution. His theory of the power of human will is discussed in *Man and Superman* (1903). He wrote more than fifty plays including *John Bull's Other Island* (1904); *Major Barbara* (1905) featuring his heroine as a Major in the Salvation Army; *The Doctor's Dilemma* (1906), a satire on the medical profession; his most popular play, *Pygmalion* (1913, later adapted as the musical and film *My Fair Lady*), a human comedy about love and class; *Heartbreak House* (1920), the spiritual flounderings of the war-generation; *Back to Methuselah* (1921), five linked plays which comprise a parable of creative evolution; and *Saint Joan* (1923), an investigation of people's reaction to heroes. Discussion is the basis of his plays and his great 'Shavian' wit, his unorthodox views, and love of paradox convinced his audiences that mental and moral passion could produce absorbing drama. His other works include *The Quintessence of Ibsenism* (1891) revealing his debt to Ibsen; *The Intelligent Woman's Guide to Socialism and Capitalism* (1928); and his letters, collected in several volumes. He was an active member of the Fabian Society, editing and contributing to *Fabian Essays in Socialism* (1889), and campaigned for many causes, including women's rights, electoral reform, and reform of the English alphabet. He was awarded the Nobel Prize for Literature in 1925.

Shaw, Richard Norman (1831–1912), British architect, a prolific, inventive, and influential designer, particularly of houses. He began working in the *Gothic Revival style, but in the 1860s he pioneered a new informal and eclectic type of revivalist domestic architecture that he called 'Old English'. Gaining inspiration from Elizabethan and Jacobean vernacular styles, and using such features as half-timbering and split levels, this had great influence on the *Arts and Crafts Movement. In the 1880s Shaw's style changed, as he turned primarily to a red-brick *Queen Anne manner. This, too, in turn gave way in the 1890s to a grand classicism, and by this time Shaw had broadened his scope to take in civic and public architecture. His later style was as influential as his early work. Shaw was an immensely resourceful and energetic designer and a complete master of his profession, for as well as being a brilliant draughtsman he had a knowledge of all aspects of building.

shawm, a double-reed musical instrument of conical bore, producing a loud and penetrating sound. The earliest evidence for such an instrument is Etruscan, around 480 BC. Thereafter it appears only spasmodically, but from the 6th century, in Sassanid Persia, it became a standard instrument in the Near East, whence it disseminated widely through contact with Islam. It entered Europe in the 13th century, through Spain and with returning Crusaders, and became the leading outdoor instrument of the waits or town bands, and *Stadtpfeifer* (German, 'town pipers'). In the mid-17th century, with the desire to move the French court oboe band indoors, a radical reconstruction created the *oboe and, there being still a need for outdoor shawms, a lesser modified version, the *Deutsche Schalmei*. By the end of the 17th century the shawm was extinct in mainstream European music. However, it survives as a folk instrument in southern Europe, from Brittany to the Balkans, and as a leading instrument in North Africa and Nigeria and throughout the Middle, Near, and Far East. The shawm is usually blown with circular breathing, inhaling through the nose while blowing from the cheeks.

Shawn, Ted (1891–1972), US dancer, teacher, and choreographer. He first toured in 1914, when he met and married Ruth *St Denis with whom he started Denishawn, the dance company and school for *modern dancers. He championed the cause of the male dancer

It is likely that the **shawm** evolved in the Middle East during the early years of Islam. A version of it may still be heard in Asia and North Africa today. The instrument shown in this detail from the 'Mary, Queen of Heaven' panel (c.1485) would have been played at state balls, on ceremonial occasions, and before the hunt. (National Gallery of Art, Washington DC)

with his all male company. He is known for his teaching and writings, particularly those on the *Delsarte system. He also promoted dance by founding Jacob's Pillow, the US dance festival.

Sheffield plate, metalware made of copper coated on one or both sides with a layer of silver, the two metals being fused by heat. This process for producing a cheap substitute for solid silver was invented in the early 1740s by Thomas Boulsover, a Sheffield cutler, who made small items such as buttons and snuff boxes with it. From about 1760 it was used for a much wider range of domestic wares, such as teapots, candlesticks, and urns. It was manufactured in many places in Europe and also in the USA and Russia, but Sheffield retained the reputation of producing the highest quality goods. From about 1840 Sheffield plate was rapidly superseded by electroplating, which was less attractive but cheaper.

Shelley, Mary Wollstonecraft (1797–1851), British novelist. She was the second wife of *Shelley, whose works she edited after his death, and daughter of the advocate of women's rights, Mary *Wollstonecraft, and the philosopher William Godwin. Her novels, notably *Frankenstein: or The Modern Prometheus* (1818), in which the monster describes his rejection by society and resentment towards his creator, are influenced by Godwin's ideas and take up many of the themes of the *Gothic novel. *The Last Man* (1826) is set in the future, amongst the ruins of civilization. Among her highly readable travel books is *History of a Six Weeks' Tour* (1817), in which she recounts the continental tour that she undertook with Shelley following their elopement.

Shelley, Percy Bysshe (1792–1822), British poet and social and political thinker. He was expelled from Oxford University for circulating *The Necessity of Atheism* (1811; with T. J. Hogg), a pamphlet attacking religious belief. His early philosophy on the perfectability of man is reflected in *Queen Mab* (1813), a long visionary poem printed privately, which advocates the destruction of various established institutions. After a crisis in his marriage to Harriet Westbrook in 1814 he eloped with Mary Godwin (see Mary *Shelley) and her step-sister 'Claire' Clairmont. In 1816 he published his narrative poem *Alastor*, passed the summer with *Byron in Switzerland, and wrote the 'Hymn to Intellectual Beauty'. In the autumn Harriet drowned herself and Shelley married Mary soon afterwards. In 1818 they moved to Italy, where Shelley wrote his greatest works. Among them are his masterpiece, the lyrical drama *Prometheus Unbound* (1820), which reflects his creative genius and belief in human love and reason; *The Mask of Anarchy* (written 1819), a powerful response to the 'Peterloo Massacre'; his political *odes 'To Liberty' and 'To Naples', and his *lyric pieces which show his mastery of language and grandeur of vision; the verse tragedy *The Cenci* (1819), which explores moral deformity; *Adonais* (1821), his *elegy on the death of Keats, which asserts the immortality of beauty; and *The Triumph of Life* (1825), a hypnotic poem with images of the sea. He was drowned, aged 29, when his small yacht *Ariel* overturned in a storm off the coast of Tuscany. His prose works include *A Philosophical View of Reform* (1820) and his famous *Defence of Poetry* (1821) which discusses the nature of poetic thought and inspiration.

shellwork, decorative work using shells. In Melanesia and Micronesia shells have been used for articles of personal adornment, for decorating ceremonial masks, and for inlaying articles such as bowls. Some North American Indian tribes have used shells for similar purposes and also for wampum—polished shells strung in sashes or belts and used as money or ornaments. Because of its resemblance to the female genitals the cowrie shell has been used, from prehistoric times and in many parts of the world, as a fertility symbol (in *amulets, for example). Cowrie shells have also been used as currency. In the West shells have long been collected for their beauty or curiosity value, and they have occasionally been used to form or decorate small ornamental objects. The art of carving *cameos from shells began in Italy in the Renaissance and reached great heights in the work of Giovanni Sabbato (fl. 1873–83), who spent ten years carving a shell with an allegory of England's greatness at sea.

Shen Fu (fl. late 18th–early 19th century), Chinese autobiographer. He was born in Suzhou and worked as a clerk in the civil service. In 1809 he wrote *Six Records of a Floating Life*, a revealing memoir, unusual in Chinese literature. It provides deep insights into the traditional Chinese family and marriage, the role of the courtesan, and the lower ranks of the civil service.

Sheraton, Thomas (1751–1806), British cabinet-maker and furniture designer. No furniture by his own hand has

A design for a cabinet from the 1802 edition of Thomas **Sheraton**'s *The Cabinet-Maker and Upholsterer's Drawing Book*. Sheraton said his book was 'intended to exhibit the present state of furniture, and at the same time to give the workman some assistance in the manufacturing part of it'. The elegance of form and delicacy of ornamentation seen in this piece are characteristic of his style.

been identified, and his fame rests on his publications, the most important of which is *The Cabinet-Maker and Upholsterer's Drawing Book* (1791–94). The designs were much used by furniture-makers in Britain and America, and Sheraton's name has come to be used as a label for the prevailing style in furniture around 1800 (simple in outline, delicate and light), just as *Chippendale's name is applied to the style of half a century earlier.

Sheridan, Richard Brinsley (Butler) (1751–1816), Anglo-Irish dramatist and Whig politician. The most celebrated of his plays are *The Rivals* (1775), with Mrs Malaprop (see *malapropism) among its characters, and *The School for Scandal* (1777), both comedies of manners combining wit and elegance. In 1777 he was elected to Johnson's Literary Club. He wrote many more plays, including *A Trip to Scarborough* (1777), and *The Duenna* (1775), both musical plays. He was elected to Parliament in 1780, where he proved himself to be a brilliant orator and held senior government posts. In 1813 he was arrested for debt and three years later he died in poverty.

Shijing ('Classic of Poetry'), Chinese *Confucian scripture, the first anthology of Chinese poetry. Known as the 'Book of Odes' or the 'Book of Songs', it is a collection of folk-songs about love, marriage, and war, and hymns for festivals, sacrifices, and hunting, 305 poems in all. Legend holds that Confucius himself edited the poems, which date back to between 1100 and 600 BC. The literary form of the *Shijing* has exercised a profound influence on Chinese poetry, stressing the lyrical rather than the narrative element of composition.

śikhara, in Indian architecture, a pyramid-like superstructure above the central shrine of a temple, built to resemble a mountain in reference to the mountain home of the gods. Often there are subsidiary towers of the same design attached at the sides. Śikharas are associated with northern India; in southern India a smaller, squatter structure crowns the sanctuary.

Shnitke, Alfred (Garriyevich) (1934–), Soviet composer. He was one of the first Soviet composers to explore *serialism. Later works have proved eclectic in style: most noteworthy are the four violin concertos (1957) and four symphonies (1972–84), written in a powerful, expressive style.

Sholokhov, Mikhail (Aleksandrovich) (1905–84), Russian novelist. His epic novel *And Quiet Flows the Don*, published in four books between 1928 and 1940, was heralded as a powerful example of *Socialist Realism and has become a classic of Soviet literature. Sholokhov was awarded the Nobel Prize for Literature in 1965.

short story, a fictional prose tale of no specified length, but too short to be published as a volume on its own, as *novellas sometimes and *novels usually are. A short story will normally concentrate on a single event with only one or two characters, by contrast with a novel's sustained exploration of social background. There are similar fictional forms of greater antiquity, such as *fables, *lays, folk tales, and *parables, but the short story as we know it flourished in the magazines of the 19th and early 20th centuries, especially in the USA, which has a particularly strong tradition from Irving to Flannery

O'Connor. The leading 19th-century short-story writers were Pushkin, Hoffmann, Poe, Maupassant, and Chekhov. In the early 20th century, outstanding authors included Kafka, Babel, Joyce, Mansfield, Maugham, Lawrence, and Borges. Prominent among their successors are Calvino and Singer.

Shostakovich, Dmitry (Dmitriyevich) (1906–75), Soviet composer. His career was a struggle between his natural inclination towards the new musical styles of Western Europe and the demands of a Soviet policy that required music to be readily comprehensible and optimistic. In 1936 his opera *The Lady Macbeth of Mtsensk*, which had enjoyed great success in 1934, was attacked for its unacceptable modernism. He withdrew a fourth symphony and commenced a fifth. This proved acceptable and highly popular (1937), and he was reinstated as the foremost Soviet composer. In 1948 he again came under attack, and lost his Moscow professorship. Shostakovich wrote in two idioms: one simple and readily accessible, the other complex and deeply personal. His output includes fifteen symphonies (1924–71) and fifteen string quartets (1935–74); on the strength of these alone he must be judged one of this century's greatest composers.

showboat, a floating theatre which travelled down the rivers of the USA, bringing entertainment to areas newly colonized. The first true showboat was launched about 1831. It travelled annually down the Ohio and Mississippi from Pittsburgh to New Orleans, giving mainly one-night stands. Showboats became extremely popular and spread to other rivers, mostly staging *melodrama and comedy; usually they were pushed by tugs and had three decks. They disappeared during the Civil War but later returned, being destroyed eventually by the Depression, the cinema, and the opening of more polished city theatres.

Sibelius, Jean (Julius Christian) (1865–1957), Finnish composer. In 1892 the success of his patriotic choral symphony *Kullervo* established him as Finland's leading composer. There followed a series of orchestral works, including *A Saga* (1892), the four *Lemminkäinen* tone-poems (including 'The Swan of Tuonela', 1893), the First Symphony (1899), and nationalist works such as *Karelia* (1893) and *Finlandia* (1899). His reputation rests mainly on seven symphonies (1899–1924) and his Violin Concerto (1903). Each symphony shows a fresh approach to the symphonic problem, the whole cycle constituting one of the major symphonic achievements of the 20th century. An eighth symphony, completed in 1929, was destroyed by the composer, who virtually ceased composing after 1926—partly through self-doubt and lack of sympathy with contemporary trends in music, and partly because of heavy drinking. His last tone-poem, *Tapiola* (1926), is filled with bleakness and despair.

Sickert, Walter Richard (1860–1942), British painter and etcher who spent much of his time in France. He became the main link between French *Impressionism and advanced ideas in British painting. Sickert painted urban scenes and figure compositions, particularly pictures of the theatre and music-hall and drab domestic interiors. He avoided fashionable good taste and depicted commonplace (often sordid) life with a penetrating but unmalicious eye. In 1911 he founded the *Camden Town Group and later belonged to the London Group, which

brought together the Camden Town Group and the *Vorticists.

Siddons, Sarah (b. Kemble) (1755–1831), British tragedienne, sister of John *Kemble. Though her engagement as an actress by David *Garrick in 1775 was unsuccessful, she returned to London in 1782, and was soon acclaimed as a great tragic actress. Her roles included Constance in *King John*, Belvidera in Otway's *Venice Preserv'd*, Zara in Congreve's *The Mourning Bride*, and above all Lady Macbeth. She was beautiful and dignified, had a rich, resonant voice and an amplitude of gesture; Reynolds painted her as *The Tragic Muse* (1784).

Sidney, Sir Philip (1554–86), English poet, statesman, soldier, and courtier. His heroic prose *romance the *Arcadia* (1590) is an intricately plotted narrative, with poems and pastoral *eclogues in a variety of verse-forms. *Astrophel and Stella* (1591), a series of witty and impassioned *sonnets and songs of unhappy love, is considered one of the finest Elizabethan examples of this genre. In his *Defence of Poesie* (1595) Sidney wrote the most notable work of Elizabethan *literary criticism, upholding the superiority of poetry above philosophy and history as a means of teaching virtue. He was a notable patron of scholars and men of letters, and more than forty works by English and European authors were dedicated to him. A member of parliament for Kent, he died fighting for the Netherlands against Spain, and was mourned in Spenser's elegy 'Astrophel' (1595).

Sienese School, the artists, and particularly the painters, of Siena, who flourished most distinctively in the 14th century, a period when Siena rivalled its neighbour Florence in artistic splendour. From the 12th century until 1555 (when it became part of the Grand Duchy of Tuscany) Siena was a rich independent republic. The most famous of Sienese painters and the founder of the city's tradition in painting was *Duccio, whose decorative beauty of line and colour influenced his contemporaries and successors profoundly. Duccio's grace and charm were continued most memorably by *Simone Martini, a friend of Petrarch, who spread Sienese influence as far as France. The other outstanding Sienese masters of the 14th century were the *Lorenzetti brothers Pietro and Ambrogio, who worked in a mixture of decorative fantasy, brilliant use of colour, and minute observation which was to characterize the *International Gothic of the end of the 14th century, the style in which the Sienese played such an illustrious part. In sculpture the leading figures in Siena's great period (although he was not Sienese by birth) were Giovanni *Pisano, who (working also as architect) masterminded the richly decorated façade of the cathedral, and Jacopo della *Quercia.

Sienkiewicz, Henryk (1846–1916), Polish novelist. In 1883 he began writing the popular trilogy *With Sword and Fire, The Deluge,* and *Pan Wołodyjowski,* set in 17th-century Poland (1883–88). As in later novels, including *Quo Vadis* (1896), which brought him the Nobel Prize for Literature in 1905, he combined carefully researched detail with romantic intrigue, intuitively sacrificing historical accuracy in order to bolster the morale of patriotic readers.

Signac, Paul (1863–1935), French *Neo-Impressionist painter; *Seurat's chief disciple. In his paintings he used mosaic-like patches of pure colour (as opposed to Seurat's pointillist dots), mostly of seascapes. In 1899 he published *D'Eugène Delacroix à néo-impressionisme,* in which he upheld the idea of painting with scientific precision.

Signorelli, Luca (c.1441–1523), Italian painter. His finest works are in Orvieto Cathedral, where he painted a magnificent series of six frescos illustrating the end of the world and the Last Judgement (1499–1504). In these grand and dramatic scenes he displayed a mastery of the nude in a wide variety of poses.

Sikh literature. The principal work is the *Ādi Granth* ('First Book'). This contains some 6,000 hymns, mostly composed by the Sikh leaders or Gurus, from the founder Nanak (1469–1539) down to the fifth Guru Arjan, who compiled the *Ādi Granth* in 1604. Emphasizing the Sikh belief in the absolute oneness of God, the *Ādi Granth* also contains verses by other saint-poets regarded as Nanak's spiritual precursors, from both Hindu *Bhakti and Islamic *Sufi literature. The tenth and last Guru Gobind Singh's works are collected in the *Dasam Granth* ('Book of the Tenth Guru'). After his death, the spiritual authority of the Guru was henceforward vested in the *Ādi Granth* itself, which is the focus of worship in the Sikh temple and central to all Sikh ceremonies. The popular *Janam-sākhīs* ('Birth-testimonies') contain anecdotes and legends about Guru Nanak, while the *Rahitnāmas* ('Books of Conduct') preserve the traditions of the Khalsa, the baptized Sikh brotherhood instituted by Guru Gobind Singh.

silhouette, a term in art to describe an outline image in one, solid, flat colour, giving the appearance of a

Portraits of the first five Sikh Gurus from a 19th-century manuscript of the *Dasam Granth.* Upper left is Sikhism's founder Guru Nanak, author of many hymns in the *Ādi Granth,* and upper right his successor Angad Das, inventor of *Gurmukhī,* the distinctive script used in **Sikh literature** (seen here in the central roundel). Lower left the third Guru Amar Das, who reformed marriage and death ceremonies and forbade suttee, and lower right Ram Das, who founded Amritsar, the Sikhs' holy city. Bottom centre is the fifth Guru, Arjan, who compiled the *Ādi Granth* in 1604. (British Library, London)

shadow cast by a solid figure. The term is applied particularly to profile portraits in black against white (or vice versa), either painted or cut from paper, which were extremely popular from about 1750 to about 1850, when photography virtually killed the art.

silk, the fibre produced for its cocoon by the larva of the moth *bombyx mori*, and fabric made from it. Silk was discovered by the Chinese (see *Chinese decorative arts), who jealously guarded the secret of its manufacture (or sericulture), exporting it along the Silk Road—a caravan route of some 10,000 km. (6,000 miles) to Iran, Rome, and Byzantium. The sophistication of early Chinese silk-weaving has been ascertained from fragments found on bronzes from the Shang period (18th–12th centuries BC). Later Chinese weaving was influenced by the designs of the silk-weaving industry (using imported raw silk) of Sassanian Iran, which were usually repeating motifs of paired heraldic animals or emblems in roundels. In the later Roman empire silk, first introduced in the 1st century BC, was a luxury commodity. The Byzantine government established a monopoly of silk-weaving staffed by hereditary workers, with designs based on Sassanian work. According to legend, in about 500 AD two disguised monks smuggled silkworm eggs out of China, allowing the Byzantines to produce silk themselves. Sericulture in western Anatolia was continued by the Ottoman Turks, whose state manufactories produced kaftans and velvets ornamented with floral and arabesque designs. In Iran silk-weaving blossomed to great heights under the Safavids. Shah Abbas established workshops in Isfahan producing *carpets, cloth, and velvets, with naturalistic designs such as hunting and court scenes based on styles seen in *miniature painting. The Muslim conquerors of Spain established sericulture there by the 9th century, specializing in veil-like fabrics with tapestry borders decorated in Arabic calligraphy and other silks with Sassanian-type motifs. By the 14th century sericulture was established in Italy, with Venice and Florence producing magnificent velvets in crimson and gold. In France, Tours and Lyons were early centres of silk-weaving (by the mid-16th century), but Louis XIV's minister Colbert reorganized the industry in the 17th century, stipulating that new patterns be produced twice yearly to stimulate demand for fashionable items. Huguenots leaving France to escape religious persecution established the major silk-weaving centre in England at Spitalfields, London. (See also *weaving.)

silk-screen printing, a colour *printing process based on stencilling. The 'silk screen' is a fine mesh through which colour can be brushed or squeezed on to paper beneath, and the design is created by masking off parts of the screen, either by means of cut-out shapes or by using a lacquer that is impervious to the paint. The process, which originated in the early 20th century, has been widely used for commercial textile printing, but in the 1930s it was developed as an artists' medium. Andy Warhol has been the most noted exponent.

silverpoint, a method of drawing using a fine silver rod, pointed at one end, on prepared paper. Other metals—copper, gold, lead—may be used, but silver is the most common. It produces an attractive fine grey line that oxidizes to a light brown. The strength of tone can hardly be varied at all and the technique demands

The sumptuous and highly decorated forms of this Spanish ewer, dating from about 1560, are typical of the **silverware** of the period, when there was a great love of virtuosity. The grotesque handle is particularly striking and elaborate, reflecting influence from Italy (Philip II brought many Italian artists and craftsmen to Spain to work on the Escorial, his huge palace near Madrid). (Victoria and Albert Museum, London)

great certainty of purpose and hand. Silverpoint first appeared in medieval Italy and was particularly popular in the 15th century. Dürer and Leonardo da Vinci were perhaps the greatest exponents of the medium.

silverware, articles made of or plated with silver. Like gold, it has been highly prized since ancient times, valued for its beauty, its scarcity, and the ease with which it can be worked. In its pure state silver is harder than gold, but still too soft to be used for metalwork, so it is usually alloyed, generally with copper. Among the earliest discoveries of gold and silver plate is the treasure from the site of Troy c.2000 BC. Between 1000 and 300 BC the Phoenicians produced high quality plate, most of which was decorated by embossing or engraving, and the Romans too valued silver plate highly from the 2nd century BC. The influential Anglo-Saxon school (7th century AD) produced artefacts such as the Ormside Bowl, made of silver and copper gilt (see *gilding), and ornamented with cursive interlacings of a Celtic character. During the Middle Ages in western Europe the Church was the main patron and much metalwork was done in monasteries. During the Renaissance Italian craftsmen predominated, particularly *Cellini, though *Brunelleschi too began his career as a silversmith. Florentine silversmiths provided

a remarkable altar frontal for San Giovanni, Florence. In Spain and Portugal much ecclesiastical silver was produced, advantage being taken of the immense quantity of silver reaching Spain from the New World. A silver-gilt processional cross made in Barcelona in the late 15th century is typical: the upright and arms are modelled with scrolling foliage interspersed with shaped plaques depicting religious scenes. In France the building and equipping of the palace of Versailles from c.1660 stimulated silversmiths to produce suites of solid silver furniture, while the reputation of French craftsmen in the manufacture of domestic silverware spread throughout Europe. Catherine the Great had a dinner service of 842 pieces made in Paris in 1771. In the mid-18th century Britain was responsible for the invention of *Sheffield plate, a substitute for solid silverware. After the industrial revolution, the encroachment of mass-production techniques led to poorly made pieces by many companies. The *Arts and Crafts Movement persuaded some artists to return to hand-crafting in the 20th century, though machine-made silver has been predominant.

Simenon, Georges (1903–89), Belgian-French novelist. He is known for his *detective novels built around the character of the Parisian Inspector Maigret, though he has also written psychological novels of a more literary nature. His characters belong to the drab world of the lower middle classes which is evoked through character and mood rather than visual description. Among the many Maigret titles may be noted *Le Chien jaune* (1936) and *Maigret aux assises* (1960). Simenon's autobiographical novel, *Pedigree* (1948), provides an important key for understanding his work. His total output includes more than 200 novels published under his own name and more than twice as many under 17 pseudonyms.

simile, an explicit comparison between two different things, actions, or feelings, using the words 'as' or 'like': 'I wandered lonely as a cloud' (Wordsworth). A very common *figure of speech in both prose and verse, simile is more tentative and decorative than *metaphor. The 'epic similes' of Homer and other epic poets are sustained comparisons of two complex actions, for instance the charging of an army and the onset of storm-clouds.

Simone Martini (c.1285–1344), Italian painter of the *Sienese School. Probably trained in *Duccio's circle, he developed further the use of outline and colour which characterize Duccio's work. His earliest surviving work *The Virgin in Majesty* (1315) is painted in a sumptuous yet delicate Gothic style. Elegance and grace mark his *Annunciation* (1333), perhaps his finest work. Simone worked in Avignon from 1340 to 1341 and his style greatly influenced French Gothic imitators.

Sinan (c.1489–c.1588), Turkish architect. Sinan is the most illustrious figure in Islamic architecture and the only one whose fame has spread to the West. He was the chief architect of the emperor Suleyman the Magnificent at the time when the Ottoman empire (see *Ottoman art) was at its peak and his output was prodigious—his autobiography credits him with more than 300 buildings. They include mosques, palaces, schools, tombs, caravanserais, hospitals, and fortifications (he began his career as an artillery officer and engineer in the Ottoman army). His best-known buildings are his mosques, which took their inspiration from the design of the Byzantine church of Hagia Sophia in Constantinople and are worthy successors in their vast domed grandeur. Among the finest are the Şehzade Mosque (1548) and the Mosque of Suleyman the Magnificent in Constantinople (1550–7) and the Sultan Selim Mosque at Edirne (1569–75), the building that Sinan himself considered his master-piece. In accordance with the requirements of Muslim worship for a large open prayer space, Sinan aimed to centralize the interiors of his mosques beneath a unifying dome. On the exteriors cascades of smaller domes descend around the main central dome to create a graceful yet sturdy silhouette.

Sinatra, Frank *crooning.

Sinclair, Upton (Beall) (1878–1968), US novelist. A prolific writer, Sinclair first came to public attention with *The Jungle* (1906), which exposed the corruption of the meat-packing industry in the Chicago stockyards. He tended to centre each of his subsequent novels, up to World War II, on a different area of American society, achieving the best results in works like *King Coal* (1917). In the 1940s he wrote a series of ten novels with Lanny Budd as hero, covering US and European history from 1913 to 1945. He became a socialist as a young man, and in 1906–7 was involved in the experimental commune, the Helicon Home Colony, in New Jersey. An influential figure in the Democratic Party, a large body of pamphlets and studies testifies to his political beliefs.

sinfonia *overture, *symphony.

Singer, Isaac Bashevis (1904–), US short-story writer and novelist writing in Yiddish. Born in Poland, the son of a rabbi, he followed his elder brother, the Yiddish novelist **Israel Joshua Singer** (1893–1944) to the USA in 1935. He became a journalist writing in Yiddish for the New York *Jewish Daily Forward*, which also published his fiction. His work began to appear in English translations from 1950 with *The Family Moskat*, which realistically presents the degeneration of a Jewish family in Warsaw from the turn of the 20th century to World War II. His stories are generally even more esteemed than his longer fiction, portraying more pungently the lives of curious characters in their ghetto settings in situations marked by fantasy and humour. He was awarded the Nobel Prize for Literature in 1978.

Singspiel *operetta.

Sisley, Alfred (1839–99), British *Impressionist painter working in Paris. Like Monet, Sisley devoted himself almost exclusively to landscape, but his work was much less varied. Apart from a few visits to England he rarely travelled, and most of his pictures are of scenes in and around Paris. The best are among the most lyrical and gently harmonious works of Impressionism, delicate in touch and with a beautiful feeling for tone. Sisley spent the last years of his life in poverty.

sistrum, a musical instrument, a *rattle either with bars sliding in a frame or with discs or plates sliding on bars. Sistra were widely used in ancient Egypt, Mesopotamia, and Rome, and were especially associated with the Isis cult. They survive today in the Ethiopian Coptic Church.

Sistrum is also a class name for any rattle with sliding elements.

sitar, one of the most important musical instruments of the classical music of the northern Indian sub-continent, a long-necked lute with four main plucked strings and three plucked as a rhythmic *drone; twelve sympathetic strings are plucked occasionally. The strings can be pulled sideways along the curved metal frets, varying the pitch up to a fifth. The strings vibrate on a flat area of the bridge, which enriches the sound. A bass sitar, the *sūrbahār*, is also often used. The sitar was created as a conflation of the Persian *setār* and the Indian *vīṇā*.

Sitwell, Dame Edith (Louisa) (1887–1964), **Sir (Francis) Osbert (Sacheverell)** (1892–1969), and **Sir Sacheverell** (1897–1988), English writers and poets. Edith's reputation as an eccentric stylist was confirmed by her public performance, in 1925, of *Façade*, a poetic entertainment with music by William *Walton and her own verses in syncopated rhythms. She wrote a novel, and some poems of emotional depth about the London blitz and the atom bomb (*Street Songs*, 1942; and *The Shadow of Cain*, 1947). Her works reveal a regret at the passing of the aristocratic age and its splendours, and in 1955 she was received into the Roman Catholic Church. Her brother, Osbert, produced many volumes of poetry (some sharply satirical in tone), travel works, and prose memoirs which convey with nostalgia the portrait of a vanished age, and give a vivid account of their eccentric father. The youngest brother, Sacheverell, is best known for his books on art, architecture, and travel. He also wrote volumes of verse, mainly in traditional metres (including *An Indian Summer*, 1982). All three encouraged the *Modernist writers (notably Pound and T. S. Eliot). Edith, as editor of the magazine *Wheels*, which introduced the poems of Wilfred *Owen, became the outspoken enemy of the *Georgian poets, whom she regarded as philistine.

Six, Les, name applied by the French critic Henri Collet in 1920 to a group of young French (and Swiss) composers who, under the influence of *Satie and *Cocteau, had rejected the German *Romanticism of *Wagner as well as the *Impressionism of *Debussy. They were Georges Auric (1899–1983), Louis Durey (1888–1979), *Honegger, *Milhaud, *Poulenc, and Germaine Taille-ferre (1892–1983). Although they soon went their separate ways, their music shared elements such as syncopated rhythms and dry sonorites.

skaldic poetry, poems composed in Scandinavia (mainly Norway and Iceland) between the 9th and 13th centuries (*skald*, Old Norse, 'poet'). One kind comprises a long poem praising the virtues of an individual, such as his prowess in battle, illustrated by reference to specific events. Another kind consists of a single *stanza (occasionally two or three) expressing a fact, opinion, or feeling in the context of specific circumstances. Verse-forms, diction, and imagery are usually complex, and were described by *Snorri Sturluson in the *Prose Edda* (*c*.1220).

Skelton, John (*c*.1460–1529), English poet and satirist, court poet to Henry VIII. His poems include the court *satire the *Bowge of courte* (*c*.1498); *Phyllyp Sparowe*, os-

tensibly a lament for a young lady's sparrow, but also a lampoon on the liturgical office of the dead; *Speke Parrot* and *Collyn Clout* (*c*.1521), both satires containing attacks on Cardinal Wolsey and on the dangers of the new learning of the humanists; *The Tunnyng of Elynour Rummyng*, a vigorous description of tavern low-life; and *Magnyfycence*, a political satire and the first secular *morality play in English. His favourite metre, with short lines based on natural speech rhythms with two or three stresses and quick, recurring rhymes, is known as 'skeltonic'.

Skidmore, Owings & Merrill (SOM), US architectural firm established in Chicago in 1936 by Louis Skidmore (1897–1962) and Nathaniel Owings (1903–84); John Merrill (1896–1975) joined the partnership in 1939. It has since become one of the largest and most distin-

This painting by Jacques-Emile Blanche shows Les **Six** (from left to right): Milhaud, Auric, Durey (conducting), Tailleferre, Poulenc, and Honegger (seated). Jean Cocteau, the noted French writer, championed their music and its attempt to create a style free from German influence. He wrote of the group that they were 'six friends whose pleasure it was to meet and work together. It was never a *school* but a *movement*. That is why I am proud of always having been its spokesman.'

guished architectural firms in the world with branches in various American cities. The major works of SOM include some of the most famous American skyscrapers since the 1950s, including Lever House in New York (1952), an elegant slab in the tradition of *Mies van der Rohe, and the Sears Tower in Chicago (1974), the tallest building in the world. The firm has done much work in Islamic countries. Most of its work has been in the sleek tradition of the *Modern Movement.

Skryabin, Alexander *Scriabin, Aleksandr.

Škvorecký, Josef (1924–), Czech-Canadian novelist. An important writer in post-war Czechoslovakia, he settled in Toronto after the 1968 Warsaw Pact invasion of his country. His novels, written in an ironic style combining the tragic and the comic, are about writers and musicians who celebrate freedom through art. In English translation they include *Miss Silver's Past* (1975), *The Bass Saxophone* (1977), *The Swell Season* (1982), *The Engineer of Human Souls* (1983), and *Dvořak in Love* (1986).

slapstick, knockabout *comedy based on falls (through the traditional banana skin or other means), the impact of messy food on faces, and other physical mishaps. The word derives from the bat, or lath, used by Harlequin in the *harlequinade to beat his adversaries' backsides. Slapstick was used by the *clown and in the *music-hall, and was also popular in films. It still survives, notably in *pantomime and in occasional films.

slip, term in pottery manufacture for a clay paste diluted to the consistency of cream. It may be the product of the final washing of the clay which is undertaken to remove impurities and render it suitable for use. The shaped vessel after drying may be dipped in a bath of slip and then burnished to render it watertight as, for example, in African domestic pottery. Slip is used for decoration of pottery in three main techniques: the design may be painted on the body of the vessel in slip of a different colour or the slip may be 'trailed' on to the body from a nozzle as in black-glazed 'Cistercian' ware, which is decorated in white slip patterns; the whole or part of the body may be covered with slip and the design then drawn with a pointed tool in the liquid slip so that the different colour of the body shows through; or, as with glaze, the design may be painted on the body in liquid wax which when dried and hardened 'resists' or repels the application of the slip, thus leaving 'negative' areas of design. In the 19th century clay for earthenware was united with a creamy mixture of powdered flint and the mixture was technically known as 'slip'.

slit drum, a musical instrument made from a wooden log hollowed through the slit or, when the slit is very narrow as on the Aztec *teponaztli,* from the back, which is then closed with a wooden plate. One lip is often thicker than the other to produce different pitches for *talking drums. Sizes vary from those held in one hand to those round the dancing grounds on Malekula, Melanesia more than 2 metres (6 ft.) high. Some are used for musical purposes and others for signalling. Modern composers have included them in orchestras, often called log drums.

Slovak literature, the literature of the Slovak-speaking part of Czechoslovakia. This is based on an oral tradition of *ballad, myth, and folk-tale. A Slovak nationalist revival against the Magyarization of the country gained momentum in the 19th century, and modern literary Slovak was eventually codified in 1840 by Ludovít Štúr (1815–56). It found its voice in the romantic poetry of Janko Král (1822–76), the *epic ballads of Ján Botto (1829–81), and the *lyric verse of Andrej Sládkovič (1820–72), who was also instrumental in the establishment of a Slovak national theatre (1841). Thereafter Slovak literature developed closely along the lines of *Czech literature, embracing *realism. In the 20th century Slovak verse found expression in the lyric poetry of Jan Smrek (1898–) and the patriotic verse of Andrej Zarnov (1903–), who inspired a whole generation of Slovak writers. Since the Communist take-over of the country *Socialist Realism has prevailed, although alternative experimental literary genres are expressed, especially in the theatre and on film.

Slowacki, Juliusz (1809–49), Polish poet. His work progresses from romantic tales, *The Father of the Plague-Stricken* (1839), to a baroque style, *Mazepa* (1840) and a final mystical phase, *Salomea's Silver Dream* (1844), which was to influence deeply the Polish *Symbolist movement. He analysed the national struggle in the drama *Kordian* (1834); exile in the prose poem *Anhelli* (1838); and conflicting elements in the Polish character in the tragedy *Lilla Weneda* (1840). *King-Spirit* (1847) is a historical vision of reincarnated forces in man which shape history.

Smart, Christopher (1722–71), British poet. A precursor of *Blake and *Clare, he is remembered for *A Song to David* (1763), a vivid poem celebrating David as author of the psalms, the creation of man, and the incarnation of Christ. His work was little regarded until the 1920s, but his reputation as an original poet was confirmed by the publication of *Jubilate Agno* (1939), which with an at times child-like penetration, celebrates the creation in a verse-form based on Hebrew poetry. He suffered from religious mania and during 1759–63 was in a home for the insane; he died in a debtors' prison.

Smetana, Bedřich (1824–84), Czech composer. Born in Bohemia, he was decisively influential at a formative stage of his nation's self-awareness, and established virtually single-handed a style of national opera. Success came with the nationalist operas *The Brandenburgers in Bohemia* and *The Bartered Bride*, both first performed in 1866. Subsequent operas, such as *Dalibor* (1867) and *Libuše* (1872), and the cycle of *symphonic poems *Má vlast* ('My Fatherland') (1874–9), continued to explore nationalist, folkloristic themes. His last years were clouded by deafness and finally insanity.

Smirke, Sir Robert (1780–1867), British architect. He began his career designing country houses in a medieval style, but turned mainly to public buildings and became England's most dedicated and distinguished exponent of the *Greek Revival. His masterpiece is the British Museum in London (1823–46)—huge, majestic, and austere. (The famous domed reading-room in the centre of the museum was built to the design of his brother—**Sydney Smirke** (1798–1877)—in 1854–7.) Smirke was renowned for his reliability and his soundness in constructional matters (he pioneered the use of concrete foundations and of cast-iron beams).

Smith, Bessie *blues.

Smith, David (1906–65), US sculptor. He acquired metalworking skills during his time in an automobile factory in 1925, and when he turned to sculpture in the 1930s he used scrap machinery and similar materials with considerable originality. During the 1940s and 1950s his work was open and linear, like three-dimensional metal calligraphy, but from the end of the 1950s till his death he concentrated on the more structural and massive work for which he is best known. Characteristically consisting of boxes and cylinders of polished metal, usually built into vertical constructions, these initiated a new era in American sculpture.

Smith, Sir Matthew (1879–1959), British painter. He studied briefly with *Matisse, spent much of his time in France and identified strongly with French art. His delicate health and nervous disposition are belied by his work, which uses colour in a bold, unnaturalistic manner echoing the *Fauves. His lush brushwork, too, has great vigour, and, as well as landscapes and still lifes, he was one of the few English painters to excel in painting the nude, creating images of great sensuousness.

Smith, Stevie (Florence Margaret Smith) (1902–71), British poet and novelist. She was brought up in the suburbs of London, where she lived most of her life with an aunt, and which inspired some of her poetry. She wrote *Novel on Yellow Paper* (1936), in a *stream-of-consciousness style but is best remembered for her witty, caustic, and enigmatic verse illustrated by her own drawings, including those contained in *A Good Time was Had By All* (1937), *Not Waving But Drowning* (1957), and the posthumously published *The Collected Poems of Stevie Smith* (1975).

Smollett, Tobias (George) (1721–71), British comic novelist and dramatist. His first novel, a *picaresque story, *The Adventures of Roderick Random* (1748), drew on his experiences as a naval surgeon's mate. His only non-fiction work, *Travels through France and Italy* (1766), reflects his fascination with cruelty and squalor. *The Adventures of Peregrine Pickle* (1751) is about a young man seeking a fortune in a ruthless world, but the hero of *Ferdinand Count Fathom* (1753) is a confidence-trickster, and his novel makes early use of *Gothic horror. The epistolary novel *The Expedition of Humphry Clinker* (1771) is a more subtle work, with more word-play, less caricature, and a great deal of realistic detail.

Smythson, Robert (c.1535–1614), the outstanding English architect of the Elizabethan period. All his buildings are country houses, among them such masterpieces as Wollaton Hall, Nottinghamshire (1580–8), and Hardwick Hall, Derbyshire (1591–7). His style was virile and self-confident, with bold massing and often a castle-like emphasis on height and rugged silhouette. His son **John Smythson** (d. 1634) was also an architect, his major work being Bolsover Castle (c.1612–34) in Derbyshire. This splendid, romantic building is more consciously medieval in feeling than Robert Smythson's work and initiates the tradition of the 'sham castle'.

Snorri Sturluson (1179–1241), Icelandic poet, historian, and statesman. His *Prose Edda* (c.1220) is a handbook on *skaldic poetry as well as a treasure-house of ancient

David **Smith**'s *Hudson River Landscape* (1951) is an example of the 'drawings-in-space' work of his earlier career. In 1940 Smith had moved to upstate New York, and this sculpture alludes to the sweeping vistas and craggy forests of the Upper Hudson valley.

Icelandic saga and mythology. He probably wrote *Egil's Saga* (c.1230), the first novel-length saga, describing the heroic exploits of the Icelandic poet Egil Skallagrimsson (c.910–990). Snorri's *St Olaf's Saga* was modified and incorporated into his *Heimskringla* (c.1230), a history of the kings of Norway from prehistoric times up to 1177. Snorri became the most powerful chieftain in Iceland, but his political scheming led to his assassination.

Snow, C(harles) P(ercy) (1905–80), British novelist. He is best known for his sequence of eleven novels, *Strangers and Brothers* (1940–70), which includes *The Corridors of Power* (1963) and other fictional studies of life in the Civil Service and in the scientific community.

Soane, Sir John (1753–1837), British architect, the creator of a highly individual, quirky brand of *Neo-classicism. His reputation was made in 1788, when he won the public competition for a new Bank of England (1788–1833), but the building has been substantially altered. Soane had a long list of work to his credit, mainly public buildings, country houses, and houses in London. His style is characterized by unusual spatial arrangements, particularly in the use of shallow domes, and a paring away of the decorative vocabulary of classical architecture to an almost diagrammatic simplicity. At his death he left to the nation the marvellously eccentric house he built for himself in Lincoln's Inn Fields, London (1812–13), to form Sir John Soane's Museum. (See also *Greek Revival.)

social dance, a dance-form with roots in *traditional and *community dances which became increasingly differentiated from court dances during the later medieval and early Renaissance period. In the early 20th century ballroom dances proliferated, with *jazz influences from North America and imports from Latin America, such as the *tango, *samba, *cueca, and *rumba. In the 1920s 'animal dances', such as the turkey trot, the bunny hug, and the foxtrot were popular: the latter remains as a classic ballroom dance alongside the quickstep and, from

earlier times, the *waltz. The lindy hop, jitterbug, and jive were all highly athletic couple dances from the *big band era of the 1930s and 1940s. The 1950s and 1960s *rock and roll impact on teenage culture and the growth of discos and clubs generated an alternative social scene. The 1970s influences were Afro-Caribbean music and heavy rock. Distinct dance styles, 'body popping', 'robotics', and 'break dancing' emerged. In turn these reappear as source material in *modern and *postmodern dances.

Social Realism, a term applied to 19th- and 20th-century art that makes overt social or political comment, generally through scenes taken from seamy or depressing aspects of contemporary life. It is to be distinguished from **Socialist Realism**, the name given to the officially approved style in the Soviet Union and some other Socialist countries which, far from implying a critical approach to social issues, involves toeing the Communist Party line in a traditional academic style.

soliloquy, a dramatic speech uttered by one character speaking aloud while alone on the stage, revealing inner thoughts and feelings to the audience. Soliloquies often appear in plays in the age of Shakespeare. A poem supposedly uttered by a solitary speaker, like Browning's 'Soliloquy of the Spanish Cloister' (1842), may also be called a soliloquy. Soliloquy is a form of *monologue, but a monologue is not a soliloquy if (as in the *dramatic monologue) the speaker is not alone.

solmization, a system of *notation whereby the musical notes of the diatonic *scale are designated by syllables and manual signs. The system was introduced by Guido d'Arezzo in the 11th century, but is more familiar as the 'Tonic sol-fa' system, established by John Curwen in 1853. The tonic sol-fa syllables are: doh, ray, me, fah, soh, la, ti, doh.

Solzhenitsyn, Aleksandr (Isayevich) (1918–), Russian novelist and historian. He served in World War II, and was imprisoned from 1945 to 1953 for criticizing Stalin. He became famous with his short novel about a forced-labour camp in the Stalin era, *One Day in the Life of Ivan Denisovich* (1962), published in the literary periodical *Novy Mir*. Two autobiographical novels, *The First Circle* and *Cancer Ward*, completed after Khrushchev's fall from power (1964), were published abroad in 1968. A three-volume history of the Soviet forced-labour system, *The Gulag Archipelago*, appeared abroad (1973–8) and the first part of a monumental account of Russia between 1914 and the Revolution, now called *The Red Wheel*, in 1974. Solzhenitsyn was awarded the Nobel Prize for Literature in 1970. After being charged with treason and exiled from the Soviet Union in 1974 he moved to the USA. In the atmosphere of *glasnost* official attitudes to his work softened and his *Gulag Archipelago* began to be published in serial form in a journal from 1989.

sonata, a musical work in several movements for piano, or for piano and one other instrument. The term was first used in the 16th century to describe any music played by instruments, as opposed to the *cantata, which was sung. During the 17th century instrumental works divided into five or more contrasting sections were known as sonatas, but by the early 18th century the sonata had become a work in several separate movements, similar to the suite. Such sonatas came in two varieties: the *sonata da chiesa* (Italian, 'church sonata'), some of whose movements were of a more serious nature, and the *sonata da camera* (Italian, 'chamber sonata'), whose movements followed dance patterns. These types merged and their movements acquired the structural sophistications of the 18th century to become the three- and four-movement sonatas of Haydn, Mozart, and Beethoven. The development of the sonata thus follows that of the *symphony.

sonata form, the musical structure usually employed for first movements of *sonatas, *symphonies, and allied works, and frequently found as the basis for other movements. It evolved during the early part of the 18th century from the *binary form and achieved its classic shape in the works of Haydn, Mozart, and their contemporaries. The basis of the form is *key relationship—the acceptance that contrasted key areas, identified by separate themes, may be set in conflict and ultimately reconciled by a restatement of all the thematic material in the main key of the overall structure. The form proceeds in three stages. First is the exposition, in which two main themes are set out in closely related but contradictory keys—a first subject (or subjects) in the tonic (main) key of the movement, followed by a second subject (or subjects) in a related key (the dominant in major keys and the relative major in minor keys). The two 'subjects' are usually distinguishable from each other, though on rare occasions they can be identical. What matters is the contrast of key area. A frequent practice is to make the second subject more lyrical than the first, which is likely to be vigorous and emphatic. This section is usually repeated, and then flows directly into the second, development section, in which the material is worked in free fantasia, modulating through various keys, but finally leading to a third recapitulation section, in which the original thematic material is restated entirely in the main (tonic) key of the movement. A *coda may provide a more decisive ending. Sonata form reigned supreme until the principles of *tonality were challenged at the end of the 19th century.

Sondheim, Stephen (1930–), US composer and lyricist. He made his first reputation as the lyricist of Bernstein's *West Side Story* (1957), but proved himself an equally talented composer in *A Funny Thing Happened on the Way to the Forum* (1962), *Anyone can Whistle* (1964), *Company* (1970), *Follies* (1971), *A Little Night Music* (1973), *Pacific Overtures* (1976), and *Sweeney Todd, the Demon Barber of Fleet Street* (1979). His achievement has been to raise the musical almost to the status of opera by means of a fully integrated score and stories of serious purpose and psychological insight.

sonnet, a *lyric poem of fourteen *iambic *pentameter lines (or lines of twelve syllables in French, eleven in Italian). Originating in Italy, the sonnet was established by Petrarch as a major form of love poetry, and adopted in France and England in the late 16th century. Sidney, Spenser, and Shakespeare wrote outstanding sequences of sonnets, while Donne and Milton extended its subject-matter to religion and politics. Keats, Wordsworth, and Baudelaire revived the form in the 19th century. The rhyme-schemes of the sonnet follow two basic patterns: the Italian or Petrarchan sonnet comprises an 'octave' of

two *quatrains, rhymed ABBAABBA, and a 'sestet' usually rhymed CDECDE or CDCDCD, with a 'turn' in the poem's argument between octave and sestet (although Milton and some other poets dispensed with this). The English or Shakespearian sonnet comprises three quatrains and a *couplet, rhymed ABABCDCDEEEFGG, delaying the 'turn' until the final couplet; a variant of this, the Spenserian sonnet, rhymes ABABBCBCCDCDEE.

Sophocles (c.496–406 BC), Greek writer of *tragedies. Seven out of 123 plays survive, but only two can be dated securely. His introduction of a third actor allowed greater complexity of plot and fuller depiction of character in *Greek theatre. Less bombastic than *Aeschylus and more formal than *Euripides, he was skilful in portraying character and evoking pathos. Aristotle considered the plot of *Oedipus Tyrannus* (c.429), based on the Oedipus legend, in which the hero gradually finds out his own guilt, a perfect example of tragedy. Sophocles' heroes are characteristically larger than life and deeply obstinate. The plays are wonderfully varied, and even the attitude to the gods is hard to generalize. Sophocles portrays human characters caught in cruel dilemmas and often bound by previous oracles, but unlike Euripides he rarely makes any protest against the divine order of the world which might seem to be causing such sufferings.

Soufflot, Jacques-Germain (1713–80), French architect, a major pioneer of *Neoclassicism. His architectural training was mainly in Rome (1731–8), where he acquired a thorough knowledge of the antique (he visited Italy again in 1749–51). Soufflot's major work is the huge domed church of Ste Geneviéve in Paris (1757–90), which during the Revolution of 1789 and its aftermath was secularized as a monumental burial place for national heroes and renamed the Panthéon. It brought a new classical purity to French architecture, although there is a feeling of typically Parisian elegance in the slim proportions. Soufflot's design has been considerably altered, notably in that the windows have been filled in, creating a starker feeling than he intended.

soul music, a development of *rhythm and blues, dating from the late 1960s. Primarily the music of black American performers (white performers' versions being known as blue-eyed soul), it combines the driving rhythms of *rock music with the emotional fervour of gospel songs and *blues. The style is characterized by an impassioned improvisatory delivery by featured vocalists (for example, Aretha Franklin, Ray Charles, Otis Redding, James Brown), or saxophonists (for example, Grover Washington Jr.), and vocal devices such as sudden shouts, sobs, and cries.

Sousa, John Philip　*march.

sousaphone　*tuba.

South American art, the art and architecture of the South American continent from the early 16th century, when it was colonized chiefly by Spain and Portugal. In the 16th, 17th, and 18th centuries South American art was overwhelmingly influenced by the two European mother countries and was mainly in the service of the Roman Catholic religion. Much art was exported from Spain and Portugal, including even whole buildings transported in numbered sections. By the time South American nations began winning their independence in the early 19th century the flamboyant *Baroque style had generally given way to a more sober *Neoclassicism. Since this time, South America's most original contribution in the arts has been in architecture and town planning, above all in the building of the new Brazilian capital, Brasilia, masterminded by the architect Oscar *Niemeyer. (See also *South American Indian art.)

South American Indian art, the art and architecture of the native inhabitants of South America, particularly in the period before the Spanish conquest in the 16th century. In artistic terms the vast area of South America divides into two fairly clear zones: firstly, the central Andean and adjacent Pacific coastal area, which is now mainly within the modern state of Peru; secondly, all the other areas. These include the northern Andean civilizations of Colombia, such as the Tairona, Quimbaya, and Muisca, all known for the remarkable metalworking techniques, particularly in goldwork, and the vast tropical forest areas, most notably the Amazon. In this latter area little remains of earlier art-forms, but contemporary Indian societies still exhibit a rich variety of creativity in their vast wood-framed dwellings (which embody in their design the symbolic order of their respective communities), magnificent featherwork, and a rich abstract decorative art. The pre-eminence of the central Andean cultures has been emphasized by the relatively cool and dry climate of the region, which, unlike other areas, has been favourable to the preservation of more fragile works of art. Andean civilization is associated above all with the Incas, who, by the 15th century, had established a far-flung empire linked by a road system that was superior even to that of the Romans. Before this time there was no cultural unity in the Andes; rather, different styles and traditions developed in various river valleys and

South American Indian art is distinguished for its metalwork, particularly in gold. This Chimu ceremonial water pot is typical of 12th–13th-century Peruvian work. Three figures representing deities surmount the arch. (Private collection)

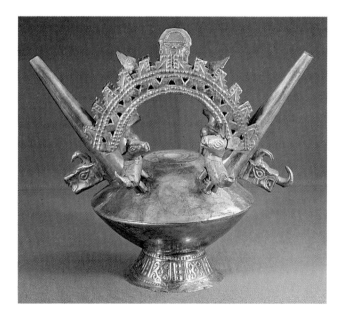

plateaux. There was often influence between them, but this was made more difficult by the great natural barrier of the mountains. There were settled communities before 2000 BC, but the earliest distinct Andean culture, called Chavín, flourished from about 900 BC to about 200 BC. It is named after the great ruin of Chavín de Huántar in the north-eastern highlands of Peru, which includes a large temple complex built with well-cut stone blocks and decorated with relief carvings. The Chavín people also produced pottery, goldwork, and textiles, all of which were to be developed to extremely high levels of artistry in the Andes. Weaving, indeed, is a field in which Peru has a tradition that is unexcelled anywhere in the world; llama wool and cotton were the main materials. Probably the most remarkable textiles were those made in the Paracas culture, named after the Paracas Peninsula, about 161 km (100 miles) south of Lima. This culture, which began at about the same time as the Chavín culture and lasted until about AD 400, is divided into two main phases: Paracas Cavernas, so-called because the dead were buried in caverns; and the later Paracas Necropolis, when the dead were buried in cemeteries ('necropolis', Greek 'city of the dead', or cemetery). In the Paracas Necropolis culture corpses were wrapped in sumptuous burial cloths, many of which have survived in good condition in the dry soil. The range and brilliance of the colours are remarkable, and the stylized human, animal, and mythological creatures have immense vigour. Of the other Andean cultures that flourished before the Incas the best known are the Mochica and the Chimú. The Mochica culture, which flourished from about 200 BC to about AD 600, is named after the great archaeological site at Moche on the coast of northern Peru. This includes the remains of the 'Pyramid of the Sun' (the name is modern and its exact purpose is uncertain), a vast structure of sun-dried mud bricks; although badly eroded, it is the largest ancient building in South America. The warlike Mochica people also built fortifications and carried out hugely ambitious irrigation schemes. Their genius was expressed most forcefully in pottery, however, for their jugs in the form of realistic portraits of heads mark the high point of Pre-Columbian ceramics. The Mochica culture was once known as Early Chimú, but there seems to have been a long interlude between the decline of the Mochica and the rise of the Chimú in about 1200. Until it was absorbed in the Inca empire in about 1470, the Chimú culture was the dominant force in northern Peru. The capital was at Chan Chan, the ruins of which are near the Pacific coast about 483 km (300 miles) north of Lima; the city, built of mud bricks, had a well-planned layout, with a sophisticated irrigation system, and is estimated to have had a population of 200,000 or more. Apart from civic design, the Chimú excelled particularly at metalwork, notably in gold and silver. The Incas have much in common with the Aztecs of Mexico: they emerged at about the same time, quickly established a mighty empire, and then totally succumbed to the Spanish *conquistadores*. Much more is known about the Incas than about any of the earlier cultures of South America, for although they had no system of writing (the Maya were the only Pre-Columbian people who had), a great deal of their oral tradition was recorded by contemporary Spanish chroniclers. 'Inca' means 'king' or 'prince', and the Incas saw their history in terms of the succession of rulers from the foundation of a dynasty in about 1200. Myth and royal propaganda became mixed with fact in this tradition, however, and little is known for sure about the origins of the Incas. Their great period lasted only about a century, from *c.*1438, when Pachacutec (or Pachacuti) became ruler, until 1532, when Francisco Pizarro landed and assumed power virtually unopposed. Pachacutec and his son Tupac (or Topa) have been compared to Philip of Macedon and his son Alexander the Great as conquerors, for under them the Incas established the greatest empire of ancient America; at its peak it stretched more than 4,025 km (2,500 miles) north to south, from the present-day border of Colombia and Ecuador to central Chile. The state was highly regimented, and the Incas were among the greatest builders and engineers in history, their achievements being all the more remarkable for having been achieved without the knowledge of the wheel. In major buildings they used immense (sometimes irregularly shaped) blocks of stone, cut with superb precision and fitted together without mortar. Many of their great walls are still visible in the city of Cuzco (formerly the Inca capital), where they have often been used as the foundations for later buildings; in the nearby fortress of Sacsahuamán some of the stone blocks are estimated to weigh over 100 tons. The most famous Inca site, however, is Machu Picchu, set in remote mountains about 80 km (50 miles) north-west of Cuzco—the site, which was unknown to the Spaniards, was not re-discovered until 1911. Its precipitous setting makes it perhaps the most breathtaking archaeological site in the world. Apart from stonemasonry, the Incas also excelled at *weaving, which continues to hold pride of place among the traditional crafts of the Indians of Peru, who still make up about half the population of the country.

South American Indian literature, South American literature before the Spanish conquest in the 16th century. Historically a clear division separates the native literature of South America that stems from the Andean highlands and the former Inca empire, Tahuantinsuyu, from that which belongs to the great forest lowlands of the Orinoco, Amazon, and Paraná. A comprehensive account of Tahuantinsuyu is given in Guaman Poma's *New Chronicle and Good Government* (*c.*1613), which claims to be transcribed in part from Inca records. These were kept in a distinctive medium of literacy, the knotted cord known as the *quipu* in Quechua, the language of the Inca. Quechua is the language of what must once have been a whole cycle of Inca kingship plays, as well as adaptations of such European motifs as the Faust legend. Another, less orthodox, view of Tahuantinsuyu, which combines politics with evolutionary history in the style of the Central American manuscript, *Popol vuh*, occurs in the 16th-century *Huarochiri* narrative. From the lowlands, there have slowly come to light over the centuries cosmogonical narratives, among them the *Ayvu rapyta* or *Origin of Human Speech*, of the Tupi-Guaraní, the language group which once extended from the Amazon to Paraguay (where Guaraní continues to exist as a literary language); the Desana narratives of the north-west Amazon; and the Carib creation cycle published in the 1970s under the title *Watunna*.

South-East Asian dance. There is a tremendously strong and varied dance tradition in South-East Asia reaching back over 1,000 years. Performance arts are usually found in combination in dance-dramas, masked

plays, and *puppet shows, often using plots from the *Hindu epics. Folk dances in the region are exceptionally widespread and numerous, and in most areas there is a strong court dance tradition. Major influences on South-East Asian dance have come from India and China. *Indian dance has provided flexed, open leg positions, sliding side-to-side head movements, and an extensive vocabulary of hand and finger gestures. Chinese influence is most apparent in Vietnam, where the *hat boi* borrows heavily from Chinese opera. Slow tempos, controlled movements, and extensive use of hand and arm gestures characterize much South-East Asian dance. Hand gestures, copied originally from the Indian *mudras, have been altered greatly, and the bent back finger positions of Thailand and neighbouring countries are unique to the area. Dances may be abstract, as in the Javanese *bedaja* court dances, or part of spectacular dance-dramas, such as those of Indonesia and Thailand. (See also *South-East Asian music.)

South-East Asian music, the music of a vast and diverse region comprising the Philippines, Borneo, Indonesia, and the mainland countries of Burma, Thailand, Kampuchea, Laos, Vietnam, and Malaysia. The mainland countries have been much influenced by Chinese culture and Buddhism, while other influences have been felt in the islands, such as Islam and Christianity in the Philippines. Although the jungle and mountainous terrain has tended to isolate nations and smaller areas, there are a number of characteristics common to the music of this region as a whole. These are: gapped *scales (i.e., ones using intervals greater than a whole tone); extended compositions with repeated sections; 'heterophony', where variations of the basic tune are played by different instruments simultaneously; 'rhythmic stratificiation', in which the different instruments in an ensemble have different levels of activity, from busy xylophones to infrequent punctuations of large gongs; and melodic percussion instruments, for example *xylophones, tuned *drum chimes, and *gongs, organized into ensembles. Orchestras or gong-chime ensembles consisting of gongs (often arranged into sets, with cases and frames brilliantly painted and intricately carved), one or more drums, xylophones, metallophones (percussion instruments containing tuned metal bars struck with mallets), flutes, oboes, and string instruments, exist in various combinations and sizes (see *Indonesian music). In Thailand the principal gong-chime ensemble is the *pī phāt*, a large and consistently loud ensemble including the *pī (a shawm), which gives the ensemble its name. Quieter groups include the *mahōrī* and *khrŭang saī*, which use fiddles, zithers, and flutes. The *pin peat* is the Kampuchean orchestra similar to *pī phāt*, used in religious ceremonies and to accompany shadow plays and dance-dramas. The smaller *phleng khmer* ensemble plays for traditional folk occasions. The *kulintang*, a gong-chime of seven to twelve gongs, gives its name to the gong-chime orchestra of the southern Philippines and northern Borneo, while in the northern Philippines ensembles of flat gongs, *gangsa*, are common. The most characteristic Burmese orchestra is the *hsaing-waing*, the main instrument of which, of the same name, is a chime of twenty-one tuned drums, which has a range of more than three octaves and plays melodies. Gong-chime orchestras are not characteristic of Vietnam, which instead has orchestras of string and wind instruments, influenced by the Chinese.

South-East Asian musical instruments. Two important solo instruments of the region are the *khāēn*, a popular *mouth-organ consisting of up to eighteen bamboo pipes, each with a metal reed, capable of playing chords, *drones, and melodies simultaneously, and the Burmese *saùng-gauk*, a fourteen-string arched lute employing complicated modes and tunings and intricate playing techniques, used to accompany songs (*kyò*). Throughout South-East Asia music accompanies all the theatrical arts, such as mask plays, puppet-shows, and operas. Of ancient origin, many genres were intended to placate the spirits of nature; later, dramatic texts from foreign sources, such as Hindu epics, were also used. The music consists of singing and instrumental ensembles of varying sizes. Examples are the *zat-kyī*, Burmese court dance-dramas accompanied by the *hsaing-waing* ensemble; the traditional Laotian *mawlum* genre, combining tales from the Hindu epic *Rāmāyaṇa* with Laotian folk tales and performed by a vocalist and *khāēn* player; and the classical Thai dance-dramas dating from the 15th century, *lakhǫn nai* (for women) and *Khon* (masked mime for men), both accompanied by the *pī phāt*.

Southey, Robert (1774–1843), British poet and biographer. He is remembered as one of the three 'Lake Poets' of the *Romantic movement, although his poetry has little in common with that of *Wordsworth and *Coleridge, who was his brother-in-law. He wrote several long narrative poems (such as the epic, *Thalaba*, 1801, in irregular verse; *Madoc*, 1805; *Roderick*, 1814), but is chiefly known for his comic-grotesque verse and ballads. As *Poet Laureate from 1813, he was mocked for abandoning the republicanism of his youth. His prose style is both easy to read and clear, a quality best seen in his *Life of Nelson* (1813). His *A Vision of Judgement* (1821) disparages Byron, who had lampooned him in *Don Juan* (1819).

Soutine, Chaïm (1894–1943), Lithuanian-born painter who settled in France in 1913 and became one of the leading *Expressionists in Paris. His style is characterized by thick, convulsive brushwork, through which he could express tenderness as well as turbulent psychological states. Portraits and landscapes were among his favourite subjects, and he also painted some powerful pictures of animal carcasses. His influence can be seen in the work of Francis *Bacon, one of his great admirers.

Soyinka, Wole (1934–), Nigerian dramatist, novelist, and poet, winner of the 1986 Nobel Prize for Literature. His first novel, *The Interpreters* (1965), captures the idealism of young Nigerians regarding the development of a new Africa. In prison for pro-Biafran activity during 1967–9, he produced increasingly bleak verse and prose: *Madmen and Specialists* (1970), and his second novel, *Season of Anomy* (1973). A brighter period followed with *Death and the King's Horseman* (1975), which embodies his post-Biafran cultural philosophy, enunciated in *Myth, Literature and the African World* (1976), of the need for the distinct aesthetics of Africa and Europe to cross-fertilize each other. His collection of poems, *Mandela's Earth* (1989), is suffused with despair at the rootlessness of modern man.

Spanish literature. The earliest major work in Spanish is the mid-12th-century *epic poem the *Song of my Cid*. In the 13th century a learned, clerical art emerged, examples of which are the poem *Book of Apollo* and the

religious poetry of Gonzalo de Berceo (*c*.1195–*c*.1268). The outstanding work of the 14th century was the poem *Book of Good Love* of Juan Ruiz (*c*.1283–*c*.1350). The late 14th century, and especially the 15th, saw the growth of the *ballad (*romanceros*) tradition in Castilian, collected from the mid-16th century. The 15th century witnessed the emergence of a courtly tradition, exemplified in the poetry of López de Mendoza, the Marqués de Santillana (1398–1458), and Juan de Mena (1411–56). The influence of Italian humanism and the discovery of the classical world led to the Golden Age of Spanish literature (*c*.1500–*c*.1681), characterized by great richness and diversity. The major poets of this period, Juan Boscán (*c*.1474–1542) and *Garcilaso de la Vega, show a marked Petrarchan influence. Didactic prose of the period is reflected in the writings of the Valdés twin brothers, Juan (*c*.1490–1541) and Alfonso (*c*.1490–*c*.1532), and there is an important body of historical writing on the conquest of America. The realistic short novel *Lazarillo de Tormes* (written by an anonymous author in 1554) initiated the *picaresque genre, of which the novels *Guzmán de Alfarache* (1599) by Mateo Alemán (1547–*c*.1614) and *The Life of a Scoundrel* (1626) by Francesco Gómez de Quevedo (1580–1645) are later examples, while *Diana* (*c*.1559) by Jorge de Montemayor (1519–61) is a major *pastoral romance. *Cervantes, who also wrote plays and poetry, is the outstanding prose writer of the period. His *Don Quixote* is considered the forerunner of the modern European novel. Religious experience dominates the writing of the great *Mystics, St Teresa of Avila and St John of the Cross. The theatre was dominated by the names of Lope de *Vega and Tirso de Molina (1580–1648) and later by *Calderón de la Barca. The later 17th century, the age of Spain's decline, is characterized by a movement towards exaggerated forms of writing, for example in the poetry of *Góngora and *Quevedo. Apart from the dramatist Leonardo Fernandez de Moratín (1760–1828), the 18th century was unremarkable. Mariano José de Larra (1808–37), the satirist, is the first major figure of the 19th century, followed by the *Romantic poets, for example José de Espronceda (1808–42) and José Zorilla (1817–93), author of the seven-act melodrama *Don Juan Tenorio* (1844). The impressionistic prose and poetry of Gustavo Adolfo Bécquer (1837–71) represents the peak of 19th-century poetic achievement. Among the major novelists of the period, who together are representative of *realism and *naturalism in Spain, are *Alas y Ureña and *Pérez Galdós. The early 20th century in Spain is dominated by the *Generation of '98 and the *modernista* movements (see *modernism), which break radically with the aesthetics of the 19th century, for example the poetry of *Darío, the novels of *Unamuno, and the theatre of *Valle-Inclán. Major contributions have been made by the poet *Jiménez and the *Generation of '27, especially *Garcia Lorca. After the Spanish Civil War (1936–9), many writers went into exile, while within Spain the most important writers were the novelist Camilo José Cela Trulock (1932– ; Nobel Prize-winner 1988) and the dramatists Alfonso Sastre (1926–) and Antonio Buero Vallejo (1892–1938). The ending of General Franco's regime in 1975 heralded a new burst of creative activity. (See also *Latin American literature.)

Spark, Muriel (Sarah) (b. Camberg) (1918–), Scottish-born novelist, dramatist, and poet. She began her literary career as an editor, poet, and biographer and turned to fiction in the 1950s, following her conversion to Roman Catholicism. Her novels show a preoccupation with the question of good and evil; many have the quality of a parable or a fable. They include *Memento Mori* (1959); *The Ballad of Peckham Rye* (1960); *The Prime of Miss Jean Brodie* (1961) (stage and film versions 1966 and 1969 respectively); *The Abbess of Crewe* (1974); *The Mandelbaum Gate* (1965); and *A Far Cry from Kensington* (1988).

Spence, Sir Basil (1907–76), British architect. He assisted *Lutyens on the Viceroy's House, New Delhi, and a certain monumentality deriving from Lutyens persisted in his later work. From 1930 he worked mainly as a designer of houses, and became a leading figure in his profession. He is best known for his rebuilding of the bombed Coventry Cathedral (1954–62). Spence was particularly involved with new housing and university projects in the 1950s and 1960s. His buildings were often controversial; the cavalry barracks in Knightsbridge (1970), for example, was criticized for the effect its tower had on London's Hyde Park skyline.

Spencer, Sir Stanley (1891–1959), British painter, an eccentric who painted his own inner vision and created an extremely distinctive style. His works include landscapes, nudes, and portraits, but he is best known for his paintings on themes from World Wars I and II and for religious subjects. Christianity was a living reality for Spencer, and he set his biblical scenes in Cookham in Berkshire, the village where he was born and spent most of his life. His figures have a dumpy, sometimes awkward quality, but they are vividly observed and convey deep human feeling. Spencer's best-known work is probably the series of murals commemorating his experiences during World War I in the Oratory of All Saints in Burghclere, Hampshire, painted in 1927–32.

Spender, Sir Stephen (Harold) (1909–), British poet and critic. He was in many ways representative of the 'new writing' of the 1930s, with its political awareness and attempts to integrate modern industrial images into the language of poetry, but his own talents were essentially for personal and introspective poetry. *Poems* (1933) included 'The Pylons', which gave the nickname of 'pylon poets' to himself and his friends and contemporaries, *Auden, *Isherwood, and *MacNeice. He modified his political stance as co-editor of *Encounter* (1953–69) and in his critical works, such as *The Creative Element* (1953). His autobiography *World within World* was published in 1951.

Spenser, Edmund (*c*.1552–99), English poet. Influenced by the Roman poet *Virgil and the 15th-century Italians *Ariosto and *Tasso, he published *The Shepheardes Calendar* in 1579, a series of *eclogues which heralded the English literary renaissance. Spenser laments the death of his patron, Sir Philip *Sidney, in his elegy 'Astrophel' (*c*.1591–5); in 'The Ruines of Time' (1591), he creates an *allegory which also laments the decline of patronage and the neglect of literature. His greatest work, *The Faerie Queene* (1590–6), is a heroic and epic allegory in intricate eight-line stanzas. The fairy queen or Gloriana signifies Glory in the abstract and Queen Elizabeth I in person. The allegory is varied, drawing on pagan myths, Christian doctrine, and medieval and contemporary story, legend, and folklore. Spenser celebrated his courtship of Elizabeth

Boyle, his second wife, in his *sonnet sequence *Amoretti* (1595) and his marriage to her in his greatest *lyric *Epithalamion* (1595).

Spielberg, Steven (1947–), US film director. He first attracted attention with his television film *Duel* (1971), a tense thriller in which a motorist is harassed by a truck driver. He had great box-office success with his film *Jaws* (1975), and with *Close Encounters of the Third Kind* (1977), about extra-terrestrial visitation. After his only failure, *1941* (1979), his successes continued with two Indiana Jones films, *Raiders of the Lost Ark* (1981) and *Indiana Jones and the Temple of Doom* (1984), and with *E.T.* (1982), a tale of a solitary extra-terrestrial marooned on earth. He then turned to an adaptation of Alice Walker's book *The Color Purple* (1985), about the tribulations of a black woman, and *Empire of the Sun* (1987), based on J. G. Ballard's prize-winning novel.

spinet, a musical instrument, in English usage from the 17th century, it describes a small wing-shaped domestic version of the *harpsichord, with strings running diagonally away from the keyboard. However, spinet was earlier used to mean the *virginals and sometimes the harpsichord itself. As with the virginals there was only one rank of strings, and normally only one keyboard. Spinets were made in large numbers from the mid-17th century almost to the end of the 18th, for many houses had no space for a harpsichord. The name has been used recently for a small piano.

spiritual, a religious song of the black peoples of the southern states of the USA, but probably derived from the evangelist hymns of the white settlers. The words serve a double purpose: as a temporary distraction from the pains of slavery, and as a heartening, subversive symbol of defiance through identification with the biblical Israelites escaping from the tyranny of Egypt. Spirituals

By the age of 30 Steven **Spielberg** had become one of the most famous film directors alive. His second big success, *Close Encounters of the Third Kind*, about an extra-terrestrial landing in America, was based on his own screenplay and showed his mastery of special effects.

became widely known after the publication of the collection *Slave Songs of the United States* (1867). Elements of spiritual music went into the creation of *jazz, while in the black churches spirituals began to be replaced by gospel music (see *hymns) at the end of the 19th century.

Spohr, Louis (1784–1859), German composer. From 1822 he directed the orchestra of the court theatre in Kassel. Spohr's considerable output includes fifteen violin concertos, nine symphonies, and much chamber music. Among his thirteen operas *Jessonda* (1823) made the most lasting impression.

Sri Lankan art, the art and architecture of Sri Lanka (formerly called Ceylon). Buddhism was introduced to the island in the 3rd century BC, and although Hinduism also made inroads, Buddhism has remained the prevailing religion to this day and has been the primary inspiration for Sri Lankan art. With the exception of royal palaces, almost all art has been religious. *Stupas, some of very great size, and monasteries are the most typical architectural forms. Wood was originally the most common building material, but later stone and brick were used. Buildings were often ornamented with sculpture, but the most grandiose examples of Sri Lankan sculpture are vast figures of the Buddha carved from rock faces; the most famous is the 12th-century Reclining Buddha at Polonnaruva (the capital of Sri Lanka at the time), which is about 14 metres (46 ft.) in length. Beautiful small bronzes are also a feature of this art. Of Sri Lankan painting, the most important remains are 5th-century cave frescos at Sigiriya depicting voluptuous celestial nymphs. Sri Lankan art declined from the 13th century, when the island was invaded from the mainland, and further from 1505, with the arrival of the Portuguese, who were followed by the Dutch and British. (See also *Buddhist art.)

Sri Lankan literature *Dravidian literature, *Tamil literature.

staccato (Italian, 'detached'), a musical term used as an instruction to players to shorten the duration of the written note. It is indicated by a dot placed over the note-head. A crotchet played staccato has the duration of a quaver. The term 'staccatissimo' indicates a note of even shorter duration.

Staël, Madame de (Staël-Holstein, Anne-Louise-Germaine Necker, baronne de) (1766–1817), French-Swiss literary critic and political propagandist. She was, with Chateaubriand, an important influence on the development of French *Romanticism. In *De l'Allemagne* (1810) she contrasted the pagan and Classical literature of southern Europe with the Christian, Romantic literature of the north. In it, she maintained that literary taste is relative and believed in the possibility of human perfectibility.

stage machinery, mechanical devices in the theatre, used to make quick scene changes and increase realism. The Greeks employed the *mechane* for propulsion through the air, and the *ekkyklema* for movement forward. Machinery was also used by the Romans. The prisms which provided scene changes (see *set design) in Renaissance Italy were rotated mechanically, and 'flying angels' could

be seen at this time. Giacomo Torelli (1608–78) invented the carriage-and-frame devices which moved scenery by means of carriages beneath the stage; he also pioneered the machine plays which specialized in elaborate mechanical effects. Philip de Loutherbourg (1740–1812), who worked for David *Garrick, was especially adept at reproducing climatic effects and the illusion of natural phenomena such as fire and volcanoes. The *Elizabethan theatre introduced an upper balcony from which machinery and actors could be lowered, as well as a cellar with trapdoors leading on to the stage. This device continued to be used in the 19th century, when a grid, constructed above the stage, permitted scenery to be 'flown'. The revolving stage was introduced in Germany in 1896. In the modern theatre whole stages can be moved into the wings and instantly replaced by new sets, and individual sections of a stage can be raised or lowered.

stained glass, glass that has been given translucent colour in any of various ways, used particularly for creating pictorial designs in church windows. The art began in the service of the Christian Church and is of Byzantine origin, but in its most characteristic development and its highest achievements it is essentially an art of Western Christendom, practised most splendidly in the west and north of Europe as an adjunct to Gothic architecture. Its early history is obscure, and the first surviving complete windows—in Augsburg Cathedral c.1050–1150—show an art already nearly perfect in technique. Medieval windows are generally made up of hundreds of small pieces of glass of varied colours and shapes held together by strips of lead. Windows of any

size were made up of several panels so treated, and these were set in a framework of iron ('armature') that served not only as a support against wind pressure, but also to accentuate the main lines of the design of the window. The period from roughly 1150 to 1250 was the greatest age of stained glass: colours were strong and simple, designs were bold and fresh, and the feelings conveyed were lofty and awe-inspiring. The cathedrals of Canterbury and Chartres, for example, have superlative glass from this period. From the 15th century stained glass tended towards a greater pictorialism, imitating the effects of oil painting, and this trend reached its height in the 18th century, when some artists painted on glass more or less as they would on canvas. With the *Gothic Revival in the 19th century there came a return to medieval principles, and William *Morris and his associates (notably *Burne-Jones) were among the foremost designers in this spirit. In the 20th century many noteworthy artists have designed stained-glass windows, in both figurative and abstract veins, among them *Chagall, *Matisse (notably at Vence in the South of France), and John *Piper in England.

Stamitz, Johann (Wenzel Anton) (1717–57), and **Carl (Philipp)** (1745–1801), German composers of Bohemian origin. As father and son they were the most outstanding members of an important musical family. Both worked as violinists and composers at the court of the Elector Palatine of Mannheim (see *Mannheim School), and were deeply involved in the development of the *symphony from its early, three-movement suite form to the integrated four-movement plan that became standard at the end of the 18th century.

stamping tube, a musical instrument usually made from a length of bamboo closed by a node at the end which is stamped on the ground. The sound is mostly that of the contained air and the pitch of the tubes is controlled by their length. Long, narrow gourds, the *shantu,* open at each end, are stamped on the thigh by women in Nigeria and elsewhere in Africa; a hand partly over the end varies the pitch like *talking drums. Wooden tubes with a constricted waist are stamped into water as water drums in New Guinea.

Stanford, Sir Charles Villiers (1852–1924), Dublin-born British composer and educationalist. Among his works are a choral setting of Tennyson's *Revenge* (1886), but his music is seen at its best in the comic opera *Shamus O'Brien* (1896) and in his fine church music.

Stanislavsky, Konstantin (Sergeyevich) (1863–1938), Russian actor, director, and teacher of acting. In 1898 he co-founded the Moscow Art Theatre, where he introduced a new style of acting based on 'inner truth' and *naturalism, which was complemented by realistic scenery and costumes. His approach was exemplified by superb productions of Chekhov, beginning with *The Seagull* (1898), and Gorky's *The Lower Depths* (1902). Later his work became more symbolic and stylized. After the Revolution of 1917 he worked on political plays and opera as well as on the classics. His teaching methods, expressed in numerous books including *My Life In Art* (1924) and *An Actor Prepares* (1936), have been very influential, especially in the USA, where Marlon Brando and other actors have adopted the controversial system

Chartres Cathedral has the finest array of medieval **stained glass** in the world. The cathedral was begun in 1194 and most of the glass was put in postion between 1215 and 1240. This example is the rose window of the north transept; in the centre is a roundel of the Virgin and Child, and converging on this are images of angels, doves, kings, and prophets, together with quatrefoils bearing the royal fleur-de-lys symbols of France.

of 'method acting', in which the actor attempts a thorough identification with the character portrayed, through a preparatory course of improvisations and other exercises.

stanza, a group of verse lines with a set pattern of *metre and *rhyme which is repeated throughout a poem, each stanza having the same number of lines. Stanzas, sometimes loosely referred to as 'verses', are usually separated by spaces in printed poems. The commonest stanza is the *quatrain; Boccaccio, Chaucer, and Spenser introduced stanzaic patterns of greater intricacy.

stave *notation.

Stead, Christina (Ellen) (1902–83), Australian novelist. Brought up in Sydney, she spent most of her life in Britain and the USA, where she was briefly a Hollywood screenwriter. Her best-known work, *The Man Who Loved Children* (1940), is a vivid study of American family life. Other novels, including *Seven Poor Men of Sydney* (1935), *House of All Nations* (1938), and *Cotter's England* (1967), reflect her left-wing and feminist views.

steel band, a type of percussion ensemble, originating in the West Indies, comprising instruments made from discarded oil drums. One end of the drum is beaten down to form a basin, and areas of it are beaten up into domes. Each section produces its own note when tapped, and is then tuned by further beating with a hammer. There are six basic types of drum: the rhythm pan, which has two sections; the melody pan, which has twenty-five; the second pan, with fourteen sections; the cello pan, with nine; and the bass pan with five. Bands composed of a set of steel drums are capable of amazing versatility, playing music ranging from *calypso and carnival music to arrangements of Western classical pieces.

Steele, Sir Richard (Isaac Bickerstaff) (1672–1729), Irish-born essayist, dramatist, and politician. He edited several periodicals; with *Addison he started the thrice-weekly periodical *The Tatler* in 1709, and together they founded the journal *The Spectator*, in which the character Sir Roger de Coverley first made his appearance (1711–12). He was elected to Parliament as a Whig in 1713, but his pamphlet *The Crisis* (1714), in favour of the Hanoverian succession, led to his expulsion from the House of Commons for 'seditious writing'. He wrote several popular plays, including the sentimental comedy *The Conscious Lovers* (1722). His attacks on *Restoration drama, his praise of tender domestic and family life, and his own reformed dramas did much to create an image of polite behaviour for the new century.

Steen, Jan (c.1625–79), Dutch painter, best known for his humorous *genre scenes, warm-hearted and animated works that have given him deserved popularity. Steen worked in various towns, including his native Leyden, where in 1672 he opened a tavern—many of his pictures represent drinking scenes. His work was widely imitated.

Steer, Philip Wilson (1890–1942), British painter. With *Sickert (his friend and exact contemporary), Steer was the leader in his generation of those progressive British artists who looked to French artists, in his case *Degas and *Monet, for inspiration. He trained in Paris in 1882–4, and in the late 1880s and early 1890s he produced works (mainly beach scenes and seascapes) that are remarkable for their great freshness and subtle handling of light. After about 1895 Steer's work became more conventional and more closely linked with the English tradition of landscape painting. In the late 1930s failing sight caused him to give up painting.

Steichen, Edward Jean (1879–1973), US photographer, born in Luxembourg. When Steichen studied painting in Paris, he was already an accomplished photographer and took a striking series of pictures of Rodin. Back in the USA, he at first concentrated on landscapes, fashion, and portraits, turning to commercial and advertising work some years later. He retired in 1938, but re-emerged to become a war photographer in World War II as he had been in World War I. In 1947 he was appointed director of the Photography Collection at New York's Museum of Modern Art, assembling in 1951 the influential exhibition *The Family of Man*.

Stein, Gertrude (1874–1946), US novelist, autobiographer, and poet. In Paris, where she lived from 1903, she became a patron and friend of modern painters, including Picasso and Matisse, and a mentor to the American *lost generation of writers, among them Hemingway and Fitzgerald. She herself had developed an innovative style which featured repetition and abnormal syntax and punctuation. Her works include *Three Lives* (1909), the stories of two German servant girls and an unhappy black woman; *Tender Buttons* (1914), experimental verse studies without conventional logic or grammar; and the rambling fictional history *The Making of Americans* (1925). Most accessible is *The Autobiography of Alice B. Toklas* (1933), memoirs written as if by her secretary and friend.

Steinbeck, John (Ernst) (1902–68), US novelist and short-story writer. His most memorable works are concerned with the rural poor of his native California: *In Dubious Battle* (1936) is an account of a strike by fruit-pickers; *Of Mice and Men* (1937) is a novella about two migrant farm labourers who represent the tragedy of a class that yearns for a home, of which it is perpetually deprived. In *The Grapes of Wrath* (1939), the great American novel of the Depression, he unfolds the tale of a refugee family from the dust bowl, its migration to California, and the struggle to find work under an almost feudal system of agricultural exploitation. Later works include *East of Eden* (1952), a family saga, using the theme of Cain and Abel in a story both symbolic and realistic of man's struggle between good and evil. He was awarded the Nobel Prize for Literature in 1962.

Stella, Frank (1936–), US painter, one of the leading members of the group of 'Post-Painterly Abstractionists' who reacted against the subjectivity of *Abstract Expressionism. His paintings are often large and deliberately avoid any personal quality in workmanship; some of his early pictures were all black, but others have used flat bands of bright colour. In the 1960s he began using shaped and notched canvases, and in the 1970s he experimented with paintings that included cut-out shapes in relief.

Stendhal (Marie-Henri Beyle) (1783–1842), one of the leading 19th-century French novelists. His two major

Although he won Pulitzer and Nobel Prizes, John **Steinbeck** was modest about his talent: 'A couple of years ago', he wrote, 'I realized that I was not the material of which great artists are made . . . And since then I have been happier simply to do the work and take the reward . . . for a day of honest work.'

novels, *Le Rouge et le noir* (1830) and *La Chartreuse de Parme* (1839), are realistic portrayals of society, the former depicting France under the restored monarchy, and the latter the intrigues of the Italian court in around 1820. The heroes of both works embody his philosophy, known as *beylisme*, according to which fulfilment lies in the pursuit of pleasure and the cult of energy. They mock the constraints and hypocrisy of conventional society, promoting his own anti-clerical and anti-monarchical stance. Stendhal is aligned with the *Romantic movement in the emphasis which he places on individualism, and his early work of criticism, *Racine et Shakespeare* (1823), echoes the literary manifestos of Mme de Staël and Hugo among others. However, his intellectual roots are in the *Enlightenment and his approach to character is too analytical to be altogether typical of his generation. Among his other works is a treatise on love, *De l'amour* (1822), and *Lucien Leuwen*, an unfinished novel published posthumously.

Sternberg, Josef von (Jonas Sternberg) (1894–1969), Austrian-born US film director. He is best known for his films with Marlene Dietrich (1902–), beginning with the German-made *The Blue Angel* (1930), about the destruction of a middle-aged professor through sexual dependence. The remaining films, made in the USA, were *Morocco* (1930), *Dishonored* (1931), *Shanghai Express* and *Blonde Venus* (both 1932), *The Scarlet Empress* (1934), and *The Devil is a Woman* (1935). Most of them combined unusual settings, implausible plots, and larger-than-life characters with great visual skill, particularly in the use of light and shadow. His earlier work included a notable gangster film, *Underworld* (1927), but his post-Dietrich films were unremarkable.

Sterne, Laurence (1713–68), Irish-born novelist and humorist. A pastor in Yorkshire from 1738, his first major novel, *Tristram Shandy* (1759–67) achieved enormous popular success. Its relegation of the story to a subordinate position and its frequent digression by the narrator make it a forerunner of 20th-century psychological fiction. His journeys in France and Italy during 1762–5 provided him with material for *A Sentimental Journey through France and Italy* (1768). In *Journal to Eliza* (written 1767, published 1905) he reflects on his love for the young Elizabeth Draper, unhappily married to an official in Bombay. Throughout his work he parodies the developing conventions of the still new novel and its problems of presenting reality, space, and time. His sharp, salacious wit is balanced by the affection he displays towards the absurdities of life.

Stevens, Wallace (1879–1955), US poet. He was never a full-time writer, but worked for an insurance firm in Hartford, Connecticut. His first collection, *Harmonium* (1923), has the finish, the elegant wit, the bizarre images, the lush figures, and the recondite diction that characterize all his work. It was followed by *Ideas of Order* (1935), *Parts of a World* (1942), *Transport to Summer* (1947), and *The Auroras of Autumn* (1950). *The Man with the Blue Guitar* (1937) and *Notes Toward a Supreme Fiction* (1942) are important long poems. All his works show a deep engagement in experience and art, and a concern with the contrast between reality and appearance. Since the publication of *Collected Poems* (1954), his stature as a major poet has been increasingly recognized.

Stevenson, Robert Louis (Balfour) (1850–94), Scottish novelist, poet, and travel-writer. His widespread travels found expression in many of his works, including *Travels with a Donkey in the Cévennes* (1879), describing a tour in France. *Treasure Island* (1883), begun as a game with his stepson Lloyd Osbourne, recounts the adventure story of Jim Hawkins and Long John Silver. The book brought him fame, which increased with the moral *allegory *The Strange Case of Dr Jekyll and Mr Hyde* (1886) and his Scottish romances *Kidnapped* (1886), *Catriona* (1893), and *The Master of Ballantrae* (1889), an exploration of moral ambiguity. Suffering from tuberculosis, he set out in 1888 with his family for the South Seas, finally settling in Samoa at Vailima. He left unfinished his masterpiece *The Weir of Hermiston* (1896). His other works include short stories, essays, travel works, and poems, including the celebrated *A Child's Garden of Verses*, first called *Penny Whistles* (1885). A writer of originality and power, beneath the lightness of touch of his poetry and prose lies a sense of apprehension, sin, and suffering.

Stieglitz, Alfred (1864–1946), US photographer, critic, and gallery director. Founder of the Photo-Secession, Stieglitz edited *Camera Notes* (1897–1902) and *Camera Work* (1903–17) and directed the Little Galleries of the Photo-Secession (1905–17), showing not only photography but the work of most of the important figures in European avant-garde art. Throughout his life he organized art exhibitions and, though a fine photo-

grapher, was finally most important for his role in shaping the art of photography—particularly pictorialist photography—in 20th-century America.

Stijl, De (Dutch, 'the style'), the name of a group of Dutch artists founded in 1917 and of the journal they published to set forth their ideas. The artists involved, the most famous of whom was *Mondrian, sought laws of equilibrium and harmony that would be applicable to life and society as well as art, and their style was one of austere abstract clarity. Their ideas had considerable influence between the two World Wars, but more on architecture and design (notably at the *Bauhaus) than on painting and sculpture.

still life, a painting (or less often another pictorial representation such as a drawing, photograph, or mosaic) of inanimate objects such as flowers, fruits, musical instruments, or dead game. Still life was practised in the ancient world, and examples of it survive in Pompeian murals and in Roman mosaics. It was never more than a subsidiary element in Christian medieval art, but during the same centuries the painters of China and Japan developed the most subtle understanding of certain aspects of the inanimate world, particularly in paintings of bamboo. As an independent subject, still life began to develop in the West in the 16th century, the earliest dated 'pure' still life being the *Dead Bird* (1504) by Jacopo de' Barbari, a Venetian painter working in northern Europe. It was in the Netherlands in the 17th century that still-life painting entered its golden age, the subject becoming so

popular that many Dutch artists of the period concentrated on narrow specialities such as pictures of fish or of tables spread for a banquet. Some so-called 'vanitas' paintings preserved an emblematic meaning reminding the spectator of the vanity of earthly pleasures, perhaps as a convenient pretext for the display of sensuous riches. In France still life was regarded as the lowest branch of painting—the mere exercise of technical skill, with no intellectual content—and in spite of the masterly achievements of *Chardin in the 18th century, it was not until the late 19th century that it began to be accorded a status equal to that of other subjects. *Cézanne was a particularly influential figure, for he used still life as one of the principal means for his revolutionary investigations into pictorial structure. Following Cézanne's example, the leaders of many modern movements (*Fauvism and *Cubism, among others) have given still life a prominent place in their work, as it was an ideal subject for experimenting with form and colour. Still life finally came into its own with the new aesthetic attitude of 20th-century art which regards a picture not primarily as the reproduction of something in nature outside itself, but as the creation of a new disposition of shapes and appearances.

Stirling, James (1926–), British architect. His practice has been particularly concerned with institutional and university buildings and his buildings have often been the subject of controversy. Most notably his History Faculty Library at Cambridge University (1964–7) has suffered from so many problems, including water penetration and falling tiles, that the university tried to sue the architect and considered demolishing the building. Stirling's work has been highly varied stylistically and recently he has worked in the spirit of *Post-Modernism, as in the Staatsgalerie New Building in Stuttgart (1977–82) and the Clore Wing at the Tate Gallery in London (1980–7), housing the Turner collection.

Chardin was the greatest **still-life** painter of the 18th century. His early works usually depict simple groups of food and a few household objects, but in the 1760s he turned to a grander type, of which this picture, *The Attributes of the Arts* (1766) is a splendid example. (Minneapolis Institute of Arts)

Stockhausen, Karlheinz (1928–), German composer. He became acquainted with *serialist music in Darmstadt (1951) and began working with *Messiaen in Paris in 1952. In 1953 he became co-director of the West German Radio studio for *electronic music. These experiences, together with his analysis of *Webern's serialism, led him to evolve a theory whereby every element in music (pitch, intensity, duration, timbre, and even position in space) might be serialized—as can be seen in such works as *Momente* (1961–4). He then explored the possibilities of random selection in the performance of musical materials, adding to this the exploration of spatial variety in the placing of performers. Electronically engineered works, such as the successful *Song of the Young Men* (1956), led him to think of music as a universal unifying agent. This grandiose vision ultimately gave rise to a massive cycle of seven quasi-operatic 'ceremonies', designed to be performed on consecutive days under the general title *Light*, begun in 1977 and launched in 1981 with *Thursday from Light*.

Stone Age art, the art-forms developed during the first known period of human culture in Europe, characterized by the use of stone implements. Similar cultures with broadly similar phases of art have occurred at different periods in other parts of the world. The earliest known artefacts in Europe date from *c.*50,000 years ago during the Palaeolithic period (Early Stone Age) and are of two main kinds: decorated or ornamental objects, usually small, directly associated with the stone and bone industries of the period (such as perforated bone or tooth pendants), and engravings and paintings, often very sophisticated found on the walls and ceilings of caves (see *cave painting). Sculptures, silhouettes, reliefs, and engravings all occur. They include the so-called Venuses, statuettes of women, often pregnant; they are found as far apart as Brassempouy in western France and on Lake Baikal in the Soviet Union and are made of many materials including stone, ivory, and occasionally even baked clay. The Mesolithic or Middle Stone Age period is well represented in northern and western European culture from about 8000 to about 3500 BC. Culturally and technologically it remained in many ways analogous to the Palaeolithic period. Mesolithic art in the Baltic region includes geometric patterns and stylized human figures engraved on bone and antler, and animal figures carved in amber, sometimes as pendants. The art associated with the Neolithic or New Stone Age period in Europe (5000 to 2500 BC) was characterized by important advances in technology; this was the period when settlers, who were farmers, learned how to weave, plait straw, and polish stone tools. Pottery began to be made by hand, usually decorated by simple techniques of impressing and incising. Another important feature of Neolithic culture is its megalithic building and monumental structures used for ritual purposes, such as the menhirs (single upright stones), stone circles, and dolmens (chamber tombs). Some of the megalithic tombs include decorated stones, carvings of spirals or owl-like stylized faces: these, and some of the architectural details can be found as far apart as the Mediterranean and Atlantic coastlines. (See also *Bronze Age art.)

stone-carving, the art of making sculpture by cutting, incising, or abrading rock. The term can embrace the delicate carving of pebbles at one extreme and the use of enormous natural outcrops of rock (as in some Indian temples, such as those at *Mahabalipuram) at the other. Large-scale carving of descriptive scenes in *relief was a memorable feature of *Assyrian and *Egyptian art. A great variety of stones have been used, some prized for their beauty, others for their durability, and some for the ease with which they can be worked. Some of the most durable and attractive stones—such as granite or basalt—are extremely difficult to carve, but they were much used by the Egyptians, for example. Other stones, for example alabaster, are so soft and easily marked that they are suitable only for indoor work. There are two methods of approach to stone-carving, known as indirect and direct carving. In indirect carving the sculpture is first made in another material (usually a cast from a clay model) which is then transferred into stone. The direct method involves sculpting the piece of stone directly into shape. For many artists this has meant that the process of carving releases the shape latent within the block of stone. Michelangelo wrote that 'the greatest artist has no conception which a single block of marble does not potentially contain within its mass, and only a hand obedient to the mind can penetrate to this image'. Direct carving is favoured by most modern sculptors.

stoneware, a type of pottery made from a mixture of clay and fusible (easily melted) stone, fired at a sufficiently high temperature to vitrify (make glassy) the stone but not the clay. It is hard, durable, non-porous, and usually opaque. Most stoneware clays fire to grey or buff, but fine red stonewares are also known. Stoneware was first produced in China in about the 4th century BC and then spread to the Middle East. It seems to have developed independently in Germany in the 9th century, and in Britain in the 18th century it was a staple of the Staffordshire pottery industry until superseded by *creamware.

Stoppard, Tom (b. Tomas Straussler) (1937–), British dramatist. Born of Czech parents, he achieved world-wide

The most remarkable example of **Stone Age art** may be the Lascaux cave paintings, shown here. Of the animals represented, the most notable are the bulls, some of them over life-size. The paintings were remarkably well preserved when discovered in 1940, but deteriorated so rapidly after becoming a tourist attraction that the cave had to be closed to the public in 1963.

In virtually all the great civilizations of the world one of the most important roles of **stone-carving** has been as an adjunct to important buildings. The sculpture of the portals of the west front of Chartres Cathedral (c.1150) is remarkable not only for its beauty and dignity, but also for the perfect way in which it is integrated with the architecture. The elongated figures, with arms held close to the body, echo the shapes of the columns against which they stand.

success with his play *Rosencrantz and Guildenstern are Dead* (1966), which places Hamlet's attendants, with structural dexterity, at the centre of the drama. It was followed by other plays, which disclose a talent for pastiche, a metaphysical wit, and a strong theatrical sense. They include *Jumpers* (1972), a parody of academic philosophy; *Travesties* (1974), a satire on political life and parliamentary misdemeanours; *Every Good Boy Deserves Favour* (1977), about a political dissident in a Soviet psychiatric hospital; *Professional Foul* (TV, 1977), set in Prague, which dramatizes the stifling of free intellectual exchange; and *The Real Thing* (1982), a marital tragi-comedy.

Stowe, Harriet (Elizabeth) Beecher (1811-96), US novelist and essayist. Her first novel, *Uncle Tom's Cabin* (1852), was a powerful, if sentimental, indictment of slavery which gained an enormous readership. Lincoln called her 'the little woman who made the book that made the great war'. Her second novel, *Dred* (1856), showed the demoralizing influence of slavery upon whites. Subsequently she wrote a series of novels describing life in New England. Her fictional essay *My Wife and I* (1871) defended woman's right to a career.

Strachey, (Giles) Lytton (1880-1932), British biographer and critic. He was a member of the *Bloomsbury Group, advocating both in his words and his life its faith in tolerance. His *Eminent Victorians* (1918) is a landmark in the history of biography, written with wit, iconoclasm, and sharp satire. His irreverent but affectionate *Life of Queen Victoria* (1921) combines anecdote and an elegant style. His last full-length work, *Elizabeth and Essex* (1928), emphasizes Elizabeth's relationship with her father and shows a clear debt to Freud.

Strand, Paul (1890-1976), US photographer. A student of Lewis *Hine, Strand established a studio in his native New York in 1912, experimenting briefly with fashionable techniques of photographic manipulation before becoming a champion of 'straight' (unmanipulated) photography. Alfred *Stieglitz was so impressed with his work that he arranged a one-man show, putting Strand in the forefront of contemporary art-photographers. Throughout his career, Strand devoted time to documentary film-making, but he is best remembered for his large-scale, contemplative, still studies in black and white.

Strauss, Johann (Baptist) father (1804-49), and son (1825-99), Austrian composers, violinists, and conductors. Johann (the elder) was the father of a remarkable family of Viennese musicians in whose hands the simple peasant *waltz (*Ländler*) developed into a highly sophisticated concert waltz. Strauss formed his band in 1825, and rapidly established himself as an inspired composer of dance music (his best known work is the *Radetzky March*, 1848, written in honour of the Austrian military hero). The waltzes, quadrilles, *polkas, and *marches of his son Johann were more elaborate than his father's, often being organized along symphonic lines—the best known include *The Blue Danube* (1867) and *Tales from the Vienna Woods* (1867). He was also successful as a composer of *operetta: *Die Fledermaus* ('The Bat') (1874), *A Night in Venice* (1883), and *The Gypsy Baron* (1885) were the most outstanding. His brothers **Josef** (1827-70) and **Eduard** (1835-1916) played in and directed the family orchestra and also made significant contributions to the waltz.

Strauss, Richard (Georg) (1864-1949), German composer and conductor. His conducting career began with the Meiningen Court Orchestra (1885) and brought him important posts in the *opera houses of Munich, Weimar, Berlin, Bayreuth, and Vienna. His music made its triumphal way through a series of magnificent *symphonic poems, including *Don Juan* and *Death and Transfiguration* (1889), *Till Eulenspiegel* (1895), *Thus Spoke Zarathustra* (1896), *Don Quixote* (1897), and *A Heroic Life* (1898); and two equally splendid *programme symphonies, *Domestic Symphony* (1903) and *An Alpine Symphony* (1915). Using and expanding upon a *Wagnerian vocabulary, these works took the art of musical description to unprecedented heights. His third opera, *Salome* (1905), took that vocabulary to extremes of dissonance, as did *Elektra* (1909), the beginning of his long and fruitful collaboration with the poet and librettist Hugo von *Hofmannsthal. Both operas represented a degree of dramatic and musical *Expressionism from which the suave manner of his later operas, beginning with *Rosenkavalier* (1911), seemed like a retreat into comparative convention. Despite the magnificence of much of his later music, including the operas *Ariadne on Naxos* (1912, revised 1916), *The Woman without a Shadow* (1918), *Arabella* (1933), and *Daphne* (1938), Strauss's genius seemed to mark time. But the shattering experience of World War II led to a remarkable 'Indian

summer' of creativity, in such works as the opera *Capriccio* (1942), the *Metamorphosis* for strings (1945), and the *Four Last Songs* (1948).

Stravinsky, Igor (Fyodorovich) (1882–1971), Russian composer. In 1909 his orchestral fantasy *Fireworks* attracted the attention of *Diaghilev, who, as director of the Ballets Russes, commissioned a ballet score, *The Firebird* (1910). Its success made Stravinksy world famous. His ballet score *Petrushka* (1911) projected thematic folk tunes against a background that was harmonically astringent and rhythmically exciting. Notoriety came with his third Diaghilev ballet score, *Le Sacre de printemps* (1913). Its savage, irregular, repetitive rhythms, extreme dissonance, and erotic subject-matter seemed to many to herald the end of civilized music. The disruptions of World War I and the Russian Revolution of 1917 led Stravinsky to settle in Paris and re-think the basis of his art. His music now entered a *Neoclassical phase, becoming economical and stripped of all romantic rhetoric. Such works as the ballet *Apollon-Musagète* adapted to a *commedia dell'arte* scenario (1928) and the *opera *The Rake's Progress* with a libretto by W. H. Auden and Chester Calman (1951), the Symphonies of Wind Instruments (1920), the Concerto 'Dumbarton Oaks' (1938), and the Symphony in C (1940), are typical of this period. The importance of ritual in his music can be felt in the opera-oratorio *Oedipus Rex* (1927) and in his first important religious work, the *Symphony of Psalms* (1930). In 1939 Stravinsky settled in the USA. In his

tireless search for a musical language appropriate to the 20th century he now turned to *serialism, evolving his own unmistakable version in such works as the *Canticum Sacrum* (1955) and the ballet *Agon* (1957)—ritual still finding its place in *Threni* (1958) and the *Requiem Canticles* (1967).

straw-work, the use of the stalks of various forms of grain to create small decorative objects and articles of household use. The craft is of inestimable age, but it was certainly highly developed by the 17th century. In England it was stimulated in the early 19th century by French prisoners from the Napoleonic Wars who were particularly skilled at it. The most familiar type of work in the medium is the corn dolly—a symbol of the harvest. The tradition of making these stems back to the ancient world, when an image of the corn goddess or some other talisman was woven from the last sheaf to be reaped, and carefully preserved to ensure an abundant crop the following year. Other items of straw-work include screens, fans, and jewellery, and it has also been used to create decorative effects on the surface of furniture.

stream of consciousness, a method of representing the mental processes of fictional characters as a continuous blending of sense-perceptions, thoughts, feelings, and memories, as if they were recorded directly without the author's intervention, sometimes without punctuation. This technique, also known as 'interior monologue', was pioneered by Dorothy Richardson in *Pilgrimage* (1915–38), by Proust in *À la recherche du temps perdu* (1913–27), by Joyce in *Ulysses* (1922), and further developed by Virginia Woolf in *Mrs Dalloway* (1925) and Faulkner in *The Sound and the Fury* (1929). It has become a common device in modern fiction.

street theatre *community theatre.

Strindberg, (Johan) August (1849–1912), Swedish dramatist, novelist, and poet. Best known outside Scandinavia as a dramatist, he is an important figure in the European *naturalist movement in literature but most influential as a precursor of *Expressionism in the theatre. Almost universally gifted, he lived a turbulent life and at times hovered on the brink of insanity. Few writers are as subjective as Strindberg, and it is often difficult to disentangle his life from his works (which occupy some 80 volumes). His naturalistic plays *The Father* (1887) and *Miss Julie* (1888) portray unhappy marriages and illustrate why Strindberg has a reputation as a misogynist; the theme recurs, notably in *The Dance of Death* (1901). The trilogy *To Damascus* (1898–1904) and, more particularly, *A Dream Play* (1902) introduced Expressionist techniques and are of seminal importance for modern drama. In his later years he established an 'Intimate Theatre' and wrote for it a series of chamber plays, of which the best known is *The Ghost Sonata* (1907). *The Red Room* (1879) is regarded as Sweden's first modern novel and made Strindberg famous as a satirist and brilliant prose stylist, but *The People of Hemsö* (1887), a delightfully comic depiction of life in the Stockholm archipelago, is his most popular novel.

Soldiers have through the ages pitted their ingenuity against the tedium of imprisonment by the enemy. Here we see an example of French **straw-work** marquetry executed by Napoleonic prisoners-of-war during the early years of the 19th century. (Lady Lever Art Gallery, Liverpool)

stringed instruments, those on which a stretched string creates a musical sound. All are coupled systems; strings produce very faint sounds, so a resonator is needed.

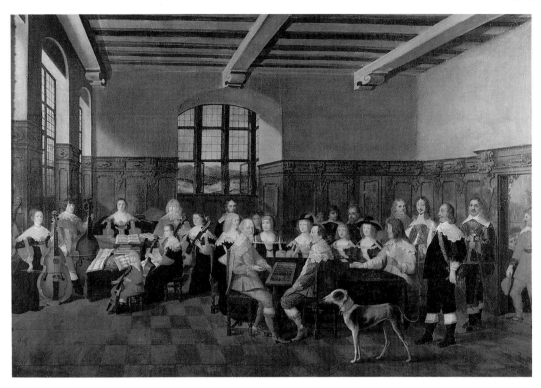

In this painting 'Herzog August the Younger and his family' (c.1645) a consort of **stringed instruments**, bass and tenor viols in this case, are accompanied by a central figure at the harpsichord. (Braunschweigisches Landesmuseum)

Usually this is a box (*violins and *guitars, etc.), but it may be a board (some *zithers and *pianos), or the player's mouth (some *musical bows), and some modern instruments have complex electrical amplification systems. There are many ways of making a string vibrate. The simplest, and oldest, is plucking it, pulling it until the string's tension overcomes its or the *plectrum's elasticity, and it snaps back with enough energy to create a sound. Another is striking it (*dulcimers and pianos). A third is stroking it with a *bow (violins, etc.), or a wheel (*hurdy-gurdies). A fourth is blowing it (*aeolian harps). A fifth, only possible with steel strings, is with electromagnets (some electronic instruments). A string's pitch is determined by its length, mass, and tension. To avoid the resonator twisting under unequal string tension, it is desirable for all the strings to be at nearly the same tension. This is achieved by varying either the length or mass of the strings, or both. There are limits to the practicable length of strings, and on instruments with a great many, such as pianos, some must be longer than others, but if all were the same mass, the bass strings would be impossibly long. Therefore the mass is varied by using different thicknesses of string and by covering some with wire. The strings of violins must obviously all be the same length, and only their mass and tension differ. Once it vibrates, the pitch of the string can be varied. The normal way is by shortening the vibrating length by stopping it part-way along. Another, as on some Indian instruments, including the *sitar, and the blues guitar, is by altering the tension of the string while playing. Many stringed instruments have sympathetic strings, always of wire, which provide special background resonance by sounding when the playing strings sound.

They are usually tuned to a *scale in the key in which the instrument is to be played.

Stroheim, Erich von (1885–1957), Austrian-born US actor and director. Of the nine films he directed and scripted (or co-scripted), all but the first two suffered from studio interference, largely because of their extravagance and excessive length. The first three, *Blind Husbands* (1918), *The Devil's Passkey* (1919), and *Foolish Wives* (1921), were witty comedies of adultery. His other films include *Greed* (1923), originally seven hours long; *The Merry Widow* (1925); *The Wedding March* (1926); and *Queen Kelly* (1928), which was halted when only one-third finished, and never shown in the USA. What remains of Stroheim's films reveals superb visual detail and great sexual sophistication. He was forced to end his career as it began, playing stiff-backed Prussians, notably in Renoir's *La Grande Illusion* (1937), but received critical acclaim for his performance in *Sunset Boulevard* (1950).

Stuart, James (1713–88), English architect. Better known as 'Athenian Stuart' because of his earnest devotion to Greek architecture, he is noted for the measured views and drawings of Greek buildings he published with Nicholas Revett (1720–1804), another architect with whom he visited Athens in 1751 to 1753. The first volume of their *Antiquities of Athens* appeared in 1762 and is regarded as a key document in promoting the *Greek Revival.

Stubbs, George (1724–1806), English animal painter and engraver, regarded as the greatest of all horse painters. In 1776 he achieved great success with his book *The Anatomy of the Horse*, which was the result of eighteen months of dissecting and drawing horses. He was soon in demand as a painter, particularly for 'portraits' of horses with their owners or grooms, though he also painted many other animals, including such exotic species as a moose, a rhinoceros, a kangaroo, and a zebra, and

succeeded in conveying the beauty of animals without sentimentalizing them.

stucco, a kind of light, malleable plaster made from dehydrated lime (calcium carbonate) mixed with powdered marble and glue and sometimes reinforced with hair. It is used for sculpture and for architectural decoration, external and internal, and has been known to virtually every civilization. In Europe it was exploited most fully in Roman times and in the 16th to 18th centuries, particularly in Italy. By adding large quantities of glue and colour to the stucco mixture it could be made to take a high polish and assume the appearance of *marble (sometimes it is difficult to distinguish the two except that stucco is warmer to touch). The term stucco is also loosely applied to a plaster coating applied to the exterior of buildings, but this is a different substance (calcium sulphate).

studio potter, a potter who uses traditional methods to produce individual hand-crafted objects, rather than working in a factory. The concept, long-established in Japan, is now applied principally to late 19th- and 20th-century potters, mainly in Britain, France, and the USA, who, influenced by the ideas of the *Arts and Crafts Movement, turned their backs on industrialization. *Leach, the most famous studio potter, studied pottery in Japan and founded a pottery at St Ives in Cornwall. He was the most important figure in establishing in the West the Japanese notion that the potter was a creative artist rather than merely a skilled craftsman. Other notable studio potters include Lucie Rie (1902–), who was born in Vienna and settled in England in 1939, and Hans Coper (1920–81); these two shared a studio from 1947 to 1958. The strength of the studio potter movement is illustrated by such events as the opening of the Crafts Centre of Great Britain in 1948 and the founding of the Craftsmen Potters Association in 1958.

stupa, in Buddhist (and also Jain) architecture, a solid, dome-like monument erected to enshrine relics of the Buddha or some other holy personage or to mark a sacred spot. Typically the stupa was surrounded by a railing with four gateways (as with the Great Stupa at *Sanchi). The form spread throughout the Buddhist world, developing into complex architectural forms in, for example, Borobudur in Java (see *Indonesian art). In *Tibetan art the equivalent of the stupa is the chorten.

Sturm und Drang ('storm and stress'), German literary movement of the 1770s using as its preferred medium the theatre. Influenced partly by the exaltation of freedom and nature by J.-J. *Rousseau, it represents a reaction against the exclusive value placed by the *Enlightenment on the intellect and refined civilization at the expense of emotion, instinct, fantasy, and natural genius. Stylistically and structurally innovative, the plays frequently criticize contemporary social and political conditions in extravagant terms, for example, *Goethe in *The Sorrows of Young Werther* (1774), and *Schiller in *The Robbers* (1781).

Stuttgart Ballet *dance companies.

Sublime, the, a sense of magnificence, vastness, and violence in nature, and of those feelings of awe and terror corresponding to it, which fascinated many writers and

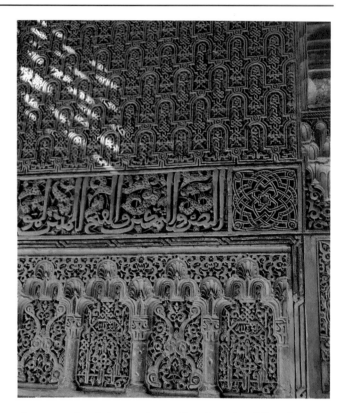

An example of **stucco** decoration from the Alhambra, Granada (c.1369). Carved stucco had been used as surface decoration by the earliest Islamic builders and the variety of repeating interlacing patterns shown here, with the use of calligraphy as both ornament and instrument of instruction, is typical of Islamic art.

artists in the late 18th century, and influenced the characteristic mood of *Romanticism. A Greek work, *On the Sublime* (c.1st century AD), attributed to *Longinus, had associated Sublimity with the immensity of natural phenomena (stars, mountains, volcanoes, oceans); but the most influential modern work was Edmund Burke's *Philosophical Enquiry into the Origin of our Ideas of the Sublime and Beautiful* (1757), which distinguished the obscurity, power, vastness, and darkness of Sublimity from the clearness, smoothness, delicacy, and smallness of Beauty. The cult of the sublime encouraged the *Gothic novel, the macabre paintings of *Fuseli, a new fashion for mountainous (especially Alpine) scenery, and renewed admiration of *Rosa's stormy landscapes.

Su Dongpo (1036–1101), Chinese poet, painter, and statesman of the Song dynasty (960–1279). Also known as Su Shi, he was an opponent of the reforming Song politician Wang Anshi and forced to spend years in partial exile. He was a prolific and philosophical poet who established the lyric *ci* as a serious verse-form. He wrote many witty and intimate verses and two memorable travel essays in literary Chinese entitled 'Red Cliff'. He also has a reputation as a notable calligrapher.

Sufi literature, the writings of Islamic mysticism, principally in Arabic, Persian, Turkish, and Urdu. Using language of symbolism and metaphor, Sufi writers expressed the human soul's longing for the divine, the path of spiritual development, and the nature of God. Images such as the lover yearning for his beloved, the nightingale

longing for the rose, and the wine goblet of intoxicating joy were employed. Amongst the earliest Sufi poets was the Arab woman saint Rābī'a (d. 801), while the most famous early mystic was al-Hallāj, martyred in 1022 for his ecstatic cry 'I am the Absolute Truth', who expressed in rhyming Arabic prose and poetry the transcendence of God, using symbols such as that of a moth approaching a flame in which it is burnt to express the idea of union with God. One of the most important Sufi theorists was Ibn 'Arabi (1165–1240) whose prolific writings in poetry and prose dwell on the revelation of inwardness, or God, in the created world. His contemporary Ibn *Fāriḍ was the author of a small number of exquisite Arabic odes, which include a scene comparing human life to a *shadow play. Mystical imagery has so thoroughly influenced Persian lyrical poetry that there is often debate as to whether the verse of poets such as *Hāfiz, *Jāmī, and *Sa'dī is mystical or erotic. The greatest of the Persian mystical poets is *Rūmī, expressing the power of love in a multitude of fluent images. The image of birds as the soul of man is found perhaps at its most developed in the work of *'Aṭṭār, who is distinguished by his gift for narrative story-telling. In the Turkish tradition of mystical poetry, the greatest work has often been by folk poets connected with dervish orders associated with dissent from the established government. Yunus Emre (d. *c*.1321) employs repetition and the metres of spoken Turkish in his poetry in which images of the Anatolian highlands recur. Similar images of austere mountain scenery, where the lover of God's isolation is compared to that of the ewe who has lost her lamb, are used by Pir Sultan Abdal, executed for treason in 1560. In India Mir Dard of Delhi (1722–85) represents the culmination of a long tradition. He wrote in both Urdu and Persian, his most admired work being his delicately fragile Urdu poetry. Most recently Sir Mohammed Iqbal (1878–1938) has used the imagery of Sufism abundantly in his poetry. (See also *Arabic literature, *Persian literature, *Turkish literature, *Urdu literature.)

suite (in music), a collection of contrasted movements. Although the term was not used until the middle of the 16th century, the form originated in the much earlier practice of performing dances in contrasted pairs—the stately *pavan followed by the lively *galliard, and so on. When adapted as purely instrumental music (usually for keyboard), such pairings became the basis of an extended work—the Baroque dance suite. The 17th-century dance suite had four dances as its almost invariable framework: the *allemande, the *courante, the saraband, and the *gigue. Optional dance movements included *minuet, gavotte, bourrée, passepied, and rigaudon. Most of the movements were in simple *binary form, and there was no special limit to their number. Within the suite the various movements were usually based on one key, though modulations could occur within the individual movement. As the earliest effective way of providing extended instrumental works, the suite is the forerunner of most of the instrumental forms of the 18th and 19th centuries, including the overture, the concerto grosso, the solo concerto, and the symphony. Once superseded by these *sonata-based forms, however, the suite became simply a collection of contrasting movements, assembled perhaps from the incidental music to a play, or from outstanding sections of an opera or ballet. Neoclassical composers of the 20th century, such as Stravinksy, revived the term in something of its original form.

Suk, Josef (1874–1935), Czech composer and violinist. His early works were influenced by *Dvořák (whose daughter he married), but he later developed a more complex harmonic and *polyphonic style, sometimes near to *atonality. His works include orchestral and chamber pieces, the most highly regarded being his Serenade in E♭ for strings (1892) and the String Quartet in B♭ (1896).

Sullivan, Sir Arthur (Seymour) (1842–1900), Irish-born British composer. Success came with a suite of incidental music to *The Tempest* (1861) and the impressive 'Irish' Symphony in E minor (1866). Even greater success followed with the *operettas he wrote for Richard D'Oyly Carte's Savoy Opera Company in collaboration with the librettist **Sir W(illiam) S(chwenk) Gilbert** (1836–1911). Starting as parodies of serious opera, they soon developed a distinctive style—tuneful, elegant, and witty. The operattas include *Trial by Jury* (1875), *The Sorcerer* (1877, revised 1884), *HMS Pinafore* (1878), *The Pirates of Penzance* (1879), *Patience* (1881), *Iolanthe* (1882), *Princess Ida* (1884), *The Mikado* (1885), *Ruddigore* (1887), *The Yeomen of the Guard* (1888), and *The Gondoliers* (1889). A quarrel between the two in 1890, though later resolved, ended their run of success, though *Utopia, Limited* (1893), and *The Grand Duke* (1896) are prized by some devotees. Neither Sullivan's serious opera *Ivanhoe* (1891) nor his oratorios have proved durable, though both were successful in their own day.

Sullivan, Louis (1856–1924), US architect, the central figure of the *Chicago School and a pioneer of *modernism. In 1881 he became the partner in Chicago of the German-born Dankmar Adler, and the firm of Adler and Sullivan existed until 1895. Sullivan was in charge of design, while Adler handled other matters. The most important buildings of the firm are the Auditorium Building in Chicago (1887–9), a complex including a 4,000-seat theatre, and two outstanding early skyscrapers: the Wainwright Building in St Louis (1890–1), and the Guaranty Building in Buffalo (1894–5). Of Sullivan's buildings after the dissolution of the partnership, the most important is the Schlesinger and Mayer (now Carson Pirie Scott & Co) Department Store in Chicago (1899–1904). In his buildings Sullivan directly expressed the metal frame structure in strong, clear façades, but he was not an uncompromising *functionalist, for he also introduced beautiful *art nouveau ornament. Sullivan was a highly influential figure, and his pupils included Frank Lloyd *Wright.

Sumerian art, the art and architecture of Sumer (the southern part of ancient Babylon, now southern Iraq), the site of a flourishing civilization of city states in the 3rd millennium BC. The Sumerians had one of the richest and most varied artistic traditions of the ancient world; it became the basis on which *Babylonian and *Assyrian art were developed. Most of our knowledge of Sumerian art is derived from the excavations of their cities, such as Ur and Erech. The dominant feature of the larger Sumerian cities was a temple-tower (ziggurat) built in from three to seven tiers or stages. The ziggurat was built of clay bricks, mainly kiln-baked and bonded with bitumen mortar. The bricks were probably brightly

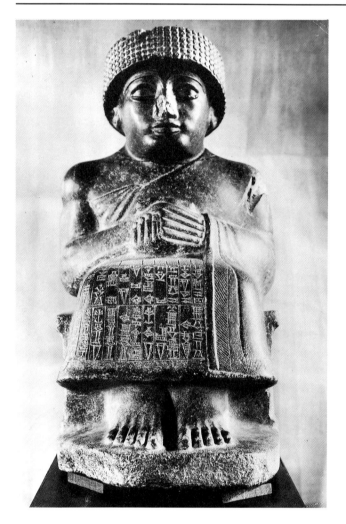

A statue of Gudea, who was ruler of Lagash (now in Iraq), one of the chief cities of Sumer, from about 2144 to 2124 BC. Under him **Sumerian art** had one of its richest flowerings. Several statues and sculpted heads of him exist; they are carved in very hard stone and typically show him with an aspect that combines serenity with strength.

coloured, white, black, purple, dark blue, red, silver, or gold, each stage of the building being a different colour. The main temples and buildings of the city clustered round the foot of the ziggurat. These buildings had wooden beams, which sometimes supported vaulted roofs, and they also used the arch and dome. The Sumerians decorated their façades with columns and bands of bitumen, into which were inlaid lapis lazuli, shell, and mother-of-pearl. They also made fine mosaics by setting variously coloured cones into clay or bitumen. Inlay work similar to the mosaics is found on many smaller objects such as boxes, lyres, and gaming boards. The Sumerians made jewellery of the most delicate gold and silver work. They made models of animals in copper, sometimes hammered over a bitumen core. Their craftsmen made pottery on a wheel, and sometimes coloured their pots deep purple in geometric and other designs. They knew the art of writing from 3300 BC or earlier, and made seals for use on the clay tablets which were their writing material. The seals were carved with a scene from some religious myth or with a picture of the owner's protecting god, and were also worn as charms. The engraving was often very fine, and the seals are the most frequent and the finest witness to the high standard of craftsmanship of their civilization. Wood, as well as stone, had to be carried from a distance, and was therefore used, like ivory, only for valuables such as musical and toilet instruments, or for essential purposes such as furniture and the sledges and wheeled vehicles which the Sumerians were the first to use. In about 2000 BC Sumer was absorbed by the Babylonian Empire.

Supervia, Conchita (1895–1936), Spanish mezzo-soprano singer. At only 16, Supervia was singing Bizet's *Carmen* and Oktavian in the first Rome production of Strauss's *Rosenkavalier*. Renowned for her interpretations of Rossini's coloratura roles (see *voice), notably Isabella in *The Italian Girl in Algiers* and Rosina in *The Barber of Seville*, Supervia was a singer of vivacious originality, with a distinctive timbre.

Suprematism, a Russian *abstract art movement, developed by *Malevich from about 1913 and officially launched by him in 1915. His Suprematist paintings were the most radically pure abstract works created up to that time, for he limited himself to basic geometrical shapes and a narrow range of colour, reaching the ultimate distillation of his ideas in a series of paintings of a white square on a white background, after which he announced the end of Suprematism. He had no significant Russian followers, but he had great influence on the development of art and design in the West.

Surrealism, a movement in art and literature that originated in France in the 1920s and subsequently had a richly varied influence on Western culture. Characterized by a fascination with the bizarre, the incongruous, and the irrational, it was a many-sided movement, but its essential aim was to try to liberate the creative powers of the unconscious mind by overcoming the dominance of reason. The group's objectives were partially anticipated by *Dadaism, a more extreme movement which flourished between about 1916 and 1922. André *Breton, the main founder and theoretician of Surrealism, said its purpose was 'to resolve the previously contradictory conditions of dream and reality into an absolute reality, a super-reality'. Within this aim it embraced a number of different and not altogether coherent doctrines and techniques, and in spite of Breton's efforts to hold the movement together there was little unity among the Surrealists, defections, expulsions, and personal attacks being a feature of the group. Many of them drew liberally on Freud's theories concerning the unconscious and its relation to dreams, but the ways in which they gave expression to these theories varied greatly. *Dali and other artists painted in a scrupulously detailed style to give a hallucinatory sense of reality to scenes that make no rational sense; while artists such as Max *Ernst experimented with relinquishing conscious control altogether (automatism). Surrealism became the most widely disseminated and controversial aesthetic movement between the wars, spreading not only throughout Europe, but also to the USA, where many artists migrated during the war years. With its stress on the marvellous and poetic, it offered an alternative approach to *Cubism and various types of abstract art, and its methods and techniques continued to influence artists in many coun-

tries. It was, for example, a fundamental source for *Abstract Expressionism.

Surrey, Henry Howard, Earl of (c.1517–47), English poet and soldier. He fought in the war with France (1543–6), but on his return was charged with high treason, and was executed, aged 30, on the orders of Henry VIII. Most of Surrey's poetry was probably written during his confinement at Windsor in his early twenties, but was not published until 1557. Like his friend *Wyatt, he followed Italian models, especially *Petrarch, but his *sonnets were in the English form which he appears to have invented. His major innovation was his use of *blank verse in his translation of Virgil's *Aeneid* Books II and IV. His most enduring poems are his love lyrics in *stanza form and his fine *elegy on Wyatt.

Sutcliffe, Frank Meadow (1853–1941). British photographer. Sutcliffe spent most of his adult life in the seaside town of Whitby, taking subtle and picturesque views of the town, its fishermen and other inhabitants, and the nearby countryside. A regular contributor to *Amateur Photographer*, as well as other magazines and newspapers, Sutcliffe was admired all over the world, though he rarely left Yorkshire. He was for almost the last two decades of his life curator of the Whitby Museum, which still owns his original negatives.

Sutherland, Graham (1903–80), British painter, graphic artist, and designer. Up to 1930 he worked mainly on *Neo-Romantic landscape etchings, influenced by the vision of Samuel *Palmer. In the 1930s he painted highly subjective landscapes and during World War II he was an official war artist, portraying the effects of bombing in views of ruined and shattered buildings. Soon after the war he took up religious painting, his most famous work being the design of the immense tapestry of *Christ in Glory* (completed 1962) in Coventry Cathedral. As a portrait painter he did oils of some of his famous contemporaries, including a notorious portrait of Winston Churchill (1954), which was so hated by the sitter that Lady Churchill later destroyed it. Sutherland's other work included the design of ceramics, posters, stage costumes, and decor.

Sutherland, (Dame) Joan (1926–), Australian soprano singer. Having created the role of Jenifer in Tippett's *The Midsummer Marriage* at Covent Garden, London in 1955, she was established as a leading dramatic coloratura (see *voice) with her 1959 performance as Lucia, in the revival of Donizetti's *Lucia di Lammermoor*. Her portrayals of Handel's heroines, notably the sorceress *Alcina*, and her performance as the three sopranos in Offenbach's *Tales of Hoffman* are also great successes.

Svevo, Italo (1861–1928), Italian writer. Born in Trieste, he was a banker and became a successful industrialist. His first novel *A Life* (1892) and his second *As a Man Grows Older* (1898) were virtually ignored. Only with *Confessions of Zeno* (1923) did he finally achieve recognition, thanks to the considerable influence of *Joyce, his tutor in English, and Eugenio *Montale, who in 1925 wrote of him as 'the greatest novelist our literature has produced from *Verga's day to our own'. Svevo brought to his writings a limpid prose and an unusual shrewdness of perception.

Sweelinck, Jan Pieterszoon (1562–1621), Dutch composer and organist. He was taught by his father and succeeded him as organist at the Oude Kerk, probably in 1577. Sweelinck's compositions include some 250 vocal works (madrigals, chansons, motets, and settings of the psalms and canticles) and about 70 for keyboard (some in the free toccata and fantasia forms, and some in the form of variations). His achievement is one of the high points of late Renaissance composition in northern Europe, and he was much admired as a teacher.

Swift, Jonathan (1667–1745), Anglo-Irish poet, political journalist, and the foremost satirist in the English language. He divided his time between England and Ireland and was ordained as an Anglican priest in 1694. His earliest works were his *satires, the mock-heroic *Battle of the Books* (1704), on the controversy between 'Ancient and Modern Learning', and *A Tale of a Tub* (1704), on 'corruptions in religioun and learning', directed with special vigour against the Roman Catholic Church. His most celebrated work, *Gulliver's Travels* (1726), a fantasy tale of travel in imaginary lands, is a powerful satire on man and human institutions. 'A Modest Proposal' (1729) in the format of a letter of advice, in which he suggests that the children of the poor should be fattened to feed the rich, is regarded as his masterpiece of satiric prose.

Joan Miró was the most subtle and poetic exponent of **Surrealism** and his work is always unpredictable: in 1933 he wrote 'It is difficult for me to speak of my painting, for it is always born in a state of hallucination, provoked by some shock or other, objective or subjective, for which I am entirely unresponsible.' This picture, *Women and Bird in the Moonlight* (1949), reflects his fascination with the theme of night, the time of silence and dreams. (Tate Gallery, London)

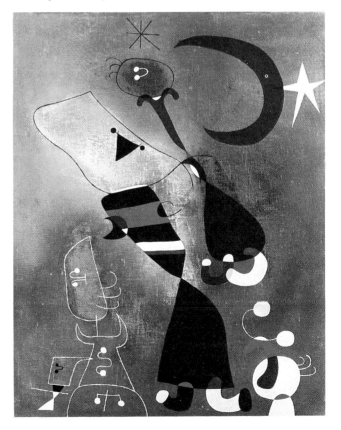

During his last years in Ireland he wrote some of his most famous tracts and characteristic poems, including *Verses on the Death of Dr Swift* (1739), in which he reviews his life with pathos and humour, and *Conversations* (1738), satirizing the stupidity and contrived wit of fashionable society.

Swinburne, Algernon Charles (1837–1909), British poet and critic, associated with the *Pre-Raphaelites. His great metrical skill is shown in *Atalanta in Calydon* (1865), a poetic drama in classical Greek form. *Poems and Ballads* (1866) shows an open contempt for Christianity (notably in 'Hymn to Proserpine') and celebrates the masochistic delights of flagellation and pagan sexual freedoms (especially in the hymn 'Dolores'). Much of his poetry centres around the idea of liberty: in *A Song of Italy* (1867) and *Songs before Sunrise* (1871) he uses an astonishing variety of verse-forms, often attempting the most complex Greek and French *metres. As a critic he contributed to the revival of Elizabethan and Jacobean drama, and his studies of Blake and the Brontës helped to establish their later appreciation.

swing *jazz.

Symbolism, a movement which flourished particularly in France in the 1880s and 1890s, based on the belief that the function of art is not simply to describe but to suggest, by means of symbols, the transcendent reality behind the surface appearance of things. In literature it had its origins in the work of Baudelaire and developed partly in reaction to the naturalism of writers such as Zola. Foremost among the Symbolist poets were *Rimbaud, *Verlaine, and *Mallarmé, who, to varying degrees, abandoned the constraints of rhyme, form, and metre in favour of liberated or free verse in which rhythm and musicality were stressed. Symbolist drama was written by *Maeterlinck, *Claudel, and *Jarry, whose work anticipated the ideas of the *Surrealists. In art the Symbolist movement reacted against the naturalistic aims of the *Impressionists. Its artists believed that colour and line in themselves could express ideas, and preferred suggestion and evocation to direct description. Stylistically, Symbolist artists varied greatly: *Moreau, for example, painted exotic pictures of great richness, whereas *Puvis de Chavannes's murals are pale, serene, and melancholy. Religious feeling of an intense, mystical kind was a feature of the movement, but so was an interest in the erotic and the perverse—death, disease, and sin were favourite subjects. Although chiefly associated with France, Symbolism had international currency and such diverse artists as *Burne-Jones and *Munch are regarded as part of the movement in its broadest sense, while in literature its influence was widespread, extending to Russia, where it stimulated a revival of poetry in the early 20th century in works by such figures as *Blok and *Bely.

symphonic poem, a musical term first applied by *Liszt to one-movement orchestral works constructed according to symphonic principles, but with the additional purpose of being descriptive of some real or imaginary story or event. The symphonic poem was very much the outcome of the *Romantic period's desire to imbue music with 'meaning' and emotion. Though few could achieve this end without at least some prompting from an apt title, or a detailed programme note, a considerable vocabulary of musical pictorial devices was built up over the years. By the time of Richard *Strauss, music was able to convey a truly amazing amount of narrative and description. Even so, composers found it essential to give such pieces a convincing musical structure over and above the 'programme'. Thus Strauss's *Till Eulenspiegel* is in *rondo form, while his *Don Quixote* is a theme and *variations. Many composers made use of Liszt's 'metamorphosis-of-themes' principle, whereby themes are subject to variation in keeping with the idea they are supposed to represent, while the entire composition is ensured a sense of symphonic coherence by being derived from a limited number of musical ideas. *Wagner's use of the *leitmotif derives from Liszt's invention. The introduction of the term 'tone-poem' in the latter part of the 19th century was as much a matter of taste as anything, though it is appropriate to works that depict a generalized 'atmosphere', as distinct from storytelling pure and simple, such as Bax's *Tintagel*. (See also *programme music.)

symphony, an extended musical work for *orchestra, usually in four contrasted movements. Derived from the Latin *symphonia*, the word was used in the 16th century to describe works in which voices and instruments 'sounded together'. In the 17th century it was applied to instrumental sections in an opera—most importantly the introductory *overture ('sinfonia'). Beginning as an extended fanfare, the overture took on the contrasted-movement characteristics of the dance *suite, as in the Italian and French overtures. Such pieces provided the model for purely concert works, constructed on a somewhat larger scale and involving four separate movements. Each movement developed its own characteristics. The first movement became an energetic *sonata form often preceded by a slow introduction; the second was slow and lyrical, a simple *aria form or a theme and variations; the third was a dance movement (invariably a *minuet (later *scherzo) and trio); while the fourth was a light-hearted *rondo or sonata form. This pattern, gradually gaining in overall proportions, intellectual weight, and thematic subtlety, remained standard throughout the 19th century. The development of the symphony is inextricably linked with that of sonata form and the whole concept of *tonality. Many composers contributed to this development, Haydn and Beethoven outstandingly. The 19th century saw the introduction of *programmatic elements (through Berlioz), and a move towards creating an even greater sense of unity between the movements through shared thematic material—the 'cyclic' symphony. At the same time there was a gradual loosening of formal structures, paralleling the general weakening of classical *tonality. Following the example of Beethoven's Ninth Symphony (1823), some composers (such as Mendelssohn and Mahler) introduced voices into their symphonies, some (Vaughan Williams, Britten) writing symphonies entirely for chorus and orchestra. The symphony has remained perhaps the greatest of all challenges to a composer's skill and imagination.

syncopation *rhythm.

Synge, (Edmund) J(ohn) M(illington) (1871–1909), Irish poetic dramatist, a key figure in the *Irish Literary Revival. He based his first plays, *In the Shadow of the*

sound can be controlled: pitch, intensity, tone-colour, quality of attack, duration, dynamics, and so on. The results can be recorded on tape for later reproduction, or played 'live' during a performance.

Synthetism, a movement in painting associated with *Gauguin and his colleagues at *Pont-Aven. Gauguin wanted to paint ideas and emotions rather than appearances, and he advised his disciples to 'paint by heart', simplifying the forms and colours of the natural world into bold patterns for the sake of more forceful expression. In Synthetist paintings the flat colours are typically enclosed with dark outlines in the manner of stained glass or *cloisonné* enamels, and the term Cloisonnism is applied to this style.

Szymanowski, Karol (Maciej) (1882–1937), Ukrainian-born Polish composer. His earliest works were influenced by *Brahms and Richard *Strauss, but from 1915 the influence of *Debussy and *Ravel began to be evident—his music became extremely ornate, highly chromatic, and voluptuous. This exotic quality was further enhanced by the brilliance and colour of his orchestration, as in the Third Symphony ('The Song of the Night', 1916), the First Violin Concerto (1916), and the opera *King Roger* (1924). Later works, such as the *Stabat Mater* (1926) and the Symphonie Concertante for piano and orchestra (1932), drew on folk sources.

This portrait of J. M. **Synge** is by John Butler Yeats, the brother of the poet. Of Anglo-Irish descent, his family claimed that the surname had been bestowed on a musical ancestor, John Millington, by Henry VIII, for the great beauty of his voice. (The Royal Library, Windsor Castle)

Glen (1903) and *Riders to the Sea* (1904), on stories and impressions he had gathered on his visits to the Aran Islands. Together with *The Well of the Saints* (1905) they were performed at the Abbey Theatre in Dublin. Synge became the theatre's director in 1906, and staged there his best-known and most controversial play, the comedy *The Playboy of the Western World* (1907), which caused riots for the frankness of its language and the implication that Irishmen would glamorize a murderer. His later plays were *The Tinker's Wedding* (1908) and the unfinished *Deirdre of the Sorrows* (1910), performed after his death. Synge used his characteristic spare, rhythmic, lyrical prose to achieve force and resonance, but many in Ireland found his ironic wit offensive.

synthesizer (in music), an electronic apparatus that changes electrical impulses into sound according to instructions given by the operator through a keyboard and a series of switches and variable controls. The sound is thus created by entirely artificial means and may differ completely from, or imitate more or less exactly, normal instrumental or vocal sound. Every aspect of synthesized

TABLA 444

T

tabla, a pair of finger-played *kettledrums, the main accompanying instruments in the classical music of the northern Indian sub-continent, with an extremely elaborate technique. The right-hand drum, tabla, a cylindrical kettledrum made of hollowed wood, is tuned to the tonic of the raga; the left-hand drum, *bāyă*, a metal or occasionally pottery bowl, is untuned, the pitch being controlled by pressure with the heel of the hand in performance. Both have a patch of tuning paste on the drumhead to eliminate the out-of-tune overtones so audible on European drums.

tablature, forms of musical *notation that do not use the new standard staves and varied note configurations, but tend to be more directly concerned with indicating where the player puts his fingers. Thus 'French' lute tablature (15th–18th centuries) normally has a six-line stave on which each line represents one course (pair of strings), adding a letter to show where the left-hand finger

In stave notation the lines represent actual notes, whereas in **tablature** they represent the strings of the instrument, while the letters indicate the position of the left-hand fingers relative to the frets. In this example of an ayre by Thomas Campion published in 1601, the stave notation for voice is printed immediately above the tablature notation for the lute accompaniment. Tablature was also used for music for the cittern, vihuela, and guitar.

should stop that string; 'Italian' lute tablature (15th–17th centuries) does the same, though with numbers instead of letters. 'German' lute tablature has no staves at all, but a different letter symbol for each intersection of string and fret on the instrument. German keyboard tablature (14th–18th centuries) simply gives the letter-names of the notes to be played; and other forms of keyboard tablature achieve the same by other means (including numbers). In all these systems the rhythm was indicated by symbols placed above the score. Tablatures used for wind instruments can be found in non-western sources back to the 9th century, and survive today in the abbreviated notations used for chords on the guitar and electronic keyboard instruments.

tableware, the cutlery, glasses, plates, and other items used while eating a meal. From ancient times much outstanding craftsmanship has been bestowed on such articles, and often their ornamentation has alluded to the foodstuffs with which they were designed to be used; the pottery of Bronze Age Crete, for example, was often painted with representations of marine life. Illustrations in medieval manuscripts show that elaborate and costly tableware was used at banquets at this time, and during the Renaissance distinguished artists sometimes designed articles for use at table—the most famous example is *Cellini, who made a celebrated salt-cellar for Francis I of France. Apart from the articles actually used in eating and drinking, there were also ornamental centrepieces and vases for flowers. From the 16th century the kind of formal table-setting with which we are familiar today gradually emerged, picturesque confusion giving way to orderly arrangement. Complete and sometimes elaborate matching table services came into general use in the 18th century, including the famous *Wedgwood dinner service commissioned by Catherine the Great of Russia. The 19th century saw the development of an elaborate system of fixed shapes for glassware and cutlery of different uses; within these basic shapes, however, ornamentation could vary widely.

tabor, a musical instrument, the drum of the *pipe and tabor, always with a snare (a strand of gut) on the struck head. Tabors vary in size. In the 13th century they were small; by the 16th they were larger, but by the late 19th the English Morris tabor was so small that a child's toy drum was often used instead. In France the Provençal *tambourin*, scored in Bizet's *L'Arlésienne* (1872), is much larger. The Basque *tambourin de Béarn* is a string drum, with heavy gut strings running along a narrow box.

Tachisme (French *tache*, 'spot' or 'blotch'), a style of painting popular in the 1940s and 1950s, particularly in France, characterized by the use of irregular dabs or splotches of colour. Tachisme had affinities with *Abstract Expressionism in that it strove to be spontaneous and instinctive, but tachiste paintings are more elegant and less aggressive than their US counterparts.

Tailleferre, Germaine *Six, Les.

Taj Mahal *Mughal art.

Tacitus, Publius Cornelius (AD *c*.56–*c*.117), Roman historian. His major works were the *Histories* (dealing with the period AD 69–96) and the *Annals*, dealing with

the difficult period in Latin history following the death of the emperor Augustus in AD 14. He saw it as the historian's function to record virtue and ensure that vice was denounced by posterity, and to this end he created a style as memorable as the events he records: condensed, rapid, and incisive. *Gibbon admired Tacitus more than any other ancient historian, and his own biting, epigrammatic style comes closest in English to the Latin of his exemplar.

Tagore, Rabindranath (1861–1941), Bengali writer. Born into a leading family of the Bengal renaissance, his earliest works appeared in his brother's magazine, *Bhāvati* ('Eloquence'). His long creative life produced over 1,000 poems and 2,000 songs (frequently set to his own music), introducing new metres and prose-poems into *Bengali literature. *Gītāñjali* ('Song Offerings'), his famous collection of mystical lyrics, appeared in 1910. Tagore's own English translations of these established him in the West, and in 1913 he was awarded the Nobel Prize for Literature. He wrote some forty plays and of his eight novels the most important is *Gorā* ('White'), contrasting orthodox and modern Hinduism. Tagore's were the first true short stories in Bengali, making Bengali prose style more colloquial and less classical. His many essays and letters reveal his political and social views and humanistic philosophy. He later achieved fame as a painter and educationalist, founding his international university at Shantiniketan.

Takemitsu, Tōru (1930–), Japanese composer. Mainly self-taught, Takemitsu has been influenced by those Western composers whose music has something in common with Japanese art—in particular an economy of line, a delicacy and sophistication in the deployment of orchestral and harmonic colouring, and the exploration of structures that do not depend on a sense of progressive time. Much of his music has been written for Western-style ensembles, but some incorporates Japanese musical instruments.

Talbot, William Henry Fox (1800–77), British inventor of photography. Talbot began experiments to preserve the images seen in a *camera lucida* (like the *camera obscura*, a device for projecting views on to a flat surface) in 1833. His first 'photogenic drawings' were 'photograms' (silhouettes of objects placed on photo-sensitive paper), but he soon progressed to photographs 'from nature'. Unlike the daguerreotypes of *Daguerre, Talbot's calotypes, as they were soon called, produced negatives from which positive prints were made. They were thus in many ways the true precursors of modern photography.

Tale of Genji, Japanese prose work of the 11th century. This long work—over 1,000 pages in translation—is often considered to be the masterpiece of Japanese literature. It tells of the life and loves of a prince, Genji, and the man presumed to be his son. Murasaki Shikibu, a court lady, is usually credited with its authorship.

Tale of Heike *Japanese literature.

talking drums, those used to imitate speech. Especially in tonal languages, whose patterns of high and low tones control the meaning of words, drummers can imitate tone and rhythm of words to transmit messages. In West Africa

*waisted drums, whose pitch is variable, or pairs of *kettledrums, are often used. Throughout Africa, and elsewhere, *slit drums and other instruments, such as paired bells, horns, and whistles, are also used. Only when linguists realized the importance of pitch tones in African languages was the efficiency of the so-called 'bush telegraph' understood.

Tallis, Thomas (c.1505–85), English composer. In 1543 he became a Gentleman of the *Chapel Royal, and remained in royal service for the rest of his life. In 1575, in partnership with William *Byrd, he was granted a monopoly in music printing. He was brought up in the Roman Catholic tradition, and his early music includes settings of the Latin liturgy, often on a grand scale. After the accession of first Edward VI and then Elizabeth I, Tallis composed excellent English anthems for the Anglican church. The *motet *Spem in alium* for forty voices combines inspired virtuosity with feeling and imagination. His masterpieces are settings of the Lamentations of Jeremiah—dark-hued, harmonically rich, and extraordinarily emotional works which can compare with the finest music ever written for Holy Week. *The Mulliner Book* (c.1560) contains examples of his keyboard music, as well as arrangements of part-songs by him.

Talman, William (1650–1719), English architect. He was the outstanding designer of country houses in the 1680s and 1690s before being eclipsed by Vanbrugh. His most important work was carried out at Chatsworth House in Derbyshire, where he rebuilt the south and east fronts (1687–96) with designs revealing a thorough knowledge of continental styles that brought a new *Baroque splendour to the English country house.

tambourin *tabor.

tambourine, a shallow, single-headed drum with miniature cymbals in the frame to add a jingle. It was used in the Middle Ages and as a folk instrument. It came into the orchestra from the military band in the 19th century, to give an Arab, Spanish, or Italian flavour; later it became an instrument in its own right. It is widely used, sometimes with a snare across the head instead of the jingles, in North Africa, the Middle East, and the Indian sub-continent, and was used in ancient times in Greece, Mesopotamia, and ancient Israel.

tambūrā, an Indian long-necked plucked musical instrument with four strings. The strings are tuned to the tonic and other important notes of the raga. They are never stopped but are plucked to produce a continuous *drone, essential in Indian music as a permanent reference point for both players and listeners.

Tamil literature, the principal *Dravidian literature. It has the oldest unbroken literary tradition of any living Indian language, beginning in the earliest centuries AD. The first texts are a grammar, *Tolkāppiyam* ('The Ancient Poem'), and over 2,000 verses of love and war collected as *Ettuttokai* ('Eight Anthologies') and *Pattuppāṭṭu* ('Ten Songs'), representing an ancient bardic tradition quite unlike the Sanskrit. The collection of proverbs *Tirukkuṟaḷ* ('The Sacred Maxims') (AD c.500) is regarded by Tamils as 'the fifth Veda'. From the 6th century Sanskrit influence is seen in epic romances such as *The Lay of the Anklet*,

describing a nobleman's passion for a courtesan. *Bhakti literature first flourished in Tamil with the mystical hymns to Shiva and Vishnu of the Nayanmar and Alvar saint-poets (7th–10th centuries). *Sanskrit literature was widely imitated, such as the Chola court-poet Kampan's 12th-century *Rāmāyaṇa*. Christian missionaries began a Tamil prose tradition in the 17th and 18th centuries, but the first Tamil novel, Vetanayakam Pillai's *The Life of Pratapa Mudaliar*, a moralistic tale of south Indian life only appeared in 1879. The first modern Tamil poet was Subrahmanya Bharati (1882–1921), who through his essays also broadened the scope of Tamil prose. Short stories were first successfully attempted by V. V. S. Aiyar (1881–1925). In both classical and modern Tamil literature drama has been comparatively undistinguished.

tam-tam *gong.

Tange, Kenzo (1913–), Japanese architect. He is one of a group of architects who, mainly inspired by *Le Corbusier, brought Japan into the mainstream of modern architecture after World War II while retaining a feeling for national tradition. In the 1950s he built a series of town halls and other civic buildings using exposed concrete in the *Brutalist manner, but with his pair of sports halls for the Tokyo Olympic Games (1964), buildings with dynamic, sweeping curves, he entered into a more original phase. From about the same time Tange has received prestigious commissions from outside Japan, and his influence has been spread by his teaching (notably at Tokyo University, where he was professor for several years), as well as by his buildings.

Tang Xianzu (1550–1616), Chinese dramatist of the Ming dynasty (1368–1644). Famed for the delicate sensitivity of his poetry, he is considered to be one of China's greatest playwrights. Of his five plays, his masterpiece is *The Peony Pavilion*, the tragic account of an aristocratic girl who reaches beyond the constraints of her family in an attempt to find her identity, and whose love for a young scholar triumphs over death.

Tanizaki Jun'ichirō (1886–1965), Japanese novelist. His early romantic works gave way to concern for social conflict, but always with strong erotic themes. His story *The Tattooer* (1910) tells of the effect of a spider tattooed on the body of a beautiful girl, the autobiographical *Some Prefer Nettles* (1928–9) deals with marital breakdown and the clash of traditional and modern culture in Japan, and *The Makioka Sisters* (1957) examines social trends through the decline of a once powerful family, based on those of the author's wife and his own.

tanka, one of the forms of *Japanese poetry. The tanka is a short poem of thirty-one syllables in five phrases of five, seven, five, seven, and seven syllables respectively. It contrasts with the longer *renga* and has been the dominant form in classical Japanese poetry from the 7th century to the present century. From it sprang both *renga* and *haiku*.

tango, a *Latin American couple dance in duple time that evolved in the late 19th century in the poorer districts of Buenos Aires and was later exported to North America and Europe. It has a characteristic halting, repeated rhythmic figure in the accompaniment, and consists of two sections of equal length. There is a stylized tango in *Stravinsky's *L'Histoire du soldat*, and the dance has found its way into the works of British composers such as *Walton.

Tansen (*c*.1500–89), considered in India as the supreme exponent of North Indian or Hindustani classical music. His musical genius first flowered in Gwalior and he was brought to Akbar's courts in Agra and Fatehpur Sikri, where he was an honoured member and one of the celebrated 'jewels' of the court. Legends about Tansen's musical achievements abound; even details about his life have assumed legendary proportions. As well as being remembered as a matchless vocalist, Tansen was also an exponent of the *bin* (a stringed instrument).

Tao Qian (365–427), one of China's major poets, the greatest of the Six Dynasties period (AD 222–589). He was a daoist recluse, whose poetry, which describes the pleasures and pains of rural life, is written in a plain style which influenced many poets who came after him. He used several verse-forms, exploring a variety of genres for lyrical expression. He is best known for a story, mostly in prose, which can lay claim to being the most famous in China: the 'Peach Blossom Spring', which tells how a fisherman lost his way and stumbled into a utopia which he was never able to find again.

tapestry, a term that is often loosely applied to any heavy ornamental fabric used as a wall-hanging, but which more correctly signifies a hand-woven textile in which the design is formed by lengthwise threads (wefts) inserted over and under the vertical threads (warps) according to the requirements of colour; the design is thus an integral part of the material, rather than something superimposed on it. Although tapestries are most often used for wall-hangings, they have also been used as upholstery fabrics; the usual materials for the warps are wool, linen, or hemp, and wool is also the most common material for the wefts, although silks and even silver and gold threads have been used for richer effects. The weaver generally worked from a full-size coloured drawing called a cartoon. Although the technique was known in the ancient world, the early history of tapestry is obscure. From the late 14th century of a continuous tradition can be traced in Europe with important developments in Paris and the Franco-Burgundian territories, and from then tapestries were an essential part of medieval interior decoration. They continued to be popular until well into the 18th century, when they began to give way to cheaper coverings such as *wallpaper. Tapestries have been woven in every continent, the silk tapestries of Asia (see *Chinese decorative arts) being particularly fine. In Europe, France has the richest tradition in the art, with particularly well-known factories at Arras, Aubusson, Beauvais, and Paris (the *Gobelins manufactory). In the 20th century leading artists of the *Modern Movement, including Matisse, Braque, and Picasso, used tapestry as a medium, while one of the most ambitious tapestries of the century, 'Christ in Glory', was designed in 1962 by Graham Sutherland for Coventry Cathedral in Britain. (See also *Brussels tapestries, *weaving.)

tār, a Persian and Causcasian long-necked plucked lute with a small double-lobed body shaped rather like a figure eight, with three double courses of thin metal

strings. The *setār* (meaning three strings) is found more widely over Central Asia and, like the *saz, has a small pear-shaped body; it was the origin of the Indian *sitar under the Mughals. The same name, but aspirated as *ṭār*, is also used for a large *frame drum in much of the Arab world and Malaysia.

Tarkovsky, Andrei (Arsenevich) (1932–86), Russian film director. He was one of a group of young directors who rejected the constraints of *Socialist Realism in the post-Stalin era, and his works were often attacked by the Soviet authorities. His first film, *Ivan's Childhood* (1962), describes a childhood disrupted by the Nazi invasion of Russia during World War II. This was followed by a mere six films, the most famous of which is *Andrei Rublev* (1966), set in medieval Russia and offering the story of an icon-painter set against the 200-year long strife between Russians and Tatars. His other major work is the science fiction film *Solaris* (1971), which explores the theme of the conflict between the spiritual and the material, and was shot in black and white. Other films included *Mirror* (1975), an account of his own childhood; *Stalker* (1978), another science fiction film; *Nostalgia* (1983); and *The Sacrifice* (1986), which won the special grand prize at Cannes.

Tartini, Giuseppe (1692–1770), Italian composer and musical theorist, who helped to establish the modern style of violin bowing and defined a set of principles, published in 1767, of musical ornamentation and harmony. Most of his career was passed in Padua, where he founded an influential school of violin playing in 1728. He composed more than 100 violin concertos and sonatas, including the 'Devil's Trill', and concerti grossi, as well as the *Art of the Bow* (a set of thirty-eight variations on a gavotte by Corelli) and religious works.

Tasso, Torquato (1544–95), Italian poet and dramatist. He entered the service of the dukes of Este at Ferrara, where from an early age he wrote poetry and produced his pastoral drama *Aminta* (1573). A serious, vulnerable, and self-questioning man, Tasso's life was a long decline into illness and insanity. His poem *Jerusalem Delivered* (1574), intended to give Italy a religious *epic, revolves round the Crusaders' conquest of Jerusalem in 1099. He succeeds in creating memorable heroes and heroines and in infusing the poem with a melodious, elegiac quality. Tasso's epics and critical works had a great influence on English literature, notably on Spenser, Milton, Dryden, and Gray, while Byron and Goethe wrote works on his tragic life.

Tati, Jacques (Jacques Tatischeff) (1908–82), French film actor and director. He began his career as a music-hall entertainer, and then wrote, produced, and acted in *slapstick film comedies. Tati's first feature was *Jour de fête* (1947), about a village postman. His fame rests largely on the character of Monsieur Hulot, whose physical ineptness and loping walk were first seen in *Les Vacances de Monsieur Hulot* (1953). With its minimal dialogue and visual jokes it established a pattern for three more Hulot films: *Mon oncle* (1958), which satirized gadgetry and social climbing; *Playtime* (1967), in which US tourists find Paris as skyscraper-ridden as home; and *Trafic* (1971), focusing on the motor-car, in which Tati once more returned to a characterization of Monsieur Hulot.

Tatlin, Vladimir (Yevrafovich) (1885–1953), Russian painter, designer, and maker of abstract constructions, the founder of *Constructivism. After seeing *Cubist pictures by Picasso in Paris in 1913, he began to produce highly original constructions made from a variety of everyday materials, including glass, wire, and wood. After the Russian Revolution of 1917 he supported the demand for socially oriented art (see *Socialist Realism), and in 1919 he was commissioned to design the monument to the Third International Communist Congress, which was to be held in Moscow in 1921. This huge structure, a sloping open-work tower planned to be bigger than the Eiffel Tower, was never built, but it is recognized as the outstanding symbol of Soviet Constructivism.

tattooing, the decoration of the human body with permanent patterns made by pricking the skin and inserting pigment. The practice is ancient (tattoos have been found on Egyptian mummies of about 2000 BC) and is known in virtually every part of the world. Apart from its decorative purpose, tattooing has been practised for a variety of reasons: in some cultures it has ritualistic significance in puberty or maturity rites; it has been believed to have talismanic powers against disease or ill luck; and it has been employed to mark criminals and persecuted groups. Among many peoples tattooing has been regarded as a sign of manliness and courage, but among others it is considered effeminate. To the Polynesians it is a mark of wealth and social prestige. Tattooing went out of favour in Europe with the advent of Christianity. At the time of the conquest of America tattooing was extensively practised by the Indians of North and Central America and by some peoples, mainly in the tropical areas, of South America. Tattooing was carried to its highest level of technical and artistic perfection in Japan, but it was banned there in 1889.

Taverner, John (*c.*1490–1545), English composer. He was the first master of the choristers at Cardinal College (now Christ Church), Oxford (1526–30), where choral music on a large scale was encouraged. He wrote a number of very fine masses, some, such as the six-part *Corona spinea* and *Gloria tibi Trinitas*, in a large-scale festal manner, not only showing great contrapuntal skill (see *counterpoint) but also profound musicality. His smaller-scale masses, including the well-known one on the 'Western Wynde' melody, point the way to the simpler style of church music which was to become common later in the century. Most notable are his three *polyphonic antiphons of the Blessed Virgin Mary.

Taylor, Paul (1930–), US dancer, choreographer, and director. He studied with *Graham and *Humphrey and danced with *Cunningham and Graham before founding his own company in 1954. His choreography ranges from *Three Epitaphs* (1956), an unusually humorous work for the modern idiom; *Aureole* (1962), a lyric, abstract dance; and *Esplanade* (1975), a masterpiece of dance made out of running and walking steps. His darker side is reflected in *Cloven Kingdom* (1976).

Taylor, Sir Robert (1714–88), British architect. He began his career as a sculptor (the pediment of the Mansion House in London is his work). City merchants and bankers formed the bulk of his clientele, and for them Taylor designed country villas as well as commercial

premises. He was immensely hard-working and is usually considered a highly competent rather than an inspired designer, working in a basically *Palladian style.

Tchaikovsky, Pyotr (Ilych) (1840–93), Russian composer. His studies included composition lessons at the St Petersburg Conservatory with the composer and pianist Anton Rubinstein (1829–94). In 1866 he moved to Moscow, teaching at the Moscow Conservatory (1866–78) and consolidating his reputation with such works as the fantasy overture *Romeo and Juliet* (1869). In 1877 he entered into a marriage which was ruined by the underlying tension of his homosexuality. A platonic relationship by letter (1876–90) with the wealthy widow Nadezhda von Meck proved an important spiritual and material aid to his well-being. Mystery surrounds his death, one theory being that he committed suicide at the behest of a 'court of honour' summoned to avert a homosexual scandal. His music includes six important symphonies (1866–93), the most famous being the Sixth or 'Pathétique'; concertos for piano (1875, 1880, 1893) and violin (1878); songs, choral and chamber music; ballets (including *Swan Lake*, 1876; *The Sleeping Beauty*, 1889; and *The Nutcracker*, 1892); and operas (including *Eugene Onegin*, 1878; and *The Queen of Spades*, 1890). The style of his emotionally charged music was marked by flair and brilliance, yet often tinged with a brooding fatalism, particularly in his later years.

Tecton, the name adopted by a group of architects who were the leading representatives of the *Modern Movement in Britain. The group was founded in London in 1932, and disbanded in 1948. The most important member was the Russian-born Berthold Lubetkin who worked in Moscow, Leningrad, and Paris, before settling in London in 1931. Amongst Tecton's most famous works

are the Penguin Pool at London Zoo (1935), which consciously imitates the forms of the Russian *Constructivist sculpture of Gabo and Pevsner, and two coolly elegant blocks of flats in Highgate, London, Highpoint I (1933–5) and Highpoint II (1936–8).

Telemann, Georg Philipp (1681–1767), German composer. He was a supreme exponent of the new *galant* style of composition, writing music designed to meet the needs not only of ecclesiastical and aristocratic patrons, but also of the growing number of middle-class musicians and audiences, for whom he established musical societies in each of the major cities where he worked. He is probably the most prolific composer in the history of music, working in every major genre, including opera. In 1721 he became Kantor of the Johanneum, Hamburg, and remained music director of the city's five main churches until his death. His music is marked by bold harmonies, natural melody, buoyant rhythm, and beautiful instrumentation.

tempera, a term originally applied to any paint in which the *pigment is dissolved in water and mixed (tempered) with an organic gum or glue, but now generally confined to the most common form of the medium—egg tempera. Egg tempera was the most important technique for *panel painting in Europe from the beginning of the 13th century until the end of the 15th, when it began to be overtaken by oil. Tempera painting has had a revival in the late 19th and 20th centuries, Andrew *Wyeth being a noted exponent.

temperament (in music), a term for the adjustment of intervals involved in the various systems used in tuning the notes of the octave. In the acoustically 'pure' or 'untempered' *scale that arises in the natural *harmonic series, the semitones vary very slightly in size. Thus a semitone between, say, the second and third degrees of one scale might not fit when required to serve between the fifth and sixth degrees of another scale. These differences pose no problems to singers, or to instruments (such as the violin family) that can vary their *pitch at will, but they do pose problems with instruments (such as the keyboard) in which the pitch is fixed as part of their construction. With fixed-pitch instruments it was not possible to pass satisfactorily from one *key to another

Tempera is a difficult medium to handle, as the colours are few and not easy to blend. The subtle effects that Botticelli achieves in his painting 'Venus and Mars' illustrated here depended on a slow building-up process, in which each layer of paint would have a calculated effect on the next. However, although it is not as versatile as oil paint, tempera produces an attractive smooth surface that withstands the passage of time well. (National Gallery, London)

until tuning in equal temperament had been adopted. A step towards this was mean-tone tuning, developed in the 16th century, which rendered tolerable the relationship between certain keys, but left others unusable. It was probably a modified version of such a system, allowing free modulation from key to key with good effect, which Bach used for his 48 preludes and fugues 'The Well-Tempered Keyboard'. The move to equal temperament was led in the 17th century by the French mathematician Mersenne. In this the octave is made up of twelve equal semitones in which each interval is slightly out of tune, but still acceptable to the average ear.

tempo *time and tempo.

Teniers, David (the Younger) (1610–90), Flemish painter, the most important member of a family of Antwerp artists. His output was huge and varied, but he is best known for his peasant scenes. In 1651 he was appointed court painter to Archduke Leopold Wilhelm of Austria, governor of the Austrian Netherlands, and was also made custodian of the archduke's art collection. He made paintings of the galleries in which the works of art were installed and painted small copies of some of the pictures. His father, **David** (the Elder) (1582–1649), was primarily a painter of religious scenes. Few paintings are known that are certainly by him, and many formerly attributed to him are now ascribed to his son, with whom he may have collaborated.

Tennyson, Alfred, 1st Baron Tennyson (1809–92), British poet. At Trinity College, Cambridge, he met Arthur Hallam, whose early death he mourned in a series of *lyrics, *In Memoriam* (published anonymously, 1850), which express his own awareness of change, evolution, and immortality. His early poems (*Poems*, 1833) include 'Mariana' (1830); and 'The Lady of Shalott', 'The Lotos-Eaters', and 'A Dream of Fair Women'. His 'Morte d'Arthur' (1842) was later incorporated in *Idylls of the King* (1885), an expansive series of twelve connected verse *romances on the Arthurian legend. He was admired by Victoria and Albert and in 1850 was appointed *Poet Laureate. In this capacity he wrote an 'Ode on the Death of the Duke of Wellington' and 'The Charge of the Light Brigade' (1854), composed after the charge at Balaclava. His long narrative poem *The Princess* (1847) and the monodrama *Maud* (1855) contain some of his best-loved lyrics. Among his later works are his narrative poem *Enoch Arden* (1864), several dramas including the tragedies *Becket* and *The Cup* (both 1884), and the short poem 'Crossing the Bar' (1889), in which the poet conveys his awed sense of the mystery of life.

Teotihuacán, a site in the Valley of Mexico, north-east of Mexico City, containing well-preserved monumental architecture from about 1st to 7th centuries AD. Here was located the most extensive and sumptuous ceremonial centre of central Mexico in the pre-Toltec period. The focal point of the ensemble is the largest and earliest structure, the Sun Pyramid, built up of solid layers over a natural cave. Later ritual platforms are supported on a honeycomb of pillars in-filled with rubble, and richly adorned with decorated façades. Smaller structures, built, like the large pyramids, on platforms, and usually screened by right-angled colonnades, have ornately carved and painted interior spaces. The layout seems to have been determined by a solar ritual, for the face of the central pyramid is aligned with the setting midsummer sun and all the other important buildings are related to it axially. When the Teotihuacán culture collapsed in AD *c*.700, features of this architecture seem to have been transferred to sites on the edge of the Valley of Mexico, notably Xochicalco and Cholula. (See also *Central American and Mexican architecture.)

Terborch, Gerard (1617–81), Dutch painter and draughtsman. He is noted for his portraits and pictures of elegant society, to which his gifts for delicate characterization and exquisite depiction of fine materials were ideally suited. Unlike most of the Dutch artists of his time he travelled extensively. In Germany in 1648 he painted *The Swearing of the Oath of Ratification of the Treaty of Münster*, a group portrait of the signatories to the treaty that gave the Dutch independence from the Spanish.

Terbrugghen, Hendrick (1588–1629), Dutch painter. After training with Bloemaert in Utrecht he spent a decade in Rome and on his return to the Netherlands he became the leader of the painters in Utrecht who adopted *Caravaggio's style. Terbrugghen was chiefly a religious painter, but he also painted some outstanding *genre works. His style was sensitive and poetic.

Terence *Roman comedy.

ternary form, a three-part musical structure consisting of two similar (or identical) outer sections with a

This portrait of **Tennyson** (1869) is one of several made of him by the pioneering Victorian photographer Julia Margaret Cameron. In an introduction to a selection of Tennyson's poems W. H. Auden wrote of him: 'He had a large, loose-limbed body, a high, narrow forehead, and huge bricklayer's hands; in youth he looked like a gypsy; in age like a dirty old monk.' Tennyson himself called this photograph 'The Dirty Monk'. (National Portrait Gallery, London)

contrasting section in between. The contrasting section is usually in a different key. This ABA pattern is one of the simplest yet most satisfying forms in music, the whole principle of statement, contrast, and restatement being at the root of even the most sophisticated formal structures. Such types as the *minuet and trio, the da capo *aria, and the lyrical slow movements of sonatas and symphonies are in ternary form.

terracotta (Italian, 'baked earth'), baked clay that has not been glazed. The word is applied also to the reddish-brown colour considered most typical of the material, although it occurs in various other colours. Terracotta is a form of earthenware, but from ancient times it has been used for statues (usually small-scale) and architectural ornaments, and it is to these rather than pottery that the term usually refers.

Terry, Dame Ellen (Alice) (1847–1928), British actress. A member of a theatrical family, her beauty of voice and gesture were widely acclaimed. In 1878 she began her famous partnership with Henry *Irving, playing most of the Shakespearian heroines as well as contemporary roles. In 1906 she appeared as Lady Cicely Waynflete in Shaw's *Captain Brassbound's Conversion*, a role created for her.

Tetley, Glen (1926–), US dancer and choreographer. He studied with Holm, Tudor, and Graham, and danced with modern dance and ballet companies, including American Ballet Theatre. *Pierrot Lunaire* (1962) shows his particular flair for mixing elements of the two genres in an expressionistic, theatrical work. It is a style that has found a ready audience in Europe, particularly through the Netherlands Dance Theatre and Rambert Dance Company.

Thackeray, William Makepeace (1811–63), British novelist. He began a career in journalism and later studied art in London and Paris. His early works include *The Luck of Barry Lyndon* (1844), a portrayal of 18th-century society. From 1842 he joined the staff of the newly founded radical pictorial *Punch*, contributing caricatures, articles, and humorous sketches, some of which were collected in *The Book of Snobs* (1846–7). His major novel *Vanity Fair* (serialized between 1847 and 1848 and illustrated by himself), was set in Regency England. It satirizes the pretensions of society through its central character, the socially ambitious and unscrupulous Becky Sharp. It was followed by a fictionalized autobiography, *Pendennis* (1848–50); *The History of Henry Esmond, Esq* (1852), a virtuoso novel in 18th-century style, and its sequel *The Virginians* (1857–9), set partly in the USA; *The Newcomes* (1853–5); and many other novels. He was at his best as a powerful satirist and moral realist exposing with a sharp eye the hypocrisy, vanity, and snobbery of society.

Thai art, the art and architecture of Thailand, formerly called Siam. The peninsula region of modern Thailand was probably the earliest part of south-east Asia to receive sustained Indian contact with Hindu merchants from southern India. The dominant people of the region, the Mon (who also played a part in *Burmese art), adopted Buddhism and produced, during the Dvāravatī kingdom (7th–9th century), stone and bronze Buddha images of serene beauty, modelled on contemporary eastern Indian images (see *Buddhist art). Lopburi (11th–13th century) became an important source of *Khmer influence, developing the sanctuary tower (*prang*) into a key feature of Thai architecture and giving new life to Khmer-style Buddha images. The first autonomous Thai kingdom was established in about the middle of the 13th century, after the provincial rulers of the Sukhothai region of central Thailand broke from a weakened Khmer empire in 1238. The architectural legacy of the Sukhothai kingdom is seen in the numerous Buddhist complexes (*wats*) at the twin cities of Sukhothai and Sisatchanalai (Sawankhalok) and at Kampheng Phet. These remains reveal a prosperous state generously endowing the Buddhist community (*sangha*). Theravāda Buddhism laid stress on accumulating merit and this resulted in the building of numerous monasteries and the commissioning of bronze images in vast quantities. Thai temple architecture followed Khmer models, but also developed an indigenous style partly inspired by Sinhalese Buddhist art. Evangelical contacts with Sri Lanka (Ceylon) introduced the concept of the 'walking Buddha', which became part of the classical repertoire of Sukhothai art. The Sukhothai-style Buddha image is sinuous, with crisp features and clinging wet 'drapery' which barely disturbs the smoothly contoured surface. Thai temples were richly decorated with stucco and glazed ceramic ornament and housed images of the Buddha, often of monumental scale. In 1438 Sukhothai came under the control of the rival kingdom, Ayudhya, which continued the Buddhist art tradition. Much of the art production of Ayudhya and of the northern school of La Na, centred at Chieng Mai, perished in regional conflicts and in the devastating wars with the Burmese, who sacked Ayudhya in 1767. The capital was moved to Bangkok, but the art of this later period, the Ratanakosin school, was consciously archaistic, looking back to the lost glories of Sukhothai and Ayudhya. From the second half of the 19th century, however, a growing interest in both Chinese and European art stimulated some fresh artistic activity. Remains of Thai ceramics are known from Neolithic times, but glazed wares are associated with the foundation of the first Thai kingdom of Sukhothai in the 13th century. By the 14th century Sukhothai and Sisatchanalai centres were producing glazed domestic stoneware, architectural ornaments and tiles, and wares for the growing export market to maritime South-East Asia. Underglaze iron-brown painted wares, typically with fish or flower designs, and a thickly glazed greenware (see *celadon) were the dominant types produced. This trade reached its peak in the 15th and 16th centuries. Other kiln centres grew up around Ayudhya and in the north around Chieng Mai.

Thai literature. The earliest example of Thai poetry, the *Sayings of Phraruang*, was compiled in the reign of King Ramkhamhaeng (*c.*1275–1317) of Sukhotai. It belongs to the didactic genre known as *suphasit* and influenced many later poetical works. Like much Thai literature, it is strongly influenced by Buddhist themes and text. An important early Thai prose work compiled

The attenuated sophistication characteristic of **Thai art** is well illustrated in this 17th-century bronze head of Buddha, *right*. Thai artisans simplified the traditional Indian form of the Buddha to present a subtly refined spiritual ideal. (Private collection)

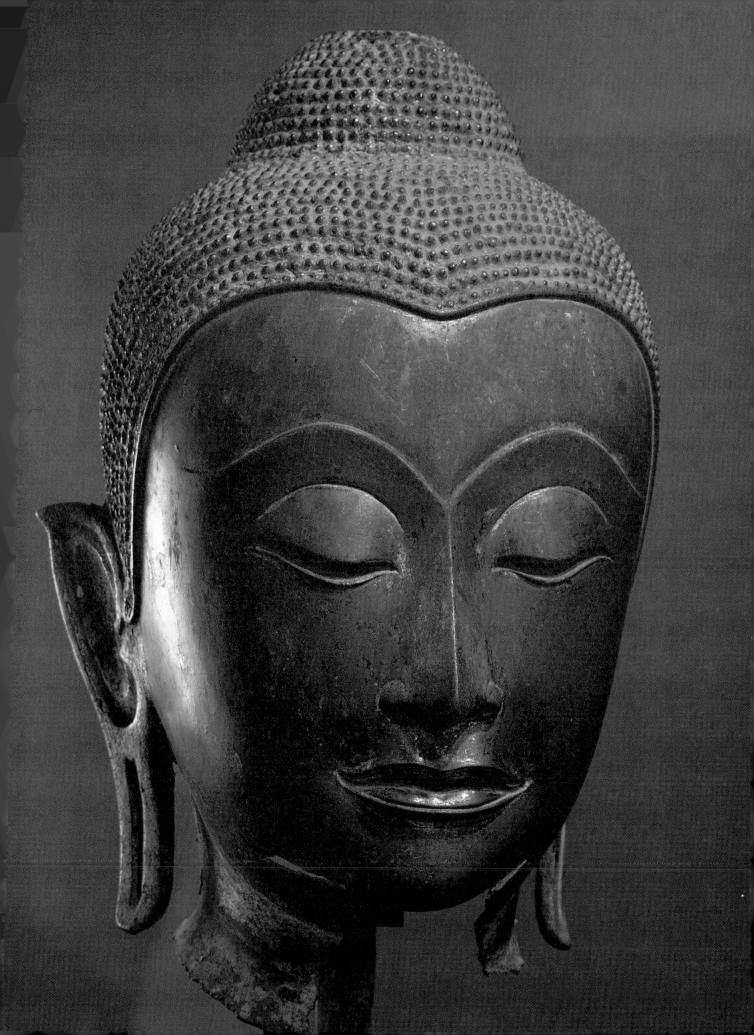

in 1345 is the *Three Worlds Cosmography of Phraruang*, which describes the hells, the earth, and the heavens according to Buddhist cosmology. The text has over the centuries been elaborated upon and is often depicted in temple wall-paintings. In the Ayutthaya period (1380–1767) poetry predominated and five main types of verse-form, with numerous sub-classifications, developed and remain in use to this day. These verse-forms (called *chan*, *kap*, *khlong*, *klon*, and *rai*) each had complex rules governing the number of syllables and their rhyming patterns. A combination of the *rai* and *khlong* verse-forms called *lilit* developed in the 15th century, while in the 17th century a form of long reflective poetry known as *nirat* reached perfection. The poem *Siprat's Lament*, written by the exiled poet Siprat, is a masterpiece of this genre. The Indian epic the **Rāmāyaṇa* (called in Thai *Ramakian*) was a source of inspiration in much Thai literature, above all in Thai drama, dance-drama, and **shadow-play performances. Many Thai literary works were lost in the Burmese destruction of Aytthaya in 1767, but following the establishment of a new Thai dynasty and capital at Bangkok in 1782, much new literature was produced and prose writing perfected. Thai kings and members of the royal family and court played a leading part in the revival of Thai literature and composed many original works. The opening up of Thailand to the West, begun by King Mongkut (1851–68), and the introduction of printing contributed to the development of a modern prose literature and to the first fictional works, some adapted and translated from Western sources. After the revolution of 1932 composition in traditional genres declined, and the short story and novel became established and popular forms of writing.

Tharp, Twyla (1942–), US dancer, choreographer, and director. She studied with Graham, Cunningham, and Taylor, and has choreographed and danced with her own group and made works for television, Broadway, and major ballet companies. Her structural explorations culminated in *The Fugue* (1970). American popular dance is evident in *Eight Jelly Rolls* (1971) and *Nine Sinatra Songs* (1982), with their casual movement and comment on current social issues.

theatre, a building or outdoor area for the performance of plays and similar entertainments. The earliest recorded theatres were in Ancient Greece, and evolved from the worship of Dionysus (see **Greek theatre). They were set on hillsides around which were ranged semicircular tiers of seats, with a circular area (orchestra) containing the altar at the foot, where the **chorus performed. Beyond the orchestra was a stage, initially low but later raised, and a stage-wall. The Roman theatre seldom used sloping ground, and the lofty stage building formed a single unit with the semicircular auditorium, both rising to the same height. The actors performed on a raised stage, the front of which was usually decorated with reliefs. The outer walls of the auditorium were composed of several storeys, each formed by a row of arches. Huge amphitheatres, like the Roman Colosseum, resembled double theatres, with an arena in the middle. The theatres of Renaissance Italy (there were none during the Middle Ages; see **booths and **liturgical drama) were modelled on the Roman and Greek, but were covered. The curtained proscenium arch between the auditorium and stage was introduced, as was **perspective, and the audience oc-

cupied what had been the orchestra. Thus the horseshoe-shaped auditorium evolved, and it quickly became the most popular design everywhere. The platform stage of the **Elizabethan theatre later became the apron stage (in front of the proscenium arch), which formed the acting area of the Restoration theatre, with proscenium doors on each side through which the actors entered and exited. The apron stage was retained in 18th-century Georgian theatres, but the actors gradually moved back behind the proscenium arch among the scenery. By the early 19th century the apron stage had disappeared and the 'picture-frame' stage reigned supreme. Many theatres were built during the 19th century; exteriors improved, interiors grew more luxurious. Modern theatres such as the picture frame and the open stage (a descendant of the Elizabethan platform stage) are usually better designed. The popular theatre-in-the-round ensures intimacy between actors and audience, especially in 'promenade' productions in which the actors mingle with a standing audience. Flexible staging, which can be adapted for various styles of presentation, is popular with **fringe groups and in the small studio theatres attached to many large theatres or forming part of arts complexes. Many theatrical performances are also given in public houses and other buildings never intended for theatrical events, and on the streets. (See also **set design, **stage machinery.)

Theatre Workshop, a British theatre company founded in 1945 by a group of actors who were dissatisfied with the commercial theatre 'on artistic, social, and political grounds'. Joan Littlewood became its artistic director. The company took over the Theatre Royal, Stratford, in London, and opened in 1953 with *Twelfth Night*. Left-wing in its ideology, it sought always to revitalize the English theatre by a fresh approach to established plays, or by commissioning working-class plays, many of which were subsequently transferred to West End theatres, among them Brendan Behan's *The Quare Fellow* (1956) and *The Hostage* (1958).

Thomas, Dylan (Marlais) (1914–53), Welsh-born poet and prose writer. His exuberant rhetorical style refreshed the post-war English literary scene, and with the publication of *Deaths and Entrances* (1946), containing 'Fern Hill', he was firmly established. His prose works include *Portrait of the Artist as a Young Dog* (1940) and *Adventures in the Skin Trade* (1955), both collections of stories. His famous radio play for voices *Under Milk Wood*, first presented at the Poetry Center in New York City in 1953 and broadcast in its final version by the BBC the following year, combines poetic alliterative prose with songs and ballads to evoke the lives of the inhabitants of an imaginary Welsh seaside town, Llareggub. His highly acclaimed *Collected Poems 1934–1952* were published shortly before his death in New York, hastened by heavy drinking.

Thomas, (Philip) Edward (Edward Eastaway) (1878–1917), British poet. He married young and supported his family by writing books about the countryside and biographies; among the best is his life of Richard Jefferies (1909). In 1913 he met Robert **Frost, who encouraged him to write poetry, using the natural speech rhythms in his prose. Thomas's poems describe country scenes in detail and examine states of feeling with stoical honesty. At the outbreak of World War I he volunteered for the

Development of Theatre Building

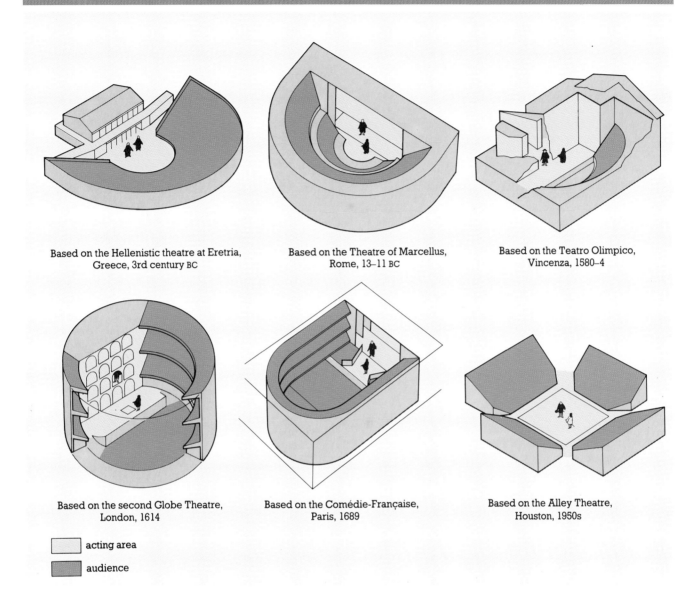

Based on the Hellenistic theatre at Eretria, Greece, 3rd century BC

Based on the Theatre of Marcellus, Rome, 13–11 BC

Based on the Teatro Olimpico, Vincenza, 1580–4

Based on the second Globe Theatre, London, 1614

Based on the Comédie-Française, Paris, 1689

Based on the Alley Theatre, Houston, 1950s

☐ acting area

■ audience

The classic Greek **theatre** was built into the hillside. The Renaissance theatre was roofed, while the Elizabethans performed on an 'apron' stage. With the introduction of the proscenium stage theatres became larger. 20th-century theatres aimed to draw the audience closer to the drama.

army and was killed in France. Although he seldom writes directly about the war, a sense of threat and loss is present in many poems, and he is now seen as one of the most moving of the 'war poets'.

Thomson, James (1700–48), Scottish poet. In 1725 he came to London where he wrote 'Winter', the first part of his long, *blank-verse poem *The Seasons* (1726–30). It was a departure from the neoclassical conventions, offering new images of nature and was adapted for Haydn's oratorio. He produced several tragedies including *Sophonisba* (1730) and *Tancred and Sigismunda* (1745). He is also remembered as the author of the ode 'Rule, Britannia', from *Alfred, a Masque* (1740), with music by Thomas

Arne. Thomson contributed greatly to the vogue of the *picturesque and his verse foreshadowed some of the attitudes of the Romantic movement.

Thomson, Virgil (1896–1989), US composer. From 1925 to 1932 he lived in Paris, where he formed a fruitful relationship with Les *Six and with Gertrude *Stein. He collaborated with the latter on two semi-Surrealistic operas (*Four Saints in Three Acts*, 1928; and *The Mother of us All*, 1947). His compositions are deliberately naïve, somewhat in the manner of *Satie.

Thoreau, Henry David (1817–62), US poet and essayist. Most of his life was spent in Concord, Massachusetts, where he was associated with *Emerson and other *Transcendentalists. In 1849 he published *A Week on the Concord and Merrimack Rivers* and his essay 'On the Duty of Civil Disobedience'; the latter, based on his imprisonment for refusing to pay poll tax during the Mexican War, was to influence both Gandhi and the US Civil Rights movement. *Walden; or Life in the Woods* (1854), one of the

classics of American literature, re-creates a two-year period in which he pursued a simple, independent existence in a self-built hut by Walden Pond, musing on natural phenomena and confirming his belief that by seeking individual salvation each man would contribute to the salvation of the whole. Some of his finest writing is in the twelve-volume *Journals*, published in 1906.

Thorndike, Dame (Agnes) Sybil (1882–1976), British actress. By the outbreak of World War I she was playing Shakespeare's heroines at the Old Vic in London. She is particularly associated with two roles: Saint Joan (1924) in·the first London production of Shaw's play, and the schoolmistress Miss Moffat in Emlyn Williams's *The Corn is Green* (1938). As a tragedienne she was greatly admired in roles such as Hecuba in Euripides' *Trojan Women* (1919), Lady Macbeth (1921), and Jocasta in Sophocles' *Oedipus the King* (1945).

Thornhill, Sir James (c.1675–1734), English decorative painter, the only British painter of his day to work successfully in the rhetorical *Baroque style during the period (roughly the first quarter of the 18th century) when large-scale decorative painting was fashionable in Britain. He is noted for his paintings on the life of St Paul (1716–19) in the dome of St Paul's Cathedral and for the Painted Hall at Greenwich Hospital, on which he worked intermittently from 1708 to 1727.

Thorvaldsen, Bertel (or Thorwaldsen) (c.1770–1844), Danish sculptor. Most of his career was spent in Rome, where he was based from 1797 to 1838. He had immense international prestige and by 1820 was handling so many commissions that he had forty assistants. Like *Canova his style was *Neoclassical, but calmer than Canova's and his works lack his contemporary's sensitive surfaces. The museum dedicated to Thorvaldsen in Copenhagen, begun in 1839 to mark his return from Rome, is itself a major work of Neoclassicism.

Thousand and One Nights (Arabic, *Alf layla wa-layla*), the most famous Arabic collection of fairy tales and stories, set within the framework of the romance of Shahriyar and Shahrazad. The stories have diverse origins: the early nucleus comes from India, Iran, and pre-Islamic Arabia. Further material was added in 9th-century Baghdad and 13th-century Egypt, and the stories are a rich source of information on life in the medieval Arab world.

Thucydides (c.450–c.399 BC), Greek historian. He wrote a history of the *Peloponnesian War between Athens and Sparta (431–404 BC) in eight books, having realized that it was to have a greater importance in the history of Greece than any previous war. His brilliant but difficult style is well suited to the narration of great events. It has a poetic flavour apparent in the use of slightly old-fashioned forms of words and the use of unnatural word order for emphasis, although his description of actual events is clear and simple.

Thurber, James (Grover) (1894–1961), US humorist and artist. From 1927 onwards, he contributed cartoons, stories, essays, fables, and reminiscences to *The New Yorker* magazine. Besides numerous collections of these writings, all with his own illustrations, he published *Is Sex Necessary?*

(1929) with E. B. White satirizing pseudo-scientific sex manuals; the comedy *The Male Animal* (1940) with Elliott Nugent; and the short story 'The Secret Life of Walter Mitty' (1939; filmed 1947). Thurber's fantastic people and animals move with sad persistence through traumatic upsets; they are misshapen and repressed products of a malignant fate which they stoically survive or combat. Resigned dogs observe predatory women at war with docile men who quietly dream of escape.

Tibetan art. Tibet's geographical position between the powerful countries of India and China has led to its art being heavily influenced by both cultures, though with its own character and finding its inspiration almost solely in religion. Buddhism was introduced from India in the 7th century AD and was adopted as the state religion in the 8th century, but its ritual retains many elements of Bon, the native animistic religion. Tibetan Buddhism is generally known as Lamaism, from the name for Tibetan monks or lamas ('superior ones'). Monasticism has played a crucial part in Tibetan life, and until the repression of Buddhism by the Chinese in the 1960s about a fifth of the male population lived in lamaseries, the most characteristic form of Tibetan architecture. The most famous example is the Potala Palace (1645–95) in Lhasa,

Scroll-paintings such as this 19th-century Buddhist temple-banner are a distinctive form of **Tibetan art**. This one shows the deity *Kalachakra*, the wheel of time, embracing his *prajna*, or insight, *Vajravarahi*. The embrace symbolizes the union of male compassion with feminine insight. Above are the white and green goddesses *Tara*, and the 'Three Gems'. (Victoria and Albert Museum, London)

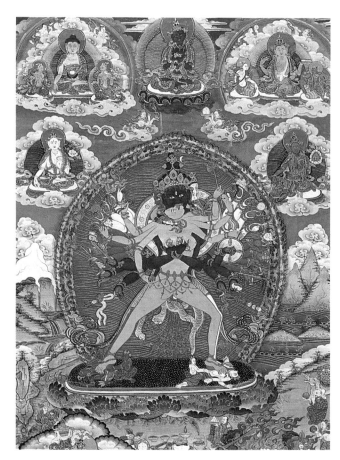

a combination of monastery, palace, and fortress, and the residence of the Dalai Lama (the traditional ruler and highest priest of Tibet) until the 14th Dalai Lama fled to exile in India in 1959, after an unsuccessful revolt against the Chinese. The palace is a massive, rectangular, almost skyscraper-like building, with walls tapering upwards echoing the forms of the mountains. Doors and windows become narrower towards the top. Another form of Tibetan architecture is the chorten, the equivalent of the *stupa in India, which usually has a bulbous dome over a square base. Tibetan sculpture is mainly in bronze and other alloys, often gilded and ornamented with jewels. As well as figures of the Buddha and other holy personages, favourite subjects were 'wrathful deities', which look to Western eyes like demons but are in fact guardians of the faith (see *Buddhist art). The most typical form of Tibetan painting is the tanka, a temple banner of cotton or silk, usually executed in brilliant colours. Among the decorative arts Tibetans have made a host of liturgical objects, notably altar lamps, and their skill in metal-working is also shown in domestic items, such as brass and copper teapots, often richly decorated. Tibetan art is essentially conservative, and objects are often difficult to date.

Tibetan literature. Written Tibetan dates from the 7th century, and until the 13th century literature in the language consisted almost entirely of Buddhist translations from the Sanskrit (the *Kanjur*), and commentaries (the *Tanjur*). An oral tradition later found its way into written annals, compendia of occult practices, and legends, and religious dramas began to develop as a literary genre. The only major secular work in traditional Tibetan literature is the medieval epic *The Great Deeds of King Gesar, Destroyer of Enemies*. The conventional literary style and types of script used in Tibet have not changed since the 7th century, and the modern colloquial language continues to be written in the traditional medium.

Tiepolo, Giambattista (1696-1770), Italian painter. His early life was spent in Venice and in northern Italy, but his fame soon became such that he was invited to Germany and Spain to carry out major commissions. He worked primarily as a *fresco painter and his masterpiece is the decoration of the palace of the Prince-Archbishop at Würzburg, where he painted the throne room and the grand staircase hall. The latter, in particular, is a stupendous piece of work, full of light and colour and perfectly attuned to the glorious architectural setting by *Neumann. He spent the last decade of his life in Spain, working on frescos in the Royal Palace in Madrid. His time there was marred by bitterness and intrigue, for he aroused the jealousy of his rival *Mengs, whose rather frigid *Neoclassical style was in complete contrast to Tiepolo's *Rococo warmth. Tiepolo also painted altar-pieces, and was an outstanding etcher and draughts-man. He had two painter sons who assisted him, **Giandomenico** (1727-1804), who became a talented artist in his own right, and **Lorenzo** (1736-c.1776).

Tiffany, Louis Comfort (1848-1933), US painter, decorator, architect, and designer, one of the outstanding exponents of the *art nouveau style. The interior decorating firm he established in New York City in 1881 is famous for its distinctive glass vases and lamps, characterized by sumptuous forms and iridescent colour, although until about 1900 it was better known for stained glass, jewellery, and mosaic work. Tiffany designed many prestigious interiors in New York and redecorated the White House in Washington in 1882-3.

timber framing, a method of building where walls are constructed of a timber framework, with the spaces filled in with plaster or brick. It was a common method of construction in France, Britain, and northern Europe from the later Middle Ages to the 17th century. The timber was sometimes covered with boards or plaster, but often it was left exposed, the term 'half-timbered' being applied to this treatment. For the most part it was a method adopted for humbler dwellings such as country cottages or smaller mercantile buildings in town. In Britain, nevertheless, it was employed in the building of quite substantial manor houses throughout the 15th and 16th centuries, particularly in the north-west. Little Moreton Hall, Congleton, Cheshire (1559), is probably the most famous and spectacular example, the black-painted timber and the white plaster creating a striking decorative effect.

time and tempo (in music). Musical time is the underlying pattern of beats in a piece of music, shown (in Western music) by means of two figures arranged one above the other. The upper figure indicates the number of beats in each bar, and the lower figure the type of beat. Thus 2/4 indicates a two-beat pattern of crotchet values, while 3/4 indicates a pattern of three such beats. These signs, called time signatures, are placed at the beginning of a piece of music and again wherever the metre changes. According to whether the beat itself can be divided into halves and quarters, or thirds and sixths, we speak of simple time and compound time. Tempo refers to the speed at which music is taken. This is usually indicated by standard Italian terms placed at the beginning of a piece of music, and again wherever the speed changes. They can be backed up by *metronome marks indicating the number of beats per second. To some extent the matter of speed has to be left to the musical sensitivity of the performer, and will in any case be modified by the acoustic properties of the place of performance. The following are the tempo markings most in use: largo (a broad, dignified pace); larghetto (not quite so slow); adagio (a slow, easy pace); andante (slowish, but flowing), moderato (an easy, moderate speed); allegro (quick and lively); presto (fast); prestissimo (very fast).

timpani, musical instruments, the orchestral and military kettledrums, introduced to Europe from Turkey via Hungary in the late 15th century. Originally played in pairs on horseback, as today in cavalry regiments, two remained the normal number when they came into the orchestra, as a bass to the trumpets, in around 1600. A third was added in the 19th century, and nowadays four are normal. Timpani are the only orchestral drums that are tuned to definite pitches, formerly by various types of hand-turned screws, today by a pedal so that players can tune while playing.

Timurid art, the art and architecture of the Timurids, a dynasty (1369-1506) founded by the Turkish conqueror Timur (1336-1405, also called Tamerlane or Tamburlaine), who created a vast Islamic empire stretch-

ing from Mongolia to the Mediterranean. Although legendary for his barbarity in war, he encouraged art, literature, and science and intended that his capital, Samarkand, should be Asia's most splendid city. One of the finest of the monuments surviving there from his time is his own vast mausoleum, the Gur-i Mir (1405), which shows the ribbed bulbous dome and lavish tile cladding typical of Timurid architecture. After Timur's death the empire broke up because of dynastic struggles and outside attacks, but art continued to flourish, particularly at Samarkand and Herat (now in Afghanistan). Architecture attained an unprecedented splendour and Islamic painting reached its peak in the Herat School, the most illustrious figure of which is *Bihzad. Herat was famous also for its carpets, and other decorative arts flourished under the Timurids. The last Timurid ruler of Herat was deposed in 1506, effectively bringing the dynasty to an end, but Babur, the Timurid ruler of Fergana, survived the collapse and established the Mughal dynasty in India (see *Mughal art).

Tin Pan Alley *popular music.

The *Rape of Europa* is one of a series of mythological scenes that **Titian** painted for Philip II of Spain. They are based on poetic texts, particularly Ovid's *Metamorphoses*, and Titian himself referred to them as poesie, a term appropriate to their air of enchantment. In Greek mythology Europa was a King's daughter, lured by Zeus disguised as a bull, to climb on his back in play, whereupon he carried her off to the sea and bore her to the island of Crete. (Isabella Stewart Gardner Museum, Boston)

Tintoretto, Jacopo (1518–94), Italian painter. He trained in Venice and may have been Titian's pupil. Most of Tintoretto's paintings were of religious subjects, but he also painted mythologies and portraits, his style characterized by a dynamic energy and a masterly handling of perspective and space. His religious paintings have an aura of deeply held personal faith, while his mythological compositions retain a more buoyant tone, reminiscent of Titian. In 1564 when the Scuola di San Rocco (a charitable religious organization) announced a competition for a ceiling decoration, he did not submit sketches like the other competing artists, but secretly had a completed canvas installed in place. His successful ruse marked the beginning of a long relationship with the Scuola, where he worked until 1587, decorating walls and ceilings with huge canvases, including a stupendous representation of the *Crucifixion* (1565). He continued to paint up to his death, and his late work has a rapturous, mystically intense quality.

tin whistle *flageolet.

Tippett, Sir Michael (Kemp) (1905–), British composer. He worked as a teacher and did not establish himself as a composer until 1939, with the Concerto for Double String Orchestra. The oratorio *A Child of Our Time* (1941) made him famous. Outspoken in defence of his beliefs, he served a prison term (1943) as a conscientious objector. Tippett's work is deeply concerned with political, social, and psychological issues—in particular the journey from the darkness of ignorance and hatred into the light of self-knowledge and acceptance. His operas *The Midsummer Marriage* (1952), *King Priam*

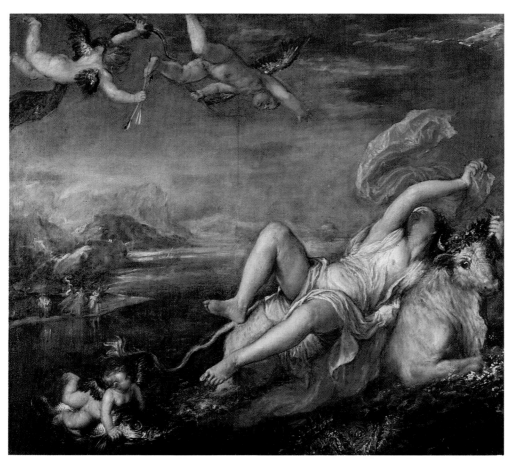

(1961), *The Knot Garden* (1969), and *The Ice Break* (1976) tackle these issues from different angles, as do such choral masterpieces as *The Vision of St Augustine* (1963–5) and *The Mask of Time* (1984). His four symphonies (1945–77), four string quartets (1935–79), and four piano sonatas (1937–84) mark the progress of his thought in powerful abstract terms. Tippett's music is notable for its rhythmic vitality and polyphonic complexity. It can be astringent and even harsh when the occasion demands, but more frequently it is lyrical and romantically luxuriant.

Tissot, James (1836–1902), French painter and etcher. He achieved success with his scenes of contemporary life, in both Paris and London, where he lived from 1871 to 1882. In 1888 he underwent a religious conversion after going into a church to 'catch the atmosphere for a picture', and thereafter he devoted himself to religious subjects, his biblical illustrations proving enormously popular.

Titian (Tiziano Vecellio) (*c*.1480–1576), Italian painter who dominated Venetian art during its greatest period. He trained in the studio of Giovanni *Bellini, but was more profoundly influenced by *Giorgione. (Titian worked in collaboration with him and completed some pictures left unfinished after his premature death.) When Bellini died in 1516 Titian succeeded him as official painter to the Venetian Republic, and his dominance there was unchallenged until his own death sixty years later, resulting in a series of magnificent altar-pieces throughout Venice. In 1533 the Holy Roman Emperor Charles V appointed him his official painter. Titian visited the imperial court at Augsburg, in 1548 and 1550, and on the second visit met Charles's son, the future Philip II of Spain, who became the most important patron of his later years. He remained active to the end of his life, and the pietà that he painted for his own tomb and left unfinished at his death is one of the greatest final testaments that any artist has left to the world. Titian was equally renowned for his portraits and for his religious and mythological paintings (which vary from profoundly moving scenes of Christ's Passion to erotic nudes) and he brought to new heights the traditional Venetian delight in beautiful colouring. His mastery of oil paint was complete, and he was the first artist to exploit its textural possibilities to the full, his late works being remarkably free in brushwork. Little is known of his personal life, but he was notoriously avaricious, and deliberately exaggerated his age to try to gain sympathy (and thereby money) from patrons.

Tlatilco, a site near Tacuba, west of Mexico City. It has yielded some of the earliest surviving art of the Valley of Mexico from about 900 to 800 BC, in the form of clay figurines, many representing 'pretty ladies', or steatopygous women. Typically, the figurines have Janusheads or three-eyed, double-aspect visages, 'ballerina' feet, and short, trotter like arms extended as if in dance. The modelling is elaborate compared with most other early Mexican figurines (most of which are built up rather than strictly modelled) and the work is further distinguished by incised detailing of both clothing and anatomical features. Similarities with discoveries as far afield as Peru have inspired speculation about a single archaic American culture. (See also *Central American and Mexican art.)

toccata, a keyboard piece that exploits the performer's musical dexterity. The word itself means 'touched' in Italian, and thus the music is *staccato in its effect. The extended trumpet fanfare that opens Monteverdi's opera *Orfeo* (1607) is labelled 'toccata', as is the last movement of Vaughan Williams's Eighth Symphony (1955).

toleware *lacquerwork.

Tolkien, J(ohn) R(onald) R(euel) (1892–1973), South African-born British writer and scholar. He became internationally known for his three fantasy books, *The Hobbit* (1937), *The Lord of the Rings* (1954–5), and *The Silmarillion* (1977). The epic is set in the Third Age of the Middle Earth, inhabited by shy, dwarfish creatures ('hobbits') with hairy feet, and a range of other races, some of whom speak their own elvish language and write in a runic alphabet. A supreme story-teller, Tolkien describes the struggle of good and evil forces for possession of a magical ring that bestows absolute power.

Toller, Ernst (1893–1939), German *Expressionist dramatist. His work depicts a society which has so drained its subjects that they are unable to achieve their natural potential, failing in their responsibility to themselves and in their search for companionship. *The Change* (1918), offering an *allegory of spiritual rebirth and self-discovery, and *Masses and Man* (1919), 'a play for the social revolution of the twentieth century', are matched by *Hinkemann* (1924), the tragedy of a worker emasculated in the war and an object of derision to his fellow-workers, and *The Machine Wreckers* (1922), set in Luddite England. He was associated with the communist government in Bavaria (1918). Exiled in 1933, he committed suicide in the USA.

Tolstoy, Count Lev (Nikolayevich) (1828–1910), Russian author and religious thinker. Born into the landowning aristocracy, he entered the army in 1852 and participated in the siege of Sebastopol (1855), a description of which he published in three sketches, *Sevastopol* (1855–6). For the next four years he enjoyed the social life of St Petersburg and Moscow, where his publication of the trilogy *Childhood, Boyhood, and Youth* (1852–4), *Two Hussars* (1856), and *Three Deaths* (1859) confirmed his reputation as a brilliant short-story writer. After his marriage in 1862 he managed his estates with success and enlightened liberalism, while at the same time writing his two masterpieces, *War and Peace* (1863–72) and *Anna Karenina* (1875–6). The former covers the period of the Napoleonic invasion of Russia as reflected in a vast tapestry of lives, including urban and rural aristocrats, peasants, soldiers, diplomats, and courtiers. The flawless structure of these characters placed in a complex series of settings in town, country, and on the battlefield, combine to make this perhaps the greatest European novel. *Anna Karenina*, which is set in the 1860s, unfolds the tragic fate of its heroine, a married woman, and her lover. In it, as in all Tolstoy's writings, he reaffirms the superiority of rural, natural life over the shallowness of urban society, and its ultimate ability to destroy the nature of love. After these two novels Tolstoy underwent a spiritual crisis, renouncing his worldly possessions and repudiating his artistic work (*My Confession*, 1881). He attempted to probe the meaning of life with *The Death of Ivan Ilich* (1885), *The Kreutzer Sonata* (1890), and a series

Tolstoy (*right*) with Chekhov on his estates at Yasnaya Polyana in 1901–2. In his early life Tolstoy had led a libertine existence, but painful self-examination converted him to a form of Christian asceticism, and he preached an ideal of the dignity of rural labour and the peaceful resistance to political force. Excommunicated by the Russian church in 1901, he none the less attained a world-wide reputation as a moral beacon, who was to exercise a profound influence on younger leaders such as Mahatma Gandhi.

of shorter pieces, concluding that personal salvation lay in serving others. He published his manifesto *What is Art?* in 1898. His last full-length novel, *Resurrection*, though brilliant in poetic atmosphere, is marred by its polemicism. His writings on pacifism and his attempts at personal salvation through self-sufficiency and love of others attracted many adherents beyond Russia itself, and he has remained a formative influence on pacifist movements in the 20th century.

Toltec art, the art of the Toltec, the dominant society in northern Mesoamerica between AD 900 and 1200. Some scholars hold that the city of Tollan (Tula) was their capital, containing a number of public buildings such as temples, colonnaded halls, palaces, and ball-courts. Virtually all of these were erected on solid, rubble-filled platforms or stepped pyramids. The main temple pyramid was highly decorated and its terraces covered with sculptured and painted friezes of grotesque creatures devouring human organs, and of human faces extending from the jaws of serpents. Carved tablets record processions of elaborately dressed dignitaries symbolizing ceremonial activities. Ceramics, textiles, and polished stone ornaments were manufactured, while obsidian (natural glass of volcanic origin) was decorated and used, for example, for ritual knives.

tonality, the relationship in music between *pitches, with particular reference to those pitches that govern the relationship of all the other notes of a major or minor *scale. Music written in accordance with the principles of tonality (Western music of, roughly, 1600–1900) assumes three such notes: a tonic (or 'key note'), a dominant, five degrees above it, and a subdominant, five degrees below. In the *key of C major these would be C, G, and F. These notes govern the cycle of keys which form the basis of the tonal system. *Atonality denies the necessity for key-relationships of this kind, regarding all the notes of the chromatic scale as being of equal importance, and seeks other means of organizing its musical material.

tone-poem *symphonic poem.

totem-pole *North American Indian art.

Toulouse-Lautrec, Henri de (1864–1901), French painter and graphic artist. The son of a nobleman, he was left permanently stunted by two falls in his early teens. In 1882 he began to study art in Paris. From about 1888 he turned to the subjects with which he is most identified—theatres, music-halls, cafés, circuses, and brothels—the low life with which he was intimately familiar. He was influenced by Japanese prints and his most original works are his *posters and *lithographs, in which he displayed masterly use of bold and arresting designs, drawing on his exceptional skill as a draughtsman, and which established the poster as a serious art-form. Alcoholism and syphilis caused his death at the age of 36.

The city of Tula in central Mexico is one of the chief monuments of **Toltec art**. These huge sculpted columns (*c*.AD900–1200) in the form of warriors or hunters are the most famous remains there. About 4.5 metres (15 ft.) tall, they originally supported the roof of the temple of the god Quetzalcoatl.

toys, articles designed to be played with, especially for the use of children. Toys have been made from prehistoric times, and numerous playthings survive from Egyptian, Greek, and Roman times, including balls, rattles, and miniature representations of houses. In later ages they became more sophisticated, and the skills of the artist became more important. During the 16th to 18th centuries baby-houses were popular: cabinets divided into room-like compartments in which miniature furniture was displayed. In the mid-18th century the Jumping-Jack (a flat marionette-like figure) was very popular, especially in France where the Duchesse de Chartres commissioned Boucher to paint one for her. The dolls of the 18th century are particularly attractive: the so-called 'Queen Anne type' have wooden heads under a thin coat of plaster, glass eyes, and delicately painted faces. In the 19th century magic lanterns became popular, projecting hand-painted slides. Wax dolls, such as those made by Augusta Montanari for the Great Exhibition of 1851, were minutely detailed, the hair being set into the wax strand by strand. By the late 19th century France had taken the lead in the manufacture of china-headed dolls, notably the large-eyed, refined Jumeau dolls. China has its own history of toy-making, its most popular contribution being the kite, invented in the early centuries BC. In the Andean highlands the cult of the miniature is associated with good luck, and annual fairs where everything is sold in miniature are still held in the Bolivian towns of La Paz, Oruro, and Cochabamba.

tracery, a term used to describe decorative stonework (or more rarely brickwork) set in the upper part of windows, and by extension to describe similar ornament applied to other architectural features or, for example, furniture. Tracery is one of the most characteristic features of medieval architecture after about 1200 and its variations or absence have been used to classify different stages of the *Gothic style, notably *Early English, *Decorated, and *Perpendicular in Britain. Two basic kinds of tracery are distinguished. The earlier form was 'plate' tracery, in which solid areas of flat stone were perforated with decorative openings; from about 1230, first in France and then elsewhere, this was replaced by a much longer-lived form called 'bar' tracery. In this, thin strips of stone, usually developing the lines of the mullions (the upright members dividing the window into panes), were arranged into a meshwork or other pattern. The tendency for tracery to become more intricate, and to be applied more extensively, not only to windows but also to walls, vaults, and screenwork, persisted down to the end of the Middle Ages in almost every part of Europe except Italy, so that eventually some buildings were conceived almost entirely in terms of tracery.

tragedy, in the Western tradition, a kind of drama (or sometimes, prose fiction) which represents the disastrous downfall of a central character, the 'protagonist'. The tragedies of Aeschylus, Euripides, and Sophocles are the most permanently impressive fruits of *Greek theatre. From their works, Aristotle arrived at a very influential definition of tragedy in his *Poetics* (4th century BC): the imitation of an action that is serious and complete, achieving a *catharsis through incidents arousing pity and terror. Aristotle also observed that the protagonist is led into a fatal calamity by his *hamartia* ('error' or 'tragic flaw'); this often takes the form of *hubris* (excessive pride or self-confidence) punished by the gods or fates. The tragic effect usually depends on our awareness of admirable qualities (manifest or potential) in the protagonist, which are wasted terribly in the unavoidable disaster. The most painfully tragic plays, like Shakespeare's *King Lear* (c.1605), display a disproportion in scale between the protagonist's initial error and the overwhelming destruction with which it is punished. The Roman tragedian Seneca set the pattern followed by English playwrights from Thomas Kyd's *The Spanish Tragedy* (1586) to Webster's *The Duchess of Malfi* (1623) in their violent 'tragedies of blood'. The major achievements in tragedy of this period are Shakespeare's *Hamlet*, *Othello*, *Macbeth*, and *King Lear*. These and other tragedies by Shakespeare employ a larger cast of characters and a wider variety of scenes than the Greek tragedies. In 17th-century France Corneille and Racine wrote tragedies modelled more closely on Greek examples, usually observing the 'unities' of time, place, and action which dramatic theorists claimed to derive from Aristotle. This strict French convention required that the action should take place in one day in one location; it was later rejected by Hugo and others in the period of French *Romanticism. Tragedy declined in the 18th and 19th centuries, and the validity of its modern revival by Ibsen, Tennessee Williams, and Miller is much disputed. Some novels, like Hardy's *The Mayor of Casterbridge* (1886), can be described as tragedies; others, like Melville's *Moby-Dick* (1851), have recognizably tragic protagonists.

Traherne, Thomas (c.1637–74), English mystical poet and religious writer. He was a clergyman in Herefordshire and London. Almost all the work for which he is admired today was discovered by chance in notebooks and only published from 1903. The *Centuries of Meditation* (1908), discovered in 1897 on a street book stall, are linked short meditations showing his joy in creation and in divine love. The work is noted for its rhythmic, ecstatic descriptions of his childhood and for his imaginative response to the idea of infinite space. His *Poems of Felicity*, discovered in the British Museum, were published in 1910. They are on similar themes and argue complex ideas in careful *stanzas. The *Thanksgivings*, published anonymously in 1699, are in exuberant *free verse based on the unrhymed rhythms and images of the Bible.

Transcendentalism, a US philosophic and literary movement that flourished in New England, particularly at Concord (c.1836–60), as a reaction against 18th-century rationalism, the sceptical philosophy of John Locke, and the confining religious orthodoxy of Calvinism. The Transcendentalists asserted the correspondence between nature and the individual mind, and the presence of the divine in both. The chief literary expressions of the movement were *Emerson's *Nature* (1836), and his essays and lectures, and *Thoreau's *Walden* (1854).

transfer printing, a method of decorating ceramics or enamels by printing a design from an engraved copper plate on to paper and then pressing the paper while still wet to the surface of the object to be decorated. The technique originated in Britain in the 1750s and soon spread to the Continent of Europe. Originally, the design transferred was monochromatic, so colour had to be added by hand, but multi-colour transfer printing was developed in the 1840s.

travel writing, a kind of literature describing the curiosities, dangers, customs, and sights of places and journeys, remote or near. A celebrated early example is the *Guide* or *Description of Hellas* (2nd century AD) by the Greek writer Pausanias. The Venetian Marco Polo recorded his journeys in China and India at the end of the 13th century. The late 16th century saw many accounts of voyages to America and elsewhere; Richard Hakluyt's *Principall Navigations, Voiages, and Discoveries of the English Nation* (1589) is an important collection of these, describing the explorations of Drake and others. By contrast, Thomas Coryat travelled on foot through Europe, publishing *Coryats Crudities* in 1611. By the 18th century it had become customary for young gentlemen from northern Europe to complete their education with the 'Grand Tour' through France and Switzerland to Rome and Naples: Smollett, Sterne, and Goethe were among many who recorded such tours. Johnson and Boswell wrote of their travels in Scotland, and Defoe published *A Tour through the Whole Island of Great Britain* (1724–6), a valuable account of the state of the country, to which Samuel Cobbett's *Rural Rides* (1830) was a worthy successor. Among the hundreds of travelogues written by explorers, missionaries, and wanderers in the 19th century, Charles Darwin's *Voyage of the Beagle* (1839) had great scientific significance, if less sensational than Richard Burton's *Personal Narrative* (1855) of his sacrilegious trip to Mecca, or Henry Stanley's *How I Found Livingstone* (1872). Notable English travel writers in the 20th century include Freya Stark (1893–), Wilfred Thesiger (1910–), and Bruce Chatwin (1940–89).

tremolo, in music, the rapid reiteration of a note, or rapid alternation between two notes. *Chords can also be treated in the same way. It is often confused with vibrato, which is a fluctuation of *pitch—pleasant if under control, unpleasant if it develops into a wobble, particularly where the human voice is concerned.

trio, in music, a composition for three voices or instruments, hence the string trio (violin, viola, and cello) and the piano trio (piano, violin, and cello). The central section of the *minuet, *scherzo, and march is called a 'trio' because it was originally written in three-part *harmony.

triptych, a painting (or less commonly a carving) in three compartments side by side, the lateral ones ('wings') usually being subordinate to the central one, and often hinged so as to fold over it. Like the *diptych and the *polyptych, the triptych was a common form for *altar-pieces in the Middle Ages and Renaissance.

Trollope, Anthony (1815–82), British novelist. His mother, **Frances Trollope** (1780–1863), won fame with her caustic *Domestic Manners of the Americans* (1832), the first of over forty books. Trollope began work as a junior clerk in the General Post Office; he introduced the pillar-box for letters before his retirement in 1867. He won literary success with his fourth novel, *The Warden* (1855), the first of the 'Barsetshire' series which included *Barchester Towers* (1857) and ended with *The Last Chronicle of Barset* (1867). They are set in a cathedral community in the imaginary West Country county of Barset and are interconnected by characters who reappear in more than one of them. He developed this technique in his series of political novels, known as the 'Palliser' novels after the central character. These include *Phineas Finn* (1869), *The Prime Minister* (1876), and the sharply satirical *The Eustace Diamonds* (1873). His vast output included forty-seven novels, travel books, biographies, and collections of short stories and sketches. He was more concerned with his characters than with plot and has been admired for his treatment of family and professional life, the variety and delicacy of portrayal of his heroines, and his accurate description of Victorian social life.

tromba marina, a long, narrow stringed musical instrument, played with a bow. In the 14th century it was sometimes plucked; it was played in the mid-15th century by touching the single string lightly at its nodal points and thus sounding the same natural *harmonics as the *trumpet. This explains half its name; the other half is a mystery. It was popular in the 17th and 18th centuries, when it was held downwards and played in natural harmonics.

trombone, a brass musical instrument. It obtains *pitches between the notes of the *harmonic series by lengthening the tube by means of extending a slide (a length of tubing that slides in and out) in the front bow (the bow at the front of the instrument); it was the only fully chromatic *brass instrument before valves were invented. Valve trombones have been made for military use and for other circumstances where extending slides is difficult. Up to the 18th century the English name was *sackbut, used today to distinguish earlier models from modern. The trombone came into the orchestra from the church and opera, and was later adopted by military bands. Three sizes were normal: alto, tenor, and bass. The soprano trombone has been used occasionally, and a contrabass was introduced by Wagner. Today all parts save for contrabass are played on B♭ instruments with an F extension controlled by a valve in the back bow.

trompe-l'oeil (French, 'deceives the eye'), a term in art applied to a painting (or a detail of one) that is intended to deceive the spectator into thinking that it is a real object rather than a two-dimensional representation of it. Such virtuoso displays of skill often have a humorous intent, and stories of visual trickery are common in artists' biographies. Giotto, for example, is said to have painted a fly so realistically on the nose of a figure by his master Cimabue that Cimabue tried to brush it away several times before he realized he had been duped.

troubadour *minstrel.

trouvère *minstrel.

Truffaut, François (1932–84), French film director. His first film, *Les Quatre Cents Coups* (1959), an autobiographical study of a troubled adolescent, established him as a leader of the *Nouvelle Vague; it was followed by several more films showing the same character at different ages: *L'Amour à 20 ans* (1962) (of which he directed an episode), *Baisers volés* (1968), *Domicile Conjugale* (1970), and *Amour en fuite* (1979). His second film, *Tirez sur le pianiste* (1960), was a thriller, and his third, *Jules et Jim* (1961), chronicling the relationship of two men with the same girl, rivalled the first in popularity and critical acclaim. His other work included *Fahrenheit 451* (1966),

made in Britain, a remarkable vision of a soulless future society; *Le Mariée était en noir* (1967), about a vengeful widow; *La Nuit américaine* (1973), in which he revealed the mechanics of film-making; and *Le Dernier Métro* (1980).

trumpet, a brass musical instrument. In the 13th century European trumpets were straight, but by the late 1300s they were often folded in an S-shape. In the 15th century they were folded with a loop of tubing, often with a long mouthpiece-stem sliding in the first length, allowing players to produce some chromatic notes. The normal baroque trumpets played only natural *harmonics, and could play melodically only in the high register. At the end of the 18th century, the key trumpet was invented, for which Haydn and Hummel both wrote concertos, and in England there was a new slide trumpet with its slide in the back bow. The latter became the English orchestral trumpet. Elsewhere, valve trumpets were used from the mid-19th century, usually in F; only towards the end of the 19th century were they reduced in length to form the modern B♭ instrument.

Tsvetayeva, Marina (Ivanovna) (1892–1941), Russian poet. Recognized early as an outstanding talent, she survived the revolution and civil war with her children, then followed her husband into exile. *Mileposts* (written 1916, published 1921) demonstrated her mature voice, distinct from that of *Akhmatova: feminine but aggressive, shamelessly extrovert, and with unprecedented rhythmical power. *After Russia* (written 1922–5, published in Paris 1928) is her apogee as a *lyric poet. From 1920 she turned increasingly to longer poems, and attained tragic majesty with her record of a doomed love affair, *Poem of the Mountain* (1924) and *Poem of the End* (1924). *The Ratcatcher* (1925) is a satirical *epic. In the 1930s, after attempting monumental drama in verse, she wrote autobiographical and critical prose. She went back to the Soviet Union in 1939 and hanged herself in 1941.

tuba, a musical instrument, a bass valved *bugle in F, with three valves, developed in the 1820s and then known as a bombardon. A fourth and then a fifth valve were added to fill the octave between the first two harmonics. A further advance was the development of the BB♭ tuba, a fifth lower (CC for orchestral use). Because upright tubas are heavy to carry on the march, the spirally coiled helicon, whose weight rests of one shoulder, was invented in 1845. This led to the sousaphone, which projects the sound forward instead of sideways.

tubular bell, a metal tube used instead of a church bell. Twelve tubes, covering a full octave, can hang on a stand occupying about one square metre or yard of floor, and can be moved by two people. The same number of real bells would weigh thirty or forty tonnes and occupy a large space. This is why tubular bells are used even though their sound is only an approximation to the real thing. The tubes are hung with 'white' notes in front and 'black' behind (see *notation), and are struck with rawhide hammers.

Tudor, Antony (William Cook) (1908–87), British dancer and choreographer. He studied with *Rambert and joined her company, creating his first work in 1931. He moved to North America to work for *American Ballet Theatre and subsequently other US companies.

This detail of a mid-15th-century painted wedding-chest shows musicians playing shawms (*right*) and a slide-**trumpet** (*left*). Such instruments were used at court and for church music, while the short, straight brass trumpets were played in tournaments and on the battlefield. In the background the black and white arches of the baptistry of Florence Cathedral are visible. (Accademia, Florence)

Renowned for musical sensitivity and for dramatic works such as *Lilac Garden* (1936) and *Dark Elegies* (1937), which explore psychological concerns, his idiom remained in the modernist ballet tradition.

Tudor architecture, a term that can in its broadest sense be applied to any buildings erected in Britain under the Tudor dynasty, that is, from the accession of Henry VII in 1485 to the death of Elizabeth I in 1603. Used in this way the term encompasses the final flowering of the *Perpendicular style at the earlier end of the time-scale and the great series of houses by *Smythson at the other end. However, in normal parlance the term 'Tudor architecture' indicates a specific style of building associated chiefly with the first half of the 16th century. It is a style expressed mainly in secular architecture (collegiate as well as domestic), for church building in Britain was virtually ended by the Reformation. The most characteristic building material was brick, often patterned by the use of contrasting colours or used to create splendid decorative chimney stacks. Forms to a large extent followed those of the Perpendicular period, but windows and doors were either flat-topped or had a very shallow arch known as a 'Tudor arch'. Outstanding examples include Hampton Court Palace, begun by Cardinal Wolsey in 1515 and continued by Henry VIII; Compton

Compton Wynyates in Warwickshire is one of the most picturesque examples of **Tudor architecture**. The rosy brickwork, mellow masonry, and irregular composition, with crenellations, twisted chimney stacks, and windows of varying shapes and sizes, create a feeling of warm tranquillity.

Wynyates in Warwickshire, one of the most idyllically beautiful of English country houses, built by Sir William Compton, one of Henry VIII's courtiers; and the Great Gate of Trinity College, Cambridge, completed in 1533. Although there is no firm dividing line, it is usual to distinguish architecture of the later Tudor period as 'Elizabethan' (Elizabeth I reigned 1558–1603). In this period stone is used more often for major buildings, houses become more grandiose in design and 'outward-looking' rather than 'inward-looking' (that is, arranged around a courtyard), and there is greater foreign influence, both in the use of the classical *Orders and in rich, often Flemish-inspired, surface ornamentation.

Turgenev, Ivan Sergeyevich (1818–83), Russian novelist, playwright, and poet. He found his prose style with *A Sportsman's Sketches* (collected 1852), short lyric glimpses of rural life which do not ignore the misery of Russia's serfs. The great novels, noted for their stylistic elegance, reveal a pastoral lyricism, an ultimately pessimistic view of personal relationships, and a tendency to idealize the female and dwell on the flawed inadequacy of the male. They also engage the political and intellectual issues of the day. Ineffectual idealism is central to the eponymous hero of *Rudin* (1856). In *A Nest of Gentlefolk* (1859) the pure and spiritual Liza cannot reconcile herself with the worldly and inconstant Lavretsky. Bazarov, the hero of *Fathers and Sons* (1862), is the prototypical positivist and nihilist, whose practical talents and emotional potential are both eventually wasted. Turgenev spent much of his mature life in France; for Western literary circles he was the embodiment of the aristocratic but passionate and unspoiled Russian intellectual.

Turkish art *Ottoman art, *Seljuq art.

Turkish literature, literature of the Turkic peoples. The characteristics of the earliest Turkish poetry are seen in the *epic poetry of the Kirghiz, who have remained in the original Central Asian heartlands: their epic, the *Manas*, has been passed down by word of mouth to modern times. The tribes which spread into the Middle East were soon converted to Islam and were greatly influenced by the Persian and Arabic languages and their literature (see *Arabic and *Persian literature). Two classical languages developed: Eastern Turkish or Chaghatai literature produced two great figures: the poets 'Alī Shīr Nevā'ī (1441–1501) and Bābur (1483–1530), who founded the Mughal empire in India, and wrote his famous memoirs, the *Bāburnāmah*. Western Turkish was called Oghuz or Ottoman, and its literature developed in various strands. Early mystical poetry, written in a simple language by Yunus Emre (d. 1321) and others, gave way at court to learned poetry, heavily influenced by Persian models, and called Dīvān poetry. The greatest exponents of this were Fuẓūlī (c.1480–1556), Baki (1526–1600) and Nedīm (d. 1730). More popular poetry continued to be composed, and poems by Kaygusuz Abdal (d. 1415), Pir Sultan Abdal (16th century), and Karacaoglan (16th century) are still sung by minstrels. With the defeat of the Ottoman empire in 1918, and the creation of modern Turkey, the script was changed from Arabic to Roman and a new literature appeared. The novelist Yasar Kemal (1923–) and the communist poet *Hikmet have achieved international fame. The most famous writer of the eastern Turkish world is the Soviet author Chingiz Aitmatov (1928–), who writes novels in Kirghiz and Russian. (See also *Sufi literature.)

Turkish music *West Asian music.

Turner, J(oseph) M(allord) W(illiam) (1775–1851), English painter, the most original genius in *landscape painting in the 19th century. Until about 1796 he worked exclusively in water-colour, becoming a leading exponent of the topographical view, but he then turned also to oils. Around the turn of the century his personal style began to emerge, as his work became more highly charged

emotionally, imbued with a *Romantic sense of movement and drama. He travelled extensively in Britain, and from 1802 he made periodic visits to the continent of Europe, the mountains of Switzerland and the haunting beauty of Venice providing him with the subjects for some of his most memorable paintings. In both oils and water-colour he developed a technique of unprecedented freedom, at times floating his colours in films of the utmost delicacy, at others swooping and swirling them around with an energy that suggests the overwhelming forces of nature. By the end of his career his paintings were approaching abstraction, as the figurative elements dissolved into beautiful mists of light and colour. His work was often attacked, but he had the most eloquent of champions in *Ruskin. Turner died a very rich man and left to the nation an enormous body of work, now housed in the specially built Clore Gallery (opened in 1987) at the Tate Gallery.

Tuwim, Julian (1894-1953), Polish poet. He made a startling début with *Lying in Wait for God* (1919); he then translated Russian poets and wrote for cabaret. His verses

for children are popular to this day. His experiments with language reveal a fascination with the commonplace and bizarre.

Tvardovsky, Aleksandr (Trifonovich) (1910-71), Russian poet. Of peasant origins, he became a national poet with his *epic *Vasily Tyorkin* (1941-5) about the Russians at war. As editor of the journal *New World* in the 1960s, he was a vital liberalizing force, pressing for greater artistic freedom and a literature based on aesthetic rather than political themes.

Twain, Mark (Samuel Langhorne Clemens) (1835-1910), US novelist, lecturer, and essayist. He was a Mississippi steamboat pilot before becoming a journalist and publishing comic sketches under the name 'Mark Twain', a phrase meaning 'two fathoms deep', in soundings on Mississippi riverboats. After the success of *Innocents Abroad* (1869), he moved to Hartford, Connecticut, and began to write a mixture of fiction and autobiographical works. He returned to his childhood world of the Mississippi in *The Adventures of Tom Sawyer* (1876), preparing the way for his masterpiece *The Adventures of Huckleberry Finn* (1884), in which he celebrates the flowering of Mississippi frontier civilization in terms of its own pungent tall talk and *picaresque adventure. His bitter satire of feudal tyranny, *A Connecticut Yankee at King Arthur's Court* (1889), and *The Tragedy of Pudd'nhead Wilson* (1894) reflect the darker tone of his later period. Twain was one of the greatest American humorists and his vernacular

Sun Setting Over a Lake (c.1845) shows the extreme freedom of **Turner**'s late style, the subject being suffused by light, colour, and atmosphere which together create the true theme of the picture. Constable wrote of him 'He seems to paint with tinted steam, so evanescent and airy.' (Tate Gallery, London)

With his lion-like mane of hair, Mark **Twain** was instantly recognizable and was one of the prototypes of the modern celebrity, greeted rapturously wherever he went. His fame and popularity depended not only on his writings and his immensely successful lectures, but also on his fortitude in adversity: in 1894 he went bankrupt because of investments in an unsuccessful typesetting machine, but he undertook a world-wide reading tour to recoup his losses and paid back every cent he owed.

prose style is regarded as the basis of the truly American tradition in modern writing.

twentieth-century music, the undermining of tonality that began in the 19th century with *Wagner's intensive use of the chromatic *scale continued in the first years of the 20th in the music of *Debussy. His style, which has been called *impressionistic, opened up new musical horizons and helped to complete the dissolution of the 'classical' principles that had guided Western music since the 17th century. With the undermining of such principles, it seemed necessary to find new explanations for the state of music's grammar. Chief among them, and for a time the most influential, was *Schoenberg's concept of *serialism formulated in the 1920s. This blossomed widely after World War II, but taken to extremes (as in the use of *total serialism by such composers as *Boulez

and *Stockhausen) it provoked reactions in favour of a simpler and less rigidly controlled approach to music—as in the exploration of *aleatory and *minimal techniques in the 1950s and 1960s. Other composers, such as *Stravinsky, while admitting a very free approach to harmonic dissonance and compulsively asymmetric rhythms, sought salvation in *Neoclassicism by returning to the neat patterns and formal structures of the 18th century. At the same time, the rhythmic vigour of *jazz seemed, to some, to offer the prospect of artistic revitalization. Nor should the importance of nationalism be underestimated as one of the 20th century's liberating influences. In the 1920s and 1930s it prompted such composers as *Bartók, *Janáček, and Vaughan Williams to explore and assimilate the *folk music of their respective countries and thereby free themselves from essentially Germanic musical traditions. The majority of 20th-century composers, however, have opted for a pragmatic mix of everything that has ever constituted 'music' and, without allying themselves to any particular dogma, have been as prepared to learn from the practices of, say, medieval cultures as they have from the music of north Africa and Asia. After World War II science itself began to add to the composer's armory through its developments in *computer music, *electronic music, and *synthesizers (see also *musique concrète). The result has been the development of an astonishing variety of muscial possibilities—from *popular music to the teasing intellectual complexities of the extreme avant-garde. Old forms, such as the symphony, have flourished alongside the entirely new structures proposed by aleatory and electronic techniques. In short, the outstanding achievement of the 20th century has been its capacity to absorb and make fruitful use of an infinite variety of musical influences regardless of their historical or geographical origins.

typography, formerly used as a synonym for printing from raised types, the word now implies the skilled planning of the appearance of printed matter including choice of paper, finished size, specification of type, and the arrangement of text and illustrations. Printing of texts from carved blocks of wood was in use in the Orient by the 8th century. Movable types were made from clay in the 1040s in Song China, and bronze types were cast in Korea during the 12th century. No certain connection between early oriental typography and the European mode of printing that began in Germany in the middle of the fifteenth century can be shown.

In the early days of European typography (roughly 1450–1500) most books tried to imitate the appearance of manuscripts, so the type looked like hand lettering (it is usually called Gothic or black letter type), but in the 16th century this was superseded by Roman type (the normal form today, as used in this book) and italic (a sloping face). Type also became more compact, so that books were easily portable. Different typefaces are usually named after those who created or popularized them, although the typeface Bembo is named after Cardinal Pietro Bembo (1470–1547) because it was based on a type used for a book written by him. Among celebrated type designers are the Italian Giambattista Bodoni (1740–1813) and the Englishmen William Caslon (1692–1766), John Baskerville (1706–75), Eric Gill (1882–1940), and Stanley Morison (1889–1967). In addition to designing typefaces, Morison was an important figure in adapting historic typefaces for mechanical typesetting.

A

SPECIMEN

OF THE

SEVERAL SORTS

O F

LETTER

GIVEN TO THE

UNIVERSITY

B Y

D.ʳ JOHN FELL

LATE

LORD BISHOP of OXFORD.

To which is Added

The LETTER Given by Mr. *F. Junius.*

O X F O R D,

Printed at the THEATER *A.D.* 1693.

An example of Oxford University Press's **typography** soon after the death of its founder, Dr John Fell. At a time when most scholarly printing was done in Holland, Germany, and France, he brought a range of distinctive typefaces in the Roman, Greek, Arabic, and Hebrew alphabets from Amsterdam to Oxford. These robust, irregular, hand-cut letterforms set the style for English printing for much of the next century.

Since the fifteenth century, movable type has also been produced for non-Latin scripts, at first Greek, Hebrew, and Arabic, and later vernacular writing systems of all parts of the world, usually under the inspiration of either scholars or missionaries. Typography as a separate branch of design began in the late 19th century among 'art compositors'. In the 1920s and 1930s it became common for the layout of printed matter to be specified by a graphic designer. The invention in recent decades of electronic means of transmitting typefaces to the printed surface or screen has led to the evolution of many new typefaces, and visually acceptable ways of combining text and images to convey information. (See also *in-cunabula.)

Uccello, Paolo (*c.*1397–1475), Italian painter. He was fascinated by the new skill of indicating *perspective, although he used it in a way that was appropriate to his subject rather than as a mere technical exercise. His mathematical rigour was tempered with a delight in decorative display that reflects his training in the *International Gothic style (in the workshop of the sculptor *Ghiberti) and he merged these two seemingly disparate stylistic currents to create effects of captivating charm. His most famous work is a series of three paintings on *The Battle of San Romano* (*c.*1455) painted for the Medici family.

ukiyo-e, Japanese term meaning 'pictures of the floating world', applied to the dominant movement in Japanese art of the 17th to 19th centuries. It refers to the subjects from transient everyday life, with its ever-shifting fashions, favoured by print-makers at this time, including such celebrated artists as *Hiroshige, *Hokusai, and *Utamaro. Favourite subjects were theatre scenes and prostitutes and bath-house girls. Prints were originally in black outline only, then hand-tinting became the custom, and colour printing was established by the 1760s. The artist made a drawing on thin, transparent paper, which was pasted face down on to the surface of a prepared piece of cherry wood and destroyed in the process of cutting. The engraver cut the block so as to leave the artist's design standing up in relief, and the printer took impressions from this in black ink. The artist indicated on one of these proofs where colour was to be printed, and the engraver then cut additional blocks, normally one for each colour. The printer, using water-colour mixed with rice paste, would then produce the finished full-colour work by imprinting sheets successively with each of the six or so blocks corresponding to the number of colours. It was entirely a hand process, but such prints were nevertheless aimed at the mass market. They were so commonplace that they entered Europe not as works of art but as wrapping and packaging on other, more expensive goods. They caught the attention of avant-garde French artists in the second half of the 19th century, influencing the *Post-Impressionists with their flat decorative colour and expressive pattern.

ukulele, a miniature four-stringed *guitar, which originated in Hawaii but derived from the small Portuguese guitar-type instrument the *machete*, which had been carried to the Philippines in the 16th century and had travelled thence to Hawaii. The ukulele became widely used in the USA in the 1920s, and thence in Europe, especially for accompanying the voice in popular music, much of which was published with ukulele tablature. In Britain the ukulele-banjo, tuned in the same way, was more often used than the ukulele itself.

Umayyad art, the art and architecture of the Arabian Umayyad dynasty (661–750), which ruled over the entire Islamic world (including most of Spain), the only dynasty ever to do so. Initially existing buildings were converted

A print or *ukiyo-e* from the late 18th-century erotic album *Poem of the Pillow*. The delicate mood of this print by **Utamaro** is heightened by the careful attention to details as in the depiction of the graceful folds of different fabrics. (Victoria and Albert Museum, London)

by the Umayyads to the demands of the Islamic faith. The Great Mosque in the Umayyad capital of Damascus (begun 707), for example, incorporated existing Hellenistic buildings into its plan, and the Dome of the Rock in Jerusalem (685–91) is built on the site of a Jewish temple and emulates the forms of the Byzantine Church of the Holy Sepulchre in the same city. Thus the term 'Umayyad' does not refer to a particular style. In Spain a branch of the Umayyad line survived until the early 11th century, and the Great Mosque of Cordoba (begun 785) is the most important example of Umayyad architecture there (see also *Moorish art). Little survives of other Umayyad arts, although there are some murals from the palace at Qaṣr ʿAmra (712–15), including nude bathing scenes based on Graeco-Roman models.

Unamuno, Miguel de (1864–1936), Spanish novelist, poet, and essayist. He seems to have suffered a major spiritual crisis in around 1897, after which all his work is characterized by an obsessive brooding on recurrent themes, especially the conflict between faith and reason. This is the core of *The Tragic Sense of Life in Men and Peoples* (1913), which advocates an attitude of creative uncertainty, and permeates all his fiction which, apart from *Peace in War* (1897), is markedly experimental. His *Mist* (1913) explores questions of free will and determinism, identity and personality, which underlie later works, especially *Abel Sánchez* (1917) and *San Manuel Bueno, Martyr* (1930). An uncompromising thinker, his works, in both forms and ideas, seek to undermine his reader's security.

Ungaretti, Giuseppe (1888–1970), Italian poet. Born in Alexandria, Egypt, he was influenced by French 'decadent' poets including *Mallarmé, *Rimbaud, and

*Apollinaire during his student days in Paris. He fought in World War I, an experience which marked his poetry. The *Symbolist, indeed cerebral, poetry of his early years gave way to a greater lyrical force: he could invest a few words with a significant depth of meaning in order to express what he called the cosmic essence of things.

Updike, John (Hoyer) (1932–), US novelist, short-story writer, and poet. Among his best-known novels is *The Centaur* (1963), in which realism combines with mythology in the presentation of three days important in the lives of a teenager and his father who, like other characters, are also presented as figures of Greek mythology. *Couples* (1968) depicts a small town's stylish set of young married couples in their almost religious observance of sexual pairing. Updike is known as a brilliant stylist in his fiction, but he has also written many poems, generally light, published in a series of collected works.

Urdu literature, literature written in Urdu, the principal language of the Muslim population of India and Pakistan, usually written in Persian script. It began in Dakani, the dialect of the Deccan Muslim kingdoms of Bijapur and Golconda. The earliest texts (mid-15th century) are Sufi verses, but court poetry reached its height with the 17th-century Nusrati and Ghavvasi. The poet Walī (1668–1707) flourished at Aurangabad and c.1700 moved to Delhi, where Urdu soon supplanted Persian for writing poetry. At Delhi three poets became prominent: the satirist Saudā (1713–81), Mīr (1722–1810), writer of love-lyrics, and Dard (1721–85), a Sufi mystic. As Mughal Delhi declined, artistic patronage centred on Lucknow (c.1750–1850). Sensuality characterized the Lucknow Urdu poetry of Insha (1756–1818) and Atish (1785–1847). Delhi poetry revived under the last Mughal emperor Bahadur Shah Zafar with his laureate Zauq (1790–1854), Momin (1800–52), and particularly Ghalib (1797–1869). Urdu prose began with folk-tales like *Garden and Spring*, produced for Fort William College (founded 1800), and was developed further by Sir Sayyid Ahmad Khan (1817–98) and the Aligarh

Movement. The first Urdu novelist was Nazir Ahmad (1836–1912) whose *The Bride's Mirror* dealt with female education. The poet Iqbal (1878–1938), the spiritual father of Pakistan, blended Islamic philosophy with nationalism. The fiction-writer Premchand, claimed by *Hindi literature, was published equally in Urdu. The story-writer Manto (1912–55) and the poet Faiz (1910–84) are also highly regarded. (See also *Sufi literature.)

Urfé, Honoré d' (1567–1625), French novelist. His major work, *L'Astrée* (1607–27), is a long *pastoral *romance embodying an ethical code of chivalrous love which found an echo in 17th-century salon society. Set in 5th-century Gaul, it combines elements of history, adventure, chivalry, and pastoral life interspersed with madrigals and sonnets. In its day it was immensely popular and inspired many later writers.

Utamaro Kitagawa (1753–1806), Japanese painter and print-maker, a leading exponent of *ukiyo-e. He specialized in portraying beautiful women (*bijinga*), usually sophisticated courtesans of the Yoshiwara district of Tokyo, where he lived for most of his life. The beauty of his colour and line and the vigour of his characterization made him enormously popular and influential in Japan and later much appreciated in the West.

Utrillo, Maurice (1883–1955), French painter. He was the illegitimate son of Suzanne *Valadon, a famous artist's model and distinguished painter. Utrillo began to paint in 1902 under pressure from his mother, who hoped that it would remedy the alcoholism to which he had been a victim from boyhood. His large output consists mainly of street scenes in Montmartre, often painted in milky tones. He subtly conveys solitude and emotional emptiness and shows a delicate feeling for atmosphere, even though he often worked from postcards. His best work was achieved by 1916; success in the 1920s led him to repeat many of his works.

Utzon, Jørn (1918–), Danish architect. He worked briefly with *Aalto in Helsinki, and then with *Asplund in Stockholm, and came to international prominence in 1956 when he won the competition for the Sydney Opera House, producing one of the most strikingly original of all 20th-century designs. The building stands on a breakwater jutting into Sydney harbour, and has a series of huge white shell roofs redolent of billowing sails. The construction of the building posed grave problems (it was eventually finished in 1973 at huge cost) and Utzon left the project in 1966 because of interference with his work; the exterior, however, is close to his original conception in all essentials. Utzon's other work includes the Parliament Building in Kuwait.

Valadon, Suzanne (*c*.1867–1938), French painter. As an artist's model she posed for Renoir, Puvis de Chavannes, and Toulouse-Lautrec. Degas was among those who encouraged her to develop her artistic talents and she eventually became a successful painter. Her painting has a fresh and personal vision, reflecting her sharpness of eye and avidity for life. She was at her best in figure paintings, which often have a splendid, earthy vigour and a striking use of bold contour and flat colour. The painter *Utrillo was Valadon's illegitimate son.

Valéry, Paul-Ambroise (1871–1945), French poet and essayist. During the 1890s Valéry published work in *La Conque* and *Le Centaure*, *Symbolist reviews, but thereafter wrote no more literature until *La Jeune Parque* appeared in 1917. This poem, and the collection *Charmes* (1922) which followed it, constitute the basis of Valéry's reputation as a poet. The latter collection contains 'Le Cimetière marin', his most famous poem, a reflection on the theme of life and death. Unlike the Symbolists, he eschews free verse and casts his thought into a regular, classical form of great beauty. His essays, on many subjects, are enhanced by his stylistic qualities of verve and compression. Among the more accessible of these is *La Soirée avec Monsieur Teste* (1896), a partial self-portrait, humorously written, about an absent-minded intellectual.

Valle-Inclán, Ramón Maria del (*c*.1866–1936), Spanish novelist and dramatist. He worked as a journalist in Madrid, standing out for his anarchic eccentricity among the group which was to become the *Generation of '98. His first major success as a novelist was with the elegantly written four *Sonatas* (1902–5), whose decadent hero is reminiscent of Nietzsche's Übermensch. *Lights of Bohemia* (1920) introduces his first *esperpento*, a technique of systematic artistic distortion of character to convey the deformed aesthetic which was to become the hallmark of the Theatre of the *Absurd.

Vallejo, César Abraham (1893–1938), Peruvian poet. Brought up in a small town in the Andes, Vallejo recalled it in later life as an ideal. His first book of poems, *The Black Heralds* (1918), showed the influence of *Darío and the *modernists, but in his second, *Trilce* (1922), he finds a remarkable original voice, disturbing and moving the reader. In the collection *Human Poem* (1938) he turns to an idiosyncratic Marxism, relating the anguish of the poor in South America to universal social themes, and to the issues raised by the Spanish Civil War, which he experienced first-hand.

valve, *brass instruments.

Vanbrugh, Sir John (1664–1726), English architect and dramatist. As a soldier he spent four years imprisoned in France as a suspected spy before becoming one of the outstanding exponents of *Restoration comedy. His best plays are *The Relapse* (1696) and *The Provok'd Wife* (1697), which wittily deal with sexual intrigue and the fashionable

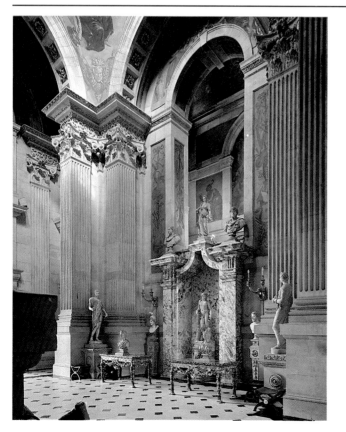

The great hall at Castle Howard is one of **Vanbrugh**'s most impressive interiors. It rises through two storeys into a dome, and never before had an English country house boasted such a grandiose Baroque room. The quality of the decoration was appropriately high, but the hall was badly damaged by a fire in 1940 and the dome paintings, by the accomplished Venetian artist Giovanni Antonio Pellegrini, were destroyed.

world of the day. Turning to architecture he became with *Hawksmoor the leading English *Baroque architect. His two most famous buildings are Castle Howard, Yorkshire (begun 1699), and Blenheim Palace, Oxfordshire (begun 1705), which are among the grandest of English country houses. Blenheim was built for John Churchill, 1st Duke of Marlborough, in thanksgiving for his victories. Vanbrugh had a notorious feud with the overbearing Sarah, Duchess of Marlborough and was eventually dismissed. Of his other works the most remarkable is Seaton Delaval, Northumberland (1720-8), in which the audacious boldness and massive grandeur of his style are concentrated into a comparatively small house. His own house, Vanbrugh Castle, Greenwich (1718), is in a medievalizing style that marks him out as a forerunner of the *Picturesque and the *Gothic Revival. Most of Vanbrugh's architectural work involved country houses for the aristocracy, but he also designed a theatre in London (destroyed) and was employed on royal buildings as *Wren's deputy.

van Campen, Jacob (1595-1657), Dutch architect. His most important building is the huge, stately Amsterdam Town Hall (now the Royal Palace), begun in 1648 and a triumphant symbol of the city in its greatest period. His other buildings include the Mauritshuis in The Hague (1633-5), designed as a royal palace and now a picture

gallery. Van Campen was also a painter, concentrating on historical scenes and decorative work.

Vančura, Vladislav (1891-1942), Czech novelist and dramatist. He is important primarily for his experiments with language, including both vocabulary and syntax. His prevalent view is nihilism, most apparent in the novel *Ploughing Fields and Battle Fields* (1925), a terrifying vision of the brutality unleashed by World War I. Vančura was executed by the Germans during World War II.

van Dyke *Dyke, Sir Anthony van.

van Gogh *Gogh, Vincent van.

Varèse, Edgard (Victor Achille Charles) (1883-1965), French-born US composer. From the 1920s his music explored modern developments—complex rhythms, strident dissonances, freely developing forms. Such works as *Ionisation* for thirteen percussion instruments (1931) look forward to the *electronic music that was to concern him in later life. In 1953 the gift of a tape recorder enabled him to create the kind of music his questing mind had imagined but been unable to realize from orthodox sound sources. *Déserts* (1954) and *Poème électronique* (1958) were fruits of this new resource. His last composition, *Nocturnal*, remained incomplete at his death.

Vargas Llosa, Mario (1936-), Peruvian novelist, dramatist, and critic. Brought up in Bolivia and Peru, he established himself with *The City and the Dogs* (1962), a novel describing his education in a military academy in Peru. As in later novels, he made no attempt to disguise the real-life inspiration for the work, using the struggle of the individual for survival against corruption to reflect the spiritual and political malaise of Peru. He has published a distinguished series of other novels, including *Conversation in the Cathedral* (1969) and *The War of the End of the World* (1981). He has also published plays and studies of Flaubert and García Márquez. Unusually for a writer of his quality, he adopts a high profile, seeming almost to seek publicity and controversy.

variation, theme and, a piece of music in which a main theme, usually a self-contained melody, is presented in a sequence of different versions. Thus the *harmony or *rhythm may be radically altered, while the melodic outline remains the same—or vice versa. All kinds of variants are possible and effective, so long as the relationship with the original is still discernible. Early examples simply decorate the given theme, but later practices make more radical changes so that each 'variation' assumes a character of its own. Variations first appeared in 16th-century keyboard music, but by the 18th century were also to be found in orchestral works. Later examples, such as Elgar's 'Enigma' Variations (1899), often explore individual aspects of a theme, rather than treating it in its entirety.

Varley, John (1778-1842), British landscape painter in water-colour. He published handbooks on water-colour technique and was perhaps the most influential teacher of his day. His style represents the transition between tinted topographical drawing and the bolder method of water-colour characteristic of the 19th century. Other members of his family were artists, notably his

brothers **Cornelius** (1781–1873) and **William** (c.1785–1856).

varnish, a liquid material used chiefly as a protective coating (on furniture, for example, as well as on pictures). Picture varnishes have traditionally consisted of a resin such as amber, copal, or sandarac, dissolved in a substance such as linseed oil or turpentine. Synthetic solutions are now also used. Albumen varnishes, usually made from the whites of egg, have been used as a temporary varnish. Spirit varnishes originated in the Far East and were not introduced into Europe until the 16th or 17th century, becoming popular in the 18th century. They are used chiefly as fixatives for water-colour or tempera paintings. Wax, chiefly bleached beeswax, or paraffin wax, has been used to give a matt protective coat. Ideally, varnish used as a protective coating should be colourless, transparent, without effect on the colour of the paint, and easily removed if it deteriorates. Varnish has seldom matched this ideal, however, and the removal of darkened varnish without damaging the paint surface underneath is one of the delicate tasks facing the picture restorer.

Vasarely, Victor (1908–), Hungarian-born painter. Active in France from 1930, he was the main originator and one of the chief practitioners of *Op art. In the 1930s he worked mainly as a commercial artist, particularly on the design of posters, showing a keen interest in visual tricks and spatial illusions. From 1943 he turned to painting, and in about 1947 adopted the kind of geometrical abstraction for which he is best known. He explored ways of creating impressions of movement through visual ambiguity, and his fascination with this field led him to experiment with *kinetic art. Vasarely's writings as well as his paintings have been of great influence on younger Op artists.

Vasari, Giorgio (1511–74), Italian painter, architect, and biographer. His *Lives of the Most Excellent Painters, Sculptors, and Architects* (1550, enlarged in 1568) is the fundamental source of information on Italian Renaissance art, its outlook shaping attitudes to the period for centuries afterwards. Vasari believed that art had declined in the Middle Ages, been revived by *Giotto, and culminated in the work of *Michelangelo, and this idea of artistic 'progress' subsequently coloured most writing on the *Renaissance. His own considerable achievements as painter and architect have sometimes been overshadowed by his reputation as an art historian. His painting style can be classified as *Mannerist, his principal works being the fresco cycles in the Palazzo Vecchio in Florence and the Sala Regia in the Vatican. Vasari was the architect of the Uffizi Palace in Florence (1560–74), built to house the Grand Ducal offices, and it remains the most familiar example of Mannerist secular architecture. He worked on the Villa Giulia, Rome (1550–5), the suburban villa of Pope Julius III and he designed the tomb of Michelangelo at Sta Croce, Florence.

Vauban, Sébastien le Prestre de (1633–1707), French soldier, military engineer, and architect. He was the foremost military engineer of the 17th century, building a cordon of fortresses around France. Vauban also designed other buildings such as gateways, barracks, and chapels in association with his fortifications, always in an austere, massive style, and he wrote various works on military architecture and siege craft. In spite of the royal favour he long enjoyed, he died in disgrace after writing a pamphlet on taxation that met with Louis XIV's disapproval.

vaudeville, US entertainment consisting of a succession of short items—singers, dancers, comedians, acrobats, animal acts—and often including sketches in which star names from the theatre could occasionally be seen. Dating from the 1880s, it resembled British 'variety' or *music-hall, both of which evolved from free-and-easy evenings into more 'respectable' family entertainments in purpose-built theatres. Vaudeville developed its own stars such as the comedian W. C. Fields (1880–1946) and the 'black-face' artist Lew Dockstader, and survived until the 1930s. The term was applied in France to a light play with music. (See also *burlesque.)

Vaughan, Henry (1621–95), Anglo-Welsh poet and mystic. He lived in Breconshire, where he seems to have practised as a physician. The rapturous *Metaphysical poetry for which he is chiefly known appeared in his remarkable third book *Silex Scintillans* ('The Shining Stone', 1650, enlarged 1655). In its preface he acknowledges his debt to the 'holy life and verse' of *Herbert; like his contemporary *Traherne, he was inspired by memories of an earlier state of childish innocence. Vaughan's poems, notably his masterpiece 'The Retreat', are filled with images of light and colour, and of natural phenomena as emblems of spiritual states. His twin brother **Thomas** (1621–66) wrote on alchemy, and his doctrine of the affinities between the spiritual and physical worlds is also evident in Henry's poems.

Vaughan Williams, Ralph (1872–1958), British composer, founder of the nationalist movement in 20th-century English music. From about 1903 he began to collect folk-songs and from 1904 to 1906 was editor of *The English Hymnal*, for which he wrote the celebrated hymn, 'For All the Saints'. His study of English *folk music and his interest in English music of the Tudor period dictated the development of his idiom away from the dominant German style of his day. He incorporated modal elements based on folk song and medieval scales, and a new rhythmic freedom of his own, into a highly personal and characteristically English style. Three works—the song cycle *On Wenlock Edge* (1909), the choral *Sea Symphony* (1909), and the *Fantasia on a Theme by Thomas Tallis* (1910)—established him as a composer of major importance. The core of his original talent may be found in his nine symphonies (1909–57) and in the opera *The Pilgrim's Progress* (1949).

vault, an arched roof or ceiling. It is to be distinguished from the *dome, the weight of which acts downward, while the vault exerts lateral thrust, in the same way as an *arch, and therefore often requires strong side *buttresses rather than massive walls or piers to support it. Whereas the dome is typically used over a roughly square or circular central space in a building, the vault is often used over a space much longer than it is wide, such as the nave of a church. The vault may have been used as long ago as the 4th millennium BC in the Middle East, but it was the Romans who first gave it a central place in their architecture. They generally used a form known as the 'barrel', 'tunnel', or 'waggon' vault, a

continuous half-cylinder of masonry, as in a railway tunnel. A great technical breakthrough came in the Middle Ages with the development of the ribbed vault, in which instead of a solid mass of masonry, the vault consists of narrow intersecting stone ribs supporting a comparatively light infilling. This was an essential component of the structural and aesthetic revolution of *Gothic architecture.

Vedas ('Sacred Knowledge'), the four books of the divinely revealed Hindu scriptures. They form the earliest *Sanskrit literature, embodying the beliefs of the Aryan warrior-herdsmen who invaded north-west India during the 2nd millennium BC. The most important book is the *Rigveda* ('The Veda of Verses'), the world's oldest religious text, still held sacred, probably composed between 1500 and 900 BC. Essential selections from the *Rigveda* (and therefore datable a century or two later) are the *Sāmaveda* ('The Veda of Chants'), with tunes for chanting the hymns, and the *Yajurveda* ('The Veda of Sacrificial Texts'), containing formulae for the priests administering the sacrifice. The *Athārvaveda* ('The Veda of the Fire-Priest'), younger and only given canonical status later, contains spells and incantations for sorcery, exorcism, and other superstitious beliefs. The Vedas were handed down orally and only committed to writing much later, perhaps in the 2nd century BC.

Vega Carpio, Lope de (1562–1635), the most prolific and influential dramatist, poet, and novelist of the Golden Age of *Spanish literature. Lope stated that more than 100 of his plays had been written in less than a day each, and that the total exceeded 1,500 plays, though only a third of these survive today. His fluency and range as a dramatist was immense; his poetry, of whatever form (and he practised most) is full of lyricism. He excelled in the writing of sonnets, ballads, and songs (*canciones*), and even his epics, novels, and many plays are full of lyrical fragments. The plays include cloak-and-dagger dramas like *The Dog in the Manger* (1618), plays on peasant honour and the pleasures of rural life such as *Peribáñez and the Commander of Ocaña* (c.1610), tragedies including *The Knight from Olmedo* (c.1620) and *Punishment without Revenge* (1631), and the historical play *The Sheep-Well* (c.1613). His verse treatise, *The New Art of Writing Comedies* (1609), established the pattern that was to characterize the dramas of his age: to mix *tragedy and *comedy in the same play; to disregard the Aristotelian unities of time and place; to divide the play into three acts for exposition, complication, and denouement; and to use colloquial language for domestic scenes.

Velázquez, Diego Rodríguez de Silva (1599–1660), Spanish painter. Most of his early works were religious pictures or *bodegones* (a Spanish term for kitchen or similar scenes with a prominent *still-life element), but after he moved from his native Seville to Madrid in 1623, on being appointed court painter to Philip IV, he concentrated mainly on portraits. In 1629–31 and 1648–51 he visited Italy, but otherwise his life revolved around the activities of the court. He always based his work on close study of nature, but his way of expressing this became increasingly subtle. His early works have a sculptural solidity and use detail to give a sense of almost palpable reality, but he gradually subordinated detail to overall effect, so that in his late works the atmosphere and sense of space in a scene are conveyed with vividness and immediacy, but the individual figures or objects dissolve into blurred brush-strokes when they are looked at closely. With this technical skill went a mastery in expressing character that has rarely been matched—even when he was painting the pathetic court dwarfs (in a marvellous series in the Prado, Madrid, where almost all his greatest works can be seen) he conveyed a sense of profound human sympathy, with no suggestion of caricature. As with almost all Spanish painters, Velázquez remained little known outside his country until it was brought into the mainstream of European affairs with the Napoleonic wars. In the mid-19th century, however, he was highly influential on progressive artists such as Manet.

Velde, Henri van de (1863–1957), Belgian architect, designer, painter, and writer, an outstanding exponent of *art nouveau. Initially he was a painter, but in about 1890, under the impact of William *Morris and the *Arts and Crafts Movement, he turned to design. In addition to designing many buildings in Belgium and Germany he was a prolific writer and lecturer and the director (1908–14) of the Weimar School of Arts and Crafts, which developed into the celebrated *Bauhaus. His finest works include his own house at Uccle near Brussels (1895), for which he designed the furniture and fittings. He was the first art nouveau designer to use completely abstract forms, rather than ones based on plants.

veneer, a thin sheet of material with a decorative or fine finish bonded to the surface of an object made of coarser and cheaper material. The term usually refers to the use of rich-coloured, expensive woods (such as mahogany or rosewood) in furniture, but veneers can also be made of other luxury materials such as ivory and *tortoiseshell. Veneering was known in the ancient world, but it did not become common in furniture-making until the 17th century (see *cabinet-making); the height of skill in the craft was reached in the 18th century, particularly in France. In the 19th century the introduction of mechanical saws allowed veneering to be used in mass-produced furniture.

Venetian art, the art and architecture of Venice, particularly in the 16th century, the period of its greatest material and cultural splendour. Culturally it was open to diverse influences and originally looked east to Byzantium, as is seen in the most famous Venetian building—the Basilica of St Mark (see *Byzantine art). In the 15th century, led by the *Bellini family, Venice became established as a leading Italian centre for painting. Giovanni Bellini established the Venetian concern for colour rather than drawing as the dominant means of artistic expression. His pupils included *Giorgione and *Titian, and the line of great painters was continued to the end of the century by *Tintoretto and *Veronese. Venetian architecture is characterized by sensuous richness. The Doge's Palace, with its lacy open stonework, and the St Mark's Library in an exuberant classical style, are two of the buildings that most clearly demonstrate this trait. The Library is by *Sansovino who—though a Florentine by birth—became the leading Venetian sculptor of the 16th century and often made his sculptures parts of the decorative schemes of his buildings. In the Veneto, the mainland area inland from Venice, the

pre-eminent architect *Palladio built villas and civic buildings, as well as churches in the city itself. By the 17th century, the native genius seemed to have exhausted itself, and most of the best painters to work there came from elsewhere in Italy or abroad. Venice, however, can boast one of the finest and most original buildings of the Italian *Baroque—the church of Santa Maria della Salute by *Longhena. With its huge scrolls buoying up the dome, it is one of the most magnificent as well as one of the most familiar sights in the city. In the 18th century Venice enjoyed its second great flowering of art. *Tiepolo and Giambattista Piazzeta were outstanding among many distinguished decorative painters who revived the brilliant colours and festive spirit of the 16th century. The engraved *veduti* (views) of the city published by Luca Carlevaris in 1703 are, together with his paintings, the foundation on which *Canaletto and *Guardi built their own popular images of the city. With the rise of *Neoclassicism in the late 18th century, the vitality again went from Venetian art, and since the 19th century the city has been more a place of cultural pilgrimage than a creative centre. In the field of 20th-century art, however, it is important for the Venice Biennale, an international exhibition instituted in 1895 and held every two years, which has acquired world-wide prestige as a show-place for contemporary art.

Venturi, Robert (1925-　　), US architect. He worked for *Saarinen and *Kahn before establishing his own architectural practice in Philadelphia in 1958. His work has included public, collegiate, commercial, and domestic buildings. His houses in particular have developed ambiguous spatial devices in a way that indicates his interest in the *Baroque. Venturi's most recent work reflects the ideas of *Post-Modernism, notably his Sainsbury Wing (begun 1987) for the National Gallery, London. In spite of such prestigious commissions, Venturi is probably better known for his writing and teaching than for his buildings. His books include *Complexity and Contradiction in Architecture* (1966).

Verdi, Giuseppe (Fortunino Francesco) (1813-1901), Italian composer. Verdi was the son of illiterate peasants in a small village in the state of Parma. His first *opera, *Oberto* (1839), met with considerable success and brought him an influential publisher (Ricordi) and commissions for more operas. While he was completing the first of these, his wife and two children died. The opera (a comedy) failed, and it was some time before he could be induced to compose again. His third opera, the biblical drama on the theme of Jewish exile, *Nabucco*, triumphed in 1842—partly because of its outstanding musical vitality, and partly because its subject-matter could be identified with the cause of Italian unification. Operas now began to pour from his pen, the pace only slackening after the world-wide success of *Rigoletto* after Hugo's drama *Le Roi s'amuse* (1851), *Il trovatore* (1853), and *La traviata* (1853), after the drama and novel *La Dame aux Camélias* by Alexandre Dumas *fils*. Dissatisfied with Italian operatic conditions, Verdi was now inclined to withdraw from the theatre, but he was tempted back by three handsome commissions: *The force of destiny* (St Petersburg, 1862), *Don Carlos* (Paris, 1867), both based on dramas by Schiller; and *Aida*, after the French prose of Camille du Locle (Cairo, 1871). There followed a silence, broken only by a String Quartet (1873) and the

great Requiem (1874), until in old age he surprised the world with his greatest masterpieces: the Shakespearian tragedy, *Otello* (1887), and a comedy *Falstaff* (1893).

Verga, Giovanni (1840-1922), Italian novelist and short-story writer. Born in Sicily, Verga wrote his early works under the influence of French *naturalist writers, then established his own style of 'verismo' or *realism to depict the life of the Sicilian peasants. Among his short-story collections are *Life in the Fields* (1880) and *Rustic Tales* (1883), the former including *Cavalleria Rusticana*, immortalized in Mascagni's opera. His two major novels are *The House by the Medlar Tree* (1881), about a family of fishermen, and *Master Don Gesualdo* (1889), about a self-made man who suffers rejection when he tries to break the class barrier. Verga perfected a unique narrative style which combined literary language with idioms and constructions from popular and dialect speech.

Verlaine, Paul (1844-96), French poet. His reputation rests chiefly on the work of the first part of his career: *Poèmes saturniens* (1866) and *Fêtes galantes* (1869), which

Verlaine's great lyric poetry found itself unexpectedly in the eye of the storm that brought World War II to an end: it was these lines, broadcast from London on the night of 5 June 1944, that the French resistance forces had long awaited. They gave the coded signal of the Allied landings at dawn the following day and the final liberation of Europe: 'Les sanglots longs / des violons de l'automne / blessent mon coeur/d'une longueur/monotone'. (Etching by Anders Zorn, Nationalmuseum, Stockholm)

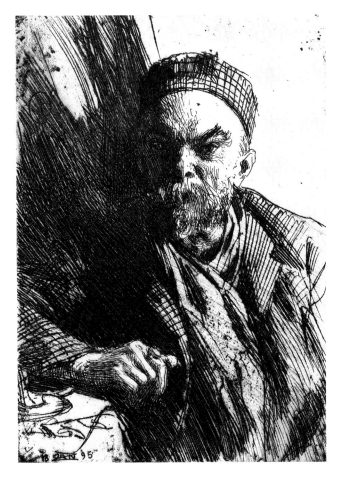

reflect the influence of the *Parnassians; *Romances sans paroles* (1874), which grew out of his stormy relationship with *Rimbaud; and *Sagesse* (1881), stimulated by his conversion to Roman Catholicism. His poetic theory, enunciated in *Art poétique* (1871–3), emphasized suggestion and musicality and therefore looked forward to the *Symbolists. However, he rejected their concept of *vers libre* or *free verse which could dispense with rhyme and metre, holding instead to *vers libérés*, verse which retained these features but with greater flexibility than had been allowed by traditional metrical schemes: his use of the *impair*, a line with an uneven number of syllables, enabled him to achieve strikingly musical effects. In 1884 he published *Les poètes maudits*, a collection of essays which helped bring the work of Rimbaud and *Mallarmé to public attention.

Vermeer, Jan (1632–75), Dutch painter. Little is known of the details of his career and his work presents many problems to scholars. As far as is known, he lived all his life in his native town of Delft, where he probably combined painting with picture-dealing and running an inn to support his large family. The likelihood that he was only a part-time artist helps to explain why so few paintings by him survive—only about thirty-five altogether. Most of them are quiet interior scenes, involving only one or two figures. There are thousands of other Dutch paintings of the period that are superficially very similar, but Vermeer's work is raised to a completely different level because of his flawless skill in composition and the matchless sensitivity of his handling of light, through which he creates images of perfect serenity and harmony.

vernacular architecture, term applied to buildings made of local materials in response to local needs, generally of unknown authorship and following traditional patterns, with minimal reference to the styles prevailing in the mainstream of architectural development. Typical materials of vernacular architecture include timber, thatch, wattle and daub, flint, and certain types of stone. Wood has been especially important in vernacular architecture as it was once such a widely available material. It has been much employed in *timber-framing. Oak was the type most commonly used in Britain, while various soft woods have been used in Europe and America. The distinction between vernacular 'building' and mainstream 'architecture' appeared only after the Renaissance, with the rise of the profession of architect. In the late 19th century, however, vernacular styles influenced the work of architects such as Lutyens.

Verne, Jules (1828–1905), French novelist. He abandoned a legal career and began writing *science fiction stories which remain popular. His most famous titles include *Le Voyage au centre de la terre* (1864), *Vingt mille lieues sous les mers* (1870), and *Le Tour du monde en quatre-vingts jours* (1873). He foresaw a number of scientific developments and devices, including space travel, television, and the submarine, and his style has been influential for later writers of science fiction.

Vernet, family of French painters. **Claude-Joseph** (1714–89) was one of the leading French land- and seascape painters of his period. From 1733 to 1753 he worked in Rome, where he was particularly impressed by the light and atmosphere of *Claude's painting. He is best known for his paintings of the sea-shore and ports, done in an idealized and somewhat sentimental style. His son, **Antoine-Charles Horace** (Carle Vernet) (1758–1835), painted battle scenes for Napoleon, and after the restoration of the monarchy was official painter to Louis XVIII, for whom he did racing and hunting scenes. His son, **Emile-Jean-Horace** (Horace Vernet) (1789–1863), was one of the most prolific of French military painters, specializing in scenes of the Napoleonic era, together with animal and oriental subjects.

Veronese (Paolo Caliari) (c.1528–88), Italian painter. In 1553 he settled in Venice, and is one of the major artists of the Venetian School. He worked on a large scale, whether in paintings or *frescos, and excelled at lavish decorative effects; his paintings resemble gorgeous pageants, giving a picture of the material splendour of Venice in its Golden Age. In a famous incident the Inquisition criticized him for including characters they thought unbecoming (including a buffoon with a parrot) in a painting of *The Last Supper*. Veronese soothed them by renaming the picture *The Feast in the House of Levi* (1573), a biblical subject to which his approach was thought more appropriate. Veronese had a busy studio in which several members of his family worked. Almost all his most ambitious works are in or around Venice, above all in the church of S. Sebastiano, where he is buried.

Verrocchio, Andrea del (1435–88), Italian sculptor, painter, and metalworker, originally trained as a goldsmith. He had the largest and most important workshop in Florence in the second half of the 15th century. His most famous works are the statue of David (c.1475) in the Bargello in Florence and the equestrian statue of Bartolommeo Colleoni in Venice (begun 1481, completed after his death). Few paintings exist that can be certainly assigned to Verrocchio's own hand, but numerous important pictures came from his workshop. He also trained several distinguished painters, most notably Leonardo da Vinci.

Versailles *Boulle, *Le Nôtre, *Louis XIV style.

vessel flute, a musical instrument with a globular rather than tubular body, such as the *ocarina and many whistles. Acoustical differences between tubular and vessel flutes are fundamental. The pitch of tubular flutes is controlled by their length and varied by opening fingerholes, whose effect is mainly determined by their position. The pitch of vessel flutes is controlled by their volume and varied by the area of open holes whose position is almost immaterial; they are blown cavity resonators. Since the *embouchure* or blowing hole is also an aperture,

'Maid with a Milk Jug' (c.1660), *right*, illustrates many of the features typical of **Vermeer**'s work: a single figure engaged in an everyday task; a window lighting the scene from the left; a favourite colour harmony of yellow, blue, and grey; and delicately grainy brushwork suggesting the play of light with exquisite vibrancy. Even though Vermeer's name was at that time almost entirely forgotten, Sir Joshua Reynolds thought this picture was one of the finest he saw when he visited the Netherlands in 1781. (Rijksmuseum, Amsterdam)

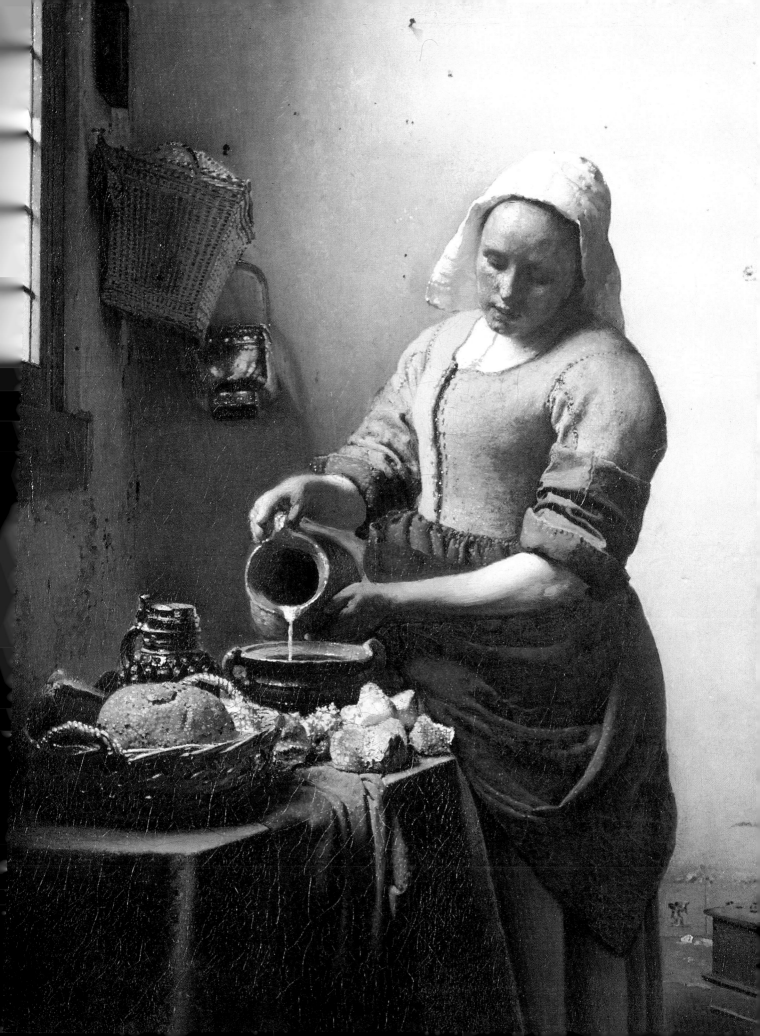

shading it with the lip also affects the pitch. Experiment shows that other instruments also function as cavity resonators: slit drums, for example, are affected by the volume of contained air and by the area of the slit, and the effect of area of open hole explains the results of cross-fingering (closing one or more finger-holes below the lowest open hole to flatten the pitch by a semitone) and altering finger-hole sizes on all wind instruments.

Vicente, Gil (*c*.1470–*c*.1536), Portuguese dramatist and poet. A playwright whose works reach back to the medieval Portuguese dramatic tradition and ahead to the Renaissance theatre, he practised both as an actor and director of *pageants. He excelled in a variety of secular and religious genres, but a persistent feature of his work is its naturalness, with related qualities of realism and humour. His works, written in Portuguese and Spanish, are particularly memorable for their rich gallery of human types, inspired by contemporary Portuguese life, each defined by his own peculiar language. Many of his works were censored by the Church and banned by the Inquisition after 1536. Irreverent in their desire to entertain and correct, they incorporate social criticism of the clergy, of corrupt religious practices, and of life at court.

Victoria, Tomás Luis de (1548–1611), the greatest Spanish composer of the Renaissance and one of the finest European composers of the time. In about 1587 he was appointed chaplain to the Dowager Empress Maria, living in retirement in a Madrid convent. He remained in her service until her death in 1603, and was organist at the convent until his own death. His music—settings of the mass and magnificat, *motets, and other liturgical compositions—is notable for its intensity and *polyphonic magnificence. His psalm-settings, employing two and three choirs, are particularly impressive, and his reputation today rests mainly on his motets. Although he wrote no secular music, a certain amount of madrigal-type word-painting can be seen in some of his works.

Victorian architecture, the architecture of Britain and of certain parts of the British Empire during the reign of Queen Victoria (1837–1901). This period was marked by great variety; one of its main characteristics was the revival of many different historical styles (a trait that was often accompanied by a love of lavish ornamentation) and Victorian architecture was long dismissed by many as heavy-handed and derivative. Now, however, the richness, vitality, and self-confidence of the best Victorian buildings are once again appreciated. To many architects and patrons certain styles were thought of as particularly 'morally' suitable for certain types of building. The most obvious instance is Gothic (see *Gothic Revival), which was regarded as the style for ecclesiastical buildings because of its association with the supreme age of Christian devotion and church-building in the Middle Ages. The way in which Victorian architects responded to the past, however, varied considerably; some were concerned with accurately reproducing the forms and details of their models, whereas others used the past as a springboard for the imagination. Thus *Burges, *Butterfield, and *Pugin all worked in a Gothic style, but their work is completely different in flavour. Victorian architects also reacted imaginatively to the functional use of new buildings (such as the railway station), to mass production,

mechanization, and new building materials, most notably *Paxton in the Crystal Palace. Some of the most grandiose Victorian buildings are outside Britain, an outstanding example being the Parliament Buildings in Ontario (1861–7).

Vidal, Gore (1925–), US novelist, dramatist, and essayist. Born into the US political élite, he achieved notoriety with the novel *The City and the Pillar* (1948), a sympathetic treatment of homosexual life, and *Myra Breckinridge* (1968), a satire about the lurid adventures of a transsexual. More substantial are his stylish, sardonic essays, and his historical novels dealing with the history of the ancient world and with the political life of the USA. The latter include the trilogy *Burr* (1973), *1876* (1976), and *Lincoln* (1984).

Vietnamese art. Northern Vietnam was conquered by China in the first century AD and Chinese influence has been dominant in Vietnamese art (see *Chinese art). Early remains such as glazed ceramics and brick tombs reflect the influence of the Han (206 BC–AD 220) and Tang (618–907) dynasties. In 697 northern Vietnam was declared the protectorate of Annam ('Pacified South') by the Tang court, but struggles throughout the 10th century resulted in the establishment of the independent Ly dynasty in 1009. Thang-long (now Hanoi) was founded as the new capital and the arts were actively patronized, particularly those associated with palace and monastic architecture. The *stupa-tower of Binh-son and decorative

The railway station was among the many new building types to achieve prominence in **Victorian architecture**. None was grander than London's Euston Station, which boasted a magnificent Greek Revival gateway (1836–9) by Philip Hardwick and this Great Hall (1846–9) by his son, Philip Charles Hardwick, evoking the splendour of a Renaissance palace. Both were demolished in 1963.

tiles and carved terracotta reliefs survive from this period. Although Vietnamese ceramics are firmly rooted in the Chinese tradition there was a conscious effort to establish an indigenous decorative repertoire. This effort was continued under the Tran dynasty (13th–15th century), but Chinese occupation in the early 15th century triggered a new wave of Chinese influence, seen in temple architecture, ceramics, and decorative arts. In central Vietnam, however, the kingdom of Champa (6th to 15th century) had an independent tradition of art, Cham art, that was more influenced by India than by China. Champa temples, like the earliest *Khmer examples, consist of a brick sanctuary tower (kalan) with outbuildings of perishable materials. The earliest Cham sculptures are in an Indian post-*Gupta style of the 6th century, and a vigorous style was maintained from the 8th to the late 12th century, when attacks by Angkor debilitated the kingdom. The Chams were also renowned for their gold jewellery, much of it intended for the decoration of sculpture. Vietnamese ceramics parallel the evolution of Chinese ceramics from the Han period onwards in form and style, except for brief periods when a strongly indigenous character emerges. Production of large-scale temple vessels and utensils continued into recent times, together with domestic wares which continue to be made in traditional kilns.

Vietnamese literature. As a consequence of China's long occupation of Vietnam (2nd century BC–10th century AD), the country has been greatly influenced by *Chinese literature, language, and philosophy. Vietnamese writers only gradually began to free themselves from Chinese models and to create a literature written in *nom*, a hybrid ideographic script developed to express purely Vietnamese vocabulary and popular oral literature. The first great *nom* works date from the 15th century, and in the 17th and 18th centuries new genres such as verse novels developed and predominated. Vietnam's greatest literary work is considered to be *The Tale of Kieu* written by Nguyen Du (1765–1820) in a period of social and political ferment. The use of the Roman script combined with diacritical marks to write Vietnamese phonetically was begun by Christian missionaries. This new script, called *quoc ngu* ('national language') became widespread after the establishment of French colonial rule in the 19th century, and was used as a modernizing tool. The script and the fusion of Western concepts and traditional Vietnamese values experienced under colonial rule transformed Vietnamese literature. The 1930s marked a watershed in Vietnamese literature, a period when modern genres flourished, most notably in the Tho Moi ('New Poetry') movement. The thirty years of war (1945–75) and the partition of Vietnam in 1954 affected Vietnamese literature. In the North, literature was required to support socialism and the reunification of Vietnam, while in the South writing was more varied and critical. A leading contemporary writer is Le Luu, whose recent novel *Time Gone By* deals with the problems experienced by a Vietnamese soldier adapting to life in his North Vietnam village after the end of the Vietnam War in 1975. His work has inaugurated a more critical, realistic, and personal style.

Vignola, Giacomo Barozzi da (1507–73), Italian architect. His style looks back to the High *Renaissance tradition of *Bramante in its dignity and sobriety, but it also has *Mannerist features in its complexity of forms, and in certain ways anticipates the *Baroque: his Roman churches of S. Andrea in Via Flaminia (1554) and S. Anna dei Palafrenieri (begun 1573), for example, were the first to use an oval plan, a type that was taken up by 17th-century architects. Vignola's most important building is the Gesù in Rome (begun 1568), the mother church of the Jesuits. In line with the ideals of the Counter-Reformation, the building was intended to provide a clear view of the altar for a large congregation and to have good acoustics for preaching. Vignola's design, with a broad nave flanked by a series of chapels rather than by the traditional aisles, shallow transepts, and a central dome, was so successful that it became one of the most imitated in the history of architecture, virtually a standard pattern for churches in Catholic countries. Vignola's other buildings include the Palazzo Farnese at Caprarola (1552–73, begun by Peruzzi), an enormous building on a pentagonal plan, with a circular courtyard. In 1562 he published an important treatise on the *Orders of architecture that became regarded as a standard work.

Vigny, Alfred de (1797–1863), French poet, dramatist, and novelist. His reputation as a *Romantic poet rests upon two collections, *Poèmes antiques et modernes* (1826) and *Les Destinées* (published posthumously, 1864). 'Moïse', in the former, describes the isolation of the leader or man of genius, while 'La mort du loup' in the latter depicts a stoic resignation to suffering. In 1826 Vigny published a successful historical novel, *Cinq-Mars*. He also wrote Romantic dramas, notably *Chatterton* (1835), considered his masterpiece, which depicts the sufferings of unrecognized genius.

vihuela, a plucked stringed musical instrument used in Spain in the Renaissance. Guitar-like in shape, it was tuned and had paired strings, or double courses, like the *lute. Like the lute it was used for serious music and coexisted with the *guitar, which was used for more popular music, much as the lute and *cittern were elsewhere in Europe. The *vihuela da mano* was plucked with the fingers, the *vihuela da peñola* with a *plectrum, and the *vihuela de arco*, the first form of the *viol, was bowed.

Viking art, the art of the Vikings, a general name for the Scandinavian (Danish, Norwegian, and Swedish) traders and warriors who from the 8th to the 11th centuries raided by sea many parts of north and west Europe. Viking art consists mainly of woodcarving, metalwork, and jewellery, much of it influenced by the art styles of nations with whom they traded. The most important group of works comes from the 9th-century Oseburg Ship Burial (showing evidence of contacts with *Carolingian art), a royal burial in Norway at which were found numerous elaborately carved wooden objects, including a cart, various sledges, and the prow and stern of a Viking ship (now in the Viking Ship Museum, Oslo). The keynote of the decoration, as with other Viking art, is complex interlace patterns with animal motifs, similar to the type of decoration found in *Celtic art. The 'art' at which the Vikings really excelled was shipbuilding—the famous longship found at Gokstad in Norway has a superb taut beauty of line that perfectly expresses its function but has an abstract purity of its own. In Britain

The Oseberg burial ship unearthed in 1904 illustrates the superb woodworking skills of **Viking art**. Human figures and plants are rare in Viking carving, but animals, particularly dragons, horses, snakes, and swans, are depicted abundantly and with great vitality, along with abstract ornament. The prow and stern of ships were often particularly finely carved. (University Museum of National Antiquities, Oslo)

Viking art influenced architecture and sculpture found in Norman (*Romanesque) churches.

Villa-Lobos, Heitor (1887–1959), Brazilian composer. Musically self-educated, preferring Rio de Janeiro's informal street music groups to academic study, he travelled widely in Brazil before establishing himself as an experimental and controversial composer, utilizing modernistic European idioms together with elements from Brazilian folklore in his music. Periods in Paris (1923–30) consolidated his reputation as Brazil's leading musical figure, after which he devoted fifteen years to revolutionizing aspects of national musical education in tandem with current political trends. He was extraordinarily prolific, his music generally exhibiting a vital and picturesque folk idiom, typified in the nine *Bachianas brasileiras* (1930–45), his own synthesis of Brazilian and European music.

Villard d'Honnecourt (d. *c.*1235), French architect. Little architectural work can be credited to him, but he is important as the author of a manuscript volume in the Bibliothèque Nationale, Paris. Part sketch-book, part treatise, it is the only such book to have survived from before the 15th century giving insight into the working practices of French architects during the period of the great *Gothic cathedrals. It includes sections on technical procedures and mechanical devices, with notes on buildings and monuments seen on the author's travels.

Villon, François (François de Montcorbier or François des Loges) (*fl. c.*1460), French poet. He was notorious for his life of criminal excess, and spent much time in prison. Sentenced to death in Paris in 1462, he was pardoned and banished from the capital for ten years, after which nothing is known of his life. One of the greatest French *lyric poets, his work comprises principally the *Lais* or *Petit Testament*, a comic poem written in 1456, and the longer, more serious, *Testament*, written in 1461. The latter incorporates a number of *ballads in *jargon* and *jobelin*, the slang of the day, and *rondeaux* (thirteen-line poems with a complex double-rhyme pattern). Among these are some of his best-known poems, including the 'Ballade des dames du temps jadis' with its famous, incantatory refrain, 'Mais ou sont les neiges d'antan?', and the 'Ballade de Notre Dame'. Perhaps his most superb work is the 'Ballade des pendus', written while awaiting execution. Villon's deep compassion for all suffering humanity, his anguish and horror of death and poignant regret for his wasted youth and squandered talent, are conveyed in direct, idiomatic language which displays a remarkable control of rhyme and an intellectual mastery of medieval literary conventions.

vīṇā, historically the most important stringed musical instrument of the Indian subcontinent. It was originally a stick *zither with gourd resonators, as it still is in northern India, though today it is elaborated with sympathetic strings of wire. In southern India the resonators have been built on to the end of the neck, turning the instrument into a long-necked lute not unlike the *sitar. There are many types of vīṇā in the Indian subcontinent, ranging from simple stick zithers to the elaborate instruments described above.

viol, a bowed musical instrument created in the 15th century in southern Spain by applying the bow of the *rebab andaluz* to the *vihuela. Viols have six strings tuned in fourths and a third, fretted fingerboards, flat backs, and bellies much less arched than those of violins. The function of the frets was to provide every note with something of the quality of an open-string sound. Viols, irrespective of size, are played *a gamba* (Italian, 'on or between the knees'). Sizes vary from treble to great bass; a soprano viol, the *pardessus de viole*, was invented in France in the 18th century. Initially used in *consort performance, the bass viol became an important *continuo instrument, and then a solo instrument, particularly in France, where a seventh string was added.

viola, the alto member of the *violin family. There is no standard size, and body lengths vary from 400 mm. to 479 mm. ($15\frac{1}{2}$ in. to 19 in.). It evolved in the mid-17th century, when it was used in orchestras as mezzo-soprano, alto, and tenor, the size of the instrument suiting the range of the music. The tuning was the same for all three, irrespective of size. The *viola da braccio* and the *viola da gamba* (Italian, 'arm viola' and 'leg viola') are terms that came into use in Italy in the 16th century to distinguish between the violin family (*da braccio*) and the viols (*da*

gamba). The *viola d'amore* was an 18th-century instrument roughly of viola size, which had sympathetic strings, and was played on the arm, without frets.

violin, a bowed stringed musical instrument evolved in Italy late in the 15th century by combining the stringing and size of the treble *rebec with the body of the **lira da braccio*. Adding a fourth string, violins retained the character, most suited to dance music, of the rebecs. Like all Renaissance instruments, violins were made in different sizes, from treble (violin) through three sizes of alto (including contralto and tenor *viola), and bass (*cello), to *double bass. The first great violin-maker was Andrea Amati (pre-1511 to pre-1580), the founder of a famous dynasty of Cremonese makers, pre-eminent among whom were his younger son Girolamo (Hieronymus) and his grandson Nicolò (1596–1684). A younger contemporary in Brescia was Gasparo da Salò (1540–1609), who was succeeded by his pupil Maggini. Characteristic of the work of all these makers was a deep body, with highly arched back and front or 'belly', and a full, rich tone. The same is true of the violins of Jacob Stainer of Innsbruck (*c.*1617–83), who may have been a pupil of Nicolò Amati. Nicolò's most famous pupil was Antonio Stradivari (1644–1737), who modified the shape of the violin, reducing its depth but with some models increasing its length, producing an instrument with a stronger and more piercing tone. Some 500 of his instruments remain in existence today. The sound of the Amati pattern was the more popular in the early Baroque period, and his model was widely copied by other makers throughout Europe; the tone of the Stradivari became the more popular in the ensuing period and his remains the standard model to this day. In violins, as in most stringed instruments, the exact position of the soundpost, a round stick of pine wedged between the belly and back, is crucial to the vibration of the sound as is that of the bass bar, a block of pine glued lengthwise beneath the foot of the bridge. Considerable changes in construction were made in the late 18th century for use in larger halls, to such an extent that today often only the soundbox and the scroll are left of the work of the great violin-makers of earlier times. (See also *fiddle, *hardingfele.)

Viollet-le-Duc, Eugène-Emmanuel (1814–79), French architect, engineer, writer, and archaeologist, the dominant figure of the *Gothic Revival in France. He is famous mainly for his restorations of medieval buildings, his pre-eminence in this field stemming from his friendship with the writer *Mérimée, who was Inspector of Ancient Monuments. His restorations, including work at Nôtre Dame in Paris and the walled town of Carcassonne, have often been attacked as too sweeping, obscuring the original fabric with his own romantic reconstructions, but his efforts saved some buildings from total demolition or collapse. He wrote a vast amount on architecture, promoting the Gothic style as the basis for a rational modern system of iron skeletal construction. His own buildings, however, are eclectic and unmemorable.

violoncello *cello.

Virgil (Publius Vergilius Maro, 70–19 BC), Latin poet. The loss of his paternal estate in the confiscations of 41 BC, following the civil war, is reflected in the imaginary scenes of his first major work, the *Eclogues*, ten pastoral poems in which the traditional themes of Greek bucolic poetry are blended with contemporary political and literary themes. His next work, the *Georgics*, is a lyrical, didactic poem on farming, which also treats the wider themes of the relationship between man and nature and outlines an ideal of national revival after civil war. His last and most famous work was the *Aeneid*, an *epic poem in twelve books modelled on the epics of *Homer, which relates the wanderings of the Trojan hero Aeneas after the fall of Troy. His wish that the poem (unfinished at his death) should be burned was not respected. All the poems show Virgil the master of a melodious and varied *hexameter verse, of a suggestive boldness of expression, and of a melancholy humanity. All, especially the *Aeneid*, deeply influenced poets down to the Romantic period, not least Dante, Milton, and Dryden. His works quickly established themselves as the greatest classics of Latin poetry and exerted an immense influence on later classical and post-classical literature.

virginals, a musical instrument, strictly, a small member of the harpsichord family with both bridges on the

The title-page of the first book of keyboard music to be printed in England, *Parthenia* (1612–13) shows a young girl or 'mayden' playing a pair of **virginals**, as the instrument was named in the Elizabethan period. There were two independent schools of fingering: in the Italian tradition the second and fourth were regarded as 'strong' fingers, whereas the fingering included in the works of the English virginalists treats the third as the strong finger. (British Library, London)

soundboard and strings running parallel with the keyboard, popular from the 15th to the 17th centuries. The name also often meant the *harpsichord. Flemish virginals sometimes had a smaller instrument, the 'child', stored in the side the case. The 'child' was placed on top of the 'mother' and the two were played together, the former being an octave above the latter.

Visconti, Luchino (Don Luchino Visconti, Conte di Modrone) (1906-76), Italian film and theatrical director. His film career began with *Ossessione* (1942), which transferred James Cain's novel *The Postman Always Rings Twice* to an Italian setting, and *The Earth Trembles* (1948), a documentary-style study of Sicilian fishermen filmed on location and without professional actors. *Sensibility* (1954), a love story set during the unification of Italy during the 1860s, was his first colour film. Later films included *Rocco and His Brothers* (1960), a kind of sequel to *The Earth Trembles* about the tragic results when brothers from southern Italy migrate to the north; *The Leopard* (1963), based on the novel by Lampedusa about a traditional aristocrat with liberal leanings; *The Damned* (1970), an anti-Nazi film about a powerful German steel family; and *Ludwig* (1972). He is best known, however, for *Death in Venice* (1971), an adaptation of Thomas Mann's novel.

Vitruvius (Marcus Vitruvius Pollio), Roman architect and military engineer active in the second half of the 1st century BC. The only building known to have been erected by him was a *basilica (destroyed) at Fanum (now Fano) in Italy, and his fame depends on his treatise *De Architectura*. This is the only book on building and architecture to have survived from the ancient world and is an invaluable source of information on Greek architecture as well as Roman. It was known in manuscript in the Middle Ages and the first of many printed editions appeared in Rome in 1486. For centuries it was regarded as the authoritative voice on classical architecture, exerting a powerful influence on other authors of treatises, notably *Alberti and *Palladio. The treatise is divided into ten books, dealing with such topics as town-planning, building materials, the *Orders of architecture, and with associated scientific and mathematical issues.

Vittorini, Elio (1908-66), Italian novelist. A Sicilian, he worked as a journalist in Milan, where he edited the political and cultural journal *The Polytechnic*. During the late 1930s and early 1940s he became increasingly hostile to the Fascist regime and was arrested in 1943. Much of his writing reflects his political stance; his best novels include *Conversation in Sicily* (1941) and *Women on the Road* (1949). His simple, direct style and choice of themes earned him the respect of Hemingway and Faulkner (whom he translated). An innovative writer, he sought to explore Italian realities with a scrupulously observant eye and through the use of fantasy.

Vivaldi, Antonio (Lucio) (1678-1741), Italian composer and violinist. Born at Venice, he trained as a priest and was ordained in 1703. In the same year he entered the service of the Pio Ospedale della Pietà, Venice—an orphanage for girls that maintained an excellent choir and orchestra, for which he was required to compose. With the publication of the twelve *concerti grossi *Harmonical Inspiration* (1711), Vivaldi's fame was assured. His

music became known throughout Italy and Europe and frequently took him away from Venice and his obligations to the Pietà, whose service he finally left in 1738. Though he wrote music in all forms, including over forty operas and much sacred music, it is his 500 or more concertos that provided the basis of his fame. These employ solo instruments of all kinds, presented in a variety of imaginative, lyrical textures and in structures that herald the form of the Classical *concerto. Many of them have descriptive titles, some of which are programmatic—for example *The Storm at Sea* and the enormously popular *The Four Seasons*, a set of four violin concertos (c.1725). Almost all instrumental composers of the 18th century (including J. S. Bach) show signs of his influence.

Vlaminck, Maurice de (1876-1958), French painter and graphic artist. With *Matisse and *Derain he was one of the leading exponents of *Fauvism, delighting in pure colour and often using paint straight from the tube in vigorous and exuberant compositions. This phase was short-lived, however, and from 1908 his work became darker and more solid. His later pictures tended to become rather slick and mannered.

voice, sound uttered with the vibration or resonance of the vocal chords. High notes are produced when the vocal cords are tightened, low notes when they are slack. The pressure of the air from the lungs controls the strength of the sound. Adult male vocal cords are larger and thicker than those of the adult female, hence their capacity to produce lower sounds. The lowest adult male voice is the bass, followed in ascending order by the baritone, tenor, and countertenor. The lowest adult female voice is the contralto, followed by the mezzo-soprano and the soprano. The boy's unbroken voice may be alto or treble (the equivalent of the adult soprano). Young girls have a similar range, but the voice is softer in quality. The ranges of the various voices are shown below.

bass baritone

tenor countertenor

contralto mezzo-soprano

soprano

alto treble

It should be noted that the countertenor voice is not the same as the male alto. The male alto sound is produced by a baritone singing falsetto; the countertenor is a high voice in its own right; while the *castrato has a soprano range. The term 'coloratura', as in coloratura soprano, indicates a style of singing and is not a voice as such— merely a voice which is flexible enough to cope with elaborate runs and trills.

Voltaire (François-Marie Arouet) (1694–1778), French satirist and critic. He was a prolific author of, among other things, plays, poems, historical works, and philosophical tales of a generally polemical nature. His attacks on political and religious intolerance brought repeated condemnation of his works, causing him to live at different periods in Britain and Switzerland. An early work, the *Lettres philosophiques* (1734), shows his admiration, shared by *Montesquieu, for the British political system, which, in allowing freedom of conscience, made it possible for the arts and sciences to flourish. Voltaire's drama is generally conventional, following the pattern established by *Corneille and *Racine, and though his plays were very successful in his own day they are now largely forgotten. His poetry is witty, reflecting the cultivated taste of his day, but otherwise has little artistic merit. The

satirical poem *Le Mondain* (1736) is interesting as a defence of the luxury of contemporary society and contrasts with the ideal simplicity advocated by Fénelon and Rousseau. Voltaire wrote several historical volumes, including the *Essai sur les moeurs* (1769). This recounts the history of civilization without recourse to divine intervention in human affairs. Voltaire's ideas receive their best literary expression in his philosophical tales, which demonstrate the characteristic clarity and concision of his style. In *Candide* (1759), the best-known of these, he launches a satirical attack on optimistic belief in a benign providence, though a later work, *L'Histoire de Jenni* (1775), reveals a shift away from a purely pessimistic view of life towards an undogmatic belief in the existence of God. He contributed articles to *Diderot's *Encyclopédie*, the supreme literary monument of the French *Enlightenment, in which movement he was a major figure.

Vonnegut, Kurt Jr. (1922–), US novelist, short-story writer, and dramatist. Captured by the Germans in World War II, he was working in the underground meat locker of a slaughterhouse in Dresden when that city was annihilated by US and British bombs. This experience was an important influence on the 'black humour' of his fiction, and is described in his best-known novel, *Slaughterhouse Five* (1969). In his other works, including *Cat's Cradle* (1963), he uses surrealism and science fiction, philosophic meditation, and brief, impressionistic scenes to present the duplicity and absurdity of modern life.

Vorticism, a short-lived British art movement originating just before World War I. The central figure of Vorticism was *Wyndham Lewis, who edited its review— *Blast*. His harsh, angular, mechanistic style was shared

The Vorticists at the Restaurant de la Tour Eiffel: Spring 1915 was painted in 1961–2 by William Roberts, one of the leading exponents of **Vorticism**, as an affectionate recollection of a meeting of his former associates at a favourite London restaurant. Ezra Pound is seated in the left foreground with legs crossed; Roberts is seated next to him with hands folded; and Wyndham Lewis is the central figure in the hat. (Tate Gallery, London)

by other artists in his circle, among them the sculptors Jacob *Epstein and Henri *Gaudier-Brzeska. Vorticism was strongly influenced by *Cubism and *Futurism, and the name was coined by the poet Ezra Pound, perhaps in reference to a statement by the Futurist artist Umberto *Boccioni that all artistic creation must originate in a state of emotional vortex. The movement did not survive World War I, but it is of great significance as the first organized movement towards abstraction in British art and it subsequently had a strong influence on the development of British *modernism.

Vouet, Simon (1590–1649), French painter. He was in Italy from 1613 to 1627 (mainly in Rome) and achieved a considerable reputation. In 1627 Louis XIII recalled him to be court painter, launching him on an extremely successful career. Vouet's style was much influenced by Italian art, but he avoided both the dramatic naturalism of *Caravaggio and the full emotionalism of the *Baroque, achieving a style that perfectly suited French taste. He was a versatile artist rather than a great one, but he introduced new life and a tradition of competence at a time when French painting was at a low ebb. Most of the leading members of the next generation of French artists trained in his studio, notably Lebrun.

Voysey, Charles Francis Annesley (1857–1941), British architect and designer. From the late 1880s until World War I he built a large number of houses that made a radical break with the fussiness and fancifulness of late Victorian revivalism. Generally fairly small and low, comfortable and unpretentious, typically with white roughcast walls and an almost complete absence of ornamentation, they were subsequently so influential on suburban housing that it is now hard to appreciate their originality. Voysey also designed furniture, textiles, and wallpaper, concerning himself with the smallest details of his houses.

Vuillard, Edouard (1868–1940), French painter and lithographer, from 1888 a member of the Nabis, a group dedicated to the expressive use of colour and rhythmic pattern. The colour and form of his work in these years shows the influence of *Gauguin and *Puvis de Chavannes, but he created a distinctive manner of his own. From about 1900 he turned to a more naturalistic style and with *Bonnard became the main practitioner of *Intimisme.

Wagner, Otto (1841–1918), Austrian architect. He began his career working in a Renaissance revival style, with which he achieved considerable success, but on his appointment as professor at the Academy of Fine Arts in Vienna (1894) he delivered a famous lecture in which he called for the abandonment of historicism and ornament and the adoption of a rational style based on contemporary social requirements. Although he never entirely abandoned ornamentation, Wagner put his beliefs into practice with buildings such as his stations for the Viennese subway, in which he made frank use of iron. Wagner was a popular teacher and influenced *Hoffmann and *Loos amongst others. He was the fountainhead of the Viennese tradition of *modernism in architecture.

Wagner, (Wilhelm) Richard (1813–83), German composer. An early passion for Shakespeare and Beethoven crystallized into a determination to write *opera and he completed his first, *The Marriage* (later partly destroyed), in 1833. Work as a chorus master and conductor in various German opera houses greatly increased his understanding of operatic techniques—as can be seen in his third opera, *Rienzi* (1840). This was rejected by

An 1876 production of **Wagner**'s opera *Lohengrin*. Wagner was passionately interested in theatre as much as in music, and it was in 1876 that he opened his opera house in Bayreuth, where he was able to implement his innovations in all aspects of set design and staging opera.

Paris but proved highly successful at its performance in Dresden (1842). *The Flying Dutchman*, a much finer work, was less successful when premièred in 1843. Through *Tannhäuser* (1844) and *Lohengrin* (1848) Wagner now began to work out a reformed type of opera, the theories for which he had promulgated in a series of essays. These theories found their fullest expression in the cycle of four music-dramas that make up *The Ring of the Nibelung*, composed between 1853 and 1874 and consisting of *The Rhine Gold*, *The Valkyrie*, *Siegfried*, and *Twilight of the Gods*. Based on the Germanic *Nibelungenlied* saga, they were first performed as a cycle in 1876 at the opening at Bayreuth, the opera house which he designed to meet his musico-dramatic ideals and which, like his extravagant life-style, had been made possible by the generosity of King Ludwig II of Bavaria and the unquestioning devotion of his second wife Cosima (Liszt's daughter). In the meantime he had completed *Tristan and Isolde* (1859), a music-drama based on *Gottfried von Strassburg's *Tristan*, whose overwhelming passions found a most precise expression in chromatic *harmonies that stretched the traditional concept of *tonality to its limits and superbly exploited the system of representative themes (*leitmotifs) which now gave his music its symphonic and dramatic coherence. The bourgeois comedy *The Mastersingers of Nuremberg* (1867), with text by the composer, and the intensely spiritual *Parsifal* (1882), after *Wolfram von Eschenbach's poem, completed his life's work.

waisted drum, a musical instrument in which a central section is narrower than the ends. Shapes vary from hourglass, as in India, Tibet, Japan, and West Africa, to goblet, as in Burma, and in the Middle and Near Eastern *darabukka*, *dombak*, and *zarb*. With some hourglass and most goblet drums, and the barrel-shaped Javanese *kendang*, with its internal constriction, the waist is an acoustical device to compel the contained air into resonance with the head; some New Guinea drums function more as *stamping tubes than as drums. With other hourglass drums, especially the *talking drums, the tension cords joining the two heads are pressed into the waist, increasing the tension and raising the pitch of the heads. Some Indian drums are played similarly, but the *ḍamaru*, like the Japanese *tsuzumi*, is usually tensioned before playing by tying the tension cords tightly into the waist.

wait *minstrel.

Walcott, Derek (Alton) (1930–), West Indian poet and dramatist. In 1959 he founded the Trinidad Theatre Workshop, which he directed until 1977, staging there many of his plays, including *Dream on Monkey Mountain* (1967). His collections of poems, including *In a Green Night* (1962) and *The Fortunate Traveller* (1982), combine European and Caribbean influences.

wallpaper, a decorative covering for interior walls made of large sheets of stout paper bearing painted, printed, stencilled, or embossed designs. In Europe, wallpaper seems to have developed in the late 15th century as a cheaper substitute for other wall coverings such as tapestry or painted cloth or silk hangings, and, although it is sometimes said to be a Chinese invention, there is no firm evidence that wallpaper was in use in the Far East at an earlier date than this. No examples from the earliest days survive, but the first wallpaper was probably painted. Panels of painted paper were imported from China and several country houses in Britain still have a 'Chinese room' decorated with these panels. Printing from wooden blocks was being used by the 16th century, and in the late 17th and 18th centuries a popular type was flock paper, in which the design was stencilled in adhesive and then scattered with powdered wool to create a velvety effect. The 19th century saw the development of machine printing and the sheet with an 'endless' design that is standard today, making wallpaper much cheaper and increasing its use enormously.

Walpole, Horace, 4th Earl of Orford (1717–97), British poet. The youngest son of the Prime Minister, Sir Robert Walpole, he was a Member of Parliament (1741–67) and settled in Twickenham (1747) at Strawberry Hill, the house he made into a pseudo-Gothic showplace. His *The Castle of Otranto* (1764) was the first of the true *Gothic novels. His tragedy *The Mysterious Mother* (1768), with its theme of incest, shocked many of his admirers. His literary reputation rests largely on his letters; they were modelled on those of Mme de Sévigné and are remarkable for their wit, charm, and their political and social interest.

Walther von der Vogelweide (c.1170–c.1235), German poet and composer. He extended the range of vernacular *lyric poetry beyond the traditions of *courtly love or *Minnesang*. Influenced by medieval Latin traditions (see *Carmina Burana), he emphasized the virtues of a balanced life, celebrating the requited love of equal partners and exploring the nature of love itself. He spent his life in the service of important political figures whose turbulent fortunes are reflected in trenchant political verse ranging from demands for specific actions to the criticism in his late poems of the decline in political, moral, and artistic standards in the changing world around him. More than 100 of his poems, and some melodies, survive.

Walton, Izaak (1593–1683), English writer. He is chiefly known for his treatise *The Compleat Angler, or the Contemplative Man's Recreation* (1653), which combines practical information on fishing and angling, with folklore, gastronomic advice, songs, verse, and pastoral interludes. Written as a dialogue in cheerful and leisurely prose, its glimpses of an idyllic rural life have made it lastingly popular. Walton's *Lives* are gentle and admiring portraits of friends and clerics, including John Donne (1640) and George Herbert (1670).

Walton, Sir William (Turner) (1902–83), British composer. He came under the influence and patronage of the *Sitwells, collaborating with Edith on *Façade* (1922), an entertainment in which music cleverly underscored poetry, and whose jazz rhythms and parodist wit earned him considerable notoriety. The overture *Portsmouth Point* (1925) and the Viola Concerto (1929) established him as a composer whose romanticism was clothed in terms of an easily assimilated modernism. His music includes the oratorio *Belshazzar's Feast* (1931), the operas *Troilus and Cressida* (1954) and *The Bear* (1967), two symphonies (1935, 1960), and concertos for violin (1939) and cello (1956), as well as a series of film scores (including Laurence Olivier's *Henry V*, 1944; *Hamlet*, 1947; and *Richard III*, 1955).

waltz. Derived from an old Austrian-German peasant dance, the *Ländler*, the waltz first gained popularity in the early 19th century and still exists in the late 20th century in various versions. It was originally a fast turning couple dance in 3/4 or 3/8 time with a marked accent on the first beat. Over the years the tempo decreased, although the 'Viennese Waltz', as in the works of the *Strauss family, has retained much of the earlier lilting fast style in contrast to the modern slower waltzes. The popularity and scandal that the waltz engendered was due not only to its hypnotic rhythm but also the innovative hold and the relative positions of the man and woman. Prior to the waltz, dances had been as much for the pleasure of the spectators as for the performers and this was reflected in the dual orientation of the dancers' movements. In demonstration and competition dancing the waltz can be as showy and spectacular as other dances, but as a *social dance it is the couple dance associated with courtship. In ballet, films, and musicals it is often used as a romantic symbol, as in the Tchaikovsky ballets such as *Swan Lake*.

Warhol, Andy (Andrew Warhola) (1928–87), US painter, graphic artist, and film-maker of Czech extrac-

Andy **Warhol** seen with the kind of banal packaging that he transformed into an expensive commodity. He has evoked widely differing critical opinions: to some he was an inspired figure in modern art, who celebrated and ridiculed middle-class American values; to others he was merely a clever self-promoter.

tion. In 1962 he achieved notoriety when he exhibited stencilled pictures of Campbell's soup cans and sculptures of Brillo soap-pad boxes, rapidly becoming the most famous figure in American *Pop art. He was opposed to the concept of a work of art as a piece of craftsmanship and turned out his works like a manufacturer, calling his studio 'The Factory'. From 1965 he concentrated on film-making—his later films gained widespread attention because of their voyeuristic concentration on sex.

Warlock, Peter (Philip Arnold Heseltine) (1894–1930), British composer, critic, and author. His compositions consist mainly of songs, notable for their sensitive response to the English language. He founded the magazine *The Sackbut* (1920) and wrote about and edited Tudor and Jacobean music. His best-known instrumental work is the collection of dances the *Capriol Suite* (1926), and there is a *Serenade* for strings (1921–2), composed as a tribute to Delius, whose work he much admired.

war photography, photographs taken at the battlefront. Usually considered the world's first war photographer, Roger Fenton (1819–69) covered the Crimean War (1855–6) with a vanload of bulky equipment, glass plates, and dangerous chemicals. This cumbersome technology, and the political requirements of those who had commissioned him, prevented him from showing the true drama and horror of war. Mathew Brady (*c.*1823–96) and others in the American Civil War (1861–5) came nearer, though even their best photographs (for example 'Death of a Sharpshooter' by Alexander Gardner (1821–82)) had to be posed. From the late 1880s photographs could be used to illustrate newspapers, and the Boer War and World War I were covered by many photographers and cinematographers. But it was the introduction of the 35mm camera in 1925 that finally enabled real action to be recorded. This new lightweight, hand-held equipment was exploited by Robert *Capa, among others, in the Spanish Civil War, and by many photographers on both sides during World War II. The Korean War (1950–3) was widely covered, and it is sometimes said that the frequent public showing of both still and moving pictures of the Vietnam War (1961–73) hastened its end. Among the most notable post-war photographers in Vietnam and other conflicts have been Larry Burrows (1926–71), Philip Jones-Griffiths (1936–), and Don McCullin (1935–).

water-colour, a term in art that refers to paint soluble in water and hence to a particular type of painting in which the colours are applied very thinly, allowing the paper to show through. This creates a sparkling luminosity, since the light reflects back from the paper; usually no white colour is used, the paper instead being left untouched for the brightest highlights. Although there were distinguished earlier exponents such as Dürer and van Dyck, water-colour had its chief flowering in Britain in the 18th and 19th centuries, particularly in the landscape painting of Turner. Opaque water-colour is known as *gouache. (See also *Chinese art.)

water drum *stamping tube.

Waterhouse, Alfred (1830–1905), British architect, a leading exponent of the *Gothic Revival. He worked first in Manchester and from 1865 in London, building up a practice specializing in secular architecture. His major

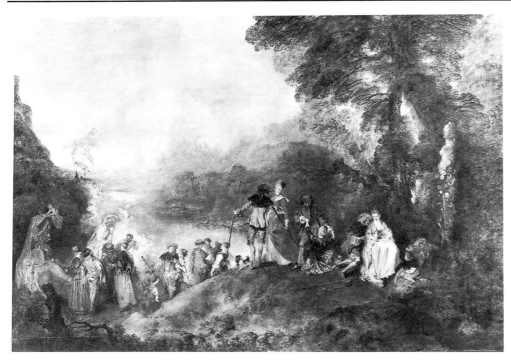

L'Embarquement pour l'île de Cythère was **Watteau**'s reception piece to the Académie Royale de Peinture et de Sculpture in 1717 and because it did not fit into conventional categories he was received as a 'peintre de fêtes galantes' (painter of courtship parties), a category invented expressly for him. The Mediterranean island of Cythera (Kithira) is said to be the place where Venus, the goddess of love, came ashore after being born from the sea, so it was a place of pilgrimage for lovers. (Louvre, Paris)

works include Manchester Town Hall (1868–77) and the Natural History Museum in London (1873–81), which is *Romanesque rather than Gothic in style. Waterhouse made use of strong colour in brick and terracotta and employed exposed iron for structural purposes, and his buildings often have a hard, bright clarity.

Water Margin, Chinese *epic novel. It is based on traditional accounts of the exploits of Song Jiang and his rebel band against the Song government in 1120–1. Written in the vernacular, it weaves a number of stories and anecdotes around a band of enlightened outlaws who have by choice made themselves social and political dissenters. The version that is read today is said to have been compiled in about 1370 by Shi Naian and Luo Guanzhong, but was heavily revised by Jin Shengtan in the 17th century. It is one of the few traditional Chinese works approved by Chinese Marxists.

Watteau, Jean-Antoine (1684–1721), French painter, one of the greatest artists of the *Rococo period. His name is most associated with a type of picture that he invented and made his own—the *fête galante* (courtship party), in which exquisitely dressed young people idle away their time in a dreamy, romantic pastoral setting. Watteau's pictures are highly artificial (apart from scenes of love, he took his themes mainly from the theatre), but underlying the frivolity is a feeling of melancholy, reflecting the certain knowledge that all pleasures of the flesh are transient. The melancholy of his pictures is seen

as a reflection of his own character, for he was restless and died young of tuberculosis. He was an influential figure, and the sophistication of his work helped French art to break free of dependence on Italian prototypes.

Watts, George Frederick (1817–1904), British painter and sculptor. He was in Italy from 1843 to 1847, where his attitude to art was formed by his admiration for the great *Renaissance masters. He invested his work with moral purpose and his most characteristic works are abstruse *allegories that were once enormously popular but now seem vague and ponderous. His portraits of great contemporaries have generally worn much better. His most famous sculpture is the equestrian figure *Physical Energy* (1904) in Kensington Gardens, London.

Waugh, Evelyn (Arthur St John) (1903–66), British novelist. His early novels *Decline and Fall* (1928) and *Vile Bodies* (1930) were followed by *Black Mischief* (1932), *A Handful of Dust* (1934), and *Scoop* (1938), stylistically brilliant works of social satire which capture the brittle, cynical, determined frivolity of the inter-war generation. *Brideshead Revisited* (1945) was a serious study of a landed family and the recovery of their faith in Roman Catholicism. His wartime experiences in Crete and Yugoslavia inspired his trilogy *Sword of Honour* (1965), in which he analyses the eternal struggle between good and evil, and civilization's fight against barbarism.

waxwork, a sculpture in beeswax, particularly a lifesize, highly realistic figure of a famous person complete with real clothes and hair. Wax has a long history in sculpture; it is easy to cut and shape and readily mixes with colouring matter, making it an ideal medium for naturalistic portraiture. It was much used in the ancient world, Middle Ages, and Renaissance for making death masks, and exhibitions of waxworks became popular entertainments in the 18th century. Easily the most famous exponent of this kind of work was Madame Marie Tussaud (1760–1850), who both cast masks from the living and death masks of many guillotined victims of

the French Revolution, opening a permanent exhibition ('Madame Tussaud's') in London in 1802 (some of her death masks are still on display in the Chamber of Horrors there). Less well known but generally more interesting is the collection of royal funeral effigies (including that of Elizabeth I) at Westminster Abbey.

Weaver, John (1673–1760), British dancer, choreographer, and theorist. He was a pioneer of *ballet d'action* (see *Noverre), demanding units of plot, choreography, and stage sets, and introducing acting instead of the technical virtuosity fashionable in his day. He adopted Italian *commedia dell'arte* characters such as *Harlequin for the first English *pantomime ballet, *Tavern Bilkers* (1702), composed the first formal libretto for his dance-drama *The Loves of Mars and Venus* (1717), and wrote extensively on dance theory.

weaving, the art of constructing fabric by interlacing threads. The principal materials used in weaving are wool, *silk, *cotton, linen, and, sometimes, metallic thread. It is not known when or where spinning and weaving were first practised but they were in use in Egypt and the Near East by the 9th millennium BC and there is evidence of silk weaving in China in the 2nd millennium. Fragments of patterned linen-weave have been found in Pharaonic tombs in Egypt, while ancient Egyptian pictures and Greek vase-paintings illustrate types of early looms which have been confirmed by archaeological finds. Homer's *Odyssey* describes the shroud Odysseus's wife Penelope was forced to unravel each night to fend off her unwanted suitors. The earliest weaving was plain, to meet the need for warmth and clothing, and *tapestry weaving was known in Egypt from the 2nd millennium BC with particularly outstanding naturalistic and symbolic examples produced by Christian Coptic weavers in the Roman period. Many ancient textiles, mainly of cotton, in a variety of weaves, including brocade, velvet, and pile-carpet-like fabrics, have been discovered in Peruvian tomb chambers. The tapestries of the Paracas Caverna culture are often highly complex, showing extravagant versions of semi-mythical god or beast characters. Chimū textiles show vigorous fish and bird motifs, while Inca textiles consist largely of magnificent clothing for high officials. The tradition of weaving continues today in many parts of South America, especially Peru and Bolivia. Africa also has an ancient and flourishing tradition of weaving (see *African costume and textiles). Other types of decorative weaves, such as velvets, damasks, and satins followed (see *Chinese decorative arts, *Ottoman art, and *Persian art), culminating in the development of the mechanized loom to produce decorative weaves by Jacquard in 1801, and the revolt against mechanization by designers such as *Morris. Sometimes dyeing techniques such as *batik or ikat (where threads are dyed in part before weaving and create a pattern according to the way in which they have been dyed) which are widespread in Central Asia, South-East Asia, and Japan, determined the decoration of the textile. Forms of *embroidery such as *crewel work were developed to embellish plain weaves, while *carpets and rugs are usually woven in pile techniques.

Webb, Philip (1831–1915), British architect and designer. With Norman *Shaw he was the leading figure in the late 19th-century breakaway from historicism to a new kind of informal domestic architecture. Webb was a friend and associate of William *Morris, for whom he designed his first and best known building, the Red House at Bexley Heath (1859), an unpretentious red-brick house, with irregular plan and façades. Although he was less outgoing than Shaw and devoted to perfecting his work, Webb was an influential figure, his reputation travelling by word of mouth. He was a founder member of Morris's decorative art firm in 1861 and became its chief designer in furniture, glass, metalwork, jewellery, and embroideries. His massive oak furniture, in particular, was influential on the *Arts and Crafts Movement.

Weber, Carl Maria von (1786–1826), German composer, conductor, and pianist, one of a large family of musicians. The success of his *operas *Der Freischütz* (1821) and *Euryanthe* (1823) led to a commission to write an opera for London (*Oberon*, 1826), where he died at the height of his powers. In *Der Freischütz* Weber established the prototype romantic German opera, in which Italianate aria vies with simple, folk-like tunes, all brilliantly orchestrated and set against a background of German legend and the supernatural.

Webern, Anton (Friedrich Wilhelm von) (1883–1945), Austrian composer. In 1904 he became a composition pupil of *Schoenberg. His first essays in *atonality came with the fourteen settings of Stefan *George poems he made between 1907 and 1909. His compositions became more concise and intense and, with the adoption of *serialism in 1924, increasingly concerned with strict symmetrical forms and rigorous contrapuntal devices, such as *canon. With thematic content reduced to a minimum, and a complete absence of romantic rhetoric, his works carry a weight of utterance that is out of all proportion to their actual duration—some movements last only a few seconds. Despised and banned by the Nazis for 'cultural Bolshevism', he was accidentally shot by a member of the US occupying forces while fleeing from the Russians at the end of the war.

Webster, John (c.1578–c.1632), English dramatist. He collaborated on several plays with *Dekker, *Ford, *Middleton, Fletcher (see *Beaumont), and others. Two plays by him alone, *The White Devil* (1612) and *The Duchess of Malfi* (1612–13), have been revived in the theatre more often than any of his time apart from those of Shakespeare. Both plays have 'Italian' settings of almost unrelieved corruption and cruelty. They combine striking language and dramatic effects with a profound understanding of human suffering, complex plots, and sensationalism.

Wedekind, Frank (1864–1918), German dramatist. His plays, which aroused much controversy, can be seen as forerunners of the Theatre of the *Absurd. His use of sexuality as a motive force reduces characters to puppets driven by their obsessions. The grotesque atmosphere of his plays is designed to shock his audience. It belies a deep moral seriousness: his characters are outsiders desperate for social acceptance and doomed to fail. *Spring Awakening* (1891) stylizes the dilemma of adolescents kept in sexual ignorance. The Lulu plays, *Earth Spirit* (1895) and *Pandora's Box* (1904), on which *Berg based his opera *Lulu*, depict a woman whose sexuality destroys all it encounters. *The Marquis of Keith* (1901) highlights the immorality and hypocrisy of contemporary society.

Wedgwood, Josiah (1730–95), British potter. He combined organizing ability and flair for business with scientific knowledge and artistic taste and was largely responsible for the great expansion of the Staffordshire pottery industry in his period. The Wedgwood pottery was founded at Burslem in Staffordshire in 1759 and in 1768 Wedgwood opened a new factory at Etruria, a village he had built for his workmen. Its cream-coloured earthenware, known from 1765 as Queen's ware (in honour of Queen Charlotte), established the factory's reputation (see also *creamware). It was either left plain or decorated with *transfer printing or enamel painting and came to rival porcelain in popularity. The factory also catered for the taste for Neoclassical tableware (inspired by antique examples). He invented a fine black stoneware in *c.*1767 which he called 'basaltes', and in 1774–5 the white stoneware which he stained blue (or green, mauve, or yellow) and called 'Jasper'. The Wedgwood products were enormously popular and were exported to Europe and to the USA. In 1774 he was commissioned to make for Catherine of Russia a service of more than 1,000 pieces enamelled in sepia. Jasperware is still made today.

Weelkes, Thomas (1567–1623), English composer. The few known facts of his life include the publication of his first book of *madrigals (1597) and his appointments as organist of Winchester College (*c.*1598–1602) and later of Chichester Cathedral (*c.*1602–17). Further volumes of madrigals followed in 1598, 1600, and 1608. His services, anthems, and madrigals are among the finest of their time, vivid in their imaginative musical imagery, skilled and sonorous in their *counterpoint.

Weill, Kurt (Julian) (1900–50), German composer. He distinguished himself with such early works as the String Quartet (1923) and the *Expressionist opera *The Protagonist* (1926), both of which came near to *atonality. Weill's collaboration with *Brecht, though it lasted only three years, can be numbered among the most notable of the 20th century. The acid but memorable tunes of *The Threepenny Opera*, an updated version of Gay's *The Beggar's Opera* (1928), and *The Rise and Fall of the City of Mahagonny* (1930) were stinging exposures of a corrupt and decaying capitalism. The operas brought first fame and success, then Nazi condemnation. Weill settled in the USA (1935), where he wrote successfully for the Broadway musical theatre. Weill's wife, the singer Lotte Lenya (1898–1981), was a memorable intepreter of his music.

Welles, (George) Orson (1915–85), US actor and film and theatrical director. He became famous with his first film, *Citizen Kane* (1941), the story of a press baron, which created a considerable critical stir with its use of sound, its deep-focus photography, and its out-of-sequence story-telling. *Citizen Kane* was not a financial success, and Welles was never again to work in such favourable conditions. His next film, *The Magnificent Ambersons* (1942), was mutilated by the studio, and when he achieved independence—as in *Macbeth* (1948), *Othello* (1951), *The Trial* (1963), based on Kafka's novel, and his Falstaff film *Chimes at Midnight* (1966)—his resources were limited. As well as acting in his own films (except *Ambersons*), he gave good performances in other people's, such as *Jane Eyre* (1944), and Reed's *The Third Man* (1949). He also continued his stage career, appearing in his own

adaptation of Melville's *Moby-Dick*, directed by John Huston (1955).

Wells, H(erbert) G(eorge) (1866–1946), British novelist, historian, and journalist. He was known for his advocacy of socialism, feminism, and rationalism and is remembered for his scientific romances, which rate among the earliest products of the new *science fiction genre. In this mode he wrote, among others, *The Island of Doctor Moreau* (1896), *The Time Machine* (1896), *The Invisible Man* (1897), and *The War of the Worlds* (1898), which combine political satire with warnings of the dangers of scientific progress. Other novels realistically and humorously reflect his lower-middle-class background, including *Kipps* (1905) and *The History of Mr Polly* (1910). He also wrote collections of short stories, works of scientific and political speculation (including *The Shape of Things to Come*, 1933) and histories (such as *The Outline of History*, 1920), which confirmed his position as a popularizer and one of the most influential voices of his age.

Welsh-language literature. Welsh has one of the oldest vernacular literatures in Europe, spanning the period from the 6th century, when the poets Aneirin and Taliesin flourished in the north of Britain, down to the present day. Among the finest achievements of writing in

Welles's first film, *Citizen Kane*, appears on almost every critic's list of the best films ever made. Here Kane's bored second wife, frustrated in her efforts to become an opera singer, passes the time with a jigsaw puzzle. Her husband (played by Welles) looks on. The empty expanse of Xanadu, Kane's enormous mansion, appears in the background.

Welsh are the poems of eulogy associated with the independent princes, the medieval prose tales known as the *Mabinogion*, and the lyric nature poetry of Dafydd ap Gwilym (*c*.1320–80), which was to influence succeeding generations of poets. A characteristic element of the Welsh *bardic tradition was expressed in the strict poetic conventions of *cynhanedd* ('harmony'), a complicated system of accentuation, *alliteration, and internal rhyme. The strict *metres have continued to this day, along with *free verse. A conscious literary use was made of prose by story-tellers whose oral tales were recorded in writing. The Reformation and the Tudor policy of encouraging the use of English led to a diminution of appreciation of the Welsh culture. The first Welsh printed book, *Yn y lhyvyr hwnn* ('In this Book', known by its opening words) (1545) was followed by a translation of the Bible into Welsh in 1588. Welsh literature in the 17th century consisted mainly of religious works. Goronwy Owen (1723–69) founded a new school of Welsh poetry which led to the establishment of local eisteddfods or meetings of competitors to perpetuate the classical forms of Welsh literature. The greatest lyric poet of the 19th century was Ceiriog (John Hughes, 1832–87), while in the 20th century poets and dramatists such as Saunders Lewis (1893–1985) drew increasingly on the rhythms and vocabulary of colloquial speech. The dramatist John Gwyllm Jones (1920–) and the novelist and short-story writer Islwyn Ffowc Elis (1924–) have been innovators in form and subject-matter, and are followed by a younger generation of enthusiastic writers.

Welty, Eudora (1909–), US novelist and short-story writer. Most of her fiction features the inhabitants of the Mississippi region, whose style of speech she catches with great precision. Her preoccupation is with the intricacies of human relationships and with characters who fail to know themselves or their neighbours. Her novels include *The Robber Bridegroom* (1942), *The Ponder Heart* (1954), and *The Optimist's Daughter* (1972). Her *Collected Short Stories* appeared in 1980, and the autobiography *One Writer's Beginnings* in 1984.

Wen Zhengming (1470–1559), Chinese painter. Wen is considered the ideal of the Wu school of scholar-amateur painters who despised the professional Zhe school of court artists. He abandoned his official career in Beijing to devote his life to literary composition, calligraphy, and painting, becoming renowned for all three. He was an austere figure, his predilection for pines and cypresses and wintry landscapes being seen as a reflection of his purity and integrity. His work was widely admired and he had many followers.

Werfel, Franz (1890–1945), Austrian novelist and poet of Jewish parentage. His early poetry, *The Friend of the World* (1911), epitomized the new humanity and brotherhood he desired. His poems from the battlefield during World War I, though almost despairing, retain a belief that mankind could sustain spiritual values. These values inspire all Werfel's work. His novel *The Song of Bernadette* (1941), written in exile and largely based on documents related to the saint's vision at Lourdes, was an immediate world-wide success, except in those countries dominated by the Nazis, where it was banned. His last play, published as *Comedy of a Tragedy* (1944), centres on the problems of race and emigration.

Wesker, Arnold (1932–), British playwright. He achieved fame through the so-called Wesker Trilogy, three plays about a Jewish family, *Chicken Soup with Barley* (1958), *Roots* (1959), and *I'm Talking about Jerusalem* (1960). *The Kitchen* (1959), showing the stresses of life in a restaurant, was influential in the development of *kitchen-sink drama. Other plays of note include *Chips with Everything* (1962), a study of class attitudes in the RAF during National Service, *The Merchant* (1977), which treats the story of Shylock in a manner that constitutes an attack on anti-Semitism, and *Caritas* (1981) about the spiritual struggle of a 14th-century anchoress.

Wesley, Samuel (1766–1837), **Samuel Sebastian** (1810–76). British composers and organists. Samuel was the son of the hymn-writer Charles Wesley (nephew of John Wesley, the founder of Methodism). His masses, motets, and anthems are of a high quality and his twelve voluntaries (1805–17) contain some of the most important organ music between J. S. Bach and Mendelssohn. His natural son, Samuel Sebastian, was also a fine organist. His anthems, such as *The Wilderness* (1832) and *Ascribe unto the Lord* (*c*.1852) are outstanding, while his brilliant command of the organ is reflected particularly in the large-scale F major Andante which forms the second of three pieces for chamber organ (Set II, 1842–3).

West, Benjamin (1738–1820), US painter, active mainly in Britain. He had early success as a portraitist in New York, studied in Italy (1760–3), then settled in London, where he enjoyed a lucrative and distinguished career. West's international reputation was based mainly on his *history paintings, in which he made the radical innovation of depicting figures in contemporary costume rather than 'timeless' draperies, notably in his famous *Death of Wolfe* (1770). At first he was attacked for breaking revered conventions, but his idea was soon adopted by other artists, notably his fellow countryman *Copley.

West, Nathanael (Nathan Wallenstein Weinstein) (1903–40), US novelist. A New Yorker, he produced three further mordant novels after his début with *The Dream Life of Balso Snell* (1931), a fantasy dwelling on human corruption. *Miss Lonelyhearts* (1933) a sad and bitter satire dealing with a male newspaper 'agony aunt'; *A Cool Million* (1934) offers a savage attack on the conventional American dream of success; and his masterpiece, *The Day of the Locust* (1939) is an apocalyptic *satire in surrealist style set in Hollywood, where he worked as a screenwriter.

West Asian music, the music of the Middle East, which comprises a crescent of land from North Africa eastwards to the Soviet Republic of Uzbekistan. Culturally the area has been dominated by the traditions of the Arabic-, Persian-, and Turkish-speaking peoples, each distinct but sharing a number of characteristics through their Islamic heritage. Until the 20th century classical music was under the patronage of imperial courts, while a large body of folk music existed independently but was much influenced by classical forms and instruments. A smaller body of religious *Islamic music also exists. The strictures imposed on music by Islam have traditionally resulted in its performance at private gatherings by a small number of specialists accorded low social status,

This musician from Bahrein plays the *qānūn*, an instrument found under different names throughout the area included by **West Asian music**. With its eighty or more strings the *qānūn* calls for considerable technical accomplishment in a player.

and the dominance of the musical scene by Jews and Christians. Nevertheless, discussion and development of musical treatises, many of which were written between the 9th and 16th centuries, has helped retain music as a respected intellectual discipline. Western notation and traditions were introduced in the late 19th and early 20th centuries resulting in some hybrid forms and attempts to unite Western and Middle Eastern musics. Classical art music of West Asia is essentially soloistic, ensembles typically consisting of a leading vocalist or instrumentalist accompanied by a stringed instrument playing in unison, or by two percussion instruments. Melodic organization is by *modes or scales, known in Arabic as *maqām*. Each prescribes an order of pitches, melodic shapes, and specific musical or non-musical characteristics. They are thus very closely connected to the ragas of *Indian music. Some are named after places, for example Hijāz (in Arabia), possibly reflecting their origin. In the Arabic tradition 30 *maqāmāt* are used. The Turkish *makam* is very similar, though its intervals have been further standardized. In Persia modes are known as *dastgāhs*, of which there are twelve, each subdivided into melodies called *gūsheh*. The various modes are catalogued in the *radīf*, a body of music whose performance is some ten hours long, memorized

by musicians and used as the basis for composition and improvisation. Rhythmically music is both non-metric, closely related to the stresses of poetry of each region and used in improvised music, and metric, where it is governed by fixed rhythmic structures. Each of these comprises a larger metric unit subdivided into a pattern of beats, the whole punctuated by heavy (*dum*) and light (*tak*) drum-beats. This system has similarities with the Indian *tāla*. Typically full performances consist of a sequence of pieces, both instrumental and vocal, and both metric and non-metric. In the Arabic tradition the sequence begins with the *beshrev*, a metric piece in sections, each repeated; this is followed by the *taqsīm*, a non-metric improvisation, and the sequence concludes with a quick dance-like section. Turkish performances contain more sections, while Persian suites interpolate songs with texts from Persian classical poetry. Other types of pieces include the Arabic *nawbah*, a long piece in one mode, and pieces used in Turkey to accompany dervish ceremonies, consisting of whirling dances and vocal and instrumental sections designed to entrance the worshippers.

West Asian musical instruments. String instruments are the most common throughout the area. Plucked instruments include long-necked lutes such as the Persian **tār* and *setār* (or **sitar*), the Turkish **saz* and *ṭanbūr*, and the Arabi *bouzouq*; the short-necked fretless *'ūd* from Arabia, from which the European lute is derived; and zithers such as the Arab *qānūn* and Persian **sānṭūr*. Bowed instruments include the *kamancha*, a fiddle held vertically, and the **rebab*. Various flutes, such as the **nay*, drums, including the goblet-shaped *darabukkah*, and reed instruments, including the **zummāra*, are also found throughout the Arab world. The bagpipes are important in North Africa.

Western, film genre dealing with various aspects of the opening up of the American West in the 19th century. In view of the substantial American contribution to the early development of the cinema, it is hardly surprising that US film-makers quickly made use of the vast store of history and legend readily available. The Western was the first film genre to emerge, beginning with *The Great Train Robbery* (1903), the story of a hold-up on the Union Pacific Railroad. *Griffith and Thomas Ince (1882–1924) made a number of short Westerns, the latter introducing the Western's first star, William S. Hart (1870–1946). By the 1920s de*Mille, *Ford, and other major directors were making Westerns, and sound increased their appeal: they were made as main features, second features, series (such as Hopalong Cassidy), and even as musical Westerns with singing cowboys. Westerns reached their heyday in the 1940s and 1950s, the advent of colour being particularly felicitous for them. A variant also appeared in Europe, including the Italian 'spaghetti' Western. Classics such as *Stagecoach* (1939), *High Noon* (1952), and *Shane* (1953) achieved resonances well beyond their immediate subject-matter; but examples of the genre are now rare, the public appetite having been sated by a surfeit of them on television.

West Indian music *calypso, *Caribbean music, *popular music, *steel band.

West Indian native art, the Pre-Columbian art of the Arawak, especially Taino and Ciguayo, peoples of the

Antilles. In the four or five centuries before the arrival of the Spaniards, they created ambitious art-forms, compared with the less developed wood-carvings, petroglyphs, and shellwork of their neighbours, in ceremonial spaces defined by stone walls, reminiscent of Mesoamerican ball courts (see *Central American and Mexican literature). Stone collars and pendants, stylized human statues in stone, and carved wooden stools called *duhos* are the typical and distinctive products of their culture. Anthropomorphic or zoomorphic symbols, called *cemis*, decorated personal ornaments, especially, in Hispaniola, of gold.

Weston, Edward (1886–1958), US photographer. Like so many 20th-century US photographers, Weston was profoundly influenced by *Stieglitz, who encouraged him to abandon his highly pictorialist style in favour of 'straight' photography. His meticulously sharp and finely textured pictures of nudes, of natural objects (for example, sand dunes, seashells, and plants), and of the decaying marks of man in the landscape, were made with a plate camera, and have been widely copied. In 1932 he was a co-founder, together with Ansel Adams and Willard van Dyke, of the influential *Group f. 64.

Weyden, Rogier van der (c.1399–1464), Netherlandish painter. Though there is little secure knowledge about his career, it is known that by 1436 he had moved to Brussels and been appointed official painter to the city. No paintings are known that can be attributed to Rogier on the basis of signatures or contemporary documentation, but several are mentioned in early sources, and the style shown in these is so distinctive that a coherent body of work has been built up around them. All his surviving pictures are either religious works or portraits. The religious works are remarkable for their emotional power and refined spirituality, the portraits for their dignified aristocratic grace. Rogier seems to have had a large workshop with numerous assistants and pupils, and many of his compositions are known in several versions.

Wharton, Edith (Newbold Jones) (1862–1937), US novelist and short-story writer. Brought up in wealthy New York society, she exploited this background in the novel *The House of Mirth* (1905), where her study of the effects of false values rises above the level of the novel of manners to become tragedy. *The Age of Innocence* (1920), considered her most skilfully constructed work, returns to the same subject-matter, but *Ethan Frome* (1911) is a tragic novella set on a New England farm. Her work shares the subtle artistic realism of her friend Henry James.

Whistler, James Abbott McNeill (1834–1903), US-born painter and graphic artist, who worked mainly in Britain and France. His contemporary fame depended not only on the quality of his work but also on his flamboyant personality—he was a wit and dandy and loved controversy. Whistler's art was based on radical ideas, the principal one being that painting should exist for its own sake, not to convey literary or moral ideas. He often gave his pictures musical titles to suggest an analogy with the abstract art of music. In 1879 he went bankrupt following a costly lawsuit with the critic *Ruskin, who had accused him of 'flinging a pot of paint

in the public's face'. Whistler won his libel action, but was awarded only a farthing as damages. In his fifties, however, he began to achieve honours and substantial success. His paintings are mainly portraits and landscapes, particularly views of the Thames, noted for the flawless harmony of tone and colour for which he is famous. Whistler was also one of the finest etchers of the 19th century.

White, Gilbert (1720–93), British naturalist and clergyman. He spent most of his life in his birthplace, Selborne, where he was curate. His correspondence from 1767 with the naturalists Daines Barrington and Thomas Pennant formed the basis of his classic *Natural History and Antiquities of Selborne* (1788), which gives detailed descriptions, in an elegantly literary style, of wildlife and nature, observed with much affection and expressing his love of picturesque landscapes.

White, Patrick (Victor Martindale) (1912–), Australian novelist. Educated in England, after wartime service in the Royal Air Force he settled on a farm near Sydney. His world reputation was achieved by *The Tree of Man* (1955), about the struggles of an Australian farmer, and by *Voss* (1957), which describes an expedition across the Australian wilderness by a visionary German explorer in the 1840s. These and other novels, including *Riders in the Chariot* (1961), *The Solid Mandala* (1966), and *The Vivisector* (1970), have been admired for their epic qualities and imaginative boldness. He was awarded the Nobel Prize for Literature in 1973.

Whitman, Walt (1819–92), US poet. Inspired partly by the writings of *Emerson and the *Transcendentalists, he published in 1855 and 1856 the first and second editions of *Leaves of Grass*, including the poems later entitled 'Song of Myself', 'Crossing Brooklyn Ferry', and 'Out of the Cradle Endlessly Rocking'. Six further expanded editions appeared in his lifetime. During the American Civil War he worked as a volunteer nurse and produced the moving collection *Drum Taps* (1865), later incorporated in *Leaves of Grass*. Whitman pioneered the use of *free verse and created a distinctive American voice in poetry, in which he celebrated the expansion and democratic vitality of the United States, but also wrote powerful poems on sexual liberation and the meaning of death.

Whittier, John Greenleaf (1807–92), US poet and journalist. After an early period in which his subject-matter was rural life and New England history, he began to write poetry reflecting his hostility to slavery and other forms of oppression: these poems are collected in *Voices of Freedom* (1846) and *Songs of Labor* (1850). Later he returned to his former themes, notably in *Snow-Bound* (1866), a reminiscence of winters during his childhood.

wide-screen cinema, projection processes using a wider screen than the 4:3 (width to height) of the original cinema. Abel *Gance used such a screen, but the letter-box shape was not generally used until the introduction of CinemaScope, a system first displayed in *The Robe* (1953). The wider screen increases audience involvement and is particularly effective in spectacular films and musicals, especially when accompanied by stereophonic sound. It also facilitates the shooting of

scenes in continuous takes, rather than by cutting. Other wide-screen processes such as Cinerama have technical drawbacks, and CinemaScope itself is less suitable for more intimate, claustrophobic subjects.

Wieland, Christoph Martin (1733–1813), German poet and man of letters; the earliest German translator of Shakespeare, who partly inspired his allegorical verse epic *Oberon* (1780). He is a keen-eyed and humorous critic of the petty bourgeoisie in *The History of the People of Abdera* (1774) and of exaggerated enthusiasm in *The Adventures of Don Silvio de Rosalva* (1764). In his *Bildungsroman The History of Agathon* (1766–7), in which a good man progresses through error to a balanced view of life, he espouses the philosophy of the *Enlightenment. His flexible, expressive prose brought to the German language qualities hitherto regarded as primarily French.

Wigman, Mary (Mary Wiegmann) (1886–1973), German *modern dancer, choreographer, and teacher. She studied with *Jaques-Dalcroze and *Laban. Her famous solo 'Witch Dance' (earliest version 1914) was a stark, uncompromising statement of *Expressionism and her subsequent solo and group compositions explored different emotional states and moods within what is now termed the *Ausdrucktanz* tradition. Her activities were severely curtailed during World War II, but she began

Walt **Whitman**, shown here during his stay in Washington in the Civil War, was frequently attacked for the freedom and sexual explicitness of his verse. He is now recognized as America's greatest poet and *Leaves of Grass* is acknowledged as one of the most influential books in the history of American literature. It broke decisively with tradition and encouraged poets to experiment with subject-matter and style.

teaching again in 1945. As a teacher and as a highly dramatic performer, she provided a focus for the performance form of early Central European modern dance.

Wilde, Oscar (Fingal O'Flahertie Wills) (1854–1900), Irish-born dramatist and poet. He proclaimed himself a disciple of the essayist and critic *Pater and of the cult of 'art for art's sake', and his flamboyant aestheticism attracted much attention. His early publications include *Poems* (1881), *The Happy Prince and Other Tales* (1888), written for his sons, and his only novel *The Picture of Dorian Gray* (1891), a *Gothic melodrama. His brilliantly written comedies for the stage include *Lady Windermere's Fan* (1892), and his masterpiece, *The Importance of Being Earnest* (1895), in which he exposes Victorian hypocrisies. The Marquis of Queensberry, father of Lord Alfred Douglas, disapproved of his son's friendship with Wilde and brought about Wilde's imprisonment in 1895 for homosexual offences. In *De Profundis* (1905) Wilde apologized for his conduct and claimed to have stood 'in symbolic relation to the art and culture' of his age. *The Ballad of Reading Gaol* (published anonymously in 1898) was inspired by his prison experiences.

Wilder, Thornton (Niven) (1897–1975), US novelist and dramatist. He achieved wide popularity with his novel *The Bridge of San Luis Rey* (1927), a delicately ironic study of the way Providence has directed disparate lives to one end. Later he was to become better known for his work for the theatre, particularly *Our Town* (1938), a celebration of a small New Hampshire community, and the comedy *The Skin of Our Teeth* (1942), a parable about the survival of humanity. His comedy *The Matchmaker* (1954) was the source of the musical *Hello, Dolly!* (1963).

Wilkie, Sir David (1785–1841), British artist. He moved from his native Scotland to London in 1805 and soon established himself as the most popular *genre painter of the day. He was strongly influenced in style and technique by 17th-century Netherlandish painters. His success did much to establish the popularity of anecdotal painting in England, and many Victorian artists were influenced by him. In 1825–8 he travelled abroad for reasons of health, and his style changed radically under the influence of Spanish painting in particular, becoming grander in subject-matter and broader in touch.

William-and-Mary style, a style in English interior decoration and design roughly coinciding with the reign of William and Mary (1689–1702). Although William was Dutch by birth, the period marked an increase in French influence compared with the *Restoration style. This was partly because of the dominance of Versailles and partly because of an influx of Huguenot (Protestant) refugees from France. In general, the William-and-Mary style was lighter, more elegant, and more domestic than the Restoration style, although there was no sharp break between the two.

Williams, Tennessee (Thomas Lanier Williams) (1911–83), US dramatist. He established his reputation in 1944 with *The Glass Menagerie*, a play of sentiment and pathos about the fantasy worlds of a withdrawn girl and her frustrated mother. His next important play, *A Streetcar Named Desire* (1947), is set in a New Orleans slum and brings into violent contrast a neurotic woman's

Tennessee **Williams** seen in the kind of sultry Southern setting associated with some of his best-known plays. These are particularly memorable for their portrayals of hypersensitive Southern women clinging to memories of a grand past that no longer exists, and are notable for brilliant dialogue and scenes of high emotional tension. His early works are regarded as his best and in his later years he was often in ill health as he struggled with addiction to alcohol and sleeping pills.

dreamworld and the animalistic realism of her brother-in-law. *Cat on a Hot Tin Roof* (1955) is a powerful study of family tensions which takes place at a wealthy cotton planter's 65th birthday. Most of his effective work deals with maladjusted characters with intense emotions, who speak the poetic language of the American South.

Williams, William Carlos (1883–1963), US poet, novelist, short-story writer, and essayist. While practising as a doctor in New Jersey, he wrote poetry, first in the manner of the *Imagists, later in a style he called Objectivism ('no ideas but in things'), which attempted to present objects without interpretation or emotion. He favoured a lean, vigorous, vernacular American poetry, and fiercely opposed the Europeanizing influence of T. S. Eliot. His answer to *The Waste Land* was *Paterson* (1946–51, 1958), a long poem about a New Jersey city and a semi-mythic protagonist, incorporating much non-poetic material. The lyrics can be found in *Collected Later Poems* (1950) and *Collected Earlier Poems* (1951).

Williamson, Henry (1895–1977), British novelist. He is best known for *Tarka the Otter* (1927), one of several wildlife tales. His pro-Hitler views damaged his later literary reputation, although he continued with a sequence of fifteen autobiographical novels, *A Chronicle of Ancient Sunlight* (1951–69).

Wilson, Sir Angus (Frank Johnstone) (1913–), British novelist and short-story writer. His stories, beginning with *The Wrong Set* (1949), and his novels from *Hemlock and After* (1952) to *Setting the World on Fire* (1980), concentrate on the realistic portrayal of middle age and family conflict and display a fine satiric wit combined with a sense of humanity.

Wilson, Edmund (1895–1972), US literary critic and essayist. A leading man of letters, his best-known works of literary criticism are *Axel's Castle* (1931), a study of the *Symbolist tradition; *Patriotic Gore* (1962), on the literature of the American Civil War; and the more miscellaneous *The Triple Thinkers* (1938, 1948) and *The Wound and the Bow* (1941). He also wrote novels, plays, and *To the Finland Station* (1940), a study of European socialist thought.

Wilson, Richard (c.1713–82), British painter. After moving to London from his native Wales in 1729 he initially worked mainly as a portraitist, and it was not until he visited Italy in 1750–6 that he devoted himself to the landscape painting for which he is famous. He was deeply influenced by the paintings of *Claude and he applied the principles of composition he learned in Italy to English and Welsh views. His most famous picture is *Snowdon from Llyn Nantlle* (c.1765), of which he painted two versions. Wilson transformed landscape from an art that was essentially topographical to one that could be a vehicle for ideas and emotions. His work was much admired by many eminent later British landscape painters, including Constable and Turner.

Winckelmann, Johann Joachim (1717–68), German art historian and archaeologist, a key figure in the *Neoclassical movement and in the development of *art history as an intellectual discipline. He moved to Rome in 1755 and soon established himself as a scholar of European fame. He had a fervent love of classical antiquity and through his writings and his friendship with the painter *Mengs he exercised an enormous influence on contemporary taste, not only in painting and sculpture, but also in literature and philosophy, proclaiming the superiority of Greek art and culture. Although he never went to Greece and unwittingly based most of his observations on Roman copies, he is regarded as having laid the foundations of modern methods of art history, explaining the character of works of art by reference to such factors as climate, religious customs, and social conditions.

wind instruments, conventionally all those musical instruments sounded by human breath, thus excluding *organs and *aeolian harps. There are two basic divisions, *woodwind (comprised of flutes and reed instruments) and *brass instruments. With wind instruments the blowing is always referred to as 'breathing', and is important in controlling the expression of the music, by varying the speed and pressure. Tonguing is the principal means of articulation. On the flute and on brass instruments this is achieved by a flick of the tongue against the teeth, and on reed instruments against the tip of the reed. An ancient practice widespread throughout the world is to hum a kind of *drone while playing a flute, and this technique has been exploited by some modern composers and by jazz performers.

Winterhalter, Franz Xavier (1806–73), German painter, the most successful court portraitist of his period. He was based in Paris for most of his career, but he painted most of Europe's royalty and was a particular favourite of Queen Victoria. His work has often been dismissed as superficial, but its technical panache is undeniable and his glossy romantic charm is faultlessly orchestrated. He was also an accomplished lithographer.

Witkiewicz, Stanislaw Ignacy (1885–1939), Polish dramatist and novelist. The nonsensical situations and grotesque characters and language of his thirty-odd plays anticipate the Theatre of the *Absurd. Disappointed by their poor reception he wrote only one, *The Cobblers*, after 1930. The novels *Farewell to Autumn* (1927) and *Insatiability* (1930) present a catastrophic vision of European culture and the individuality of man crumbling in the face of totalitarianism.

Wodehouse, Sir P(elham) G(renville) (1881–1975), English humorous writer, US citizen after 1955. In a writing career that spanned more than seventy years his prolific output included over 120 volumes, and he became Broadway's leading writer of musical comedy lyrics. His best-known characters include the butler Jeeves, his youthful employer Bertie Wooster, and the absent-minded and wealthy Lord Emsworth. Wodehouse's stories, told with exuberant vitality, are mostly set in a British upper-class world of his own invention, and exist in a realm that is oblivious of reality.

Wolf, Hugo (Filipp Jakob) (1860–1903), Austrian composer and critic. Apart from an early symphonic poem, *Penthesilea* (1885), the 'Italian Serenade' for string quartet (1887), and the opera *The Mayor* (1895), Wolf wrote mainly songs, of which some 300 are in existence. These are notable for their psychological insight, their bold, declamatory vocal lines, Wagnerian harmonies, and subtle, dramatic accompaniments.

Wolfe, Thomas (Clayton) (1900–38), US novelist and dramatist. He is best known for his two lengthy autobiographical novels featuring Eugene Gants, *Look Homeward, Angel* (1929), which shows the hero breaking away from his troubled family, and encountering love and literature, and *Of Time and the River* (1935), which covers the author's sojourn at Harvard and a tour of Europe with friends. Two further novels, *The Web and the Rock* (1939) and *You Can't Go Home Again* (1940), were edited from material left at his death.

Wolf-Ferrari, Ermanno (1876–1948), Italian composer. He studied first as a painter and only gradually turned his attention to music. His compositions made headway in Germany and, apart from a period as director of the Liceo Musicale, Venice (1903–9), he lived mainly in Germany, Austria, and Switzerland. His music was traditional and romantic, with a special flair for 18th-century pastiche, and he is best remembered for the comic operas *The Curious Women* (1903), *The School for Fathers* (1906), the one-act intermezzo *Susanna's Secret* (1909), and *The Jewels of the Madonna* (1911).

Wolfram von Eschenbach (d. c.1225), German poet. One of the principal figures of the *Minnesang* or *courtly love poetry of the chivalric age, he is the writer of several lyric and three narrative poems: *Parzival* (c.1200–10), *Titurel*, and *Willehalm* (probably both left unfinished after his patron's death in 1217). *Parzival* describes the hero's quest for a chivalric perfection conceived in religious terms and symbolized by the Holy Grail; it served as the source of *Wagner's opera. In *Willehalm* Wolfram describes the moral dilemma of a hero constrained to conduct a crusade against his wife's Islamic family and, stressing the common humanity of all people, explores the morality of religious wars.

Wollstonecraft, Mary (1759–97), British writer and feminist. She wrote the feminist classic *A Vindication of the Rights of Woman* (1792) which attacks the educational restrictions which kept women in a state of 'ignorance and slavish dependence', and a novel *Mary* (1788). She moved to Paris in 1792 to witness the French Revolution, but returned to London after the birth of an illegitimate child. She became part of an influential radical group that included the political and social reformer Thomas Paine (1737–1809), Blake, Wordsworth, and the philosopher William Godwin (1756–1836), whom she married in 1797. She died shortly after the birth of their daughter, the future Mary Shelley.

Wood, John (the elder) (1704–54), British architect, active mainly in his native Bath, which he was largely responsible for transforming into the finest Georgian town in England. Wood learnt about building as a young man in London, and from 1729 his career was devoted largely to creating splendid new streets of houses in Bath, conceived as unified compositions in a dignified *Palladian style. The most original and magnificent part of his scheme is The Circus, begun in the year of his death and completed by his son, **John Wood** (the Younger) (1728–81). It is a vast circular space completely surrounded by regular housing except where three streets radiate out of it. One of the streets leads into Wood the Younger's Royal Crescent (1767–75), in which the houses are arranged in a semi-elliptical block, a scheme that had immediate and lasting influence on British urban planning.

woodcarving, the art of cutting or incising wood. The great variety in the colour of woods available, from the almost ivory paleness of sycamore to the rich black satin of walnut and ebony, can be exploited to stunning effect. Woodcarving is a widespread art, the richest traditions today being in Africa and Oceania. In Europe little woodcarving has survived from the ancient world, but the late Middle Ages saw a great flowering of the art. Inside medieval churches the skills of the woodcarver were displayed in the beautifully decorated choir-stalls, screens, pulpits, lecterns, and *misericords. Woodcarving was also used to decorate secular furniture, as in the work of Grinling *Gibbons. In Africa one of the most ubiquitous pieces of furniture is the low wooden stool; artistic elegance reaches its climax in the caryatid stools of Zaïre, showing a female figure with ornate hair-styles and an intricate pattern of body scars, supporting the seat of the stool. Woodcarving has also been used to decorate ritual and ceremonial objects, such as masks, ancestor figures, and royal stools in Africa, and the totem-poles of *North American Indian art. Wooden musical instruments have often been carved, some of the finest being the drums of the Aztec culture of Central America, which were carved

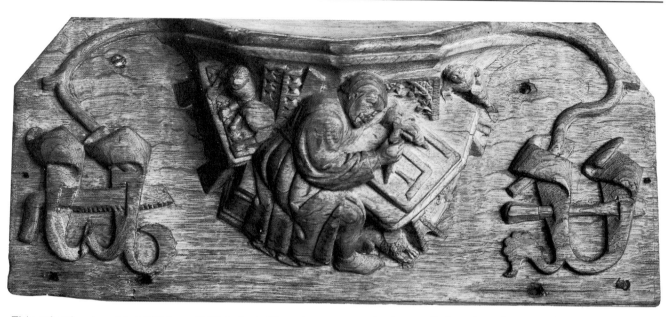

This oak misericord (c.1415) from St Nicholas's Chapel, King's Lynn, gives an insight into the tools and techniques of medieval **woodcarving**. In the centre a master carver is shown at his desk, and behind him two of his apprentices are at work. At the sides are woodworking tools. (Victoria and Albert Museum, London)

with jaguars and eagles. In most societies statues have been carved of wood, and these were mostly painted in European art until the 20th century. The present century has seen a flowering of abstract wood sculpture in the work of *Brancusi, *Hepworth, and *Moore. (See also *woodwork.)

woodcut, the technique of making a print from a block of wood sawn along the grain (the term is also applied to the print so made). It is the oldest technique for making prints and its principles are very simple. The design is drawn on a smooth block of wood (almost any wood of medium softness can be used) and the parts that are to be white in the print are cut away with knives and gouges, leaving the design standing up in relief. This is then inked and pressed against a sheet of paper. The origin of woodcut is obscure (the principle was employed in fabric printing in the Middle East at least as early as the 5th century AD), but woodcut as we know it appeared in Europe in the early 15th century. It was much used as an illustrative technique in the early days of printed books, but in the 16th century it lost ground to line engraving. In the late 19th and early 20th centuries there was a major revival of interest in woodcut as a medium of original artistic expression, artists such as Munch, Gauguin, and the German Expressionists realizing the potential of the rugged boldness that is characteristic of the technique. Coloured woodcuts can be made either by cutting the block in such a way that different coloured inks can be applied separately to distinct parts, or (more usually) by making successive impressions from a series of blocks, each of which is inked with a separate colour. The latter was the method used in the extremely rich tradition of coloured prints in Japan (see *ukiyo-e).

wood-engraving, the technique of making a *print from a block of hardwood sawn across the grain (the

term is also applied to the print so made). It derives from the *woodcut, but because of the harder surface and the use of tools similar to those of the copperplate engraver, the effect is generally finer and more detailed. Thomas *Bewick in the late 18th century was the first fully to exploit its possibilities, and he succeeded in making it the most popular medium for book illustration until it was superseded by photo-mechanical processes.

woodwind, musical instruments, the orchestral *flutes and *reeds. Today this name is illogical, for many are made of other materials, but all were originally wooden except *saxophones, which, because their reed and mouthpiece are similar to those of *clarinets, are nevertheless regarded as woodwind. Ivory has occasionally been used for *flutes since the 16th century, for *oboes in the 18th century, and for clarinets in the 19th, and glass was fashionable for flutes early in the 19th century. Metal was used for all woodwind from the mid-19th century, often for military bands and ships' orchestras; it withstood the vicissitudes of military life and vagaries of tropical climates. Ebonite and vulcanite were used late in the century for similar reasons, just as plastic is now used for children's instruments. The woodwind section, as it is known in the symphony *orchestra, was established by Beethoven, with two each of flutes, oboes, clarinets, and *bassoons. In their early works, Haydn and Mozart often scored for oboes only, with a pair of *horns which, although they are brass instruments, have always been intermediary between woodwind and brass, plus (one can usually assume) at least one bassoon playing with the bass. Oboes were sometimes scored in the outer movements and flutes in the quieter slow movement; players were expected to change from one to the other. The woodwind section was enlarged by Berlioz and Wagner to three or more of each instrument. A flautist was expected to play *piccolo, and later alto flute, an oboist to play *cor anglais, a clarinettist to play high or low clarinets, and a bassoonist to play contrabassoon. Thus today woodwind players are prepared to play all the higher and the lower members of their respective families.

woodwork, the art or craft of making objects in wood. Wood is one of the few natural materials that is found

almost ready for working and it has been one of the fundamental commodities of virtually every human society. In many parts of the world, for example Scandinavia, Russia, and colonial America, it has been the commonest building material, and for this purpose strength and resilience are its most valued qualities. The distinct building styles of Switzerland, Austria, and Slovenia were developed in order to exploit the abundant supply of wood. In the tradition of *Maori art the carving of wooden buildings was refined to a level of great beauty. Wood can also be used to create superb architectural effects as in the numerous wooden roofs that form one of the glories of English medieval art, and the cedarwood Mudejar roofs of Spain, such as those of the Alhambra at Granada, composed of interlaced geometrical patterns of wonderful complexity. The development of *furniture depended heavily on the exploitation of wood: the stylistic differences to be seen in early European furniture were due in part to the preference for oak in the north and walnut in the south. The second half of the 18th century saw the use of an increasing range of imported hardwoods, often used as *veneer. When used in furniture, it is often

the sensuous and tactile beauty of wood that is brought out by the craftsman. A variety of techniques have been used to exploit this, among them inlay and *marquetry. The resonance of certain woods (for example pinewood grown at high altitudes in the Alps) produce the quick and even response required of stringed instruments. (See also *woodcarving.)

Woolf, (Adeline) Virginia (née Stephen) (1882-1941), British novelist and literary critic. The house that she, her sister Vanessa (the painter Vanessa Bell), and her brothers occupied in Gordon Square, London, was the centre of the *Bloomsbury Group. She began writing for the *Times Literary Supplement* and in 1912 married the political journalist Leonard Woolf. Together they founded in 1917 the Hogarth Press, which published much of her work. Her third novel, *Jacob's Room* (1922), was recognized as a departure from traditional fiction in its poetic impressionism. She was hailed as a principal exponent of *modernism and established her reputation securely with subsequent novels, including *Mrs Dalloway* (1925), *To the Lighthouse* (1927), *The Waves* (1931), and *The Years* (1937). Shortly after completing *Between the Acts* (1941) she experienced the last of her recurring bouts of mental illness, which led to her suicide by drowning in the River Ouse. She is now acclaimed as one of the great innovative writers of the 20th century, many of whose experimental techniques, such as *stream of consciousness, have since been drawn into the mainstream of fiction. Her distinguished literary criticism includes *A Room of One's Own* (1929), now a classic of the feminist movement, collections of critical essays, and short stories. Her letters

Bewick, the son of a small farmer, was self-taught. Lacking all drawing material, he began as a small child to etch with chalks on the flagstones and hearth of his home. The villagers of Ovingham asked him to draw scenes from daily farm life on the walls of their cottages, and this led to etchings with quill pen and blackberry juice. Today his genius for **wood-engraving**, illustrated here by 'The Chillingham Bull' (1789) is universally recognized. (Newcastle City Library)

This portrait of Virginia **Woolf** was painted in about 1912 by her sister Vanessa Bell. A seminal influence on modern literature and a complex and well-documented figure, she has attracted more biographers than any writer in history, including Shakespeare. (Monk's House, Sussex)

(published 1975–80) and diaries (published 1977–84) are a vivid record of the period.

Wordsworth, William (1770–1850), British poet. The leading spirit of English *Romanticism, he grew up in Cumberland in the Lake District, and travelled in Europe, witnessing the French Revolution: 'Bliss was it in that dawn to be alive', as he wrote in his masterpiece, *The Prelude*, a philosophical *blank-verse autobiography (written 1798–1805; revised, and published in 1850). His greatest poems were written in the decade 1797 to 1807. In 1795 he met *Coleridge in Somerset, where they collaborated on *Lyrical Ballads* (1798), which contains Wordsworth's great *lyric, 'Lines written a few miles above Tintern Abbey'. Its publication in 1798 was a landmark in English poetry, and heralded the new age of Romanticism. Its second edition (1800) contained Wordsworth's important Preface attacking the artificial 'poetic diction' of the 18th century and redefining poetry as the language of human passions; it also included his celebrated 'Lucy' poems, remarkable for their lyrical intensity and purity. In 1799 he settled at Grasmere in the Lake District, where his devoted sister Dorothy (1771–1855) kept a remarkable journal of observations on nature and local people, *Grasmere Journals 1800-03*, which was to give inspiration to Wordsworth and to Coleridge. Here Wordsworth wrote many of his finest lyrics, including

'Ode: Intimations of Immortality from Recollections of Early Childhood', 'I Wandered Lonely as a Cloud' (both 1807) and several *Sublime sonnets. Wordsworth's simple style and his choice of rural, commonplace subjects were sometimes unintentionally comical and became the target of parodies. Like his fellow 'Lake Poet' *Southey (whom he succeeded as Poet Laureate in 1843) he was scorned by younger poets from Byron to Browning for betraying his earlier radical politics, but amid the doubts of the Victorian age he was venerated for revealing the sanctity of childhood and the healing power of Nature.

Worpswede School, a term applied to the colony of painters (primarily landscapists) who settled in the north German village of Worpswede (near Bremen) in the last decade of the 19th century, following the example of the *Barbizon School in France. The most famous artist to work there was Paula Modersohn-Becker (1876–1907), one of the most important precursors of German *Expressionism. Up to about 1900 she painted landscapes and scenes of peasant life; later concentrating on single figures, including self-portraits and portraits of peasants, and still lifes.

Wren, Sir Christopher (1632–1723), British architect. He had one of the most brilliant minds of his age and his early success was as a mathematician and astronomer (he became professor of astronomy at Oxford University in 1661). His expertise in applied geometry led him to be consulted on such matters as fortifications and the restoration of buildings, and in his early thirties he began to receive architectural commissions at Oxford and Cambridge Universities. His growing preoccupation with architecture was confirmed when he made a study trip to Paris in 1665, during which he met *Bernini and possibly *Mansart. The Great Fire of London of 1666 gave him the opportunity to focus his interests. Appointed one of the Commissioners for the rebuilding of the city, he produced many of his most famous buildings: St Paul's Cathedral (1675–1710) and fifty-two new parish churches, renowned particularly for their inventive spires. From 1669 to 1718 Wren was Surveyor-General of the King's Works, involving him in a great deal of work on royal buildings in addition to his church-building. His finest work in palace-building is his extension of Hampton Court (1689–94). Wren's vast output also included several important public buildings, such as the Royal Hospital, Chelsea (1682–92). Given such productivity, it is not surprising that some of Wren's work is undistinguished; his city churches, for example, were often of necessity built quickly and cheaply on difficult, cramped sites. However, they display the ingenuity and resourcefulness that were such important aspects of his work, and Wren's masterpiece, St Paul's Cathedral, is by itself enough to secure his place among the great European architects. Wren had only one important pupil—Nicholas *Hawksmoor, who developed the *Baroque aspects of his master's eclectic, empirical style, but his influence was great in the USA as well as Britain.

Wright, Frank Lloyd (1869–1959), the greatest of US architects. With *Gropius, *Le Corbusier, and *Mies van der Rohe, he is regarded as one of the pre-eminent architects of the 20th century, and of these he was the most versatile and imaginative. He was a pupil and devoted admirer of Louis *Sullivan, but his master's

Outstanding among Frank Lloyd **Wright**'s domestic buildings in the 1930s was the Kaufmann house in Pennsylvania, dramatically cantilevered over a natural waterfall.

influence was philosophical rather than stylistic or technical, helping to shape Wright's idea of 'organic' architecture, in which he advocated a close relationship between building and landscape and the nature of the materials used. This notion was put into practice in the first decade of the 20th century when Wright created a novel type of house, the 'Prairie House', several examples of which are in the outskirts of Chicago. 'The prairie has a beauty of its own,' he wrote, 'and we should recognize and accentuate this natural beauty, its quiet level. Hence, gently sloping roofs, low proportions, quiet sky lines, suppressed heavy-set chimneys and sheltering overhangs, low terraces and out-reaching walls sequestering private gardens.' In 1909–11 Wright visited Europe, but he was little influenced by developments there and continued to follow an independent path. For example, his most celebrated building, the Kaufmann House ('Falling Water'), Bear Run, Pennsylvania (1935–9), has some kinship with the *Modern Movement in its use of smooth slabs of concrete, but it is startlingly original in its position projecting over a waterfall and its dynamic interlocking of forms. Wright's inventiveness remained undimmed to the end of his long career, and most of his biggest commissions came in the last two decades of his life, beginning with the Johnson Wax Factory at Racine, Wisconsin (1946–9).

Wright, Joseph (1734–97), British painter, active mainly in his home town of Derby and generally known as 'Wright of Derby'. In the 1760s he began to paint candlelit scenes of various types, showing the fascination with unusual lighting effects that was to last throughout his career. His most original works in this vein are his depictions of the contemporary scientific world. In 1774–5 Wright visited Italy, where he broadened his repertoire to include subjects such as Vesuvius in eruption. On his return to England he worked briefly in Bath and in 1777 settled permanently in Derby. Landscape occupied an increasingly important role in his later work: he made tours of the Lake District in 1793 and 1794.

Wright, Richard (Nathaniel) (1909–60), US novelist and short-story writer. He was among the first American black writers to protest against white racial prejudice. He made his literary début with *Uncle Tom's Children* (1938), a collection of stories describing the oppression of blacks in the South. With the publication of his novel *Native Son* (1940), a story of a black boy reared in the Chicago slums, Wright was considered not only the leading black author of the USA, but also a major heir of the naturalist tradition. It became a best seller and was staged successfully on Broadway (1941) by Orson Welles. His autobiography, *Black Boy*, was published in 1945, and its sequel, *American Hunger*, in 1977.

Wu Cheng'en *Monkey.

Wu Daozi (c.700–c.760), Chinese painter. No originals of his work exist, but there is a large number of copies and later paraphrases. Most valuable perhaps are rubbings of stone copies in relief, which show his gift for combining monumentality with deep Buddhist religious feeling. He is said to have executed 300 wall-paintings in Luoyang, the Tang dynasty secondary capital, and his famous nirvana and Guanyin (Bodhisattva) compositions formed the models for many similar works in later times. According to legend he was an early master of figure painting, the originator of the monochromatic calligraphic style of bamboo painting known as *mo zhu*, and the inventor of a method of printing silk used by the Tang artists and called *sêng jüan*.

Wyatt, James (1746–1813), British architect. He was versatile, prolific, and highly successful, the most fashionable architect of the generation after *Chambers and Robert *Adam. His most famous work was Fonthill Abbey in Wiltshire (1796–1807), a colossal and spectacular *Gothic Revival mansion built for William *Beckford, a fabulously wealthy collector, writer, and eccentric. It was built at speed and the central tower collapsed in 1825; only a fragment of the building now remains, but while it stood it was one of the marvels of the age. His surviving buildings include numerous country houses, mainly in an Adamesque style. He was also involved in restoration work at various English cathedrals, his careless approach to which earned him the nickname 'The Destroyer'. More than thirty other members of Wyatt's family are known to have been involved in architecture or allied professions. The best known among them is probably his nephew **Sir Jeffrey Wyattville** (1766–1840; he changed the form of his surname in 1824), who was chiefly responsible for the present form of Windsor Castle.

Wyatt, Sir Thomas (1503-42), English poet. He held diplomatic posts under Henry VIII, and some of his poems are thought to be addressed to Anne Boleyn. Wyatt translated the poems of *Petrarch, and introduced the *sonnet verse-form into English literature. His many *lyrics have a personal voice, worldly-wise and disabused, with lines often varied by irregular speech-rhythms that prefigure those of Donne. His poem beginning 'They fle from me, that sometyme did me seke' is among his best known, and reflects the vicissitudes of his career from favoured diplomat to alleged traitor.

Wycherley, William (c.1640-1716), English dramatist and poet. His plays are highly regarded for their acute social criticism, particularly of sexual morality and the marriage conventions. The best of these are *The Country Wife* (1675), a satiric attack on social and sexual hypocrisy, greed, and the corruption of town manners, and *The Plain-Dealer* (c.1676), loosely based on Molière's *Le Misanthrope*, concerning an honest misanthropic seaman. Criticized in their time for alleged obscenity, his plays are now highly acclaimed for their thematic organization and characterization. Wycherley's *Miscellany Poems* (1704) led to friendship with *Pope, who revised many of his works.

Wyeth, Andrew Newell (1917-), US painter. His work consists almost entirely of depictions of the people and places of the two areas he knows best—the Brandywine Valley around his native Chadds Ford, Pennsylvania, and the area near Cushing, Maine. He paints with a precise and detailed technique and often conveys a feeling of loneliness or nostalgia. Although he has become enormously successful, there is wide critical disagreement about his status.

Wyndham Lewis, Percy (1882-1957), British painter and writer. In the period leading up to World War I he was the most original and idiosyncratic of British avant-garde artists (he was one of the first artists in Europe to produce completely abstract paintings and drawings), and he was the central figure of *Vorticism, whose aggressive, angular style he carried into his work as an official war artist. From the late 1920s he devoted himself mainly to writing, his novels including *The Revenge for Love* (1937) and *Self Condemned* (1957). He also wrote literary criticism, inlcuding savage satirical attacks on his contemporaries in the *Bloomsbury Group.

Wyspiański, Stanislaw (1869-1907), Polish dramatist and painter. His treatment of historical themes and concern for the precision of detail have permanently influenced Polish theatre. He introduced myth and symbolic figures into *November Night* (1904), about the 1830 Uprising, and in *The Wedding* (1901), which combines folk music, art, and popular verse to dramatize Poland's social and political inertia.

Xenakis, Iannis (1922-), French composer of Greek parentage and Romanian birth. His family returned to Greece in 1932 and it was his first intention to study engineering. In 1941 he joined the underground resistance in the struggle for Greek liberation, but was wounded and condemned to death. He escaped to Paris (1947), where he produced his first important compositions, including *Metastasis* (1954). Although his music is largely concerned with abstract structures based on complex mathematical models, often involving the use of computer calculations, it also has powerful humanistic and emotional elements.

Xenophon (c.428-c.354 BC), Greek writer from Athens who spent many years in the service of Sparta. His writings reflect the viewpoint of a conventional and practically minded gentleman who supported aristocratic ideals and virtues. His historical works include the *Anabasis*, an eye-witness account of the expedition of the Persian prince Cyrus II against Artaxerxes (401-399 BC) in which he led the Greek mercenaries in their retreat to the Black Sea after they had been left in a dangerous situation between the Tigris and Euphrates; the *Apology*, *Memorabilia*, and *Symposium* recall the life and teachings of his friend Socrates; the *Cyropaedia* is a historical romance on the education of Cyrus II, seen as the ideal prince. He also wrote treatises on politics, war, hunting, and horsemanship.

Xia Gui (c.1180-c.1230), Chinese painter, an eminent master of landscape. He was expert at controlling ink, a virtuoso of the chopping 'axe-cut' brushstroke, the dragged dry brush, and the flowing wash. Line is reduced to a minimum in his paintings, and large parts of the picture are typically obscured in mist. His most famous painting is the handscroll *A Pure and Remote View of Rivers and Mountains*.

xylophone, a percussion musical instrument consisting of a series of wooden bars, each tuned to a different pitch. It is known in South-East Asia and Indonesia as well as in Africa, Mexico, and Guatemala, often under the name of marimba, which in Western music implies a larger, lower-pitched instrument than the ordinary xylophone. The European form derives from the African. The East African log xylophone, which has bars lying on banana stems resting on the ground with no resonators below the bars, was imported into Europe, where the bars rested on hanks of straw, in the late 15th century. The 19th-century form of this instrument, with the bars arranged in four rows, may have originated in Hungary. It was used in Europe up to the 1920s or 1930s. The West African variety, with bars lashed to a wooden frame, with gourd or horn resonators beneath the bars, was re-created in Central America by African slaves. This was copied by North American instrument-makers to create the modern international form, with bars laid out like the piano keyboard and tubular resonators beneath the bars.

yangqin, a musical instrument, the Chinese *dulcimer, deriving from the Persian *santūr, with thin brass or steel strings struck with very light bamboo beaters. The resonator is a lacquered trapezoid box, the sloping sides usually being curved, with a small, central drawer to store the beaters and a heavy brass tuning hammer, and a lift-off lid. There are two bridges, the left-hand about one-third of the way across the soundboard, and the right-hand a quarter of the way. The yangqin is an important instrument in much Chinese ensemble music.

Yeats, Jack Butler (1871–1957), the best-known Irish painter of the 20th century, brother of the poet William Butler Yeats. Until about 1910 he worked mainly as an illustrator, then turned to oils. His early work as a painter was influenced by French *Impressionism, but he then developed a more personal *Expressionist style marked by vivid colour and extremely loose brushwork. He painted scenes of Celtic myth and everyday Irish life, contributing to the upsurge of nationalist feeling in the arts inspired by the movement for Irish independence.

Yeats, W(illiam) B(utler) (1865–1939), Irish poet and dramatist. A leader of the *Irish Literary Revival, he is a major voice of modern Irish poetry in English. As a young art student, he developed a lifelong interest in mysticism, and studied Irish folklore. In the early 1890s he established the Rhymers Club with other young poets in London, and published a collection of stories, *The Celtic Twilight* (1893), which defined the mystical tone of the early Irish literary revival. With his patron Lady Gregory he founded the Irish Literary Theatre in 1899, and was a director of the Abbey Theatre, Dublin from 1904. He wrote nearly thirty plays, including the poetic *The Countess Cathleen* (1892) and the more realistic *Cathleen ni Houlihan* (1902), but is remembered chiefly for his poetry. His early verse, in *The Wind Among the Reeds* (1899) and other collections, has a dreamy *Pre-Raphaelite atmosphere, but in *The Green Helmet* (1910) and *Responsibilities* (1914) he develops a more austere and public style which introduces his characteristic blending of personal longings (notably his unrequited love for the revolutionary Maud Gonne), political hopes and fears for the Irish nation, and mythological images. His most celebrated collections are *The Wild Swans at Coole* (1917), *Michael Robartes and the Dancer* (1921), which contains 'Easter 1916' and 'The Second Coming', and *The Tower* (1928), including 'Sailing to Byzantium' and 'Among School Children'; although some of his later poems (notably 'Byzantium' and 'The Statues') are much admired. His dabblings in the occult produced an elaborate system of spiritual symbols outlined in *A Vision* (1925). Yeats was a senator of the Irish Free State from 1922 to 1928, and was awarded the Nobel Prize for Literature in 1923.

Yesenin, Sergey (Aleksandrovich) (1895–1925), Russian poet. Of peasant origin, he was accepted by literary intellectuals as a natural lyric genius. He welcomed the October Revolution, but his life later degenerated into drunken despair (*Tavern Moscow*, 1924). He went on to travel abroad and marry the dancer Isadora *Duncan, eventually committing suicide. He is still one of the most genuinely popular Russian poets, loved for his sentimental lyrics of rural life.

Yevtushenko, Yevgeny (Aleksandrovich) (1933–), Russian poet and novelist of the post-Stalinist generation. He reintroduced a personal voice into his work, declaimed in the brash, unpoetic language of the early Revolutionary poets. His poem 'Babiy Yar' (1961), commemorating the Nazi massacre of Ukrainian Jews, was interpreted as a criticism of Soviet anti-Semitism, and he fell into official disfavour with the publication of his *Precocious Autobiography* (1963). His writings have since received a measure of success in the Soviet Union.

Yiddish literature, writing in Yiddish, the language of Ashkenazi (Central and East European) Jews. Early works adapted traditional Jewish sources, medieval European *epic poetry, or both, for example, *Shmuel bukh*, a reworking of the biblical narrative of Samuel into courtly *romance. Old Yiddish literature (*c.*1250–*c.*1540) and Middle Yiddish literature (*c.*1540–*c.*1800) were written in a quasi-standard Western Yiddish (dialects of Germany and Holland), which survived until the late 18th century, when it was replaced by a new literary language based on Eastern Yiddish (Slavonic and Baltic lands). Modern Yiddish literature (from *c.*1800) was initiated by the *Chassidim*, adherents of an 18th-century mystical movement, and their opponents, the *maskilim* (purveyors of the European *Enlightenment movement), both using the language for ideological works. During the later 19th century it became a serious art-form in the hands of the satirist Mendele Moykher Sforim (Sh. Y. Abramovitsh, *c.*1834–1917), the humorist Sholem Aleichem (Sh. Rabinowitz, 1859–1916), and the Romanticist Y. L. Peretz (1853–1915). In the 20th century, Yiddish prose, poetry, and drama flourished in Eastern Europe; and the migration of an exceptionally high number of gifted writers has carried Yiddish literature worldwide.

yueqin, a musical instrument, the Chinese moon-guitar. The circular resonator has a flat belly and back, and the neck is short, with high bamboo frets which continue on the belly. The four silk strings are in two courses or pairs tuned a fifth apart.

Z

Zadkine, Osip (1890–1967), Russian-born sculptor who worked mainly in Paris and became a French citizen in 1921. He was influenced by *Cubism, but his primary concern was with dramatically expressive forms and he evolved a personal style that made use of hollows and concavities, his figures often having holes pierced through them. His greatest commission, the bronze *To a Destroyed City* (1953) standing at the entry to the port of Rotterdam, is an extremely powerful figure that is widely regarded as one of the masterpieces of 20th-century sculpture.

Zamyatin, Yevgeny (Ivanovich) (1884–1937), Russian novelist, playwright, and satirist. His stories of survival in post-Revolutionary Petrograd (now Leningrad) include 'The Cave' (1922); he was among the most eminent Soviet literary figures in the 1920s. His most famous work, the anti-Utopian novel *We* (1924), was published in the Soviet Union only in 1988. He fell out of favour and emigrated to Paris in 1931, after which he struggled to survive as a film scenarist.

Zapotec art, the art of a southern Mexican people, who occupied Monte Albán in Oaxaca from *c.* 2nd to *c.* 8th centuries AD. Builders and sculptors on a monumental scale, broadly in the *Olmec tradition, were succeeded by producers of fluid and technically proficient clay sculpture, the most powerful examples of which take the form of anthropomorphic ritual vessels, carved in wet clay and fired with faithful precision. The early sculptors of this period preferred expressive simplicity, achieving sumptuous decorative effects while keeping to strict conventions in the depiction of physiognomy and posture. Later occupants of the site and others nearby, such as Mitla and Zaachila, usually classified as post-Zapotec or Mixtec, added delicate ceramics, lapidary work, and woodwork. Their goldwork, often in the form of elaborate pendants, is probably all of the 13th century or later.

zarzuela *operetta.

Zeromski, Stefan (1864–1925), Polish novelist. During early years of hardship he came to abhor social injustice, as reflected in his short stories and *Homeless People* (1900). In *Ashes* (1904) he mirrored the Napoleonic period, in *Faithful River* (1912) the 1863 Uprising, and *Before the Spring* (1925) newly independent Poland.

Zeuxis (*fl.* late 5th century BC), Greek painter. None of his works survive, but ancient writers describe him as one of the greatest Greek painters, and one of the stories about his powers of imitation tells that he painted some grapes so naturalistically that birds pecked at them. He is said to have specialized in panel paintings, and there are also references to his works in clay.

zheng *koto.

Zhuangzi, Chinese classic writing on philosophy, a 3rd-century BC Daoist text attributed to Zhuang Zhou (369–286 BC). It develops the thinking of the *Dao De Jing*, an earlier Daoist work ascribed to Laozi , and is paradoxical and cryptic, a work of religion and literature. A famous passage, which illustrates its style, is an account of the author dreaming he was a butterfly and, on waking, wondering whether it might have been a butterfly dreaming of being him.

Zhu Da, also known as Bada Shanren (1626–*c.*1705), Chinese painter, an individualist and eccentric master. Descended from a branch of the Ming imperial family, he became a Buddhist monk after the fall of the dynasty in 1644, and became mentally unbalanced. Most of his painting is said to have been done while drunk, and his brushwork is often extremely bold and spontaneous. Misshapen birds balancing unsteadily on one leg, sketchy landscapes, and masterly lotus paintings all possess a certain enigmatic quality and a memorable combination of energy and elegance. He was little appreciated in his own lifetime, but now enjoys a great reputation.

Ziegfeld, Florenz (1867–1932), US theatrical producer and showman. He is best known for his *Follies*, a spectacular *revue featuring beautiful girls (often in seminudity) and elaborate scenery and costumes, inspired by the Folies-Bergère in Paris. The *Follies* opened in 1907, with new editions almost annually until his death; there were also several posthumous editions, the last being in 1957. Ziegfeld also produced many straight plays and musicals, notably Jerome Kern's *Show Boat* (1927).

Zimmermann, Dominikus (1685–1766), one of the leading German *Rococo architects, active in Bavaria and Swabia, chiefly as a designer of churches. He began his career as a stuccoist and he regularly worked in collaboration with his brother the fresco painter **Johann Baptist Zimmermann** (1680–1758), facts that help to explain the superb decorative unity and masterful craftsmanship of his interiors. The masterpiece of the Zimmermann brothers is the pilgrimage church of Die Wies, near Munich (1746–54), where the simple white exterior gives no hint of the airy vision in pastel colours and gilt within.

zither, a plucked stringed folk instrument of Austria and Bavaria, in its present most common form comprising a shallow wooden soundbox over which are stretched five melody strings and accompanying strings tuned to form chords. In the modern ethnomusicological sense it covers a far wider range of instruments, with strings running parallel with the resonator, which may be a tube, trough, stick, raft, bar, or board. Very commonly, especially in Europe, the board is the upper surface of a box. Such instruments are usually plucked (*psalteries) or hammered (*dulcimers), but some are bowed (the *hurdy-gurdy with a wheel, others with a bow), and a few are blown (*aeolian harps). They are widely distributed, with tube zithers being found in Indonesia and Madagascar (*valiha*), half-tube zithers in China (for example, *qin*), Korea (*kayagŭm*) and Japan (*koto), trough zithers chiefly in East Africa, stick zithers in India (*vīṇā*), raft zithers in Africa, India and elsewhere, bar zithers in Africa, India, and South-East Asia, board zithers chiefly in Africa, and box zithers throughout Europe, North America, North Africa (*qānūn*), Iran and Iraq (*santūr*), and China (*yangqin*). The simplest raft and tube zithers

have strings cut from the surface of the resonator, bridged up with small pieces of gourd, etc. Others have attached strings of other material, which may simply be tied to the ends of the resonator or may have tuning pins so that their pitch can be easily adjusted.

Zoffany, Johann (1733–1810), German-born painter who settled in Britain in about 1760 after working in Rome. He made his name with paintings representing scenes from plays, usually showing the celebrated actor David *Garrick in one of his favourite parts, and also painted *conversation pieces in the same relaxed vein. George III and Queen Charlotte were his special patrons, and he did some of his best work for the royal family. In 1783 Zoffany went to India, where he made a fortune painting Indian princes and British expatriates, but his career after his return to England in 1789 was undistinguished. For a long time chiefly accepted for his documentary value, Zoffany is now also appreciated for his considerable charm.

Zola, Émile (1840–1902), French novelist and critic. His first major novel, *Thérèse Raquin* (1867), was based on the principles of *realism associated with the *Goncourt brothers. From this he developed the more extreme, pseudo-scientific concept of *naturalism, which aimed to demonstrate how the behaviour of individuals is determined by historical and social factors combined with the influence of heredity. These views are set out in a theoretical work, *Le Roman expérimental* (1880), and are illustrated in a series of twenty novels known under the collective title of *Les Rougon-Macquart*, written between 1871 and 1893, which trace the history of one family through five generations. Some of the more important titles in the series are *L'Assommoir* (1877), *Germinal* (1885), and *La Débâcle* (1893). Despite their weaknesses *Les Rougon-Macquart* provide a striking picture of life under the Second Empire (1852–70) during the early stages of urban, industrial society, and they display an imaginative power in the re-creation of individual scenes which links Zola to the *Romantic writers of the early 19th century. Zola is also known for his defence of the Jewish French Army officer Alfred Dreyfus in the famous open letter *J'accuse* (1898) to the President of the French Republic, which led to a year-long exile in Britain.

Zuccaro, Taddeo (1529–66) and **Federico** (*c*.1540–66), brothers, Italian *Mannerist painters. Taddeo worked mainly in Rome and although he died young he was one of the most prolific fresco decorators of his day. His style was based on *Michelangelo and *Raphael and tended to be rather dry and wooden. Federico took over his brother's flourishing studio. His talent was no more exceptional than Taddeo's, but he was even more successful and enjoyed a brilliant reputation throughout Europe. He worked in various parts of Italy, in Spain, and in England.

zukra *hornpipe.

zummāra, one name for a *reed musical instrument common throughout the Islamic world: a pair of reed, bone, or bamboo pipes with single-beating reeds. Some have finger-holes in both pipes, which are tuned slightly differently to produce beats between them; others have finger-holes in one pipe, the other being a *drone. The drone pipe of the Egyptian *arghūl* is varied by attaching extensions. Most such pipes are mouth-blown, but some, such as the Indian *pūngī* or snake-charmer's pipe, have a gourd wind-chamber; others are blown as *bagpipes.

Zurbarán, Francisco (1598–1664), Spanish painter, active mainly in Seville. Most of his work consisted of religious paintings: he worked for churches and monasteries over a wide area of southern Spain and his work was also exported to South America. His style was solemn and emotionally direct, combining austere naturalism with mystical intensity, making him an ideal painter for such a fervently religious country as Spain at the time of the Counter-Reformation. The most characteristic of his paintings are single figures of monks or saints in meditation. They are usually depicted against a plain background, standing out with massive physical presence. Towards the end of his career Zurbarán's work lost some of its power and simplicity, as he tried to adapt to the much sweeter style of *Murillo.

Zweig, Stefan (1881–1942), German poet, short-story writer, and dramatist. Of Jewish decent, his work was deeply influenced by the psychology of Sigmund Freud, notably the stories *First Experience* (1911), *Amok* (1922), *Conflicts* (1925), and *The Royal Game* (1942). In this intricate narrative the game of chess provides an analogy to the psychological deterioration of a Jewish intellectual under interrogation by the Gestapo. Zweig wrote several plays, including *Jeremias* (1917), and provided Richard *Strauss with the libretto for *The Silent Woman* (1935). He is also the author of the longer biographical study *Triumph and Tragedy of Erasmus of Rotterdam* (1935), which has an equal claim with *The Royal Game* to be his best work. He created a new minor genre in his 'historical miniatures' (*Miniaturen*), *The Tide of Fortune* (1927).

Acknowledgements

Photographs

Alte Pinakothek, München (photo: Artothek) 13, 393;

American Museum, Bath 342;

Ashmolean Museum, Oxford 52, 78, 278;

Arcaid 24;

Archaeological Museum, Olympia, Greece 189;

Architectural Association Slide Library 91, 194;

Archiv für Kunst und Geschichte 64;

Archivi Alinari 11, 53;

Jean-Pierre Armand/IRCAM 12;

© 1989 Art Institute of Chicago, © ADAGP, Paris and DACS, London 1990 87, 354;

Catherine Ashmore 299;

Bargello, Florence 61;

Beethoven-Haus, Bonn 41;

by permission of the Trustees of the will of the 8th Earl of Berkeley (photo: Courtauld Institute of Art) 297;

Biblioteca Casanatense, Rome (photo: Scala) 123;

Biblioteca Nazionale Marciana, Venice 346;

Biblioteca Nazionale Vittorio Emanuele III, Naples 288;

Bibliothèque Municipale d'Arras 5;

Bibliothèque Nationale, Paris 138, (photo: Bridgeman Art Library) 31;

Bildarchiv Preussicher Kulturbesitz 480;

Roger Blin Production Photo 40;

Bodleian Library 52;

Braunschweigisches Landesmuseum 437;

Bridgeman Art Library 83, 93;

British Library 21, 100, 418;

Reproduced by Courtesy of the Trustees of the British Museum 25, 33, 142, 147, 149, 150, 240, 272, 410;

Richard Bryant/ACAID 363, 495;

Bulloz 213, © DACS 1990 421;

The Syndics of Cambridge University Library 204, 246, 325, 416;

Chester Beatty Library, Dublin 219;

William L Clements Library, Ann Arbor 75;

Gerald Clyde 287;

Columbia Pictures Television (photo: British Film Institute) 429;

Comédie Française 301;

Contemporary Films, London, © Sovexportfilm, Moscow (photo: British Film Institute) 143;

Courtauld Institute of Art 187, 435;

Culver Pictures Inc. 102, 188;

Czartorisky Museum, Krakow (photo: Scala) 263;

Deutsches Theater, Berlin 59;

Deutsches Theatermuseum, München 202;

Devonshire Collection, Chatsworth, Reproduced by permission of the Chatsworth Settlement Trustees (photo: Courtauld Institute of Art) 140, 241;

Zoë Dominic 327;

Durban Art Museum, South Africa/Estate of Mrs G A Wyndham Lewis. By permission 144;

Edifice 226;

Edimedia 44;

Mary Evans Picture Library 245, 340, 401;

The Executive Council of the Socialist Republic of Croatia, Zagreb 312;

The Viscount FitzHarris 198;

Fitzwilliam Museum 160, 211;

Fondazione Giorgio Cini 268;

Werner Forman Archive 6, 9, 19, 27, 38, 85, 86, 153, 221, 233, 235, 237, 281, 284, 288, 289, 316, 321, 357, 451, 466;

Gemäldegallerie Alte Meister, Dresden, photo: Gerhard Reinhold, Leipzig-Molkau 178;

Germanisches Nationalmuseum, Nuremberg 76;

Goethe-Nationalmuseum, Weimar 181;

Reha Günay 228;

G D Hackett 37;

Sonia Halliday 186, 430;

Robert Harding 169;

Lucien Henré 260;

Hamburger Kunsthalle 389;

Robert Harding 169;

Hermitage, Leningrad (photos: Bridgeman Art Library) 77, 286 © Succéssion Henri Matisse/DACS 1990, 378;

Ken Heyman 482;

Hans Hinz 434;

Hirmer Fotoarchiv 282, 298, 334, 385;

Michael Holford 67, 92, 94, 97, 150, 155, 206, 219, 232, 304, 307, 367, 369, 400, 401, 411, 425, 454, 458;

Angelo Hornak 57, 294;

Hulton-Deutsch 464, 489;

Hutchison Library 15, 256, 487;

The Iveagh Bequest, Kenwood (English Heritage) 196;

Internationale Stiftung Mozarteum 306;

A F Kersting 81, 171, 300, 305, 337, 377, 388, 462, 468;

Kobal Collection 295, 309;

Koninklijk Museum voor Schone Kunsten, Antwerp 369;

Kunstsammlungen der Veste Coburg 168;

Kunsthistorisches Museum, Vienna (photo: Bridgeman Art Library) 183;

Kunstverlag Peda 332;

Lauros-Giraudon 269, 275;

© 1959 Loew's Inc. Ren. 1987 Turner Entertainment Co. (photo: British Film Institute) 207;

Lords Gallery, London 362;

Yvonne Loriod 291;

Mallett & Sons (Antiques) Ltd, (photo: Bridgeman Art Library) 253

Raymond Mander and Joe Mitchenson Theatre Collection 40;

The Mansell Collection 3, 63, 45, 144, 386, 440;

Mas 170, 215, 353;

Lord McAlpine of West Green © the artist (photo: Waddington Galleries Ltd) 319;

Jean Mazenod 'Islam and Muslim Art' Editions Citadelles, Paris 399, 438;

Metropolitan Museum of Art, Bequest of Theodore M Davis, 1915. Theodore M Davis Collection © DACS 1990 218;

The Minneapolis Institute of Arts 433;

Moro Roma 350;

F W Murnan-Stiftung (photo: British Film Institute) 255;

Musée des Beaux Arts, Nantes (photo: Bridgeman Art Library) 30;

Musée Carnavalet (photo: Giraudon) 313

Musée Fabre, Montpellier (photo: Frederic Jaulmes) 376;

Musée Guimet, Paris 99, 248, 276;

Musée du Louvre, Paris (© photo: RMN) 126, 127, 151, 173, 223, 315. (photo: Giraudon) 328, 483

Photographie Musée national d'art moderne, Centre Georges Pompidou, Paris, © ADAGP, Paris and DACS, London 1990 392, © DACS 1990 403;

Musées Royaux d'art et d'histoire (photo: © A.C.L. Bruxelles) 79;

Musées Royaux des Beaux-Arts de Belgique 157;

Musei Civici di Padova 179;

Museo Archeologico, Florence 149;

Museo Archeologico Nazionale, Naples 356, 387;

Museo Arqueologico Nacional, Madrid 346;

Museo del l'Opera Metropolitana, Siena (photo: Scala) 135;

Museo del Prado, Madrid 54, (photo: Bridgeman Art Library) 199;

Museum of the City of New York 174;

Museum of Fine Arts, Boston 172, 236;

Nasjonalgalleriet, Oslo 308;

Reproduced by Courtesy of the Trustees, The National Gallery, London 42, 74, 104, 111, 113, 158, 182, 265, 271, 280, 364, 448;

National Gallery of Art, Washington, (Widener Collection) 177, (Samuel H Kress Collection) 415

National Gallery of Ireland 292;

National Museum of Ireland 84;

National Museums and Galleries on Merseyside, Lady Lever Art Gallery, Port Sunlight 436;

National Palace, Mexico City, by permission of Instituto Nacional de Bellas Artes (photo: Bridgeman Art Library) 164

National Portrait Gallery, London 370, 414, 449;

The National Trust Photographic Library 494;

National Trust for Scotland 274;

Nationalmuseum, Stockholm 471;

Newcastle upon Tyne, City Libraries 493;

Novosti Press Agency 105, 133, 185;

Oeffentliche Kunstsammlung Basel Kunstmuseum, © COSMOPRESS, Geneva and DACS, London 1990 (photo: Colorphoto Hans Hinz) 249;

Oxford University Press 130, 465;

Sydney Parkinson, 325;

Philadelphia Museum of Art, Louise and Walter Arensberg Collection, © ADAGP, Paris and DACS, London 1990 137;

Axel Poignant Archive 1, 109, 339;

Popperfoto 58;

Princeton University Library 156;

Pushkin Museum, Moscow (photo: Bridgeman Art Library) © DACS 1990 348;

William Ransom Hogan Jazz Archive, Tulane University Library, New Orleans 238;

Redferns 50;

Mrs Reichmann 78;

Rex Features Ltd 358;

RIBA 474;

Rijksmuseum-Stichting, Amsterdam 473;

© 1941 RKO Radio Pictures, Inc. Ren. 1968 RKO General, Inc. (photo: British Film Institute) 485;

Roger-Viollet 407;

Rothschild Collection, Paris (photo: Giraudon) 72;

Roy Export Company Establishment (photo: British Film Institute) 89;

Royal Albert Hall 39;

Scala 16, 35, 50, 69, 102, 107, 125, 132, 225, 305, 379, 412, 461;

Scottish National Portrait Gallery 408;

Society for Cultural Relations with the USSR 90, 216, 310, 457;

Spectrum Colour Library 192;

Staatliche Kunsthalle Karlsruhe 117;

Städelsches Kunstinstitut, Frankfurt 159;

Städtische Galerie im Lenbachhaus, München 406, © ADAGP, Paris and DACS, London 1990 243;

Städtisches Museum, Flensburg 47;

Stedlijk Museum, Amsterdam 395;

Isabella Stewart Gardner Museum/Art Resource NY, 456;

Martha Swope 490;

Tate Gallery, London 2, 366, 463, © ADAGP, Paris and DACS, London 1990 119, 176, 441, and 479;

Tokyo National Museum (Photograph through the courtesy of the International Society for Educational Information Inc) 264;

Tretyakov Gallery, Moscow (photo: Novosti) 371;

Trinity College Library, Dublin 217;

Uffizi Gallery, Florence (photo: Scala) 55, 139;

Ulster Museum 203;

University Museum of National Antiquities, Oslo 476;

University of Pennsylvania School of Medicine 14;

UPI/Bettmann 432;

Vatican Museums 293, 374;

Victoria and Albert Museum, London 17, 80, 115, 118, 180, 224, 229, 234, 250, 252, 283, 317, 333, 336, 381, 419, 492 (photo: Bridgeman Art Library 145, 266, 277, (photo: Scala) 114

Trustees of the Wallace Collection, London 22, 146;

A P Watt Ltd on behalf of Anne Yeats and Michael B Yeats/Windsor Castle, Royal Library © 1990 Her Majesty the Queen 443;

Weidenfeld Archives 26;

Whitworth Art Gallery, University of Manchester 49;

Whitney Museum of American Art, New York 423;

Windsor Castle, Royal Library, © Her Majesty the Queen 209;

From the collection at Wrotham Park, on long-term loan to the Fitzwilliam Museum, Cambridge 211;

Yale Center for British Art, Paul Mellon Collection 347.

The publishers have made every attempt to contact the owners of the photographs appearing in this book. In the few instances where they have been unsuccessful, they invite the copyright holders to contact them direct.

Picture researchers:

Sandra Assersohn

Philippa Lewis

Illustrations

Lynn Williams: 20, 167, 193, 453;

David Woodroffe: 32, 322, 331, 352.

From 1400 to 1799

DATE	VISUAL ARTS	PERFORMING ARTS	LITERATURE	MUSIC
1400–1499	peak of bronze sculpture, Benin, Western Africa Atala Mosque, Jaunpur Brunelleschi, Spedale degli Innocenti, Florence Fra Angelico, frescoes, S. Marco, Florence Donatello, Gattamelata equestrian statue, Padua Leonardo da Vinci peak of Persian miniature painting Botticelli, *Primavera*	Shrovetide plays and farces, Germany basse dance spreads throughout Europe revival of classical drama, Italy	Christine de Pisan, *Dit de la Rose* François Villon, *Testament* Malory, *Morte d'Arthur* Sebastian Brant, *The Ship of Fools*	*Meistersinger*, Germany flowering of Burgundian school of secular music refinement of music in Japanese No dramas Dufray and Binchois flourish Dunstable develops cantus firmus mass development of keyboard tablature earliest wholly printed music in Europe Jean d'Ockeghem
1500–1599	Bramante, St Peter's, Rome Michelangelo, Sistine Chapel ceiling Dürer, *Knight, Death, and the Devil* peak of Inca civilization Palladio, Villa Rotonda Cathedral of St Basil the Blessed, Moscow Wen Zhengming, Chinese painter Bruegel, *Hunters in the Snow* Mexico Cathedral El Greco, *Burial of Count Orgaz*	*intermedii* court spectacles evolve in Italy boy actors' companies flourish in England Inquisition bans realist dramas of Gil Vicente *commedia dell'arte* plays spread from Italy through Europe Golden Age of Spanish theatre flowering of *ballet de cour* in France Marlowe, *Dr Faustus* The Globe, Elizabethan theatre, opens in London	Castiglione, *The Book of the Courtier*, Italy Rabelais, *Pantagruel* Cranmer, *The Book of Common Prayer* More, *Utopia* Camões, *The Lusiads* Tulsīdās, *Rāmcaritmānas* Montaigne, *Essais* Spenser, *The Faerie Queene*	consort music flourishes Taverner, 'Western Wynde' mass emergence of the madrigal Palestrina, *Missa Papae Marcelli* Tallis 40-part motet, *Spem in alium* variation form developed in keyboard works Byrd, *Psalmes, Sonets and Songs* Farnaby, *Canzonets to Fowre Voyces*
1600–1699	beginning of porcelain manufacture, Japan *ukiyo-e* art in Japan Blue Mosque, Constantinople Taj Mahal, Agra, India Rembrandt, *The Night Watch* Velazquez, *Las Meninas* Bernini, Church at Castel Gandolfo, Italy Wren, St. Paul's Cathedral, London	Kathakali dance-form emerges in India Shakespeare, *Hamlet* court masques in England kabuki troupes, Japan Calderón, *Life is a Dream* Corneille, *Le Cid* Restoration comedy, England Molière, *Le Misanthrope* Racine, *Phèdre* Comédie Française, Paris, founded	Tang Xianzu, *The Peony Pavilion*, China Donne, 'The Progress of the Soul' Cervantes, *Adventures of Don Quixote* Shakespeare, *Sonnets* King James Bible, England Bashō, Japanese haiku master, flourishes Milton, *Paradise Lost* Grimmelshausen, *Simplicissimus*	beginning of Baroque music and rise of monody Dowland, *Lachrimae* or *Seaven Teares* Monteverdi, *L'Orfeo* Praetorius, *Terpsichore*: collection of dance music Frescobaldi, *Fiori musicali* Schütz, *St. Matthew Passion* Purcell, *Dido and Aeneas* François Couperin, harpsichord music
1700–1799	Tsarskoye Selo Palace, Russia Vanburgh, Bleinheim Palace, England Sans Souci Palace, Potsdam Redwood Library, Newport; USA Neumann, Bishops' Palace, Würzburg, Germany Utamaro, Japanese print-maker flourished Adam, Kenwood House, London David, *Oath of the Horatii*	Chikamatsu's puppet plays, Japan Gay, *The Beggar's Opera* ballet developed by Noverre into separate art-form Goldsmith, *She Stoops to Conquer*	Pope, 'The Rape of the Lock' Abbé Prévost, *Manon Lescaut* Fielding, *Tom Jones* Voltaire, *Candide* Sterne, *Tristram Shandy* Walpole, *Castle of Otranto* Goethe, *The Sorrow of Young Werther* *Sturm und Drang* movement in Germany Blake, *Songs of Innocence* Wordsworth and Coleridge, *Lyrical Ballads*	Corelli, 12 Concerti grossi J. S. Bach, *St Matthew Passion* Vivaldi, *The Four Seasons* Gay, *The Beggar's Opera* Handel, *Messiah* J. S. Bach, *Art of Fugue* C. P. E. Bach, keyboard sonatas Mozart, *Don Giovanni* Haydn, *The Creation*